MAPPING *CULTURE & VALUES*

Today we view the Earth from satellites and navigate via GPS on our smartphones and in our cars. But mapping is an ancient art by which journeyers and explorers set down their most accurate impressions of where things were on stone tablets, papyrus, and, eventually, paper. There are maps that show the boundaries of nations and peoples, maps that reveal the height of frigid peaks and the icy depths of oceans, maps that shows lands arid and fertile, maps that define human populations and migrations.

The maps throughout *Culture & Values* provide a geographical context for the development of the humanities—language and literature, art and architecture, music, religion and philosophy. We follow the historic sweep of cultures in which the world's major languages—ancient forms of Chinese, Greek, Latin, and myriad African tongues—were spoken by millions. We see empires that grew like uncontrolled vines, empires that were shredded, empires whose cultural values and pursuits changed rapidly even as their geographical borders did not.

Culture and values are influenced by their geographical location—their climate, their soil, their plant and animal life—and also by their social and political histories. Maps show us who were next to whom and how that proximity affected cultural exchange. We see who was distant from whom and understand why cultures can seem "a world apart." Maps show us how and why peoples came to settle in various regions, bringing their cultural lives with them, often sharing them with indigenous peoples and moving them both in new directions.

And in more recent years, we come to understand why the poet Rudyard Kipling's line, "Oh East is East and West is West and never the twain shall meet" is no longer as true as it once may have seemed. Music from diverse cultures can be downloaded to iPods and computers on every continent; books from every corner of the world are being translated electronically; and museum collections can be accessed by logging on to their websites for a "virtual tour."

The lines that define the borders of nations in the world map that follows comprise a snapshot—a snapshot of the world as it is now. As the maps throughout *Culture & Values* testify, such borders have shifted throughout the millennia. And they suggest ways in which those shifts have impacted the blossoming and the decline of languages, religions, political and social movements—and the arts. The snapshot before us now may be familiar, but, as history has taught us, it is but an image of things in motion.

ABBREVIATIONS

AUS.	AUSTRIA
BEL.	BELGIUM
B. H.	BOSNIA AND HERZEGOVINA
CR.	CROATIA
CZ.	CZECH REPUBLIC
DEN.	DENMARK
HUNG.	HUNGARY
K.	KOSOVO
LUX.	LUXEMBOURG
MAC.	MACEDONIA
MO.	MONTENEGRO
NETH.	NETHERLANDS
SE.	SERBIA
SLK.	SLOVAKIA
SLN.	SLOVENIA
SWITZ.	SWITZERLAND

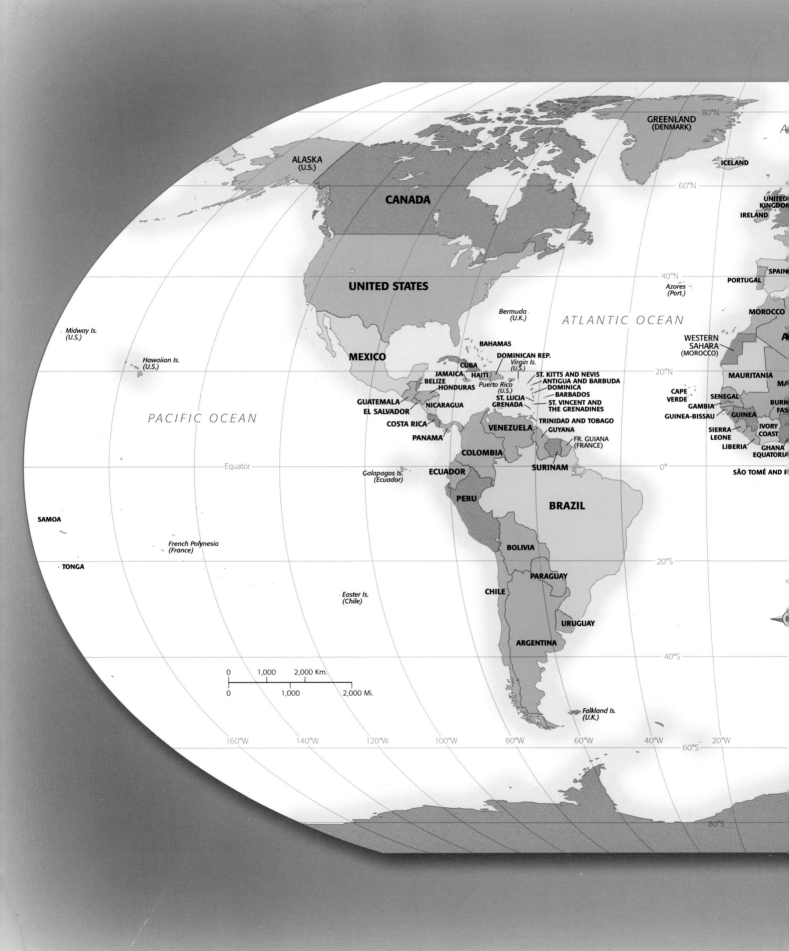

CULTURE &VALUES

A SURVEY OF THE HUMANITIES

EIGHTH EDITION

LAWRENCE S. CUNNINGHAM

John A. O'Brien Professor of Theology
University of Notre Dame

JOHN J. REICH

Syracuse University
Florence, Italy

LOIS FICHNER-RATHUS

The College of New Jersey

WADSWORTH
CENGAGE Learning·

AUSTRALIA • BRAZIL • JAPAN • KOREA • MEXICO • SINGAPORE • SPAIN • UNITED KINGDOM • UNITED STATES

Culture and Values: A Survey of the Humanities, Eighth Edition
Lawrence S. Cunningham, John J. Reich, Lois Fichner-Rathus

Publisher: Clark Baxter

Senior Development Editor: Sharon Adams Poore

Assistant Editor: Ashley Bargende

Editorial Assistant: Marsha Kaplan

Associate Media Editor: Chad Kirchner

Brand Manager: Lydia LeStar

Market Development Manager: Joshua I. Adams

Senior Content Project Manager: Lianne Ames

Senior Art Director: Cate Rickard Barr

Manufacturing Planner: Sandee Milewski

Senior Rights Acquisition Specialist: Mandy Groszko

Production Service: Lachina Publishing Services

Text and Cover Designer: Frances Baca

Cover Image: *Nike of Samothrace, Goddess of Victory.* Hellenistic, ca. 190 BCE. Louvre, Paris, France. Credit: Erich Lessing / Art Resource, NY

Compositor: Lachina Publishing Services

For product information and technology assistance, contact us at **Cengage Learning Customer & Sales Support, 1-800-354-9706**

For permission to use material from this text or product, submit all requests online at **www.cengage.com/permissions**
Further permissions questions can be emailed to **permissionrequest@cengage.com**

Library of Congress Control Number: 2012943421

ISBN-13: 978-1-133-94533-8

ISBN-10: 1-133-94533-3

Wadsworth
20 Channel Center Street
Boston, MA 02210
USA

Cengage Learning is a leading provider of customized learning solutions with office locations around the globe, including Singapore, the United Kingdom, Australia, Mexico, Brazil and Japan. Locate your local office at **international.cengage.com/region**

Cengage Learning products are represented in Canada by Nelson Education, Ltd.

For your course and learning solutions, visit **www.cengage.com**.

Purchase any of our products at your local college store or at our preferred online store **www.cengagebrain.com**.

Instructors: Please visit **login.cengage.com** and log in to access instructor-specific resources.

Printed in the United States of America
1 2 3 4 5 6 7 16 15 14 13 12

About the Cover

Since 1884, the Winged Victory of Samothrace has beckoned waves of museumgoers to climb a grand staircase toward its perch on a marble ship fragment in Paris's Louvre Museum. Archaeologists believe that the Hellenistic Greek statue of Nike, the goddess of victory—which was found in pieces on a small island in the northern part of the Aegean Sea—may have been carved to commemorate the triumphant outcome of a naval battle. Nike alights on the prow of a warship, bracing herself against the wind and spray of the sea, her wings still fluttering and her water-soaked garments billowing and clinging sensuously to her torso. The artist maximized the potential of the surroundings, tucked in a rocky niche overlooking the Sanctuary of the Gods, to heighten the illusion of reality and to augment the drama of the piece. The marble prow was set in a pool at the top of a fountain whose water splashed against it like crashing waves. Nike's dynamic forward stance, and what we imagine to be the swelling and pitching of the sea and the ship, are equalized by the steadying force of the goddess's outstretched wings. Even in the museum setting in which we find the Winged Victory today, the power of its presence can be felt. It is as if the goddess, having just alighted, may at any instant soar over us.

The drama surrounding the Winged Victory has extended beyond the artist's theatrical site-specific installation on the island of Samothrace. In the year 1939, as the world began to brace itself for war, museums braced themselves for its impact on art treasures. At the Louvre, antique sculptures were rounded up and stored in the basement and paintings were removed from their frames and sent to châteaus in the French countryside for safekeeping. In the middle of the night on September 3, the Winged Victory—hoisted by a system of ropes and pulleys—made its way from the top of the staircase down specially constructed wooden ramps and was shipped off to spend the war years at the Château de Valençay in the French province of Berry.

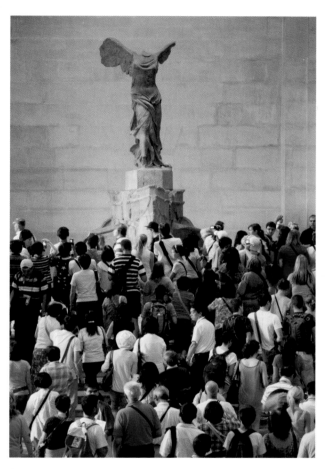

▲ Winged Victory (Nike of Samothrace), ca. 190 BCE. Marble, 129″ (328 cm). Musée du Louvre, Paris, France.

Contents

Rome 117

Ancient Civilizations of India and China 159

The Rise of the Biblical Tradition 189

The High Middle Ages 303

The Fourteenth Century: A Time of Transition 339

The Seventeenth Century: The Baroque Era 505

The Eighteenth Century 555

Romanticism, Realism, and Photography 595

Toward the Modern Era: 1870–1914 659

The Contemporary Contour 821

Reading Selections

iTunes Playlists by Chapter

Find the iTunes playlist by chapter on iTunes.

William S. Gilbert and Arthur Sullivan: *HMS Pinafore*:
 "When I Was a Lad"

Gilbert & Sullivan: HMS Pinafore (1948 Version)
Martyn Green, Darrell Fancourt & D'Oyly Carte
 Opera Company

Piotr Ilych Tchaikovsky: *The Nutcracker*, Op.71: XIII.
 Waltz of the Flowers
Tchaikovsky: The Nutcracker
Orchestra of the Kirov Opera, St. Petersburg & Valery Gergiev

Piotr Ilych Tchaikovsky: *The Nutcracker*, Op.71: XIIb. Character
 Dances: Coffee (Arabian Dance).
Tchaikovsky: The Nutcracker
Orchestra of the Kirov Opera, St. Petersburg & Valery Gergiev

Claude Debussy: *Suite bergamasque*: "Claire de lune"
The Debussy Collection
Paul Crossley

Arnold Schoenberg: *Pierrot Lunaire*, Op. 21: I. "Mondestrunken"
Schoenberg: Pierrot Lunaire
Ensemble Musique Oblique, Marianne Pousseur &
 Philippe Herreweghe

Igor Stravinsky: *Le Sacre du printemps* (The Rite of Spring):
 "Danses des adolescentes"
Stravinsky: Pétrouchka, Rite of Spring
Cleveland Orchestra & Pierre Boulez

20

"Good Lord (Run Old Jeremiah)"
*Negro Religious Field Recordings from Louisiana, Mississippi,
 Tennessee Vol. 1 1934–1942*

Paul Robeson: "Go Down, Moses"
The Originals: Spirituals (Remastered)
Paul Robeson

Charles Albert Tindley: "We Shall Overcome"
Freedom Songs: Selma, Alabama
Workers in Selma at Mass for Jimmie Lee Jackson

21

Scott Joplin: "Maple Leaf Rag"
Scott Joplin: Piano Rags
Alexander Peskanov

Joe "King" Oliver: "West End Blues"
Louis Armstrong and His Hot Five

Ella Fitzgerald: "Blue Skies"
Ella Fitzgerald: Gold
Ella Fitzgerald

Billy Strayhorn: "Take The 'A' Train"
Duke Ellington Plays Billy Strayhorn
Duke Ellington & His Orchestra

Benny Goodman: "Sing, Sing, Sing"
The Essential Benny Goodman (Remastered)
Benny Goodman

Glenn Miller: "In the Mood"
In the Mood—The Very Best of Glenn Miller
Glenn Miller

Lotte Lenya: *Threepenny Opera*: "Mack the Knife"
Sony Classical—Great Performances, 1903–1998
Lotte Lenya

George and Ira Gershwin: *Porgy and Bess*: Summertime
Classical Gershwin
Anna Moffo, Lehman Engel Chorus, Lehman Engel & Lehman
 Engel Orchestra

22

John Cage: Sonata #2
John Cage: Sonatas & Interludes for Prepared Piano
Joshua Pierce

Steve Reich: *The Desert Music*: Third Movement,
 Part One (slow); *The Desert Music*: Third Movement,
 Part Two (moderate)
Steve Reich: Works—1965–1995
Brooklyn Philharmonic Orchestra & Michael
 Tilson Thomas

Philip Glass: *Music in 12 Parts, Part 1*
Glass: Music in 12 Parts—Part 1
Philip Glass Ensemble

Dmitri Shostakovich: Symphony No. 13, "Babi Yar":
 II. Humour
The Very Best of Shostakovich
Eder Quartet & Dmitri Shostakovich

Andrew Lloyd Webber: *Jesus Christ Superstar*: "Superstar"
Jesus Christ Superstar (20th Anniversary London Cast Recording)
Andrew Lloyd Webber

Claude-Michel Schönberg: *Miss Saigon*: "The Heat Is On
 in Saigon"
Miss Saigon
London Theatre Orchestra and Cast

Rodgers and Hammerstein II: *South Pacific*: "You've Got to Be
 Carefully Taught"
South Pacific (The New Broadway Cast Recording)
Matthew Morrison

"Hair"
Hair (The New Broadway Cast Recording)
Gavin Creel, Will Swenson & Tribe

Jonathan Larson: *Rent*: "One Song Glory"
Rent (1996 Original Broadway Cast)
Original Broadway Cast

Elvis Presley, written by Mae Boren Axton and Tommy Durden:
 "Heartbreak Hotel"

The Essential Elvis Presley (Remastered)
Elvis Presley

John Lennon and Paul McCartney: "I Want to Hold Your Hand"
1
The Beatles

John Lennon and Paul McCartney: "Back in the U.S.S.R."
The Beatles (White Album)
The Beatles

Brian Wilson and Mike Love: "California Girls"
Sounds of Summer—The Very Best of The Beach Boys
The Beach Boys

Steven Tyler and Joe Perry: "Walk This Way"
Ultimate Run-D.M.C.
Run-D.M.C.

Rod Temperton: "Thriller"
Thriller
Michael Jackson

Preface to the Eighth Edition

The eighth edition of *Culture & Values* continues in its mission to teach students about the history of the world through the lens of the humanities—language and literature, art and architecture, music, philosophy, and religion. It is through the study of the humanities that we aim not only to *know* but to *understand*—to consider what humans across time and lands have thought about, how they have felt or acted, how they have sought to express or come to terms with their relationship to the known and unknown, to their values, their spirituality, their inner selves. *Culture & Values* encourages students to place their own backgrounds and beliefs in context and to consider how understanding both their own and other heritages contribute to becoming a true citizen of the world in the 21st century.

A NEW EDITION

Users of the book will find that the eighth edition is familiar yet, in many respects, quite new.

New Coverage

- More than 200 new works of art, including historic landmarks and global art in the 21st century.
- Enhanced discussion of architecture, from the ancient walls of Jericho and mosques of the Islamic caliphates, to Postmodern and Deconstructivist architecture, to Shanghai's explosive new skyline.
- Dozens of new literary works from many periods and cultures—women writers such as the Roman poet Sulpicia, the Chinese poet Li Qingzhao, and the Venetian courtesan Veronica Franco; artist-poet William Blake; Mary Shelley and Edgar Allan Poe; Oscar Wilde; Gertrude Stein and Ernest Hemingway; Ralph Ellison; John Updike, Jack Kerouac; Maya Angelou and Toni Morrison; excerpts from the Bhagavad Gita and *Rig-Veda*; *The Thousand and One Nights* and Omar Khayyam; and the poetry and novels of Ihara Saikaku of Japan.
- More works by women; by artists, writers, and musicians of color; and by the peoples of Asia and Africa.
- Expanded coverage of the histories of photography, film, and video art, beginning with photographers such as Niépce and Daguerre and including contemporary artists such as Cindy Sherman, Matthew Barney, and Bill Viola; new discussions of film genres ranging from Japanese "monster flicks" such as *Godzilla* to American classics like *Gone with the Wind*.
- New discussion of opera and musical theatre, including the works of Bizet (*Carmen*), Puccini (*Madame Butterfly, La Bohème, Tosca*), and Gilbert and Sullivan (*H.M.S. Pinafore, The Mikado*), and the 20th-century American musical-theater phenomena *Hair* and *Rent*.
- Students are now directed with "Go Listen!" icons to download selections from iTunes from the iTunes playlist. Instructors also now have an extended playlist for use in the classroom.

New Features

A DYNAMIC, ELEGANT, AND ACCESSIBLE NEW DESIGN features enlarged, high-quality images: brilliant, accurate-color reproductions of works of art, in many cases half- to full-page width or depth, along with large-format reproductions of original pages of literary works such as Chaucer's *The Canterbury Tales*, the Limbourg brothers' *Les Très riches heures du duc de Berry*, and the original Gutenberg Bible. Students will be better able to fully appreciate the visual impact of these works and may be inspired to seek out art in museums and to visit historic sites.

NEW CHAPTER PREVIEWS draw students into each chapter by connecting intriguing chapter-opening works of art and other images with the ideas and ideals that permeate the eras under discussion. From the opening chapter—in which students discover how contemporary technologies are used to reconstruct the human past—to the last—in which the emergence of new media chart multiple cultural and artistic directions in the 21st century—students are encouraged to face each new period with curiosity and anticipation. At the same time, the previews reinforce connections to the knowledge students have accumulated from previous chapters.

NEW COMPARE + CONTRAST features present two or more works of art or literature side by side and encourage students to focus on stylistic, technical, and cultural similarities and differences. The features promote critical thinking by encouraging students to consider the larger context in which works were created, honing their interpretive skills, and challenging them to probe for meaning beyond first impressions. Compare + Contrast parallels the time-honored pedagogy of analyzing works or art, texts, and ideas by describing their similarities and differences.

A sample of COMPARE + CONTRAST topics follows:

- "Unraveling Penelope," in the chapter called "The Rise of Greece," examines the magnetism of the Homeric hero Odysseus's wife as a poetic subject, asking students to think about what prevailing contemporary gender ideologies might have been when the texts were authored

and, more generally, about gendered representation in the arts.

- "Stadium Designs: Thumbs-Up or Thumbs-Down?" in the chapter on Rome asks students to consider the style, function, and message behind each of four stadiums, including the famous Roman Colosseum and Hitler's 1936 Olympic Stadium in Berlin.
- "Ganesh, the Hindu Deity: Don't Leave Home Without Him," in the expanded chapter on ancient India and China, provides a springboard for a discussion of the relevance of age-old beliefs and traditions to contemporary life by looking closely at adaptations and appropriations of the god's iconic image.
- "Journeys of Faith," in the expanded chapter on Islam, asks students to explore the geographical and theological intersections among pilgrimage routes and destinations sacred to Jews, Christians, and Muslims.
- "Courtesans, East and West" compares and contrasts the gender and societal roles of courtesans in Renaissance Venice and Japan, and explores correspondences between diverse cultural perspectives on gender equality and the female body.
- "Vision and Difference: Three Paintings Entitled *Susanna and the Elders*" raises student awareness of the ways in which, in familiar narratives, gender ideology both reflects and constructs societal attitudes.
- "Mona Lisa: From Portrait to Pop Icon" asks students to reflect on factors that contribute to iconic status and the power of iconic imagery as a vehicle for social commentary.

READINGS PLACED WITHIN THE RUNNING NARRATIVE, rather than clustered in sections or at the ends of chapters, maintain the flow of the discussion of material and are chosen to succinctly illustrate major points. As an example, five brief extracts from the *Epic of Gilgamesh* are woven into the discussion of ancient Sumer in chapter 1. Similarly, five excerpts from the *Aeneid* by Virgil are interspersed in the coverage of that epic's content and the context in which it was written.

NEW CLEAR AND CONCISE TIMELINES early in each chapter give students a broad framework for the periods under discussion by highlighting seminal dates and events.

NEW END-OF-CHAPTER GLOSSARIES provide students with an easy way to access and review key terms and their meanings.

THE BIG PICTURE, new to the eighth edition, these bring each chapter to a close by gathering summaries of the cultural events and achievements that shaped the character of each period and place. Organized into categories (Language and Literature; Art, Architecture, and Music; Philosophy and Religion), the Big Picture reinforces for students the simultaneity of developments in history and the humanities.

WHAT'S NEW IN THE EIGHTH EDITION— CHAPTER BY CHAPTER

1 Beginnings

- New chapter preview on methods used to reconstruct the face of the pharaoh Tutankhamen
- Twenty-one new figures and works of art, including a 100,000-year-old bowl for mixing paints and a 35,000-year-old bone flute
- New Compare + Contrast feature on ancient fertility goddesses: "Mystery Ladies of the Ancient World"
- New Values feature on Egypt: "Righteousness as the Path to Emerging Forth into the Light"
- New readings from the Law Code of Hammurabi, Akhenaton ("Hymn to the Sun"), the Leiden Hymns, and ancient Egyptian love songs

2 The Rise of Greece

- New chapter preview on the Shield of Achilles as a microcosm of Greek culture and values
- Six new figures and works of art
- New Compare + Contrast feature on images of Zeus and of George Washington: "Gods into Men, Men into Gods"
- New Compare + Contrast Feature, "Unraveling Penelope," with traditional and more feminist views of Penelope's travails as she awaits the return of Odysseus from the Trojan War
- New Values feature: "Fate, Chance, and Luck"
- New Voices feature: "Life and Death in the World of Homer"

3 Classical Greece and the Hellenistic Period

- New chapter preview on Aeschylus and *The Persians*
- Expanded coverage of early Greek philosophers
- New readings from the drama of Aeschylus

4 Rome

- New chapter preview on Aeneas as the embodiment of Roman virtues of seriousness of purpose, duty, dignity, and courage
- Twelve new figures and works of art
- New Compare + Contrast feature on stadium designs past and present: "Stadium Designs: Thumbs-Up or Thumbs-Down?"
- New Values feature: "Roman Ideals as Seen Through the Prism of the *Aeneid*"
- New Voices feature: "Correspondence Between Pliny the Younger and the Emperor Trajan About Christians"

- New readings from the works of Julius Caesar, Cicero, Lucretius, Seneca, Epictetus, Sulpicia, Horace, and Ovid

5 Ancient Civilizations of India and China

- New chapter preview on Hermann Hesse's *Siddhartha* and Buddhism

- Eleven new figures and works of art

- New coverage of the six canons of Chinese painting

- New Compare + Contrast feature on ancient and current depictions of the god Ganesh, "Ganesh, the Hindu Deity: Don't Leave Home Without Him," including a 21st-century painting and plastic figures

- New Values feature on Buddhism: "The Four Noble Truths"

6 The Rise of the Biblical Tradition

- New chapter preview on the *Sacrifice of Isaac*

7 Early Christianity: Ravenna and Byzantium

- New chapter preview on Saint Augustine

- New Compare + Contrast feature: "Boethius's *Consolation of Philosophy* and Marcus Aurelius's *Meditations*"

- New Values feature: "The Greens and the Blues: A Clash of Values"

8 Islam

- New chapter preview on Muhammad's Night Journey

- Sixteen new figures and works of art

- New Compare + Contrast feature on pilgrimages in the three Abrahamic religions: "Journeys of Faith"

- New coverage of Islamic music

- New Values feature: "The Five Pillars of Islam"

- New Voices feature: "Jalal ad-Din Muhammad Rumi on the Three Blind Men and the Elephant"

- New coverage of styles of calligraphy

- New coverage of *The Thousand and One Nights* and The *Rubáiyát of Omar Khayyám*

9 The Rise of Medieval Culture

- New chapter preview on Hildegard of Bingen

- Seven new figures and works of art

- New coverage of *Beowulf*

- New Compare + Contrast feature: "Four Paintings of Saint Matthew"

10 The High Middle Ages

- New chapter preview on jousting—in the Middle Ages and today

- New Compare + Contrast feature: "The Old Woman in the *Romance of the Rose* and The Wife of Bath in *The Canterbury Tales*"

- New coverage of the *Romance of the Rose*

- New Values feature: "Chivalry and Courtly Love"

- New coverage of troubadours and troubairitz, with poems by Guillem de Peiteus; Bernart de Ventadorn; Beatriz, Comtessa de Dia; and Bertran de Born

- New coverage of Moses Maimonides

11 The 14th Century

- New chapter preview on Dante and Giotto

- New Compare + Contrast feature: "Scenes from the Passion of Christ by Giotto and Duccio"

- New Voices feature: "Giovanni Boccaccio, Witness to the Black Death"

12 The 15th Century

- New chapter preview on Botticelli

- New reading by Lorenzo de' Medici

13 The High Renaissance and Mannerism in Italy

- New chapter preview on Pope Julius II and Michelangelo

- Five new figures and works of art

- New Compare + Contrast feature: "Courtesans, East and West"

- New coverage of the writing of Leonardo da Vinci ("Letter of Application to Ludovico Sforza") and the poetry of Michelangelo, Vittoria Colonna, and Veronica Franco

14 The High Renaissance in the North

- New chapter preview on Shakespeare as the epitome of northern Renaissance humanism

- New Compare + Contrast feature: "Plutarch and Shakespeare's Descriptions of Cleopatra on the Barge"

- New coverage of the poetry and drama of Thomas Wyatt, Edmund Spenser, Queen Elizabeth I, and Christopher Marlowe

- New readings from several of Shakespeare's plays, including *Romeo and Juliet*; *Henry IV, Part 1*; *Julius Caesar*; *and Antony and Cleopatra*

- New inclusion of Shakespeare's sonnets

15 The 17th Century

- New chapter preview on *The Ecstasy of Saint Teresa*

- Seven new figures and works of art

- Two new Compare + Contrast features: "The *Davids* of Donatello, Verrocchio, Michelangelo, and Bernini" and

"Vision and Difference: Three Paintings Entitled *Susanna and the Elders*"

- New Voices feature on Giambattista Passeri describing the suicide of Francesco Borromini

- New coverage of the poet Andrew Marvell

16 The 18th Century

- New chapter preview on Jacques-Louis David

- Five new figures and works of art

- New Compare + Contrast feature: "David's *Napoleon Crossing the Alps* with Wiley's *Napoleon Leading the Army Over the Alps*"

- New coverage of Robert Burns and Mary Wollstonecraft

17 Romanticism, Realism, and Photography

- New chapter preview on *A Tale of Two Cities*

- New chapter directions: chapter retitled "Romanticism, Realism, and Photography"

- Nineteen new figures and works of art

- New Compare + Contrast feature: "Women, Art, and Power: Ideology, Gender Discourse, and the Female Nude"

- New Values feature: "Transcendentalism"

- New Voices feature: "Charles Baudelaire: A View of the Modernization of Paris"

- New coverage of the poets and novelists William Blake, Samuel Taylor Coleridge, Jane Austen, Mary Wollstonecraft Shelley, Henry David Thoreau, Edgar Allan Poe, and Nathaniel Hawthorne

- New section on the development of photography

18 Toward the Modern Era: 1870–1914

- New chapter preview on Édouard Manet and Émile Zola

- Seventeen new figures and works of art

- New Compare + Contrast feature: "The Politics of Sexuality: The Female Body and the Male Gaze"

- New coverage of the opera composers Georges Bizet and Giacomo Puccini

- New coverage of light opera, with a focus on Gilbert and Sullivan

- New coverage of the writers Mark Twain, Émile Zola, Oscar Wilde, Mona Caird, A. E. Housman, and Rudyard Kipling

19 India, China, and Japan: From Medieval to Modern Times

- New chapter preview on the Silk Road

- Nine new figures and works of art, including 20th- and 21st-century works of art and architecture

- New Compare + Contrast feature: "Mahatma Gandhi and Martin Luther King Jr."

- Two new Values features: "Satyagraha" and "Bushido: The Eight Virtues of the Samurai"

- New coverage of the writers Rabindranath Tagore, Murasaki Shikibu, and Ihara Saikaku

- New coverage of Indian and Japanese film, including the films of Satyajit Ray and Akira Kurosawa and *Godzilla*

20 Africa

- New chapter preview on the emergence of modern humans in Africa

- Eleven new figures and works of art

- New section on slavery and colonialism

- New Compare + Contrast feature: "Out of Africa: The Enduring Legacy of the Ceremonial Mask," which discusses relationships between traditional masks and 20th- and 21st-century appropriations

- New Values feature: "From the Autobiography of Wangari Muta Maathai"

- New section on African music, including discussion of cross-rhythm and African instruments

21 The World at War

- New chapter preview on the bombing of Guernica

- New discussion of the history of World Wars I and II

- Sixteen new figures and works of art

- New Compare + Contrast feature: "Mona Lisa: From Portrait to Pop Icon"

- New coverage of the poets and writers Rupert Brooke, Isaac Rosenberg, Ernest Hemingway, and Sinclair Lewis

22 The Contemporary Contour

- New chapter preview on Jackson Pollock and his legacy

- Forty new figures and works of art

- New sections: "The 1960s," "The Feminist Perspective," "Minimal Art," "Conceptual Art," "Site-Specific Art," "Pop Art," "Art, Identity, and Social Consciousness," "Sculpture," and "Video"

- New Compare + Contrast feature on "Heizer's Rift with Libeskind's Jewish Museum"

- New Voices feature: Woody Allen's Universe: On Being, Nothingness, and Laughter

- New coverage of the poets and writers Jack Kerouac, Paul Celan, Kurt Vonnegut Jr., John Updike, Edward Albee, Ralph Ellison, Maya Angelou, Sylvia Plath, Anne Sexton

- New coverage of rock opera, musical theater, rock and roll, hip-hop and rap, and the music video

THE CONTINUING PEDAGOGICAL TRADITIONS OF *CULTURE & VALUES*

THE WRITING STYLE of the eighth edition of *Culture & Values* retains its vivid, personal character and incisive presentation of key historic events. Comprehensive yet purposeful in its coverage, the first goal of *Culture & Values* remains *accessibility*.

THE POPULAR "VOICES" FEATURES capture the sense of real people in real time—their reactions to and thoughts about the cultural events of their day. The features foster critical thinking by asking students to reflect on the uniqueness and universality of some human traits and behavior, and the ways in which beliefs and mores influence actions. Topics new to the eighth edition include the eruption of Mount Vesuvius in 79 CE as seen through the eyes of Pliny the Younger, whose uncle and thousands of others perished in the disaster that buried Pompeii; and the ravages of the Black Plague of 1348, described first hand by the Italian writer Boccaccio in the *Decameron*.

THE FEATURES ON "VALUES" PROVIDE the seeds for deeper discussions of cultural values that have contributed to people's views of right and wrong, good and evil, and what inspires them to achieve. Themes new to the eighth edition include the pursuit of—and path to—eternal life in Egyptian religion; resistance as a revolutionary tool in India's pursuit of freedom from British colonial rule; and bushido, the chivalric code of behavior and ethics for the Japanese samurai warriors.

ACKNOWLEDGMENTS

I wish to thank those reviewers who helped revise this edtion: Lara Apps, Athabasca University; Marnie Brennan, Harrisburg Area Community College; Skip Eisiminger, Clemson University; Phyllis Gooden, American InterContinental University Online; Jason Horn, Gordon State College; Suzanne Jacobs, Salt Lake Community College; Seth Lerman, Florida Technical College; Colin Mason, Temple College; Debra Maukonen, University of Central Florida; Victoria Neubeck, Moraine Valley Community College; Nancy Shelton, Valencia Community College; Pamela Smith-Irowa, College of DuPage; Brandy Stark, St. Petersburg College; Jeffery Vail, Boston University; Sandra Yang, Cedarville University; and the nearly two hundred instructors who responded to our survey and participated in interviews.

The authors acknowledge that an edition with revisions of this magnitude could not be undertaken, much less accomplished, without the vision, skill, and persistent dedication of a superb team of publishing professionals. First and foremost is Clark Baxter, Publisher, who saw the book you are holding in your hands in his mind's eye and rallied it all to make it happen. Sharon Adams Poore, Senior Development Editor, whose expertise and sensibilities make their mark on every project she oversees, worked tirelessly on the manuscript, figures, literary extracts, music, and design. Lianne Ames, Senior Content Project Manager, brilliantly negotiated the myriad details, desires, and decisions and kept all of the parts of the project moving toward their grand conclusion. Abbie Baxter, Photo Researcher, literally scoured the four corners of the Earth to acquire the splendid art you see throughout the book. When it couldn't be done, she still made it happen— with her signature blend of imagination, determination, good taste and good humor. Senior Art Editor Cate Rickard Barr coordinated all of the visual aspects of the project and it is her elegant and striking aesthetic that permeates the look and feel of the book. Matt Orgovan, Project Manager at Lachina Publishing Services, was indefatigable in his efforts to capture our vision between two covers.

We can only list the others involved in the production of this edition or the kudos would fill a chapter itself: Ashley Bargende, assistant editor; Marsha Kaplan, editorial assistant; Chad Kirchner, associate media editor; Lydia LeStar, brand manager; Sandee Milewski, print buyer; Mandy Grozko, senior rights acquisition specialist; Pinky Subi, text researcher; Frances Baca, text and cover designer; and Joshua Adams, market development manager. Lois Fichner-Rathus would also like to thank Spencer Rathus, her husband and her silent partner, for the many roles he played in the concept and execution of this edition.

ABOUT THE AUTHORS

Lawrence Cunningham is the John A. O'Brien Professor of Theology at the University of Notre Dame. He holds degrees in philosophy, theology, literature, and humanities.

John Reich, of Syracuse University in Florence, Italy, is a trained classicist, musician, and field archaeologist. Both Cunningham and Reich have lived and lectured for extended periods in Europe.

Lois Fichner-Rathus, the new coauthor of the eighth edition, is a professor of art history at the College of New Jersey. She holds degrees from the Williams College Graduate Program in the History of Art and in the history, theory, and criticism of art from the Massachusetts Institute of Technology. She is the author of the textbooks *Understanding Art* and *Foundations of Art and Design*. She has taught in Paris and Rome, and resides in New York.

RESOURCES

For Faculty

POWERLECTURE WITH DIGITAL IMAGE LIBRARY
This flash drive is an all-in-one lecture and class-presentation tool that makes it easy to assemble, edit, and present customized lectures for your course using Microsoft® PowerPoint®.

Available on flash drive, the Digital Image Library provides high-resolution images for lecture presentations, either in an easy-to-use PowerPoint® presentation format or in individual file formats compatible with other image-viewing software. A zoom feature allows you to magnify selected portions of an image for more detailed display in class; you can also display images side by side for comparison and contrast. You can easily customize your classroom presentation by adding your own images to those from the text. The PowerLecture also includes an electronic instructor's manual and a test bank with multiple-choice, matching, short-answer, and essay questions in ExamView® computerized format.

WEBTUTOR WITH E-BOOK ON WEBCT® AND BLACKBOARD® Combining course management with a flexible, easy-to-use format, WebTutor enables you to assign preformatted, text-specific content that is available as soon as you log on. You can also customize the WebTutor environ-ment in any way you choose. Content includes the test bank, practice quizzes, video study tools, and CourseMate.

To order, contact your Cengage Learning representative.

For Students

COURSEMATE WITH E-BOOK Make the most of your study time by accessing everything you need to succeed in one place. Open the interactive e-book, take notes, review images and audio flash cards, watch videos, listen to music, and take practice quizzes. Use the flash cards of images in the book to test your knowledge and prepare for tests.

To order, if an access code did not accompany your text, go to *www.cengagebrain.com.*

WEBSITE For resources, go to the Student Companion Site, accessed through *www.cengagebrain.com.*

The Arts: An Introduction

One way to see the arts as a whole is to consider a widespread mutual experience: a church or synagogue service or the worship in a Buddhist monastery. Such a gathering is a celebration of written literature done (at least in part) in music in an architectural setting decorated to reflect the religious sensibilities of the community. A church service makes use of visual arts, literature, and music. While the service acts as an integrator of the arts, each art, considered separately, has its own peculiar characteristics that give it shape. The same integration may be seen, of course, in an opera or in a music video.

Music is primarily a temporal art, which is to say that there is music when there is someone to play the instruments and sing the songs. When the performance is over, the music stops.

The *visual arts* and *architecture* are spatial arts that have permanence. When a religious service is over, people may still come into the building to admire its architecture or marvel at its paintings or sculptures or look at the decorative details of the building.

Literature has a permanent quality in that it is recorded in books, although some literature is meant not to be read but to be heard. Shakespeare did not write plays for people to read, but for audiences to see and hear performed. Books nonetheless have permanence in the sense that they can be read not only in a specific context but also at one's pleasure. Thus, to continue the example of the religious service, one can read the psalms for their poetry or for devotion apart from their communal use in worship.

What we have said about a religious service applies equally to anything from a rock concert to grand opera: artworks can be seen as an integrated whole. Likewise, we can consider these arts separately. After all, people paint paintings, compose music, or write poetry to be enjoyed as discrete experiences. At other times, of course, two (or more) arts may be joined when there was no original intention to do so, as when a composer sets a poem to music or an artist finds inspiration in a literary text or, to use a more complex example, when a ballet is inspired by a literary text and is danced against the background or sets created by an artist to enhance both the dance and the text that inspired it.

However we view the arts, either separately or as integrated, one thing is clear: they are the product of human invention and human genius. When we speak of *culture*, we are not talking about something strange or highbrow; we are talking about something that derives from human invention. A jungle is a product of nature, but a garden is a product of culture: human ingenuity has modified the vegetative world.

In this book we discuss some of the works of human culture that have endured over the centuries. We often refer to these works as *masterpieces*, but what does the term mean? The issue is complicated because tastes and attitudes change over the centuries. Two hundred years ago the medieval cathedral was not appreciated; it was called *Gothic* because it was considered barbarian. Today we call such a building a masterpiece. Very roughly, we can say that a masterpiece of art is any work that carries with it a surplus of meaning.

Having a surplus of meaning means not only that the work reflects technical and imaginative skill, but also that its very existence sums up the best of a certain age, which spills over as a source of inspiration for further ages. As one reads through the history of Western humanistic achievements, it is clear that certain products of human genius are looked to by subsequent generations as a source of inspiration; they have a surplus of meaning. Thus the Romans' achievement in architecture with the dome of the Pantheon both symbolized their skill in architecture and became a reference point for every major dome built in the West since. The dome of the Pantheon finds echoes in 7th-century Constantinople (the Hagia Sophia); in 15th-century Florence (the Duomo); in 16th-century Rome (St. Peter's Basilica); and in 18th-century Washington, DC (the Capitol).

The notion of a surplus of meaning provides us with a clue as to how to study the humanistic tradition and its achievements. Admittedly simplifying, we can say that such a study has two steps that we have tried to synthesize into a whole in this book.

THE WORK IN ITSELF. At this level we are asking the question of fact and raising the issue of observation: what is the work and how is it achieved? These questions include not only the basic information about, say, what kind of visual art this is (sculpture, painting, mosaic) or what its formal elements are (Is it geometric in style? bright in color? very linear? and so on), but also questions of its function: Is this work an homage to politics? For a private patron? For a church? We look at artworks, then, to ask questions about both their form and their function.

This is an important point. We may look at a painting or sculpture in a museum with great pleasure, but that pleasure would be all the more enhanced were we to see that work in its proper setting rather than as an object on display. To ask about form and function, in short, is to ask equally about context. When reading certain literary works (such as the *Iliad* or the *Song of Roland*), we should read them aloud, since in their original form they were written to be recited, not read silently on a page.

THE WORK IN RELATION TO HISTORY. The human achievements of the past tell us much about earlier cultures both in their differences and in their similarities. A study of the tragic plays that have survived from ancient Athens gives us a glimpse into Athenians' problems, preoccupations, and aspirations as filtered through the words of Sophocles or Euripides. From such a study we learn both about the culture of Athens and something about how the human spirit has faced the perennial issues of justice, loyalty, and duty. In that sense we are in dialogue with our predecessors across the ages. In the study of ancient cultures we see the roots of our own.

To carry out such a project requires a willingness to look at art and closely read literature with an eye equally to the aspect of form and function and to the past and the present. Music, however, requires a special treatment because it is the most abstract of arts (How do we speak about that which is meant not to be seen but to be heard?) and the most temporal. For that reason, a somewhat more extended guide to music follows.

HOW TO LOOK AT ART

Anyone who thumbs through a standard history of art can be overwhelmed by the complexity of what is discussed. We find everything from paintings on the walls of caves and huge sculptures carved into the faces of mountains to tiny pieces of jewelry or miniature paintings. All of these are art, because they were made by human hands in an attempt to express human ideas or emotions. Our response to such objects depends a good deal on our own education and cultural biases. We may find some modern art ugly or stupid or bewildering. We may think of all art as highbrow or elitist despite the fact that we like certain movies (film is an art) enough to see them over and over. At first glance, art from unfamiliar traditions may seem odd simply because we do not have the reference points with which we can judge it as good or bad.

Our lives are so bound up with art that we often fail to recognize how much we are shaped by it. We are bombarded with examples of graphic art (television commercials, magazine ads, DVD covers, displays in stores) every day; we use art to make statements about who we are and what we value in the way we decorate our rooms and in the style of our clothing. In all of these ways, we manipulate artistic symbols to make statements about what we believe in, what we stand for, and how we want others to see us. The many sites on the Web bombard us with visual clues that attempt to make us stop and find out what is being offered or argued.

The history of art is nothing more than the record of how people have used their minds and imaginations to symbolize who they are and what they value. If a certain society in a certain age spends enormous amounts of money to build and decorate churches (as in 12th-century France) and another spends the same kind of money on palaces (like 18th-century France), we learn about what each values the most.

The very complexity of human art makes it difficult to interpret. That difficulty increases when we are looking at art from a much different culture or a far different age. We may admire the massiveness of Egyptian architecture but find it hard to appreciate why such energies were used in the cult of the dead. When confronted with the art of another age (or even our own art, for that matter), a number of questions we can ask of ourselves and of the art may lead us to greater understanding.

What Is the Purpose of This Work of Art?

This is essentially a question of *context*. Most of the religious paintings in museums were originally meant to be seen in churches in very specific settings. To imagine them in their original setting helps us to understand that they had a devotional purpose that is lost when they are seen on a museum wall. To ask about the original setting, then, helps us to ask further whether the painting is in fact devotional or meant as a teaching tool or to serve some other purpose.

Setting is crucial. A frescoed wall on a public building is meant to be seen by many people, while a fresco on the wall of an aristocratic home is meant for a much smaller, more elite class of viewer. The calligraphy decorating an Islamic mosque tells us much about the importance of the sacred writings of Islam. A sculpture designed for a wall niche is going to have a different shape from one designed to be seen by walking around it. Similarly, art made under official sponsorship of an authoritarian government must be read in a far different manner than art produced by underground artists who have no standing with the government. Finally, art may be purely decorative or it may have a didactic purpose, but (and here is a paradox) purely decorative art may teach us, while didactic art may end up as no more than decoration.

What, If Anything, Does This Work of Art Hope to Communicate?

This question is one of *intellectual* or *emotional* context. Funeral sculpture may reflect the grief of the survivors, commemorate the achievements of the deceased, affirm what the survivors believe about life after death, or fulfill a combination of these purposes. If we think of art as a variety of speech, we can then inquire of any artwork: what is it saying?

An artist may strive for an ideal ("I wish to paint the most beautiful woman in the world," or "I wish my painting to be taken for reality itself," or "I wish to move people to love or hate or sorrow by my sculpture"), illustrate the power of an

music's power to affect human feeling and behavior. Thus for the Greeks, music represented a religious, intellectual, and moral force. Once again, music is still used in our own world to affect people's feelings, whether it be the stirring sound of a march, the solemnity of a funeral dirge, or the eroticism of much modern pop music (which Plato would have thoroughly disapproved of).

Virtually all of the music—and art, for that matter—that survived from the Middle Ages is religious. Popular secular music certainly existed, but since no real system of notation was invented before the 11th century, it has disappeared without a trace. The ceremonies of both the Western and the Eastern (Byzantine) church centered around the chanting of a single musical line, a kind of music that is called *monophonic* (from the Greek for "single voice"). Around the time musical notation was devised, composers began to become interested in the possibilities of notes sounding simultaneously—what we would think of as harmony. Music involving several separate lines sounding together (as in a modern string quartet or a jazz group) became popular only in the 14th century. This gradual introduction of *polyphony* ("many voices") is perhaps the single most important development in the history of music, since composers began to think not only horizontally (that is, melodically), but also vertically, or harmonically. In the process, the possibilities of musical expression were immeasurably enriched.

The Experience of Listening

Richard Wagner, one of the greatest of all composers, described the power of music to express universal emotions:

> What music expresses is eternal, infinite, and ideal. It does *not* express the passion, love, or longing of this or that individual in this or that situation, but passion, love, or longing in itself; and this it presents in that unlimited variety of motivations which is the exclusive and particular characteristic of music, foreign and inexpressible in any other language.

Yet for those unaccustomed to serious listening, it is precisely this breadth of experience with which it is difficult to identify. We can understand a joyful or tragic situation. Joy and tragedy themselves, though, are more difficult to comprehend.

There are a number of ways by which the experience of listening can become more rewarding and more enjoyable. Not all of them will work for everyone, but over the course of time they have proved helpful for many newcomers to the satisfactions of music.

1. *Before listening to the piece you have selected,* ask yourself some questions: What is the historical context of the music? For whom was it composed—for a general or an elite audience?

 Did the composer have a specific assignment? If the work was intended for performance in church, for example, it should sound very different from a set of dances. Sometimes the location of the performance affected the sound of the music: composers of masses to be sung in Gothic cathedrals used the buildings' acoustical properties to emphasize the resonant qualities of their works.

 With what forces was the music to be performed? Do they correspond to those intended by the composer? Performers of medieval music, in particular, often have to reconstruct much that is missing or uncertain. Even in the case of later traditions, the original sounds can sometimes be only approximated. The superstars of the 18th-century world of opera were the *castrati*, male singers who had been castrated in their youth and whose soprano voices had therefore never broken; contemporaries described the sounds they produced as incomparably brilliant and flexible. The custom, which seems to us so monstrous, was abandoned in the 19th century, and even the most fanatic musicologist must settle for a substitute today. The case is an extreme one, but it proves that even with the best of intentions, modern performers cannot always reproduce the original sounds.

 Does the work have a text? If so, read it through before you listen to the music; it is easiest to concentrate on one thing at a time. In the case of a translation, does the version you are using capture the spirit of the original? Translators sometimes take a simple, popular lyric and make it sound archaic and obscure in order to convey the sense of old music. If the words do not make much sense to you, they would probably seem equally incomprehensible to the composer.

 Is the piece divided into sections? If so, why? Is the relationship of the sections determined by purely musical considerations—the structure of the piece—or by external factors—the words of a song, for example, or the parts of a Mass?

 Finally, given all these considerations, what do you expect the music to sound like? Your preliminary thinking should have prepared you for the kind of musical experience in store for you. If it has not, go back and reconsider some of these points.

2. *While you are listening to the music,* Concentrate as completely as you can. It is virtually impossible to gain much from music written in an unfamiliar idiom unless you give it your full attention. Read written information before you begin to listen, as you ask yourself you preliminary questions—not *while* the music is playing. If there is a text, keep an eye on it but do not let it distract you from the music.

 Concentrating is not always easy, particularly if you are mainly used to listening to music as a background, but there are some ways in which you can help your own concentration. To avoid visual distraction, fix your eyes on some detail near you—a mark on the wall, a design in

Composition

Background: A landscape of great depth with rock formations and valleys with light from the setting sun.

Middle ground: A naturalistic landscape of plants and vegetation among the rocks with a canopy of rock formations suggesting a grotto and plants that encircle the group.

Foreground: Four figures are seated along a rocky edge of land with very naturalistic plants and grasses. The Virgin is seated in the center and dominates the group. Her right hand reaches around the young John the Baptist, who kneels on one knee and looks to the Christ Child seated to Mary's front left-hand side. Jesus is seated in a three-quarter profile to the viewer and directly under Mary's blessing left hand. To the right is a seated angel who looks out at the viewer while pointing to John. The figural group forms a pyramidal or triangular composition with the Madonna at the apex (see **Fig. 13.4B** on page 422).

artwork (Is this well done in terms of craft and composition?), but such an approach does not do full justice to what the artist is trying to do. Conversely, to judge every work purely in terms of social theory excludes the notion of an artistic work and, as a consequence, reduces art to politics or philosophy. For a fuller appreciation of art, then, all of these elements need to come into play.

HOW TO LISTEN TO MUSIC

The sections of this book devoted to music are designed for readers who have no special training in music theory or practice. Response to significant works of music, after all, should require no more specialized knowledge than should the ability to respond to *Oedipus Rex*, say, or a Byzantine mosaic. Indeed, many millions of people buy recorded music in one form or another, or enjoy listening to it on the radio, without the slightest knowledge of how the music is constructed or performed.

The gap between the simple pleasure of the listener and the complex skills of the composer and performer often prevents the development of a more serious grasp of music history and its relation to the other arts. The aim of this section is to help bridge that gap without trying to provide too much technical information. After a brief survey of music's role in Western culture, we shall look at the language used to discuss musical works—both specific terminology, such as *sharp* and *flat*, and more general concepts, such as line and color.

Music in Western Culture

The origins of music are unknown, and neither the excavations of ancient instruments and depictions of performers nor the evidence from modern societies gives any impression of its early stages. Presumably, like the early cave paintings, music served some kind of magical or ritual purpose. This is borne out by the fact that music still forms a vital part of most religious ceremonies today, from the hymns sung in Christian churches and the solo singing of the cantor in an Orthodox Jewish synagogue to the elaborate musical rituals performed in Buddhist or Shinto temples in Japan. The Hebrew Bible makes many references to the power of music, most notably in the famous story of the Battle of Jericho, and it is clear that by historical times music played an important role in Jewish life, both sacred and secular.

By the time of the Greeks, the first major Western culture to develop, music had become as much a science as an art. It retained its importance for religious rituals; in fact, according to Greek mythology the gods themselves invented it. At the same time, the theoretical relationships between the various musical pitches attracted the attention of philosophers such as Pythagoras (ca. 550 BCE), who described the underlying unity of the universe as the "harmony of the spheres." Later 4th-century BCE thinkers, like Plato and Aristotle, emphasized

An Exercise in Looking at Art

When we view a work of art, we need to consider the subject matter (what is being depicted), the elements of art (line, shape, and so on), the symbolism of the work (possible underlying meanings), and the social and cultural environment in which the work was created. The composition of the work—the organization of the visual elements—is also important. Consider Leonardo da Vinci's *Madonna of the Rocks* (Fig. 13.4a).

Subject Matter

A representational depiction of the Virgin Mary with the Christ Child, young John the Baptist, and an angel in a rocky landscape.

Art Elements

The elements of art include line; shape, volume, and mass; light and value; color; texture; space; and time and motion.

In *Madonna of the Rocks*, light is the most important element, affecting all the others. The light is very dramatic, and its source appears to be from the upper left, off the canvas. The light defines everything; it illuminates and focuses the viewer's attention on the figures. The light affects the colors and creates the warm feeling of flesh against the coldness of the rocky landscape of great depth. This use of light is called *chiaroscuro*, a contrast of very dark to very light values in the brightness of a color. Chiaroscuro creates the atmosphere, the shape and volume of the figures, and the space they occupy, a vast landscape in which real people exist.

Symbolism

Absent a halo or a regal crown, Mary, the virgin mother of Jesus is portrayed not as the queen of heaven but as an ordinary mother, reflecting Leonardo da Vinci's humanistic perspective. A number of interpretations of the symbolism have been based on the interactions among the principal characters, although none is substantiated. It has been suggested that the tension in Mary's fingers as she reaches toward her son presages her inability to protect him from harm. Her wistful expression and downcast eyes add an almost somber tone that contrasts with the otherwise lively interactions among the figures.

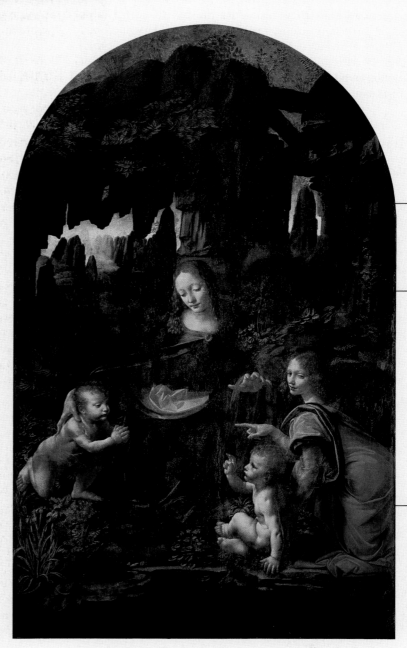

▲ Leonardo da Vinci, *Madonna of the Rocks,* 1483. Oil on panel, transferred to canvas, 78 1/4" × 48" (199 × 122 cm). Museé du Louvre, Paris, France.

Social Elements

Leonardo created the *Madonna of the Rocks* in the city of Milan, within a couple of years after he left Florence to work for Ludovico Sforza, the Duke of Milan. The painting was commissioned by the Confraternity of the Immaculate Conception for a chapel in the church of San Francesco Grande.

idea, or capture the power of the spirit world for religious or magical purposes.

An artist may well produce a work simply to demonstrate inventiveness or to expand the boundaries of what art means. The story is told of Pablo Picasso's reply to a woman who said that her 10-year-old child could paint better than he. Picasso replied, "Congratulations, madame. Your child is a genius." We know that before he was a teenager, Picasso could draw and paint with photographic accuracy. He said that during his long life, he tried to learn how to paint with the fresh eye and spontaneous simplicity of a child.

How Was This Work of Art Made?

This question inquires into both the materials and the skills the artist employs to turn materials into art. Throughout this book we will speak of different artistic techniques, like bronze casting or etching or panel painting; here we make a more general point. Learning to appreciate the craft of the artist is a first step toward enjoying art for its worth as art—to developing an eye for art. This requires *looking* at the object as a crafted object.

We might stand back to admire a painting as a whole, but then looking closely at one portion of it teaches us the subtle manipulation of color and line that creates the overall effect.

What Is the Composition of This Work of Art?

This question addresses how the artist composes the work. Much Renaissance painting uses a pyramidal construction so that the most important figure is at the apex of the pyramid and lesser figures form the base. Some paintings presume something happening outside the picture itself (such as an unseen source of light); a Cubist painting tries to render simultaneous views of an object. At other times, an artist may enhance the composition by the manipulation of color with a movement from light to dark or a stark contrast between dark and light, as in the chiaroscuro of Baroque painting. In all of these cases the artists intend to do something more than merely depict a scene; they appeal to our imaginative and intellectual powers as we enter into the picture or engage the sculpture or look at the film.

Composition, obviously, is not restricted to painting. Filmmakers compose with close-ups or tracking shots just as sculptors carve for frontal or side views of an object. Since all of these techniques are designed to make us see in a particular manner, only by thinking about composition do we begin to reflect on what the artist has done. If we do not think about composition, we tend to take an artwork at face value, and as a consequence are not training our eye. Much contemporary imagery is made by the power of mixing done on the computer.

What Elements Should We Notice About a Work of Art?

The answer to this question is a summary of what we have already stated. Without pretending to exclusivity, we should judge art on the basis of the following three aspects.

Formal elements. What kind of artwork is it? What materials are employed? What is its composition in terms of structure? In terms of pure form, how does this particular work look when compared to a similar work of the same or another artist?

Symbolic elements. What is this artwork attempting to say? Is its purpose didactic, propagandistic, pleasurable, or what? How well do the formal elements contribute to the symbolic statement being attempted in the work of art?

Social elements. What is the context of this work of art? Who paid for it and why? Whose purposes does it serve? At this level, many different philosophies come into play. A Marxist critic might judge a work in terms of its sense of class or economic aspects, while a feminist critic might inquire whether it affirms women or acts as an agent of subjugation or exploitation.

It is possible to restrict oneself to formal criticism of an

someone's clothing, the cover of a book. At first this will seem artificial, but after a while your attention should be taken by the music. If you feel your concentration fading, do not pick up a magazine or gaze around; consciously force your attention back to the music and try to analyze what you are hearing. Does it correspond to your expectations? How is the composer trying to achieve an effect? By variety of instrumental color? Are any of the ideas, or tunes, repeated?

Unlike literature or the visual arts, music occurs in the dimension of time. When you are reading, you can turn backward to check a reference or remind yourself of a character's identity. In looking at a painting, you can move from a detail to an overall view as often as you want. In music, the speed of your attention is controlled by the composer. Once you lose the thread of the discourse, you cannot regain it by going back; you must try to pick up again and follow the music as it continues—and that requires your renewed attention.

On the other hand, in these times of easy access to recordings, the same pieces can be listened to repeatedly. Even the most experienced musicians cannot grasp some works fully without several hearings. Indeed, one of the features that distinguishes "art" music from more "popular" works is its capacity to yield increasing rewards. On a first hearing, therefore, try to grasp the general mood and structure and note features to listen for the next time you hear the piece. Do not be discouraged if the idiom seems strange or remote, and be prepared to become familiar with a few works from each period you are studying.

As you become accustomed to serious listening, you will notice certain patterns used by composers to give form to their works. They vary according to the styles of the day; throughout this book there are descriptions of each period's musical characteristics. In responding to the general feeling the music expresses, therefore, you should try to note the specific features that identify the time of its composition.

3. *After you have heard the piece*, ask yourself these questions: Which characteristics of the music indicated the period of its composition? Were they due to the forces employed (voices or instruments)? How was the piece constructed? Did the composer make use of repetition? Was there a change of mood, and if so, did the original mood return at the end? What kind of melody was used? Was it continuous or did it divide into a series of shorter phrases? If a text was involved, how did the music relate to the words? Were they intelligible? Did the composer intend them to be? If not, why not?

Were there aspects of the music that reminded you of the literature and visual arts of the same period? In what kind of buildings can you imagine it being performed? What does the music tell you about the society for which it was written?

Finally, ask yourself the most difficult question of all: What did the music express? Wagner described the meaning of music as "foreign and inexpressible in any other language." There is no dictionary of musical meaning, and listeners must interpret for themselves what they hear. We all understand the general significance of words like *contentment* or *despair*, but music can distinguish between a million shades of each.

Concepts in Music

There is a natural tendency in talking about the arts to use terms from one art form to describe another. Thus most people would know what to expect from a "colorful" story or a painting in "quiet" shades of blue. This metaphorical use of language helps describe characteristics that are otherwise often very difficult to isolate, but some care is required to remain within the general bounds of comprehension.

LINE. In music, *line* generally means the progression in time of a series of notes: the melody. A melody in music is a succession of tones related to one another to form a complete musical thought. Melodies vary in length and in shape and may be made up of several smaller parts. They may move quickly or slowly, smoothly or with strongly accented (stressed) notes. Some melodies are carefully balanced and proportional, others are irregular and asymmetrical. A melodic line dictates the basic character of a piece of music, just as lines do in a painting or the plotline does for a story or play.

TEXTURE. The degree to which a piece of music has a thick or thin *texture* depends on the number of voices or instruments involved. Thus the monophonic music of the Middle Ages, with its single voice, has the thinnest texture possible. At the opposite extreme is a 19th-century opera, where half a dozen soloists, a chorus, and a large orchestra are sometimes combined. Needless to say, thickness and thinness of texture are neither good nor bad in themselves, merely simple terms of description.

Composers control the shifting texture of their works in several ways. The number of lines heard simultaneously can be increased or reduced—a full orchestral climax followed by a single flute, for example. The most important factor in the texture of the sound, however, is the number of combined independent melodic lines; this playing (or singing) together of two or more separate melodies is called *counterpoint*. Another factor influencing musical texture is the vertical arrangement of the notes: six notes played close together low in the scale will sound thicker than six notes more widely distributed.

COLOR. The *color*, or *timbre*, of a piece of music is determined by the instruments or voices employed. Gregorian chant is monochromatic, having only one line. The modern symphony orchestra has a vast range to draw upon, from the bright sound of the oboe or the trumpet to the dark, mellow sound of the cello or horn. Different instruments used in Japa-

nese or Chinese music will result in a quite distinct and very different timbre. Some composers have been more interested than others in exploiting the range of color that instrumental combinations can produce; not surprisingly, Romantic music provides some of the most colorful examples.

MEDIUM. The *medium* is the method of performance. Pieces can be written for solo piano, string quartet, symphony orchestra, or any other combination the composer chooses. A prime factor will be the importance of color in the work. Another is the length and seriousness of the musical material. It is difficult, although not impossible, for a piece written for solo violin to sustain the listener's interest for half an hour. Still another factor is the practicality of performance. Pieces using large or unusual combinations of instruments stand less chance of being frequently programmed. In the 19th century, composers often chose a medium that allowed performance in the home, thus creating a vast piano literature.

FORM. *Form* is the outward, visible (or hearable) shape of a work as opposed to its substance (medium) or color. This structure can be created in a number of ways. Baroque composers worked according to the principle of unity in variety. In most Baroque movements, the principal melodic idea continually recurs in the music, and the general texture remains consistent. The formal basis of much Classical music is contrast, where two or more melodies of differing character (hard and soft, or brilliant and sentimental) are first laid out separately, then developed and combined, then separated again. The Romantics often pushed the notion of contrasts to extremes, although retaining the basic motions of Classical form. Certain types of work dictate their own form. A composer writing a requiem mass is clearly less free to experiment with formal variation than one writing a piece for symphony orchestra. The words of a song strongly suggest the structure of the music, even if they do not impose it. Indeed, so pronounced was the Baroque sense of unity that the sung arias in Baroque operas inevitably conclude with a repetition of the words and music of the beginning, even if the character's mood or emotion has changed.

Thus music, like the other arts, involves the general concepts described earlier in this introduction. A firm grasp of them is essential to an understanding of how the various arts have changed and developed over the centuries and how the changes are reflected in similarities—or differences—between art forms. The concept of the humanities implies that the arts did not grow and change in isolation from one another or from around the world. As this book shows, they are integrated among themselves and with the general developments of Western thought and history.

HOW TO READ LITERATURE

"Reading literature" conjures up visions of someone sitting in an armchair with glasses on and nose buried in a thick volume—say, Tolstoy's *War and Peace*. The plain truth is that a fair amount of the literature found in this book was never

meant to be read that way at all. Once that fact is recognized, reading becomes an exercise in which different methods can serve as a great aid to both pleasure and understanding. That becomes clear when we consider various literary forms and ask ourselves how their authors originally meant them to be encountered. Let us consider some of the forms that will be studied in this volume to make the point more specifically.

Dramatic Literature

Drama is the most obvious genre of literature that calls for something more than reading the text quietly. Plays—ancient, medieval, Elizabethan, or modern—are meant to be acted, with living voices interpreting what the playwright wrote in the script. What seems to be strange and stilted language as we first encounter Shakespeare becomes powerful and beautiful when we hear his words spoken by someone who knows and loves language.

A further point: Until relatively recent times, most dramas were played on stages nearly bare of scenery and, obviously, extremely limited in terms of lighting, theatrical devices, and the like. As a consequence, earlier texts contain a great deal of description that in the modern theater (and, even more, in a film) can be supplied by current technology. Where Shakespeare has a character say "But look, the morn in russet mangle clad / Walks o'er the dew of yon high eastward hill," a modern writer might simply instruct the lighting manager to make the sun come up.

Dramatic literature must be approached with a sense of its oral aspect as well as with awareness that the language reflects the intention of the author to have the words acted out. Dramatic language is meant to be *heard* and *seen*.

Epic

Like drama, epics have a strong oral background. It is commonplace to note that before Homer's *Iliad* took its present form, it was memorized and recited by a professional class of bards. Similarly, the *Song of Roland* was probably heard by many people and read by relatively few in the formative decades of its composition. Even epics that are more consciously literary echo the oral background of the epic; Virgil begins his elegant *Aeneid* with the words "Of arms and the man I sing," not "Of arms and the man I write." The Islamic scriptures—the Qur'an—is most effectively recited.

The practical conclusion to be drawn from this is that these long poetic tales take on a greater power when they are read aloud with sensitivity to their cadence.

Poetry

Under the general heading of poetry we have a very complicated subject. To approach poetry with intelligence, we need to inquire about the kind of poetry with which we are dealing. The

lyrics of songs are poems, but they are better heard sung than read in a book. On the other hand, certain kinds of poems are so arranged on a page that not to see them in print is to miss a good deal of their power or charm. Furthermore, some poems are meant for the individual reader, while others are public pieces meant for the group. There is, for example, a vast difference between a love sonnet and a biblical psalm. Both are examples of poetry, but the former expresses a private emotion while the latter most likely gets its full energy from use in worship: we can imagine a congregation singing a psalm, but not the same congregation reciting one of Petrarch's sonnets to Laura.

In poetry, then, context is all. Our appreciation of a poem is enhanced once we have discovered where the poem belongs: With music? On a page? With an aristocratic circle of intellectuals? As part of a national or ethnic or religious heritage? As propaganda or protest or an expression deep emotions?

At base, however, poetry is the refined use of language. The poet is the maker of words. Our greatest appreciation of a poem comes when we say to ourselves that this could not be said better. An authentic poem cannot be edited or paraphrased or glossed. Poetic language, even in long poems, is economical. One can understand that by simple experiment: take one of Dante's portraits in the *Divine Comedy* and try to do a better job of description in fewer words. The genius of Dante (or Chaucer in the General Prologue to the *Canterbury Tales*) is his ability to sketch out a fully formed person in a few stanzas.

You can go to the following URL to learn more about "How to Read a Poem."

http://www.poets.org/viewmedia.php/prmMID/19882

Prose

God created humans, the writer Elie Wiesel once remarked, because he loves a good story. Narrative is as old as human history. The stories that stand behind the *Decameron* and the *Canterbury Tales* have been shown to have existed not only for centuries, but in widely different cultural milieus. Stories are told to draw out moral examples or to instruct or warn, but by and large, stories are told because we enjoy hearing them. We read novels in order to enter into a new world and suspend the workaday world we live in, just as we watch films. The difference between a story and a film is that one can linger over a story; in a film there is no second look.

Some prose obviously is not fictional. It can be autobiographical like Augustine's *Confessions*, or it may be a philosophical essay like Jean-Paul Sartre's attempt to explain what he means by existentialism. How do we approach that kind of writing? First, with a willingness to listen to what is being said. Second, with a readiness to judge: Does this passage ring true? What objections might I make to it? And so on. Third, with an openness that says, in effect, there is something to be learned here.

A final point has to do with attitude. We live in an age in which much of what we know comes to us in very brief sound bites via television, and much of what we read comes to us in the disposable form of newspapers and magazines and inexpensive paperbacks. To read—*really* to read—requires that we discipline ourselves to cultivate a more leisurely approach to that art. There is merit in speed-reading the morning sports page; there is no merit in doing the same with a poem or a short story. It may take time to learn to slow down and read at a leisurely pace (leisure is the basis of culture, says Aristotle), but if we learn to do so we have taught ourselves a skill that will enrich us throughout our lives. A good thought exercise is to ask whether reading from a computer screen is a different exercise than reading from a book.

HOW TO READ MAPS

Maps may serve various functions. In the ancient world a *mappa mundi* illustrated the imagined size of the known world. In military campaigns maps serve to illustrate the location of the enemy and the physical obstacles ahead of the army's march. Most maps today show political and natural boundaries or, more usefully, the route from one place to another.

The maps in this book have a more restricted purpose. They are meant to illuminate the points made in the text. For example, when the text speaks of the Hellenistic world, the map shows us the extent of that world. When the text speaks of the rapid expansion of Islam after its founding, the map shows the geographical areas and rapidity of its expansion. Students will gain the most benefit from the maps in this book by looking at them with a few pertinent questions in mind:

- How does the map relate to the text? Does the information available in the map enhance the discussion in the text? Does the map shed light on discussions in earlier chapters?
- How does a map illustrate the power and movement of ideas or artistic styles discussed in this book?
- If a map shows the expansion of a certain movement, what can we say about the area shown outside that movement?

Finally, it is very productive to think of each map as another kind of text and not merely as an illustration. By that approach we soon learn not to look at maps but to read them.

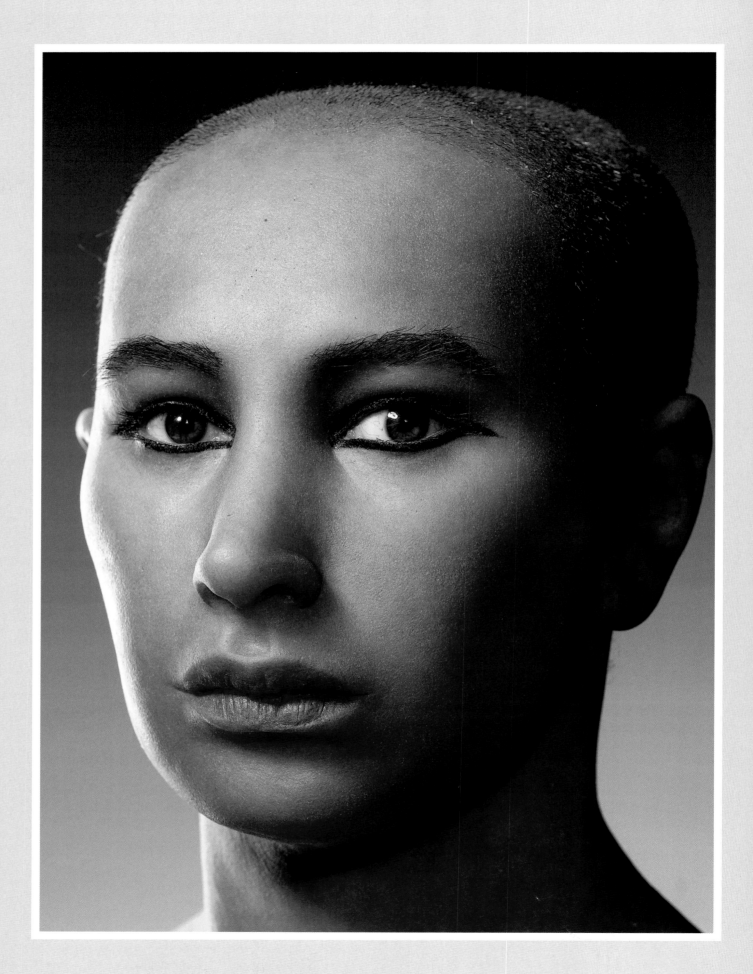

Beginnings

PREVIEW

The Valley of the Kings, Luxor, Egypt; January 5, 2005. Nearly 3300 years after his death, Tutankhamen's leathery mummy was delicately removed from its tomb and guided into a portable CT scanner. It was not the first time that modern technology had been tapped to feed the curiosity of scientists, archaeologists, and museum officials about the mysteries surrounding the reign and death of the legendary boy-king Tut. More than three decades earlier, the mummy was x-rayed twice, in part to try to solve the mystery of the young pharaoh's death; he was crowned at the age of eight and died only ten years later. These early X-rays revealed a hole at the base of Tut's cranium, leading to the suspicion that he was murdered. This time around, the focus—and the conclusions—changed. Dr. Zahi Hawass, then secretary general of the Supreme Council of Antiquities in Cairo, announced, "No one hit Tut on the back of the head." Scientists concluded that the damage noted in earlier X-rays was probably due to the rough removal of the golden burial mask by the tomb's discoverers. But they found something else: a puncture in Tut's skin over a severe break in in his left thigh. As it is known that this accident took place just days before his death, some experts on the scanning team conjectured that this break, and the puncture caused by it, may have led to a serious infection and Tut's consequent death. Otherwise, the young pharaoh was the picture of health—no signs of malnutrition or disease, with strong bones and teeth, and probably five and a half feet tall.

Scientists, including experts in anatomy, pathology, and radiology, spent two months analyzing more than 1700 high-resolution three-dimensional images taken during the CT scan. Then artists and scholars took a turn. Three independent teams, one each from Egypt, France, and the United States, came up with their own versions of what Tut might have looked like in life: a bit of an elongated skull (normal, they say), full lips, a receding chin, and a pronounced overbite that seems to have run in the family. It was the first time—but certainly not the last—that CT scans would be used to reconstruct the faces of the Egyptian celebrity dead.

Although the price tag on this endeavor was most certainly steep, the Egyptian government stood to gain financially from the images. Their release was timed to coincide with the launch of the world-traveling exhibition *Tutankhamen and the Golden Age of the Pharaohs*. Along with the scans and reconstruction images, the exhibit would feature Tut's diamond crown and gold coffin, along with almost 200 objects from his and various other noteworthy tombs. If history were any predictor of the insatiable thirst for things Egyptian, this, like an earlier exhibition of treasures from Tut's tomb, would attract millions of visitors.

We stare at Tut's image and his gaze transfixes us. We set aside the bubble-bursting fact that it is a computer-generated rendering not unlike any we might see in video games and allow ourselves to put a face to the name. The unknown becomes tangible, the myth a reality. What does this fixation reveal about us, about our needs, about human nature? Perhaps that we have a

◄ 1.1 King Tutankhamen's face reconstructed. This silicone bust is believed to be an accurate forensic reconstruction of the face of the Egyptian pharaoh, also called King Tut, who died some 3300 years ago at the age of about 18 or 19. It is based on CT scans of the mummy.

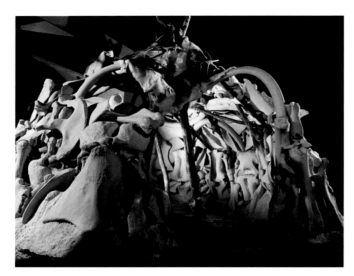

⌃ 1.2 Mammoth Bone Hut, Teeth Tusks, and Tar Pits, ca. 15,000 BCE. Exhibit, The Field Museum of Natural History, Chicago, Illinois. This house was built of hundreds of mammoth bones by hunters on windswept, treeless plains in Ukraine. Working as a team, hut builders needed only a few days to haul together hundreds of massive bones and stack them into a snug abode.

desire to connect with the *humanness* of our ancestors, to know them as we know anyone else. We study history to discover how events have sculpted the course of human existence and to fill in our chronological blanks. But it is in the study of what people thought about themselves and cared enough about leaving behind—philosophy and religion, literature, the arts and architecture—that we find our connection to humanity.

BEFORE HISTORY

Archaeologists have unearthed bits and pieces of culture that predate the age of Tutankhamen by thousands, if not tens of thousands, of years. Scientists have determined that our species—*Homo sapiens*—walked the Earth at least 150 millennia before the famous pharaoh was born. And incredible as it may seem, a thousand centuries before Tut adorned his eyes with black pigment, someone in a prehistoric workshop was mixing paint.

The words *Stone Age* can conjure an image of our human ancestors dressed in skins, huddling before a fire in a cave, while the world around them—the elements and the animals—threatens their survival. We may not envision them as intelligent and reflective, as having needs beyond food, shelter, and the survival of the species. Yet they did have beliefs and rituals; they did make art and music. They were self-aware. They wanted to preserve and communicate something of who they were, what they had done, and how they mattered, even if they had, as yet, no ability to write.

Prehistoric art and culture—created before recorded history—are divided into three phases that correspond to the periods of the Stone Age: Paleolithic (ca. 2,000,000–ca. 10,000 BCE; the Old Stone Age), Mesolithic (ca. 10,000–ca. 5500 BCE; the Middle Stone Age), and **Neolithic** (ca. 5500–ca. 2500 BCE; the New Stone Age). Archaeological finds from the Stone Age include cave paintings; relief carvings; figurines of stone, ivory, and bone; and musical instruments. The first works of art feature animals and abstract representations of the human figure. The earliest humans found shelter in nature's protective cocoons—the mouth of a yawning cave, the underside of a rocky ledge, the dense canopy of an overspreading tree. Beyond these ready-made opportunities, they sought ways to create shelter. But before humans devised ways of transporting materials over vast distances, they had to rely on local possibilities. Fifteen thousand years ago, humans dragged the skeletal remains of woolly mammoths to a protective spot and piled them into dome-like structures complete with a grand entrance framed by colossal tusks. The author Howard Bloom quipped, "First came the mammoth, then came architecture" (**Fig. 1.2**). In all, very few Stone Age structures have survived.

Paleolithic Developments

The **Paleolithic** period begins with the making of tools. Human ancestors that preceded *Homo sapiens*—us—left evidence of the use of stone implements, but *Homo sapiens* fashioned sophisticated tools such as hammerstones, chisels, and axes and weapons with blades of flint rock. These were useful in cutting and gathering edible plants and also in hunting game. Flint was also the material that led to the discovery of fire.

Before History

30,000 BCE	8000 BCE	2300 BCE
PALEOLITHIC PERIOD (OLD STONE AGE)	**NEOLITHIC PERIOD (LATE STONE AGE)**	

First ritual burying of the dead is observed	Agriculture begins; animals are domesticated and the ox-drawn plow is used
Humans create paintings and reliefs on cave walls and carve small figurines	Settled communities are formed
Hunting provides the main food source	Pottery is made and used by farmers
Implements and weapons are made of stone	Large-scale architecture and sculpture are born
	Tools and weaponry are made of bronze

Controlling fire, harnessing its potential, and maintaining it together form the wellspring for material culture.

The importance of such tools to human survival is clear. But a recent discovery in a South African cave has shown that some innovations in technology may have served other purposes. *Homo sapiens* apparently mixed paints 100,000 years ago.[1] They pounded and ground colorful earth with an iron oxide into an orange-brown powder called ochre. It was liquefied, mixed into paint, and scooped out of a large abalone shell (**Fig. 1.3**) with a spatula made from bone. The paint may have been applied to the skin as a protectant or as decoration.

Many of the great cave paintings of the Old Stone Age were discovered by accident in northern Spain and southwestern France. At Lascaux four teenagers found a hole in the ground and went exploring and discovered vibrant paintings of bison, horses, and cattle that are estimated to be more than 15,000 years old. At first, because of their realism and fresh appearance, the paintings were thought to be forgeries, but geological methods proved their authenticity.

One of the most splendid examples of Old Stone Age painting, the so-called Hall of the Bulls (**Fig. 1.4**), was found

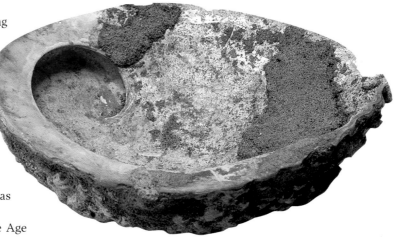

▲ **1.3 Abalone shell, ochre filled, ca. 100,000 BCE Blombos Cave, Still Bay, South Africa. Residue of liquefied ochre-rich mixture ca. ¼″ (5 mm) deep.** It is believed that humans mixed the first known paint in this abalone shell. Photograph by Francesco d'Errico & Christopher Henshilwood/© University of Bergen, Norway.

1. C. S. Henshilwood et al. A 100,000-year-old ochre-processing workshop at Blombos Cave, South Africa. *Science* 334, no. 6053 (2011): 219–222.

▼ **1.4 Hall of the Bulls, ca. 15,000–13,000 BCE.** Cave paintings like these were probably associated with prehistoric rituals that may have included music. Some researchers believe that the caves may have been chosen for their acoustical properties and that the paintings had some sort of magical significance connected to game hunts during the hunter-gatherer phase of Paleolithic culture.

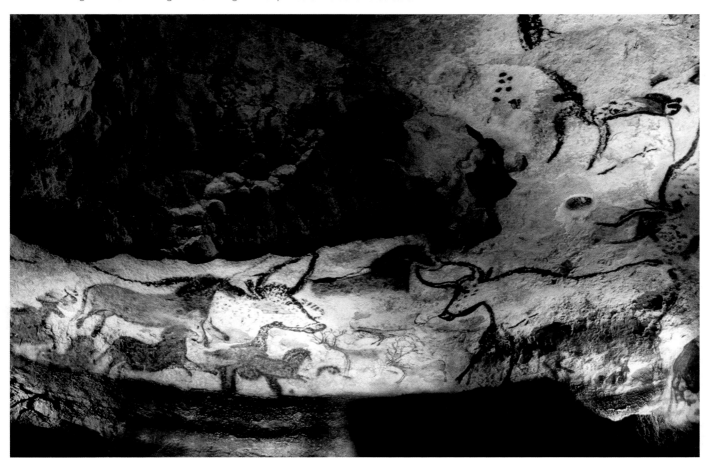

in a cave at Lascaux in southern France. Here, lively animals—bulls, reindeer, horses—were drawn on the walls, some superimposed upon one another, stampeding in all directions. The artists captured the simple contours of the beasts with bold, confident black lines and then filled in details with shades of ground ochre and red pigments. A variety of materials and techniques were used to create a sense of naturalism. Chunks of raw pigment were dragged along the rocky wall surface, and color was applied with fingers and sticks. Some areas of the murals reveal a "spray-painting" technique in which dried, ground pigments were blown through a hollowed-out bone or reed. Although the tools were simple, the results were sophisticated. **Foreshortening** (a perspective technique) and modeling (using light and gradations of shade to create an illusion of roundness), although rough and basic, are combined to give the animals a convincing likeness.

Why did early humans create these paintings? We cannot know for certain, though it is unlikely that they were merely decorative. The paintings were found in the deepest, almost unreachable recesses of the caves, far from the areas that were inhabited. New figures were painted over earlier ones with no regard for a unified composition; researchers believe that successive artists added to the drawings, respecting the sacredness of the figures that were already there. Some have conjectured that the paintings covering the walls and ceilings embellished a kind of inner sanctuary where religious rituals concerning the capture of prey were performed. In capturing these animals in art, did Stone Age people believe that they would guarantee success in capturing them in life?

Archaeological evidence also suggests a relationship between music and art in the Paleolithic period. The remains of several ancient flutes with finger holes, carved from bone and ivory at least 35,000 years ago, were found in caves near wall paintings (**Fig. 1.5**).[2] Were these Paleolithic concert halls? Because the art appears in the deeper recesses of the caves, one scientist has conjectured that the spots were chosen for their acoustical resonance and afterward painted

◀ **1.5** Bone flute, ca. 35,000 Isturitz (Pyrénées), France. Vulture wing bone, hollow, 8 3/8" (21.2 cm) long. Musée d'Archeologie Nationale, Saint-Germain-en-Laye, France.

▶ **1.6** *Venus of Willendorf*, ca. 28,000–23,000 BCE Willendorf, Austria. Limestone, 4 1/4" (10.8 cm) high. Naturhistorisches Museum, Vienna, Austria. This figurine is one of numberless representations of earth-mother goddesses from the Paleolithic period. Parts of the body associated with fertility and childbearing have been emphasized.

with backdrops for ritual ceremonies. The natural acoustics of a carved-out cave would have amplified musical rhythms and voices. We can picture a mysterious-looking interior, illuminated by torches, with early humans singing and dancing before the images and chanting to the music of flutes and drums, the sounds echoing through the spaces.

Prehistoric artists also created small figurines, called Venuses by the first archaeologists who found them. The most famous of these is the so-called *Venus of Willendorf* (**Fig. 1.6**), named after the site in Austria where it was unearthed. The tiny stone sculpture is just over four inches high and bears characteristics similar to those of other female figures that may represent earth mothers or fertility goddesses: the parts of the body associated with fertility and childbirth are exaggerated in relation to the arms, legs, and head. Does this suggest a concern for survival of the species? Or was this figure of a fertile woman created and carried around as a talisman for fertility of the earth itself—abundance in the food supply? In any case, early humans may have created their images, and perhaps their religion, as a way of coping with—and controlling—that which was unknown to them.

Neolithic Developments

During the New Stone Age, life became more stable and predictable. People domesticated plants and animals, and food production took the place of food gathering. Improved farming techniques made it possible for a community to accumulate stores of grain and thereby become less dependent for its survival on a good harvest each year. In some areas, toward the end of the Neolithic period crops such as maize, squash, and beans were cultivated. Pottery was invented around 5000 BCE, and not long afterward, metal began to replace stone as the principal material for tools and weapons. The first metal used was copper, but it was soon discovered that an alloy of copper and tin would produce a far stronger metal: bronze. The use of bronze became widespread, giving its name to the Bronze

2. N. J. Conard, M. M. Malina, & S. C. Münzel. New flutes document the earliest musical tradition in southwestern Germany. *Nature* 460, (2009) 737–740.

▲ 1.7 Stone tower built into the wall of the settlement, ca. 8000–7000 BCE Jericho. The defensive walls of the Neolithic city of Jericho were constructed of stone without mortar.

➤ 1.8 Human skull, with features restored, ca. 7200–6700 BCE Jericho. Features modeled in plaster, painted, and inlaid with seashells, life-size. Archaeological Museum, Amman, Jordan. The restored skulls of Jericho were distinguished by individual characteristics, suggesting that they were connected to ancestor worship.

Age, which lasted from around 3000 BCE to the introduction of iron around 1000 BCE. In some places, writing appeared. People began to move into towns and cities, and significant architectural monuments were erected.

Jericho was built around an oasis on a plateau in the Jordan Valley of the Middle East. As Jericho prospered, the inhabitants felt the need to protect themselves—and their water—from roaming nomads, so they built the first known stone defenses. A 30-foot-high circular tower (**Fig. 1.7**), with an interior staircase leading to the top, was constructed of stones laid together without mortar. The tower could have been used as a lookout to watch for invaders or as high ground to defend against them—or both. Jericho was abandoned ca. 7000 BCE, but another level of excavation reveals that it was occupied by a second wave of settlers. Human skulls with facial features restored in plaster (**Fig. 1.8**) were found buried beneath the floors of the houses. Painted details that individualize the skulls suggest that they served as rudimentary portraits, perhaps of ancestors.

The most famous of the Neolithic monuments is Stonehenge (**Fig. 1.9**) in southern England. It consists of two concentric rings of colossal stones surrounding others placed in

▼ 1.9 Stonehenge, ca. 1800–1400 BCE Salisbury Plain, Wiltshire, England. Approximately 24′ high × 97′ across (732 × 2957 cm). The function of Stonehenge remains a mystery, although it is believed to have been some sort of astronomical observatory and solar calendar.

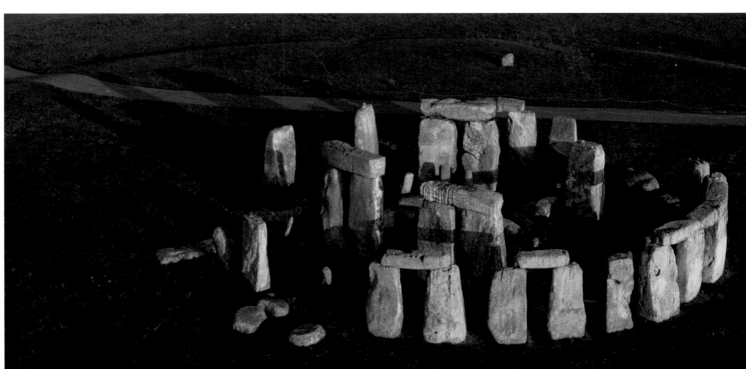

Mystery Ladies of the Ancient World

Austria, Bulgaria, Syria, Egypt, Ecuador, India, China, Siberia, Sudan—what do these places have in common? Their prehistoric sites have all yielded versions of what seem to be earth mothers or fertility goddesses, suggesting that in very early cultures a feminine deity may have occupied the top spot in the pantheon of gods.

As much ties them together as distinguishes them. Their heads and faces are relatively small and far less detailed than other parts of the body, and in almost every

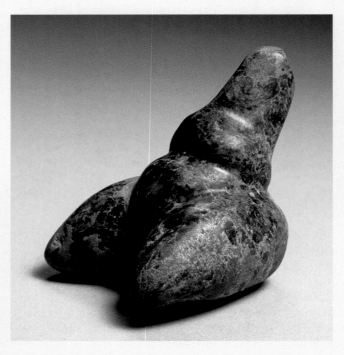

▲ **1.11** Female figurine, 7000–6000 BCE Syria. Hardstone, 2½″ (6.4 cm) high. Private collection.

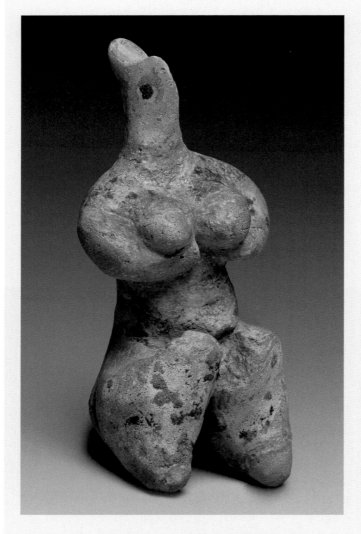

▲ **1.10** Female figurine, 4300–4000 BCE Turkey. Clay and pigment, 4⅛″ high × 1⅞″ wide × 1⅝″ deep (10.4 × 4.7 × 4.2 cm). Brooklyn Museum, New York.

example, the limbs are either shortened and stumpy, spindly, or wholly absent (Fig. 1.10). The conclusion that these figurines may be associated with fertility—or, if not, that they most certainly indicate a fascination with the life-giving mysteries of the female body—is drawn from the fact that attributes of the female body associated with fertility and childbearing are emphasized or exaggerated

Beyond their basic similarities, the statuettes differ significantly from one another in terms of style and also, perhaps, function. Most of them are tiny, suggesting that they may have been portable talismans. Some, like the Cycladic idols (see Fig. 1.40), the ancient Nubian figure from present-day Sudan (Fig. 1.11), and the so-called *Bird Lady* from predynastic Egypt (Fig. 1.12) are highly simplified or abstract and have a certain appeal to the modern eye. Others, like the *Lady of Pazardzik* from Bulgaria, exhibit fine attention to decorative detail (Fig. 1.13).

Archaeologists and art historians have debated the meaning of the figures, but no real clue to whom or what they represent has survived. Perhaps they served some ritual purpose or perhaps they were simply dolls. But since

they outnumber the men significantly (there are many more sculptures of female figures than male figures in prehistoric art), one thing is clear: the female body represented power.

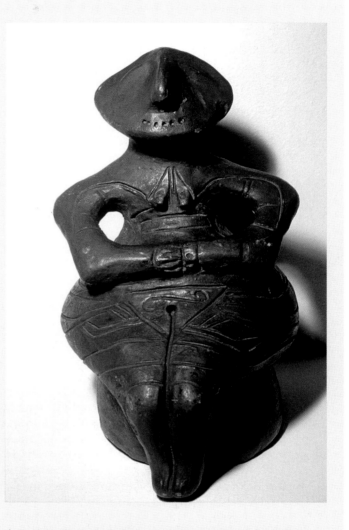

▲ **1.13** **Lady of Pazardzik, ca. 4500 BCE Bulgaria. Ceramic (burnt clay), 7½″ (19 cm) high. Naturhistorisches Museum, Wien, Austria.** This enthroned goddess figure is embellished with incised lines in the pattern of a double spiral, an ancient symbol of regeneration.

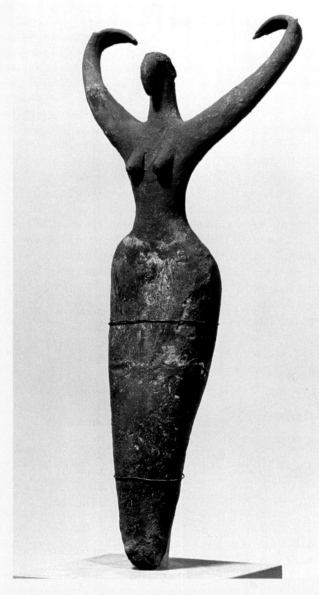

▲ **1.12** **Female figure, ca. 3500–3400 BCE Egypt. Painted terra-cotta, 11½″ high × 5½″ wide × 2¼″ deep (29.2 × 14 × 5.7 cm). Brooklyn Museum, New York.**

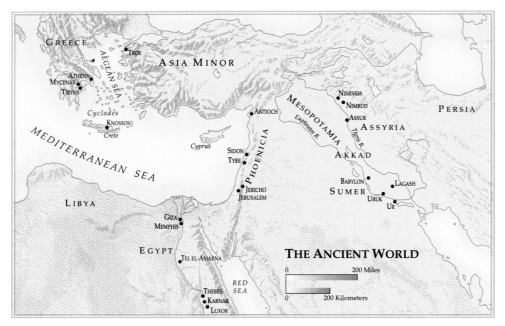

▲ MAP 1.1 Map of the Ancient World

a U configuration. Some of these *megaliths* (from the Greek, meaning "large stones") weigh several tons and are evidence of Neolithic capabilities—both physical and intellectual. The purpose of Stonehenge remains a mystery, although archaeologists and astronomers have posited that the monument served as a solar calendar and observatory that charted the movements of the sun and moon, as well as eclipses. Whatever the meaning or function, the fact that it was undertaken at all is fascinating.

The Neolithic period in Europe overlapped with the beginning of civilization in the Middle East, ca. 5000 BCE. *Civilization* is so broad a term that it is not easy to define simply. Societies that qualify for the label "civilized" generally possess most, if not all, of the following characteristics:

- some form of urban life involving the construction of permanent settlements—cities, in short
- a system of government that regulates political relations
- the development of distinct social classes, distinguished from one another by the two related factors of wealth and occupation
- tools and specialized skills for the production of goods, leading to the rise of manufacturing and trade
- some form of written communication, making it possible to share and preserve information
- a shared system of religious belief, whose officials or priests often play a significant role in community affairs

Civilization is no guarantee of what most people would consider civilized behavior. As the twentieth century demonstrated, some of the most civilized societies in history can be responsible for incalculable human suffering.

The wellsprings of our own civilization reach back to developments in ancient cultures across the globe, including the great river cultures established in the Fertile Crescent of Mesopotamia's Tigris and Euphrates Rivers and along the Fertile Ribbon of the Nile River in Egypt. Water provided sustenance and, as for the ancient cultures of the Aegean, opportunities for trade and interaction with other parts of the known world.

MESOPOTAMIA

Civilization began in what is today the country of Iraq, on land made fertile by the Tigris and Euphrates Rivers that join and empty into the Persian Gulf. Called the Fertile Crescent, that area of land is essentially flat and, thus, ultimately indefensible. The story of ancient civilization in this region—Mesopotamia—is the story of a succession of ruling peoples, each with their own language, religion, customs, and art.

The history of Mesopotamia can be divided into two major periods: the Sumerian (ca. 3500–2350 BCE) and the Semitic (ca. 2350–612 BCE, when Nineveh fell). The Sumerian and Semitic peoples differed in their racial origins and languages; the term **Semitic** is derived from the name of Shem, one of the sons of Noah, and as a name for a group of people it is generally used to refer to those speaking a Semitic language. In the ancient world, these included the Akkadians, Babylonians, Assyrians, and Phoenicians. The most commonly identified Semitic group is the Jewish people, whose traditional language, Hebrew, falls into the same group; they also originated in Mesopotamia (for a discussion of the early history of the Jews, see Chapter 6). Arabic and some other Mediterranean languages—including Maltese—are also Semitic.

Sumer

The earliest Sumerian communities were agricultural settlements on the land between the Tigris and Euphrates Rivers (**Map 1.1**). Because the land here is flat, dikes and canals were needed to irrigate farmland, to control flooding during the rainy season, and to provide water predictably during the rest of the year. Since such large-scale construction projects required a great deal of manpower, small villages often consolidated into towns.

The focus of life in a Sumerian town was the temple, sacred to the particular god who watched over it. The Sumerian gods were primarily deifications of nature (**Fig. 1.14**): sky and earth, sun and moon, lightning and storms. Anu was the god of the sky, Nanna the god of the moon, and Abu the god of vegetation The chief religious holidays were linked to

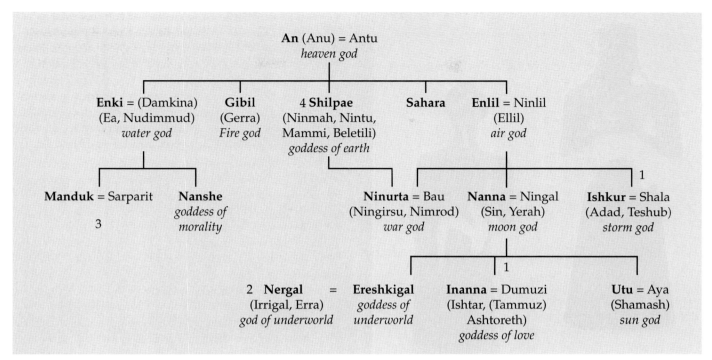

An (Anu) = Antu
heaven god

Enki = (Damkina)
(Ea, Nudimmud)
water god

Gibil
(Gerra)
Fire god

4 **Shilpae**
(Ninmah, Nintu,
Mammi, Beletili)
goddess of earth

Sahara

Enlil = Ninlil
(Ellil)
air god

Manduk = Sarparit
3

Nanshe
*goddess of
morality*

Ninurta = Bau
(Ningirsu, Nimrod)
war god

Nanna = Ningal
(Sin, Yerah)
moon god

Ishkur = Shala
(Adad, Teshub)
storm god

1

1

2 **Nergal** =
(Irrigal, Erra)
god of underworld

Ereshkigal
*goddess of
underworld*

Inanna = Dumuzi
(Ishtar, (Tammuz)
Ashtoreth)
goddess of love

Utu = Aya
(Shamash)
sun god

▲ **1.14 The Sumerian Pantheon.** From Guide to the Mesopotamian Pantheon of Gods
(http://www.ianlawton.com/mesindex.htm). © 2000 by Ian Lawton.

the seasons and revolved around rites intended to ensure bountiful crops. The most celebrated was the New Year festival, held in recognition of the pivotal moment when the cold and barren winter (connected to the death of the fertility god Tammuz at the end of his yearly life cycle) made way for a fertile spring (made possible by his resurrection and sacred marriage to the goddess Inanna).

Governing in cities like Uruk was primarily in the hands of the priests, who controlled and administered economic as well as religious affairs. The king served as the representative on earth of the god of the city but, unlike the Egyptian pharaoh, was never thought of as divine nor became the center of a cult. His focus was guarding the spiritual and physical well-being of his people—building grander temples to the gods they relied on, or providing for more sophisticated irrigation systems to ensure sustenance. The acquisition of personal wealth, enduring fame, or deified status was not a goal, yet the kings had great power.

The White Temple at Uruk (**Fig. 1.15A and Fig. 1.15B**), so called because of its white-washed walls, is among the earliest and best-preserved shrines in the region. It stands on a **ziggurat**, a platform some 40 feet high whose corners are oriented toward the compass points. As grand as it is, the White Temple pales in comparison to the scale of later ziggurats (the ziggurat known to the Hebrews as the Tower of Babel, a symbol of mortal pride, was some 270 feet high). Sumerians believed that their gods resided above them and that they would descend to meet

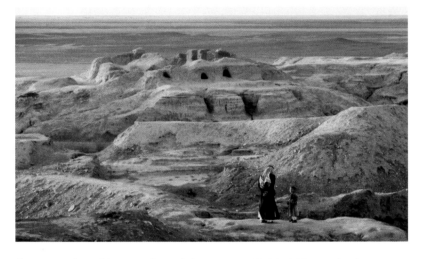

▲ **1.15A The White Temple and ziggurat, ca. 3200–3000 BCE Uruk (modern Warka), Iraq.** *Ziggurat* means "pinnacle" or "mountaintop" and is the name of the elevated platform on which a temple sits. Mesopotamians thought their gods would come down from the heavens and reveal themselves there.

▼ **1.15B Reconstruction of the White Temple and ziggurat.** The White Temple and ziggurat is so called because of its whitewashed walls.

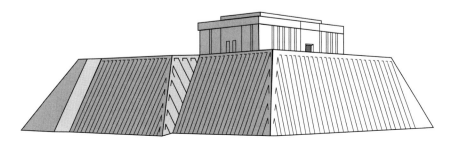

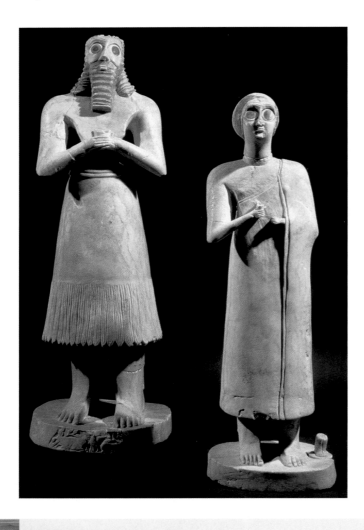

◄ **1.16 Statues from Abu Temple, ca. 2700** BCE **(Sumerian, Early Dynasty period) Tel Asmar. Gypsum with shell and black limestone inlay, male figure, 28¼" (72 cm) high, female figure, 23" (59 cm) high. National Museum, Baghdad, Iraq.** Votive figures were placed in temples as stand-ins for worshippers who were not there.

their priests in the temples built high above the ground. They called these shrines waiting rooms for the gods.

Votive sculptures found beneath the floor of a temple to Abu in Tell Asmar (**Fig. 1.16**) reinforce the essential role of religion in Sumerian society. These works functioned as stand-ins, as it were, for donor worshippers who, in their absence, wished to continue to offer prayers to a specific deity. They range in height from less than 12 to more than 30 and are carved from gypsum (a soft mineral found in rock) with alert inlaid eyes of shell and black limestone. The figures are cylindrical, and all stand erect with hands clasped at their chests around now-missing flasks. Distinctions are made between males and females: The men have long, stylized beards and hair and wear knee-length skirts decorated with incised lines describing fringe at the hem. The women wear dresses with one shoulder bared and the other draped with a shawl. Although these sculptures are gypsum, the Sumerians worked primarily in clay, because of its abundance. They were expert ceramists and, as we have seen, were capable of building monumental structures with brick while their Egyptian contemporaries were using stone. It is believed that the Sumerians traded crops for metal, wood, and stone and used these materials to enlarge their repertory of art objects.

Mesopotamia

3500 BCE	2332 BCE	2150 BCE	1600 BCE	612 BCE	559 BCE	330 BCE	636 CE
SUMERIAN	AKKADIAN	NEO-SUMERIAN AND BABYLONIAN	HITTITE AND ASSYRIAN	NEO-BABYLONIAN	ACHAEMENIAN	GRAECO ROMAN AND SASSANIAN	
First cities emerge, the largest at Uruk	Sargon unifies Mesopotamia	Akkadian empire collapses	Hittites sack Babylon but then leave Mesopotamia	Neo-Babylonian kings control the former Assyrian Empire	Reign of Cyrus the Great and expansion of Persian Empire	Alexander integrates Mesopotamia and Persia into the Graeco-Roman Empire	
Cuneiform writing is developed	Akkadian is spoken throughout the region	Mesopotamia is reunited by the kings of Ur	Assyrians control major trade routes	Nebuchadnezzar II rebuilds Babylon	Egypt falls to Achaemenians	Sassanians challenge Roman rule in Asia	
First ziggurats and shrines are constructed	Earliest preserved hollow-cast bronze statues	Sumerian becomes the chief language	Ruthless kings build fortified and lavishly decorated palaces	Hanging Gardens become one of the Seven Wonders of the World	Darius I and Xerxes build vast palace complex at Persepolis	New Persian Empire is established	
First palaces indicate royal authority		Ziggurat at Ur is built	Assyrian Empire falls	Cyrus of Persia captures Babylon and founds Achaemenian dynasty	Achaemenian line ends with defeat by Alexander the Great	Sassanians are driven out of Mesopotamia by Arabs after 400 years	
Reign of Gilgamesh		Hammurabi gathers 282 laws into a judicial code					

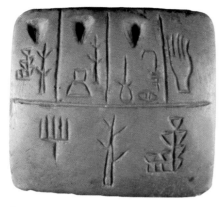 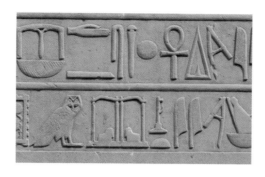 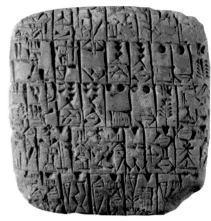

▲ **1.17 Forms of early writing.** Left: Tablet, ca. 3200 BCE Kish, Iraq. Limestone, 1³/₄″ (4.5 cm) long × 1³/₄″ (4.3 cm) wide × ⁷/₈″ (2.4 cm) deep. Musée du Louvre, Paris, France.Among the earliest examples of writing, the pictographs on this tablet show a list of slaves' names, with a hand on the upper right representing their owner. Center: Detail of a limestone bas-relief, ca. 2065–1785 BCE (Middle Kingdom) near the White Chapel of Karnak, Thebes, Egypt. This hieroglyphic inscription is dedicated to Amon-Min in his role as god of fertility. Note the "life" sign—the "ankh"—the fourth sign from the right on the top line. Right: Terracotta tablet, ca. 2550 BCE Sumer. Musée du Louvre, Paris, France. The cuneiform writing in this inscription records a bill of sale for a house and field paid for in silver. Note that the cuneiform signs have lost their resemblance to picture writing.

The Sumerian repertory of subjects included fantastic creatures such as music-making animals, bearded bulls, and composite man-beasts with bull heads or scorpion bodies. These were depicted in lavishly decorated objects of hammered gold inlaid with **lapis lazuli**. Found among the remains of Sumerian royal tombs, they are believed by some scholars to have been linked to funerary rituals.

For a long time, the Sumerians were the principal force in Mesopotamia, but they were not alone. Semitic peoples to the north became increasingly strong, and eventually they established an empire that ruled all of Mesopotamia and assimilated the Sumerian culture.

By far the most important event of this stage in the development of Sumerian culture was the invention of the first system of writing, known as **cuneiform** (**Fig.1.17**). The earliest form of writing was developed at Uruk (now Warka, in southern Iraq), one of the first Mesopotamian settlements, around the middle of the fourth millennium BCE. It consisted of a series of simplified picture signs (pictographs) that represented the objects they described and, in addition, related ideas. Thus a leg could mean either a leg itself or the concept of walking. The signs were drawn on soft clay tablets, which were then baked hard. These pictorial signs evolved into a series of wedge-shaped marks that were pressed in clay with a split reed. The cuneiform system (*cuneus* is the Latin word for "wedge") had the advantages of being quick and economical, and inscribed clay tablets were easy to store. The ability to write made it possible to trade and to keep detailed records, and with the increasing economic strength this more highly organized society brought, several powerful cities began to develop.

Musical texts in cuneiform writing have been found, suggesting that the Mesopotamians had a rich tradition of music theory and practice. There is credible evidence that they had a system of interrelated heptatonic scales—scales with seven pitches per octave.

THE *EPIC OF GILGAMESH* The most famous of Sumerian kings, Gilgamesh, ruled Uruk ca. 2700 BCE. Under his reign, the massive city walls around Uruk were constructed, but his name is more famously associated with the mythic tales that evolved into the first great masterpiece of poetic expression—the *Epic of Gilgamesh*. It has come down to us on twelve clay tablets dating to about 2000 BCE—including tablet XI, the so-called flood tablet (**Fig. 1.18**)—found in the library of the Assyrian king Ashurbanipal in the city of Nineveh. Believed to have been written originally by Sumerians in cuneiform, it later was reworked by Akkadians, Babylonians, and Assyrians.

The epic begins with the ancestry of King Gilgamesh and his deeds as ruler of Uruk. They are many, and he is seen as a wise man of great courage, but his people do not like him. They find him cruel and oppressive. The gods become aware of their discontent and create Enkidu—a worthy adversary for the warrior king who, unlike Gilgamesh, is also kind.

◄ **1.18 Tablet XI of The Epic of Gilgamesh, 700–600 BCE Nineveh (Kuyunjik), Iraq. Clay tablet fragment, 6″ long × 5¹/₄″ wide × 1¹/₄″ deep (15.24 × 13.33 × 3.17 cm). The British Museum, London, United Kingdom.** The stone fragment identified as tablet XI was one of twelve found in the library of King Ashurbanipal in Nineveh, Assyria.

Enkidu lives in a forest, at one with the animals, and is thus untainted by the negative fallout of civilization. But Gilgamesh becomes aware of the gods' object lesson and cuts it off at the pass by sending Shamhat, a woman from the temple at Uruk, to civilize Enkidu by having intercourse with him in the forest for seven nights and six days. After the encounter, the animals turn away from Enkidu and he turns toward the city. When Enkidu sees Gilgamesh in Uruk, he boldly challenges the king to a wrestling match. Although this would seem the worst possible idea in the world, Gilgamesh is impressed by Enkidu's strength and moxie, and the two wind up being the closest of friends. Enkidu's kindness and generosity inspire Gilgamesh—who had been the embodiment of arrogance and tyranny—to become a better person and a more amiable and caring ruler.

The two subsequently set out on a series of adventures that will gain fame for Gilgamesh, if not immortality. In one, they kill Humbaba, the guardian of the Cedar Forest, a realm of the gods. The goddess Inanna (later known as Ishtar) is smitten with Gilgamesh, but he spurns her advances. She retaliates by asking her father, Anu, to send the Bull of Heaven to attack Gilgamesh, but the brave king dispatches the beast with skill and bravery.

Enkidu shares with Gilgamesh his ominous dreams following the slaying of the sacred bull: the gods have decided that he, Enkidu, should die as retribution for the slaying and as a way to punish Gilgamesh's arrogance and pride. The gods will take from Gilgamesh that which is most precious to him. Enkidu becomes gravely ill and dreams about the terrors of the underworld he encounters after death.

READING 1.1 THE *EPIC OF GILGAMESH*

Enkidu's dream of the afterlife, Tablet 3

Enkidu slept alone in his sickness and he poured out his heart to Gilgamesh: "Last night, I dreamed again, my friend. The heavens moaned and the earth replied; I stood alone before an awful being; his face was somber like the black bird of the storm. He fell upon me with the talons of an eagle and he held me fast, pinioned with his claw, till I smothered; then he transformed me so that my arms became wings covered with feathers. He turned his stare towards me, and he led me away to the palace of Irkalla, the Queen of Darkness, to the house from which none who enters ever returns, down the road from which there is no coming back.

"There is the house whose people sit in darkness; dust is their food and clay their meat. They are clothed like birds with wings for covering, they see no light, they sit in darkness. I entered the house and I saw the kings of the earth, their crowns put away forever; rulers and princes, all those who once wore kingly crowns and ruled the world in the days of old."

From *The Epic of Gilgamesh*, translated with an introduction by N. K. Sandars (Penguin Classics 1960, Third Edition 1972), copyright © N. K. Sandars, 1960, 1964, 1972. Reproduced by permission of Penguin Books, Ltd.

The heartbreaking loss of Enkidu brings home to Gilgamesh the reality and the nearness of death and frames his pursuit of immortality. He embarks on an arduous journey, along which he encounters many who urge him to give up his quest and instead seize the life he was given to live.

READING 1.2 *THE EPIC OF GILGAMESH*

Advice to Gilgamesh from the tavern keeper, Siduri

Gilgamesh, whither rovest thou?
The life thou pursuest thou shalt not find.
When the gods created mankind,
Death for mankind they set aside,
Life in their own hands retaining.
Thou, Gilgamesh, let full be thy belly,
Make thou merry by day and by night.
Of each day make thou a feast of rejoicing,
Day and night dance thou and play.
Let thy garments be sparkling and fresh,
Thy head be washed, bathe thou in water.
Pay heed to the little one that holds thy hand,
Let thy spouse delight in thy bosom,
For this is the task of mankind.

Patrick V. Reid (Ed.). *Readings in Western Religious Thought: The Ancient World*. New York & Mahwah, NJ: Paulist Press, 1987, p. 17.

Eventually, Gilgamesh reaches the home of Utnapishtim, a righteous man who was granted immortality by the gods after following their commands to build an ark to save his relatives, craftsmen, and all the beasts of the field from a great flood that lasted for seven nights and six days. Utnapishtim tells Gilgamesh his story.

READING 1.3 *THE EPIC OF GILGAMESH*

The flood

With the first light of dawn a black cloud came from the horizon; it thundered within where Adad, lord of the storm, was riding. In front over the hill and plain Shyllat and Hanish, heralds of the storm, led on. Then the gods of the abyss rose up; Nergal pulled out the dams of the nether waters, Ninurta the warlord threw down the dykes, and the seven judges of hell, the Annunaki, raised their torches, lighting the land with their livid flame. A stupor of despair went up the heaven when the god of the storm turned daylight to darkness, when he smashed to land like a cup. One whole day the tempest raged gathering fury as it went, it poured over the people like the tides of battle; a man could not see his brother nor the people be seen from heaven. Even the gods were terrified at the flood, they fled to the highest heaven, the firmament of Anu; they crouched against the walls, cowering like curs. Then Ishtar

the sweet-voiced Queen of Heaven cried out like a woman in travail:

> "Alas the days of old are turned to dust because I commanded evil; why did I command this evil in the council of all the gods? I commanded wars to destroy the world, but are they not my people, for I brought them forth? Now like the spawn of fish they float in the ocean." The great gods of heaven and hell wept, they covered their mouths.

Tablet XI is specific: the sides of the boat were 120 cubits long, there were so many compartments, and the entry door was sealed when the boat was launched. The story of Utnapishtim's flood bears a striking resemblance to Noah's in the biblical book of Genesis, and may have been a source for the story in the Hebrew Bible. The *Epic of Gilgamesh* and the Bible have parallel accounts: the building of boats, the coming of torrential rain, the release of birds to bring back evidence of the receding of the floods, and the landing of boats on a mountain. The flood likely refers to some historic Mesopotamian event.

Utnapishtim was granted everlasting life by the gods for his heroism and piety. He sets a challenge for Gilgamesh to prove his worth for the same reward—to stay awake for seven nights and six days. Gilgamesh falls asleep almost immediately and is about to leave the company of Utnapishtim empty-handed when he is given a parting gift: instructions for where to find a plant that will render him young once more. Gilgamesh ties stones to his feet, walks along the ocean floor, and recovers the thorny plant, only to have it stolen by a serpent.

Gilgamesh goes back to Uruk to await death, exhausted, resigned, but wiser. Enlil, the father of the gods, tries to console him. Gilgamesh, after all, does possess certain gifts: wisdom, courage, and the skills to be victorious in battle and to govern with greatness. Together, these would stand as a monument unsurpassed for generations. Yet the death of Gilgamesh is final.

READING 1.4 THE *EPIC OF GILGAMESH*

The death of Gilgamesh

The king has laid himself down and will not rise again,
The Lord of Kullab[3] will not rise again;
He overcame evil, he will not come again;
Though he was strong of arm he will not rise again;
He had wisdom and a comely face, he will not come again;
He is gone into the mountain, he will not come again;
On the bed of fate he lies, he will not rise again,
From the couch of many colors he will not come again.

Unlike the ancient Egyptians, the Mesopotamians saw life as a continual struggle whose only alternative, death, was bleak. Egyptians, if they were righteous, could expect a happy existence in the life after death, but for the Mesopotamians there was only the prospect of eternal gloom.

The *Epic of Gilgamesh* touches on universal themes about human nature—the elevation of some human beings over others; the disregard for nature and the natural order of things; the virtues and rewards of the simple life and the pleasures of love, companionship, food, and drink; the fear of death; and the desire for fame and glory that will be some equivalent to the immortality that is out of human reach. Gilgamesh is encouraged to live to the fullest the life he was given—to seize the day (*carpe diem*, as the Romans would later say)—and to not be distracted by that which is unattainable.

Akkadian and Babylonian Culture

The *Epic of Gilgamesh* blends elements of history and mythology to tell the story of a Sumerian king in a powerful Mesopotamian city ca. 2700–2500 BCE. Shortly after his time, between 2350 and 2150 BCE, the whole of Mesopotamia fell under the control of the Semitic king Sargon and his descendants. The art of this Akkadian period (named for Sargon's capital city, Akkad) continued the trends of the Sumerian age, although total submission to the gods was tempered by the acknowledgement of human achievement. A copper head from Nineveh (**Fig. 1.19**), perhaps a portrait of Sargon, is the first known life-size **hollow-cast** sculpture in the history of art. It was once part of a complete figure that was later destroyed; the deep gouging of the eye sockets suggests mutilation associated

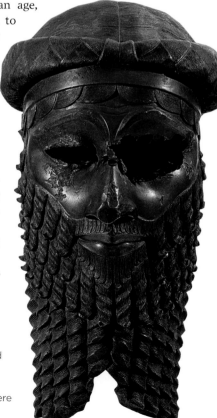

➤ **1.19 An Akkadian ruler, ca. 2200 BCE Nineveh (Kuyunjik), Iraq. Bronze, 12″ (30.7 cm) high. National Museum, Baghdad, Iraq.** The earliest surviving example of a hollow-cast sculpture, this bronze head may have been part of a full-length portrait of King Sargon. The eyes were mutilated but were originally inlaid with gems or other semiprecious materials.

3. A title of Gilgamesh.

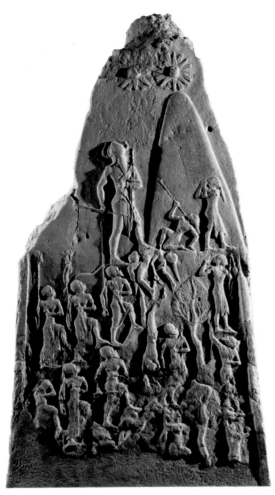

under the watchful celestial bodies of Ishtar and Shamash, the goddess of fertility and god of justice.

The artist used **conceptual representation** in the figures of the king and his men. That is, all of the parts of the body are there and they have identifying characteristics, but the body is not as it would appear to the eye at a single moment in time. Conceptual representation mixes and matches optimal frontal and profile views: one can see legs in profile, the triangular shape of a frontal view of the torso, and a profile head with a frontal eye. If there is any naturalism, it was reserved for the enemy, whose soldiers fall to their deaths in a variety of contorted positions. It may be that the convention of conceptual representation was used as a sign of respect.

Akkadian rule was brought to an abrupt and violent end with the invasion of the Gutians from Iran. The Sumerian cities rallied in retaliation, however, and the region again came under their control. The Neo-Sumerian state was then established but, characteristically, was short-lived.

THE LAW CODE OF HAMMURABI By around 1800 BCE, independent city-states once again took shape in Mesopotamia; one of them was Babylon. Its most famous and powerful king, Hammurabi, united the region under the name Babylonia, created a centralized government, and gathered the laws of the various local states into a unified code that stands as one of the earliest attempts to achieve social justice by legislation. It was a major development in the growth of civilization. The Stele of Hammurabi (**Fig. 1.21**) is the physical embodiment

▲ **1.20** Victory Stele of Naram-Sin, ca. 2300–2200 BCE (Akkadian). Susa, Iran. Rose limestone, 79″ × 41″ (200.7 × 104.1 cm). Musée du Louvre, Paris, France. King Naram-Sin marches victoriously up a mountain under symbols of protective gods, crushing his enemy as he goes. Conceptual representation is used in describing the figures.

➤ **1.21** Upper portion of stele inscribed with the Law Code of Hammurabi, ca. 1760 BCE Susa, Iran. Basalt, 88″ high (223.52 cm) (entire stele). Musée du Louvre, Paris, France. Hammurabi, the legendary lawgiver of Babylon, stands before the throne of the god Shamash, who sanctions his authority. On the stele beneath the relief sculpture, the Hammurabic Code is incised in cuneiform.

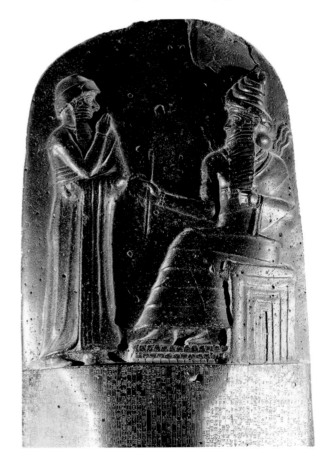

with acts of conquest. Even so, the head exudes the king's power, authority, and superiority. Of the relatively few Akkadian works that survive, the Victory **Stele** of Naram-Sin (**Fig. 1.20**) shines as one of the most significant. The relief sculpture commemorates the military exploits of Sargon's grandson and successor, Naram-Sin. The king, represented somewhat larger in scale than the other figures, ascends a mountain, trampling his enemies underfoot. He is accompanied by a group of marching soldiers with spears erect, whose positions contrast strongly with those of the fallen enemy. One of the conquered wrestles to pull a spear out of his neck, another pleads for mercy, and another falls headfirst off the mountain. The chaos on the right side of the composition is opposed by the rigid advancing on the left. All takes place

READING 1.5 *THE LAW CODE OF HAMMURABI*

Selected provisions, including "an eye for an eye and a tooth for a tooth"

131. If a man accuses his wife and she has not been taken in lying with another man, she shall take an oath in the name of god and she shall return to her house.

142. If a woman hates her husband and says, "Thou shalt not have me," her past shall be inquired into for any deficiency of hers; and if she has been careful and be without past sin and her husband has been going out and greatly belittling her, that woman has no blame. She shall take her dowry and go to her father's house.

145. If a man takes a wife and she does not present him with children, and he sets his face to take a concubine, that man may take a concubine and bring her into his house. That concubine shall not take precedence over his wife.

162. If a man takes a wife and she bears him children and that woman dies, her father may not lay claim to her dowry. Her dowry belongs to her children.

191. If a man destroy the eye of another man, they shall destroy his eye.

200. If a man knock out a tooth of a man of his own rank, they shall knock out his tooth.

206. If a man strike another man in a quarrel and wound him, he shall swear: "I struck him without intent," and he shall be responsible for the physician.

219. If a physician operate on a slave of a freeman for a severe wound with a bronze lancet and cause his death, he shall restore a slave of equal value.

220. If he open an abscess (in his eye) with a bronze lancet, and destroy his eye, he shall pay silver to the extent of one-half of his price.

From *The Law Code of Hammurabi*, Robert Francis Harper (trans.). 1904.

of the law—the Hammurabic Code. The lower three-quarters of the basalt stele bear the inscription and the upper part depicts Hammurabi, in profile, in the presence of the seated god Shamash. Just as in the Victory Stele of Naram-Sin, that presence is intended to make the point that the gods sanction this human behavior. What impresses us is the nitty-gritty of the code's legal provisions, ranging from those that pertain to family court and medical malpractice to very specific punishments to be meted out for criminal offences.

The Assyrians

By 1550 BCE, Babylonia had been taken over and occupied by the Kassites, a formerly nomadic people. In turn, they fell to the Assyrians—fierce warriors whose conquests in the region evolved into a vast empire. The peak of Assyrian power in Mesopotamia was between 1000 and 612 BCE; at that same historical moment, Greek civilization had begun on a much smaller area of land across the Aegean Sea.

A magnificent fortified palace complex was constructed during the reign of Ashurnasirpal II (883–859 BCE) in the Assyrian capital of Nimrud on the Tigris River. The alabaster walls of the palace interiors were decorated lavishly with carved reliefs that featured assorted scenes of violence—battles, hunts, dying soldiers, and suffering animals. The reliefs expand upon the stylistic vocabulary of earlier Mesopotamian art. In a fragment depicting the king Ashurnasirpal II hunting lions (**Fig. 1.22**), the figures have vigor and move freely, their actions very convincingly portrayed. The artist

▼ **1.22** Ashurnasirpal II hunting lions, 883–859 BCE Palace of Ashurnasirpal II, Nimrud, Iraq. Panel 19, alabaster relief, 88″ × 35″ (223.5 × 88.9 cm). The British Museum, London, United Kingdom. Themes of violence against humans and animals characterize Assyrian reliefs.

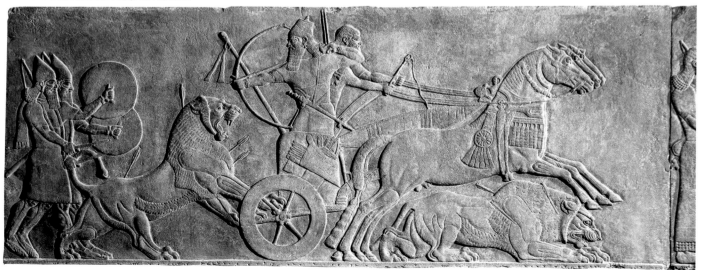

attempts to illustrate depth within the very shallow space by placing one figure in front of another, as in the soldiers with shields on the left and the horses rearing in unison on the right. Unlike the figures in the Victory Stele of Naram-Sin, which were rendered using conceptual representation, these soldiers appear more the way the eye would actually see them—pretty much in full profile. This is called **optical representation**. Worth noting also is the repetition of imagery that tells two parts of the story simultaneously. We see the king in the center, facing backward on his chariot, shooting a lion with his bow and arrow. To the right of the relief, we see that same lion dead and trampled under the horses' hooves.

Within a few years of the fall of the city of Nineveh in 612 BCE to the Babylonians—who had previously been under Assyrian domination intermittently—the Assyrian empire fell. The Babylonian kings established their city of Babylon as the center of Mesopotamia, where they stayed in power for just over 100 years until the Persians conquered them in 520 BCE. Neo-Babylonia is the name given to this period, which has two contrasting claims to fame: the fifty-year-long captivity of the Hebrews and King Nebuchadnezzar's building of the Hanging Gardens of Babylon, one of the Seven Wonders of the World.

Persia

As Persia, led by Cyrus the Great (c. 590–529 BCE), marched toward empire, Babylonia was but one of a growing list of casualties. By the sixth century BCE, the Persians had already conquered Egypt; less than a century later, they were poised to subsume Greece into their far-reaching realm. The Persian Empire stretched from southern Asia to northeastern Europe and would have included southeastern Europe had

the Greeks not been victorious over the Persians in a decisive battle at Salamis in 480 BCE. Cyrus's successors grew the empire until the defeat of Darius II by Alexander the Great in 330 BCE.

The citadel at Persepolis, the capital of the ancient Persian Empire, was a sprawling complex of palatial dwellings, government buildings, grand stairways, and columned halls whose architectural surfaces were richly adorned with relief sculpture. A processional frieze from the royal audience hall (**Fig. 1.23**) illustrates a technique that is notably different from Assyrian imagery. The Persian relief is more deeply carved; that is, the figures stand out more against the background. They are fleshier, more well-rounded. The artist has paid particular attention to detail, distinguishing the costumes of the participants, who include Persian nobles and guards and visiting dignitaries from nations under Persian rule. Although the procession is regimented, some figures twist and turn in space, alleviating the visual monotony. Persian art is also characterized by fanciful animal forms and stylized floral decoration.

In 525 BCE, Persia conquered the kingdom of Egypt, where civilization had begun some 3,000 years earlier.

ANCIENT EGYPT

Geography was a major determinant in the development of civilization in Egypt, just as it was in Mesopotamia. Because rainfall was sparse along the Nile River, agriculture was dependent on the yearly flooding of the river and the ability to control it. At the delta of the Nile was Lower Egypt, broad and flat, within easy reach of neighboring parts of the Mediterranean. Upper Egypt, more isolated from foreign contacts, consisted of a long, narrow strip of fertile soil, hemmed in by high cliffs and desert, running on either side of the Nile for

Ancient Egypt

3500 BCE	2575 BCE	2040 BCE	1550 BCE	1070 BCE	30 CE
PREDYNASTIC AND EARY DYNASTIC	**OLD KINGDOM**	**MIDDLE KINGDOM**	**NEW KINGDOM**	**FIRST MILLENIUM**	
Hieroglyphic writing is invented Upper and Lower Egypt are unified Imhotep builds first pyramid at Saqqâra for King Djoser	First mummification of the deceased Great Pyramids are constructed at Gizeh Artistic canons are established for statues of pharaohs to communicate the eternal nature of their divine kingship	Thebes becomes the capital of unified Egypt Rock-cut mortuary complexes are introduced Egyptians establish trade with eastern Mediterranean cultures	Wealth leads to the flowering of art and architecture Hatshepsut reigns as pharaoh for two decades, the first female monarch recorded in history Akhenaton establishes monotheism Return to polytheism with the reign of Tutankhamen	Egypt comes under Persian rule in 343 BCE Alexander the Great conquers Egypt in 332 BCE Alexandria, the new waterfront capital, faces the Mediterranean and the Hellenistic world Egypt becomes a province of the Roman Empire in 30 BCE	

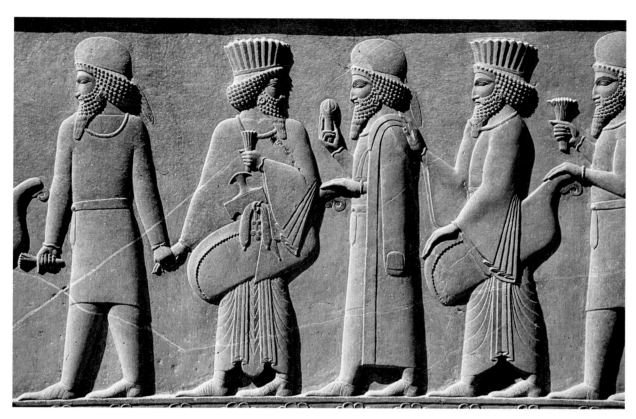

⋏ 1.23 Processional frieze (detail) from the royal audience hall, ca. 521–465 BCE Persepolis, Iran. Limestone, 100″ (254cm) high. The figures of visiting dignitaries to the court at Persepolis are rendered using both optical and conceptual representation.

most of its 1250 miles (2000 kilometers). In total area, ancient Egypt was only a little larger than the state of Maryland.

The extraordinarily long span of Egyptian history was divided into thirty-one dynasties by an Egyptian priest, Manetho, who wrote a *History of Egypt* in Greek around 280 BCE. Modern scholars still follow his system, putting the dynasties into four groups and calling the period that preceded them predynastic. The four main divisions, with their approximate dates, are the *Old Kingdom*, beginning c 2575 BCE; the *Middle Kingdom*, starting ca. 2040 BCE; the *New Kingdom*, from ca. 1550 BCE; and the *Late Period*, from ca. 1185 BCE until Egypt was absorbed into the Persian Empire around 500 BCE. The periods were separated from one another by intervening times of disturbances and confusion.

During the final centuries of the Late Period, Egypt was invaded by the Nubians of the upper Nile, a black people whom the Egyptians called Cushites. Overrunning first Upper Egypt in 750 BCE and then Lower Egypt around 720 BCE, they and their successors, the Nobatae, helped preserve Egyptian culture through the periods of foreign rule.

Despite its long history, the most striking feature of Egyptian culture is its unity and consistency. Nothing contrasts more strongly with the process of dynamic change initiated by the Greeks—and still characteristic of our culture today—than the relative absence of change in Egyptian art,

religion, language, and political structure over thousands of years. Naturally, even the Egyptians were subject to outside influences, and events at home and abroad affected their worldview. It is possible to trace a mood of increasing pessimism from the vital, life-affirming spirit of the Old Kingdom to the New Kingdom's vision of death as an escape from the grim realities of life. Nevertheless, the Egyptians maintained a strong resistance to change. Their art, in particular, remained conservative and rooted in the past.

In a land where regional independence already existed in the natural separation of Upper from Lower Egypt, national unity was maintained by a strong central government firmly controlled by a single ruler, the **pharaoh**. The pharaoh had absolute power over all matters temporal and spiritual, although the preservation of belief and ritual fell to an official bureaucracy of priests whose influence increased over time.

Egyptian Religion

The gods, the pharaoh, and the afterlife—these are inextricably intertwined in Egyptian religion. Like the Mesopotamians, Egyptians worshipped many deities, but unlike the kings of Mesopotamia, the pharaoh stood among them as a living god and their near equal.

The chief deity in the Egyptian pantheon was Amen-Re, the sun god who created the world by imposing order on the primeval chaos of the universe. He then created the first among many gods (**Fig. 1.24**), whose generations of immortal progeny included Osiris (the god of order who was responsible for civilization), Seth (the god of chaos who killed his brother Osiris and cut him into pieces), Isis (the goddess of mourning and sister of Osiris, who gathered the pieces of her brother, brought him back to life, and then mated with him), and Horus (the sky god and offspring of Osiris and Isis). The pharaohs were believed to be the children of the goddess Hathor, herself a daughter of Re. They were identified with the sky god Horus during life and with Osiris, ruler of the underworld, after death; in Egyptian art, the pharaoh often wears the signature bowling-pin-shaped crown of Osiris, which was similar to the crown of Upper Egypt (**as seen in Fig. 1.27**)

The most striking aspect of Egyptian religion is belief in an afterlife. Notions about the possibility that mortals could continue having experiences that resembled those of their present lives after passage into an underworld motivated righteous behavior—and the construction of lavish and well-equipped tombs that would anticipate whatever needs were to come. Not all Egyptians had grand tombs, but all had the hope of continuing to *be* after death. Elaborate funeral rituals prepared the deceased for judgment.

The funeral rites, together with their meaning, were described in a series of sacred texts known collectively as the *Book of the Dead*. The god who presided over these ceremonies was Osiris. Osiris owed his own resurrection to the intervention of Isis, protector of the living and the dead, and his rebirth was a divine parallel to the annual flooding of the Nile, which was essential to agriculture. Worship of Isis became an important and enduring Egyptian cult; a temple to her was even found among the ruins of the ancient Roman city of Pompeii. Our knowledge of the meaning of these and other texts was made possible by unlocking the key to their writing system of **hieroglyphics**.

The Romans had a significant history with Egypt; after it collapsed, they subsumed it as a province of their empire and even built temples there. But Egypt was largely ignored thereafter until the late eighteenth century, when Europeans began to take a strong interest in the exotic culture after an expedition to the country led by French emperor Napoléon Bonaparte in 1799. It was then that the **Rosetta Stone** was discovered, a large stone fragment inscribed with text in three languages: ancient hieroglyphics, demotic (a late Egyptian language), and Greek. Jean-François Champollion (1790–1832) deciphered the hieroglyphics by comparing them to the more familiar Greek.

▼ **1.24** **The Gods and Goddesses of Ancient Egypt, Their Roles and Representations**

Amun	King of the Gods	A man with a ram head or wearing an ostrich-plumed hat
Anubis	God of embalming and the dead	A man with the head of a jackal
Aten-Ra	A form of the sun god Ra, made the one god during the reign of Akhenaten	A sun disk with rays that end in hands
Atum	A creator god	A man with a double crown
Hathor	The wife of Horus; a protective goddess; also the goddess of love and joy	A woman with a headdress of horns and a sun disk
Horus	A god of the sky	A man with the head of a hawk
Isis	The sister and wife of Osiris and mother of Horus; a protective goddess who used magic to help the needy	A woman with a headdress in the shape of a throne or of cow horns surrounding a disk of the sun
Ma'at	The daughter of Ra; goddess of truth, justice, and harmony	A woman with a feather on her head
Osiris	God of the dead; ruler of the underworld	A mummifed man wearing a cone-shaped headdress with feathers
Ptah	God of crafts; according to one creation myth, a creator who spoke the words that brought the world into being	A man carrying a staff, dressed in white cloak
Ra	Sun god; the most important god of the ancient Egyptians	A man with the head of a hawk and a headdress with a disk of the sun
Seth	Brother of Osiris. God of chaos and evil who threatened harmony in Egypt	A man with the head of an unidentified animal
Thoth	Scribe of the gods; gave Egyptians the gift of hieroglyphics	A man with the head of an ibis, holding a palette for writing

Old Kingdom

The first golden age of Egyptian civilization arrived with the **Old Kingdom**, but Egypt's history along the Nile goes back farther. The land had been divided into two kingdoms: Upper and Lower Egypt. Unification of the two kingdoms occurred over a few centuries, but it is commemorated as a specific, single event in the palette of King Narmer (**Fig. 1.26**).

The slate object resembles Egyptian cosmetic palettes that had shallow wells in which to mix paint—applied around

On Righteousness as the Path to Emerging Forth into the Light*

Early Egyptian belief held that only the pharaoh could be reborn, upon death, and continue into an afterlife. As the centuries passed, the pharaoh's unique prerogative was extended to priests, the pharaoh's court, and their families. The *Book of the Dead*—also known as the *Book of Emerging Forth into the Light*—was intended as a sort of manual of spells, incantations, and declarations that would facilitate passage through the underworld and into the afterlife. The most important part of this journey was the judgment of the deceased before Osiris, god of the underworld. In one passage, an Egyptian official named Hunefer is brought to judgment by the jackal-headed god Anubis (**Fig. 1.25**). Hunefer must declare that he has not committed any one of 42 sins (some of which are listed here); his declaration of innocence is verified as his heart is weighed on a scale against the Feather of Truth. If the heart is lighter, proof of righteousness will be revealed. But if the heart is heavy—the origin of the expression "having a heavy heart"—his soul will be lost forever.

I have not done crimes against people,
I have not mistreated cattle,
I have not sinned in the Place of Truth.
I have not known what should not be known,
I have not done any harm.
I did not begin a day by exacting more than my due,

My name did not reach the bark of the mighty ruler,
I have not blasphemed a god,
I have not robbed the poor.
I have not done what the god abhors,
I have not maligned a servant to his master.
I have not caused pain,
I have not caused tears.
I have not killed,
I have not ordered to kill,
I have not made anyone suffer.
I have not damaged the offerings in the temples,
I have not depleted the loaves of the gods,
I have not stolen the cakes of the dead.
I have not copulated nor defiled myself.
I have not increased nor reduced the measure,
*I have not diminished the arura,*** *
I have not cheated in the fields.
I have not added to the weight of the balance,
I have not falsified the plummet of the scales.
I have not taken milk from the mouth of children.

* Miriam Lichtheim, *Ancient Egyptian Literature, Vol. II: The New Kingdom*. Berkeley and Los Angeles, CA: University of California Press, 1976, p. 125.

** Acreage.

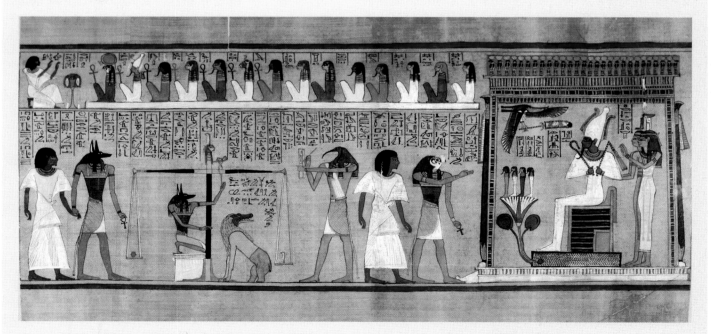

⌃ 1.25 Last judgment of Hunefer, from his tomb at Thebes (modern-day Luxor), Egypt, ca. 1300–1290 BCE (Nineteenth Dynasty). Painted papyrus scroll, 13½″ (34.3 cm) high. British Museum, London, United Kingdom.

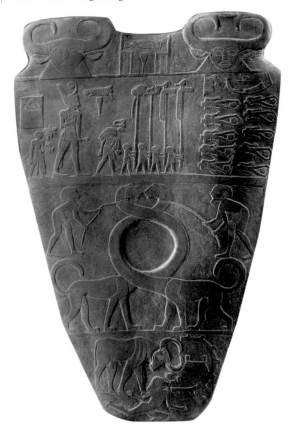
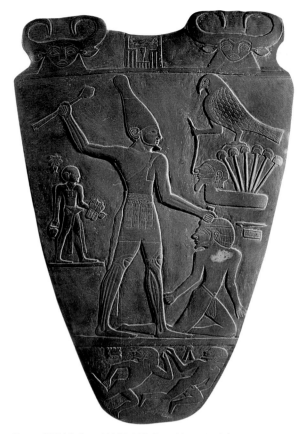

⌃ 1.26 **Narmer Palette, ca. 3200** BCE. **Front (left) and back (right) views. Slate, 25″ high × 16 ½″ (63.5 × 42 cm) wide.** **Egyptian Museum, Cairo, Egypt.** The shallow reliefs on both sides of a cosmetic palette, likely used for ceremonial purposes, commemorates the unification of Lower and Upper Egypt under a single ruler, King Narmer.

the eyes, as our athletes do today, to reduce the glare of the sun. The size of the Narmer Palette and the event represented on it suggest that it had a ceremonial rather than utilitarian purpose. Imagery is carved in shallow relief on both sides of the palette and Narmer is depicted on both. On the back he is shown wearing the crown of Upper Egypt (a bowling-pin shape), ready to strike a captive whom he has grabbed by the hair. To the right, a falcon—the god Horus—is perched on a cluster of papyrus stalks that sprout from an object that includes a man's head. The papyrus is a symbol for Lower Egypt, and Horus holds a rope tied around the man's neck; he is, perhaps, the ruler of Lower Egypt who has been vanquished by Narmer. On the other side of the palette, the imagery is carved in three separate **registers**, or horizontal bands, of different widths. In the center register, the palette's hollowed-out well is framed by the elongated, intertwined necks of animals tamed by two men with leashes. Narmer appears in the top register, looking over the pile of enemy dead whose heads have been cut off and neatly tucked between their legs. This is not the first time that we have seen such a monument to a royal conquest, complete with gory details; we saw a similar version in the Akkadian Victory Stele of Naram-Sin (**Fig.1.21**). In both works, the kings are shown in commanding positions, larger than the surrounding figures, but in the Narmer Palette, the king is also depicted as a god. The top of the palette, on both sides, features the goddess Hathor, distinguishable by her feminine face and horns.

Narmer is shown larger than the people surrounding him to indicate his status as a divine ruler. The artist has used conceptual representation: his head, hips, and legs are carved in low relief and in profile, and his eye and upper torso are shown as from a full frontal view. Narmer's musculature is defined with incised lines that appear more as stylized patterns than as realistic details. The artist worked within strict artistic conventions that would last some 3,000 years. Art historian Erwin Panofsky observed that these strict conventions reflected Egyptian belief and their attitude toward life, "directed not toward the variable, but toward the constant, not toward the symbolization of the vital present, but toward the realization of a timeless eternity.

ARCHITECTURE The Narmer Palette was found in a temple, and the imagery carved in relief on both sides is intended either to record a momentous historical event or to carefully construct an image of the king as an absolute ruler whose dominion is god-given. In either case, unlike a great deal of Egyptian sculpture, it has nothing to do with the funerary rituals that support the Egyptian obsession with an afterlife.

Colossal tombs are the most spectacular monuments to Egyptian beliefs and the glory of its pharaohs. One of the earliest is the stepped pyramid of King Djoser (**Fig. 1.27**), designed by Imhotep, a royal architect whose name is the first artist's to be recorded in history. Like so many hotshot architects to the present day, Imhotep's talent reached mythic proportions. He

was even deified after his death. At first glance, the pyramid may seem to resemble a ziggurat with its wedding-cake stacking of sloping rectangles that diminish in size from bottom to top. But this is the important distinction: the ziggurat is a temple and the pyramid is a tomb. Djoser's pyramid was the centerpiece of a mortuary complex that included a funerary temple and other structures arranged around a large court. Beneath the temple was a vast underground network of rooms, designed, presumably, to serve as Djoser's palace in the afterlife.

The most recognizable remains of Old Kingdom Egypt, and the most famous, are the Great Pyramids at Gizeh (**Fig. 1.28**)—tombs for the pharaohs Khufu, Khafre, and Menkaure. In size and abstract simplicity, these structures show Egyptian skill in design and engineering on a massive scale—an achievement probably made possible by slave labor, although recent excavations suggest that the building of the great monuments may have been essentially the work of farmers during the off-season. In any case, the pyramids and almost all other Egyptian works of art perpetuate the memories of members of the upper

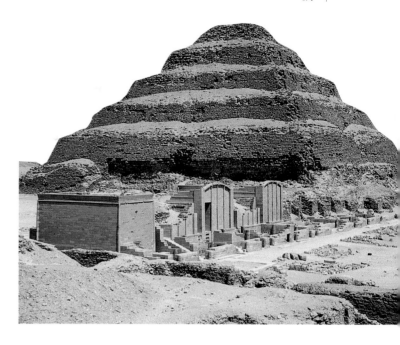

⌃ 1.27 Imhotep, stepped pyramid of Djoser, ca. 2630–2611 BCE (Third Dynasty). Saqqâra, Egypt.

The architect, Imhotep, is the first artist whose name is recorded.

◄ 1.28 The Great Pyramids at Gizeh, Egypt. From bottom: pyramids of Menkaure, ca. 2490–2472 BCE; Khafre, ca. 2520–2494 BCE; and Khufu, ca. 2551–2528 BCE. The pyramid tombs were only one part of a vast funerary complex that included temples and ceremonial causeways.

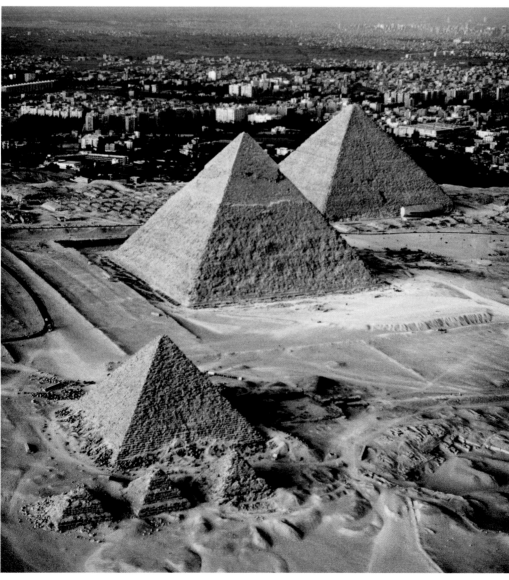

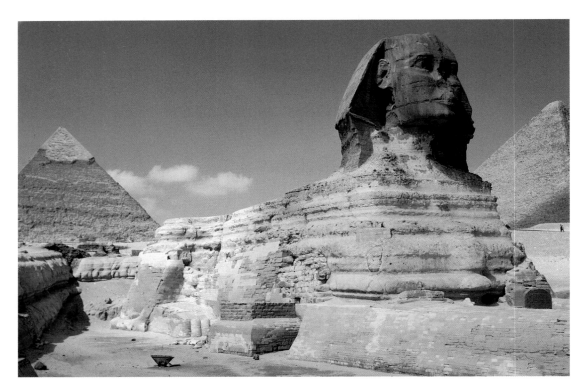

◀ **1.29** The Great Sphinx, ca. 2520–2494 BCE (Fourth Dynasty). Gizeh, Egypt. Sandstone, 65′ high × 240′ long (19.8 × 73.2 m). Part of the funerary complex of Khafre, the colossal sculpture has the body of a lion and the head of a man; it may be a stylized portrait of the pharaoh.

classes and bear witness to a lifestyle that would not have been possible without slaves. We still know little about the slaves or the poor Egyptians who were farm laborers. Many of the slaves were captured prisoners who were forced to labor in government quarries and on the estates of the temples. Over time, the descendants of slaves could enlist in the army; as professional soldiers they could take their place in Egyptian society.

The construction of the pyramids was an elaborate and complex affair. Stone quarried on the spot formed the core of each structure, but the fine limestone blocks originally used for facing, now eroded away, came from across the Nile. These were quarried in the dry season; when the floods came, they were ferried across the river, cut into shape, and dragged into place. The interiors of the pyramids contained a network of galleries, air shafts, and chambers, one of which held the mummified body of the pharaoh surrounded by the treasures that were to follow him into the next life. The pharaohs planned these massive constructions as their resting places for eternity and as monuments that would perpetuate their names. Their success was partial: 4,500 years later, their names are remembered—their pyramids, still dominating the flat landscape, symbolize the enduring character of ancient Egypt. As shelters for the occupants and their treasures, however, the pyramids were vulnerable. The size of the pyramids drew attention to the riches hidden within them, and robbers were quick to tunnel through and plunder them, sometimes only shortly after the burial chamber had been sealed. During the Middle Kingdom, Egyptians would design less vulnerable dwelling places for their spirits.

SCULPTURE The earliest examples of Egyptian sculpture are small—figurines, ivory carvings, ceramics. The Old Kingdom brought with it life-size sculpture in the round. Khafre, who commissioned the second of the three pyramids at Gizeh, is connected to the most famous of Egyptian sculptures, the colossal Great **Sphinx (Fig.1.29)** that served as a guardian for his tomb. The aloof tranquility of the human face, perhaps a portrait of the pharaoh, set on a lion's body made an especially strong impression fifteen hundred years later on the classical Greeks, who saw it as a divine symbol of the mysterious and enigmatic. Greek art frequently uses the sphinx as a motif, and it also appears in Greek mythology, most typically in the story of how Oedipus solved its riddle and thereby saved the Greek city of Thebes from disaster.

Khafre's appearance is preserved for us in several statues, such as the one carved in diorite (a gray-green stone) in which he is seated on a throne ornamented with the lotus blossoms and papyrus that symbolize Upper and Lower Egypt (**Fig. 1.30**). The artist contained the figure within the overall shape of the stone block from which it was carved. The legs and torso appear molded to the throne, and the arms and fists are attached to the body. A sense of solidity is maintained and, with that, a certain confidence that the sculpture would remain intact. Few pieces, if any, were likely to break off. Permanence was essential, as sculptures like these were created as alternate dwelling places for the *ka*, or soul, should the mummified remains of the deceased disintegrate.

Khafre was rendered according to a specific **canon of proportions** relating anatomical parts to one another that relied on predetermined rules, not on optical fact. (Naturalism was intermittent in Egyptian art, and more evident in the Middle Kingdom and the Amarna period.) He sits rigidly; his frontal gaze reminiscent of the staring eyes of the Mesopo-

tamian votive figures. Khafre is shown with the conventional attributes of the pharaoh: a finely pleated kilt, a linen headdress gracing the shoulders, and a long, thin beard (present on the carved faces of both male and female pharaohs), part of which has broken off. The sculptor's approach to anatomy and drapery is realistic, and details are shown with great precision, but the features of the pharaoh are idealized; it is a portrait not of an individual but of the concept of divine power, power symbolized by the falcon god Horus perched behind the pharaoh's head. The calmness, even indifference, of the expression is particularly striking.

◄ **1.30** **Statue of Khafre, ca. 2500** BCE **Gizeh, Egypt. Diorite, 66″ high (167.6 cm). Egyptian Museum, Cairo, Egypt.** The pharaoh's divine power is represented by Horus, the falcon god of the morning sun, perched behind his head.

Middle Kingdom

The art of the Old Kingdom reflects a mood of confidence and certainty that ended abruptly around 2200 BCE with a period of violent disturbance. Divisions between the regions began to strengthen the power of landowning local governors. By the time of the **Middle Kingdom**, it was no longer possible for pharaoh, priests, or nobles to face the future with complete trust in divine providence. Middle Kingdom art reflects this new uncertainty in two ways: As the Old Kingdom came to represent a kind of golden age, artists tried to recapture its lofty serenity in their own works, interspersed with some experimentation outside the mainstream of strict conventionalism. At the same time, somber expressions and more sensitively rendered royal portraits reveal the more troubled spirit of the age. The occupation of a Middle Kingdom pharaoh was hardly relaxing.

A striking aspect of Middle Kingdom architecture was the **rock-cut tombs**, which may have been designed to prevent robberies. They were carved out of the **living rock**, and their entranceways were marked by columned **porticoes** of **post-and-lintel construction**. These porticoes led to a columned entrance hall, followed by a chamber along the same axis. The walls of the hall and tomb chamber were richly decorated with relief sculpture and painting, much of which has a liveliness not seen in Old Kingdom art.

New Kingdom

The Middle Kingdom also collapsed, and Egypt fell under the rule of the Hyksos, foreigners with Syrian and Mesopotamian roots. They introduced Bronze Age weapons to Egypt, as well as the horse and the horse-drawn chariot. Eventually the Egyptians overthrew them, and the **New Kingdom** was launched. It proved to be one of the most vital periods in Egyptian history, marked by expansionism, increased wealth, and economic and political stability.

The art of the New Kingdom combined characteristics of the Old and Middle Kingdom periods. The monumental forms of the earliest centuries were coupled with the freedom of expression of the Middle Kingdom years. A certain vitality appeared in painting and relief sculpture, although sculpture in the round retained its solidity and sense of permanence, with few stylistic changes.

Egypt's most significant monuments continued to be linked to death or worship of the dead. During the New Kingdom, a new architectural design emerged—the **mortuary temple**. Mortuary temples were carved out of the living rock, as were the rock-cut tombs of the Middle Kingdom, but their function was quite different: they served as a place for worshipping the gods, pharaohs, and their queens during the pharaoh's life,

Instructions to a Son

Instructional texts were common in ancient Egypt, and they served as guidebooks to a well-ordered life. They were usually handed down from father to son and offered advice on any number of subjects—avoiding pride and gluttony, seeking social harmony and justice. The following instructions to a son were written by a city governor and vizier named Ptahotep during the Middle Kingdom.*

1. Do not be arrogant because of your knowledge, but confer with the ignorant man as with the learned, for the limit [maximum] of skills has not been attained, and there is no craftsman who has (fully) acquired his mastery....Good speech is more hidden than malachite**, yet it is found in the possession of women slaves at the millstones.

2. If you find a disputant arguing, one having authority and superior to you, bend down your arms and bow your back; if you disagree with him, he will not side with you. You should make little of the evil speaking by not opposing him in his argument; it means that he will be dubbed an ignoramus when your self-control has matched his prolixity.

3. If you find a disputant arguing, your equal who is on your level, let your virtue be manifest against him in silence when he is speaking ill; great will be the talk on the part of the hearers, and your name will be fair in the opinion of the magistrates.

4. If you find a disputant arguing, a humble man who is not your equal, do not be aggressive against him in

proportion as he is humble; let him alone, that he may confute himself. Do not question him in order to relieve your feelings, do not vent yourself against your opponent, for wretched is he who would destroy him who is poor of understanding; men will do what you wish, and you will defeat him by the disapproval of the magistrates.

5. If you are a leader, controlling the destiny of the masses, seek out every good thing, until there is no fault in your governance, . . . Truth is great, and (its) effectiveness endures; it has not been confounded since the time of Wesir.

6. Do not inspire terror in men, for God also is repelled.

. . .

11. Follow your desire as long as you live and do not perform more than is ordered; do not lessen the time of following desire, for the wasting of time is an abomination to the spirit; do not use up...the daytime more than is (necessary) for the maintenance of your household. When riches are gained, follow desire, for riches will not profit if one is sluggish.

. . .

14. As for him whose heart obeys his belly, he puts dislike of himself...in the place of love; his heart is sad and his body unanointed. Joyous are the hearts of those whom God has given, but he who obeys his belly has an enemy.

. . .

23. Do not repeat slander; you should not hear it, for it is the result of hot temper. Repeat (only) a matter seen, not what is heard.

. . .

25. One who is serious all day will never have a good time, while one who is frivolous all day will never establish a household.

* Fragments from a papyrus manuscript in the Bibliotheque Nationale, Paris. Source: *The Literature of Ancient Egypt*, edited by William Kelly Simpson, New Haven and London, Yale University Press, 1973. http://www.philae.nu/akhet/Ptahotep.html

** A green semi-precious stone formed naturally from copper.

and a place where the pharaoh would be memorialized and worshipped after death.

One of the most impressive mortuary temples of the New Kingdom is that of the female pharaoh Hatshepsut (**Fig. 1.31**). The temple backs into imposing cliffs and is divided into three terraces, which are approached by long ramps that rise from the floor of the valley to the top of pillared **colonnades**. Although the terraces are now as barren as their surroundings, during Hatshepsut's time they were covered with exotic plants. The uppermost level features numerous large sculptures of Hatshepsut standing or seated, all in a rigid frontal pose. The interior of the temple was just as lavishly decorated, with some 200 large

sculptures as well as painted relief carvings. Sculptures of Hatshepsut are to some extent stylized according to typical conventions, although her face is recognizable from one work to another. In many portraits, her body is masculinized. She wears the same pleated kilt, royal headdress, and false beard that the male pharaohs do. In others she is represented as a woman with slender proportions, breasts, and a delicate, distinctive angular face. After the death of her husband, Hatshepsut ascended to the throne of Egypt as the regent for her son, who was still too young to succeed his father. However, in time she seized the title of pharaoh for herself, ruling Egypt for two decades. Reliefs in her mortuary temple intended to justify her actions show

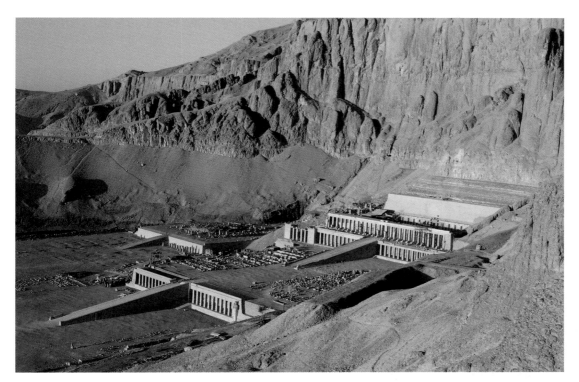

◀ **1.31 Mortuary temple of Queen Hatshepsut, ca. 1480 BCE Thebes, Egypt.** Some statues of the Hatshepsut show her with the same ceremonial false beard seen in sculptures of male pharaohs.

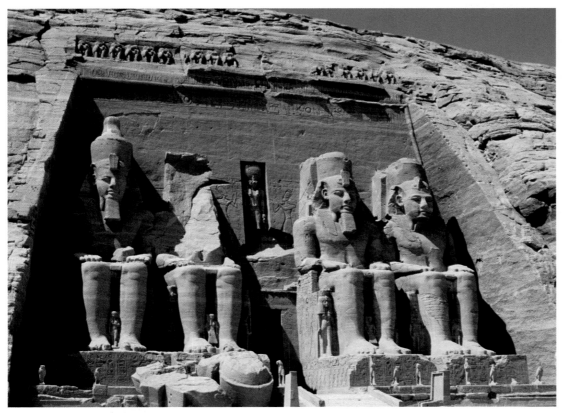

◀ **1.32 Temple of Ramses II, ca. 1275–1225 BCE. Originally at Abu Simbel, Egypt; now relocated because of the creation of Lake Nasser. Approximately 65′ high (colossi) (19.8 m).** Ramses II glorified his accomplishments as ruler of the Egyptian Empire in his rock-cut temple at Abu Simbel in Nubia. The four seated monumental figures at the entrance are images of the pharaoh. The temple was literally moved with the building of the Aswan High Dam to save it from complete submersion in the dam's reservoir.

her father, Thutmose I, crowning her as king as the gods look on. We have seen other examples of rulers who presented their achievements as sanctioned by deities, such as Naram-Sin (**Fig. 1.20**) and Hammurabi (**Fig. 1.21**). Hatshepsut was succeeded by her son, Thutmose III, who had her portraits destroyed.

Ramses II, who reigned over the Egyptian Empire from 1279 to 1213 BCE, ordered the construction of the New Kingdom's most spectacular temple complexes and monumental statuary—bigger was better. Like Hatshepsut's rock-cut mortuary temple, the temple at Abu Simbel (**Fig.1.32**) was cut into the area's natural rock cliffs. The entrance is

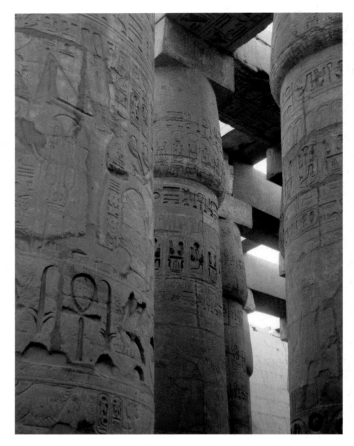

▲ **1.33 The hypostyle hall of the temple of Amen-Re, ca. 1290–1224 BCE (Nineteenth Dynasty). Karnak, Thebes, Egypt.** The monumental columns of the hypostyle audience hall of the temple at Karnak are carved with sunken reliefs that maintain the overall smooth profile of the column shaft. Two styles of columns are used, one in the shape of an open flower (or bell) and the other in the shape of a closed bud.

flanked by colossal sculptures of Ramses that are 65 feet high—sitting down. Picture the pharaoh rising from his throne; it is truly awe-inspiring. Inside, along the walls of the first room, colossal sculptures representing Ramses as the god Osiris stand across from one another as silent and powerful sentinels. Inner chambers placed along a single axis press some 200 feet deeper into the rock and are covered with painted wall reliefs that depict the conquests of Ramses and his interaction with the gods. Looking at the scale of Abu Simbel embedded in rock, the notion of moving it would seem outrageous and incredible. But it was moved. In the 1960s, Egypt's Aswan High Dam project was undertaken, creating a reservoir that would have put this and other monuments under water. Abu Simbel was moved 700 feet; the relatively miniscule Temple of Dendur—given to the United States by Egypt in 1965 and now in the collection of New York's Metropolitan Museum of Art—was also rescued.

The temple of Amen-Re at Karnak (**Fig. 1.33**) represents another type of complex. Unlike the temples of Queen Hatshepsut and Ramses II, the temple of Amen-Re was built to honor several gods and was expanded by successive pharaohs, including Ramses. The site is vast—almost 250 acres—and was surrounded by a 26-foot-high wall. Like all complexes of this design, entry was through an enormous stone gateway called a pylon that led first to an open courtyard and then into a *hypostyle* hall—an audience hall that was reserved only for the pharaoh and priests. Beyond the hall was a dimly lit ritual chamber—the sanctuary. The hypostyle hall of the Karnak complex even today is a remarkable site. The columns number 134 in all, and some of them reach a height of 75 feet; they supported substantial **lintels** that, in turn, supported the roof. Between the vertical shaft of the **column** and the lintel is a **capitals** in the shape of either a closed bud or an open flower The shafts of the columns are covered with **sunken reliefs** with figures, hieroglyphics, cartouches, and decorative motifs.

THE AMARNA REVOLUTION: THE REIGN OF AKHENATON AND NEFERTITI During the mid-fourteenth century BCE, the pharaoh Amenhotep IV (r. 1379–1362 BCE) instituted radical changes in religion and politics. Egyptian gods were many, but Amenhotep IV abandoned almost all of them. He pronounced Aton the one and only true god and worshipped that deity—symbolized by a sun disk—exclusively. It did not stop there; he changed his name to Akhenaton and declared himself the son and only legitimate prophet of Aton. He moved the capital of Egypt from Thebes—where it had been since the beginning of the New Kingdom—north to Tel el Amarna. The period of Akhenaton's reign is called the Amarna Revolution

The most sincere and moving expression of Akhenaton's devotion to Aton survives in the form of a hymn to the god.

READING 1.6 AKHENATON

From "Hymn to the Sun"

When in splendor you first took your throne
 high in the precinct of heaven,
 O living God,
 life truly began!
Now from eastern horizon risen and streaming,
 you have flooded the world with your beauty.
You are majestic, awesome, bedazzling, exalted,
 overlord over all earth,
 yet your rays, they touch lightly, compass the lands
 to the limits of all your creation.
There in the Sun. you reach to the farthest of those
 you would gather in for your Son,[4]
 whom you love;
Though you are far, your light is wide upon earth;
 and you shine in the faces of all
 who turn to follow your journeying.

Ancient Egyptian Literature, John Lawrence Foster (trans), University of Texas Press, 2001.

4. The pharaoh Akhenaton is referring to himself.

In his monotheistic zeal, Akhenaton emptied temples dedicated to deities other than Aton and ordered the name of Amen-Re, the former chief god, scratched out wherever it appeared.

In addition to instigating upheavals in religion, Akhenaton cast aside time-honored artistic conventions and initiated a radically new, though short-lived, style. Curving lines and soft, organic forms flouted the rigidity of Old and Middle Kingdom conventions. The fluid body contours in the statue of Akhenaton (**Fig. 1.34**) contrast strongly with those in portraits of earlier kings, as do the elongated jaw, full lips, and thick-lidded eyes. Akhenaton's torso appears somewhat feminized, or at least androgynous: a thin waist; wider hips; narrow, sloping shoulders; and thin arms.

One of the most striking works of the Amarna period is the bust of Akhenaton's wife, Queen Nefertiti (**Fig.1.35**). In profile, the arc formed by her heavy crown, sinuous neck, and delicate upper back is, simply, elegant. Nefertiti's refined features, enhanced by vividly painted details, give us some idea of what must have been an arresting beauty (her name means "the beautiful one has come").

The portraits of these royals take an endearing turn in a small sunken relief of Akhenaton, Nefertiti, and their three daughters (**Fig. 1.36**). Such intimacy had never before been seen in images of the pharaoh. Despite the looming presence of the sun disk Aton, whose rays shine on the couple and their family and sanctify the scene, Akhenaton

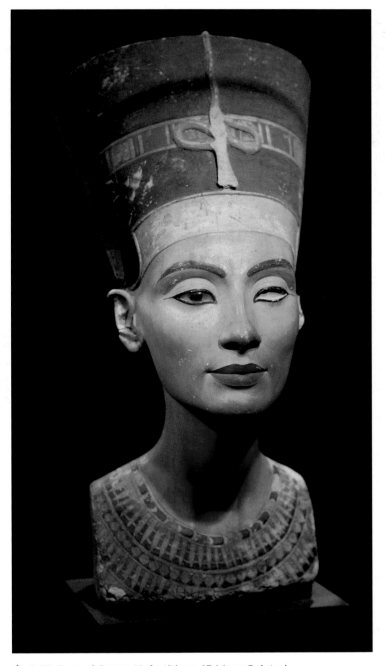

▲ **1.35 Bust of Queen Nefertiti, ca. 1344 BCE Painted limestone, 19 ³/₄″ (50 cm) high. Ägyptisches Museum, Berlin, Germany.** *Nefertiti* means "the beautiful one has come."

◀ **1.34 Pillar statue of Akhenaton, ca. 1356 BCE Temple of Amen-Re, Karnak, Egypt. Sandstone, painted, 13′ high (400 cm). Egyptian Museum, Cairo, Egypt.** Akhenaton subverted conventions in politics, religion, and art.

more than anything else comes across as a dad. He holds one of his daughters gently in his arms and kisses her. Nefertiti has one of the children on her lap and another perched on her shoulder. The latter is clearly the youngest and is playing with an object dangling from her mother's crown, as any child would.

Akhenaton's revolutionary reforms were short-lived. After his death, they were repealed; it was as if the clock were turned back. His successors re-established the capital in Thebes, restored the temples to Amen-Re, and returned to the more regimented artistic styles of the earlier dynasties. With

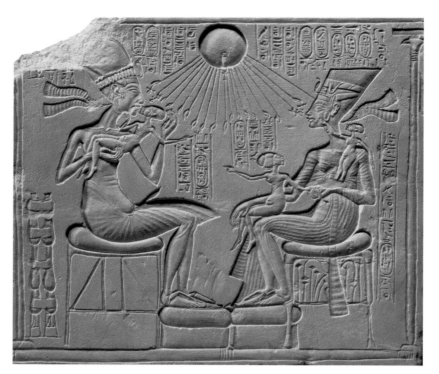

Akhenaton's death came the death of monotheism in Egypt. His belief in a single god who ruled the universe was threatening to the priests, who had a vested interest in preserving the old polytheistic traditions. Not surprisingly, Akhenaton's successors branded him a heretic and fanatic and cut out his name from all of the monuments that survived him.

TUTANKHAMEN AND THE POST-AMARNA PERIOD

The reaction against Akhenaton's religious policy and the Amarna style was almost immediate. Akhenaton's direct successor Tutankhamen, however, is not remembered for leading the opposition—or for any event in his short life. He owes his fame to the treasures found intact in his undisturbed tomb on February 17, 1922. These sumptuous gold objects still show something of the liveliness of Amarna art, but a return to conservatism was beginning.

It is not so much for what they reveal about trends in art that the treasures of Tutankhamen are significant. The discovery of the tomb is important for a different reason. Our knowledge of the cultures of the ancient world is constantly being revised by the work of archaeologists; many of their finds are minor, but some are major and spectacular. In the case of excavations such as the tomb of Tutankhamen, the process of uncovering the past sometimes becomes as exciting and significant as what is discovered.

Tutankhamen—the famed boy-king Tut—died at about age 18. His tomb was not discovered until 1922, when a British archaeological team led by Howard Carter unearthed a trove of gold objects, many inlaid with semiprecious stones (**Fig.1.37**). By far the most spectacular find was three gold coffins nested one inside the other, the last of which held the young pharaoh's mummified body; the three together weighed almost 250 pounds (the weight of a black bear). The innermost cof-

fin (**Fig.1.38**) is magnificent in detail: Tut's effigy is fashioned of hammered gold inlaid with turquoise, lapis lazuli, and carnelian (a brownish-red semiprecious gem), and his eyes are of **aragonite** (a mineral) and **obsidian** (black volcanic glass). He clutches the royal attributes of the crook and the flail. Tut's body was found inside this coffin, wrapped in fine linen with a solid-gold mask, also with inlaid stone, placed over his head and shoulders. Carter described his awe at the discovery: "And as the last was removed a gasp of wonderment escaped our lips, so gorgeous was the sight that met our eye: a golden effigy of the young boy king, of most magnificent workmanship, filled the whole of the interior of the sarcophagus."

After Tutankhamen, the conventions of the earlier periods of Egyptian art—along with their characteristic rigidity—reappeared. The aura of permanence that was so valued endured for another 1,000 years virtually unchanged, despite the empire's gradual decline.

LITERATURE Much art and architecture from ancient Egypt has survived, but all that remains of literature is some scattered fragments. From the Old Kingdom, only religious texts such as the *Book of the Dead*, and others intended to ease the soul's passage to the afterlife, have come down to us. Lyric poetry and narratives of the New Kingdom, however, paint a picture of a much richer and more diverse literary tradition.

The Leiden Hymns were written on a papyrus that dates to the rule of Ramses II, ca. 1238 BCE. In one, the author describes the self-creation of Aton, the sun god and chief deity who was "skilled in the intricate ways of the craftsman." The first lines of the hymn acknowledge that the form of the god is ultimately unknowable and unfathomable.

READING 1.7 THE LEIDEN HYMNS

From "God is a master craftsman"

God is a master craftsman;
 yet none can draw the lines of his Person.
Fair features first came into being
 in the hushed dark where he mused alone;
He forged his own figure there,
 hammered his likeness out of himself—
All powerful one (yet kindly,
 whose heart would lie open to men).

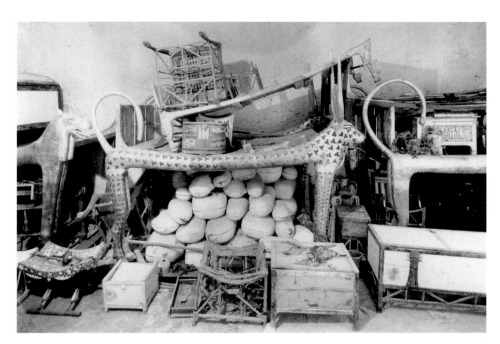

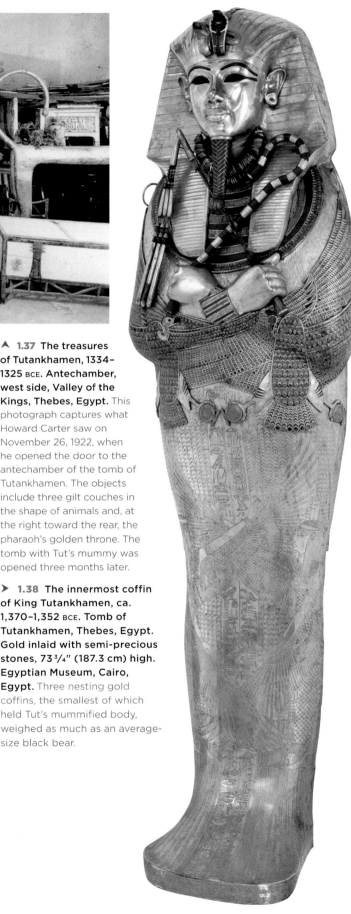

Love songs are among the most engaging and accessible literary works of the period, honest in their reflections on the joys and torments of the heart in the game called love. They range in sentiment from romantic and coquettish to seductive and frankly erotic.

READING 1.8 LOVE SONGS

"Love, how I'd love to slip down to the pond"

Love, how I'd love to slip down to the pond,
 bathe with you close by on the bank.
Just for you I'd wear my new Memphis swimsuit,
 made of sheer linen, fit for a queen—
Come see how it looks in the water!

READING 1.9 LOVE SONGS

From "My love is one and only, without peer"

So there she stands, epitome
 of shining, shedding light,
Her eyebrows, gleaming darkly, marking
 eyes which dance and wander.
Sweet are those lips, which chatter
 (but never a word too much),
And the line of the long neck lovely, dropping
 (since song's notes slide that way)
To young breasts firm in the bouncing light
 which shimmers that blue-shadowed sidefall of hair. . . .
(He who could hold that body tight
 would know at last
 perfection of delight)

⌃ 1.37 The treasures of Tutankhamen, 1334–1325 BCE. Antechamber, west side, Valley of the Kings, Thebes, Egypt. This photograph captures what Howard Carter saw on November 26, 1922, when he opened the door to the antechamber of the tomb of Tutankhamen. The objects include three gilt couches in the shape of animals and, at the right toward the rear, the pharaoh's golden throne. The tomb with Tut's mummy was opened three months later.

➤ 1.38 The innermost coffin of King Tutankhamen, ca. 1,370–1,352 BCE. Tomb of Tutankhamen, Thebes, Egypt. Gold inlaid with semi-precious stones, 73³/₄" (187.3 cm) high. Egyptian Museum, Cairo, Egypt. Three nesting gold coffins, the smallest of which held Tut's mummified body, weighed as much as an average-size black bear.

THE PREHISTORIC AEGEAN

Three civilizations developed during the Bronze Age in the area of the Aegean Sea: the Cycladic, Minoan, and Mycenaean civilizations. Cycladic culture sprang up during the Bronze Age on an archipelago (a cluster of islands) in the Aegean between the coasts of mainland Greece and Asia Minor. On the island of Crete in the southern Aegean, the Minoan civilization—the first great one in Europe—thrived until it was destroyed by natural catastrophe. And on mainland Greece, the Mycenaeans—forerunners of the ancient Greeks—built great citadels and lavished their tombs with gold. Centuries after their demise, the Greek poet Homer immortalized these Mycenaeans in his *Iliad*, an epic tale of the war between the Greeks and the Trojans. His epithet "Mycenae, rich in gold" was one of the inspirations for archaeological adventures that yielded the remains of a glorious civilization.

The Cycladics

Little is known about Cycladic culture. As with all prehistoric cultures, there are no written records. The people of the Cyclades islands used bronze tools and produced imaginative painted pottery. The most famous and idiosyncratic

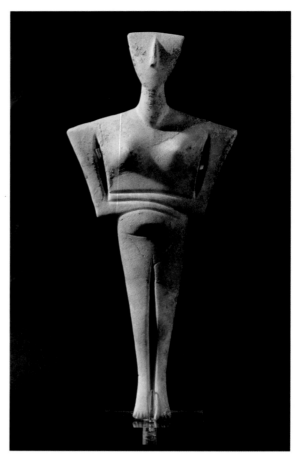

⋏ 1.39 Female idol, ca. 2000 BCE Chalandriani, Syros, Greece. Marble, 18″ (22.8 cm) high. National Archaeological Museum, Athens, Greece. Statuettes like this female idol were found in droves in graves and around settlements. It is not clear whether they represent mortal women or goddesses, or both.

works, however, are the abstract marble figurines (**Fig. 1.39**) found in great quantities, in many cases buried with the dead. The statues range in height from a few inches to almost life-size; the average is about a foot high. Most of the figures are

The Prehistoric Aegean

3000 BCE	2000 BCE	1600 BCE	1400 BCE	1200 BCE
Settlements and burial sites on Cyclades and Crete indicate thriving cultures and economies Cyclades are the center of the marble industry in the Aegean Cycladic sculptors carve figurines for graves to accompany the deceased into the afterlife	Minoans construct palace complexes on Crete that are destroyed by fire ca. 1600 BCE Volcano destroys the island of Thera ca. 1600 BCE Palace at Knossos on Crete is rebuilt; vast, rambling design is legendary home of King Minos and the Minotaur's labyrinth Development of writing using a linear script	Mycenaean civilization flourishes on mainland Greece Gold masks and other objects are placed in shaft graves of powerful elite Mycenaeans occupy Crete Center of Aegean culture shifts from Crete to the mainland	Mycenaeans construct great fortified palace citadels and beehive-shaped tombs Mycenaean war against Troy ca. 1250 BCE Destruction of Mycenaean palaces ca. 1200 BCE Greek-speaking Dorians establish themselves on the mainland	

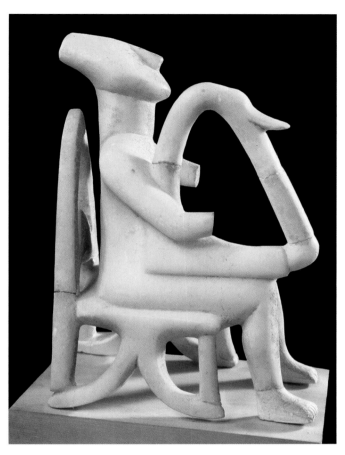

female and typically nude, portrayed in highly simplified terms—a few geometric shapes with incised details used sparingly. The minimalist quality of the slender bodies—thin arms and legs, smallish head, protruding breasts, and triangle defining the pubic area—would suggest a connection to the earth-goddess or fertility figures we have already seen (**Fig. 1.6** to **1.10**). The truth is, we have no idea whether they represent goddesses, or why they were carved, or what purposes they served. Figures of men playing musical instruments (**Fig. 1.40**) were also found in graves, suggesting that music was a part of funerary rituals or perhaps entertainment in the afterlife. They too are carved in simple, abstract shapes.

Excavations at Akrotíri on the southernmost Cycladic island of Thera have revealed extraordinary frescoes that were preserved in volcanic debris following an eruption ca. 1638 BCE. The *Spring Fresco* (**Fig.1.41**) may be art history's

◄ **1.40** Male harp player, ca. 2,600–2,300 BCE Keros, Greece. Marble, 9″ (22.8 cm) high. National Archaeological Museum, Athens, Greece. The very modern-looking figure of a harp player is composed of abstract shapes. Its purpose is not fully understood, but the musician may be playing for an audience in the afterlife.

▼ **1.41** Landscape with swallows (*Spring Fresco*), ca. 1,650 BCE Room Delta 2, Akrotíri, Thera, Greece. Fresco, 98″ (250 cm) high, central wall, 102¼″ (260 cm) long, side walls, 87¼″ (222 cm) long and 74″ (188 cm) long. National Archaeological Museum, Athens, Greece. The fresco found on the Cycladic island of Thera may be the earliest known example of landscape as a purely decorative device.

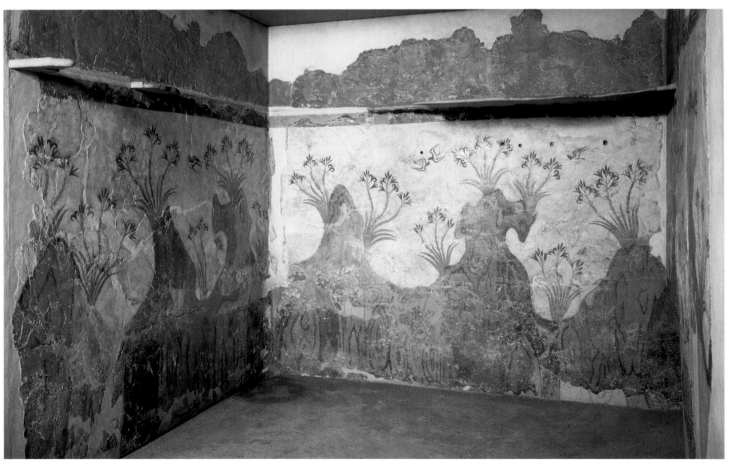

first example of pure landscape painting created solely for the purpose of interior decoration. The artist made no attempt to describe accurately the hilly landscape dotted with leafy plants and sprigs of flowers. Instead, we see an eye for color and patterns, for undulating shapes and rhythmic lines that have a mood-elevating effect. The birds that fly and glide and, in one place, nearly kiss complete the carefree ambience.

Politically speaking, when the Theran eruption occurred, the island was most likely a satellite of the Minoans on Crete. The *Spring Fresco* has its artistic counterpart in the palace decorations at Knossos on the northern coast of Crete.

The Minoans

Cycladic civilization developed in small settlements on the smallest islands of the Aegean. On Crete, however, there were palaces, and among them a famed one at that. The palace of the legendary king Minos at Knossos was constructed during the prime of Cretan civilization, rebuilt on the ruins of an earlier one that had been destroyed.

In Greek mythology, Minos was the offspring of Europa and Zeus, who abducted Europa in the guise of a white bull. As the king of Crete, Minos constructed a glorious palace with a labyrinth (a maze designed by his architect Daedalus). Inside the labyrinth roamed the Minotaur—a monstrous creature that was half man, half bull (*taurus* means bull), the product of the union of Minos's wife Pasiphae with a bull. Every year, according to the myth, King Aegeus of Athens presented seven boys and seven girls to Minos as tribute, whereupon they were sent into the maze to be devoured by the Minotaur. This gory sacrificial custom continued until Theseus, cofathered by Aegeus and the god Poseidon, volunteered to take on the beast. He went to Knossos with the new group of intended victims and, with the help of the king's daughter Ariadne (who had fallen in love with him), killed the Minotaur in its lair in the middle of the labyrinth. He then escaped with Ariadne and the Athenian boys and girls. Theseus later abandoned Ariadne on the Cycladic island of Náxos, but the god Dionysus discovered her there and comforted her. (In the early twentieth century, the composer Richard Strauss would write a comedic opera called *Ariadne auf Naxos*—"Ariadne on Náxos.")

What does the Greek myth of Minos, the Minotaur, and the labyrinth tell us? That the Greeks had a picture of Knossos as a prosperous and thriving city from which a powerful and ruthless king ruled Crete. By the time Athens reached its golden age in the fifth century BCE, what remained of Knossos—or what Homer refers to as "Crete of a hundred cities"—was nothing more than legend. The Greeks never went in search of the roots of the legend, but this is not surprising. Archaeology, after all, is a relatively modern pursuit, and there is little indication of any serious enthusiasm in classical antiquity for the material remains of the past. For many centuries the story of Minos and the labyrinth was thought to be a good tale with no foundation in fact. One look at the plan of the palace at Knossos (**Fig. 1.42**) reveals it as a sprawling complex with a central court for processions or games surrounded by buildings whose configurations can only be described as mazelike.

THE EXCAVATION OF KNOSSOS In the 1870s, the German businessman and amateur archaeologist Heinrich Schliemann proved that the stories of the war against Troy—and the Mycenaeans who had waged it—were far from mere legends. Was it possible that the mythical palace of King Minos at Knossos

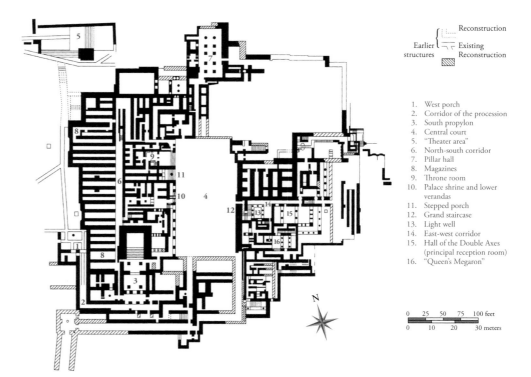

➤ **1.42 Plan of the palace at Knossos (Crete), Greece, ca. 1700–1370 BCE.** The mazelike plan may have given birth to the myth of the Minotaur, half man and half bull, which roamed the labyrinth of the palace of King Minos and devoured Greek youths.

Earlier structures { Reconstruction / Existing / Reconstruction

1. West porch
2. Corridor of the procession
3. South propylon
4. Central court
5. "Theater area"
6. North-south corridor
7. Pillar hall
8. Magazines
9. Throne room
10. Palace shrine and lower verandas
11. Stepped porch
12. Grand staircase
13. Light well
14. East-west corridor
15. Hall of the Double Axes (principal reception room)
16. "Queen's Megaron"

0 25 50 75 100 feet
0 10 20 30 meters

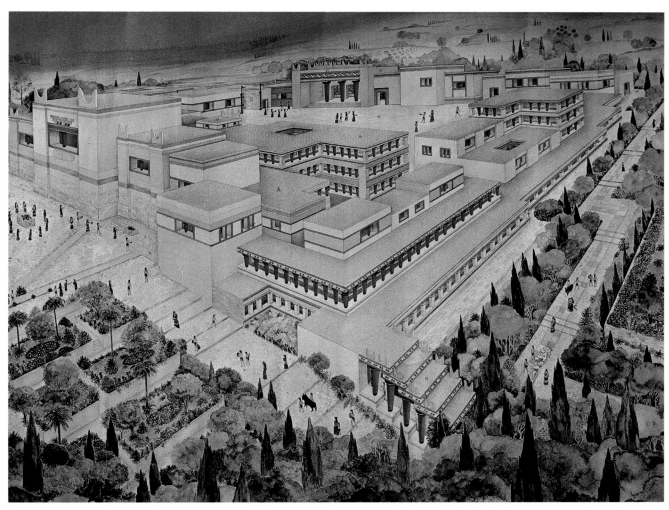

⋀ 1.43 **Reconstruction drawing of the palace at Knossos (Crete), Greece, ca. 1700–1370** BCE. Each Cretan palace had a central court with a north–south orientation, state apartments to the west, and royal living quarters to the east.

also really existed? In 1894 the English archaeologist Arthur Evans first went to Crete to see if he could discover something of its Bronze Age history. At Knossos he found evidence of ancient remains, some of them already uncovered by amateur enthusiasts. He returned in 1899 and again in 1900 with a permit to excavate. On March 23, 1900, serious work began at Knossos, and within days it became apparent that the finds represented a civilization even older than that of the Mycenaeans. The quantity was staggering: pottery, frescoes, inscribed tablets, and more. Evans's discoveries at Knossos (and finds later made elsewhere on Crete by other archaeologists) did much to confirm legendary accounts of Cretan prosperity and power. Yet these discoveries did far more than merely give a true historical background to the myth of the Minotaur. Evans had in fact found an entire civilization, which he called Minoan after the legendary king. Evans is said to have once remarked modestly, "Any success as an archaeologist I owe to two things: very short sight, so I look at everything closely, and being slow on the uptake, so I never leap to conclusions."

Actually, the magnitude of his achievement can scarcely be exaggerated. All study of the Minoans has been strongly influenced by his initial classification of the finds, especially the pottery. Evans divided the history of the Bronze Age in Crete into three main periods—Early Minoan, Middle Minoan, and Late Minoan—and further subdivided each of these into three periods. The precise dates of each can be disputed, but all of the excavations of the years following Evans have confirmed his reconstruction of the main sequence of events.

LIFE AND ART IN THE MINOAN PALACES During the Early Minoan period small settlements began to appear in the south and east of Crete, and the first contacts were established with Egypt and Mesopotamia. Around 2000 BCE, these scattered towns were abandoned and large urban centers evolved, marking the beginning of the Middle Minoan period and the first major development in Minoan civilization—the palaces. More than elaborate homes for ruling families, they functioned as small cities. Sometime around 1600 BCE, these structures from what is called the Old Palace period were destroyed by a fire that may have followed an earthquake and were then rebuilt on an even grander scale. These palaces of the Late Minoan period represent the zenith of Minoan culture. The best-known is the one at Knossos (**Fig. 1.43**); others were found at Phaistos, Malia, and Kato Zakros.

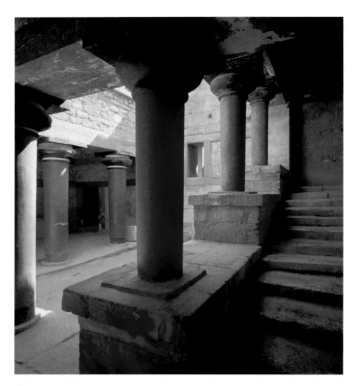

The main palace buildings were constructed around an open rectangular courtyard and included the king's and queen's bedrooms, a throne room, rooms for public receptions and banquets, a shrine, spaces for religious ceremonies, administrative offices, and work areas for slaves and craftsmen. The complex also included residences ranging from servant quarters to private houses for aristocrats and religious leaders. Although the plan seems haphazard, in fact it was not: rooms with similar or related functions were clustered together. Rows upon rows of magazines (storage areas) were stocked with large vessels of grain and wine, embedded in the earth for safekeeping and natural refrigeration. Beneath the palace were the makings of an impressive water-supply system of terra-cotta pipes that would have provided running water. The palace was designed to remain cool in summer and be heated easily in winter.

Aside from amenities that suggest a high standard of living, the scale and complexity of the palace architecture befit an impressive maritime power. The architects expanded outward from the central court and also built upward. Some parts of the palace are three stories high and accessed by gradually ascending staircases with light wells—vertical shafts running down through the building that bring light to the

∧ 1.44 Stairwell to the residential quarter of the palace, Knossos (Crete), Greece, ca. 1700–1370 BCE. The different levels of some buildings were accessed by staircases that were illuminated by light wells. Unlike Egyptian (and later Greek) columns, Minoan columns tapered toward the base. The columns shown here are reconstructions.

∨ 1.45 Bull-leaping fresco, ca. 1400–1370 BCE **Palace, Knossos (Crete), Greece. Fresco, 32″ (81.3 cm) high, including border. Archaeological Museum, Herakleion, Greece.** Bull leaping may have have been a rite of passage or part of a blood-sacrifice ritual. The young women's skin is light and the young man's is suntanned, a common convention for distinguishing gender.

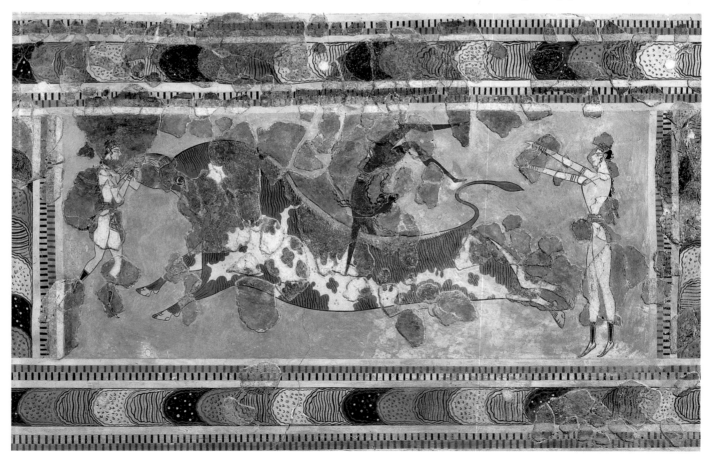

lower stories (**Fig. 1.44**). Characteristic Minoan columns can be seen in the stairwells and throughout the palace. Minoan columns were carved of wood and thus have not survived. We do know that they tapered downward and were narrowest at the base. This proportion is the reverse of standard columns found in Mesopotamia, Egypt, and, later, Greece. Cushion-shaped capitals loom large over the curious stem of the column shaft, which was painted bright red or blue.

The rough stonework of the thick palace walls was hidden behind plaster painted with vibrant, colorful landscapes like the *Spring Fresco* found on Thera. Many of the paintings depict subjects that reflect the palace's island setting—fish, sea mammals, coastal plants—but others, like the bull-leaping fresco (**Fig. 1.45**), clearly illustrate some sort of ceremony or ritual. As a bull leaps through space, front and hind legs splayed, a trio of youths performs daring feats. One takes the bull by the horns, a second vaults over its back, and a third lands safely with the flourish of a gymnast scoring a perfect ten. Although the body types and flowing black locks all look the same, the light-skinned youths are female and the one with dark skin is a male. This distinction between the sexes is common in ancient art: the males look suntanned because they spend more time outdoors. What are they doing and why? Bull leaping may have been a ritual or a rite of passage; we know that bulls were slain by the Minoans as a blood sacrifice. And doesn't this maneuver look exceptionally dangerous? Can one help but wonder if visitors to Crete saw such bull-leaping ceremonies—some of which must have resulted in death—and sowed the seeds of the legend of the Minotaur in the retelling of what they had witnessed?

Unlike in Mesopotamia and Egypt, we have neither evidence of temples on Crete nor any indication that Minoans created monumental sculpture of any kind. Only small sculptures have been found; unique among them is the so-called *Snake Goddess* (**Fig. 1.46**). There is a bit of a debate about whom this figurine represents and how it was restored after being found in pieces by Evans's team of archaeologists. The female figure is outfitted in a long tiered dress with an apron over her hips and an open bodice. While her clothing appears to be Minoan in fashion, her exposed breasts prompt the question, Is she a version of a fertility goddess? If not, is she another deity or perhaps a priestess? Although the rulers of the palaces seem to have been male, research suggests that Minoans worshipped female deities associated with fertility and that their palaces were sited in relation to the topography of the island, which resembles the shape of the female body. Absent decipherable texts, there is little that we know for certain about Minoan religion.

LINEAR A AND LINEAR B Throughout the Late Minoan period, there is evidence of cultural exchange—including artistic styles—between Crete and Mycenae on mainland Greece. During the second millennium BCE, two Minoan writing systems were devised and used in the palace for administrative and religious purposes. Linear A remains undeciphered, but in 1952, Michael Ventris discovered that Linear B—a written

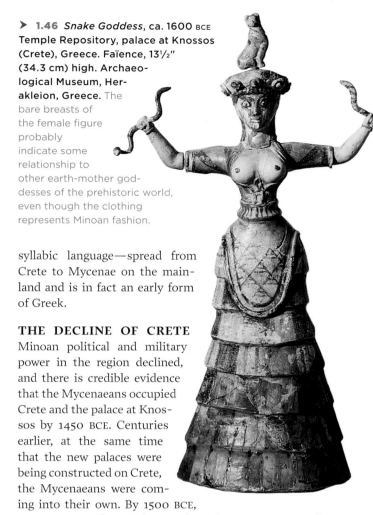

▶ 1.46 *Snake Goddess*, ca. 1600 BCE Temple Repository, palace at Knossos (Crete), Greece. Faïence, 13½″ (34.3 cm) high. Archaeological Museum, Herakleion, Greece. The bare breasts of the female figure probably indicate some relationship to other earth-mother goddesses of the prehistoric world, even though the clothing represents Minoan fashion.

syllabic language—spread from Crete to Mycenae on the mainland and is in fact an early form of Greek.

THE DECLINE OF CRETE Minoan political and military power in the region declined, and there is credible evidence that the Mycenaeans occupied Crete and the palace at Knossos by 1450 BCE. Centuries earlier, at the same time that the new palaces were being constructed on Crete, the Mycenaeans were coming into their own. By 1500 BCE, a Mycenaean culture—distinct from the Minoans—was flourishing on the mainland. By the time that Knossos was utterly and finally destroyed—ca. 1200 BCE—the Mycenaeans had already erected their great, fortified citadels on the mainland.

The Mycenaeans

The origins of the Mycenaean people are uncertain, but we do know that they came to the Greek mainland as early as 2000 BCE and spoke Greek. They are named after the largest of their settlements, at the city of Mycenae. Most of the centers of Mycenaean culture were in the southern part of Greece known as the Peloponnesus, although there were also some settlements farther north, the two most important of which were Athens and Thebes. The Mycenaeans were sophisticated in the forging of bronze weaponry and versatile in the arts of ceramics, metalworking, and architecture. The Minoans clearly influenced their art and culture, but by about 1400 BCE, Mycenae had become the natural leader in the Aegean area. Mycenaean traders traveled throughout the Mediterranean, from Egypt and the Near East as far west as Italy; their empire became more prosperous and more powerful. One successful expedition was launched against Troy on the coast of Asia Minor ca. 1250 BCE, perhaps because of a trade rivalry. A short time later

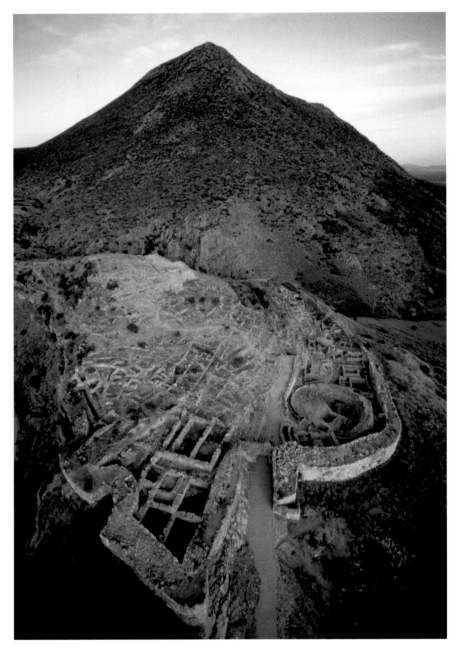

◀ **1.47 Remains of the citadel of Mycenae, ca. 1600–1200 BCE Mycenae, Greece.** Mycenaeans lived in vast palace complexes surrounded by massive fortification walls. Schliemann's Grave Circle A can be seen to the right in this photograph of the citadel at Mycenae, just inside the Lion Gate at the end of the path in the foreground.

Heinrich Schliemann dedicated his life and work to proving that the legends were founded on reality. Born in Germany in 1822, Schliemann was introduced as a child to the Homeric poems by his father and was overwhelmed by their incomparable vividness. He became determined to discover Homer's Troy and to prove the poet true. Schliemann made his first fortune in business, retired early, picked up his second career, and devoted his profits to the pursuit of his goal. After a period of study and travel, he began excavations in 1870 beneath the Roman city of Ilium, where he believed the remains of Homer's Troy lay buried. Three years later, he found not only walls and the gate of the ancient city but also quantities of gold, silver, and bronze objects.

Inspired by the success of his Trojan campaign, Schliemann moved on to the second part of his task: to discover the Mycenaeans who had made war on Troy. In 1876 he began to excavate within the walls of Mycenae, and there he almost immediately came upon the Royal Grave Circle with its stupendous quantities of gold treasures. Homer's description of Mycenae as "rich in gold" had Schliemann convinced that the royal family whose graves he had unearthed was that of Agamemnon, leader of the Mycenaean expedition against Troy. We now know that the finds date to an even earlier period, and later excavations both at Mycenae and at other mainland sites have provided a much more exact picture of Mycenaean history. This does not diminish Schliemann's achievement; however unscientific his methods, he had proved the existence of a civilization in Bronze Age Greece that surpassed in splendor even the legends. He had opened a new era in the study of the past.

(around 1200 BCE) the Mycenaean empire fell, its major centers destroyed and most of them abandoned. Invasion by enemies, internal strife, and natural causes have all been suggested, but the fall of the Mycenaeans remains mysterious.

HEINRICH SCHLIEMANN AND THE DISCOVERY OF MYCENAE Like the Minoans, the Mycenaeans were familiar from Greek myths long before their material remains were excavated; they were famous in legend for launching an expedition against Troy, across the Aegean Sea. The Trojan War (ca. 1250 BCE) and its aftermath provided the material for later Greek works—most notably the *Iliad* and the *Odyssey*, Homer's two great epic poems—but for a long time it was believed that the war and even Troy itself were only myths.

MYCENAEAN ART AND ARCHITECTURE Like the Minoans, the Mycenaeans constructed great palace complexes, but unlike Cretan palaces, theirs were fortified. Lacking the natural defense of a surrounding sea that was to Crete's advantage, the Mycenaeans faced constant threats from land invaders. They met them with massive fortifications, such as those found in the citadels at Tiryns (Homer referred to it as

"Tiryns of the great walls") and Mycenae (**Fig. 1.47**). At 20 feet in thickness, the sheer scale of the defensive walls makes the collapse of Mycenae incomprehensible. The stones laid were so enormous that Greeks later attributed the erection of the walls to a race of giants—the **Cyclopes**. Art historians still refer to the materials and construction techniques used in the citadels as **cyclopean masonry**.

The need for impenetrable fortification did not, however, preclude aesthetic solutions to architectural challenges. Although little painting survives, we know that some interiors were embellished with frescoes. Most of the sculpture unearthed is small in scale, but an example of monumental sculpture can be seen at one of the entryways to the citadel of the city of Mycenae—the so-called Lion Gate (**Fig. 1.48**).

The actual gateway is an example of post-and-lintel construction: a heavy stone lintel rests on two massive weight-bearing pillars. Around the gateway, stones are piled high in **courses** (rows) and **beveled** (cut at an angle) to form a **corbeled arch** that frames an open **relieving triangle** (so called because the design relieves the weight that is typically born by the lintel in post-and-lintel construction). The relieving triangle, in this instance, was filled with a triangular slab of stone carved in relief. Two facing lions rest their front paws on the base of a Minoan-style column, the slant of their bodies corresponding to the diagonal lines of the triangle. Their

heads, now gone, were carved in the round from separate pieces of stone and fitted into place. Although these guardian figures are not intact, their size and realistic musculature, carved in high relief, comprise an awesome sight, one that signified to intruders the strength of the army within the walls.

The corbeling technique was used to great effect in the construction of domed spaces in **tholos** tombs—beehive-shaped burial chambers entirely covered with earth so that they look, from the outside, like simple mounds. The Treasury of Atreus (**Fig. 1.49**), so named by Schliemann because he believed it to be the tomb of the mythological Greek king Atreus, is typical of such constructions. The tomb consists of two parts: the **dromos**, or narrow passageway leading to the tomb proper; and the tholos, or tomb chamber. The dome is constructed of hundreds of stones that were laid on top of one another in concentric rings of diminishing size and precisely shaped by stoneworkers. The Treasury rose to a height of 43 feet and enclosed a vast amount of space, an architectural feat not to be duplicated until the Romans constructed the dome of the Pantheon using concrete.

Homer's epithet for Mycenae was upheld with Schliemann's discovery of extraordinary quantities of finely wrought gold objects in simpler, more inconspicuous graves in a mound just inside the Lion Gate; the tholos tombs, like the pyramids before them in Egypt, were plundered well

▼ **1.48** Lion Gate, ca. 1300 BCE Mycenae, Greece. Sculpture above lintel: 114 ½" (290 cm) high. A relief sculpture of facing lions, with monumental heads carved in the round and attached to the relief, sat in the relieving triangle above a post-and-lintel gateway.

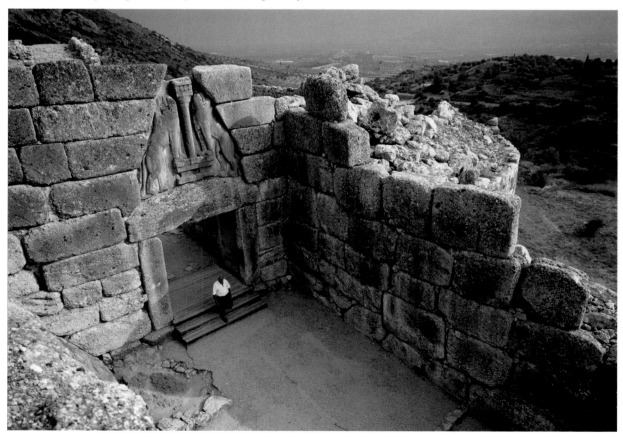

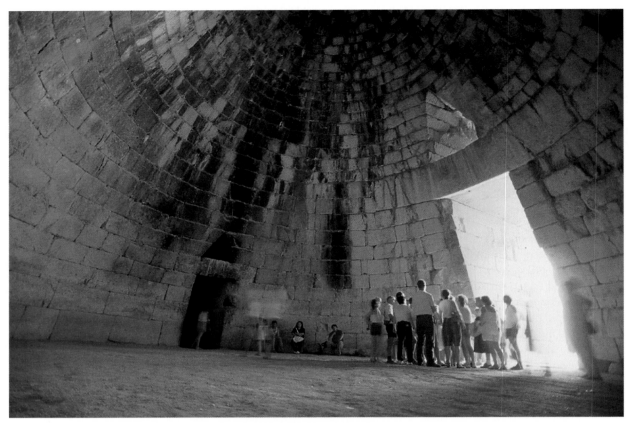

∧ **1.49** **The Treasury of Atreus, ca. 1300–1250 BCE Mycenae, Greece.** This tholos, or beehive, tomb so impressed Schliemann that he believed it had to be the tomb of the legendary King Atreus—but it is not.

before the modern excavations. Archaeologists refer to this burial mound as Grave Circle A. The most impressive finds were gold funerary masks, one of which Schliemann believed was that of Agamemnon himself (**Fig. 1.50**).

Masks such as these were created from gold hammered into thin sheets and then given shape by pressing parts of the sheet from the underside to create raised surfaces. The masks were found over the faces of the deceased and there was clearly some attempt to distinguish one person from another. Some aspects of the masks were stylized, such as the ears, eyebrows, and coffee-bean-shaped eyes, but the artists did endeavor to recreate specific portrait features. Schliemann found many other luxurious objects, including gold cups, bronze vessels, and daggers inlaid with silver and gold. As with other ancient burial practices, we conclude that the Mycenaeans stocked their tombs with precious objects they believed would have some purpose in the afterlife.

Something—the onslaught of better-equipped enemies, internal warfare, or both—brought about the collapse of the Mycenaean civilization ca. 1200 BCE. A few of the palaces were inhabited again, and some Mycenaeans fled eastward, where they settled on the islands of Rhodes and Cyprus off the southern coast of Asia Minor. By 1100 BCE, renewed violence extinguished the last traces of Bronze Age culture in Greece, and a period followed about which we know almost nothing. The people who emerged from this Dark Age would sow the seeds of the West's most influential civilization and enduring artistic legacy— that of ancient Greece.

◄ **1.50** **Funerary mask, ca. 1600–1500 BCE Grave Circle A, Mycenae, Greece. Beaten gold, 10¼″ (26 cm) high. National Archaeological Museum, Athens, Greece.** Shaft graves for members of the royal family in Grave Circle A yielded a cache of splendid gold objects, giving credence to the poet Homer's description of the city as "Mycenae, rich in gold."

GLOSSARY

Aragonite (p. 30) The primary mineral in mother-of-pearl, the iridescent inner layer of a mollusk shell.

Beveled (p. 39) Cut to create a slanted edge.

Canon of proportions (p. 24) A set of rules (or formula) governing what are considered to be the perfect proportions of the human body or correct proportions in architecture.

Capital (p. 28) In architecture, the uppermost part of a column on which rests the horizontal lintel.

Colonnade (p. 26) A series of columns, usually capped by a lintel, that can support a roof.

Column (p. 28) A vertical weight-bearing architectural member.

Conceptual representation (p. 16) The portrayal of a person or object as it is known or thought (conceptualized) to be rather than copied from nature at any given moment. Conceptual figures tend to be stylized rather than realistic.

Corbeled arch (p. 39) An arch in which each successive layer of stone projects slightly beyond the course below.

Course (p. 39) A horizontal row of stone or brick.

Cuneiform (p. 13) A system of writing featuring wedge-shaped characters; used in ancient Akkadian, Assyrian, Babylonian, and Persian writing.

Cyclopean masonry (p. 39) Walls constructed of extremely large and heavy stones.

Cyclopes (p. 39) A mythical race of one-eyed giants known for their inhuman strength.

Dromos (p. 39) A narrow passageway leading to a tomb.

Foreshortening (p. 6) A perspective technique used to convey the appearance of contraction of a figure or object as it recedes into space.

Hieroglyphics (p. 20) An ancient Egyptian system of writing that used pictures or symbols.

Hollow-casting (p. 15) A sculpture technique using molds that are lined with molten material—such as copper or bronze—rather than filled with the material (which would yield a solid rather than a hollow form).

Lapis lazuli (p. 13) An opaque blue, semiprecious stone.

Lintel (p. 28) In architecture, a horizontal member supported by posts or columns, used to span an opening.

Living rock (p. 25) Natural rock formations, as on a mountainside.

Middle Kingdom (p. 25) The period in ancient Egyptian history ca. 2040–1640 BCE

Mortuary temple (p. 25) An Egyptian temple in which pharaohs worshipped during their lifetimes and were worshipped after death.

Neolithic (p. 4) The New Stone Age.

New Kingdom (p. 25) The period in ancient Egyptian history ca. 1550–1070 bce, marked by the height of Egyptian power and prosperity; also referred to as the Egyptian Empire.

Obsidian (p. 30) A black, semiprecious, glasslike substance formed naturally by the rapid cooling of lava.

Old Kingdom (p. 20) The period in ancient Egyptian history ca. 2575–2040 BCE, during which the civilization achieved its first golden age

Optical representation (p. 18) The portrayal of a person or object as it is seen at any given moment from any given vantage point.

Paleolithic (p. 4) The Old Stone Age, during which the first sculptures and paintings were created.

Pharaoh (p. 19) An ancient Egyptian king believed to be divine.

Portico (p. 25) A roofed entryway, like a front porch, with columns or a colonnade.

Post-and-lintel construction (p. 25) Construction in which vertical elements (posts) are used to support horizontal crosspieces (lintels).

Prehistoric (p. 4) Prior to record keeping or the written recording of events.

Register (p. 22) A horizontal band that contains imagery; registers are usually placed one on top of another to provide continuous space for the depiction of a narrative (like a comic strip).

Relieving triangle (p. 39) An open triangular space above a lintel, framed by the beveled contours of stones, that relieves the weight carried by the lintel; seen, for example, in the Lion Gate at Mycenae.

Rock-cut tomb (p. 25) A burial chamber cut into a natural rock formation (living rock), usually on a hillside.

Rosetta Stone (p. 20) An ancient Egyptian stele dating to 196 BCE with text inscribed in three languages: hieroglyphics, demotic Egyptian, and Greek. Discovery of the stone enabled Europeans to decipher the meaning of hieroglyphics.

Semitic (p. 10) A family of languages of Middle Eastern origin, including Akkadian, Arabic, Aramaic, Hebrew, Maltese, and others.

Sphinx (p. 24) A mythical creature with the body of a lion and the head of a human, ram, or cat. In ancient Egypt, sphinxes were seen as benevolent and statues of sphinxes were used to guard the entrances to temples.

Stele (p. 16) An upright slab or pillar made of stone with inscribed text or relief sculpture, or both. Stelae (pl.) served as grave markers or commemorative monuments.

Sunken relief (p. 28) In sculpture, the removal of material from a surface so that the figures appear to be cut out or recessed.

Tholos (p. 39) A tomb chamber in the shape of a beehive.

Votive (p. 12) In a sacred space like a temple, a voluntary offering to a god, put in place as a petition or to show gratitude; as in votive candle.

Ziggurat (p. 11) In ancient Mesopotamia, a monumental platform on top of which a temple was erected. The height of the ziggurat was intended to bring worshipers closer to the gods.

THE BIG PICTURE BEGINNINGS

BEFORE HISTORY

Language and Literature

- Stone Age cultures, for the most part, had no written language, but symbols seem to have been used to record events or transmit beliefs.

Art, Architecture, and Music

- Paintings and relief sculptures on cave walls and small, portable figurines indicate the ability and desire of early humans to represent the world around them.
- Flutes with finger holes, carved of bone and ivory, suggest that music was played, perhaps for rituals in acoustically resonant spaces that also featured art.
- Houses were built of mammoth bones, including arched doorways framed by enormous tusks.
- In the settlement of Jericho in the Middle East, ca. 7500 BCE, a fortification wall and 30-foot-high tower was constructed in cut stone without mortar. In the same place, human skulls with features reconstructed in plaster were placed beneath the floors of houses.
- Pottery appeared in quantity, revealing technical skill in painting and firing.
- During the late Neolithic period, monumental stone architecture appeared, including Stonehenge, whose elaborate design may have functioned as a solar calendar.
- In the Aegean, carved idols representing the female figure were buried with the dead in simple graves.

Philosophy and Religion

- Paleolithic art and the evidence of musical traditions support the existence of rituals. It remains unclear, however, what these rituals may have been and what role the art played in them.
- Objects and embellishments were buried with the dead, suggesting a belief in an afterlife.
- Jericho's plastered skulls may have been linked to a belief that ancestors were mediators between the human world and the unknown world of the afterlife.
- Large numbers of nude female figurines were carved, suggesting worship of a mother goddess that may have been associated with fertility rituals.

MESOPOTAMIA

Language and Literature

- In Sumer, pictographs were used in early documents referring to business and administrative transactions. By ca. 3000 BCE, these signs were simplified into wedge-shaped characters in a form of writing called cuneiform.
- The life of the Sumerian king and hero Gilgamesh was glorified in an epic poem, the first work of literature in ancient history.

Art, Architecture, and Music

- Ziggurats with temples were constructed by the Sumerians.
- Small statuary was placed in temples; luxury items of gold and finely crafted objects made of wood and inlaid with lapis lazuli, shell, and other semiprecious materials were placed in tombs of the wealthy.
- Life-size, hollow-cast bronze sculptures illustrated sophisticated metalworking techniques.
- The Assyrian kings built sprawling and lavishly decorated palaces in citadels with defensive walls.
- Relief sculpture exalted the power of kings, invested by the gods, in images of victorious military campaigns.
- King Nebuchadnezzar of Babylon created the Hanging Gardens, one of the Seven Wonders of the World and perhaps the earliest example of landscape architecture.
- The Persians built a citadel at Persepolis, a vast complex of administrative buildings, religious structures, and ceremonial spaces adorned with reliefs and architectural sculpture.
- Musical instruments were placed in royal burial sites and musicians were depicted in art. Musical texts inscribed on tablets in cuneiform writing suggest a rich and highly developed theory and practice.

Philosophy and Religion

- Mesopotamian civilizations were polytheistic and most deities were connected to nature.
- Mesopotamians believed that their gods resided above them and would descend to meet their priests in the temples built high upon the platforms of ziggurats. Sumerians called these shrines waiting rooms.

ANCIENT EGYPT

Language and Literature

- Egyptian language appeared in written form ca. 3400 BCE in hieroglyphics, a complex writing system that consists of stylized pictographs. It was deciphered after the discovery of the Rosetta Stone.
- The earliest Egyptian texts had a sacred purpose, but in the Middle Kingdom literature expanded to narratives, poetry, love songs, history, biography, scientific texts, and instructive literature.
- The *Book of Emerging Forth into the Light* (also known as the *Book of the Dead*)—placed in burial chambers—is an illuminated papyrus scroll bearing spells and incantations that were deemed necessary to ease the passage of the deceased through the underworld.

Art, Architecture, and Music

- Egyptians created narrative paintings and reliefs, statuary, and colossal sculptures. For most of their history, the human figure was rendered according to strict pictorial codes.
- The first record of an artist's name—Imhotep—dates to Old Kingdom Egypt. He was the famed architect of the stepped pyramid of King Djoser.
- The three Great Pyramids at Gizeh, splendid pharaonic tombs, were constructed within the short span of 75 years.
- In the Middle and New Kingdoms, pyramidal tombs were replaced with tombs and mortuary temples carved into Egypt's imposing rocky cliffs.
- Amenhotep IV (Akhenaton) cast aside time-honored artistic conventions and initiated a radically new, but short-lived, style. Curving lines and soft, organic shapes flouted the traditional canon of geometric forms.
- Musical instruments including lyres, pipes, and flutes were found in burial chambers, which, along with fresco paintings of musicians, indicates that music was vitally connected to Egyptian life and ritual.

Philosophy and Religion

- Throughout almost its entire history, Egypt was polytheistic.
- Deities, subdeities, and nature spirits were worshipped; they were responsible for all aspects of existence and inspired mythology and ritual that affected the daily lives of all Egyptians.
- Egyptians were obsessed with immortality and the possibilities of life after death. Bodies were preserved through mummification and burial rituals sought to provide the deceased with the means to continue a life similar to that of this world.

THE PREHISTORIC AEGEAN

Language and Literature

- Linear A is a hieroglyphic script used mainly on seals in ancient Crete; Linear B, an early form of Greek, began on Crete and spread to Mycenae. Only Linear B has been deciphered.

Art, Architecture, and Music

- The Cycladic culture produced imaginative pottery and large numbers of nude female figurines carved in a simplified, abstract style.
- Small Cycladic sculptures of musicians playing a harp and double flute were found in a grave, suggesting that music was a part of funerary rituals.
- In the second millennium BCE, sprawling mazelike palaces were constructed at Knossos on the island of Crete and decorated with wall frescoes illustrating bull-leaping rituals, goddesses, and lively scenes from nature.
- Funerary masks and assorted objects of gold were fashioned by the Mycenaeans and placed, with their dead, in shaft graves; the Mycenaeans also built large beehive-shaped tombs with corbeled, domed ceilings.
- Citadels with massive fortification walls were constructed in Mycenae and Tiryns.

Philosophy and Religion

- In the absence of deciphered texts, Minoan religion remains a mystery. As in other prehistoric cultures, however, female figurines may have been connected to worship of an earth mother or fertility goddess.
- A bull-leaping ritual in a Minoan fresco may portray a fertility or initiation rite or ritual blood sacrifice.
- Luxurious and finely crafted objects of silver and gold found at Mycenaean burial sites suggest some belief in an afterlife.

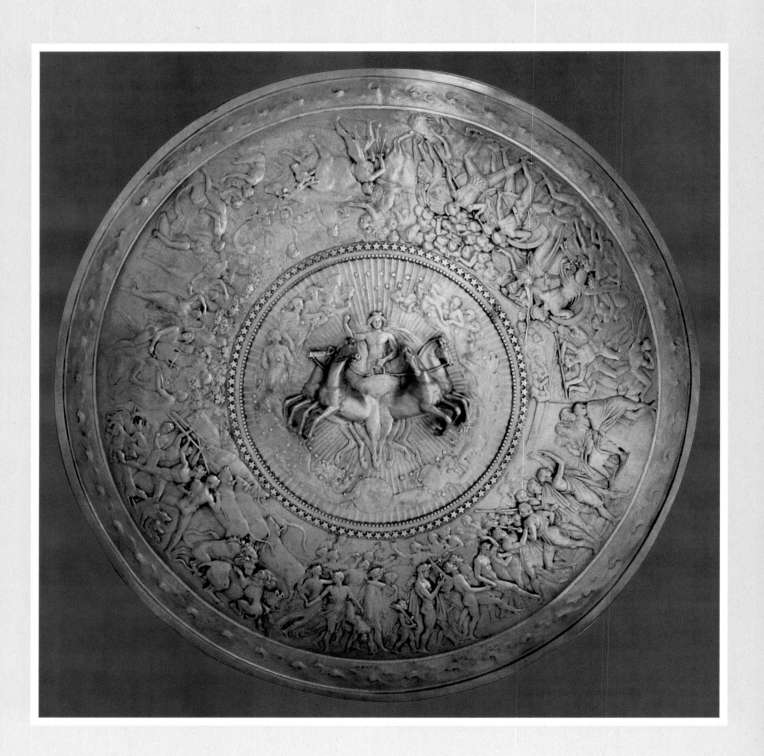

The Rise of Greece

PREVIEW

We know nothing of Homer except for his name. We have no idea what he looked like. We do not know for certain where he was born. We have no definitive proof that the *Iliad* and the *Odyssey*—as we read them today—were the work of his hand. But someone, some single voice, wove the stories of generations of bards, who sang of a long-past heroic age as far back as the eighth century BCE, into an epic narrative that would be written down, canonized, and commemorated. By law, the 15,693 lines of the *Iliad* would be recited in Athens every four years. And Homer, the "immortal poet," would be known as its author.

Homer's epics underscore the importance of the Mycenaean legacy to the Greeks, the shaping of their identity, and their emerging sense of self. The poems speak to us of the relationship between humans and their gods and the delicate interplay of fate—ordained by the divine—and destiny—shaped by the actions of an individual with free will. Enmeshed in the heroic figures of the *Iliad* and the *Odyssey* are Homer's reflections on the human condition as it is affected by the destruction of war and the security of peace. These become vivid in his description of the great shield of Achilles, forged by the god Hephaestus himself, in the eighteenth book of the *Iliad*. The shield's imagery is a microcosm of Greek culture and values, set in the contexts of the world and human life. In our mind's eye we see the earth, sky, and the sea; the sun, moon, and stars; and "two noble cities filled with mortal men." One is besieged, its inhabitants locked in battle with an enemy army, death all around. Life goes on in the other, unburdened by conflict: a wedding takes place, a law case is brought to court for justice, fields are plowed, harvests are reaped, and grapes are picked for the making of wine. The two scenarios are juxtaposed, as if to suggest that these two, discrete aspects of humanity will endure, irreconcilable.

Homer's descriptive powers have yielded various physical manifestations of the shield's narrative, including one by John Flaxman (Fig. 2.1), which was presented to the United Kingdom's King George IV in 1821 on the occasion of his coronation banquet Achilles's "indestructible shield" was recreated for the son and successor of George III, "the king who lost America."

◄ **2.1** John Flaxman, *The Shield of Achilles*, 1821. Silver-gilt 35³/₄" (90.7 cm) diameter. The Royal Collection, London, United Kingdom.

EARLY GREECE

Western culture's debt to the ancient Greeks lies principally in the achievements of their city life: art, politics, philosophy, history, and all the other factors described in this and the following chapter. Greece itself, however, was basically an agricultural society, and as Homer implies in the description of Achilles's shield, most cities viewed farming and its products as of the highest importance to the whole community. Athenian young men, at the age of eighteen, swore an oath to protect their city's grain, vines, figs, and olives, as well as obey its laws (**Fig. 2.2**).

Survival depended on healthy eating. On the whole, the average Greek's diet was simple, based chiefly on cereals. Bread was unleavened and often had various herbs and flavorings—thyme, rosemary, olives—mixed in the dough. Sweet loaves contained raisins and dried figs. According to one ancient gourmet, citizens of Athens could choose from seventy-two varieties of bread.

With starch as the basic filler, the Greeks added a wide variety of accompaniments: beans and lentils, olives, onions, and cheese, generally using goat milk for the latter. Poorer Greeks probably lived mainly on this simple diet, along with anchovies and sardines, washing it all down with water ("the best drink of all," says the poet Pindar).

Prosperous diners could flavor their food with fine olive oil, for which Athens was famous throughout the Mediterranean, and eat excellent fruit, also an Athenian specialty. Game

◄ **2.2 Antimenes (attr.), Men Harvesting Olives, 520 BCE. Black-figure amphora, 16″ (40.64 cm) high. British Museum, United Kingdom.** Imagery on Greek vases ranges from mythological and historical subjects to vignettes of everyday life. Much of what we know about the look of battle armor, musical instruments, farming practices, and textile looms—to name a few things—comes from their representations on painted pottery.

such as hare and pheasant was popular, but on the whole, meat remained a rarity, even for the wealthy. Homer's heroic banquets, at which warriors slaughtered whole oxen and roasted them over coals, represented only a dream for most of his audience. Fish was more common. Both fresh Mediterranean tuna and dried tuna imported from the Black Sea were popular, as were squid and shrimp.

The Greeks drank their wine diluted with water and often added honey and spices. They exported it in jars made waterproof by an inner layer of pine resin—the origin of the retsina (resinated wine) still drunk in Greece today.

The Early History of Greece

One of the major turning points of history ca. 1000 BCE, with the advent of the Iron Age in the Mediterranean region. Athens had been a Mycenaean city long before the Iron Age began; but by the fifth century BCE it would become the intellectual and cultural center of Greece, which would form the foundation of Western civilization.

The Rise of Greece

1100 BCE	1000 BCE	750 BCE	600 BCE	480 BCE
DARK AGE	**THE HEROIC AGE**	**THE AGE OF COLONIZATION**	**THE ARCHAIC PERIOD**	
Collapse of Mycenaean Empire; Greece split into city-state including Athens, Thebes, and Sparta	Development of Iron Age culture at Athens	Greeks expand trade network and found colonies throughout Mediterranean from Egypt to the Black Sea	Solon reforms Athenian constitution in 594.	
Greece loses contact with the outside world	Life of Homer	Greeks adopt Phoenician alphabet	Growth of Athenian power and expansion of Persian Empire	
Widespread poverty	Greeks begin colonizing in East and in Italy	Evolution of large free-standing sculpture	Greek cities in Asia Minor rebel against Persian Rule	
	Olympic games founded 776	Development of aulos (flute) and cithara (stringed instrument)	Persian Wars begin; forces of Darius I defeated at Marathon 480	
			Forces of Xerxes win battle of Thermopylae and sack Athens but Greeks defeat Persians in naval battle at Salamis	

The Mycenaeans had writing, they were accomplished builders, and they were skilled metalworkers, but this legacy was lost when their civilization came to an abrupt and violent end ca. 1100 BCE. What followed was a century of disturbance and confusion—what has been called the Dark Age of ancient Greece. The people of the Iron Age had to discover for themselves, and develop from scratch, almost all of the aspects of civilization—organized government and society, writing and literature, religion and philosophy, art and architecture. To follow their first attempts is to witness the birth of Western civilization.

The history of early Greece falls naturally into three periods, each marked by its own distinctive artistic achievement. During the first three hundred years or so of the Iron Age, culture developed at a slow pace. The Greeks had only limited contact with other Mediterranean peoples, living in relative isolation. Yet it is during this period that the *Iliad* and the *Odyssey*, two epic poems considered to be the first great works of Western literature, found their origins in stories that were sung by bards throughout Greece. Because the themes of these poems are heroic, the early Iron Age in Greece is also known as the *Heroic Age*. The artistic style of this period is called *Geometric* because of the prevalence of abstract motifs in vase painting, but it is important to note that at the same time that the heroic epic narratives were being composed, the Greeks returned to the representation of the human figure in their art.

By the beginning of the eighth century BCE, Greek travelers and merchants had already begun to explore the lands to their east and west. They sailed from the mainland and established colonies throughout the Mediterranean from Egypt to the Black Sea. Over the next one hundred fifty years (ca. 750–600 BCE), called the *Age of Colonization*, the Greeks were exposed to new and different ideas; they adopted the Phoenician alphabet, and in art they borrowed motifs and styles from Mesopotamia and Egypt that can be seen in the *Orientalizing* period. These foreign influences were assimilated in the *Archaic* period (ca. 600–480 BCE), when life-size statues appeared and the first large temples were constructed. The Archaic period was a culmination of the first five hundred years of Greek culture, but it was also the period during which a series of wars with Persia shook Greece to the core. With the Greeks' ultimate victory over the Persians, their relationship to the world took a decisive turn, paving the way for the *Classical* period (discussed in Chapter 3).

The Heroic Age (ca. 1000 BCE–750 BCE)

During the period of Mycenaean supremacy, most of Greece was united under a single authority. With the fall of Mycenae, the social order of the Bronze Age collapsed. Greece was split into independent regions whose borders were determined by topography—mountain ranges and high hills that crisscross the rugged terrain. Each of these geographically discrete areas developed an urban center from which the surrounding countryside was controlled. Thus Athens became the dominant force in the geographical region known as Attica; Thebes oversaw the territory of Boeotia; Sparta controlled Laconia; and so on (see **Map 2.1**, "Ancient Greece"). These independent,

▼ **MAP 2.1** Ancient Greece

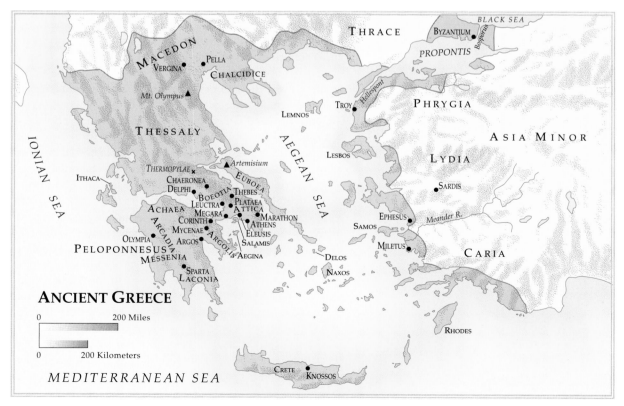

self-governing cities were called *city-states*, or **poleis** (singular *polis*). They served as the focal point for all political, religious, social, and artistic activities within their regions. Citizens felt a loyalty toward their own city-state that was far stronger than any generalized sense of community they may have had with their fellow Greeks over the mountains. Fierce competition among city-states led to bitter and destructive rivalries. The city-state structure of government in Greece had its pros and cons: on the one hand it created an unequaled concentration of intellectual and cultural developments; on the other, it fostered a tendency toward internal squabbling at the least provocation.

Even though city-states were often in conflict with one another, the citizens all called themselves *Hellenes* (the people of Hellas, the ancient name for Greece) and they all spoke Greek—the common language that separated them from the outsiders. They shared sanctuaries, such as the one at Delphi, and came together for the Panhellenic (all-Greek) games;

▼ **2.3 Panathenaic amphora with footrace, 6th century** BCE, **24 ¼″ (61.8 cm) high, 16 ⅛″ (41 cm) diameter. National Museum of Denmark, Copenhagen, Denmark.** Competitive games in many Greek cities drew participants from all of the city-states. Events included athletic competitions—what we today associate with the Olympics—but the earliest games showcased poetry and music contests. The award for the victorious was typically a Panathenaic amphora—a two-handled vase filled with precious oil.

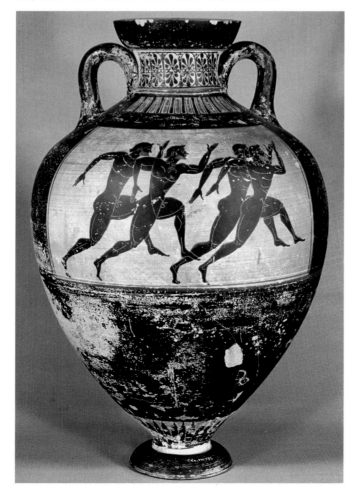

the first ancient Olympic Games were held in 776 BCE (**Fig. 2.3**). And in times when the future of Greece was at risk of coming under the thumb of non-Greek-speaking nations—*barbarians*, to the Greeks—the city-states rallied.

Religion

The fragmentation of social and cultural life in the early years of Greece's history had a marked effect on the nature of Greek religion and mythology. A mass of folktales, primitive customs, and traditional rituals sprang up during the Heroic Age but were never combined into a single unified belief system. Individual cities had their own mythological traditions, some of them going back to Bronze Age Greece and others influenced by encounters with neighboring peoples. Poets and artists felt free to choose the versions that appealed to their own tastes or helped them express their ideas. What was consistent about Greek religion was its inconsistency: often there are varying versions of the same basic story that are difficult to reconcile. The very characters of the Greek gods and goddesses often seem confused and self-contradictory. Zeus, for example, president of the immortals and father of gods and humans, represented the concept of an objective moral code to which both gods and mortals were expected to conform; he imposed justice and supervised the punishment of wrongdoers (see figure 2.5). Yet this same majestic ruler was also involved in many love affairs and seductions, in the course of which his behavior was often undignified and even comical. How could the Greeks have believed in a champion of morality whose own moral standards were so lax? These contradictions were perfectly apparent to the Greeks, but they used their religion to illuminate their own lives rather than to give them divine guidance. One of the clearest examples is the contrast that Greek poets drew between the powers of Apollo and Dionysus, two of the most important of their gods. Apollo represented logic and order, the power of the mind; Dionysus was the god of the emotions, whose influence, if excessive, could lead to violence and disorder. By worshiping both of these forces, the Greeks were acknowledging an obvious dual nature in human existence and trying to strike a prudent balance. Later Greeks tried to organize all of these conflicting beliefs into something resembling an order.

Zeus ruled from Mount Olympus, where the other principal Olympian deities surrounded him (**Fig. 2.4**). His wife Hera was the goddess of marriage and morality and the protector of the family. His daughter Athena symbolized intelligence and understanding, but was also a warrior goddess. Aphrodite was the goddess of love; Ares, her lover, the god of war; and so on. But the range and variety of the Greek imagination defied this kind of categorization. The Greeks loved a good story, so tales that did not fit the ordered scheme continued to circulate.

The Greek deities therefore served many purposes, but these purposes were very different from those of the deities in other Western religions. No Greek god, not even Zeus,

▼ **2.4 The Principal Deities of Ancient Greece**

Zeus	King of the gods; brother of Poseidon and Hades; god of the sky
Hera	Sister and wife of Zeus; goddess of marriage
Poseidon	Brother of Zeus and Hades; god of the sea
Hephaestus	Son of Zeus and Hera, and husband of Aphrodite; god of fire and metalworking
Ares	Son of Zeus and Hera, and lover of Aphrodite; god of war
Apollo	Son of Zeus and Leda, daughter of a Titan; twin brother of Artemis; god of prophecy, light, and music; associated with the sun
Artemis	Twin sister of Apollo; goddess of wild animals and the hunt; associated with the moon
Demeter	Sister of Zeus; goddess of agriculture and fertility
Aphrodite	Daughter of Zeus and the nymph Dione; wife of Hephaestus; mother of Eros by her lover Ares and of the Trojan hero Aeneas by the mortal Anchises; goddess of love and beauty
Athena	Daughter of Zeus, born full-grown from his head; goddess of wisdom and warfare; protector of Athens
Hermes	Son of Zeus and the nymph Maia; messenger of the gods and guide to travelers
Dionysus	Non-Olympian; son of Zeus and the mortal Semele; god of wine
Hades	Non-Olympian; brother of Zeus and Poseidon; god of the dead and king of the underworld

represents supreme good. At the other end of the moral scale, there is no Greek figure of supreme evil corresponding to the Judeo-Christian concept of Satan. The Greeks turned to their deities for explanations of natural phenomena and the psychological characteristics they recognized in themselves. At the same time, they used their gods and goddesses as yet another way of enhancing the glory of their individual city-states, as in the case of the cult of Athena at Athens. Problems of human morality required human, rather than divine, solutions. The Greeks turned to art and literature, rather than prayer, as a means of trying to discover the solutions.

The Homeric Epics

At the beginning of Greek history stand two epic poems, which even the quarrelsome Greeks saw as national—indeed, universal—in significance. The *Iliad* and the *Odyssey* have, from that early time, been held in the highest esteem. Homer, their accepted author, is generally regarded as not only the first figure in the Western literary tradition but also one of the greatest. Yet even though Homer's genius is beyond doubt, little else about him is clear. In fact, the many problems and theories connected with the Homeric epics and

their creator are generally summed up under the label of the "Homeric Question."

The ancient Greeks were not sure who had composed the *Iliad* and the *Odyssey*, when and where the author had lived, or even whether one person was responsible for both of them. In general, tradition ascribed the epics to a blind poet called Homer; almost every city worthy of the name claimed to be his birthplace. Theories about when he had lived ranged from the time of the Trojan War, around 1250 BCE, to five hundred years later.

The problem of Homer's identity, and whether he existed at all, continues to vex scholars to this day. In any case, most experts would probably now agree that the creation of the *Iliad* and the *Odyssey* was a highly complex affair. Each of the epics consists basically of several shorter folktales that were combined, gradually evolving over a century or more into the works as we now know them.

These epic poems were almost certainly composed and preserved at a time before the introduction of writing in Greece, by individuals who passed them down by word of mouth. Professional bards—storytellers—probably learned a host of ready-made components: traditional tales, stock incidents, and a whole catalog of repeated phrases and descriptions. In the absence of any written text the works remained fluid, and individual reciters would bring their own contributions. However, both the Homeric epics show a marked unity of style and structure.

The first crystallization of these popular stories had probably occurred by around 800 BCE, but the poems would still not appear in their final form for more than a century. The first written official version of each epic was probably not made before the late sixth century BCE. A scribe working at Alexandria in the second century BCE made the edition of the poems used by modern scholars.

Where, then, in this long development must we place Homer? He may perhaps have been the man who first began to combine the separate tales into a single whole; or perhaps he was the man who, sometime after 800 BCE, imposed an artistic unity on the mass of folk stories he had inherited. The differences between the *Iliad* and the *Odyssey* have suggested to several commentators that a different Homer may have been responsible for the creation or development of each work, but here we enter the realm of speculation. Perhaps it would be best to follow the ancient Greeks, contenting ourselves with the belief that at some stage in the evolution of the poems they were filtered through the imagination of the first great author of the Western literary tradition, without being too specific about precisely which stage it was.

Both epic narratives, then, evolved from oral tradition and reflect the fact. There are occasional minor inconsistencies in plot. Phrases, lines, and entire sections are often repeated—a strategy for memorization. All of the chief characters are given standardized descriptive adjectives—**epithets**—that accompany their names whenever they appear: Achilles is "swift-footed" and Odysseus "cunning."

Gods into Men, Men into Gods

Early in the nineteenth century, one of France's most influential painters borrowed something from Homer. It was only a brief episode, but it inspired an imposing canvas that gave a face to a famous name: Zeus.

> She sank to the ground beside him, put her left arm round his knees, raised her right hand to touch his chin, and so made her petition to the Royal Son of Cronos. (*Iliad*, book 1)

Jean-Auguste-Dominique Ingres depicted the fearsome king of the gods and ruler of the sky on his imperial throne—one arm raised and wrapped around his royal scepter and the other casually resting on a cumulus cloud. His stare is intense and his physique is powerful. He is mighty in strength and, from the looks of it, unshakable in will. Or is he? The body of a beautiful woman curls serpentinely around his knee. She lays one arm across his lap and stretches the other upward to touch his beard. She is Achilles's mother, Thetis, and she is worried about her son, who is out fighting bloody battles against the Trojans. What she wants from Zeus is some sort of intervention; she cannot leave his life to fate. Thetis entreats Zeus, grabbing delicately at his beard. It is a gesture he cannot resist.

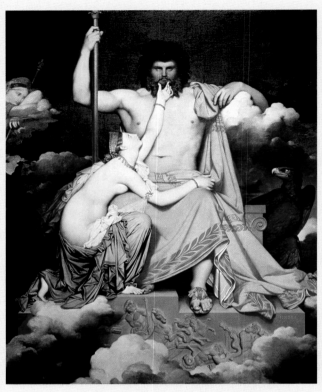

▲ **2.6** Jean-August-Dominique Ingres, *Jupiter and Thetis*, 1811. Oil on canvas, 128³/₄" × 102³/₈" (327 × 260 cm). Musée Granet, Aix-en-Provence, France.

The cult statue that resided in the Temple of Zeus at Olympia (**Fig. 2.5**) was the inspiration for Ingres's image of Zeus (whose Roman name is Jupiter) in his *Jupiter and Thetis* (**Fig. 2.6**). The original, definitive representation has not survived except in small replicas. Composed of ivory and gold and 43 feet high, it was one of the Seven Wonders of the World in ancient times. Ingres painted his canvas in 1811, but at the time it was not well received. It languished in his studio for almost a quarter century until the French government purchased the work.

On the other side of the Atlantic Ocean, only a dozen years after Ingres's composition was painted, the United States Congress commissioned a statue of George Washington for the Rotunda of the Capitol building in Washington, DC. Chosen for the project was Horatio Greenough, an American sculptor who had studied in Rome and whose works were inspired by classical ideals. When he delivered his monumental portrait of the Father of the Country in 1840,

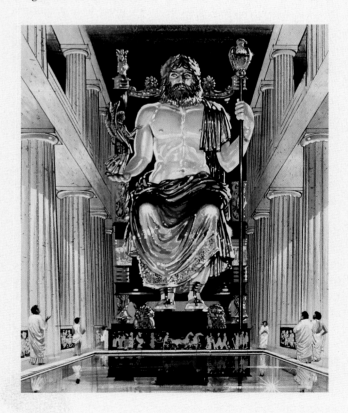

◄ **2.5** Phidias, statue of Zeus in the Temple of Zeus at Olympia, Greece, ca 435 BCE.

(Imaginary reconstruction, gouache, © Sian Frances).

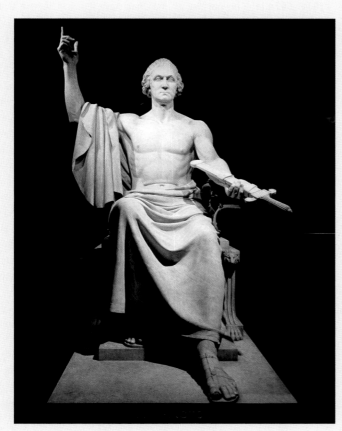

▲ **2.7** Horatio Greenough, *George Washington*, 1840. Smithsonian American Art Museum. Marble, Marble, 136″ × 102″ × 82½″ (345.4 × 259 × 209.6 cm). The National Museum of American History, Washington, DC.

Greenough could never have imagined that the reception of his masterpiece would be so chilly—literally. George Washington, naked from the waist up and masquerading as Zeus (**Fig. 2.7**), drew sharp criticism and biting sarcasm. It was laughable to some and, to many, outrageously offensive. When the sculpture was taken from its intended prominent display in the Capitol Rotunda to a spot outside on the lawn, the sarcasm continued; one of the common jokes had George Washington reaching for his clothes, which were on display in a nearby building. Congress was clearly concerned about the first president's image, literally and figuratively. It was brought in from the cold and first displayed in the Smithsonian Castle; in 1964, the 11-foot-high-monument was moved to what is now the National Museum of American History. Greenough's representation of George Washington prompts the question, What might the first president have thought of this portrayal, this deified status? If Washington himself would have rejected

this notion soundly, others did not. The deification of the first president is indeed the subject of *The Apotheosis of Washington* (**Fig. 2.8**), an ambitious ceiling fresco in the Rotunda dome. The painter, Constantino Brumidi, kept Washington's clothing on but nonetheless depicted him as a god—or at least glorified him as an ideal. Washington holds court on a ring of clouds that gives way to a golden, celestial light. The president is flanked by personifications of Liberty and Victory/Fame, a godlike man in a circle of 13 beautiful maidens—symbols of the 13 founding states. As a counterpart to Zeus, Washington is in fitting company: around the base of the dome, six groups of figures represent subjects including war, science, commerce, and agriculture. Visitors from the Greek and Roman pantheons accompany their personifications and representatives: Minerva (the Greek Athena, goddess of wisdom) imparts knowledge to Benjamin Franklin, Robert Fulton, and Samuel F. B. Morse; Ceres (the Greek Demeter, the goddess of agriculture) sits on a McCormick reaper. Elsewhere, Venus (the Greek Aphrodite) holds the transatlantic cable under Neptune's (Poseidon's) supervision, and Vulcan (the Greek Hephaestus), at his anvil, forges a cannon and a steam engine.

The U.S. forefathers established a democracy based on the guiding principle of shared governance that had its origin in ancient Greece. But symbols were as important as actions: it is no coincidence that the buildings of the U.S. capital—Washington, DC—bear an obvious resemblance to classical temple architecture, and no surprise that George Washington—as close to a god in stature as one could get—might be portrayed as Zeus's beneficent doppelganger.

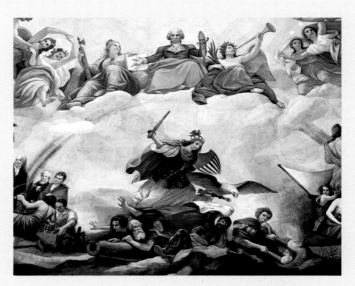

▲ **2.8** Constantino Brumidi, *The Apotheosis of Washington* (detail), 1865. Ceiling fresco, Capitol, Washington, DC.

The heroic world of warfare is made more accessible to the poem's audience through the use of elaborate similes that compare the story's events to familiar vignettes of everyday life in the early Iron Age; the massing of the Greek forces, for example, is likened to a swarm of flies buzzing around pails of milk.

Although the two poems are of a single tradition, they differ in spirit. The *Iliad* is somber, taut, direct. The theme is concentrated, and the plot is easier to understand—and certainly easier to explain—than that of the more digressive and lighthearted *Odyssey*. But the *Odyssey* is not a lesser work; if anything, its range and breadth of humanity are even greater, and its design more elaborate.

THE METER OF THE *ILIAD* AND *ODYSSEY* The *Iliad* and *Odyssey* are written in **heroic verse**, which is generally associated with the meter, or rhythm, of epic poetry in Greek and Latin. In Greek and Latin the meter is **dactylic hexameter**. *Hexa-* means six and derives from the same root as the six-sided geometric figure we call a hexagon. Thus a line of dactylic hexameter consists of six dactyls. A *dactyl* is a unit or foot of poetry containing three syllables; the first is long or stressed, and the following two are shorter or unstressed.

Dactylic hexameter does not fit the English language very well, so there are very few examples in English. An exception is Henry Wadsworth Longfellow's poem "Evangeline," first published in 1847. Here are the first two lines:

This is the forest primeval. The murmuring pines and the hemlocks,
Bearded with moss, and in garments green, indistinct in the twilight, . . .

Let us divide the lines into feet and boldface the accented syllables. If you read them aloud, do not *try* to accent the boldfaced syllables; just read naturally and the rhythm of the lines will emerge on its own.

This is the / **for**est prim- / **ev**al. The / **mur**muring /
pines and the / **hem locks**,
Bearded with / **moss**, and in / **gar**ments / **green**, indis-
/ **tinct** in the / **twi light**, . . .

You will notice that the structure of each line is not perfect dactylic hexameter. (Neither was the meter perfectly consistent in the *Iliad* and *Odyssey*.) Each line could be said to begin with a sort of clap and then slide into a rhythm, despite the alterations. The first line has five dactyls and then a final foot with two accented syllables. That foot is called a **spondee**. The second line ends in a spondee as well. But notice the third foot in the second line, **garments**; it consists of a stressed or accented syllable followed by an unaccented syllable. This foot is called a **trochee**. Homer did the same thing—mix dactyls with spondees and trochees. The variation stimulates interest and allows for emphasis.

The extracts from Homer's epics do not appear here as translated in dactylic hexameter. Efforts at translation into dactylic hexameter have not been very successful. Some of the extracts are lines of verse; others are prose. But they cannot capture the sound of the originals.

THE *ILIAD* The action of the *Iliad* takes place during the final year of the Greeks' siege of Ilium, or Troy. The audience enters the story in the middle of things—**in medias res**. In due course, the reason for the siege will be illuminated: Paris, a prince of Troy, ran off with Helen, the wife of King Menelaus of Sparta, while on a diplomatic mission to that city. (Menelaus's father was Atreus and his brother was Agamemnon—names associated with the tombs and treasures we saw from Mycenae in Chapter 1.) The Trojan War commences when the brothers, along with a thousand ships, set sail for Troy to reclaim Helen. Even though the events of the war permeate the text of the poem, they are secondary to the principal theme of the *Iliad*, stated in the opening lines of book 1. The poet begins by invoking the goddess who provides his inspiration: "Sing, goddess, of the anger of Peleus' son Achilles, which disastrously inflicted countless sufferings on the Greeks, sending the strong souls of many heroes to Hades and leaving their bodies to be devoured by dogs and all birds." These words establish the tragic mood of the work.

The subject of the *Iliad*, then, is the anger of Achilles and its consequences. Its message is a direct one: we must be prepared to answer for the results of our own actions and realize that when we act wrongly, we will cause suffering both for ourselves and, perhaps more important, for those we love. Although the setting of the *Iliad* is heroic, even mythic, the theme of human responsibility is universal. This relevance to our own experience is underlined by the realism in the scenes of battles and death, which are characteristic of epic literature's interest in heroic warfare. The story of Achilles's disastrous mistake is told in a basically simple and direct narrative. It begins with a quarrel between Agamemnon, commander in chief of the Greek forces, and Achilles, his powerful ally, who resents Agamemnon's overbearing assertion of authority. After a public argument, Achilles decides to punish Agamemnon by withdrawing his military support and retiring to his tent, in the hope that without his aid the Greeks will be unable to overcome the Trojans. In the battles that follow he is proved correct; the Trojans inflict a series of defeats on the Greeks, killing many of their leading warriors.

Agamemnon eventually (book 9) admits that he behaved too high-handedly (although he gives no formal apology) and, through intermediaries, offers Achilles generous gifts to return to the fighting and save the Greek cause. Achilles, however, rejects this attempt to make amends and stubbornly nurses his anger as the fighting resumes and Greek casualties mount. While he continues to sulk, his dearest friend, Patroclus, suits up in Achilles's armor and, disguised, leads his men into battle. Patroclus slays Trojan warriors one after the other after the other. Book 16 contains some of the most graphic, unromanticized depictions of war.

READING 2.1 HOMER

The *Iliad*, book 16

Patroclus' heart was set on finding Hector, eager to strike him down. But Hector's own swift horses carried him away. Just as in late summer rainstorms, the dark earth is all beaten down, when Zeus pours out his waters with utmost violence, when he's enraged with men who have provoked him with their crooked judgments, corrupting their assemblies and driving justice out, not thinking of gods' vengeance, so all the rivers in flood, their torrents carving many hillsides, as they roar down from the mountains in a headlong rush toward the purple sea, destroying the works of men—that's how, as they sped on, the Trojan horses screamed.

When Patroclus had cut the Trojans' front ranks off, he pushed them back again towards the ships, keeping them from the city they were trying to reach. Between the ships, the river, and the lofty wall, in that middle ground, he kept charging at them, killing them, avenging deaths of many comrades. There he first struck Pronous with his shining spear, where Pronous' shield had left his chest exposed. His limbs gave way, and he fell down with a thud. Patroclus next rushed at Thestor, son of Enops, who just sat crouching in his polished chariot, paralyzed with terror, reins slipping from his hands. Coming up, Patroclus struck him with his spear right on the jawbone, smashing through his teeth. Patroclus pulled his spear back, dragging Thestor out across the chariot rail. Just as a man sitting on a rocky point hauls up a monstrous fish out of the sea, using a line and bright bronze hook—that's how Patroclus dragged Thestor from his chariot, mouth skewered on the shining spear. He threw him down, face first. As Thestor fell, his spirit abandoned him.

. . .

Death, who destroys men's hearts, flowed all around Patroclus, as he slaughtered Erymas, Amphoterus, Epaltes, Tlepolemus, son of Damastor, Echius, Pyris, Ipheus, Euippus, and Polymelus, son of Argeas—all these Patroclus laid out, one by one, on the earth, which nourishes all men.

Excerpt from the *Iliad* by Homer, translatd by Richard Lattimore, copyright 1951 from Books XVIII, XXIII, XV, XXIV. Copyright 1951 University of Chicago Press. Reprinted by permission.

When his dearest friend Patroclus is killed by the Trojan leader Hector, Achilles enters the fight with a vengeance. His anger toward Agamemnon is now turned on the Trojans—Hector in particular.

After killing Hector in single combat (book 22), Achilles abuses Hector's corpse in order to relieve his own sense of guilt at having permitted Patroclus's death (**Fig. 2.9**). Finally, King Priam of Troy—Hector's father—steals into the Greek camp by night to beg for the return of his son's body (book 24). In this encounter with Priam, Achilles at last recognizes and accepts the tragic nature of life and the inevitability of death. His anger

melts, and he hands over the body of his dead enemy. The *Iliad* ends with the funeral rites of Hector, "tamer of horses."

As is clear even from this brief summary, there is a direct relationship between human actions and their consequences. The gods appear in the *Iliad* and frequently play a part in the action, but at no time can divine intervention save Achilles from paying the price for his unreasonable anger. Furthermore, Achilles's crime is committed not against a divine code of ethics but against human standards of behavior. All of his companions, including Patroclus, realize that he is behaving unreasonably.

From its earliest beginnings, therefore, the Greek view of morality is in strong contrast to the Judeo-Christian tradition. The gods are not at the center of the Homeric universe; rather, it is human beings who are at least partly in control of their own destiny. If they cannot choose the time when they die, they can at least choose how they live. The standards by which human life will be judged are those established by one's fellow humans. In the *Iliad* the gods serve as divine umpires: they watch the action and comment on it, and at times enforce the rules, but they do not affect the course of history. Humans do not always, however, fully realize the consequences of their behavior. In fact, they often prefer to believe that things happen "according to the will of the gods" rather than because of their own actions. Yet the gods claim no such power. In a remarkable passage at the beginning of book 1 of the *Odyssey*, we see the world for a moment through the eyes of Zeus as he sits at dinner on Mount Olympus: "How foolish men are! How unjustly they blame the gods! It is their lot to suffer, but because of

➤ **2.9 The Diosphos painter, lekythos with Achilles dragging the body of Hector, ca. 500 BCE. Black-figure painting, 8¼" (21 cm) high. Musée du Louvre, Paris, France.** Achilles drags Hector's body after killing him, thus avenging the death of Patroclus. The winged goddess Iris petitions for the return of Hector's body to Hector's parents.

Fate, Chance, and Luck

The Greeks had conflicting ideas on just how much human lives were preordained by a force in the universe that they called *fate*. Homer speaks of three Moirai, goddesses who dispensed to every person their ultimate fate: Klotho spun the thread of life, Lachesis measured its length, and Atropos cut the thread at the moment of death (**Fig. 2.10**).

Neither Homer nor the later Greeks seems clear on how the Moirai related to the other gods. One author, Hesiod, describes them as the daughters of Zeus and Themis (Righteousness), whereas Plato calls them the daughters of Ananke (Necessity). Sometimes fate is a force with unlimited power, feared by humans and deities alike—including the almighty Zeus. On other occasions Zeus may intervene with fate of behalf of an individual; even humans sometimes succeed in reversing their fate.

The Greeks also acknowledged another powerful force in the universe—that of pure chance. The goddess of chance, Tyche (or Fortune), may bestow lavish benefits on individuals, but she does so at random. Her symbols—wings, a wheel, and a revolving ball—convey her variability. With the general decline of traditional religious beliefs in later Greek history, Tyche was revered for her potency.

The Romans adopted the Greek Moirai (in the form of the Parcae), but they paid far more attention to *luck*, worshiped as the goddess Fortuna. She appeared in numerous aspects pertinent to human situations in need of a little good fortune, although she could bring bad luck as well. To name but a few, Fortuna Victrix brought victory in war, Fortuna Annonaria brought abundant harvests, and Fortuna Redux assured safe return from a journey.

▲ 2.10 Atropos cutting the thread of life. Bas-relief.
Photo by Tom Oates.

their own folly they bring upon themselves sufferings over and above what is fated for them. And then they blame the gods."[1]

THE *ODYSSEY* The principal theme of the *Odyssey* is the hero Odysseus's return to his kingdom of Ithaca after the Trojan War—his homecoming, or **nostos**, as the Greeks called it. His journey takes ten years—the same length as the war itself—and is fraught with perilous adventures with the likes of one-eyed giants and an array of monsters, a seductive enchantress and romantic young girl, a floating island and a visit to the underworld. We do not meet Odysseus in person, however, until the fifth book of the poem. The first four tell the story of his son's attempts to find out more about the father he has never seen. Telemachus was born on the very day that Odysseus was called to fight in the Trojan War, and he is now

20 years old. These four chapters, known as the Telemachy, describe Telemachus's visits to other Greek leaders who have returned safely from Troy, including Menelaus and Helen. They tell Telemachus of his father's bravery and also that he has been seen alive. If the subject of the *Iliad* is Achilles's anger and its consequences, the subject of the Telemachy is Odysseus's absence and its consequences. It is in these four books that we come to learn about what is going on in the palace: His wife, Penelope, is plagued by suitors who are eating them out of house and home—and worse, they want Penelope to declare Odysseus dead and remarry. The prize is the throne of the kingdom of Ithaca. Telemachus tries to evict them.

1. H. D. F. Kitto. *The Greeks*. Piscataway, NJ: Transaction Publishers, Rutgers—The State University of New Jersey, 1951, 1964, p. 54.

READING 2.2 **HOMER**

The *Odyssey*, book 1, lines 406–419

"O wooers of my mother insolent
And over-masterful! This eventide
Feast we and make we merry, nor let brawl
Be raised among us. . . . [At] morn I call
The people, where in public session met
My summons plain I may before you set
To quit these halls, that henceforth other feasts
From house to house among yourselves to get,
And feed on your own substance as is fit.
But if you deem it worthier still to sit
As now, devouring one man's [livestock]
And rendering no [payment] for it,
Waste on: but to the deathless Gods will I
Make my appeal, and [by chance] Zeus on high
Repayment of your deeds exact from you:
So in this house you unavenged shall die."

The suitors, however, are not the least bit intimidated by Telemachus. At the beginning of book 2, one of them—Antinoös—rips into both Telemachus and his mother Penelope. He rants and blames Penelope for their languishing at the palace; she has hatched a plan to keep the suitors at bay and they are on to her treachery.

READING 2.3 **HOMER**

The *Odyssey*, book 2, lines 89–112

"Telemachus, what speech is this you frame,
High-mouthed, unbridled, purposing our shame
By evil imputations? For your case
. . . the Achaean wooers are [not] to blame;
But your own mother, by whose cunning sleight
Three years are fled and now the fourth takes flight, . . .
When a great loom she built within her hall,
And wrought thereon a broad web woven fine,
Saying to us: O youthful wooers mine,
Since dead is bright Odysseus, cease awhile
My heart to hasty marriage to incline,
Until this web be finished, lest I leave
A labor spoiled the weaving that I weave,
A shroud for the burial of the aged prince
Laertes: since it would [truly] grieve
Full many Achaean women in the town,
If shroudless he should lie, who had renown
For the [well-being] of his [subjects], when the doom
Of Death the Leveler shall strike him down.
So spoke she: and, as is the way of men,
We were persuaded. All the daytime then
At the great loom she wove, and every night
With torches she unwove her work again."

The suitors, contemplating Telemachus's rage, get the idea that he will murder them; they will have to kill the boy first. Telemachus walks down to the sea and prays for the gods to be near him as he travels the sea for news of his father. Athena hears him and speaks to him in the guise of Mentor (we get the meaning of the word *mentor* from this passage). She tells him that he has his "father's spirit" and that she will sail beside him as she did with his father "in the old days."

READING 2.4 **HOMER**

The *Odyssey*, book 2, lines 289–297

"For seldom like the father is the son;
Degenerate most, though here and there may one
Excel his father: but you will not fail
In wit or will until your task be done.
Then what the suitors' foolish mind has planned
Cease to consider: for they understand
No wisdom and no justice, nor perceive
Death and the black-veiled phantom close at hand:
When all shall perish in a single day."

Telemachus sails off, but his journey is more than information gathering; it is also his journey to manhood. He will come back to Ithaca and the suitors stronger and angrier. He just needs help. And he will get it once he finds his father.

In the meantime, Odysseus has spent seven years with the nymph Calypso. Even though they have slept together and he reassures her that she is more beautiful than his wife, Odysseus wants to be back home. The only problem is that he is captive: he has no crew and no vessel. Athena petitions Zeus to intervene and take him from Calypso's grasp; Zeus complies and sends the messenger god Hermes to see to it. Zeus's words to Hermes frame what will be Odysseus's harrowing experiences as he wanders the unknown seas on his way back to Ithaca.

READING 2.5 **HOMER**

The *Odyssey*, book 5, lines 32–47

"Hermes, . . . Now to the fair-tressed nymph I bid you say,
Touching sore-tried Odysseus's home-going
Fixed is our [direction], that go he may:
Sped by no God nor yet by mortal hand,
But on a raft made fast with bolt and band
Through perils great shall he the twentieth day
Reach fruitful Scheria, the Phaeacians' land:
Who by descent are [near] the Gods of kin;
And as a God he honor there shall win,
And they on shipboard shall convey him home
With bronze and gold and rich array therein,

". . . so surely he must reach
His friends, and high-roofed house and native soil."

At the beginning of book 9, Odysseus arrives at the Phaeacians and recounts to King Alcinous the details of what he encountered—and endured—along the way. The reader is presented with an edited version of Odysseus's trials in his own words. The symbolism of some of his adventures is interesting. The Lotus-Eaters offer his sailors a plant (perhaps cannabis) that will make them forget their homeland. Odysseus calls to them, "All hands aboard; come, clear the beach and no one taste the Lotus, or you lose your hope of home The hero becomes single-minded in his efforts to resume his life and restore order in his kingdom.

Odysseus finally returns home in the last half of the poem, but he does so in disguise. Without revealing his identity to his ever-faithful wife Penelope, he kills all of the suitors in a bloodbath with Telemachus at his side. Homer keeps us waiting for the love scene—the moment of recognition—until almost the last lines of the poem. All ends as it should: Odysseus, his father Laertes, and his wife Penelope are reunited. War is replaced with peace, discord with harmony, disorder with hierarchical structure, and destruction with the potential for creativity. The gods assert and insinuate themselves, but humans make decisions about the lives they want to lead. The *Odyssey* closes with these lines, spoken by Athena (in disguise).

READING 2.6 HOMER

The *Odyssey*, book 24, lines 562–570

"Odysseus, subtle-counseled, hold your hand
And cease contention . . .
Lest Cronus' son, far-sounding Zeus, be [wrathful]
Against you." So Athena said: and he
Obeyed her bidding. . . .
Then truce betwixt them to endure once more
The maid of Zeus the aegis-bearer swore,
Pallas Athena, but the semblance she
Of Mentor in both voice and body bore.

Homer's epics were the backbone of history as the early Greeks taught it, and a steady reminder of the culture's values. They were recited every four years in Athens and school children knew the lines of the *Iliad* and the *Odyssey* by heart.

➤ **2.11 Geometric krater from Dipylon cemetery, Athens, Greece, ca. 740 BCE Terra-cotta, 42⅝" (108.3 cm) high, 28½" (72.4 cm) diameter. Metropolitan Museum of Art, New York, New York.** This depiction of a funeral and the cemetery location of the immense vase suggest that it was originally a grave marker. The bottom is open, perhaps to allow for visitors' libations to seep into the ground beneath. The Geometric period of Greek art takes its name from the geometric patterns on vases from this era.

They reinforced an unshakable Greek identity, rooted in the common ancestry of heroes.

Geometric Art

Two important things characterize Greek art during Homer's time: the return of the human figure and the adaptation of motifs and styles from eastern cultures as the Greeks came to explore, and to trade with, more of the world around them. The first efforts toward regenerating the visual arts and architecture were tentative; after all, knowledge of how to paint or sculpt or engineer buildings was completely lost in the Dark Age.

A large vase used as a grave marker in the Dipylon cemetery in Athens is one of the earliest works of Greek art to feature the human figure and is an example of the Geometric style (**Fig. 2.11**). It is over three and one-half feet tall and by

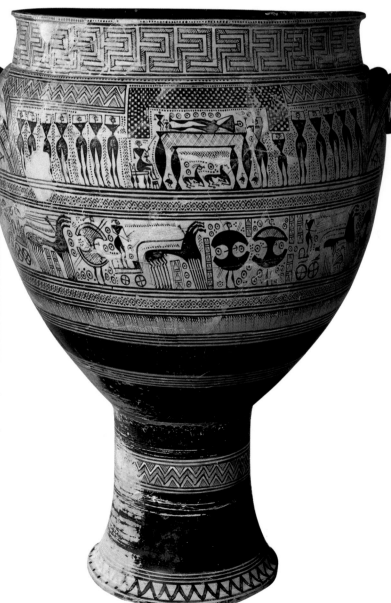

Unraveling Penelope

Epithets in Homer's *Iliad* and *Odyssey* are legendary. Achilles is "swift-footed," Athena is "bright-eyed," and the sea is "wine-dark." Homer describes Odysseus as a man of action and Penelope, his wife and queen, as cautious. Odysseus is hotheaded, whereas Penelope is circumspect and discreet. Of all of the characters in the Homeric epics, Odysseus holds the record for epithets; to name a few, he is a man of twists and turns, much enduring, wise, greathearted, cunning, and the great teller of tales.

By most traditional accounts, Penelope is long-suffering; her husband is gone for twenty years—ten in the Trojan War and ten more trying (or so he would say) to get home—while she minds the kingdom and fends off the suitors who would replace Odysseus as ruler of Ithaca. While she waits for her husband, not knowing if he will ever return, she devises a clever way to stall what appears to be the inevitable (marrying one of the ungracious suitors who have been cluttering the palace). She tells the suitors that she will chose among them only after she finishes the funeral shroud that she is weaving for her father-in-law. Unbeknownst to them, Penelope works on the shroud by day and then unravels the threads at night. We are hard-pressed, in Homer, to find any passages in which Penelope is anything less than steadfast and loyal. In the *Odyssey*, the triumphant values of marriage and family—the patriarchal order—overshadow Penelope's emotional profile. Even when the two are reunited, Penelope does not reproach Odysseus for his lengthy absence. As soon as she understands the man before her is Odysseus, her heart melts and she even apologizes for not recognizing him immediately:

> Her knees were loosened, and her heart melted within her.
> . . . Then she fell aweeping, and ran straight toward him
> and cast her hands about his neck, and kissed his head and spoke,
> saying: "Be not angry with me, Odysseus, for thou were ever at
> other times the wisest of men, It is the gods who gave us
> sorrow, the gods who begrudged us that we should abide
> together and have joy of our youth, and come to the
> threshold of old age. . . ." Thus she spoke, and . . . he wept
> as he embraced his beloved wife and true.
> And even as the sight of land is welcome to swimmers
> whose well-wrought ship Poseidon has smitten on the deep, . . .
> so welcome to her was the sight of her lord [that] her white
> arms she would never quite let go from his neck (book 23).

It was left to other poets and writers to construct a fuller picture of who Penelope might have been and how she really felt about her husband, his tales, and his immortalization. In his *Heroides*, the Roman poet Ovid penned a letter from Penelope to Odysseus in which she informs him of the badgering suitors who, she says, are "playing the part as king" and squandering his wealth. Penelope tells him that she will always be his, but she also lets him know that he is "rashly absent" and even hints that he may not be so different from these suitors:

> Why should I relate to you Pisandrus and Polybus and the
> dreadful Medon, and the greedy hands of Eurymachus and
> Antinous, and others, all of whom you, rashly absent, are
> feeding on things gained by your blood.

Anne Killigrew, a seventeenth-century English poet, also drafted a letter to Odysseus from Penelope. In the first lines, Penelope beseeches her "dearest Lord" to return so that she can cease to mourn his absence. But in the second stanza, she shares something that is haunting her:

> Sometimes I think, (but O most Cruel Thought,)
> That, for thy Absence, th'art thy self in fault:
> That thou art captiv'd by some captive Dame,
> Who, when thou fired'st Troy, did thee inflame
> And now with her thou lead'st thy am'rous Life,
> Forgetful, and despising of thy Wife.

In the twentieth century, Dorothy Parker's poem "Penelope" imagined how Penelope may have bided her time waiting for Odysseus and what thoughts and emotions she may have concealed:

> In the pathway of the sun,
> In the footsteps of the breeze,
> Where the world and sky are one,
> He shall ride the silver seas,
> He shall cut the glittering wave,
> I shall sit at home, and rock;
> Rise, to heed a neighbor's knock;
> Brew my tea, and snip my thread;
> Bleach the linen for my bed.
> They will call him brave.

What are your thoughts on Penelope's magnetism as a poetic subject? What do these gendered representations suggest about the prevailing gender ideologies when the poets were writing? Do they reflect contemporary views or aim to upend them?

Life and Death in the World of Homer

Homer's passage in the *Iliad* on Achilles's shield is an example of **ekphrasis**, a literary device in which a work of art is described in such detail that a clear visual picture emerges. He shares with us two cities—and two sides of the coin of human experience: the destructive realities of war and the potential for creativity and productivity in times of peace. Their blending in a unified realm on the shield that the god Hephaestus forged for Achilles suggests that the two are distinct, but related, imperatives: war, which for all of its devastation provides the opportunity for heroism and for *arete* (reaching the highest human potential); and peace, which provides the opportunity for orderly existence, culture, and the pursuit of societal ideals. As such, the shield not only serves as a microcosm of the world but also captures the contrasting themes of the *Iliad* and the *Odyssey*.

In one city, weddings and wedding feasts go on while a claim between two parties over compensation for the murder of a relative is settled by a group of elders; the justice system works. But in another city, inhabitants are besieged by enemy troops:

> They armed for a raid, hoping to break the siege—
> loving wives and innocent children standing guard
> on the ramparts, flanked by elders bent with age
> men marched out to war.
>
> . . .
>
> And Strife and Havoc plunged in the fight, and violent Death—
> now seizing a man alive with fresh wounds, now one unhurt,
> now hauling a dead man through the slaughter by the heels,
> cloak on her back stained red with human blood.

So they clashed and fought like living, breathing men grappling each other's corpses, dragging off the dead. (*Iliad*, book 18, lines 598–601, 622–628)

As gruesome as this event is, most of the remaining lines of the passage illustrate the consequences of *uneventful* times—orderly, bountiful, and joyous life made possible by peace:

> [Hephaestus] forged a thriving vineyard loaded with clusters,
> bunches of lustrous grapes in gold, ripening deep purple
> and climbing vines shot up on silver vine-poles.
> And round it he cut a ditch in dark blue enamel
> and round the ditch he staked a fence in tin.
> And one lone footpath led toward the vineyard
> and down it the pickers ran
> whenever they went to strip the grapes at the vintage—
> girls and boys, their hearts leaping in innocence,
> bearing away the sweet ripe fruit in wicker baskets.
> And there among them a young boy plucked his lyre,
> so clear it could break the heart with longing,
> and what he sang was a dirge for the dying year,
> lovely . . . his fine voice rising and falling low
> as the rest followed, all together, frisking, singing,
> shouting, their dancing footsteps beating out the time. (*Iliad*, book 17, lines 654–669)

Excerpt from the *Iliad* by Homer, translatd by Richard Lattimore, copyright 1951 from Books XVIII, XXIII, XV, XXIV. Copyright 1951 University of Chicago Press. Reprinted by permission.

shape is a **krater**. Except for the large areas of black on the foot (pedestal) of the vase, the surface is decorated with geometric motifs, some of which may have been inspired by the patterns of woven baskets—zigzags, triangles, diamonds, and, at the very top, a **meander** (a mazelike design). Two thick bands encircle the widest part of the vase and feature numerous abstract figures. The imagery is connected to the purpose of the vase; this one and others like it had holes in their bases so that offerings poured into them could seep down to the dead below. In the upper band, a man lies on a funeral bier flanked by women who mourn his passing. The thick, squat U shape that floats above him, painted in a checked pattern, represents a shroud that has been lifted to reveal his corpse. In the band below, a funeral procession is depicted, complete with horse-drawn chariots and men carrying apple-core shields from behind which their heads and legs protrude. Distinctions are made between the males and females (the deceased has a penis sticking out of his thigh and the women have breasts in their armpits), but overall they march along with the same rigidity of the geometric patterns. The figures are a familiar combination of frontal, wedge-shaped torsos; profile legs and arms; and profile heads with frontal eyes: conceptual representation.

Vase painting was the dominant genre in Geometric art, although the human figure—which made its reappearance during the eighth century BCE—was also portrayed in small bronze sculptures and ivory statuettes.

The Age of Colonization (ca. 750 BCE–600 BCE)

During Homer's era and the Geometric period of Greek art, individual city-states were ruled by small groups of aristocrats who concentrated wealth and power in their own hands. As centuries of peace led to further prosperity, ruling classes became increasingly concerned with the image of their individual city-states. They functioned as military leaders but also became patrons of the arts. The success of the city-state created fierce pride and competition. In the eighth century BCE, festivals began at Olympia, Delphi, and other sacred sites, at which athletes and poets—representing their city-states—would compete for recognition and the title of best.

As trade with fellow Greeks and with Near Eastern peoples increased, economic success became a crucial factor

in the growth of a polis; shortly before 600 BCE, individual poleis began to mint their own coins. Yet political power remained in the hands of a small hereditary aristocracy, leading to frustration among a rapidly growing urban population. Both the accumulation of wealth and the problem of overpopulation led to a logical solution: colonization.

Throughout the eighth and seventh centuries BCE, enterprising Greeks went abroad either to seek their fortunes or to bolster them. To the south and east of Greece, colonies were established in Egypt and on the Black Sea, and to the west, in Italy and Sicily. Some of these, like Syracuse on Sicily or Sybaris in southern Italy, became even richer and more powerful than the mother cities from which the colonizers had come. Inevitably, the settlers took with them not only the culture of their polis but also their intercity rivalries, often with disastrous results.

The most significant wave of colonization was that which moved eastward to the coast of Asia Minor. From there, colonizers established trade contacts with Near Eastern peoples, including the Phoenicians and the Persians. Within Greece, this expansion to the east had a significant effect on life and art. After almost three hundred years of cultural isolation, in a land cut off from its neighbors by mountains and sea, the Greeks were brought face-to-face with the immensely rich and sophisticated cultures of the ancient Near East. New and different ideas and artistic styles were seen by the colonizers and carried back to Greece by traders. Growing quantities of eastern artifacts—ivories, jewelry, metalwork, and more—were sent back to the Greek city-states as well as to colonies in Italy. So great was the impact of the interchange with cultures such as Mesopotamia and Egypt that the seventh century BCE is called the **Orientalizing period** (*orient* means "east").

Orientalizing Art

The influence of eastern cultures on Greek art can be seen in the lively depictions of animals and fantastic beasts on pottery, which call to mind the human-animal blends of Mesopotamia and Egypt. Corinth, in particular, dominated the export business in painted ceramics early on. The city-state grew very wealthy because of its strategic location on an isthmus that connects the Peloponnesus to the Greek mainland—an excellent geographic position for trade. Corinthian artists developed a vibrant version of black-figure vase painting that featured eastern motifs—sphinxes, winged humans, composite beasts, and floral patterns—arranged in bands to cover almost the entire surface of the vessel. White, yellow, and purple paint were often used to highlight details, producing a bold and striking effect (**Fig. 2.12**). Pottery workshops were busy meeting the market demands in Corinth, as they were in Athens as well. During the Archaic period, Athenian potters and painters would be the dominant players in this craft.

Corinthian vases have been found throughout Greece, but also as far away as Italy, Egypt, and sites in the Near East—even Russia. Who would not have wanted to own an elegant little flask for perfume, oil, or makeup that would be recognized instantly as Corinthian? Corinth's political influence and economic strength throughout the seventh and early sixth centuries BCE was attributable in part to the commercial success of these little pots and their contents.

The Athenians brought two interesting things to the art form that pushed beyond the decorative aesthetic of the Corinthians: the focus on the human figure and the telling of stories. As the Athenians began to take over an increasing share of the market for painted vases and their contents, Corinth's position declined and a trade rivalry developed between the two city-states, which would lead to devastating conflict during the Peloponnesian War.

The Archaic Period (ca. 600 BCE–480 BCE.)

In the early seventh century BCE, hereditary aristocrats began to lose their commanding status. In Athens, the legislator and poet Solon (ca. 639–559 BCE) reformed the legal system in 594 BCE and divided the citizens into four classes; members of all four could take part in the debates of the assembly and sit in the law courts. A new class of rich merchant traders, who had made their fortunes in the economic expansion, gained power by capitalizing on the discontent of the oppressed lower classes. These new rulers were called *tyrants*, although the word had none of the unfavorable implications it now has. The most famous of them was Pisistratus, who ruled Athens from 546 BCE until 528 BCE. Many tyrants were patrons of the arts who oversaw revolutionary changes in the arts.

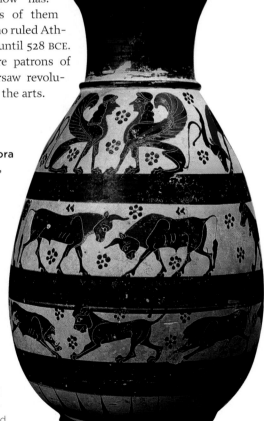

➤ **2.12 Corinthian black-figure amphora with animal friezes, ca. 625–600** BCE. **Terra-cotta, 11½" (29.4 cm) high. Archaeological Museum, Syracuse, Sicily, Italy.** The black-figure technique and the bands with animals and floral designs are characteristic of the Orientalizing style of Greek pottery. Finer details were incised into the black glaze with a sharp-pointed instrument.

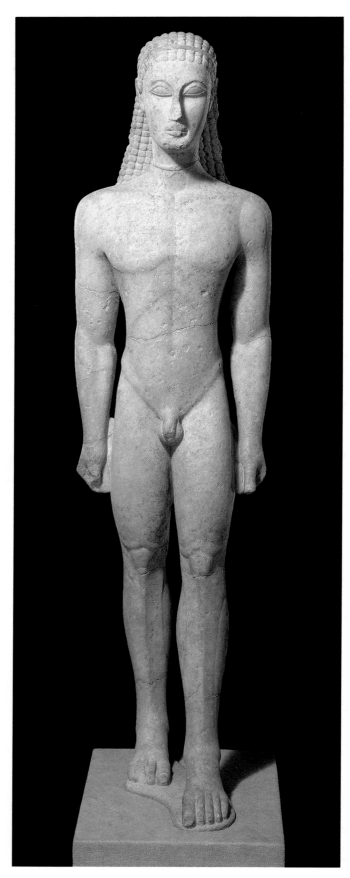

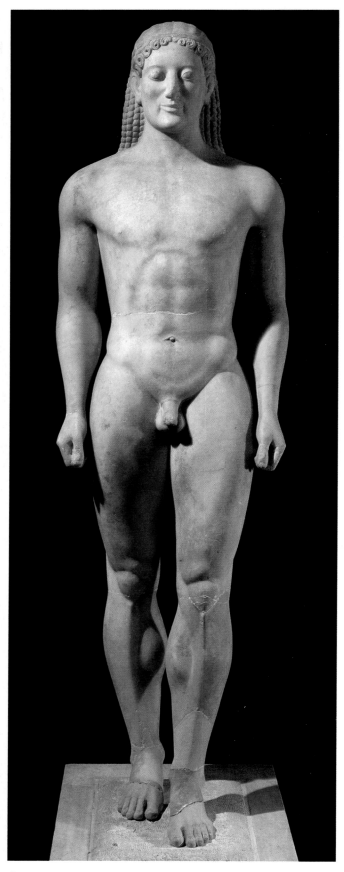

⌃ 2.13 New York Kouros, ca. 600 BCE. Marble, 76⅝″ (194.6 cm) Metropolitan Museum of Art, New York, New York. Early Greek artists working with life-size figurative sculpture adopted the poses of their Egyptian prototypes, albeit with significant exceptions: they freed the figure from the block of stone and depicted the body in the nude.

⌃ 2.14 Kroisos, ca. 530 BCE. Marble, 76″ (193 cm). National Archaeological Museum, Athens, Greece. An inscription on the base of the funerary sculpture informs us that it was erected in honor of a warrior who died heroically in battle. Although the stance remains rigid, the figure is overall more naturalistically rendered.

Archaic Art

The influence of eastern cultures, particularly Egypt, defined Greece's early attempts at life-size statuary. The first Greek settlers in Egypt were given land around the mid-seventh century BCE by the Egyptian pharaoh Psammetichos I, and it is surely no coincidence that the earliest Greek stone sculptures, which date from roughly the same time period, markedly resemble Egyptian cult statues. By 600 BCE, though—the beginning of the Archaic period—the entire character of Greek painting and sculpture had changed. Greek artists abandoned abstract designs and rigid Egyptian conventions and began to focus on **naturalism**. Early representations of the human figure modeled in bronze, carved in stone, or painted in silhouettes on vases were schematic, stylized. During the Archaic period artists asked such questions as, What do human beings really look like? How do perspective and foreshortening work? What in fact is the true nature of appearance? For the first time in history, artists began to reproduce the human figure in a way that was true to nature rather than merely to echo the standard formats of their predecessors.

It is tempting to view Archaic works of art as steps along the road to perfection in the Classical era, or Golden Age, of the fifth and fourth centuries BCE, rather than to appreciate them for their own groundbreaking qualities. This seriously underestimates the vitality of one of the most creative periods in the development of Greek culture. In some ways, in fact, the spirit of adventure, of striving toward new forms and new ideas, makes achievement during the Archaic period more exciting; perhaps the poet Robert Louis Stevenson was on to something when he said that it is better to travel hopefully than to arrive.

STATUARY The first life-size marble sculptures from the Archaic period feature two characteristics that departed from the traditional Egyptian format: the male body was depicted fully in the nude and it did not conform to the overall shape of the block of stone from which it was carved, as it did, for example, in the figure of King Khafre (see **Fig. 1.30**). Yet, the New York Kouros (**Fig. 2.13**) still reflects the Egyptian influence: one foot striding forward, fists clenched and attached to the sides, stylized muscular detail, and flat planes in the face. **Kouroi** (singular *kouros*) were carved as votive figures for temples or grave markers. Kroisos (**Fig. 2.14**), a kouros figure that served as a marker on the grave of a fallen soldier by that name in Anavyssos, Greece, is later than the New York Kouros by about seventy years, and it shows significant progress toward naturalism over that period of time. The shape and proportions of the body are more realistic, as are the flesh of the face and the flow of the hair down the back. The patterned lines describing muscle groups in the New York Kouros give way to a much more accurate portrayal of the chest, groin, kneecaps, and ankles. Some of the conventions remain the same, but the statue has a sense of vigor. Kroisos's slightly smiling lips, a feature that would become standard in Archaic sculpture, infuse the sculpture with a life-like feeling.

The Calf-Bearer (**Fig. 2.15**) was created in the years between these two kouroi, ca. 560 BCE, and was found in

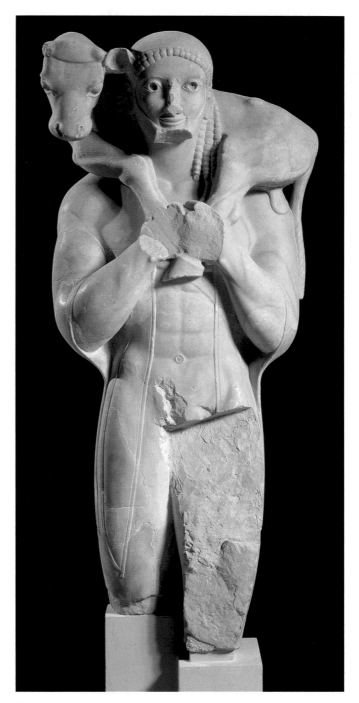

▲ 2.15 Calf-Bearer, ca. 550 BCE. Marble, 66″ (165 cm). Acropolis Museum, Athens, Greece. Realistic musculature, visible through a thin sheath of fabric, is combined with a sensitive portrayal of a man carrying a sacrificial calf. The intersection of diagonal lines formed by the limbs of man and beast indicate that the artist had an eye for composition. The "archaic smile" signified that the subject of the sculpture was a living human being.

pieces on the Athenian Acropolis (the hill that dominated the center of the ancient city). The bond between man and beast is conveyed simply and sensitively. It is a well-thought-out and beautifully executed composition: The tiny calf is draped around the man's neck and shoulders and their heads are close and aligned. Diagonals formed by his arms

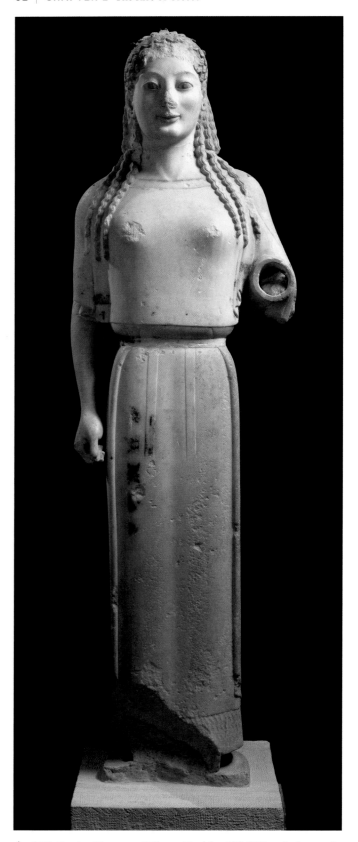

2.16 Peplos Kore, ca. 530 BCE. Marble, 48″ (122 cm). **Acropolis Museum, Athens, Greece.** The statue is named after the woolen dress, or peplos, one of four garments on the goddess figure. Her missing arm was extended and probably held an attribute associated with her. Traces of paint lend a lifelike appearance and tell us that the Greeks painted their stone sculpture.

and the calf's legs join to form a prominent X shape over the man's chest. The Calf-Bearer, unlike the kouroi, is not nude, although the clothing is transparently rendered so as to reveal the shape of the body. The presence of a beard tells us that this is a mature man; the artist has foregone the vision of youth typical of kouroi. The man's lips are curled into what looks like a smile, although it is not a smile at all as we would define it. Scholars believe that this so-called archaic smile signified that the person depicted in stone was alive.

Archaic statues of the female figure were also found on the Acropolis. When the Persians sacked Athens in 480 BCE, they destroyed temples and broke large quantities of sculpture. When the Athenians returned to their city after defeating the Persians, they reverently buried the pieces. The so-called Peplos Kore (**Fig. 2.16**), named after a women's garment called a **peplos**, owes her striking realism to the fact that much of the paint used to create her lifelike appearance was preserved under the earth. **Korai** (singular *kore*)—female figures—were also created as votive statues, although unlike the kouroi, they were clothed. The Peplos Kore, researchers have recently concluded, is an image of a goddess, who would have held her identifying attribute in her extended, missing arm.

RELIEF SCULPTURE Freestanding statuary was placed in temples, but the technique of **relief sculpture** was used widely for decorating grave stele and embellishing temple architecture. Relief sculpture is carved on stone slabs; the artist chisels away material, leaving imagery that projects from the background. In **high relief**, the imagery projects from the background by at least half of the thickness of the slab; removing large amounts of material can leave figures that appear almost three-dimensional. In **low relief** the carving is subtler and preserves the flat surface of the stone. Architectural sculpture was frequently carved in high relief, as we will see in Chapter 3. Carved stone slabs used as grave markers—such as the Stele of Aristion (**Fig. 2.17**)—were typically carved in low relief. It is worth noting the degree to which this stele departs from the conceptual representation used in relief sculpture from Mesopotamia and Egypt. Here the artist has rendered the subject in complete and consistent profile. This is an example of **optical representation**. Attention is paid to details and contrasts of textures: the warrior wears greaves (protective shin guards), stiff body armor over a tunic of softer fabric, and a cap that provides a cushion between his head and his bronze helmet.

TOWARD THE CLASSICAL ERA Kritios Boy (**Fig. 2.18**) marks a literal turning point between the late Archaic and early Classical styles: for the first time in ancient art, the figure is neither looking nor walking straight ahead. The head and the upper part of the body turn slightly; as they do so, the weight shifts from one leg to the other and the hips position themselves accordingly. Having solved the problem of how to realistically represent a standing figure, the sculptor has tackled a new and even more complex one—depicting a figure in motion. The consequences of this breakthrough would lead to the perfection of the heroic nude in the Classical period.

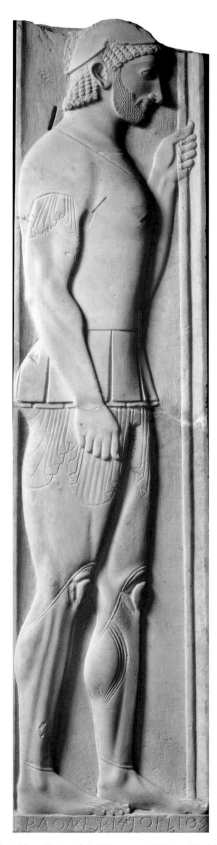

▲ **2.17** Aristokles, **Stele of Aristion, ca. 510 BCE. Marble, 96″ (243.8 cm) high (without base). National Archaeological Museum, Athens, Greece.** Optical representation is used to describe the figure: all parts of the body are consistently rendered in profile. Attention is paid to the contrast of textures, as seen in the folds of lighter fabric peeking out of the warrior's stiff body armor.

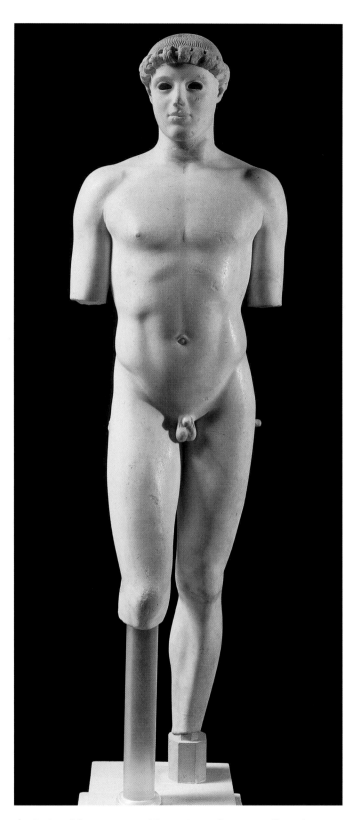

▲ **2.18** **Kritios Boy, ca. 490 BCE. From the Acropolis, Athens. Marble, 46″ (116.8 cm). Acropolis Museum, Athens, Greece.** The archaic smile has been superceded by a more natural expression, as the turn of the body is shown realistically in the movement of the hips and stomach muscles. Note the extraordinarily fine surface of the stone, which distinguishes between skin, muscle, and bone.

The range of Archaic sculptures is great, and the best pieces communicate the excitement of their makers in solving new artistic challenges. Artists understood how to more realistically represent a standing figure; now they turned to how they would depict a figure in motion. The consequences of this breakthrough would lead to the perfection of the heroic nude in the Classical period.

VASE PAINTING By the mid-sixth century BCE, there were also significant innovations in vase painting. Exekias perfected the **black-figure technique**, in which black figures were set against a reddish background and enhanced with details that were incised, or cut into the surface with a sharp instrument. The combination of black figures and red ground was achieved through three separate and specifically controlled kiln firings, in which oxygen was either introduced to or withheld from the kiln. The vase itself was created from relatively coarse clay, and the figures were painted on the surface with a brush using a mixture of finer clay and water (called a **slip**). Through the successive firing phases, the composition of the clay pot and the painted figures reacted differently: the pot remained the reddish clay color and the figures turned black. After all of this was said and done, the very fine details were added.

The versatility of the black-figure technique is seen in the François Vase (**Fig. 2.19**), an early example that was signed by both the potter (Ergotimos, the artist who created the vessel using a potter's wheel) and the painter (Kleitias). The imagery of the very large krater, which was found in an Etruscan cemetery in Italy, was divided into bands, or registers—as on the Corinthian vase in Fig. 2.13—but, rather than patterned decoration, the François Vase features an action-packed narrative with mythological figures and battles, including one with the hero Achilles. Only the lowest register of the vase bows to the Orientalizing style, with its fantastic beasts.

The genuine breakthrough in black-figure painting came with Exekias, whose command of the art form was unparalleled in his day. His draftsmanship and power of expression can be seen in yet another vase painting whose subject comes from the *Iliad*—Ajax the Greater playing a game of dice with his cousin Achilles (**Fig. 2.20**). Unlike the figures in the François Vase, which still reflect old conventions in their conceptual representation, Exekias's protagonists are rendered in almost-full profile. The almond-shaped eyes, drawn in profile, are the only feature out of sync in an otherwise optical approach. Both men hunch over a small table, their spears resting on their shoulders. Achilles is on the left, helmet on; their shields are resting behind them as if propped against a

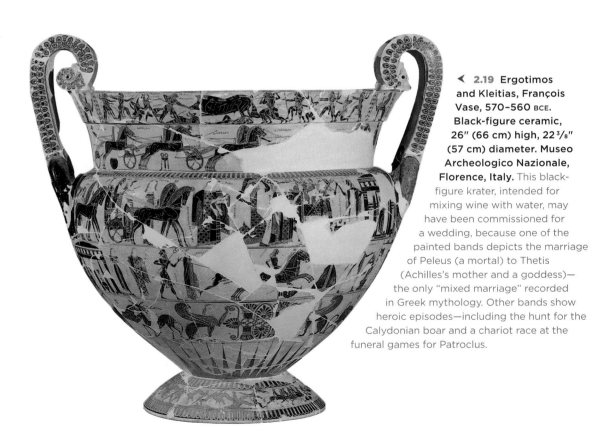

◀ **2.19** Ergotimos and Kleitias, François Vase, 570–560 BCE. Black-figure ceramic, 26″ (66 cm) high, 22³/₈″ (57 cm) diameter. Museo Archeologico Nazionale, Florence, Italy. This black-figure krater, intended for mixing wine with water, may have been commissioned for a wedding, because one of the painted bands depicts the marriage of Peleus (a mortal) to Thetis (Achilles's mother and a goddess)—the only "mixed marriage" recorded in Greek mythology. Other bands show heroic episodes—including the hunt for the Calydonian boar and a chariot race at the funeral games for Patroclus.

wall. It is a moment of calm between the cousins, and yet the game of chance that they play is prophetic: Ajax will carry Achilles's dead body off the battlefield.

Exekias was both the potter and the painter of this work, and the fluid relationship between the shape of the vessel and the scene reveal that fact. The imagery is placed on the broadest part of the vase and the curving lines of the men's backs are echoed in the soft tapering of the vase toward the handles and neck. Similarly, the V shape created by the intersecting spears corresponds to the taper of the vase toward its base.

However accomplished Exekias was in rendering figures, their blackness ultimately thwarted their potential for naturalism. But around 530 BCE, the **red-figure technique** was developed, and with that, vase painting reached its apogee. The same firing process was used, but instead of painting the figures on the pot with the slip (which, remember, created black figures against the reddish background), the artist outlined the contours of the figures and then painted everything *but* the figures (the entire background, that is) with the slip. This reversal resulted in reddish figures against a black background. The red clay of the figures offered a neutral-colored expanse that could then be fleshed out with much detail, applied with a fine brush rather than incised. A glimpse at the work of Euphronios (**Fig. 2.21**) will immediately show the advantages of red-figure technique over black-figure. The subject here is the death of Sarpedon, a Trojan warrior killed by Achilles's best friend, Patroclus. In the description of the moment that Sarpedon was felled by Patroclus's hand, Homer uses simile to juxtapose the graphic violence of the world of war with a mental picture of nature and ordinary life—the normalcy of familiar things longed for and taken for granted.

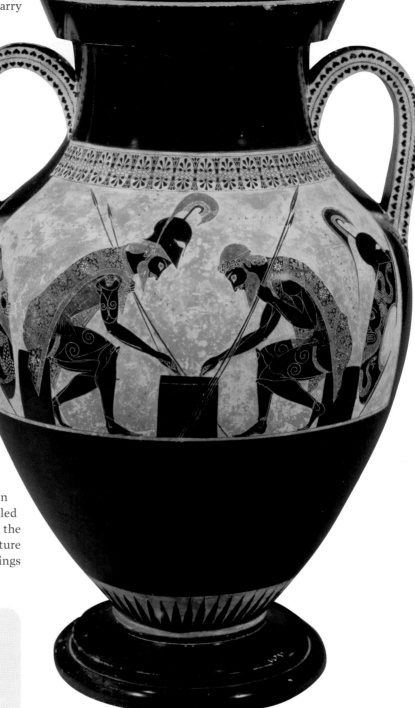

▲ **2.20** Exekias, Achilles and Ajax Playing Dice, ca. 540–530 BCE. Amphora, 24″ (61 cm). Museo Gregoriano Etrusco, Vatican City State, Italy. As both potter and painter, Exekias complemented the shape of the vessel with his figural compositions, creating a unified work. He was unparalleled in the black-figure technique.

READING 2.7 HOMER

The *Iliad*, book 16, lines 71–76

[Patroclus] struck him right where the midriff packs the pounding heart
and down Sarpedon fell as an oak or white poplar falls
or towering pine that shipwrights up on a mountain
hew down with whetted axes for sturdy ship timber—
and so he stretched in front of his team and chariot,
sprawled and roaring, clawing the bloody dust.

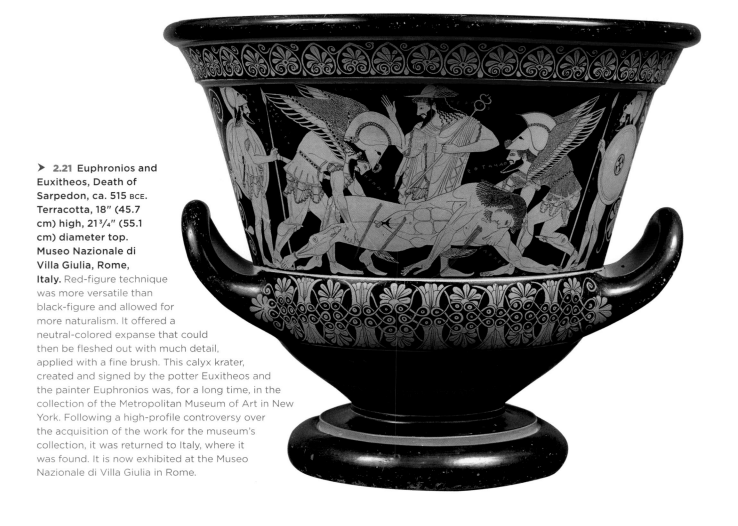

➤ **2.21** Euphronios and Euxitheos, Death of Sarpedon, ca. 515 BCE. Terracotta, 18″ (45.7 cm) high, 21³⁄₄″ (55.1 cm) diameter top. **Museo Nazionale di Villa Giulia, Rome, Italy.** Red-figure technique was more versatile than black-figure and allowed for more naturalism. It offered a neutral-colored expanse that could then be fleshed out with much detail, applied with a fine brush. This calyx krater, created and signed by the potter Euxitheos and the painter Euphronios was, for a long time, in the collection of the Metropolitan Museum of Art in New York. Following a high-profile controversy over the acquisition of the work for the museum's collection, it was returned to Italy, where it was found. It is now exhibited at the Museo Nazionale di Villa Giulia in Rome.

Euphronios depicts Sarpedon, now dead, being carried to the underworld by two winged figures, Hypnos (Sleep; the word *hypnotic* is related) and Thanatos (Death). Hermes, the messenger god, watches over the group; in his hand is the attribute that helps us to identify him—a magical rod called a *caduceus*. The characters are rendered in naturalistic poses: the winged helpers are shown in profile, and Sarpedon is mostly a frontal view (although his legs and arms twist realistically). The artist has described the musculature, the wings, the armor, and the clothing in great detail—all in delicate, linear brushwork. Colorful painted accents are used on Sarpedon's flowing hair and the blood that is streaming from several wounds. The static quality that pervades Exekias's vase has disappeared. The relationship of the scene to the shape of the pot is again noteworthy—as is the symmetrical composition.

Although some artists continued to produce black-figure works (there are even a few painted in black-figure on one side and red-figure on the other), by the end of the Archaic period, almost all had turned to the new style. The last Archaic vase painters were among the greatest red-figure artists. Works such as the Euphronios Vase have a solidity and monumentality that altogether transcend the usual limitations of the medium.

Temple Architecture

Some aspects of Egyptian architecture influenced Greek architects, although by the Archaic period, the basic design of Greek temples was established, and it differed significantly from any prototypes the Greeks may have seen in their travels throughout the Mediterranean and Near East. The earliest Greek temples were made of wood and, like the Sumerian temples, mudbrick; none survive. By the seventh century BCE, more permanent materials were used, such as limestone and marble quarried at sites on the Aegean Islands (Náxos and Páros) and the mainland.

The model for Greek temple architecture that emerged in the Archaic period was based on the Mycenaean *megaron*, a rectangular reception hall that had a portico with two columns. That basic shape appears at the center of the floor plan of a typical Greek temple (**Fig. 2.22**) and consists of a *pronaos* (portico); a **cella**, or *naos* (a large room that held the cult statue of the god or goddess to whom the temple was dedicated); and an *opisthodomos* (a rear-facing portico). When columns surround this central grouping of rooms, it is called *peristyle*; **peripteral** temples had a single row of columns around the cella and porticos, whereas dipteral

temples had a double row. The length of a typical temple was roughly twice the width (although earlier temples were longer and narrower); the number of columns on the long side of the temple is twice that on the short end. This compulsive ordering of parts to the whole reflected the Greeks' emerging sense of the perfect, or ideal. It characterized architectural design as well as proportions in sculpture.

The systems used for determining proportions, as well as specific design detail, are known as Greek architectural **orders**. The two most commonly featured are the *Doric* and *Ionic* orders (**Fig. 2.23**); the Doric is associated with mainland Greece and the Ionic with Asia Minor (Ionia) and the Aegean

Islands. The two orders were sometimes mixed and were not exclusive to the regions in which they developed.

DORIC AND IONIC ORDERS: A COMPARISON The Doric and Ionic orders share certain characteristics. Both are examples of post-and-lintel construction in which the posts are columns and the lintels consist of two parts—the *architrave* and the *frieze*. These two horizontal elements, along with the cornice (the lower edge of the triangular frame of the short ends of the gable roof), comprise the *entablature*. The sloping sides of this triangular frame are called the *raking cornice*; within the wide triangle—the *pediment*—both orders featured sculpture carved in relief. In both orders, the columns sit on the top step of a platform—the *stylobate*. The *column shafts*, which typically consisted of smaller drum-shaped cylindrical sections stacked one on top of the other,

N

0 10 20 30 40 50 feet
0 5 10 15 meters

1. Cella with central row of columns
2. Pronaos with three columns in antis

◄ **2.22 Plan of a typical Greek peripteral temple.** The typical plan of a Greek temple is rectangular, with an inner sanctuary (cella) surrounded by columns. The cella held a cult statue of the deity to whom the temple was sacred.

▼ **2.23 Elevations of Doric and Ionic orders.** The Doric and Ionic orders are two of the three styles associated with Greek architecture. (The third, the Corinthian order, was infrequently used, although it became a favorite among Roman architects.) Distinction among the orders is mainly to be found in the capitals and the frieze. Artwork by John Burge.

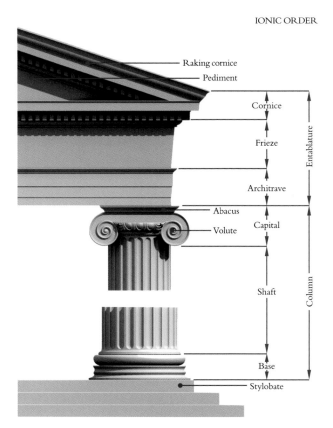

DORIC ORDER

Raking cornice
Pediment
Cornice
Entablature
Frieze — Triglyph
Metope
Architrave
Capital — Abacus
Echinus
Column
Shaft
Stylobate

IONIC ORDER

Raking cornice
Pediment
Cornice
Frieze
Entablature
Architrave
Abacus
Volute — Capital
Column
Shaft
Base
Stylobate

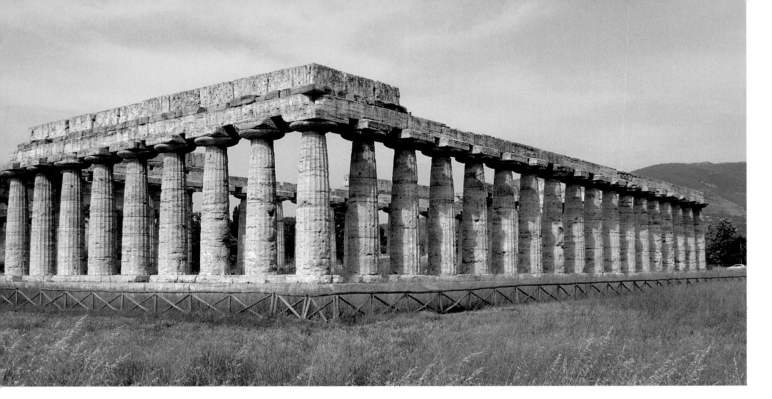

▲ **2.24 Temple of Hera I (Basilica), ca. 540-530 BCE (looking northeast). Paestum, Italy.** This temple to Hera is one of the earliest surviving Greek temples. The bulging columns and spreading capitals are typical of Doric architecture of the Archaic period. The temple probably featured a Doric frieze of triglyphs and metopes, but none of this embellishment has survived.

were carved top to bottom with vertical striations called *fluting* (20 flutes that meet at right angles in the Doric order, 24 in the Ionic order, all separated by narrow vertical bands). Both orders also feature *capitals* at the top of the column shaft, on which rest the lintels. From there, however, the styles differ. Let us take a look from the bottom up.

The column in the Doric order rests directly on the stylobate; in the Ionic, the column shaft has an intricately carved base. The Doric capital is like a flattened cushion or spreading convex disc; the Ionic capital consists of a distinctive scroll, or *volute*. The architrave in the Doric order is a flat-surfaced slab; in the Ionic order this element is divided into three thinner, projecting horizontal bands. Perhaps the most distinguishing feature of the orders, aside from the capitals, is the frieze. In the Doric order, the frieze is carved with an alternating pattern of *triglyphs* and *metopes* around the entire outer perimeter of the temple; the triglyphs are divided by grooves into three vertical bands and the metopes, which appear blank in our figure, are often carved with sculptural decoration. In the Ionic order, this frieze (which also appears blank) was a continuous (rather than partitioned) space that provided an uninterrupted space for relief carving.

The two orders produced different effects. The Doric order suggested simple dignity; the absence of decorative detail drew attention to the weight and massiveness of the Doric temple. Ionic temples, on the other hand, conveyed a sense of lightness and delicacy by means of ornate decorations and fanciful carving. The surface of an Ionic temple is as important as its structural design.

An early example of the Doric order is found in the Temple of Hera I—also known as the Basilica at Paestum in Italy (**Fig. 2.24**). All that remains of the enormous rectangular structure is its peripteral colonnade (its single row of columns that stood around the cella) and parts of the entablature that sat on top of it. The floor plan reveals a variation on the design of a typical temple's central rooms: the Temple of Hera has a pronaos with three (rather than two) columns, a cella divided into two zones by a row of seven columns, and no rear portico. The ratio of the number of columns on the long sides to the number on the short sides is 2:1. Even though the sculpture of the frieze and pediments has not survived, the Doric order is evident in the fluted columns and their capitals. The column shafts in the Temple of Hera I taper toward the top (unlike Minoan columns, which did the opposite), are quite thick, and swell a bit in the center. This swelling is called *entasis*. The overall impression of the design is stocky, and somewhat heavy due to the fact that the columns are so closely spaced; in later temples, there would be fewer columns with wider spaces between them, yielding a much more graceful result.

MUSIC AND DANCE

The history of Greek music is much more difficult to reconstruct than that of the visual arts and architecture. Although frequent references to performance make it clear that music played a vital role in all aspects of Greek life, less than a dozen fragments of Greek music have survived, and the sys-

tem of notation makes authentic performance of these fragments impossible.

To the Greeks, music was associated with the divine. Athena created the flute, and Hermes a tortoise-shell lyre; Amphion was taught to play the lyre by Hermes and used it to cajole stones into the foundation of the city of Thebes; the songs of Orpheus moved trees and tamed wild beasts. Choral odes were performed in honor of various gods: gratitude to Apollo and his sister Artemis for delivery from misfortune was expressed by the singing of a paean, or solemn invocation to the gods; the **dithyramb**, or choral hymn to Dionysus, was sung in his honor at public ceremonies. Music was also a feature at the Pythian and Olympic Games.

In book 9 of the *Iliad,* when Agamemnon's ambassadors arrive at the tent of the "divine Achilles," they find the great hero singing "of men's fame," accompanying himself on a "clear-sounding, splendid and carefully wrought" lyre. In fact, evidence suggests that early Greek music was primarily vocal and that musical instruments (**Fig. 2.25**) were used mainly to accompany the singers. The first composer whose existence we can be relatively certain of was Terpander, who came from the Aegean island of Lésbos and lived during the first half of the seventh century BCE. He developed a seven-note scale for the **kithara**, an elaborate seven-string lyre, with which he accompanied vocal music. The simple lyre (following Hermes's invention) was relatively small and easy to hold, and had a sound box made of a whole tortoise shell and sides formed of goat horns or curved pieces of wood. The kithara, by contrast, had a much larger sound box made of wood, metal, or even ivory, and broad, hollow

sides, to give greater resonance to the sound. The musician had to stand while playing; the instrument had straps to support it, leaving the player's hands free. Another musical instrument developed at about this time was the **aulos**, a double-reed instrument similar to the modern oboe. Like the kithara and lyre, the aulos was generally used by singers to accompany themselves; some song lyrics have survived.

Purely instrumental music seems to have been introduced at the beginning of the Archaic period. We know that in 586 BCE, Sakadas of Argos composed a work to be played on the aulos for the Pythian Games at Delphi—a well-known piece that remained popular for centuries. The first piece of program music in history, it revolves around the myth of the god Apollo's defeat of Python, the dragon-serpent guard of the oracle at Delphi. In addition to athletic contests, which would come later, the Pythian Games featured competitions in poetry and music; Sakadas was the first to win, and took the prize a total of three times.

MUSIC THEORY Early Greek music, as far as we can tell, was **monophonic**, that is, made of single melodies based on notes—placed in intervals—that comprise a system of scales. Music composition featured a series of distinct scale types, or modes, each of which had its own name and character (see Chapter 3). According to the doctrine of **ethos** (summarized by the philosophers Plato and Aristotle in the fourth century BCE), the unique sound of each mode reflected the characteristics and temperament of the tribe for which the mode was named (for example, Dorian after the Dorians on the Peloponnesus, Phrygian and Lydian after groups in Asia Minor).

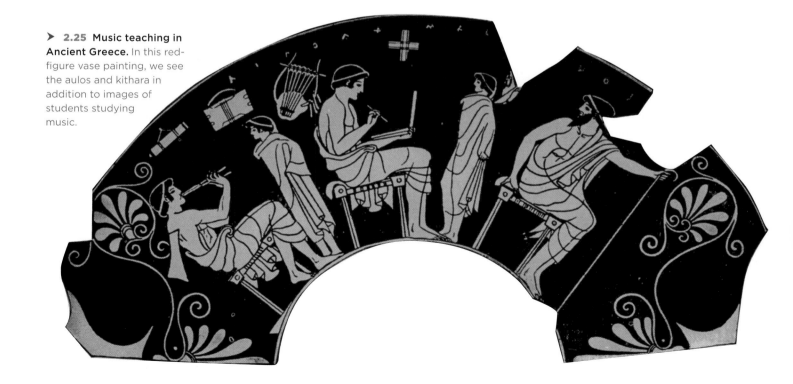

➤ **2.25 Music teaching in Ancient Greece.** In this red-figure vase painting, we see the aulos and kithara in addition to images of students studying music.

Music written in a specific mode was so powerful that it could affect human behavior in a specific way. Thus, the Dorian mode incited firm, powerful, even warlike feelings, whereas the Phrygian mode produced passionate, sensual emotions.

An understanding of doctrines of musical theory was considered fundamental to a good general education. A vast literature on music theory developed, with philosophical implications that became explicit in the writings of Plato and Aristotle; through this literature some information on early music has been preserved. Dance, however, was described more rarely in writing—although Homer's description of Achilles's shield in book 18 of the *Iliad* details an elaborate scene.

READING 2.8 HOMER

The *Iliad*, book 18, lines 721–737

Next on that shield, the celebrated lame god made
an elaborately crafted dancing floor, like the one
Daedalus created long ago in spacious Cnossus,
for Ariadne with the lovely hair. On that floor,
young men and women whose bride price would require
many cattle were dancing, holding onto one another
by the wrists. The girls wore fine linen dresses,
the men lightly rubbed with oil wore woven tunics.
On their heads the girls had lovely flower garlands.
The men were carrying golden daggers on silver straps.
They turned with such a graceful ease on skillful feet,
just as a potter sits with a wheel between his hands,
testing it, to make sure that it runs smoothly.
Then they would line up and run towards each other.
A large crowd stood around, enjoying the dancing magic,
as in the middle two acrobats led on the dance,
springing, and whirling, and tumbling.

Copyright 1951 University of Chicago Press. Reprinted by permission.

LITERATURE

Our knowledge of literary developments between the time of Homer and the Archaic period is limited. An exception is Hesiod, who probably lived during the late eighth century BCE. He is the author of a poetic account of the origins of the world called the *Theogony* and a rather more down-to-earth long poem, the *Works and Days*, which mainly concerns the disadvantages in being a poor, oppressed (and depressed) farmer in Boeotia, where the climate is "severe in winter, stuffy in summer, good at no time of year."

A link between Hesiod's two major works is to be found in an opening passage of the *Theogony* in which the Muses appear to the poet as he is tending sheep and set him on the path to his new career.

READING 2.9 HESIOD

***Theogony*, lines 25–42**

The Muses once taught Hesiod to sing
Sweet songs, while he was shepherding his lambs
On holy Helicon; the goddesses
Olympian, daughters of Zeus who holds
The aegis, first addressed these words to me:
"You rustic shepherds, shame: bellies you are,
Not men! We know enough to make up lies
Which are convincing, but we also have
The skill, when we've a mind, to speak the truth."
So spoke the fresh-voiced daughters of great Zeus
And plucked and gave a staff to me, a shoot
Of blooming laurel, wonderful to see,
And breathed a sacred voice into my mouth
With which to celebrate the things to come
And things which were before. They ordered me
To sing the race of blessed ones who live
Forever, and to hymn the Muses first
And at the end. No more delays: begin.

Following is Hesiod's description of the origins of the universe and the genealogy of the gods—constructed from episodes ranging from the tender to the terrible. Consider the following lines from a section of the poem that describes the battle for supremacy between the Titans and the Olympian gods led by Zeus.

READING 2.10 HESIOD

***Theogony*, lines 690–697 and 705–717**

Zeus no longer checked his rage, for now
His heart was filled with fury, and he showed
The full range of his strength. He came from heaven
And from Olympus, lightening as he came,
Continuously; from his mighty hand
The bolts kept flying, bringing thunder-claps
And lighting-flashes, while the holy flame
Rolled thickly all around.

. . .

To the ear
It sounded, to the eye it looked as though
Broad Heaven were coming down upon the Earth:
For such a noise of crashing might arise
If she were falling, hurled down by his fall.
Just such a mighty crash rose from the gods
Meeting in strife. The howling winds brought on
Duststorm and earthquake, and the shafts of Zeus,
Lighting and thunder and the blazing bolt,
And carried shouting and the battle-cry
Into the armies, and a dreadful noise
Of hideous battle sounded, and their deeds
Were mighty, but the tide of the war was turned.

The result of the bitter struggle is the creation of the human societal order under which the Greeks lived. Along the way, Hesiod weaves an elaborate ancestral tapestry of generations of rivalries and alliances, including some threads of typical and not-so-typical family squabbling.

As the Greeks expanded their trade with eastern and western countries during the eighth century BCE, they were influenced by many cultural traditions. Although in many ways Hesiod's *Theogony* is idiosyncratically Greek, it does owe something to Near Eastern creation epics—particularly those of Egypt and Babylonia.

As the Archaic period approached, a burst of energy that had also revolutionized the visual arts produced a new wave of poets. The medium they chose was lyric verse.

Lyric Poetry

The emergence of lyric poetry was, like developments in the other arts, a sign of the times. The heroic verse of Homer was intended for the ruling class of an aristocratic society that was interested in the problems of mighty leaders like Agamemnon and Achilles and had the leisure and the inclination to hear of their great and not-so-great deeds. Lyric verse—intended to be accompanied by a lyre—is concerned above all else with the poet's own feelings, emotions, and opinions rather than the glories of battle and adventures of heroes. The writers of the sixth century BCE do not hesitate to tell us how they feel about life, death, love, drinking too much wine, or anything else that crosses their minds.

More than any other Greek lyric poet, Sappho has captured hearts and minds throughout the ages. She is the first woman to leave a literary record that reflects her own personal experiences. Her poems have survived only in fragmentary form, and the details of her life remain unclear and much disputed.

Sappho was born ca. 630 BCE on Lésbos and spent most of her life on the island. She seems to have combined the roles of wife and mother (she mentions a daughter in her work) with those of poet and teacher; within her own lifetime she was widely respected and was surrounded by a group of younger women who may have come to Lésbos to finish their education, in much the same way that American writers used to go to Paris. They probably stayed until it was time for marriage; some of Sappho's poems reflect on the bittersweet parting of women from each other's company as they prepare to assume their lives as married women.

The affection between Sappho and her circle of pupils was deep and sincere and is reflected in her poems. The nature of this affection has been debated: was there a homo-erotic relationship between her and the young women she mentored? Such relationships—between older and younger men—were not unusual or unacceptable. They too lasted until men went off to marry and have their own families.

Sappho's poems do mention men, but often only as a point of departure for her passionate emotional responses to women. She probes the depths of her own passions and, by describing them, reveals dimensions of female sensuality—and her own.

READING 2.11 SAPPHO

"Like the very gods in my sight is he"

Like the very gods in my sight is he who
sits where he can look in your eyes, who listens
close to you, to hear the soft voice, its sweetness
 murmur in love and
laughter, all for him. But it breaks my spirit;
underneath my breast all the heart is shaken.
Let me only glance where you are, the voice dies,
 I can say nothing,
but my lips are stricken to silence, under-
neath my skin the tenuous flame suffuses;
nothing shows in front of my eyes, my ears are
 muted in thunder.
And the sweat breaks running upon me, fever
shakes my body, paler I turn than grass is;
I can feel that I have been changed, I feel that
 death has come near me.

Richard Lattimore, trans. *Greek Lyrics*, second edition. Chicago: University of Chicago Press, 1960. Used with permission.

The chief subject of Sappho's poetry is love, but her work also gives voice to the contrasting and equally painful agonies of loneliness and passionate commitment. Poems such as these reveal a reluctant resignation that comes only from profound understanding.

READING 2.12 SAPPHO

"Age and Light"

Here are fine gifts, children,
O friend, singer on the clear tortoise lyre,
all my flesh is wrinkled with age,
my black hair has faded to white,
my legs can no longer carry me,
once nimble as a fawn's,
but what can I do?

It cannot be undone,
No more than can pink-armed Dawn
not end in darkness on earth,
or keep her love for Tithonos,
who must waste away;
yet I love refinement, and beauty and light
are for me the same as desire for the sun.

Excerpt from *Sappho and the Greek Lyric Poets*, translated by Willis Barnstone, copyright © 1962, 1967, 1988 by Willis Barnstone. Used by permission of the author.

Just as contemporary sculptors and painters sought to understand their physical bodies by analyzing them, so Sappho revealed, both to herself and to us, the complex inner world of human emotion.

PHILOSOPHY

The century that saw the expression of the intimate self-revelations in lyric poetry was also marked by the development of rational philosophy, which challenged the religious beliefs and traditions of Homer and Hesiod and scoffed at the notion that gods took human form. A philosopher-poet (and religious critic) named Xenophanes of Colophon (ca. 560–478 BCE) quipped that if horses and cows had hands and could draw, they would draw gods that looked like horses and cows.

The word *philosophy* literally means "love of wisdom," but in the Western tradition it usually refers to inquiries into the nature and ultimate significance of the human experience. Some of its branches are logic (the study of the structure of valid arguments), metaphysics (investigation into the nature of ultimate reality), epistemology (the theory of knowledge), ethics (moral philosophy), aesthetics (the philosophy of the arts and, more generally, taste), and political philosophy.

Philosophers of the Archaic period turned away from religious teachings for the first time in history. Instead, they used the power of human reason to investigate how the world came into being and how it works, and to understand the place of humans in it.

PRESOCRATICS During the sixth century bce, a wide variety of schools of philosophical thought developed, collectively described by the catchall label Presocratic. All of these early philosophers lived and died before the time of Socrates (469–399 bce) and his pupil Plato (ca. 427–347 bce), two of the greatest names in Greek philosophy. However, these sixth-century philosophers had little in common with one another except the time in which they lived. Thus it is important to remember that the term Presocratic does not describe any single philosophical system. Many of the so-called Presocratic philosophers, with their investigations into the origins of the world and the workings of nature, were examining questions that we would consider scientific rather than philosophical. The various schools were united principally by their use of logic and theoretical reasoning to solve practical questions about the world and human existence. Unlike subsequent philosophers, the Presocratics had no predecessors on whom to base their ideas or methods. They created the discipline as they went along.

The earliest school of philosophy developed with the *Materialists*, who sought to explain all natural phenomena in terms of one or more of the earth's elements. Thales of Miletus (ca. 624–546 BCE), who is usually accorded the title of "first Western philosopher," posited that water alone underlay the changing world of nature. Even though limited and ultimately faulty, his notion that the world had evolved naturally, rather than as a result of divine creation, was revolutionary and marked a fundamental break from the Homeric view of the world. Thales countered the widespread Greek belief that natural forces were the handiwork of the gods. He argued, instead, that natural and human-driven events had concrete, scientific explanations: Occurrences in nature, rather than the whims of Zeus, accounted for unpredictable weather; the traits of human beings, rather than disputes among the gods, explain the warfare described in the *Iliad*. Thales also accurately predicted an eclipse and calculated, mathematically, the height of the pyramids in Egypt. Perhaps more importantly, he initiated the Greek tradition of free discussion of ideas in the marketplace and other public areas. Intellectual exchange was no longer limited to an educated elite or a priestly class.

Empedocles of Acragas (ca. 490–430 BCE) introduced the four elements—fire, earth, air, water—and used their relationship to describe natural phenomena and human behavior. A cyclical pattern of elements combining (through love and peace) or separating (by strife and war) explained how creatures as well as nations were born, grew, decayed, and died. Anaxagoras of Clazomenae (ca. 500–428 BCE) postulated an infinite number of small particles that, however small they might be, always contained a dominant substance (for example, bone or water) as well as stray bits of other substances in lesser quantities. Unity in nature, Anaxagoras claimed, came from the force of reason.

The Presocratic philosopher who had the greatest influence on later philosophical thought was Pythagoras (ca. 570–500 to 490 BCE). He left his birthplace on the Aegean island of Sámos for political reasons and settled in Croton, a Greek colony in southern Italy, where he founded his own school of philosophy. It became quite an exclusive, rigidly controlled, and secretive brotherhood: he required his followers to lead chaste and devout lives and to uphold morality and the ideals of order and harmony as forces in the universe. Disagreement between Pythagoras's sect, which was politically active, and the people of Croton over local governance turned violent, leading to the deaths of many followers. Pythagoras himself fled and spent the last years of his life in another city.

It is difficult to know which of the principles of Pythagoreanism can be directly attributed to Pythagoras and which were later added by his disciples. His chief religious doctrines seem to have been belief in the transmigration of souls and in the kinship of all living things—teachings that led to the development of a religious cult that bore his name. As a philosopher, Pythagoras taught that the universe was harmonious, and as a mathematician (a familiar geometrical

theorem bears his name), he taught that all things in the universe could be placed in sequence, ordered, and counted. He discovered the numerical ratios of frequencies that comprise the musical scale. Our modern musical scale, consisting of an **octave** (a span of eight tones) divided into its constituent parts, derives ultimately from his theoretical research. Inspired by this discovery, Pythagoras went on to claim that mathematical relationships represented the underlying principle of the universe and of morality, the so-called harmony of the spheres. Even today, physicists continue the search for a theory of everything, a single principle or theory that will unify that which they see operating on a grand scale—among the galaxies and energies that make up the universe at large—with that which operates on the smallest scale—among the particles and forces that make up atoms. Albert Einstein searched for it with some frustration for nearly sixty years.

In contrast to Pythagoras's belief in universal harmony, the *Dualists* claimed that there existed two separate universes: the world around us, which was subject to constant change, and another ideal world, perfect and unchanging, which could be realized only through the intellect. The chief proponent of this school was Heraclitus of Ephesus (ca. 540–480 BCE), who summed up the unpredictable, and therefore unknowable, quality of nature in the oft-quoted saying, "It is not possible to step twice into the same river." In other words, the river flows and is filled with life such that the molecules of water, drifting plants, and darting fish change its character from moment to moment; at the same time, the river retains its identity or sameness despite change. Heraclitus believed that permanence was an illusion, and that the only constant was change. On the other hand, he did not see change as random. He thought that change was determined by a cosmic order that he called *Logos*.

Unlike his predecessors, who tried to understand the fundamental nature of matter, Heraclitus drew attention, then, to the process whereby matter changed; he proposed that the basic element is fire because of the way in which it ceaselessly changes:

> This world, which is always the same for all men, neither god nor man made; it has always been, it is, and always shall be: an everlasting fire rhythmically dying and flaring up again.[2]

Parmenides of Elea (ca. born 510 BCE), on the other hand, went so far as to claim that true reality can only be apprehended by reason and is all-perfect and unchanging, without time or motion. Our mistaken impressions come from our senses, which are flawed and subject to error. As a result, the world we perceive through them, including the processes of time and change, is a sham and a delusion. Parmenides laid out his ideas in a poem divided into three parts: the Prologue, the Way of Truth (one of the longest of

READING 2.13 PARMENIDES

From the Way of Truth

Now I shall show you—do you listen well and mark my words—the only roads of inquiry which lead to knowledge. The first is that of him who says, "That which exists is real; that it should not exist is impossible." This is the reasonable road, for Truth herself makes it straight. The other road is his who says, "There are, of necessity, things which do not exist,"—and this, I tell you, is a fantastic and impossible path. For how could you know about something which does not exist? A sheer impossibility. You could not even talk about it, for thought and existence are the same.

There remains only to tell of the way of him who maintains that Being does exist; and on this road there are many signs that Being is without beginning or end. It is the only thing that is; it is all-inclusive and immoveable, without an end. It has no past and no future; its only time is *now,* for it is one continuous whole. What sort of creation could you find for it? From what could it have grown, and how? I cannot let you say or think that it came from nothing, for we cannot say or think that something which does not exist actually does so [i.e., if we say that Being comes from Not-being, we imply that Not-being exists, which is self-contradictory]. What necessity could have roused up existence from nothingness? And, if it had done so, why at one time rather than at another? No; we must either admit that Being exists completely, or that it does not exist at all. Moreover, the force of my argument makes us grant that nothing can arise from Being except Being. Thus iron Law does not relax to allow creation and destruction, but holds all things firm in her grasp.

Excerpt from *The Classics in Translation*, Volume I, edited by Paul L. MacKendrick and Herbert M. Howe, copyright 1952. Reprinted by permission of The University of Wisconsin Press.

all Presocratic text fragments to have survived), and the Way of Opinion.

Parmenides's pupil Zeno (ca. 495–430 bce) devised several difficult paradoxes, or philosophical problems, in support of Parmenides's doctrines; Zeno's paradoxes were later discussed by Plato and Aristotle.

The last—and perhaps most important—school of Presocratic philosophy was that of the *Atomists*, led by Leucippus and his student Democritus (ca. 460–370 BCE). They both believed that the ultimate, unchangeable reality consisted of

2. Douglas J. Soccio, *Archetypes of Wisdom,* sixth edition. Belmont, CA: Thomson/Wadsworth, 2007.

atoms—small, imperceptible, and indivisible particles—and the void, or nothingness, in which these particles moved freely. (The word *atom*, in use today, has not changed from the original Greek, *atomos*, meaning "undivided." We know now, however, that atoms can indeed be divided into many particles, forces, and other things yet to be discovered.) They further considered atoms to be eternal and uncreated—always there. Atoms made up objects by combining with one another in various ways—an ingenious notion foretelling the discovery of molecules. Atomism survived into Roman times in the later philosophy of Epicureanism and into the nineteenth century in the early atomic theory of John Dalton. In 1905, Albert Einstein conducted experiments that provided the crucial evidence for the existence of molecules; more recently, the physicist Werner Heisenberg (1901–1976), who astonished the world of science with his discoveries in quantum mechanics, derived his initial inspiration from the Greek Atomists.

Presocratic ideas survive only in fragments of text, but in their focus on the human rather than the divine, their influence reached across the chronological spectrum from Classical Athens to the Renaissance in Europe and the eighteenth-century Age of Reason. This contribution to the evolution of human thought is summed up in a well-known statement attributed to Protagoras (ca. 485–415 BCE), a Presocratic philosopher who lived during the Golden Age of Greece and whom we will encounter in the next chapter: "Man is the measure of all things, of the existence of those that exist, and of the nonexistence of those that do not."

Herodotus: The First Greek Historian

At the beginning of the fifth century BCE, the Greeks faced the greatest threat to their civilization. Their success in meeting the challenge precipitated a decisive break with the world of Archaic culture.

In 499 BCE the Greek cities of Asia Minor, with Athenian support, rebelled against their Persian rulers. The Persian king Darius I succeeded in checking this revolt; he then launched a punitive military expedition against the mainland Greek cities that had sent help to the eastern cities. In 490 BCE he led a massive army into Greece; to everyone's surprise, the Persians were defeated by the Athenians at the Battle of Marathon. After Darius's death in 486 BCE, his son Xerxes I launched an even larger and more aggressive campaign in 480 BCE. Xerxes defeated the Spartans at Thermopylae and then attacked and sacked Athens. While the city was falling, the Athenians took to their ships, obeying an oracle that had enjoined them to "trust to their wooden walls." Eventually they inflicted a crushing defeat on the Persian navy at nearby Salamis. In 479 BCE, after being bested on land and at sea, at Plataea and Mycale, the Persians returned home, completely beaten.

Herodotus (484–420 BCE), once called "the father of history," left us in his nine-book *Histories* a detailed account of the wars with Persia during the closing years of the Archaic period. Controversies about his methods and contributions abound, but this much is certain: he was the first writer in the Western tradition to devote himself entirely to historical writing; he was systematic about collecting information; and he was a great storyteller, with the ability to sustain the reader's interest in the main narrative with frequent and entertaining digressions.

Herodotus was not a scientific historian in our terms—he had definite weaknesses. He never really understood the finer points of military strategy. He almost always interpreted events in terms of personalities, showing little interest in underlying political or economic causes. His strengths, however, were many. Although his subject involved conflict between Greeks and foreigners, he remained remarkably impartial and free of nationalist prejudice. His natural curiosity about the world around him and about his fellow human beings was buttressed by acute powers of observation. Above all, he recorded as much information as possible, even when versions conflicted. He also tried to provide a reasonable evaluation of the reliability of his sources so later readers could form their own opinions.

Herodotus's analysis of the Greek victory over the Persians was based on an unwavering philosophical, indeed theological, belief that the enemy was defeated because they were morally in the wrong. Their fault was **hubris**—pride, excessive ambition, and behavior that humiliates or shames a protagonist's victim. The Greeks' victory was, at the same time, an example of right over might and a demonstration that the gods would guarantee the triumph of justice. In book 7 of Herodotus's account, Artabanus, the uncle of the Persian king Xerxes, warns him in 480 BCE not to invade Greece.

In another reckless exhibition of hubris, Herodotus tells us, Xerxes gave orders to mutilate the body of Leonidas, the Spartan leader of Greeks in the seminal battle at Thermopylae. Leonidas's men, however, retrieved his body before this could happen.

Both moral and political lessons were to be learned from the Greeks' ultimate defeat of the Persians. Right may have explained some of it, but the Greeks were successful, in part, because for once they had managed to unite in the face of a common enemy. The Battle of Thermopylae took place in August of 480 BCE; Leonidas commanded a force of 300 of his own Spartan warriors and thousands from other city-states defending a pass at that city. When the Persians attacked the Greeks, Leonidas and his troops held the pass for six days; it is estimated that some 20,000 Persians, along with about 2,500 Greeks, died over that short time. When Leonidas became aware of a sneak attack from the rear by the Persians, he sent all but the Spartans and a couple of thousand other warriors away; he famously perished with his 300 in a bitter, bloody fight to the last man.

Subsequent victories over the Persians in decisive naval battles inaugurated the greatest period in Greek history—the Classical, or Golden, Age.

Histories, book 7

For four days Xerxes waited, in constant expectation that the Greeks would make good their escape; then, on the fifth, when still they had made no move and their continued presence seemed mere impudent and reckless folly, he was seized with rage and sent forward the Medes and Cissians with orders to take them alive and bring them into his presence. The Medes charged, and in the struggle which ensued many fell; but others took their places, and in spite of terrible losses refused to be beaten off. They made it plain enough to anyone, and not least to the king himself, that he had in his army many men, indeed, but few soldiers. All day the battle continued; the Medes, after their rough handling, were at length withdrawn and their place was taken by Hydarnes and his picked Persian troops—the King's—Immortals who advanced to the attack in full confidence of bringing the business to a quick and easy end. But, once engaged, they were no more successful than the Medes had been; all went as before, the two armies fighting in a confined space, the Persians using shorter spears than the Greeks and having no advantage from their numbers. On the Spartan side it was a memorable fight; they were men who understood war pitted against an inexperienced enemy, and amongst the feints they employed was to turn their backs in a body and pretend to be retreating in confusion, whereupon the enemy would come on with a great clatter and roar, supposing the battle won; but the Spartans, just as the Persians were on them, would wheel and face them and inflict in the new struggle innumerable casualties. The Spartans had their losses too, but not many. At last the Persians, finding that their assaults upon the pass, whether by divisions or by any other way they could think of, were all useless, broke off the engagement and withdrew. Xerxes was watching the battle from where he sat; and it is said that in the course of the attacks three times, in terror for his army, he leapt to his feet.

Next day the fighting began again, but with no better success for the Persians, who renewed their onslaught in the hope that the Greeks, being so few in number, might be badly enough disabled by wounds to prevent further resistance. But the Greeks never slackened. . . .

In the morning Xerxes poured a libation to the rising sun, and then waited till about the time of the filling of the marketplace, when he began to move forward. . . . As the Persian army advanced to the assault, the Greeks under Leonidas, knowing that the fight would be their last, pressed forward into the wider part of the pass much farther than they had done before; in the previous days' fighting they had been holding the wall and making sorties from behind it into the narrow neck, but now they left the confined space and battle was joined on more open ground. Many of the invaders fell; behind them the company commanders plied their whips, driving the men remorselessly on. Many fell into the sea and were drowned, and still more were trampled to death by their friends. No one could count the number of the dead. The Greeks, who knew that the enemy were on their way round by the mountain track and that death was inevitable, fought with reckless desperation, exerting every ounce of strength that was in them against the invader. By this time most of their spears were broken, and they were killing Persians with their swords.

In the course of that fight Leonidas fell, having fought like a man indeed. Many distinguished Spartans were killed at his side—their names, like the names of all the three hundred, I have made myself acquainted with, because they deserve to be remembered. Amongst the Persian dead, too, were many men of high distinction—for instance, two brothers of Xerxes, Habrocomes and Hyperanthes, both of them sons of Darius by Artanes' daughter Phratagune.

There was a bitter struggle over the body of Leonidas; four times the Greeks drove the enemy off, and at last by their valor succeeded in dragging it away. So it went on, until the fresh troops with Ephialtes were close at hand; and then, when the Greeks knew that they had come, the character of the fighting changed. They withdrew again into the narrow neck of the pass, behind the walls, and took up a position in a single compact body—all except the Thebans—on the little hill at the entrance to the pass, where the stone lion in memory of Leonidas stands today. Here they resisted to the last, with their swords, if they had them, and, if not, with their hands and teeth, until the Persians, coming on from the front over the ruins of the wall and closing in from behind, finally overwhelmed them.

Of all the Spartans and Thespians who fought so valiantly on that day, the most signal proof of courage was given by the Spartan Dieneces. It is said that before the battle he was told by a native of Trachis that, when the Persians shot their arrows, there were so many of them that they hid the sun. Dieneces, however, quite unmoved by the thought of the terrible strength of the Persian army, merely remarked: "This is pleasant news that the stranger from Trachis brings us: for if the Persians hide the sun, we shall have our battle in the shade." He is said to have left on record other sayings, too, of a similar kind, by which he will be remembered. After Dieneces the greatest distinction was won by the two Spartan brothers, Alpheus and Maron, the sons of Orsiphantus; and of the Thespians the man to gain the highest glory was a certain Dithyrambus, the son of Harmatides.

The dead were buried where they fell, and with them the men who had been killed before those dismissed by Leonidas left the pass. Over them is this inscription, in honor of the whole force:
Four thousand here from Pelops' land

> Against three million once did stand.
> The Spartans have a special epitaph; it runs:
> Go tell the Spartans, you who read:
> We took their orders, and are dead.
> For the seer Megistias there is the following:
> I was Megistias once, who died
> When the Mede passed Spercheius' tide.
> I knew death near, yet would not save
> Myself, but share the Spartans' grave.

From the *Histories* by Herodotus, translated by Aubrey de Selicourt, revised with introduction and notes by A. R. Burn (Penguin Classics 1954, Revised edition 1972).

GLOSSARY

Aulos (p. 69) A double-reed musical instrument similar to the modern oboe.

Black-figure technique (p. 64) A Greek vase-painting technique in which only the figural elements are applied using a mixture of fine clay and water (see **slip**); kiln firings produce the combination of a reddish clay pot with black figures. Details are added to the figures with a fine-pointed implement that scratches away some of the black paint.

Cella (p. 66) The small inner room of a Greek temple, used to house the statue of the god or goddess to whom the temple was dedicated; located behind solid masonry walls, the cella was accessible only to temple priests.

Dactylic hexameter (p. 52) A poetic meter or rhythm consisting of six feet or units of *dactyls*. A dactyl contains three syllables, the first of which is long ir stressed, and the following two of which are shorter or unstressed.

Dithyramb (p. 69) A choral hymn sung in honor of the god Dionysus; often wild or violent in character.

Ekphrasis (p. 58) A literary device in which a work of art is described in such detail that a clear visual picture emerges.

Epithet (p. 49) A descriptive word or phrase that refers to a particular quality in a person or thing

Ethos (p. 69) Literally "character," but used by Greeks to describe the ideals or values that characterize or guide a community.

Heroic verse (p. 52) The meter or rhythm used in epic poetry, primarily in Greek and Latin.

High relief (p. 62) Sculpture that projects from its background by at least half its natural depth.

Hubris (p. 74) Extreme pride or arrogance, as shown in actions that humiliate a victim for the gratification of the abuser.

In medias res (p. 52) Literally, "in the middle of things"; a phrase used to describe a narrative technique in which the reader encounters the action in the middle of the story, rather than at the beginning.

Kithara (p. 69) A seven-stringed lyre.

Kore (p. 62) Literally, "girl"; a clothed female figure as represented in the sculpture of the Archaic period of Greek art, often carved with intricate detail (plural *korai*). A counterpart to the kouros.

Kouros, pl., kouroi (p. 61) Literally, "boy"; a male figure as represented in the sculpture of the Geometric and Archaic periods of Greek art (plural *kouroi*).

Krater (p. 58) A wide-mouthed ceramic vessel used for mixing wine and water.

Low relief (p. 62) Sculpture that projects only slightly from its background.

Meander (p. 58) A continuous band of interlocking geometric designs

Naturalism (p. 61) Representation that strives to imitate appearances in the natural world.

Nostos (p. 54) Literally, "homecoming"; the theme of the heroes' journeys homeward in the Homeric epics (plural *nostoi*).

Octave (p. 73) The interval of eight degrees between two musical pitches whose frequencies have a ratio of 2:1; originated from Pythagorean ideas about harmony.

Optical representation (p. 62) The portrayal of a person or object as it is seen at any given moment from any given vantage point.

Order (p. 67) An architectural style as described, primarily, by the design of the columns and frieze.

Orientalizing period (p. 59) The early phase of Archaic Greek art, so named for the adoption of motifs from Egypt and the Near East.

Peplos (p. 62) A body-length garment worn by women in Greece prior to 500 BCE.

Peripteral (p. 66) Referring to a Greek temple design that has a colonnade around the entire cella and its porches.

Polis (p. 48) A self-governing Greek city-state (plural *poleis*).

Red-figure technique (p. 65) A Greek vase-painting technique in which everything *but* the figural elements is covered with a mixture of fine clay and water (see **slip**); kiln firings produce a combination of a black pot with reddish figures.

Relief sculpture (p. 62) Sculpture in which figures project from a background to varying depths (see **high relief** and **low relief**); often used to decorate architecture or furniture.

Slip (p. 64) In ceramics, clay that is thinned to the consistency of cream; used in the decoration of Greek vases (see **black-figure technique** and **red-figure technique**).

Spondee (p. 52) A foot of poetry consisting of two syllables, both of which are stressed.

Trochee (p. 52) A foot of poetry consisting of two syllables, in which the first syllable is stressed and the second is unstressed.

THE BIG PICTURE THE RISE OF GREECE

Language and Literature

- The poet Homer lived during the eighth century BCE. His epic narratives on the Trojan War—the *Iliad* and the *Odyssey*—were composed centuries after the actual event and were recited by generations of bards until they were written down sometime in the sixth century BCE.
- Hesiod's *Works and Days* captures Greek agrarian values as well as the trials, tribulations, and rewards of the life of a farmer. Hesiod also wrote the *Theogony*, a poetic account of the origins of the world.
- The Greeks adopted the Phoenician alphabet ca. 700 BCE.
- Lyric verse replaced Homeric heroic verse during the Archaic period; Sappho of Lésbos was the first woman to leave a literary record that reflects her own personal experiences.
- Herodotus (484–420 BCE), who has been called the "father of history," wrote the *Histories* in nine volumes.

Art, Architecture, and Music

- By the eighth century BCE, Greeks returned to the representation of the human figure, first in painting on pottery, then in small bronze sculptures. Because of the prevalence of abstract motifs in vase painting, this period is called the Geometric period.
- Contact with cultures of the Near East brought eastern artifacts to Greece; motifs and styles borrowed from Mesopotamia and Egypt are seen in the Orientalizing period of Greek art.
- The earliest life-size Greek stone sculptures coincided with the first Greek settlement in Egypt, around the mid-seventh century BCE, and markedly resembled Egyptian cult statues.
- During the Archaic period, life-size figures of the nude male appeared and artists began to represent the human form in a way that was true to nature; smiles were added to create a more lifelike appearance.
- In architecture, the Archaic period was marked by the construction of several major peripteral temples and the development of the Doric and Ionic orders.
- Athenians developed black-figure vase painting by the mid-sixth century BCE, with Exekias as its unparalleled master; red-figure vase painting is traced back to ca. 530 BCE.
- The introduction of contrapposto in the *Kritios Boy*, along with the sideward glance of the head, separate the Archaic period from the Classical period of Greek art.
- Greek music was composed using a series of distinct modes or scale types; each mode was seen as powerful enough to effect human behavior in a specific way.
- The kithara (a seven-string lyre) and the aulos (a double-reed instrument) were developed ca. 675 and were used, like most musical instruments, to accompany singers; purely instrumental music was introduced at the end of the Archaic period.
- A vast literature on music theory developed; Pythagoras discovered the numerical relationship of music harmonies and our modern musical scales.

Religion and Philosophy

- Greeks sought explanations from their deities for natural phenomena and psychological characteristics they recognized in themselves.
- Greek mythology offered no central body of information; rather, there were often varying versions of the same basic story. Greek myth and religion consisted of folktales, primitive customs, and traditional rituals.
- It is often said that the Greeks made their gods into men and their men into gods; the difference between gods and human beings was simply that gods were immortal.
- The Presocratic philosophers (who lived and died before Socrates and Plato) were united by their use of logic and theoretical reasoning to solve practical questions about the world and human experience. Presocratic schools of philosophy included Materialism, Pythagoreanism, Dualism, and Atomism.
- Presocratics emphasized the human rather than the divine; Protagoras said, "Man is the measure of all things, of the existence of those that exist, and of the nonexistence of those that do not."

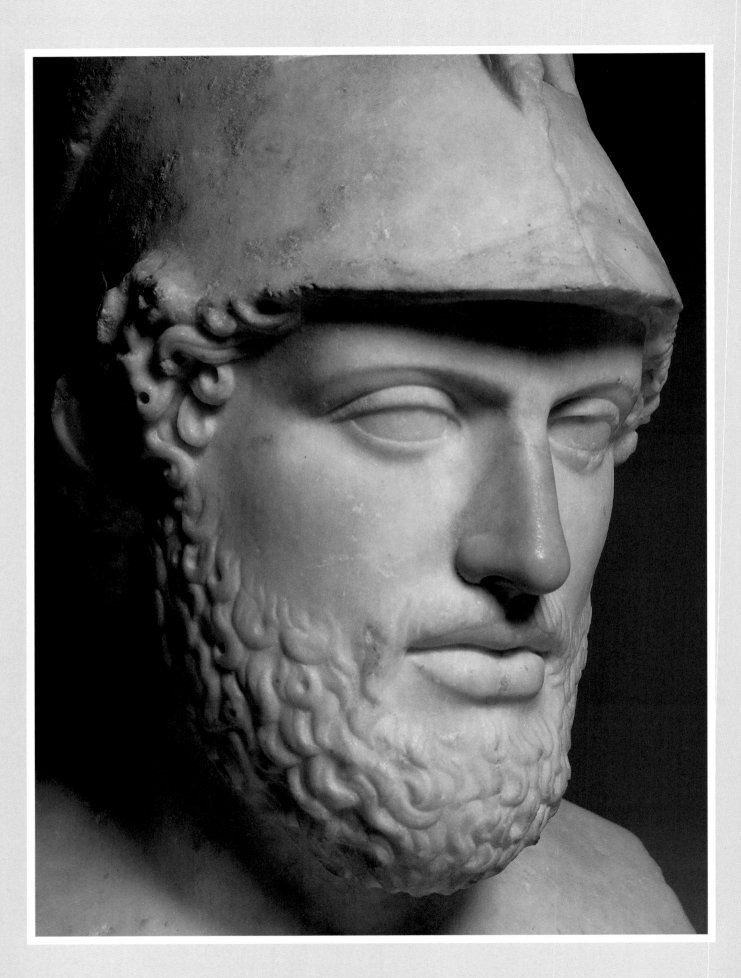

Classical Greece and the Hellenistic Period

3

PREVIEW

By the time Aeschylus took first prize in a drama competition for his renowned *Oresteia* trilogy in 458 BCE, the stories of the Heroic Age from which it sprang were hundreds of years old and as familiar to the Greeks as their own names—stories of King Agamemnon and the divine Achilles, of blood revenge and the wrath of the gods. It was not the first time Aeschylus had won. In 472 BCE he was awarded the same prize for a play whose subject hit much closer to home—*The Persians*. Performed just eight years after the Greeks defeated Xerxes I, it is the earliest surviving play by Aeschylus's hand and the only Greek tragedy we have that describes a historical event that would have occurred in the recent memory of the audience. Herodotus would write his *Histories* three decades later based on information he had gathered from many sources, but Aeschylus had been there. He fought in the Battle at Marathon with his brother, who was killed. And he fought again—10 years later—in the decisive naval battle of Salamis that turned the tide of the prolonged conflict in favor of the Greeks. Like Herodotus in his account of the Persian defeat, Aeschylus—through the voices of characters including the ghost of Xerxes's dead father, Darius—attributes the loss to hubris that unleashed the anger of the gods. (The theme of hubris also would be an undercurrent in *Agamemnon*, the first of the three plays of the *Oresteia*).

As much as it describes the tragic circumstances of war, *The Persians* exalts the strength and spirit of the Greek alliance and glorifies the city-state of Athens—just coming into its Golden Age with a renewed sense of pride and determination to rebuild its temples and reaffirm its democratic values. Spearheading the postwar campaign was the statesman Pericles (**Fig. 3.1**), under whose leadership Athens reached its peak in the arts, literature, and philosophy. Perhaps significantly, Pericles had been the *choregos* for *The Persians*—in effect, the producer. He paid for the chorus preparations and other production expenses that the state did not cover and, in so doing, granted his services to the polis and the people. He was wealthy and could do it; the reward was an honorific that confirmed Pericles's standing among the elite.

Aeschylus died just a few years after the *Oresteia* was performed to great acclaim, but the inscription on his tomb makes no mention of the many accolades bestowed upon him as the Father of Greek Tragedy. Rather, it is the epitaph of a warrior: "Beneath this stone lies Aeschylus, son of Euphorion, the Athenian, who perished in the wheat-bearing land of Gela; of his noble prowess the grove of Marathon can speak, and the long-haired [Persian] knows it well."

◄ **3.1 Cresilas, Pericles, 2nd century BCE. Marble. 23" (58.5 cm) high. British Museum, London, United Kingdom.** This portrait bust of the Athenian statesman Pericles (ca. 490–429 BCE) is said to be from Hadrian's villa at Tivoli, Italy.

CLASSICAL CIVILIZATION IN ANCIENT GREECE

The victories in the Persian Wars produced a new spirit of optimism and unity in Greece. Divine forces, it appeared, had guaranteed the triumph of right over wrong. There seemed to be no limit to the possibilities of human achievement. The accomplishments of the Greeks in the Classical period, which lasted from 479 BCE to the death of Alexander the Great in 323 BCE, do much to justify the Greeks' pride and self-confidence. The period represents an apogee of civilization that has rarely, if ever, been reached since—one that continues to inspire our own culture.

Classical civilization reached its peak in Athens during the last half of the fifth century BCE, a time of unparalleled richness in artistic and intellectual achievement that is often called the Golden Age of Greece. Athenians were pioneers in drama and historiography, town planning and medicine, painting and sculpture, mathematics and government. Their contributions to the development of Western culture not only became the foundation for later achievements but have endured, and their importance—and exceptionality—is continually validated. Greek tragedies are still read and performed, because the experience of these works is as emotionally intense and intellectually satisfying as anything in the Western dramatic tradition.

The Classical Ideal

The rich legacy that is Greece did not take root amid tranquility; the Athenians of the golden age lived not in an environment of calm contemplation but in a world of tension and violence. Their tragic inability to put noble ideals into practice and live in peace with other Greeks—the darker side of their genius—proved fatal to their independence; it led to war with the rest of Greece in 431 BCE and to the fall of Athens in 404 BCE. In this context, the Greek search for order takes on an added significance. The belief that the quest for reason and order could succeed gave a unifying ideal to the immense and varied output of the Classical period. The central principle of this Classical ideal was that existence could be ordered and controlled, that human ability could triumph over the apparent chaos of the natural world and create a balanced society. In order to achieve this equilibrium, individual human beings should try to stay within what seem to be reasonable limits, for those who do not are guilty of hubris—the same hubris of which the Persian leader Xerxes was guilty and for which he paid the price. The aim of life should be a perfect balance: everything in due proportion and nothing in excess. "Nothing too much" was one of the most famous Greek proverbs, and the word "moderation" appears in many texts.

The emphasis that the Classical Greeks placed on order affected their spiritual attitudes. Individuals could achieve order, they believed, by understanding why people act as they do and, above all, by understanding the motives for their own actions. Thus confidence in the power of both human reason and human self-knowledge was as important as belief in the gods. The greatest of all Greek temples of the Classical period—the Parthenon, which crowned the Athenian Acropolis (**Fig. 3.2**)—was planned not so much to honor the goddess Athena as to glorify Athens and thus human achievement. Even in their darkest days, the Classical Greeks never lost sight of the magnitude of human capability and, perhaps even more important, human potential—a vision that has returned over the centuries to inspire later generations and has certainly not lost its relevance in our own times.

Classical Greece and the Hellenistic Period

500 BCE	450 BCE	404 BCE	323 BCE	146 BCE
	CLASSICAL PERIOD		HELLENISTIC PERIOD	
	Golden Age	Late Classical Period		
The Delian League forms; beginning of Athenian empire	Pericles commissions work on the Acropolis	Athens falls to Sparta 404	Alexander's successors vie for power	
Pericles comes to prominence at Athens	Pericles is in full control of Athens until his death in 429 from a plague that devastates Athens	The Thirty Tyrants rule Athens r. 404–403	Pergamum becomes an independent kingdom	
The treasury of the Delian League is moved to Athens	The Peloponnesian War begins 431	Socrates is executed in 339	Eomenes II rules Pergamon r. 197-159	
	Sophocles writes *Oedipus the King*	Thebes ascends	Romans sack Corinth in 146; Greece becomes a Roman province	
		Phillip II rules Macedon r. 359-336		

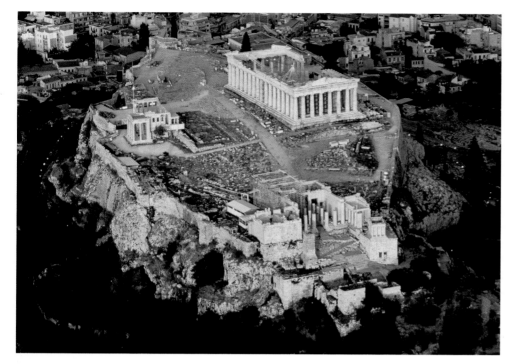

◀ **3.2 The Acropolis. Athens, Greece.** Pericles oversaw the reconstruction of the Acropolis after its sacking by the Persians during their second invasion, in 480 BCE. The Parthenon is at the upper right, and the small Temple of Athena Nike is at the lower right. Note that the Parthenon was not built in the center of the Acropolis, but at its highest point, where it was most visible from below.

death in 429 BCE; the period under his leadership is sometimes called the Age of Pericles.) As tensions mounted over the Delian treasury, the spirit of Greek unity began to erode. The Greek states were divided: on one side, Athens and its allies (the cities that remained in the league), and on the other, the rest of Greece. Conflict was inevitable. The Spartans were persuaded to lead the opposition alliance against Athens to check its "imperialistic designs." This war, called the **Peloponnesian War** after the homeland of the Spartans and their supporters, began in 431 BCE and continued indecisively for 10 years until an uneasy peace was signed in 421 BCE. Shortly afterwards, the Athenians made an ill-advised attempt to replenish their treasury by organizing an unprovoked attack on the wealthy Greek cities of Sicily. The expedition proved a total disaster; thousands of Athenians were killed or taken prisoner. When the war began again in 411 BCE, the Athenian forces were fatally weakened. The end came in 404 BCE. After a siege that left many people dying in the streets, Athens surrendered unconditionally to Sparta and its allies.

With the fall of Athens and the end of the Peloponnesian War, neither Greek politics nor cultural life was dominated by Athens.

THUCYDIDES Our understanding of the Peloponnesian War and its significance owes much to the account of the great historian Thucydides, who lived through its calamitous events. Thucydides did not mean to entertain the reader with digressions and anecdotes (as did Herodotus) but rather to search out the truth and use it to demonstrate universal principles of human behavior. Born around 460 BCE, Thucydides played an active part in Athenian politics in the years before the war. In 424 BCE he was elected general and put in charge of defending the northern Greek city of Amphipolis against the Spartans. Before he could assume his post, however, the Spartans negotiated terms of surrender with the people of Amphipolis. The Athenian leadership blamed Thucydides for the loss of the city and exiled him from Athens; he did not return until the city was under Spartan control in 404 BCE.

Thucydides intended his *History of the Peloponnesian War* to describe the entire course of the war, but he may have died before completing it; the narrative breaks off at the end

The political and cultural center of Greece during the first half of the Classical period was Athens. Here, by the end of the Persian Wars in 479 BCE, the Athenians had emerged as the most powerful people in the Greek world. For one thing, their role in the defeat of the Persians had been decisive. For another, their democratic system of government, first established in the late sixth century BCE, was proving to be both effective and stable. All male Athenian citizens were not only entitled but required to participate in the running of the state, either as members of the General Assembly, the **Ecclesia** (with its directing council, the **Boule**), or as individual magistrates. They were also eligible to serve on juries.

THE DELIAN LEAGUE In the years immediately following the wars, a defensive organization of Greek city-states was formed to guard against any future outside attack. The money collected from the participating members was kept in a treasury on the island of Delos, sacred to Apollo and politically neutral. This organization became known as the **Delian League**.

Within a short time several other important city-states, including Thebes, Sparta, and Athens' old trade rival Corinth, began to suspect that the league was serving not so much to protect all of Greece as to strengthen Athenian power. They believed the Athenians were turning an association of free and independent states into an empire of subject peoples. Their suspicions were confirmed when (in 454 BCE) the funds of the league were transferred from Delos to Athens and money that should have been spent by the Athenians for the common good of the member states was used instead to finance Athenian building projects, including the Parthenon. Pericles was the leader of the Athenians and the one responsible for expropriating the funds. (He came to power ca. 461 BCE and was reelected every year until his

of 411 BCE. The work is extremely valuable for its detailed description of events, but Thucydides tried to do more than write about a local war. The history was an attempt to analyze human motives and reactions so that future generations might understand how and why the conflict occurred and, in turn, better understand something about themselves. Writing as an exiled Athenian on the Peloponnesus presented Thucydides with the opportunity to see the war from both sides; his account is both accurate and impartial. In Chapter 3, for example, he reports on a meeting of the Congress of the Peloponnesian Confederacy, at which a vote is taken to go to war against Athens. A good part of the chapter is given over to a speech by the Corinthians intended to incite the Lacedaemonians (Spartans) to action, that is, to leading the Peloponnesian states against the Athenians because of their military might. The Corinthian strategy seems to have been to shame the Spartans by comparing them unfavorably to the Athenians.

READING 3.1 **THUCYDIDES**

From *History of the Peloponnesian War*

The Athenians are addicted to innovation, and their designs are characterized by swiftness alike in conception and execution; you have a genius for keeping what you have got, accompanied by a total want of invention, and when forced to act you never go far enough. Again, they are adventurous beyond their power, and daring beyond their judgment, and in danger they are sanguine; your wont is to attempt less than is justified by your power, to mistrust even what is sanctioned by your judgment, and to fancy that from danger there is no release. Further, there is promptitude on their side against procrastination on yours; they are never at home, you are never from it: for they hope by their absence to extend their acquisitions, you fear by your advance to endanger what you have left behind. . . . Their bodies they spend ungrudgingly in their country's cause; their intellect they jealously husband to be employed in her service. . . . Thus they toil on in trouble and danger all the days of their life, with little opportunity for enjoying, being ever engaged in getting: their only idea of a holiday is to do what the occasion demands, and to them laborious occupation is less of a misfortune than the peace of a quiet life. To describe their character in a word, one might truly say that they were born into the world to take no rest themselves and to give none to others.

Such is Athens, your antagonist. And yet, Lacedaemonians, you still delay, and fail to see that peace stays longest with those, who are not more careful to use their power justly than to show their determination not to submit to injustice.

At the time of this meeting, it happens that two Athenian envoys are in town on business. Hearing these exhortations to war, they ask to speak to the assembly, not so much to convince them of Athens's innocence but to ask them to refrain from acting hastily. The envoys remind Sparta and its allies of Athens's contribution to the defeat of the Persians even though they "are rather tired of continually bringing this subject forward." By recounting the heroism of the Athenians, the envoys suggest "what sort of an antagonist she is likely to prove."

READING 3.2 **THUCYDIDES**

From *History of the Peloponnesian War*, chapter III, "Congress of the Peloponnesian Confederacy at Lacedaemon"

We assert that at Marathon we were at the front, and faced the barbarian single-handed. That when he came the second time, unable to cope with him by land we went on board our ships with all our people, and joined in the action at Salamis. This prevented his taking the Peloponnesian states in detail, and ravaging them with his fleet; when the multitude of his vessels would have made any combination for self-defense impossible. The best proof of this was furnished by the invader himself. Defeated at sea, he considered his power to be no longer what it had been, and retired as speedily as possible with the greater part of his army.

Such, then, was the result of the matter, and it was clearly proved that it was on the fleet of Hellas that her cause depended. Well, to this result we contributed three very useful elements, viz., the largest number of ships, the ablest commander, and the most unhesitating patriotism. . . . Receiving no reinforcements from behind, seeing everything in front of us already subjugated, we had the spirit, after abandoning our city, after sacrificing our property (instead of deserting the remainder of the league or depriving them of our services by dispersing), to throw ourselves into our ships and meet the danger, without a thought of resenting your neglect to assist us. We assert, therefore, that we conferred on you quite as much as we received. For you had a stake to fight for; the cities which you had left were still filled with your homes, and you had the prospect of enjoying them again. . . . But we left behind us a city that was a city no longer, and staked our lives for a city that had an existence only in desperate hope, and so bore our full share in your deliverance and in ours.

In the end, the Spartans, the Corinthians, and their allies voted to go to war against Athens. They would be victorious and Athens would once again be sacked, this time by their own countrymen. But the "city that was a city no longer," the "city that had an existence only in desperate hope" after the Persian Wars had been resurrected. The hero of Thucydides's account of these years immediately preceding the Peloponnesian War is Pericles, whose funeral oration in honor of the

READING 3.3 **THUCYDIDES**

History of the Peloponnesian War, **Pericles's funeral oration, Book II**

Our form of government does not enter into rivalry with the institutions of others. Our government does not copy our neighbors', but is an example to them. It is true that we are called a democracy, for the administration is in the hands of the many and not of the few. But while there exists equal justice to all and alike in their private disputes, the claim of excellence is also recognized; and when a citizen is in any way distinguished, he is preferred to the public service, not as a matter of privilege, but as the reward of merit. Neither is poverty an obstacle, but a man may benefit his country whatever the obscurity of his condition. . . . A spirit of reverence pervades our public acts; we are prevented from doing wrong by respect for the authorities and for the laws, having a particular regard to those which are ordained for the protection of the injured as well as those unwritten laws which bring upon the transgressor of them the reprobation of the general sentiment.

And we have not forgotten to provide for our weary spirits many relaxations from toil; we have regular games and sacrifices throughout the year; our homes are beautiful and elegant; and the delight which we daily feel in all these things helps to banish sorrow. Because of the greatness of our city the fruits of the whole earth flow in upon us; so that we enjoy the goods of other countries as freely as our own.

Then, again, our military training is in many respects superior to that of our adversaries. Our city is thrown open to the world, though and we never expel a foreigner and prevent him from seeing or learning anything of which the secret if revealed to an enemy might profit him.

For we have compelled every land and every sea to open a path for our valor, and have everywhere planted eternal memorials of our friendship and of our enmity. Such is the city for whose sake these men nobly fought and died; they could not bear the thought that she might be taken from them; and every one of us who survive should gladly toil on her behalf.

I have dwelt upon the greatness of Athens because I want to show you that we are contending for a higher prize than those who enjoy none of these privileges, and to establish by manifest proof the merit of these men whom I am now commemorating. Their loftiest praise has been already spoken. For in magnifying the city, I magnify them, and men like them whose virtues made her glorious.

war dead Thucydides also recorded. It stands apart from typical funeral addresses in that Pericles used it as an opportunity to glorify Athens. As the oration was delivered during wartime, it is possible that Pericles's double intent was to praise those who had sacrificed their lives and to remind the living warriors about what it was they were fighting for—home and country.

Pericles died, most likely from the plague, in 429 BCE and never lived to see the demise of Athenian power. The age of Pericles was dominated by the vision of Pericles—to create a glorious city out of the one laid waste by the Persian army (Fig. 3.3).

PERICLES AND THE ATHENIAN ACROPOLIS

The great outcrop of rock that forms the **Acropolis** of Athens—the "high city"—was at the heart of Pericles's postwar building campaign. The sacred (and desecrated) site, which towers above the rest of the city, served as a center for Athenian life going back to Mycenaean times, when, because of its defensible elevation, it was the site of a citadel. Throughout the Archaic period, a series of temples were constructed there, the last of which was destroyed by the Persians in 480 BCE. General work on the Acropolis was begun in 449 BCE under the direction of Phidias, the greatest sculptor of his day and a personal friend of Pericles.

The Parthenon (Fig. 3.4) was the first building to be constructed under Pericles the jewel of the Acropolis restoration. The word *Parthenon* is generally thought to mean "temple of the virgin goddess," in this case Athena. It was built between 447 and 438 BCE; its sculptural decoration was complete by

▼ **3.3** **Athens in the Age of Pericles (ruled 443–429 BCE)**

Area of the city	7 square miles
Population of the city	100,000–125,000
Population of the region (Attica)	200,000–250,000
Political institution	General Assembly, Council of 500, Ten Generals
Economy	Maritime trade; crafts (textiles, pottery); farming (olives, grapes, wheat)
Cultural life	History (Thucydides); drama (Aeschylus, Sophocles, Euripides, Aristophanes); philosophy (Socrates); architecture (Ictinus, Callicrates, Mnesicles); sculpture (Phidias)
Principal buildings	Parthenon, Propylaea (the Erechtheum, the other major building on the Athenian Acropolis, was not begun in Pericles's lifetime)

432 BCE. Even larger than the Temple of Zeus at Olympia—home to the colossal ivory-and-gold sculpture of the god enthroned—the Parthenon became one of the most influential buildings in the history of architecture.

Parthenon Architecture

Constructed by the architects Ictinus and Callicrates, the Parthenon stands as the most accomplished representation of the Doric order, although parts of the building are decorated with a continuous running Ionic frieze. The Parthenon is a **peripteral** temple featuring a single row of **Doric** columns, gracefully proportioned, around a two-roomed **cella** that housed a treasury and a 40-foot-high statue of Athena made of ivory and gold. The proportions of the temple were based on precisely calculated harmonic numeric ratios. There are 17 columns on each of the long sides of the structure and eight columns on the ends. At first glance, the design may appear austere, with its rigid progression of vertical elements crowned by the strong horizontal of its **entablature**. Yet it incorporates refinements intended to prevent any sense of monotony or heaviness and gives the building an air of richness and grace. Few of the building's lines are strictly vertical or horizontal. Like earlier Doric columns, those of the Parthenon are thickest at the point one-third from the base and then taper toward the top, a device called **entasis**. In addition, all the columns tilt slightly toward each other (it has been calculated that they would all meet if extended upward

for 1.5 miles), and they are not evenly spaced. The columns at the corners are thicker and closer together than the others, and the entablature leans outward. The seemingly flat floor is not flat at all but convex, higher in the center than it is at the periphery of the temple. The reasons for these variations are not known for certain, but it has been suggested that they are meant to compensate for perceptual distortions that would make straight lines look curved from a distance. All of these refinements are extremely subtle and barely visible to the naked eye. The perfection of their execution is the highest possible tribute to the Classical search for order.

Parthenon Sculpture

The sculptor Phidias was commissioned by Pericles to oversee the entire sculptural program of the Parthenon. Although he concentrated his own efforts on creating the **chryselephantine** (ivory and gold) statue of Athena, his assistants followed his style closely for the other carved works on the temple. The Phidian style is characterized by delicacy, unparalleled realistic drapery that relates to the form and movement of the body, textural contrasts, a play of light and shade across surfaces owing to variations in the depth of carving, and fluidity of line.

As on other Doric temples, the sculpted ornamentation on the Parthenon was confined to the **friezes** and the **pediments**. The outward-facing frieze is of the Doric order; the inner frieze on the top of the cella wall is Ionic. The subjects of the Doric frieze are epic mythological battles between the Lap-

▼ **3.4 Ictinus and Callicrates, the Parthenon, Acropolis, Athens, Greece, 447–438 BCE.** The Parthenon remained almost undamaged until 1687, when Turkish forces occupying Athens had their gunpowder stored inside the building. A cannonball fired by besieging Venetian troops blew up the deposit, and with it the Parthenon. In spite of the damage, the Parthenon remains one of the most influential buildings in Western architectural history.

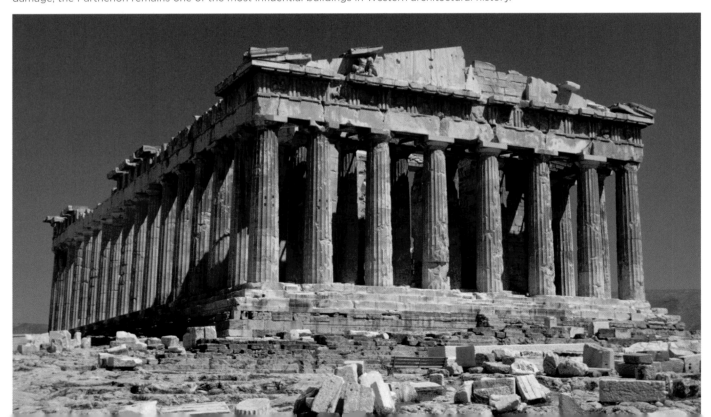

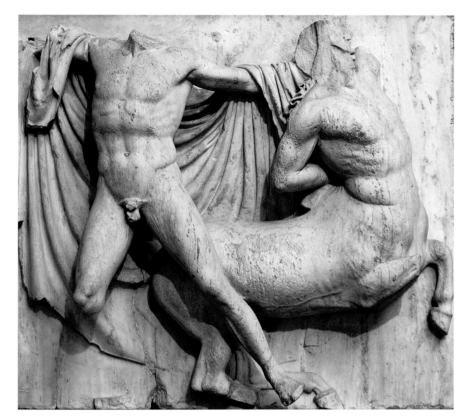

directions, arching outward toward the sides of the square frame. Behind them, the cloak of the Lapith warrior falls in U-shaped folds, carrying the eye from one figure to the other in a pendulum-like motion. Together, the figures form almost a perfect circle with their countermovement, as if they were choreographed to create the perfect balance between motion and restraint.

The sculptural decoration of the Parthenon was created using various carving techniques. The Lapith-and-centaur metope, for example, combines **middle relief** and high relief, with parts that were carved completely in the round. The sculptures for the pediments were also carved in the round; the subject of the east pediment is the birth of the goddess Athena, and the west pediment tells the story of the contest between Athena and Poseidon for the title of patron deity of the city of Athens. Three goddesses (**Fig. 3.6**), present at Athena's birth, form a

iths and the centaurs, the Greeks and the Amazons, and the gods and the giants—metaphors for the Greek battles with the Persians. The square shape of the **metope** sandwiched between **triglyphs** was a somewhat restricted space with which to work, unlike the continuous space that the Ionic frieze provided. One of the most fluid compositions among the metopes is one in which a Lapith man grasps the hair of a centaur as it pulls away from him (**Fig. 3.5**). The figures thrust in opposite

▼ **3.6** The Three Goddesses, ca. 438–432 BCE. From the east pediment of the Parthenon, Acropolis, Athens, Greece Pentelic marble, ca. 48⅜″ high × 91¾″ long (123 × 233 cm). British Museum, London, United Kingdom. The sculptor's technical virtuosity can be seen in the extreme realism of the drapery that flows over the bodies and visually unites them. The shape of the sculptural group—a triangle with a long, sloping side—corresponds to the space in the right corner of Parthenon's east pediment where it was tucked. The goddesses are present to observe the birth of Athena, which was represented in the apex of the pediment triangle.

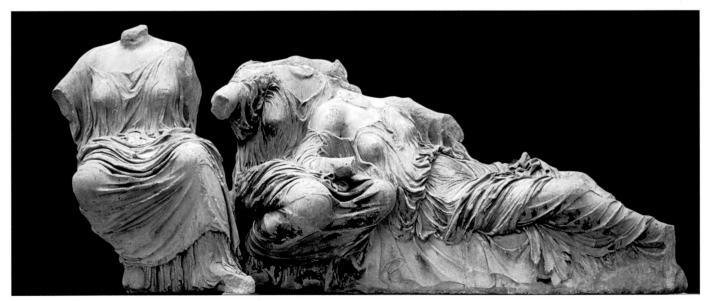

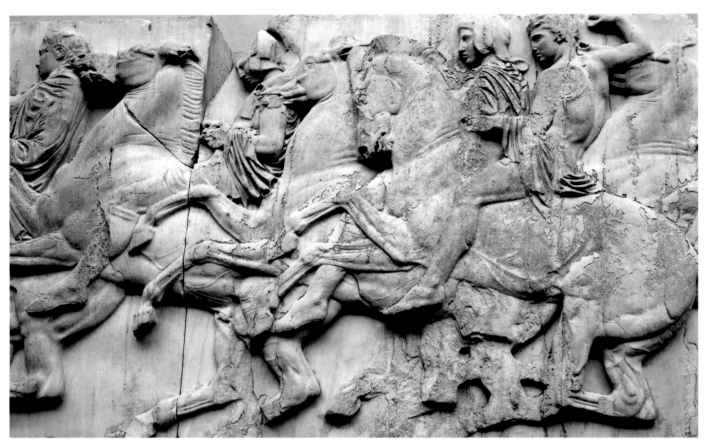

▲ **3.7 Equestrian Group, ca. 438–432 BCE Detail from the frieze on the north face of the Parthenon, Acropolis, Athens, Greece. Marble relief, 39 ³/₈" (100 cm) high. British Museum, London, United Kingdom.** The Ionic frieze of the Parthenon depicts the Panathenaic procession, part of a festival honoring Athena. The sense of movement—of stopping and of starting—convincingly suggests the erratic flow of a crowded procession.

figural group that was placed into the space of one of the outer angles of the east pediment; so accomplished is this portion of the pediment that it is thought to have been designed by Phidias himself and perhaps carved by him too. The anatomy and the drapery are both carved with meticulous realism, even in places where the details of the workmanship would have been barely visible to the spectator below. The bodies are weighty and well articulated, and the poses and gestures are relaxed and natural. The drapery falls over the bodies in realistic folds and there is a convincing contrast between the heavier cloth that falls over the legs or wraps around them and the more delicate fabric that clings to the upper torsos, following the contours of the flesh. The intricate play of these linear folds creates a tactile quality not seen in art before. The lines both gently envelop the individual figures and flow from one to another, creating a dynamically flowing composition. This stark realism is combined with a characteristically Classical preoccupation with proportion and balance; the result is a sculptural group that is a perfect blend of idealism and naturalism.

The most extraordinary sculpture on the Parthenon comes from its Ionic frieze—520 running feet of figures carved in relief. Scholars generally agree that the subject is a procession that took place every four years on the occasion of the Panathenaic Festival. The narrative begins on the western

end of the temple, where the parade assembles, and continues along the north and south sides, mimicking the length of the parade route up the Acropolis, through the Propylaea (a monumental gateway), past the Parthenon, and on to the Erechtheum, which housed an ancient wooden idol of the goddess Athena. The group—riders on horses, chariots, musicians, animals to be sacrificed—stops and starts along the way as any large contingent of celebrants might (**Fig. 3.7**). On the eastern frieze—in the front of the temple—gods and goddesses and honored guests wait for the procession to arrive. They gesture to one another as if in conversation; in one segment Aphrodite points her son Eros's gaze in the direction of the parade—a scene between a parent and child that anyone could imagine. The naturalism of the detail and the fluid movement create a lively, believable scene in which deities have come as spectators—almost like any others—to this human event that honors one of their own. It is interesting to note that, in light of optical effects created with the shapes and placement of the columns and the convex **stylobate**, the relief is not uniformly carved. The upper zone of the frieze is carved in higher relief than the lower. Imagine standing on the ground and looking up at the frieze high on the cella wall; if the depth of carving were uniform, it would be difficult to see the upper part of the figures. The deeper carving up the upper part makes the entire relief much more visible.

The Parthenon sculptures are among the most valuable treasures of Greek art—and the most controversial. At the beginning of the 19th century, Lord Elgin, the British ambassador to the Ottoman Empire (which was occupying Greece), removed most of the frieze, together with other parts of the sculptural ornamentation, from the building; these are now in the British Museum and are generally known as the Elgin Marbles. A raging debate about cultural property has swirled around the marbles and whether they should be returned to Greece. The argument has been that Greece was or is incapable of caring properly for the antiquities, which are as much the patrimony of all human civilization as of Greek citizens in particular. Some have contested this position—most notably perhaps, Christopher Hitchens in his article "The Parthenon Marbles: A Case for Reunification"—since the 2009 opening of the new Acropolis Museum in Athens, a structure that was hailed as "one of the most beautiful exhibition spaces in modern architecture." Hitchens believed that, while it is true that the marbles may have been at risk when Greece was unstable and suffered from "repeated wars, occupations, demolitions, and so on," these issues no longer pertain. He insisted that the Greeks have a "natural right" to the Parthenon sculptures. What do you think?

ERECHTHEUM The Acropolis was the site of a temple to Athena that was built during the Archaic period and razed by the Persians. The Periclean building program included a new temple, the Erechtheum (**Fig. 3.8**), that would be built on that site but with multifold purposes—it had to commemorate numerous religious events and honor several different deities.

The Erectheum, begun in 421 BCE but not completed until 406 BCE, posed numerous design challenges. The ground level was uneven. The structure had to include multiple shrines; one housed the ancient wooden statue of Athena that was at the center of the Panathenaic Festival depicted on the Parthenon frieze. There were also altars to Poseidon; Erechtheus, an early Athenian king; the legendary Athenian hero Butes; and Hephaestus, the god of the forge. The design also had to incorporate the exact spot where, Athenians believed, Poseidon struck a rock and gave birth to a saltwater spring, leaving the marks of his trident. This story is told on the west pediment of the Parthenon. The building also included the grave of another early and probably legendary Athenian king, Cecrops. These criteria, in addition to the irregular topography, called for creative solutions to architectural problems. The building is designed on multiple levels and has four different entrances, one on each side. The asymmetry is striking when compared to the compulsive order of the Parthenon.

The sculptural decoration of the temple is elaborate and delicate, almost fragile. Its most famous feature is the Porch of the Maidens, on the south side of the temple, where **caryatids**, statues of young women, hold up the roof and, by association, the polis. The graceful figures exude an air of dignity and calm, their bodies posed in a **contrapposto** stance with one leg slightly bent at the knee. They are united as a group by their common function—they serve the purpose of columns, and the striations of their drapery even suggest fluting—but

▼ **3.8 The Erechtheum with the Temple of Caryatids, Acropolis, Athens, Greece, 430–406 BCE.**
The Erechtheum, like so many other Acropolis structures, was erected to honor Athena. It housed the wooden statue of the goddess that was part of the ritual of the Panathenaic Festival. The multilevel structure reflects the uneven terrain on which it was built, and its various rooms incorporated tombs, shrines, and other sacred sites.

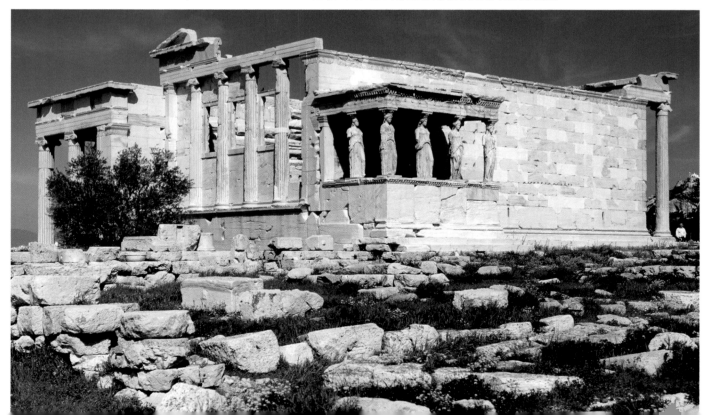

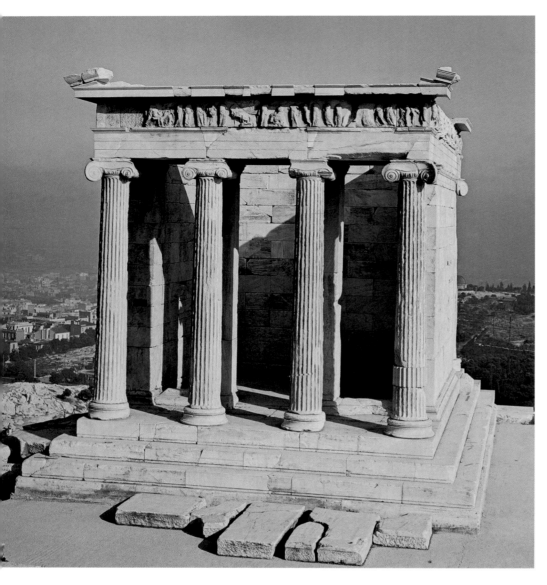

architects of the Parthenon, was also responsible for the sculpture of the Temple of Athena Nike and the delicate, sensuous carving and play of line across the surfaces. These features are evident, for example, in the Three Goddesses, and can be seen in a relief showing Nike adjusting her sandal (**Fig. 3.10**) as well. The exceptional naturalism can be attributed not only to the carving but also to the subject; the goddess stops for a moment to fasten a sandal that has come loose, a tiny nuisance that any mere mortal has certainly experienced.

THE VISUAL ARTS IN CLASSICAL GREECE

The pursuit of naturalism was at the core of the visual arts during the Classical period. Sculptors in the mid-fifth century BCE continued to explore the possibilities of portraying the body in motion that the sculptor of the Kritios Boy (see **Fig. 2.18**) introduced. At the same time, they sought ways to perfect the proportions of the human figure, finding a visual counterpart to mathematical harmonies and the ideals of moderation, balance, and order. Painters added an array of colors to their palettes to more closely approximate nature and experimented with foreshortening to more realistically portray figures in three-dimensional space. These developments originated with a close observation of the world, the pursuit of underlying, universal harmonies, and the desire to be the most perfect version of the self that was possible.

the artist has distinguished them from one another through slight variations in body shape and details in their garments. The caryatids represent the most complete attempt until then to conceal the structural functions of a column behind its form. (One of the caryatids is now in the British Museum; the others have been moved to the Acropolis Museum and have been replaced on the actual building by copies.)

Temple of Athena Nike

Perhaps the most beloved of the temples of the Acropolis is the tiny Temple of Athena Nike, only 27 by 19 feet and an exquisite example of the Ionic order (**Fig. 3.9**). *Nike* means victory (think about the brand of athletic shoes with the same name that channels that theme); one part of the Ionic frieze depicts the Battle of Marathon, one of the most important for the Greeks in their war against the Persians. Four monolithic Ionic columns grace the front and back entrances to the temple, which was erected at the edge of a parapet overlooking the Parthenon and the city beneath the Acropolis.

Some of the most stunning reliefs of the Classical period appear on the Temple of Athena Nike. Callicrates, one of the

Classical Sculpture

Among the finest examples of sculpture from the mid-fifth century BCE are two bronze statues of warriors that were found in a sunken cargo ship off the coast of southeast Italy in the 1980s. Known as the *Riace Bronzes*, they were probably on their way from the Greek mainland to Rome, where Greek statuary was much admired and copied. In fact, many exam-

ples of Greek bronze sculpture exist today only in Roman marble copies. Bronze was melted down for many purposes (weaponry, coins, and building material, for example); it is through exceptional good luck that these works were found as they are, almost completely intact. The sculptor of the Riace warrior (**Fig. 3.11**) is unknown, but his work represents a continuation of the innovations seen in the Kritios Boy.

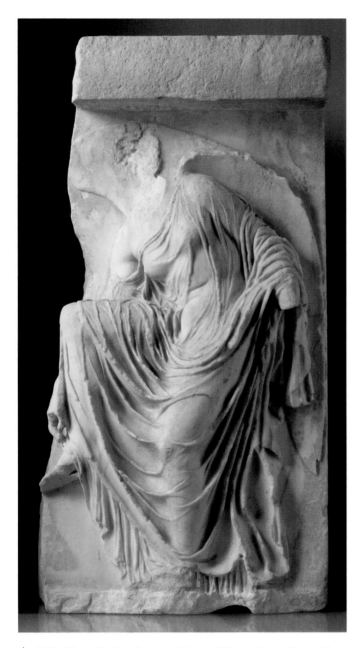

⌃ 3.10 Nike adjusting her sandal, ca. 420 BCE. From the south side of the parapet of the Temple of Athena Nike, Acropolis, Athens, Greece, ca. 410 BCE. Marble, relief, 37³/₄″ high × 22″ wide × 7¹/₈″ (96 × 56 × 18 cm). Acropolis Museum, Athens, Greece. The parapet on which the Temple of Athena Nike stands was decorated with reliefs of Nike—winged Victory. This image of Nike captures the goddess in an ordinary, quite human, action, adjusting a sandal that has perhaps come unfastened. The drapery is nearly transparent, suggesting the filmiest of fabrics falling sensuously over the body.

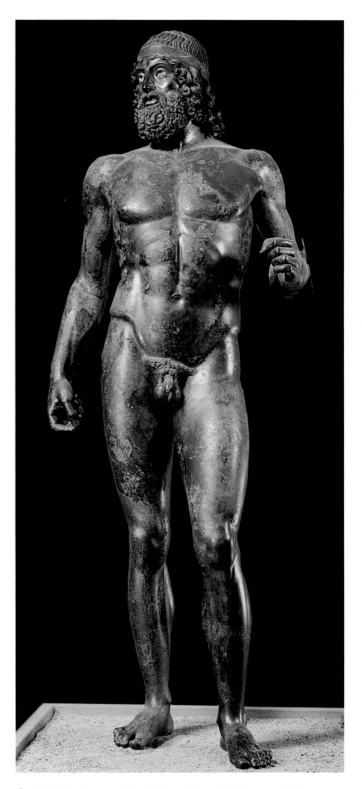

⌃ 3.11 Warrior, ca. 460–450 BCE. Found in the sea off Riace, Italy. Bronze, 78″ (198.1 cm) high. Museo Archeologico Nazionale, Reggio Calabria, Italy. The statue is one of two discovered by a diver a few hundred yards off the southeastern coast of Italy. They were likely being shipped to a patron in Rome and may have been tossed overboard in rough seas. The warrior is shown without the accessories that would have completed the work—a shield, helmet, and spear—but is otherwise complete. The bronze sculpture had inlaid eyes, silver teeth and eyelashes, and copper lips.

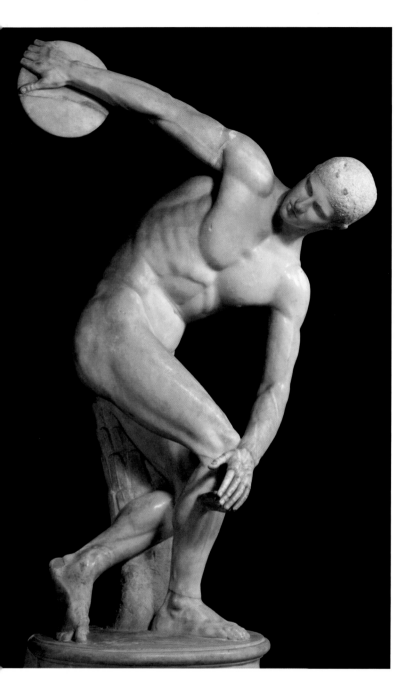

◄ 3.12 **Myron, Discobolos (Discus Thrower), Roman copy of a bronze statue of ca. 450 BCE. Marble, 61″ (155 cm) high. Museo Nazionale Romano—Palazzo Massimo alle Terme, Rome, Italy.** The short, untidy hair and pronounced musculature are typical of the Early Classical period, as is the juxtaposition of physical tension and a calm facial expression. The athlete is caught in action, his torso resembling an arrow about to be shot through the taut bow of his arms.

tensed as he reaches for the strength to release it; his torso intersects the arc of his extended arms, resembling an arrow pulled taught on a bow. It is an image of pent-up energy at the moment before release. As in most Classical Greek art, there is a balance between motion and stability, emotion and restraint.

POLYCLITUS AND THE CANON OF PROPORTIONS

While Phidias was supervising a team of artists working on his sculptural designs for the Parthenon, his contemporary Polyclitus of Argos was devising a formula that could be used to create the perfect, ideal figure—his **canon of proportions**. His favorite medium was bronze and his preferred subject, athletes. We also know his work primarily from Roman copies of the bronze originals. If Phidias delighted in the appearance of things and the changeability and fluidity of surfaces influenced by the play of light and line, Polyclitus was interested primarily in the core. If Phidias's touch seems more instinctive, Polyclitus's work exudes reason and intellect.

Polyclitus's *Canon*, built on harmonic proportions and codified into a precise mathematical formula, did not come out of nowhere; Pythagoras, as we read in Chapter 2, concluded that harmonic relationships in music could be expressed mathematically. The idea behind the *Canon* was that ideal beauty (perfection) in a sculpture of the human form could be achieved through the exacting application of principles regarding ratios and proportions to all parts of the body. Polyclitus's treatise is lost, but it had been referred to by several important writers, including the historian Pliny the Elder (see Chapter 4) and the physician-philosopher Galen of Pergamum (129—ca. 200 CE).

The contrapposto here is even more exaggerated, yielding an even livelier figure, one that seems to move confidently and to engage with the space around it.

The bronze original of the Discobolos (Discus Thrower) **(Fig. 3.12)** is also lost—the work only survives in a marble replica—although we know the sculptor's name: Myron. He was considered one of the foremost masters of sculpture in the early years of the Classical period. Myron's Discobolos is among the most famous examples of Greek art. The life-size statue depicts an event from the Olympic Games—the discus throw. The artist catches the athlete, a young man in his prime, at the moment when his arm stops its backward swing and prepares to sling forward to release the discus. His head faces inward in unbroken concentration and his muscles are

> #### READING 3.4 GALEN
>
> #### *De placitis Hippocratis et Platonis*, 5
>
> [Beauty in art results from] the commensurability of the parts, such as that of finger to finger, and of all the fingers to the palm and the wrist, and of these to the forearm, and of the forearm to the upper arm, and, in fact, of everything to everything else, just as it is written in the *Canon* of Polykleitos.... Polykleitos supported his treatise [by creating] a statue according to the tenets of his treatise, and called the statue, like the work, the Canon.

Polyclitus's most famous work is the Doryphorus (Spear Bearer) **(Fig. 3.13)**. Imposing his canon on the fig-

ure, Polyclitus loses some of Phidias's spontaneity, but the result is an almost godlike image of grandeur and strength. As in the Kritios Boy and Riace Warrior, contrapposto, or weight shift, is employed, but in the Doryphorus, Polyclitus goes further to perfect the balance between motion and rest. The figure supports his weight on his right leg, which is firmly planted on the ground. It forms a strong vertical that is echoed in the relaxed arm on the same side of the body. These are counterbalanced by a relaxed left leg bent at the knee and a tensed arm bent at the elbow. Tension and relaxation of the limbs are balanced across the body *diagonally*. The relaxed arm *opposes* the relaxed leg, and the tensed arm *opposes* the tensed, weight-bearing leg. The result is a harmonious balance of opposing parts that creates ease and naturalism belying the rigor of the process of constructing the form.

Vase Painting

The goal of naturalism that dominated the visual arts in the Classical period is also present in vase painting. Taking his cue from contemporary panel painting, the Niobid Painter—so named after the **krater** depicting Apollo and Artemis's slaughter of the children of the fertile Niobe after their mother boasted about herself—uses the entire field of the vase to array his narrative (**Fig. 3.14**). Thinly drawn ground lines define the fluctuations in the landscape; figures are placed on or under what appear to be outcroppings of rock. The figures twist and turn in space and all are engaged in

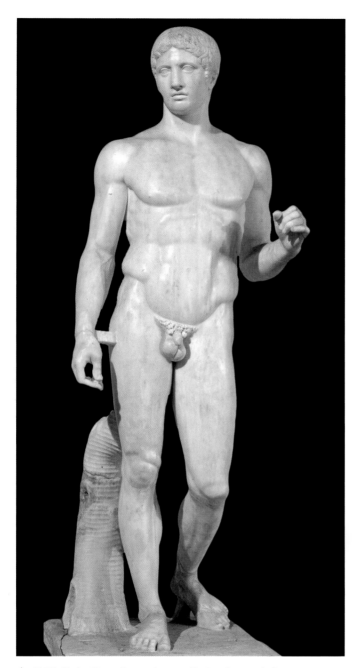

▲ **3.13** Polyclitus, **Doryphorus (Spear Bearer)**, Roman copy (from the palaestra of Pompeii, Italy) of a bronze statue of ca. 450–440 BCE. Marble, 83″ (210.8 cm) high. Museo Archeologico Nazionale, Naples, Italy. Polyclitus devised a canon of proportions in pursuit of the perfect male form, tied to mathematical harmonies. The sculpture epitomizes the control—balance between motion (or emotion) and restraint—that reflected the model human behavior to which Greeks aspired.

➤ **3.14** Niobid Painter, **Artemis and Apollo Slaying the Children of Niobe**, ca. 450 BCE. Orvieto, Italy. Athenian clay, red-figure (white highlights) calyx krater, 21¼″ high × 22″ diameter (54 × 56 cm). Musée du Louvre, Paris, France. The figures in the narrative are arranged on different levels, suggesting a naturalistic landscape. The effort to create a sense of three-dimensional space likely reflects the style of contemporary panel paintings, all of which have not survived.

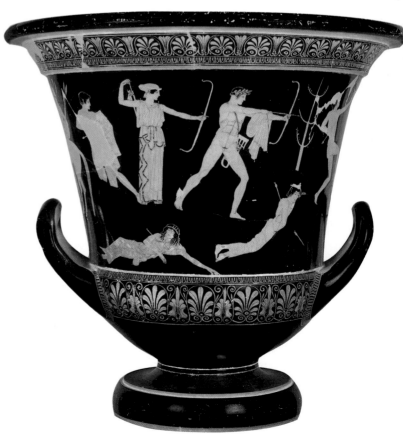

action. This was a noble attempt at naturalism based on optical perception, although the uniform scale of the figures precludes a more developed sense of foreground and background. The ability to arrange figures in space convincingly came later, with the development of perspective.

During the Classical period, white-ground painting was introduced, providing a neutral backdrop for exquisitely drawn images accented with touches of vibrant color. This technique also likely mimicked those of wall and panel painting that have not survived. Because white-ground painting was less durable, it was reserved for pottery that was not utilitarian. Among the most touching works from the period are oil flasks—*lekythoi*—used for funerary offerings and painted with mourning or graveside scenes. A **lekythos (Fig. 3.15)** by the so-called Reed Painter illustrates a woman laying her hand upon the tomb of her husband, the fallen warrior who sits before it. The figures are depicted with a calm dignity but also with considerable feeling. The warrior appears hopeless and exhausted, a sentiment that would have rung true in the late fifth century BCE as the Greeks became embroiled in the Peloponnesian War and as the toll of human life grew daily. This intimate reaction to death and, in general, a growing concern for the human rather than for aspirations to an ideal characterizes much art of the fifth century BCE.

PHILOSOPHY IN CLASSICAL GREECE

It was in Athens that the Western philosophical tradition truly was forged—from Socrates, who openly questioned traditional values and engaged fellow citizens of the

◀ **3.15 Reed Painter, Warrior Seated at His Tomb, 410–400 BCE. Clay, white-ground lekythos, 18³⁄₄″ (47.8 cm) high, 5¹⁄₈″ (13 cm) shoulder diameter. National Archaeological Museum, Athens, Greece.** In white-ground vase painting, an array of colors are added after firing. Lekythoi were used for libations related to funerary rituals. Here, a warrior who was likely killed in the Peloponnesian War is mourned by his wife.

polis in philosophical debate, and Plato his student, who believed that the ideal, the Good, existed in all forms, including the state, and that reality was a reflection of that ideal; to Plato's student Aristotle, who believed that the true essence of things—reality—could be comprehended by observing the material world and deriving truths from observation.

The intellectual and cultural spirit of the new century was foreshadowed in its first year in an event at Athens. In 399 BCE the philosopher Socrates was charged with impiety and leading youth to question authority, found guilty, and executed. Yet the ideas that Socrates represented—concern with the fate of the individual and questioning traditional values—could not be killed so easily. They had already begun to spread and came to dominate the culture of the fourth century BCE.

Protagoras

As to the gods, I have no means of knowing that they exist or that they do not exist.

—PROTAGORAS

A group of philosophers who came to be called **Sophists** (wise men) visited Athens from time to time. The Sophists shared some of the interests in the workings of nature that occupied the cosmologists, but their principal focus was on the human world. They were concerned with ethics, psychology, political philosophy, and theories of knowledge, such as how people know what they know and whether they can know reality. But the Sophists were also professional teachers who roamed Greece, selling their services as masters of reasoning and rhetoric to wealthy families who wanted to advance the education of their sons.

The most well-known Sophist of the fifth century BCE was Protagoras of Abdera (ca. 485–410 BCE). Although his books no longer exist, some quotations have come down to us through other authors. Protagoras famously said, "Man is the measure of all things." To artists and natural scientists, this remark has been taken to mean that people see themselves as the standard of beauty, or they judge other things as large or small in terms of their own size. The philosopher Plato interpreted it to mean that there is no such thing as absolute knowledge, that one person's views of the world are as valid as those of the next person. Since Plato believed that there was an objective reality (a reality that existed regardless of whether people perceived it), he objected to this idea.

Protagoras boasted that he was so skilled as a debater that he "could make the weaker side defeat the stronger." This statement was alarming because it implied that reliance on rational debate to sift out truth and justice could be undermined by a clever speaker, one who was skilled in sophistic arguments. We might ask whether it is so ourselves. Does the truth always win out in an argument, or does the clever speaker often have the advantage? After all, lawyers are hired to advocate for both sides of arguments and for criminals whom they believe to be guilty. Lawyers are expected to be persuasive even when the facts are against them. Sophistry is alive and well.

Socrates

Socrates is one of the most important figures in Greek history. He is also one of the most difficult to understand clearly. Much of the philosophy of the Greeks and of later ages and cultures has been inspired by his life and teachings. Yet Socrates wrote nothing; most of what we know of him comes from the works of his disciple Plato. Socrates was born around 469 BCE, the son of a sculptor and a midwife; in later life he claimed to have followed his mother's profession in being a "midwife to ideas." He seems first to have been interested in natural science, but soon turned to the problems of human behavior and morality. Unlike the Sophists, he neither took money for teaching nor founded a school. Instead he went around Athens, to both public places like the markets and the gymnasia and private gatherings, talking and arguing, testing traditional ideas by subjecting them to a barrage of questions—as he put it, "following the argument wherever it led."

Socrates gradually gained a circle of enthusiastic followers, drawn mainly from the young. At the same time he acquired many enemies, disturbed by both his challenge to established morality and the uncompromising persistence with which he interrogated those who upheld it. Socrates was no respecter of the pride or dignity of others, and his search for the truth inevitably exposed the ignorance of his opponents. Among Socrates's supporters were some who had taken part in an unpopular and tyrannical political coup at Athens immediately following the Peloponnesian War. The rule of the so-called Thirty Tyrants lasted only from 404 to 403 BCE; it ended with the death or expulsion of its leading figures. The return of democracy gave

READING 3.5 PLATO

From the *Apology*

Consider now why I tell you this; I am going to explain to you the source of the slander against me. When I had heard the answer of the oracle, I said to myself: "What in the world does the god mean, and what is this riddle? For I realize that I am wise in nothing, great or small; what then does he mean by saying that I am the wisest? Surely, he does not lie; that is not in keeping with his nature." For a long time I was perplexed; then I resorted to this method of inquiry. I went to one of those men who were reputed to be wise, with the idea of disproving the oracle and of showing it: "Here is one wiser than I; but you said that I was the wisest." Well, after observing and talking with him (I don't need to mention his name; but he was a politician), I had this experience: the man seemed in the opinions of many other men, and especially of himself, to be wise; but he really wasn't. And then I tried to show him that he thought he was wise, but really wasn't; so I found myself disliked by him and by many of those present. So I left him, and said to myself: "Well, I am wiser than this man. Probably neither of us knows anything noble; but he thinks he knows, whereas he doesn't, while I neither know nor think I know. So I seem to have this slight advantage over him, that I don't think I know what I don't know." Next I went to another man who was reputed to be even wiser, and in my opinion the result was the same; and I got myself disliked by him and by many others.

After that I went to other men in turn, aware of the dislike that I incurred, and regretting and fearing it; yet I felt that God's word must come first, so that I must go to all who had the reputation of knowing anything, as I inquired into the meaning of the oracle. And by the Dog! gentlemen, for I must tell you the truth, this is what happened to me in my quest: those who were in greatest repute were just about the most lacking, while others in less repute were better off in respect to wisdom. I really must expound to you my wanderings, my Herculean labors to test the oracle. After the politicians, I went to the poets, tragic, dithyrambic, and the rest, with the expectation that there I should be caught less wise than they. So picking up those of their poems which seemed to me to be particularly elaborated, I asked them what they meant, so that at the same time I might learn something from them. Now I am ashamed to tell you the truth, but it must be spoken; almost every one present could have talked better about the poems than their authors. So presently I came to know that the poets, too, like the seers and the soothsayers, do what they do not through wisdom but through a sort of genius and inspiration; for the poets, like them, say many fine things without understanding what they are saying. And I noticed also that they supposed because of their poetry that they were wisest of men in other matters in which they were not wise. So I left them, too, believing that I had the same advantage over them that I had over the politicians.

Finally I went to the craftsmen; for I knew that I knew hardly anything, but that I should find them knowing many fine things. And I was not deceived in this; they knew things that I did not know, and in this way they were wiser than I. But even good craftsmen seemed to me to have the same failing as the poets; because of his skill in his craft each one supposed that he excelled also in other matters of the greatest importance; and this lapse obscured their wisdom. So I asked myself whether I would prefer to be as I was, without their wisdom and without their ignorance, or to have both their wisdom and their ignorance; and I answered myself and the oracle that I was better off just as I was.

From this inquiry many enmities have arisen against me, both violent and grievous, as well as many slanders and my reputation of being "wise." For those who are present on each occasion suppose that I have the wisdom that I find wanting in others; but the truth is that only God is wise, and by that oracle he means to show that human wisdom is worth little or nothing.

Excerpt from *The Classics in Translation*, Volume I, edited by Paul L. MacKendrick and Herbert M. Howe, copyright 1952. Reprinted by permission of The University of Wisconsin Press.

Socrates's enemies a chance to take advantage of the hostility felt toward those who had "collaborated" with the tyrants; thus in 399 BCE he was put on trial. It seems probable that to some degree the proceedings were intended for show and that those who voted for the death sentence never seriously thought it would be carried out. Socrates was urged by his friends to escape from prison, and the authorities offered him every opportunity. However, the strength of his own morality and his reverence for the laws of his city prohibited him from doing so. After a final discussion with his friends, he was put to death by the administration of a draft of hemlock.

Socrates had apparently earned many enemies because he challenged the wisdom of those he happened across by asking them about the nature of virtue and of the specific virtues of justice, piety, and courage. Those he met generally believed that they had some wisdom and that their abilities in politics, poetry, or crafts permitted them to expound their opinions about unrelated matters—as is the case today with celebrities endorsing products they know nothing about. At his trial, Socrates spoke of the origins of some of the slanders spoken about him. He told the story of his friend Chaerephon, who journeyed to the oracle at Delphi and asked whether Socrates was, in fact, the wisest man in the world. The oracle replied that "no one was wiser," which, of course, could be read as an acknowledgement of Socrates's special genius or a slur on the entire human species. Since Socrates believed he was not wise, he took the oracle's reply as a riddle to solve. Following are Socrates's words, as recorded by Plato in his *Apology.*

Many of Socrates's disciples tried to preserve his memory by writing accounts of his life and teachings. The works of only two have survived. One of these is the Greek historian Xenophon, whose *Apology, Symposium,* and *Memorabilia* are interesting, if superficial. The other is Plato, who, together with his pupil Aristotle, stands at the forefront of the whole intellectual tradition of Western civilization.

➤ **3.16 Plato's Allegory of the Cave.**
Plato used his Allegory of the Cave to symbolize human misperceptions of reality that result from superstition and falsehood, and to suggest that the philosopher, who thrives in the light of reason and intellect, is uniquely positioned to educate others and liberate them from beliefs that prevent them from acquiring truth.

Plato

The dialogues of Plato claim to record the teachings of Socrates. In almost all of them Socrates appears, arguing with his opponents and presenting his own ideas. How much of Plato's picture of Socrates is historical truth and how much is Plato's invention, however, is debatable. The Socratic problem has been almost as much discussed as the identity of Homer. In general, modern opinion supports the view that in the early dialogues Plato tried to preserve something of his master's views and methods, whereas in the later ones he used Socrates as the spokesman for his own ideas. There can certainly be no doubt that Plato was deeply impressed

by Socrates' life and death. Born in 428 BCE, Plato was drawn by other members of his aristocratic family into the Socratic circle. He was present at the trial of Socrates, whose speech in his own defense Plato records in the *Apology*, one of three works that describe Socrates's last days. In the *Crito*, set in prison, Socrates explains why he refuses to escape. The *Phaedo* gives an account of his last day spent discussing with his friends the immortality of the soul and his death.

After Socrates's death, Plato left Athens, horrified at the society that had sanctioned the execution, and spent several years traveling. He returned in 387 BCE and founded the Academy, the first permanent institution in Western civilization devoted to education and research, and thus the forerunner of all our universities. Its curriculum concentrated on mathematics, law, and political theory. Its purpose was to produce experts for the service of the state. Some 20 years later, in 368 BCE, Plato was invited to Sicily to put his political theories into practice by turning Syracuse into a model kingdom and its young ruler, Dionysius II, into a philosopher-king. Predictably, the attempt was a dismal failure, and by 366 BCE, Plato was back in Athens. Apart from a second equally unsuccessful visit to Syracuse in 362 BCE, he seems to have spent the rest of his life in Athens, teaching and writing. He died there in 347 BCE.

Much of Plato's work deals with political theory and the construction of an ideal society. The belief in an ideal is, in fact, characteristic of most of his thinking. It is most clearly expressed in his *theory of Forms*, according to which in a higher dimension of existence there are perfect Forms, of which all the phenomena we perceive in the world around us represent pale reflections.

To illustrate the limits of, or blinders on, our perceptions, Plato presents the Allegory of the Cave in the *Republic* (**Fig. 3.16**). He asks us to picture prisoners chained in an underground cave who can see nothing their entire lives but shadows cast on a wall by objects backlit by a fire. The only reality the prisoners know is the shadows on the wall, and they think themselves clever if they can guess which is going to appear next. They have little or no imagination and are ruled by the opinion of others. Imagine what would happen if a prisoner were released from the shackles and could wend his way up and out toward the light. His eyes at first might be blinded. He would have to adjust, and he might doubt what he would see. He might be frightened by the new as he is acquiring knowledge through reason, especially if new knowledge is shattering superstition and false ideas, and he might wish he could return to the cave. But eventually he might come to truly see and appreciate the fullness and warmth of the real world that is to be perceived through reason and intelligence. It is the task of the philosopher, who is free from the chains of misperception, to liberate others and educate them in such a way as to set them free from the imprisonment of the senses. Below is part of the passage of the Allegory of the Cave, presented as a dialogue.

Socrates's death made Plato skeptical about the capacity of democracies to deliver justice. In the *Republic*, he proposes that a state has nourishing needs, protection needs, and ruling

READING 3.6 **PLATO**

Republic, book 7, "The Allegory of the Cave"

"Next, then," I said," take the following parable of education and ignorance as a picture of the condition of our nature. Imagine mankind dwelling in an underground cave with a long entrance open to the light across the whole width of the cave; in this they have been from childhood, with necks and legs fettered, so they have to stay where they are. They can not move their heads round because of the fetters, and they can only look forward, but light comes to them from fire burning behind them higher up at a distance. Between the fire and the prisoners is a road above their level, and along it imagine a low wall has been built, as puppet showmen have screens in front of their people over which they work their puppets."

"I see," he said.

"See, then, bearers carrying along this wall all sorts of articles which they hold projecting above the wall, statues of men and other living things, made of stone or wood and all kinds of stuff, some of the bearers speaking and some silent, as you might expect."

"What a remarkable image," he said, "and what remarkable prisoners!"

"Just like ourselves," I said. "For, first of all, tell me this: What do you think such people would have seen of themselves and each other except their shadows, which the fire cast on the opposite wall of the cave?"

"I don't see how they could see anything else," said he, "if they were compelled to keep their heads unmoving all their lives!"

"Very well, what of the things being carried along? Would not this be the same?"

"Of course it would."

"Suppose the prisoners were able to talk together, don't you think that when they named the shadows which they saw passing they would believe they were naming things?"

"Necessarily."

"Then if their prison had an echo from the opposite wall, whenever one of the passing bearers uttered a sound, would they not suppose that the passing shadow must be making the sound? Don't you think so?"

"Indeed I do," he said.

"If so," said I, "such persons would certainly believe that there were no realities except those shadows of handmade things."

"So it must be," said he.

needs, which are to be provided by workers, warriors and philosopher-kings. Either philosophers must become kings or kings philosophers, he writes, because a just state requires rulers whose acquaintance with the Forms has bestowed on them the knowledge needed to rule wisely and the virtue necessary to rule in the best interests of the state. How can an individual gain acquaintance with the Forms? Through the careful selection of talented men or women and rigorous education. The few who can complete the process will be qualified to play the role in the state that reason plays in a well-ordered soul. In a well-ordered soul, Plato argues, reason supported by valor rules passions and appetites. Likewise, in a well-ordered state, philosophers supported by loyal auxiliaries should rule over those who seek material prosperity. Philosophers, unlike politicians, will not rule because they desire to gain power or to promote their own interests. True philosophers would prefer to spend their time contemplating the Forms; they rule because virtue demands their service.

Yet the details of Plato's vision of an ideal society are too authoritarian for most tastes, involving among other restrictions the careful breeding of children, the censorship of music and poetry, and the abolition of private property. In fairness to Plato, however, it must be remembered that his works are intended not as a set of instructions to be followed literally but as a challenge to think seriously about how our lives should be organized. Furthermore, the disadvantages of democratic government had become all too clear during the last years of the fifth century BCE. If Plato's attempt to redress the balance seems to veer excessively in the other direction, it may in part have been inspired by the continuing chaos of fourth-century Greek politics.

Aristotle

Plato's most gifted pupil, Aristotle (384–322 BCE), continued to develop his master's doctrines, at first wholeheartedly and later critically, for at least 20 years. In 335 BCE, Aristotle founded a school in competition with Plato's Academy, the Lyceum, severing fundamental ties with Plato from then on. Aristotle in effect introduced a rival philosophy—one that has attracted thinking minds ever since. In the 19th century the English poet Samuel Taylor Coleridge was to comment, with much truth, that one was born either a Platonist or an Aristotelian.

The Lyceum seems to have been organized with typical Aristotelian efficiency. In the morning Aristotle lectured to the full-time students, many of whom came from other parts of Greece to attend his courses and work on the projects he was directing. In the afternoon the students pursued their research in the library, museum, and map collection attached to the Lyceum, while Aristotle gave more general lectures to the public. His custom of strolling along the Lyceum's circular walkways, immersed in profound contemplation or discourse, gained his school the name *Peripatetic* (the "walking" school).

As a philosopher, Aristotle was the greatest systematizer. He wrote on every topic of serious study of the time. Many of his classifications have remained valid to this day, although some of the disciplines, such as psychology and physics, have severed their ties with philosophy and become important sciences in their own right. The most complex of Aristotle's works is probably the *Metaphysics*, in which he deals with his chief dispute with Plato, which concerned the theory of Forms. Plato had postulated a higher dimension of existence for the ideal Forms and thereby created a split between the

READING 3.7 ARISTOTLE

Nicomachean Ethics, book 7, "The Nature of Happiness"

The nature of happiness is connected with the nature of man. No doubt, however, to say that happiness is the greatest good seems merely obvious, and what is wanted is a still clearer statement of what it is. It may be possible to achieve this by considering the function of man. As with a flute player or sculptor or any artisan, or generally those who have a function and an activity, the good and good performance seem to lie in the performance of function, so it would appear to be with a man, if there is any function of man. Are there actions and a function peculiar to a carpenter and a shoemaker, but not to man? Is he functionless? Or as there appears to be a function of the eye and the foot and generally of every part of him, could one also post some function of man aside from all these? What would this be? Life he shares even with plants, so that we must leave out the life of nourishment and growth. The next in order would be a kind of sentient life, but this seems to be shared by horse and cow and all the animals. There remains an active life of a being with reason. This can be understood in two senses: as pertaining to obedience to

reason and as pertaining to the possession of reason and the use of intelligence; and since the latter as well is spoken of in two senses, we must take the one which has to do with action, for this seems to be regarded as higher.

If the function of man is an activity of the soul according to reason or not without reason, and we say that the function of a thing and of a good thing are generically the same, as of a lyre-player and a good lyre-player, and the same way with all other cases, the superiority of virtue being attributed to the function— that of a lyre-player being to play, that of a good one being to play well—if this is so, the good for man becomes an activity of the soul in accordance with virtue, and if there are more virtues one, in accordance with the best and most perfect. And further, in a complete life; for one swallow does not make it spring, nor one day, and so a single day or a short time does not make a man blessed and happy.

Nicomachean Ethics, Book VII, "The Nature of Happiness," Edwin L. Minar, Jr., trans., from *Classics in Translation*, Vol. I, Greek Literature, Paul MacKendrick and Herbert M. Howe, ed., Madison: University of Wisconsin Press, 1952.

apparent reality that we perceive and the genuine reality that we can only know by philosophical contemplation. Moreover, knowledge of these Forms depended on a theory of remembering them from previous existences.

Aristotle, on the other hand, claimed that the Forms were actually present in the objects we see around us, thereby eliminating the split between the two realities. Elsewhere in the *Metaphysics*, Aristotle discusses the nature of God, whom he describes as "thought thinking of itself" and "the Unmoved Mover." The nature of the physical world ruled over by this supreme being is further explored in the *Physics*, which is concerned with the elements that compose the universe and the laws by which they operate.

In the *Nicomachean Ethics*, Aristotle argues that the ultimate goal of human life is happiness, perhaps better translated as "human flourishing." His concept of happiness is not simply a matter of pleasure or freedom from want. Since people are rational beings, human flourishing requires that actions be guided by reason, but Aristotle understood that humans have needs for friends, family, and material comforts. Aristotle believed that humans are political as well as rational beings and that a fully human life is possible only within a political community. He calls political science the master science, since without the benefits of political order the human condition is worse than the condition of beasts: he remarks: "For man when perfected is the best of animals, but, when separated from law and justice ... is the most unholy and savage of animals and the most full of lust and gluttony."

In the following passage from the *Nicomachean Ethics*, Aristotle describes the nature of happiness as he sees it. In the passage you may notice the familiar saying, "One swallow does not make it spring."

Other important works by Aristotle include the *Rhetoric*, which prescribes the ideal model of oratory, and the *Poetics*, which does the same for poetry and includes the famous definition of tragedy mentioned earlier. Briefly, Aristotle's formula for tragedy is as follows: The tragic hero, who must be noble, through some undetected tragic flaw in character meets with a bad end involving the reversal of fortune and sometimes death. The audience, through various emotional and intellectual relations with this tragic figure, undergoes a cleansing or purgation of the soul, called **catharsis**. Critics of this analysis sometimes complain that Aristotle was trying to read his own subjective formulas into the Greek tragedies of the time. This is not entirely justified, because he was probably writing for future tragedians, prescribing what ought to be rather than what was.

Aristotle's influence on later ages was vast, although not continuous. Philip of Macedon employed him to tutor young Alexander, but the effect on the young conqueror was probably minimal. Thereafter, Aristotle's works were lost and not recovered until the first century BCE, when they were used by the Roman statesman and thinker Cicero (106–43 BCE). During the Middle Ages they were translated into Latin and Arabic and became a philosophical basis for Christian theology. Thomas Aquinas's synthesis of Aristotelian philosophy and Christian doctrine still remains the official philosophical position of the Roman Catholic Church. In philosophy, theology, and scientific and intellectual thought as a whole, many of the distinctions first applied by Aristotle were rediscovered in the early Renaissance and are still valid today. No survey such as this can begin to do justice to one described by Dante as "the master of those who know." In the more than 2000 years since Aristotle's death, only Leonardo da Vinci has come near to equaling his creative range.

MUSIC IN CLASSICAL GREECE

Pythagoras connected harmonic chords in music with similar harmonies found in nature and construed a mathematical formula to explain the relationship. The word *harmony* is Greek in origin, coming from a word that literally means a "joining together." In a musical context, the Greeks used harmony to describe various kinds of scales, but there is no evidence that Greek music featured harmony in the more modern sense of the word—that is, the use of pitches (tones and notes) or chords (groups of notes) sounded simultaneously.

Both Plato and Aristotle found a place for music in their ideal states, owing principally to the link that they saw between music and moral development. As a mathematician, Aristotle believed that numerical relationships, which linked the various pitches in music, could be used by musicians to compose works that imitated the highest state of reason, and thus virtue—just as Polyclitus believed that he could create the ideal human figure through harmonic principles derived from reason and the intellect. Aristotle also believed in the doctrine of ethos, whereby music had the power to influence human behavior. As such, he saw the study of music as vital to Greek life and education.

READING 3.8 ARISTOTLE

Politics, 1340a and 1340b

In rhythms and melodies there are . . . close imitations of anger and gentleness and of courage and moderation and of all their opposites and of the other moral qualities and this verified from experience: we experience change in our souls when we hear such things.

. . .

Therefore it is evident that music is able to produce a certain effect on the character of the soul, and if it is able to do this, it is plain that the young must be introduced to and educated in [music].

Similarly, Plato held the view that participation in musical activities molded the character for worse (which is why he suggested banning certain kinds of music) and for better.

READING 3.9 PLATO

Protagoras, 326a

Teachers of the kithara . . . cultivate moderation and aim to prevent the young from doing anything evil. Moreover, whenever [students] learn to play the kithara, [they are taught] the poems of morally good poets, setting them to the music of the kithara and compel rhythms and harmonies to dwell in the souls of the boys to make them more civilized, more orderly, and more harmonious, so that they will be good in speech and action.

For all its importance in Greek life and thought, the actual sound of Greek music and the principles whereby it was composed are neither easily reconstructed nor completely understood. The numerical relationship of notes to one another established by Pythagoras was used to divide the basic unit of an octave (series of eight notes) into smaller intervals named after their positions relative to the lowest note in the octave. The interval known as a **fourth**, for example, represents the distance between the lowest note and the fourth note up the octave. The intervals were then combined to form a series of scales, or **modes**. Each mode was associated with a particular emotional characteristic: the Dorian mode was serious and warlike, the Phrygian exciting and emotional, and the Mixolydian plaintive and melancholic.

The unit around which Greek music was composed was the **tetrachord**, a group of four pitches, the two outer ones a perfect fourth interval apart and the inner ones variably spaced. The combination of two tetrachords formed a mode. The Dorian mode, for example, consisted of the following two tetrachords.

The Lydian mode was composed of two different tetrachords.

The origin of the modes and their relationship to one another is uncertain; it was disputed even in ancient times. The search for these origins is further clouded by the fact that medieval church music adopted the same system of mathematical construction—and even some of the names of the Greek modes—although they used these names for entirely different modes.

Throughout the fifth century BCE, while music played an important part in dramatic performances, it was generally subordinated to verse. Musical rhythms accompanied words or dance steps and were tied to them. Special instruments such as cymbals and tambourines were used to mark the rhythmic patterns, and Greek writers on music often discussed the specific challenges for composers that the Greek language and its accents presented. As it expanded beyond accompaniment, instrumental music became especially popular.

Although few traces have survived, a system of notation was used to write down musical compositions; it probably was borrowed from the Phoenicians, as was the Greek alphabet. Originally used for lyre music, the notation used symbols to mark the position of fingers on the lyre strings, rather like modern guitar notation (tablature). The system was then adapted for vocal music and for nonstring instruments, such as the aulos. The oldest of the few surviving examples of musical notation dates to ca. 250 BCE.

THEATER IN CLASSICAL GREECE

The tumultuous years of the fifth century BCE, passing from the spirit of euphoria that followed the end of the Persian Wars to the mood of self-doubt and self-questioning of 404 BCE, may seem unlikely to have produced the kind of intellectual concentration characteristic of Classical Greek drama. Yet in the plays written specifically for performance in the theater of Dionysus at Athens in these years, Classical literature reached its most elevated heights. The tragedies of the three great masters—Aeschylus, Sophocles, and Euripides—not only illustrate the development of contemporary thought but also contain some of the most memorable scenes in the history of the theater.

The Drama Festivals of Dionysus

Tragic drama, however, did not begin in the fifth century BCE. It had evolved over the preceding century from choral hymns—**dithyrambs** sung in honor of the god Dionysus, and the religious nature of its origins was still present in its fully developed form. (Like the Egyptian god Osiris, Dionysus died and was reborn, and the festivals held in his honor may be related to earlier ceremonies developed in Egypt.) To go to the theater was to take part in a religious ritual; the theaters were regarded as sacred ground. The plays that have survived from the Classical period in Athens were all written for performance at one of the two annual festivals sacred to Dionysus before an audience consisting of the entire population of the city. Breathtakingly large **theatres** were designed to accommodate throngs of people; the one at Epidaurus (**Fig. 3.17**) could seat some 12,000 spectators in 55 rows. The architect was Polyclitus the Younger, who some historians believe was the nephew of the sculptor renowned for his *Canon*. The wedges of the roughly semicircular, cone-shaped structure taper at ground level and envelop a circular stage for the actors; a building tangential to the circle, called the *skene*, was used for dressing rooms and as a backdrop for the play.

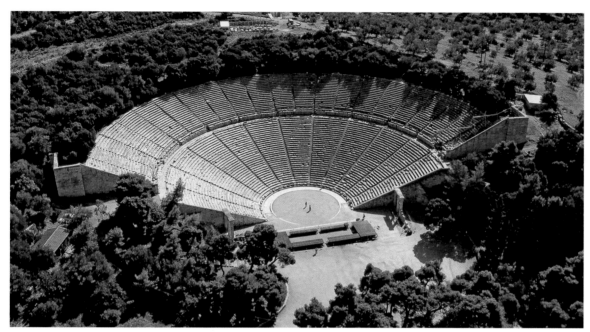

▲ **3.17** **Polyclitus the Younger, Theater of Epidaurus, Greece, ca. 350** BCE**.** The Greeks built their theaters into hillsides to support the tiers of stone seats that overlooked the circular stages. The theater at Epidaurus seated an audience of 12,000.

Each playwright participating in the festival submitted four plays to be performed consecutively on a single day— three tragedies, or a **trilogy**, and a more lighthearted piece called a **satyr play** (a satyr was a mythological figure: a man with an animal's ears and tail). The trilogies sometimes consisted of three parts of a single narrative, although more often the three works were based on different stories connected to a common theme. The plots, generally drawn from mythology, often dealt with the relationship between humans and deities. The style of performance was serious, lofty, and dignified. The actors, who in a sense served as priests of Dionysus, wore masks, elaborate costumes, and platform shoes. At the end of each festival, the plays were judged and a prize awarded to the winning author.

THE GREEK CHORUS: FROM DITHYRAMB TO DRAMA The **chorus**, whose sacred dithyrambic hymns had been the starting point for the development of tragedy, retained an important role in Classical Greek theatre. In earlier plays, like those written by Aeschylus, the chorus is centrally involved in the action; later, as in Sophocles's *Oedipus the King*, the chorus does not participate directly in the events on stage but rather assumes the role of the spectator, commenting on the actions of the principal characters and reducing to more human terms their larger-than-life circumstances and emotions. Later still, in the time of Euripides when dramatic confrontation took the place of extended poetic or philosophical musings, the chorus retained an important function that reflected its theatrical roots: that of punctuating the action and dividing the play into separate episodes with lyric odes, the subjects of which were sometimes only indirectly related to the play's narrative.

The text of the surviving Classical tragedies, then, represents only a small part of the total experience of the original performances. The words (or at least some of them) have survived, but the music to which the words were sung and that accompanied much of the action, the elaborate choreography to which the chorus moved, and the whole grandiose spectacle performed out of doors in theaters located in sites of extreme natural beauty before an audience of thousands—all of this can only be recaptured in the imagination. It is interesting to note that, almost 2,000 years after the Classical era, Florentine humanists interested in reviving classical drama in all of its dimensions—music, acting, dance—would wind up creating opera. In the 19th century, German composer Richard Wagner would coin the concept of the *Gesamtkunstwerk* (literally "total work of art"), combining all of the arts into one in his dramatic operas.

The Athenian Tragic Dramatists

Even if some the surviving Greek dramas are lost, we do have the words. The differing worldviews of the authors of these works vividly illustrate the changing fate of Athens in the fifth century BCE.

AESCHYLUS The earliest of the playwrights, Aeschylus (525–456 BCE), died before the lofty aspirations of the early years of the Classical period could be shaken by contemporary events. His work shows a deep awareness of human weakness and the dangers of power (as noted earlier, he had fought at the Battle of Marathon in 490 BCE) but retains an enduring belief that in the end right—and reason—will triumph. In

Aeschylus's plays, the process of recognizing and doing what is moral is painful. Progress and self-knowledge come only through suffering and are achieved by the will of Zeus. In the opening scene of *Agamemnon*, the chorus tells us as much.

READING 3.10 AESCHYLUS

Agamemnon, lines 250–255

Justice turns the balance scales,
sees that we suffer
and we suffer and we learn.
And we will know the future when it comes.
Greet it too early, weep too soon.
It all comes clear in the light of day.

The essential optimism of Aeschylus's philosophy must be kept in mind because the actual course of the events he describes is often violent and bloody. Perhaps his most impressive plays are the three that form the *Oresteia* trilogy. This trilogy, the only complete one that has survived, won first prize in the festival of 458 BCE at Athens. The subject of the trilogy is nothing less than the growth of civilization, represented by the gradual transition from the primitive justice of *vendetta* ("blood for blood") to a legal system of justice guiding a rational, civilized society.

The first of the three plays, *Agamemnon*, casts a harsh light on blood justice and bloodguilt. King Agamemnon returns to his homeland, Argos, after leading the Greeks to victory at Troy. Ten years earlier, before the launch of his expedition, he had been forced to make a choiceless choice: to abandon the campaign because of unfavorable tides or to obtain easy passage by sacrificing his daughter Iphigenia. (The situation may seem contrived, but it clearly symbolized the conflict between public and personal responsibilities.) After considerable hesitation and self-doubt, Agamemnon makes the decision to sacrifice his daughter. The chorus describes the violence and, further, alludes to what lies in store for Agamemnon.

READING 3.11 AESCHYLUS

Agamemnon, lines 218–226

Once he slipped his neck in the strap of Fate,
his spirit veering black, impure, unholy,
once he turned he stopped at nothing,
seized with the frenzy
blinding, driving to outrage—
wretched frenzy, cause of all our grief!
Yes, he had the heart
to sacrifice his daughter!—
to bless the war that avenged a woman's loss,
a bridal rite that sped the men-of-war.

Upon his return home at the end of the Trojan War, he pays the price: his wife Clytemnestra and her lover Aegisthus murder him. Her ostensible motive is vengeance, but an equally powerful, if less noble, one is her desire to replace Agamemnon, both as husband and king, with Aegisthus. Aeschylus shows us, however, that "a life for a life" has its domino effect: The punishment of one crime creates in turn another crime to be punished. If Agamemnon's murder of his daughter merits vengeance, then so does Clytemnestra's sacrifice of her husband. Violence breeds violence.

The second play, *The Libation Bearers*, shows us the effects of the operation of this principle on the son of Agamemnon and Clytemnestra, Orestes. After spending years in exile, Orestes returns to Argos to avenge his father's death by killing his mother. Although a further murder can accomplish nothing except the transfer of bloodguilt to Orestes, the ancient and primitive code of vendetta requires him to act. With the encouragement of his sister Electra, he kills Clytemnestra. His punishment follows immediately. He is driven mad by the Furies, the implacable goddesses of vengeance, who hound him from his home.

The Furies are transformed into *The Eumenides* ("the Kindly Ones") at the conclusion of the third play, to which they give their name. In his resolution of the tragedy of Orestes and his family, Aeschylus makes it clear that violence can only be brought to an end by the power of reason and persuasion (Athena says, "I am in my glory! Yes, I love Persuasion"). After a period of tormented wandering, Orestes comes finally to Athens, where he stands trial for the murder of his mother before a jury of Athenians, presided over by Athena. Orestes describes his motive for revenge and submits himself to justice.

READING 3.12 AESCHYLUS

The Eumenides, lines 473–485

 What an ignoble death he died
When he came home—Ai! My blackhearted mother
Cut him down, enveloped him in her handsome net—
It still attests his murder in the bath.
But I came back, my years of exile weathered—
Killed the one who bore me, I won't deny it,
Killed her in revenge. I loved my father,
Fiercely.
 And Apollo shares the guilt—
He spurred me on, he warned of the pains I'd feel
Unless I acted, brought the guilty down.
But were we just or not? Judge us now.
My fate is in your hands. Stand or fall
I shall accept your verdict.

The Furies insist on his condemnation on the principle of blood for blood, but Apollo, the god of reason, who would

VALUES

Civic Pride

Aristotle's comment that "man is a creature who lives in a city," sometimes translated as "man is a political animal," summarizes the Greeks' attitude toward their polis (city). The focus of political, religious, and cultural life, and most other aspects as well—sport, entertainment, justice—the polis came to represent the central force in the life of each individual citizen.

The Greeks saw the importance of their city-states as the fundamental difference between their culture and that of the "barbarians," because it enabled them to participate in their community's affairs as responsible individuals. This participation was limited to adult male citizens; female citizens played little significant role in public life, and slaves and resident foreigners were completely excluded.

If the polis was responsible for many of the highest achievements of Greek culture, the notion of civic pride produced in the end a series of destructive rivalries that ended Greek independence. The unity forged in the threat of the Persian invasions soon collapsed in the buildup to the Peloponnesian War. Even in the face of the campaigns of Philip of Macedon, the Greek cities continued to feud among themselves, unable to form a common front in the face of the danger of conquest.

The notion of the individual city as the focus of political and cultural life returned in the Italian Renaissance. Renaissance Florence, Siena, Milan, Venice, and Verona saw themselves as separate city-states, with their own styles of art and society. Even a small community such as Urbino became an independent political and artistic unit, modeled consciously on the city-states of Classical Greece. As in Greek times, civic pride led to strife between rivals and left the Italians helpless in the face of invasions by French forces or those of the Holy Roman Emperor.

ultimately win an acquittal, defends Orestes. Orestes's fellow mortals comprise a jury of his peers and deliver a tied verdict. Athena casts the final vote in favor of Orestes. Thus, the long blood feud is brought to an end, and the apparently inevitable violence and despair of the earlier plays is finally dispelled by the power of persuasion and human reason, which—with the help of Athena and Apollo—have managed to bring civilization and order to primeval chaos: from then on, homicide cases were to be tried by the Athenian court system, as Athena tells all gathered.

READING 3.13 AESCHYLUS

The Eumenides, lines 693–697

And now
If you would hear my law, you men of Greece,
you who will judge the first trial of bloodshed.
Now and forever more, for Aegeus' people
This will be the court where judges reign.

Despite all the horror of the earlier plays, therefore, the *Oresteia* ends on a positive note. Aeschylus affirms his belief that progress can be achieved by reason and order. This gradual transition from darkness to light is handled throughout the three plays with unfailing skill. Aeschylus matches the grandeur of his conception with majestic language. His rugged style makes him sometimes difficult to understand, but all the verbal effects are used to dramatic purpose. The layering of images and complexity of expression produce an emotional tension that is unsurpassed.

SOPHOCLES The life of Sophocles (496–406 BCE) spanned both the glories and the disasters of the fifth century BCE. Of the three great tragic poets, Sophocles was the most prosperous and successful; he was a personal friend of Pericles. He is said to have written 123 plays, but only seven have survived, all of which date from the end of his career. They all express a much less positive vision of life than those of Aeschylus. His philosophy is not easy to extract from his work, because he is more concerned with exploring and developing the individual characters in his dramas than with expounding a point of view; in general, Sophocles seems to combine an awareness of the tragic consequences of individual mistakes with a belief in the collective ability and dignity of the human race.

The consequences of human error are vividly depicted in his play *Antigone*, first performed ca. 440 BCE. Thebes has been attacked by forces under the leadership of Polyneices, the son of Oedipus; the attack is beaten off and Polyneices killed. In the aftermath, Creon, now king of Thebes, declares the dead warrior a traitor and forbids anyone to bury him on pain of death. Antigone, Polyneices's sister, disobeys, claiming that her religious and family obligations override those to the state. Creon angrily condemns her to death but she stands firm and proud in her decision, further accusing Creon of tyranny.

READING 3.14 **SOPHOCLES**

Antigone, lines 555–574

Antigone: Creon, what more do you want
Than my arrest and execution?
Creon: Nothing. Then I have it all.
Antigone: Then why delay? Your moralizing repels me,
every word you say—pray god it always will.
So naturally all I say repels you too.

 Enough.
Give me glory! What greater glory could I win
than to give my own brother decent burial?
These citizens here would all agree,
[*To the* Chorus]
they would praise me too
if their lips weren't locked in fear.
[*Pointing to* Creon]
Lucky tyrants—the perquisites of power!
Ruthless power to do and say whatever pleases *them*.
Creon: You alone, of all the people in Thebes,
see things that way.
 Antigone: They see it just that way
but defer to you and keep their tongues in leash.
Creon: And you, aren't you ashamed to differ so from them?
So disloyal!
Antigone: Not ashamed for a moment,
not to honor my brother, my own flesh and blood.

Creon subsequently reverses his position, but too late: Antigone, his son (who is betrothed to Antigone), and his wife have all committed suicide. Creon's stubbornness and bad judgment thus result in tragedy for him as well as for Antigone. Creon laments over the body of his son.

READING 3.15 **SOPHOCLES**

Antigone, lines 1394–1402, 1467–1471

 Ohhh,
so senseless, so insane . . . my crimes,
my stubborn, deadly—
Look at us, the killer, the killed,
father and son, the same blood—the misery!
My plans, my mad fanatic heart,
my son, cut off so young!
Ai, dead, lost to the world,
not through your stupidity, no my own.
After these words, a messenger comes to Creon with news of more death—this one his wife's. He is in anguish, but the messenger does nothing to console him. On the contrary, he reaffirms Creon's guilt. Creon prays for his own death, but the chorus leader tells him that there is no cure for his misery:

Creon: [*Kneeling in prayer*]
Come, let it come—that best of fates for me
that brings the final day, best fate of all.
Oh quickly, now—
so I never have to see another sunrise.
Leader: That will come when it comes;
we must deal with all that lies before us.
The future rests with the ones who tend the future.
Creon: That prayer—I poured my heart into that prayer!
Leader: No more prayers now. For mortal men
there is no escape from the doom we must endure.

Creon asks "where to lean for support." He laments that "whatever [he] touch[es] goes wrong" and that "a crushing fate's come down upon [his] head." The chorus responds to him, closing the play with these lines:

Wisdom is by far the greatest part of joy,
and reverence toward the gods must be safeguarded.
The mighty words of the proud are paid in full
with mighty blows of fate, and at long last
those blow will teach us wisdom.

More than any of his contemporaries, Sophocles emphasizes how much lies outside our own control, in the hands of destiny or the gods. His insistence that we respect and revere the forces that we cannot see or understand makes him the most traditionally religious of the tragedians. These ambiguities appear in his best known play, *Oedipus the King*, which has stood ever since Classical times as a symbol of Greek tragic drama. A century after it was first performed (ca. 429 BCE), Aristotle used it as his model when, in the *Poetics*, he discussed the nature of tragedy. Its unities of time, place, and action, the inexorable drive of the story with its inevitable yet profoundly tragic conclusion, the beauty of its poetry—all have made *Oedipus the King* a classic, in all senses.

Oedipus is the king of Thebes. The scope of his incalculable tragedy—his murder of his father and marriage to his mother—is revealed to him over the course of the play as he pursues truth and blood justice, but the audience already knows it well. When he appears on stage at the beginning of the play, Oedipus is grappling with what to do about a plague that has devastated his city. He consults with the oracle, who warns that things will not be set right until the murder of his predecessor, Laius, is avenged. Oedipus tells his people that he will do what he must to bring the criminal to justice. The words that Oedipus speaks have particular meaning to the audience, even though Oedipus is unaware of their significance; this literary technique is known as **dramatic irony**. When the play opens, Oedipus, unbeknownst to him, has already committed the crimes that will bring about

his downfall. In this passage, he speaks to the chorus, who represent the citizens of Thebes, ordering them to provide any information they might have so that the killer might be apprehended.

READING 3.16 **SOPHOCLES**

***Oedipus the King*, lines 215–241**

If any one of you knows who murdered Laius,
the son of Labdacus, I order him to reveal
the whole truth to me. Nothing to fear,
even if he must denounce himself,
let him speak up
and so escape the brunt of the charge—
he will suffer no unbearable punishment,
nothing worse than exile, totally unharmed.
[Oedipus *pauses, waiting for a reply*.]
 Next,
if anyone knows the murderer is a stranger,
a man from alien soil, come, speak up.
I will give him a handsome reward, and lay up
gratitude in my heart for him besides.
[*Silence again, no reply*.]
But if you keep silent, if anyone panicking,
trying to shield himself or friend or kin,
rejects my offer, then hear what I will do.
I order you, every citizen of the state
where I hold throne and power: banish this man—
whoever he may be—never shelter him, never
speak a word to him, never make him partner
to your prayers, your victims burned to the gods.
Never let the holy water touch his hands,
Drive him out, each of you, from every home.
He is the plague, the heart of our corruption,
as Apollo's oracle has just revealed to me.
So I honor my obligations:
I fight for the god and for the murdered man.
Now my curse on the murderer. Whoever he is,
a lone man unknown in his crime
or one among many, let that man drag out
his life in agony, step by painful step—
I curse myself as well . . . if by any chance
he proves to be an intimate of our house,
here at my hearth, with my full knowledge,
may the curse I just called down on him strike me!

The audience knows that the future will mark Oedipus's words, that the fate he draws for this murderer will be his own. It is Oedipus who is clueless, and it is painful to watch. Again, in an interchange with Tiresias, the blind **soothsayer**, allusions are made to the events that will transpire. Tiresias speaks to Oedipus.

READING 3.17 **SOPHOCLES**

***Oedipus the King*, lines 404–412**

 So,
you mock my blindness? Let me tell you this.
You with your precious eyes,
you're blind to the corruption of your life,
to the house you live in, those you live with—
who *are* your parents? Do you know? All unknowing
you are the scourge of your own flesh and blood,
the dead below the earth and the living here above,
and the double lash of your mother and your father's curse
will whip you from this land one day, their footfall
treading you down in terror, darkness, shrouding
your eyes that now can see the light!

When Oedipus finds out who his parents are, that he was left to die by his mother who was fearful of prophecies that the child would grow to kill his parents, and that he killed his father unknowingly and then came to marry the same woman who thought he was dead—Oedipus gouges his eyes.

READING 3.18 **SOPHOCLES**

***Oedipus the King*, lines 1148–1152**

 O god—
all come true, all burst to light!
O light—now let me look my last on you!
I stand revealed at last—
cursed in my birth, cursed in marriage,
cursed in the lives I cut down with these hands!

Oedipus's story is extreme, idiosyncratic. Yet the universal admiration of the play—and its relevance—may have something to do with the fact that even though Oedipus is a king whose actions break societal taboos, we have sympathy for him; he is a tragic hero. Like any human being, he has good qualities and bad ones. In spite of the trajectory of his life toward ruin, he is hopeful. He is confident and intelligent, but in the end, these things are not enough. Given Oedipus's situation, rather than condemning him, the audience finds itself asking, "What would I have done under the circumstances?" As the play closes, Oedipus goes into exile and Creon tells him, "Here your power ends. None of your power follows you through life." Yet somehow we do not believe it. We do not believe that Oedipus will wander and wallow in the disaster that has befallen him; rather, we have hope that he will pick up the pieces of his life and assemble

something better from them. In the play that follows, *Oedipus at Colonus*, he has done just that. The ill-fated king whom we meet in the opening lines of *Oedipus the King*—the one who says, "Here I am myself—you all know me, the world knows my fame: I am Oedipus," for whom knowledge bred suffering and who would gain self-knowledge through that suffering, returns as a wise and magnificent ruler.

Why does Oedipus, though, deserve to suffer for his actions? Certainly he does not knowingly kill his father nor knowingly marry his mother. The events that unfold have been prophesied; fate simply plays out. The play seems to be saying, in part, that humans cannot avoid destiny, although we are responsible for our own conduct as this destiny is met. The end may be predetermined, but how we journey toward it reveals our true character. *Oedipus the King*, for all of its suspense and spellbinding details, is also a psychological profile of one man who, as it happened, made some mistakes.

Aristotle writes on plot and character in the *Poetics*, his analysis of the nature of tragedy and the tragic hero. He theorizes that pity and fear are aroused in the audience when it recognizes that the unfortunate plight of the character is universal—that it could befall anyone, not "through vice or depravity, but . . . because of some mistake."

READING 3.19 ARISTOTLE

From *Poetics*, 14

The plot ought to be so constructed that, even without the aid of the eye, he who hears the tale told will thrill with horror and melt to pity at what takes place. This is the impression we should receive from hearing the story of Oedipus.

Aristotle makes the point that the downfall of a tragic figure is the result of a character flaw or an intellectual miscalculation (the Greek word is *hamartia*). Does Sophocles see tragic flaws in his character of Oedipus? Oedipus's pride and stubborn insistence on discovering the truth, and the anger he shows in the process, lead to his destruction—the final, disastrous revelation. These flaws, or weaknesses, in his character overcome his assets—his intelligence, civic devotion, persistence, hopefulness. His personality is multidimensional and it is the sum total of his personality that accounts for the situation in which he finds himself. In the end, however, some aspects of existence are beyond his—and human—understanding and control, aspects that operate by principles outside the range of human experience. And so Sophocles addresses the relationship between character and fate.

EURIPIDES The significance for the Athenians of Oedipus's fall from greatness emerges in full force in the work of Euripides (ca. 484–406 BCE). Although only slightly younger than Sophocles, Euripides expresses all the weariness and disillusionment of the war-torn years at the end of the fifth century BCE. Of all the tragedians, the outlook of Euripides is

perhaps the closest to that our own time, with his concern for realism and his determination to expose social, political, and religious injustices.

Although Euripides admits the existence of irrational forces in the universe that can be personified in the forms of gods and goddesses, he certainly does not regard them as worthy of respect and worship. This skepticism won him the charge of impiety. His plays show characters frequently pushed to the limits of endurance; their reactions show a new concern for psychological truth. In particular, Euripides exhibits a profound sympathy and understanding for the problems of women who live in a society dominated by men. Characters like Medea and Phaedra challenged many of the basic premises of Athenian society.

Euripides's deepest hatred is reserved for war and its senseless misery. Like the other dramatists, he draws the subject matter of his plays from traditional myths, but the lines delivered by the actors must have sounded in their listener's ears with a terrible relevance. *The Suppliant Women* was probably written in 421 BCE, when 10 years of indecisive fighting had produced nothing but an uneasy truce. Its subject is the recovery by Theseus, ruler of Athens, of the bodies of seven chiefs killed fighting at Thebes, in order to return them to their families for burial. His first response to the families' request is no, but his own mother reminds him of what is right.

READING 3.20 EURIPIDES

***The Suppliant Women*, lines 293–319**

Aethra: Ah, poor, poor women!
Theseus: Mother, you are not one of them!
You do not share their fate.
Aethra: My son, shall I say something which will give you and our city some
honor?
Theseus: Yes, do. Women can offer much wise council.
Aethra: But, I'm a little hesitant to utter what is in my mind.
Theseus: That's a shame, mother. Keeping wise words from your dear son!
Aethra: No, I won't stay silent now so as to have this silence punish me some time in the future. Nor will I hold back something that needs to be said through fear that speech making is unbecoming to women.

. . .

This is an insult to all the Greeks. It is a violation of the laws of the heavens, laws respected highly by all of Hellas. With no respect for the laws, there is no respect for the communities of men.
And then, if you will not act upon this, people will say that it was due to cowardice on your behalf. That you have failed to deliver the garland of glory to our city through lack of courage. They will say that you have once shown courage by fighting a wild boar but you now show cowardice when you need to fight against spears and helmets. Courage in the face of a trifling errant but cowardice in the face

of a noble task.
You are my son, Theseus, so you should not act like that.

Translated by George Theodoridis, 2010.http://bacchicstage
.wordpress.com/

Theseus comes to understand that what his mother says honors the men, the gods, their families, and the state. He agrees to go to Thebes and bring the bodies of the dead warriors home, even at risk to his own safety, but he tells his mother that he will have to bring the matter to a vote, as the people ought to decide whether they want to put their warriors, their sons, in harms way.

READING 3.21 EURIPIDES

The Suppliant Women, lines 339–355

But you're right. It's not in my character to run away from dangerous tasks and by my many deeds of virtue in the past, I have already exhibited to the Greeks my willingness to punish those who perform evil deeds.

No, it is not possible for me to refuse a task simply because it's difficult. What would my enemies say if they found out that the person who has asked me to perform it was you, mother, the very person who bore me and the very person whose heart trembles for my safety?

I will do this, mother. I will go and persuade the Thebans to release the corpses of the fallen men. I will try using words first but if words fail to persuade them, then I will use force. The gods will not go against us for such a purpose.

I also want the city to vote on this and I am sure they will agree with me, not only because I wish it but because they, too want it even more than I do.

In any case, I have made the citizens of this city its rulers, by giving them freedom and the equal rights to vote as they wish.

Translated by George Theodoridis, 2010.http://bacchicstage
.wordpress.com/

Euripedes uses *The Suppliant Women* as a pulpit from which to preach the glories of Greek democracy. A debate ensues between Theseus and a messenger from Thebes, who has come to bring Creon's position on the return of the dead to their mothers and on which city and government is superior—one ruled by a king or one ruled by the people. Theseus feels that he has the upper hand in the argument.

READING 3.22 EURIPIDES

The Suppliant Women, lines 430–454

To begin with, a city like that has no laws that are equal to all of its citizens. It can't. It is a place where one man holds all the laws of the city in his own hands and dictates them as he wants. What then of equality?

Written laws, however, give this equal treatment to all, rich and poor. If a poor man is insulted by a rich one, then that poor man has every right to use the same words against that rich man.

The poor can win against the rich if justice is on his side.

The essence of freedom is in these words: "He who has a good idea for the city let him bring it before its citizens."

You see? This way, he who has a good idea for the city will gain praise. The others are free to stay silent.

Is there a greater exhibition of fairness than this?

No, where the people hold the power, they can watch with great enjoyment the youth of their city thrive.

Not so when there is a single ruler. He hates that. The moment he sees someone who stands out in some way, he becomes afraid of losing his crown and so he kills him.

So how could a city possibly flourish like that? How could it grow in strength when someone goes about culling its bright youth like a farmer goes about cutting off the highest tips of his wheat during Spring?

Who would anyone want to bother with wealth and livelihood for his boys if it will all end up in the ruler's hands? Or his girls. Why bother raising sweet daughters in your house if they, too, will end up with the ruler, whenever he wants them, leaving you with tears of sorrow? I'd rather die than have my daughters dragged against their will into a wedding bed!

Translated by George Theodoridis, 2010.http://bacchicstage
.wordpress.com/

Theseus does wind up embattled with Theban warriors, but he brings the fallen soldiers home, and those he does not return to their families, he buries with honor. A significant portion of the play thereafter continues the lament over the loss of Greek children, the future of the country, cementing Euripides's play as a bold antiwar statement. It concludes with a stirring and painful plea from Iphis, the king of Argos, whose men were the ones who were lost in Thebes.

READING 3.23 EURIPIDES

The Suppliant Women, lines 1080–1090

Ah!
How I wish!
How I wish that mortals could live their youth twice and twice their old age, too!
When we make mistakes in our homes, we think about them again and the second time around, we correct them; but not with life.
If we could live as youths twice and twice as old men, we could also correct the mistakes we made in our first life, during our second.
I used to see people around me have children and it made me wish to have children of my own but it was that very wish that has destroyed me. But if I had suffered this

present destruction back then, and if by being a father like all the others, had learnt what a terrible thing it is to lose your children, I would have never had to endure this evil destruction!

Translated by George Theodoridis, 2010.http://bacchicstage .wordpress.com/

When the play premiered, Euripedes's audience would have had little need to be reminded of the grief of wives and mothers or of the kind of political processes that produced years of futile fighting in the Peloponnesian War.

If Aeschylus's belief in human progress is nobler, Euripides is certainly more realistic. Although unpopular in his own time, he later became the most widely read of the three tragedians. As a result, more of his plays have been preserved (19 in all), works with a wide range of emotional expression. They extend from romantic comedies like *Helen* and *Iphigenia in Tauris* to the profoundly disturbing *Bacchae*, his last completed play, in which Euripides the rationalist explores the inadequacy of reason as the sole approach to life. In this acknowledgment of the power of emotion to overwhelm the order and balance so typical of the Classical ideal, he is most clearly speaking for his time.

Aristophanes and Greek Comedy

Euripides was not the only poet-playwright to bring a laser-like focus to the futility of war. The plays of Aristophanes (ca. 450–385 BCE), the greatest comic poet of fifth-century-BCE Athens, combine political satire with unforgiving caricature along with a strong dose of scatological humor and sexual innuendo.

In *The Birds*, produced in 414 BCE, two Athenians who are tired of war and paying taxes decide to leave home to find a better place to live. They join forces with the birds and build a new city in midair called Cloud-cuckoo-land, which cuts off contact between gods and humans by blocking the path of the smoke rising from sacrifices. The gods are forced to come to terms with the new city, and Zeus hands over his scepter of authority to the birds.

This is comedic escapism, but *Lysistrata*, written a few years later in 411 BCE, brings humorous twist to a serious subject—the prolonged war and the inability of the men in conflict to come up with a solution to end it. Aristophanes brings out Athenian women as a secret weapon. With Lysistrata inciting them to action, they mean to bring the war to an end by using their bodies as weapons. She comes up with abstinence as the cure and presents the idea to her friends, who are not sure, at first, whether they are fond of the idea.

In addition to the sex strike, the Athenian women seize the Acropolis treasury, thus depriving their men of what they crave and must have—women and money to keep the war going. The action spreads and women all over Greece refuse to make love with their husbands until peace is negotiated. The Athenian men, teased and frustrated, finally give in, and envoys are summoned from Sparta. The play ends with the Athenians and Spartans dancing together for joy at the new peace. Aristophanes suggests, perhaps, that war is, for men, a substitute for sex, and therefore sex can be a substitute for war.

THE LATE CLASSICAL PERIOD

When the Peloponnesian War came to an end with the defeat of Athens, Greece came under the leadership first of the vic-

READING 3.24 ARISTOPHANES

From *Lysistrata*, lines 124–127, 129–134, 138–140, 152–161

Lysistrata: We can force our
husbands to negotiate Peace,
Ladies, by exercising steadfast Self-Control—
By Total Abstinence.
[*A pause.*]
　　　Kleonike: From WHAT?
　　　　　　. . .
Lysistrata: Total Abstinence
　　　From SEX!
[*The cluster of women dissolves.*]
—Why are you turning away? Where are you going?
[*Moving among the women.*]
—What's this? Such stricken expressions!
Such gloomy gestures!
—Why so pale?
　　　—Whence these tears?
　　　—What IS this?
Kleonike: Afraid I can't make it. Sorry.
　　　On with the War!

Myrrhine: Me neither. Sorry.
　　　On with the War!
　　　　　　. . .
　　　Kleonike: [*Breaking in between* Lysistrata *and* Myrrhine.] Try
Something else. Try anything. If you say so,
I'm willing to walk through fire barefoot
　　　But not
to give up SEX—there's nothing like it, Lysistrata!
　　　　　　. . .
　　　Kleonike: Well, just suppose we *did*
as much as possible, abstain from . . . what you said,
you know—not that we *would*—could something like
that bring Peace any sooner?
　　　Lysistrata: Certainly. Here's how it works:
We'll paint, powder, and pluck ourselves to the last
detail, and stay inside, wearing those filmy
tunics that set off everything we *have*—
　　　and then
slink up to the men. They'll snap to attention, go
absolutely *mad* to love us—
　　　but we won't let them. We'll Abstain.
—I imagine they'll conclude a treaty rather quickly.

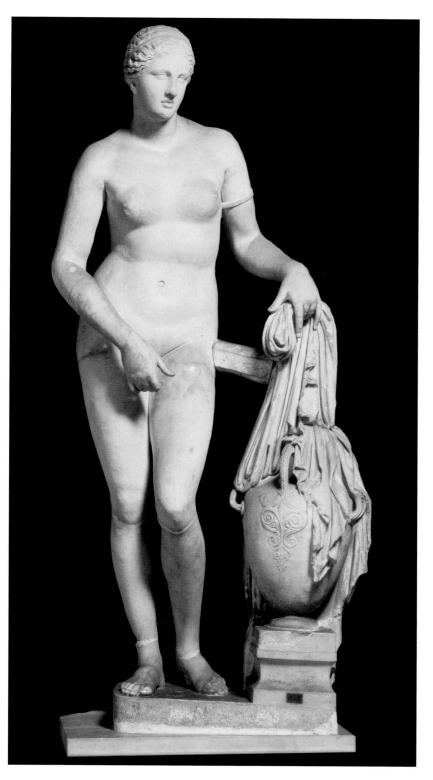

3.18 Praxiteles, Aphrodite of Cnidus, Roman copy of a marble statue of ca. 350–340 BCE. Marble, 80″ (203.2 cm) high. Musei Vaticani, Vatican City State, Italy. Praxiteles's sculpture of Aphrodite at her bath was the first completely nude sculpture of a female deity. People traveled far and wide to see the work and to marvel at Praxiteles's ability to create the illusion of living, breathing flesh from cold, unyielding marble.

torious Spartans and then of the rulers of Thebes (home of Oedipus, Creon, and Antigone). It would not be long, however, until outsiders again threatened the city-states—this time the Macedonians under King Philip II (359–336 BCE). They could not rally this time, and Greece went down to defeat, coming under the control of Philip followed by his son Alexander III (336–323 BCE), known as Alexander the Great.

In the aftermath of the Peloponnesian War, the ideals in which the Athenians so steadfastly believed must have seemed to crumble as cold reality set in. This is reflected in the art: the Classical ideal, the perfect human form, gave way to an art that looked to the real world rather than a set of abstract principles. The result was a remarkable realism, in terms of both appearance and the expression of human emotion.

Late Classical Sculpture

The Late Classical period, then, brought a more humanizing and naturalistic style, one that emphasized expression. A more languid sensuality and graceful proportions replaced the stocky muscularity of the Polyclitan ideal. One of the major proponents of this style was Praxiteles, whose sculpture of Aphrodite (**Fig. 3.18**) was one of the most famous of its day. People traveled specifically to the temple in Cnidus where the statue stood (in present-day Turkey) just to marvel at its beauty; the town was famous for the fully nude sculpture of the goddess, the first one ever to be placed in a religious building. Unlike the monumental and imposing cult statues—some 40 feet high—of Athena and Zeus in their temples, making their might seem awesome and inhuman, Praxiteles's Aphrodite is doing something that ordinary people do. She piles her clothes on a water pitcher and prepares to step into a bath.

The sculpture here illustrated is not original. Like many, if not most, of the sculpture we have seen in this chapter, it is one of many Roman copies. The original in this case, however, was marble rather than bronze; Praxiteles excelled in carving, and marble was his preferred medium. His Hermes Carrying the Infant Dionysus (**Fig. 3.19**) is the only undisputed original work we have by a Greek sculptor dating back to this era. Praxiteles's ability to transform harsh stone surfaces into subtly modeled flesh was unsurpassed. We need only compare his figural group with the Doryphorus to witness the changes that had taken place since the Classical period. Hermes is delicately carved, and his musculature is realistically depicted, suggesting the preference of nature as a model over adherence to a rigid, predefined canon. The

messenger god holds the infant Dionysus, the god of wine, in his left arm, which is propped up by a tree trunk covered with a drape. His right arm is broken above the elbow but reaches out in front of him. It has been suggested that Hermes once held a bunch of grapes toward which the infant was reaching.

Praxiteles's skill in depicting variations in texture was extraordinary. Note, for example, the differences between the solid, toned muscles of the man and the soft, cuddly flesh of the child; or rough, curly hair against the flawless skin; or the deeply carved, billowing drapery alongside the subtly modeled flesh. The easy grace of Hermes's body is a result of the shift of weight from the right leg to the left arm which, in turn, rests on the tree trunk. This position causes a sway which is called an **S curve**, because the contours of the body form an S shape around an imaginary vertical axis.

Perhaps most remarkable is the emotional content of the sculpture. The aloof quality of Classical statuary is replaced with a touching scene between the two gods. Hermes's facial expression as he teases the child is one of pride and amusement. Dionysus, on the other hand, exhibits typical infant behavior—he is all hands and reaching impatiently for something to eat. There remains a certain restraint to the movement and to the expressiveness, but it is definitely on the wane. In the Hellenistic period, that Classical balance will no longer pertain, and the emotion present in Praxiteles's sculpture will reach new peaks.

The most important and innovative sculptor to follow Praxiteles was Lysippus. He introduced a new canon of proportions that resulted in more slender and graceful figures, departing from the stockiness of Polyclitus and assuming the fluidity of Praxiteles. Most important, however, was his new concept of the motion of figure in space. All of the sculptures that we have seen so far have had a two-dimensional perspective. That is, the whole of the work can be viewed from a single point of view, standing in front of the sculpture. This is not the case in works such as the Apoxyomenos (**Fig. 3.20**) by Lysippus. The figure's arms envelop the surrounding space. The athlete is scraping oil and grime from his body with a dull, knifelike implement. This stance forces the viewer to walk around the sculpture to appreciate its details. Rather than adhere to a single plane, as even the S curve figure of Hermes does, the Apoxyomenos seems to spiral around a vertical axis.

Lysippus's reputation was almost unsurpassed. Years after the Apoxyomenos was created, it was still seen as a magnificent work of art. Pliny, a Roman writer on the arts, recounted an amusing story about the sculpture.

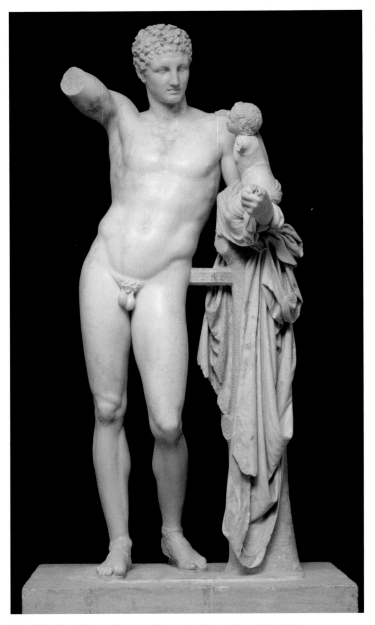

∧ 3.19 Praxiteles, Hermes Carrying the Infant Dionysus, ca. 330–270 BCE. Copy from the Temple of Hera, Olympia, Greece, sculpted by a son or grandson of Praxiteles. Parian marble, 84½″ (215 cm) high. Archaeological Museum, Olympia, Greece. The long, lean proportions and pronounced sway of Praxiteles's statue differ markedly from the canon and contrapposto of Polyclitus's figures.

READING 3.25 PLINY

On Lysippus

Lysippos made more statues than any other artist, being, as we said, very prolific in the art; among them was a youth scraping himself with a strigil, which Marcus Agrippa dedicated in front of his baths and which the Emperor Tiberius was astonishingly fond of. [Tiberius] was, in fact, unable to restrain himself in this case and had it moved to his own bedroom, substituting another statue in its place. When, however, the indignation of the Roman people was so great that it demanded, by an uproar, that the Apoxyomenos be replaced, the Emperor, although he had fallen in love with it, put it back.

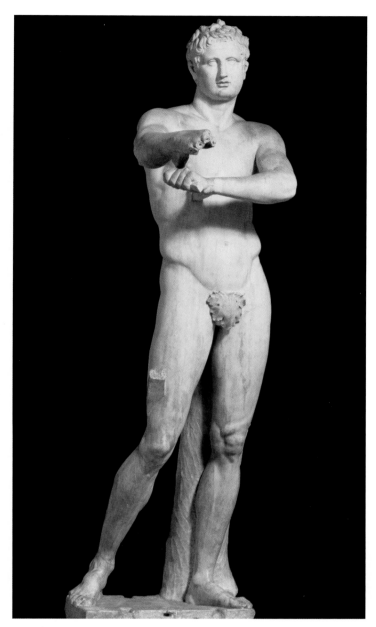

▲ **3.20** Lysippus, **Apoxyomenos (Scraper)**, Roman copy of a bronze statue of ca. 330 BCE. Marble, 80¾″ (205 cm) high. **Musei Vaticani, Vatican City State, Italy.** The *Apoxyomenos* illustrates an athlete scraping sweat and dirt off his body with a strigil, or blunt, knifelike implement.

In fact, Lysippus's work was so widely admired that Alexander the Great—the Macedonian king who conquered Persia and Egypt and spread Greek culture throughout the Near East—chose him as his court sculptor. It is said that Lysippus was the only sculptor permitted to execute portraits of Alexander (**Fig. 3.21**).

Late Classical Architecture

In architecture, as in the arts generally, the Late Classical period was one of innovation. The great sanctuaries at Olympia and

Delphi were expanded, and new cities were laid out at Rhodes, Cnidus, and Priene, using Classical principles of town planning. The fourth century BCE was also notable for the invention of building forms new to Greek architecture, including the **tholos** ("circular building") (**Fig. 3.22**). The most grandiose work of the century was probably the Temple of Artemis at Ephesus, destroyed by fire in 356 BCE and rebuilt on the same massive scale as before. Although the Greeks of the fourth century BCE lacked the certainty and self-confidence of their predecessors, their culture shows no lack of ideas or inspiration. If Athens had lost any real political or commercial importance, the ideas of its great innovators began to affect an ever-growing number of people. The Macedonian Empire had spread Greek culture throughout the Mediterranean world.

When Alexander died in the summer of 323 BCE, the division of his empire into separate independent kingdoms spread Greek culture even more widely. The kingdoms of the Seleucids in Syria and the Ptolemies in Egypt were the true successors to Periclean Athens. Even as far away as India,

▼ **3.21** **Head of Alexander the Great**, 3rd century BCE. Marble, 12″ (30 cm) high. **Archaeological Museum, Pella, Greece.** The thick, tousled hair and angle of the head correspond with contemporary descriptions of a lost full-length sculpture of Alexander that was attributed to Lysippus.

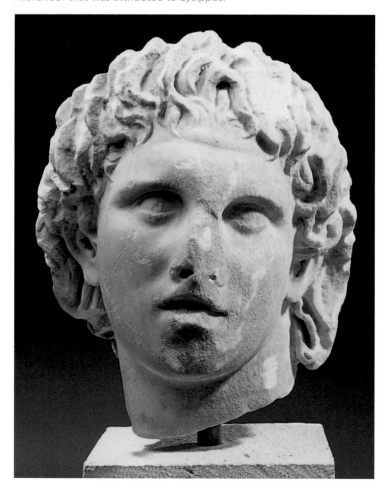

sculptors and town planners were influenced by ideas developed by Athenians of the fifth and fourth centuries BCE. In due course, the cultural achievement of Classical Greece was absorbed and reborn in Rome, as Chapter 4 will show. Meanwhile, in the Hellenistic period, which lasted from the death of Alexander to the Roman conquest of Greece in 146 BCE, that achievement took a new turn.

THE HELLENISTIC PERIOD

The inability of Alexander's generals to agree on a single successor after his death made the division of the Macedonian Empire inevitable. The four most important kingdoms that split off—Syria (the kingdom of the Seleucids), Egypt, Pergamun, and Macedonia (see **Map 3.1**)—were soon at loggerheads, and remained so until they were finally conquered by Rome. Each of these, however, in its own way continued the spread of Greek culture, as the name of the period implies (it is derived from the verb *hellenize*, or "spread Greek influence").

The greatest of all centers of Greek learning was in the Egyptian city of Alexandria, where King Ptolemy, Alexander's former personal staff officer and bodyguard, planned a large institute for scholarship known as the Temple of the Muses, or the Museum. The library at the Museum contained everything of importance ever written in Greek, up to 700,000 separate works, according to contemporary authorities. Its destruction by fire when Julius Caesar besieged the city in 47 BCE must surely be one of the great intellectual disasters in the history of Western culture.

In Asia Minor and farther east in Syria, the Hellenistic rulers of the new kingdoms fostered Greek art and literature as one means of holding foreign influences at bay. Libraries were built at Pergamum and the Syrian capital of Antioch, and philosophers from Greece were encouraged to visit the new centers of learning and lecture there. In this way Greek ideas not only retained their hold but also began to make an impression on more remote peoples even farther east. The first Buddhist monumental sculpture, called Gandharan after the Indian province of Gandhara where it developed, used Greek styles and techniques. There is even a classic Buddhist religious work called *The Questions of Milinda* in which a local Greek ruler, probably called Menander, is described exchanging ideas with a Buddhist sage, ending with the ruler's conversion to Buddhism—one example of the failure of Greek ideas to convince those exposed to them.

Yet however much literature and philosophy could do to maintain the importance of Greek culture, Hellenistic rulers turned primarily to the visual arts. In so doing they inaugurated the last great period of Greek art. The most powerful influence on the period immediately following Alexander's death was the memory of his life. The daring and immensity of his conquests, his own heroic personality, the new world he had sought to create—all these combined to produce a spirit of adventure and experiment.

The all-pervading spirit of the Classical age had been order. Now artists began to discover the delights of freedom. Classical art was calm and restrained, but Hellenistic art was emotional and expressive. Classical artists sought clarity and balance even in showing scenes of violence, but Hellenistic artists allowed themselves to depict riotous confusion involving strong contrasts of light and shade and the appearance of perpetual motion. It is not surprising that the term *baroque*, originally used to describe the extravagant European art of the 17th century CE, is often applied to the art of the Hellenistic period. The artists responsible for these innovations created their works for a new kind of patron. Most of the great works of the Classical period had been produced for the state, with the result that the principal themes and inspirations were religious and political.

With the disintegration of the Macedonian Empire and the establishment of prosperous kingdoms at Pergamum, Antioch, and elsewhere, there developed a group of powerful rulers and wealthy businessmen who com-

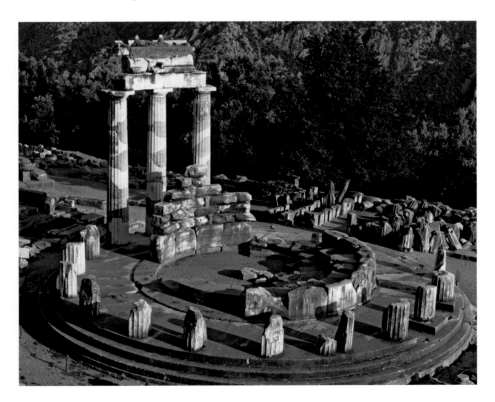

◄ **3.22** Theodorus of Phocaea, Tholos, **ca. 375** BCE. **Delphi, Greece.** The tholos at Delphi, only partially reconstructed, is one of the first round temples in Greek architecture. Originally, 20 Doric columns encircled the temple on the outside and 10 Corinthian columns were set against the wall of the cella within.

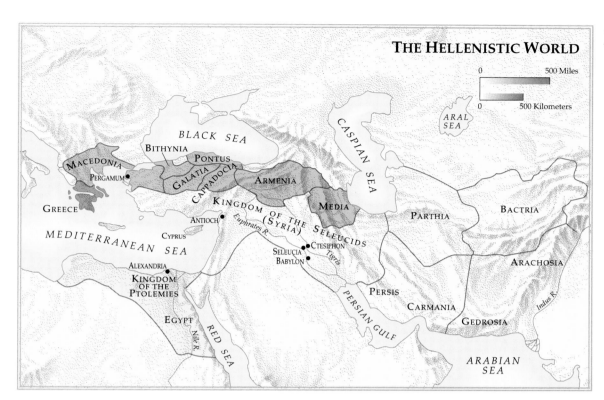

missioned works either to provide lavish decoration for their cities or to adorn their private palaces and villas. Artists were no longer responsible to humanity and to the gods, but to whoever paid for the work. Their patrons encouraged them to develop new techniques and surpass the achievements of rivals. At the same time, the change in the artist's social role produced a change in the function of the work. Whereas in the Classical period architects had devoted themselves to the construction of temples and religious sanctuaries, the Hellenistic age is notable for its marketplaces and theaters, as well as for scientific and technical buildings like the Tower of the Winds at Athens (a combination sundial, clock tower, and wind vane) and the Lighthouse at Alexandria (450 feet high and destroyed in an earthquake). Among the rich cities of Hellenistic Asia, none was wealthier than Pergamum, ruled by a dynasty of kings known as the Attalids. Pergamum was founded in the early third century BCE and reached the high point of its greatness in the reign of Eumenes II (197–159 BCE). The Upper City—or Upper Acropolis—was inspired by the Athenian Acropolis, although the site included much more than sacred temples: royal residences, an agora or marketplace, a library of some 200,000 volumes, a theater that seated 10,000 spectators on the steepest-rising seats in ancient times (**Fig. 3.23**), and more. Embedded among these buildings, but on an elevated platform of great prominence,

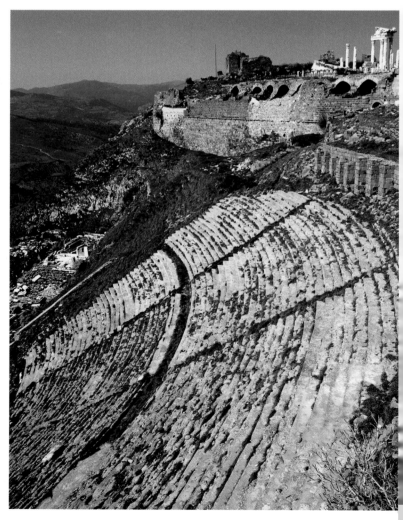

➤ **3.23 Ruins of the theater in the Upper City, Pergamum, Turkey, 3rd century BCE, with 2nd century CE additions.** Built on the model of the Athenian Acropolis, the Upper City of Pergamum included temples, an agora, and royal palaces. The outdoor theater, shown here, was the most steeply sloping in the ancient world.

Kerdo the Cobbler

Herondas was a Greek poet of the third century BCE whose mimes were probably written for public performance. This passage comes from one of them.

Kerdo:

Step lively: open that drawer of sandals.

Look first at this, Metro; this sole, is it not adjusted like the most perfect of soles? Look, you also, women, at the heel-piece; see how it is held down and how well it is joined to the straps; yet, no part is better than another: all are perfect. And the color!—may the Goddess give you every joy of life!—you could find nothing to equal it. The color! neither saffron nor wax glow like this! Three minæ, for the leather, went to Kandas from Kerdo, who made these. And this other color! it was no cheaper. I swear, by all that is sacred and venerable, women, in truth held and maintained, with no more falsehood than a pair of scales—and, if not, may Kerdo know life and pleasure no more!—this almost drove me bankrupt! For enormous gains no longer satisfy the leathersellers. They do the least of the work, but our works of art depend on them and the cobbler suffers the most terrible misery and distress, night and day. I am glued to my stool even at night, worn out with work, sleepless until the noises of the dawn. And I have not told all: I support thirteen workmen, women, because my own children will not work. Even if Zeus begged them in tears, they would only chant: "What do you bring? What do you bring?" They sit around in comfort somewhere else,

warming their legs, like little birds. But, as the saying goes, it is not talk, but money, which pays the bills. If this pair does not please you, Metro, you can see more and still more, until you are sure that Kerdo has not been talking nonsense.

Pistos, bring all those shoes from the shelves. You must go back satisfied to your houses, women. Here are novelties of every sort: of Sykione and Ambrakia, laced slippers, hemp sandals, Ionian sandals, night slippers, high heels, Argian sandals, red ones:—name the ones you like best. (How dogs—and women—devour the substance of the cobbler!)

A Woman:

And how much do you ask for that pair you have been parading so well? But do not thunder too loud and frighten us away!

Kerdo:

Value them yourself, and fix their price, if you like; one who leaves it to you will not deceive you. If you wish, woman, a good cobbler's work, you will set a price—yes, by these gray temples where the fox has made his lair which will provide bread for those who handle the tools. (O Hermes! if nothing comes into our net now, I don't know when our saucepan will get another chance as good!)

"Kerdo the Cobbler" by Herondas from *Greek Literature in Translation*, translated by George Howe & Gustave Adolphus Harrer (NY, Harper, 1924). Reprinted by permission of Marcella Harrer.

was the chief religious shrine of Pergamum—the altar of Zeus (**Fig. 3.24**).

Eumenes II erected the altar ca. 180 BCE to commemorate the victories of his father, Attalus I, over the Gauls. Its base is decorated with a colossal frieze depicting the battle of the gods and giants. The triumphant figure of Zeus stands

presumably as a symbol for the victorious king of Pergamum. The drama and violence of the battle find perfect expression in the tangled, writhing bodies, which leap out of the frieze in high relief, and in the intensity of the gestures and facial expressions (**Fig. 3.25**). The immense emotional impact of the scenes may prevent us from appreciating the remarkable skill

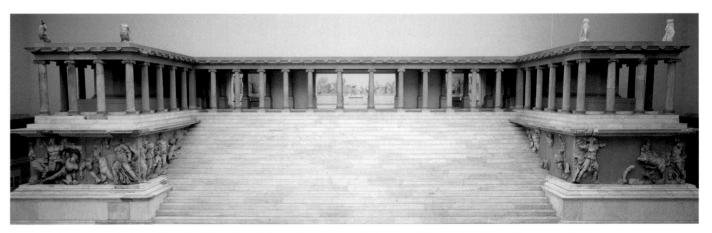

⌃ 3.24 Reconstructed west front of the altar of Zeus, Pergamum, Turkey, ca. 175 BCE. Staatliche Museen zu Berlin, Berlin, Germany. The altar stood on an elevated platform, framed by an Ionic colonnade. Around the platform is a nearly 400-foot-long frieze depicting the battle of gods and giants and alluding to the victory of King Attalus I over the Gauls.

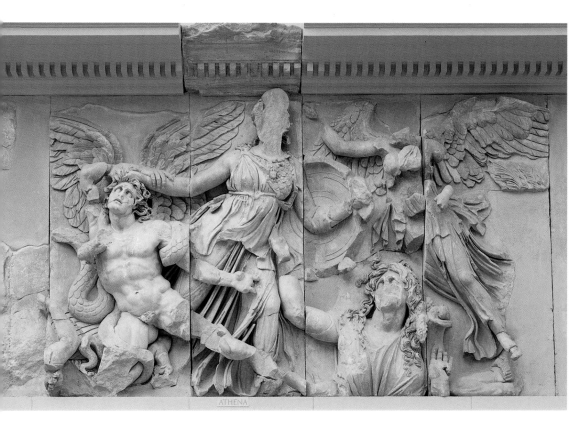

The reliefs of the altar of Zeus contain battle scenes characterized by extreme physical violence and anguish. Athena is shown here grasping the giant Alcyoneus by the hair, the source of his strength, to lift him off the ground. His mother—Gaea, the earth goddess—looks on despairingly from below.

and elaboration, and they returned to some of the principles of Classical art. Simultaneously, the gradual conquest of the Hellenistic kingdoms by Rome and their absorption into the Roman Empire produced a new synthesis in which the achievements of Classical and Hellenistic Greece fused with the native Italian culture and passed on to later ages.

of the artists, some of who were brought from Athens to work on the project. However, the movement of the figures is far from random, and the surface of the stone has been carefully worked to reproduce the texture of hair, skin, fabric, metal, and so on.

The altar of Zeus represents the most complete illustration of the principles and practice of Hellenistic art. It is, of course, a work on a grand, even grandiose, scale, intended to impress a wide public. But many of its characteristics also occur in freestanding pieces of sculpture such as the Laocoön (**Fig. 3.26**). This famous work shows the Trojan priest Laocoön, punished by the gods for his attempt to warn his people against bringing into their city the wooden horse left by the Greeks. To silence the priest, Apollo sends two sea serpents to strangle him and his sons. The large piece is superbly composed, with the three figures bound together by the sinuous curves of the serpents; they pull away from one another under the agony of the creatures' coils.

By the end of the Hellenistic period, both artists and public seemed a little weary of so much richness

➤ **3.26** Athenadorus, Agesander, and Polydorus of Rhodes, Laocoön and His Sons, early first century CE. Roman copy, marble, 82¾" (210 cm) high. Musei Vaticani, Vatican City State, Italy. From an incident described in Virgil's *Aeneid*, sea serpents strangle the Trojan priest Laocoön and his sons in retaliation for their telling the Trojans to be wary of the gift of the Trojan horse. The figures writhe in agony, futilely attempting to free themselves from the death grip of the serpents. Stylistic similarities between Laocoön and the struggling Alcyoneus in the frieze on the altar of Zeus (Fig. 3.25) have been noted by scholars.

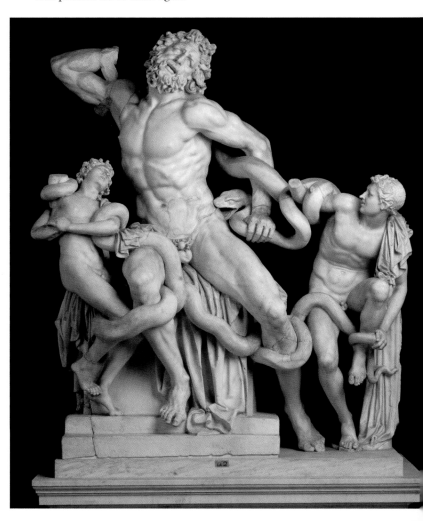

GLOSSARY

Acropolis (p. 83) Literally "high city"; the flat-topped rock in Athens that rises 490 feet above sea level and has buildings that were erected during the golden age, including the Parthenon.

Boule (p. 81) The ruling council of the Athenian Ecclesia

Canon of proportions (p. 90) A set of rules (or formula) governing what are considered to be the perfect proportions of the human body or correct proportions in architecture.

Caryatid (p. 87) A stone sculpture of a draped female figure used as a supporting column in a Greek-style building.

Catharsis (p. 97) A cleansing of the soul, or release of pent-up emotions.

Cella (p. 84) The small inner room of a Greek temple, used to house the statue of the god or goddess to whom the temple is dedicated; located behind solid masonry walls, the cella was accessible only to the temple priests.

Chorus (p. 99) In Greek drama, a company or group of actors who comment on the action in a play, either by speaking or singing in unison.

Chryselephantine (p. 84) Made of gold and ivory.

Contrapposto (p. 87) A position in which a figure is obliquely balanced around a central vertical axis.

Delian League (p. 81) A politically neutral organization of Greek city-states that kept a treasury on the island of Delos to fund military defenses in case of an attack.

Dithyramb (p. 98) A frenzied or impassioned choral hymn of ancient Greece, especially one dedicated to Dionysus, the god of wine.

Doric (p. 84) The earliest and simplest of the Greek architectural styles, consisting of relatively short, squat columns, sometimes unfluted, and a simple, square-shaped capital.

Dramatic irony (p. 102) The literary technique in which the words spoken by a character have particular significance for the audience although the character himself or herself is unaware of their meaning.

Ecclesia (p. 81) The main assembly of the democracy of Athens during its golden age.

Entablature (p. 84) In architecture, a horizontal structure supported by columns that in turn supports any other element, such as a pediment, that is placed above; from top to bottom, the entablature consists of a *cornice*, a **frieze**, and an *architrave*.

Entasis (p. 84) In architecture, a slight convex curvature of a column, which provides the illusion of continuity of thickness as the column rises.

Fourth (p. 98) In music, the distance between the lowest note and the fourth note up an octave.

Frieze (p. 84) In architecture, a horizontal band between the *architrave* and the *cornice* that is often decorated with sculpture.

Krater (p. 91) A wide-mouthed ceramic vessel used for mixing wine and water.

Lekythos (p. 92) An oil flask used for funerary offerings and painted with mourning or graveside scenes (plural *lekythoi*).

Metope (p. 85) In architecture, a panel containing *relief sculpture* that appears between the *triglyphs* of the Doric frieze.

Middle Relief (p. 85) Relief sculpture that is between low relief and high relief in its projection from a surface.

Mode (p. 98) In music, the combination of two *tetrachords*.

Pediment (p. 84) In architecture, any triangular shape surrounded by *cornices*, especially one that surmounts the *entablature* of the *portico façade* of a Greek temple.

Peloponnesian War (p. 81) The war between Athens and its allies and the rest of Greece, led by the Spartans.

Peripteral (p. 84) Having columns on all sides.

Satyr play (p. 99) A lighthearted play; named for the satyr, a mythological figure of a man with an animal's ears and tail.

S curve (p. 108) A double weight shift in Classical sculpture in which the body and posture of a figure form an S shape around an imaginary vertical axis or pole.

Soothsayer (p. 103) A person who can foresee the future.

Sophist (p. 92) A wise man or philosopher, especially one skilled in debating.

Stylobate (p. 86) A continuous base or platform that supports a row of columns.

Theatres (p. 98) A round or oval structure, typically unroofed, having tiers of seats rising gradually from a center stage or arena.

Tholos (p. 109) In architecture, a circular building or a beehive-shaped tomb.

Tetrachord (p. 98) A group of four pitches, the two outer ones a perfect fourth interval apart and the inner ones variably spaced.

Triglyph (p. 85) In architecture, a panel incised with vertical grooves (usually three, hence *tri-*) that serve to divide the scenes in a *Doric* **frieze**.

Trilogy (p. 99) A series of three tragedies.

THE BIG PICTURE CLASSICAL GREECE AND THE HELLENISTIC PERIOD

Language and Literature

- Aeschylus, author of the *Oresteia* trilogy, was awarded the first prize in the drama festival of Dionysus in 458 BCE.
- Sophocles's *Antigone* is performed in 440 BCE
- Sophocles wrote *Oedipus the King* ca. 429 BCE.
- Euripides wrote *The Suppliant Women* ca. 421 BCE.
- Thucydides wrote the *History of the Peloponnesian War* ca. 420–ca. 399 BCE.
- Aristophanes wrote *The Birds* in 414 BCE.
- Aristophanes wrote *Lysistrata* in 411 BCE.

Art, Architecture, and Music

- The introduction of contrapposto in the Kritios Boy, along with the sideward glance of the head, separate the Archaic period from the Classical period of Greek art.
- Myron sculpted the Discobolos (Discus Thrower) ca. 450 BCE.
- Ictinus and Callicrates designed and erected the Parthenon 448 BCE–432 BCE; Phidias completed the Parthenon sculptures.
- Polyclitus created his canon of proportions for statuary, and Ictinus applied mathematical formulas to achieve harmonious temples design. Polyclitus sculpted the Doryphorus ca. 440 BCE.
- Following a sacking by the Persians, Pericles rebuilt the Acropolis.
- Corinthian capitals were introduced in architecture.
- Music dominated dramatic performances ca. 400 BCE. Instrumental music became popular in the fourth century BCE.
- Late Classical sculpture created more realistic portraits of deities and heroes as, for example, in Lysippus's depiction of Hercules as muscled but weary.
- The tholos and other new building forms appear 323 BCE–146 BCE.
- Hellenistic sculpture became yet more realistic, often choosing common people as subjects and portraying violence and emotion. Laocoön and His Sons was sculpted ca. 150 BCE.

Religion and Philosophy

- Socrates (ca. 469 BCE–399 BCE) introduced his dialectic method of inquiry to examine central moral concepts such as the good and justice. He posed series of questions to help people understand their underlying beliefs and challenge them.
- Socrates questioned the apparent Athenian belief that might made right and spoke positively of Athens's enemy Sparta; he was tried and executed in 399 BCE.
- Plato published the *Republic* before 387 BCE; it is a Socratic dialogue which examines the concept of justice and lauds the rule of the philosopher-king.
- Plato founded his Academy in 387 BCE.
- Xenophon chronicled the teachings of Socrates ca. 385 BCE.
- Aristotle (ca. 384–ca. 322 BCE) studied and taught at Plato's Academy
- Aristotle wrote the *Poetics* and *Metaphysics*.
- Aristotle tutored King Philip II's son, Alexander.
- Aristotle founded the Lyceum in 335 BCE.

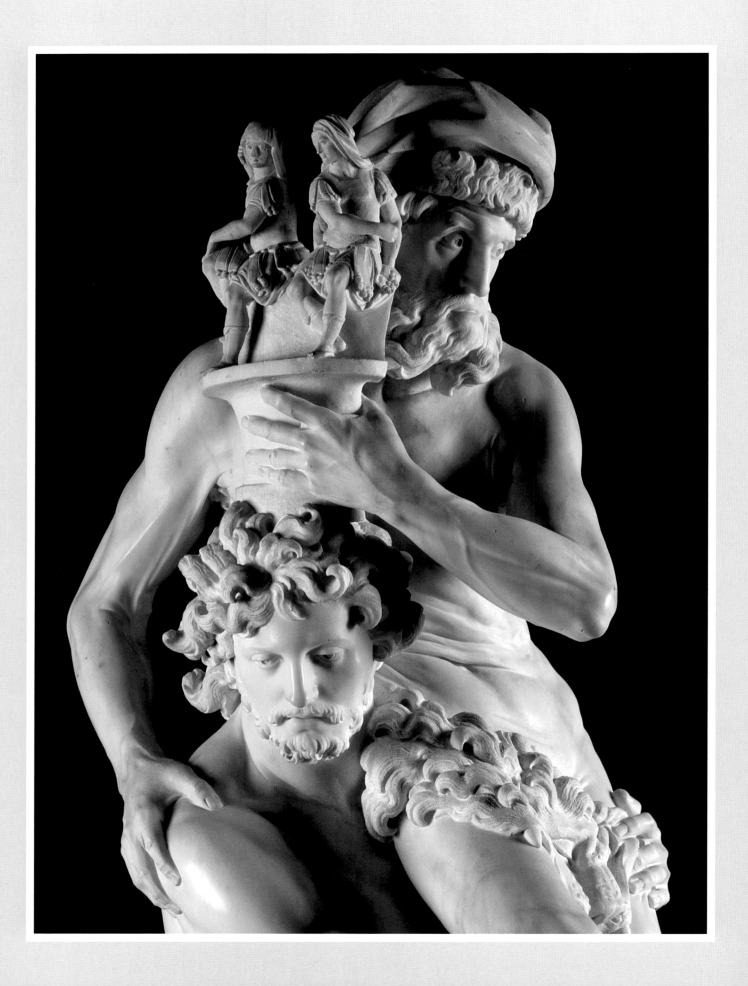

Rome

<div style="text-align: right;">4</div>

PREVIEW

So much of Greek culture was a point of departure for that of Rome. The Greek gods and their temples, art and architecture, drama and poetry all provided a springboard for Roman synthesis, creativity, and innovation. While the legacy of Greece offered precedents, it did not force parameters. Rome was unmistakably Roman.

When the poet Virgil undertook his epic on the founding of Rome, he had ample models from ancient Greece to consider, not the least of which were Homer's own epic narratives—the *Iliad* and the *Odyssey*. In some ways, Virgil's *Aeneid* reflects the themes of those two stories. Aeneas, Virgil's protagonist, was a Trojan prince and warrior who escaped the burning city— after the deadly ruse of the Trojan horse—to face any number of obstacles between him his goal: the founding of a city that would become the centerpiece of a Roman state. But he is neither like Achilles, the brooding hero, nor Odysseus, the long-suffering survivor who prevails in his quest to reach home against all odds. Aeneas, it turns out, is archetypically Roman. His heroism lies not in sacrifices he makes for himself, but in those he makes for the greater good of the generations that will follow him. In the end he loses almost everything—his home, wife, father, his lover, and ultimately his life. Aeneas makes choices that he would prefer not to make, ever mindful of his duty to the gods who have ordained his mission and his responsibility to the future—to something bigger than himself.

In the early seventeenth century, the Italian sculptor Gian Lorenzo Bernini carved the figural group *Aeneas, Anchises, and Ascanius* (left) for his patron, Scipione Cardinal Borghese. Forced to flee the destruction that is Troy, Aeneas carries his aged father on his broad shoulders and keeps his son close. Anchises clutches the household gods protectively while Ascanius, with one arm holding fast to his father's leg, holds on to an oil lamp—keeps a flame—to light their way. The scene from the *Aeneid*, here faithfully depicted, symbolizes the Roman ideal of devotion to the gods, family, and duty. In Aeneas we find the embodiment of Roman virtues: *gravitas*, a seriousness of purpose and sense of responsibility; *pietas*, a dutifulness and devotion to others; *dignitas*, a sense of self-worth; and *virtus*, manliness, courage, and character.

If the origins of our intellectual heritage go back to the Greeks and, less directly, to the peoples of Egypt and the Near East, the contribution of Rome to the wider spreading of Western civilization was tremendous. In language, law, politics, religion, art, and more, Roman culture continues to affect our lives. The road network of modern Europe is based on one planned and built by the Romans some two thousand years ago; the alphabet we use is the Roman

◀ **4.1** Gian Lorenzo Bernini, detail of *Aeneas, Anchises, and Ascanius*, 1618–1619. Marble, 86 5/8" (220.0 cm). Galleria Borghese, Rome, Italy.

alphabet; and the division of the year into twelve months of unequal length is a modified form of the calendar introduced by Julius Caesar in 45 BCE. Even after the fall of the Roman Empire the city of Rome stood for centuries as the symbol of civilization; later empires deliberately shaped themselves on the Roman model.

The enormous impact of Rome on our culture is partly the result of the industrious and determined character of the Romans, who early in their history saw themselves as the divinely appointed rulers of the world. In the course of fulfilling their mission, they spread Roman culture from Britain in the north to Africa in the south, from Spain in the west to Asia in the east (see **Map 4.1**). This Romanization of the entire known world permitted the Romans to disseminate ideas drawn from other cultures. Greek art and literature were handed down and incorporated into the Western tradition through the Romans, not the Greeks. The rapid spread of Christianity in the fourth century CE was a result of the decision by the Roman emperors to adopt it as the official religion of the Roman Empire.

Roman art and literature absorbed and assimilated influences from conquered lands and beyond, and created from them something typically Roman. The **lyric poetry** of first-century-BCE writers like Catullus was inspired by the works of Sappho, Alcaeus, and other Greek poets of the sixth century BCE, but nothing could be more Roman in spirit than Catullus's poems. And while Greece most certainly provided models for Roman buildings and sculptures, Roman engineering and design expanded their architectural vocabulary to create one of the most impressive of our legacies from the ancient world. The study of Roman art, architecture, and drama includes examining the influences on it while recognizing the ways in which the Romans absorbed and combined other ideas in creative and unexpected ways.

Rome's history was a long one, beginning with the foundation of the city in the eighth century BCE. For the first two and one-half centuries, Rome was ruled by kings. The rest of the vast span of Roman history is divided into two periods: Republican Rome (509–27 BCE), during which time democratic government was developed and then allowed to collapse, and Imperial Rome (27 BCE–476 CE), during which the Roman world was ruled, at least in theory, by one man— the emperor. The date 476 CE marks the deposition of the last Roman emperor in the West.

Shortly after the foundation of the Roman Republic, the Romans began their conquest of neighboring peoples, first in Italy, then throughout Europe, Asia, and North Africa. As their territory grew, their civilization developed as well, assimilating the cultures that fell under Roman domination.

THE ETRUSCANS (CA. 700 BCE–89 BCE)

The late eighth century BCE was a time of great activity in Italy. The Greeks had reached the south coast and Sicily. In the valley of the Tiber, farmers and herdsmen of a group of tribes known as the Latins (the origin of the name of the language spoken by the Romans) were establishing small

Rome

700 BCE	89 BCE	509 BCE	27 BCE	337 BCE
THE ETRUSCANS		**REPUBLICAN ROME**	**IMPERIAL ROME**	

THE ETRUSCANS	REPUBLICAN ROME	IMPERIAL ROME
The Etruscans emerge as a culture distinct from the rest of the Italian peninsula, Greece, and the Near East Etruscan Kings rule the region until the Roman Republic is established in 509 Etruscans dominate sea trade in the Mediterranean, exchanging metals and finely painted ceramic ware for foreign goods	The legend of Romulus and Remus places the founding date of Rome at 753 BCE Roman Republic established in 509; beginning of a constitutional government Arts and ideas of various cultures, particularly Greece, impact Roman art and architecture Single, unified code of civil law (jus civile) implemented under Julius Caesar The republic collapses after a civil war that begins with the assassination of Julius Caesar in 44 Octavian defeats forces of Mark Antony and Egypt's Queen Cleopatra; Egypt becomes a Roman province	Roman Senate bestows on Octavian the title of Augustus and powers of emperor; Imperial period begins Augustus establishes a citizen army of half a million soldiers A nexus of roads bring freedom of travel and trade, expanding the economy of the empire The Pax Romana—a period of relative peace—lasts over 200 years, from the time of Augustus to the death of Marcus Aurelius in 180 Mount Vesuvius erupts in 79 CE; Pompeii and Herculaneum buried in volcanic ash Struggles for imperial power and external threats weaken the empire Military spending leads to a decline in the quality of life for Roman citizens

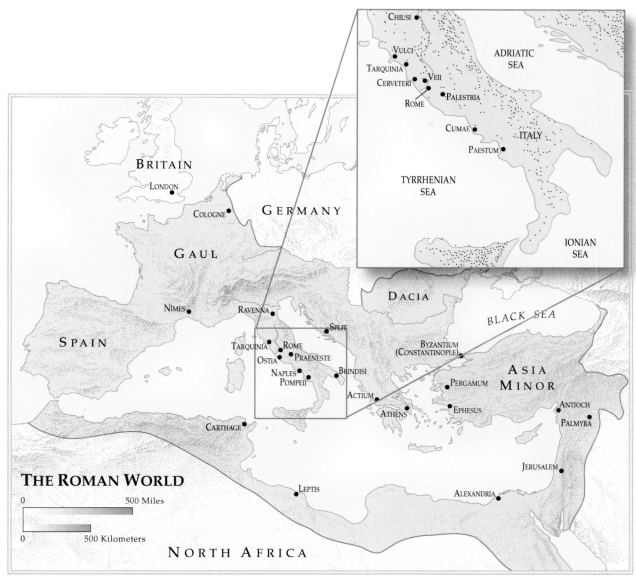

▲ **MAP 4.1 The Roman World**

settlements, one of which was to become the future imperial city of Rome. But in central Italy—in a region named after them called Tuscany—the Etruscan culture was flourishing.

The Etruscans are among the most intriguing of ancient peoples; ever since early Roman times, scholars have argued about who they were, where they came from, and what language they spoke. Even today, despite the discoveries of modern archaeologists, we still know little about the origins of the Etruscans. The ancient Greeks and Romans thought that the Etruscans had come to Italy from the east, perhaps from an ancient kingdom in Asia Minor. Indeed, some aspects of their life and art have pronounced Eastern characteristics. Their language has not yet been deciphered fully, although we know that the Etruscans spoke a non-European language that was written in a script derived from Greek. The longest extant text is the *Liber Linteus* (the *Linen Book*).

It survived because it was cut into strips by Egyptians and used to wrap a mummy.

Etruscan Art and Architecture

The commercial contacts of the Etruscans extended over most of the western Mediterranean; in Italy, Etruscan cities such as Cerveteri and Tarquinia developed rich artistic traditions. Etruscan art is sophisticated in technique and exciting and energetic in appearance. Life-size terra-cotta sculptures, finely crafted bronze objects, and sumptuous gold treasures buried in their tombs all point to superb craftsmanship and material prosperity.

A sense of confidence that one can imagine prevailed among the Etruscans at the peak of their power is exuded in the painted terra-cotta sculpture of the god Apulu known to

How, then, do we know what an Etruscan temple looked like? First, the existing foundations allow us to see the general floor plans (see Figure 4.16). Second, the Roman architect Vitruvius, who wrote on the architecture of his day, provided detailed information about the construction and style of Etruscan temples. The model in (**Fig. 4.3**) is based on Vitruvius's notes.

Just as we can pick out a few similarities between Greek and Etruscan sculpture, Etruscan tombs might appear to us as a throwback to ancient Egypt. Unlike the Greeks who, at the same time, were burying their dead in simple shaft graves, the Etruscans were constructing elaborate tombs that simulated their earthly environments. Carved out of bedrock, the walls of underground tombs were covered with hundreds of everyday items carved in low relief, including kitchen utensils, mirrors, pillows, weapons, and shields. Networks of rooms resemble actual houses, complete with seating on which terra-cotta sculptures of the deceased may have perched. It is as if someone lived there. Completing this picture is a **sarcophagus** with a reclining couple, found in a cemetery in Cerveteri, Italy (**Fig. 4.4**). A husband and wife appear to be at a banquet enjoying the evening's entertainment. He places his arm affectionately around her shoulders and their gestures suggest that they are engaged in lively conversation. The sarcophagus, which contained ashes of the cremated deceased, is unprecedented in the ancient world. And while we do find banquet scenes on Greek pottery, which the Etruscans eagerly imported, we do not see men and women dining together. The sarcophagus bears the unique characteristics of Etruscan sculpture and also suggests the position of Etruscan women relative to other ancient societies: They were participants. They also were more literate, more independent, and of higher legal status.

The vivaciousness of the Etruscan culture can also be seen in vibrant frescoes (**Fig. 4.5**) found on tomb walls. The subject matter, again, references life: scenes of banquets, hunting

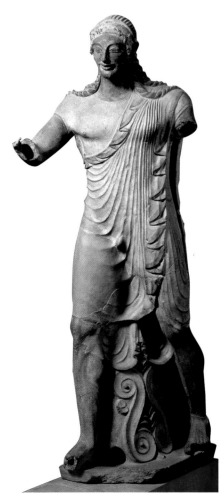

▲ **4.2 Apollo of Veii, ca. 510–500 BCE. From the roof of the Portonaccio Temple, Veii, Italy. Painted terra-cotta, 69″ (175 cm) high. National Etruscan Museum of Villa Giulia, Rome, Italy.** This Etruscan figure, which was originally painted, strides forward energetically, the body clearly visible beneath the drapery. One of Apollo's roles was as god of music, and a lyre—the symbol of music—stands between his legs.

➤ **4.3 Model of a typical Etruscan temple of the 6th century BCE, as described by Vitruvius. Plastic. Istituto di Etruscologia e di Antichità Italiche, Università di Roma, Rome.** Etruscan temples resembled Greek temples but had widely spaced wood columns in the front only, brick walls, and a staircase in the center of the façade.

us as the Apollo of Veii (**Fig. 4.2**). He features several stylistic details that we saw in Archaic Greek art—the zigzag folds of drapery, slight smile, thick-lidded eyes, and eyebrows that come down to form the bridge of the nose—but his gesturing arms and vigorous stride set him apart from the static bodies of the Greek sculptures. We know that the Apollo of Veii would have occupied a prominent place on the rooftop of an Etruscan temple, although none of these structures have survived beyond their foundations, because they were constructed of impermanent materials such as wood and mudbrick.

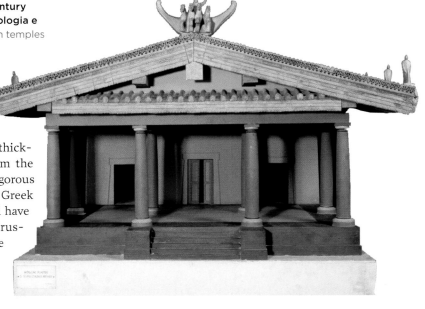

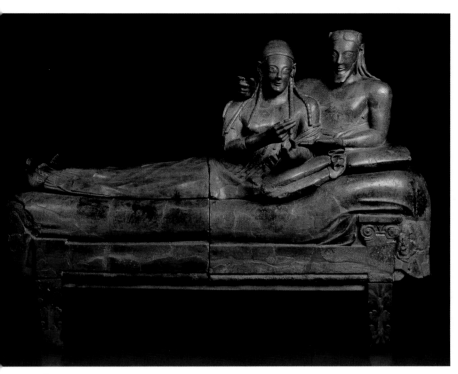

▲ **4.4** Sarcophagus, ca. 520 BCE (Etruscan). Cerveteri, Italy. Terra-cotta, 44⁷⁄₈″ high × 27¹⁄₄″ wide × 74³⁄₈″ long (114 × 134 × 190 cm). National Etruscan Museum of Villa Giulia, Rome, Italy. Sarcophagi in the form of a husband and wife on a dining couch have no parallel in ancient Greece. The artist's focus on the upper half of the figures and the emphatic gestures are Etruscan hallmarks.

▼ **4.5** Etruscan scene of fishing and fowling, ca. 520 BCE. Detail, fresco, 66″ (167.6 cm) high. Tomb of Hunting and Fishing, Tarquinia, Italy. Men, fish, and birds are all rendered naturalistically, with acute observation.

and fishing, music and dancing, and all sorts of sports and athletic competitions. The sheer joyousness of Etruscan art in the heyday of their rule and influence can be contrasted with an Etruscan bronze sculpture, the Capitoline Wolf (**Fig. 4.6**), probably created after the last of the Etruscan kings who ruled Rome was driven from the city in 509 BCE. It became a symbol of the new republic. Even now—as it assuredly did then—the animal's taut muscles, lowered head, piercing eyes, and tooth-bearing grin convey power and fearlessness.

The Capitoline Wolf traditionally has been interpreted as an image of the defiant and protective she-wolf said to have nurtured the abandoned twins Romulus and Remus (the two little suckling babies, however, were created during the Renaissance). One of Rome's foundation myths (the other is the story of Aeneas) holds that Romulus, who killed his brother, went on to found Rome and become its first king in 753 BCE. In actual fact, for a good part of the period between this date and 509 BCE, Rome was little more than a small country town on the Capitoline Hill living under Etruscan rule. The Romans' own grandiose picture of their early days was intended to glamorize its origins, but it was only with the arrival of the Etruscans that it developed into an urban center. Etruscan engineers drained a large marshy area, previously uninhabitable, that became the community's center—the future Roman **Forum**. They built infrastructure—

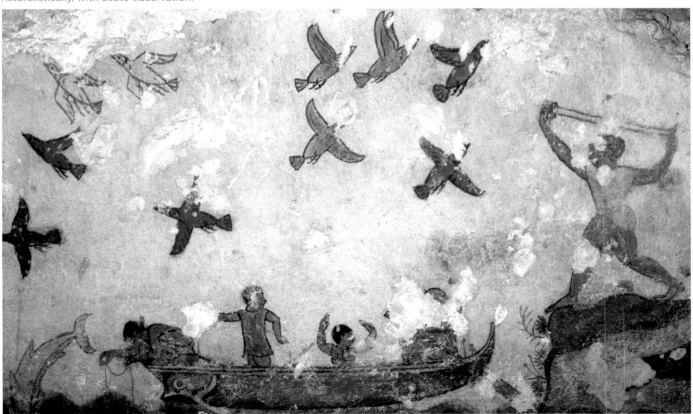

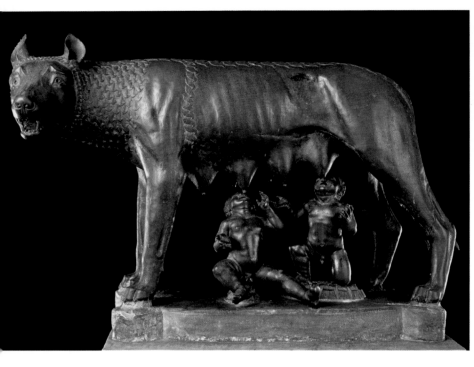

sewers, roads, and bridges—as well as temples, including an enormous one called the Temple of Jupiter Optimus Maximus on the Capitoline Hill.

The Etruscans exerted a strong influence on the development of civilization in Rome and the rest of Italy. Under their rule, the Romans found themselves, for the first time, in contact with the larger world. No longer simple villagers in a small community governed by tribal chiefs, they became part of a large cultural unit with links throughout Italy and abroad. By 509 BCE they had assimilated Etruscan culture, absorbed Etruscan technology, grown powerful enough to overthrow Tarquinius Superbus, the last of the Etruscan kings, and established their own constitutional govern-

◄ **4.6** Capitoline Wolf, ca. 500–480 BCE. Rome, Italy. Bronze, 31½" (80 cm) high. Musei Capitolini, Rome, Italy. An Etruscan sculptor cast this bronze statue of the she-wolf that nursed the infants Romulus and Remus, founders of Rome. The animal has a tense, gaunt body and an unforgettable psychic intensity.

▼ **4.7** Model of Rome during the early 4th century CE. Museo della Civiltà Romana, Rome, Italy. (1) Temple of Portunus, (2) Circus Maximus, (3) Palatine Hill, (4) Temple of Jupiter Capitolinus, (5) Pantheon, (6) Column of Trajan, (7) Forum of Trajan, (8) Markets of Trajan, (9) Forum of Julius Caesar, (10) Forum of Augustus, (11) Forum Romanum, (12) Basilica Nova, (13) Arch of Titus, (14) Temple of Venus and Roma, (15) Arch of Constantine, (16) Colossus of Nero, (17) Colosseum. By the time of Constantine, the city of Rome was densely packed with temples, forums, triumphal arches, theaters, baths, racetracks, aqueducts, markets, private homes, and apartment houses.

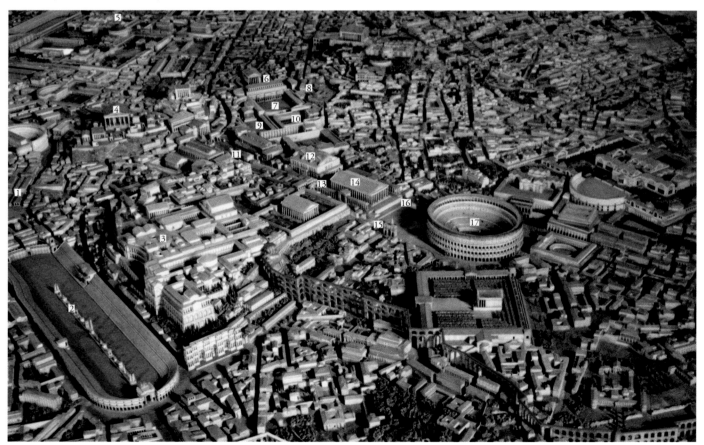

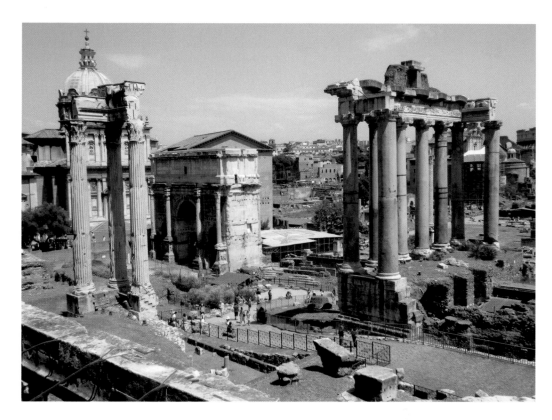

◄ **4.8 Ruins of the Roman Forum, Italy.** As the center of the evolving political, economic, and religious life of the Roman world, the Forum's buildings were constructed over a period of more than a thousand years.

ment—their republic. What followed was the conquering of one Etruscan city after the next and, with those military victories, the appropriation of more and more territory on the Italian peninsula. By 89 BCE, all of Italy was in control of the Romans. Etruscans were granted the right of Roman citizenship and were assimilated into the Roman state.

By the reign of the emperor Constantine in the fourth century CE, the roots of the city of Rome would be unrecognizable. A model of the city (**Fig. 4.7**) shows a dense urban landscape that gives the appearance of mostly haphazard growth. The cluster of huts that once occupied the Palatine Hill (no. 3) and overlooked swampland have been replaced with imposing buildings that seem to preside over the social and religious life of the city and the political affairs of an empire. From this aerial perspective, we can pick out temples here and there that seem at least to have been inspired by Greek architecture (no. 14, for example) and one that seems completely Roman (no. 5; and **Fig. 4.34**) we can see what appear to be two sports facilities not unlike ones in or near our cities today—the *Colosseum* (no. 17 and **Fig. 4.30**, site of the infamous gladiator games) and the Cir-

cus Maximus (no. 2, a chariot-racing stadium that looks a bit like a present-day racetrack); large rectangular spaces for public gathering (fora; singular, *forum*) that were the centers of Roman life, politics, and commerce (nos. 7, 9, 10, and 11; **Fig. 4.8** and **Fig. 4.36**); and the *Markets of Trajan* (no. 8; and **Fig. 4.9**), the equivalent of a mall that had offices and shops on several floors. We can imagine this marketplace teeming

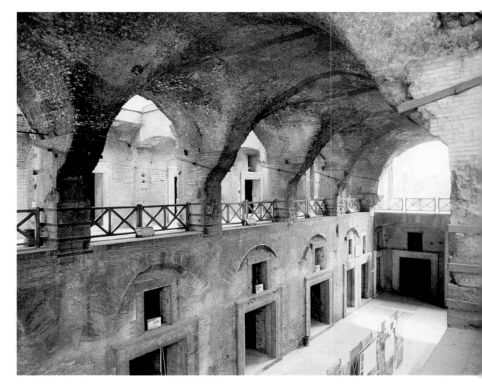

➤ **4.9 Apollodorus of Damascus, interior of the great hall, Markets of Trajan, ca. 100–112 CE. Rome, Italy.** The great hall of Trajan's Markets resembles a modern shopping mall. It housed two floors of shops, with the upper ones set back and lit by skylights. Concrete groin vaults cover the central space.

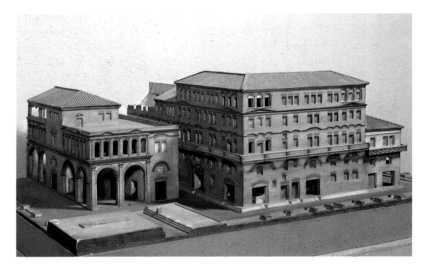

◄ **4.10** Model reconstruction of a Roman apartment block, 2nd century CE. Museo della Civiltà Romana, Rome, Italy Shown here is a reconstruction of an *insula*—a multistory, brick-faced, concrete apartment house in Ostia, the seaport of ancient Rome. As can be seen from the size of the windows, the ground floor, which was intended for shops, was more spacious, with higher ceilings. The apartments on the floors above were cramped; few had private toilet facilities.

with people who dwelled in the crowded city, some in multi-story apartment buildings that, like today, made the most of dwindling patches of available land (**Fig. 4.10**).

Imagine also the celebrated homecomings of victorious generals who led courageous campaigns to vanquish Rome's enemies, secure the peace, and expand the empire. A main road, the Via Sacra, ran from the Capitoline Hill down into the forum area and was, among other things, the traditional parade route of the Roman Triumph, an annual ceremony that honored military successes—particularly ones in foreign lands. Monuments such as the *Arch of Titus* (no. 13; and **Fig. 4.11**) were constructed along the Via Sacra. This **triumphal arch** glorified Titus's conquest of Judaea; relief sculptures on the inside of the archway depict his armies carrying spoils from Jerusalem to Rome—including a *menorah*, a sacred Jewish candelabra. The design of the triumphal arch inspired many imitators, including the French emperor Napoléon Bonaparte, who in the early nineteenth century commissioned a triumphal arch in Paris to honor those who died in the French Revolution and the Napoleonic Wars. Before Napoléon's remains were placed in a tomb, they were carried under the arch.

The model of the city transports us to Rome in the fourth century CE, but the story of Rome as its own republic begins about eight centuries earlier.

REPUBLICAN ROME (509 BCE–27 BCE)

Rome initially constituted itself as a republic, governed by the people somewhat along the lines of the Greek city-states. Two chief magistrates, or *consuls*, were elected for a one-year term by all male citizens, but the principal assembly, the Senate, drew most of its members from Roman aristocratic families. Therefore, power was concentrated in the hands of the upper class, the **patricians**, although a lower class of free Roman citizens, called **plebeians**, were permitted to form their own assembly. Plebeians could become

influential and wealthy but for many years were prohibited from intermarrying with patricians. They also served in the military, and once elected to the Plebeian Council, they became **tribunes** who could propose legislation, represent plebeians' interests, and protect plebeians from state officials who treated them unjustly. The meeting place for both the Senate and the assembly of the people was the forum.

From the founding of the Roman Republic to its bloody end in the civil wars following the assassination of Julius

▼ **4.11** Arch of Titus, 81 CE. Rome, Italy. Roman arches commemorated victories by successful generals. This arch celebrates the victory of Titus, son of the reigning emperor Vespasian, over the Jews in 70 CE—a victory that saw the destruction of Solomon's Temple when Titus's army captured the city of Jerusalem. While early Imperial arches resembled this one, those built later generally had a large central arch flanked by two smaller ones.

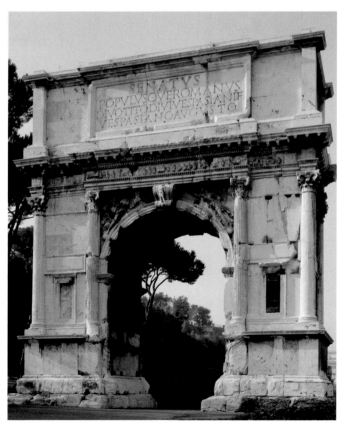

Caesar (44 BCE), Rome's history was dominated by agitation for political equality. Yet the first major confrontation—the conflict between patricians and plebeians—never seriously endangered political stability in Rome or military campaigns abroad. Both sides showed flexibility and a spirit of compromise that produced gradual growth in plebeian power while avoiding any dissension great enough to interrupt Rome's expansion throughout the Italian peninsula. The final plebeian victory came in 287 BCE, with passage of a law that made the decisions of the plebeian assembly binding on the entire Senate and Roman people.

Increasing power brought new problems. In the third and second centuries BCE, Rome began to build its empire abroad. Rome came into conflict with the city of Carthage, which was founded by the Phoenicians around 800 BCE and by the third century had become the independent ruler of territories in North Africa, Spain, and Sicily. The Romans defeated the Carthaginians in the Punic Wars (after the Roman name for the Phoenicians, *Poeni*) and confiscated their territories. By the first century BCE, the entire Hellenistic world was in Roman hands. From Spain to the Near East stretched a vast territory consisting of subject provinces, protectorates, and nominally free kingdoms, all of which depended on Roman goodwill and administrative efficiency.

It turned out that the Romans were better at expanding their empire than governing it. Provincial administration could be incompetent and corrupt. The long series of wars had hardened the Roman character, leading to insensitivity and, frequently, brutality in the treatment of conquered peoples. The quelling of chaos abroad was not abetted by growing political instability at home. The balance of power struck between the patricians and plebeians was being increasingly disrupted by the rise of a middle class, the *equites*, many of whom were plebeians who had made their fortunes in the wars. Against this backdrop, bitter struggles eventually led to the collapse of the Republic.

The political system that had been devised for a thriving but small city five hundred years earlier was inadequate for a vast empire. Discontent among Rome's Italian allies led to open revolt. Although the Romans were victorious in the Social War of 90–88 BCE, the cost in lives and economic stability was significant. The ineffectuality of the Senate and the frustration of the Roman people led to struggles among statesmen for power. The struggles culminated in a series of civil wars leading to the emergence of Julius Caesar as dictator in 45 BCE, only to be assassinated a year later on the Ides of March (March 15), 44 BCE. Another series of civil wars that followed Caesar's death led to the end of the republic and the beginning of the empire.

Republican Literature

The Republican era is characterized by a diversity of literary genres, from historical commentaries and narratives to treatises on Roman values; from comedic farces to poems of love.

JULIUS CAESAR Julius Caesar (100–44 BCE)—brilliant politician, skilled general, expert administrator and organizer—wrote the history of his military campaigns in his *Commentaries*. His style is straightforward but gripping, and some of his one-liners have become iconic: "Veni, vidi, vici" ("I came, I saw, I conquered") is Caesar's succinct summation of a victory following a battle that lasted only four hours. That battle was only one in a protracted series of civil wars. A few years before Caesar became dictator of Rome, he battled his political-partner-turned-rival, Pompey (Gnaeus Pompeius). In early passages describing the campaign, Caesar writes that the success of his forces is thwarted by his opponent's treachery and by natural obstacles such as floods. But passages 61–72 describe a fast-paced turnaround in 49 BCE, with Pompey's army retreating. Note how Caesar refers to himself in the third person, as "Caesar" and "he" not as "I."

READING 4.1 JULIUS CAESAR

Commentaries on the Civil Wars (De bello civili), **book 1, passage 64 (45 BCE)**

At break of day, it was perceived from the rising grounds which joined Caesar's camp, that their rear was vigorously pressed by our horse; that the last line sometimes halted and was broken; at other times, that they joined battle and that our men were beaten back by a general charge of their cohorts, and, in their turn, pursued them when they wheeled about: but through the whole camp the soldiers gathered in parties, and declared their chagrin that the enemy had been suffered to escape from their hands and that the war had been unnecessarily protracted. They applied to their tribunes and centurions, and entreated them to inform Caesar that he need not spare their labor or consider their danger; that they were ready and able, and would venture to ford the river where the horse had crossed. Caesar, encouraged by their zeal and importunity, though he felt reluctant to expose his army to a river so exceedingly large, yet judged it prudent to attempt it and make a trial. Accordingly, he ordered all the weaker soldiers, whose spirit or strength seemed unequal to the fatigue, to be selected from each century, and left them, with one legion besides, to guard the camp: the rest of the legions he drew out without any baggage, and, having disposed a great number of horses in the river, above and below the ford, he led his army over. A few of his soldiers being carried away by the force of the current, were stopped by the horse and taken up, and not a man perished. His army being safe on the opposite bank, he drew out his forces and resolved to lead them forward in three battalions: and so great was the ardor of the soldiers that, notwithstanding the addition of a circuit of six miles and a considerable delay in fording the river, before the ninth hour of the day they came up with those who had set out at the third watch.

CICERO Perhaps the most endearing figure of the late republic was Marcus Tullius Cicero (106–43 BCE), who first

made his reputation as a lawyer. He is certainly the figure of this period about whom we know the most, for he took part in several important legal cases before embarking on a political career. In 63 BCE he served as consul, during which time he put down a plot against the government. The severity with which he went about it, however, earned him a short period in exile thanks to the scheming of a rival political faction. Cicero returned to Rome in triumph however, and became involved once again in power and politics. He took the side of Pompey in the struggle for power between him and Caesar—ultimately the wrong bet, although Caesar seems to have forgiven him. In spite of Cicero's admiration for Caesar's abilities, he never really trusted the dictator.

Cicero is best known to history as one of its greatest orators, although Cicero himself thought that his greatest accomplishments were in the political realm. He was also a writer. Cicero's *On Duties* comprises several books of letters that reflect on individual character and the responsibility of citizens to each other and the state.

READING 4.2 CICERO

On Duties, book 3, passages 5 and 6

Hercules denied himself and underwent toil and tribulation for the world, and, out of gratitude for his services, popular belief has given him a place in the council of the gods. The better and more noble, therefore, the character with which a man is endowed, the more does he prefer the life of service to the life of pleasure. Whence it follows that man, if he is obedient to Nature, cannot do harm to his fellow-man. Finally, if a man wrongs his neighbor to gain some advantage for himself he must either imagine that he is not acting in defiance of Nature or he must believe that death, poverty, pain, or even the loss of children, kinsmen, or friends, is more to be shunned than an act of injustice against another. If he thinks he is not violating the laws of Nature, when he wrongs his fellow-men, how is one to argue with the individual who takes away from man all that makes him man? But if he believes that, while such a course should be avoided, the other alternatives are much worse—namely, death, poverty, pain—he is mistaken in thinking that any ills affecting either his person or his property are more serious than those affecting his soul. This, then, ought to be the chief end of all men, to make the interest of each individual and of the whole body politic identical. For, if the individual appropriates to selfish ends what should be devoted to the common good, all human fellowship will be destroyed.

From letters such as these, we can derive a vivid picture of Cicero and of Rome, its ideas, and ideals. Almost nine hundred letters were published, most after his death. While they reveal Cicero's human frailties—his vanity, indecisiveness, and stubbornness—they also confirm his humanity, sensitivity, and sense of justice.

Conquest brought the Romans into contact with myriad cultures, the most influential among them Greece. Roman dramatic literature followed that of the Greeks in terms of form and content as far back as the third century BCE. Ennius (239–169 BCE), who was later described as the father of Roman poetry, appears to have adapted Greek models for his tragedies, although almost all of his works are lost. His *Annals*, an epic chronicle of the history of Rome, represents the first time a Greek metrical scheme was used to write Latin verse.

When educated Romans of the late republic stopped to think about something other than history and politics, it was likely to be laughs and love. The first Roman works to have survived in quantity were written by two comic playwrights—Plautus (ca. 254–184 BCE) and Terence (ca. 195/185–159 BCE). Their plays are adaptations of Greek comedies; whereas the Greek originals are comic satires, the Roman versions turn human foibles into almost slapstick comedy. Plautus, the more boisterous of the two, is known for humorous songs and farcical intrigues. Terence's style is more balanced and refined, and his characters show greater realism. It says something about the taste of the Roman public, however, that Plautus was by far the more successful of the two. Both authors were fond of elaborate, convoluted plots built around nonsense, like mass confusion caused by mistaken identities that sort themselves out in the end.

CATULLUS Roman lyric poetry featured romantic themes such as the love affair charted by Rome's first great lyric poet, Catullus (ca. 84–54 BCE) Inspired by Sappho of Lésbos, Catullus's poem "Lesbia" is one of twenty-five short poems describing the course of his ill-fated relationship, ranging from the ecstasy of its early stages to the disillusionment and despair of the final breakup. The clarity of his style is the perfect counterpart to the direct expression of his emotions. These poems, personal though they are, are not simply an outpouring of feelings. Catullus makes his own experiences universal. However trivial one man's unhappy love affair may seem in the context of the grim world of the late republic, Lesbia's inconstancy has achieved a timelessness unequaled by many more serious events.

READING 4.3 CATULLUS

Lyrics to his lover Lesbia

Lyric 5[1]

My sweetest Lesbia, let us live and love;
And though the sager sort our deeds reprove,
Let us not weigh them. Heaven's great lamps do dive
Into their west, and straight again revive,
But soon as once is set our little light,
Then must we sleep one ever-during night.

Give me a thousand kisses, then a hundred.
Then, another thousand, and a second hundred.
Then, yet another thousand, and a hundred.
Then, when we have counted up many thousands,

Let us shake the abacus, so that no one may know the number,
And become jealous when they see
How many kisses we have shared.

But then Lesbia rejects Catullus, and he undergoes fits of frustration and indignation, which he variously describes as the tragedy of his soul or the history of his heart. There are some 20 Lesbia poems, and through them the reader can follow Catullus's initial homage and rapture through to his doubts—can love be lost?—and ultimate repulsion. In Lyric 8, the poet calls on himself to admit that the affair is over. Catullus would later write an epigram which illuminates the struggle within between his old feelings of love and his newly developing emotion of hate:

Odi et amo

Can Love breed hate, Hate love? Ah, who shall say?[2]
And yet I feel it . . . and have torment aye.

Roman Philosophy

Stoicism, which originated in ancient Greece, was the most important school of philosophy in Rome. It was founded by the Greek philosopher Zeno (ca. 335–263 BCE) who met with his followers in **stoas** (hence the name *Stoicism*). Noted Roman Stoics include Cicero, Seneca (ca. 4 BCE–65 CE), Epictetus (ca. 55–135 CE), and Marcus Aurelius (121–180 CE). Stoicism was appealing to Romans because it advocated acceptance of all situations, including hardships, thus reinforcing the Roman virtues of manliness and courage.

The stoics taught that the universe was ordered by the gods, which gave it its *Logos*—that is, its moving spirit or meaning. Stoics believed that they could not change the course of tragic events, but they could psychologically distance themselves from them by controlling their attitudes toward them. Politically, providence and natural law meant that the Roman Empire was destined to spread throughout the world by means of assimilation or conquest. The loss of individual lives in that conquest was for the greater good and should be accepted as inevitable. Foot-soldiers, farmers, philosophers, and emperors all contributed to the empire in their own way. All were part of the whole.

Epicureanism was also popular, although not as agreeable to the Roman palate as stoicism. It spread from Greece to Rome, where it survived into the latter part of the second century CE. Epicureanism was appealing because of its recognition that natural desires must be satisfied to lead a pleasant life. The Epicureans looked upon death as being a passing event without great meaning, a view that was also voiced by many philosophers in Rome, including, as we shall see, Lucretius, a follower of atomic theory, and an emperor, Marcus Aurelius.

Another school of thought, **Neo-Platonism**, came into being in places in the empire in the century following Marcus Aurelius. Many of its concepts would pave the way for the further development of Judaism, Christianity, and Islam.

EPICUREANISM According to Epicurus (341–271 BCE), the founder of the school (Epicureanism), the correct goal and principle of human actions is pleasure. However, Epicurus is commonly misunderstood. He believed that it was wise to seek pleasure and avoid pain, but reason is also required. We must sometimes endure pain to achieve happiness, and at other times, the pleasures of the moment can lead to prolonged suffering.

Although Epicureanism stresses moderation and prudence in the pursuit of pleasure, many Romans thought of the philosophy as a "typically Greek" enthusiasm for self-indulgence and debauchery. As a result, Epicureanism never really gained many followers, despite the efforts of the Roman poet Lucretius (99–55 BCE), who described its doctrines in his poem *On the Nature of Things* (*De rerum natura*), a remarkable synthesis of poetry and philosophy. Lucretius emphasized the intellectual and rational aspects of Epicureanism. As we see in the following passage, Reading 4.4, the principal teaching of Epicureanism was that the gods, if they exist, play no part in human affairs or in the phenomena of nature.

READING 4.4 LUCRETIUS

On the Nature of Things (50 BCE), from Book V

Thou canst ne'er
Believe the sacred seats of gods are here
In any regions of this mundane world;
Indeed, the nature of the gods, so subtle,
So far removed from these our senses, scarce
Is seen even by intelligence of mind.
And since they've ever eluded touch and thrust
Of human hands, they cannot reach to grasp
Aught tangible to us. For what may not
Itself be touched in turn can never touch.

We can therefore live our lives free from superstitious fear of the unknown and the threat of divine retribution. The Epicurean theory of matter explains the world in physical terms. It describes the universe as made up of small particles of matter, or atoms, and empty space. So far it sounds consistent with modern science. But Lucretius also believed that atoms are solid and can be neither split nor destroyed. We now know that atoms themselves consist mostly of space and that they can be split, as in nuclear fission. Epicureans taught that atoms coalesced to form complex structures (we would call them molecules) as a result of random swerving in space, without interference from the gods. As a result, human life can be lived in complete freedom; we can face the challenges of existence and even natural disasters like earthquakes or plagues with serenity, because their occurrence is beyond our control. According to Epicurus, at death the atoms that

1. Trans. Thomas Campion, English composer, poet, and physician, 1601.

2. Trans. D. A. Slater. In "The Poetry of Catullus." A Lecture Delivered to the Manchester Branch of the Classical Association on February 2nd, 1912. Manchester University Press, 1912.

compose our bodies separate such that body, mind, and soul are lost. Because we are not immortal, we should have no fear of death; death offers no threat of punishment in a future world but rather brings only the ending of sensation.

STOICISM The Stoics taught that the world was governed by Reason, and that Divine Providence watched over the virtuous, never allowing them to suffer evil. The key to virtue lay in willing or desiring only that which was under one's own control. Thus riches, power, or even physical health—all subject to the whims of Fortune—were excluded as objects of desire.

Although Stoicism had already won a following at Rome by the first century BCE and was discussed by Cicero in his philosophical writings, its chief literary exponents came slightly later. The philosophy of the stoic Lucius Annaeus Seneca (ca. 4 BCE–65 CE), known as Seneca the Younger, is encapsulated in his many proverbs, such as "It is not because things are difficult that we do not dare, it is because we do not dare that they are difficult" or "Calamity is virtue's opportunity." Seneca was born in southern Spain, the son of a wealthy rhetorician, but was educated in Rome, where he would become a dramatist, essayist, philosopher, and powerful statesman. He counseled that in order to achieve peace of mind, human beings should avoid burdens and anxieties, remain of modest means, and essentially take in stride whatever comes along. He sets down his views in his dialogue *On the Tranquility of Mind*.

> **READING 4.5 SENECA**
>
> ***On the Tranquility of Mind***
>
> All life is bondage. Man must therefore habituate himself to his condition, complain of it as little as possible, and grasp whatever good lies within his reach. No situation is so harsh that a dispassionate mind cannot find some consolation in it. If a man lays even a very small area out skillfully it will provide ample space for many uses, and even a foothold can be made livable by deft arrangement. Apply good sense to your problems; the hard can be softened, the narrow widened, and the heavy made lighter by the skillful bearer.

Despite this Stoic wisdom, Seneca himself became deeply involved in political intrigues and grew fabulously wealthy. He was implicated in a plot to kill the emperor Nero—his former student—and ordered by Nero to kill himself. A bitter irony, one of Seneca's most well known proverbs reads: "There has never been any great genius without a spice of madness (Latin: *Nullum magnum ingenium sine mixtura dementiae fuit*; *On the Tranquility of Mind* 17.10).

The writings of the Stoic philosopher Epictetus—a Greek slave born in present-day Turkey who obtained his freedom and taught philosophy in Rome—would have a significant impact on the emperor Marcus Aurelius. He embraced the teachings of Epictetus and, as we shall see, incorporated the tenets of Stoicism in his own writings. An excerpt from Epictetus's *Encheiridion* explains his basic Stoic ideas, namely that there are things subject to our power (such as judgment, desire, and impulse) and those things that are not (such as health). Humans differ from other creatures in that we can make judgments as to what to seek and what to avoid. However, good and evil reside in our judgment only, not in external things. The student who grasps these principles can find a serene state of mind—fulfillment and contentment—that reflects the predetermined and fixed order of the universe.

> **READING 4.6 EPICTETUS**
>
> ***Enchiridion***
>
> It is not the things themselves that disturb men, but their judgments about these things. For example, death is nothing dreadful, or else Socrates too would have thought so, but the judgment that death is dreadful, this is the dreadful thing. When, therefore, we are hindered, or disturbed, or grieved, let us never blame anyone but ourselves, that means, our own judgments.

Shakespeare would later have Hamlet say, "for there is nothing either good or bad, but thinking makes it so" (*Hamlet*, 2.2).

Marcus Aurelius, whose full name was Marcus Aurelius Antoninus Augustus, occupies a unique place in history as a Roman soldier and emperor and as a Stoic philosopher. He wrote his powerful *Meditations* while on one of the seemingly endless military campaigns that defined his reign, from 170–180 CE. It is a spiritual guide to self-improvement inscribed by a man who believed that death was final.

> **READING 4.7 MARCUS AURELIUS**
>
> ***Meditations***
>
> We live for an instant [but to be swallowed in] complete forgetfulness and the void of infinite time. . . . Of the life of man the duration is but a point, its substance streaming away, its perception dim, the fabric of the entire body prone to decay, and the soul a vortex, fortune incalculable and fame uncertain. In a word all things of the body are as a river, and the things of the soul as a dream and a vapor. [It matters not how long one lives,] for look at the yawning gulf of time behind thee and before thee at another infinity to come. In this eternity the life of a baby of three days and [a span] of three centuries are as one.

The *Meditations* have been described as an infinitely tender work written by a professional, hardened soldier who

never asked why events were as ugly as they were or whether it was right that there should be such pain in the world. The world was as it was; it had always been that way, and one could only choose one's attitude toward it. "A cucumber is bitter," he wrote. "Throw it away. There are briars in the road. Turn aside from them. This is enough. Do not add, 'And why were such things made in the world?'"

NEO-PLATONISM In the century following the life of Marcus Aurelius, there gathered in Rome a school of religious and mystical philosophers—including the Egyptian Plotinus (ca. 205–270 CE)—who called themselves Platonists. Although they saw themselves as following in the footsteps of Plato, they diverged sufficiently enough from their source that they are now more appropriately called Neo-Platonists. The teachings of Plotinus, the father of Neo-Platonism, are found in his six *Enneads*, assembled by a pupil who also penned the philosopher's biography.

Neo-Platonists adopted the concept of the One as defined in Plato's *Timaeus*. Plotinus taught that the One was a transcendent and unknowable being who had created life and, unlike Greek and Roman gods who were capable of whimsical and amoral behavior, was good. Neo-Platonists taught that humans had a soul (Plotinus spoke of being ashamed that his immortal soul had been born into a mortal body) that returned to the One—the source—upon death. But the Neo-Platonists had no universally agreed-upon description of the One. When it came to what happens to the soul after the death of the body, some imagined something akin to a heaven, others spoke of reincarnation, and still others spoke of spending eternity with the ancient Greek heroes in Hades (the ideal of Socrates) or of suffering eternal punishment in a hell. Later, Neo-Platonic philosophers set the stage for divine or semidivine creatures such as angels and demons that mediate between the One and human beings. Neo-Platonic philosophy had a profound influence on Christian thinkers such as Augustine, Islamic scholars such as al-Farabi, and Jewish philosophers such as Maimonides.

Roman Law

Among the most lasting achievements of Julius Caesar's dictatorship and of Roman culture in general was the creation of a single unified code of civil law: the **jus civile**. The science of law is one of the few original creations of Roman literature. The earliest legal code of the republic was the so-called Law of the Twelve Tables of 451–450 BCE. By the time of Caesar, however, most of this law had become either irrelevant or outdated and been replaced by a mass of later legislation, much of it contradictory and confusing. Caesar's jus civile, produced with the help of eminent legal experts of the day, served as the model for later times, receiving its final form in 533 CE when it was collected, edited, and published by the Byzantine emperor Justinian (482–565 CE).

Justinian's Corpus Juris Civilis remained in use in many parts of Europe for centuries and profoundly influenced the development of modern legal systems. Today, millions of people live in countries whose legal systems derive from that of ancient Rome; one eminent British judge has observed of Roman law that "there is not a problem of jurisprudence which it does not touch: there is scarcely a corner of political science on which its light has not fallen."[3] According to the great Roman lawyer Ulpian (died 228 CE), "Law is the art of the good and the fair." The Romans developed this art over the centuries during which they built up their empire of widely differing peoples. Roman law was international, adapting Roman notions of law and order to local conditions, and changing and developing in the process. Many of the jurists responsible for establishing legal principles had practical administrative experience from serving in the provinces. Legal experts were in great demand at Rome; the state encouraged public service, and problems of home and provincial government frequently occupied the best minds of the day. Many of these jurists acquired widespread reputations for wisdom and integrity. Emperor Augustus gave to some of them the right to issue "authoritative opinions," while a century or so later, Emperor Hadrian formed a judicial council to guide him in matters of law. Their general aim was to equate human law with that of Nature by developing an objective system of natural justice. By using this system, the emperor could fulfill his duty to serve his subjects as benefactor and bring all peoples together under a single government.

Thus, over the centuries, the Romans built up a body of legal opinion that was comprehensive, concerned with absolute and eternal values, and valid for all times and places; at its heart lay the principle of "equity"—equality for all. By the time Justinian produced his codification, he was able to draw on a thousand years of practical wisdom.

Roman Religion

Rome was home to a religion resplendent with a multitude of gods bequeathed by numerous cultures, among them the Etruscans and the Greeks (**Fig. 4.12**). According to Roman mythology, a king of Rome purchased books of prophecies from the Cumaean sibyl, who was consulted by Aeneas before he descended to the underworld (*Aeneid*, book 6, line 10).

The Sibylline Books were written in Greek hexameter and kept in the temple of Jupiter Capitolinus (that is, on the Capitol Hill in Rome). The books were consulted at times of great peril, such as plague or invasion. Directed by the prophecies in the volumes, Romans made sacrifices to ward off

3. Viscount James Bryce, *Studies in History and Jurisprudence, Vol. II.* New York: Oxford University Press, 1901, p. 896.

disaster. Such was the nature of superstition among the Romans, who believed that all events were pre-ordained and that it was necessary for humans to placate gods who could be as changeable in mood as the weather.

The Romans devoured the Greek gods along with Greek literature, sculpture, and architecture. It was a cultural and religious feeding frenzy. In religion, the Romans may have imported the Greek gods from Mount Olympus, but they constructed temples for them everywhere. The Greeks could never have imagined the building boom they inspired throughout the empire, and how their gods would be integrated with dozens of lesser ones, along with emperors who were deified after death. The Romans also worshipped household deities (we saw that Anchises carried statues of their own from Troy to Rome) and ones that would guide and protect them when they went out the door and into the streets. A festival called the *Compitalia* was celebrated annually in honor of the gods of the crossroads—that is, intersections—because in Roman times, such meetings were symbolic of many possibilities, of positive prospects and dangers alike.

The Romans had so many gods and goddesses that in some instances they might even forget why they were worshipping them at all. By the time of Julius Caesar, for example, no one could remember who the goddess Furrina was or why she was celebrated or petitioned for advice or favors. This lapse of communal memory, however, did not prevent the Romans from holding a festival in her honor. The Roman calendar was filled with festivals. Life had its problems, but Romans knew how to have a good time.

For centuries, the Romans were tolerant of the local religions of the peoples whom they conquered or otherwise brought into the empire. In the case of Christianity, a period of persecution was followed by the emperor Constantine's

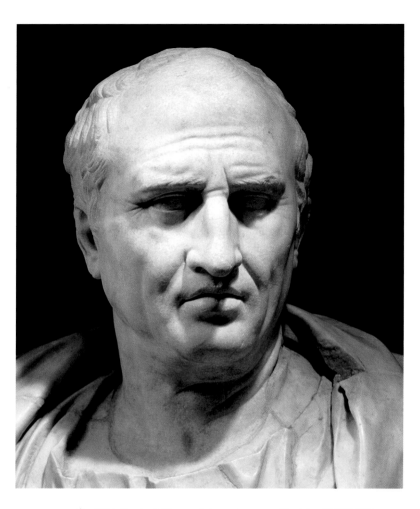

▲ **4.13** Bust of Cicero, 1st century BCE. Marble, 36½" (93 cm). Museo Capitolino, Rome, Italy. This portrait of one of the leading figures of the late republic suggests the ability of Roman sculptors of the period to capture both likeness and character. Cicero is portrayed as thoughtful and preoccupied.

conversion and Christianity's becoming the official religion of Rome. The Romans were generally tolerant for practical reasons. Running a far-flung empire was a spotty business; as long as the locals paid tribute, provided soldiers for the Roman army, and stirred up no trouble, Rome was usually—but not always—content. For example, at the trial of Jesus, the Roman governor of Judaea, Pontius Pilate, may have been as concerned with smothering political instability as with religious differences.

Roman notions of an afterlife varied, from the Greek-style view of an underworld ruled by Pluto to a pre-Christian view of body—soul dualism.

Republican Art and Architecture

During the Republican period, the visual arts and architecture bore the marks of both the Greek and Etruscan styles. As the Romans pushed beyond Italy in their conquests, their exposure to Greek art in particular broadened their cultural horizons. Greece became a province of Rome in 146 BCE and

▼ **4.12** **Etruscan, Greek, and Roman Counterparts of Gods and Heroes.**

ETRUSCAN	GREEK	ROMAN
Tinia	Zeus	Jupiter
Uni	Hera	Juno
Menrva	Athena	Minerva
Apulu	Apollo	Apollo
Artumes	Artemis	Diana
Laran	Ares	Mars
Sethlans	Hephaestus	Vulcan
Aita	Hades	Pluto
Turms	Hermes	Mercury
Nethuns	Poseidon	Neptune
Turan	Aphrodite	Venus
Hercle	Herakles	Hercules

all things Greek became fashionable and highly sought after. That said, older Etruscan works continued to influence Roman artists.

In many respects, portraiture represents Roman art at its most creative and sensitive. It certainly opened up new expressive possibilities, as artists discovered how to use physical appearance to convey something more about the sitter. Many of the best Roman portraits serve as revealing psychological documents; painstaking realistic details convincingly capture outer appearances at the same time that they suggest inner character. In the bust of Cicero (**Fig. 4.13**) we see a balding older man whose furrowed brow and wrinkles around deep-set eyes suggest that this is an individual who has lived through a lot. Yet in his soft cheeks with their chiseled laugh lines we detect an element of sensitivity and humanity. Subtly parted lips remind us that Cicero was renowned for his skills as an orator. Romans in the Republican period were fond of this "warts and all" superrealistic style and understood the power

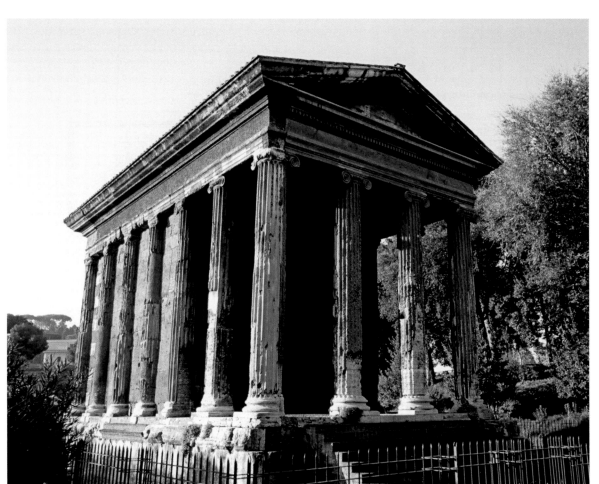

◄ **4.14 Denarius with portrait of Julius Caesar, 44 BCE. Silver, ³/₄″ diameter. American Numismatic Society, New York.** Julius Caesar was the first to place his own portrait on Roman coinage during his lifetime. This denarius, issued just before his assassination, shows the dictator with a deeply lined face and neck.

of this art form to convey a specific message about the subject. Politicians and statesmen learned that they could project a carefully constructed self-image through their portraits. Julius Caesar certainly realized this when he issued silver coins bearing his profile along with the words *dictator perpetua* (dictator for life) positioned to either side of his head like a victory wreath (**Fig. 4.14**). Shortly after the coins were issued, Caesar was assassinated.

The Republican-period Temple of Portunus (also known as the Temple of Fortuna Virilis; (**Fig. 4.15**)) can be linked to both Greek and Etruscan precedents, as seen through a

◄ **4.15 Temple of Portunus (Temple of Fortuna Virilis), ca. 75 BCE. Rome, Italy.** Republican temples combined Etruscan plans and Greek elevations. This temple, made of stone, adopts the Ionic order, but it has a staircase and freestanding columns only at the front.

comparison of temple plans in (**Fig. 4.16**). From the Etruscans the Romans took the elevated podium, columned porch, and single flight of stairs in front in front leading to the cella. From the Greeks they took the Ionic order for the frieze and the columns, as well as the suggestion of a peripheral temple, even though freestanding columns are used only on the porch. Instead, engaged (half) columns are attached to the exterior walls of the cella. We can see these influences on the design of the Temple of Portunus, but the synthesis of these elements in new and unusual ways give the building its telltale Roman character.

Roman Music

Roman music was intended mainly for performance at religious events like weddings and funerals and as a background for social occasions. Musicians were often brought into aristocratic homes to provide after-dinner entertainment at a party, and individual performers, frequently women, would play before small groups in a domestic setting. Small bands of traveling musicians (**Fig. 4.17**), playing on pipes and such percussion instruments as cymbals and tambourines, provided background music for the acrobats and jugglers who performed in public squares and during gladiatorial contests. For the Romans, music did not have the intellectual and philosophical significance it bore for the Greeks, and Roman

writers who mention musical performances often complain about the noise. The Romans lengthened the Greek trumpet, producing a longer and louder bronze instrument called a tuba. It was used at public occasions like games and processions; an especially powerful version of the instrument—some four feet long—was used to signal attacks and retreats. The sound was anything but pleasant. Roman music lovers—mainly aristocrats—seemed content with the Greek music played on Greek instruments that grew in popularity with the spread of Greek culture. The emperor Nero was one such enthusiast, although his public performances on the kithara (a string instrument resembling a lute) were decried by his contemporaries, including Tacitus and Juvenal.

IMPERIAL ROME (27 BCE–337 CE)

With the assassination of Julius Caesar in 44 BCE, a brief respite from civil war was followed by further turmoil. Caesar's lieutenant, Mark Antony, led the campaign to avenge his death and punish the conspirators. He was joined in this endeavor by Caesar's young great-nephew Octavius, who had been named by Caesar as his heir and who had recently arrived in Rome from the provinces. It soon became apparent that Antony and Octavius (or Octavian, to use the name he then adopted) were unlikely to coexist happily, even though Antony married Octavian's sister, Octavia. After the final defeat of the conspirators (42 BCE), a temporary peace was obtained by putting Octavian in charge of the western provinces and sending Antony to the east. A final confrontation

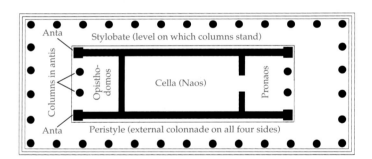

A. Greek Temple Plan

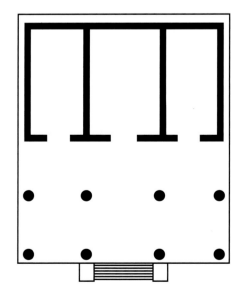

B. Etruscan Temple Plan

▲ **4.16 Typical Greek, Etruscan, and Roman temple plans. (A)** Greek temple plan; (B) Etruscan temple plan; (C) Roman temple plan showing (1) podium or base, (2) engaged column, (3) freestanding column, (4) entrance steps, (5) porch, and (6) cella.

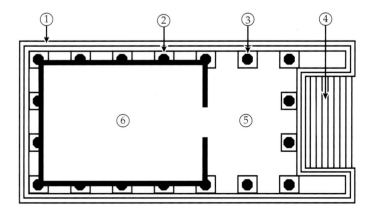

C. Roman Temple Plan

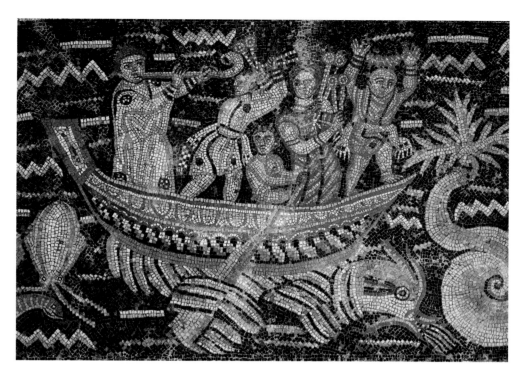

◀ **4.17** Musicians in a boat, early 3rd century CE. Border detail of a stone mosaic of a bestiary in the House of Bacchus, Archaeological Museum of Djemila, Algeria.

of the Senate and Roman people." He in fact did the reverse: while maintaining the appearance of a reborn republic, Augustus took all effective power into his and his imperial staff's hands.

From the time of Augustus, the emperor and his bureaucracy controlled virtually all decisions. A huge civil service developed, with various career paths. A typical middle-class Roman might begin with a period of military service, move on to a post as fiscal agent in one of the provinces, then serve in a governmental department back in Rome, and end up as a senior official in the imperial postal service or the police.

Augustus also began the reform of the army, which the central government had been unable to control during the last chaotic decades of the republic. Its principal function now became guarding the frontiers. It was made up of some 250,000 Roman citizens, and about the same number of local recruits. The commanders of these half a million soldiers looked directly to the emperor as their general-in-chief. The troops did far more than fight: They served as engineers, building roads and bridges. They sowed crops and harvested them. They surveyed the countryside and helped police it. In the process, they won widespread respect and gratitude from Rome's provincial subjects.

Protected by the army and administered by the civil service, the empire expanded economically. With freedom of travel and trade, goods circulated with no tariffs or customs duties; traders only had to pay harbor dues. From the time of Augustus, the Roman road system carried increasing numbers of travelers—traders, officials, students, wandering philosophers, the couriers of banks and shipping agencies—between the great urban centers. Cities like Alexandria or Antioch were self-governing to some degree, with municipal charters giving them constitutions based on the Roman model.

Not all later emperors were as diligent or successful as Augustus. Caligula, Nero, and some others have become notorious as monsters of depravity. Yet the imperial system that Augustus founded was to last for almost five hundred years.

Approximately a century after the empire was born, there occurred one of the greatest natural disasters in human history.

POMPEII At midday on August 24 in the year 79 CE, Mount Vesuvius—a volcano above the Bay of Naples—erupted, spewing

could not be long delayed, and Antony's fatal involvement with Cleopatra alienated much of his support in Rome. The end came in 31 BCE at the Battle of Actium. The forces of Antony, reinforced by those of Cleopatra, were routed, and the couple committed suicide in 30 BCE. Octavian was left as sole ruler of the Roman world, which was now in ruins. His victory marked the end of the Roman Republic.

When Octavian took supreme control after the Battle of Actium, Rome had been continuously involved in both civil and external wars for the better part of a century. The political and cultural institutions of Roman life were beyond repair, the economy was wrecked, and large areas of Italy were in complete turmoil. By the time of Octavian's death (14 CE), Rome had achieved a peace and prosperity unequaled in its history—before or after. The art and literature created during and following his reign represent the peak of Roman cultural achievement. To the Romans of his own time it seemed that a new Golden Age had dawned, and for centuries afterward his memory was revered. As the first Roman emperor, Octavian inaugurated the second great period in Roman history—the empire, which lasted technically from 27 BCE, when he assumed the title Augustus, until 476 CE, when the last Roman emperor was overthrown. However, we can also place the end date at 337 CE, when Constantine founded the eastern empire in Byzantium. In many ways, however, the period began with the Battle of Actium and continued in the subsequent western and Byzantine empires.

Augustus's cultural achievement was stupendous, but it could only have been accomplished in a world at peace. In order to achieve this, it was necessary to build a new political order. The republican system had shown itself to be inadequate for a vast and multiethnic empire. Augustus tactfully, if misleadingly, claimed that he "replaced the state in the hands

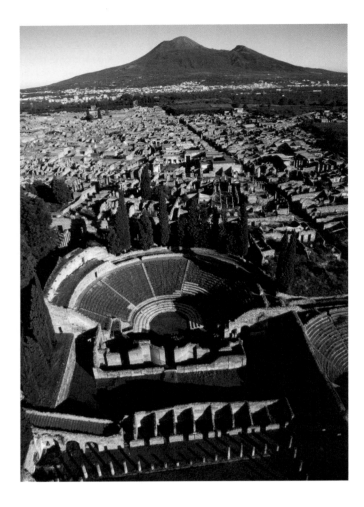

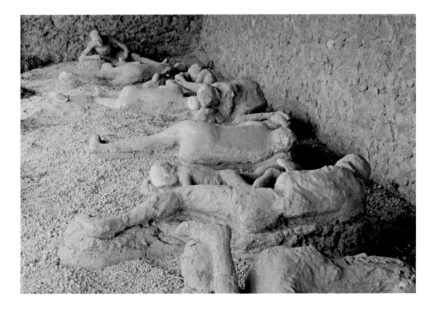

4.18 **Excavated portions of Pompeii, Italy, with the amphitheater in the foreground and the two peaks of Vesuvius in the distance.** The crater of the volcano lies between the peaks. Pompeii covers 166 acres, and although excavations have been in progress for more than two centuries, two-fifths of the city remain buried.

a column of ash and pumice 66,000 feet (12 ¹/₂ miles) into the air. Then scorching materials rained on Pompeii, Herculaneum, and other towns in the region, blanketing Pompeii with eight feet of pumice (**Fig. 4.18**). Roofs and floors collapsed, rendering the area uninhabitable. Some 20,000 inhabitants of Pompeii fled during these hours, which proved to be wise, if frightening and painful. During the phase of the eruption to follow, an avalanche of superheated gas and dust poured down the sides of the volcano, killing everything and everyone in its path. The haunting remains of the some 2,000 victims unearthed in Pompeian excavations show that most probably died during the second phase of the eruption, as they were found on top of a layer of pumice (**Fig. 4.19**). Excavation of Pompeii began more than two hundred years ago. The finds preserved by the volcanic debris give us a rich and vivid impression of the way of life in a provincial town of the early Roman Empire—from the temples in which the Pompeians worshiped and the baths in which they cleansed themselves to the food they prepared.

Scientists have classified geological events that match those of the first phase of the Vesuvius eruption as *plinian*, after the Roman politician and literary figure Pliny the Younger (ca. 61–112 CE), who bequeathed to history his eyewitness report on the destruction in a letter written to the historian Tacitus (ca. 56–117 CE). Pliny the Younger was so called to distinguish him from his uncle, Pliny the Elder (23–79 CE). Pliny the Elder, who authored a *Natural History* in 37 volumes, wanted to investigate for himself the nature of the explosion and made his way toward Vesuvius. On his way across the Bay of Naples, a friend in need of rescue sent Pliny a message, whereupon he changed course and headed in the direction of evacuations underway along the shore. The men with him on his ship reported the circumstances of his death—which they attributed to toxic fumes from the eruption—to Pliny the Younger, who had remained behind with his mother at a town named Misenum.

4.19 **Victims of the Vesuvius eruption, 79 CE. Pompeii, Italy.** The bodies of these people were found near a gate to Pompeii, where they were apparently attempting to push their way out of the darkness when they were felled by searing gases spewed down the slopes of the mountain. The man in the back appears to be trying to lift himself up.

READING 4.8 PLINY THE YOUNGER

Letter to Tacitus on the eruption of Vesuvius

Though my mind shudders to remember, I shall begin. After my uncle departed I spent the rest of the day on my studies; it was for that purpose I had stayed. Then I took a bath, ate dinner, and went to bed; but my sleep was restless and brief. For a number of days before this there had been a quivering of the ground, not so fearful because it was common in Campania. On that night, however, it became so violent that everything seemed not so much to move as to be overturned.

My mother came rushing into my bedroom; I was just getting up, intending in my turn to arouse her if she were asleep. We sat down in the rather narrow courtyard of the house lying between the sea and the buildings. I don't know whether I should call it iron nerves or folly—I was only seventeen: I called for a book of Titus Livy and as if at ease I read it and even copied some passages, as I had been doing. Then one of my uncle's friends, who had recently come from Spain to visit him, when he saw my mother and me sitting there, and me actually reading a book, rebuked her apathy and my unconcern. But I was as intent on my book as ever.

It was now the first hour of day, but the light was still faint and doubtful. The adjacent buildings now began to collapse, and there was great, indeed inevitable, danger of being involved in the ruins; for though the place was open, it was narrow. Then at last we decided to leave the town. The dismayed crowd came after us; it preferred following someone else's decision rather than its own; in panic that is practically the same as wisdom. So as we went off we were crowded and shoved along by a huge mob of followers. When we got out beyond the buildings we halted. We saw many strange fearful sights there. For the carriages we had ordered brought for us, though on perfectly level ground, kept rolling back and forth; even when the wheels were checked with stones they would not stand still. Moreover the sea appeared to be sucked back and to be repelled by the vibration of the earth; the shoreline was much farther out than usual, and many specimens of marine life were caught on the dry sands. On the other side a black and frightful cloud, rent by twisting and quivering paths of fire, gaped open in huge patterns of flames; it was like sheet lightning, but far worse. Then indeed that friend from Spain whom I have mentioned spoke to us more sharply and insistently: "If your brother and uncle still lives, he wants you to be saved; if he has died, his wish was that you should survive him; so why do you delay to make your escape?" We replied that we would not allow ourselves to think of our own safety while still uncertain of his. Without waiting any longer he rushed off and left the danger behind at top speed.

Soon thereafter the cloud I have described began to descend to the earth and to cover the sea; it had encircled Capri and hidden it from view, and had blotted out the promontory of Misenum. Then my mother began to plead, urge, and order me to make my escape as best I could, for I could, being young; she, weighed down with years and weakness, would die happy if she had not been the cause of death to me. I replied that I would not find safety except in her company; then I took her hand and made her walk faster. She obeyed with difficulty and scolded herself for slowing me. Now ashes, though thin as yet, began to fall. I looked back; a dense fog was looming up behind us; it poured over the ground like a river as it followed. "Let us turn aside," said I, "lest, if we should fall on the road, we should be trampled in the darkness by the throng of those going our way." We barely had time to consider the thought, when night was upon us, not such a night as when there is no moon or there are clouds, but such as in a closed place with the lights put out. One could hear the wailing of women, the crying of children, the shouting of men; they called each other, some their parents, others their children, still others their mates, and sought to recognize each other by their voices. Some lamented their own fate, others the fate of their loved ones. There were even those who in fear of death prayed for death. Many raised their hands to the gods; more held that there were nowhere gods any more and that this was that eternal and final night of the universe. Nor were those lacking who exaggerated real dangers with feigned and lying terrors. Men appeared who reported that part of Misenum was buried in ruins, and part of it in flames; it was false, but found credulous listeners.

It lightened a little; this seemed to us not daylight but a sign of approaching fire. But the fire stopped some distance away; darkness came on again, again ashes, thick and heavy. We got up repeatedly to shake these off; otherwise we would have been buried and crushed by the weight. I might boast that not a groan, not a cowardly word, escaped from my lips in the midst of such dangers, were it not that I believed I was perishing along with everything else, and everything else along with me; a wretched and yet a real consolation for having to die. At last the fog dissipated into smoke or mist, and then vanished; soon there was real daylight; the sun even shone, though wanly, as when there is an eclipse. Our still trembling eyes found everything changed, buried in deep ashes as if in snow. We returned to Misenum and attended to our physical needs as best we could; then we spent a night in suspense between hope and fear. Fear was the stronger, for the trembling of the earth continued, and many, crazed by their sufferings, were mocking their own woes and others' by awful predictions. But as for us, though we had suffered dangers and anticipated others, we had not even then any thought of going away until we should have word of my uncle.

You will read this account, far from worthy of history, without any intention of incorporating it; and you must blame yourself, since you insisted on having it, if it shall seem not even worthy of a letter.

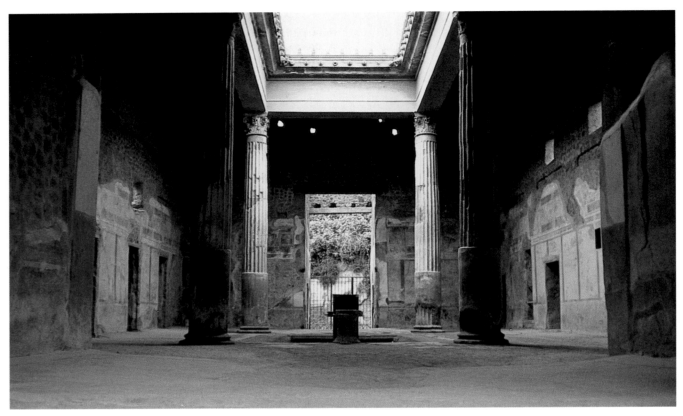

▲ **4.20 Atrium, House of the Silver Wedding, 1st century CE. Pompeii, Italy.** The open plan of substantial houses such as this helped keep the interior cool in summer. The adjoining rooms were closed off in the winter by folding doors.

Excavations of cities around Mount Vesuvius, in addition to yielding a large cache of artworks, have revealed how their inhabitants lived, worked, and played. The general picture is impressive. Cool, comfortable houses, remote from the noise of busy streets, were designed around an open space—an atrium—and were decorated with elaborate frescoes, mosaics, fountains, and gardens (Fig. 4.20). Household silver and other domestic ornaments found among the ruins of houses were often of high quality. Although the population of Pompeii was only 20,000, there were several public baths, a theater, a concert hall, an amphitheater large enough to seat the entire population, and a significant representation of brothels. The forum was closed to traffic, and the major public buildings arranged around it include a splendid basilica or large hall housed both the stock exchange and the courts of law. For those with money, life appears to have been extremely comfortable at Pompeii. Although only a small part of Herculaneum has been excavated, some mansions found there surpass the houses of Pompeii.

In terms of technical virtuosity, some of Pompeii's most impressive works of art are its mosaics—wall or floor decorations created with pieces of glass or tile embedded into surfaces coated with cement. The House of the Tragic Poet (also called the Homeric House, (Fig. 4.21)) was named by archaeologists for one of its mosaics featuring a group of actors preparing backstage for a performance. They are gathered around an older man who supervises the rehearsal. One actor warms up on a musical instrument while another changes into costume. A box of masks in the style of those worn by Greek actors sits on the floor in the center of the room. This and other decorative works in the house that feature themes from Greek mythology and the Homeric epics suggest that the owner desired to present himself as a educated man with a love of Greek culture.

The actors mosaic was the inspiration for an epic-style poem by the twentieth-century Czech poet Vladimír Janovic entitled *House of the Tragic Poet*. Although focused on the actors and director of the satyr play about to be performed, the poem reconstructs life in Pompeii on the eve of the eruption. Janovic is but one among many writers inspired by Pompeii and its ruins. Johann Wolfgang von Goethe (1749–1832) visited the buried city in 1787 and wrote "of all the disasters there have been in this world, few have provided so much delight to posterity." Johann Winckelmann (1717–1768), sometimes called the father of archaeology and art history, discussed the excavations at Pompeii in his *History of Ancient Art*. Artists such as Ingres, David, and Canova were influenced by Pompeian paintings and sculpture; even Wedgwood china designs were based on Pompeian motifs.

Imperial Literature

Augustus actively supported and encouraged the writers and artists of his day and many of their works echo the chief

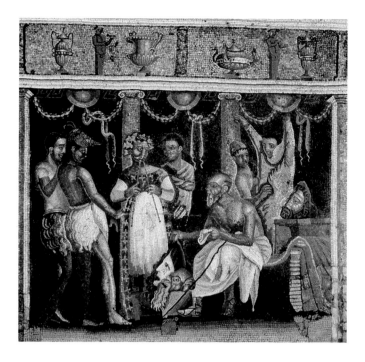

themes of Augustan politics: the return of peace, the importance of the land and agriculture, the putting aside of ostentation and luxury in favor of a simple life, and above all the belief in Rome's destiny as world ruler. Some of the greatest works of Roman sculpture commemorate Augustus and his deeds; Horace and Virgil sing his praises in their poems. It is sometimes said that much of this art was propaganda, organized by the emperor to present the most favorable picture possible of his reign. Even the greatest works of the time do relate in some way or other to the Augustan worldview, and it is difficult to imagine a poet whose philosophy differed radically from that of the emperor being able to give voice to it. But we have no reason to doubt the sincerity of the gratitude felt toward Augustus or the strength of what seems to have been an almost universal feeling that at last a new era had dawned. In any case, from the time of Augustus, art in Rome became largely official. Most of Roman architecture and sculpture of the period was public, commissioned by the state, and served state purposes.

VIRGIL Virgil (Publius Vergilius Maro; 70–19 BCE), the most renowned of Roman poets, devoted the last ten years of his life to the composition of an epic poem intended to honor Rome and, by implication, Augustus. The *Aeneid* is one of history's greatest and most influential poems. A succession of poets including Dante, Tasso, and Milton regarded him as their master. Probably no work of literature in the entire tradition of Western culture has been more loved and revered than the *Aeneid*—described by T. S. Eliot as the classic of Western society—yet its significance is complex and by no means universally agreed upon. As the Homerian epics, The *Aeneid* was written in **dactylic hexameter**.

The *Aeneid* was not Virgil's first poem. The earliest authentic works that have survived are ten short pastoral poems known as the *Eclogues* (sometimes called the *Bucolics*), which deal with the joys and sorrows of the country and the shepherds and herdsmen who live there. Virgil was the son of a farmer; his deep love of the land emerges also in his next work, the four books of the *Georgics* (29 BCE). Their most obvious purpose is to serve as a practical guide to farming—they offer helpful advice on such subjects as cattle breeding and beekeeping as well as a deep conviction that the strength of Italy lies in its agricultural richness. In a passage in book 2, Virgil hails the "ancient earth, great mother of crops and men." He does not disguise the hardships of the farmer's life, the poverty, hard work, and frequent disappointments, but still feels that only life in the country brings true peace and contentment.

The spirit of the *Georgics* matched Augustus's plans for an agricultural revival. The emperor probably commissioned Virgil to write an epic poem that would be to Roman literature what the *Iliad* and *Odyssey* were for Greek literature: a national epic. The task was immense. Virgil had to find a subject that would do appropriate honor to Rome and its past as well as commemorate the achievements of Augustus. The *Aeneid* is not a perfect poem (on his deathbed Virgil ordered his friends to destroy it), but in some ways it surpasses even the high expectations Augustus must have had for it. Virgil succeeded in providing Rome with its national epic and stands as a worthy successor to Homer. At the same time, he created a profoundly moving study of the nature of human destiny and personal responsibility.

The *Aeneid* is divided into twelve books. Its hero is a Trojan prince, Aeneas, who flees from the ruins of burning Troy and sails west to Italy to found a new city, the predecessor of Rome. Virgil's choice was significant: Aeneas's Trojan birth establishes connections with the world of Homer; his arrival in Italy involves the origins of Rome; and the theme of a fresh beginning born, as it were, out of the ashes of the past corresponds perfectly to the Augustan mood of revival. We first meet Aeneas and his followers in the middle of his journey from Troy to Italy, caught in a storm that casts them upon the coast of North Africa. They make their way to the city of Carthage, where they are given shelter by the Carthaginian ruler, Queen Dido. At a dinner in his honor, Aeneas describes the fall of Troy (book 2) and his wanderings from Troy to Carthage (book 3), in the course of which his father Anchises had died. Dido is struck by Aeneas's manliness and his tales of battle (his *virtus*).

In book 4, perhaps the best known, the action resumes where it had broken off at the end of book I. The tragic love that develops between Dido and Aeneas tempts Aeneas to stay in Carthage and thereby abandon his mission to found a new home in Italy. Mercury, the divine messenger of the gods, is sent to remind Aeneas of his responsibilities. He leaves after an agonizing encounter with Dido, and the distraught queen kills herself; "the blade aflush with red blood

drenched her hands" (lines 888–889).[4] During the encounter, Dido confronts Aeneas about his preparations to leave Carthage, and her. He had not been forthright with her about his plans.

READING 4.9 VIRGIL

The *Aeneid*, book 4, lines 397–404

"And thou didst hope, traitor, to mask the crime,
and slip away in silence from my land?
Our love holds thee not,
nor the hand thou once gavest,
nor the bitter death that is left for Dido's portion?
Nay, under the wintry star thou labourest on thy fleet,
and hastenest to launch into the deep amid northern gales;
ah, cruel!"

Despite his love for Dido, "the fates opposed it; /God's will blocked the man's once kindly ears" (lines 583–584). Aeneas sees himself as bound to fulfill his destiny elsewhere.

READING 4.10 VIRGIL

The *Aeneid*, book 4, lines 520–526

But good Aeneas,
though he would fain soothe and comfort her grief,
and talk away her distress,
with many a sigh,
and melted in soul by his great love,
yet fulfills the divine commands
and returns to his fleet.

Book 5 brings the Trojans to Italy. In book 6, Aeneas journeys to the underworld to hear from the spirit of his father the destiny of Rome. However, he also comes upon Dido in her "dim form."

READING 4.11 VIRGIL

The *Aeneid*, book 6, lines 238–260

"Alas, Dido! So the news was true that reached me;
thou didst perish, and the sword sealed thy doom!
Ah me, was I cause of thy death? By the stars I swear,
by the heavenly powers and all that is sacred
beneath the earth, unwillingly, O queen, I left thy shore.
But the gods, at whose orders now I pass through this
shadowy place,
this land of mouldering overgrowth and deep night,
the gods' commands drove me forth; nor could I deem
my departure would bring thee pain so great as this."

. . .

In such words and with starting tears Aeneas soothed
the burning and fierce-eyed soul.
She turned away with looks fixed fast on the ground,
stirred no more in countenance by the speech he essays
than if she stood in iron flint or Marpesian stone.[5]
At length she started, and fled
wrathfully into the shadowy woodland, . . .

This visit to the underworld also marks the turning point of the poem. Before it we see Aeneas, and he sees himself, as a man prone to human weaknesses and subject to personal feelings. But the shade of his father, Anchises, sets Aeneas's eyes upon his own destiny and the far future of Rome, which he will not live to see in the world above.

READING 4.12 VIRGIL

The *Aeneid*, book 6, lines 661–669

"Hither now bend thy twin-eyed gaze;
behold this people, the Romans that are thine.
Here is Caesar and all Iülus'[6] posterity
that shall arise under the mighty cope of heaven.
Here is he, he of whose promise
once and again thou hearest,
Caesar Augustus, a god's son,
who shall again establish the ages of gold in Latium[7]
over the fields . . ."

Anchises's revelations fortify Aeneas's sense of mission, and the weary, suffering Trojan exile becomes transformed into a "man of destiny."

In books 7 and 8, the Trojans arrive at the Tiber River, and Aeneas visits the future site of Rome while the Italian peoples prepare to resist the Trojan invaders. In book 8, Aeneas's mother, the goddess Venus, appears before him with gifts, including a shield forged by her husband, Vulcan, that he will use in battle.

READING 4.13 VIRGIL

The *Aeneid*, book 8, lines 608–618

Venus the white goddess drew nigh,
bearing her gifts through the clouds of heaven;
and when she saw her son withdrawn far apart

4. Sarah Lawall & Maynard Mack (Eds.). *The Norton Anthology of World Literature, Second Edition, Volume A.* New York: W. W. Norton & Company. Translated by Robert Fitzgerald.

5. Stone from the Mediterranean island of Páros.

6. Julius.

7. The region of Italy in which Rome was founded and grew into the capital of the Empire.

VALUES

Roman Ideals as Seen Through the Prism of the *Aeneid*

Following the death of Julius Caesar, Rome was ruled by the triumvirate of Octavian (who would become Augustus Caesar), Marcus Antonius (Mark Antony), and Marcus Aemilius Lepidus. Octavian ruled the western provinces, Antony the eastern, and Lepidus Hispania and Africa. Lepidus was expelled after attempting to usurp power from Octavian. Despite being married to Octavian's sister, Antony lived openly with Cleopatra of Egypt, fathering three children with her. Octavian convinced the Senate to declare war on Egypt, and after their defeat, Antony and Cleopatra committed suicide. From the perspective of Octavian—now Augustus—Antony had subordinated his duty to Rome to the love of a woman.

Is it coincidence that Aeneas, Virgil's protagonist in the *Aeneid*, leaves his Carthaginian lover, Queen Dido, to pursue his duty and his destiny to found Rome across the Mediterranean in the Italian peninsula? We noted that unlike the Greek warrior Achilles, who is besotted with his egoistic vision of immortal fame, Aeneas, the ideal Roman, sacrifices not for personal gain but for the greater good of generations yet to be born. Unlike the Trojan prince Paris, he does not place his country in jeopardy for the love of a woman. Unlike Mark Antony, he does not dally in an idyllic land. Rather, he sets sail against brutal winds into the unknown, leaving despair behind and willing to

experience more. It would have been easier for him to stay in Carthage or settle somewhere else along the way, rather than press onward under harsh circumstances into a hostile foreign land.

While Achilles seeks personal glory, while Paris looks at Helen's beauty and not ahead, while Antony lets Rome slip into more wars, Aeneas devotes himself to duty and family. Aeneas carries not only his father on his back, but also the future of civilization. Whereas so many warriors of yesteryear concern themselves with the self, Aeneas practices self-denial. He weeps in the underworld when the shade of Dido turns from him. He hurts. Yet he embodies all the virtues valued by Romans: seriousness (gravitas), duty and devotion to others (pietas), self-possession (dignitas), and courage (virtus).

Augustus Caesar himself likely had some sort of hand in the creation of the *Aeneid*. He and the poet had met. Aeneas's mother was Venus, and Augustus and his uncle, Julius Caesar had claimed Venus in their ancestry. The poem was written just following social and political upheavals, when the general belief in the greatness of Rome and its destiny were in danger of faltering. The *Aeneid* reasserted the traditional values of Rome—the holy journey to a better place, not for personal gain but for the future of one's people.

in the valley's recess by the cold river,
cast herself in his way,
and addressed him thus:
 "Behold perfected the presents
of my husband's promised craftsmanship:
so shalt thou not shun, O my child,
soon to challenge the haughty Laurentines
or fiery Turnus to battle."

On the shield is written the future of Rome. Among other things,

 "Vulcan had made
The mother wolf, lying in Mars' green grotto;
Made the twin boys at play around her teats,
Nursing the mother without fear, . . ." (lines 29–32). The helmet sported "terrifying plumes and gushing flames"; the sword blade was "edged with fate" (lines 17–18).

The last four books describe the war between the Trojans and the Latins, in the course of which there are losses on

both sides. The *Aeneid* ends with the death of Turnus—the king of an Italic people allied with the Latins—and the final victory of Aeneas.

It is tempting to see Aeneas as the archetype of Augustus; certainly Virgil must have intended for us to draw some parallels. Yet the protagonist of the *Aeneid* represents a far more complex view of his character than we might expect. And Virgil goes further yet. If greatness can be acquired only by sacrificing individuals, he may be subtly asking, is it worth the price? Does the future glory of Rome excuse the cruel treatment of Dido? Readers will provide their own answers. Virgil's response might have been that the sacrifices were probably worth it, but barely. Much depends on individual views of the nature and purpose of existence, and for Virgil there is no doubt that life is essentially tragic. The prevailing mood of the poem is one of melancholy regret for the sadness of human lives.

SULPICIA The poet Sulpicia was a contemporary of Augustus and Virgil, although the precise dates of her life are unknown. She was the daughter of Servius Sulpicius (ca. 106–43 BCE), a jurist and one of the assassins of Julius Caesar, and probably the

niece of Messala, a patrician who fought against Mark Antony at the Battle of Actium. We have only six poems from Sulpicia, a total of 40 lines, and they were once attributed to a male poet, Tibullus, with whose works they were found. Her poems have nothing to do with politics, philosophy, history, mythology, or the destiny of Rome. Rather, they tell of her passion for a young man she identifies as Cerinthus,[7] which is likely to be a pseudonym. Nor do her poems reflect the styles of her era. They are lively, fresh, and spontaneous, and may well have been circulated among her uncle's glitterati friends. The following poem speaks of a love that was apparently more than "platonic"; the "joys" and "joining" of which Sulpicia writes are apparently physical.

READING 4.14 **SULPICIA**

"Love has come at last"

Love has come at last, and such a love as I
should be more shamed to hide than to reveal.
Cytherea,[8] yielding to my Muse's prayers,
has brought him here and laid him in my arms.
Venus has kept her promise. Let people talk, who never
themselves have found such joys as now are mine.
I wish that I could send my tablets to my love
unsealed, not caring who might read them first.
The sin is sweet, to mask it for fear of shame is bitter.
I'm proud we've joined, each worthy of the other.

Trans. By Jon Corelis. Reprinted with his permission.

HORACE Horace (Quintus Horatius Flaccus; 65–8 BCE) was the son of a freed slave, but like many patricians, he was educated in Athens. He rose to become the poet laureate of Augustus and a friend of Virgil. Many of his poems are satirical, using humor and wit to mock human frailties such as vanity and ambition. He even turned a satirical eye on patriotism and war. However, as a Stoic, he also believed that wishing would not remove the stings from life or change its ending. People could only distance themselves from the outcomes by seizing the pleasures of the day. Hence Horace's **ode** "Carpe Diem" (Seize the Day).

READING 4.15 **HORACE**

"Carpe Diem" (Seize the Day)

Ask not, Leuconoë (we cannot know), what end the gods
have set for me, for thee, nor make trial of the Babylonian
tables! How much better to endure whatever comes, whether
Jupiter allots us added winters or whether this is last, which
now wears out the Tuscan Sea upon the barrier of the cliffs!
Show wisdom! Busy thyself with household tasks; and since
life is brief, cut short far-reaching hopes! Even while we
speak, envious Time has sped. Reap the harvest of today
[*carpe diem*], putting as little trust as may be in the morrow!

JUVENAL omics and satirists can have a reputation for being nasty and vulgar, even bitter. The tradition was as alive in ancient Rome as it is today, and Juvenal (Decimus Junius Juvenalis; ca. 55/60–127 CE) was perhaps the most renowned satirist of his time. Life in Rome had many of the problems of big-city living today; noise, traffic jams, dirty streets, and overcrowding were all constant sources of complaint—by Juvenal as well as many of the populace. Born in the provinces, Juvenal came to Rome, where he served as a magistrate and irritated the then-current emperor, Domitian—not a difficult task. After a period of exile, probably in Egypt, he returned to Rome and lived in considerable poverty. Toward the end of his life, however, his circumstances improved. His sixteen Satires make it clear that Juvenal liked neither Rome nor Romans. He tells us that he writes out of fierce outrage at the congestion of the city, the corruption and decadence, the depraved aristocracy, and the general greed and meanness. "At such a time who could not write satire?" Despite his own meanness, Juvenal is among the greatest satirical poets in Western literature, and he strongly influenced many of his successors, including Jonathan Swift.

READING 4.16 **JUVENAL**

From Satire III, lines 376–399

Translated by John Dryden, 1693, from Dryden's complete satires of Juvenal and Persius. There are many translations of Juvenal; this one is made interesting because it is written by an accomplished 17th century British poet.

"'Tis frequent here, for want of sleep, to die,
Which fumes of undigested feasts deny,
And, with imperfect heat, in languid stomachs fry.
What house secure from noise the poor can keep,
When even the rich can scarce afford to sleep? [380]
So dear it costs to purchase rest in Rome,
And hence the sources of diseases come.
The drover,[9] who his fellow-drover meets
In narrow passages of winding streets;
The wagoners, that curse their standing teams, [385]
Would wake even drowsy Drusus[10] from his dreams.
And yet the wealthy will not brook delay,
But sweep above our heads, and make their way,
In lofty litters borne, and read and write,
Or sleep at ease, the shutters make it night; [390]
Yet still he reaches first the public place.
The press before him stops the client's pace;
The crowd that follows crush his panting sides,
And trip his heels; he walks not, but he rides.
One elbows him, one jostles in the shole, [395]
A rafter breaks his head, or chairman's[11] pole;

7. A word for the gum of the juniper, which tastes sweet, similar to honey.
8. A poetic alternate name for the goddess Venus.
9. A driver of sheep or cattle
10. The emperor Claudius, who had a reputation for being sleepy
11. A person who carries a chair

Stockinged with loads of fat town-dirt he goes,
And some rogue-soldier, with his hobnailed shoes,
Indents his legs behind in bloody rows.

OVID The poet Ovid (Publius Ovidius Naso; 43 BCE–17 CE) produced collections of erotic poetry, including *Amores* (*Love Affairs*) and a sex manual called *Ars amatoria* (*The Art of Love*), that serve as evidence of his romantic obsession with women. A couplet from *Amores* reads "Offered a sexless heaven, I'd say *No thank you*, women are such sweet hell." These texts are so explicit that they may have been the reason Augustus exiled Ovid to what is now Romania. It may be no surprise that the more common reading from Ovid assigned to students is his *Metamorphoses* (*Changes of Shape or Form*), a poem that recounts mythological tales from the creation of the world and the gods through to the death of Julius Caesar. Caesar was assassinated about half a century before Ovid penned this work.

Metamorphoses remains a key source of information about Greek and Roman mythology, and some of the tales therein found their way into literature and drama throughout the ages. In book 10 we find the story of Pygmalion, the sculptor of Cyprus, who became enamored of a statue he had created, and Venus taking pity on him brings the statue to life. Pygmalion has served as the inspiration for the musical *My Fair Lady*, among other interpretations. In Ovid's story of the young lovers Pyramus and Thisbe, the rival families of the ill-fated couple, rivals, forbid them to marry. Pyramus commits suicide and Thisbe, finding his body, kills herself as well. The story has its counterparts in *Romeo and Juliet* (and *West Side Story*).

The following excerpts from "The Tale of Pyramus and Thisbe" first describe the couple's passion when their love is forbidden by their parents.

READING 4.17 OVID

"The Tale of Pyramus and Thisbe," *Metamorphoses, book 4"*

What parents could not hinder, they forbad.
For with fierce flames young Pyramus still burn'd,
And grateful Thisbe flames as fierce return'd.
Aloud in words their thoughts they dare not break,
But silent stand; and silent looks can speak.
The fire of love the more it is supprest,
The more it glows, and rages in the breast.
Before Thisbe joins Pyramus in death, she has a final request
for their parents.
Now, both our cruel parents, hear my pray'r;
My pray'r to offer for us both I dare;
Oh! see our ashes in one urn confin'd,
Whom love at first, and fate at last has join'd.
The bliss, you envy'd, is not our request;
Lovers, when dead, may sure together rest.

The Art of Imperial Rome

At around the same time that Virgil wrote the *Georgics*, his exaltation of agriculture and nature found expression in one of the most stunningly beautiful frescoes of ancient Rome—a gardenscape from a villa that belonged to Livia, the wife of Augustus (**Fig. 4.22**). The walls of the setting must have

▼ **4.22** Gardenscape, Villa of Livia, Primaporta, Italy, ca. 30–20 BCE (Second style). Fresco, overall size 8'11" high × 38'5" long (2.72 × 11.7 m). Museo Nazionale Romano—(Palazzo Massimo alle Terme), Rome, Italy. Livia's gardenscape is perhaps the ultimate example of a painted Roman picture window. The painter suggests depth by attempting linear perspective in the fence surrounding the tree in the center and by using atmospheric perspective—intentionally blurring the more distant objects.

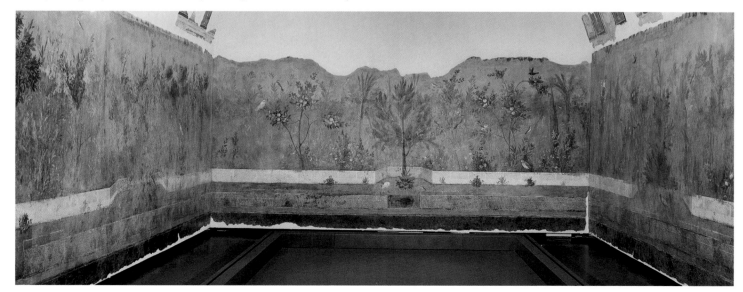

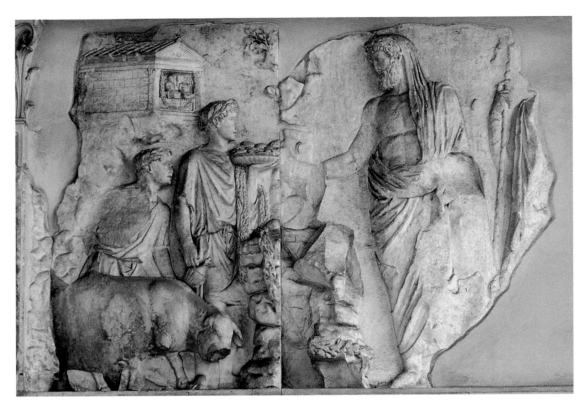

◀ **4.23 Aeneas performs a sacrifice, 13–9 BCE. Detail from the Ara Pacis Augustae, Rome, Italy. Marble, 63″ (160.0 cm) high. Museo dell'Ara Pacis, Rome, Italy.** Aeneas (right) is shown in the manner of a classical Greek god. The landscape and elaborate relief detail are typical of late Hellenistic art.

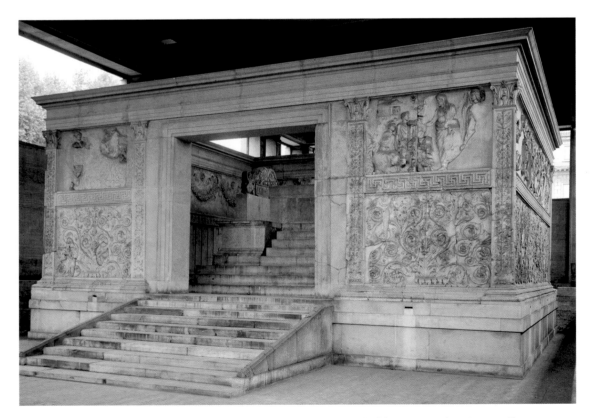

▲ **4.24 Ara Pacis Augustae (Altar of Augustan Peace), 13–9 BCE. Marble, rectangular stone wall surrounding a stone altar; wall, 34′5″ long × 38′ wide × 23′ high (10.5 × 11.6 × 7 m). Museo dell'Ara Pacis, Rome, Italy.** The central doorway, through which the altar is just visible, is flanked by reliefs showing Romulus and Remus, and Aeneas. On the right side is the procession of the imperial family, led by Augustus. The altar originally stood on Rome's ancient Via Flaminia. Fragments were discovered in the 16th century; the remaining pieces were located in 1937 and 1938, and the structure was reconstructed near the mausoleum of Augustus.

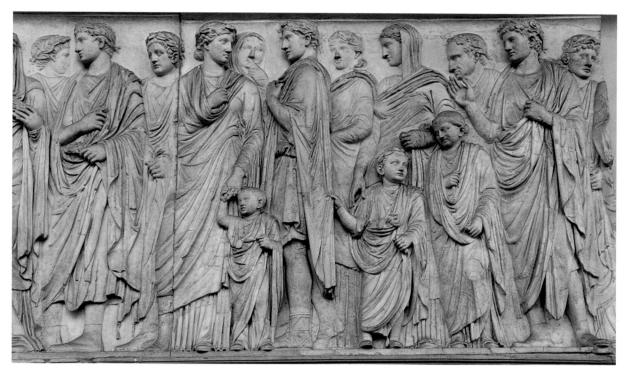

⋀ 4.25 Procession of the imperial family, detail of south frieze of the Ara Pacis Augustae, 13–9 BCE. **Marble, 63″ (160.0 cm) high. Museo dell'Ara Pacis, Rome, Italy.** Although inspired by the frieze of the Parthenon, the Ara Pacis processions depict recognizable individuals, including children. Augustus promoted marriage and childbearing.

seemed to melt away under the spell of masterful illusion—a crisp blue sky alive with the songs of birds, the feel of lush foliage underfoot, and the sweet scent of flowering trees. The garden fresco represents one of four styles of Roman wall painting created between the second century BCE and 79 CE; many of the best—and best-preserved—examples were found among the ruins of Pompeii.

Lines of Virgil's poetry also find their visual counterpart in a relief carving depicting Aeneas (**Fig. 4.23**) on the front of the *Ara Pacis* (Altar of Peace), one of the most important works commissioned by Augustus and perhaps the single most comprehensive statement of how he wanted his contemporaries and future generations to view his reign (**Fig. 4.24**). Aeneas, shown in the manner of a Classical Greek god, performs a sacrifice on his arrival in Italy before a small shrine that contains the two sacred images brought from Troy. Virgil glorified Aeneas, who was the son of a goddess, and Augustus who constructed a divine lineage by tracing his ancestry to Aeneas and, therefore, to Venus. Yet the Ara Pacis was not dedicated to any one god but to Livia, his wife, symbolizing the continuity of generations and reinforcing the ideal of stability of family and thus of state. Just as significantly, the reliefs of the Ara Pacis—with its allegorical figures of peace and fertility and luxuriously intertwined fruits and flowers—symbolize the abundance of nature and the flourishing of society made possible by the peace Augustus secured.

The relief of Aeneas and, across from it, one depicting Romulus and Remus together serve as a reminder of Rome's glorious beginnings; scenes at the back of the altar show a female figure—the earth mother or an allegory of peace—and the goddess of war, emphasizing both the abundance of nature and the need for vigilance. The rich vegetation of the lower panels is a constant reference to the rewards of agriculture that can be enjoyed in an era of flourishing peace. Reliefs on the long sides of the Ara Pacis capture a celebratory procession. On one side Augustus leads the way, accompanied by priests and followed by members of his family. Augustus is shown as the first among equals rather than supreme ruler; although he leads the procession, he is marked by no special richness of dress. The presence of Augustus's family indicates that he intends his successor to be drawn from among them and that they have a special role to play in public affairs. On the other side (**Fig. 4.25**), senators and dignitaries march, some of them holding the hands of small children who fidget and talk—as children are wont to do when they are bored. But don't let this charming realism and seeming spontaneity fool you. Just as Republican portraits played an important role in the construction of personal image and in propaganda, so was the scene of family men on the Ara Pacis intended to send a message. Members of the Roman nobility—here depicted—were not having many children; to encourage them otherwise, Augustus enacted laws to promote the institution of marriage and to support larger families. The linchpin, symbolized by the dedication of the Ara Pacis to his wife, was Augustus's call for fidelity. The fact that Augustus had divorced his first

wife to marry his pregnant mistress Livia seems a distant memory.

The detailed political and social message of the Ara Pacis is expressed without pretentiousness and with superb workmanship. The style is deliberately and self-consciously classical, based on works such as the Parthenon frieze (see Chapter 3). To depict the new golden age of Augustus, his sculptors chose the artistic language of the golden age of Athens, although with a characteristic Roman twist.

The elaborate message illustrated by the Ara Pacis echoes that of an earlier work: the Augustus of Primaporta (**Fig. 4.26**). This best-preserved statue of the emperor was named for the location of the imperial villa (Livia's) at which the sculpture was excavated. The sculpture was probably carved close to the time of the emperor's death, yet he is shown in the full vigor of life—young, handsome, calm, and determined, with a stance of quiet authority. It was a carefully constructed and idealized image that *was* Augustus in the minds of the people, even though they never saw their emperor except in art and on coins and did not know what he actually looked like.

The ornately carved breastplate Augustus wears recalls one of the chief events of his reign. In 20 BCE he defeated the Parthians, an eastern tribe, and recaptured from them the Roman standards that had been lost in battle in 53 BCE. The cupid on a dolphin at Augustus's feet is a symbol of the goddess Venus, connecting Augustus and his family with Aeneas (whose mother, we recall, was Venus) and thereby with the origins of Rome. But the toddler may also represent Augustus's grandson Gaius, who was born in the year of the victory over the Parthians and was at one time considered a possible successor to his grandfather.

Naming a successor was one problem that Augustus never managed to resolve to his own satisfaction. The deaths of possible candidates forced him reluctantly to fall back on his unpopular stepson Tiberius. The succession problem would recur throughout the long history of the empire, because no really effective mechanism was ever devised for guaranteeing a peaceful transfer of power.

Imperial Architecture

Augustus and his successors also used architecture to express authority. In Imperial Rome, public buildings, civic architecture, temples, monuments, and private houses were constructed in numbers and on a scale that

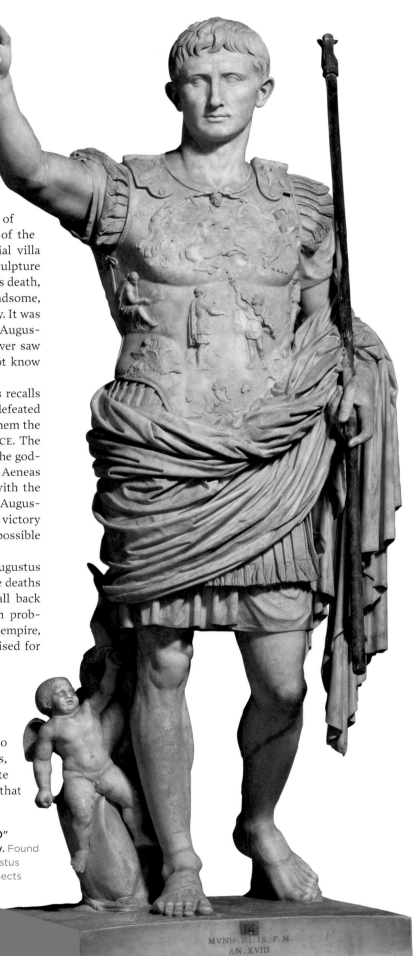

➤ **4.26** **Augustus of Prima Porta, ca. 20 BCE, Marble. 80″ (203.2 cm) high. Musei Vaticani, Vatican City State, Italy.** Found in the imperial villa of Prima Porta, the statue shows Augustus about to deliver a speech. The small cupid at his feet connects the emperor to the legendary founder of Rome, Aeneas, who, like Cupid, was a child of the goddess Venus.

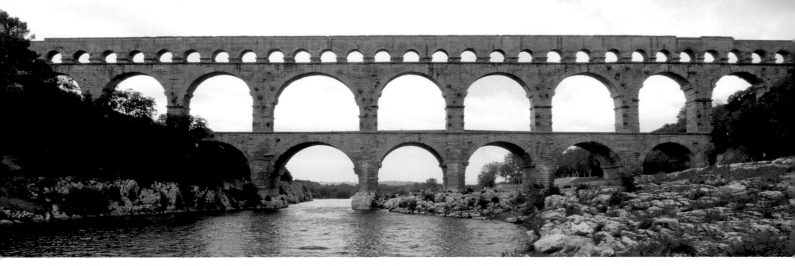

▲ **4.28 Pont du Gard, ca. 16 CE. Near Nîmes (ancient Nemausus), France. Stone block, 902′ long × 161′ (275 × 49 m) high; each large arch spans 82′ (25 m).** Note the precise three-for-one positioning of the top row of arches. The entire aqueduct was 25 miles long. This section carried water over the canyon of the Gard River in what is today the south of France.

remains impressive by any standard. Roman achievements in both architecture and engineering had a lasting effect on the development of later architectural styles. The *arch*, *vault*, and *dome*—some versions of which we have seen in earlier cultures—appear as regulars in Roman architecture, but with a twist of engineering that upped the game: the invention of *concrete* (**Fig. 4.27**).

Arches and vaults were used to construct roofs over structures of increasing size and complexity. Greek and Republican Roman temples had been relatively small, partly because of the difficulty of roofing over a large space without numerous substantial supports. With the invention of concrete in the first century BCE and an increased understanding of the principles of stress and counterstress, Roman architects were able to experiment with new forms that—like the **barrel vault** and the **dome**—would pass into the Western architectural tradition.

The Greeks rarely built arches, but the Etruscans used them as early as the fifth century BCE. The Romans used arches regularly for civic projects like bridges and aqueducts. The Pont du Gard (**Fig. 4.28**), an aqueduct-bridge that spans

the Gard River in southern France, carried water more than 30 miles and furnished each inhabitant of the colonial city of Nîmes with some 100 gallons per day. Constructed of three levels of masonry arches, the largest of which spans about 82 feet, the aqueduct is about 900 feet long (a regulation football field is 360 feet) and 160 feet high (approximately the height of a 16-story building). Gravity brought the water from the source to its destination: the aqueduct sloped gradually over the long distance and water flowed in a channel along the top. The two lower stories of wide arches functionally and visually anchor the weighty structure to the earth, whereas the quickened pace of the smaller arches complements the rush of water in the upper tier. The grandeur and simplicity of the Pont du Gard illustrate the principle, enunciated by modern architects, that *form follows function*.

The system of aqueducts throughout the empire, perhaps one of the most impressive of Roman engineering feats, had immense public-relations value. It was a way to assert the beneficence of the emperor who provided the citizens of Rome with a basic necessity of life: water. A vast network of pipes brought millions of gallons of water a day

▼ **4.27 Roman construction using concrete. (a) A barrel vault; (b) a groin vault; (c) a fenestrated sequence of groin vaults; (d) a hemispherical dome with an oculus.** Concrete vaults and domes permitted Roman architects to create revolutionary designs. Artwork by John Burge

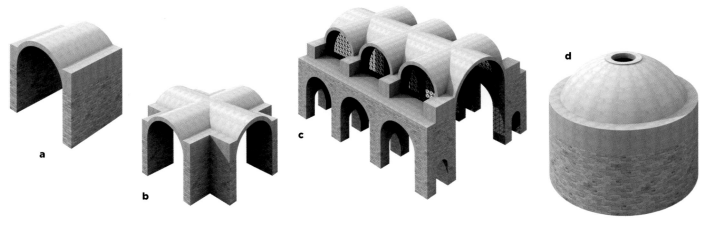

Stadium Designs: Thumbs-Up or Thumbs-Down?

The sports stadium has become an inextricable part of our global landscape and our global culture. A city's bid for host of the Olympic Games can hinge entirely on the stadium it has to offer. These megastructures are not only functional— housing anticipated thousands—but they tend to become symbols of the cities, the teams, or now the corporations who fund them. There is something about a space like this. The passion of friends and strangers and "fors"and "againsts" alike creates an odd sense of uniformity regardless of diversity. This observation has led some of history's political leaders to use—and abuse—the phenomenon of the stadium for their own propagandistic purposes.

The Colosseum (Fig. 4.29) represented Rome at its best, but it also stood for Rome at its worst. A major feat of architectural engineering coupled with practical design, this vast stadium accommodated as many as 55,000 spectators who—thanks to 80 numbered entrances and stairways— could get from the street to their designated seats within ten minutes. In rain or under blazing sun, a gargantuan

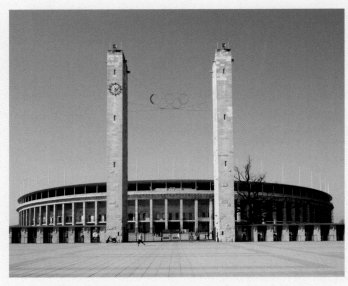

▲ 4.30 Werner March, Olympic Stadium, 1936. Berlin, Germany.

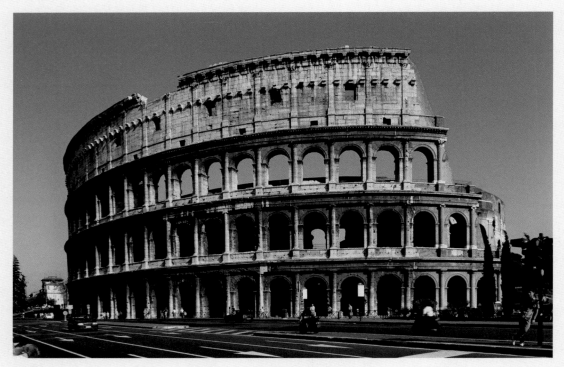

▲ 4.29 Colosseum, ca. 70–80 CE (Early Empire). Rome, Italy. Concrete (originally faced with marble).

△ **4.31** Pier Luigi Nervi, Palazzo dello Sport, 1960. Rome, Italy.

canvas could be hoisted from the arena up over the top of the stadium.

Although the Colosseum was built for entertainment and festivals, its most notorious events ranged from sadistic contests between animals and men and grueling battles to the death between pairs of gladiators. If one combatant emerged alive but badly wounded, survival might depend on whether the emperor (or the crowd) gave the thumbs-up or the thumbs-down.

As in much architecture, form can follow function and reflect and create meaning. In 1936, Adolf Hitler commissioned Germany's Olympic Stadium in Berlin (**Fig. 4.30**). Intended to showcase Aryan superiority (even though Jesse Owens, an African American, took four gold medals in track and field as Hitler watched), architect

Werner March's stadium is the physical embodiment of Nazi ideals: order, authority, and the no-nonsense power of the state.

How different the message, noted critic Nicolai Ouroussoff, when an architect uses design to cast off the shackles of "nationalist pretensions" and "notions of social conformity" in an effort to imbue the structure—and the country—with a sense of the future. Created by Pier Luigi Nervi in 1957 for the 1960 Olympics, the Palazzo dello Sport (**Fig 4.31**) in Rome symbolized an emerging internationalism in the wake of World War II. The unadorned and unforgiving pillars of March's Berlin stadium seem of a distant and rejected past. Nervi's innovative, interlacing concrete roof beams define delicacy and seem to defy gravity.

In 2008, China hosted the Olympic Games in the city of Beijing. A doughnut-shaped shell crisscrossed with lines of steel as if it were a precious package wrapped in string, the stadium (**Fig. 4.32**), dubbed by many the Bird's Nest—housed 100,000 spectators and came with a price tag in excess of $500 million. But beyond these staggering numbers, and like the Colosseum and the Berlin Stadium it stands to symbolize the transformation of its city—and its country—into a major political and cultural force of its time.

▽ **4.32** Herzog and de Meuron, Beijing National Stadium, 2005. Beijing, China.

into the city of Rome itself, distributing it to drinking and display fountains, to public baths, and to the private villas of the wealthy. At the same time, a system of covered street drains was built, eliminating the unpleasantness and health risks of open sewers. With the passage of time, most of the aqueducts that supplied ancient Roman cities and towns collapsed or were demolished. The engineering skills for projects like the sewage system were lost during the Middle Ages.

The arch is also the principal design element used on the exterior of the Colosseum (see **Fig. 4.29**), the infamous public arena built during the reign of Vespasian and dedicated by his successor, Titus, in 80 CE. Three tiers of arches encircle the building, the lowest of which admitted throngs of spectators through numbered gates and into corridors that led to their seats above the oval-shaped arena. In today's version of the Colosseum—sports stadiums—the seats closer to the field are the most expensive and the cheapest ones are in the top tiers high above the athletes. Back in the days of ancient Rome, the good seats were reserved for the upper classes and the lower classes had to climb.

The architect of the Colosseum was as design conscious as the one who built the Pont du Gard, if not more, for the arches around the façade served only a decorative purpose (the structure is made of concrete). The engaged columns between the arches pay homage to three architectural orders: the lowest level features the Tuscan order, a variation on the Doric order of the Greeks; the columns in the second tier are Ionic; and the third tier boasts the Corinthian order. As we progress from the ground level up toward the top and the most solid of the four bands, the column styles get more delicate and lighter in appearance.

The Colosseum is a spectacular sight, even in a state of ruin. Much of the work of Roman architects was destroyed during the Barbarian invasions of the fifth and sixth centuries CE, and yet more was wrecked during the Renaissance by popes who, in effect, used Roman sites as quarries for brick and marble for their own buildings and monuments. The term *spolia*, from the Latin meaning "spoils," describes the reuse of building materials and sculpture in the construction and ornamentation of new structures and monuments. By great good fortune, one of the most superb of all Imperial structures has been preserved almost intact. The Pantheon (**Fig. 4.33**) was built around 126 CE during the reign of Hadrian (117–138 CE), even though a prominent inscription on a frieze above the entrance reads "M.AGRIPPA.L.F.COS. TERTIUM.FECIT" (meaning "Marcus Agrippa, son of Lucius, having been consul three times, built it"). For a very long time, archaeologists and art historians thus believed that the Pantheon, dedicated to all of the gods (*pan* is a prefix meaning "all," and *theon* comes from the Latin *theologia*, referring to religion) was constructed under the reign of Marcus Agrippa. However, excavations revealed that the concrete in the Pantheon was of type used only after Agrippa's reign. Why, then,

◄ **4.33 Pantheon, 118–125 CE (Early Empire). Rome, Italy. Exterior view.** The Pantheon's traditional façade masked its revolutionary cylindrical drum and huge hemispherical dome. The interior symbolized both the orb of the earth and the vault of the heavens.

◄ **4.34** Pantheon,
118–125 CE **(Early
Empire). Rome, Italy.
Interior view.** The
coffered dome of the
Pantheon is 142 feet
(43 meters) in diameter
and 142 feet high. Light
entering through its
oculus forms a circular
beam that moves across
the dome as the sun
moves across the sky.

did Hadrian put Agrippa's name on a building that he made possible? We know this: even though Hadrian is responsible for the construction or rebuilding of architectural monuments throughout the city of Rome, he wished for only one work to be attributed to him—the Temple of the Deified Trajan, the emperor who preceded him and named Hadrian his successor just before his death.

The Pantheon's design combines the simple geometric shapes of a cylinder and a circle (**Fig. 4.34**). An austere and majestic exterior portico, supported by freestanding granite columns with Corinthian capitals, leads to the central rotunda—a domed space that is 142 feet high at its center and measures the same distance across. The dome rests on a concrete cylinder pierced with deep, vaulted niches that accept the downward thrust of the dome and distribute its weight to the cylinder's 20-foot-thick wall. These deep niches alternate with shallow ones along the inside perimeter of the rotunda in which statues were placed. While the cylinder

Correspondence Between Pliny the Younger and the Emperor Trajan About Christians

Historians record the years of 27 BCE to 180 CE as a time of peace throughout the Roman Empire and on its borders—the so-called "Pax Romana." Art, great public works such as the Pantheon and major aqueducts, and literature all flourished during these years, including the satires of Juvenal, the philosophical musings of Marcus Aurelius, and the writings of Gaius on the law. Despite the peace, Christians were being persecuted.

Pliny the Younger, who wrote so poignantly about the devastation wrought by the eruption of Mt. Vesuvius in 79 CE, served as governor of the adjacent regions of Pontus* and Bithynia from 111 to 113 CE, and he exchanged letters with the emperor Trajan about his handling of Christians in that province.** Here he seeks the advice of the emperor.

Pliny to Trajan

It is my custom, Sire, to refer to you in all cases where I am in doubt, for who can better clear up difficulties and inform me? I have never been present at any legal examination of the Christians, and I do not know, therefore, what are the usual penalties passed upon them, or the limits of those penalties, or how searching an inquiry should be made.

. . .

In the meantime, this is the plan which I have adopted in the case of those Christians who have been brought before me. I ask them whether they are Christians, if they say "Yes," then I repeat the question the second time, and also a third—warning them of the penalties involved; and if they persist, I order them away to prison. For I do not doubt that—be their admitted crime what it may—their pertinacity and inflexible obstinacy surely ought to be punished.

. . .

My entertaining the question led to a multiplying of accusations and a variety of cases were brought before me. An anonymous pamphlet was issued, containing a number of names of alleged Christians. Those who denied that they were or had been Christians and called upon the gods with the usual formula, reciting the words after me, and those who offered incense and wine before your image—which I had ordered to be brought forward for this purpose, along with the regular statues of the gods—all such I considered acquitted—especially as they cursed the name of Christ, which it is said *bona fide* Christians cannot be induced to do.

Still others there were, whose names were supplied by an informer. These first said they were Christians, then denied it, insisting they had been, "but were so no longer"; some of them having "recanted many years ago. . . ." These all worshiped your image and the god's statues and cursed the name of Christ. . . . I then thought it the more needful to get at the facts behind their statements. Therefore I placed two women, called "deaconesses," under torture, but I found only a debased superstition carried to great lengths, so I postponed my examination, and immediately consulted you. This seems a matter worthy of your prompt consideration, especially as so many people are endangered. Many of all ages and both sexes are put in peril of their lives by their accusers; and the process will go on, for the contagion of this superstition has spread not merely through the free towns, but into the villages and farms.

Trajan Replies:

You have adopted the right course, my dear Pliny, in examining the cases of those cited before you as Christians; for no hard and fast rule can be laid down covering such a wide question. The Christians are not to be hunted out. If brought before you, and the offense is proved, they are to be punished, but with this reservation—if any one denies he is a Christian, and makes it clear he is not, by offering prayer to our gods, then he is to be pardoned on his recantation, no matter how suspicious his past. As for anonymous [accusations], they are to be discarded absolutely, whatever crime they may charge, for they are not only a precedent of a very bad type, but they do not accord with the spirit of our age.

* It was in writing of his brief battle at Pontus that Julius Caesar declared "I came, I saw, I conquered" some 160 years earlier.

**William Stearns Davis, ed., *Readings in Ancient History: Illustrative Extracts from the Sources,* (Boston: Allyn and Bacon, 1912–1913), vol. 2, Rome and the West, 196–210, 215–222, 250–251, 289–290, 295–296, 298–300.

wall was constructed of concrete mixed according to a recipe that would provide the greatest strength, the concrete used in the dome was much lighter. The concrete is thickest at the point where the dome begins to rise off its cylindrical base and thinnest at the very top, where it culminates in a circular opening—an **oculus** (after the Latin word meaning "eye") that frames a patch of sky and allows in the only natural light in the space. The actual weight of the dome—as well as its visual massiveness—was alleviated with *coffering*, the carving of squares within squares in a regular pattern across its surface. In ancient times, the innermost squares may have contained gold-gilded bronze rosettes and, if so, were

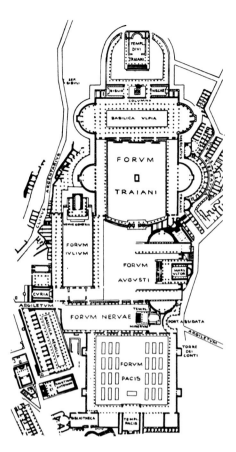

◀ 4.35 Imperial fora. Rome, Italy. Unlike the Republican forum, which served as a public meeting place, the Imperial fora were huge complexes constructed as monuments to the emperors who commissioned them. Note the Forum of Trajan (Forum Traiani), one of the largest, in the upper portion.

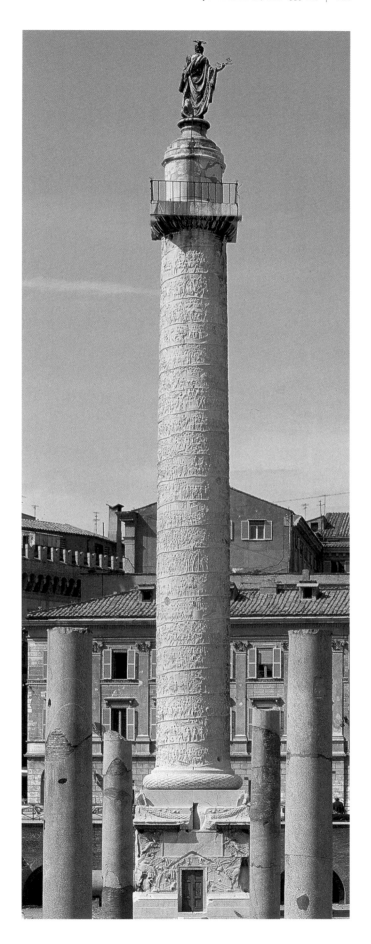

among the decorative elements decried by Pope Boniface IV as "pagan filth" when he converted the Pantheon into a Christian church in the early seventh century CE.

The Pantheon was dwarfed by the enormous complex of open spaces, buildings, and monuments that made up the Imperial fora, among which was the Forum of Trajan (Fig. 4.35). One of the most original and stunning monuments in the forum, at a height of 128 feet, is Trajan's Column (Fig. 4.36). The entire surface of the column is carved in low relief with scenes from Trajan's military campaign against the Dacians. The spiral band on which these adventures are carved, if unwound, would measure over 600 feet in length. The ascending spiral forced the spectator to move around the column, thus mimicking the Roman funerary ritual of circumambulation. Trajan's body was cremated upon his death on August 8, 117 CE, and his ashes placed in a chamber in the column.

Elsewhere in the city, baths, theaters, temples, racetracks, and libraries catered to the needs and fancies of an ever-expanding urban population. Architects continued to mix Greek and Roman styles in new and different contexts and to experiment with new techniques of construction. Roman

➤ 4.36 Trajan's Column, dedicated 112 CE. Forum of Trajan, Rome, Italy. Carrara marble shaft ca. 98′ (30 m) high, 11′ (3.7 m) diameter on 27′ (8 m) pedestal. The spiral frieze of Trajan's Column tells the story of the Dacian Wars in 150 episodes. The reliefs depict all aspects of the campaigns, from battles to sacrifices to road and fort construction.

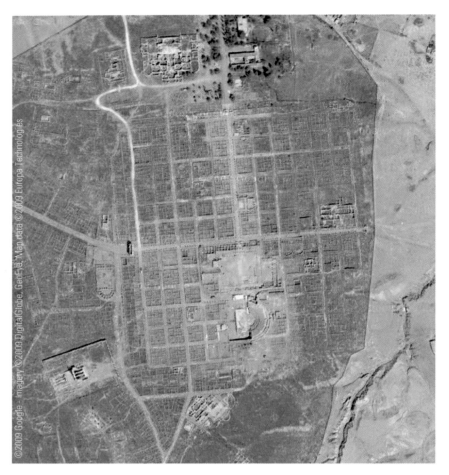

If Timgad reveals an almost militaristic approach to town planning in its extreme regularity and precision, the tomb in Petra (known as the *Khaznah* or "Treasury") reveals the Roman love for mixing and matching when it comes to architectural style. What *isn't* going on in this façade? We see two pediments (one broken, one not); an entrance that is flanked by unevenly spaced columns; something that looks like a cylindrical mini-temple in the second story; deep, shadowy recesses; and delicately carved reliefs. This suggestion of a split personality when it comes to Roman art and design calls to mind a quote by the nineteenth-century American poet Walt Whitman: "Do I contradict myself? Very well, then I contradict myself, I am large, I contain multitudes."

Back in Rome, artists and their patrons were departing—at long last—from some of the strict conventions of Classical Greece. Consider the portrait of the emperor Marcus Aurelius (**Fig. 4.39**) and how far the artist has come from the mandate of the canon of proportions. Marcus sits astride a horse that is, by any measure, unrealistically small in relation to its rider. The proportions of the figural group are manipulated to symbolize the

▲ **4.37 Satellite view of Timgad, Algeria, founded 100 CE.** The plan of Trajan's new colony of Timgad in North Africa features a strict grid scheme, with the forum at the intersection of the two main thoroughfares, the *cardo* and the *decumanus*.

➤ **4.38 Khaznah (Treasury), 2nd century CE. Petra, Jordan.** This rock-cut tomb façade is a prime example of Roman baroque architecture. The designer used Greek architectural elements in a purely ornamental fashion and with a studied disregard for classical rules.

design and engineering principles were applied throughout the empire from Spain to the Middle East.

The influence of Roman architecture and urban planning can be seen in two examples in the far-flung empire: Timgad, a colony in present-day Algeria (**Fig. 4.37**), and the façade of an elaborate rose-colored rock-cut tomb in Petra, Jordan (**Fig. 4.38**). The aerial view of Timgad reveals a hyperplanned community in which a large square of land is divided first by two wide roads that intersect to form four main quadrants. The quadrants, in turn, are divided into smaller blocks by a grid of narrower streets. The centerpiece of the city is a forum, reflecting the importance of the Roman fora as centers of city life. The tidiness of the plan couldn't look more different from Rome's haphazard cityscape (see again **Fig. 4.7**). Timgad is a signature example of the template used for Roman settlements, wherever in the world they might be.

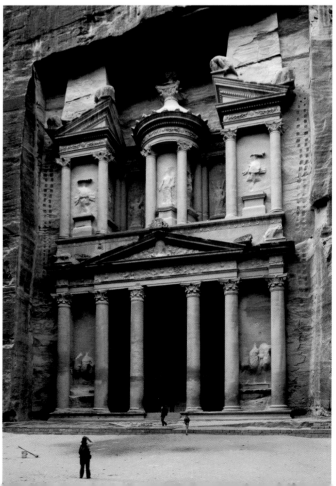

emperor's power and authority, although in the details of his face we read something else. Just as Marcus revealed his personal philosophy and thoughts on the self and the world in his *Meditations* (see p. 132), so does his portrait reveal his concerns about the fate of the empire and the burden of wearing the crown. For all of the spirit and energy embodied in his horse, Marcus looks sad and tired.

The bronze sculpture of Marcus Aurelius is of a type that is called an equestrian portrait. The material alone would have marked it for destruction (during the Middle Ages, any bronze that could be seized was melted down for other uses), was it not for a case of mistaken identity.

The statue of Marcus Aurelius was spared because it was believed to have portrayed Constantine, the first Christian emperor of Rome.

The End of the Roman Empire

Few historical subjects have been as much discussed as the fall of the Roman Empire. It is not even possible to agree on when it fell, let alone why. The traditional date—476 CE—marks the deposition of the last Roman emperor, Romulus Augustulus. By that time, however, the political unity of the empire had already disintegrated. Perhaps the beginning of the end came in 330 CE, when Constantine moved the capital of the empire from Rome to a new city on the Bosporus and renamed it Constantinople. But his transfer of the seat of the empire may have represented a new development as much as a conclusion. It might even be possible to argue that Constantine's successors in the east, the Byzantine emperors, were the heirs of Augustus, and that the Imperial traditions begun in 31 BCE continued until the fall of Constantinople in 1453 CE.

Fascinating though the question may be, in a sense it is theoretical rather than practical. The Roman Empire did not fall overnight. Many of the causes for its long decline are obvious, though not always easy to order in importance. One crucial factor was the growing power and changing character of the army. The larger it became, the more necessary it was to recruit troops from the more distant provinces—Germans, Illyrians, and others: the very people the army was supposed to be holding in check. Most of these soldiers had never been anywhere near Rome. They felt no loyalty to the empire, no reason to defend Roman interests. A succession of emperors had to buy their support by raising their pay and promising gifts of lands. At the same time, the army came to play an increasingly prominent part in the choice of a new emperor, and because the army was largely non-Roman, so were many of the emperors chosen. Rulers of the third and fourth centuries included Africans, Thracians, a Syrian, and an Arab—men unlikely to feel any strong reason to place the interests of Rome over those of themselves and their own men.

Throughout this late period, the empire was increasingly threatened from outside. To the west, barbarian tribes like the Huns, the Goths, and the Alemanni began to penetrate farther and farther into the empire's defenses and even to

◀ **4.39 Equestrian statue of Marcus Aurelius, ca. 175 CE. Rome, Italy. Bronze, 138″ (350.5 cm) high. Musei Capitolini—Palazzo dei Conservatori, Rome, Italy.** In this equestrian portrait of Marcus Aurelius as omnipotent conqueror, the emperor stretches out his arm in a gesture of clemency. An enemy once cowered beneath the horse's raised foreleg.

∧ **4.40** Ruins of the Basilica Nova, 306–315 CE. Forum Romanum, Rome, Italy. The last great Imperial building in Rome, the basilica was begun in 306 by Maxentius and completed by Constantine after 315. Only the northern side still stands; the central nave and south aisle collapsed in antiquity. The brickwork visible today was originally hidden behind marble panels, both inside and out.

sack Rome. Meanwhile, in the east, Roman armies were continually involved in resisting the growing power of the Persians. In many parts of the empire it became clear that Rome could provide no help against invaders, and some of the provinces set themselves up as independent states with their own armies.

Problems like these inevitably had a devastating effect on the economy. Taxes increased and the value of money depreciated. The constant threat of invasion or civil war made trade impossible. What funds there were went for the support of the army, and the general standard of living suffered a steady decline. The eastern provinces, the old Hellenistic kingdoms, suffered rather less than the rest of the empire, because they were protected in part by wealth accumulated over the centuries and by their long tradition of civilization. As a result, Italy sank to the level of a province rather than remaining the center of the imperial administration.

Total collapse was prevented by the efforts of two emperors: Diocletian, who ruled from 284 to 305 CE, and Constantine, who ruled from 306 to 337. Both men were masterful organizers who realized that the only way to save the empire was to impose the most stringent controls on every aspect of life—social, administrative, and economic. In 301 CE, the Edict of Diocletian was passed, establishing fixed maximums for the sale of goods and for wages. A vast bureaucracy was set up to collect taxes and administer the provinces. The emperor became once again the focal point of the empire, but to protect himself from the dangers of coups and assassinations, he never appeared in public. As a result, an elaborate court with complex rituals developed, and the emperor's claim to semi-divine status invested him with a new religious authority.

Late Roman Art and Architecture

Even if the emperor did not show himself to his subjects, he could impress them in other ways, and the reigns of Diocletian and Constantine marked the last great age of Roman architecture. The immense Basilica Nova (**Fig. 4.40**) was begun by the emperor Maxentius and completed by Constantine. Though it now lies in ruins, it must have been a powerful reminder of the emperor's authority, with its scale—300

◄ **4.41** Colossal head of Constantine, ca. 315–330 ᴄᴇ. Basilica Nova, Rome, Italy. Marble, 102″ (259 cm) high. Musei Capitolini—Palazzo dei Conservatori, Rome, Italy. Constantine's portraits revive the Augustan image of an eternally youthful ruler. The colossal head is one fragment of an enthroned Jupiter-like statue of the emperor holding the orb of world power.

to a height of 100 feet. In ancient Rome, basilicas were large public meeting halls that were usually built around or near fora (you can see a few of them in **Fig. 4.36**). The Basilica Nova was that and more. It was the setting for a colossal sculpture of a seated Constantine that featured a wooden torso sheathed in bronze and a head and limbs carved of marble. The head alone (**Fig. 4.41**) is eight and one-half feet tall. Thinking back to the verism of Republican portraits—including the profile of an aging Julius Caesar on a silver coin—and the idealism of the head of Augustus on the Primaporta portrait, the head of Constantine, by contrast, is something altogether different. His austere, emotionless expression and thick-lidded, wide-staring eyes exude an aura of uncompromising authority.

The appearance and eventual triumph of Christianity is outside the scope of this account, but its emergence as the official religion of the empire played a final and decisive part in ending the Classical era. Pagan art, pagan literature, and pagan culture as a whole represented forces and ideals that Christianity strongly rejected, and the art of the early Christians is fundamentally different in its inspiration. Yet even the fathers of the early church, implacable opponents of paganism, could not fail to be moved by the end of so great a cultural tradition.

feet long (the size of a football field without the end zones), 215 feet wide (55 feet, about five car lengths, wider than a football field)—and enormous barrel vaults in the aisles that supported a groin-vaulted ceiling over a central *nave* that rose

The memory of Rome's greatness lived on through the succeeding ages of turmoil and achievement, and the Classical spirit survived to be reborn triumphantly in the Renaissance.

GLOSSARY

Barrel vault (p. 145) A continuous arch or vault that looks like a semicircle in cross-section (also called a *tunnel vault*)

Dactylic hexameter (p. 137) The rhythmic scheme used in epic poetry by Homer and Virgil; each line consists of six dactyls, a dactyl is a long syllable followed by two short syllables.

Dome (p. 145) A vaulted roof usually having a circular base and shaped like half a sphere.

Epicureanism (p. 127) A school of philosophy that argues that the world consists of chance combinations of atoms and that happiness or the avoidance of pain and anxiety are the greatest goods, although pleasure is to be enjoyed in moderation.

Forum (p. 121) An open public space in the center of a Roman city (plural *fora*).

Jus civile (p. 129) Rules and principles of law as derived from the laws and customs of Rome.

Lyric poetry (p. 118) A form or genre of poetry characterized by the expression of emotions and personal feelings; so called because such poetry was sung to a lyre.

Neo-Platonism (p. 127) The school of philosophy that develops Plato's concept of the One, the source of all life, which is transcendent and unknowable through reasoning.

Oculus (p. 150) A circular opening in a dome that allows the entry of natural light from above.

Ode (p. 140) A form of lyrical poetry, based on Greek models, which usually glorifies events or people, or describes nature.

Patrician (p. 124) A member of an elite family in ancient Rome.

Plebeian (p. 124) A land-owning Roman citizen, but not a patrician.

Sarcophagus (p. 120) A coffin; usually cut or carved from stone, although Etruscan sarcophagi were made of terra-cotta (plural *sarcophagi*).

Stoa (p. 127) A covered colonnade; a roofed structure, like a porch, that is supported by a row of columns opposite a back wall.

Stoicism (p. 127) A school of philosophy with the view that the universe was ordered by the gods and that people could not change the course of events; people could, however, psychologically distance themselves from tragic events by controlling their attitudes toward them.

Tribune (p. 124) The title given elected officials in Rome; they could convene the Plebeian Council and the Senate and propose legislation.

Triumphal arch (p. 124) A monumental structure that takes the form of one or more arched passageways, often spanning a road, and commemorates military victory.

THE BIG PICTURE ROME

THE ETRUSCANS (CA. 700–89 BCE)

Language and Literature

- Etruscans spoke a non-European language that was written in a script derived from Greek. Some texts have survived, but they are not fully deciphered.
- The longest extant text is the *Liber Linteus* (the *Linen Book*), which survived because it was cut into strips by Egyptians and used to wrap a mummy.

Art, Architecture, and Music

- Etruscans were admirers of Greek art, but not imitators. Unlike the Greeks, they built their temples of wood and mudbrick and preferred terra-cotta as a medium for their life-size statues.
- While the rippling drapery and enigmatic smiles of Etruscan statues are reminiscent of the Archaic Greek style, the movement, animated gestures, and lively facial expressions are telltale Etruscan characteristics.
- Subterranean tombs, carved from bedrock limestone, reflect the floor plans of Etruscan houses and feature interiors decorated with reliefs that depict household utensils and status symbols.

Philosophy and Religion

- The pantheon of Etruscan gods has its equivalents in Greek and Roman mythology.

REPUBLICAN ROME (509–27 BCE)

Language and Literature

- The Romans spoke Latin, an Indo-European language. So-called Classical Latin was a literate form of the language that was in usage by the late years of the Republic. As Rome expanded, the various dialects of conquered peoples mixed with Latin.
- Roman poetry and plays followed Greek models in form and content. Subjects ranged from pure comedy to love.
- Insights into Roman life and military campaigns come to us in the form of written commentaries and letters.

Art, Architecture, and Music

- Roman temples are hybrids of Greek and Etruscan architectural styles.
- Portrait sculpture is characterized by *verism*, or a superrealistic style, and is often used to project a specific, constructed self-image.
- Wall painting emerged as a complex art form.
- Music consisted mainly of performance at religious events—from marriages to funerals—and entertainment—from private dinner parties to public gladiator contests.

Philosophy and Religion

- Two main schools of philosophy—*Epicureanism* and *Stoicism*—were "imported" from Greece.
- The pantheon of Roman gods assimilated the deities of the Greeks and Romans.

IMPERIAL ROME (27 BCE–337 CE)

Language and Literature

- Literary works from epics to odes related to the Augustan worldview: peace, the importance of the land and agriculture, the merits of the simple life, and Rome's destiny as ruler of the world.
- Satirical verse appears, along with poetry about love and sex that flies in the face of Augustus's call for a family-oriented lifestyle.
- Historical narratives provide insight into the reigns of Roman emperors and the catastrophe of the eruption of Vesuvius.

Art, Architecture and Music

- Imperial sculpture and architecture mimic the Classical style of Periclean Athens.
- Buildings and monuments were constructed using Roman techniques and innovations: the arch, the vault, the dome, and bold use of concrete.
- Wall paintings and intricate mosaics decorate Roman houses and gardens, many of which were preserved in the volcanic ash spewed by Vesuvius.
- Forums, constructed in Rome's city center, are sites for temples and basilicas, monuments, and markets.
- Form and function merge in the design of public works, most notably aqueducts that carried water from the outskirts of Rome into the heart of the city, and in the apartment blocks constructed to alleviate overcrowding.
- In the waning days of the empire, classical ideals abandoned; portraits of emperors revealed the anxiety of the age.

Religion and Philosophy

- Neo-Platonism developed. Interest in Epicureanism and Stoicism is replaced with an enthusiasm for Eastern religious cults, including Christianity.

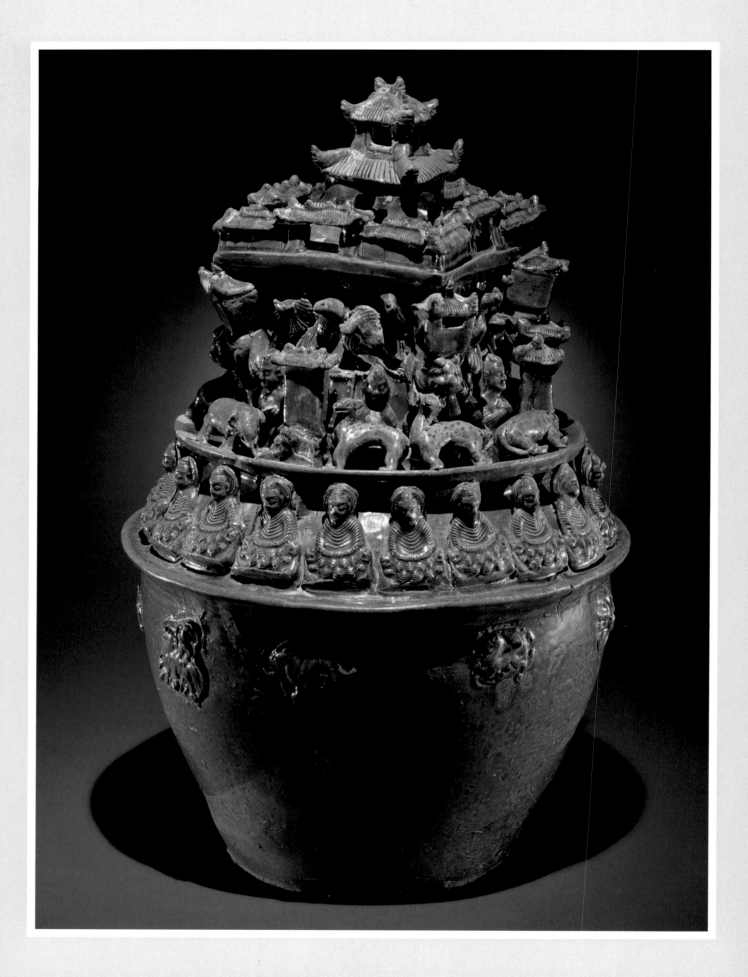

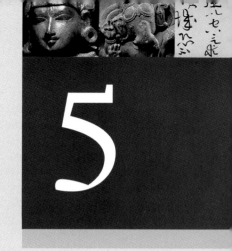

Ancient Civilizations of India and China

<div style="text-align: right">**5**</div>

PREVIEW

It is 566 BCE and the Panathenaic Games have been inaugurated in Athens. There would be athletic competitions, to be sure, but prizes would also be awarded for poetry and music and the best recitation of Homer. The full texts of the *Iliad* and the *Odyssey* would be read at the games. In the Near East, the vast Persian Empire was just beginning to take shape; by the time Darius the Great took over as ruler, the empire already included parts of northeast Africa, Anatolia (Turkey), Mesopotamia, and the Aegean coast. Egypt followed, only a few years before Darius became king in 522 BCE. Greece would have been next, but Darius's son, Xerxes, ultimately was defeated in 490 BCE. The outcome of the Persian Wars with Greece would determine the course of Western civilization. But at the same time, in other places, there were other civilizations, other outcomes.

In 1922, the German novelist Hermann Hesse penned his story of a young man whose life overlapped this era, many miles to the east of Persia. Born into wealth and insulated from human suffering, he fled his life of privilege to experience both the ordinary beauty and the extraordinary horror of the world beyond his palatial realm. His adventures run the gamut between asceticism and hedonism. Rejecting both, he settles into an uneventful life of a ferryman, which, nevertheless, brings certain awareness.

> Tenderly, he looked into the rushing water, into the transparent green, into the crystal lines of its drawing, so rich in secrets. Bright pearls he saw rising from the deep, quiet bubbles of air floating on the reflecting surface, the blue of the sky being depicted in it. With a thousand eyes, the river looked at him, with green ones, with white ones, with crystal ones, with sky-blue ones. How did he love this water, how did it delight him, how grateful was he to it! In his heart he heard the voice talking, which was newly awaking, and it told him: Love this water! Stay near it! Learn from it! Oh yes, he wanted to learn from it, he wanted to listen to it. He who would understand this water and its secrets, so it seemed to him, would also understand many other things, many secrets, all secrets.[1]

1. Hermann Hesse, Siddhartha, trans. Hilda Rosner (1922; trans. New York: New Directions Publishing Corporation, 1951), p. 101.

◄ **5.1 Funerary urn (*hunping*), ca. 3rd century CE (Western Jin dynasty, 265–317 CE). Earthenware with green glaze, 17⁷⁄₈″ × 11³⁄₄″ (45.4 × 30.3 cm). Metropolitan Museum of Art, New York, New York.** The urn has a rich gathering of figures and architecture, organized in tiers. Around the waist of the urn sits a row of Buddhas with lotus petals on lion thrones. It was intended that the soul of the departed individual would return to dwell in the urn.

The scene takes place in ancient India and is a fictionalized account of the spiritual awakening of a man called Siddhartha—in **Sanskrit**, "he who has achieved his goals" or "he who has found the meaning of life"—who lived during the time of the Buddha, Siddhartha Gautama. In reality, Gautama Buddha was likely born into a royal family in Nepal. According to popular biographical narrative, he abandoned his life of luxury and sought enlightenment through meditation. After forty-nine days spent under a sacred fig tree, Gautama achieved enlightenment and thereafter was called the Buddha (that is, the "awakened one") by his followers. Gautama's teachings were passed down orally for some four centuries and finally committed to writing at about the time that Julius Caesar was assassinated in Rome. Buddhism, a religion and philosophy that traveled eastward from India to China and beyond, is based on the teachings of Siddhartha Gautama.

Of the many religions of India and China, Buddhism is the one that is common to both cultures. The *hunping* (soul jar), a glazed ceramic funerary urn from around the third century CE features what may be the earliest images of the Buddha in China (**Fig. 5.1**). Found in a region south of the Yangtze River, it is a type that was often placed in Han-dynasty tombs. Intricately modeled animals and birds gather around the base of a pagoda-style structure, all perched on a ring of Buddhas meditating on the petals of lotus flowers. As in Egyptian and Etruscan tombs, the urn would have been one of many objects intended for use by the deceased in the afterlife. The Metropolitan Museum of Art in New York, where the hunping now resides, suggests that the birds and beasts are auspicious (they are there to promise success) and that, together with the Buddhas, they could guide the soul of the deceased to rebirth in paradise.

INDIA

Indian civilization sprang up in the valley of the Indus River, like Egypt on the Nile and Mesopotamia in the Fertile Crescent of the Tigris and Euphrates—and at roughly the same time. The word *India* derives from the Sindhi, an ethnic group who lived in this region. What we know of ancient India comes from archaeological evidence, although it is only imperfectly understood. They possessed a written language based on picture signs that has yet to be deciphered. Like the other river civilizations, theirs was an agrarian society (they were probably the first people to cultivate cotton), but they also had large, significant urban centers, notably Harappā and Mohenjo-daro. Stone and ceramic artifacts suggest a highly developed religion, of which we know little, and some carved objects seem to indicate that, as on Crete, the bull may have been important. They also used standardized weights and measures, likely for trade purposes. They created a drainage system and the close examination of pottery shows that some centralized agency handled the distribution of goods.

Ancient Civilizations of India and China

3000 BCE	1500 BCE	200 CE	600 CE	1000 CE
Earliest South Asian cities develop in the Indus River Valley (modern day Pakistan)	Indian emperor Ashoka (r. 272–231) converts from Brahmanism to Buddhism and facilitates the spread of the religion	Gupta Empire establishes a period of economic stability, religious tolerance, and cultural achievements in India	The Tang Dynasty After (r. 618–906) emerges after centuries of confusion in China	
Mohenjo-daro designed with a grid plan of streets, central marketplace, public bath, and sewage system	Shang dynasty of China (ca. 1520–1027 bce) develops an urban civilization based on trade and commerce	Guptas build universities in which subjects such as mechanics, medicine, and mathematics are taught		
Aryan people settle in the Indus Valley and introduce a caste system	Zhou dynasty (ca. 1046–221 BCE) replaces the Shang dynasty and coordinates separate kingdoms	Indian scholars invent what we now call Arabic numerals and develop decimals, quadratic equations, and other mathematical concepts		
The Longshan culture establishes cities along the Yellow River in China	The Qin dynasty, from which China derives its name, is founded in 221; a single writing system and standard weights and measures are imposed			
	The Han dynasty (r. 202-220) is established in China			

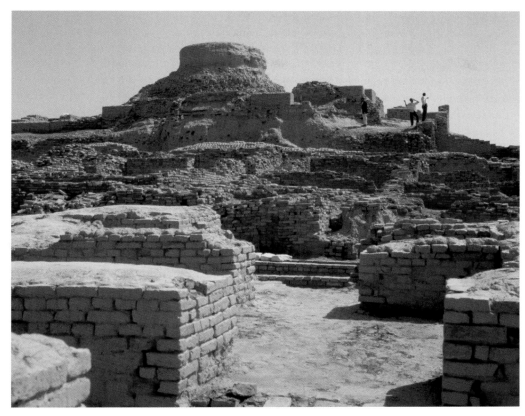

▲ **5.2 Citadel ruins, ca. 2500 BCE. Mohenjo-daro (modern Pakistan).** The ruins of the residential quarter lead to the citadel, which houses ritual baths and is thought to have been the site of other religious rituals. Mohenjo-daro, meaning "mounds of the dead," was once the largest city of the Indus civilization and probably the capital.

The Indus Valley Civilization

Mohenjo-daro was the largest and oldest center of Indus Valley civilization, and its urban plan and engineering finesse are impressive: a grid plan of streets with fire-brick rectilinear buildings, a central marketplace with a public well, a public bath waterproofed with bitumen, and a sewage system, to name but some of its features. The size of the city (at its peak it housed 35,000 inhabitants), its fortifications, and its variety of structures indicate that it was a city of great importance, perhaps the civilization's administrative center. They used standard weights and measures for trading purposes as well methods of distributing goods (mainly pottery). Excavation of Mohenjo-daro began in the 1920s, and today the ruins are designated as a UNESCO World Heritage site (**Fig. 5.2**).

Indus Valley artisans were highly skilled in bronze and stone sculpture. The Robed male figure (**Fig. 5.3**) from Mohenjo-daro is carved from limestone with carefully crafted detail that seems to indicate the man's high status. His robe, draped over one shoulder, is delicately carved with a cloverleaf pattern, and he wears what appears to be jewelry around his exposed arm and head. The serene expression, enhanced by his placid lips and only slightly opened eyelids, perhaps indicates that he is a ruler or member of a priestly hierarchy.

Around the time of the New Kingdom in Egypt, 1550 BCE, the Indus Valley civilization began to decline. The area was struck by a series of floods, the soil was exhausted, and the woodlands had been overused. In the maelstrom of these ecological disasters, apparent in the archaeological record, a new threat appeared: invasions from the northwest by a people called the **Aryans**. The disintegration of the older Indus Valley culture was so complete that archaeologists have failed to find any significant artworks from the period between its decline and the much later emergence in the area of Buddhist culture.

➤ **5.3 Robed male figure, ca. 2000–1900 BCE. Mohenjo-daro (modern Pakistan).** Limestone, 6 ⁷/₈″ (17.5 cm) high. National Museum of Pakistan, Karachi, Pakistan.

The Aryans

The Aryans had settled in the Indus Valley by around 1500 BCE, but who they were and where they came from is not at all clear. Some scholars have suggested that they came from the area of the Russian steppes—grassland plains—but the full picture of their migration into the Indian subcontinent is not completely understood. Agriculture was a common way of life, but it was not as prestigious as cattle breeding and herding. Cattle were traded as a medium of currency. Aryans also bred horses, but more for use in warfare than as beasts of burden. Horses were so valued by warriors that some of the earliest hymns refer to rare but important horse rituals that included animal sacrifice. The Aryans also possessed advanced technical skills, including the mastery of bronze. Early Aryan culture was tribal and thus did not establish urban centers. Yet their growth as a civilization was aggressive; over the centuries Aryans would migrate from their strongholds in the northwest of the subcontinent into the southern reaches of India.

The material evidence mapping the spread of the Aryan peoples is at best spotty. What we do know (mainly from later historical texts) is that they spoke the language we call Sanskrit, a branch of Indo-European language groups and the ancestor of Indo-Aryan and Latin, from which Romance languages developed. The connection of these languages can be seen some words: *yoga* (yoke for an animal; later: discipline)—*jugum* (Latin: yoke)—*yoke* (English); *Agni* (God of fire)—*ignis* (Latin: fire)—*ignition* (English).

Epic Poetry

The great epic poems of India—the *Ramayana* and the Mahabharata—were written centuries after the events they purport to describe: the wars by which the Aryans subdued the inhabitants of the Indus Valley. These epics, with their complex story lines featuring gods, heroes, and battles, are central to Indian culture. Even today they are dramatized on Indian television. But they are more than simply stories. The Ramayana influenced the Sanskrit poetry to follow and set forth the teachings of what were even then "ancient" Hindu sages, having religious and philosophical features.

THE MAHABHARATA The **Mahabharata**, was probably begun sometime between the eighth and ninth centuries BCE, although the preserved texts date no farther back than about 400 BCE. It achieved its final form ca. 400 CE. It is attributed to Krishna Dvaipayana Vyasa and is the longest epic ever written, comprised of some 100,000 verses organized into 18 books. It is written in a meter based on the *length* of syllables—short and long—rather than on the arrangement of accented and unaccented syllables, as is typical in English verse.

The epic recalls a number of events that were believed to have occurred during the wars between two branches of the Indo-Aryan Kuru clan—the Kauravas and the Pandavas—over the succession to the kingdom of the Kurus (Kuruksetra) in the Ganges River Valley in north India. Like the *Iliad* and the *Odyssey*, some of the story may be based on actual historical events, but they are embellished by fanciful interactions between gods and humans. In the first book of the Mahabharata, the tale is told of the birth of one of the epic's heroic protagonists, Karna. Kunti, a virtuous, beautiful, but infertile woman, is given a magic spell by a sage which, he says will enable her to bear children. She tries the spell, which invokes the sun god—the "light of the universe"—who impregnates her with a son who became the "foremost of warriors." Karna was born wearing armor and earrings. Like Achilles, Karna was the offspring of a divine parent and a mortal. Without a father to be seen, Kunti hid her "transgression" by throwing Karna into the Ganges River, whereupon he was plucked to safety by a Kuru charioteer who raised him as his own son. Karna grows up as a Kaurava, not realizing that he has brothers who are Pandavas. Thus Karna winds up in battle against his own kin. Interestingly in the Hebrew Bible, Moses—the prophet and leader of the Hebrews—was similarly placed in a basket in the Nile River by his mother, who feared that Egyptians would otherwise kill him. Moses was discovered and raised in the court of the pharaoh, and, as such, at first oppressed his own people—the Hebrews—who were enslaved by the Egyptians.

The epic is hailed as teaching universal truths and values, but much of the detail is devoted to the rituals and violence of war in the ancient world of the heroic age. Early on, in book 2, we meet the wrathful Bhima, the second brother of the Pandavas who has been insulted by the Kaurava warrior Duhsasana and vows revenge. In book 8, we find Karna and Bhima on the same battlefield.

READING 5.1 KRISHNA DVAIPAYANA VYASA

The Mahabharata, book 8, passage 48

During the fighting on that day there was a dreadful and thrilling battle between Karna and the Pandavas which increased the domain of the god of Death. After that terrible and gory combat only a few of the brave Samsaptakas survived. Then Dhrstadyumna and the rest of the Pandavas rushed towards Karna and attacked him. As a mountain receives heavy rainfall, so Karna received those warriors in battle. Elsewhere on the battlefield Duhsasana boldly went up to Bhima and shot many arrows at him. Bhima lept like a lion attacking a deer, and hurried towards him. The struggle that took place between those two, incensed against each other and careless of life, was truly superhuman.

Fighting fiercely, Prince Duhsasana achieved many difficult feats in that duel. With a single shaft he cut off Bhima's bow; with six shafts he pierced Bhima's [chariot] driver. Then, without losing a moment he pierced Bhima himelf with many shafts discharged with great speed and power, while Bhima hurled his mace at the prince. With that weapon, from a distance of ten bow-lengths, Bhima

forcibly dislodged Bhima from his car. Struck by the mace, and thrown to the ground, Duhsasana began to tremble. His charioteer and all his steeds were slain, and his car too was smashed to pieces by Bhima's weapon.

Then Bhima remembered all the hostile acts of Duhsasana towards the Pandavas. Jumping down from his car, he stood on the ground, looking steadily on his fallen foe. Drawing his keen-edged sword, and trembling with rage, he placed his foot upon the throat of Duhsasana and, ripping open the breast of his enemy, drank his warm lifeblood, little by little. Then, looking at him with wrathful eyes, he said "I consider the taste of this blood superior to that of my mother's milk, or honey, or ghee[2], or wine, or excellent water, or milk, or curds, or buttermilk."

All those who stood around Bhima and saw him drink the blood of Duhsasana fled in terror, saying to each other, "This one is no human being!" Bhima then said, in the hearing of all those heroes, "O wretch among men, here I drink your lifeblood. Abuse us once more now, 'Beast, beast,' as you did before."

The Mahabharata is the ancestral narrative of the Indian people, but within it is one of their most well-known religious and philosophical texts—the Bhagavad Gita. Much of what the West knows about Hinduism—the religion of the majority of Indians today—comes from this text.

Aryan culture had brought strict societal class distinctions between the nobility and the common people to the Indus Valley. Over time, this distinction developed into a **caste system** that separated society into distinct strata and went hand in hand with religious beliefs. Societal rank was hereditary, and movement from one rank to a higher one (or lower one) was believed to be connected to good or bad deeds during one's lifetime. In the next life, one might be better—or worse—off. The caste system was also endogamous, meaning that one could only marry within one's particular caste. At the top level were the *Brahmins* (priests), followed by *Kshatriyas* (warriors), *Vaishyas* (merchants and landowners), and *Kshudras* (commoners, peasants, and servants), and finally the *Dalit*, the "untouchables" who did all the lowest-level work and were subordinate to all other castes. The untouchables, also called the *outcasts* (literally, out of caste), performed menials tasks that other castes shunned (cleaning latrines or sweeping streets, for example). The caste system was one of the shaping social forces in India, reinforced by many laws concerning ritual purity, marriage, and even who could eat with whom.

Hinduism

Unlike Judaism, Christianity, and Islam, and unlike Buddhism, the Hindu religion (derived from an Arabic word meaning "those who live in the Indus Valley") has no founder, no prophet. It simply means "the religion of the Indians." It combines a highly ritualized worship of the gods of the pantheon with a strong speculative tradition that tries to grasp the ultimate meaning of the cosmos and those who live in it. Indian religion, in short, is both a religion of the priest and the temple as well as the religion of solitary meditation and study. The three most important deities are the gods **Vishnu**, **Shiva**, and **Brahma**. Vishnu is regarded as the preserver of the universe. Shiva is known as the Lord of Lords and god of creation and destruction, which in Hindu philosophy are one and the same (see **Fig. 5.4**). In the Bhagavad Gita, Shiva says, "Now I am become Death, the destroyer of worlds." (J. Robert Oppenheimer, an American physicist and so-called "Father of the Atomic Bomb," said he thought of Shiva's words after he witnessed the world's first test of the weapon in 1945.) Brahma, the god of creation, is also portrayed as the goddess **Devi** or Deva, whose name means "shining one." Unlike divas on the stage today, the goddess Devi was seen as gentle and approachable, sometimes as "Mother of the Universe."

Most Indian homes to this day have a small altar for a god or goddess, in order for the family to show respect and worship in the home. The fundamental aim of Indian religion, however, is to find the path that leads one to the correct knowledge of ultimate reality, which, when known, leads one to be liberated from the illusory world of empirical reality and be absorbed into the one true reality, *brahman*.

Broadly speaking, three paths have been proposed for attaining such knowledge:

The path or discipline (that is, yoga) of asceticism (fasting, nonpossession, bodily discipline, and so on), in which one lives so that the material world becomes accidental and that person becomes enlightened. This is the hardest path of all, which, if at all undertaken, usually comes after one has had a normal life as a householder.

The path or discipline of **karma**, in which one does one's duty according to one's caste obligations (for example, priests should sacrifice, warriors fight) and not out of greed or ambition—motives that cloud the mind.

READING 5.2 KARMA

The *Brihad-Aranyaka Upanishad* (eighth–seventh century BCE), the Supreme Teaching

According as a man acts and walks in the path of life, so he becomes. He that does good becomes good; he that does evil becomes evil. By pure actions he becomes pure; by evil actions he becomes evil.

And they say in truth that a man is made of desire. As his desire is, so is his faith. As his faith is, so are his works. As his works are, so he becomes. It was said in this verse: A man comes with his actions to the end of the determination.

2. A substance having the consistency of clarified butter

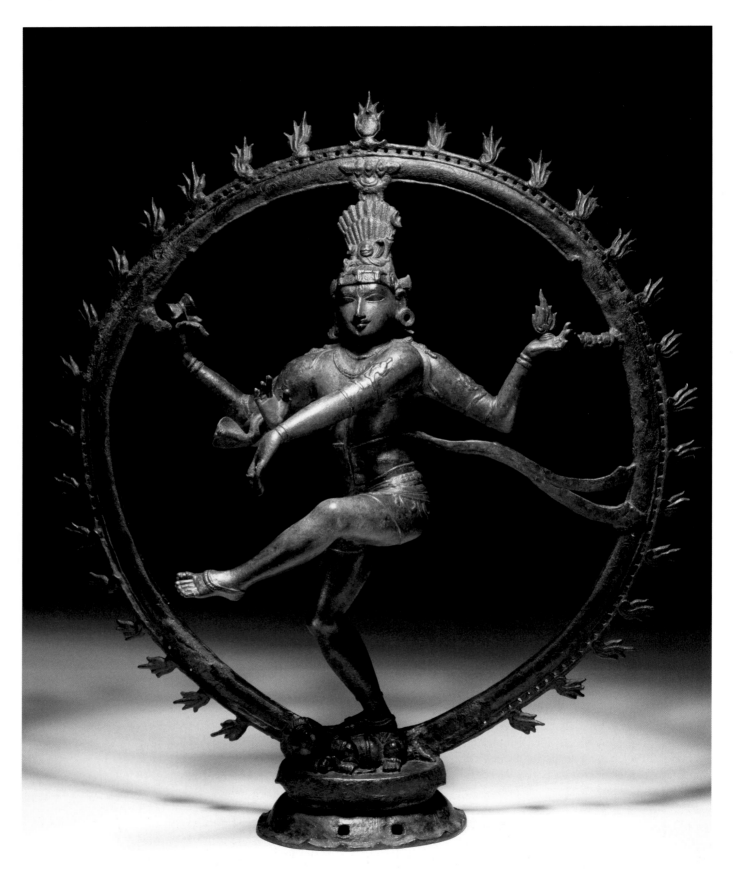

▲ **5.4 Shiva as Nataraja, the King of Dance, 12th century CE. South India. Bronze, 43⅞" × 40" (111.4 × 101.6 cm). Victoria and Albert Museum, London, United Kingdom.** With one foot on the Demon of Ignorance, Shiva dances within a fiery aura. His periodic dance destroys the universe, which is then reborn. So, in Hindu belief, is the human spirit reborn after death, its new form reflecting the sum of the virtues of its previous existences.

Reaching the end of the journey begun by his works on earth, from that world a man returns to this world of human action.

Thus far for the man who lives under desire.

From *The Upanishad*, translated with an introduction by Juan Mascaro (Penguin Classics, 1965). Copyright © Juan Mascaro, 1965.

The path of devotion, in which all people refer all of their deeds as an act of devotion (**bhakti**) to the gods or to the one god to whom a person has a special devotion. By doing everything out of devotion, one does not fall into the trap of greed or self-centeredness.

THE BHAGAVAD GITA The **Bhagavad Gita** ("Song of the Lord") is a Sanskrit poem of seven hundred verses organized into eighteen chapters. It is hailed as the great scripture of the Hindu religion. It is said to have inspired the contemporary Indian leader Mahatma Gandhi (1869–1948), who advocated civil disobedience rather than force to counter the occupying British, and it is well-known in the West. The Bhagavad Gita may have originally been an independent philosophical poem, but it was placed in the sixth book of the Mahabharata, at the beginning of hostilities. Its tone is completely different from that of the warfare which follows.

The following passage recounts a dialogue between Arjuna, a champion of the Pandavas, and his charioteer, Krishna. Arjuna is reluctant to bring his weapons to bear against his kinsmen, who, after all, include relatives and

3. A bow he won from the fire god.

4. Krishna is a god, but he is also referring to reincarnation, as we shall see.

5. Fighting is not a choice for Arjuna; he belongs to the warrior class.

READING 5.3 **THE BHAGAVAD GITA**

From the First Teaching

Arjuna saw them standing there:
fathers, grandfathers, teachers,
uncles, brothers, sons,
grandsons, and friends.

He surveyed his elders
and companions in both armies,
all his kinsmen
assembled together.

Dejected, filled with strange pity,
he said this:

"Krishna, I see my kinsmen
gathered here, wanting war.

My limbs sink,
my mouth is parched,
my body trembles,
the hair bristles on my flesh.

The magic bow[3] slips
from my hand, my skin burns,
I cannot stand still,
my mind reels.

I see omens of chaos,
Krishna: I see no good
in killing my kinsmen
in battle.

Krishna, I see no victory,
or kingship or pleasures.
What use to us are kingship,
delights, or life itself?

. . .

They are teachers, fathers, sons,
and grandfathers, uncles, grandsons,
fathers and brothers of wives,
and other men of our family.

. . .

How can we ignore the wisdom
of turning from this evil
when we see the sin
of family destruction, Krishna?"

From the Second Teaching
Lord Krishna (speaks):

You [Arjuna] grieve for those beyond grief,
and you speak words of insight;
but learned men do not grieve
for the dead or the living.
Never have I not existed,[4]
nor you, nor these kings;
and never in the future
shall we cease to exist.

Just as the embodied self
enters childhood, youth, and old age,
so does it enter another body;
this does not confound a steadfast man.

Contacts with matter make us feel
heat and cold, pleasure and pain.
Arjuna, you must learn to endure
fleeting things—they come and go!

. . .

Our bodies are known to end,
but the embodied self is enduring,
indestructible, and immeasurable;
therefore, Arjuna, fight the battle!

. . .

Look to your own duty (dharma);
do not tremble before it;
nothing is better for a warrior[5]
than a battle of sacred duty.

The Norton Anthology of World Literature, second edition, Volume A. Sarah Lawall and Maynard Mack (Eds.). New York: W. W. Norton & Company, 2002, pp. 1014–1018.

teachers, and he halts his chariot between the opposing forces. Krishna, however, who is actually an incarnation of the preserver god Vishnu, will tell Arjuna that it is his sacred duty (dharma) to fight, because action performed as a sacred obligation will lead to the emancipation of his spirit and release him from the dreaded cycle of karma and rebirth.

The elaborate religious system of the Aryan culture placed enormous emphasis on ritual sacrifice to the pantheon of gods. The fact that the priests had the highest place in the caste system was a result of their responsibility in carrying out the religious ceremonies in honor of the gods. Highly complex in their detail, the rituals had to be carried out exactly according to tradition in order for the ceremonies to attain their goal (for example, the fertility of the soil, the arrival of the rains, and so on). These ceremonies and their companions—hymns and gestures—were passed from one generation of hereditary priests to the next in a fixed oral form beginning at around 1500 BCE to 1200 BCE. It was only around 300 BCE that these texts were committed to writing in a compilation which is now known as the Vedas, with the best-known of these compilations called the *Rig-Veda*. The Vedas represent the oldest strain of Indian religious literature and are still chanted by Hindus at all important moments in Indian religious life: at birth, naming ceremonies, rites of passage to adulthood, in sickness, and at death. They also form the core text of Hindu temple worship. The Vedas, in fact, represent one of the oldest bodies of religious writings known to humanity.

THE RIG-VEDA The **Rig-Veda** comprises a collection of 1,028 hymns to the gods written in verses. Some were meant for use during religious ceremonies; some were meant to address deep philosophical and religious questions, such as the origins of the universe and of the social order. Hymn 129 from book 10 of the Rig-Veda, containing seven verses, addresses the creation of the universe and tries to approach certain philosophical question: If something cannot emerge from nothing, what was the first something, the "prime mover"? And how could we hope to explain the origin of such a creator, how and when a creator came into being?

READING 5.4 THE *RIG-VEDA*

"In the beginning"

1 Then neither Being nor Not-Being was,
 Nor atmosphere, nor firmament, nor what is beyond.
 What did it encompass? Where? In whose protection?
 What was the water, the deep, unfathomable?
2 Neither death nor immortality was there then,
 no sign of night or day.
 That One breathed, windless, by its own energy:
 Nought else existed then.
3 In the beginning was darkness swathed in darkness;
 All this was but unmanifested water.

 Whatever was, that One, coming into being,
 Hidden by the void,
 Was generated by the power of heat.
4 In the beginning this [One] evolved,
 Became desire, first seed of mind.
 Wise seers, searching within their hearts,
 Found the bond of Being in Not-being.
5 Their cord was extended athwart:
 Was there a below? Was there an above?
 Casters of seed there were, and powers;
 Beneath was energy, above was impulse.
6 Who knows truly? Who can here declare it?
 Whence it was born, whence this emanation.
 By the emanation of this the gods
 Only later [came to be].
 Who then knows whence it has arisen?
7 Whence this emanation hath arisen,
 Whether [God] disposed it, or whether he did not,—
 Only he who is its overseer in highest heaven knows.
 [He only knows,] or perhaps even he knows not!

Many scholars have compared these verses to the Book of Genesis. In both we begin with nothing. We have concepts of darkness and of the deep, the unfathomable. In both, something that cannot be understood by the human mind—here referred to as "that One" or "this One"—somehow breathed and created the world. But there is a questioning in the *Rig-Veda* version that we find nowhere in Genesis. Can humans truly imagine or say what might have happened? There is even questioning as to whether God created the universe, or whether even God—who is unknowable—can understand how things came to be.

We saw that the Aryans brought a caste system to India divided society into castes of priests, warriors, laborers, and serfs (workers who were attached to the land and sold or bought by a feudal lord as part of a property). A hymn from the *Rig-Veda* that has come down to us as "The Sacrifice of the Primal Man" reinforces the religious belief in sacrifice as a creative event and justifies the social order. In this myth, the primal man is sacrificed to become the world, and the several castes emanate from different parts of his body.

READING 5.5 THE *RIG-VEDA*

From "The Sacrifice of the Primal Man"

1 A thousand heads had [primal] Man,
 A thousand eyes, a thousand feet:
 Encompassing the earth on every side,
 He exceeded it by ten fingers' [breadth].
2 [That] Man is this whole universe,
 What was and what is yet to be,

The Lord of immortality
Which he outgrows by [eating] food.

. . .

4 With three-quarters Man rose up on high,[6]
A quarter of him came to be again [down] here:[7]
From this he spread in all directions,
Into all that eats and does not eat.

. . .

6 When with Man as their oblation[8]
The gods performed their sacrifice,
Spring was the melted butter,
Summer the fuel, and the autumn the oblation.

. . .

8 From this sacrifice completely offered
The clotted ghee was gathered up:
From this he fashioned beasts and birds,
Creatures of the woods and creatures of the village.

. . .

10 From this were horses born, all creatures
That have teeth in either jaw;
From this were cattle born,
From this sprang goats and sheep.

11 When they divided [primal] Man,
Into how many parts did they divide him?
What was his mouth? What his arms?
What are his thighs called? What his feet?

12 The Brahman[9] was his mouth,
The arms were made the Prince,
His thighs the common people,
And from his feet the serf was born.

13 From his mind the moon was born,
And from his eye the sun,
And from his mouth Indra[10] and the fire,
From his breath the wind was born.

14 From his navel arose the atmosphere,
From his head the sky evolved,
From his feet the earth, and from his ear
The cardinal points of the compass:
So did they fashion forth these worlds.

THE UPANISHADS Shortly after the composition of the *Rig-Veda*, a new kind of literature came into being. The sages of India were interested in the large questions of what we would call philosophical issues, for example: What caused the cosmos to be? How did human beings arise? Why is human life short? Why do people suffer? What is the deep meaning behind the priestly rituals and sacrifices? The responses to these and similar questions are treated in a series of classical Indian texts known as the **Upanishads** (meaning a "session," that is, from a learned person). We possess more than one hundred Upanishadic texts, which vary in length and sophistication. Some deal with the allegorical meaning of ritual, whereas others are more philosophical in nature. They even memorialized an early view of dreams as a form of wish fulfillment.

READING 5.6 DREAMS

The *Brihad-Aranyaka Upanishad* (eighth–seventh century BCE), the Supreme Teaching

When the Spirit of man retires to rest, he takes with him materials from this all-containing world, and he creates and destroys in his own glory and radiance. Then the Spirit of man shines in his own light.

In that land there are no chariots, no teams of horses, nor roads; but he creates his own chariots, his teams of horses, and roads. There are no joys in that region, and no pleasures nor delights; but he creates his own joys, his own pleasures and delights. In that land there are no lakes, no lotus ponds, nor streams; but he creates his own lakes, his lotus ponds, and streams. For the Spirit of man is Creator.

From *The Upanishad*, translated with an introduction by Juan Mascaro (Penguin Classics, 1965).

The fundamental worldview of the Upanishads may be stated briefly. The ultimate reality is an impersonal reality called **brahman**. Everything else is a manifestation of this underlying reality. Each individual person has within the self Brahman, which, in a person, is called **atman**. The secret of life is to come to the knowledge that brahman is the ultimate reality (that is, one's inner self is part of this fundamental reality) and everything else is, in a certain fashion, permeable and unreal. This fundamental assertion is summed up in a classical Sanskrit expression *Tat tvam asi*: "You (the individual) are that (the eternal essence or brahman)."

Buddhism

Into this highly complex world of the Indian subcontinent, the person who came to be called Buddha was born. His given name was Siddhartha and his family name was Gautama. He was born around 563 BCE into the family of a king who belonged to the warrior caste in the foothills of the Himalayas in what is present-day Nepal. Raised in luxury, he married young and fathered a son. When he was not yet thirty, he traveled outside his palatial quarters and saw enough suffering (beggars, a corpse, a sick person, and a wandering, begging ascetic) to wonder about the inescapability of suffering and death. Leaving his family, he took up a wandering life as an ascetic practitioner of meditation and self-denial. According

6. Three-quarters of primal man became divine beings who dwell in heaven.

7. One-quarter of primal man became beings on the earth.

8. The act of making an offering.

9. The eternal ultimate reality, incapable of being understood by humans.

10. A chief Vedic god associated with rain and thunder.

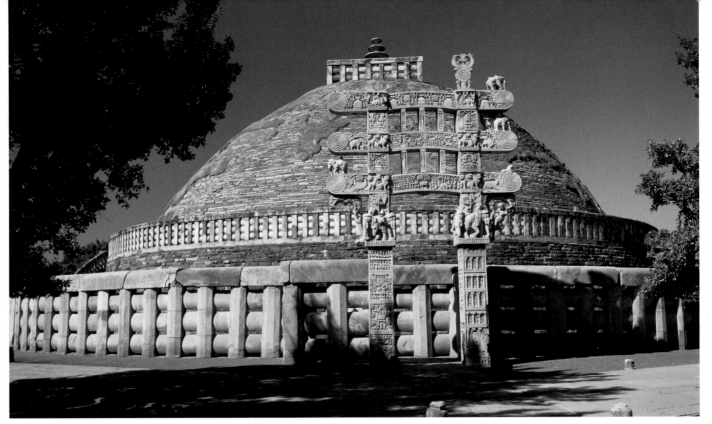

▲ **5.5 Great Stupa, 3rd century BCE–early 1st century CE. Sanchi, India. 65′ (19.8 m) high.** The shape of the stupa develops from the ancient practice of building a hemispherical mound atop the remains of the deceased. It is believed that eight such stupas serve as reliquaries for Buddha. They may also be repositories of Buddhist texts.

to Buddhist tradition, he visited learned men, undertook meditation, and practiced fasting and self-deprivation. At age thirty-five, frustrated by his lack of insight, he decided to sit under the shade of a tree until he intuited the truth about existence. At the climax of this long vigil, he received the illumination that caused him to be called the Enlightened One (Buddha). He left his spot and went to the deer park at Sarnath, near what is present-day Benares (Varanasi), to teach his new doctrine. There he preached his famous first sermon outlining the "Middle Way" between extreme asceticism and self-indulgence. Buddha's doctrine has been called the Four Noble Truths:

1. Existence itself is suffering.
2. Suffering comes from craving and attachment.
3. There exists a cessation of suffering, which is called **nirvana**.
4. There is a path to nirvana, which is eightfold.

The Eightfold Path can be summarized as a "way of life," which derives from the following: right views, right resolve, right speech, right action, right livelihood, right effort, right mindfulness, and right concentration. When these eight basic dispositions are lived correctly, one then might escape the never-ending cycle of rebirth and find nirvana. The specific character of this eightfold disposition would emphasize ethical living; awareness of who one is and what one does; nonviolence; temperance in dealing with material realities; erasure of impulses to greed, acquisition, sensual living; and so on. This kind of life leads a person to understand the

READING 5.7 SIDDHARTHA GAUTAMA, THE BUDDHA (CA. 563–483 BCE)

from the First Sermon

Then the Exalted One (Buddha) thus spake unto the company of five monks. "Monks, these two extremes should not be followed by one who has gone forth as a wandered. What two?

"Devotion to the pleasures of sense, a low practice of villagers, a practice unworthy, unprofitable, the way of the world (on the one hand); and (on the other) devotion to self-mortification, which is painful, unworthy, and unprofitable.

"By avoiding these two extremes the Tathagata [another name for Buddha] has gained knowledge of that middle path which giveth vision, which giveth knowledge, which causeth calm, special knowledge, enlightenment, Nirvana.

"And what, monks, is that middle path which giveth vision . . . Nirvana?

"Verily it is this Ariyan eightfold way, to wit: Right view, right aim, right speech, right action, right living, right effort, right mindfulness, right concentration. This, monks is that middle path which giveth vision, which giveth knowledge, which causeth calm, special knowledge, enlightenment, Nirvana."

From *The Wisdom of Buddhism*, trans. Christmas Humphries, p. 36–37, 42–45.

passing reality in which people are enmeshed and thus find liberation.

Buddhism preaches liberation through knowledge. The typical figures that represent Buddha makes the point forcefully: Buddha sits in a meditative position with eyes half-closed and a half smile on his face because he has discovered within himself the ultimate truth, which has enlightened him. Buddha does not look up to the heavens to a god or kneel in worship. Truth comes from within.

THE EMPEROR ASHOKA When Buddha died in 483 BCE, his religious tradition was one of many that circulated within India. That situation was to change through the efforts of perhaps the greatest emperor of ancient India: Ashoka. He was a superb and ruthless ruler who unified India (including such faraway places as Afghanistan and Baluchistan) around 261 BCE. However, Ashoka was appalled by the suffering and bloodshed he had caused in this enterprise. Out of remorse, he converted from traditional Hinduism to Buddhism and, out of his Buddhist conviction, began to preach the doctrine of nonviolence in his empire. Although tolerant of all religious traditions, he established Buddhism as the religion of the state. He mitigated the harsh laws of the empire, regulated the slaughter of animals, founded and sus-

tained Buddhist monasteries (called **sanghas**), and erected many **stupas**—those characteristic domed buildings found in Buddhist lands.

After his death, Buddha's cremated remains were reportedly placed in stupas in eight different locations in India. These sites became places of worship and devotion for his followers. The Great Stupa at Sanchi (**Fig. 5.5**) was completed in the first century CE. The stupa is crowned by a large dome that symbolizes the sky. The dome is visually separated from the base of the structure by a stone railing or fence—known as the *vedika*—echoing the separation of the heavenly and earthly spheres. Pilgrims circumnavigate the mound in a clockwise direction, as if tracing the path of the sun across the sky. The worshippers' relationship to the monument concentrates on the exterior rather than the interior as, for example, in the case of the Christian church.

The bracket figure (**Fig. 5.6**) on a gateway to the Great Stupa is a **yakshi**, a pre-Buddhist goddess who was believed to embody the generative forces of nature. She appears to be nude, but a hemline reveals that she wears a diaphanous garment. Her ample breasts and sex organs symbolize the force of her productive powers. The voluptuousness of such figures stands in contrast to the often ascetic figures we find in Western religious art

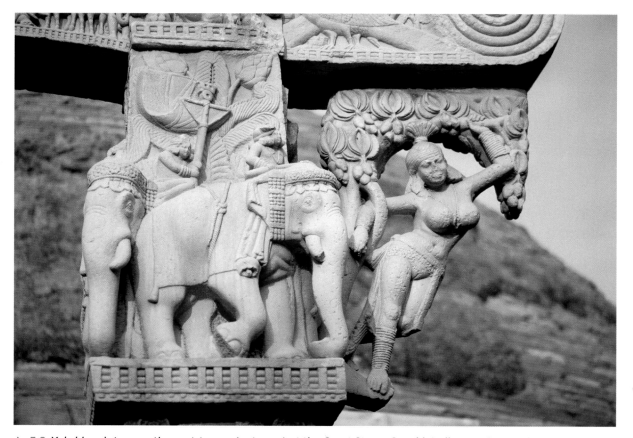

⌃ 5.6 *Yakshi* **sculpture on the east** *torana* **(gateway) at the Great Stupa, Sanchi, India.** In Indian mythology, yakshis were a class of benevolent nature spirits who guard treasures hidden in the earth and among the roots of trees. This yakshi is intended to secure favorable conditions at the site of the stupa. Four such gateways face the four directions around the building. This yakshi figure is a tree spirit who was believed to usher in spring by kicking the trunk of a tree while breaking a branch off, thereby stimulating the tree to blossom. The yakshi and the elephants symbolize the passageway from the profane world outside the stupa to the sacred space within.

War and Religion in the Age of Ashoka

Ashoka's intrinsic tolerance emerges in this extract from his rock edict 12.

His Sacred and Gracious Majesty does reverence to men of all sects, whether ascetics or householders, by gifts and various forms of reverence. His Sacred Majesty, however, cares not so much for gifts or external reverence as that there should be a growth of the essence of matter in all sects. The root of this is restraint of speech; to wit, a man must not do reverence to his own sect by disparaging that of another man without reason. Concord, therefore, is meritorious; to wit, hearkening, and hearkening willingly to the law of piety as accepted by other

people. For it is the desire of his Sacred Majesty that adherents of all sects should hear much teaching and hold sound doctrine.

In his rock edict 13, the king describes his attitude toward war.

This pious edict has been written in order that my sons and grandsons, who may be, should not regard it as their duty to conquer a new conquest. If, perchance, they become engaged in a new conquest by arms, they should take pleasure in patience and gentleness, and regard the only true conquest the conquest won by piety. That avails for both this world and the next.

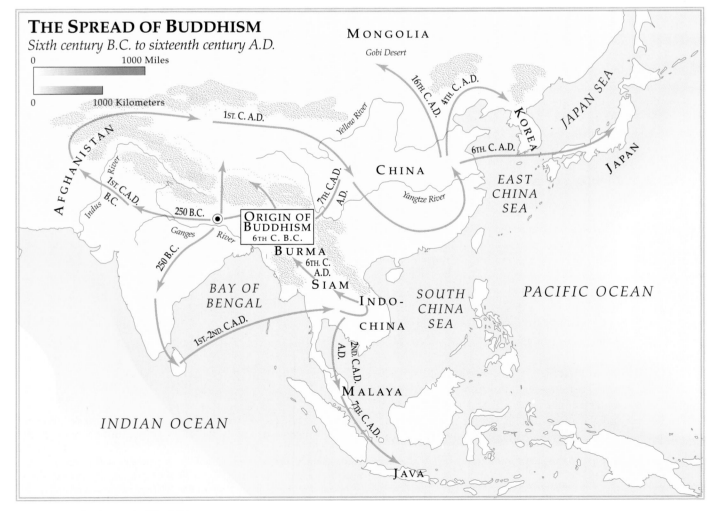

∧ MAP 5.1 The Spread of Buddhism

In addition to stupas, Ashoka erected pillars and towers with his decrees carved on them, some of which exist to this day. Finally, Ashoka is credited with calling a vast Buddhist convocation to fix the canon of sacred books for Buddhism (that is, the authoritative list of writings that are the measure or canon of Buddhist belief and practice).

Perhaps Ashoka's most important contribution to the spread of Buddhism was sending Buddhist monks as missionaries throughout India and beyond to share Buddhist wisdom. There is evidence that his missionaries went as far as Syria, Egypt, and Greece. One of his most important missions was sending a blood relative (perhaps a son or a brother) to Ceylon (present-day Sri Lanka), where the Buddhist doctrine took root and then spread to other parts of Southeast Asia (see **Map 5.1**). Although Buddhism—like all major religions of the world—has a variety of forms and different cultural expressions, at its core is the code enshrined in the Buddha's Four Noble Truths. It is one of the small ironies of history that Ashoka, the emperor of all of India, spread Buddhism all over the East, while in his native India, Buddhism would shrink in time to a small minority, which is the situation at present.

Hindu and Buddhist Art

There is little evidence for artistic production in the period following the disappearance of the Indus Valley people. Only with the reign of Ashoka does a tradition of large-scale sculpture and architecture begin to appear, probably influenced by developments to the west, in Persia. Ashoka erected large monolithic pillars, 30 to 40 feet high, each carved from a single piece of stone. They were planted deep in the ground so as to connect the earth and the sky and create an "axis of the universe" that would become a key theme in Buddhist architecture. The pillars stood along pilgrimage routes to meaningful sites in Buddhism. The pillars were capped with embellished capitals which, like the columns themselves, were carved from single blocks of stone. A pillar was erected at Sarnath, where the Buddha delivered his first sermon (**Fig. 5.7**). Although the style of the pillar resembles similar works found at Persepolis, the capital of Persia, its symbolism is Buddhist. Two pairs of lions stand back to back, facing the four cardinal directions of the world. Their open mouths would appear to trumpet the message of the Buddha.

Both Hindu and Buddhist art are overwhelmingly religious in spirit. The great statues and sculptural reliefs that decorate the temples are narrative, telling the stories of the Hindu deities and the life of Buddha to their worshippers. The difference between the two styles of art reflects the differing characteristics of the two faiths. Much of Hindu art is openly erotic, reflecting the belief of pious Hindus that sexual union represents union with their gods.

Hindu temples are considered to be the dwelling places of the gods, not houses of worship. The proportions of the

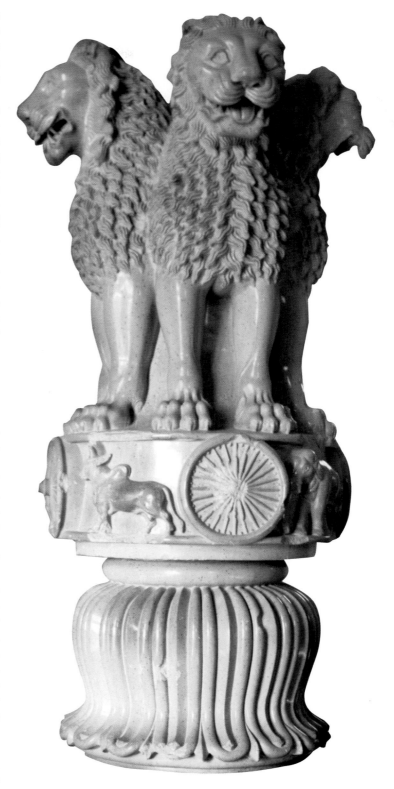

▲ **5.7 Lion capital, from a column erected by Ashoka, 242–232 BCE. Polished sandstone, 84" (213 cm). Sarnath Museum, Uttar Pradesh, India.** One of a series of columns set up during Ashoka's reign, this capital comes from Sarnath, where Buddha preached his first important sermon. The wheel on the base represents the Wheel of the Law, and the four small animals (one is visible here) symbolize the four corners of the earth. The lions crowning the column originally bore a wheel on their backs.

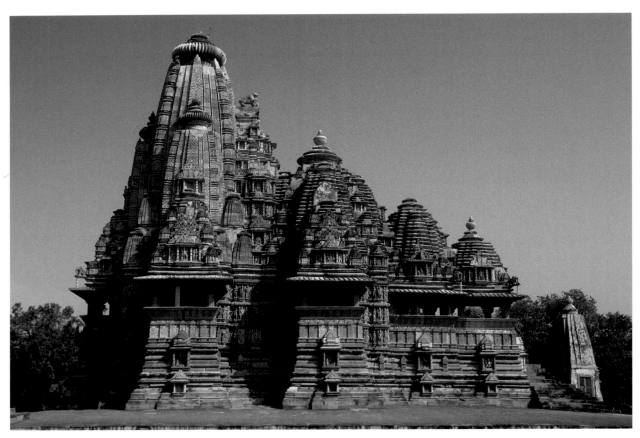

▲ **5.8 Vishvanatha Temple, ca. 1000 CE. Khajuraho, India.** This type of temple is characteristic of Hindu temples in northern India. The organically shaped towers of ascending height symbolize the way in which the foothills of the Himalayas rise gradually to their peak, the home of the god Shiva. Vishvanatha is another name for Shiva.

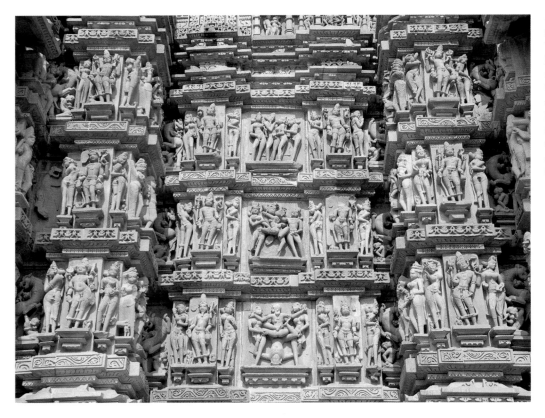

◄ **5.9 Reliefs, detail of the north side of the Vishvanatha Temple, ca. 1000 CE. Khajuraho, India.** The openly erotic subjects of many of these reliefs illustrate the close link for the Hindu culture between amorous and religious ecstasy. These and similar sculptures were always placed on the outside walls of the temples.

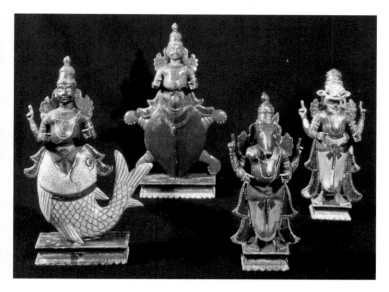

▲ **5.10** Wooden figures representing the first four avatars (incarnations) of the god Vishnu (from left): the fish Matsya, the tortoise Kurma, the boar Varaha, and the lion Narasimha. Vishnu represented the preserving and protecting aspect of the divine.

▼ **5.11** Krishna and Radha on a canopy, 1825. Indian miniature, gouache on paper, 9" × 7" (22.8 × 18.0 cm). Musée national des arts asiatiques Guimet, Paris, France. In this scene from the Mahabharata, Krishna, who is regarded by the followers of Vishnu as another incarnation of the god, is easily recognizable by the blue color of his skin.

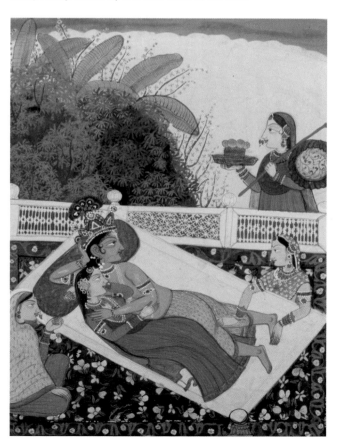

Vishvanatha Temple at Khajuraho (**Fig. 5.8**) symbolize cosmic rhythms. The gradual unfolding of spaces within is highlighted by the sculptural procession of exterior forms. The organic, natural shapes of the multiple roofs are in most sections separated from the horizontal registers of the base by sweeping cornices. The main tower is an abstracted mountain peak, reached visually by ascending what appear to be architectural and natural hurdles. All of this can be seen as representing human paths to oneness with the universe. Much of Hindu art is openly erotic, reflecting the belief of pious Hindus that sexual union represents union with their gods; the registers of the base of the temple are populated by high reliefs of gods, allegorical scenes, and idealized men and women in erotic positions (**Fig. 5.9**).

Other works illustrate the Hindu sense of the unity of all forms of life. Thus, Vishnu—the supreme Hindu spirit— appears in a series of **avatars**, or incarnations, of various animals and humans (**Fig. 5.10**). Over time, scenes from the Mahabharata and other great Hindu epics combined the elements of eroticism and naturalism. Figure 5.12 shows Krishna, the hero of the Mahabharata's central section, the Bhagavad Gita, in a pleasant setting painted in great detail (**Fig. 5.11**).

By contrast, Buddhist art emphasizes the spiritual, even austere nature of Buddhist doctrines. For many hundreds of years, there were no images of the Buddha, but sculptures and other representations began to appear in the second century CE. Buddha and his many saints are shown as calm, often transcendent images, inviting prayer and meditation (**Fig. 5.13**). Sometimes the Buddhist command to renounce all worldly pleasures becomes even more powerfully expressed, as in the image of the Fasting Buddha (**Fig. 5.12**). Some sculpted Buddhas show a Western influence that can be traced to the conquest

➤ **5.12** The Fasting Buddha, 2nd–3rd century CE. Sikri, Pakistan. Schist, 33" (83.8 cm) high. Lahore Museum, Lahore, Pakistan. The powerful realism used to depict Buddha's emaciated body is also Gandharan in inspiration. The austerity and renunciation contrast strongly with Hindu images of the joys of the flesh.

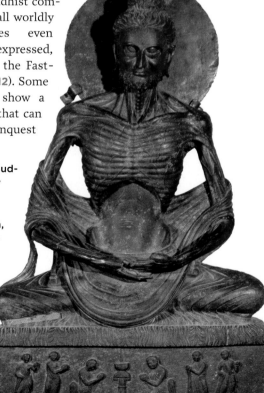

The Four Noble Truths

Prince Siddhartha Gautama was born to wealth. His father, a king, sought to protect him from the miseries of the world and kept him cloistered. He married a beautiful woman and had a son. But then he came upon the world outside and witnessed suffering in the forms of poverty, hunger, violence, and disability.

Gautama left the chains of comfort to search for enlightenment as to why suffering existed and how it could be ended. He tried conventional forms of meditation and they accomplished nothing. He tried asceticism. He and five followers starved themselves on the banks of the Nairanjana River for six years, but then he discovered that austerity would not lead to wisdom. His followers were disgusted by his apparent failure and deserted him.

He moved toward the village of Senani, where he was offered milk by a Brahmin girl and a mat from a grass cutter. The Buddha-to-be seated himself beneath a pipal tree, where he resolved to remain until he found enlightenment—from within. His body might shrivel, he declared. His skin, flesh, and bones might dissolve. But he would not move.

Myth would have it that Māra, the Lord of Illusion, was threatened by Gautama's imminent enlightenment and sought to distract him. Gautama touched the earth, calling upon it to bear witness to the countless cycles of death and rebirth—*reincarnation*—that had led him to this place. The earth shook to confirm his assertion, and Māra unleashed demons. An epic battle ensued, during which Gautama finally saw through illusion and perceived truth. The weapons of the demons were transformed into flowers and Māra fled.

There was no claim of revelation or divine inspiration as in Western religions. For Gautama, now the Buddha (the Enlightened One), four noble truths had come from within:

One: Life is suffering (**dukkha**). We may feel happy for a while, but happiness is transitory. At some point we experience pain, decay, and all-pervasive suffering. Death is not a cure because of **reincarnation**: we will be born into a different body, but that body will also suffer.

Two: The causes of suffering are attachment, anger, and ignorance. We are attached to sweets, to life itself. Harming others will recoil into harming ourselves. Ignorance? Reality is not as it seems, and realization of ultimate truth is difficult.

Three: Suffering can end if we enter nirvana, a state beyond suffering. Suffering is dependent on the state of the mind; by changing the way one perceives the world and the self, one can end suffering.

Four: One can help others and end suffering via the eightfold path:

By avoiding jealousy, the desire to harm others, and wrong views (right thought)

By avoiding lying, harsh speech, and gossip (right speech)

By avoiding killing, stealing, and sexual transgressions (right actions)

By making a living without hurting others, lying, or committing crimes (right livelihood)

By developing wisdom (right understanding)

By persevering in our endeavors (right effort)

By focusing on the "here and now," not what was or what might be (right mindfulness), and

By maintaining a calm, attentive state of mind (right concentration)

of northwestern India by Alexander the Great in 327 BCE. Others have a sensuous, rounded look that recalls the ancient seals and is decidedly Indian. The slender chlorite Buddha (**Fig. 5.13**) shows delicate fingers and gauzelike, revealing drapery. The face exhibits a pleasant cast that is as inscrutable as the expression of La Gioconda in Leonardo's *Mona Lisa* (see **Fig. 13.5**).

The Gupta Empire and Its Aftermath

In the years following the death of Ashoka, his empire began to fall apart, and a series of invaders from the north established small kingdoms in the Indus and Ganges valleys. These

northerners never penetrated the southern regions, where numbers of small independent states flourished economically by trading with Southeast Asia and, to the west, with the expanding commercial power of the Roman Empire.

Only in 320 CE did Chandra Gupta I lay the foundations of a new large-scale kingdom, known as the Gupta Empire, which reached its zenith under his grandson, Chandra Gupta II (ruled ca. 380–415 CE). Known as "The Sun of Power," Chandra Gupta's reign was famous for its cultural achievements, economic stability, and religious tolerance. As a Buddhist monk noted, "The people vie with each other in the practice of benevolence and righteousness." Despite this general tolerance, however, the Gupta period saw the rapid decline of Buddhism in India and a return to the traditions of Hinduism.

GUPTA LITERATURE AND SCIENCE Literary skills assumed vast importance at the Gupta court, where poets competed with one another to win fame. The language they used was ancient Sanskrit, that of the old Hindu Vedas, which served as the literary language of the period; it was no longer spoken by the general population. The most famous of all classical Indian writers was Kalidasa (active ca. 400), who wrote plays, epics, and lyric poetry. His best-known work was the play *Sakuntala*, which describes the happy marriage of the beautiful Shakuntala to King Dushyanta, the marriage's collapse as a result of a curse pronounced by an irascible holy man, and the couple's eventual triumphant reunion. By contrast to the classical dramas of the Greek tradition, with their analysis of profound moral dilemmas, Kalidasa's play has the spirit of a fairy tale with a happy ending. The work of another author of the same period, Shudraka, is more realistic. Among the characters in his play *The Little Clay Cart* are a nobleman, a penniless Brahmin, a prostitute, and a thief who at one point offers a vivid description of his technique of housebreaking.

Under the Guptas, many important scientific discoveries were made possible by the foundation of large universities. The most important, at Nalanda,

had some five thousand students who came from various parts of Asia. Among the subjects taught were mechanics, medicine, and mathematics. In this latter field, Indian scholars continued to make important advances. The system of so-called Arabic numerals, which only became widespread in Western Europe in the Renaissance (fifteenth and sixteenth centuries), had first been invented in India in the late third century BCE. By the time of the Gupta Empire, Indian mathematicians were using a form of decimal notation, and the concept of the zero may have been first employed at this time. Among their work in algebra were quadratic equations and the use of the square root of two.

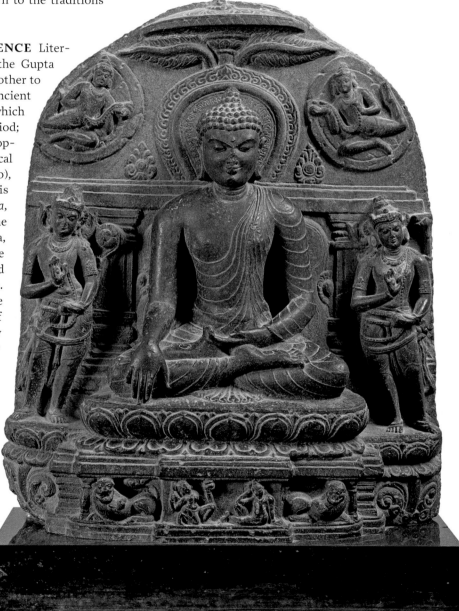

➤ **5.13** Buddha calling on earth to witness, 10th century CE (Pala period, 750–1197 CE). Bihar, India. Basalt, 18 ⁷/₈" (48 cm) high. Musée national des arts asiatiques Guimet, Paris, France.

Ganesh, the Hindu Deity: Don't Leave Home without Him

In Hinduism's vast pantheon of gods, one of the more familiar and beloved is the elephant-headed Ganesh. Also known as Ganesha or Ganapati, he is the son of Shiva, the most powerful of the Hindu deities, and Parvati, the goddess of power who gives energy to all beings. Ganesh is the Lord of Success—and the destroyer of evils and obstacles. He is also worshipped as the god of knowledge, wisdom, and wealth. Hindus interpret dreams of elephants as messages of transformation and divine power—the emergence of one's highest self from the collective unconscious mind.

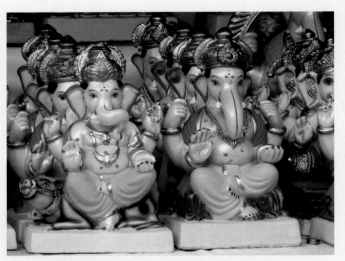

▲ **5.15 Statuettes sold during the Ganesh festival. Maharashtra, India.**

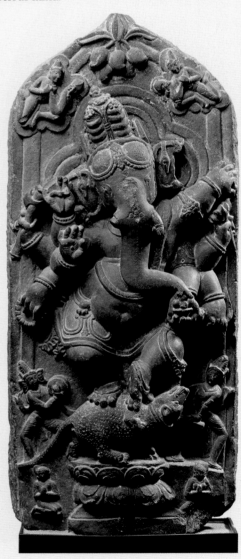

▲ **5.14 Dancing Ganesh (Ganesha), 11th century CE. North Bengal, India. Slate, 22 ⅛" × 9 ⅞" (56.5 × 25 cm). Museum für Asiatische Kunst, Berlin, Germany.**

The distinctive form of Ganesh is seen in temple carvings, sculptures, miniature paintings and any number and variety of small statuettes purchased by Hindus as votives. Ganesh is always visualized as a man with a pot belly, an elephant head with one tusk (the other is broken), and multiple arms (typically four) holding attributes that vary from one representation to another including: a goad (a pointed instrument) used to prod humans toward proper goals, his broken tusk, prayer beads, an ax, a mace, a noose, a lotus flower, seashell, a small water vessel and more. He is also shown in many incarnations, as in an eleventh-century stone sculpture (**Fig. 5.14**) in which he is dancing on a mouse, a tiny creature seen frequently in Ganesh iconography.

The immense popularity and importance of Ganesh, who is invoked at the start of any undertaking, is evidenced by the Hindu calendar's 10-day-long festival to the deity known as the Ganesh Chathurhi. In many places in India (and elsewhere throughout the world) elaborate celebrations include parades, performances, cultural events, and community activities centered around charitable giving. Thousands of plaster statues of Ganesh in all shapes and sizes (**Fig. 5.15**) are displayed and purchased for the decoration of public spaces and individual homes and, at the end of the festival, they are immersed in water—any water, whether a river, sea, or small bucketful (**Fig. 5.16**). Originally, Ganesh icons had been made of clay, which dissolved in water and symbolized the natural lifecycle of birth and death.

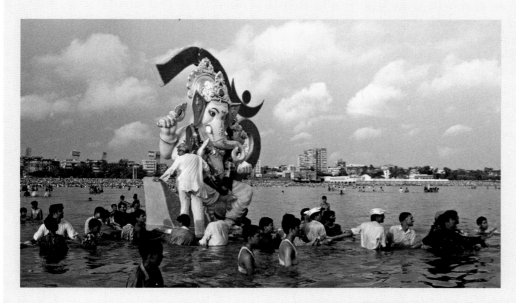

◄ **5.16** Lord Ganesh idol being immersed in the sea at Girgaum Chowpatty, Mumbai, Maharashtra, India.

However, in this day and age, the celebratory practice has led to environmental problems like water pollution caused from toxic plaster and paint, as well as unsightly accumulations of non-biodegradable plastic used for accessories to adorn the Ganesh icons.

The clash of age-old traditions with the perils and strains of contemporary life is also evoked in a painting (**Fig. 5.17**) by Prajakta Palav Aher from her Ganpati Series. Aher's is not an iconic representation of the deity such as might be found in a temple or shrine. Rather, Ganesh rides a well-worn commuter train—like anyone else shuttling to the city for a day's work—accompanying those who petition him for success and good fortune. In what may be interpreted as an allusion to the "rat race" to economic success in today's world, Ganesh has an air of exhaustion, as if he has just plopped down in his seat with all of the tools of his trade at the end of a long, long day. In a true manifestation of globalization, the Destroyer of Obstacles may be returning from the realm of outsourced troubleshooters managing worldwide software glitches and catching his breath before moving on to the next.

➤ **5.17** Prajakta Palav Aher, *Untitled I*, 2007 (Ganpati Series). Acrylic on canvas, 96″ × 72″ (243.8 × 182.9 cm). © Prajakta Palav Aher, Courtesy Vadehra Art Gallery, New Delhi, India.

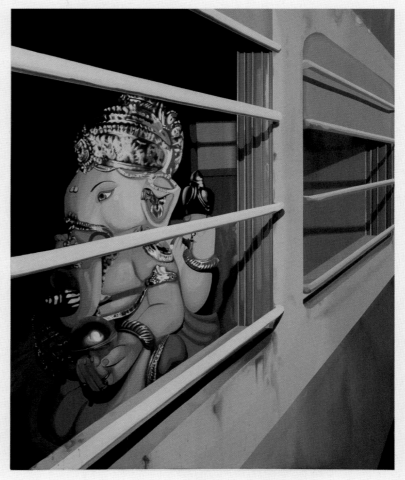

THE COLLAPSE OF GUPTA RULE The decline of the Gupta Empire, which began with the death of Chandra Gupta II, became headlong with a series of invasions around 480–500 CE by the White Huns, a people related to the Huns and other Central Asian tribes. Around the same time, other related tribes moved westward from Central Asia and sacked Rome in 476 CE, thereby effectively ending the Roman Empire. The White Huns never managed to establish a secure power base in India, however, and over the following centuries innumerable local princely states fought both among themselves and against foreign invaders. In part, the difficulty in constructing a central government and a lasting peace was caused by the powerful Hindu priestly class, who were unwilling to surrender conflicting religious interests to an overall secular, political settlement. When a new united Indian Empire did begin to develop in the fifteenth and sixteenth centuries, its rulers were Muslim, not Hindu.

CHINA

In the late Neolithic period, the Longshan culture developed along the Yellow River in China, overlapping chronologically with both the Egyptian Old Kingdom and the Sumerian civilization of Mesopotamia. Excavations in China have revealed numerous settlements, along with pictographic carvings that some scholars have tied to early written language. As with other river civilizations, the Longshan is marked by the establishment of urban centers and the development of technology and the arts. Of particular interest are examples of finely wrought pottery, some of which was wheel-thrown. The distinctive black vessels were exceptionally thin walled,

➤ **5.19** Ceremonial vessel (*guang*), 12th century BCE. Covered pouring vessel with tiger and owl decoration, cast bronze with green patina, 9 ³/₄″ × 12 ³/₈″ × 4 ¹/₈″ (25 × 31.5 × 10.6 cm). Arthur M. Sackler Museum, Harvard University Art Museums, Cambridge, Massachusetts.

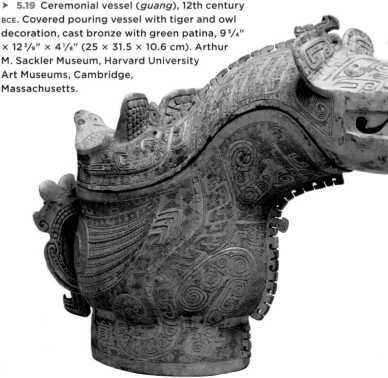

➤ **5.18** Black eggshell pottery, 3000–2000 BCE (Longshan culture). High-stemmed cup, 10 ³/₈″ (26.5 cm) high. Shandong Museum, Jinan, Shandong, China.

highly polished, and often decorated with elaborate patterns of incised lines (**Fig. 5.18**).

During the years that the Shang dynasty (ca. 1520–1027 BCE; see **Map 5.2**) ruled China, Tutankhamen became pharaoh, the Mycenaeans lived in their fortified cities, and the Minoans decorated their elaborate palaces with brilliant frescos. The Shang dynasty, too, was a Bronze Age urban civilization ruled by kings who, as in Egypt, inherited their positions and who, like the pharaohs, claimed their authority from the divine. Trade and commerce began to develop. The Shang culture is known for its accomplished metalwork, including bronze weaponry, fittings for chariots, and sophisticated ceremonial vessels such as the one in **Figure 5.19**, which was discovered in a royal tomb. The two-headed fantastic animal is embellished with elaborate, stylized, linear detail that complements the curving shapes of the vessel. The casting technique perfected by Shang artisans consisted of pouring molten bronze into piece molds and, after casting, assembling the individual parts into a cohesively designed whole. The Shang royal tombs, as in Egypt and Mesopotamia, were filled with precious objects such as these.

The Zhou Dynasty

Around 1100 BCE, a new dynasty replaced the Shang—the Zhou (ca. 1046–221 BCE). Zhou rulers did not provide a strong central government, but served as the coordinators of a series of separate kingdoms, each with its own local lord. The relationship of these local rulers with the Zhou emperors was often unstable. In times of trouble they could supply the Zhou with military aid, but they frequently feuded with both the central authority and each other. Over time, Zhou influence began to diminish; the last period of their dynasty is known as the Warring States period (475–221 BCE). During these centuries of increasing crisis, the foundations of Chinese thought and culture were laid.

Confucianism and Daoism

Confucius (ca. 551–479 BCE) and Laozi (active ca. 570 BCE) founded the two chief schools of Chinese philosophy. Born in humble circumstances in central China at a time when local wars were raging, Confucius's chief aim was to restore the peace of earlier times by encouraging the wise and virtuous to enter government service. A state run by a wise ruling class, he believed, would produce similar characteristics in

ANCIENT CHINA

its people. To achieve this he traveled throughout China in search of pupils (**Fig. 5.20**).

According to the central dogma of Confucianism, the morally superior person should possess five inner virtues and acquire another two external ones. The five with which each virtuous person is born are righteousness, inner integrity, love of humanity, altruism, and loyalty. Those with these natural gifts should also acquire culture (education) and a sense of decorum or ritual. If individuals with these qualities served their rulers in government, they would be loyal and unconcerned with material rewards, yet fearlessly critical of their masters.

Traditional religion played no part in Confucius's teachings. He refused to speculate about the gods or the possibility of life after death; he is said to have commented, "Not yet understanding life, how can we understand death?" Confucius was a revolutionary figure in that he defended the rights of the people and believed that the state existed for the benefit of the people, rather than the reverse. At the same time, however, he strongly endorsed strict authority and discipline, within both the state and the individual family—devotion to parents, worship of ancestors, respect for elders, and loyalty to rulers were all crucial to the Confucian system. In the centuries following his death, many totalitarian regimes in China abused the innate conservatism of Confucius's teaching, using it to justify their assaults on the freedom of individuals.

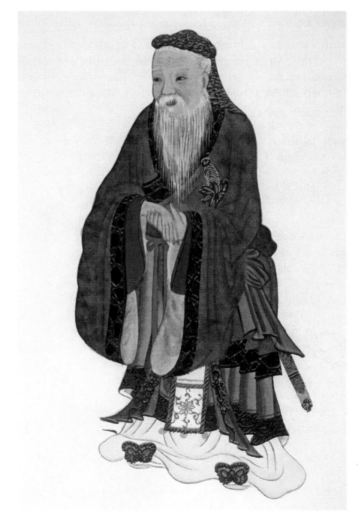

➤ **5.20 Portrait of Confucius, ca. 3rd century** BCE. This image of Confucius is stylized rather than realistic. The wise old sage with a long beard and hands peacefully folded symbolizes the nature of Confucian teaching. There is no evidence of realistic portraiture from this period.

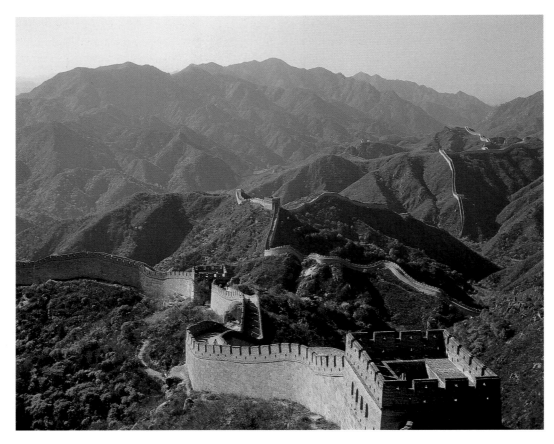

◄ **5.21 The Great Wall of China, Qin dynasty. Roughly 5,500 miles (8,850 km) long, averaging 16–20′ (4.9–6.1 m) wide × 16–26′ (4.9–7.9 m) high, plus 13′ (3.9 cm) at the watchtowers.** Wide enough for horsemen to ride along it, the Great Wall has been extended, repaired, and rebuilt many times since its first construction in the late 3rd century BCE.

If the central principle of Confucianism is the possibility of creating a new, virtuous social order, Daoism emphasized the limitations of human perceptions and encouraged withdrawal and passivity. Its central concept is that of "the Way" (*dao*). According to this principle, one should follow one's own nature, not distinguishing between good and bad, but accepting both as part of the Way. The traditional founder of this school of philosophy, Laozi, an obscure, even legendary figure, is said to have lived around the time of Confucius. Many modern scholars, however, believe that the book that sets forth Laozi's teachings, *The Classic of the Way and Its Power* (*Daodejing*), was written two or more centuries after the death of Confucius, at some point in the third century BCE.

The followers of Daoism often expressed their ideas in obscure and frequently contradictory language. Their overriding concept is perhaps best illustrated by one of the central images of Daoist art: water. As it flows, water gives way to the rocks in its path, yet over time "the soft yield of water cleaves the obstinate stone." Humans should, in the same way, avoid participating in society or culture or seeking actively to change them. Far from sharing Confucius's mission to reform the world, the Daoists preached passivity and resignation. Worst of all was war, for "every victory celebration is a funeral rite."

Both Confucianism and Daoism can be seen as reactions—albeit opposing ones—to the increasingly chaotic struggles of the later Zhou period. They were to remain powerful sources of inspiration over the succeeding centuries, and the tension between them played a large part in the evolution of Chinese civilization.

The Unification of China: The Qin, Han, and Tang Dynasties

THE QIN DYNASTY In the struggle for power in the last years of the Zhou period, one state emerged victorious. In 221 BCE, the king of the state of Qin succeeded in conquering all of his rivals and ruling them by means of a centralized government, thereby establishing the Qin dynasty—from which the word *China* is derived. He took the name of Shihuangdi ("First Emperor") and was remembered by later generations for the brutality of his conquests as much as the brilliant skill with which he organized his new empire.

He ordered the building of a magnificent capital city, Xianyang (near modern Xi'an), and instructed the leading noble families from the former independent kingdoms to move there, where they would be under his direct control and thus unable to lead revolts. No private citizen was allowed to possess weapons, and it was left to the imperial army to maintain order. The emperor divided his territory into thirty-six provinces, imposed a single writing system, and standardized weights and measures. In order to check criticism, he ordered the destruction of all philosophical writings, the so-called Burning of the Books—including, of course, the works of Confucius—an action that his successors bitterly condemned.

To defend his empire from outside invaders, Shihuangdi connected a series of preexisting defensive walls to make the Great Wall, some 5,500 miles long (**Fig. 5.21**). Peasants and

prisoners of war were forced into construction gangs. In the extreme climates of north and south, it was said that each single stone cost the life of one worker. The Great Wall has remained continuously visible to this day; it is one of the few human constructions on earth that can be seen from space. The emperor's other great building project, the massive tomb he designed for himself, barely survived his death and was only rediscovered in 1974. Ever since, archaeologists have been exploring its riches (**Fig. 5.22**).

Shihuangdi believed that he was creating an empire to last forever, but his ruthless methods ensured that his rule barely survived his death. One contemporary described him as "a monster who had the heart of a tiger and a wolf. He killed men as though he thought he could never finish, he punished men as though he were afraid he would never get round to them all." When Shihuangdi died in 210 BCE, the empire plunged into chaos as nobles and peasants alike ran riot.

THE HAN DYNASTY By 202 BCE a new dynasty had established itself—the Han. It would rule China for the next four centuries. The first Han emperor, Gaozu (256–195 BCE), returned a degree of power to the local rulers but maintained the Qin system of provinces, with governors appointed by the central authority. In order to strengthen the imperial administration, Gaozu and his successors created an elaborate central bureaucracy. To reinforce their authority, the early Han emperors lifted the ban on philosophical works and encouraged scholars to reconstruct the writings of Confucius and others either from the few surviving texts or from memory. With the emperor's encouragement, many of these reconstructions emphasized the need for loyalty to the emperor and a central bureaucracy, and omitted Confucius's emphasis on constructive criticism by virtuous observers.

THE TANG DYNASTY By the second century CE, the central government gradually lost its control over the provinces. The great aristocratic families began to take control, as successive emperors became paralyzed by internal feuding and plotting. In the ensuing civil war, the last Han emperor finally abdicated in 220 CE, only to plunge China into another extended period of confusion. Finally, in the early seventh century, the Tang dynasty (618–906 CE) managed to reunite China. The political and economic stability they created made possible a period of cultural achievement known as China's golden age.

▼ **5.22** Army of Shihuangdi (First Emperor) in pits next to his burial mound, ca. 210 BCE (Qin dynasty). Painted terracotta, average figure height: 71″ (180.34 cm). Lintong, China. There are more than 8,000 life-size clay warriors and horses, as well as bronze chariots and horses, in the excavation. The parts of the bodies (arms, torsos, legs) were made from a limited number of molds, but they were put together in many different combinations, with the result that no two figures are identical. The emperor's burial chamber has been located but remains unexcavated: Chinese archaeologists do not want to disturb it until they have developed more sophisticated archaeological techniques.

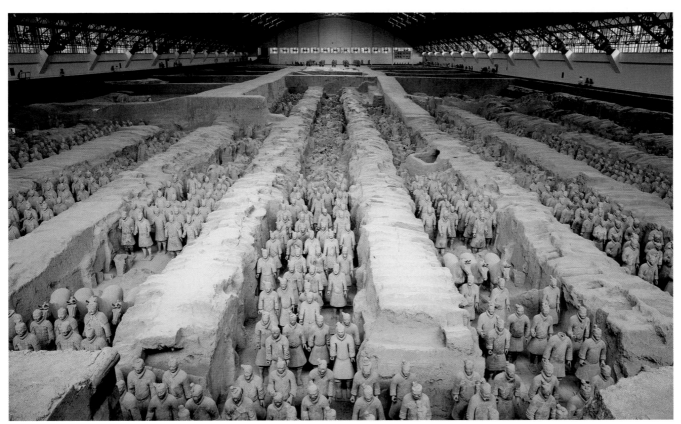

Classical Chinese Literature

With the notable exception of the period of Qin rule, literature played an important part in Chinese culture. As early as the Zhou period, standard texts known as the *Five Classics*, circulated widely—Confucius may have been partly responsible for editing them. They included history, political documents such as speeches, and descriptions of ceremonies. The *Classic of Songs* contained more than three hundred poems dealing with private life (love, the family) and public affairs. Because the Chinese language uses pitch and stress (inflections; the meanings of words and/or phrases change according to the way they are pronounced), poetry became especially popular, and any educated Chinese person was expected to memorize and recite classical verse.

Later generations drew inspiration from these classical texts, developing their themes and expressing new ideas based on familiar concepts. The introduction of Buddhism into China during the Han dynasty provided a new subject for philosophical writing; during the years of chaos following the fall of the Han rulers, Buddhist texts provided consolation for the suffering by offering eventual release from pain. The two main strains of Buddhism were *Mahayana*, the "Great Vehicle," and *Hinayana*, the "Lesser Vehicle." The first of these was less ascetic and more worldly than the second, and thus appealed more to those influenced by Confucianism. It also met with more favor in the eyes of the ruling class, although when the Buddhist monasteries began to grow in wealth and influence, the central authorities started to limit the number of monasteries permitted and to control the ordination of monks and priests.

During the Tang dynasty, a new literary form developed: the short story. Unlike the works inspired by classical models, these tales often provide a vivid picture of contemporary life.

LI BAI Many lovers of Chinese poetry consider Li Bai (701–762 CE) a leading Chinese poet of premodern times. He was famous in his day for his unique rapport with nature and his love of wine. He grew up in Sichuan province. After spending a few years as a hermit, he trained himself in the arts of the "wandering knight," protecting the weak and avenging injustices.

In 742 he was summoned to the emperor's court as a kind of official poet, but his wild lifestyle soon lost him the emperor's favor. He took to wandering, accompanied by a following of singing girls. For a while he became involved with a rival to the imperial throne and was exiled, but then reprieved. He was married four times, but, as a contemporary remarked, "none detained him for very long."

His addiction to wine was legendary, celebrated in many of his poems. Like the Roman poet Horace, he also advised seizing the day.

READING 5.8 LI BAI

From "Bring the Wine"

Have you never seen
The Yellow River waters descending from the sky,
Racing restless toward the ocean, never to return?
Have you never seen
Bright mirrors in high halls, the white-haired ones lamenting,
Their black silk of morning by evening turned to snow?
If life is to have meaning, seize every joy you can;
Do not let the golden cask sit idle in the moonlight!
Heaven gave me talents, and meant them to be used;
Gold scattered by the thousand comes home to me again.
Boil the mutton, roast the ox—we will be merry,
At one bout no less than three hundred cups.

From *The Columbia Book of Chinese Poetry: From Early Times to the Thirteenth Century.*

He was also interested in alchemy and what he called "spiritual journeys." He impressed his admirers with his spontaneous genius and his personal appearance: they called him the "banished immortal." For all the ups and downs of his career, he was not given to bitterness or despair; on the whole, his poetry is calm and even sunny. His search for spiritual freedom and communion with nature were united with a deep sensitivity to the beauties of language. Today, the Chinese praise him for his "positive romanticism."

READING 5.9 LI BAI

"Autumn Cove"

At autumn cove, so many white monkeys
Bounding, leaping up like snowflakes in flight!
They coax and pull their young ones down from the branches
To drink and frolic with the water-borne moon.

From *The Columbia Book of Chinese Poetry: From Early Times to the Thirteenth Century.*

Inspired by Daoism, Li Bai preferred simple language and ignored the rules of the classical style. Impressing his contemporaries as much by his charisma and personal appearance as by his writings, he could produce poems of

all kinds and lengths, and his unconventional life-style provided him with unlimited subject matter. Many of his best-loved poems describe scenes from nature, often involving rivers or waterfalls—images central to Daoist thought.

LI QINGZHAO A woman poet, Li Qingzhao (ca. 1084−1155 CE), was born into a family of scholars and government officials. She was well educated by her patrician family, and, like the Roman poet Sulpicia, her poetry was known within elite circles while she was still a teenager. She married at the age of eighteen and she and her husband shared interests in collecting art and books. Her husband's work required travel, and they would write each other love poems when apart.

Some hundred of her poems survive. Most of her poetry is in *ci* form, a sort of Chinese lyric poetry which was originally intended to be sung according to key words in the title—with specific rhythms, rhyme, and tempo. **Ci poetry** was generally used to express desire.

> ### READING 5.10 LI QINGZHAO
>
> **"Like a Dream"** (*Re meng ling*)
>
> I will always recall that day at dusk,
> the pavilion by the creek,
>
> and I was so drunk I couldn't tell
> the way home. My mood left me,
>
> it was late when I turned back in my boat
>
> and I strayed deep among lotuses—
>
> how to get through?
>
> how to get through?
>
> and I startled to flight a whole shoal
> of egrets and gulls.

Li's husband died when she was still young, and she spent her last years alone.

Visual Arts

In the visual arts, traditional styles were combined with new ones. A jade pendant from the end of the Chou Dynasty (**Fig. 5.23**) depicting a dragon is reminiscent of the Shang bronzes of centuries earlier, whereas a bronze horse from a little later shows much greater realism (see **Fig. 5.24**).

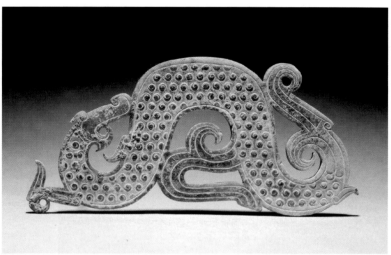

▲ **5.23** Pendant in the form of a dragon, 403–221 BCE (**Warring States period**). China. Perforated, green jade, 7¼″ × 3½″ (18.5 × 9.0 cm). **Musée national des arts asiatiques Guimet, Paris, France.** Jade, an extremely hard stone, was commonly used for objects to be buried with the dead. The perforated dragon, seen here in a characteristic spiral pose, was doubly symbolic. The ancient Chinese believed that dragons flew between earth and sky, bringing rain. They thus represented fertility and, at the same

THE SIX CANONS OF CHINESE PAINTING China has a rich history in the theory, history, and criticism of art. In the sixth century CE, a man versed in these three areas, Xie He, set down six points to consider when critiquing a painting, in the preface of his book *The Record of the Classification of Painters of Old*. The date was about 550 CE, and to Xie He, that was "today."

The six canons or points[11] are:

Engender a sense of movement through spirit consonance.

Use the brush with the bone method.

Responding to things, depict their forms.

According to kind, describe appearances (with color).

Dividing and planning, positioning and arranging.

Transmitting and conveying earlier models through copying and transcribing.

The sense of movement in canon 1 means creating a sense of life through merging the painter's inner self with that of the subject. The bone method is a way of handling the brush in writing—**calligraphy**—as well as painting.

11. James Cahill, "The Six Laws and How to Read Them," *Ars Orientalis* 4 (1961): 372−381.

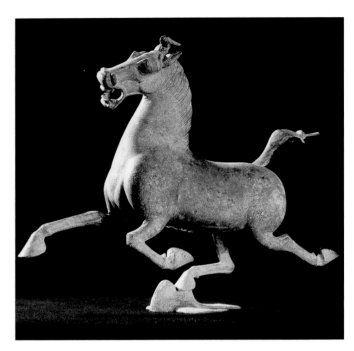

▲ **5.24** Flying horse, from the tomb of Governor-General Zhang, late 2nd century CE (Han dynasty). Wuwei, China. Bronze, 13½″ × 1½″ (34.5 × 3.8 cm). Gansu Provincial Museum, Lanzhou, China. The only horses native to China were small and slow animals. The Han emperors, learning that the peoples of Central Asia used much faster animals as warhorses, sent a series of missions to try to import Central Asian horses into China. So great was the delight that the Chinese took in their new warhorses—one of which is shown here with one leg resting on a swallow—that they called them heavenly horses.

Depicting the forms of things means painting from nature rather than from the mind of the artist or the use of conventional forms. Describing appearances is depicting what things truly look like. Canon 5 refers to what we call composition—the organization of the visual elements in a work of art. Canon 6 means learning from artists of the past, imitating their strengths and bringing their works up to date. But most important—number 1—was to communicate the vitality of the subject.

Figure 5.25 suggests mastery of the six canons of painting. It is a vital picture of a horse by Han Gan, who lived in the eighth century CE. The work brings the spirit of the animal to life with calligraphic brushstrokes and contour lines that breathe life into the work. The red-orange stamps on the work were the seals of artists and scholars who left their "comments" over the centuries. They are literal "stamps of approval."

A painting of Tang ladies at a feast shows elegant ladies of the palace court enjoying dinner and music (**Fig. 5.26**). Figures higher in the picture are farther from the viewer, but note that they are the same size as the lower figures, which are closer to the picture plane. The artist apparently had no knowledge of linear perspective, a method of representing depth in two-dimensional media such that objects grow smaller as they recede from the viewer.

With the coming of Buddhism, Chinese devotees began to construct shrines and decorate them with monumental carvings. Many of these show the influence of similar relief sculptures in India, particularly in the treatment of drapery (**Fig. 5.27**).

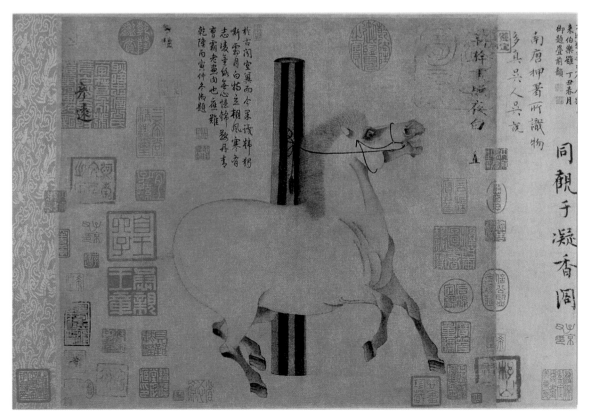

◀ **5.25** Han Gan, *Night Shining White*, ca. 750 CE. Handscroll, ink on paper, image 12⅛″ × 13⅜″ (30.8 × 34 cm); overall with mounting, 14″ × 37′5⅛″ (35.4 cm × 11.4 m). Metropolitan Museum of Art, New York, New York. This spirited horse was painted by a master of the six canons of painting who lived during the Tang dynasty.

5.26 A palace concert, 10th century CE. Hanging scroll, ink and colors on silk, 19¼" × 27⅜" (48.7 × 69.5 cm). National Palace Museum, Taipei, Taiwan. The Tang dynasty is often known as the golden age of Chinese figure painting. This typical example, showing elegant ladies of the imperial court enjoying a feast and music, has no background setting but convincingly places the figures in space. The forms of the bodies are visible beneath the simple, dignified lines of the drapery, and the faces portray the individual feelings of these court ladies with considerable subtlety. Note the dog, a household pet, beneath the table.

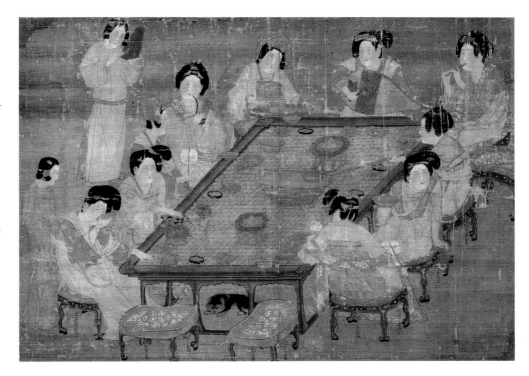

5.27 Fengxian Temple. Longmen grottoes, Luoyang, Henan, China. Limestone grotto, 136′ (41 m) long × 118′ (36 m) deep. The Buddhist sculptures were begun in the sixth century CE and greatly extended around 690, when Luoyang became the new Tang capital. The central figure of the Vairochana Buddha (the Buddha of Illumination) is 56′3″ (17.4 m) high; to either side stand monks, bodhisattvas, and guardian figures. The simplicity of the folds of the Buddha's robe adds to the grandeur of the figure.

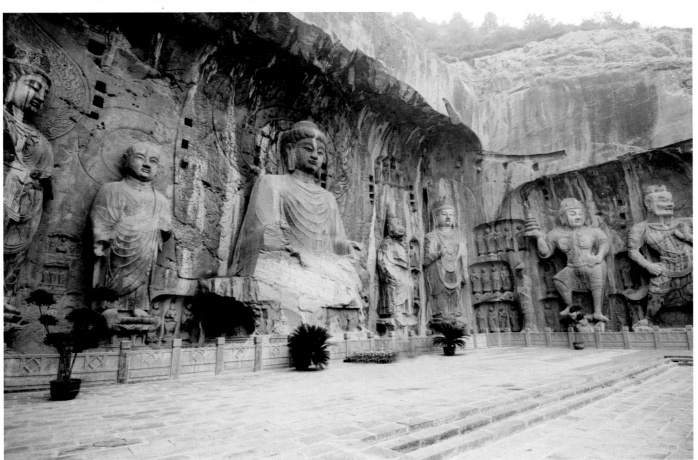

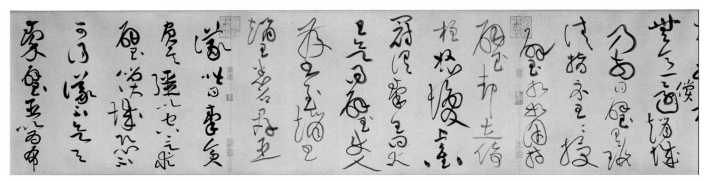

▲ **5.28** Huang Tingjian, Biographies of Lian Po and Lin Xiangru, ca. 1095 CE. Hand scroll, ink on paper, image: 13¼" × 60′4½" (33.7 × 1840.2 cm), overall with mounting: 13½" × 71′5⅝" (34.3 × 2178.4 cm). **Metropolitan Museum of Art, New York, New York.** The biographies comprise a hand scroll that is nearly 60 feet long and contains some 1,200 cursive characters. The writing shows a spontaneity and exuberance that reflects the style of the "mad monk" Huaisu, with whose work the calligrapher was familiar.

Writing also became an art, as rabbit hair and other materials were collected into fine brushes and dipped into ink. Examples of fine handwriting—calligraphy—were as prized as works made of precious material. **Figure 5.28** shows a segment of a calligraphic scroll that set down the biographies of two rival officials who had served the same king some 1,200 years earlier.

While the ancient civilizations of India and China were rising in the East, giving birth to several of the world's major religions—Hinduism, Buddhism, Confucianism, Daoism a religious tradition based on a man named Abraham was rising to the West.

GLOSSARY

Aryan (p. 161) A member of one of the peoples supposedly descended from Indo-Europeans; particularly, a speaker of an Iranian or Indian language in ancient times.

Atman (p. 167) The basic principle of life; the individual self, known after enlightenment to be identical with Brahman.

Avatar (p. 173) An incarnation of an animal or a human.

Bhagavad Gita (p. 165) A section of the Mahabharata; considered a great scripture of the Hindu religion.

Bhakti (p. 165) An act of devotion.

Brahma (p. 163) The Hindu god of creation.

Brahman (p. 167) In Hinduism, the one true reality, which can not be fully understood by humans.

Calligraphy (p. 183) A stylized form of elegant handwriting,

Caste system (p. 163) A system of rigid social stratification characterized by being heritable and limiting of marriage prospects to a member of one's own caste.

Ci poetry (p. 183) A form of Chinese lyric poetry meant to be sung and usually expressing desire.

Devi (p. 163) The gentle and approachable Hindu goddess considered to be the Mother of the Universe.

Dukkha (p. 174) Suffering.

Karma (p. 163) The path according to which one carries out one's duty according to his or her caste.

Mahabharata (p. 162) The Mahabharata (ca. 400 BCE—400 CE), attributed to Krishna Dvaipayana Vyasa, is an epic poem that embellishes probably events of India's heroic age.

Nirvana (p. 168) A state characterized by the absence of suffering.

Reincarnation (p. 174) One's rebirth into another body, according to one's karma.

Rig-Veda **(p. 166)** A collection of 1,028 hymns to the Hindu gods.

Sangha (p. 169) A Buddhist monastery.

Sanskrit (p. 160) An ancient Indo-Aryan language; the classical language of India and Hinduism.

Shiva (p. 163) The Hindu god of creation and destruction; the "destroyer of worlds."

Stupa (p. 169) A dome-shaped reliquary of the Buddha, possibly also of Buddhist texts.

Upanishads (p. 167) A series of classical Indian teaching texts addressing issues such as karma, death, and dreams.

Vishnu (p. 163) A Hindu god; the preserver of the universe.

Yakshi (p. 169) A pre-Buddhist voluptuous goddess who was believed to embody the generative forces of nature.

THE BIG PICTURE ANCIENT CIVILIZATIONS OF INDIA AND CHINA

INDIA

Language and Literature
- The Aryans bring the Sanskrit language to the Indus Valley region.
- India's epic poems, such as the *Ramayana* and the Mahabharata, reflect the "heroic age" when Aryans subdued the native people.
- The Bhagavad Gita, which is part of the Mahabharata, displays the importance of altruism but places foremost emphasis on acceptance of one's duty in one's social class.
- The *Rig-Veda* contains 1,028 hymns to the gods and addresses matters such as the creation of the universe and the origins of the social caste system.
- The Upanishads present the view that the ultimate reality is brahman, which can be found within and is called atman within the individual. The Upanishads address matters from death to karma to dreams.
- During the Gupta Empire, Kalidasa writes plays, epics, and lyric poetry.

Art, Architecture, and Music
- Hindu temples are built with organic shapes that reflect cosmic rhythms and foothills ascending into mountains. Their exterior walls are decorated with erotic reliefs, indicating that within Hindus, sexual pleasure is one path to nirvana, a state which breaks the cycle of endless rebirth.
- The emperor Ashoka builds domed stupas to house relics of Buddha and possibly religious texts. Ashoka also erects immense pillars and towers that hold his decrees and exalt Buddhism.
- Buddhist art emphasizes the spiritual, austere nature of Buddhist doctrines. Images of the Buddha begin to appear in the second century CE and tend to support the meditative life and the renunciation of worldly pleasures.

Philosophy and Religion
- Early epic poems lauded heroism and piety.
- The Bhagavad Gita supports the concepts of duty (dharma) and gradual development into an enlightened state through karma and reincarnation.
- The pantheon of Aryan gods develops into the Hindu religion, with the three main gods Brahma, Vishnu, and Krishna.
- Buddhism develops as a path to enlightenment and the end of suffering via the Four Noble Truths and the Eightfold Path.
- Whereas Hinduism acknowledges sexual pleasure and the enjoyment of erotic imagery, Buddhism tends to renounce worldly pleasures and value the meditative life.

CHINA

Language and Literature
- The book that sets forth Laozi's teachings, *The Classic of the Way and Its Power* (*Daodejing*), was written in the third century BCE.
- Early Han emperors (after 202 BCE) lift the ban on philosophical works and encouraged scholars to reconstruct the writings of Confucius.
- Beginning in the Zhou period, the *Five Classics* circulate widely—addressing history, political documents such as speeches, and descriptions of ceremonies. The *Classic of Songs* contains poems dealing with private life (love, the family) and public affairs.
- Because the meaning of Chinese words and phrases changes according to their pronunciation, poetry becomes especially popular. Li Bai writes poetry lauding wine and nature.
- The short story develops during the Tang dynasty.
- Li Qingzhao writes *Ci* poetry.
- Calligraphy becomes a form of fine art, as on lengthy scrolls.

Art, Architecture, and Music
- To defend his empire, Shihuangdi, the first Qin emperor, connects existing defensive walls into the Great Wall of China, 1,400 miles long.
- In about 550 CE, Xie He set down the six canons of Chinese painting.
- Painters chose many courtly subjects and nature.
- Chinese Buddhists build shrines and decorate them with monumental carvings.
- Calligraphy becomes a form of fine art.

Philosophy and Religion
- Confucius and Laozi founded Confucianism and Daoism.
- Confucianism taught that the morally superior individual should possess five inner virtues and acquire another two; the five were righteousness, integrity, love of humanity, altruism, and loyalty. Those to be acquired were culture (education) and a sense of decorum or ritual. Confucius would not speculate about the possibility of gods or an afterlife. He argued that the state should exist for the benefit of the people, rather than the reverse.
- Daoism preaches that people should follow their own nature, not distinguishing between good and bad. Daoism taught passivity and resignation, particularly avoiding war because "every victory is a funeral rite."
- After Shihuangdi's Burning of the Books, Han emperors lift the ban on philosophical works and encourage scholars to reconstruct the writings of Confucius.
- Buddhism is introduced into China during the Han dynasty. Following the collapse of the Han rulers, Buddhist monasteries grow in wealth and power.

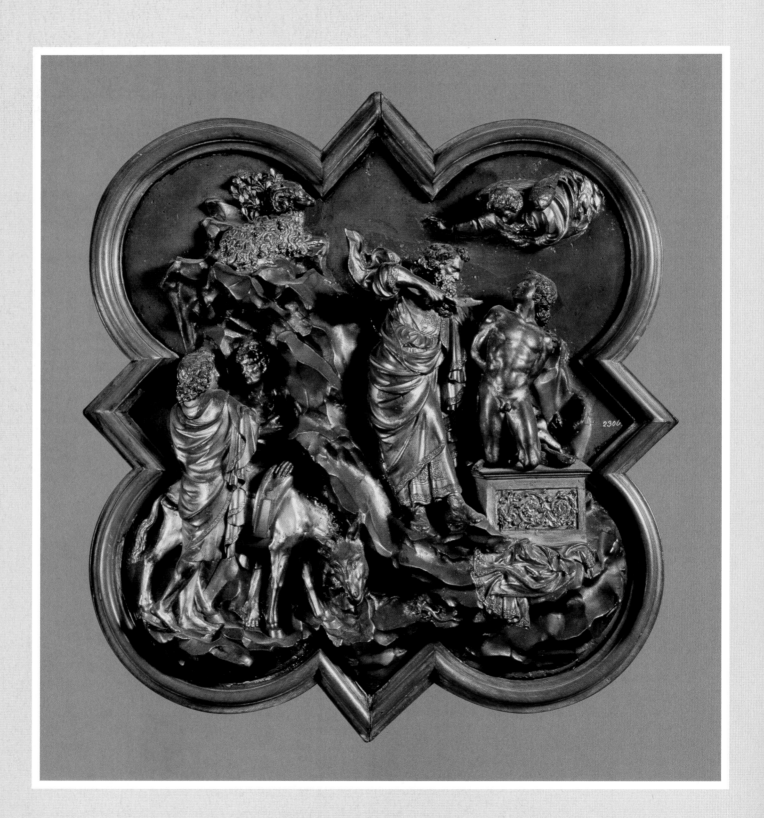

The Rise of the Biblical Tradition

6

PREVIEW

In Italy, at the very start of the fifteenth century, guild officials in the city of Florence announced a competition for a high-profile sculpture commission—a set of bronze doors for the small, octagonal baptistery that faced the entrance to the city's spectacular cathedral. The commission would secure for the winning artist many years of employment as well as recognition and fame. To level the field for the participants— seven in all—the sample panel that was to be submitted for consideration had to meet certain criteria: it had to be made of bronze; the imagery had to be placed within an elaborate frame embellished by curves and triangles; and all of the artists had to depict the same subject— the sacrifice of Isaac (Fig. 6.1). Following the description of the event in the Old Testament, or Hebrew Bible, the content of the trial panels was specified further: each had to include Abraham, Isaac, two servants and a donkey, an altar, an angel, a sheep, and the suggestion of the setting of Mount Moriah.

The Book of Genesis contains the passage in which these details are found. God tests Abraham, who will ultimately become the father of the Hebrew people and a great prophet, by telling him to make of his son Isaac a burnt offering. Abraham saddles a donkey and leaves his home with Isaac and two young men. When he arrives at the place that God has specified for the sacrifice, Abraham binds Isaac to an altar and is about to slay him with a knife when, at the last moment, God, assured of Abraham's loyalty, sends an angel to stay his hand. The burnt offering to God in Isaac's place is a ram that Abraham spots in a nearby thicket.

Lorenzo Ghiberti (1378—1455) was awarded the commission and worked on the project for 21 years. Shortly after the commission for the east-baptistery doors had gone out, the city of Florence came under the assault of the forces of the Duke of Milan, Gian Galeazzo Visconti. Florence was most certainly the underdog in this fight; most thought that the Milanese would prevail. But at the last moment, Gian Galeazzo contracted a fever, and a month later he was dead. The biblical story of the sacrifice of Isaac resonated with the Florentines. The weaker of the two powers, it would seem that their "deliverance" had a convincing parallel in God's deliverance of Isaac.

◄ **6.1** Lorenzo Ghiberti, *Sacrifice of Isaac*, 1401–1402. Gilt bronze, 21″ × 17½″ (53.3 x 44.5 cm). Museo Nazionale del Bargello, Florence, Italy.

ABRAHAM

The story of Abraham begins in the twelfth chapter of the book of Genesis in the Hebrew Bible, when God tells him to leave Ur, his country, and his relatives, to go to a land that God will show him. God promises Abraham: "I will make of you a great nation and I will bless you and make your name great." This land that God will show Abraham is the promised land—the land of Canaan. The next 13 chapters tell Abraham's story, including two of the most wrenching and perplexing: his near sacrifice of his son Isaac and his abandonment of another son, Ishmael.

In the fifteenth chapter of Genesis, God tells Abraham to look at the sky and to count the stars—so innumerable would be his descendants. The three great monotheistic religions—Judaism, Christianity, and Islam—are often called the Abrahamic religions because they consider this ancient patriarch to be their common ancestor. Abraham is considered the father of the Jewish people. Jesus of Nazareth, who was born a Jew, calls God the "God of Abraham," and in a Christian epistle to the Hebrews, Abraham is praised as a model of faith:

> "By faith, Abraham obeyed when he was called to set out for a place that he was to receive as an inheritance; and he set out. By faith he stayed a long time in the land he had been promised as in a foreign land, living in tents, as did Isaac and Jacob, who were heirs with him of the same promise. . . . Therefore from one person . . . descendants were born, as many as the stars of the heaven and the innumerable grains by the seashore." (Heb. 11:8–12)

Muslims also count themselves among the descendants of Abraham (*Ibrahim*, in Arabic) and call him the Father of the Arabs. Abraham is honored as one of Islam's revered prophets and bears the title *hanif*—a revealer of belief in one God. Muslims believe that Abraham built the *Ka'bah*, a shrine in Mecca to which devout Muslims make a pilgrimage at least once in their lifetimes. They believe that, in their journey, they follow the footsteps of Abraham, Ishmael, and Ishmael's mother, Hagar.

Isaac and Ishmael, then, both sons of Abraham but by different mothers, went on to found these separate nations—the Hebrew and the Arab nations. Ishmael was the older of the two brothers, fathered by Abraham with an Egyptian servant, Hagar, when it was thought that Abraham's wife, Sarah, would not able to conceive. After many years—when Sarah was in her old age and Abraham himself was 100, we are told—Sarah gave birth to Isaac, whose name in Hebrew means "he will laugh." In Genesis 21:6–7, Sarah says, "God has brought me laughter, and everybody who hears about this will laugh with me. . . . Who would have said to Abraham that Sarah would nurse children? Yet I have borne him a son in his old age." After Isaac is born, Sarah worries that Ishmael may wish to share in her son's inheritance and tells Abraham to turn out "that slave woman and her son." In Genesis 21:11, Abraham complies. He gives Hagar and Ishmael a bit of food and water, takes them out into the desert, and leaves them there. Abraham has some trepidation, but God tells him that Ishmael will survive and that God will make his descendants, too, "into a nation." When the exiles run out of water, God does indeed provide for them, and Ishmael goes on to fulfill his destiny.

When Ishmael was sent from his father's house, Isaac was a very small child, but when his own story with Abraham unfolds, he is probably at least twelve and maybe quite a bit older. We know from the passage that he is old enough to walk for three days to Mount Moriah and to carry wood for the burnt offering.

The Rise of the Biblical Tradition

2000 BCE	1260 BCE	1000 BCE	922 BCE	587 BCE	63 BCE	381 CE
Age of Hebrew Patriarchs Abraham, Isaac, Jacob (r. 1800–1600) Hebrews in Egypt until Exodus in 1280	Hebrews begin to penetrate land of Canaan Reign of Saul first king of Israel 1040–1000	Reign of King David 1000–961 Reign of King Solomon 961–922; height of ancient Israel's cultural power	Civil war after Solomon's death splits Israel; prophetic period begins Northern Israeli kingdom destroyed by Assyria in 721	Jews driven into captivity in Babylonia in 587 King Cyrus allows Jews to return to Jerusalem in 539 Dedication of Second Temple in 516 Conquest by Alexander the Great in 332	Rome conquers Jerusalem in 63 Reign of King Herod 37–4 Herod Birth of Jesus ca. 6 Titus sacks Jerusalem in 70 Reign of Emperor Constantine 307–327 Edict of Milan 313 Founding of Constantinople Christianity declared state religion	

READING 6.1 THE HEBREW BIBLE

Genesis 22:1–18

¹God tested Abraham and said to him, "Abraham!" And he[1] said, "Here am I." ²He said, "Take your son, your only son Isaac, whom you love, and go to the land of Moriah, and offer him there as a burnt offering on one of the mountains of which I shall tell you." ³So Abraham rose early in the morning, saddled his donkey, and took two of his young men with him, and his son Isaac. And he cut the wood for the burnt offering and arose and went to the place of which God had told him. ⁴On the third day Abraham lifted up his eyes and saw the place from afar. ⁵Then Abraham said to his young men, "Stay here with the donkey; I and the boy will go over there and worship and come again to you." ⁶And Abraham took the wood of the burnt offering and laid it on Isaac his son. And he took in his hand the fire and the knife. So they went both of them together. ⁷And Isaac said to his father Abraham, "My father!" And he said, "Here am I, my son." He said, "Behold, the fire and the wood, but where is the lamb for a burnt offering?" ⁸Abraham said, "God will provide for himself the lamb for a burnt offering, my son." So they went both of them together.

⁹When they came to the place of which God had told him, Abraham built the altar there and laid the wood in order and bound Isaac his son and laid him on the altar, on top of the wood. ¹⁰Then Abraham reached out his hand and took the knife to slaughter his son. ¹¹But the angel of the Lord called to him from heaven and said, "Abraham, Abraham!" And he said, "Here am I." ¹²He said, "Do not lay your hand on the boy or do anything to him, for now I know that you fear God, seeing you have not withheld your son, your only son, from me." ¹³And Abraham lifted up his eyes and looked, and behold, behind him was a ram, caught in a thicket by his horns. And Abraham went and took the ram and offered it up as a burnt offering instead of his son. ¹⁴So Abraham called the name of that place, "The Lord will provide"; as it is said to this day, "On the mount of the Lord it shall be provided."

¹⁵And the angel of the Lord called to Abraham a second time from heaven ¹⁶and said, "By myself I have sworn, declares the Lord, because you have done this and have not withheld your son, your only son, ¹⁷I will surely bless you, and I will surely multiply your offspring as the stars of heaven and as the sand that is on the seashore. And your offspring shall possess the gate of his enemies, ¹⁸and in your offspring shall all the nations of the earth be blessed, because you have obeyed my voice."

From Genesis, Exodus, Job, Amos, Matthew, Acts, I Corinthians, and II Corinthians of Revised Standard Version Bible, copyright 1946, 1952, © 1972 by the Division of Christian Education of the National Council, Churches of Christ in the U.S.A.

Abraham resigns himself to his situation and releases himself to faith. God would challenge Abraham's faith and loyalty again when God tells him to sacrifice his son Isaac. Commentators have asked why God would test Abraham in this heartless way and have wondered why Abraham would have carried out God's will with no objection. Søren Kierkegaard, the nineteenth-century Danish philosopher, pondered the anguish he assumed Abraham must have felt and concludes that his ultimate complicity was a "leap to faith." In *Fear and Trembling*, Kierkegaard postulates that "infinite resignation is the last stage before faith, so anyone who has not made this movement does not have faith, for only in infinite resignation does an individual become conscious of his eternal validity, and only then can one speak of grasping existence by virtue of faith."[2]

JUDAISM AND EARLY CHRISTIANITY

More than three thousand years ago in the Middle East, a small tribe-turned-nation became one of the central sources for the development of Western civilization: the marriage of the biblical tradition and Graeco-Roman culture.

We have very little of the art, music, or philosophy—other than the religious precepts—of these ancient people. Some commentators have attributed the scarcity of art to the second of the Ten Commandments: "You shall not make for yourself a graven image, or any likeness of anything that is in heaven above, or that is in the earth beneath, or that is in the water under the earth; you shall not bow down to them or serve them; for I the Lord your God am a jealous God" (Exod. 20:4–5). But other commentators emphasize that this commandment is given in the context of idol worship; it has most often been interpreted as a warning to the Hebrews not to make idols of wood, stone, or metal and worship them. If this is so, the commandment does not proscribe the visual arts in general.[3] We do have the texts of the Hebrews' hymns, canticles, and psalms, but we can only speculate how they were sung and how they were accompanied instrumentally. The major gift bequeathed to us is a book; more precisely, the collection of books Jews call the Hebrew Bible, or *Tanakh*, and Christians often refer to as The Old Testament.

These people called themselves the Children of Israel or Israelites. At a later time they became known as the Jews, from the area around Jerusalem known as Judaea. In the Bible they are called Hebrews (most often by their neighbors), which is the name now most commonly used to describe these biblical people.

1. Abraham.

2. Søren Kierkegaard, *Fear and Trembling*, in *Kierkegaard's Writings*, ed. and trans. Howard V. Hong and Edna H. Hong, vol. 6, *Fear and Trembling/Repetition* (Princeton, NJ: Princeton University Press, 1983; original copyright 1843).

3. See, for example, John Williams, ed., *Imaging the Early Medieval Bible* (University Park: Pennsylvania State University, 1999).

In the story of Abraham, Hagar, and Ishmael, we are told that Abraham grieved over his abandonment of his son, but was reassured in his faith that God, indeed, would provide for them.

Biblical History

The history of the Hebrew people is long and complex, but the stages of their growth can be outlined as follows:

- *The period of the patriarchs.* According to the Bible, the Hebrew people had their origin in Abraham, the father (**patriarch**) of a tribe who took his people from ancient Mesopotamia to the land of Canaan on the east coast of the Mediterranean about 2000 BCE. After settling in this land, divided into twelve tribal areas, they eventually went to Egypt at the behest of Joseph, who had risen to high office in Egypt after his enslavement there.
- *The period of the Exodus.* The Egyptians eventually enslaved the Hebrews (perhaps around 1750 BCE), but the Hebrews were led out of Egypt under the leadership of Moses. This going out (**exodus**) is one of the central themes of the Bible; this great event also gives its name to one of the books of the Bible.
- *The period of the conquest.* The biblical books of Joshua and Judges relate the struggles of the Hebrews to conquer the land of Canaan as they fought against the native peoples of that area and the competing "sea people" (the Philistines who came down from the north).
- *The united monarchy.* The high point of Hebrew political power came with the consolidation of Canaan and the rise of a monarchy. There were three kings: Saul, David, and Solomon. An ambitious flurry of building during the reign of Solomon (ca. 961–922 BCE) culminated in the construction of the great temple in Jerusalem (**Fig. 6.2**).
- *Divided kingdom and exile.* After the death of Solomon, a rift over the succession resulted in the separation of the northern kingdom (Israel) and the southern kingdom (Judah), the center of which was Jerusalem. Both were vulnerable to pressure from the surrounding great powers. Israel was destroyed by the Assyrians in the eighth century BCE, and its inhabitants (the so-called Lost Tribes of Israel) were swept away by death or exile. In 587 BCE the Babylonians conquered the Southern Kingdom, destroyed Solomon's temple in Jerusalem, and carried the Hebrew people into an exile known to history as the Babylonian Captivity.
- *The return.* The Hebrews returned from exile about 520 BCE to rebuild their shattered temple and to

▼ **6.2 Spoils of Jerusalem (detail of the Arch of Titus), 81 CE. Rome, Italy.** This honorific arch was erected in the Roman Forum to commemorate Titus's victory over the Hebrews in 70 CE. The left inner relief shows soldiers carrying off a menorah and other spoils from the Temple of Jerusalem.

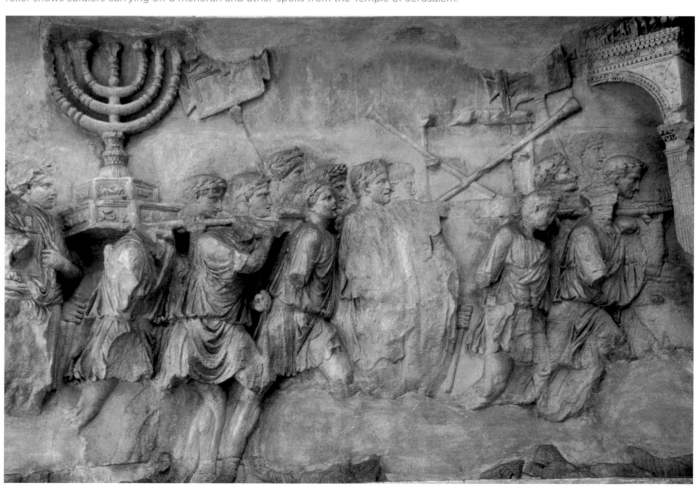

resume their religious life. Their subsequent history was marked by a series of foreign (Greek, Egyptian, and Syrian) rulers, one brief period of political independence (ca. 165 BCE), and, finally, rule by Rome after the conquest of 63 BCE. In 70 CE, after a Jewish revolt, the Romans destroyed Jerusalem and razed the rebuilt temple. One small band of Jewish rebels that held off the Romans for two years at a mountain fortress called Masada was defeated in 73 CE. Except for pockets of Jews who lived there over the centuries, not until 1948, when the state of Israel was established, would Jews hold political power in their ancestral home.

▼ **6.3 Books of the Old and New Testaments**

OLD TESTAMENT	NEW TESTAMENT
Genesis	**Gospels**
Exodus	Matthew
Leviticus	Mark
Numbers	Luke
Deuteronomy	John
Joshua	
Judges	**Acts of the Apostles**
Ruth	
1 and 2 Samuel	***Letters of Paul***
1 and 2 Kings	Romans
1 and 2 Chronicles	1 and 2 Corinthians
Ezra	Galatians
Nehemiah	Ephesians
Esther	Philippians
Job	Colossians
Psalms	1 and 2 Thessalonians
Proverbs	1 and 2 Timothy
Ecclesiastes	Titus
Song of Songs	Philemon
Isiah	Hebrews
Jeremiah	
Lamentations	***Letters of***
Ezekiel	***James***
Daniel	1 and 2 Peter
Hosea	1, 2, and 3 John
Joel	Jude
Amox	
Obadiah	**Revelation (also called the Apocalypse)**
Jonah	
Micah	
Nahum	
Habakkuk	
Zephaniah	
Haggai	
Zechariah	
Malachi	

The Hebrew Bible and Its Message

The English word *bible* comes from the Greek name for the ancient city of Gebal (Byblos), from which the papyrus reed used to make books was exported. The Bible is a collection of books that took its present shape over a long period.

The ancient Hebrews divided the books of their Bible into three large groupings: the Law, the Prophets, and the Writings. The Law referred specifically to the first five books of the Bible, called the **Torah** (from the Hebrew word for "instruction" or "teaching"). The Prophets consist of writings attributed to the great moral teachers of the Hebrews, who were called **prophets** because they spoke with the authority of God (*prophet* derives from a Greek word for "one who speaks for another"). The Writings contain the wisdom literature of the Hebrew Bible, in prose, poetry (like the book of Psalms), or a mixture of the two, as in the book of Job (**Fig. 6.3**).

The list of books contained in the modern Bible was not established until 90 CE, when an assembly of rabbis drew up such a list, or **canon**, even though its main outline had been known for centuries. The Christians in turn accepted this canon and added the twenty-seven books that make up what we know as the Christian New Testament. Roman Catholics and Orthodox Christians also accept as canonical some books of the Hebrew Bible that are not in the Hebrew canon but are found in an ancient Greek version of the Hebrew scriptures known as the **Septuagint** (a version of the Bible widely used in the ancient world (**Fig. 6.4**)).

One fundamental issue about the Bible must be emphasized: Both ancient Israel, subsequent Jewish history, and the Christian world have made the Bible *the* central document not only for worship and the rule of faith but also as a moral guide and anchor for ethical and religious stability. The Bible, directly and indirectly, has shaped our law, literature, language, ethics, and social outlook. It permeates our culture. To cite one single

▼ **6.4 The Deuterocanonical Books of the Bible.**
Roman Catholicism and Orthodox Christianity accept in their canon some additional books that were accepted as canonical in the Greek Old Testament known as the Septuagint version. These books are called the deuterocanonical books. The Roman Catholics accept the following:

Roman Catholic and Orthodox Christian
Tobit
Judith
Wisdom of Solomon
Ecclesiasticus (also known as the **Wisdom of Ben Sira**)
Baruch (containing the Letter of *Jeremiah*)
I and II Maccabees
Some additional chapters of Esther and Daniel
Orthodox Christian
First Esdras
Prayer of Manasseh
Psalm 151

example: At Solomon's temple the people sang hymns of praise (**psalms**) to God, just as they are sung in Jewish synagogues today. Those same psalms were sung by Jesus and his followers in their time, just as they are sung and recited in Christian churches in every part of the world. That ancient formulation is, in a deep sense, part of our common religious culture.

The Bible is not a philosophical treatise; it is a sacred book. It is, nonetheless, a book that contains ideas; those ideas have enormously influenced the way we think and the way we look at the world. Some of the basic motifs of the Bible have been so influential in our culture that they should be considered in some detail. We will examine four such motifs that run like strands throughout the Hebrew scriptures.

BIBLICAL MONOTHEISM A central conviction of biblical religion is that there is one god, that this god is good, and (most crucially) that this god is involved in the arena of human history. God is conceived of as a person and not as some impersonal force in the world of nature. **Monotheism** (the belief in one god) can thus be distinguished both from **henotheism** (the belief that there may be other gods, although only one is singled out for worship) and **polytheism** (the belief that there are many gods).

The opening pages of the Hebrew Bible—the Book of Genesis—set out a creation story: a story that addresses the creation of the universe ("the heavens and the earth") and the creation of humans.

The creation story of Genesis provides us with a rather complete vision of what the Bible teaches about God. The story makes three basic assertions about God. First, God exists before the world and called it into existence by the simple act of utterance. God, unlike the gods and goddesses of the Hebrews' ancient neighbors, is not born out of the chaos that existed before the world. God is not to be confused with the world, and neither did God have to struggle with the forces of chaos to create. Second, God pronounces each part of creation, and creation as a whole as "good." Thus, the book of Genesis does not present the material universe as evil or, as certain Eastern religions teach, an illusory world that conceals the true nature of reality. Finally,

READING 6.2 **THE HEBREW BIBLE**

Genesis 1 and 2:1-25

1

¹In the beginning God created the heavens and the earth. ²The earth was without form and void, and darkness was upon the face of the deep; and the Spirit of God was moving over the face of the waters. ³And God said, "Let there be light"; and there was light. ⁴And God saw that the light was good; and God separated the light from the darkness. ⁵God called the light Day, and the darkness he called Night. And there was evening and there was morning, one day.

⁶And God said, "Let there be a firmament in the midst of the waters, and let it separate the waters from the waters." ⁷And God made the firmament and separated the waters which were under the firmament from the waters which were above the firmament. And it was so. ⁸And God called the firmament Heaven. And there was evening and there was morning, a second day.

⁹And God said, "Let the waters under the heavens be gathered together into one place, and let the dry land appear." And it was so. ¹⁰God called the dry land Earth, and the waters that were gathered together he called Seas. And God saw that it was good. ¹¹And God said, "Let the earth put forth vegetation, plants yielding seed, and fruit trees bearing fruit in which is their seed, each according to its kind, upon the earth." And it was so. ¹²The earth brought forth vegetation, plants yielding seed according to their own kinds, and trees bearing fruit in which is their seed, each according to its kind. And God saw that it was good. ¹³And there was evening and there was morning, a third day.

¹⁴And God said, "Let there be lights in the firmament of the heavens to separate the day from the night; and let them be for signs and for seasons and for days and years, ¹⁵and let them be lights in the firmament of the heavens to give light upon the earth." And it was so. ¹⁶And God made the two great lights, the greater light to rule the day, and the lesser light to rule the night; he made the stars also. ¹⁷And God set them in the firmament of the heavens to give light upon the earth, ¹⁸to rule over the day and over the night, and to separate the light from the darkness. And God saw that it was good. ¹⁹And there was evening and there was morning, a fourth day.

²⁰And God said, "Let the waters bring forth swarms of living creatures, and let birds fly above the earth across the firmament of the heavens." ²¹So God created the great sea monsters and every living creature that moves, with which the waters swarm, according to their kinds, and every winged bird according to its kind. And God saw that it was good. ²²And God blessed them, saying, "Be fruitful and multiply and fill the waters in the seas, and let birds multiply on the earth." ²³And there was evening and there was morning, a fifth day.

²⁴And God said, "Let the earth bring forth living creatures according to their kinds: cattle and creeping things and beasts of the earth according to their kinds." And it was so. ²⁵And God made the beasts of the earth according to their kinds and the cattle according to their kinds, and everything that creeps upon the ground according to its kind. And God saw that it was good.

²⁶Then God said, "Let us make man in our image, after our likeness; and let them have dominion over the fish of the sea, and over the birds of the air, and over the cattle, and over all the earth, and over every creeping thing that creeps upon the earth." ²⁷So God created man in his own image, in the image of God he created him; male and female he created them. ²⁸And God blessed them, and God said to them, "Be fruitful and multiply, and fill the earth and subdue it; and have dominion over the fish of the sea and over

God creates human beings as the apex and crown of creation. The material world is a gift from God, and human beings are obliged to care for it and be grateful for it. A basic motif of biblical prayer is gratitude to God for the gift of creation.

Biblical monotheism must not be thought of as a theory that simply sees God as the starting point or originator of all things after the fashion of a craftsperson who makes a chair and then forgets about it. The precise character of biblical monotheism is its conviction that God creates and sustains the world in general and chose a particular people to be both vehicle and sign of divine presence in the world. The exact nature of that relationship can be found in the biblical notion of covenant.

THE COVENANT **Covenant** is the crucial concept for setting out the relationship between God and the Hebrew people. The covenant can be summed up in the simple biblical phrase "I will be your God; you will be my people." In Hebrew history, the Bible insists, God has always been faithful to that covenant that was made with the people of Israel, whereas the people must learn and relearn how to be faithful to it. Scholars have pointed out that the biblical covenant may be based on the language of ancient marriage covenants (for example, "I will be your husband; you will be my wife"); if that is true, it gives us an even deeper understanding of the term: the relationship of God and Israel is as close as the relationship of husband and wife.

This strong portrait of a single, deeply involved god who is beyond image or portrayal has had a profound impact on the shape of the Judeo-Christian worldview. The notion of covenant religion not only gave form to Hebrew religion, but the idea of a renewed covenant became the central claim of Christianity. (Another word for covenant is **testament**; hence the split between Old and New Testaments that Christianity insists upon.) The idea has even spilled over from synagogues and churches into our national civil religion, where we affirm a belief in "one nation under God" and "In God we trust"—both sentiments rooted in the idea of a covenant.

ETHICS The Bible is not primarily an ethical treatise; it is a theological one, even though it does set out a moral code of behavior both for individuals and for society. The Bible

the birds of the air and over every living thing that moves upon the earth." ²⁹And God said, "Behold, I have given you every plant yielding seed which is upon the face of all the earth, and every tree with seed in its fruit; you shall have them for food. ³⁰And to every beast of the earth, and to every bird of the air, and to everything that creeps on the earth, everything that has the breath of life, I have given every green plant for food." And it was so. ³¹And God saw everything that he had made, and behold, it was very good. And there was evening and there was morning, a sixth day.

2

¹Thus the heavens and the earth were finished, and all the host of them. ²And on the seventh day God finished his work which he had done, and he rested on the seventh day from all his work which he had done. ³So God blessed the seventh day and hallowed it, because on it God rested from all his work which he had done in creation.

⁴These are the generations of the heavens and the earth when they were created.

In the day that the Lord God made the earth and the heavens, ⁵when no plant of the field was yet in the earth and no herb of the field had yet sprung up—for the Lord God had not caused it to rain upon the earth, and there was no man to till the ground; ⁶but a mist went up from the earth and watered the whole face of the ground—⁷then the Lord God formed man of dust from the ground, and breathed into his nostrils the breath of life; and man became a living being. ⁸And the Lord God planted a garden in Eden, in the east; and there he put the man whom he had formed. ⁹And out of the ground the Lord God made to grow every tree that is pleasant to the sight and good for food, the tree of life also in the midst of the garden, and the tree of the knowledge of good and evil.

¹⁰A river flowed out of Eden to water the garden, and there it divided and became four rivers. ¹¹The name of the first is Pishon; it is the one which flows around the whole land of Havilah, where there is gold; ¹²and the gold of that land is good; bdellium and onyx stone are there. ¹³The name of the second river is Gihon; it is the one which flows around the whole land of Cush. ¹⁴And the name of the third river is Tigris, which flows east of Assyria. And the fourth river is the Euphrates.

¹⁵The Lord God took the man and put him in the garden of Eden to till it and keep it. ¹⁶And the Lord God commanded the man, saying, "You may freely eat of every tree of the garden; ¹⁷but of the tree of the knowledge of good and evil you shall not eat, for in the day that you eat of it you shall die."

¹⁸Then the Lord God said, "It is not good that the man should be alone; I will make him a helper fit for him." ¹⁹So out of the ground the Lord God formed every beast of the field and every bird of the air, and brought them to the man to see what he would call them; and whatever the man called every living creature, that was its name. ²⁰The man gave names to all cattle, and to the birds of the air, and to every beast of the field; but for the man there was not found a helper fit for him. ²¹So the Lord God caused a deep sleep to fall upon the man, and while he slept took one of his ribs and closed up its place with flesh; ²²and the rib which the Lord God had taken from the man he made into a woman and brought her to the man. ²³Then the man said, "This at last is bone of my bones and flesh of my flesh; she shall be called Woman, because she was taken out of Man."

²⁴Therefore a man leaves his father and his mother and cleaves to his wife, and they become one flesh. ²⁵And the man and his wife were both naked, and were not ashamed.

has many rules for worship and ritual, but its fundamental ethical worldview lies in the idea that humans are created in "the image" and "likeness" of God (Gen. 1:26). The more detailed formulation of that link between God and individual and social relationships is contained in the Ten Commandments—also known as the **Decalogue**—which the Bible depicts as being given by God to Moses after the latter brings the people out of the bondage of Egypt and before they reach the Promised Land (see Exodus 20).

READING 6.3 THE HEBREW BIBLE

Exodus 20:1–17 (the Decalogue)

20

[1]And God spoke all these words, saying, [2]"I am the Lord your God, who brought you out of the land of Egypt, out of the house of bondage.

[3]"You shall have no other gods before me.

[4]"You shall not make for yourself a graven image, or any likeness of anything that is in heaven above, or that is in the earth beneath, or that is in the water under the earth; [5]you shall not bow down to them or serve them; for I the Lord your God am a jealous God, visiting the iniquity of the fathers upon the children to the third and fourth generation of those who hate me, [6]but showing steadfast love to thousands of those who love me and keep my commandments.

[7]"You shall not take the name of the Lord your God in vain: for the Lord will not hold him guiltless who takes his name in vain.

[8]"Remember the sabbath day, to keep it holy. [9]Six days you shall labor, and do all your work; [10]but the seventh day is a sabbath to the Lord your God; in it you shall not do any work, you, or your son, or your daughter, your manservant, or your maidservant, or your cattle, or the sojourner who is within your gates; [11]for in six days the Lord made heaven and earth, the sea, and all that is in them, and rested on the seventh day; therefore the Lord blessed the sabbath day and hallowed it.

[12]"Honor your father and your mother, that your days may be long in the land which the Lord your God gives you.

[13]"You shall not kill.

[14]"You shall not commit adultery.

[15]"You shall not steal.

[16]"You shall not bear false witness against your neighbor.

[17]"You shall not covet your neighbor's house; you shall not covet your neighbor's wife, or his manservant, or his maidservant, or his ox, or his ass, or anything that is your neighbor's."

From Genesis, Exodus, Job, Amos, Matthew, Acts, I Corinthians, and II Corinthians of Revised Standard Version Bible, copyright 1946, 1952, © 1972 by the Division of Christian Education of the National Council, Churches of Christ in the U.S.A.

The commandments, consisting of both prohibitions (against murder, theft, idolatry, and so on) and positive commands (for worship, honoring of parents, and so on), are part of the larger ethical commands of all civilizations. The peculiarly monotheistic parts of the code appear in the first cluster, with the positive command to worship God alone and the prohibition of graven images and their worship.

Ancient Israel's ethics take on a more specific character in the writings of the prophets. The prophet (Hebrew *nabi*) speaks with God's authority. In the Hebrew religion, the prophet was not primarily concerned with the future (prophet and seer are thus not the same thing), even though the prophets do speak of a coming of peace and justice in the age of the **messiah** (the Hebrew word meaning "anointed one"). The main prophetic task was to call people back to the observance of the covenant and to warn them about the ways in which they had failed that covenant. The great eighth-century prophets who flourished in both the north and the south after the period of the monarchy left a great literature. They insisted that worship of God, for example, in the worship of the temple, was insufficient if that worship did not come from the heart and include love and compassion for others. The prophets were radical critics of social injustice and defenders of the poor. They linked worship with a deep concern for ethics. They envisioned God as a god of all people and insisted on the connection between worship of God and righteous living.

Prophets were not a hereditary caste in ancient Israel as the priests were. Prophets were "called" to preach. In many instances they even resisted that call and expressed reluctance to undertake the prophetic task. The fact that they had an unpopular message explains both why many of them suffered a violent end and why some were reluctant to undertake the task of preaching.

The prophetic element in religion was one of Israel's most enduring contributions to the religious sensibility of the world. The idea that certain people are called directly by God to preach peace and justice in the context of religious faith would continue beyond the biblical period in Judaism and Christianity. It is not accidental, to cite one modern example, that the great civil-rights leader Martin Luther King Jr. (1929–1968) often cited the biblical prophets as exemplars for his own struggle on behalf of African Americans. That King died a violent death by assassination in 1968 is an all too ready example of how disquieting the prophetic message can be.

MODELS AND TYPES Until modern times, relatively few Jews or Christians actually read the Bible on an individual basis. Literacy was rare, books expensive, and leisure at a premium. Bibles were read to people most frequently in public gatherings of worship in synagogues or churches. The one time that the New Testament reports Jesus as reading is from a copy of the prophet Isaiah kept in a synagogue (Luke 4:16). The biblical stories were read over the centuries in a familial setting (as at the Jewish Passover) or in formal worship on the Sabbath. The basic point, however, is that for more than three thousand years, the stories and (equally important) the people in these stories have been etched in the Western imagination. The faith of Abraham, the guidance of Moses, the wisdom of

READING 6.4 THE HEBREW BIBLE

From Job 38 and 40

38

[1] Then the LORD answered Job out of the whirlwind:

[2] "Who is this that darkens counsel[4] by words without knowledge?

[3] Gird up your loins like a man. I will question you, and you shall declare to me.

[4] "Where were you when I laid the foundation of the earth? Tell me, if you have understanding.

[5] Who determined its measurements—surely you know! Or who stretched the line upon it?

[6] On what were its bases sunk, or who laid its cornerstone,

[7] when the morning stars sang together and all the sons of God shouted for joy?

[8] "Or who shut in the sea with doors when it burst out from the womb,

[9] when I made clouds its garment and thick darkness its swaddling band,

[10] and prescribed limits for it and set bars and doors,

[11] and said, 'Thus far shall you come, and no farther, and here shall your proud waves be stayed'?"

. . .

[28] "Has the rain a father, or who has begotten the drops of dew?

[29] From whose womb did the ice come forth, and who has given birth to the frost of heaven?

[30] The waters become hard like stone, and the face of the deep is frozen."

40

[1] And the LORD said to Job:

[2] "Shall a faultfinder contend with the Almighty? He who argues with God, let him answer it."

[3] Then Job answered the LORD and said:

[4] "Behold, I am of small account; what shall I answer you? I lay my hand on my mouth.

[5] I have spoken once, and I will not answer; twice, but I will proceed no further."

[6] Then God answered Job out of the whirlwind:

[7] "Gird up your loins like a man. I will question you, and you shall declare to me.

[8] Will you even put me in the wrong? Will you condemn me that you may be justified?

[9] Have you an arm like God, and can you thunder with a voice like his?

[10] "Deck yourself with majesty and dignity; clothe yourself with glory and splendor.

[11] Pour out the overflowings of your anger, and look on everyone who is proud and abase him.

[12] Look on everyone who is proud and bring him low; and tread down the wicked where they stand.

[13] Hide them all in the dust together; bind their faces in the world below.

[14] Then[5] will I also acknowledge to you that your own right hand can give you victory."

From Genesis, Exodus, Job, Amos, Matthew, Acts, I Corinthians, and II Corinthians of Revised Standard Version Bible, copyright 1946, 1952, © 1972 by the Division of Christian Education of the National Council, Churches of Christ in the U.S.A.

Solomon, the sufferings of Job, and the fidelity of Ruth have become proverbial in our culture.

THE BOOK OF JOB As noted in the discussion of Abraham and the sacrifice of Isaac, belief in God, or belief that God is benevolent, has been a challenge for Jews at many times in history—for instance, during the Spanish Inquisition, which began in the same year that Columbus sailed into the New World, and as recently as the mid-twentieth century, in the devastation of the **Holocaust**. The question for Jews—and indeed for peoples all over the world, regardless of their religion—is why bad things happen to good people. The book of Job deals with that painful question.

It relates the story of a righteous man—Job (rhyming with *lobe*). God and Satan discuss Job's piety, and Satan cynically contends that Job is observant only because God has protected him and blessed him with prosperity and a large family. Should God strike Job's possessions, Job would curse God. God permits Satan to put Job's righteousness to the test, and all of Job's possessions and livestock are soon obliterated or stolen. His offspring are killed. But instead of cursing God, Job prays, "Naked I came from my mother's womb, and naked shall I return; the Lord has given, and the Lord has taken away;

blessed be the name of Lord" (Job 1:21). Satan is then permitted by God to afflict Job's body but not take his life. Job is assaulted with an excruciating case of boils, which he tries to manage by scraping his skin with shards of pottery. Job's wife prompts him to curse God at this point, but Job answers, "Shall we receive good from God and not receive evil?" (Job 2:10). Nevertheless, he finally curses the day he was born.

In one of the most poetic, though mystifying, passages in the Bible, God answers Job (see Reading 6.4). But God does not directly explain why the righteous suffer. Rather, He paints the magnificence of his creation and of his own power. Is the point that the sufferings of one man matter little in the grand scheme? Some readers will find the "answer" less than satisfying, but the writing soars. It evokes a line from John Milton's *Paradise Lost*, which we shall see in Chapter 15; Milton declares that he wrote his poem to "justify the ways of God to men."

At the end of the story, Job's health has been restored. He has a new family and is again rich in livestock. But again,

4. Advice; especially advice that can lead one on the path to moral perfection.

5. That is, if Job can do the things mentioned in lines 9 to 14, then God will accept that he is capable of engaging in actions that will cause God to change his ways.

readers may ask whether one child is the same as another, and whether one can simply replace one's children such that one's pain is relieved. And what of the children who were killed?

These events and stories from the Bible are models of instruction and illumination; they have taken on a meaning far beyond their original significance. The events described in the book of Exodus, for example, are often invoked to justify a desire for freedom from oppression and slavery. It is not accidental that Benjamin Franklin suggested depicting the crossing of the Reed Sea (not the Red Sea, as is often said) by the Children of Israel as the centerpiece of the Great Seal of the United States. Long before Franklin's day, the Pilgrims saw themselves as the new Children of Israel who had fled the oppression of Europe (read: Egypt) to find freedom in the land "flowing with milk and honey" that was America. At a later period in history, slaves in this country saw themselves as the oppressed Israelites in bondage. The desire of African Americans for freedom was couched in the language of the Bible as they sang "Go down, Moses. . . . Tell old Pharaoh: Let my people go!"

Dura-Europus

An archeological find in the 1930s provides evidence of the diversity and coexistence of religions in the Roman Empire of the third and fourth centuries, and is one of the few reposi-

tories of ancient Jewish art and architecture. The site is the Syrian town of Dura-Europus, which was destroyed by Persian armies in 256 CE and cloaked by desert sands for nearly 1700 years. From the perspectives of archaeology and art history, it is a wonder that buildings from this era and this place survived at all, much less so well preserved. After an erratic history of shifting control of the town, the population of Dura-Europus left once and for all in 256 CE. It is as if they just closed the doors behind them and walked away. Among the collection of buildings are pagan temples and homes, one of which had been converted into an early Christian meeting house, and a synagogue replete with glorious frescoes.

The synagogue in Dura-Europus (**Fig. 6.5**) belies the assumption that Jews, following the proscriptions of the Ten Commandments, did not create images associated with the worship of their god. The walls of the synagogue, divided into picturelike spaces, are covered with scenes from biblical stories and Jewish history. Stone benches line the walls of the meeting space, and on one wall is a niche with a projecting arch and two columns that housed the Torah scroll.

In one fresco, the figure of Moses dominates a scene depicting the parting of the Red Sea and the Exodus from Egypt under the protective, outstretched arms of the Hebrew God (**Fig. 6.6**). Although God's face is never represented in the frescoes, a guiding hand along the upper edge of a painting sometimes suggests his presence. In terms of style, Moses might look familiar to you. The frescoes of Dura-Europus

⌄ **6.5 Interior of the synagogue, Dura-Europus, Syria, with wall paintings of themes from the Hebrew Bible, ca. 245–256 CE. Tempera on plaster. Reconstruction in the National Museum, Damascus, Syria.**

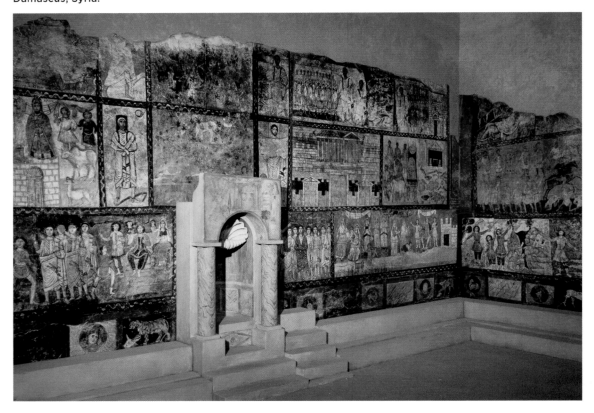

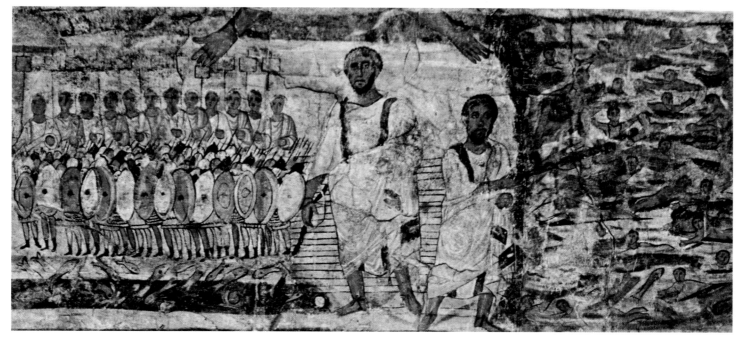

∧ **6.6** **Moses and the Exodus, ca. 245–256 CE. Fresco detail from the Dura-Europus synagogue. Reconstruction in the National Museum, Damascus, Syria.** Moses (staff in hand), his brother Aaron, and the Israelites are pursued by Egyptian armies across the Red Sea. Egyptians are shown drowning on the left.

owe much to Roman prototypes, in terms of both the overall historical narrative and stylistic details. The emotionless expression on the face of Moses, for example, recalls the stoicism of Marcus Aurelius.

It is impossible to ignore the impact of the biblical tradition on our common culture. Our literature echoes it; our art is saturated with it; our social institutions are shaped by it. Writers in the Middle Ages said that all knowledge came from God in the form of two great books: the book of nature and the book called the Bible. We have enlarged that understanding today but nonetheless have absorbed much of the Hebrew scriptures into the texture of our culture.

THE BEGINNINGS OF CHRISTIANITY

The fundamental fact to remember when studying the life of Jesus is that he was a Jew, born during the reign of Roman emperor Augustus in the Roman-occupied land of Judaea (see **Map 6.1**, "Israel at the Time of Jesus"). What we know about him, apart from a few glancing references in pagan and Jewish literature, comes from the four gospels (**gospel** derives from an Anglo-Saxon word meaning "good news") attributed to Matthew, Mark, Luke, and John. The Gospels began to appear

VALUES

Revelation

One deep theme that runs through the Bible is the concept of revelation. Revelation means a disclosure or "making plain" (literally, "pulling back the veils"). The Bible has the strong conviction that God reveals himself in the act of creation but also, more important, through the process of human history. The Old Testament makes clear the Hebrew conviction that God actually chose a people, exercised his care for them (providence), prompted prophets to speak, and inspired people to write. Christians accepted this divine intervention and expanded it with the conviction that God's final revelation to humanity came in the person of Jesus of Nazareth.

Several consequences derive from the doctrine of revelation. First is the idea that God gives shape to history and is most deeply revealed through history. Second, biblical religion conceived of God not as a distant figure separated from people but as one who guided, encouraged, and finally shaped the destiny of a particular people (the Jews) and eventually the whole human race. The concept of revelation is intimately connected to the idea of covenant, which is discussed in the text.

It should also be noted that Islam, in continuity with biblical religion, also focuses on the idea of revelation. Islam teaches respect for the Hebrew patriarchs, prophets, and the person of Jesus, but insists that Muhammad receives the final unveiling of God's purposes for the human race.

➤ **MAP 6.1**
Israel at the
Time of Jesus

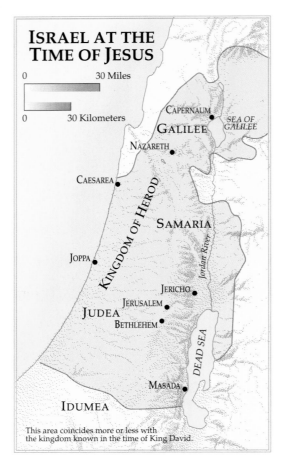

ISRAEL AT THE TIME OF JESUS

0 ————— 30 Miles

0 ————— 30 Kilometers

CAPERNAUM

SEA OF GALILEE

GALILEE

NAZARETH

CAESAREA

KINGDOM OF HEROD

SAMARIA

JOPPA

Jordan River

JERICHO

JERUSALEM

JUDEA

BETHLEHEM

DEAD SEA

MASADA

IDUMEA

This area coincides more or less with
the kingdom known in the time of King David.

more than a generation after the death of Jesus, which probably occurred in 30 CE. The Gospels are religious documents, not biographies, but they contain historical data about Jesus as well as theological reflections about the meaning of his life and the significance of his deeds.

Jesus must also be understood in light of the Jewish prophetical tradition. He preached the coming of God's kingdom, which would be a reign of justice and mercy. Israel's enemies would be overcome. Until that kingdom arrived, Jesus insisted on a life of repentance; an abandonment of earthly concerns; love of God and neighbor; and compassion for the poor, downcast, and marginalized; and he set forth his own life as an example. His identification with the poor and powerless antagonized his enemies—who included the leaders of his own religion and the governing authorities of the ruling Romans. Perhaps the most characteristic expression of the teachings of Jesus is to be found in his parables and in the moral code he expressed in what is variously called the Beatitudes or the Sermon on the Mount.

The Sermon on the Mount (see Reading 6.5) is among the most familiar passages in the New Testament. It promises heaven for the righteous. There are many expressions that have become part of common speech: "salt of the earth," "a city set on a hill," "the light of the world." It is in the sermon that we find the Roman Catholic prohibition of divorce, the concept of turning the other cheek when assaulted, and the command to love one's enemies. But make no mistake: there is also the repeated threat of hellfire for transgressors.

READING 6.5 THE CHRISTIAN BIBLE, NEW TESTAMENT

Matthew 5:1-48

5

¹Seeing the crowds, he went up on the mountain, and when he sat down his disciples came to him.

²And he opened his mouth and taught them, saying:

³"Blessed are the poor in spirit, for theirs is the kingdom of heaven.

⁴"Blessed are those who mourn, for they shall be comforted.

⁵"Blessed are the meek, for they shall inherit the earth.

⁶"Blessed are those who hunger and thirst for righteousness, for they shall be satisfied.

⁷"Blessed are the merciful, for they shall obtain mercy.

⁸"Blessed are the pure in heart, for they shall see God.

⁹"Blessed are the peacemakers, for they shall be called sons of God.

¹⁰"Blessed are those who are persecuted for righteousness' sake, for theirs is the kingdom of heaven.

¹¹"Blessed are you when men revile you and persecute you and utter all kinds of evil against you falsely on my account.

¹²Rejoice and be glad, for your reward is great in heaven, for so men persecuted the prophets who were before you.

¹³"You are the salt of the earth; but if salt has lost its taste,

how shall its saltness be restored? It is no longer good for anything except to be thrown out and trodden under foot by men.

¹⁴"You are the light of the world. A city set on a hill cannot be hid. ¹⁵Nor do men light a lamp and put it under a bushel, but on a stand, and it gives light to all in the house. ¹⁶Let your light so shine before men, that they may see your good works and give glory to your Father who is in heaven.

¹⁷"Think not that I have come to abolish the law and the prophets; I have come not to abolish them but to fulfill them. ¹⁸For truly, I say to you, till heaven and earth pass away, not an iota, not a dot, will pass from the law until all is accomplished. ¹⁹Whoever then relaxes one of the least of these commandments and teaches men so, shall be called least in the kingdom of heaven; but he who does them and teaches them shall be called great in the kingdom of heaven. ²⁰For I tell you, unless your righteousness exceeds that of the scribes and Pharisees, you will never enter the kingdom of heaven.

²¹"You have heard that it was said to the men of old, 'You shall not kill; and whoever kills shall be liable to judgment.' ²²But I say to you that every one who is angry with his brother shall be liable to judgment; whoever insults his brother shall be liable to the council, and whoever says, 'You fool!' shall be liable to the hell of fire.

²³So if you are offering your gift at the altar, and there remember that your brother has something against you,

Matthew 6 (see Reading 6.6 on page 200) communicates some essentials of Christian life and worship. First, there is a prohibition against praying for show—that is, for the approval of other people. Prayer should be sincere, and for that reason, it is well to pray in private. (In Chapter 16 we will meet Tartuffe, a character in a French comedy of the same name by Molière. Tartuffe calls for his servant to put away his hair shirt and his scourge—two means used to mortify the flesh. However, he does so loudly and in the view of others, revealing his hypocrisy.) Matthew 6 is also the origin of the familiar phrase "do not let your left hand know what your right hand is doing," whose meaning is often lost when it is used in the present day. Lines 9—13 contain "The Lord's Prayer."

The teachings of Jesus reflect a profound grasp of the piety and wisdom of the Jewish traditions, but the Gospels make a further claim for Jesus, depicting him as the **Christ** (a Greek translation of the Hebrew *messiah*, "anointed one")—the savior promised by the ancient biblical prophets who would bring about God's kingdom. His tragic death by crucifixion (a punishment so painful and degrading that it was reserved slaves, foreigners, vile criminals, and revolutionaries) would seem to have ended the public career of Jesus. The early Christian church, however, insisted that Jesus overcame death by rising from the tomb three days after his death. This belief in the resurrection became a centerpiece of Christian faith and preaching and the basis on which early Christianity proclaimed Jesus as the Christ.

The Spread of Christianity

The slow growth of the Christian movement was given an early boost by the conversion of a Jewish zealot, Saul of Tarsus, around the year 35 CE near Damascus, Syria. Paul (his postconversion name) won a crucial battle in the early Christian church, insisting that non-Jewish converts to the movement would not have to adhere to all Jewish religious customs, especially male circumcision. Paul's victory was to change Christianity from a religious movement within Judaism to a religious tradition that could embrace the non-Jewish world of the Roman Empire. One dramatic example of Paul's approach to this pagan world was a public sermon he gave in the city of Athens, in which he used the language of Greek culture to speak to the Athenians with the message of the Christian movement (see Acts 17:16—34).

Paul was a tireless missionary. He made at least three long journeys through the cities on the northern shore of the Mediterranean (and may once have gotten as far as Spain). On his final journey he reached Rome, where he met his death at the hands of a Roman executioner around the year 62 CE. In many of the cities he visited, he left small communities of believers. Some of his letters (to the Romans, Galatians, Corinthians, and so on) are addressed to believers in these places and provide details of his theological and pastoral concerns.

The following letter of Paul seen in Reading 6.7 (on page 201) addresses the meaning and power of love. "Seeing with a mirror dimly" may strike you as a familiar phrase.

[24]leave your gift there before the altar and go; first be reconciled to your brother, and then come and offer your gift. [25]Make friends quickly with your accuser, while you are going with him to court, lest your accuser hand you over to the judge, and the judge to the guard, and you be put in prison; [26]truly, I say to you, you will never get out till you have paid the last penny.

[27]"You have heard that it was said, 'You shall not commit adultery.' [28]But I say to you that every one who looks at a woman lustfully has already committed adultery with her in his heart. [29]If your right eye causes you to sin, pluck it out and throw it away; it is better that you lose one of your members than that your whole body be thrown into hell. [30]And if your right hand causes you to sin, cut it off and throw it away; it is better that you lose one of your members than that your whole body go into hell.

[31]"It was also said, 'Whoever divorces his wife, let him give her a certificate of divorce.' [32]But I say to you that every one who divorces his wife, except on the ground of unchastity, makes her an adulteress; and whoever marries a divorced woman commits adultery.

[33]"Again you have heard that it was said to the men of old, 'You shall not swear falsely, but shall perform to the Lord what you have sworn.' [34]But I say to you, Do not swear at all, either by heaven, for it is the throne of God, [35]or by the earth, for it is his footstool, or by Jerusalem, for it is the city of the great King. [36]And do not swear by your head, for you cannot make one hair white or black. [37]Let what you say be simply 'Yes' or 'No'; anything more than this comes from evil.

[38]"You have heard that it was said, 'An eye for an eye and a tooth for a tooth.' [39]But I say to you, Do not resist one who is evil. But if any one strikes you on the right cheek, turn to him the other also; [40]and if any one would sue you and take your coat, let him have your cloak as well; [41]and if any one forces you to go one mile, go with him two miles. [42]Give to him who begs from you, and do not refuse him who would borrow from you.

[43]"You have heard that it was said, 'You shall love your neighbor and hate your enemy.' [44]But I say to you, Love your enemies and pray for those who persecute you, [45]so that you may be sons of your Father who is in heaven; for he makes his sun rise on the evil and on the good, and sends rain on the just and on the unjust. [46]For if you love those who love you, what reward have you? Do not even the tax collectors do the same? [47]And if you salute only your brethren, what more are you doing than others? Do not even the Gentiles do the same? [48]You, therefore, must be perfect, as your heavenly Father is perfect."

From Genesis, Exodus, Job, Amos, Matthew, Acts, I Corinthians, and II Corinthians of Revised Standard Version Bible, copyright 1946, 1952, © 1972 by the Division of Christian Education of the National Council, Churches of Christ in the U.S.A.

READING 6.6 THE CHRISTIAN BIBLE, NEW TESTAMENT

Matthew 6:1–15

6

¹"Beware of practicing your piety before men in order to be seen by them; for then you will have no reward from your Father who is in heaven.

²"Thus, when you give alms, sound no trumpet before you, as the hypocrites do in the synagogues and in the streets, that they may be praised by men. Truly, I say to you, they have received their reward. ³But when you give alms, do not let your left hand know what your right hand is doing, ⁴so that your alms may be in secret; and your Father who sees in secret will reward you.

⁵"And when you pray, you must not be like the hypocrites; for they love to stand and pray in the synagogues and at the street corners, that they may be seen by men. Truly, I say to you, they have received their reward. ⁶But when you pray, go into your room and shut the door and pray to your Father who is in secret; and your Father who sees in secret will reward you.

⁷"And in praying do not heap up empty phrases as the Gentiles do; for they think that they will be heard for their many words. ⁸Do not be like them, for your Father knows what you need before you ask him. ⁹Pray then like this:

Our Father who art in heaven,
Hallowed be thy name.
¹⁰Thy kingdom come.
Thy will be done,
On earth as it is in heaven.
¹¹Give us this day our daily bread;
¹²And forgive us our debts,
As we also have forgiven our debtors;
¹³And lead us not into temptation,
But deliver us from evil.

¹⁴ For if you forgive men their trespasses, your heavenly Father also will forgive you; ¹⁵but if you do not forgive men their trespasses, neither will your Father forgive your trespasses.

From Genesis, Exodus, Job, Amos, Matthew, Acts, I Corinthians, and II Corinthians of Revised Standard Version Bible, copyright 1946, 1952, © 1972 by the Division of Christian Education of the National Council, Churches of Christ in the U.S.A.

EARLY MARTYRS By the end of the first century ce, communities of Christian believers existed in most of the cities of the vast Roman Empire (see **Map 6.2**, "Christian Communities"). Their numbers were sufficient that, in 64 CE, Emperor Nero could make Christians scapegoats for a fire that destroyed the city of Rome (probably set by the emperor's own agents). As we see in Reading 6.8, the Roman writer Tacitus provides a vivid description of the terrible torutres meted out to the Christians.

THE GROWTH OF CHRISTIANITY Why were the Christians successful in spreading their religion? Why did they become the object of persecution at the hands of the Romans?

Several social factors aided the growth of Christianity: There was peace in the Roman Empire; a good system of safe roads made travel easy; there was a common language in the empire (a form of common Greek called Koine, the language of the New Testament); and Christianity was first preached in a network of Jewish centers. Scholars have also offered some religious reasons: the growing interest of pagans in monotheism; the strong Christian emphasis on salvation and freedom from sin; the Christian custom of offering mutual aid and charity for its members; and its relative freedom from class distinctions. Paul wrote that in this faith there was "neither Jew nor Gentile; male nor female; slave nor free person."

This new religion met a good deal of resistance. The first martyrs died before the movement spread outside Jerusalem because of the resistance of the Jewish establishment. Very quickly, too, the Christians earned the enmity of the Romans. Even before Nero's persecution in 64 CE, the Christians had been expelled from the city of Rome by Emperor Claudius. From those early days until the third century, there were sporadic outbreaks of persecutions. In 250 CE, under Emperor Decius,

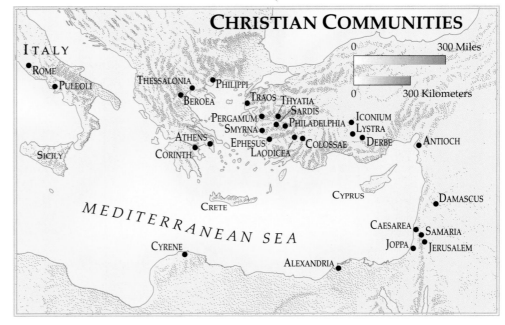

> **MAP 6.2** Christian Communities

READING 6.7 THE CHRISTIAN BIBLE, NEW TESTAMENT

1 Corinthians 13:1–13

13

[1]If I speak in the tongues of men and of angels, but have not love, I am a noisy gong or a clanging cymbal. [2]And if I have prophetic powers, and understand all mysteries and all knowledge, and if I have all faith, so as to remove mountains, but have not love, I am nothing. [3]If I give away all I have, and if I deliver my body to be burned, but have not love, I gain nothing.

[4]Love is patient and kind; love is not jealous or boastful; [5]it is not arrogant or rude. Love does not insist on its own way; it is not irritable or resentful; [6]it does not rejoice at the wrong, but rejoices in the right. [7]Love bears all things, believes all things, hopes all things, endures all things.

[8]Love never ends; as for prophecy, it will pass away; as for tongues, they will cease; as for knowledge, it will pass away. [9]For our knowledge is imperfect, and our prophecy is imperfect; [10]but when the perfect comes, the imperfect will pass away. [11]When I was a child, I spoke like a child, I thought like a child, I reasoned like a child; when I became a man, I gave up childish ways, [12]For now, we see with a mirror dimly, but then face to face. Now I know in part; then I shall understand fully, even as I have been fully understood. [13]So faith, hope, love abide, these three; but the greatest of these is love.

From Genesis, Exodus, Job, Amos, Matthew, Acts, I Corinthians, and II Corinthians of Revised Standard Version Bible, copyright 1946, 1952, © 1972 by the Division of Christian Education of the National Council, Churches of Christ in the U.S.A.

there was an empire-wide persecution, with two others coming in 257 (under Emperor Valerian) and in 303 (under Emperor Diocletian). Finally, in 312 CE, Emperor Constantine issued a decree in Milan allowing Christianity toleration as a religion.

What was the basis for this long history of persecution? The reasons are complex. Ordinarily, Rome had little interest in the religious beliefs of its subjects so long as these beliefs did not threaten public order. The Christian communities seemed secretive; they had their own network of communication in the empire; they kept away from active life in the political realm; most telling of all, they refused to pay homage to the state gods and goddesses. A common charge made against them was that they were atheists: they denied the existence of the Roman gods. Romans conceived of their society as bound together in a web of *pietas*, a virtue that meant a combination of duty and devotion to others. The Romans felt that one should express pietas to the parents of a family, the family should express that pietas toward the state, and the state in turn owed pietas to the gods. That brought everything into harmony, and the state would flourish. The Christian refusal to express pietas to the gods seemed to the Romans to strike at the heart of civic order. The Christians, in short, were traitors to the state.

APOLOGISTS Christian writers of the second century tried to answer these charges by insisting that the Christians wished to be good citizens and in fact could be. These writers (called apologists) wrote about the moral code of Christianity, about their beliefs and the reasons they could not worship the Roman deities. Their radical monotheism, inherited from Judaism, forbade such worship. Furthermore, they protested their roles as ready scapegoats for every ill—real or imagined—in society. The acid-tongued North African Christian writer Tertullian (ca. 155/160–225 CE) provided a sharp statement concerning the Christian grievance about such treatment: "If the Tiber floods its banks or the Nile doesn't flood; if the heavens stand still or the earth shakes, if there is hunger or drought, quickly the cry goes up, 'Christians to the lions!'"

One of the most important of the early Christian apologists was Justin Martyr. Born around 100 CE in Palestine, he converted to Christianity and taught, first at Ephesus and later in Rome. While in Rome he wrote two lengthy apologies to the emperors asking for toleration and attempting at the same time to explain the Christian religion. These early writings are extremely important because they provide a window onto early Christian life and Christian attitudes toward both

READING 6.8 TACITUS

From *Annals 15*

Nero charged, and viciously punished, people called Christians who were despised on account of their wicked practices. The founder of the sect, Christus, was executed by the procurator Pontius Pilate during the reign of Tiberius. The evil superstition was suppressed for a time but soon broke out afresh not only in Judea where it started but also in Rome where every filthy outrage arrives and prospers. First, those who confessed were seized and then, on their witness, a huge number was convicted, less for arson than for their hatred of the human race.

In their death they were mocked. Some were sewn in animal skins and worried to death by dogs; others were crucified or burned so that, when daylight was over, they could serve as torches in the evening. Nero provided his own gardens for this show and made it into a circus. He mingled with the crowd dressed as a charioteer or posed in his chariot. As a result, the sufferers guilty and worthy of punishment although they were, did arouse the pity of the mob who saw their suffering resulted from the viciousness of one man and not because of some need for the common good.

Vibia Perpetua

Following are excerpts from the narrative of Vibia Perpetua, who was martyred in Carthage in 203 CE, when she was twenty-two years old. She refused to deny that she was a Christian and was condemned to death by beasts. The last line of her narrative, written the day before her death, says simply, "If anyone wishes to write of my outcome, let him do so."

⁶Another day, while we were dining at noonday, we were summoned away to a hearing at the forum. At once, rumors swept the neighborhoods and a huge crowd assembled. We mounted the tribune. The others, when questioned, confessed. Then it was my turn. My father arrived with my infant son and pulled me down saying, "Sacrifice! Have mercy on your child!" The governor Hilarianus; . . ."You are a Christian?" And I answered, "I am a Christian." . . . Then the governor read out the sentence: condemned to the beasts of the arena. Cheerfully, we returned to prison. Since my child was an infant and accustomed to breastfeeding in prison, I sent the deacon Pomponius to my father imploring that my child be returned to me. But . . . somehow, through the will of God, the child no longer required the breast nor did my breasts become sore. I was neither tortured with grief over the child nor with pain in my breasts.

. . .

¹⁰The day before we fought I saw in a vision that Pomponius the deacon had come hither to the door of the prison, and knocked hard upon it. And I went out to him and . . . he said to me: Perpetua, we await you; come. And he took my hand, and we began to go through rugged and winding places. At last with much breathing hard we came to the amphitheatre, and he led me into the midst of the arena. And he said to me: Be not afraid; I am here with you and labour together with you. And he went away. And . . . there came out against me a certain ill-favored Egyptian with his helpers, to fight with me. . . . And there came forth a man of very great stature, . . . And he besought silence and said: The Egyptian, if he shall conquer this woman, shall slay her with the sword; and if she shall conquer him, she shall receive this branch. And he went away. And we came nigh to each other, and began to buffet one another. He tried to trip up my feet, but I with my heels smote upon his face. And I rose up into the air and began so to smite him as though I trod not the earth. . . . I joined my hands . . . and I caught his head, and he fell upon his face; and I trod upon his head. And the people began to shout, . . . And I went up to the master of gladiators and received the branch. And he kissed me and said to me: Daughter, peace be with you. And I began to go with glory to the gate called the Gate of Life. And I awoke; and I understood that I should fight, not with beasts but against the devil; but I knew that mine was the victory. Thus far I have written this, till the day before the games; but the deed of the games themselves let him write who will.

The Passion of Perpetua and Felicity. Translated by W. H. Shewring. London: Sheed and Ward, 1931.

Roman and Jewish culture. Justin's writings did not, however, receive the audience for which he had hoped. In 165 CE he was scourged and beheaded in Rome under the anti-Christian laws.

EARLY CHRISTIAN ART

Very little Christian art or architecture dates from before the fourth century because before the Edict of Milan and the declaration of tolerance for Christianity, followers were forbidden to establish places for worship. They did so clandestinely. We do have art from cemeteries and some cities that were maintained by Christian communities. These cemeteries, which were outside the Roman limits, consisted of an extensive network of galleries and burial chambers for thousands of Christians. They are called **catacombs**, from the word *catacumbas*, which means "in the hollows." Contrary to romantic notions, these underground galleries, hollowed out or hewn from the soft rock known as *tufa*, were never hiding places for Christians during the times of persecution; neither were they secret places for worship. Also contrary to popular belief, only a small number

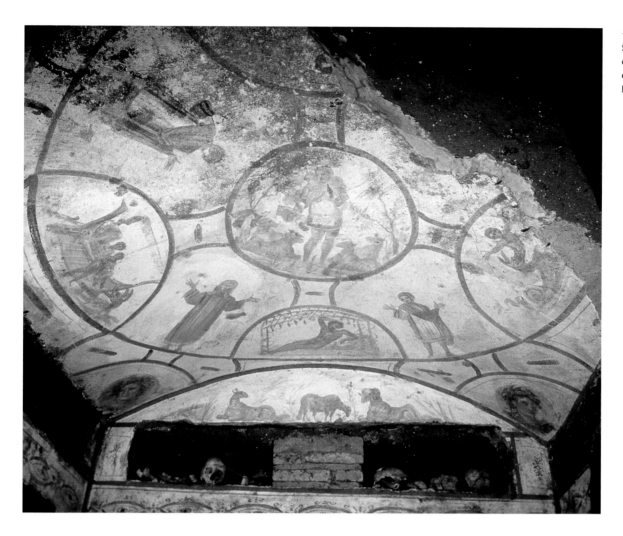

of tombs contained the remains of martyrs of the Christian faith. None do today, in fact, because martyrs were reburied inside the walls of the city of Rome in the early Middle Ages.

These underground cemeteries are important, however, because they provide us with some visual evidence of early Christian beliefs and customs.

Frescoes

A number of **frescoes** (wall paintings on wet plaster) have survived in the catacombs, one of the most accomplished of which was found in the Catacomb of Saints Pietro and Marcellino (**Fig. 6.7**). Jesus stands within a perfect circle, represented as a young shepherd who carries one of his rescued sheep over his shoulders. Four arms in the shape of a cross extend outward from the circle, culminating in semicircular frames depicting scenes from the biblical story of Jonah

and the whale. The meaning and style of the fresco illustrate a convergence of three traditions: Christian, Jewish, and Roman. The reference to Christ as a shepherd is traced to his own words, according to the Gospel of John:

> I am the good shepherd; I know my sheep and my sheep know me—just as the Father knows me and I know the Father—and I lay down my life for the sheep. I have other sheep that are not of this sheep pen. I must bring them also. They too will listen to my voice, and there shall be one flock and one shepherd." (John 10:11–18)

For Christians, the image of the shepherd and his flock symbolized Jesus and his followers, his loyalty and sacrifice. The symbolism of Jonah provided an important connection between the Christian (New Testament) and the Hebrew

(Old Testament) Bibles scriptures: early Christians saw the miracle of Jonah's deliverance after three days from the belly of the monster that swallowed him as a prefiguration of Christ's resurrection three days after his crucifixion. And though the image of the good shepherd proved to be one of the most enduring in Christian iconography, it likely did not originate among Jesus's followers. It may be possible

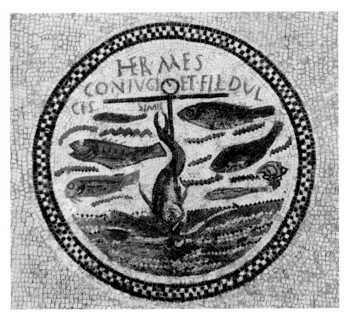

∧ 6.8 Anchor with entwined fish, 4th century CE. Mosaic from the Catacombs of Hermes, Sousse, Tunisia. A symbol of Jesus and his followers, the anchor motif was a hidden reference to the cross, which was rarely depicted before the 4th century.

to draw a connection between sacrificial animals in Greek ritual and biblical references to a Lamb of God (the Messiah) who would be sacrificed to save humanity. In addition, the style of the figures in the Good Shepherd fresco is more generally reminiscent of those found in vase and wall paintings from Greece and Rome. The poses and proportions are realistic and the drapery falls over the body in natural folds. Early Christians shared the art and culture of Rome, even if not its religion. There were bound to be similarities in style.

Other subjects reflect the Christian hope of salvation and eternal life. Jesus's raising of Lazarus from the dead, for example, alluded to the belief that all of the dead would be raised at the end of time. Another common theme was Jesus's communion meal during the Last Supper; it anticipated the heavenly banquet that awaited all believers in the next life. These frescoes herald the beginnings of artistic themes and images that would continue down through the centuries of Christian art.

Tombs in the catacombs were covered by slabs of marble cemented in place and inscribed with the name and death date of the deceased. Frequently, the slabs also featured symbols that alluded to Jesus Christ, his followers, or the promise of faith. Among them are the anchor (hope) and the dove with an olive branch (peace). One of them most common symbols was a fish (**Fig. 6.8**); the letters that spell the Greek word for "fish" were considered an anagram for the phrase "Jesus Christ, Son of God and Savior." The fish symbol became a stenographic way of confessing faith. Another enduring symbol of Christ is the overlapping Greek letters, *chi* and *rho*—the first two letters of the Greek word *christos* (**Fig. 6.9**).

Sculpture

Sculpture with Christian imagery was particularly rare, and despite their connection to Roman culture, Christians did not populate their houses of worship with an equivalent of a cult statue. The few examples that do exist pick up on Graeco-Roman modes of representation, as in the statue of Christ as the Good Shepherd (**Fig. 6.10**).

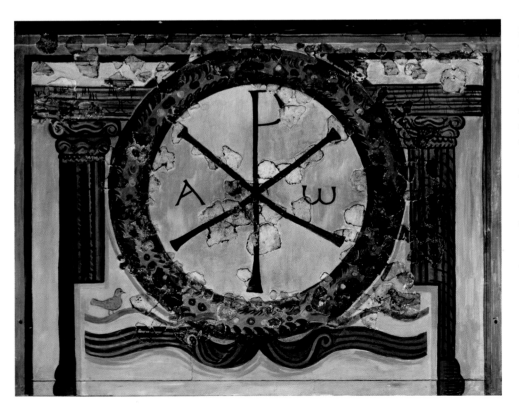

◁ 6.9 Chi-rho monogram, 4th century ce. From a Roman villa, Lullingstone, Kent, England. Detail of wall painting, 35½" (90 cm), diameter of inner circle. The British Museum, London, United Kingdom. The area bears a monogram formed by the Greek letters chi and rho, the first two letters of christos, together with the Greek letters alpha and omega, the first and last letters of the Greek alphabet, another symbol of Jesus drawn from the New Testament book of Revelation.

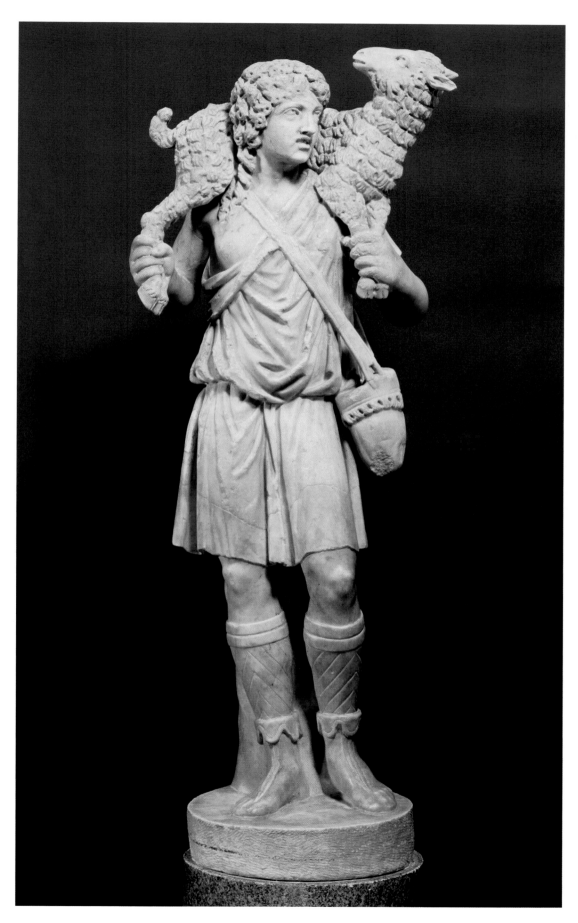

◄ **6.10** **The Good Shepherd, ca. 300 CE. Marble, 39″ (99 cm) high. Museo Pio Cristiano, Vatican Museums, Vatican City State, Italy.** This depiction of Christ, borrowed from Graeco-Roman models, is common in early Christian art, although sculptural examples are rather rare.

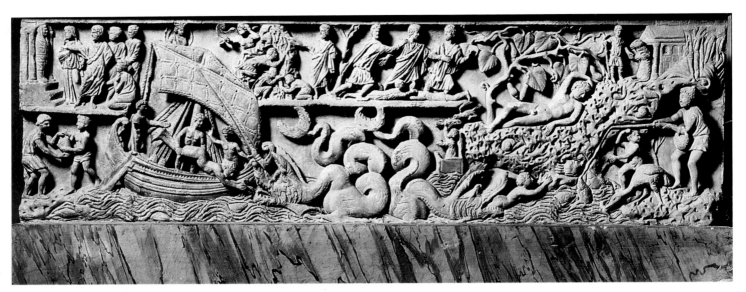

▲ **6.11 Jonah Sarcophagus, 4th century CE. Limestone. Museo Lateranense, Vatican Museums, Vatican City State, Italy.** In addition to the Jonah cycle, there are other biblical scenes: at the top left, the raising of Lazarus; to the right of the sail at top, Moses striking the rock; at the top far right, a shepherd with a sheep.

The artist depicts Jesus as a beardless young man in a contrapposto stance, with his weight shifting from one leg to the other as he balances the sheep over his shoulders. His drilled, curly hair and slightly parted lips are distinctly Classical, as is the subtle draping of his tunic.

Wealthy Christians also commissioned carved sarcophagi, and imagery found in the reliefs is consonant with the themes depicted in painting. The Jonah Sarcophagus includes scenes from the biblical story of Jonah and the whale as well as the raising of Lazarus in the upper left corner and, in the upper right, a shepherd with a sheep (**Fig. 6.11**). As in the fresco from the Catacomb of Saints Pietro and Marcellino, the artist creates a harmonious blend of Old and New Testament scenes, emphasizing the common denominator of an afterlife.

EARLY CHRISTIAN ARCHITECTURE

Two of the most famous Christian churches are associated with the reign of Emperor Constantine (306–337 CE): Old Saint Peter's Basilica and the Church of the Holy Sepulcher. Old Saint Peter's was erected on the site where it was believed that Saint Peter was buried, and it was dedicated by Constantine in 326 CE. (The present Saint Peter's in Vatican City in Rome rests on the remains of the old **basilica**.) We do not have a fully articulated plan of that church, but its main outlines are clear—the plan looks to the past and to the future. The scale of the building, including many of its parts, reflects those of Roman basilicas. Both have wide, long, central **naves** flanked by two narrower side aisles, framing the main congregational space. Unlike many Roman basilicas, however, Old

Saint Peter's (see **Fig. 6.12**) was entered from one of the short sides, rather than the long sides of the rectangular plan. The faithful would enter through a kind of gateway into an **atrium** (an open courtyard surrounded by an arcade), cross the open space, and then pass through a vestibule called the **narthex** into the wide nave and the church proper. On the opposite end of the 300-foot-long structure was the **transept**, an aisle that crossed over and was perpendicular to the nave and side aisles and that separated the congregational space from the altar. The transept often extended beyond the boundaries of the side aisles, so that it resembled the arms of a cross. The altar, the focus of ritual and ceremony, was placed in a semicircular space called the **apse**, another holdover from Roman basilicas. This plan is called a **Latin Cross plan** or, because of the length of the nave and the orientation of the plan along a single dominant axis, a **longitudinal plan**. The roof of the structure was pitched, with wooden trusses, and supported by the outer walls and the columned interiors.

The walls that flanked the nave consisted, on the lowest level, of a colonnade and, in the upper reaches, just below the ceiling, a series of small arched windows called a **clerestory**; these windows provided most of the interior illumination. This basilican plan became a model from which many of the features of later church architecture evolved.

Old Saint Peter's was decorated lavishly with inlaid marble and mosaics, none of which survive. In fact, no early Christian churches except for one escaped destruction by fire, in large part because their roofs were constructed of wood. The art of mosaic, much of it Classical in style, was adopted from the Romans and comprised most of the ornamentation in early Christian churches.

Constantine also ordered the construction of the Church of the Holy Sepulcher within the walls of the city of Jerusalem (**Fig. 6.13**), on the site of a demolished temple to Venus.

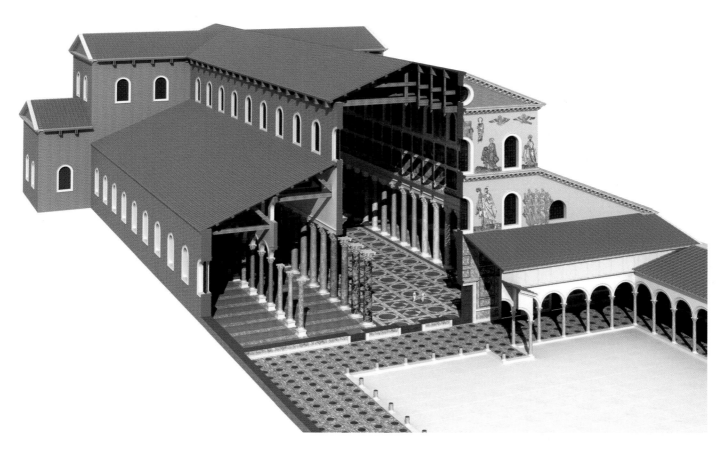

▲▼ **6.12 Old Saint Peter's Basilica, begun ca. 319 CE. Rome, Italy. 835' (254.5 m) long (grand axis)
× 295' (90 m) wide (transept).** Restored cutaway view (top) and plan (bottom). (1) Nave, (2) aisle,
(3) apse, (4) transept, (5) narthex, (6) atrium. This kind of basilica floor plan would be common in the
West until the rise of the Romanesque period. Artwork by John Burge.

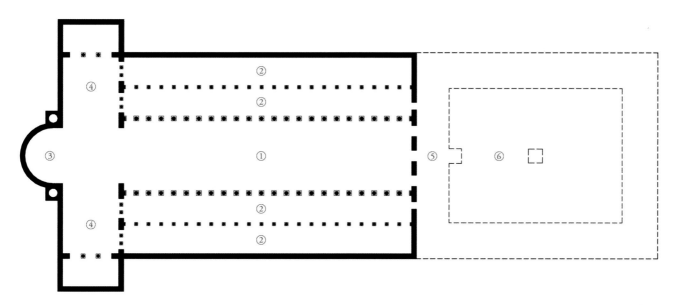

The plan included two connected churches that contained important Christian sites: Calvary, (also known as Golgotha) the place where Jesus was crucified, and a rock-cut tomb believed to be the one into which Jesus's body was placed and from which he was resurrected after three days. Even though the structure today is not from Constantine's era (it was destroyed, rebuilt, and expanded and embellished), one can still see the parts of the church that owe their design to Roman architectural models: a basilican plan is combined with a domed space that recalls the Pantheon in Rome.

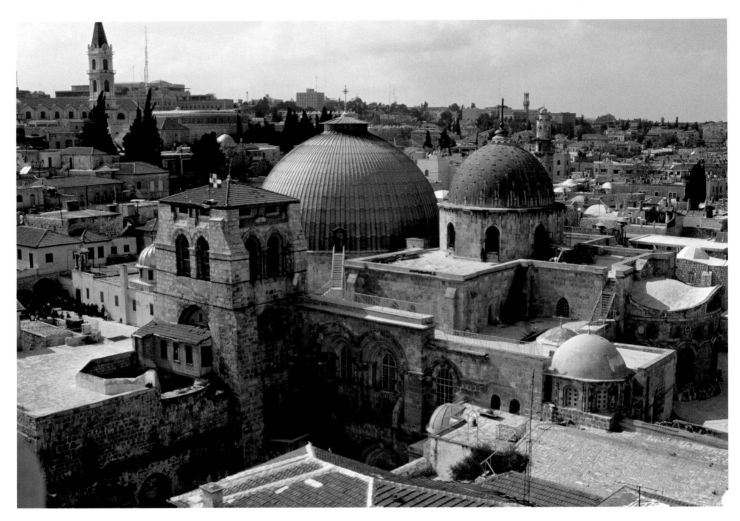

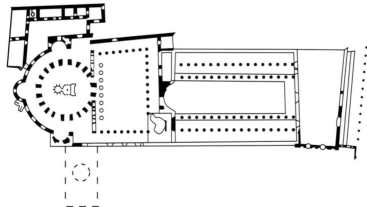

◀⌃ **6.13 Church of the Holy Sepulcher, ca. 345** CE. **Jerusalem, Israel.** (a) Floor plan of the original church built by the emperor Constantine and his mother, Saint Helena (b) Today the church is nestled in among other buildings in the Old City of Jerusalem. It was erected on the site of the hill of Calvary (also known as Golgotha), where Christians believe that Jesus was crucified. It also contains Jesus's tomb, in which He was buried until His resurrection. The church has been damaged and restored several times, with the current main dome (center) dating to 1870.

EARLY CHRISTIAN MUSIC

If the visual arts of early Christianity turned to Graeco-Roman models for inspiration, the music of the early church drew on Jewish sources. The tradition of singing (or, rather, chanting) sacred texts at religious services was an ancient Jewish custom that appears to go back to Mesopotamian sources. What little we know of Jewish music, in fact, suggests that it was influenced strongly by the various peoples

with whom the Jews came into contact. The lyre used by Jewish musicians was a common Mesopotamian instrument, whereas the harp for which King David was famous came to the Jews from Assyria by way of Egypt (**Fig. 6.14**).

By early Christian times, Jewish religious services consisted of a standardized series of prayers and scriptural readings organized to create a cycle that fit the Jewish calendar. Many of these readings were taken over by early Christian congregations, particularly those where the number of converted Jews was high. In chanting the psalms, the style of execution often depended on how well they were known by the congregation. Where the Jewish component of the congregation was strong, the congregation would join in the chant. Increasingly,

however, the singing was left to trained choruses, with the other congregants joining in only for the standard response of "amen" or "alleluia." As the music fell more into the hands of professionals, it became increasingly complex.

This professionalization proved unpopular with church authorities, who feared that the choirs were concerned more with performance than with worship. In 361 CE a provincial council of the Christian church in Laodicea ordered that there should be only one paid performer (**cantor**) for each congregation. In Rome the authorities discouraged poetic elaboration on the liturgical texts, a practice common among the Jews and the Christians of the East.

Part of the early Christian suspicion of music, in the West at least, was a reaction against the Greek doctrine of ethos in music, which claimed that music could have a profound effect on human behavior. That music might induce moods of passion or violence or might even be an agreeable sensation in itself was not likely to appeal to a church that required the ethos of its music to express religious truth alone. For this reason instrumental music was rejected as unsuitable for the Christian liturgy. Such instrumentation was, in the minds of many Christians, too reminiscent of pagan customs.

By the fourth century, then, the standard form of music in Christian churches was either **responsorial singing**, with a cantor intoning lines from the Psalms and the congregation responding with a simple repeated refrain, or **antiphonal singing**, with parts of the congregation (or the cantor and the congregation) alternating verses of a psalm in a simple chant tone. By the beginning of the fifth century, there is evidence of nonscriptural hymns being composed. Apart from some rare fragments, we have no illustration of music texts with notation before the ninth century.

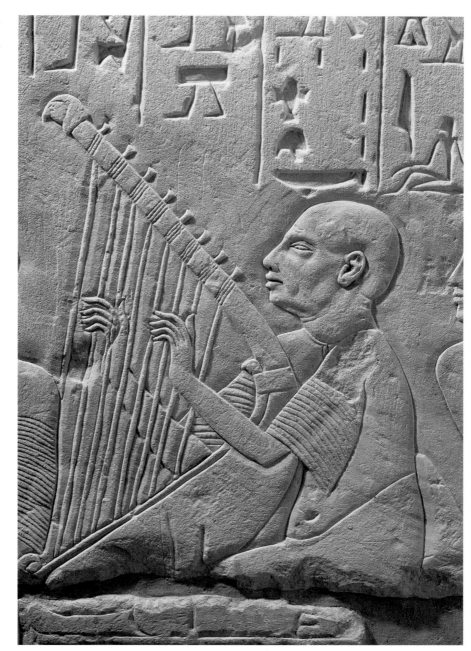

▲ **6.14** **The Blind Harper, ca. 1340–1330 BCE. From the tomb of Paatenemmheb, Saqqâra, Egypt. Limestone basalt relief, detail, 11½″ (29 cm) high. Rijksmuseum van Oudheden, Leiden, The Netherlands.** It is quite possible that the stringed instrument depicted here is similar to those mentioned in the book of Psalms. The word *psalm* derives from a Greek word meaning "to pluck a lyre."

GLOSSARY

Apse (p. 208) A semicircular or polygonal projection of a building with a semicircular dome, especially on the east end of a church.

Antiphonal singing (p. 211) A form of religious singing in which segments of a congregation chant alternating verses of a psalm.

Atrium (p. 208) A courtyard, especially as surrounded by a colonnaded arcade.

Basilica (p. 208) A large oblong building or hall with colonnades and an apse; used for public functions, such as a court of law, or as a church.

Canon (p. 193) A code of law, an honored list, or an ecclesiastical regulation enacted by a religious council; as in a canon of "great works of literature" or a canon of writings that belong in a bible.

Cantor (p. 211) Singer, especially a person who takes a special role in singing or leading songs at a ceremony or at synagogue and church services.

Catacomb (p. 204) An underground cemetery consisting of tunnels or chambers that have recesses for coffins and tombs.

Christ (p. 201) The Messiah, or savior, as prophesied in the Hebrew Bible; Jesus of Nazareth, held by Christians to be the fulfillment of the prophecy.

Clerestory (p. 208) High windows permitting light to enter a building, but not enabling people to look in or out.

Covenant (p. 195) Agreement; referring to the "special relationship" between God and the Israelites.

Decalogue (p. 196) Another term for the Ten Commandments, as set forth in the book of Exodus.

Exodus (p. 192) Going out.

Fresco (p. 205) A type of painting in which pigments are applied to a fresh, wet plaster surface or wall and thereby become part of the surface or wall (from Italian for "fresh").

Gospel (p. 199) The teachings of Jesus and the apostles, especially as described in the first four books of the New Testament; also conceived as "good news" in the redemption has become possible.

Henotheism (p. 194) The belief that there are many gods, but only one is chosen for worship.

Holocaust (p. 197) Mass slaughter or destruction, as by fire or nuclear war; the name given to the Nazi slaughter of Jews during World War II.

Latin cross plan (p. 208) A cross-shaped church design in which the nave is longer than the transept.

Longitudinal plan (p. 208) A church design in which the nave is longer than the transept and in which parts are symmetrical against an axis.

Messiah (p. 196) Savior; from the Hebrew for "anointed one."

Monotheism (p. 194) The belief in one god.

Narthex (p. 208) A vestibule leading from an atrium into a church.

Nave (p. 208) The central part of a church, constructed for the congregation at large; usually flanked by aisles with less height and width.

Patriarch (p. 192) The male head of a family or a tribe.

Polytheism (p. 194) Belief in many gods.

Prophet (p. 193) A person who speaks with the authority of God, either to predict the future or to call people to observance.

Psalm (p. 194) A song, hymn, or prayer from the book of Psalms; used in Jewish and Christian worship.

Responsorial singing (p. 211) A form of religious singing in which a cantor intones lines from psalms and the congregation responds with a simple refrain.

Septuagint (p. 193) An ancient Greek version of the Hebrew scriptures that was originally made for Greek-speaking Jews in Egypt.

Testament (p. 195) Originally, a covenant between God and humans; now referring more often to either of the two main divisions of the Bible: the Hebrew Bible (Old Testament) and the Christian Bible (New Testament).

Torah (p. 193) A Hebrew word meaning "teaching" or "law" and used to refer to the first five books of the Hebrew Bible; also known as the *Pentateuch*.

Transept (p. 208) The crossing part of a church built in the shape of a cross.

THE BIG PICTURE THE RISE OF THE BIBLICAL TRADITION

Language and Literature

- The first five books of the Hebrew scriptures (the Torah) are put into writing ca. 600–400 BCE.
- The book of Psalms was written ca. 950 BCE.
- The books of Kings, Isaiah, Jeremiah, Ezekiel, Amos, and Job are set down in writing ca. the 10th–5th centuries BCE.
- "The Sermon on the Mount" is set down in the Gospel of Saint Matthew ca. 70 CE.
- Justin Martyr writes *Apology* ca. 150 CE.
- Vibia Perpetua sets down her narrative of martyrdom ca. 203 CE.

Art, Architecture, and Music

- Depiction of divinity is prohibited in the Jewish religion ca. 1000 BCE.
- The Temple of Solomon is built ca. 961–922 BCE.
- Musical instruments—drums, reed instruments, lyres, harps, and horns—often accompanied psalms.
- Solomon's Temple is destroyed by the Babylonians in 587 BCE.
- Herod begins rebuilding the Temple of Solomon in 19 CE; it is destroyed by Titus under Emperor Vespasian in 70 CE.
- Frescoes embellish Christian catacombs ca. 250 CE.
- A Jewish synagogue and art are made at Dura-Europus in the 3rd century CE.
- Christian sculpture appears ca. 300 CE.
- Inscriptions, particularly chi-rho, decorate Christian tombs in the 4th century CE.
- Old Saint Peter's Basilica is built in Rome ca. 333 CE.
- The Church of the Holy Sepulcher is built in Jerusalem ca. 326–345 CE.

Philosophy and Religion

- The age of the Hebrew patriarchs—Abraham, Isaac, and Jacob—lasted from 1800 BCE to 1600 BCE.
- Jesus is born ca. 6 BCE.
- The death of Jesus occurs ca. 30 CE.
- The age of persecution of Christians begins in 64 CE and ends with the Edict of Milan, which grant Christians freedom of religion, in 313 CE.
- Christianity is made the state religion of the Roman Empire in 381 CE.

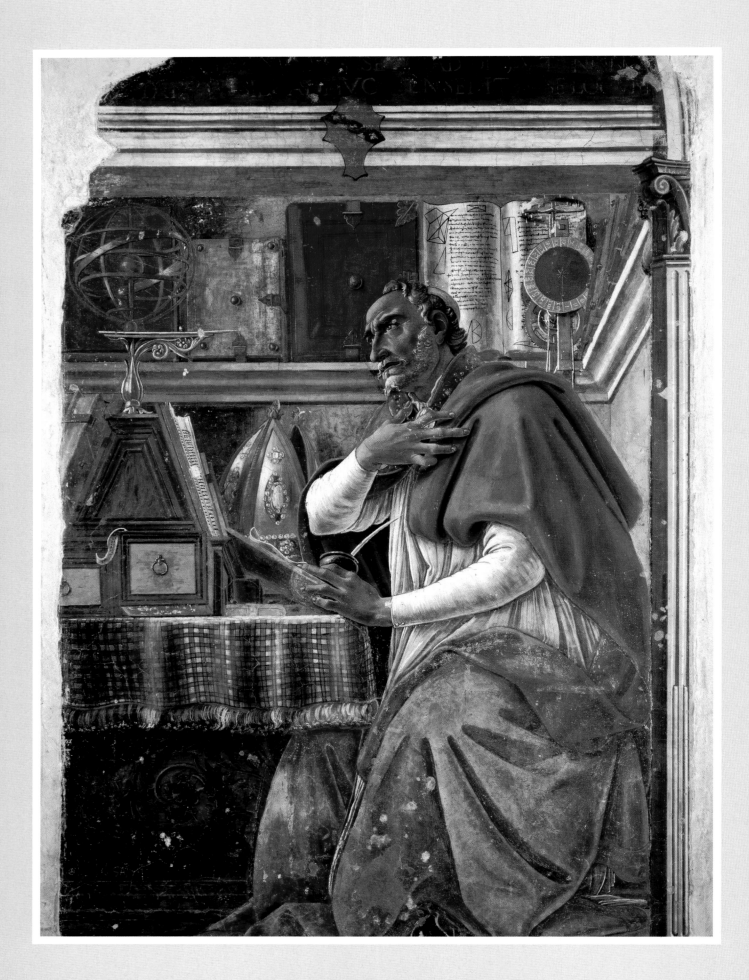

Early Christianity: Ravenna and Byzantium

PREVIEW

In 1480, Sandro Botticelli painted an image of Saint Augustine for the Church of Ognissanti in Florence, Italy (Fig. 7.1). The saint sits at a cloth-draped desk surrounded by books and objects that create the effect of a scholar's cluttered study. Pen, ink, and writing tablet in hand, he pauses to look up from his work. He draws his right hand to his heart; his brow is furrowed and his eyes look misty.

This is Augustine of Hippo—philosopher, rhetorician, theologian, bishop, canonized saint, and doctor of the Roman Catholic Church, called the "first medieval man and the last classical man." His influential writings bridge the Graeco-Roman philosophical traditions with Judeo-Christian beliefs and scripture. A towering figure of medieval philosophy, Augustine filled his writings with reflections on the absolute majesty of God, the immutability of God's will, and the flawed state of the human condition. They also include reflections on pagan wisdom and Neo-Platonist philosophy.

Saint Augustine lived during the era of the Byzantine Empire. He was born and died in North Africa but spent a few transformational years in Rome and Milan. His father was pagan and his mother Christian, and Augustine himself did not convert to Christianity until he was 33 years old. In his *Confessions*, viewed as the first self-reflective writing in the West, Augustine documented his journey toward his newfound faith, as well as the extreme spiritual conflict it generated within him. Is it this personal struggle that is the subject of Botticelli's painting? Art historian Richard Stapleford believes it is.[1]

One of the challenges in the discipline of art history concerns the decipherment of symbols and narratives that have been lost or confused over time. Numerous artists had portrayed the subject of Augustine in his study by the time Botticelli came to the task, and he most certainly would have been aware of the precedents. The long-standing interpretation of Botticelli's painting, based on comments by the Renaissance writer Giorgio Vasari, viewed it as a paradigmatic image of "profound meditation and subtle perception characteristic of men of wisdom who ponder continuously on difficult and elevated matters." As such, Botticelli's painting was read *not* as the portrayal of a specific event in the saint's life, but rather as a work that reflected the big ideas of the artist's era—the revival of classical philosophy, its emphasis on intellectualism, and the reconciliation of pagan philosophy, humanism, and Christianity. Yet Stapleford argues that the imagery within the painting is connected to passages from the *Confessions* in which Augustine describes the torment he experiences as he comes to the point of conversion: "I now found myself driven by the tumult in my breast to take refuge in this garden, where no one could interrupt that

◄ **7.1** Sandro Botticelli, *Saint Augustine in His Study*, ca. 1480. Fresco, 59³⁄₄" × 44" (152 × 112 cm). Church of Ognissanti, Florence, Italy.

1. Richard Stapleford, "Intellect and Intuition in Botticelli's Saint Augustine," *Art Bulletin* 76, no. 1 (March 1994): 69–80.

fierce struggle in which I was my own contestant, until it came to its conclusion. . . . I was beside myself with madness that would bring me sanity. I was dying a death that would bring me life. I knew that evil that was in me, but the good that was soon to be born in me I did not know." Augustine ends this profound passage with the statement that, after he came to this realization, he went out into a garden.

Botticelli's Saint Augustine is surrounded by the trappings of a scholarly man—richly bound texts, a clock, an armillary sphere that is used to plot the movements of the sun, moon, and planets. On a shelf are three volumes: the blue one has been identified as a sacred book, the red one in the middle a book of poetry, and the open one above the saint's shoulder a mathematics text whose pages are filled with writing. Could the text offer a clue to the meaning of the painting? Most of it, Stapleford notes, is illegible— the sort of fill-in pseudoscript often seen in works of art. However, three lines of actual words, in Italian, appear on the painted page: "Dove sant agostino a d[eus] a sp[er]ato e dov'e andato a fuor dela porta al prato" ("Where Saint Augustine put his trust in God, and where he went outside to the meadow"). Botticelli's narrative is inspired by that very moment, described in *Confessions*, when Augustine turned to God. Stapleford poignantly concludes that the artist "has presented us with the spiritual pain of a person of reason, a man of thought and feeling, faced with apparently irreconcilable choices. Augustine is Botticelli's Everyman."

THE TRANSFORMATION OF ROME

By the early fourth century, the Roman Empire already had severe economic, political, and social problems. In 330,

Emperor Constantine dedicated a Greek trading town on the Bosporus as his eastern capital, changing its name from Byzantium to Constantinople. It was to be a new Rome.

Constantinople had some obvious advantages for a major city: It straddled the most prominent land route between Asia and Europe. It had a deepwater port with natural shelter. It guarded the passage between the Mediterranean and the Black Sea. The surrounding countryside was rich in forests and water. The neighboring areas of Europe (Thrace) and Asia (Bithynia) were rich agricultural areas that could supply the city's food needs.

Because of the tumultuous conditions, the emperors spent less time in Rome. At the beginning of the fifth century (in 402), Emperor Honorius moved the capital of the Western Roman Empire to the northern Italian city of Ravenna, on the Adriatic coast. Seventy-four years later, in 476, the last Roman emperor in the West would abdicate the throne. Goths would occupy Ravenna only to be defeated in turn by the imperial forces from Constantinople in 540 (see **Map 7.1**).

While Rome declined in the waning decades of the fourth and fifth centuries, Christianity flourished. It continued to grow and expand in influence, and would eventually become the religion of those who destroyed the empire in the West. During that period, in far different places, two writers would live who saw the decline of the West: Augustine in Roman North Africa and Boethius in the city of Ravenna. Their writings were to have an enormous impact on the culture of Europe.

The Council of Nicaea

He sat on a chair of gold "like some heavenly angel of God, his bright mantle shedding luster like beams of light, shining

The Flowering of Christianity

64 CE	313 CE	395 CE	565 CE	1453 CE
EARLY CHRISTIAN ERA			**BYZANTINE ERA**	
Period of Persecution	**Period of Recognition**	**Growth of Empire**	**Decline and Fall**	
Christians are persecuted under the Roman emperor Decius The Roman Empire is divided into Eastern and Western Empires, and the capital of the West is moved from Rome to Milan Reign of Constantine, the first Christian emperor 307–327	Edict of Milan grants Christians freedom of worship Constantine founds city of Constantinople Council of Nicaea in 325 upholds the doctrine of the Holy Trinity Ostrogoths accept Christianity Capital of the Western Empire is moved from Milan to Ravenna in 402	Visigoths sack Rome in 410 Vandals sack Rome in 455 The last Western Roman emperor abdicates in 476; the Ostrogoths take over rule in Italy Justinian reigns as Eastern Roman emperor 527–565 Ravenna comes under the rule of Justinian in 540	Muhammad born in Mecca in 570 Pope Leo III bans representations of the divine; era of iconoclasm 726–843 Russians accept Christianity Constantinople falls to the Ottoman Turks in 1453, bringing an end to the Byzantine Empire	

with the fiery radiance of a purple robe, and decorated with the dazzling brilliance of gold and precious stones." Those who were called before him were "stunned and amazed at the sight—like children who have seen a frightening apparition."[2]

So did the emperor Constantine—the first Christian emperor of Rome—preside over the bishops at the Council of Nicaea, which was held in modern-day Turkey in the year 325 CE. Only a year earlier, as Augustus of the Eastern Roman Empire, he had seized control of the entire Roman Empire from Licinius, who was forced to cede the Western states. It was a scant dozen years since he and Licinius had inscribed the Edict of Milan, which sought to end religious clashes and the persecution of Christians within the empire by proclaiming tolerance throughout: "No one whatsoever should be denied freedom to devote himself either to the cult of the Christians or to such religion as he deems best suited for himself." As emperor, Constantine demanded order, yet now he found conflict, often bloody, between Christian groups who held disparate beliefs. According to a participant at the council, the bishop Eusebius, "The bishop of one city was attacking the bishop of another. . . . [Populations] were rising up against each other, . . . so that desperate men, out of

their minds, were committing sacrilegious acts, even daring to insult the images of the emperors."[3]

Constantine was in no mood to brook dissension in his empire or minor squabbling among his guests. They had been embroiled in the so-called **Arian controversy**, which concerned the true nature of Jesus, for years. Orthodox Christians—including a Greek named Alexander, the bishop of Alexandria—believed that Jesus the Son was divine and fully a part of the Godhead, equal and unified with God the Father and the Holy Spirit. Arius, another Greek and an elder in Alexandria, held another view. He and others argued that Jesus, as the created Son, was distinct from God the Father, who was eternal. The Arians could point to the Gospels in arguing their cause. In Mark 10:18 Jesus says, "Why do you call me good? No one is good but God alone." Matthew 26:39 records Jesus's agony at Gethsemane: "My father, if possible, let this cup pass me by. Nevertheless, let it be as you, not I, would have it." Arians viewed Jesus as being sent to earth

2. Eusebius, *Life of Constantine*, ed. and trans. Averill Cameron and Stuart Hall (Oxford: Oxford University Press, 1999), p. 125.

3. Quoted in Charles Freeman, *The Closing of the Western Mind* (New York: Knopf, 2003), p. 163.

▾ **MAP 7.1 The Byzantine World**

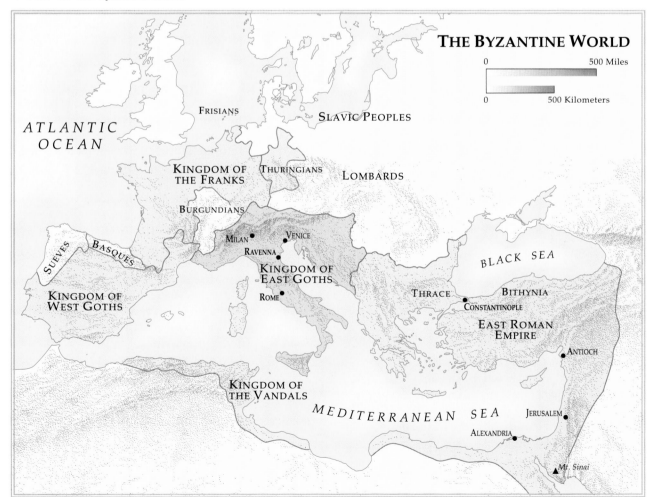

THE BYZANTINE WORLD

ATLANTIC OCEAN

FRISIANS
SLAVIC PEOPLES

KINGDOM OF THE FRANKS
THURINGIANS
LOMBARDS

BURGUNDIANS

SUEVES
BASQUES

MILAN
VENICE
RAVENNA
KINGDOM OF EAST GOTHS
ROME

BLACK SEA

KINGDOM OF WEST GOTHS

THRACE
BITHYNIA
CONSTANTINOPLE
EAST ROMAN EMPIRE
ANTIOCH

KINGDOM OF THE VANDALS
MEDITERRANEAN SEA
JERUSALEM
ALEXANDRIA
Mt. Sinai

not so much to save helpless humanity as to inspire ordinary women and men to develop their own godlike potential by imitating him.[4]

Constantine apparently had no patience for the Arian view. Perhaps he feared that construing Christ as human or even a divine being of some sort—but less than God the Father—might sow further seeds of disruption in the empire. Jesus, after all, had been crucified because Rome viewed him as a threat, a revolutionary. Jesus, moreover, had sung the praises of peace, and the warlike god of the Hebrew Bible might be more in sympathy with the militarism of Rome. How much safer it would be if Jesus were one with God the Father, if Jesus could not be said to be a different yet admirable person.

The bishops, followers of both Arius and Alexander, were spellbound by Constantine—not only by his person but by the facts that Constantine was the first Christian emperor, had ended their persecution, and had summoned them to the council and paid their way by ship or donkey. In effect, Constantine locked them together, as cardinals are now locked in until they elect a pope, and admonished them not to emerge until key clerical matters had been put to rest. In the end, the Alexandrian victory was resounding. However, many Arians continued to propound their views at the local level.

In 381, the emperor Theodosius held another council on Christian doctrine, the Council of Constantinople, and the outcome reinforced the teachings of the Council of Nicaea. Theodosius proclaimed, "We now order that all churches are to be handed over to the bishops who profess Father, Son, and Holy Spirit of a single majesty, of the same glory, of one splendor, who establish no difference by sacrilegious separation, but [who avow] the order of the Trinity by recognizing the Persons and uniting the Godhead."[5]

At these councils, many of the core beliefs of the Church were enumerated and affirmed. The emperors who supported them helped reinforce the foundations of a religious institution that has outlived the empire in which it was born.

Literature, Philosophy, and Religion

Four important **Latin fathers** of the church were philosophers and theologians:

- Saint Ambrose of Milan (ca. 338–397 CE), bishop of Milan;
- Saint Jerome of Stridon (ca. 347–420 CE), who translated the Bible from Hebrew and Greek into Latin;
- Saint Augustine of Hippo (354–430 CE), who, as we will see, developed the idea of the church as the City of God, apparently as an eternal bulwark against the disintegrating City of Man (Rome);
- Pope Gregory I (the Great; ca. 540–604 CE), who may have had the greatest influence on the early medieval church.

Because of their teaching, these four are also called **doctors of the church**.

AMBROSE The story is told of Ambrose that bees dropped honey on his face while he lay in his cradle, which his father interpreted as a symbol of a honeyed tongue to come. Ambrose was popular in Milan and was appointed bishop for political reasons. But at the time, he had been neither baptized nor educated in theology. Fearful of the task before him, he fled to the home of a friend. Yet finally he ventured forth, overcame his religious deficits, and rose to the occasion.

As a theologian, Ambrose supported the idea of the virginity of Mary and her importance as the Mother of God. In believing that Mary was a virgin, Ambrose admitted that he was rejecting the natural order in favor of belief in the divine. He also supported the view—contested in the early centuries of the church—that Christ was one person. Others argued that Christ was two persons: a human being and God. Ambrose's writings include treatises on faith, the Holy Spirit, the mysteries, Abraham, Isaac, Noah, and virgins. We also have letters to emperors and others, and a collection of hymns.

Ambrose also navigated the political and military currents of his day, including remaining at his post after the loss of Milan to Magnus Maximus of Gaul (France). Rome later regained Milan.

Ambrose gave succor to the poor but vehemently expressed his disdain for pagans and Jews. He was also a mentor of Augustine of Hippo. Ambrose died a natural death, and his body lies in the crypt in the Sant'Ambrogio Basilica in Milan.

AUGUSTINE OF HIPPO In the year 386 CE, a 32-year-old man from North Africa wrote one of the most famous prayers in history: "Grant me chastity and continence,[6] but not yet" (*da mihi castitatem et continentiam, sed noli modo*). Although this man would come to teach that lust was sinful, even in marriage, his own life in his early years reveled in lust.

His name was Augustine, and he was from Hippo, a North African town on the Mediterranean Sea west of Carthage. Augustine was of Berber descent and spent most of his life in what is now Algeria. His mother was a devout Roman Catholic, but his father was a pagan. At school he came under pagan influences but also became immersed in Latin literature. At the age of 17 a sponsor arranged to support his studies in Carthage, where "a cauldron of illicit loves leapt and boiled"[7] about him (*Confessions*, 3.51). At this time he was attracted to the polytheistic Manichaean religion, which had originated in Persia and spread as far as Rome to the west and China to the east. That stern religion taught

4. Richard E. Rubenstein, *When Jesus Became God* (Harcourt, 1999).

5. Quoted in Richard P. C. Hanson, *The Search for the Christian Doctrine of God: The Arian Controversy, 318–381 A.D.* (Edinburgh, Scotland: T. & T. Clark, 1988), 215.

6. Self-restraint; moderation, especially in sexual matters.

7. Michael P. Foley (Ed.). Translated by F. J. Shield. Saint Augustine, *Confessions*. Indianapolis: Hackett Publishing Company, Inc., p. 37.

that the material world—the world of greed and lust—was one of darkness, while the spiritual world was one of light. But Augustine was also attracted to a hedonistic lifestyle. In book 3, chapter 51 of one of his two great works, *Confessions*, he recounts, "I came to Carthage, and all around me in my ears were the activities of impure loves. I was not yet in love, but I loved the idea of love." Regardless of any momentary flings, he took a young woman as a concubine. Of her, he wrote, "It was a sweet thing to be loved, and sweeter still when I was able to enjoy the body of a woman."

At the time, marriage was precisely regulated under Roman law. It had nothing to do with love, and sex was incidental although necessary to extend the lineage and thereby channel the property of the family. It was essentially an alliance between families. Marriage between people of different classes, such as between nobility and freed men, or between freed men and slaves, was forbidden. Concubinage was usually stable and monogamous, but it did not come with property rights. Augustine lived with his concubine for more than 13 years, during which time they had a son. But if they had lived together for a century, there would still have been no common-law marriage between them. His concubine would have had no right to alimony, or to palimony.

Augustine moved to Rome and then to Milan, where he converted to Christianity in 387—partly due to the influence of Ambrose, the bishop there. He chronicled his spiritual journey in *Confessions*. But it is thought that Manichaeism helped shape his views on the nature of good and evil, hell, predestination, and his eventual hostility toward the flesh and sexual activity. Following his conversion and his denunciation of the flesh, Augustine became a priest and then a bishop back in Hippo, and eventually one of the Latin fathers of the church. He developed the concepts of original sin and just war. He wrote that humans are depraved—perhaps as he was depraved in his earlier years—and could not become righteous without the grace of God.

When the Visigoths sacked Rome in 410, the pagan world was aghast, and many blamed the rise of Christianity for it. Partially as a response to this charge, Augustine framed the concept of the church as an eternal spiritual City of God in his book *The City of God (De civitate Dei)*. The City of God was distinct from the material and flawed City of Man. *The City of God* asserts that history has a direction willed by God and that in the end all will be made right as the City of Man gives way to the City of God. The City of God, of course, is closely identified with the church and Rome, and survives regardless of invasions—as have the writings of Augustine of Hippo, the young man who swam in a hot cauldron of passion but would eventually become Saint Augustine.

Augustine of Hippo's intellectual impact on the subsequent cultural history of the West is difficult to overestimate. His influence within Christianity is without parallel. Until Thomas Aquinas in the 13th century, all Christian theologians in the West started from explicitly Augustinian premises. Even Thomas did not shake off his debt to Augustine, although he replaced Augustine's strong Platonic orientation with a more empirical Aristotelian one. Augustine emphasized the absolute majesty of God, the immutability of God's will, and the flawed state of the human condition (notions derived from the Apostle Paul). These tenets received a powerful reformulation in the Reformation by Martin Luther (who as a Catholic friar had lived under the rule of Saint Augustine) and by John Calvin, a profound student of Augustine's theological writings.

The Confessions Augustine invented the genre of self-reflective writing in the West. "I would know myself that I might know Thee," he writes to God in the *Confessions*. Before Augustine's time, memoirs related a life in terms of social, political, or military affairs (as did, for example, Caesar's *De bello civili*), but Augustine's intimate self-scrutiny and inquiry into the significance of life were new in Western culture. There would be no other work like the *Confessions* until Petrarch, an indefatigable student of Augustine, wrote his "Letter to Posterity" in the mid-14th century. The Renaissance writers, extremely self-conscious, were devoted students of Augustine's stately Latin prose; even the great later autobiographies of Gibbon, Mill, and Newman are literary and spiritual descendants of Augustine.

Augustine's *Confessions* is a compelling analysis of his spiritual and intellectual development from his youth until the time of his conversion to Christianity and readiness to return to his native Africa. The title can be understood in a triple sense—a confession of sin, an act of faith in God, and a confession of praise.

The following passage recounts Augustine's conversion experience in 387 in his garden in Milan, Italy.

READING 7.1 SAINT AUGUSTINE

From *Confessions*, book 8, chapter 12

I felt that I was still the captive of my sins, and in my misery I kept crying "How long shall I go on saying 'tomorrow, tomorrow'? Why not now? Why not make an end of my ugly sins at this moment?"

I was asking myself these questions, weeping all the while with the most bitter sorrow in my heart, when all at once I heard a sing-song voice of a child in a nearby house. Whether it was the voice of a boy or a girl I cannot say, but again and again it repeated the refrain "Take it and read, take it and read." At this I looked up, thinking hard whether there was any kind of game in which children used to chant words like these, but I could not remember ever hearing them before. I stemmed the flood of tears and stood up, telling myself that this could only be a divine command to open my book of scripture and read the first passage on which my eyes should fall.

. . .

So I hurried back to the place where Alypius [a friend] was sitting, for when I stood up to move away I had put

down the book containing Paul's epistles. I seized it and opened it, and in silence I read the first passage on which my eyes fell: *Not in reveling and drunkenness, not in lust and wantonness, not in quarrels and rivalries. Rather, arm yourself with the Lord Jesus Christ; spend no more thought on nature and nature's appetites.* I had no wish to read more and no need to do so. For in an instant, as I came to the end of the sentence, it was as though the light of confidence flooded into my heart and all the darkness of doubt was dispelled.

From Book VIII and Book IX of *Confessions by Saint Augustine*, translated with an introduction by R. S. Pine-Coffin (Penguin Classics, 1961).

Although strongly autobiographical, the *Confessions* is also a meditation on the hidden grace of God as Augustine's life is shaped toward its appointed end. Augustine confesses to God (and the reader) how his early drive for fame as a teacher of rhetoric, his flirtation with the Manichaean sect and its belief in gods of evil and good, his liaison with a woman that resulted in the birth of a son, and his restless movement from North Africa to Rome and Milan were all part of a web of circumstance that made up an individual life. Interspersed in the narrative line of his early life are Augustine's reflections on the most basic philosophical and theological questions of the day, always linked to his own experience.

The City of God Augustine made a notable impact beyond theology. The City of God, begun about 412, was an attempt to formulate a coherent and all-embracing philosophy of history, the first such attempt in the West. For Augustine, history moves on a straight line in a direction from its origin

in God until it ends, again in God, at a consummation in the Last Judgment. Augustine rejects the older pagan notion that history repeats itself in endless cycles. His reading of the Bible convinced him that humanity had an origin, plays out its story, and will terminate. The City of Man will be judged and the City of God will be saved. Subsequent philosophers of history have secularized this view but, with a few exceptions (the 17th-century Italian philosopher Giambattista Vico, for example), have maintained the outlines of Augustine's framework to some extent. "A bright future," "an atomic wasteland of the future," and "a classless society" are all statements about the end of history, all statements that echo, however quietly, the worldview of Augustine.

In Readings 7.2 and 7.3. from *The City of God*, Augustine ponders a perennial subject for all people: the character of peace in both its personal and its social context. These reflections on peace are all the more compelling because they were written against the backdrop of the barbarian invasions of Europe and Roman North Africa as well as Augustine's own shock at the sack of the city of Rome—the occasion for his writing the book in the first place.

Augustine's philosophical treatment of the concept of time remains popular today. One could say that he transferred Plato's Good and Plotinus's One to the Christian God, writing in *Confessions* that the eternal God exists outside of time, whereas people exist within time. Time did not exist prior to the creation because time is perceived in terms of space and motion. Within the creation time exists in the mind, and there is only the present; the past is memory in the present, and the future is expectation in the present. As an aside, one view of the current big bang theory of the origin of the universe also holds that time and space were born then, although the theory does not propose an intelligent process of creation.

READING 7.2 SAINT AUGUSTINE

The City of God, book 19, chapter 7

7. Human society divided by differences of language. The misery of war, even when just

After the city or town comes the world, which the philosophers reckon as the third level of human society. They begin with the household, proceed to the city, and then arrive at the world. Now the world, being like a confluence of waters, is obviously more full of danger than the other communities by reason of its greater size. To begin with, on this level the diversity of languages separates man from man. For if two men meet, and are forced by some compelling reason not to pass on but to stay in company, then if neither knows the other's language, it is easier for dumb animals, even of different kinds, to associate together than these men, although both are human beings. For when men cannot communicate their thoughts to each other, simply because of difference of language, all the similarity of their common

human nature is of no avail to unite them in fellowship. So true is this that a man would be more cheerful with his dog for company than with a foreigner. I shall be told that the Imperial City has been at pains to impose on conquered peoples not only her yoke but her language also, as a bond of peace and fellowship, so that there should be no lack of interpreters but even a profusion of them. True; but think of the cost of this achievement! Consider the scale of those wars, with all that slaughter of human beings, all the human blood that was shed!

In chapter 12 of that same book, Augustine argues that all people wish for peace, even if they resort to war to achieve it. Certainly there are many warlike individuals who may fit within the confines of his argument, but the current obsession with violence in the media—in novels, films, television shows, and video games—might leave one wondering whether Augustine was overly optimistic about human nature.

Scientists aver that the big bang occurred some 13.7 billion years ago, whereas some readers of the Bible contend that the universe has existed for only 6000 years. In "The Literal Interpretation of Genesis," Augustine warns against taking the Bible literally if it flies in the face of reason and observation. The Hebrew Bible speaks of six days of creation followed by a day of rest, but as we see in Reading 7.4, Augustine was concerned that biblical accounts that defy reason could be harmful to Christianity.

On the other hand, Augustine believed he understood why the Bible was written as it was. He rationalized it this way: "It must be said that our authors knew the truth about the nature of the skies, but it was not the intention of the Spirit of God, who spoke through them, to teach men anything that would not be of use to them for their salvation." He believed that God created everything in the universe at once, not in six days; the six days found in Genesis were intended to provide a conceptual rather than a physical framework for describing creation.

Augustine wrote that original sin, the guilt of Adam for eating the forbidden fruit, is inherited by all humans. Humans are depraved and incapable of doing good without divine grace. Augustine believed in predestination, the doctrine that God has foreordained who will be saved. Yet there is free will, and people can choose to live so that they are saved. Although God knows who will be saved, what he knows is how people will choose their destinies. The Eastern Orthodox Church split from the Roman Catholic Church in 1054, partly because of differences in doctrine such as that of original sin. The Eastern Orthodox Church does not follow the Augustinian descriptions of original sin as a moral and spiritual stain upon the soul and of the inheritance of guilt. The Eastern Orthodox Church sees original sin as a break in the human communion with God; a loss of grace; the introduction of disease, decay,

and death; and weakened resistance to temptation. Both churches agree that Christ has made salvation possible.

Augustine wrote that war can be just when it is fought for a good purpose and not for personal gain or power. A just war can only be waged by a proper authority, such as the state, and even though war is violent, the motive of a just war is love.

Augustine came to associate sexual desire with original sin. He did not see the sexual act itself as evil, but rather the lustful emotions that can accompany it. To virgins raped during the sack of Rome, he wrote, "Another's lust cannot pollute thee." On the other hand, virtue is lost when a person intends to sin, even if the act is not carried out.

Augustine condemned the practice of abortion, as did other church fathers. Yet the seriousness of abortion depends

READING 7.4 SAINT AUGUSTINE

From "The Literal Interpretation of Genesis" 1:19–20, chapter 19

It not infrequently happens that something about the earth, about the sky, about other elements of this world, about the motion and rotation or even the magnitude and distances of the stars, about definite eclipses of the sun and moon, about the passage of years and seasons, about the nature of animals, of fruits, of stones, and of other such things, may be known with the greatest certainty by reasoning or by experience, even by one who is not a Christian. It is too disgraceful and ruinous, though, and greatly to be avoided, that [the non-Christian] should hear a Christian speaking so idiotically on these matters . . . that he could scarcely keep from laughing.

READING 7.3 SAINT AUGUSTINE

The City of God, book 19, chapter 12

12. Peace is the instinctive aim of all creatures, and is even the ultimate purpose of war

Anyone who joins me in an examination, however slight, of human affairs, and the human nature we all share, recognizes that just as there is no man who does not wish for joy, so there is no man who does not wish for peace. Indeed, even when men choose war, their only wish is for victory; which shows that their desire in fighting is for peace with glory. For what is victory but the conquest of the opposing side? And when this is achieved, there will be peace. Even wars, then, are waged with peace as their object, even when they are waged by those who are concerned to exercise their warlike prowess, either in command or in the actual fighting. Hence it is an established fact that peace is the desired end of war. For every man is in quest of peace, even in waging war, whereas no one

is in quest of war when making peace. In fact, even when men wish a present state of peace to be disturbed they do so not because they hate peace, but because they desire the present peace to be exchanged for one that suits their wishes. Thus their desire is not that there should not be peace but that it should be the kind of peace they wish for. Even in the extreme case when they have separated themselves from others by sedition, they cannot achieve their aim unless they maintain some sort of semblance of peace with their confederates in conspiracy. Moreover, even robbers, to ensure greater efficiency and security in their assaults on the peace of the rest of mankind, desire to preserve peace with their associates.

From Book XIX of *Concerning the City of God: Against the Pagans* by Saint Augustine, translated by Henry Bettenson, introduction by G R Evans (First published in Pelican Books 1972, Reprinted in Penguin Classics, 1984, Reissued Penguin Classics 2003). Translation copyright © Henry Bettenson, 1972. Chronology, Introduction, Further Reading copyright © G R Evans, 2003. Reprinted by permission of Penguin Books, Ltd.

on the ensoulment status of the fetus—that is, whether or not it has received its soul at the time. Augustine believed, along with the Greek philosopher Aristotle (384–322 BCE) that male fetuses receive a soul at 40 days of gestation and female fetuses at 90 days.[8]

BOETHIUS In the twilight period in Ravenna, between the death of the last Roman emperor and the arrival of the troops of Justinian, who ruled the Eastern Roman Empire, an important figure who bridged the gap between classical paganism and Christianity lived and died. Anicius Manlius Severinus Boethius was a highly educated Roman who entered the service of the Gothic king Theodoric in 522. Imprisoned in the city of Pavia for reasons that are not clear, Boethius wrote a treatise called *Consolation of Philosophy* while awaiting his probable execution. Cast as a dialogue between Lady Philosophy and the author on the philosophical and religious basis for human freedom, the work blends the spirit of the biblical book of Job with Roman Stoicism. Attempting to console him in his sad state of disgrace and imprisonment, Lady Philosophy demands that the author avoid self-pity and face his troubles with serenity and hope. Insisting that a provident God overcomes all evil, Philosophy insists that blind fate has no control over humanity. She explains that human freedom exists along with an all-knowing God and that good will triumph.

In the following reading, Boethius describes how Lady Philosophy visits him in his prison cell. As *Consolation* goes on, it becomes clear that his dialogue with the lady is a dialogue with himself. *Consolation* is an early example of the manner in which writers create characters who embody parts—often conflicting parts—of themselves. Lady Philosophy convinces Boethius of things he is likely attempting to convince himself are true.

READING 7.5 **BOETHIUS**

From *Consolation of Philosophy*, book 1, chapter 1

While I was thus mutely pondering within myself, and recording my sorrowful complainings with my pen, it seemed to me that there appeared above my head a woman of a countenance exceeding venerable. Her eyes were bright as fire, and of a more than human keenness; her complexion was lively, her vigour showed no trace of enfeeblement; and yet her years were right full, and she plainly seemed not of our age and time. Her stature was difficult to judge. At one moment it exceeded not the common height, at another her forehead seemed to strike the sky; and whenever she raised her head higher, she began to pierce within the very heavens, and to baffle the eyes of them that looked upon her. Her garments were of an imperishable fabric, wrought with the finest threads and of the most delicate workmanship; and these, as her own lips afterwards assured me, she had herself woven with her own hands.

Consolation of Philosophy was one of the most widely read and influential works of the Middle Ages and Elizabethan England. Geoffrey Chaucer made a Middle English translation of it from an already existing French version, and Queen Elizabeth I translated the work into modern English. Its message of hope and faith was quoted liberally by every major medieval thinker from Thomas Aquinas to Dante Alighieri.

Boethius sets out a basic problem and provides an answer that would become normative Christian thought for subsequent centuries. In *Consolation*, he asks how one can reconcile human freedom with the notion of an all-knowing God. Put another way: if God knows what we do before we do it, how can we be said to be free agents who must accept responsibility for personal acts? The answer, Boethius insists through Lady Philosophy, is to look at the problem from the point of view of God, not from the human vantage point. God lives in eternity. Eternity does not mean a long time with a past and a future; it means no time: God lives in an eternal moment that for him is a now. In that sense, God does not foresee the future—there is no future for God. He sees everything in one simple moment that is only past, present, and future from the human point of view. Boethius says that God does not exercise *praevidentia* (seeing things before they happen) but *providence* (seeing all things in the simultaneity of their happening). Thus God, in a single eternal, ineffable moment, grasps all activity, which exists for us as a long sequence of events. More specifically, in that moment, God sees our choices, the events that follow from them, and the ultimate consequences of those choices.

The consolation for Boethius, as Lady Philosophy explains it, rests in the fact that people do act with freedom, that they are not in the hands of an indifferent fate, and that the ultimate meaning of life rests with the all-seeing presence of God, not a blind force. Lady Philosophy sums up her discussion with Boethius by offering him this consolation. It is her assurance that his life, even while he is awaiting execution in a prison cell, is not the product of a blind fate or an uncaring force in the universe.

The language of Boethius, with its discussion of time, eternity, free will, and the nature of God, echoes the great philosophical tradition of Plato and Aristotle (Boethius had translated the latter's works), as well as the Stoicism of Cicero and the theological reflections of Augustine. It is a fitting end to the intellectual tradition of the late Roman Empire in the West.

BYZANTIUM

The city of Byzantium is said to have been founded in 667 BCE, 67 years before the beginning of the Archaic period in Greece. Legend would have it that the Greek king Nisos

8. Paul A. B. Clarke and Andrew Linzey, *Dictionary of Ethics, Theology, and Society* (New York: Routledge, 1996); Odd Magne Bakke, *When Children Became People: The Birth of Childhood in Early Christianity*, trans. Brian McNeil (Minneapolis, MN: Augsburg Fortress, 2005).

Boethius's *Consolation of Philosophy* and Marcus Aurelius's *Meditations*

In Boethius's *Consolation of Philosophy*, written in a prison cell as he was awaiting execution, Lady Philosophy explains to the author that hopes for glory are in vain and that the human life span is nothing in the eternity of time. What is so deeply meaningful to us is, to seek an analogy from Muhammad's Night Journey in Chapter 8, like a particle of sand thrust into the desert. In book 2, chapter 7, Lady Philosophy speaks:

> "How many of high renown in their own times have been lost in oblivion for want of a record! Indeed, of what avail are written records even, which, with their authors, are overtaken by the dimness of age after a somewhat longer time? But ye, when ye think on future fame, fancy it an immortality that ye are begetting for yourselves. Why, if thou scannest the infinite spaces of eternity, what room hast thou left for rejoicing in the durability of thy name? Verily, if a single moment's space be compared with ten thousand years, it has a certain relative duration, however little, since each period is definite. But this same number of years—ay, and a number many times as great—cannot even be compared with endless duration; for, indeed, finite periods may in a sort be compared one with another, but a finite and an infinite never. So it comes to pass that fame, though it extend to ever so wide a space of years, if it be compared to never-lessening eternity, seems not short-lived merely, but altogether nothing. But as for you, ye know not how to act aright, unless it be to court the popular breeze, and win the empty applause of the multitude—nay, ye abandon the superlative worth of conscience and virtue, and ask a recompense from the poor words of others. Let me tell thee how wittily one did mock the shallowness of this sort of arrogance. A certain man assailed one who had put on the name of philosopher as a cloak to pride and vain-glory, not for the practice of real virtue, and added: 'Now shall I know if thou art a philosopher if thou bearest reproaches calmly and patiently.' The other for awhile affected to be patient, and, having endured to be abused, cried out derisively: 'Now, do you see that I am a philosopher?' The other, with biting sarcasm, retorted: 'I should have hadst thou held thy peace.' Moreover, what concern have choice spirits—for it is of such men we speak, men who seek glory by virtue—what concern, I say, have these with fame after the dissolution of the body in death's last hour? For if men die wholly— which our reasonings forbid us to believe—there is no such thing as glory at all, since he to whom the glory is said to belong is altogether non-existent. But if the mind, conscious of its own rectitude, is released from its earthly prison, and seeks heaven in free flight, doth it not despise all earthly things when it rejoices in its deliverance from earthly bonds, and enters upon the joys of heaven?"

Lady Philosophy's perspective is reminiscent of this passage in the *Meditations* of the Stoic Roman emperor Marcus Aurelius:

> We live for an instant [but to be swallowed in] complete forgetfulness and the void of infinite time. . . . Of the life of man the duration is but a point, its substance streaming away, its perception dim, the fabric of the entire body prone to decay, and the soul a vortex, fortune incalculable and fame uncertain. In a word all things of the body are as a river, and the things of the soul as a dream and a vapor. [It matters not how long one lives,] for look at the yawning gulf of time behind thee and before thee at another infinity to come. In this eternity the life of a baby of three days and [a span] of three centuries are as one.

Of course, Lady Philosophy's discourse is about vanity, whereas Marcus Aurelius was writing about suffering and moving on despite pain and misfortune. Nevertheless, the philosophers and their writings share a sense of Roman Stoicism, even though Marcus Aurelius believed that "men die wholly." Although Christian themes permeate Boethius's work, there is no explicit mention of Christian doctrine. What one does sense is the recasting of Roman thought into Christian patterns. In a way, *Consolation of Philosophy* is one of the last works of the late Roman period. It reflects the elegance of Roman expression, the burgeoning hope of Christianity, and the terrible sadness that must have afflicted any sensitive Roman living in this period. Marcus Aurelius, of course, did not live to witness the disintegration of his proud empire.

consulted the oracle at Delphi to learn where his son, Byzas, should found his own city. The oracle instructed him to settle where, as it turned out, Constantine would later seat his Eastern Roman Empire. The city would be renamed Constantinople, but the entirety of the Eastern Roman Empire would be referred to as Byzantium in centuries to come.

Constantinople

The city of Constantinople in present-day Turkey became the center of imperial life in the early fifth century and reached its highest expression of power in the early sixth century with the ascension of Justinian to the throne in 527 (see **Map 7.2**). Justinian's stated intention was to restore the empire to a condition of grandeur. In this project he was aided by his wife Theodora. A former dancer and prostitute, Theodora was a tough-minded and capable woman who added strength and resolve to the grandiose plans of the emperor. She was Justinian's equal, and perhaps more.

The reign of Justinian and Theodora was impressive, if profligate, by any standard. The emperor encouraged Persian monks residing in China to bring back silkworms for the introduction of the silk industry into the West. Because the silk industry of China was a fiercely guarded monopoly, the monks accomplished this rather dangerous mission by smuggling silkworm eggs out of the country in hollow tubes, and within a decade, the silk industry in the Western world rival that of China.

Justinian also revised and codified Roman law, a gigantic undertaking of scholarship and research. Roman law had evolved over a 1000-year period; by Justinian's time it was a vast jumble of disorganized and often contradictory decisions, decrees, statutes, opinions, and legal codes. Under the aegis of the emperor, a legal scholar named Tribonian produced order out of this chaos. First a code that summarized all imperial decrees from the time of Hadrian (in the second century) to the time of Justinian was published. The code was followed by the Pandects ("Digest"), which synthesized a vast quantity of legal opinion and scholarship from the past. Finally came the Institutes, a legal collection broken down into four categories by which the laws concerning persons, things, actions, and personal wrongs (in other words, criminal law) were set forth. The body of this legal revision became the basis for the law courts of the empire and, in later centuries, the basis for the use of Roman law in the West.

Justinian and Theodora were fiercely partisan Christians who took a keen interest in theology and ecclesiastical governance. Justinian's fanatical devotion prompted him to shut down the last surviving Platonic academy in the world on the grounds that its paganism was inimical to the true religion. His own personal life—despite evidences of cruelty and capriciousness—was austere and abstemious, influenced by the presence of so many monks in the city of Constantinople. His generosity to the church was great, with his largesse shown most clearly in openhanded patronage of church building. The Hagia Sophia, his most famous project, has become legendary for the beauty and opulence of its decoration.

THE HAGIA SOPHIA: MONUMENT AND SYMBOL
The Hagia Sophia (Greek for "Holy Wisdom") was the principal church of Constantinople. It had been destroyed twice, once by fire and once—during Justinian's reign—by the civil

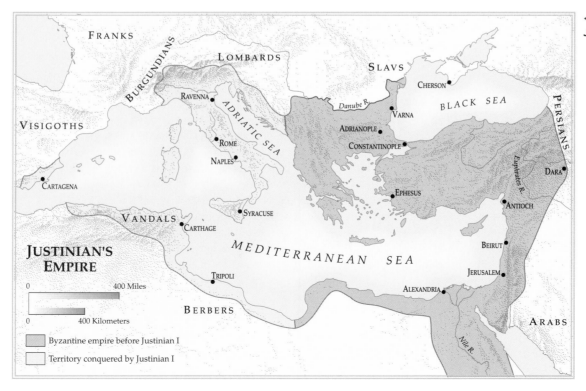

◄ MAP 7.2
Justinian's Empire

FRANKS
BURGUNDIANS
LOMBARDS
SLAVS
CHERSON
RAVENNA
Danube R.
VARNA
BLACK SEA
PERSIANS
VISIGOTHS
ADRIATIC SEA
ADRIANOPLE
CONSTANTINOPLE
ROME
Euphrates R.
NAPLES
DARA
CARTAGENA
ANTIOCH
EPHESUS
VANDALS
SYRACUSE
CARTHAGE
MEDITERRANEAN SEA
BEIRUT
JUSTINIAN'S EMPIRE
JERUSALEM
0 400 Miles
ALEXANDRIA
0 400 Kilometers
TRIPOLI
BERBERS
ARABS
Nile R.

☐ Byzantine empire before Justinian I
☐ Territory conquered by Justinian I

The Greens and the Blues: A Clash of Values

Television has made us aware of sports fans who riot at athletic events, but one of the worst instances of fans run amok happened long before television even existed, in sixth-century Constantinople. The *Nika revolt* was a strange episode in which sports, religion, and political unrest created a "perfect storm" of chaos, destruction, and revolt. It was something akin to the rivalry of Protestants and Catholics in Northern Ireland, but actually more deadly.

Christian values in Constantinople had forced a ban on the ancient gladiatorial games and on the theater, in which entertainers often engaged in lewd dancing. People flocked instead to the chariot races held at the city's *hippodrome*, the centerpiece of urban athletics, complete with a box for the emperor. The passion for these races was such that around the year 500, the fans organized themselves into opposing factions called the Greens and the Blues, each supporting different teams of charioteers and horses—effectively dividing the city. The emperor Justinian supported the Blues. Each faction dressed in ways that asserted its allegiance; the Blues, for example, shaved their heads in the front and let their hair grow long in back in imitation of the Huns. Each faction also claimed allegiance to a different position on the divinity of Christ. The Blues believed that Christ had two natures (human and divine) in one person, while the Greens held that Christ had only one nature, which was either divine or a synthesis of the human and the divine.

These rivalries came to a head in January 532, when the Nika revolt (named for the Greek word *nike*, meaning "victory," used as a battle cry by the participants) broke out in the hippodrome. According to the contemporary historian Procopius, what started as a riot soon became a bloodbath in an open revolt against Justinian's attempts to suppress the traditional rights of the factions. In the end, both Blues and Greens merged into an anti-imperial movement. Justinian almost fled the city until his wife, the formidable Theodora, rallied him and Belisarius, the head of the military, to lead the imperial army against the dissidents. Theodora is believed to have told Justinian, "Those who have worn the crown should never survive its loss. Never will I see the day when I am not saluted as empress."

The Greens and Justinian's favored Blues were at the hippodrome. Through some verbal convincing, along with some passing of money, the leaders of the Blues led their faction out of the stadium. The Greens remained, uncomprehending. Belisarius's troops stormed into the hippodrome and slaughtered the remaining Greens. The troops continued their bloody rampage outside the confines of the hippodrome; when they were finished, neighborhoods inhabited by Greens were aflame, and there were, by some estimates, thirty thousand dead. The races were stopped for five years, resuming in 537 with the factions more orderly and less polarized.

Procopius: Volume I, Loeb Classical Library®, Volume 48, translated by H. B. Dewing, Cambridge, Mass: Harvard University Press, 1914. The Loeb Classical Library® is a registered trademark of the President and Fellows of Harvard College.

disorder of the Nika revolt in 532 that devastated most of the European side of the city. Soon afterward, Justinian decided to rebuild the church using the plans of two architects: Anthemius of Tralles and Isidorus of Miletus. Work began in 532, and the new edifice was solemnly dedicated five years later in the presence of Justinian and Theodora.

The Hagia Sophia was a stunning architectural achievement that combined the longitudinal shape of the Roman basilica with a domed central plan. Two centuries earlier, Constantine had used both the dome and basilica shapes in the Church of the Holy Sepulcher in Jerusalem, but he had not joined them into a unity. In still earlier domed buildings in the Roman world, such as the Pantheon, the dome rested on a circular drum. This gave the dome solidity but limited its height and expansiveness. Anthemius and Isidorus solved this problem by the use of **pendentives** (**Fig. 7.2**), triangular masonry devices that carry the weight of the dome on massive piers rather than straight down from the drum.

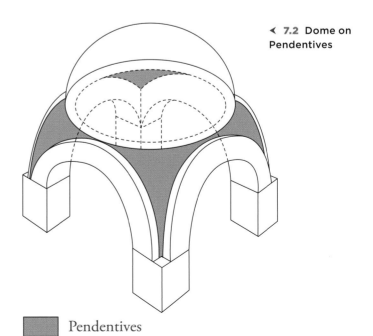

◀ **7.2 Dome on Pendentives**

Pendentives

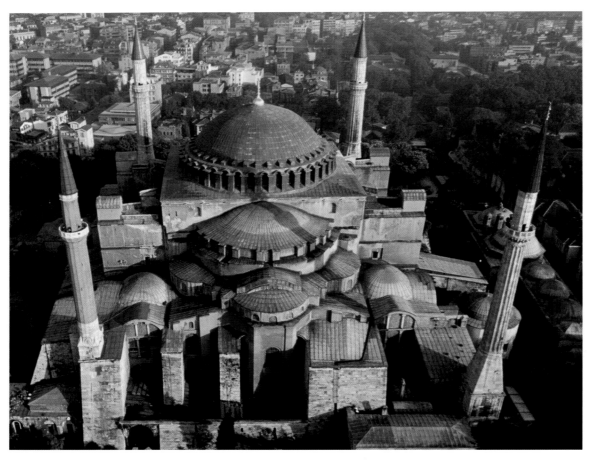

◄ **7.3 Hagia Sophia, 532–537. Constantinople (Istanbul), Turkey.** Exterior view from the southeast. The minarets, of Turkish origin, are a later addition.

In the Hagia Sophia, the central dome is abutted by two half domes, so that a person looking down at the building from above might see a nave in the form of an oval instead of a quadrangle (**Fig. 7.3**). The church—at 184 feet high, 41 feet higher than the Pantheon—retains a hint of the old basilican style as a result of the columned side aisles and the gallery for female worshipers in the triforium—the space above the arches of the side aisles—but the overwhelming visual impression comes from the massive dome. Because the pendentives reduce the weight of the dome, the area between drum and dome could be pierced by forty windows that make the dome seem to hang in space. Light streams into the church from the windows and refracts off the rich mosaics and colored marbles that cover the interior (**Fig. 7.4**).

Light, in fact, was a key theoretical element behind the entire conception of the Hagia Sophia. It is the symbol of divine wisdom in the philosophy of Plato and in the New Testament. A common metaphor in pagan and biblical wisdom had the sun and its rays represent the eternity of God and his illumination of mortals. The suffusion of light was an element in the Hagia Sophia that went far beyond the functional need to illuminate the interior of the church. Light refracting in the church created a spiritual ambience analogous to that of heaven, where believers would be bathed in the actual light of God.

WORSHIP IN THE HAGIA SOPHIA The sequence of the various parts of the worship service at Constantinople—the **liturgy**—was developed from the inspiration of Saint John Chrysostom (347–407), patriarch of the city in the century before Justinian. The official liturgy of Byzantine Christianity is still the Divine Liturgy of Saint John Chrysostom, modified and added to over the centuries. In that liturgy, the worshiping community visualizes itself as standing in the forecourt of heaven when it worships in the church. Amid the swirling incense, the glittering light, and the stately chants of the clergy and people comes a sense of participation with the household of heaven standing before God. A fragment from the liturgy—added during the reign of Justinian's successor Justin II (565–578)—underscores the point dramatically. Note the characteristic cry of "Wisdom!" and the description of the congregation as mystically present in heaven.

Priest Wisdom! That ever being guarded by Thy power, we may give glory to Thee, Father, Son, and Holy Spirit, now and forevermore.

Congregation Amen. Let us here who represent the mystic Cherubim in singing the thrice holy hymn to the life-giving Trinity now lay aside every earthly care so that we may welcome the King of the universe who comes escorted by invisible armies of angels. Alleluia. Alleluia. Alleluia.

The Hagia Sophia was enriched by subsequent emperors, and after repairs were made to the dome in 989, new mosaics

Procopius of Caesarea

Procopius was in the service of Emperor Justinian. His *Secret History* was an unvarnished portrait of the emperor and the empress. But here he describes his reaction to the Hagia Sophia.

> The whole ceiling is overlaid with pure gold . . . yet the light reflecting from the stones [of the mosaics] prevails, shining out of rivalry with the gold. There are two colonnades, one on each side, not separated in any way from the church itself. . . . They have vaulted ceilings and are decorated with gold. One of these is designated for men-worshipers and the other for women but they have nothing to distinguish them nor do they differ in any way. Their very equality serves to beautify the church and their similarity to adorn it.
>
> Who can recount the beauty of the columns and the stones with which the church is decorated? One might imagine that he had come upon a meadow with its flowers in full bloom. For he would surely marvel at the purple of some, the green tint of others, and at those from which the white flashes, and again, at those which Nature, like some painter, varies with contrasting colors.
>
> And whenever anyone enters this church to pray . . . his mind is lifted up toward God and is exalted, feeling that He cannot be very far away, but must especially love to dwell in this place which He has favored. And this does not happen only to one who sees the church for the first time, but the same experience comes to him on each successive occasion, as though the sight were new each time. Of this spectacle no one ever has a surfeit, but when present in the church people rejoice in what they see, and when they depart they take enormous delight in talking about it.*

* *Procopius*: Volume I, Loeb Classical Library®, Volume 48, translated by H. B. Dewing, Cambridge, Mass: Harvard University Press, 1914. The Loeb Classical Library® is a registered trademark of the President and Fellows of Harvard College.

were added to the church. After the fall of Constantinople in 1453, the Turks turned the church into a mosque; the mosaics were whitewashed or plastered over because the Qur'an (also spelled *Koran*) prohibited the use of images. When the mosque was converted to a museum by the modern Turkish state, some of the mosaics were uncovered, so today we can get some sense of the splendor of the original interior.

OTHER CHURCHES IN CONSTANTINOPLE Other monuments bear the mark of Justinian's creative efforts. His Church of the Holy Apostles, built on the site of an earlier church of the same name destroyed by an earthquake, did not survive the fall of the city in 1453 but did serve as a model for the San Marco Basilica in Venice. Near the Hagia Sophia is the Hagia Eirene ("Holy Peace"), now a mosque, whose architecture also shows the combination of

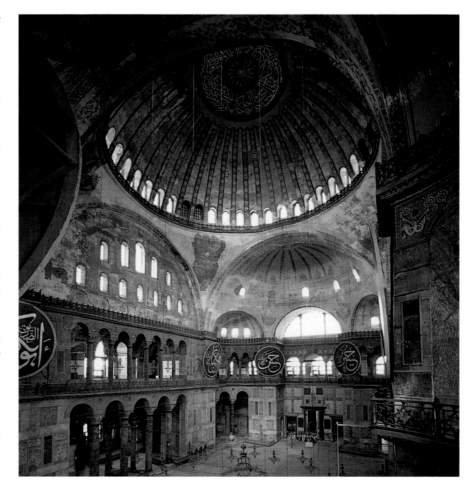

> **7.4 Interior of the Hagia Sophia.** Looking toward the apse, this view shows how the windows between drum and dome give an impression of floating lightness that continues down to the floor. Note the hanging shields with Arabic quotations from the Qur'an.

basilica and dome. The church, dedicated to the martyr saints Sergius and Bacchus and begun in 527, was a preliminary study for the later Hagia Sophia. In all, Justinian built more than 25 churches and convents in Constantinople. His program of secular architecture included an impressive water-conduit system that still exists.

RAVENNA

As the Western Roman Empire tried to adjust to changing conditions, the capital was moved from Rome to Milan in 286, and from Milan to Ravenna in 402.

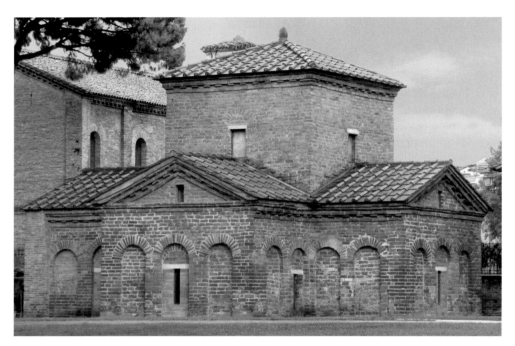

◄ **7.5 Mausoleum of Galla Placidia, early 5th century. Ravenna, Italy.** The building has sunk more than 3′ (1 m) into the marshy soil, thus making it rather squat in appearance.

▼ **7.6 Christ as the Good Shepherd, 5th century. Lunette mosaic, Mausoleum of Galla Placidia, Ravenna, Italy.** Symbolizing the heavens, the motif of stylized gold sunbursts and stars set in a deep-blue ground can be seen in the vault. Note the beardless Christ dressed in a Roman toga.

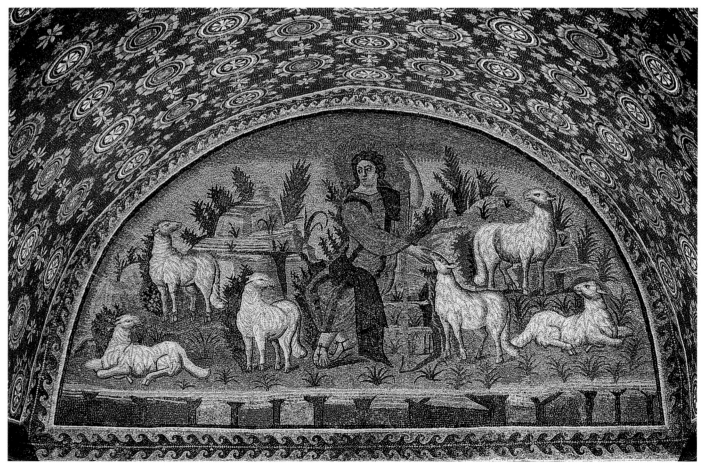

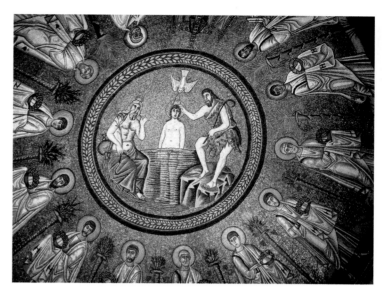

◄▲ **7.7 Baptisteries of the Orthodox and Arians. Ravenna, Italy.** On the left is the mosaic of the Baptistery of the Orthodox (middle of the 5th century); on the right, the mosaic of the Baptistery of the Arians (end of the 5th century). In the central disks of both ceiling mosaics, John the Baptist baptizes Christ in the river Jordan (symbolized by a seated Neptune) while the apostles encircle them in an outer disk. Notice the more severe style of the Arian mosaic.

Ravenna today is a repository of monuments that reflect its late Roman, Gothic, and Byzantine history. The Mausoleum ("burial chapel") of Galla Placidia (who reigned as regent from 430 to 450) was built at the end of the Roman period of the city's history (**Fig. 7.5**). Once thought to be the tomb of the empress (hence its name), it is more likely a **votive chapel** to Saint Lawrence originally attached to the nearby Church of the Holy Cross. This small chapel in the shape of a cross, very plain on the outside, shows the architectural tendency to combine the basilica-style nave with the structure of a dome (it even uses a modified pendentive form) used later in monumental structures like the Hagia Sophia.

Mosaics

The importance of the Mausoleum of Galla Placidia rests in the complete and breathtakingly beautiful mosaics that decorate the walls and ceiling. The north niche, just above the entrance, has a *lunette* (small arched space) mosaic depicting Christ as the Good Shepherd (**Fig. 7.6**). Clothed in gold and royal purple, and with a gold staff in his hand, the figure of Christ has a courtly, almost languid elegance that refines the more rustic depictions of the Good Shepherd theme in earlier Roman Christian art. The vaulting of both the *apse* (the altar end of the church) and the dome is covered with a deep-blue mosaic interspersed with stylized sunbursts and stars in gold. This "Persian rug" motif symbolizes the heavens, the

dwelling place of God. Because the *tesserae* (the small cubes that make up the mosaic) are not set fully flush in the wall, the surfaces of the mosaic are irregular. These surfaces thus refract and break up the light in the chapel, especially from flickering lamps and candles.

Baptisteries

The two baptisteries of Ravenna represent a major religious division of the time—between the **Orthodox Christians**, who accepted the divinity of Christ, and the **Arian Christians**, who did not. The Neonian Baptistery, built by Orthodox Christians in the early fifth century next to the ancient cathedral of the city, is octagonal, as were most baptisteries because of their derivation from Roman bathhouses. The ceiling mosaic, directly over the baptismal pool, is particularly striking (**Fig. 7.7**). The lower register of the mosaic, above the windows, shows floral designs based on common Roman decorative motifs. Just above is a circle of empty thrones interspersed with altars with biblical codices open on them. In the band above are the apostles, who seem to be walking in a stately procession around the circle of the dome. In the central disk is a mosaic of the baptism of Christ by John the Baptist in the river Jordan. The spirit of the river is depicted as Neptune.

The mosaic ensemble in the ceiling was designed to reflect the beliefs of the participants in the ceremonies below. The circling apostles reminded the candidates for baptism

Autocracy and Divine Right

The Byzantine Empire was characterized by its acceptance of the belief that the emperor was God's representative on earth, who was the sole ruler of the empire and from whom all social and political good for the empire flowed. This view of the political order is called autocracy, which means, in essence, that the imperial power is unlimited, and whatever power others may have (for example, in the military or in the state bureaucracy) flows from the unlimited power of the emperor. In this case and many others throughout history, it was also claimed that the emperor held his position by divine right. The emperor was both the civil and religious ruler of the empire.

In the actual political order, of course, emperors were overthrown or manipulated by political intrigue. Even so, autocracy was generally accepted as the divinely ordered nature of things. Symbolic reinforcement of the divinely sanctioned autocratic power of the emperor (visually represented in the Ravenna mosaics of Justinian and Theodora) came through various symbolic means. The emperor alone dressed in the purple and gold once reserved for the semidivine pagan emperors. He lived in a palace with a rigid protocol of ceremony. When participating in the public worship of the church (the liturgy), he was given a special place and special recognition within that liturgy. Public insignia and other artifacts like coins recognized his authority as coming from God. It was commonplace in the literature of the time to see the emperor as the regent of God on earth, with his role compared to the sun, which brings light and warmth to his subjects.

Many autocracies (from the Egyptian pharaohs to the French kings just before the Revolution) claimed such a relationship to the divine. The Byzantine Empire not only built itself on this idea but also maintained an intimate bond between the human and the divine in the person of the emperor. This concept would last almost a millennium in Constantinople and be replicated in Russia with the tsar until modern times.

that the church was founded on the apostles; the convert's baptism was a promise that one day he or she would dwell with the apostles in heaven. Finally, the codices on the altars taught of the sources of their belief, whereas the empty thrones promised the new Christians a place in the heavenly Jerusalem. The art, then, was not merely decorative but, in the words of a modern Orthodox thinker, "theology in color."

The Arian Baptistery, built by the Goths toward the end of the fifth century, is far more severely decorated. Again the traditional scene of Christ's baptism is in the central disk of the ceiling mosaic. Here the figure of the river Jordan has lobsterlike claws sprouting from his head—a curiously pagan marine touch. The twelve apostles in the lower register are divided into two groups: one led by Peter and the other by Paul. These two groups converge at a throne bearing a jeweled cross (the crucifix with the body of Christ on the cross is uncommon in this period) that represents in a single symbol the passion (that is, the events and suffering of Jesus during the hours prior to and during his execution) and the resurrection of Christ.

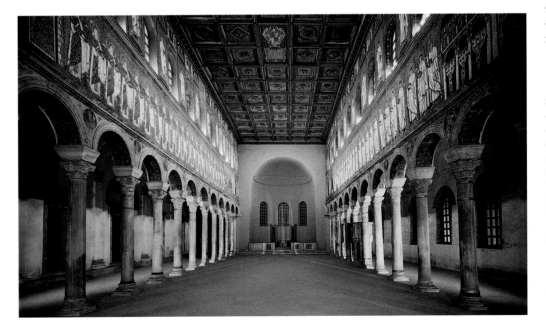

◀ **7.8 Church of Sant'Apollinare Nuovo, ca. 493–526. Ravenna, Italy.** There are three registers of mosaics above the arched colonnades, showing Hebrew prophets and scenes from the life of Christ. The church was originally dedicated to "our lord Jesus Christ" but was rededicated in the ninth century when the relics of Apollinaris were acquired. Bishop Apollinaris, a second-century apologist for Christianity, had defended his faith in a treatise addressed to Emperor Marcus Aurelius.

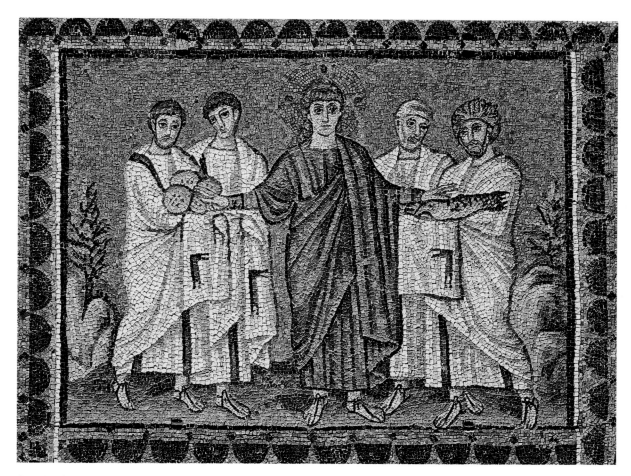

⌃ **7.9** Miracle of the loaves and fishes. Mosaic from the uppermost register of the nave wall, above the clerestory windows, Church of Sant'Apollinare Nuovo, Ravenna, Italy. There is no blue sky, as in Figure 7.6; instead, we have "heavenly" gold.

Sant'Apollinare Nuovo

Theodoric, the king of the Goths who executed Boethius and reigned over all of the Italian Peninsula from 493 to 526, was buried in a massive mausoleum that may still be seen on the outskirts of Ravenna. The cap of the mausoleum is a huge stone that measures 36 feet by 10 feet (11 × 3 m). Aside from this mausoleum, the most famous extant monument of Theodoric's reign is the Church of Sant'Apollinare Nuovo (originally called the Church of the Redeemer), Theodoric's palace church (**Fig. 7.8**). This church is constructed in the severe basilican style: a wide nave with two side aisles partitioned off from the nave by double columns of marble. The apse decorations have been destroyed, but the walls of the basilica, richly ornamented with mosaics, can be seen.

The mosaics are of two different dates and reflect in one building both the Roman and Byzantine styles of art. At the level of the clerestory windows are scenes from the New Testament—the miracles of Christ on one side (**Fig. 7.9**) and scenes from his passion on the other. These mosaics are very different in style from the procession of sainted martyrs on

the lower level. The Gospel sequence is more Roman in inspiration: severe and simple. Certain themes of earlier Roman Christian iconography are evident. The procession of saints, most likely erected by artists from a Constantinople studio, is much more lush, reverent, and static in tone.

San Vitale

The Church of San Vitale most clearly testifies to the presence of Justinian in Ravenna (**Fig. 7.10**). Dedicated by Bishop Maximian in 547, it had been begun by Bishop Ecclesius in 526, the year Justinian came to the throne while the Goths still ruled Ravenna. The Church of San Vitale is octagonal, with only the barest hint of basilican length. The octagon has another octagon within it. This interior octagon, supported by columned arches and containing a second-story women's gallery, is the structural basis for the dome. The dome is supported on the octagonal walls by small vaults called *squinches* that cut across the angles of each part of the octagon.

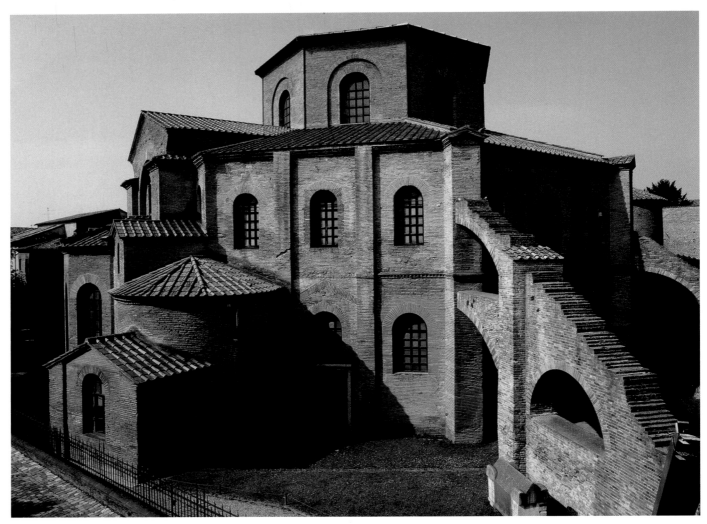

▲ **7.10 Church of San Vitale, ca. 530–548. Ravenna, Italy.** This complex building, the inspiration for Charlemagne's church at Aachen (see Figure 9.12), gives little exterior evidence that it is constructed in the basilica style. The church honors Saint Vitalis, a second century martyr.

The most arresting characteristic of San Vitale, apart from its intricate and not fully understood architectural design, is its stunning program of mosaics. In the apse is a great mosaic of Christ the Pantocrator, the one who sustains all things in his hands (**Fig. 7.11**). He is portrayed as a beardless young man, clothed in royal purple; in his left hand he holds a book with seven seals (a reference to the book of Revelation) and with his right he offers the crown of martyrdom to Saint Vitalis. Flanked by the two archangels Michael and Gabriel, Christ is offered a model of the church by Bishop Ecclesius, who laid its foundations. Above the figures are symbolic representations of the four rivers of paradise.

Mosaics to the left and right of the apse mosaic represent the royal couple as regents of Christ on earth. On the left wall of the sanctuary is a mosaic depicting Justinian and his attendants (**Fig. 7.12**). It is no mere accident or exercise of simple piety that the soldiers carry a shield with the **chi-rho** (the first letters in the Greek name of Christ) or that the figure of the emperor divides clergy and laity. The emperor considered himself the regent of Christ, an attitude summed

up in the iconographic, or symbolic, program: Justinian represents Christ on earth, and his power balances both church and state. The only figure identified in the mosaic is Bishop (later Archbishop) Maximian, flanked by his clergy, who include a deacon with a jeweled gospel and a subdeacon with a chained incense pot.

The figures form a strong friezelike horizontal band that communicates unity. Although they are placed in groups, some slightly in front of the others, the heads present as points in a single line. Thickly lidded eyes stare outward. The heavily draped bodies have no evident substance, as if garments hang on invisible frames, and the physical gestures of the men are unnatural. Space is tentatively suggested by a grassy ground line, but the placement of the figures on this line and within this space is uncertain. The feet seem to hover rather than support, like Colorforms stuck to a tableau background. These characteristics contrast strongly with the Classicism of Early Christian art and point the way toward a manner of representation in which the corporeality of the body is less significant than the soul.

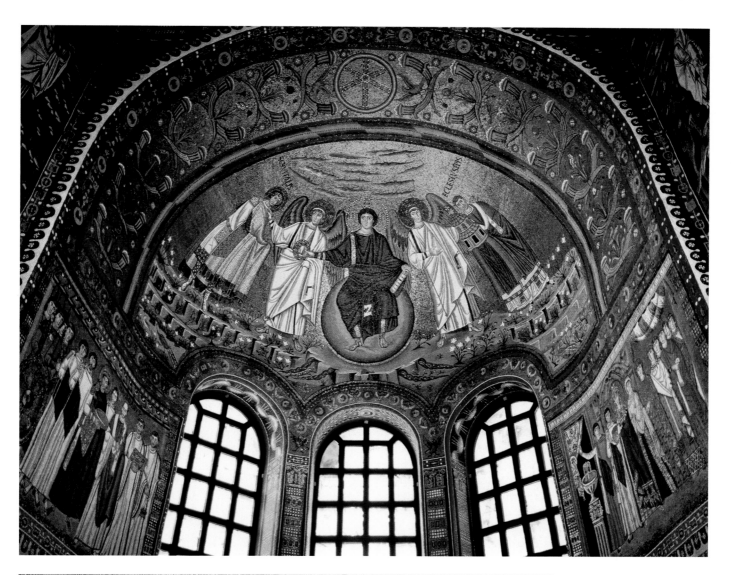

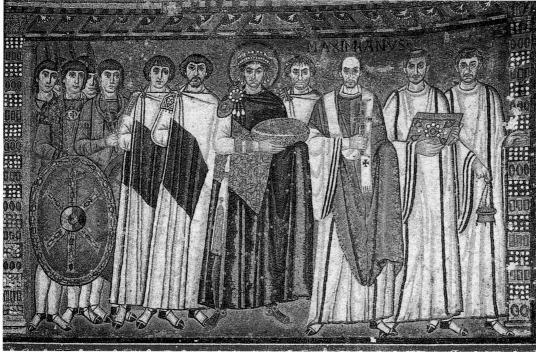

▲ **7.11 Christ enthroned, with Saint Vitalis and Bishop Ecclesius, ca. 530. Ceiling mosaic, Church of San Vitale, Ravenna, Italy.** At the extreme right, the bishop holds a model of the church, while Christ hands the crown of martyrdom to the saint on the left.

◄ **7.12 Emperor Justinian and courtiers, ca. 547. Mosaic, north wall of the apse, Church of San Vitale, Ravenna, Italy.** The church authorities stand at the emperor's left; the civil authorities are at the right. Note the chi-rho on the shield of the soldier.

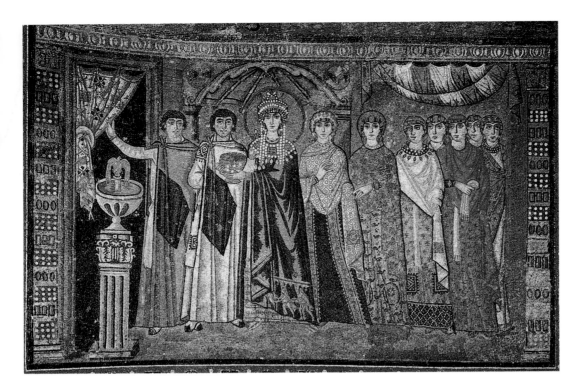

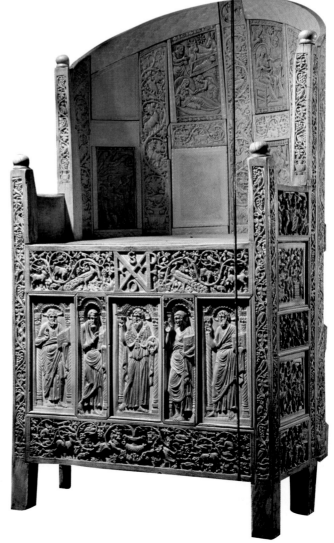

◀ **7.13** Empress Theodora and retinue, ca. 547. Mosaic, south wall of the apse, Church of San Vitale, Ravenna, Italy. Note the Magi on the hem of the empress's gown.

▾ **7.14** Bishop's cathedra ("throne") of Maximian, ca. 546–556. Ivory panels on wood frame, 22″ (55.9 cm) wide × 59″ (150 cm) high. Museo Arcivescovile, Ravenna, Italy. Bishop Maximian (Maximianus) is portrayed in the Justinian mosaic of the Church of San Vitale (Fig. 7.12).

Opposite the emperor's retinue, Empress Theodora and her attendants look across at the imperial group (**Fig. 7.13**). Theodora holds a chalice to complement the *paten* (bread basket) held by the emperor. At the hem of Theodora's gown is a small scene of the Magi bringing gifts to the Christ child. Scholars disagree whether the two mosaics represent the royal couple bringing the Eucharistic gifts for the celebration of the liturgy or the donation of the sacred vessels for the church. It was customary for rulers to give such gifts to the more important churches of their realm. The fact that the empress seems to be leaving her palace (two male functionaries of the court are ushering her out) makes the latter interpretation more probable. The women at Theodora's left are striking; those to the extreme left are stereotyped, but the two closest to the empress appear more individualized, leading some art historians to suggest that they are idealized portraits of two of Theodora's closest friends: the wife and daughter of Belisarius, the conqueror of Ravenna.

MAXIMIAN'S THRONE The royal generosity extended not only to the building and decoration of the Church of San Vitale. An ivory throne, now preserved in the episcopal museum of Ravenna, was a gift from the emperor to Bishop Maximian (**Fig. 7.14**). A close stylistic analysis of the carving on the throne has led scholars to see the work of at least four different artists on the panels, all probably from Constantinople. The front of the throne bears portraits of John the Baptist and the four evangelists, while the back has scenes from the New Testament, with sides showing episodes from the life of Joseph in the Old Testament. The purely decorative elements of trailing vines and animals show the style of

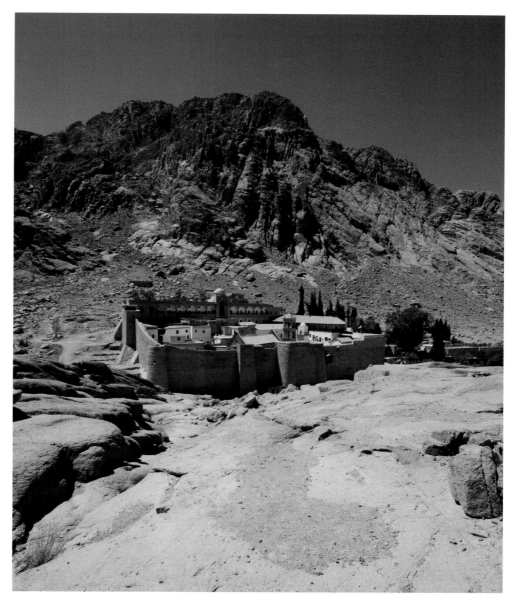

> **7.15 Aerial view of the fortress of Saint Catherine's Monastery, 6th century. Sinai Desert, Egypt.** Constructed by order of Emperor Justinian between 527 and 565 at the foot of Mount Sinai, the fortress surrounds the monastery and its church, which was built over what is thought to be Moses's burning bush. The church can be seen flanked by a bell tower in the lower center of the walled enclosure. The formal name of the monastery is the Monastery of the Transfiguration.

a different hand, probably Syrian. The bishop's throne (*cathedra* in Latin; a cathedral is a church where a bishop presides) bears a small monogram: "Maximian, Bishop." The entire ensemble of San Vitale, with its pierced capitals typical of the Byzantine style, its elaborate mosaic portraits of saints and prophets, its lunette mosaics of Old Testament prefigurements of the Eucharist, and monumental mosaic scenes, is a living testimony to the rich fusion of imperial Roman, Christian, and Middle Eastern cultural impulses. San Vitale is a microcosm of the sociopolitical vision of Byzantium fused with the religious worldview of early Christianity.

Saint Catherine's Monastery at Mount Sinai, Egypt

Justinian is remembered not only in Constantinople and Ravenna but also in the Near East, where he founded a monastery that is still in use some 1500 years later—a living link back to the Byzantine world.

In her *Peregrinatio*, that wonderfully tireless traveler of the fourth century, Etheria, describes a visit to the forbidding Sinai Desert to pray at the site where God appeared to Moses in a burning bush (which, Etheria assures us, "is still alive to this day and throws out shoots") and to climb the mountain where the law was given to Moses. She says that there was a church at the spot of the burning bush, with some hermits living nearby to tend it and see to the needs of pilgrim visitors. More than a century later, Emperor Justinian built a monastery fortress at the foot of Mount Sinai and some pilgrimage chapels on the slopes of the mountain

(**Fig. 7.15**). An Arabic inscription over one of the gates tells the story.

> The pious king Justinian, of the Greek Church, in the expectation of divine assistance and in the hope of divine promises, built the monastery of Mount Sinai and the Church of the Colloquy [a church over the spot where Moses spoke to God in the burning bush] to his eternal memory and that of his wife, Theodora, so that all the earth and all its inhabitants should become the heritage of God; for the Lord is the best of masters. The building was finished in the thirtieth year of his reign and he gave the monastery a superior named Dukhas. This took place in the 6021st year after Adam, the 527th year [by the calendar] of the era of Christ the Savior.

Because of several factors—most important ones being its extreme isolation and the very dry weather—the monastery is an immense repository of ancient Byzantine art and culture. It preserves some of Justinian's architecture and also some of the oldest icons in Christianity. The monastery is also famous as the site of the rediscovery of the earliest Greek **codex** of the New Testament hitherto found. Called the *Codex Sinaiticus*, it was discovered in the monastery by the German scholar Konstantin von Tischendorf in the nineteenth century. The codex, from the middle of the fourth century, was given by the monks to the tsar of Russia. In 1933 the Soviet government sold it for 100,000 pounds to the British Museum, where it remains today—a precious document.

The monastery is surrounded by heavy, fortified walls, the main part of which dates from before Justinian's time. Within those walls are some modern buildings, including a fireproof structure that houses the monastery's library and icon collections. The major church of the monastery dates from the time of Justinian, as recently discovered inscriptions carved into the wooden trusses in the ceiling of the church prove. Even the name of the architect, Stephanos, was uncovered. This church thus is unique: signed sixth-century ecclesiastical architecture.

ICONS One of the more spectacular holdings of the monastery is its vast collection of religious **icons**. Because of the **iconoclastic controversies** of the eighth and ninth centuries in the Byzantine Empire, repealed in 1843, almost no pictorial art remains from the period before the eighth century. Sinai survived the purges of the iconoclasts that engulfed the rest of the Byzantine world because of its extreme isolation. At Sinai, a range of icons (the Greek word *eikōn* means "image") that date from Justinian's time to the modern period can be seen. In a real sense, the icons of the monastery of Saint Catherine show the entire evolution of icon painting.

In the Byzantine Christian tradition, an icon is a painting of a religious figure or a religious scene that is used in the public worship (the liturgy) of the church. Icons are not primarily decorative, and they are didactic only in a secondary sense: for Orthodox Christians, the icon is a window into the world of the sacred. Just as Jesus Christ was in the flesh but imaged God in eternity, so the icon is a thing but permits a glimpse into the timeless world of religious mystery. One stands before the icon and speaks through its image to the reality beyond it. This explains why the figures in an icon are usually portrayed in full front with no shadow or sense of three-dimensionality. The figures "speak" directly and frontally to the viewer against a hieratic background of gold.

This iconic style becomes clear from an examination of an icon of Christ that may well have been sent to the new monastery by Justinian himself (**Fig. 7.16**). The icon is done using the *encaustic* method of painting (a technique common in the Roman world for funerary portraits): painting with molten wax that has been colored by pigments. Christ, looking directly at the viewer, is robed in royal purple; in his left hand he holds a jeweled codex, and with his right hand he blesses the viewer.

This icon is an example from a large number found at Sinai that can be dated from before the 10th century. The entire corpus represents a continuous tradition of Byzantine art and piety. Mount Sinai is unique in its great tradition of historical continuity. Despite the rise of Islam, the harshness of the atmosphere, the vicissitudes of history, and the changing culture of the modern world, the monastery fortress at Sinai is living testimony of a style of life and a religiosity with an unbroken history stretching back to the time of Justinian's building program.

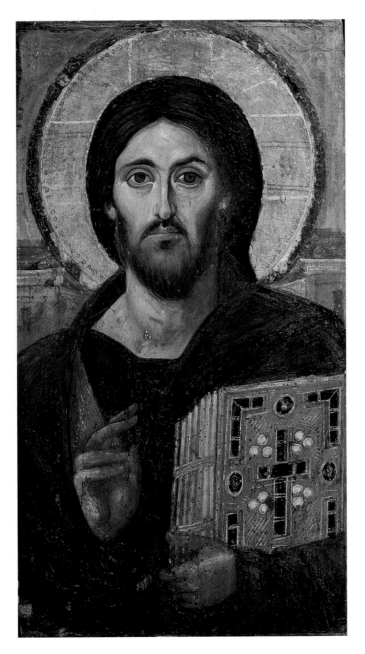

◄ **7.16 Christ Pantocrator, ca. 500–530. Encaustic on wood panel, 32″ × 27″ (84 × 46 cm). Saint Catherine's Monastery, Sinai, Egypt.** The book is a complex symbol of the Bible, Christ as the Word of God, and the record of human secrets that will be opened on the last day.

THE LEGACY OF BYZANTINE CULTURE

It is simplistic to describe Byzantine art as unchanging—it underwent regional, intellectual, social, and iconographic changes—but a person who visits a modern Greek or Russian Orthodox church is struck more by the similarities than by the dissimilarities with the art of early medieval Constantinople. Furthermore, the immediately recognizable Byzantine style can be found in the history of art in areas as geographically diverse as Sicily in southern Italy and the far eastern reaches of Russia. What explains this basic persistence of style and outlook?

Russia

Until it fell to the Turks in 1453, Constantinople exerted an extraordinary cultural influence over the rest of the Eastern Christian world. Russian emissaries sent to Constantinople in the late 10th century to inquire about religion brought back to Russia both favorable reports about Byzantine Christianity and a taste for the Byzantine style of religious art. Services in the Hagia Sophia most impressed the delegates of Prince Vladimir, the first Christian ruler in Russia. Although art in Christian Russia was to develop its own regional variations, it was still closely tied to the art of Constantinople; Russian onion-domed churches, for example, are native adaptations of the central-domed churches of Byzantium.

Russia, in fact, accepted Christianity about 150 years after the ban on icons was lifted in Constantinople in 843. By this time the second golden age of Byzantine art was well under way. In the 11th century, Byzantine artists were working in Russia and had even established schools of icon painting in such centers as Kiev. By the end of the century, these schools had passed into the hands of Russian monks, but their stylistic roots remained the artistic ideas of Byzantium. Even after the Mongol invasions of Russia in 1240, Russian religious art continued to have close ties to the Greek world—although less with Constantinople than with the monastic centers of Mount Athos and Salonika in Greece.

Italy

Byzantine influence was also strong in Italy. We have already seen the influence of Justinian's court on Ravenna. Although northern Italy fell to Lombard rule in the eighth century, Byzantine influence continued in the south of Italy for the next 500 years. During the iconoclastic controversy in the East, many Greek artisans went into exile in Italy, where their work is still to be seen. Even while the kingdom of Sicily was under Norman rule in the 12th century, Byzantine artisans were still active, as the great mosaics of Monreale, Cefalù, and Palermo testify. In northern Italy, especially in Venice, the trade routes to the east and the effects of the Crusades permitted a strong presence of Byzantine art, as the mosaics of the San Marco Basilica and the cathedral on the nearby island of Torcello

attest (as well as Byzantine art looted when the crusaders entered Constantinople in 1204). We shall see in later chapters the impact of this artistic presence on panel painting in Italy. Until the revolutionary changes by Cimabue and Giotto at the end of the 13th century, the pervasive influence of this style was so great that Italian painting up to that time is often characterized as Italo-Byzantine.

Byzantine Art

There is another reason that Byzantine aesthetics seem so changeless over the centuries. From the time of Justinian (and even more so after controversies of the eighth and ninth centuries), Byzantine art was intimately tied to the theology and liturgical practices of the Orthodox Church. The use of icons, for example, is not merely a pious practice but a deep-rooted part of the faith, celebrated annually by the Feast of the Triumph of Orthodoxy.

Art, then, is tied to theological doctrine and liturgical practice. Because of the innate conservatism of the theological tradition, innovation either in theology or in art was discouraged. The ideal of the artists was not to try something new but to infuse their work with a spirit of deep spirituality and unwavering reverence. This art, while extremely conservative, was never stagnant. The artists strove for fidelity to the past as their aesthetic criterion. As the art historian André Grabar has noted, "Their role can be compared to that of musical performers in our day, who do not feel that their importance is diminished by the fact that they limit their talent to the interpretation of other people's work, since each interpretation contains original nuances."

This attitude of theological conservatism and aesthetic stability helps explain why, for example, the art of icon painting is considered a holy occupation in the Eastern Orthodox Church. Today, when a new Orthodox church is built, the congregation may commission from a monk or icon painter the necessary icons for the interior of the church. The modern scholars who went on expeditions to Saint Catherine's Monastery to study the treasures there recall the sadness they felt at the funeral of a monk, Father Demetrios, in 1958. The last icon painter in the monastery, he marked the end of a tradition that stretched back nearly 1500 years.

Travelers to Mount Athos in Greece can visit (with some difficulty) the small monastic communities (*sketes*) on the south of the Peninsula of Athos, where monastic icon painters still work at their art. There has been a renaissance of the appreciation of this style of painting. In Greece there has been a modern attempt to purge icon painting of Western influences (especially those of the Renaissance and the Baroque periods) in order to recover a more authentic link with the great Byzantine tradition of the past. In Russia there has been a surge of interest in the treasures of past religious art. This has resulted in careful conservation of the icons in Russia, exhibits of the art in the museums of Russia and abroad, and an intense scholarly study of this heritage as well as a revival of interest in the Orthodox Church.

The Literary, Philosophical, and Theological Aspects of Byzantine Culture

Byzantine culture was not confined to artistic concerns. We have already seen that Justinian made an important contribution to legal studies. Constantinople also had a literary, philosophical, and theological culture. Although Justinian closed the pagan academies, later Byzantine emperors encouraged humanistic and theological studies. Even though the links between Constantinople and the West were strained over the centuries, they did remain intact. At first a good deal of Greek learning came into the West (after having been lost in the early Middle Ages) through the agency of Arabic sources. The philosophical writings of Aristotle became available to Westerners in the late 12th and early 13th centuries in the form of Latin or Arabic translations of the Greek: Aristotle came to the University of Paris from the Muslim centers of learning in Spain and northern Africa Even in the 14th century, Petrarch and Boccaccio had a difficult time finding anyone to teach them Greek; the language was not yet widely known in the West. By the 15th century this situation had changed. One factor contributing to the Renaissance love for the classics was the presence in Italy of Greek-speaking scholars from Constantinople.

The importance of this reinfusion of Greek culture can be seen easily enough by looking at the great libraries of 15th-century Italy. Of the nearly 4000 books listed in a catalog of the Vatican library in 1484, 1000 were in Greek, most of them from Constantinople. The core of the great library of the San Marco Basilica in Venice was Cardinal Bessarion's collection of Greek books, brought from the East when he went to the Council of Ferrara–Florence in 1438 to discuss the union of the Greek and Latin churches. Bessarion brought with him, in addition to his books, the noted Platonic scholar Gemistus Plethon, who lectured on Platonic philosophy for the delighted Florentines. This event prompted Cosimo de' Medici to subsidize the collection, translation, and study of Plato's philosophy under the direction of Marsilio Ficino. Ficino's Platonic Academy, supported by Medici money, became a rallying point for the study of philosophical ideas.

The fall of Constantinople to the Turks in 1453 brought a flood of émigré Greek scholars to the West, in particular to Italy. The presence of these scholars enhanced the already considerable interest in Greek studies. Greek refugee scholars soon held chairs at the various **studia** ("schools") of the leading Italian cities. These scholars taught language, edited texts, wrote commentaries, and fostered an interest not only in Greek pagan learning but also in the literature of the Greek fathers of the church. By the end of the 15th century, the famous Aldine Press in Venice was publishing a whole series of Greek classics to meet the great demand for such works. This new source of learning and scholarship spread rapidly throughout Western Europe, so that by the early 16th century the study of Greek was an ordinary but central part of both humanistic and theological education.

The cultural worldview of Justinian's Constantinople is preserved directly in the conservative traditionalism of Orthodox religious art and indirectly in Constantinople's gift of Greek learning to Europe during the Renaissance. Although the seat of power of the Byzantine Empire ended in the 15th century, its cultural offshoots remain very much with us.

GLOSSARY

Arian Christians (p. 229) Christians who believe that Jesus was a person created by, and separate and distinct from, God the Father.

Arian controversy (p. 217) The dispute as to whether Jesus was divine and unified with God the Father and the Holy Spirit (the Orthodox Christian view), or whether Jesus, as the created Son, was distinct from the eternal God the Father (the view held by Arius).

Chi-rho (p. 232) A symbol for Christ, consisting of the first two letters of the Greek word *christos*.

Codex (p. 236) Manuscript pages held together by stitching; an early form of a book.

Doctor of the church (p. 218) A title given by the Roman Catholic Church to 33 eminent saints, including Augustine, who distinguished themselves by soundly developing and explaining church doctrine.

Icon (p. 236) An image or symbol.

Iconoclastic controversy (p. 236) The dispute as to whether or not it was blasphemous to use images or icons in art, based on the second of the Ten Commandments, in which God forbids the creation and worship of "graven images" the Greek word *iconoclasm* translates as "image breaking" and refers to the destruction of religious icons within a culture.

Latin fathers (p. 218) The early and influential theologians of Christianity.

Liturgy (p. 226) The arrangement of the elements or parts of a religious service.

Orthodox Christians (p. 229) Christians who believe in the divinity of Christ and the unity of Jesus, God the Father, and the Holy Spirit.

Pendentive (p. 225) A triangular section of vaulting between the rim of a dome and each adjacent pair of the arches that support it.

Studia (p. 238) Schools.

Votive chapel (p. 229) A chapel that is consecrated or dedicated to a certain purpose.

THE BIG PICTURE THE FLOWERING OF CHRISTIANITY

Language and Literature

- Saint Ambrose, bishop of Milan and a Latin father of the church, wrote theological treatises such as *On Faith*, letters, and a collection of hymns ca. the 380s.
- Saint Jerome, another father of the church, translated the Bible into Latin in 386.
- Saint Augustine of Hippo, another father of the church, wrote his *Confessions*, recounting his early unchaste years and his conversion to Christianity.
- As the Roman Empire in the West was declining, Saint Augustine wrote *The City of God*—about an eternal city to be contrasted with the city of man.
- Procopius wrote the *History of the Wars*, *The Buildings*, and a *Secret History* of the reign of Justinian (ca. 550–562).

Art, Architecture, and Music

- Byzantine music developed in the Eastern Roman Empire (Byzantium).
- Saint Ambrose began the use of hymns in church services.
- Mosaics, including one of Christ as the Good Shepherd, were created at the Mausoleum of Galla Placidia in Ravenna, which had become the capital of the Roman Empire in the West.
- A dome mosaic with floral designs, the apostles, and a depiction of the baptism of Christ was created in the Bapistery of the Orthodox at Ravenna.
- The Church of Sant'Apollinare Nuovo was constructed in Ravenna, with a wide nave and side aisles partitioned off by double columns of marble.
- The octagonal Church of San Vitale, which was later adorned with its mosaic of Christ the Pantocrator, was constructed in Ravenna.
- The monastery at Mount Sinai was founded by Justinian; Saint Catherine's preserves Justinian's architecture and some of the oldest Christian icons.
- The Hagia Sophia, combining the longitudinal shape of the Roman basilica with a domed central plan, was constructed in Constantinople.
- Emperor Justinian of Byzantium gave an ivory throne to Archbishop Maximian.
- Gregorian chant was established at Rome during the papacy of Gregory the Great.
- During the iconoclastic controversy (740–843), the creation of religious imagery was banned, based on an interpretation of the second commandment that prohibited the creation and worship of "graven images."
- Following the Islamic Turskish capture of Constantinople in 1453, the Hagia Sophia was converted into a mosque.

Philosophy and Religion

- The Apostle Paul, bearer of Christian messages throughout the Mediterranean, was martyred at Rome ca. 67 CE.
- Christians were persecuted under Decius ca. 250.
- The final but extreme persecution of Christians occurred ca. 303, under Diocletian.
- The Edict of Milan granted Christians (and other peoples throughout the Byzantine Empire) religious freedom in 313.
- The Council of Nicaea, convened by Constantine, proclaimed in 325 that Jesus was divine, equal to, and unified with God the Father and the Holy Spirit.
- Saint Ambrose supported the idea of the virginity of Mary and her importance as the Mother of God.
- Saint Augustine proclaimed that all humans inherit the original sin of eating the forbidden fruit and are depraved—capable of being saved solely by Jesus.
- Christianity became the state religion in 381, unifying church and state.
- Boethius wrote *Consolation of Philosophy* ca. 522–524 while awaiting his probable execution in a prison cell.

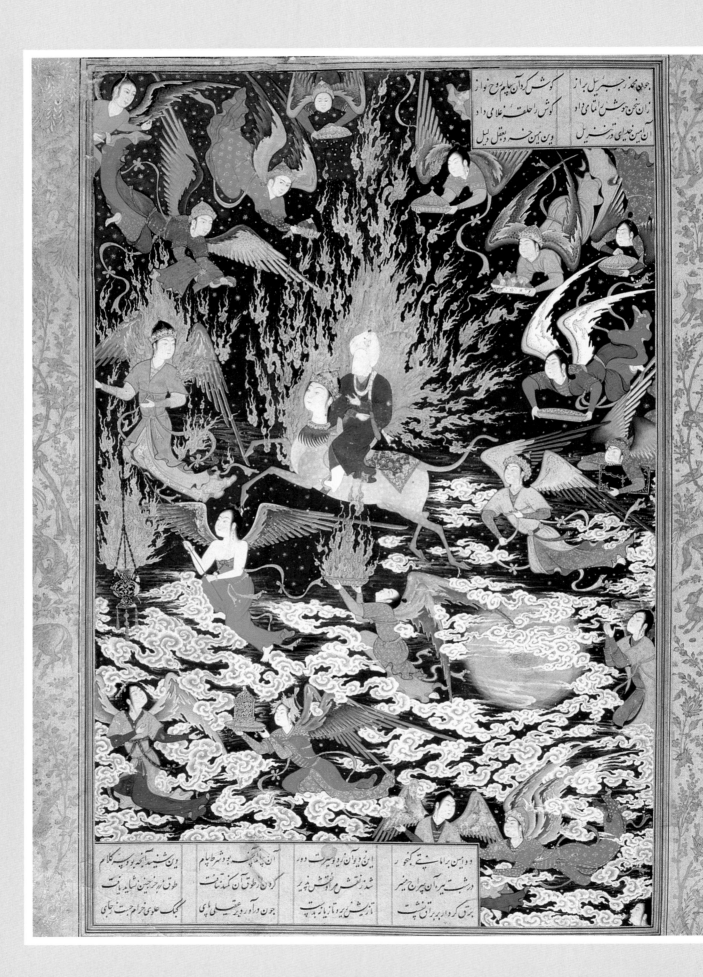

Islam

PREVIEW

Five times a day, from minarets all over the world, a call goes out to the followers of the prophet Muhammad to uphold the Second Pillar of the Islamic faith—to recite the *salah*, the ritual prayer. Between first light and sunrise, after the sun has passed the middle of the sky, between midafternoon and sunset, between sunset and the last light of day, and between darkness and midnight, practicing Muslims, wherever they may be—in a mosque, an airport, or a corporate office—pause in the course of everyday life to unfurl their prayer mats, prostrate themselves, and pray in the direction of Mecca, directly to the one God, called *Allah* in Arabic.

Salah has its origins in the texts of the *Qur'an*—the word of Allah as given directly to his prophet Muhammad—and *Hadith*, the repository of writings about Muhammad's life. Allah gave instructions for obligatory prayer, according to Islamic tradition, to Muhammad during a physical and spiritual journey that took place over a single night in the year 621. The story of the two-part Night Journey—the *Isra* and the *Mi'raj*—is briefly mentioned in a chapter in the Qur'an.

The Night Journey begins with Muhammad at prayer in the Ka'bah—a sacred building in Mecca. There he is visited by the archangel Gabriel (Jibril in Arabic), who brought with him a white, winged steed—Buraq—who flew faster than the wind and whose single stride stretches farther than the eye could see (Fig. 8.1).

Muhammad mounts Buraq and is carried to many places, including the "farthest mosque," the *masjid al-aqsa*, which some Muslims believe is the present-day Al-Aqsa Mosque on the Temple Mount (also the site of two destroyed Hebrew temples) in the Old City of Jerusalem. It is there that Muhammad meets prophets who preceded him—Adam (*Adem* in Arabic), Moses (*Musa* in Arabic) , and Jesus (*Isa* in Arabic) and leads them in prayer. It is on the Temple Mount that the Prophet ascended into heaven from the same rock on which, according to Hebrew tradition, Abraham was about to sacrifice his son Isaac before an angel of God stayed his hand.

In the second part of the Night Journey, Muhammad travels through the seven circles of heaven and once again met earlier prophets. It is in this realm that Allah instructs him regarding the nature and number of obligatory prayers. At first, Allah tells him that believers must worship 50 times each day, but on the advice of Moses, Muhammad beseeched God to reduce the number so that the obligation might be more manageable. After some negotiation, Allah finally assented to five times a day, the pattern for prayer that Muslims follow to this day.

◄ 8.1 "Muhammad's ascent into heaven on Buraq, guided by Gabriel and escorted by angels, during his Night Journey," 1539–43, Iran. Folio 195 recto, illuminated miniature, from Nizami's Khamsa (Five Poems). British Library, London, United Kingdom.

"THE LAMPS ARE DIFFERENT, BUT THE LIGHT IS THE SAME"

"The lamps are different, but the Light is the same: it comes from Beyond."

—FROM "THE ONE TRUE LIGHT," JALAL AL-DIN RUMI

When the Sufi mystic and poet Rumi was writing in the 1200s CE, Islam was in its golden age, Christianity was in the High Middle Ages, and it had been more than two millennia since the Hebrews drafted the tenets of their faith after, according to their belief, Moses received the Ten Commandments at Mount Sinai. Judaism, Christianity, and Islam—three "lamps" representing three of the world's most influential religions—have things in common: their "light" comes from a single God, and all are built on the belief in divine revelation from beyond. Jews believe that God, whom the ancient Hebrews called Yahweh, spoke directly to Abraham and to Moses, establishing a covenant with their generations as his chosen people. Christians believe that the same God spoke to Jesus at his baptism, calling him his beloved Son. And Muslims believe that the same God, whom they call **Allah**, revealed their holy book—the **Qur'an**—to the prophet Muhammad. Rumi referred to a single God as "the kernel of Existence" but acknowledged the perspectives of many religions.

MUHAMMAD AND THE BIRTH OF ISLAM

Muhammad, the founder of Islam, was born in 570 in the Arabian city of Mecca. Orphaned as a child and reared in poverty, while still young he married a rich widow who would bear him a daughter, Fatima. Fatima would later marry the first imam (authoritative religious leader) of the Shiites. An ancestor of followers of Islam, Fatima is highly venerated by Muslims as a model of piety and purity. Muhammad's deep religious nature led him to ponder the reasons for his good fortune, and he began to retreat into caves in the neighboring mountains to meditate. Muslims believe that at about the age of 40, he began receiving revelations from God through the agency of the angel Gabriel. When he began to speak publicly about his ideas of religious reform, Muhammad soon encountered severe opposition from the citizens of Mecca, who had little patience with his sermons against the city's polytheism and idolatry and his insistence on the worship of one god.

As Muhammad preached and the numbers of his followers grew, a number of them were tortured and killed. A slave named Sumayya bint Khubbat, considered Islam's first martyr, was killed by her master when she refused to renounce her faith. People kicked stones at Muhammad when he was praying, and it is said that he ran away with bleeding feet. The antagonism between Muhammad and local clansmen became so great that Muhammad had to flee the city to a desert oasis—now called Medina ("City of the Prophet")—in 622 CE. This date marks the beginning of Islam and the first year in the Islamic calendar.

Muhammad returned to Mecca in 630 CE, eight years later, with several thousand soldiers. He defeated the polytheists, converted the population to Islam, removed the idols of Arabian tribal gods that were housed in a small cubical building—called the **Ka'bah**, or "cube" in Arabic—and rededicated it as an Islamic house of worship. On pilgrimages to Mecca today, Muslims circle the Ka'bah, which is the spiritual center of their world (see **Fig. 8.4**). From this beginning, Islam has grown to be the world's second largest religion, after Christianity, with nearly one and a half billion adherents. Islam today stretches from communities in Europe throughout North Africa, the Middle East, much of South Asia, and Indonesia. Muslims once swept into and took con-

Islam

570 CE	632 CE	1099 CE	1258 CE	1492 CE
Muhammad born in Mecca in 570	Muslims capture Jerusalem in 638	Christian Crusaders capture Jerusalem in 1099	Mongols sack Baghdad in 1258, ending Abbasid Caliphate	
Spread of Islam to Arabia, Egypt, Iraq, Northern Africa, and southern Spain	The Umayyad Caliphate r. 661–750	Saladin, the Sultan of Egypt, retakes Jerusalem in 1187	Ottoman Empire is founded in 1281	
Muhammad flees to Medina in 622—an event called "the Hejira"; 622 CE becomes Year 1 in the Islamic calendar	Charles Martel stems Muslim expansion at Tours, France, in 732	The Third Crusade pits Richard the Lion-hearted against Saladin in 1189	Constantinople falls to the Ottoman Turks in 1453, ending the Byzantine Empire	
Muhammad captures Mecca in 630	The Abbasid Caliphate begins in 750	Richard and Saladin agree to a truce in 1192	Muslims are driven from Spain in the "Reconquista" in 1492	
Muhammad dies in 632				

VALUES

The Five Pillars of Islam

The fundamental principle of the faith of Islam is a bedrock **monotheism** (the word *Islam* means "submission [to God]"). This belief was a conscious rejection of not only the polytheism that Muhammad found throughout the Arabian peninsula, but also of the Christian doctrine of the Trinity of persons in God. Muhammad articulated the so-called Five Pillars—the core values—of Islam:

- Recitation of the Muslim act of faith that there is one God and that Muhammad is his messenger.
- The obligation to pray five times a day in a direction that points to the Ka'bah in Mecca. Soon there was added the obligation to participate in Friday prayers as a community and hear a sermon.
- Donation of a portion of the surplus of one's wealth to charity.
- Observance of a fast during the holy month of **Ramadan**—abstinence from all food and drink from sunrise to sunset.

- The duty to make a pilgrimage to Mecca (called a hajj) at least once in a lifetime.

That latter obligation was performed by Muhammad around the purified and restored Ka'bah in 632, which was the same year he died in the arms of his wife. The pilgrimage to Mecca today draws millions of Muslims.

In addition to these core practices, there are other characteristic practices of Islam: Like Jews, Muslims do not eat pork products. Unlike Jews and Christians, Muslims are forbidden to consume alcoholic beverages. Again as with Jews, Muslim males are circumcised. Polygamy is permitted under Islamic law but not practiced universally. The taking of interest on loans or lending for interest (usury) is forbidden by Islamic law, as it was at one point by Christian law. (Today both Christian nations and most Islamic nations participate in international banking systems.) Over the course of time, a cycle of feast days and observances developed (for example, the birthday of the Prophet).

trol of the Iberian Peninsula, but were eventually pushed back by Christians. In the Middle Ages, Christians also fought Muslims to reclaim the "Holy Land," which is now Israel and the Palestinian Territories.

The word *Islam* means "submission"—surrender of the self to the will of Allah. A follower of Islam is called a Muslim, an etymologically related word meaning "one who has submitted to Allah." Muslims believe that their holy book, the Qur'an (also spelled *Koran* in English), was revealed to Muhammad by the angel Gabriel. The Qur'an and Muhammad's life, words, and deeds, as recorded in the *Sunnah* and **Hadith**, constitute the basic texts of Islam. Muslims worship God directly, without any hierarchy of rabbis, priests, pastors, or saints. In Islam, there is unity of church and state; the state is to be ruled by Islamic law, or **Shariah**, as revealed in the basic texts. The proper ruler is both a religious and secular leader, a successor to Muhammad known as a **caliph**.

Islam, like Judaism, has an unbending teaching about the oneness of God; the Islamic statement of faith begins, "There is but One God, Allah. . . ." To grasp this belief in radical monotheism is to understand a whole variety of issues connected to Islam. The revelation of Allah is seen as final and definitive; Islam sees the reality of God beyond the revelation of the God of the Jewish scriptures and is explicitly resistant to the Trinitarian faith of Christianity. Jesus is honored as a prophet, but the idea of Jesus as divine is denied in the pages of the Qur'an. Islamic society usually refers to

an individual as a person's son to clarify paternity; and the Christian Gospels describe Jesus as the Son of God to solidify his place in the Trinity. However, the Qur'an repeatedly refers to Jesus as the son of Mary, reinforcing Mary's particular importance in the history of the Abrahamic religions and at the same time denying that Jesus is the son of God. In this way, Muslims see the revelations to Muhammad as returning the monotheism of Moses back from the Trinity to its original meaning.

Consider verse 116 of the fifth **sura** (chapter) of the Qur'an:

And when Allah saith: O Jesus, Son of Mary! Didst thou say unto mankind: Take me and my mother for two gods beside Allah? He [Jesus] saith: Be glorified! It was not mine to utter that to which I had no right. If I used to say it, then Thou knewest it. Thou knowest what is in my mind, and I know not what is in Thy mind. Lo! Thou, only Thou are the knower of things hidden.

Just as Christian scholars, Muslim scholars have debated theological issues such as whether the attributes of God, or Allah, allow for free will. A close reading of the Qur'an suggests that people are probably seen as having free will, because Allah is repeatedly warning them to choose not to engage in wrongdoing or evil.

Islam, like Christianity, has a tradition of missionary expansion. The omnipotent will of God is for all humanity to

Journeys of Faith

The journey to sites deemed holy by followers of the three Abrahamic religions—Judaism, Christianity, and Islam—can be traced to the earliest years of each faith. The practice of such journeying—of the pilgrimage—takes its name from the Latin word peregrinatio meaning a trip undertaken by a traveler over a long distance. The earliest religious pilgrims traversed extraordinary distances to visit spiritual touchstones and, in some cases, to bring back relics or mementos that would continue their connection to the sites and the protections of the holy figures associated with them.

The holiest site in the Judaic faith was the Temple in Jerusalem where the Ark of the Covenant (the Tablets of Stone with the Ten Commandments) had been housed; Jews were obligated to worship there once a year. Today pilgrims of the Jewish faith and others visit the remnants of a wall that Jews believe surrounded the courtyard of the Second Temple, built in Jerusalem around 19 BCE. The Western Wall, in Hebrew the Kotel, is also referred to as the Wailing Wall, based on the Arabic description of the wall as el-Makba—the "Place of Weeping." Pilgrims pray at the site (Fig. 8.2) and some press small pieces of paper inscribed with prayers or petitions into the cracks between the stones. In a curious adaptation to the times in which we live, "virtual pilgrims" can use the Twitter social networking service to "tweet" their prayers to the Western Wall, which are then printed out and placed between the stones.

Jerusalem also became a pilgrimage destination for Christians as early as the second century CE, when followers began to visit sites such as the Holy Sepulcher (see Fig. 6.13) where they believed Jesus was buried. Beginning during the reign of Constantine, other sanctuaries were built in Jerusalem and throughout Palestine that eventually become points of interest on the pilgrim's map. In the towns in which the sanctuaries were located (such as Bethlehem, the birthplace of Jesus according to

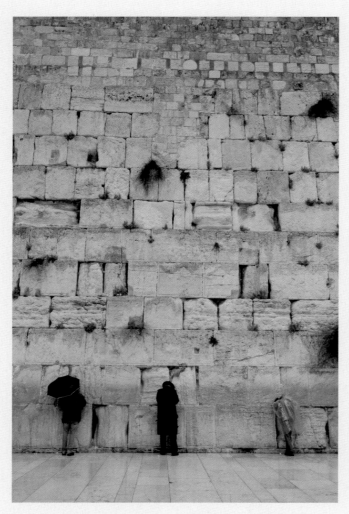

▲ 8.2 Wailing Wall, 19 BCE–mid-1st century CE. Limestone retaining wall on the western side of Temple Mount, entire wall 1600′ (488 m) long, exposed height 62′ (19 m). Jerusalem, Israel.

▲ 8.3 Cathedral of Santiago de Compostela , 1075-1211. Western facade (Obradoiro Square), 1738-1750, architect Fernando Casas y Nóvoa. Granite. Santiago de Compostela, Spain.

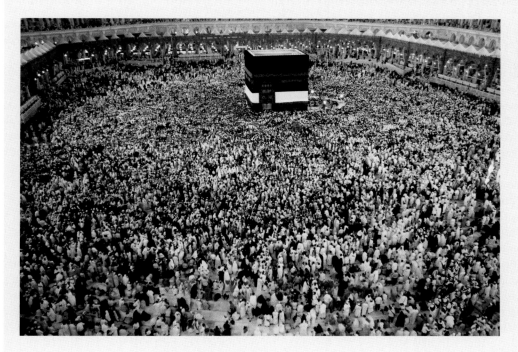

◄ **8.4** **Muslim pilgrims circumnavigating the Ka'bah during a hajj (pilgrimage). Mecca, Saudi Arabia.** Pious pilgrims believe they can see the footprints of Abraham upon the stone. Near the Ka'bah is the tomb of Ishmael, from whom Muslims trace their descent. Muslims believe that heaven is directly above the Ka'bah.

Christians), places for worship were constructed and many businesses were created to accommodate pilgrims.

The most famous Christian pilgrimage route in Europe honors Saint James, an apostle of Jesus who, it is believed, left Palestine to spread the Christian faith in Galicia in northwestern Spain. His martyred remains were believed to be buried on the site of what is now the city of Santiago de Compostela. The pilgrimage is over 1000 years old and still attracts pilgrims who traverse different routes to the shrine. Every year on July 25th—Saint James's Day—Santiago de Compostela holds an outsized festival that includes pyrotechnic displays and concerts. When July 25th falls on a Sunday, a Holy Year is declared and pilgrims are welcomed with parties, parades, and pop music. (Past jubilee years have featured performers such as David Bowie, Bob Dylan, Bruce Springsteen, and The Rolling Stones.) During the jubilee celebrations, churches in the city exhibit rare treasures typically not on view and a massive incense burner is lifted by a group of priests during masses. Pilgrims to the Cathedral of Saint James (**Fig. 8.3**) who are marking the end of a 60-mile journey enter the church through the Door of Pardon, kiss the silver statue of Saint James behind the high altar, and are absolved of sin.

Santiago de Compostela was named a U.N.E.S.C.O. World Heritage Site in 1985 but it is only recently (2012) that the Friday mosque—the Masjed-e Jame' of Isfahan was so designated. This important monument is seen as a prototype for later mosques in Central Asia, adapting the courtyard layout of secular palaces to Islamic religious architecture; this plan can also be seen in the Umayyad Mosque of Damascus (see **Fig. 8.7**), a World Heritage Site connected to Islamic pilgrimages.

The most sacred journey in the Islamic faith, however, is the pilgrimage to Mecca in Saudi Arabia—the Hajj. One of the Five Pillars of Islam, it is each Muslim's duty to undertake the pilgrimage at least one time in their life if health and finances permit. The destination is connected with the Prophet Muhammad, but in fact, the tradition of pilgrimage to Mecca goes back to ancient times, perhaps even to the time of Abraham. Muhammad himself performed the Hajj, leading his followers to Mecca from Medina in 631 CE. The pilgrimage is held once a year in the 12th month of the Islamic calendar from the 8th to the 12th day.

Today's Muslim pilgrims—hundreds of thousands strong—engage in traditional preparations and rituals associated with the Hajj. All male pilgrims don the Ihram, a white garment of unhemmed cloth secured by a sash, and wear sandals. Women wear the hijab, a veil or scarf that covers the head, but are not permitted to cover their faces. These stipulations, among others, are intended to create oneness before Allah, with no one Muslim different from or above another. The pilgrims converge on Mecca from all points and distances to the Ka'bah, a black, cube-shaped shrine in the center of the Great Mosque. It is in the direction of this sacred spot that Muslims around the world orient themselves five times a day to pray. During the Hajj, the pilgrim is required to circumambulate (walk around) the Ka'bah seven times and to touch or kiss its stone surfaces (**Fig. 8.4**). With each circuit, the takbir or Islamic phrase, "God is Great" is recited. The sacred pilgrimage to Mecca reinforces the bonds of the Muslim community of believers and demonstrates the practice of Islam—submission to God as individual's submission to God and to Muhammad as His chief and last prophet.

submit to him; if people are not aware of that fact, they are not living according to his will. Hence, the devout are encouraged to teach people this fundamental truth.

Sunni, Shia, Sufi

Islam was beset by internal strife almost from its beginning. The Muslim denominations of Sunni and Shia were born from this dissension. **Sunnis**, whose name means "tradition" or "well-trodden path," believe that Muhammad's rightful successor was the father of his wife, Abu Bakr, and that the Qur'an endorses the selection of caliphs according to the consensus of the Muslim community (also called the **ummah**). The lands and peoples ruled by the caliph are called the *caliphate*. At first, only members of Muhammad's tribe were eligible to become caliphs, but then the ummah allowed for the choice of any qualified leader. Both Sunnis and Shia believe that some day the **Mahdi**, the redeemer of Islam, will come. Some believe that the Mahdi will rule for several years before the Day of Judgment to rid the world of error and injustice.

Shia believe that Muhammad, as commanded by Allah, ordained his son-in-law, Ali, as the next caliph, and that legitimate successors must be drawn from the descendants of Muhammad and Ali. Shia believe that Ali, like Muhammad, had special spiritual qualities. Muhammad and Ali are imams—without sin and capable of interpreting the Qur'an. So-called Twelvers believe that the Mahdi will be the twelfth imam, that he exists but is hidden by Allah for the time being. Shia maintain the interesting Muslim practice of "temporary marriage," which permits people to express affection without a permanent commitment.

Some 85–90 percent of Muslims are Sunnis, and 10–15 percent are Shia. Sunnis comprise the majority of Muslims in most countries with large Muslim populations throughout the Arab world, Asia, and Africa. Shia are in the majority in Iran, Iraq, Azerbaijan, Bahrain, and Lebanon. The first Islamic religious civil war occurred in 657 CE; Sunni–Shia violence continues today with attacks by each group on the other's holy sites and people.

Sufism is the inner, mystical dimension of Islam. Sufis may be either Sunnis or Shia, and their quest is to purify the inner self and turn away from all but Allah. All Muslims believe that if they live justly they will become close to Allah in paradise, but Sufis believe that it is possible to draw closer to Allah on earth by arriving at a mystical state in which one's sole motivation is love of Allah.

THE GROWTH OF ISLAM

The simplicity of the original Islamic teaching—its emphasis on submission to the will of the one God, insistence on daily prayer, appeal for charity, and demand for some asceticism in life—all help explain the phenomenal and rapid spread of this new religion coming out of the deserts of Arabia. In less than 10 years after the death of the Prophet, Islam had spread to all of Arabia, Egypt, Syria, Iraq, and parts of North Africa (see **Map 8.1**). A generation after the Prophet's death, the first (unsuccessful) Muslim attack on Constantinople was launched; within two generations, Muslims constituted a forceful majority in the holy city of Jerusalem. By the eighth century, Islam had spread to all of North Africa (modern-day Libya, Morocco, Tunisia, and Algeria) and had crossed the Mediterranean near Gibraltar with the creation of a kingdom in southern Spain.

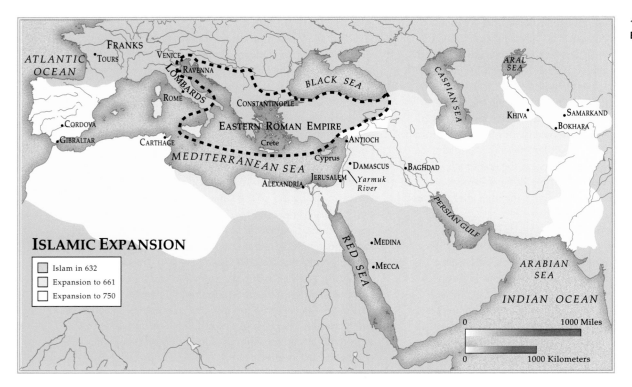

◄ **MAP 8.1** Islamic Expansion

ISLAMIC EXPANSION

- ☐ Islam in 632
- ☐ Expansion to 661
- ☐ Expansion to 750

The Umayyad Caliphate

Following the death of Muhammad in 632 CE, disputes arose over who would succeed him. A series of civil wars and assassinations eventually led to the founding of the Umayyad Caliphate (661–750 CE). At its largest, the caliphate extended Islamic rule north into Persia, east into South Asia (modern-day Afghanistan, Pakistan, and adjacent regions), west across the north of Africa (to present-day Morocco), and, from there, across what is now the Strait of Gibraltar to the Iberian Peninsula (now Portugal and Spain) and the south of present-day France. The Umayyads were overthrown by the Abbasid Caliphate and moved into what is now Spain, where they founded the caliphate of Córdoba, which they ruled until 1031.

Architecture

Islam has a 1500-year history. Its communities are found in every part of the world. In that long history, it has made its buildings suitable to the circumstances in which it finds itself, even though the basic needs of the **mosque** remain fairly constant: a large covered space for the faithful to pray, especially when the community gathers for Friday prayers. Typically the gathering area is covered with rugs; except for the steps leading up to a **minbar** (pulpit), there is no furniture in a mosque.

A niche in the wall called a **mihrab** indicates the direction of Mecca so that the congregation at prayer are accurately oriented. In traditional Friday mosques, there is also usually some type of fountain so that worshippers may ritually cleanse their hands, feet, and mouth before prayer. Adjacent to the mosque is a tower or minaret so that the **muezzin** may call the faithful to prayer five times a day. Visitors to Islamic countries soon become accustomed to the muezzin's predawn call, "Wake up! Wake up! It is better to pray than to sleep."

Although primarily designed to shelter Muslims at prayer, the mosque serves a larger community function in Islam. It is a community gathering center; it is a place where scholars meet to study and debate; courtroom proceedings could be held there; leisurely conversations could be held in its courtyards, and people could escape the heat of the sun in its covered areas. As scholars have noted, the mosque is to Islamic countries what the Roman forum or the precincts of the medieval cathedral or the town square were to other cultures: a gathering place for the community to express itself. The simple requirements for the mosque leave much for the ingenuity and genius of the individual architect to develop. As a result, the history of Islamic architecture provides extraordinary examples of art.

THE DOME OF THE ROCK The Dome of the Rock in Jerusalem is the earliest and one of the most spectacular achievements of Islamic architecture (**Fig. 8.5**), built toward the end

▼ **8.5 The Dome of the Rock, 687–692. Jerusalem, Israel.** The blue decoration in the upper registers is made of tile. The tile work replaces earlier mosaic work that probably was done by Byzantine artisans, who were acknowledged experts in that art.

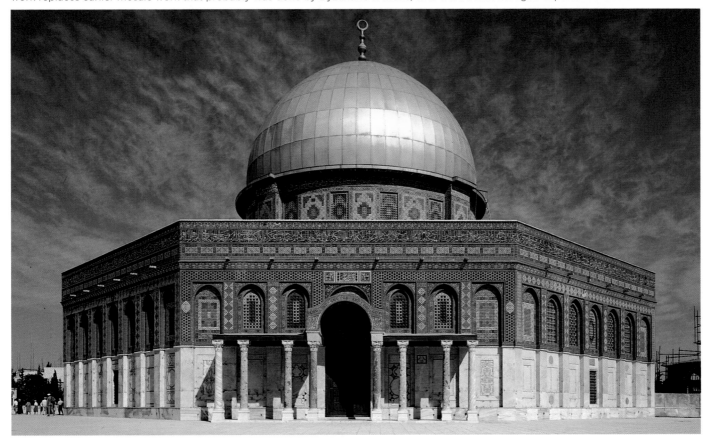

of the seventh century by Caliph Abd al-Malik of Damascus on *al-Haram al-Sharif* ("the Noble Sanctuary"), known by Jews as the Temple Mount, in Jerusalem. It is an elevated space that was once the site of the second Jewish temple, which was destroyed in 70 CE. The Dome of the Rock is an octagonal building capped by a golden dome, which sits on a heavy drum supported by four immense piers and twelve columns. The interior is decorated lavishly with **mosaics**, as was the outside of the building until, in the late Middle Ages, the mosaics were replaced by tiles. The building owes a clear debt to Roman and Byzantine architecture, but the Qur'anic verses on its inside make it clear that it was intended to serve an Islamic function.

The original mosaics decorating the interior of the Dome of the Rock are largely intact (**Fig. 8.6**). The interior contains a still-visible rock outcropping that is of great significance in the Abrahamic tradition. The Dome of the Rock may have been erected to serve as a counterpoint to the Church of the Holy Sepulcher in Jerusalem, acting as a rebuff in stone to Christianity and making the artistic argument (as does the Qur'an itself) that Islam is a worthy successor to both Judaism and Christianity. Scholars do not agree on the building's original purpose (some have even argued that it was built as a rival to the Ka'bah in Mecca), but they are unanimous that it is a splendid example of Islamic architecture.

The rock outcropping itself is believed by many to be the site of Adam's grave. Many Jews, Christians, and Muslims alike believe that this is the rock upon which Abraham was prepared to sacrifice his son, Isaac, although at the last min-

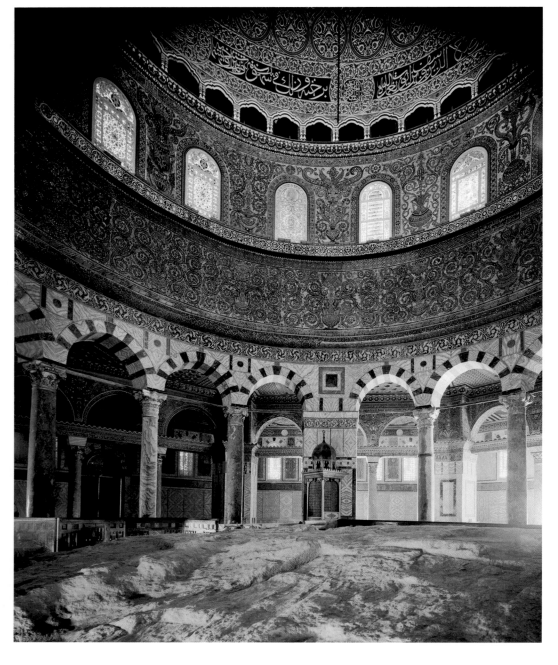

◄ **8.6 The Dome of the Rock (interior), 687–692. Jerusalem, Israel.** The original mosaics inside the dome remain reasonably intact. The rocky outcropping in the center has been believed to be the burial place of Adam, the rock upon which Abraham prepared to sacrifice his son, and, the place from which Muhammad ascended to heaven during his Night Journey.

ute an angel stayed his sword. A ninth-century story speaks of it as the place from which the Prophet traveled to heaven during his Night Journey.

THE GREAT MOSQUE OF DAMASCUS The Ummayad Mosque (**Fig. 8.7**), also known as the Great Mosque of Damascus, was completed in what is now Syria in 715 CE.

The plan reflects standard features of Islamic houses of worship including a large courtyard, entrance dome, minarets and, in the interior, a hypostyle hall, a grand prayer hall with a mihrab, and other essential elements. The aerial view of the Ummayad Mosque also illustrates the influence of Roman and Byzantine styles on Islamic architecture of the period in the pediment, dome, and arcades surrounding the courtyard.

▼ **8.7 The Great Mosque of Damascus, Syria, 706–715 CE.** Worshippers at Friday prayers would spill over from the mosque to gather in the courtyard. The mosque incorporates a former Christian church, details of which (for example, the façade, laterals, and dome) can be detected in the present-day architecture. Congregants use the domed fountain in the courtyard to refresh themselves and to bathe their hands and feet before prayers.

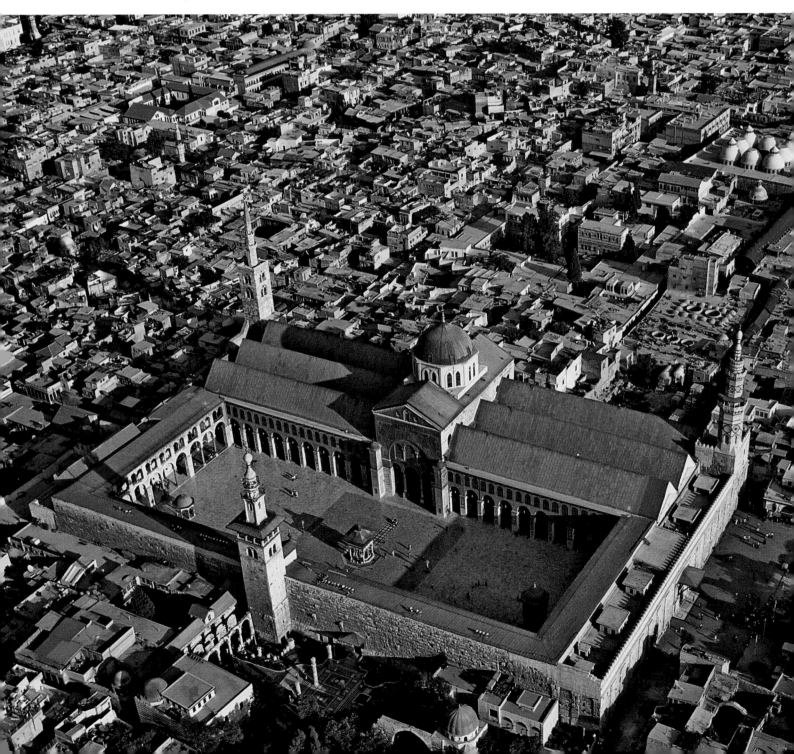

◄ **8.8 Mosaic decoration on the façade of the Great Mosque of Damascus, Syria.** Even though trees and houses are readily detectable in the mosaic, the absence of any human figure is noteworthy. This choice reflects the early Islamic resistance to depicting the human figure.

Mosaic decoration further echoes Roman, Early Christian, and Byzantine models. The main entrance (**Fig. 8.8**) is resplendent in golden glass, leafy trees, and beautiful structures that evoke the image of Paradise described in the Qur'an.

As with the Dome of the Rock, the interior was decorated lavishly, with the lower walls paneled in marble and the upper registers decorated by Byzantine artisans with mosaics, including a depiction of heaven resplendent with palaces and flowing waters. Figure 8.8 shows the mosaic decoration on the exterior of the mosque. The caliph's palace, now gone, was adjacent to the mosque so that the ruler could pass easily from one to the other.

THE MOSQUE AT CÓRDOBA The most highly regarded architectural legacy of the Umayyad Caliphate is the Great Mosque of Córdoba (now called the *Mezquita-Catedral* by the Spanish, which means "mosque-cathedral" in English) in what is now the city of Córdoba in south central Spain. The building originated as a Christian church in about 600 CE. After the Islamic conquest of the region, the church was divided between Christians and Muslims. The Umayyad prince Abd ar-Rahman I purchased the Christian half and began the development in 784 CE of what would become, upon its completion in 987 CE, the Great Mosque of Córdoba. The interior (**Fig. 8.9**) shows the system of arches that spans

▽ **8.9** **The hypostyle prayer hall of the Great Mosque of Córdoba, Spain, 8th–10th century** CE.
Córdoba was the Spanish capital of the Umayyad Caliphate. The horseshoe-shaped arches in the city's Great Mosque are supported by 514 columns.

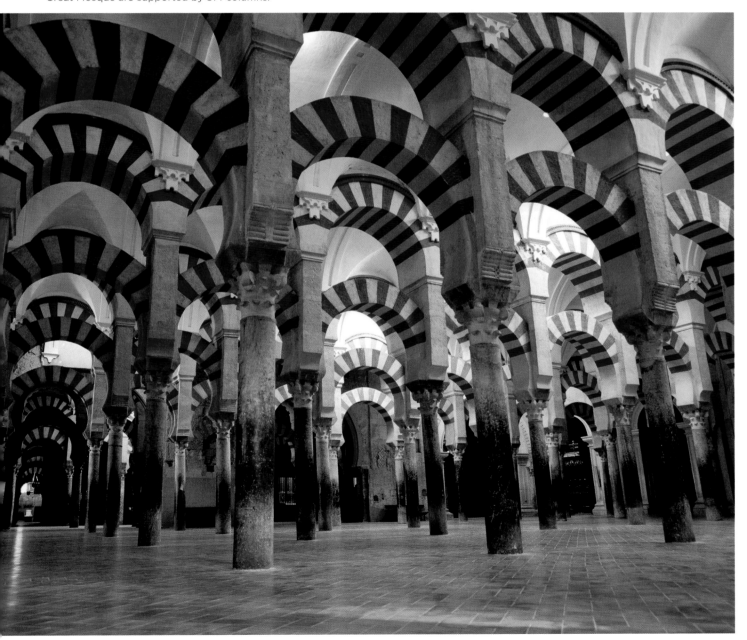

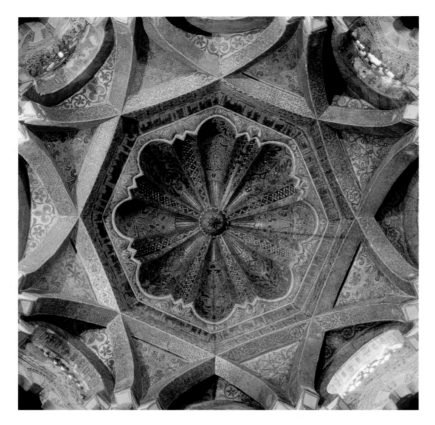

◄ **8.10** **Central dome of the Great Mosque of Córdoba, Spain, mid-10th century.** The decoration of the mosque, done a century after its construction, is elaborate. Contemporary records show that the ruler of Córdoba imported 30,000 mosaic tesserae as well as workmen from Constantinople to execute the lavish decoration. This dome covers the mihrab, which points toward the Ka'bah in Mecca.

The Golden Age of Islam

The time of the Abbasid Caliphate, which succeeded the Umayyads, has been called the Golden Age of Islam. It spanned five centuries, from 750 CE to 1258 CE (when the Mongols invaded and sacked Baghdad). During the Golden Age, citrus fruits were imported from China and rice, cotton, and sugarcane were brought in from India and trained to grow in Islamic lands. A precursor of free markets and capitalism was established. The scientific method was instituted, in which hypotheses are tested through experimentation. Muslim astronomers considered the possibility that the sun was the center of the solar system and that the earth spun on an axis. Algebra and trigonometry were invented. The concepts of inertia and momentum, later adopted by Newton, were discovered. The construction of the Great Mosque of Córdoba was begun.

the distances between columns in the hypostyle system. The hypostyle system enabled expansion in any direction as a congregation grew. By bowing toward Mecca in the same yard, worshippers were granted equal psychological access to Allah. A series of vaults, supported by heavier piers, overspreads the arches. There is no grand open space as in the Western cathedral; rather, air and light flow as through a forest of high-crowned trees.

In the late 10th century, al-Hakam II, the ruler of the city, decided to enhance his mosque to make it a rival to the Great Mosque of Damascus. The interior of the mosque seems to be a vast tangle of columns supporting Roman arches. To enhance the interior, al-Hakam sent emissaries to the emperor in Constantinople with a request for workmen. Contemporary sources state that the emperor complied by sending not only workmen but also roughly 17 tons of **tesserae**. The master mosaic artist, who enjoyed the hospitality of the caliph, decorated the interior of the mosque lavishly, finishing his work, according to an inscription, in 965 (**Fig. 8.10**). The mosque managed to survive the destruction of Islamic buildings when the Christians drove the Muslims out of Spain in 1492—the period known as the *Reconquista*. Within the confines of the mosque, an undistinguished cathedral was begun in 1532; much of its original interior of the mosque still remains today.

THE GREAT MOSQUE OF SAMARRA' During the early part of the golden age, the Great Mosque of Samarra' in present-day Iraq was commissioned by the Abbasid caliph al-Mutawakkil in 848 CE and completed in 851. When built, it was the largest mosque in the world. From the vast spiraling structure for which the mosque is known—the Malwiyah minaret (**Fig. 8.11**)—a muezzin called followers to prayer at certain hours. *Malwiyah* is Arabic for "snail shell." The photograph was taken before the top of the minaret was damaged by insurgents in 2006, during the Iraq War.

Mosques avoid symbols, and early mosques in particular do not show ornamentation. The mosque at Samarra' was a simple building, 800 feet long and 520 feet wide, covered in part by a wooden roof, with a great open courtyard. The roof was supported by the hypostyle system of multiple rows of columns. Hundreds of years ago, the interior walls were paneled with resplendent dark-blue glass mosaics.

THE ALHAMBRA The Alhambra (from the Arabic *al-Hamra*, "the red one"), a fortress and palace, was built by Islamic Moorish rulers in Granada (in modern-day Spain) during the fourteenth century. It sits atop a hill on the edge of

⋀ **8.11 The Malwiyah minaret of the Great Mosque of Samarra', Iraq, 848–852** CE. The immense expanse of the prayer hall is a simple wooden structure. The mosque is renowned for its spiral-shaped minaret.

the city. The Moors were expelled from the Iberian Peninsula at about the same time as Christopher Columbus set sail on his western voyage, and today the Alhambra exhibits a combination of characteristic Islamic architectural elements and a courtyard and fountain—the Court of the Lions (**Fig. 8.12**)—that seem reminiscent of those found in ancient Roman villas. The mild Spanish winters make possible the full integration of

the palace with its environment through a stately progression of intricately carved arched openings.

FRIDAY MOSQUE, ISFAHAN The exterior and interior decorations of the great classical mosques are rendered in an art form that emphasizes the abstract and the geometric, because Muslims believe that one cannot depict

divinity, since Allah is beyond all imagining. It is therefore commonplace to see an intricate blend of abstract geometric designs entwined with exquisitely rendered sacred texts from the Qur'an. Some of the decoration found on the exterior of mosques—like that found decorating the great 17th-century Friday Mosque of Isfahan in Iran—uses blue tiling to set forth intricate patterns of **arabesques** and highly stylized bands of calligraphic renderings of lines from the Qur'an (**Fig. 8.13**).

Although Islamic decoration is usually abstract, it is not exclusively so. Some mosques do in fact have representational scenes in the interior. These usually depict nonhuman images of plants and flowers executed mainly in mosaic—especially when the skills of Byzantine mosaic artists were available to do such work.

THE CONVERSION OF THE HAGIA SOPHIA

The Golden Age was brought to an end by the Mongol invasion, but the Mongols who remained in Islamic lands converted to Islam over the following century, as did Turks, who had also come in from the east. The Ottoman Empire emerged in the 13th and 14th centuries and was centered in present-day Turkey. The Hagia Sophia was the cathedral of Constantinople— renamed as Istanbul—from its dedication in 360 CE to the 1453 conquest by the Ottoman Turks, who had the building converted into a mosque. The cathedral's bells, altar, and religious figures were removed; a mihrab and the four minarets we see outside the structure today were installed (**Fig. 8.14**). The Ottoman Empire was among the losers of World War I, in 1918; 17 years later, in 1935, the Republic of Turkey

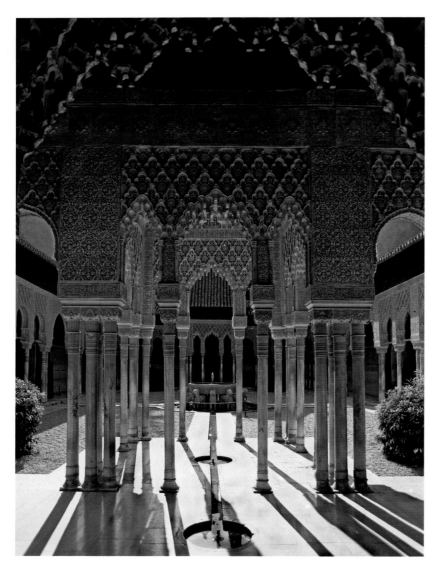

⌃⟩ 8.12 Court of the Lions in the Alhambra, Granada, Spain, ca. 1391. Above: The delicacy of the architecture of the interior rooms of the court is striking. Note the multiple columns, the waterways, and the fountains at floor level. The court takes its name from the lions that support the fountain basin in the center. Below: The sturdy lions which ring the base of the great fountain are in the center of the court, surrounded by interiors that have delicate columns with arabesque decorations.

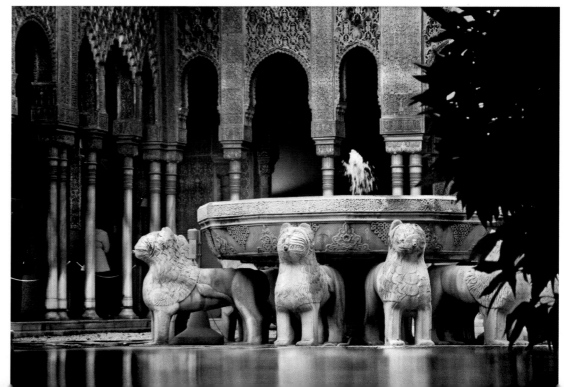

made the Hagia Sophia into a museum—ending the Christian–Muslim conflict over the building.

ISLAMIC LITERATURE

Islamic literature is rich with religious writings, stories— some of which are fantastic tales—and poetry. Foremost among religious writings is the Islamic holy book—the Qur'an. The Qur'an consists of the revelations of Allah to Muhammad. Other writings—Hadith—are the sayings of Muhammad or reports of things he is supposed to have done. Muslims consider the Qur'an to be infallible, but questions are sometimes raised as to how certain material might have entered Hadith.

The Qur'an

Evidently, many of the revelations received by the Prophet during his life at both Mecca and Medina were maintained

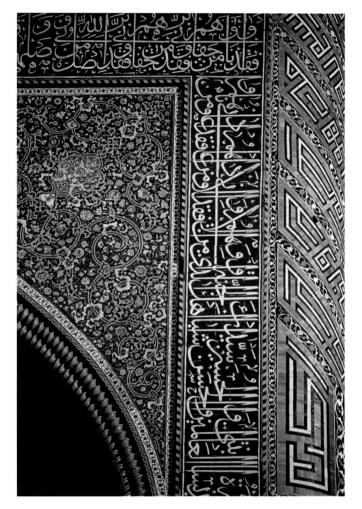

➤ **8.13 Detail of wall mosaic from the portal of the Friday Mosque, Isfahan, Iran (1611–1666).** Decorative blue, white, and gold mosaic tile work combines with Islamic script to decorate a long pier of the portal (entrance). The interplay of calligraphy and abstract design is typical of mosque decoration in various periods.

➤ **8.14 Anthemius of Tralles and Isodorus of Miletus, the Hagia Sophia. 532–537. Istanbul, Turkey. Minarets added in the 15th century.**

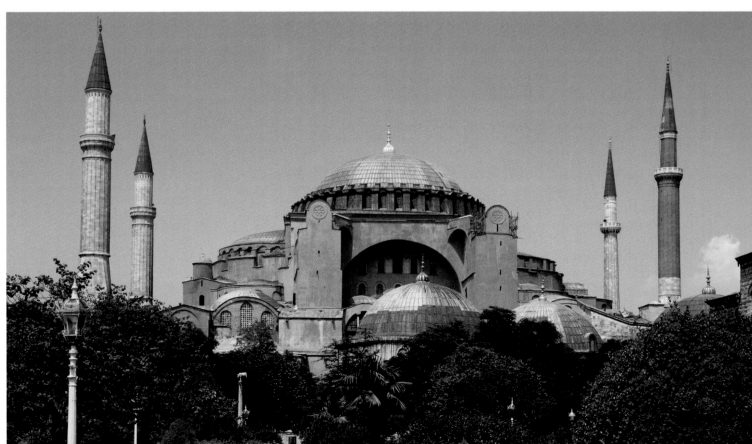

orally, but soon after his death followers began to write down the revelations as they had received them from him. Within a generation, a serious attempt was made to collate the various oral revelations with a view of producing a uniform edition of the revelations received both at Medina and Mecca. The net result of these long editorial efforts resulted in the central sacred text of Islam, the Qur'an (the word is Arabic for "recitation").

The Qur'an is roughly as long as the Christian New Testament. The book is divided into 114 chapters (suras). There is an opening chapter in the form of a short prayer invoking the name of God, followed by 113 chapters arranged in terms of their length, with the second chapter being the longest and the final one only a line or two long. Muslims have devised ways of dividing these chapters—for example, into 30 parts of near-equal length so that one could complete reciting the entire book during the 30 days of the sacred month of Ramadan, which is a time of intense devotion accompanying the annual fast.

The language of the Qur'an is Arabic. Like all Semitic languages (for example, Hebrew and Syriac), the text is written and read from right to left. Because Muslims believe that the Qur'an came as a result of divine dictation, it cannot be translated into other languages. Although many vernacular versions of the Qur'an exist, they are considered to be paraphrases or glosses. The result of this conviction is that no matter where Muslims live, they will hear the Qur'an recited only in Arabic. Although Arabs (contrary to popular belief) make up only a relatively small proportion of the total Muslim population of the world, the Qur'an serves as a source of unification for all Muslims. Reverence for the Qur'an, further, means that it is believed to be God's word to people and as such is held in the highest respect. Committing the entire Qur'an to memory is a sign of devotion, and the capacity to chant it aloud is a much-admired gift, because the beauty and care of such recitation is deemed an act of religious piety in its own right. Today, public competitions of recitations of the Qur'an are a regular feature on radio and television in Islamic countries. In cities having a Muslim majority, it is not uncommon to find radio stations that feature reading of the Qur'an 24 hours a day.

The Qur'an is the central text of Islam, but the Hadith has also shaped Islamic religion and culture. From this living stream of sacred text and tradition, Islamic sages and jurists have developed Sharia. When Islamic countries are described as adopting Islamic law for their governance, that refers to Sharia. Sharia is traditional and conservative, yet adaptable to the needs and circumstances of time.

The following selections from the Qur'an are taken from a Muslim scholar who called his work an "explanatory translation," because, again, humans are not supposed to be capable of translating the words of Allah spoken to the prophet Muhammad.

READING 8.1 THE QUR'AN

Sura 1, The Opening, revealed at Mecca

In the name of Allah, the Beneficent, the Merciful.
Praise be to Allah, Lord of the Worlds,
The Beneficent, the Merciful.
Owner of the Day of Judgment,
Thee (alone) we worship; Thee (alone) we ask for help.
Show us the straight path,
The path of those whom Thou hast favored;
Not (the path) of those who earn Thine anger nor of those who go astray.

From "The Opening," "The Table Spread," "The Children of Israel," "The Coursers," "The Unity" from *The Meaning of Glorious Koran*, translated by Mohammed Marmaduke Pickthall, 1930, George Allen & Unwin, an imprint of HarperCollins Publishers, Ltd., 1930.

Verses from sura 5 recount some history concerning Jews and Christians, according to the Qur'an.

READING 8.2 THE QUR'AN

Sura 5, The Table Spread, revealed at al-Madīnah [Medina]

44. Lo! We[1] did reveal the Torah, wherein is guidance and a light, by which the Prophets who surrendered (unto Allah) judged the Jews, and the rabbis and the priests (judged) by such of Allah's Scripture as they were bidden to observe, and thereunto were they witnesses. So fear not mankind, but fear Me. And barter not My revelations for a little gain. Whoso judgeth not by that which Allah hath revealed; such are disbelievers.

45. And We prescribed for them therein: The life for the life; and the eye for the eye, and the nose for the nose, and the ear for the ear, and the tooth for the tooth, and for wounds retaliation. But whoso forgoeth it (in the way of charity), it shall be expiation for him. Whoso judgeth not by that which Allah hath revealed; such are wrong-doers.

46. And We caused Jesus, son of Mary, to follow in their footsteps, confirming that which was (revealed) before him, and We bestowed on him the Gospel wherein is guidance and a light, confirming that which was (revealed) before it in the Torah—a guidance and an admonition unto those who ward off (evil).

From "The Opening," "The Table Spread," "The Children of Israel," "The Coursers," "The Unity" from *The Meaning of Glorious Koran*, translated by Mohammed Marmaduke Pickthall, 1930, George Allen & Unwin, an imprint of HarperCollins Publishers, Ltd., 1930.

1. Allah.

The Thousand and One Nights

Aside from the Qur'an, *The Thousand and One Nights*, compiled between the 9th and 14th centuries, is the most widely read and beloved work of Islamic and Arabic culture. The stories differ, and critics have questioned whether they were ever meant to be joined together. However, their constant frame is the story of King Shahryar and his bride Shahrazad, although her name may be more familiar in English as Scheherazade, as in the hauntingly pulsating symphonic suite of the same name composed by the Russian Nikolay Rimsky-Korsakov in the latter part of the nineteenth century.

The king was embittered by the adulterous betrayal of his queen, and he sought to express his enmity toward women by wedding them, bedding them for a night, then having them executed in the morning. Shahrazad, daughter of the king's vizier, decides to try to end the king's practice by offering herself to him and nightly telling him tales of such wonder, pausing as the dawn approached, that he would forgo executing her to hear the conclusion.

Many of the tales are highly erotic, even edgy. Yet they are composed in a luxurious prose and lyric poetry that elevates them to the level of literature. Following is an extract from "The Tale of the Porter and the Young Girls."

READING 8.3 THE THOUSAND AND ONE NIGHTS

From "The Tale of the Porter and the Young Girls"

There were vases and carved seats, curtains . . . , and in the middle a marble couch, inlaid with pearl and diamond, covered with a red satin quilt. On the bed lay a third girl who exceeded all the marvel that a girl can be. Her eyes were Babylonian, for all witchcraft has its seat in Babylon. Her body was slim as the letter alif,[2] her face so fair as to confuse the bright sun. She was a star among the shining of the stars, a true Arabian woman, as the poet says:
Who sings your slender body is a reed
His simile a little misses,
Reeds must be naked to be fair indeed
While your sweet garments are but added blisses.

As the tales draw to an end, the king is no longer thinking of killing Shahrazad, or indeed any woman.

READING 8.4 THE THOUSAND AND ONE NIGHTS

From "Conclusion"

Then she fell silent, and King Shahryar cried: "O Shahrazad, that was a noble and admirable story! O wise and subtle one, you have taught me many lessons, letting me see that every man is at the call of Fate; you have made me consider the words of kings and peoples passed away; you have told me some things which were strange, and many that were worthy of reflection. I have listened to you for a thousand nights and one night, and now my soul is changed and joyful, it beats with an appetite for life. I give thanks to Him Who has perfumed your mouth with so much eloquence and has set wisdom to be a seal upon your brow!"

. . .

King Shahryar and Queen Shahrazad, . . . and Shahrazad's three small sons, lived year after year in all delight, knowing days each more admirable than the last and nights whiter than days, until they were visited by the Separator of friends, the Destroyer, the Builder of tombs, the Inexorable, the Inevitable.

Such are the excellent tales called *The Thousand Nights and One Nights*, together with all that is in them of wonder and instruction, prodigy and marvel, astonishment and beauty.

But Allah knows all! He alone can distinguish between the true and the false. He knows all!

Omar Khayyam

The Persian Omar Khayyam (1048–1131) was versed in many disciplines: philosophy, mathematics, astronomy, mechanics, mineralogy, climatology, and music. He was also a poet, whose brief works have come down to us from the world of Islam. The tenets of Islam would seem to demand as austere a life as do the more conservative views within Judaism and Christianity: Taste the pleasures of the flesh with caution. The reward for a proper, pious life is paradise. And for many believers, hell gapes open for those who would seize the day. Yet surprisingly Khayyam's *rubaiyat*—that is, his quatrains (four-line poems)—appear to preach precisely that we should make the most of time. They are filled with doubt about the value of waiting for the final reward.

Khayyam's verses are some of the most beloved of the Eastern poetry that has found its way to the West. Many of his phrasings, as translated by Edward Fitzgerald,[3] may sound very familiar: "the bird is on the wing," "a jug of wine, a loaf of bread, and thou," "the rumble of a distant drum," "the Moving Finger writes: and, having writ, / Moves on."

2. The first letter of the Arabic alphabet, which looks like a lowercase L.

3. *The Rubaiyat of Omar Khayyám*, trans. Edward Fitzgerald, 5th ed. (London: Bernard Quaritch, 1889).

We also see that Khayyam openly challenged Islamic—or any religious—views of the creation of the universe and of humankind's place within it. That was the scientist within him speaking, the skeptic, as well as the poet.

Sufi Writings

From the perspective of literature, one of the most influential Islamic traditions is Sufism. The name *Sufi* most likely derives from the Arabic word for unbleached wool—the simple clothing many Sufis adopted. Sufi *tariqas* (communities) are to be found in various Islamic lands, with a significant presence in North Africa and Egypt.

Sufism describes a complex group of communities or small groups of teachers with religious authority, called *sheiks*, and their disciples. Like most mystical movements in a religious tradition, Sufism was sometimes embraced with enthusiasm by religious and civil authorities. During other periods its practices and followers were viewed through the prism of suspicion or hostility. Sufi mystics tended to live a life of retirement in poverty, preaching piety and repentance.

Westerners have expressed a keen interest in Sufi practices, with most large bookstores stocking translations of Sufi texts. Two representative Sufi writers might provide us with some sense of the range of Sufi thought and expression.

RABI'AH AL-ADAWIYAH AL-QAYSIYYA Rabi'ah (717–801), or Rabia, was a Sufi mystic who believed that a highly developed love of God was the key to union with him. Kidnapped and sold into slavery as a child, she became convinced that she was one of God's chosen ones after being granted freedom by her master. Rabia expressed her philosophy of divine love in a series of aphorisms, poems, and meditations inspired by verses in the Qur'an that spoke of Allah's concern for his people and the corresponding love that they should have for him. Like many mystics (and others meditating on the meaning of God's love), Rabia expressed her feelings in the form of poetry. She believed that with Allah as the central focus in one's life, nothing else mattered, not even fear of damnation or hope of paradise: "The best thing in the whole world is to possess nothing in this world or the next world except Allah."

JALAL AD-DIN MUHAMMAD RUMI Perhaps the most famous of the Sufi mystic poets was the 13th-century writer known as Rumi (1207–1273). Born in what is now Afghanistan, Rumi moved with his family to what is present-day Turkey. A prolific writer of religious verse in a form developed by ear-

Jalal ad-Din Muhammad Rumi on the Three Blind Men and the Elephant*

The Sufi mystic Jalal ad-Din Muhammad Rumi (1207–1273 CE) would tell his version of the fable of the three blind men and the elephant as a way of showing that people cannot perceive the features or dimensions of Allah, and therefore as a way of preaching tolerance of different points of view.

> The elephant was in a dark house; some Hindus had brought it for exhibition.
>
> In order to see it, many people were going, every one, into that darkness.
>
> As seeing it with the eye was impossible, [each one] was feeling it in the dark with the palm of his hand.
>
> The hand of one fell on its trunk; he said: "This creature is like a water-pipe."
>
> The hand of another touched its ear: to him it appeared to be like a fan.
>
> Since another handled its leg, he said: "I found the elephant's shape to be like a pillar."
>
> Another laid his hand on its back: he said, "Truly, this elephant was like a throne."
>
> Similarly, whenever anyone heard [a description of the elephant], he understood [it only in respect of] the part that he had touched.
>
> On account of the [diverse] place [object] of view, their statements differed: one man titled it "dal,"** another "alif."***
>
> If there had been a candle in each one's hand, the difference would have gone out of their words.

* *The Mathnawi of Jalalu'ddin Rumi*, trans. and ed. Reynold A. Nicholson, Vol. 4. Gibb Memorial New Series 4. (London: E. J. W. Gibb Memorial Trust/Luzac & Co., 1921), 3.1259–1268.

** A crooked Arabic letter.

*** A long, straight Arabic letter.

lier Sufis that used rhyming **couplets**, Rumi, writing mostly in the Persian language, composed more than 3000 poems while also leaving behind 70 long discourses on mystical experience. His poetic corpus is extensive and so powerfully expressed that some have called his body of work the Qur'an in Persian. He was most admired for his capacity to take almost any ordinary thing and turn his observance of it into a poem of religious praise.

One feature of Rumi's poetry was his practice of reciting his poems while dancing in a formal but ecstatic fashion. Rumi believed that the combination of recitation and movement would focus the devotee's total attention on Allah. He founded a community of these ecstatic dancers (dervishes), whose practitioners continue ecstatic dancing to this day (**Fig. 8.15**).

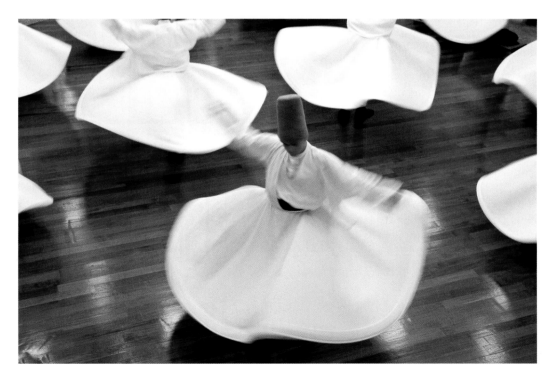

◀ **8.15** "Whirling" **dervishes.** As part of their religious devotions, many Sufi orders perform ecstatic dancing to the accompaniment of musical instruments. The practice, not universally admired by Muslims, may represent the souls of the just whirling toward paradise.

ISLAMIC ARTS

Islamic arts include mosaics and tile work, pottery, fiber arts, and forms of calligraphy that rival the beauty of ancient Chinese calligraphy.

Calligraphy

Calligraphy was developed to render adequate honor to the written text of the Qur'an. The evolution of Arabic script is a long and highly complex study in its own right, but certain standard forms of writing were developed. One of the most characteristic forms of this writing, although it also admits of many variations, is called **Kufic**.

Kufic calligraphy is named after the city of Kufah in Iraq, where Arabic script was refined in the seventh and eighth centuries. It contained angular and square lines, as well as bold circular forms. Horizontal strokes tend to be extended. By the latter part of the eighth century, Kufic became the official script for copying the Qur'an. In the 10th century, slender verticals and oblique strokes gave more of an animated quality to earlier Kufic, as in Eastern Kufic (see

➤ **8.16 Kufic styles.** Early Kufic was developed in the seventh and eighth centuries. Eastern Kufic was popular in books, and other styles developed over the following centuries. Square Kufic and foliate Kufic were used frequently on architectural monuments. Knotted Kufic seems to embrace plant life.

Fig. 8.16), which was popular on ceramics. Foliated Kufic and square Kufic became used on architectural monuments, with square Kufic sometimes used to cover entire buildings.

The stylized Arabic from a leaf of the Qur'an drawn around the middle of the Golden Age (**Fig. 8.17**) shows rounded letters that serve as counterpoint to the angular script. The colored marks are aids that help the reader pronounce the script, but for those who are not readers of Arabic, the whole can have something of a pictographic quality created by the strong, measured strokes. Calligraphic skills were brought to bear not only on the text of the Qur'an but also as decorative features of public buildings, including mosques, and of ceramics.

Mosaics

Mosaics are used to decorate the exteriors and interiors of Islamic buildings, especially mosques and shrines. We saw them in the Dome of the Rock, the interior of the dome in front of the mihrab of the Great Mosque in Córdoba, and the exterior wall of the Friday Mosque in Isfahan. We find another example in the finely detailed mosaics in the mihrab from the Madrasa Imami in Isfahan (**Fig. 8.18**). The pointed

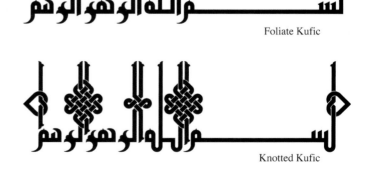

Early Kufic

Eastern Kufic

Foliate Kufic

Knotted Kufic

Square Kufic

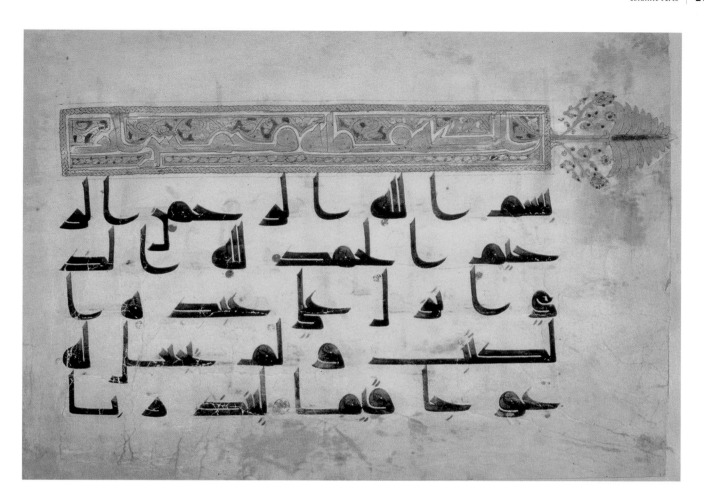

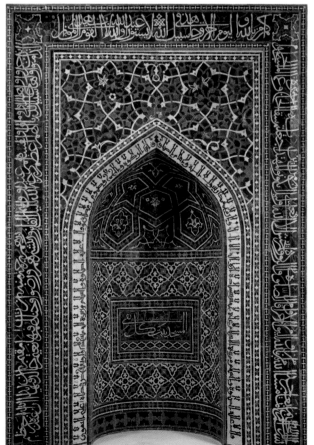

▲ **8.17 Page from the Qur'an, 9th–10th century. From Iraq or Syria. 8″ × 13″ (20.3 × 33 cm). Museum für Islamische Kunst Berlin, Germany.** The highly stylized calligraphy is known as Kufic script; it is one of the earliest and most beautiful of Arabic calligraphy styles. Arabic, like Hebrew, is written from right to left.

◄ **8.18 Mihrab from the Madrasa Imami, Isfahan, Iran, ca. 1354 CE. 135″ × 113³/₄″ (343.1 × 288.8 cm). Metropolitan Museum of Art, New York, New York.** A mosaic of monochrome-glaze tiles on a composite body is set on plaster to create floral and geometric patterns and inscriptions.

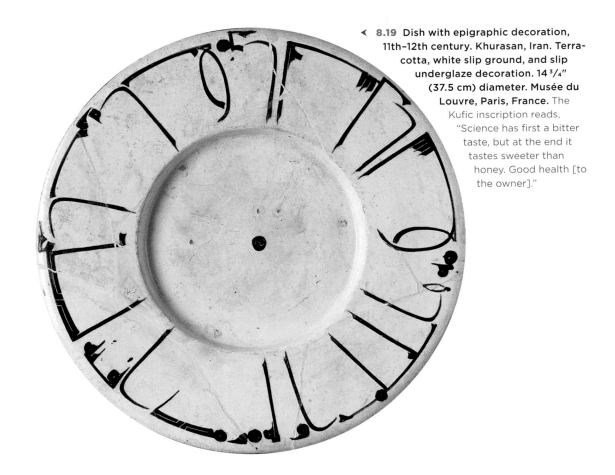

◀ **8.19** Dish with epigraphic decoration, 11th–12th century. Khurasan, Iran. Terracotta, white slip ground, and slip underglaze decoration. 14 ³/₄″ (37.5 cm) diameter. Musée du Louvre, Paris, France. The Kufic inscription reads, "Science has first a bitter taste, but at the end it tastes sweeter than honey. Good health [to the owner]."

arch bears a Kufic inscription from the Qur'an. We also find geometric and floral motifs.

Ceramics

Potters during the golden age were turning out simple, elegant glazed works frequently decorated with calligraphy.

A dish from the 11th or 12th century Iran (**Fig. 8.19**) shows Kufic text around the rim that achieves an abstract, painterly quality. Elongated letters are extended in horizontal and vertical directions to embrace the full width of the rim. The Arabic is translated into English as follows: "Science has first a bitter taste, but at the end it tastes sweeter than honey. Good health [to the owner]."

Fiber Arts

The Ardabil carpet (**Fig. 8.20**), created during the Islamic Golden Age, is the oldest dated carpet in the history of art. It is huge, covering some 35 feet by 18 feet, and has more than 25 million knots. In the center is a sunburst design that apparently represents the interior of a dome in a mosque or shrine. Although the carpet is not a religious work per se, the field of interlacing flowers and vines likely draws on references to paradise as a garden in the Qur'an.

ISLAMIC MUSIC

Islamic music includes many genres and styles, including sacred, secular, and classical music. Muslims were aware of Greek music and musical theory, and adapted them to their own purposes.

Music has a checkered history in Islam. Certainly the calls to prayer of muezzins are melodic. And over the centuries music sprang up everywhere. There are a variety of traditional instruments. **Figure 8.21** shows a **rebab**, a long-necked stringed instrument that is usually played with a bow, although it can be plucked. The **dadabwaan** (**Fig. 8.22**) is a traditional drum, this one from the Philippines, which has both Muslim and Christian populations. Wind instruments and gongs have also been in common usage.

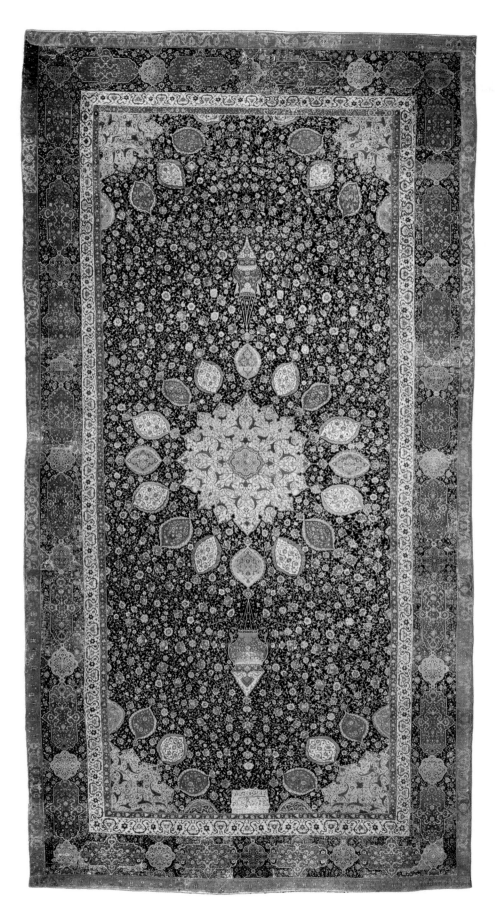

◄ **8.20** **Maqsud of Kashan, carpet from the funerary mosque of Shaykh Safi al-Din, Ardabil, Iran, 1540. Wool and silk, 34'6" × 17'7" (10.5 × 5.2 m). Victoria and Albert Museum, London, United Kingdom.** The immense carpet is apparently intended to provide the illusion of a golden, heavenly dome surrounded by mosque lamps, as reflected in a pool of floating lotus flowers with interlacing vines. It contains some 25 million knots.

◀ **8.21 Rebab, late 19th century. Algeria or Morocco. Wood, parchment, metal, and ivory, 29½" (74.9 cm) long (bow 13½", 34.3 cm) Metropolitan Museum of Art, New York, New York.** The term *rebab* refers to lutes and lyres used in Islamic lands. The rebab is held across the player's body like a cello or bass fiddle and is played with a bow. It is used only to accompany singing. This example is embellished with a delicate ivory inlay.

▲ **8.22 Dadabwaan, 19th century. Mindanao, Philippines. Wood, mother-of-pearl, and skin, 32³/₈" × 24½" (82.2 × 62 cm); head 21" (55.3 cm) across. Metropolitan Museum of Art, New York, New York.** Islamic influences contributed to the name, goblet shape, mother-of-pearl inlay, and leaf decoration of the drum. It was blackened by rubbing oil into the wood, and is played with two sticks made of rattan.

There has a great deal of sacred music and much poetry set to music. **Figure 8.23** shows the son of a Syrian merchant, Bayad, serenading an erudite young woman, Riyad, in the court of an important official in Iraq. He plays the **oud**, a traditional, short-necked stringed instrument which is plucked, as a guitar. The serenade occurs in a 13th-century illustrated manuscript called *The Story of Bayad and Riyad*. The manuscript was written during the latter years of the Islamic Golden Age (ca. 750–1258 CE), when Muslim philosophers and scientists preserved the earlier traditions of their own culture and those of nearby countries, while advancing their own technology and culture. Suffice it to say that music was generally popular.

Despite these varied uses of music, some Muslims over the centuries have argued in favor of vocal music only, and the use of instruments has sometimes been forbidden. There is thus a tradition of a cappella devotional singing. Other Muslims consider all instruments to be lawful as long as they are used for sacred and other forms of acceptable music. Some would allow only drums.

At various times, male instrumentalists have been associated with "vices" such as love of poetry, drinking of wine, chess, and homosexuality. (Does that view resonate with anything you might have heard about pop musicians in the twenty-first century?) Zealots burned musical scores and writings on music. In recent years the Taliban,

a fundamentalist Islamic group comprised mainly of Pashtuns in Afghanistan and Pakistan, forbade music and dancing along with chess, cinema, television, lipstick, clapping at athletic contests, and on and on. Some Muslims have claimed that music is forbidden by both the Qur'an and the Hadith. Muhammad is quoted as having censured music: "There will be among my [followers] people who will regard as permissible adultery, silk, alcohol and musical instruments." But the context of this remark is debated. Some commentators note that Muhammad made the remark at a time when he was converting polytheists who had been using music and musical instruments in their previous modes of worship. In any event, many Muslims have lauded the joy and uses of music. There is no single Islamic view on the uses (or the dangers) of music.

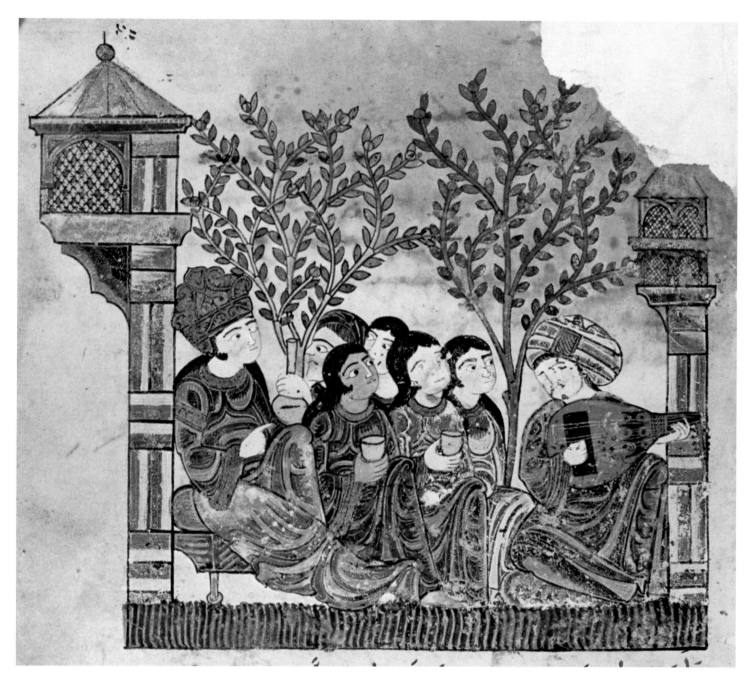

∧ **8.23** "The Story of Bayad and Riyad," 13th century. Manuscript illumination, 6 ⁷⁄₈″ × 7 ¹⁄₂″ (17.5 × 19.1 cm). **Biblioteca Apostolica Vaticana, Vatican City State, Italy.** In this tale, the son of a Syrian merchant woos a beautiful and highly educated young woman in the court of a vizier (an important official) in Iraq.

THE CULTURE OF ISLAM AND THE WEST

Harun al-Rashid (r. 786–809 CE) was the fifth and most famous caliph of the Abbasid period. Famous for encouraging music, poetry, art, and science at his court in Baghdad, and an inspiration for *The Thousand and One Nights*, Harun achieved mythic stature. A military leader as well, he waged intermittent war on the Byzantine Empire. But in 798, with his army encamped around Constantinople, he negotiated with the empress Irene to accept an annual tribute of 70,000 pieces of gold in lieu of certain victory. Not until 1453 would Constantinople fall to Islam.

During a reign that marked the high point of the Abbasid dynasty's social and political power, Harun al-Rashid maintained diplomatic ties with countries as far away to the east as China. To the west he conducted a diplomatic correspondence with Charlemagne (see Chapter 9). Charlemagne's biographers describe negotiations over Christian access to the holy places in Jerusalem. These negotiations were critical to Charlemagne because the Christian West bitterly regretted the loss of Jerusalem in 638—a bitterness that would erupt into the Crusades several centuries later.

As was customary, Charlemagne sent his delegates with gifts for the caliph. Because Harun was a keen equestrian, Charlemagne sent Spanish horses and hunting dogs, as well as Frisian woven cloth. In 802 Harun reciprocated, sending—among silks, candelabras, perfumes, ivory chessmen, and slaves—evidence of the technological inventiveness of the Islamic world: a water clock with 12 bronze balls that marked the hour by falling on a cymbal as 12 mechanical knights paraded out of small windows. Implausibly, Harun also sent Charlemagne an elephant named Abul-Abbas. Somehow, the elephant traveled from Baghdad (present-day Iraq) to Aachen (present-day Germany), where it fascinated the populace until 811, when it succumbed to the northern cold.

One of the high points of Islamic culture in its earlier history was centered in Baghdad under the Abbasid dynasty. It was there that papermaking was learned from a Chinese prisoner who had learned the process in China, where it had long been commonplace. Baghdad opened its first papermaking factory in 794. It would be some centuries before this process would pass to the West.

The House of Wisdom

Caliph Al-Ma'mun built a library and study center, completed in 833, that was known as the *Bayt al-Hikmah* ("House of Wisdom"). Scholars flocked to that center from all over the Islamic world. A crucial part of the scholarly labors at the House of Wisdom was the translation of texts into Arabic. We owe to this center the preservation of the works of Aristotle, which were translated into Arabic by a team of Greek-speaking Christians who were in the center's employ. It is estimated that every text of Aristotle we know today (except *Politics*) was translated in the House of Wisdom. Additionally, these scholars translated several Platonic texts, the medical texts of Galen, and many treatises of the Neo-Platonic authors. When scholars (like Thomas Aquinas) read Aristotle in Paris in the 13th century, they did so in Latin versions translated from Arabic manuscripts—the work of the scholars of Baghdad.

AL-KHWARIZMI AND MATHEMATICS The greatest single scholar at the House of Wisdom was the polymath researcher al-Khwarizmi (780–850), who made revolutionary discoveries. He led three expeditions to India and Byzantium in order to gather manuscripts and meet other scholars. As a consequence, al-Khwarizmi had at his disposal much learning from both Indian and Byzantine (Greek) sources. He invented algebra (the word *algebra* derives from the Arabic title of one of his books). Medieval Europeans who knew his writings in Latin gave us another important mathematical term, which is a corruption of his name: *algorithm*.

The most important contribution made by al-Khwarizmi was his adaptation of Hindu notations for numbers that used nine symbols and a placeholder. This simplified numerical system replaced the clumsy Greek and Latin notational system, as any person who has tried to multiply CLXII by LIV instead of 162 by 54 will testify. The Hindu placeholder called *sunya* in Sanskrit and *cifra* (from which the English word "cipher" is derived) in Arabic, which came to be called *zero* in some European languages, was now regarded not merely as a placeholder but as a number. One further advance, made in the next century by an otherwise obscure Syrian Muslim named Al-Uqlidisi, was the development of decimal fractions, which then permitted, for example, the computation of a solar year at 365.242199 days.

Although these profound mathematical advances developed rapidly in the Islamic world, their development in the West would be slow. It would take nearly 150 years before these ideas entered the Christian West via translations in those places that had the closest connection to the Islamic world, namely Sicily (not a distant voyage from North Africa) and especially that part of Spain that was Islamic.

SCIENCE AND MEDICINE Mathematics was not the only area where Islamic scholarship advanced. The Egyptian scientist Alhazen (died 1038) did crucial work in optics and on the technology of grinding and making lenses. Three other scholars in the Islamic world who had had contact with Greek medicine and other sources shaped the future of medicine. Rhazes (died 932), head of the hospital in Baghdad, excelled in clinical observation, giving the world for the first time a clear description of smallpox and measles that demonstrated them to be two distinct diseases. It was from the observations of Rhazes that other scientists began to understand the nature of infection and the spread of infectious diseases. In the following

two centuries, influential writers like Avicenna (died 1037) and Averröes (died 1198), in addition to their important work in philosophy, wrote influential treatises in medicine. The Jewish philosopher and physician Moses Maimonides (died 1204) was trained in medicine by Muslims in Spain, where he was born, and Morocco. Because of his education, he stressed the need for personal hygiene as a way of avoiding disease (a concept not common in his day) and did influential work on the nature of poisons. The high reputation of Jewish doctors trained in Arabic medicine was such that popes consulted Jewish physicians who lived in the Jewish quarter across from the Vatican right through the Renaissance period.

OTHER CONTRIBUTIONS FROM THE ISLAMIC WORLD Despite the antagonism between the Christian West and the Islamic world in the centuries between the Abbasid dynasty in Baghdad and the flourishing culture of North Africa and Islamic Spain, the two cultures developed a common exchange of ideas and goods. The results were widespread. Westerners learned how to make windmills from the Muslims. The sword makers of both Damascus (Syria) and Toledo (Spain) were legendary for the quality of their work. The woven silk of Damascus lingers in our word *damask*. Among the earlier gifts of the Islamic world is coffee. The fruit of the plants, native to tropical Africa, became a common hot beverage when Muslim traders in Ethiopia began to pulverize the beans to brew the drink. So popular was the result that in a short time one could find in Mecca, Damascus, and even in Constantinople an institution popular to this day: the coffeehouse.

English Words from the Islamic World

The exchanges between the Western world and the Islamic world have enriched the English vocabulary. Arabic has given us *algebra, amber, almanac, azimuth, caliph, cotton, hazard, lute, mattress, mosque, saffron,* and *syrup*. From Persian (via Iran) we have gained the words *azure, mummy, scarlet,* and *taffeta*, as well as *chess* and two words from that game: *rook* and *checkmate*.

Finally, Muslim scholars provided not only a great body of Greek philosophical writing, but also a vast commentary on it in the High Middle Ages. When al-Ghazali (died 1111) attacked Greek philosophy in a book called *The Incoherence of the Philosophers*, he was answered by Averröes, who wrote a treatise showing how Islam could be reconciled with Greek philosophy. Averröes called his book *The Incoherence of the Incoherence*. Dante regarded Muhammad and Islam with disdain, but a century after the death of Averröes, Dante would salute him in the *Divine Comedy* as "He of the Great Commentary."

GLOSSARY

Allah *(p. 242)* The Arabic word for God.

Arabesque *(p. 254)* A surface decoration based on rhythmic patterns of scrolling and interlacing lines, foliage, or tendrils.

Caliph *(p. 243)* A spiritual and secular leader of the Islamic world, claiming succession from Muhammad.

Calligraphy *(p. 260)* A stylized form of elegant handwriting.

Couplet *(p. 259)* Two successive lines of verse that rhyme.

Dadabwaan *(p. 262)* A kind of Islamic drum.

Hadith *(p. 243)* A collection of the sayings of Muhammad and reports of his behavior.

Ka'bah *(p. 242)* Arabic for "cube"; the cube-shaped building in Mecca, believed by Muslims to have been built by Abraham and to lie directly beneath heaven, that is the holiest site of Islam.

Kufic *(p. 260)* Styles of calligraphy that were largely developed in the Iraqi city of Kūfah.

Mahdi *(p. 246)* The redeemer of Islam.

Mihrab *(p. 247)* A niche in the wall of a mosque that indicates the direction of Mecca so that the congregation can direct their prayers in that direction.

Minbar *(p. 247)* The pulpit in a mosque.

Monotheism *(p. 243)* Belief that there is one god.

Mosaic *(p. 248)* An image created by assembling small pieces of materials such as glass, stone, or tile.

Mosque *(p. 247)* An Islamic house of worship (as a synagogue in Judaism or a church in Christianity).

Muezzin *(p. 247)* The crier who calls Muslims to prayer five times a day.

Oud *(p. 264)* A short-necked stringed instrument that is plucked like a guitar; a lute.

Qur'an *(p. 242)* The Muslim holy book, which is believed to have been revealed by Allah to Muhammad.

Ramadan *(p. 243)* The ninth month of the Islamic calendar; considered a holy month during which there are limitations on eating, smoking, and sex (alcohol is prohibited at all times).

Rebab *(p. 262)* A long-necked stringed instrument played with a bow.

Shariah *(p. 243)* The moral code and religious law of Islam.

Shia *(p. 246)* The Islamic denomination that believes that Muhammad, as commanded by Allah, ordained his son-in-law, Ali, as the next caliph, and that legitimate successors must be drawn from the descendants of Ali.

Sufism *(p. 246)* The inner, spiritual dimension of Islam.

Sunni *(p. 246)* The Islamic denomination that believes that Muhammad's rightful successor was his father-in-law, Abu Bakr, and that the Qur'an endorses the selection of leaders according to the consensus of the Muslim community.

Sura *(p. 243)* A section of the Qur'an; a chapter.

Tesserae *(p. 252)* Small pieces of stone, glass, or ceramic tile used in the creation of a mosaic (singular *tessera*).

Ummah *(p. 246)* The Muslim community at large.

THE BIG PICTURE ISLAM

Language and Literature

- The Qur'an was written in Arabic, a Semitic language. It contains 114 chapters (suras).
- Copies of the Qur'an were made with calligraphy in the so-called Kufic styles. Calligraphy was also used to decorate buildings and pottery.
- *The Thousand and One Nights*, compiled over several centuries, was the most popular secular work in the Arab world.
- Omar Khayyam's four-line verses taught that people should seize the day.
- Sufis such as Rabi'ah al-'Adawiyah al-Qaysiyya (Rabia) and Jalal ad-Din Muhammad Rumi (Rumi) wrote prose and poetry embracing a mystical relationship with Allah.

Art, Architecture, and Music

- The most magnificent Islamic works were architectural—from the Dome of the Rock in Jerusalem to the Alhambra in Spain. Architectural works were frequently decorated with mosaics and calligraphy.
- The interior spaces of mosques were often extended in hypostyle fashion. Mosques have minarets from which muezzins cry to the faithful that it is time for prayer. Mihrabs are focal points in mosques that direct worshippers' prayers in the direction of Mecca.
- Many manuscripts were illuminated (illustrated) with miniature paintings. It was generally forbidden to depict Allah or the face of the prophet Muhammad.
- Various forms of pottery were innovated, and some were decorated with Kufic calligraphy.
- Carpet weaving was a high art, with the famed Ardabil carpet having some 25 million knots.
- The use of music has been quite varied in Islam. In some cases, instruments were forbidden. There is debate as to whether Muhammad opposed music.

Philosophy and Religion

- Islam is a monotheistic religion in the tradition of Abraham. Islam denies the Trinitarianism of Christianity in favor of a single God. The holy book is the Qur'an, and other religious writings are found in the Hadith and the Sunnah.
- Islam numbers Adam, Moses, Jesus, and John the Baptist among its prophets but denies the divinity of Jesus and considers Muhammad to be the final prophet.
- The state is to be ruled according to Islamic law, or Shariah. The caliph is both a spiritual and a secular ruler.
- The holiest site in Islam is the Ka'bah in Mecca, which is believed to have been built by Abraham and to be directly under heaven (paradise).
- The five pillars of Islam are (1) recitation of the Muslim act of faith that there is one God and that Muhammad is his messenger, (2) the obligation to pray five times a day, (3) donation to charity, (4) observance of a fast during the holy month of Ramadan, and (5) the duty to make a pilgrimage to Mecca (hajj) at least once.
- The Sunni and Shia denominations have conflicting views on the rightful successors to Muhammad and his son-in-law, Ali. Sufis seek a direct mystical relationship with Allah.

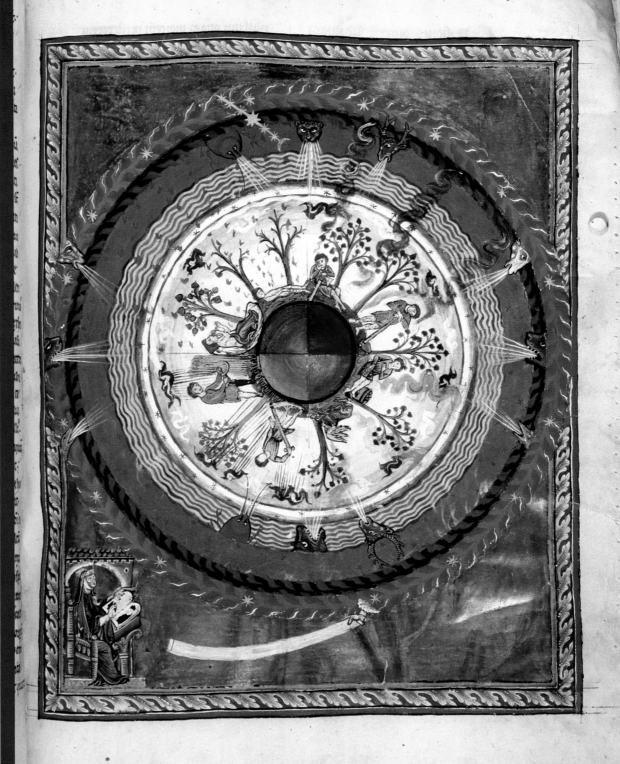

The Rise of Medieval Culture

9

PREVIEW

If Hildegard of Bingen had been a man, and had lived during the Renaissance, she would have counted among the great thinkers whose achievements defined the concept of a *renaissance man*—someone whose spheres of knowledge are many and whose understanding of them is profound. Hildegard was a medieval **polymath**—she was a Christian mystic and philosopher, a poet and composer. She founded and led two communities of Benedictine nuns as abbess. She authored a compendium on human diseases and another on medicinal practices, and catalogued plants, animals, and chemical elements. She interpreted religious texts and went on speaking tours to monasteries and cathedrals, and her spiritual visions were meticulously described in brilliant manuscript illuminations. Her *Ordo Virtutum* (*Order of the Virtues*), a morality play, is the earliest piece of musical drama that survives with both script and score.

The 14th-century Italian humanist scholar Petrarch labeled the era in which Hildegard lived (the Early Middle Ages) the Dark Ages; he saw it as a period of intellectual and creative stagnation that followed the decline of the Western Roman Empire and the collapse of classical learning. If anything, Hildegard single-handedly defeats that notion.

Hildegard's experiences reveal a great deal about the Early Middle Ages—about the relationship between church and state; the significance of monasteries as centers of learning; the preservation of sacred texts during a prolonged period of barbaric invasions; the inequality of the sexes and the gender ideology of the Christian Church; the presence and influence of learned and powerful women; the intertwined nature of religion, architecture, art, and music; and the essential role of mystery in human life and belief.

Hildegard's output was prodigious. By the age 76, she had completed three theological texts describing her mystical visions and expounding on aspects of her faith, the most important of which were *Scivias* and the *De operatione Dei* (Book of Divine Works). The visualization of these visions in manuscript illuminations (Fig. 9.1) dates from the 12th century; the original folio of *Scivias* has been missing since World War II.

◄ **9.1** Hildegard of Bingen, "Vision of God's Plan for the Seasons," folio 38 recto from *De operatione Dei* ("On God's Activity") (also known as *Liber divinorum operum* "Book of Divine Works") 1163–1174. Illuminated miniature on vellum in mandala form. Biblioteca Statale, Lucca, Italy.

THE MIDDLE AGES

As the power of the Roman Empire declined, warrior lords fought for territory and political authority. Conflicts and competition were fierce among Huns, Vandals, Franks, Merovingians, Goths, and other non-Roman peoples who populated Europe. Once called barbarian tribes, these peoples gained control of parts of Europe.

Migrations

When one of these tribes managed to establish itself in the former center of the Western Empire, Italy, or elsewhere in Europe, another tribe might come crashing across its borders and compel it to move on. Consider the Visigoths, who sacked Rome in 410. They occupied part of Italy and created a kingdom into what is now southern France, but the Franks pressed in, forcing the Visigoths southwest into Spain. The Franks had migrated from the east and crossed the Rhine River, establishing themselves in what is now France, the Netherlands, Switzerland, and parts of Germany. The Ostrogoths, who had become Christian in 383, moved down from eastern Europe into Italy, establishing a kingdom there under Theodoric following the abdication of the last Western Roman emperor in 476. But within a century, the Ostrogoths were forced to move on by the Lombards, a Germanic tribe. Saxons from Germany migrated to Britain and joined with people already living there to form an Anglo-Saxon nation. Celts migrated southward from Ireland and other parts of the British Isles to inhabit parts of France. Vikings controlled Scandinavia.

Over the centuries of tribal migrations across Eurasia, populations coalesced in what eventually would become the familiar countries of Europe—France, Italy, the nations of Scandinavia, Great Britain, and others. The complexions of the peoples in these places changed literally and figuratively.

Not much in the way of art and architecture remains of these migratory tribes, although finely wrought ornaments of gold, inlaid stones, and enamelware give us some indication of their artistic capabilities as well as the wealth and importance of their leaders. Two cemeteries excavated at Sutton Hoo, England, yielded a large number of ornaments and

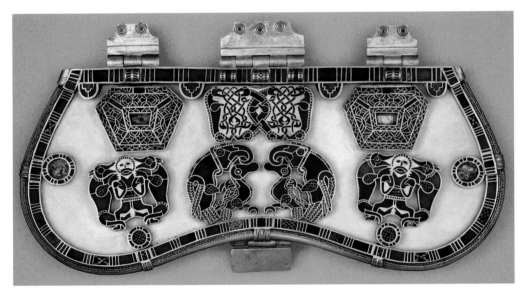

▲ **9.2** Purse cover, ca. 625. Sutton Hoo ship burial, Suffolk, United Kingdom. Gold frame with three gold hinges along a straight top and central projecting gold buckle on the curved lower edge; body of whale-bone ivory (since decayed) set with seven gold rimed garnet cloisonné and millefiori glass designs. 7½" long × 3¼" wide, (19 × 8.3 cm) excl. hinges. British Museum, London, United Kingdom.

The Rise of Medieval Culture

400 CE	800 CE	1200 CE

Monasteries are founded	The feudal system becomes the dominant social structure throughout Europe
Warring tribes migrate throughout Europe following the collapse of the Roman Empire	Charlemagne, a Frank, is crowned emperor of the new Holy Roman Empire
Venerable Bede writes the Ecclesiastical History of the English People	Charlemagne supports learning, monasteries, and the writing of books
The Old English epic Beowulf is created	The Ottonian period begins following the death of Charlemagne
Charlemagne battles the Spanish emirate without conclusive Results; events gives rise to The Song of Roland	William I (William the Conqueror) invades England and becomes England's first Norman king
	The Romanesque style of architecture dominates European cathedral construction

portable artifacts as well as an entire ship burial dating to the early seventh century CE. One treasure found on the ship is a purse cover made of gold, glass, and semiprecious garnets (**Fig. 9.2**). The surface is completely covered with interlaced decoration, a common stylistic characteristic that suggests the tangled world of mythic monsters in epics such as *Beowulf*.

Many works of Christian art from the Early Middle Ages combine characteristics of the small carvings and metalwork of these warrior tribes with symbols of the Christian faith. A page from the Lindisfarne Gospels, so called for its resemblance to intricately patterned textiles made by these tribes (**Fig. 9.3**), features a stylized cross inscribed with layers of intertwined, multicolored scrolls. The framed space surrounding the cross is similarly filled with repetitive linear patterns that can be decoded as snakes devouring

themselves—an animal-interlace motif adapted from the decorative arts of non-Roman peoples.

CHARLEMAGNE

The most important name linked to medieval culture during the period immediately following the migrations is that of a Frank—Charlemagne (Charles the Great, ca. 742—814). This powerful ruler tried to unify the warring factions of Europe under the aegis of Christianity, and modeling his campaign on those of Roman emperors, he succeeded in doing so. In the year 800, on Christmas Day, Charlemagne was crowned Holy Roman emperor by Pope Leo III. It was the first imperial coronation in the West since the late sixth century. The papal coronation was rebellion in the eyes of the Byzantine court,

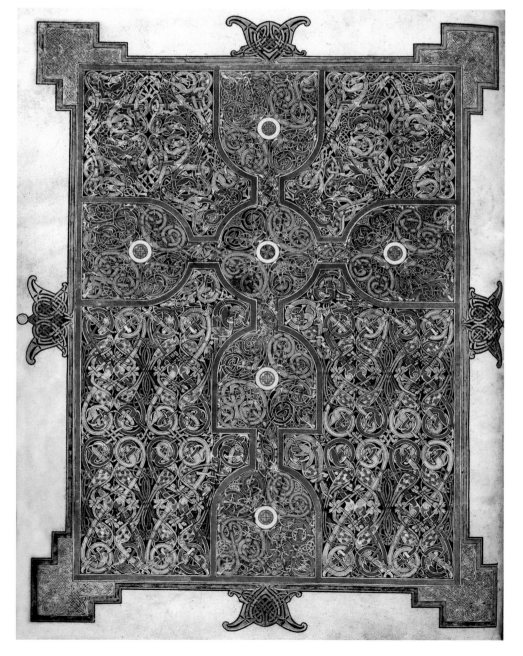

◀ **9.3** Bishop Eadfrith of Lindisfarne attr., folio 72 verso from the Lindisfarne Gospels, ca. 680–720. Illuminated manuscript, ink, pigments, and gold on vellum, 13¹/₂″ × 9³/₄″ (34.2 × 24.8 cm). British Library, London, United Kingdom.

and the emperor in Constantinople considered Charlemagne a usurper, but this coronation, which took place in Rome itself, marked the revival of the Roman Empire in the West.

Charlemagne was an able administrator of lands brought under his subjugation. He modified and adapted the classic Roman administrative machinery to fit the needs of his own kingdom. Charlemagne's rule was essentially a form of **feudalism**—structured in a hierarchical fashion, with lesser rulers bound by acts of fealty to higher ones. Lesser rulers were generally large landowners who derived their right to own and rule their land from their tie to the emperor. Serfs were bound to the land at the lowest rung of society; only slaves ranked beneath serfs. It is estimated that the majority of serfs almost never traveled more than 10 miles from where they were born. They worked in the fields or as artisans in the small villages wholly owned by the manorial lords. A third of what they produced belonged to the manor; the rest sustained them with precious little left over. If lands worked by serfs were sold, the serfs went to the new owner as well, because they were understood to be part of the land.

Charlemagne also maintained several vassal dependents at his court who acted as counselors at home and as legates to execute and oversee the imperial will abroad. From his palace the emperor regularly issued legal decrees modeled on old Imperial Roman decrees. These decrees were detailed sets of instructions that touched on a wide variety of secular and religious issues. Those that have survived give us some sense of what life was like in the early medieval period. The legates of the emperor carried the decrees to the various regions of the empire and reported back on their acceptance and implementation. This burgeoning bureaucratic system required a class of civil servants with a reasonable level of literacy, an important factor in the cultivation of letters that was so much a part of the so-called Carolingian Renaissance.

The popular view of the Early Middle Ages—often referred to as the Dark Ages—is that of a period of isolated and ignorant peoples with little contact outside the confines of their own immediate surroundings, and at times that was indeed the general condition of life. Nonetheless, it is important to note that in the late eighth and early ninth centuries, Charlemagne not only ruled over an immense kingdom (all of modern-day France, Germany, the Low Countries, and Italy as far south as Calabria) but also had extensive diplomatic contact outside that kingdom (see **Map 9.1**). Charlemagne maintained regular, if somewhat testy, diplomatic relations with the emperor in Constantinople (at one point he tried to negotiate a marriage between himself and the Byzantine empress Irene in order to consolidate the two empires). Envoys from Constantinople were received regularly in his palace at Aachen, and Charlemagne learned Greek well enough to understand the envoys speaking their native tongue.

Charlemagne and Islam

Charlemagne's relationship with the rulers of Islamic kingdoms is interesting. Islam had spread all along the southern Mediterranean coast in the preceding century. Muslim Arabs were in complete command of all the Middle East, North Africa, and most of the Iberian Peninsula. Charlemagne's grandfather Charles Martel (Charles the Hammer)

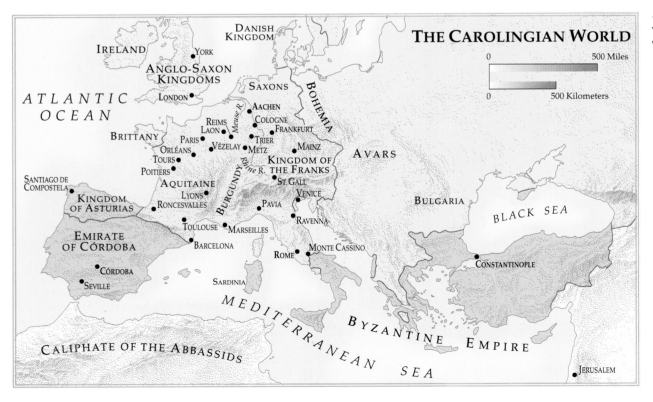

◄ **MAP 9.1**
The Carolingian World.

VALUES

Feudalism

The social organization of late **Carolingian** society was based on feudalism, a form of government that had its primary focus on the holding of land. Theoretically, the monarch held all land, with nobles, who swore allegiance to the monarch, possessing it as a gift from the monarch. Under the nobles were people, again pledging allegiance to their noble superiors, who held a smaller piece of land (for example, a manor). The agricultural peasants (serfs) had the use of the land in exchange for fees and for cultivating a certain percentage for the lord above them. The clergy also had the legal right to certain tithes on the production of goods and services. This highly stratified system also affected the system of warfare. Each knight (a small landholder) pledged loyalty to a higher noble, who in turn pledged loyalty to the crown. Armies could be raised when, for instance, a monarch would call up the nobles pledged to him, and they in turn would call up the knights who had sworn loyalty to them.

Feudal society existed only so long as a country remained rural and without large towns. Italy, with its long history of town life, never had as strong a feudal society as did the Frankish lands of what are today France and Germany. Feudalism was a highly static, hierarchical, and basically agricultural way of organizing life. It would undergo vast changes with the slow emergence of city life and the increased mobility brought on by vigorous trade and such military movements as the Crusades.

had defeated the Muslims decisively at Poitiers in 732, thus halting an Islamic challenge from Spain to the rest of Europe. Charlemagne had fought the Muslims of the Umayyad caliphate on the Franco-Spanish borders; the Battle of Roncesvalles (778) was the historical basis for the epic poem *The Song of Roland*, discussed later in the chapter.

Despite his warlike relationship with Muslims in the West, Charlemagne had close diplomatic ties with the great Harun al-Rashid, the caliph of Baghdad. In 787 Charlemagne sent an embassy to the caliph to beg protection for the holy places of the Christians in Muslim-held Palestine. The caliph (who was the inspiration for *The Thousand and One Nights*—see Chapter 8) received and welcomed the Frankish legates and their gifts (mainly bolts of the much-prized Frisian cloth) and sent an elephant back to the emperor as a gesture of friendship. This elephant lived at Aachen for a few years before succumbing to the harsh winter climate. Charlemagne's negotiations were successful. He received the keys to the Church of the Holy Sepulcher and other major Christian shrines, an important symbolic act that made the emperor the official guardian of the holiest shrines in Christendom.

Charlemagne and Economics

Charlemagne's reign was also conspicuous for its economic developments. He stabilized the currency system of his kingdom. The silver *denier*, struck at the royal mint in Frankfurt after 804, became the standard coin of the time; its presence in archaeological finds from Russia to England testifies to its widespread use and the faith traders had in it.

Trade and commerce were vigorous. There were annual trade fairs at Saint-Denis near Paris, at which English merchants could buy foodstuffs, honey, and wine from the Carolingian estates. A similar fair was held each year at Pavia, an important town of the old Lombard kingdom of northern Italy. Port cities such as Marseilles provided mercantile contracts with the Muslims of Spain and North Africa.

TOLERANCE OF JEWS Although as the Holy Roman emperor Charlemagne was responsible for the welfare of the Christian Church in his dominion, he was tolerant of Jews and welcomed them to his kingdom. Jews in France generally lived where they wished and owned land. In many other European areas, Jews were either unwelcome or compelled to live in Jewish quarters. By the end of the 10th century, Jewish scholars were explicating biblical texts in French, and Jewish women were taking French names.[1]

Jewish merchants operated as go-betweens in France for markets throughout the Near East. The chief of Charlemagne's mission to Harun al-Rashid's court was a Jew named Isaac who had the linguistic ability and geographic background to make the trip to Baghdad and back—with an elephant—at a time when travel was a risky enterprise. Rivers such as the Rhine and the Moselle were utilized as important trade routes. Among the most sought-after articles from the Frankish kingdom were the iron broadswords produced at forges in and around the city of Cologne and sold to Arabs in the Middle East through Jewish merchants at the port cities. Vivid testimony to these swords' value can be read in the repeated embargoes (imposed under penalty of death) decreed by Charlemagne against their export to the land of the Vikings, who too often put them to effective use against their Frankish manufacturers in coastal raids on North Sea towns and trading posts.

1. Howard N. Lupovich, *Jews and Judaism in World History* (New York: Routledge, 2010).

COMPARE + CONTRAST

Four Paintings of Saint Matthew

The style of Charlemagne's own gospel book, called the Coronation Gospels (Fig. 9.4), reflects his love of Classical art. Matthew, an evangelist who was thought to have written the first gospel, is represented as an educated Roman writer diligently at work. Only the halo around his head reveals his sacred identity. He does not appear as an otherworldly weightless figure awaiting a bolt of divine inspiration. His attitude is calm, pensive, and deliberate. His body has substance; it is seated firmly, and the drapery of his toga falls naturally over his limbs. The artist uses painterly strokes and contrast of light and shade to define his forms much in the same way that the wall painters of ancient Rome had done.

Although Classicism was preferred by the Holy Roman emperor, it was not the only style during the Carolingian period. The gospel book of Archbishop Ebbo of Reims

▼ 9.4 "Saint Matthew," folio 15 recto of the Vienna Coronation Gospels (gospel book of Charlemagne), ca. 800–810. Tempera on purple-dyed vellum, 9 7/8" × 12 3/4" (25.1 × 32.2 cm). Schatzkammer, Kunsthistorisches Museum, Vienna, Austria.

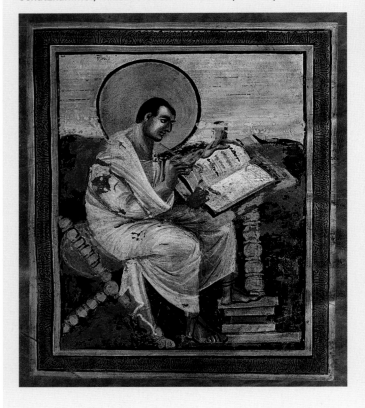

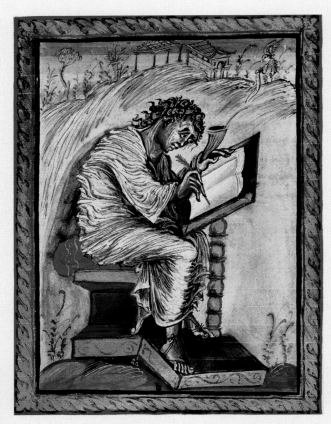

▲ 9.5 "Saint Matthew," folio 18 verso of the Ebbo Gospels (gospel book of Archbishop Ebbo of Reims), ca. 816–835. Ink and tempera on vellum, 10 1/4" × 8 3/4" (26 × 22.2 cm). Bibliothèque Municipale, Épernay, France.

(Fig. 9.5) was created only five to 10 years after the Coronation Gospels and yet it could not be more different. The sense of rational calm evident in Charlemagne's gospel book stands in marked contrast to the passion and energy overtaking Ebbo's evangelist. In both gospels, Matthew sits at a writing table surrounded by a landscape. Charlemagne's Matthew, however, appears to rely on his own intellect to pen his gospel, whereas Ebbo's evangelist, scroll in hand, seems to rush to jot down every word relayed to him by the angel of God, feverishly trying to keep up. His brow is furrowed, and his hands and feet cramp under the strain of his task.

The mood in the paintings differs dramatically. In the Coronation Gospels, the soft folds of Matthew's garment are echoed in his serene surroundings. He is pensive, dignified,

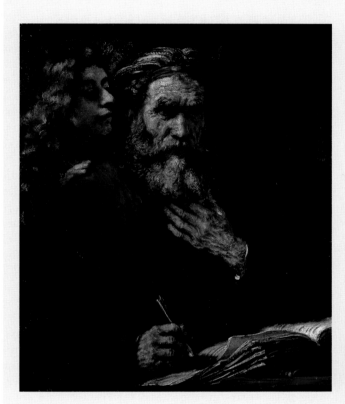

▲ **9.6** Rembrandt van Rijn, *Saint Matthew and the Angel*, 1661. Oil on canvas, 34³/₄" × 31⁷/₈" (96 × 81 cm). Musée du Louvre, Paris, France.

and scholarly. By contrast, the restless drapery, disheveled hair, facial contortions, and heaving landscape in the Ebbo Gospels convey the sense of a dramatic, highly charged spiritual experience.

The Matthew of the Ebbo Gospels may not be as realistically rendered as the Matthew of the Coronation Gospels, but he does seem more human. Centuries later, the subject of the evangelist and his angel remained popular. Differences in style and pictorial devices reveal very personal perspectives on Matthew. Rembrandt van Rijn, the Dutch master of the 17th century, portrays him as mature man with the wisdom to pen this biography of Christ (**Fig. 9.6**). He pauses, quill in hand, and stares as if lost in thought. He brings his left hand to his heart and twirls the strands of his coarse beard with his fingertips. As if to offer encouragement to continue, an angel lays a hand gently on his shoulder and seems to whisper in his ear.

The differences between the St. Matthews of the Coronation and Ebbo Gospels are revisited, it seems, in the contrast between Rembrandt's version of the saint and Guido Reni's (**Fig. 9.7**). Reni, an Italian Baroque painter whose work was created about 30 years earlier, portrays Matthew with a shock of tousled white hair, his gaze fixed intently on a young boy—the angel—who seems to count off on his small fingers the essential points to be included in the gospel. Matthew grips his journal and balances it in the air, not daring to lift his pen lest he miss something important. He stoops and leans in closely, listening carefully to every word. Matthew's faith in God and devotion to his task are magnified by the almost absurd suggestion that a grown man would be so deferential to a youth. The sense of urgency that permeates Reni's depiction of Matthew has its own symbolism, its own prophetic character; Matthew would become a Christian martyr, slain for the practice of his faith.

▲ **9.7** Guido Reni, *Saint Matthew the Evangelist*, 1635–40. Oil on canvas, 33¹/₂" x 26³/₄" (85 x 68 cm). Pinacoteca, Vatican Museums, Vatican City State, Italy.

Learning in the Time of Charlemagne

Although he could not write, Charlemagne was an admirer of the arts, Classical culture, and learning. Books were of great importance to him, whether they were of a religious nature or a secular. The best known of these, his Coronation Gospels, was written early in the ninth century and has text written in gold. There are numerous manuscript illuminations, four of which show the authors of the Gospels in the midst of writing (see **Fig. 9.4**).

Charlemagne opened his famous palace school at Aachen—an institution that was a prime factor in initiating what has been called the Carolingian Renaissance. Literacy in Western Europe before the time of Charlemagne was rather spotty; it existed, but hardly thrived, in certain monastic centers that kept alive the old tradition of humanistic learning taken from ancient Rome. Original scholarship was rare, although monastic copyists did preserve the tradition of literary conservation.

The scholars and teachers Charlemagne brought to Aachen provide some clues about the various locales in which early medieval learning had survived. Peter of Pisa and Paul the Deacon (from Lombardy) came to teach grammar and rhetoric at his school because they had had contact with the surviving liberal-arts curriculum in Italy. Theodulf of Orléans was a theologian and poet. He had studied in the surviving Christian kingdom of Spain and was an heir to the encyclopedic tradition of Isidore of Seville and his followers. Finally and importantly, Charlemagne brought an Anglo-Saxon, Alcuin of York, to Aachen after meeting him in Italy in 781. Alcuin had been trained in the English intellectual tradition of the Venerable Bede, the most prominent intellectual of his day—a monk who had welded together the study of humane letters and biblical scholarship. These scholar–teachers were hired by Charlemagne for several purposes.

First, Charlemagne wished to establish a system of education for the young of his kingdom. The primary purpose of these schools was to develop literacy; Alcuin of York developed a curriculum for them. He insisted that humane learning should consist of those studies that developed logic and science. From this distinction, later medieval pedagogues developed the two courses of studies for all schooling before the university: the *trivium* (grammar, rhetoric, and dialectic) and the *quadrivium* (arithmetic, geometry, music, and astronomy). These subjects remained at the heart of the school curriculum from the medieval period until modern times. The trivium and quadrivium made up the seven liberal arts that for centuries constituted a classical education and that are still discussed in programs in education today.

Carolingian Culture

Few books were available, and writing was done on slates or waxed tablets, because parchment was expensive. In grammar, some of the texts of the Latin grammarian Priscian might be studied and then applied to passages from Latin prose writers. In rhetoric, the work of Cicero was studied, or Quintilian's *Institutio oratoria* if it was available. For dialectic, some of the work of Aristotle might be read in the Latin translation of Boethius. In arithmetic, multiplication and division were learned, and perhaps there was some practice on the abacus, because Latin numerals were clumsy to compute with pen and paper. Arithmetic also included some practice in chronology, as students were taught to compute the variable date of Easter. They would finish with a study of the allegorical meaning of numbers. Geometry was based on the study of the Greek mathematician Euclid. Astronomy was derived from the Roman writer Pliny the Elder, with some attention to Bede's work. Music was the theoretical study of scale, proportion, the harmony of the universe, and the "music of the spheres." Music in this period was distinguished from *cantus*, which was the practical knowledge of chants and hymns for church use. In general, all study was based largely on rote mastery of the texts.

Beyond the foundation of schools, Charlemagne needed scholars to reform existing texts and to halt their terrible corruption, especially for those used in church worship. Literary revival was closely connected with **liturgical** revival. Part of Charlemagne's educational reform envisioned people who would read aloud and sing in church from decent, reliable texts. Literacy was conceived as a necessary prerequisite for worship.

Alcuin of York mainly worked at the task of revising the liturgical books. He published a book of Old and New Testament passages in Latin for public reading during Mass. He sent for books from Rome in order to publish a *sacramentary*, a book of prayers and rites for the administration of the sacraments of the church. Alcuin's sacramentary was made obligatory for the churches of the Frankish kingdom in 785. Charlemagne made the Roman chant (called *Gregorian* after Pope Gregory the Great, who was said to have initiated such chants at the end of the sixth century) obligatory in all churches of his realm. Alcuin also attempted to correct scribal errors in the **Vulgate Bible** (the Latin version of Saint Jerome) by a comparative reading of manuscripts—a gigantic task he never completed.

Beyond the practical need for literacy, there was a further aim of education in this period. It was generally believed that all learning would lead to a better grasp of revealed truth—the Bible. The study of profane letters (by and large the literature of Rome) was a necessary first step toward the full study of the Bible. The study of grammar would set out the rules of writing, while dialectic would help distinguish true from false propositions. Models for such study were sought in the works of Cicero, Statius, Ovid, Lucan, and Virgil. These principles of correct writing and argumentation could then be applied to the study of the Bible in order to get closer to its truth. The pursuit of analysis, definition, and verbal clarity are the roots from which the scholastic form of philosophy would spring in the High Middle Ages. Scholasticism, which dominated European intellectual life until the eve of the Renaissance, had its first beginnings in the educational methodology established by Alcuin and his companions.

These educational enterprises were not centered exclusively at the palace school at Aachen. Under Charlemagne's direction, Alcuin developed a system of schools throughout the empire—schools centered in both monasteries and towns. Attempts were also made to attach them to parish churches in rural areas. The monastic school at Metz became a center for singing and liturgical study; schools at Lyons, Orléans, Mainz, Tours, and Laon had centers for teaching children rudimentary literary skills and offered some opportunity for further study in the liberal arts and the study of scripture. The establishment of these schools was accomplished by a steady stream of decrees and **capitularies** emanating from the Aachen palace. A circular letter written most likely by Alcuin, called *Epistola de litteris colendis (Letter on the Cultivation of Writing)*, encouraged monks to study the Bible and to teach the young to do the same. A decree of 798 insisted that prelates and country clergy alike start schools for children.

This program of renewal in educational matters was an ideal set forth at a time when education was at an ebb in Europe. Charlemagne tried to reverse that trend and in so doing encouraged real hope for an educated class in his time. His efforts were not entirely successful; many of his reforms came to naught in following generations, when Europe slipped back into violence and ignorance.

Most of those who were educated were young men, although there is some evidence of learning among the aristocratic women of Charlemagne's court. The only book written in Charlemagne's time by a Frankish woman who was not a nun was a sort of manual for Christian living, written by Dhuoda for the instruction of her own son. We do, however, know that there had to be a certain level of literacy for nuns, and some evidence also suggests that illuminated manuscripts that have come to us were done by women in convents.

MONASTICISM

Monasticism—from the Greek *monos* ("single")—was an integral part of Christianity from the third century on. Monasticism came into the West from the great Eastern tradition of *asceticism* (self-denial) and *eremitism*[2] (the solitary life). Its development in the West was complex, and we cannot speak of any one form of monasticism as predominant before the time of Charlemagne.

Celtic monasticism in Ireland was characterized both by austere living and by a rather lively intellectual tradition. Monasticism in Italy was far more simple and rude. Some of the monasteries of continental Europe were lax, and the region was full of wandering monks. No rule of life predominated in the sixth and seventh centuries. Monastic

2. You may notice that this term and the word *hermit* share a common origin.

An Abbot, an Irish Scholar, and Charlemagne's Biographer

A ninth-century copyist monk describes labor in the **scriptorium**.

Even as the sailor, fatigued with his labors, rejoices when he sights the familiar shore toward which he has long aspired, so does the scribe rejoice who sees the long-desired end of the book which has so overcome him with weariness. The man who does not know how to write makes light of the scribes' pains, but those who have done it know how hard is this work.

An Irish scholar and his cat.

I love, better than all glory, to sit in diligent study over my little book. Pangur Ben has no envy of me, for he finds a mouse in his snares while only a difficult argument falls into mine. He bumps against the wall and I against the rigors of science. . . . He rejoices when he has a mouse in his paw as I rejoice when I have understood a difficult question. . . . Each of us loves our art.

Einhard, a scholar, courtier, and servant of Charlemagne, in his biography of Charlemagne.

He paid the greatest attention to the liberal arts. He had great respect for men who taught them, bestowing high honors on them. When he was learning the rules of grammar he received tuition from Peter the Deacon of Pisa who, by then, was an old man. For all other subjects he was taught by Alcuin, surnamed Albinus, a man of the Saxon race who came from Britain and was the most learned man anywhere to be found. Under him, the emperor spent much time and effort in studying rhetoric, dialectic, and especially astrology. He applied himself to mathematics and traced the course of the stars with great attention and care. He also tried to learn to write. With this end in view he used to keep writing tablets and notebooks under the pillows of his bed, so that he could try his hand at forming letters during his leisure moments; but, although he tried very hard, he had begun late in life and he made very little progress.

lifestyles varied not only from country to country but also from monastery to monastery.

The Rule of Saint Benedict

One strain of European monasticism derived from a rule of life written in Italy by Benedict of Nursia (480–547) in the early sixth century. Although it borrowed from earlier monastic rules and was applied only to a small proportion of monasteries for a century after its publication, the Rule of Saint Benedict eventually became the Magna Carta of monasticism in the West. Charlemagne had Alcuin of York bring the rule to his kingdom and impose it on the monasteries to reform them and instill some sense of regular observance. In fact, the earliest copy of the Rule of Saint Benedict we possess today (a ninth-century manuscript preserved in the Swiss monastery of Saint Gall) is a copy of a copy Charlemagne had made in 814 from Saint Benedict's autographed copy, which had been preserved at the abbey of Monte Cassino in Italy but is now lost.

The Rule of Saint Benedict consists of a prologue and 73 chapters (some only a few sentences long), which set out the ideal of monastic life. Monks (the brethren) were to live a family life in community under the direction of a freely elected father (the abbot) for the purpose of being schooled in religious perfection. They were to possess nothing of their own (poverty); they were to live in one monastery and not wander (stability); their life was to be one of obedience to the abbot; and they were to remain unmarried (chastity). Their daily life was to be a balance of common prayer, work, and study. Their prayer life centered on duly appointed hours of liturgical praise of God that were to mark the intervals of the day. Called the Divine Office, this liturgy consisted of the public recitation of psalms, hymns, and prayers, with readings from the scriptures. The offices were interspersed throughout the day and were central to the monks' lives. The periods of public liturgical prayer set off the times for reading, study, and the manual labor that was performed for the good of the community and its sustenance. The lifestyle of Benedictine monasticism can be summed up in its motto: "Pray and work." The rule was observed by both men and women.

THE REGULATED DAY IN THE MONASTERY The daily life of a monk was determined by sunrise and sunset (as it was for most people in those days). Here is a typical day—called the *horarium*—in an early medieval monastery. The italicized words designate the names for the liturgical hours of the day.

This daily regimen changed on feast days (less work and more prayer) and during the summer (rising earlier, working later in the day when the sun was down a bit, eating more food, and so on). Although the schedule now seems harsh, it would not have surprised a person of the time. Benedict would have found it absurd for people to sleep while the sun was shining and then stay up under the glare of artificial light. When we look at the horarium closely, we see that

Horarium Monasticum

2:00 A.M.	Rise
2:10–3:30	*Nocturns* (later called *Matins*; the longest office of the day)
3:30–5:00	Private reading and study
5:00–5:45	*Lauds* (the second office; also called "morning prayer")
5:45–8:15	Private reading and *Prime* (the first of the short offices of the day); at times, there was communal Mass at this time and, in some places, a light breakfast, depending on the season
8:15–2:30	Work punctuated by short offices of *Tierce*, *Sext*, and *None* (literally the third, sixth, and ninth hours)
2:30–3:15	Dinner
3:15–4:15	Reading and private religious exercises
4:15–4:45	*Vespers*—break—*Compline* (night prayers)
5:15–6:00	To bed for the night

monks prayed and studied eight hours a day, whereas they worked for an additional six hours. The rest of the day was devoted to personal chores, eating, and the like.

The triumph of the Benedictine monastic style of life (the Early Middle Ages have been called the Benedictine centuries by some historians) is to be found in its sensible balance between the extreme asceticism of Eastern monastic practices and the unstructured life of Western monasticism before the Benedictine reforms. There was a balance of prayer, manual labor, and intellectual life.

Women and Monastic Life

We tend to think of monasticism as a masculine enterprise, but the vowed religious life was open to both men and women. The entire early history of Christianity records a flourishing monastic life for women. In the late Roman period, groups of religious women flourished all over the Roman Empire. Benedict's own sister, Scholastica (died ca. 543), was head of a monastery not far from her brother's establishment at Monte Cassino. Her contemporary Brigit of Ireland (died ca. 525) was such a powerful figure in the Irish church that legends grew up about her prowess as a miracle worker and teacher. Her reputation as a saint was such that churches dedicated to her dotted Ireland, England, and places on the continent where Irish monasticism took root. In England in the seventh century, Hilda, abbess of Whitby (614–680), not only ruled over a prominent monastery that was a center of learning (many Anglo-Saxon bishops were educated there) but held a famous episcopal gathering (synod) to determine church policy. Hilda also encouraged lay learning. She fostered the talents of the cowherd poet Caedmon, who produced vernacular poetry concerned with Christian themes.

We possess several edifying lives written by the contemporaries of these women, which laud their decision to give up marriage in order to serve God. These lives of the saints were extremely popular because they served as exemplars of holy living. They were read publicly in churches (hence they were called *legends*—things read aloud) and privately for devotions.

MUSIC

The main occupation of the monk was the *opus Dei* (work of God)—the liturgical common prayer of the *monastic horarium*—and life revolved around the monastic church, where the monks gathered seven times a day for prayer. The centrality of the liturgy also explains why copying, correcting, and illuminating manuscripts were such important parts of monastic life. Texts were needed for religious services as well as for spiritual reading. The monks were encouraged to study the scriptures as a lifelong occupation. This study was *lectio divina* (divine reading), central to their development as a monk. The monastic life encouraged the study of the Bible and such ancillary disciplines (grammar, criticism, and the like) as necessary for the study of scripture. From the seventh century on, monastic scriptoria were busily engaged in copying a wealth of material, both sacred and profane.

The monasteries were also centers for the development of sacred music. We have already seen that Charlemagne was interested in church music. His biographer Einhard tells us that the emperor "made careful reforms in the way in which the psalms were chanted and the lessons read. He was himself an expert at both of these exercises but he never read the lesson in public and he would sing only with the rest of the congregation and then in a low voice." Charlemagne's keen interest in music explains why certain monasteries of his reign—notably those at Metz and Trier—became centers for church music.

Gregorian Chant

Charlemagne brought monks from Rome to stabilize and reform church music in his kingdom as part of his overall plan of liturgical renovation. In the earlier period of Christianity's growth, diverse traditions of ecclesiastical music developed in various parts of the West. Roman music represented one tradition—later called *Gregorian chant*. Milan had its own musical tradition, known as *Ambrosian* music—in honor of Saint Ambrose, who had been a noted hymn writer, as Saint Augustine attests in the *Confessions*. There was a peculiar regional style of music in Spain known as *Mozarabic* chant, and the Franks also had their own peculiar style of chant. All of these styles derive from earlier models of music that have their roots in Hebrew, Graeco-Roman, and Byzantine styles. Lack of documentation permits only an educated reconstruction of this early music and its original development.

GO LISTEN! ANONYMOUS

"Victimae paschali Laudes"

This listening selection is an early example of Gregorian Chant in which every syllable has its own note and the only extended phrases come at the end of each line. Even the final alleluia is simple and unelaborated.

Note that of the three elements that characterize most Western music—melody, harmony, and rhythm—only the first is present. The melody is based entirely on the words of the text. No accompanying line provides harmony and no repeated rhythm provides musical form: the text dominates the musical structure. The only element of musical variety is the contrast between a single voice and massed voices. The musical content of the listening selection is intended to heighten the significance of the text, rather than add any extra element of its own.

Gregorian chant as we know it today was not codified until the 11th and 12th centuries, so it is rather difficult to reconstruct precisely the music of Charlemagne's court. It was probably a mixture of Roman and Frankish styles of singing. It was **monophonic** (one or many voices singing a single melodic line) and, ordinarily, would be sung **a cappella** (without instrumental accompaniment) in the monastic churches. Scholars believe that most music consisted of simple chants for the recitation of the psalms at the Divine Office; more elaborate forms were used for the hymns of the office and the Mass chants. The music was simply called *cantus planus* (plainsong or plainchant).

GREGORIAN STYLE As the printed example shows, the written form of the music does not correspond to the modern style, which would not be invented until around 1000 by Guido d'Arezzo. In its elementary form the chant consisted of a single note for each syllable of a word. The basic symbols used to notate Gregorian chant are called *neumes*. In the Gregorian notational system with its four-line staff, the opening line of Psalm 109, "Dixit Dominus Domino meo, sede a dextris meis" (The Lord said to my Lord: sit on my right hand), would look like the following.

1. Di-xit Dóminus Dómino mé- o : * Séde a déxtris mé- is.

Even in the earliest form of chants, a **cadence** (a rhythmic flow of a sequence of sounds or words) was created by emphasizing the final word of a phrase with the addition of one or two extra notes, as seen in the example. Later, more notes were added to the final words or syllables for elaboration and variation.

The simplicity of syllabic chant should not be regarded as useful only for the monotonous chanting of psalm verses. Very simple yet hauntingly melodic Gregorian compositions still exist that do not use elaborate cadences but rely on simple syllabic notes.

Certain phrases, especially words of acclamation (like *alleluia*) or the word at the end of a line, were musically elaborated beyond the one-to-one correlation between note and syllable in the simple chant. This extensive addition of a chain of intricate notes sung on the vowel sound of a single syllable was called a **melisma**. Thus, for example, a melisma might elaborate the final *a* ("ah") of *alleluia* or the *ie* ("ee-ay") of *kyrie* in the Kyrie Eleison (the Greek "Lord, have mercy on us" retained in the Latin Mass).

The Liturgical Trope

Because books were scarce in the Carolingian period, monks memorized a great deal of liturgical chant. To aid memorization and add variety in the chant, words would be added to the long melismas. These words, **tropes**, were verbal elaborations of, or comments on, the text. Thus, for example, the melismatic Kyrie Eleison might take on such tropes as *sanctus* (holy) and *dominus* (lord), which were sung to the tune of the melisma. The use of tropes grew rapidly and became standard in liturgical music, until they were removed from the liturgy at the time of the Counter-Reformation in the 16th century.

Scholars have pointed to the introduction of tropes into liturgical music as the origin of drama in the Western world. There had been drama in the Classical and Byzantine worlds, but drama in Europe developed from the liturgy of the medieval church after having largely been lost (or suppressed) in the very early Middle Ages.

A ninth-century manuscript (preserved at the monastery of Saint Gall) demonstrates an early trope that was added to the music of the Easter entrance hymn (the Introit) for Mass. It is in the form of a short dialogue and seems to have been sung by either two different singers or two choirs. It is called the *Quem quaeritis* trope, from its opening lines.

De resurrectione Domini	Of the Lord's Resurrection
Int[errogatio]:	Question [of the angels]:
Quem quaeritis in	*Whom seek ye in the*
sepulchro, {o}Christicolae?	*sepulcher, O followers*
	of Christ?
R[esponsio]:	Answer [of the Marys]:
Jesum Nazarenum	*Jesus of Nazareth,*
crucifixum, o coelicolae.	*which was crucified,*
	O celestial ones.
[Angeli:]	[The angels:]
Non est hic; surrexit, sicut,	*He is not here; he is risen,*
praedixerat.	*just as he foretold.*
Ite, nuntiate quia surrexit	*Go, announce that he is*
de sepulchro.	*risen from the sepulcher.*

Very shortly after the introduction of this trope into the Easter Mass, the short interrogation began to be acted, not at Mass but at the end of the night services preceding Easter dawn. The dialogue of the *Quem quaeritis* (*Whom do you seek* ["in the sepulcher, O Christians"?]) was not greatly enlarged, but the directions for its singing were elaborated into the form of a short play. By the 11th and 12th centuries, the dialogue was elaborated and more people were added. By the 12th century, the stories took on greater complexity.

It was a logical step to remove these plays from the church and perform them in the public square. By the 14th century, sizable cycles of plays were performed in conjunction with various feast days and underwritten by the craft or merchants' guilds. Some of these cycles acted out the major stories of the Bible, from the Creation to the Last Judgment. The repertory also began to include plays about the lives of the saints and allegorical plays about the combats of virtue and vice, such as the 15th-century work *Everyman*. These plays were a staple of public life well into the 16th century; William Shakespeare, for example, may well have seen such plays in his youth.

LITERATURE

Writing continued during the Middle Ages in the West, some of it in Latin, some in Old English, and some in the other languages used throughout Europe. Some of these languages, including English, German, and most of the Nordic tongues, are *Teutonic*. French, Italian, Spanish, Portuguese, and Romanian are *Romance* languages. Arabic was also spoken in the Iberian peninsula. Oral traditions and writings appeared in all these languages.

Venerable Bede

In early medieval England, a monk by the name of Bede—called Saint Bede or the Venerable Bede (ca. 672/673–735)—wrote more than 60 books on religious and secular topics, many of which survive. He wrote in Latin and Old English, and knew some Greek and Hebrew. His topics range from music and mathematics to religious commentaries, and his *Ecclesiastical History of the English People* has led scholars to call him the Father of English History. He described the planet Earth as spherical and calculated the passages and phases of the moon. In chapter 2 of book 1 of his *Ecclesiastical History*, Bede describes Julius Caesar's efforts to conquer the Britons, one of the groups of people occupying present-day England. Caesar sailed to Great Britain with some 80 ships in 60 BCE. His early battles with the Britons did not go well, and he met a violent storm in the English Channel, losing much of his fleet. Caesar returned later with some 600 ships, according to Bede, but many of them were "driven upon the sands" by the weather and destroyed. After numerous battles, Caesar was gaining the upper hand, as described in Reading 9.1

Caesar left for Gaul—present-day France—and finding himself "beset and distracted with wars and tumults raised against him on every side," did not return to England.

In the *Ecclesiastical History*, Bede also tells of a serf who managed to escape his bondage. According to Bede, the formidable abbess Hilda of Whitby spotted a swineherd singing.

READING 9.1 VENERABLE BEDE

***The Ecclesiastical History of the English Nation*, book 1, chapter 2**

[Caesar then] proceeded to the river Thames, where an immense multitude of the enemy had posted themselves on the farthest side of the river, under the command of Cassibellaun, and fenced the bank of the river and almost all the ford under water with sharp stakes: the remains of these are to be seen to this day, apparently about the thickness of a man's thigh, and being cased with lead, remain fixed immovably in the bottom of the river. This, being perceived and avoided by the Romans, the barbarians not able to stand the shock of the legions, hid themselves in the woods, whence they grievously galled the Romans with repeated sallies. In the meantime, the strong city of Trinovantum, with its commander Androgeus, surrendered to Caesar, giving him forty hostages. Many other cities, following their example, made a treaty with the Romans.

Enchanted by the quality of his voice, and presiding over a men's and women's monastery, she had him brought to the monks to be educated. In Bede's words: "So Caedmon stored up in his memory all that he learned and like one of the clean animals chewing the cud, turned it into such melodious verse that his delightful renderings turned his instructors into listeners" (book 4, chapter 24).

Only one of his poems has survived, a nine-line piece known as "Caedmon's Hymn" that begins, "Now [we] must honor the guardian of heaven, the might of the architect." The importance of "Caedmon's Hymn" lies in the fact that it is the oldest example we have of a composition in Old English. Caedmon died in 680, but his hymn has immortalized this onetime serf as a pioneer in the history of English poetry.

Beowulf

The origin of *Beowulf* is a mystery. It is an Old English epic poem, written in the **vernacular** rather than in literary Latin, but we do not know whether it was first sung or written. It was created sometime between the seventh and 10th centuries and discovered in England, although it tells a tale of Danes and Swedes beyond the northern sea, set early in the sixth century. It shows knowledge of the Hebrew Bible, and one may read knowledge of, or at least sensitivity to, Christianity in it. Its birth does seem to follow the spread of Christianity in northern Europe. It was copied by scribes around the year 1000, then nearly lost in a fire in the 18th century.

Beowulf (the name literally means "bee wolf," or bear) comes to aid the good but grief-stricken king Hrothgar, whose soldiers have been mercilessly slaughtered by the "man-monster" Grendel for the strangest of reasons. Hrothgar has

built a wondrous mead[3] hall for his retinue, called Heorot, but the singing and telling of tales in the evening annoys Grendel. It is for Grendel a capital crime.

READING 9.2 *BEOWULF*, LINES 79–81

Each day, one evil dweller in darkness
spitefully suffered the din from that hall
where Hrothgar's men made merry with mead.

The poem is translated into modern English, but as in the lines you have read, there is no rhyme scheme. Rather, there is **alliteration**: consonants are repeated throughout the lines—"dweller in darkness," "made merry with mead." There are also pauses in the lines, providing a rhythm, as if they swing left and right.

One night the murders begin.

READING 9.3 *BEOWULF*, LINES 92–110

Then crime came calling,
a horror from hell, hideous Grendel,
wrathful rover of borders and moors,
holder of hollows, haunter of fens,
He had lived long in the homeland of horrors,
born to the band whom God had banished
as kindred of Cain, thereby requiting
the slayer of Abel.

. . .

After nightfall he nosed around Heorot,
saw how swordsmen slept in the hall,
unwary and weary with wine and feasting,
numb to the sorrows suffered by men.
The cursed creature, cruel and remorseless,
swiftly slipped in. He seized thirty thanes
asleep after supper, shouldered away
what trophies he would, and took to his lair
pleased with the plunder, proud of his murders.

Daylight comes and there are "fits of weeping" and "cries of outrage." Hrothgar beholds the carnage and sinks on his throne. The killing goes on for years, and Horthgar offers a reward for anyone who can rid his kingdom of Grendel.

Beowulf—from a nearby land, "kind to kinfolk," righteous, and "more mighty than any then living"—arrives and presents himself to Hrothgar. Beowulf and Hrothgar talk of a legendary feat at sea in which Beowulf swam against whale-like currents. Beowulf boasts of having the strength and skill to kill Hrothgar with his bare hands. To make his point, he

3. An alcoholic drink made of fermented honey and water.

removes his armor and puts aside his sword when he sets to sleep with Hrothgar's men. Grendel comes that night.

READING 9.4 *BEOWULF*, LINES 664-685, 722-733

For his first feat he suddenly seized
A sleeping soldier, slashed at the flesh,
bit through bones and lapped up the blood
that gushed from veins as he gorged on gobbets.
Swiftly he swallowed those lifeless limbs,
hands and feet whole; then he headed forward
with open palm to plunder the prone.
One man angled up on his elbow:
the fiend soon found he was facing a foe
whose hand-grip was harder than any other
he ever had met in all Middle-Earth.
Cravenly cringing, coward at heart,
he longed for a swift escape to his lair,
his bevy of devils. He never had known
from his earliest days such awful anguish.
[Beowulf] recalling his speech to the king,
straightaway stood and hardened his hold.
Fingers fractured. The fiend spun round;
the soldier stepped closer. Grendel sought
somehow to slip that grasp and escape,
flee to the fens; but his fingers were caught
in too fierce a grasp.

. . .

The strength of his sinews would serve him no more;
no more would he menace mankind with his crimes,
his grudge against God, for [Beowulf] had hold of his hand.
Each found the other loathsome in life;
but the murderous [Grendel] got a great wound
as tendons were torn, shoulder shorn open,
and bone-locks broken. Beowulf gained
glory in war; and Grendel went off
bloody and bent to the boggy hills,
sorrowfully seeking his dreary dwelling,
Surely he sensed his lifespan was spent.

Beowulf's contests are not finished. He will go on to war with, and defeat, Grendel's vengeful mother. Then he will fight with a dragon. He will vanquish the dragon but lose his own life as he does so.

The monsters in *Beowulf* are not simply born with instinctive aggressiveness, as are the lion and the wolf; they represent wrath and evil. *Beowulf* was written in the oldest form of English after Nordic peoples—including the Danes and Swedes in the poem—emigrated to the British Isles from their native lands and, presumably, brought their legends and their stories with them. Yet some of those in the epic are actually recorded in the history of the sixth century—although not as having been in conflict with monsters.

Hildegard of Bingen

Because monasticism presumed a certain degree of literacy, it was possible for women to exercise their talents in a way that was not available to them within the confines of the more restricted life of the court or the family. The Benedictine tradition produced great figures such as Hildegard of Bingen (1098–1179), who wrote treatises on prayer, philosophy, medicine, and devotion. Her *Scivias* (*The Way to Knowledge*) includes mystical, cosmic visions symbolizing the structure of a universe created and sustained by God, such as the following one.

> Then I saw a huge image, round and shadowy. It was pointed at the top, like an egg. . . . Its outermost layer was of bright fire. Within lay a dark membrane. Suspended in the bright flames was a burning ball of fire,

⌃ 9.8 Hildegard of Bingen, "Vision of the Ball of Fire," 1141-51. From *Scivias* ("Know the Ways"). Illuminated miniature on manuscript page 12 ³/₄" × 9 ¼" (32.5 × 23.5 cm). Original destroyed, faithful illuminated copy 1927-1933, Benedictine Abbey of St. Hildegard, Eibingen, Germany.

so large that the entire image received its light. Three more lights burned in a row above it. They gave it support through their glow, so that the light would never be extinguished[4] (**Fig. 9.8**).

Hildegard's visions were exceptionally detailed and often described God's call to her to reveal the mysteries embedded in scripture and to preach them.

READING 9.5 *HILDEGARD OF BINGEN*

Scivias, Vision One: God Enthroned Shows Himself to Hildegard

I saw a great mountain the color of iron, and enthroned on it One of such great glory that it blinded my sight. . . . And behold, He Who was enthroned upon that mountain cried out in a strong, loud voice saying, "O human, who are fragile dust of the earth and ashes of ashes! Cry out and speak of the origin of pure salvation until those people are instructed, who, though they see the inmost contents of the Scriptures, do not wish to tell them or preach them, because they are lukewarm and sluggish in serving God's justice. Unlock for them the enclosure of mysteries that they, timid as they are, conceal in a hidden and fruitless field. Burst forth into a fountain of abundance and overflow with mysterious knowledge, until they who now think you contemptible because of Eve's transgression are stirred up by the flood of your irrigation. For you have received your profound insight not from humans, but from the lofty and tremendous judge on high, where this calmness will shine strongly with glorious light among the shining ones.

"Arise therefore, cry out and tell what is shown to you by the strong power of God's help, for He Who rules every creature in might and kindness floods those who fear Him and serve Him in sweet love and humility with the glory of heavenly enlightenment and leads those who persevere in the way of justice to the joys of the Eternal Vision."

From *Hildegard of Bingen*: Scivias, translated by Mother Columbia Hart and Jane Bishop, from The Classics of Western Spirituality.

Embedded in the passage is an allusion to the church's view of women as culpable for the downfall of humanity, as the descendants of Eve and the inheritors of her transgression. But Hildegard's voice is sanctioned, having received "profound insight" not from members of the church (humans who are "lukewarm and sluggish in serving God's justice") but from God directly.

Between the writing of her visionary books, Hildegard also completed two medical works: *Physica* catalogues, among other things, the medicinal benefits of herbs and other plants; *Causae et Curae* is an encyclopedia of illnesses and their cures as well as an exposition on physiology. *Causae et Curae* was controversial both for its explicit portrayals of sexual acts and its anatomical and physiological assumptions.

READING 9.6 *HILDEGARD OF BINGEN*

Causae et Curae, Women's Physiology, On Intercourse

When a woman is making love with a man, a sense of heat in her brain, which brings with it sensual delight, communicates the taste of that delight during the act and summons forth the emission of the man's seed. And when the seed has fallen into its place, that vehement heat descending from her brain draws the seed to itself and holds it, and soon the woman's sexual organs contract, and all the parts that are ready to open up during the time of menstruation now close, in the same way as a strong man can hold something enclosed in his fist.

Causae et Curae from *Women Writers of the Middle Ages: A Critical Study of Texts from Perpetua to Marguerite* by Peter Dronke.

In addition to these more practical works, Hildegard composed a song cycle of hymns and sequences called the *Symphonia* that honored, in particular, the Virgin Mary. Hildegard's musical style has been described as having both monophonic (single melodies without harmonies) and melismatic (consisting of single syllables sung while moving between several successive notes) elements.

The Nonliturgical Drama of Roswitha

At the end of the Early Middle Ages we also have evidence of plays that did not depend on liturgical worship. Thus, a German poet and nun named Roswitha (or Hroswitha; the name is spelled variously), who lived at the aristocratic court of Gandersheim and died around the year 1000, has left us a collection of legends written in Latin and six plays modeled on the work of the Roman dramatist Terence. What is interesting about this well-educated woman is the broad range of her learning and her mastery of classical Latin in an age that did not put a high premium on the education of females. Scholars also point out that her prose legend of Theophilus is the first known instance in German

4. From *Hildegard of Bingen: Scivias*, translated by Mother Columbia Hart and Jane Bishop, from *The Classics of Western Spirituality*, Copyright © 1990 by the Abbey of Regina: Laudis Benedictine Congregation Regina Laudis of the Strict Observance, Inc., New York/Mahwah, N.J. Used with permission of Paulist Press, www.paulistpress.com

literature of the Faust theme—the selling of one's soul to the devil for material gain and public glory.

Roswitha's plays were probably meant to be read aloud by a small circle of literate people, but some internal evidence suggests that they may also have been acted out in some rudimentary fashion. They are heavily moralistic (typically involving a religious conversion or steadfastness in faith during a time of persecution) and didactic. In the play *The Conversion of the Harlot Thaïs*, for example, the holy man Pafnutius begins with a long conversation with his disciples on a liberal education and the rules of musical proportion and harmony. Such a discussion would seem a wild digression to us today, but for Roswitha's audience it would be not only a way of learning about the liberal arts but also a reminder that their study inevitably leads to a consideration of God. That her plays do not have a finished dramatic quality underscores the fact that she was the *first* dramatist writing in Germany (as well as Germany's first female poet). Her model was the ancient drama of Rome as far as style was concerned, but her intention was to use that style to educate and convert. She was a direct heir of the humane learning that developed in the Carolingian and Ottonian periods.

In the following lines from scene 3, in the second half of the play, Pafnutius pretends to visit Thaïs for sexual purposes, and then undertakes her conversion.

READING 9.7 ROSWITHA

From *The Conversion of the Harlot Thaïs*, scene 3

PAFNUTIUS Are you inside, Thaïs, whom I'm seeking?/

THAÏS Who is the stranger speaking?/

PAFNUTIUS One who loves you.

THAÏS Whoever seeks me in love/ finds me returning his love./

PAFNUTIUS Oh Thaïs, Thaïs, what an arduous journey I took to come to this place/ in order to speak with you and to behold your face./

THAÏS I do not deny you the sight of my face nor my conversation./

PAFNUTIUS The secret nature of our conversation/ necessitates the solitude of a secret location./

THAÏS Look, here is a room well furnished for a pleasant stay./

PAFNUTIUS Isn't there another room, where we can converse more privately, one that is hidden away?/

THAÏS There is one so hidden, so secret, that no one besides me knows its inside except for God./

PAFNUTIUS What God?/

THAÏS The true God./

PAFNUTIUS Do you believe He knows what we do?/

THAÏS I know that nothing is hidden from His view./

PAFNUTIUS Do you believe that He overlooks the deeds of the wicked or that He metes out justice as its due?/

THAÏS I believe that He weighs the merits of each person justly in His scale/ and that, each according to his deserts receives reward or travail./

PAFNUTIUS Oh Christ, how wondrous is the patience, of Thy great mercy! Thou seest that some sin with full cognition,/ yet Thou delay their deserved perdition./

THAÏS Why do you tremble? Why the change of color? Why all these tears?

PAFNUTIUS I shudder at your presumption,/ I bewail your sure perdition/ because you know all this so well,/ and yet you sent many a man's soul to Hell./

THAÏS Woe is me, wretched woman!

PAFNUTIUS You deserve to be damned even more,/ as you offended the Divine Majesty haughtily, knowing of Him before./

THAÏS Alas, alas, what do you do? What calamity do you sketch?/ Why do you threaten me, unfortunate wretch?/

PAFNUTIUS Punishment awaits you in Hell/ if you continue in sin to dwell./

THAÏS Your severe reproach's dart/ pierces the inmost recesses of my heart./

PAFNUTIUS Oh, how I wish you were pierced through all your flesh with pain/ so that you wouldn't dare to give yourself to perilous lust again./

THAÏS How can there be place now for appalling lust in my heart when it is filled entirely with the bitter pangs of sorrow/and the new awareness of guilt, fear, and woe?/

PAFNUTIUS I hope that when the thorns of your vice are destroyed at the root,/ the winestock of penitence may then bring forth fruit./

THAÏS If only you believed/ and the hope conceived/ that I who am so stained,/ with thousands and thousands of sins enchained,/ could expiate my sins or could perform due penance to gain forgiveness!

PAFNUTIUS Show contempt for the world, and flee the company of your lascivious lovers' crew./

THAÏS And then, what am I to do?/

PAFNUTIUS Withdraw yourself to a secret place,/ where you may reflect upon yourself and your former ways/ and lament the enormity of your sins.

THAÏS If you have hopes that I will succeed,/ then I will begin with all due speed./

. . .

PAFNUTIUS Oh how you have changed from your prior condition/ when you burned with illicit passions/ and were inflamed with greed for possessions./

THAÏS Perhaps, God willing,/ I'll be changed into a better being./

PAFNUTIUS It is not difficult for Him, Himself unchangeable, to change things according to His will./

The Conversion of the Harlot Thais by Hrosvitha von Gandersheim from *The Plays of Hrostvit von Gandersheim*, translated by Katharina Wilson.

The Morality Play: *Everyman*

Everyman is a 15th-century play that may well be a translation from a much earlier Dutch play. The subject is no longer a redoing of a biblical theme but rather the personification of abstractions representing a theme dear to the medieval heart: the struggle for the soul. The unprepared reader of *Everyman* will note the heavy-handed allegorizing and moralizing (complete with a Doctor who makes a final appearance to point up the moral of the play) with some sense of estrangement, but with a closer reading, students will also note the stark dignity of the play, the earnestness with which it is constructed, and the economy of its structure. *Everyman* is a good example of the transitional play that forms a link between the earlier liturgical drama and the more secular drama that was to come at the end of the English medieval period.

The plot of *Everyman* is simplicity itself; it is summarized by the messenger who opens the play. Everyman must face God in final judgment after death. Yet as we see here, God, a character in the play, is angry—or at least frustrated—with his creation.

READING 9.8 *EVERYMAN*, LINES 22–35

[GOD SPEAKETH]

GOD I perceive here in my majesty,
How that all the creatures be to me unkind,
Living without dread in worldly prosperity:
Of ghostly sight the people be so blind,
Drowned in sin, they know me not for their God;
In worldly riches is all their mind,
They fear not my rightwiseness, the sharp rod;
My law that I shewed, when I for them died,
They forget clean, and shedding of my blood red;
I hanged between two, it cannot be denied;
To get them life I suffered to be dead;
I healed their feet; with thorns hurt was my head:
I could do no more than I did truly,
And now I see the people do clean forsake me.

"Everyman" from *Everyman and Medieval Miracle Plays*, edited by A. C. Crowley, 1952, © Everyman's Library, Northburgh House, 10 Northburgh Street, London EC1V0AT

None of the aids and friends of this life will support Everyman, as the speeches of the allegorical figures of Fellowship and others make clear. The strengths for Everyman come from the aiding virtues of Confession, Good Deeds, and Knowledge. The story, however, is not the central core of this play; the themes that run through the entire play are what should engage our attention. First is the common medieval notion of life as a pilgrimage, which surfaces repeatedly. It is embedded not only in the medieval penchant for pilgrimage but also in the use of the metaphor (as one sees, for example, in Chaucer). Second, the notion of the inevitability of death as the defining action of human life is omnipresent in medieval culture. Everyman has an extremely intense *memento mori* ("Keep death before your eyes!") motif. Finally, medieval theology places great emphasis on the will of the human being in the attainment of salvation. It is not faith (this virtue is presumed) that will save Everyman; his willingness to learn (Knowledge), act (Good Deeds), and convert (Confession) will make the difference between salvation and damnation.

The Messenger says that *Everyman* is "by figure a moral play." It is meant not merely to instruct on the content of religion (as does a mystery play) but to instruct for the purposes of moral conversion. The earlier mystery plays usually point out a moral at the end of the performance. The morality play uses its resources to moralize throughout the play.

The one lingering element from the liturgy in a play like *Everyman* is its pageant quality: the dramatic force of the presentation is enhanced by the solemn wearing of gowns, the stately pace of the speeches, and the seriousness of the message. The play depends less on props and place. Morality plays did not evolve directly out of liturgical drama (they may owe something to the study of earlier plays based on the classics studied in schools), but the liturgical overtones are not totally absent.

The Song of Roland

The memory of Charlemagne and his epoch was kept vividly alive in cycles of epic poems and in tales and memoirs developed, embellished, and disseminated by poets and singers throughout Europe from shortly after his time until the Late Middle Ages. These are the famous *chansons de geste* ("songs of deeds") or, as some were called, *chansons d'histoire* ("songs of history"). Of these songs, the oldest extant—as well as the best known—is *The Song of Roland*.

The Song of Roland was written sometime late in the 11th century, but behind it lie some 300 years of oral tradition and earlier poems celebrating a battle between Charlemagne's army and a Muslim force at the Spanish border. Charlemagne did campaign against the emirate of Spain in 777 and 778 without conclusive result. In August 778, Charlemagne's rear guard was ambushed by the Basques while making its way through the Pyrenees after the invasion of Spain. The real extent of that battle (later placed, on not too much evidence, at the town of Roncesvalles) is unclear. Some experts maintain that it was a minor skirmish, remembered in the area in local legends later told and retold (and considerably embroidered in the process) by monks of the monasteries and sanctuaries that were on the pilgrimage routes to the great shrine of Saint James at Santiago de Compostela in Spain. Other historians insist that the battle was a horrendous bloodbath for the army of Charlemagne and that the tale was carried back to the Frankish cities; the legend was transformed as it was repeated by the descendants of the few survivors.

In any event, by the 11th century the tale was widely known in Europe. Excerpts from *The Song of Roland* were sung to inspire the Norman army of William the Conqueror before the Battle of Hastings in 1066, and in 1096 Pope Urban II cited it in an appeal to French patriotism when he attempted to raise armies for a crusade to retake the Holy Land. Medieval translations of the poem into German, Norse, and Italo-French attest to its widespread popularity outside the French-speaking area.

The Song of Roland is an epic poem; its unknown writer or writers had little interest in historical accuracy or geographic niceties. Its subject matter is the glory of the military campaign, the chivalric nature of the true knight, the constant possibility of human deviousness, and the clash of good and evil. Although the poem is set in the eighth century, it reflects the military values and chivalric code of the 11th century.

The story is simple: Muslims attack the retreating rear portion of Charlemagne's army (through an act of betrayal) while it is under the command of Roland, a favorite nephew of the emperor. Roland's army is defeated, but not before he sounds his ivory horn to alert the emperor to the peril.

The emperor in turn raises a huge army from throughout Christendom while the Muslims also raise a great force. An epic battle follows; Charlemagne, with divine aid, is victorious.

The Song of Roland is some 4000 lines long; it is divided into stanzas, and each line contains 10 syllables. It is impossible to reproduce the rhyme in English, because each stanza ends with an **assonance**, so the poem is best read in a blank-verse translation—although that sacrifices the recitative quality of the original.

This poem was meant to be heard, not read. It was recited by wandering minstrels—*jongleurs*—to largely illiterate audiences. This fact explains the verse style, the immediacy of the adjectives describing the characters and situations, and the somewhat repetitive language. The still-unexplained "AOI" at the end of many stanzas may have something to do with the expected reaction of the jongleur as he uttered that particular sound to give emphasis to a stanza. (Some sense of the immediacy of the original may be gained by a reader today who declaims some of these stanzas with gestures and appropriate pauses.)

READING 9.9 *THE SONG OF ROLAND*, LINES 532–557, 627–657

The Death of Roland

169 The hills are high, and very high the trees;
four massive blocks are there, of gleaming marble;
upon green grass Count Roland lies unconscious.
And all the while a Saracen is watching:
he lies among the others, feigning death;
he smeared his body and his face with blood.
He rises to his feet and starts to run—
a strong, courageous, handsome man he was;
through pride he enters into mortal folly—
and pinning Roland's arms against his chest,
he cries out: "Charles's nephew has been vanquished;
I'll take this sword back to Arabia."
And as he pulls, the count revives somewhat.

170 Now Roland feels his sword is being taken
And, opening his eyes, he says to him:
"I know for certain you're not one of us!"
He takes the horn he didn't want to leave
and strikes him on his jeweled golden casque;
he smashes through the steel and skull and bones,
and bursting both his eyeballs from his head,
he tumbles him down lifeless at his feet
and says to him: "How dared you, heathen coward,
lay hands on me, by fair means or by foul?
Whoever hears of this will think you mad.
My ivory horn is split across the bell,
and the crystals and the gold are broken off."

175 Now Roland is aware his time is up:
he lies upon a steep hill, facing Spain,
and with one hand he beats upon his chest:
"Oh God, against Thy power I have sinned,
because of my transgressions, great and small,
committed since the hour I was born
until this day when I have been struck down!"
He lifted up his right-hand glove to God:
from Heaven angels came to him down there. AOI

176 Count Roland lay down underneath a pine,
his face turned so that it would point toward Spain:
he was caught up in the memory of things—
of many lands he'd valiantly subdued,
of sweet France, of the members of his line,
of Charlemagne, his lord, who brought him up;
he cannot help but weep and sigh for these.
But he does not intend to slight himself;
confessing all his sins, he begs God's mercy:
"True Father, Who hath never told a lie,
Who resurrected Lazarus from the dead,
and Who protected Daniel from the lions,
protect the soul in me from every peril
brought on by wrongs I've done throughout my life!"
He offered up his right-hand glove to God:
Saint Gabriel removed it from his hand.
And with his head inclined upon his arm,
hands clasped together, he has met his end.
Then God sent down his angel Cherubin
and Saint Michael of the Sea and of the Peril;
together with Saint Gabriel they came
and took the count's soul into Paradise.

Robert Harrison, trans. *The Song of Roland*. New York: New American Library, Penguin Putnam, 1970.

Certain details of the poem merit particular attention. One portion recounts Charlemagne's arrival on the scene and his victory over the Arabs who are beleaguering the forces commanded by Roland. Most striking is the mixture of military and religious ideals, not an uncommon motif in the medieval period. This mixture is reflected not only in the imagery and in the plot (Charlemagne's prayer keeps the sun from setting in order to allow time for victory, an echo of the biblical siege of Jericho by Joshua) but also in the bellicose Archbishop Turpin. Christian valor is contrasted with Saracen wickedness and treachery; the anti-Muslim bias of the poem is clear. The Muslim Saracens are pagans and idolaters—an odd way to describe the rigidly monotheistic followers of Islam. *The Song of Roland*, like much of the epic tradition from which it springs, is devoted to the martial virtues of courage and strength, the comradeship of the battlefield, and the power of great men as well as the venality of evil ones.

Following is a passage describing a final episode of heroism as Roland lies dying from his battle wounds.

The Song of Roland was immensely popular in its day. It spawned several other compositions, such as the *Pseudo-Turpin* and *Aspremont*, in order to continue the story or elaborate portions of it. At a much later time in Italy, the story was redone in the telling of the exploits of Orlando (Roland). To this day, children in Sicily visit the traditional puppet shows in which the exploits of brave Roland and his mates are acted out with great clatter and verve. Spectators at those shows witness stories that go back to the beginnings of the medieval period.

VISUAL ARTS

The visual arts progressed significantly throughout medieval Europe. Once life became more settled and predictable, the central role of Christianity swept through the visual arts, from small manuscript illuminations to immense churches and cathedrals. Heavy blocks of stone rose skyward, seeking heaven, as architecture became more sophisticated. Yet except for the very few who managed to reach the highest rungs of the social ladder, medieval life had its drudgery and drabness. But individuals of every social rank could believe that life on earth was but a test and that an eternal reward awaited those who strived to be righteous, who worked and worshipped for the divine intervention of Jesus Christ. Those are the yearnings that the Western visual arts illuminated—beginning in books.

The Illuminated Book

Given Charlemagne's preoccupation with literary culture, it should not be surprising that a great deal of artistic effort was expended on the production and illumination of manuscripts. Carolingian manuscripts were made of parchment (treated animal skins, mainly from cows and sheep) because papyrus was unavailable and the process of papermaking was unknown in Europe during this period. For very fine books, the parchment was dyed purple and the letters were painted on with silver and gold pigments.

Although a good deal of decoration of Carolingian manuscripts shows the influence of Irish models, the illustrations often show other influences as well. This is apparent in the illustrations of the Gospel Book of Charlemagne (800–810), where it is clear that the artists were conscious of the Roman style. The page showing the four evangelists with their symbolic emblems is classical: the four evangelists are clad in togas like ancient Roman consuls (**Fig. 9.9**). Some evidence shows that the

◄ **9.9** "The Four Evangelists," folio 13 recto of the Aachen Coronation Gospels, ca. 820. Illuminated miniature on vellum, 8½" × 11¾" (21.7 × 30 cm). Aachen Cathedral Treasury, Aachen, Germany. Over the four evangelists are their symbols (clockwise from top left): Matthew (angel), John (eagle), Luke (ox), and Mark (lion). The symbols derive from the Book of Ezekiel.

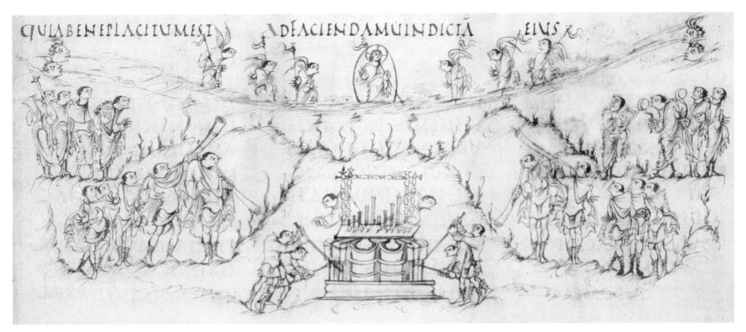

▲ **9.10** Drawing for Psalm 150, detail of folio 83 verso from Utrecht Psalter, ca. 820–840. Bistre (dark brown ink) on vellum, page 13″ × 10″ (33 × 25.4 cm) University Library, Utrecht, The Netherlands. This page is typical of the quick, nervous style of the unknown illustrator who did similar symbolic drawings for the entire Psalter of 150 psalms. Note the variety of musical instruments representing those mentioned in Psalm 150: "Praise the LORD . . . with the sound of the trumpet, . . . with the psalter and harp, . . . with tambourine and dance, . . . with stringed instruments and organs, . . . upon the loud cymbals."

artists attempted experiments in three-dimensionality. The wooded background in the receding part of the upper two illustrations tends to bring the evangelists forward and thus diminish the flatness we associate with both Byzantine and Celtic illustrations.

THE UTRECHT PSALTER The Utrecht Psalter (so called because its present home is the University of Utrecht in the Netherlands) has been called the masterpiece of the Carolingian Renaissance. Executed at Reims sometime around 820 to 840, it contains the whole Psalter, with wonderfully free and playful pen drawings around the text of the psalms. The figures are free from any hieratic stiffness; they are mobile and show a nervous energy. The illustration for Psalm 150, for example, has a scene at the bottom of the page showing various figures praising God with horn and cymbals (**Fig. 9.10**). There are two other interesting aspects of this illustration. One is that the figures are in the act of praising Christ, who stands at the apex of the composition with the symbols of his resurrection (including the staff-like cross in his hand). Although the psalms speak of the praise of God, for the medieval Christian the hidden or true meaning of the scriptures was that they speak in a prefigurative way of Christ. Thus the psalmist who praises God is a shadow of the church that praises Christ. A second thing to note in this illustration is the bottom-center scene of an organ with two men working the bellows to supply the air for the organ pipes.

The style of the Utrecht Psalter has much in common with early Christian illustration. The lavish purple-and-silver manuscripts show a conscious imitation of Byzantine taste. We have also noted the influence of Irish illustration. Carolingian manuscript art thus had a certain international flavor, and the various styles and borrowings offer ample testimony to the cosmopolitan character of Charlemagne's culture. This internationality diminished in the next century; not until the period of the so-called International Style in the 14th century would such a broad eclecticism again be seen in Europe.

CALLIGRAPHY One other advance in manuscript production during the Carolingian period was in the area of fine handwriting or **calligraphy**. Handwriting before the Carolingian period was cluttered, unformed, and cramped. It was difficult to read because of its erratic flourishes and lack of symmetry. After 780, scribes in Carolingian scriptoria began to develop a precise and rounded form of lettering that became known as the Carolingian minuscule, as opposed to the majuscule or capital letter. This form of lettering was so crisp and legible that it soon became a standard form of manuscript writing. Even in the 15th century, the Florentine humanists preferred minuscule calligraphy for their manuscripts. When printing became popular in the early 16th century, printers soon designed type fonts to conform to Carolingian minuscule. It superseded Gothic type in

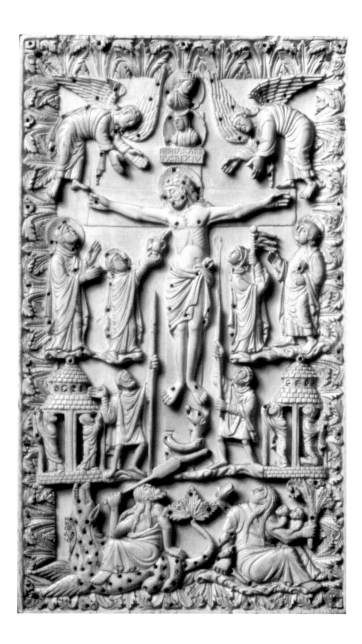

◄ **9.11** Crucifixion, ca. 860–870 . Carved ivory panel, 4 ⁵/₈″
9.11 Crucifixion, ca. 860–870 . Carved ivory panel, 4 ⅝″ × 8 ¼″ × ¼″ (11.8 x 21 x .7 cm). Victoria and Albert Museum, London, United Kingdom. The crowded scene refers to the saving power of the cross. The figure to the left captures blood from the dying Christ, an allusion to the Eucharist (Mass) of the body and blood of Christ. Such ivories were often used as covers for gospel books and other liturgical works and were frequently produced as gifts for special occasions.

Carolingian Architecture

Beyond his immediate commercial, military, and political goals, Charlemagne had an overwhelming desire to model his kingdom on that of the Roman Empire. His coronation in Rome symbolized the fusion of the ancient imperial ideal with the notion of Christian destiny. It was not accidental that Charlemagne's favorite book—he had it read to him frequently at meals—was Augustine's *City of God*. One highly visible way of making this ideal concrete was to build a capital.

At Aachen (called Aix-la-Chapelle in French) Charlemagne built his palace and royal chapel. Except for the chapel (incorporated into the present cathedral), all the buildings of Charlemagne's palace have been destroyed. The Aachen city hall (built in the 14th century) covers the palace site. The palace proper was a long one-story building; its main room was the large royal hall, which measured roughly 140 feet by 60 feet. So richly decorated that even the fastidious and sophisticated Byzantine legates were favorably impressed, the room had as its focal point at the western end the emperor's throne. In front of the palace was an open courtyard, around which were outbuildings and apartments for the imperial retinue. Around the year 800, the courtyard held a great bronze statue of Theodoric, once king of the Ravenna Ostrogoths, that Charlemagne had brought back from Ravenna to adorn his palace.

The royal hall was joined to Charlemagne's chapel by a long wooden gallery. With 16 exterior walls, it was a central-plan church based on an octagon (**Fig. 9.12**); its model undoubtedly was the Church of San Vitale in Ravenna, which Charlemagne had visited and admired. The octagon formed the main nave of the church, which was surrounded by **cloisters**; the building was two storied. At the eastern end of the chapel was an altar dedicated to the Savior, with a chapel dedicated to the Virgin directly below it. The central space was crowned with an octagonal cupola, the lower part of which was pierced by windows—the main source of light in the church. The outside of the church was austere, but the inside was richly ornamented with marbles brought to Aachen from Ravenna and Rome. The interior of the cupola was decorated with a rich mosaic depicting Christ and the 24 elders of the book of Revelation (now destroyed; the present mosaics in the chapel are modern copies) while the other planes of the interior were covered with frescoes (now also destroyed). The railing of the upper gallery was made from bronze screens that are still in place, wrought in geometrical forms.

popularity and is the ancestor of modern standard lettering systems.

IVORY CARVING One other art form that developed from the Carolingian love for the book is ivory carving. This technique was not unique to Charlemagne's time; it was known in the ancient world and highly valued in Byzantium. The ivories that have survived from Charlemagne's time were used for book covers. One beautiful example of the ivory carver's art is a Crucifixion panel made at the palace workshop at Aachen sometime in the early ninth century (**Fig. 9.11**). Note the crowded scenes that surround the Crucifixion event. The entire ivory is framed with acanthus-leaf floral designs. The composition indicates that the carver had seen some examples of Christian carving, whereas the bearded Christ and the flow of the drapery indicate familiarity with Byzantine art.

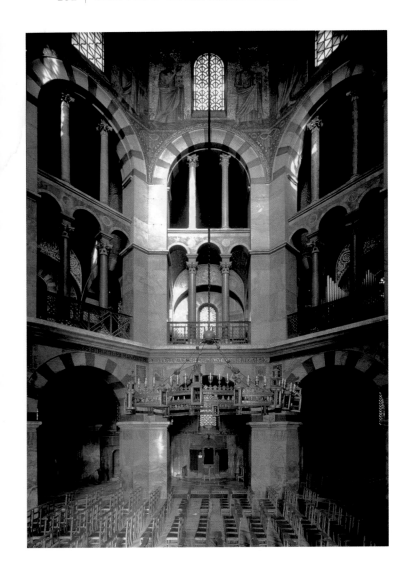

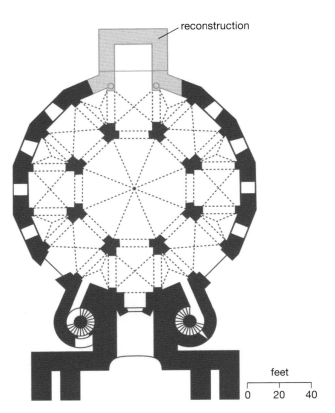

reconstruction

feet
0 20 40

◄▲ **9.12** Palatine Chapel (palace chapel of Charlemagne), 792–805. Interior of the octagonal rotunda and plan. Aachen Cathedral, Aachen, Germany.

▼ **9.13 The Major Parts of the Monastery**

Monastic Church	Site of the major religious services
Chapter House	Ordinary meeting room of the monastic community; the name comes from the custom of reading a chapter of the Rule of Saint Benedict aloud each day to the community
Cloister	Technically, the enclosed part of the monastery; more commonly, the enclosed garden and walkway in the interior of the monastery
Scriptorium	Library and copying area of the monastery
Refectory	Monks' dining hall
Novitiate	Quarters for aspirant monks not yet vowed in the community
Dormitory	Sleeping area for the monks
Infirmary	Resting place for sick, retired, and elderly monks
Guest House	Lodgings for visitors, retreatants, and travelers
Outbuildings	Buildings for the farms and crafts of the monastery; small buildings far from the main monastery that housed farmer monks were called *granges*

The chapel included two objects that emphasized its royal status: the most important relic of the kingdom—Saint Martin of Tours's cape—and a throne. Charlemagne's throne was on the second floor, opposite the Savior chapel. From this vantage point, the emperor could observe the liturgical services being conducted in the Savior chapel and at the same time view the Virgin chapel, with its rich collection of relics.

Charlemagne's throne, with its curved back and armrests, was mounted by six stone steps. This arrangement was taken from King Solomon's throne as described in the Bible (1 Kings 10:18–19). Charlemagne was to be thought of as the new Solomon, like his ancient prototype an ambitious builder, a wise lawgiver, and a symbol of national unity. That this analogy was not an idle fancy is proved by a letter to the emperor from Alcuin in anticipation of Alcuin's return to Aachen: "May I soon be allowed to come with palms, accompanied with children singing psalms, to meet your triumphant glory, and to see once more your beloved face in the Jerusalem of our most dear fatherland, wherein is the temple set up to God by this most wise Solomon."

THE CAROLINGIAN MONASTERY In the period between Saint Benedict and Charlemagne, the Benedictine monastery underwent a complex evolution. Originally the monasteries were made up of small communities with fewer than 15 members, who led a life of prayer and work in a rather simple setting. With the decline of city life and the disorder brought on by repeated invasions after the fifth century, the monastery became increasingly a center of life for rural populations. Monasteries not only kept learning alive and worship intact but were also called on to serve as shelters for travelers, rudimentary hospitals for the sick, places of refuge in time of invasion, granaries for farmers, centers of law for both religious and civil courts, and places that could provide agricultural services such as milling and brewing.

This expansion of services, making the monastery into what has been called a miniature civic center, inevitably changed the physical character of the monastery compound. By Charlemagne's time the monastery was an intricate complex of buildings suitable for the many tasks it was called on to perform (**Fig. 9.13**). One vivid example of the complexity of the Carolingian monastery can be found in a plan for an ideal monastery developed about 820 at the Benedictine abbey of Saint Gall in present-day Switzerland (**Fig. 9.14**).

In the Saint Gall plan the monastic church dominated the area. Set off with its two round towers, it was a basilica-style church with numerous entrances for the use of the monks. To the south of the church was a rectangular garden

▾ **9.14** Plan for an ideal monastery, ca. 820. Saint Gall, Switzerland. Reconstruction based on original plan (44" across, drawn to scale on vellum) in the Library of the Monastery of Saint Gall, Switzerland. The monastery site would have been 480′ × 640′ (146.3 × 195 m) and would have housed 120 monks and 170 serfs. Over the centuries, the Saint Gall Gall plan for future monasteries exerted considerable influence on monastery construction. The areas colored green highlight the gardens within the monastery complex. Reconstruction by Cecilia Cunningham.

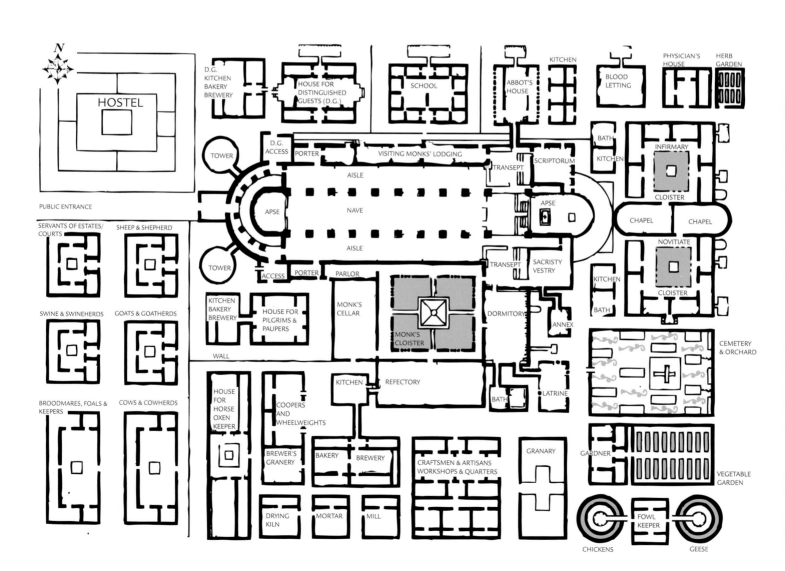

space surrounded by a covered walkway (the cloister), from which radiated the monks' dormitory, dining hall (**refectory**), and kitchens. To the north of the church were a copying room (scriptorium), a separate house for the abbot, a school for youths and young novices, and a guest house. To the extreme south of the church were ranged workshops, barns, and other utilitarian outbuildings. To the east beyond the church were an infirmary and a separate house for aspirant monks (the *novitiate*), gardens, poultry houses, and the community cemetery.

Ottonian Art

Following Charlemagne's death, internal and external strife threatened the existence of the Holy Roman Empire. It was torn apart on several occasions, only to be consolidated time and again under various rulers. The most significant of these were three German emperors, each named Otto, who succeeded one another in what is now called the Ottonian period. In many respects, their reigns symbolized an extension of Carolingian ideals, including the architectural and artistic styles that dominated Charlemagne's era.

The most important architectural achievement of the Ottonian period was the construction of the Church of Saint Michael in Hildesheim, Germany (**Fig. 9.15**). The Church of Saint Michael offers us our first glimpse at a modified Roman basilican plan that will serve as a basis for **Romanesque** architecture.

The abbey church does not retain the propylaeum (vestibule) or atrium of Old Saint Peter's Basilica, and it reverts to the side entrances of Roman basilicas. But all of the other elements of a typical Christian cathedral are present: **narthex**, **nave**, side aisles, **transept**, and a much enlarged **apse** surrounded by an **ambulatory**. Most significant for the future of Romanesque and Gothic architecture is the use of the **crossing square** as a template for other spaces within the church. The crossing square is the area of overlap formed by the intersection of the nave and the transept. In the plan of the Church of Saint Michael, the nave consists of three consecutive modules that are equal in dimensions to the crossing square and marked off by square pillars.

The Church of Saint Michael also uses an *alternate-support system* in the walls of its nave. In such a system, alternating structural elements (in this case, pillars and col-

▾ **9.15** Church of Saint Michael (restored exterior), ca. 1001–1031. Hildesheim, Germany.

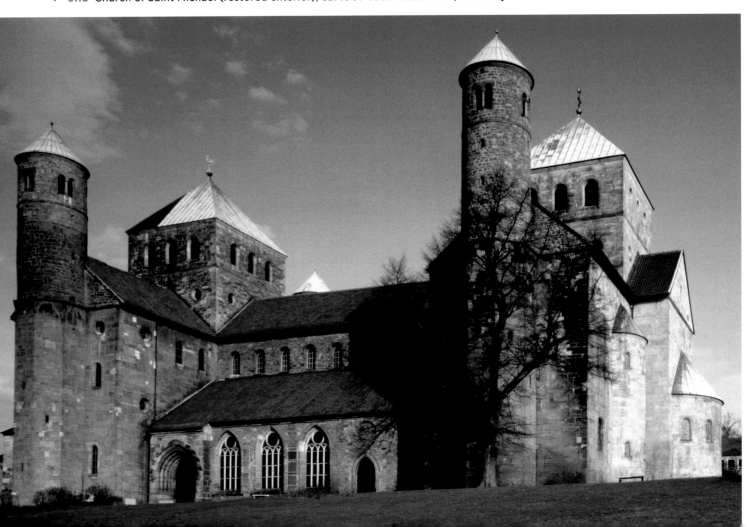

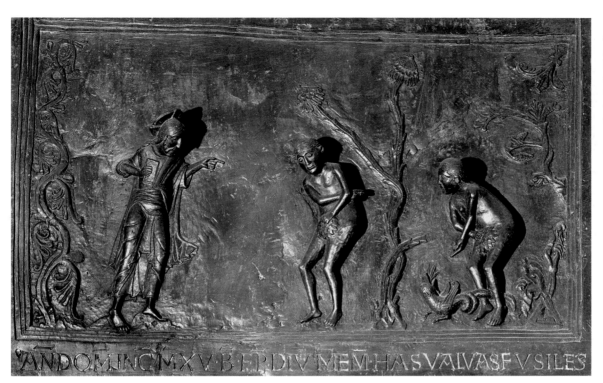

◄ **9.16** *Adam and Eve Reproached by the Lord*, 1015. Panel of bronze doors, 23" × 43" (58.4 × 109.2 cm). Dom Museum of Saint Mary's Cathedral, Hildesheim, Germany.

umns) bear the weight of the walls and ultimately the load of the ceiling. The alternating elements in the Church of Saint Michael read as pillar—column—column—pillar; its alternate support system is then classified as ABBA in terms of repetition of the supporting elements (A is assigned to a pillar and B is assigned to a column). An alternate support system of one kind or another will be a constant in the Romanesque architecture to come.

As with Old Saint Peter's, the exterior of the Church of Saint Michael reflects the character of its interior. Nave, side aisles, and other elements of the plan are clearly articulated in the blocky forms of the exterior. The exterior wall surfaces remain unadorned, as were those of the early Christian and Byzantine churches. However, the art of sculpture, which had not thrived since the fall of Rome, was reborn in the Church of Saint Michael.

Adam and Eve Reproached by the Lord (**Fig. 9.16**), a panel from the bronze doors of Saint Mary's Cathedral in Hildesheim (originally commissioned in the 11th century for Saint Michael's, by Bishop Bernward), represents the first sculpture cast in one piece during the Middle Ages. In mood and style, the imagery closely resembles that seen in manuscript illumination of the period. It is an emotionally charged work, in which God points his finger accusingly at the pathetic figures of Adam and Eve. They, in turn, try to deflect the blame; Adam points to Eve and Eve gestures toward Satan, who is in the guise of a fantastic dragon-like animal crouched on the ground. These are not Classical figures who bear themselves proudly under stress. Rather, they are pitiful, wasted images who cower and try frantically to escape punishment. In this work, as well as in that of the Romanesque period, God is shown as a merciless

judge, and human beings as quivering creatures who must beware of his wrath.

Romanesque Art

In the 11th century, after a long period of desolation and warfare, Europe began to stir with new life. Pilgrimages became popular as travel became safe. Pilgrimage routes—in particular to sites in Spain, England, and Italy—crisscrossed Europe. Crusades were mounted to capture the holy places of the Middle East from the Muslims so that pilgrims could journey in peace to their most desired goal: Jerusalem. During this period, monks built and maintained pilgrimage churches and hostels on the major routes of the pilgrims.

The building style of this period (roughly from 1000 to 1200) is called Romanesque, because the architecture was larger and more Roman looking than the work done in the earlier medieval centuries. The two most striking characteristics of this architecture are the heavy stone arches and generous exterior decoration, mainly sculpture. The Romanesque style had two obvious advantages. First was that the use of heavy stone and masonry walls permitted larger and more spacious interiors. Second, the heavy walls could support stone arches (mainly the Roman barrel arch), at least in France and Spain, which in turn permitted fireproof stone and masonry roofs. Long experience had shown that basilica-style churches, with their wooden trusses and roofs, were notoriously susceptible to destruction by fire.

SAINT SERNIN The church of Saint Sernin in Toulouse, France, met all of the requirements for a Romanesque

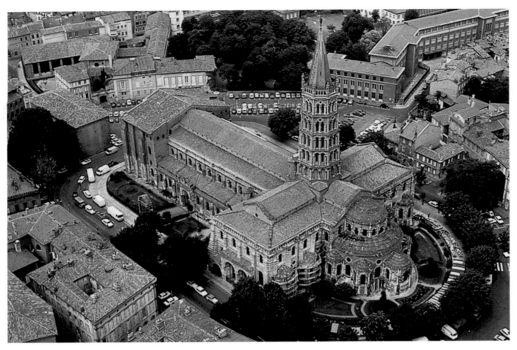

▲ **9.17** Saint Sernin, ca. 1080–1120. Toulouse, France.

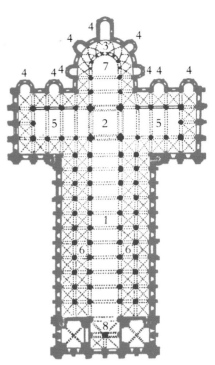

➤ **9.18** Floor plan, Saint Sernin. Toulouse, France. Note the ample aisles for easy passage of pilgrim groups around the entire church. The radiating chapels around the ambulatory permitted many priests to celebrate Mass simultaneously.

0	50	100 feet	
0	10	20	30 meters

1 nave	5 transept
2 choir	6 aisles
3 ambulatory	7 apse
4 chapels	8 narthex

cathedral. An aerial view of the exterior (**Fig. 9.17**) shows the blocky forms that outline a nave, side aisles, the narthex to the west, a prominent transept crowned by a multilevel spire above the crossing square, and an apse at the eastern end from whose ambulatory extend five radiating chapels. In the plan of Saint Sernin (**Fig. 9.18**), the outermost side aisle continues around the outer borders of the transept arm and runs into the ambulatory around the apse. Along the eastern face of the transept, and around the ambulatory, a series of chapels radiates, or extends, from the aisle. These spaces provided extra room for the crowds of pilgrims and offered free movement around the

➤ **9.19** Nave, Saint Sernin, ca. 1080–1120. Toulouse, France. The massive ceiling vaults are called barrel or tunnel vaults. The heavy stonework required heavy walls to support the weight of the vaults. The galleries, with their own vaults, also helped support the cut-stone ceiling vaults. The pulpit to the left is a much later addition to the church.

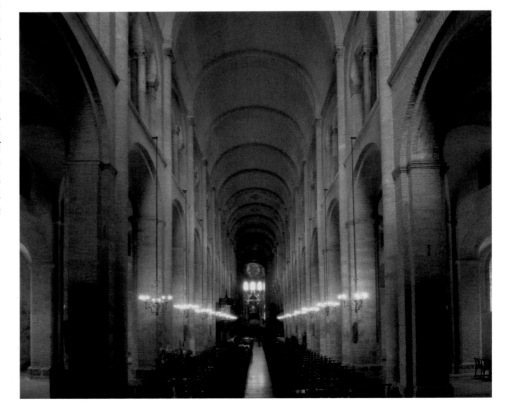

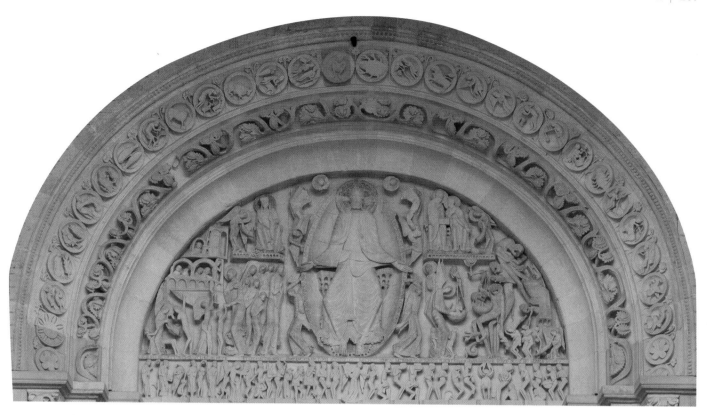

▲ **9.20** Cathedral of Saint-Lazare, west tympanum detail of Last Judgment, ca. 1120–1135. Marble, 21′ (640 cm) wide at the base. Autun, France.

church, preventing interference with worship in the nave or the celebration of Mass in the apse.

In Saint Sernin, a shift was made from the flat wooden ceiling characteristic of the Roman basilica to a stone vault that was less vulnerable to fire. The ceiling structure, called a **barrel vault**, resembles a semicircular barrel punctuated by arches that spring from **engaged columns** (that is, attached columns) in the nave to define each bay. The massive weight of the vault is supported partly by the nave walls and partly by the side aisles that accept a share of the downward thrust.

Because the barrel vault rests directly on top of the **tribune gallery**, and because **fenestration** would weaken the structure of the vault, there is little light in the interior of the cathedral (**Fig. 9.19**). Lack of light was considered a major problem, and solving it would be the primary concern of future Romanesque architects. The history of Romanesque architecture can be written as the history of vaulting techniques, and the need for light provided the incentive for their development.

SCULPTURE Although we occasionally find freestanding sculpture from the Romanesque period, it was far more common for sculpture to be restricted to architectural decoration around portals. Some of the most important and elaborate sculptural decoration is found in **tympanums**—the semicircular spaces above the doors of cathedrals—such as that of the cathedral at Autun in Burgundy (**Fig. 9.20**). The carved portals of cathedrals bore scenes and symbols that acted as harsh reminders of fate in the afterlife. They were intended to communicate pictorially a profound message, if not a direct warning, to the primarily illiterate that repentance through prayer and action was necessary for salvation.

At Autun, the scene depicted is that of the Last Judgment. The tympanum rests on a lintel carved with small figures representing the dead. The archangel Michael stands in the center, dividing the horizontal band of figures into two groups. The naked dead on the left gaze upward, hopeful of achieving eternal reward in heaven, while those to the right look downward in despair. Above the lintel, Jesus is depicted as an evenhanded judge. To his left, tall, thin figures representing the apostles observe the scene while some angels lift bodies into heaven. To Jesus's right, by contrast, is a gruesome event. The dead are snatched up from their graves, and their souls are weighed on a scale by an angel on the left and a devil serpent on the right. (In Chapter 1 we noted that the ancient Egyptians believed that upon death, the heart of the deceased would be weighed, and if the deceased were found to have a heart as light as a feather, he or she would be considered worthy of the afterlife.) The devil cheats by adding a little weight, and some of his companions stand ready to grab the souls and fling them into hell. Humankind is shown as pitiful and defenseless, no match for the wiles of Satan. The figures crouch in terror of their surroundings, in strong contrast to the serenity of their impartial judge.

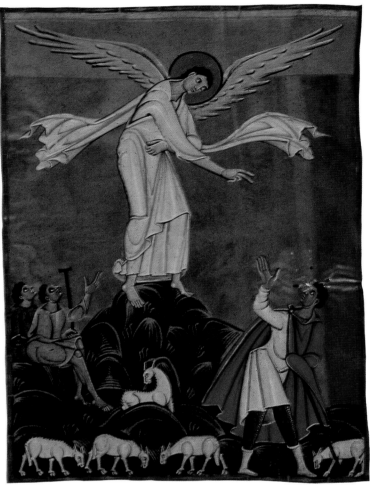

The Romanesque sculptor sought stylistic inspiration in Roman works, the small carvings of the pre-Romanesque era, and especially manuscript illumination. In the early phase of Romanesque art, naturalism was not a concern. Artists turned to art rather than to nature for models, and thus their figures are at least twice, and perhaps a hundred times, removed from the original source. It is no wonder, then, that the figures appear as dolls or marionettes. The figure of Jesus is squashed within a large oval, and his limbs bend in sharp angles in order to fit the frame. Although his drapery seems to correspond broadly to the body beneath, the folds are reduced to stylized patterns of concentric arcs that play across a relatively flat surface. Realism is not the goal. The sculptor is focused on conveying the frightful message with the details and emotions that will have the most dramatic impact on the worshipper or penitent sinner.

The relationship between Romanesque sculpture and manuscript illumination can be seen in "The Annunciation to the Shepherds" (**Fig. 9.21**), a page from the Lectionary of Henry II. As with the figure of Jesus in the Autun tympanum, the long and gangling limbs of the figures join their torsos at odd angles. Drapery falls at harsh, unnatural angles. Sent by God, the angel Gabriel alights on a hilltop to announce the birth of the Christ child to shepherds tending their flocks. The angel towers over the rocky mound and appears to be almost twice the size of the shepherds. The shepherds, in turn, are portrayed as unnaturally large in relation to the animals. The animals along the bottom edge of the picture stand little more than ankle high. The use of hierarchical scaling implies that humans are less

▲ **9.21** "Proclamation to the Shepherds," folio 8 verso from the Lectionary of Henry II, 1007. Manuscript illumination on vellum, 16 ¾" × 12 ⅝" (42.5 cm × 32 cm). Bayerische Staatsbibliothek, Munich, Germany.

▼ **9.22** Battle of Hastings, detail of the Bayeux Tapestry, ca. 1070–1080. One of a series of connected panels, embroidered wool on linen, 20" (50.8 cm) high, entire length of fabric 229′ (69.8 m). Centre Guillaume le Conquérant, Bayeux, France.

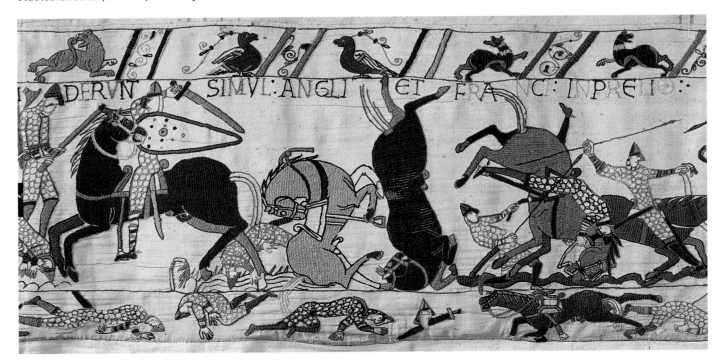

significant than celestial beings and that animals are lower than humans. The symbols in the scene take precedence over truth; reality fades in their wake.

Toward the end of the Romanesque period, there was a significant increase in naturalism. Drapery falls softly rather than in sharp angles, and the body begins to acquire more substance. The gestures are less frantic, and a balance between emotion and restraint begins to reappear. These elements reached their peak during the Gothic period, as we see in the next chapter, and pointed to a full-scale revival of classicism during the Renaissance of the 15th century.

TAPESTRY Although the tasks of copying sacred texts and embellishing them with manuscript illuminations were sometimes assumed by women, that art form remained primarily a male preserve. Not so with the medium of tapestry. In the Middle Ages, weaving and embroidery were taught to women of all social classes and walks of life. Noblewomen and nuns would weave and decorate elaborate tapestries, clothing, and liturgical vestments, using the finest linens, wools, gold and silver threads, pearls, and other gems.

One of the most famous surviving tapestries, the Bayeux Tapestry (**Fig. 9.22**), was almost certainly created by a team of women at the commission of Odo, the bishop of Bayeux. The tapestry describes the invasion of England by William I of Normandy in 1066 in a continuous narrative. William, the first Norman king of England, became known as William the Conqueror. Although the tapestry is less than two feet in height, it originally measured in excess of 230 feet long and was meant to run clockwise around the entire nave of the Bayeux Cathedral. In this way, the narrative functioned much in the same way as the continuous narrative of the Ionic frieze of the Parthenon.

THE LEGEND OF CHARLEMAGNE

Charlemagne's kingdom did not long survive intact after his death. By the 10th century, the Frankish kingdom was fractured and Europe reduced to a state worthy of being called the Dark Ages. Anarchy, famine, ignorance, war, and factionalism were constants in 10th-century Europe; Charlemagne's era was idealized as a long-vanished Golden Age. By the 12th century, Charlemagne's reputation was such that he was canonized (in Aachen on December 29, 1165) by the emperor Frederick Barbarossa. Charlemagne's cult was immensely popular throughout France—especially at the royal abbey of Saint-Denis in Paris, which made many claims of earlier links with the legendary emperor.

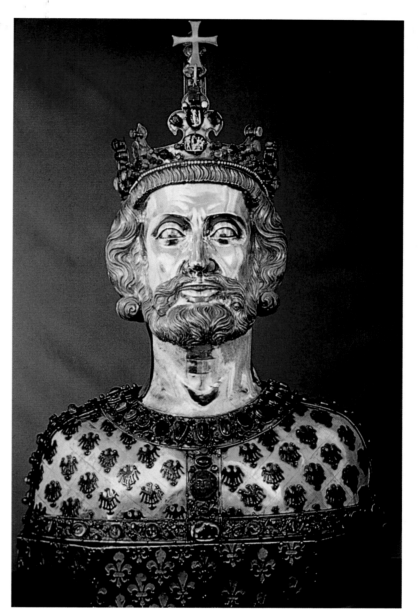

⌃ 9.23 Reliquary of Charlemagne, crown before 1349, bust after 1349. Gold, silver, gems, and enamel, 34″ (86 cm) high. Aachen Cathedral Treasury, Aachen, Germany. Reliquaries of this type are containers for a relic of the person depicted by the statue—in this case, the crown of Charlemagne's skull.

A 15th-century oil painting in Aachen depicts an idealized Charlemagne as saint, wearing the crown of the Holy Roman emperor and carrying a model of the church he had built at Aachen. Frederick Barbarossa commemorated the canonization by commissioning a great wrought-bronze candelabra to hang in the Aachen cathedral. He also ordered a gold reliquary (now in the Louvre in Paris) to house the bones of one of his sainted predecessor's arms; another reliquary, in the form of a portrait bust that contains fragments of Charlemagne's skull, is in the cathedral treasury at Aachen (**Fig. 9.23**).

GLOSSARY

A cappella (p. 281) Sung without instrumental accompaniment.

Alliteration (p. 283) A form of rhyme characterized by the repetition of consonant sounds in nearby words.

Ambulatory (p. 294) In a church, a continuation of the side aisles into a passageway that extends behind the choir and **apse** and allows traffic to flow to the chapels, which are often placed in this area (from *ambulare*, Latin for "to walk").

Apse (p. 294) A semicircular or polygonal projection of a building with a semicircular dome, especially on the east end of a church.

Assonance (p. 288) A form of rhyme characterized by the repetition of vowel sounds in nearby words.

Barrel vault (p. 297) A roofed-over space or tunnel constructed as an elongated arch.

Cadence (p. 281) A modulation or inflection of the voice.

Calligraphy (p. 290) Decorative handwriting, particularly as produced with a brush or a pen.

Capitulary (p. 279) A royal rule or decree, especially one made by a Frankish king.

Carolingian (p. 275) Of Charlemagne.

Cloister (p. 291) A covered walkway, particularly in a monastery, convent, college, or church, with a wall on one side and a row of columns open to a quadrangle on the other side.

Crossing square (p. 294) The area of overlap in a church plan formed by the intersection of the **nave** and the **transept**.

Engaged column (p. 297) A column embedded in a wall and partly projecting from the surface of the wall

Fenestration (p. 297) The presence and arrangement or design of windows and doors in a building.

Feudalism (p. 274) The dominant social system in medieval Europe from the ninth through the 15th centuries, in which vassals were granted fiefs—estates or property—by their lords and were required to serve under their lords in the event of war.

Melisma (p. 282) A group of notes or tones sung to a single syllable of text.

Monasticism (p. 279) The style of life under religious vows in which a community of people shares an ascetic existence in order to focus on spiritual pursuits.

Monophonic (p. 281) Having a single melodic line.

Narthex (p. 294) A lobby or vestibule that leads to the **nave** of a church.

Nave (p. 294) The central aisle of a church, constructed for use by the congregation at large.

Polymath (p. 271) A person of great learning and achievement in several fields of study, especially unrelated fields such as the arts and the sciences.

Refectory (p. 294) A room used for communal dining, as in a monastery or college.

Romanesque (p. 294) Referring to a style of European art and architecture from the ninth through 12th centuries, descended from Roman styles; in architecture, characterized by heavy masonry, round arches, and relatively simple ornamentation.

Scriptorium (p. 279) A room dedicated to writing.

Transept (p. 294) The side parts of a church plan with a **crossing square**, crossing the nave at right angles.

Tribune gallery (p. 297) In architecture, the space between the nave arcade and the clerestory that is used for traffic above the side aisles on the second stage of the elevation.

Trope (p. 282) A literary or rhetorical device, such as the use of metaphor or irony.

Tympanum (p. 297) A semicircular space above the doors of a cathedral.

Vernacular (p. 283) The native dialect or language of a region or country, as contrasted with a literary or foreign language.

Vulgate Bible (p. 278) A late-fourth-century version of the Bible, largely translated into Latin by Saint Jerome.

THE BIG PICTURE THE RISE OF MEDIEVAL CULTURE

Language and Literature

- Scribes wrote mainly on slates and waxed tablets, although some precious works were written on parchment.
- Charlemagne recruited scholars to keep Classical texts alive and correct errors in texts, especially one that had liturgical uses.
- In England, a monk called the Venerable Bede, who wrote more than 60 books, became known as the Father of English History for writing his *Ecclesiastical History of the English Nation*.
- *Beowulf*, an Old English epic poem, told a fantastic tale of men battling monsters in Scandinavia.
- The nun Hildegard of Bingen was a philosopher, physician, painter, musician, and preacher. Her main literary works are *Scivias*, which recounts her religious visions and their meanings, and the medical treatises *Physica* and *Causae et Curae*.
- A German nun and poet, Roswitha, wrote moralistic plays involving religious conversion, such as *The Conversion of the Harlot Thaïs*, and preaching steadfastness of faith during times of persecution.
- The morality play *Everyman* preached the value of confession, good deeds, and knowledge.
- *The Song of Roland* embellished an actual battle between Charlemagne on the border with Spain (ca. 777 and 778) and used a hero, Roland, to teach the values of patriotism and courage.

Art, Architecture, and Music

- A ship buried in Sutton Hoo, England, held treasures such as a 7th-century purse cover made of gold, glass, and garnets.
- A page from an illuminated manuscript, the Lindisfarne Gospels (ca. 700), featured a stylized cross inscribed with layers of intertwined, multicolored scrolls.
- The Utrecht Psalter (ca. 820–840) was decorated with playful pen drawings around the text of the psalms.
- Carolingian ivory carvings were made for use as book covers.
- Charlemagne's chapel (ca. 795) was constructed in Aachen with a central plan based on an octagon and cloisters surrounding it.
- The most important architectural achievement of the Ottonian period was the construction of the Church of Saint Michael in Hildesheim, Germany, with its use of a crossing square and an alternate support system.
- Romanesque architecture used heavy stone arches and generous exterior decoration, mostly sculpture.
- The Bayeux Tapestry was created by a team of women to describe the invasion of England by William the Conqueror in a continuous narrative.
- Monasteries were centers for the development of sacred music.
- Charlemagne promoted the Gregorian chant, which was monophonic and sung a cappella.
- The use of tropes, or verbal elaborations of text, became a standard of liturgical music.
- The manuscript illuminations in the Gospel Book of Charlemagne indicated that the artists were aware of the Roman style.

Philosophy and Religion

- Monasticism became widespread from the third century on, with monks and nuns forming communities under religious vows and adopting ascetic lives, but monastic lifestyles varied.
- In the sixth century, Saint Benedict set forth rules for monasteries to reform them and impose regular religious observance; the motto was "Pray and work."
- Women also entered the monastic life, including Hilda, abbess of Whitby, in seventh-century England.
- Morality plays extolled the virtues of conversion to Christianity and steadfastness in times of persecution and doubt.

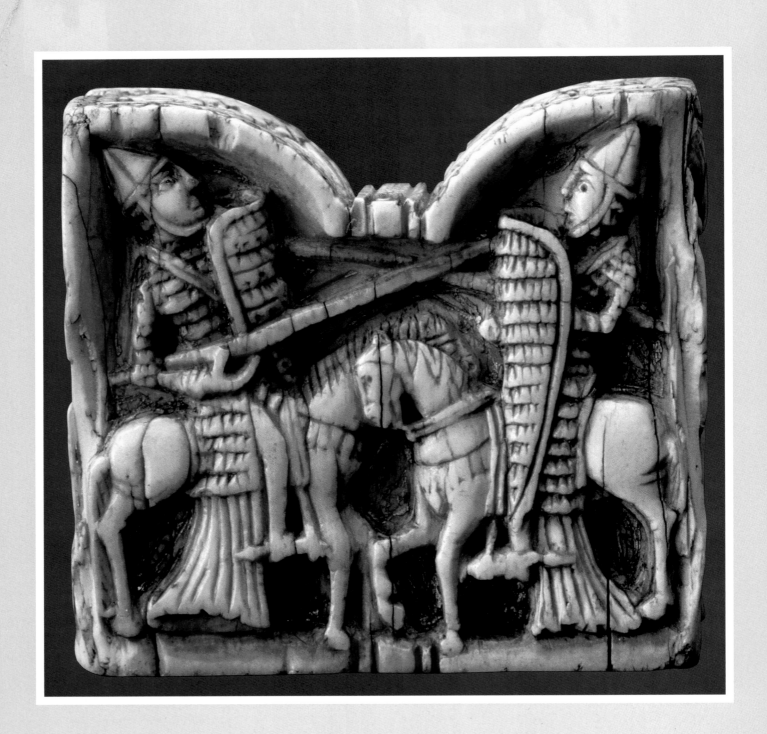

The High Middle Ages

<div style="text-align: right">10</div>

PREVIEW

Television in the early 21st century will be remembered for the birth of so-called reality television programming that combined nimble strategy with competitive physical challenges—*Survivor, Fear Factor, The Amazing Race*. To say that these few shows represent the tip of the iceberg would be an epic understatement. With the extreme popularity of reality television—and the unending pursuit of new concepts—perhaps it comes as no surprise that the medieval world would be tapped for material. *Full Metal Jousting*, a History Channel reality jousting competition, aims to capture the experience of medieval jousting in tournaments and in warfare. Contestants in full armor charge at each other on horses galloping at 30 miles per hour and attempt to unhorse each other with the impact of a well-targeted, 11-foot-long wooden lance. The casting call for *Full Metal Jousting* sought the "toughest and bravest" horsemen who were proficient riders. The winner's purse: $100,000.

What do these present-day jousters, or other sports figures, have in common with medieval knights? More than one would at first imagine. In the Middle Ages, jousting was a popular form of entertainment that was promoted in poems and songs by the equivalent of sports journalists. Intense rivalries developed on the tournament circuit, and individual knights—medieval superstars—earned enormous sums of money in addition to much-coveted titles.

Jousting did not begin as a sport, but rather as training for battle. Knights were armored warriors who rode on horseback and swore allegiance to feudal lords who, in obedience to a king, raised armies for war. Knights skilled in jousting who were not attached to nobles were available to fight for the highest bidder; they were called freelancers, a word that remains in use today to describe someone who is not committed to a single employer in providing services. Freelancers were medieval mercenaries. Although jousting was a primary form of combat, a medieval army comprised ranks of foot soldiers who carried weapons such as swords, pikes, and staves, as well as expert bowmen. Below these ranks were hordes of camp followers who supplied food, drink, gambling, and prostitution; some wives and families even tagged along with the armies as they traveled during a season of warfare. The knight, who was wealthy enough to own armor and a mount and who lived in a castle or royal court, was the jewel in the crown of the fighting force.

Medieval tournaments provided entertainment, but they also enabled knights to hone their skills and stay in combat-ready shape. Jousting was extremely dangerous but knights wore surprisingly little in the way of protection—seasoned leather, chain mail, and occasionally helmets. The full body armor we associate with them today, which could weigh as much as 100 pounds, would have been too cumbersome.

Jousting was not the exclusive purview of knights. The pursuit of accolades for valor was tantalizing as well to nobility and kings, who also took part in tournaments. An exquisitely carved ivory chess piece from 12th-century France (**Fig. 10.1**), with its image of jousters, reveals

◄ **10.1** Chess piece (rook), showing a tournament scene, 12th century. Ivory. Musée du Louvre, Paris, France.

a connection between two entertaining pastimes associated with prestige and high culture: the tournament and chess—the so-called game of kings.

PARIS

At the same time that this very ivory rook was gliding across its board, taking pawns and knights and capturing queens, the city of Paris was the center of Western civilization. Beyond its position as a royal seat, it was a strong mercantile center. Its annual trade fair was famous. In addition, Paris gave birth to Gothic architecture, the philosophical and theological traditions known as Scholasticism, and the educational community that in time became known as the university (see **Map 10.1**). These three creations have their own distinct history but sprang from a common intellectual impulse: the desire to articulate all knowledge systematically.

The culture of the Middle Ages derives from the twin sources of all Western high culture: (1) the humane learning inherited from the culture of Greece and Rome and (2) the accepted faith of the West, which had its origin in the worldview of the Judeo-Christian scriptures and religious worldviews.

The flowering of a distinct expression of culture in and around medieval Paris from about 1150 to 1300 was made possible by many factors. There was a renewed interest in learning, fueled largely by the discovery of hitherto lost texts from the Classical world—especially the writings of Aristotle—that came to the West via the Muslim world. The often ill-fated Crusades began in the 11th century, to retake the Holy Land, and the increasing vogue for pilgrimages created a certain cosmopolitanism that in turn weakened the static feudal society. Religious reforms initiated by new religious orders like the Cistercians in the 12th century and the begging friars in the 13th breathed new life into the church.

Beyond these more generalized currents, one can also point to individuals of genius who were crucial in the humanistic renaissance of the time. The University of Paris is inextricably linked with the name of Peter Abelard just as **Scholasticism** is associated with the name of Thomas Aquinas. The Gothic style, unlike most art movements, can be pinpointed to a specific time at a particular place with a single individual. Gothic architecture began near Paris at the abbey of Saint-Denis in the first half of the 12th century under the sponsorship of the head of the abbey, Abbot Suger (1080–1151).

THE GOTHIC STYLE

It is perhaps one of the ironies of history that the term *Gothic* in architecture is associated with the creation of some of the most magnificent and sophisticated buildings ever erected—the Gothic cathedrals of Europe, such as the famed Notre-Dame in Paris and the cathedrals in Reims and Chartres. Yet the Goths, for much of their history seemed bent on raw destruction—destruction in many of the very places where airy Gothic cathedrals now test the limits of the sky. The Goths migrated into central, southern, and western Europe from the north and east and first attacked the Roman Empire in 258 CE. The Romans were so impressed with their ferocious enemy that they recruited Goths into military service whenever they could. But the Goths would not remain subdued, even after they converted to Christianity. In the fifth and sixth centuries they divided into two tribes, the Visigoths and Ostrogoths, both of which further contributed to the demise of the Roman Empire in the West.

But the Goths were not the ones who built or inspired the cathedrals. The word *Gothic* was originally intended as an insult. Its first documented use is by the Florentine historian Giorgio Vasari (1511–1574), in reference to a rude and barbaric

The High Middle Ages

1096 CE	1194 CE	1300 CE
EARLY GOTHIC PERIOD	**HIGH GOTHIC PERIOD**	

Universities of Paris and Bologna founded	The rebuilding of Chartres Cathedral begins
During the First Crusade, Christians capture Jerusalem	During the Fourth Crusade, crusaders sack Constantinople on the way to the Holy Land
Oxford University founded	The University of Cambridge is founded
The Gothic style begins with the construction of Saint-Denis	The Magna Carta, limiting the powers of the king, is signed in England
Saint Bernard de Clairvaux leads the condemnation of Peter Abelard at the Council of Sens	Robert de Sorbon founds a Paris hospice for scholars, the forerunner of the Sorbonne
Philip Augustus ascends to the throne of France and promotes Paris as the capital	Marco Polo travels to China and India
	Acre, the last Christian stronghold in the Holy Land, falls

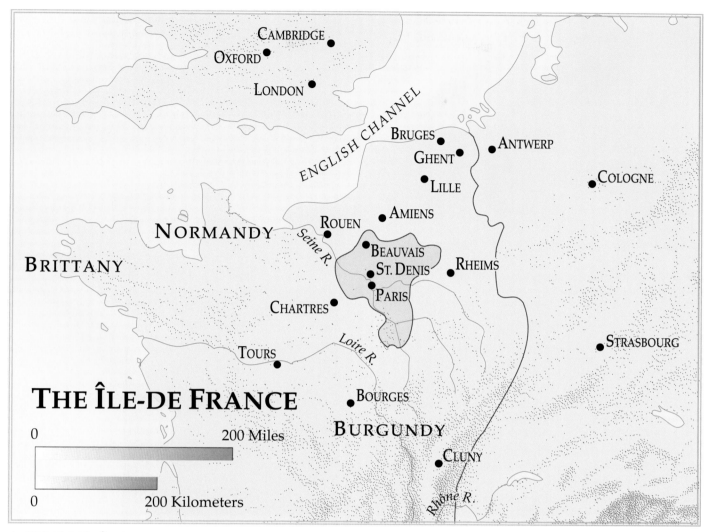

^ MAP 10.1 The Île-de France.

culture—even as the term is used in the Western world today to describe youngsters with excessive piercings and tattoos.

Vasari was apparently irritated that the architects of the Gothic era had not sought to revive Classical architecture, as did the architects in his own day.[1] In any event, the term *Gothic* caught on, and the buildings we call Gothic are among the most revered and popular ever erected—visited and worshiped in by millions.

Saint-Denis

It is rare to be able to trace a particular style of art to a single work, or the beginning of a movement to a specific date. However, it is generally agreed that the **Gothic style** of architecture began in 1140 with the construction of the **choir** of the church of Saint-Denis just north of Paris. The vaults of the choir consisted of weight-bearing ribs that formed the skeleton of the ceiling structure. The spaces between the ribs were then filled in with cut stone. At Saint-Denis, pointed arches were used in the structural skeleton rather than the

rounded arches of the Romanesque style. The vault construction also permitted the use of larger areas of stained glass, dissolving the massiveness of the Romanesque wall.

The Benedictine abbey of Saint-Denis, over which Abbot Suger presided from 1122 until his death nearly 29 years later, was the focal point for French patriotism. The abbey church—built in Carolingian times—housed the relics of Saint Denis, a fifth-century martyr who had evangelized the area of Paris before his martyrdom. The **crypt** of the church served as the burial place for Frankish kings and nobles from before the reign of Charlemagne, although it lacked the tomb of Charlemagne himself. One concrete link between the abbey of Saint-Denis and Charlemagne came through a series of literary works. The fictional *Pèlerinage de Charlemagne* (*The Pilgrimage of Charlemagne*) claims that the relics of the Passion housed at the abbey were brought there personally by Charlemagne when he returned from a pilgrimage crusade to the Holy Land.

1. Julien Chapuis, "Gothic Art," *Heilbrunn Timeline of Art History*, Metropolitan Museum of Art, October 2002, http://www.metmuseum.org/toah/hd/mgot/hd_mgot.htm.

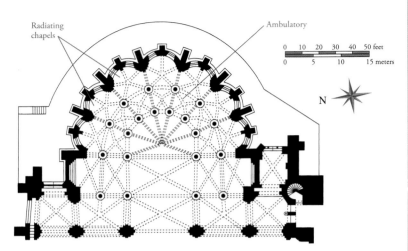

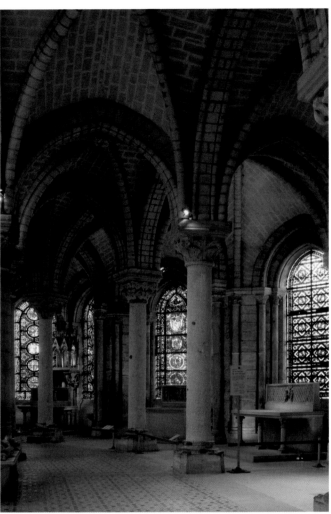

⌃ ➤ 10.2 **Abbey church of Saint-Denis, France, built around 1140, photo and floor plan.** The floor plan, above, of the East end of the church shows how the builders used light rib vaults to eliminate the walls between the radiating chapels. The photograph of the ambulatory, right, shows how the ribbed vaults and pointed arches rise from slender columns admitting light through the stained glass windows.

Another work, the *Pseudo-Turpin*, has Charlemagne returning to the abbey of Saint-Denis after his Spanish campaign and proclaiming all France to be under the protection and tutelage of the saint. These two legends were widely believed in the Middle Ages; there is fair evidence that Suger accepted their authenticity. The main themes of the legends—pilgrimages, crusades, and the mythical presence of Charlemagne—created a story about the abbey that made it a major Christian shrine as well as one worthy of the royal city of Paris.

Pilgrims and visitors came to Paris to visit Saint-Denis either because of the fame of the abbey's relics or because of the annual *Lendit*, the trade fair held near the precincts of the abbey. (Now there is another reason for tourists to descend upon Saint-Denis: the bodies of Louis XVI and Marie-Antoinette, who were guillotined during the French Revolution, are interred there.) Accordingly, in 1124 Suger decided to build a new church to accommodate those who flocked to the popular pilgrimage. This rebuilding program took the better part of 15 years and never saw completion. Suger took as models two sacred buildings that by his time already had archetypal significance for Christianity. He wanted his church to be as lavish and brilliant as the Hagia Sophia in Constantinople, which he knew only by reputation, and as loyal to the will of God as the Temple of Solomon described in the Bible.

The first phase of Suger's project was a demolition and repair job; he had to tear down the more deteriorated parts of the old church and replace them. He reconstructed the western façade of the church and added two towers. In order to better handle the pilgrimage crowds and the increasingly elaborate processions called for in the medieval liturgy, the entrance was given three portals. The **narthex**, the part of the

church one enters first (before the **nave**), was rebuilt and the old nave was to be extended by about 40 feet. In about 1140 Suger abruptly ceased work on the narthex to commence work at the opposite end—the choir. By his own reckoning, he spent three years and three months on this new construction. The finished choir made a revolutionary change in architecture in the West.

Suger's choir was surrounded by a double **ambulatory**, an aisle around the **apse** and behind the high altar. The outer ambulatory had seven radiating chapels to accommodate the increasing number of monks who were priests and thus said Mass on a daily basis. Two tall windows pierced the walls of each chapel, so there was little external masonry wall in relation to the amount of space covered by windows. The chapels were shallow enough to permit the light from the windows to fall on the inner ambulatory (**Fig. 10.2**).

Emulation of the style of Saint-Denis blossomed by the end of the century into a veritable explosion of cathedral building in the cities and towns radiating out from Paris, called Île-de-France. The Gothic impulse so touched other countries as well that, by the end of the 13th century, there were fine examples of Gothic architecture in England, Germany, and Italy.

Characteristics of the Gothic Style

One characteristic of Gothic cathedrals is the desire for verticality. We tend to identify the Gothic style with pointed arches, pinnacles and columns, and increasingly higher walls buttressed from the outside by **flying buttresses** to accommodate the weight of a pitched roof and the sheer size of the ascending walls. **Figure 10.3** is a cutaway view of a typical French Gothic cathedral. The flying buttresses channel much of the weight of the roof and walls laterally and then downward, so that the walls—freed of much of the need to carry the load of the structure above—can be pierced with fenestration, allowing exterior light to stream through to

▼ **10.3** **Cutaway view of a typical Gothic cathedral. Artwork by John Burge. Pinnacle** (1) A sharply pointed ornament capping the piers or flying buttresses; also used on cathedral facades.

Flying buttresses (2) Masonry struts that transfer the thrust of the nave vaults across the roofs of the side aisles and ambulatory to a tall pier rising above the church's exterior wall.

Vaulting web (3) Thee masonry blocks filling the area between the ribs of a groin vault.

Diagonal rib (4) One of the ribs forming the X of a groin vault; in the figure, the diagonal ribs are the lines *AC* and *DB*.

Transverse rib (5) A rib crossing the nave or aisle at a 90-degree angle; in the figure, lines *AB* and *DC*.

Springing (6) Thee lowest stone of an arch; in Gothic vaulting, the lowest stone of a diagonal or transverse rib.

Clerestory (7) The windows below the vaults in the nave elevation's uppermost level. By using flying buttresses and rib vaults on pointed arches, Gothic architects could build huge clerestory windows and fill them with stained glass held in place by ornamental stonework called tracery.

Oculus (8) A small, round window.

Lancet (9) A tall, narrow window crowned by a pointed arch.

Triforium (10) The story in the nave elevation consisting of arcades, usually blind arcades but occasionally filled with stained glass.

Nave arcade (11) The series of arches supported by piers separating the nave from the side aisles.

Compound pier (cluster pier) with shafts (responds) (12) A pier with a group, or cluster, of attached shafts, or responds, extending to the springing of the vaults.

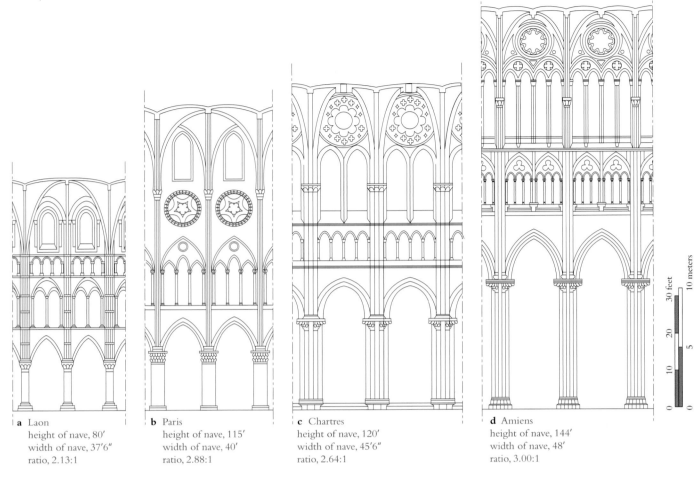

a Laon
height of nave, 80′
width of nave, 37′6″
ratio, 2.13:1

b Paris
height of nave, 115′
width of nave, 40′
ratio, 2.88:1

c Chartres
height of nave, 120′
width of nave, 45′6″
ratio, 2.64:1

d Amiens
height of nave, 144′
width of nave, 48′
ratio, 3.00:1

➤ **10.4 Nave elevations of four French Gothic cathedrals at the same scale.** Gothic nave designs evolved from the Early Gothic four-story elevation to the High Gothic three-story elevation (arcade, triforium, and clerestory). The height of the vault also increased from 80 to 144 feet.

illuminate the interior of the church and stained-glass windows. Medieval builders seemed to engage in contests to build higher and higher, almost as a matter of civic pride (Fig. 10.4): Chartres (begun in 1194) reached a height of 122 feet; almost as a response, the builders of Amiens (begun in 1220) stretched that height to 140 feet, while Beauvais (begun in 1247) pushed verticality nearly to the limit with a height of 157 feet from the cathedral pavement to the roof arch. Beauvais had a serious collapse of the roof when the building was barely completed.

The verticality that is typical of Gothic architecture is indisputable, yet Romanesque architects only a generation before Suger had also attempted verticality, as is evident in such churches as the proposed third abbey church of Cluny or the **pilgrimage church** at Santiago de Compostela in Spain. What prevented Romanesque architects from attaining greater verticality was not lack of desire but insufficient technical means. The pointed arch was known in Romanesque architecture but not fully understood. It distributed weight more thoroughly in a downward direction and lessened the need for the massive interior piers of the typical Romanesque church. The size of the piers was further reduced by

using buttresses outside the building to prop up the interior piers and absorb some of the downward thrust. Furthermore, the downward thrust of the exterior buttresses could be increased by the addition of heavy decorative devices such as spires.

The net result of these technical innovations was to lessen the thickness, weight, and mass of the walls of the Gothic cathedral. This reduction provided an opportunity for greater height with less bulk to absorb the weight of the vaulted roof. Such a reduction made the walls more available as framing devices for the windows that are so characteristic of the period.

LAON CATHEDRAL Although Laon Cathedral is considered an Early Gothic building, its plan resembles those of Romanesque churches. For example, the ceiling is a **sexpartite rib vault** supported by groups of columns in an alternate ABAB rhythm (Fig. 10.5). Yet there were important innovations at Laon. The interior displays a change in wall elevation from three to four levels. A series of arches, or **triforium**, was added above the tribune gallery to pierce further the solid surfaces of the nave walls. The obsession with reducing the

appearance of heaviness in the walls can also be seen on the exterior (**Fig. 10.6**). If we compare the façade of Romanesque churches with that of Laon Cathedral, we see a change from a massive, fortress-like appearance to one that seems lighter and more organic. The façade of Laon Cathedral is divided into three levels, although there is less distinction between them than in a Romanesque façade. The portals jut forward from the plane of the façade, creating a tunnel-like entrance. The stone is pierced by arched windows, arcades, and a large rose window in the center, and the twin bell towers seem to be constructed of voids rather than solids.

As the Gothic period progressed, all efforts were directed toward the dissolution of stone surfaces. The walls were penetrated by greater expanses of glass, nave elevations rose to new heights, and carved details became more complex and delicate. There was a mystical quality to these buildings in the way they seemed exempt from the laws of gravity.

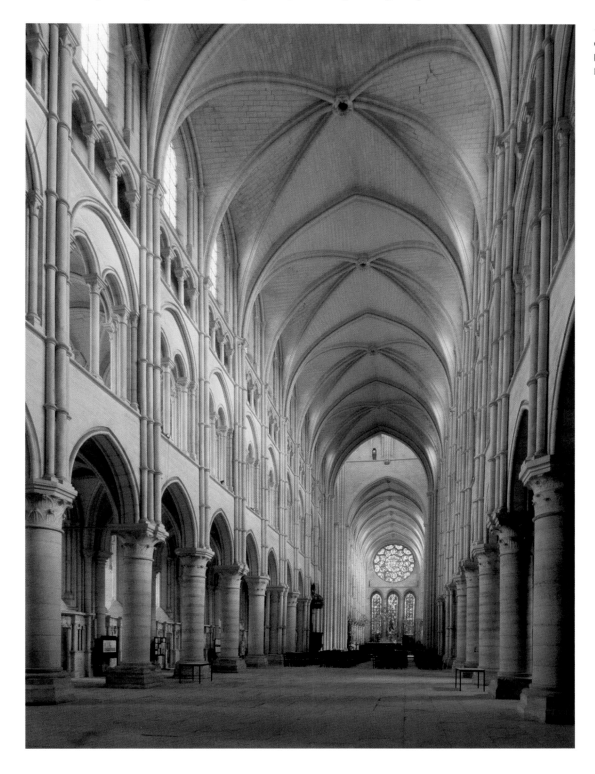

◄ **10.5** Laon Cathedral, interior, begun ca. 1190. Laon, France.

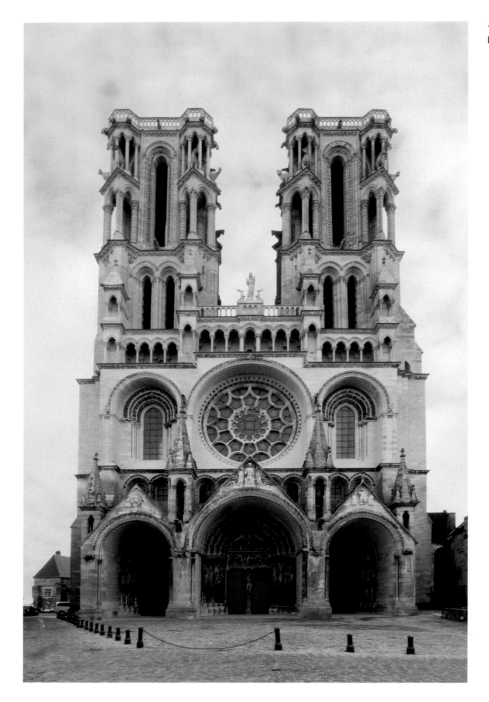

NOTRE-DAME CATHEDRAL One of the most famous buildings in the history of architecture is the Cathedral of Notre-Dame de Paris (**Fig. 10.7**). Perched on the banks of the Seine, it has enchanted visitors ever since its construction. Notre-Dame is a curious mixture of old and new elements. It retains a sexpartite rib vault and was originally planned to have an Early Gothic four-level wall elevation. It was begun in 1163 and not completed until almost a century later, undergoing extensive modifications between 1225 and 1250. Some of these changes reflected the development of the High Gothic style, including the elimination of the triforium and the use of flying buttresses to support the nave

walls. The exterior of the building also reveals this combination of early and late styles. Although the façade is far more massive than that of Laon Cathedral, the north and south elevations look light and airy because of their fenestration and the lacy buttressing.

CHARTRES CATHEDRAL Chartres Cathedral is generally considered to be the first High Gothic church. Unlike Notre-Dame, Chartres was planned from the beginning to have a three-level wall elevation and flying buttresses. The three-part wall elevation allowed for larger windows in the clerestory, admitting more light into the interior (**Fig. 10.8**).

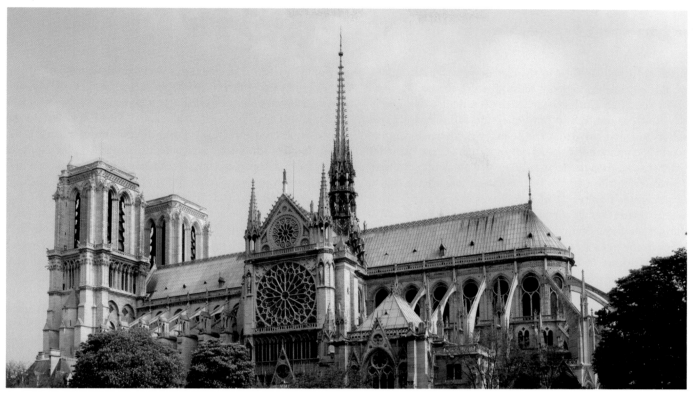

∧ **10.7** Cathedral of Notre-Dame de Paris, begun 1163, completed 1250. Paris, France

∨ **10.8** Chartres Cathedral, begun 1134, rebuilt after 1194. Chartres, France.** Considered the first High Gothic church, Chartres was planned to have a three-level wall elevation and flying buttresses. Flying buttresses support the walls and roof from the exterior, permitting the installation of more non-supporting glass windows.

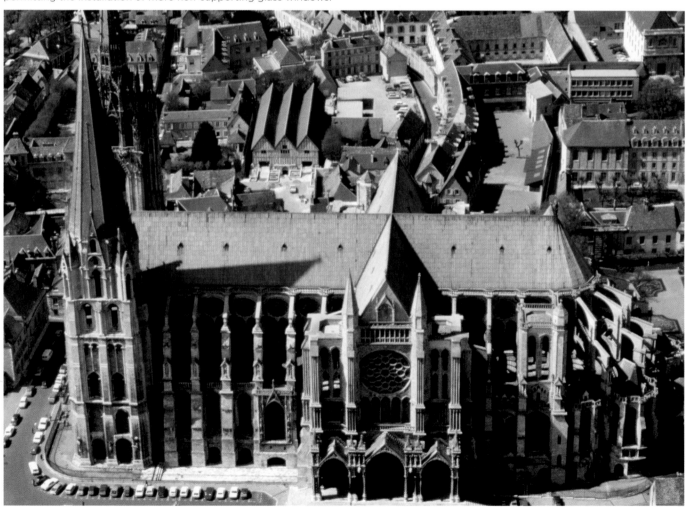

The use of large windows in the clerestory was in turn made possible by the development of the flying buttress.

In the High Gothic style, each rectangular bay has its own cross rib vault, and only one side aisle square flanks each rectangular bay. Thus, the need for an alternate support system is eliminated. The interior of a High Gothic cathedral presents several dramatic vistas. There is a continuous sweep of space from the narthex to the apse along a nave that is uninterrupted by alternating supports. There is also a strong vertical thrust from floor to vaults that is enhanced by the elimination of the triforium and the increased heights of the arches in the nave arcade and clerestory windows. The solid wall surfaces are further dissolved by quantities of stained glass that flood the interior with spectacular patterns of soft-colored light. The architects directed all of their efforts toward creating a spiritual escape to another world. They did so by effectively defying the properties of matter: creating the illusion of weightlessness in stone and dissolving solid surfaces with mesmerizing streams of colored light.

The Mysticism of Light

It has been said, perhaps with some exaggeration, that walls in Gothic cathedrals were replaced by skeletal masonry scaffolding for windows (**Fig. 10.9**). The key characteristic of Gothic architecture that sets it apart from the Romanesque style is not verticality, but luminosity. The Gothic style may be described as transparent—diaphanous—architecture.

Abbot Suger wrote two short booklets about his stewardship of the abbey and his ideas about the building and decorating program he initiated for the abbey church—sources for our understanding of the thought that stood behind the actual work of the builders and artists. Underlying Suger's description of the abbey's art treasures and architectural improvements was a theory of beauty. Suger was heavily indebted to his reading of certain mystical treatises written by Dionysius the Areopagite (whom Suger and many of his contemporaries wrongly assumed was the Saint Denis for whom the abbey was named), a fifth-century Syrian monk whose works on mystical theology were strongly influenced by Neo-Platonic philosophers as well as by Christian doctrine. In the doctrine of the Pseudo-Dionysius (as later generations have called him), every created thing partakes, however imperfectly, of the essence of God. There is an ascending hierarchy of existence that ranges from inert mineral matter to the purity of light, which is God. The Pseudo-Dionysius described all of creation under the category of light: Every created thing is a small light that illumines the mind a bit. Ultimately, as light becomes more pure, one ascends the hierarchy and gets closer to pure light, which is God.

STAINED GLASS The high point of this mysticism of light is expressed in the stained-glass window. Suger believed that when he finished his nave with its glass windows (never completed in fact) to complement his already finished choir, he

would have a total structure that would make a single statement: "Bright is that which is brightly coupled with the bright, and bright is the noble edifice which is pervaded by the new light [*lux nova*]." The *lux nova* is an allusion to the biblical description of God as the God of light. Suger did not invent stained glass, but he fully exploited its possibilities both by encouraging an architecture that could put it to its most advantageous employment and by providing a theory to justify and enhance its use.

No discussion of light and glass in this period can overlook the famous windows of the Chartres Cathedral, southwest of Paris. When the cathedral was rebuilt after a disastrous fire in 1194 (which destroyed everything except the west façade of the church), the new building gave wide scope to the glazier's art.

When the walls were rebuilt, more than 173 windows were installed, covering an area of about 2000 square yards (1672 square meters). Except for some fine details like facial contours, the glass is not painted. The glaziers produced the col-

▼ **10.9** Sainte-Chapelle, 1243–1248. Paris, France. **Interior of the upper chapel.** Built to house relics of Christ's Passion, this is an exquisite example of Gothic luminosity. Although the chapel has been restored heavily, the overall effect is of skeletal architecture used to frame the windows has nonetheless been maintained.

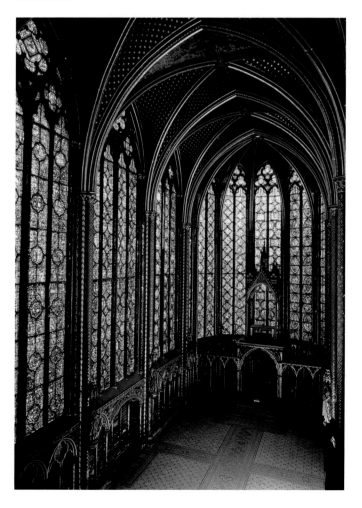

ors (the blues and reds of Chartres are famous, and the tones were never again reproduced exactly) by adding metallic salts to molten glass. Individual pieces were fitted together like a jigsaw puzzle and fixed by leading the pieces together. Pieces were rarely larger than eight feet square, but 30-foot sections could be bonded together safely in the leading process. The sections were set into stone frames (**mullions**) and reinforced in place by the use of iron retaining rods. Windows as large as 60 feet high could be created in this fashion.

Let us compare the aesthetics of the stained-glass window to the mosaics discussed in Chapter 7 (see pp. 228–234). There was a strong element of mysticism of light in the art of Byzantine mosaic decoration, derived from some of the same sources later utilized by Abbot Suger: Neo-Platonism and the allegorical reading of the Bible. The actual perception of light in the two art forms, however, was radically different. The mosaic scattered reflected light off an opaque surface. The sacred aura of the light in a Byzantine church comes from the oddly mysterious breaking up of light as it strikes the irregular surface of the mosaic tesserae. The stained-glass window was the medium through which the light was seen directly, even if it was subtly muted into diverse colors and combinations of colors.

You can only read the meaning of the window by looking at it from the inside with an exterior light source—the sun—illuminating it. (*Read* is not a rhetorical verb in this context. It was a commonplace of the period to refer to the stained-glass windows as the Bible of the poor, because the illiterate could read the biblical stories in their illustrated form in the cathedral.) It was a more perfectly Platonic analogy of God's relationship to the world and its creatures. The viewer sees an object (the illustrated window) but through it is conscious of a distant unseen source (the sun—God) that illumines it and gives it its intelligibility.

IMAGES OF THE VIRGIN AND THE CHRIST CHILD A close examination of one window at Chartres will illustrate the complexity of this idea. *La Belle Verrière* ("Our Lady of the Beautiful Window") (**Fig. 10.10**), created in the 12th century, was saved from the rubble of the fire of 1194 and reinstalled in the south choir. The window, with its characteristic pointed arch frame, depicts the Virgin enthroned with the Christ child, surrounded by worshipping angels bearing candles and censers (incense vessels). Directly above her is the dove that represents the Holy Spirit, and at the very top a stylized church building represents the cathedral built in her honor.

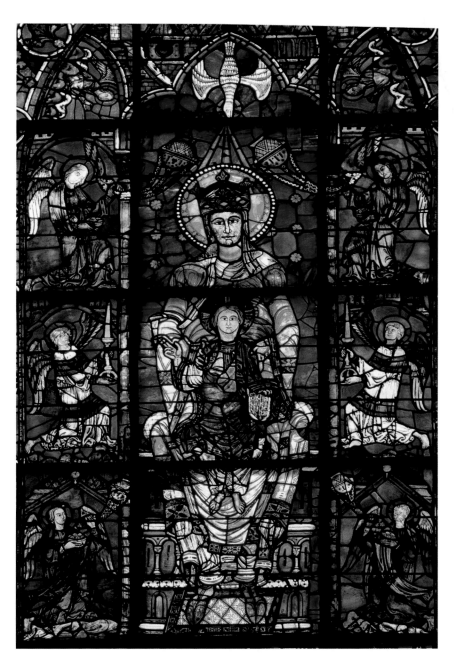

∧ **10.10** *Notre Dame de la Belle Verriere,* **Virgin and Child panel, ca. 1170, side panels with angels, 13th century, stained glass, 12′9″ high, choir of Chartres Cathedral, Chartres, France.** Almost all of the stained glass in Chartres Cathedral is original, giving us a good sense of the colored light effects that the designers had in mind. Chartres is particularly known for its blue and red glass.

The scene shows the Virgin enthroned as the symbol of Mary as the seat of wisdom, an ancient motif in religious art. The window also has a conceptual link with the exterior sculptural program. In the tympanum of the portal is an enthroned Madonna and Christ child with two **censer**-bearing angels. This scene is surrounded by sculpted arches, called **archivolts**, which have symbolic representations of the

seven liberal arts (**Fig. 10.11**) that together constitute a shorthand version of the window.

The Blessed Virgin depicted as the seat of wisdom would be an especially attractive motif for the town of Chartres. The cathedral school was a flourishing center of literary and philosophical studies—studies that emphasized that human learning became wisdom only when it led to the source of wisdom: God. The fact that Mary was depicted here in glass would also call to mind an oft-repeated *exemplum* (moral example) used in medieval preaching and theology: Christ was born of a virgin. He passed through her body as light passes through a window, completely intact without changing the glass. The analogy of Christ to light and Mary to glass is an apt and deepened metaphor to be seen in *La Belle Verrière*.

Builders and theologians worked together while a cathedral was under construction. Church authorities sought not only to build a place suitable for worship but also to use every opportunity to teach and edify worshippers. The famous Gothic **gargoyles** (**Fig. 10.12**) blend functionality and instruction. These carved beasts funnel rainwater off the roofs while, in their extended and jutting positions on the roofs and buttresses, they also signify that evil flees the sacred precincts of the church. The entire decorative scheme of a cathedral was an attempt to tell the story of the history of salvation. Modern visitors may be overwhelmed by an apparent jumble of sculptures depicting biblical scenes, allegorical figures, symbols of the labors of the months, signs of the zodiac, representatives of pagan learning, and panoramic views of the Last Judgment; but for medieval viewers the var-

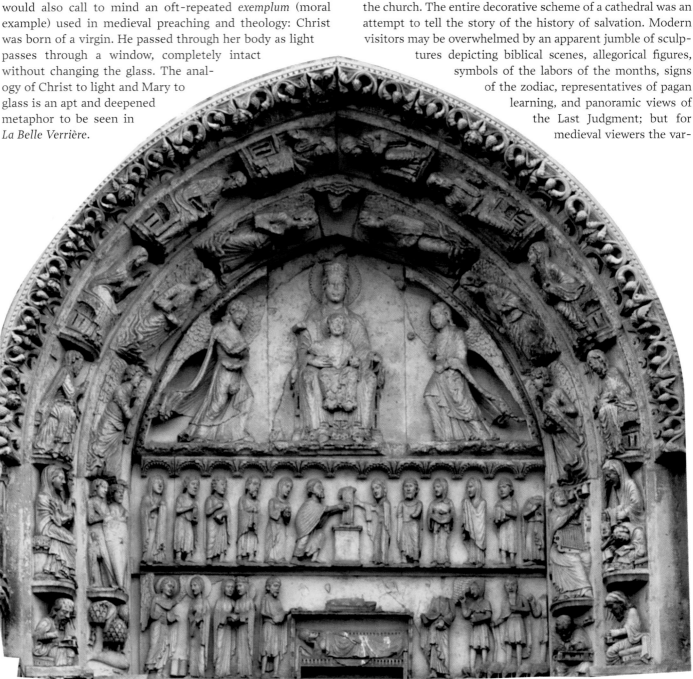

⋀ **10.11 Tympanum, west façade, right door royal portal, carved 1145–1170. Chartres Cathedral, Chartres, France.** The central panel shows the Virgin and Child framed by adoring angels within an interior arch, while the outer arch depicts the seven liberal arts. At the lower left is Aristotle dipping his pen in ink with the female of Dialectic above him. Under the central of the Virgin, the lintel shows scenes from the life of Mary and the young Christ; on the upper level, the Presentation in the Temple, and on the lower level (from left), representations of the Annunciation, the Visitation, the Nativity, and the Adoration of the Shepherds.

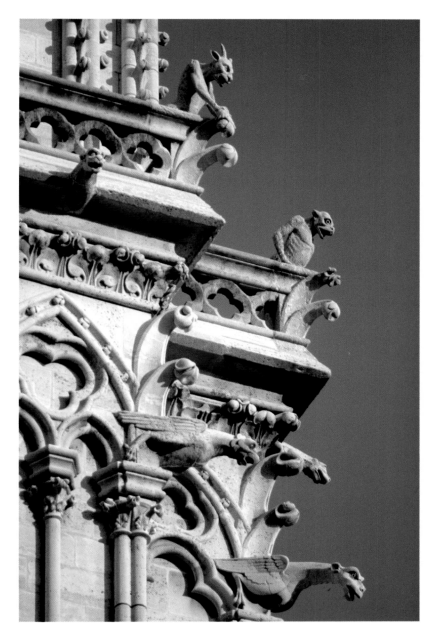

◄ **10.12** **Gargoyles on Notre-Dame. Paris, France.** Gargoyles are grotesque stone figures used on cathedral such as Notre-Dame to convey water away from the roof and the side of the building.

Gothic sculpture was still generally confined to decoration of cathedral portals. Every square inch of the tympanums, lintels, and archivolts of most Gothic cathedrals was carved with a dazzling array of figures and ornamental motifs. However, some of the most advanced sculptures adorn the jambs, such as those flanking the portals of Chartres Cathedral (**Fig. 10.13**). The figures are rigid in their poses, confined by the columns to which they are attached. The drapery falls in predictable stylized folds reminiscent of those seen in manuscript illumination. Yet there is a certain weight to the bodies, and the hinged treatment of the limbs is eliminated, heralding change from the Romanesque. During the High Gothic period, these simple elements lent a naturalism that had not been witnessed since Classical times.

The jamb figures of Reims Cathedral (**Fig. 10.14**) illustrate an interesting combination of styles. No doubt the individual figures were carved by different artists. The detail of the central portal of the façade illustrates two groups of figures. To the left is an Annunciation scene with the angel Gabriel and the Virgin Mary, and to the right is a Visitation scene depicting the Virgin Mary and Saint Elizabeth. All of the figures are detached from columns and instead occupy the spaces between them. Although they have been carved for these specific niches and are perched on small pedestals, they suggest a freedom of movement that is not found in the jamb figures at Chartres.

The Virgin Mary of the Annunciation group is the least advanced in technique of the four figures. Her stance is the most rigid, and her gestures and facial expression are the most stylized. Yet her body has substance, and anatomical details are revealed beneath a drapery that responds realistically to the movement of her limbs. The figure of Gabriel contrasts strongly in style with that of the Virgin Mary. He seems relatively tall and lanky. His head is small and delicate, and his facial features are refined. His body has a subtle sway that is accented by the flowing lines of his drapery. The stateliness and sweetness of the style it will be carried forward into the Early Renaissance.

Yet classicism will be the major style of the Renaissance, and in the Visitation group of the Reims portals, we have a fascinating introduction to it. The weighty figures of Mary and Elizabeth are placed in a **contrapposto** stance. The folds of drapery articulate the movement of the bodies beneath with a realism that we have not seen since Classical

ious scenes represented a patterned whole. The decoration of the cathedral was, as it were, the common vocabulary of sermons, folk wisdom, and school learning fleshed out in stone.

Sculpture

Sculpture during the Gothic period reveals a change in mood from that of the Romanesque. The iconography is one of redemption rather than damnation. The horrible scenes of Judgment Day that threatened the worshipper upon entrance to the cathedral were replaced by scenes from the life of Jesus or visions of the Apocalypse. The Virgin Mary also assumed a primary role. Carved tympanums, whole sculptural programs, even cathedrals themselves (for example, Notre-Dame, which means "Our Lady") were dedicated to her.

times. Even the facial features and hairstyles are reminiscent of Greek and Roman sculpture. Although we have linked the reappearance of naturalism to the Gothic artist's increased awareness of nature, we must speculate that the sculptor of the Visitation group was looking directly to Classical statues for inspiration. The similarities are too strong to be coincidental. With this small and isolated attempt to revive Classicism, this unknown artist stands as a transitional figure between the spiritualism of the medieval world and the rationalism and humanism of the Renaissance.

The Many Meanings of the Gothic Cathedral

The cathedral was the preeminent building in the towns of Île-de-France. The cathedral overwhelms the town either by crowning a hilly site, as at Laon, or rising up above the town plain, as at Amiens. The cathedrals were town buildings (Saint-Denis, a monastic church, is a conspicuous exception), and one might well inquire into their functional place in the life of the town.

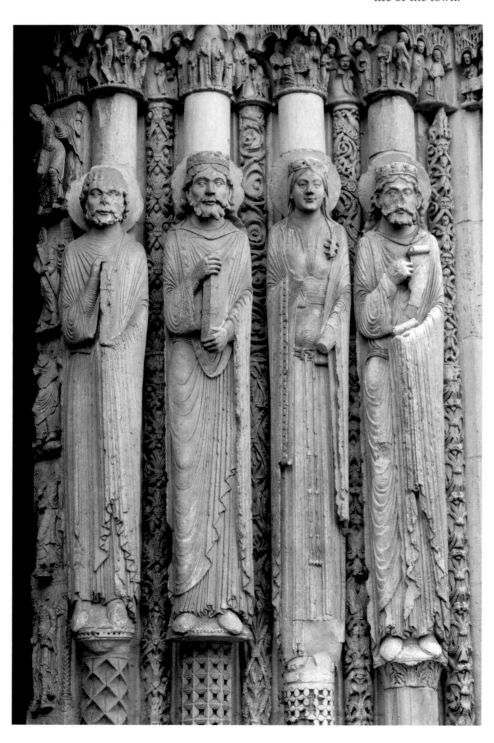

A modern analogy illustrates the social function of architecture and building. Many a small town in America, especially in rural areas of the South and the Northeast, centers its civic and commercial life in a town square. The courthouse symbolically emanates social control (justice), social structures (registration of births, weddings, and deaths), power (the workplace of the sheriff, commissioners or aldermen, and mayor), and—to a degree—culture, with its adjacent park and military or civic monuments to the founders and war dead. The better stores, the churches, and the other appurtenances of respectability—banks, lawyers' and physicians' offices—cluster about the square. The cathedral square of the typical European or Latin American town is the ancestor of the courthouse square. The difference is that the medieval cathedral exercised a degree of social control and integration more comprehensive than that of the courthouse.

The cathedral shaped individual and social life in the town. Individuals were baptized in, made communicants of, married in, and buried from the cathedral. Schooling was obtained from the cathedral school and social services (hospitals, relief of the poor, orphanages, and so on) directed by the decisions of the cathedral staff (the *chapter*). The daily and yearly round of life was regulated by the **horarium** of the cathedral. People rose and ate and went to bed in rhythm with the toll-

◀ **10.13** Jamb figures, west portals, Chartres Cathedral, ca. 1140–1150. Chartres, France.

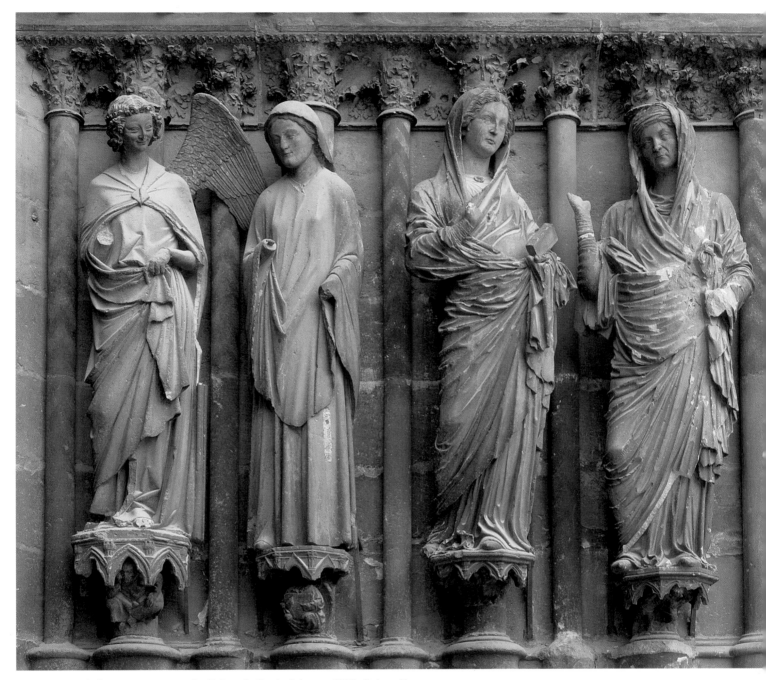

▲ **10.14** Jamb figures, west portals, Reims Cathedral, begun 1210. Reims, France.

ing of the cathedral bell, just as they worked or played in line with the feast days of the liturgical calendar of the church year. Citizens could sue and be sued in the church courts, and those same courts dispensed justice on a par with the civil courts; the scenes of the Last Judgment over the central portals of medieval cathedrals referred to more than divine justice.

More significant than the social interaction of town and cathedral was the economic impact of the cathedral on the town. The building of a cathedral was an extremely expensive enterprise. When the people of Chartres decided to rebuild their cathedral in 1194, the bishop pledged all of the diocesan

revenues for three years (equivalent to three to five million U.S. dollars in today's money) simply to initiate the project. A town like Chartres was small in the late 12th century, with no more than 10 to 15 thousand residents.

From the late ninth century, Chartres had been a major pilgrimage site. The cathedral claimed possession of a relic of the Virgin (the tunic she wore when Jesus was born), given in 877 by Charles the Bald, the great-grandson of Charlemagne. **Relics** were popular throughout the Middle Ages, and this particular one was especially important to the pilgrims of the time: the relic had not been destroyed by the fire of 1194, a

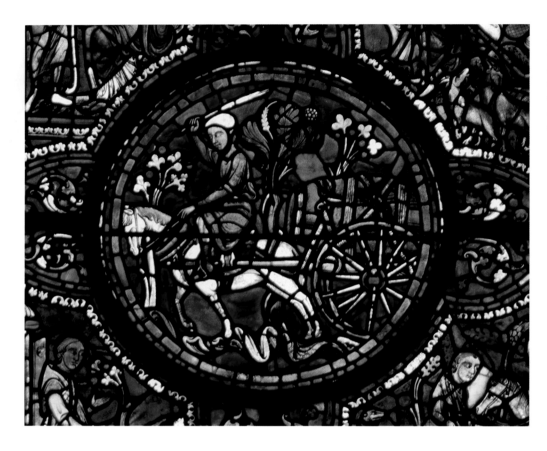

◄ **10.15** Vintner's window, Chartres Cathedral, ca. 1215. Stained glass roundel. Chartres, France. This panel from a window donated by the winemakers of the area shows a wine merchant transporting a cask of wine.

sure sign in the eyes of the populace that the Virgin wished the church rebuilt. Furthermore, the four great feasts of the Blessed Virgin in the liturgical year (the Purification of Mary on February 2, the Annunciation on March 25, the Assumption on August 15, and the Nativity of the Virgin on September 8) were celebrated in Chartres in conjunction with large trade fairs that drew merchants and customers from all over Europe.

These fairs were held in the shadow of the cathedral and their conduct was specified by legislation issued by the cathedral chapter. For example, the prized textiles of the area were to be sold near the north portal, while the purveyors of fuel, vegetables, fruit, and wine were to be located by the south portal. There were also venders of images, medals, and other religious objects (forerunners of the modern souvenir) to the pilgrims, who came both for the fair and for reasons of devotion. The church, then, was as much a magnet for outsiders as it was a symbol for the townspeople.

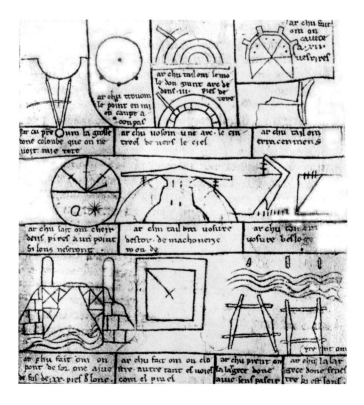

➤ **10.16** Villard de Honnecourt, Plate 39 from *Portfolio of Villard de Honnecourt,* 1220–1250. Pen and ink on parchment showing practical geometry for the construction of buildings, 9¼" × 6⅛" (23.5 × 15.5 cm). Bibliothèque Nationale de France, Paris, France. *Top row:* Measuring the diameter of a partially visible column; finding the middle of a circle; cutting the mold of an arch; arching a vault with an outer covering; making an apse with twelve windows; cutting the spring stone of an arch. *Second row:* Bringing together two stones; cutting a voussoir (a wedge-shaped brick for constructing arches) for a round building; cutting an oblique voussoir. *Third row:* Bridging a stream with timbers; laying out a cloister without plumb line or level; measuring the width of a river without crossing it; measuring the width of a distant window.

GUILDS The patrons who donated the windows of Chartres Cathedral also give some indication of the economics of the place. Some of the large windows—such as rose windows—were the gift of a royal family. A tall, pointed *lancet* window, such as those in the choir, were given by the nobility or the higher clergy. Many of the windows, however, were donated by the members of the local craft and commercial guilds; their signature frames can be found at the bottoms of the windows. Five large windows in honor of the Virgin in the *chevet*, the east end of the cathedral, were donated by merchants—principally the bakers, butchers, and vintners—which is suggestive of the power of the guilds (**Fig. 10.15**).

The guild, a fraternal society of craftsmen or merchants, was a cross between a modern-day union and a fraternal organization like the Elks or the Knights of Columbus. Members of guilds placed themselves under the patronage of a saint, promised to perform charitable works, and acted as a mutual-aid society. Many of the economic guilds appear to have developed out of earlier, more religious groups. One had to belong to a guild to obtain regular work. The guild—the forerunner of the union—accepted and instructed apprentices; certified master craftsmen; regulated prices, wages, and working conditions; and maintained funds to care for older members and bury their dead. The university developed from the guild in the 12th century.

BUILDERS The motivation for the building of a medieval cathedral, then, came from theological vision, religious devotion, civic pride, and socioeconomic interest. The construction depended on people who raised the money and hired the master builder or architect. He in turn, hired the master craftsmen, designed the building, and created the decorative scheme. Master craftsmen (masons, stonecutters, glaziers) hired their crews, obtained their materials, and set up work quarters. Manual and occasional labor was recruited from the local population, but construction crews usually migrated from job to job.

The names of several master builders, including the builder of Chartres, have been lost, but others have survived in funerary inscriptions, commemorative plaques, and building records. Notes written by Villard de Honnecourt (ca. 1235), an architect from northern France, and intended for students of buildings are preserved in a unique copy at the Bibliothèque Nationale in Paris. They provide us a rare glimpse into the skills of a medieval cathedral builder. Honnecourt writes that he could teach a willing apprentice skills ranging from carpentry and masonry to practical geometry (**Fig. 10.16**) and plan drafting. The notebook also has sketches and ideas jotted down for his personal use; they include religious figures to serve as models for stone carvers, animals and buildings that caught his eye, a perpetual-motion machine (which did not work), the first example of clockwork in the West, and a self-operating saw for cutting huge timbers for buttressing and roofing. He visited Reims and made sketches of the cathedral. He traveled as far as Hungary to get work. Honnecourt's notebook reveals a highly skilled, persistently inquisitive, and inventive man.

A cathedral has more than religious and social significance; it is a stunning technological achievement, as we see in the elegant spire of Strasbourg Cathedral. Finished in 1439, the spire is 466 feet high from pavement to tip—as high as a 40-story building.

For those who entered a cathedral in faith, it provided a transcendental religious experience of passing from the profane to the sacred world. In his wonderfully eccentric book, *Mont-Saint-Michel and Chartres*, Henry Adams—a journalist and descendent of the President John Adams—writes that only a person coming to Chartres as a pilgrim could understand the building. The pilgrim is a central metaphor for the period, whether one is speaking of an actual pilgrim on the road to Santiago de Compostela or Canterbury or of life itself as a pilgrimage toward God. Pilgrims to Chartres or the other cathedrals journeyed in both senses: they traveled to visit a real monument and, at the same time, hoped to find peace and salvation (**Fig. 10.17**). Abbot Suger called Saint-Denis the Gate of Heaven.

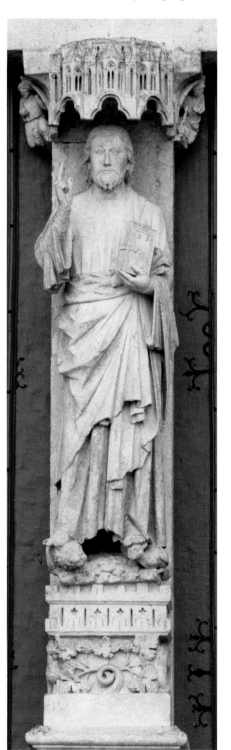

◄ **10.17** Le Beau Dieu ("Beautiful Lord") Amiens Cathedral, Amiens, France, ca. 1220–1235. Showing Christ in the act of blessing, this figure symbolically blesses all pilgrims who pass through the door, the "Gate of Heaven," of Amiens Cathedral. Marble sculpture on the trumeau (the central column supporting the tympanum) of the central doorway, west facade.

MUSIC OF THE SCHOOL OF NOTRE-DAME

In the Gothic era of artistic and architectural development, the austere music of the early church also underwent change. From the time Charlemagne introduced Gregorian chant into the church life of the Frankish kingdom, there were further developments of that musical form. In the 11th century, Guido d'Arezzo worked out a system of musical notation that provided the basis for the development of the musical notation used today. Church musicians from the 10th century on also experimented with a single melodic line of plainchant by adding parallel voices at different musical intervals above the line of chant. This first step toward **polyphony**, a musical term for many voices, was called **organum**. Outside the church, the knightly classes also composed and performed secular music. Some of the melodies of the *troubadours* have survived, providing insight into secular music in the 12th and 13th centuries. The German *minnesingers* (*minne* means "love") of the 13th century used traditional church modes and melodies to create secular and sacred songs.

The school of Notre-Dame in Paris was the center of systematic musical study and composition in the 12th century. Léonin's *Magnus liber organi* (ca. 1160) is an important source for our knowledge of music in the period of the Gothic cathedral. Léonin's book was a collection of organum compositions for use during the liturgical services throughout the church year. His work was carried on by the other great composer of the century, Pérotin, who assumed the directorship of the music school of Notre-Dame sometime around 1181.

GO LISTEN! LÉONIN

"Viderunt omnes fines terre"

As in the earlier listening selection of Gregorian chant, a clear pronunciation of the text remains the music's main feature. But as opposed to the earlier monophony, here Léonin introduces a new musical element by using additional voices or lines to provide interest. Most of the time, particularly in the opening, the additional lower voice simply serves as a bass background, but as the piece develops, parallel voices enter to accompany the principal line. This organum form was to become increasingly important in the development of Western music. It must be added that many modern scholars believe that Léonin did not so much compose the music (in the modern sense) as encourage his singers to improvise. The form in which we have his work was not written down until over a century after his death. The music is still purely vocal, although secular music of the same period may well have made use of musical instruments.

In Pérotin's music, the Notre-Dame organum utilized the basic melodic line of the traditional chant (the *cantus firmus*) while a second melodic line (the *duplum*), a third (*triplum*), and in some cases a fourth (*quadruplum*) were added above the melody. These added lines mirrored the rhythmic flow of the cantus firmus. It was soon learned, however, that pleasing and intricate compositions could be created by having the duplum and triplum move in opposition to the cantus firmus. This *counterpoint* (from *contrapunctus*, "against the note") meant, at its most basic level, that a descending series of notes in the cantus firmus would have an ascending series of notes in the melodic lines above it.

One development in the Gothic period deriving from the polyphony of organum was the motet. The *motet* usually had three voices (in some cases four). The tenor—from the Latin *tenere* ("to hold")—another term for *cantus firmus*, maintained the traditional line, usually derived from an older ecclesiastical chant. Because some of the manuscripts from the period show no words for this tenor position, it has been thought

◄ MAP 10.2 The University.

VALUES

Dialectics

In ancient Greece the word *dialectics* originally meant the "art of conversation." By the fifth century, dialectics took on the meaning of techniques used to come to logical conclusions based on a rigorous style of reasoning. Plato singled out dialectics in the *Republic* as a mark of the philosopher-king, whereas Aristotle saw it containing the "path to the principles of all inquiries."

The rediscovery of dialectics (which was the common medieval term for *logic*) coincided with the rise of the university. The study of theology and philosophy were increasingly cast into terms that could be expressed in logic modes like the deductive syllogism. University professors of theology, for example, had three duties: to explain the text of scripture; to preach; and to dispute— that is, to set out Christian doctrines in some logical form.

What was true of these Christian scholars was also true of contemporary Muslim and Jewish thinkers who had also inherited the tradition of Aristotle's logic. Modern scholars have pointed out that dialectical reasoning, with its focus on resolving problems, had ramifications for both literature and architecture.

The greatest weakness of this emphasis was the temptation to turn the logical process into an end in itself, forgetting the search for truth in a desire to dazzle people with the sheer technique of logic. Dante would open canto 9 of the *Paradiso* with a critique of such mental pyrotechnics as he complained of those who were useless in their "reasoning" (literally: their "syllogisms") that make the wings of the mind bend "in downward flight."

that for many motets the tenor line was the musical accompaniment. Above the tenor were two voices who sang interweaving melodies. In the early 13th century, these melodies were invariably in Latin and exclusively religious in content. In the late 13th century, it was not uncommon to sing the duplum in Latin and the triplum in French. The two upper voices could be singing quite distinct songs: a hymn in Latin with a love lyric in French with a tenor voice (or instrument) maintaining an elaborated melody based on the melismas of Gregorian chant.

This increasingly sophisticated music, built on a monastic basis but with a new freedom of its own, is indicative of many of the intellectual currents of the period. It is a technically complex music rooted in the distant past but open to daring innovation, a blend of the traditional and the vernacular—all held together in a complicated balance of competing elements. Gothic music was an aural expression of the dynamism inherent in the medieval Gothic cathedral.

SCHOLASTICISM

Several modern-day institutions have their roots in the Middle Ages. Trial by jury is one, constitutional monarchy another. A third institution perhaps has the most relevance to the majority of readers of this book: the university.

The Rise of the Universities

Some of the most prestigious centers of European learning today stand where they were founded more than 800 years ago: Oxford and Cambridge in England; the University of Paris in France; the University of Bologna in Italy (see **Map 10.2**).

There is also a remarkable continuity between the organization and purposes of the medieval university and our own, except that we have coeducation. Medieval students would be puzzled, to be sure, by the idea of football games, coeducation, degrees in business or agriculture, and well-manicured campuses, were they to visit an American university.

But such students might find themselves at home with the idea of a liberal-arts curriculum, the degrees from the baccalaureate through the master's to the doctorate, and the high cost of textbooks. They would also be well acquainted with drinking parties, fraternities, and friction between town and gown (the phrase itself has a medieval ring). The literature that has come down to us from the period is full of complaints about poor housing, high rents, terrible food, and lack of jobs after graduation. Letters from the Middle Ages between students and parents have an uncanny contemporaneity about them, except for the fact that women did not study in the medieval universities.

European universities developed in the late 12th and early 13th centuries along with the emergence of city life. In the Early Middle Ages, schools were most often associated with monasteries, which were generally situated in rural areas. As cities grew in importance, schools also developed at urban monasteries or, increasingly, under the aegis of bishops whose cathedrals were in the towns. The episcopal or cathedral school was a direct offshoot of the increasing importance of towns and the increasing power of bishops, the spiritual leaders of town life. In Italy, where town life had been relatively strong throughout the Early Middle Ages and where feudalism never took hold, there was also a tradition of schools controlled by the laity. The center of medical studies in Salerno and the law faculty of Bologna had been in secular hands since the 10th century.

Several factors help explain the rapid rise of formal educational institutions in the 12th century. First, the increasing

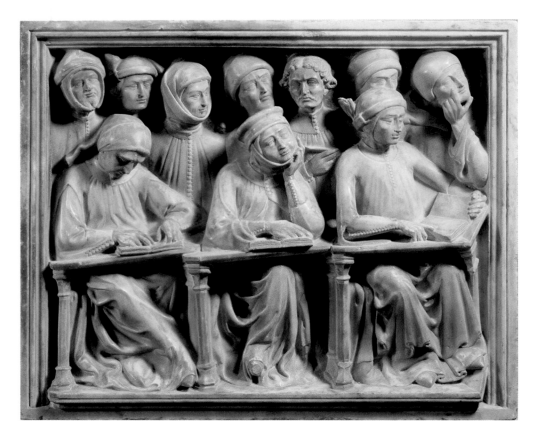

◄ **10.18** Jacobello and Pier Paolo dalle Masegne, Students, 1383–1386. Detail from the Tomb of Giovanni da Legnano. Marble, 25″ × 30⅛″ (63.3 × 76.5 cm) Museo Civico, Bologna, Italy. The facial expressions of the students suggest that the professor has not earned their rapt attention. The seated student in the center would appear to be a woman, which would be unusual because women were generally excluded from professions such as medicine and law during the Middle Ages. Moreover, most women who received education at all during that time did so privately.

complexity of urban life created a demand for an educated class who could join the ranks of administrators and bureaucrats. Urban schools were not simply interested in providing basic literacy; they were designed to produce an educated class who could give support to the socioeconomic structures of society. Those who completed the arts curriculum of a 12th-century cathedral school (like the one at Chartres) could find ready employment in either the civil or the ecclesiastical bureaucracy as lawyers, clerks, or administrators.

There were also intellectual and cultural reasons for the rise of the universities. In the period from 1150 to 1250 came a wholesale discovery and publication of texts from the ancient world. Principal among these were lost books by Aristotle that came to the West through Muslim sources in Spain. The relationship between Christian and Muslim scholars brought scientific and mathematical knowledge into Europe (**Fig. 10.18**). There was also a renaissance of legal studies centered primarily at Bologna, the lone intellectual center that could rival Paris. Finally, a new tool was being refined by such scholars as Peter Abelard and Peter Lombard: **dialectics**. Theologians and philosophers began to apply the principles of logic to the study of philosophy and theology. Abelard's book *Sic et non* (1121) combined conflicting opinions concerning theological matters with contradictory passages from the Bible and the church fathers, then attempted to reconcile the divergences. This method was later refined as Scholasticism, so called because it was the philosophical method of the schools, the communities of scholars at the nascent universities.

THE UNIVERSITY OF PARIS The best-known university to emerge in the Middle Ages was the University of Paris. The eminence of Paris rested mainly on the fame of its professors, many of whom were recruited from abroad. At this stage of educational development, the teacher was the school. Students in the 12th century flocked from all over Europe to frequent the lectures of teachers such as William of Champeaux (1070–1121) and his student and critic, Peter Abelard (1079–1142). Paris also had other well-reputed centers of learning. There was a school attached to the Cathedral of Notre-Dame, a theological center associated with the canons of the Abbey of Saint-Victor, and a school of arts maintained at the ancient Abbey of Sainte-Geneviève.

The University of Paris developed in the final quarter of the 12th and early part of the 13th centuries. Its development began with the *magistri* (masters or teachers) of the city forming a corporation after the manner of the guilds. At this time the word **universitas** simply meant a guild or corporation.

The masters formed the universitas in Paris in order to monitor the quality of teaching and the performance of students. At Bologna, the reverse was true: the students formed the universitas to hire the teachers with the best qualifications and on the most advantageous financial terms.

The Universitas soon acquired a certain status in law, with a corporate right to borrow money, to sue (and be sued), and to issue official documents. As a legal body it could issue stipulations for the conduct of both masters and students. When a student completed the course of studies and passed examinations, the universitas would grant him a teaching

certificate that enabled him to enter the ranks of the masters: he was a master of arts (our modern degree has its origin in that designation). After graduation, a student could go on to specialized training in law, theology, or medicine. The completion of this specialized training entitled one to be called *doctor* (from the Latin *doctus*, "learned") in his particular field. The modern notion that a professional person (doctor, lawyer, and the like) should be university trained is an idea derived directly from medieval university usage.

Since the Carolingian period—indeed, earlier—the core of education was the arts curriculum. In the late 12th century in Paris, the arts began to be looked on as a prelude to the study of theology, which became a source of tension between the arts faculty and the theology masters. In 1210 this tension resulted in a split, with the masters and students of arts moving their faculty to the Left Bank of the Seine, where they settled in the area intersected by the rue du Fouarre ("Straw Street"—so named because the students sat on straw during lectures). That part of the Left Bank has traditionally been a student haunt. The name *Latin Quarter* reminds us of the language that was once the only tongue used at the university. Did women study at the university? By and large they did not. Medieval customs sheltered women in a manner we find difficult to imagine. If women were educated, it was accomplished privately or within the convent.

HÉLOÏSE AND ABELARD In a sorrowful scandal of the period, Abelard and a private student, Héloïse, entered into a love affair; she became pregnant in the home of her uncle, Canon Fulbert, in 1119. The couple secretly had a son and were married. But Fulbert, enraged at learning of the affair that took place under his roof, hired criminals to castrate Abelard and had Héloïse sent to a convent. Humiliated as well as grievously injured, Abelard retreated to the monastic life at Saint-Denis under Abbot Suger. Abelard left Saint-Denis in about 1121 and founded a Benedictine monastery, the Paraclete (from the Greek for "one who consoles"). When he was elected abbot of another monastery, he turned the Paraclete over to Héloïse, who became its abbess

and remained there for the rest of her life. Although the couple rarely saw each other, they exchanged letters which have become famous. The couple were buried together at the Paraclete, Abelard when he died in 1142 and Héloïse joining him 22 years later, in 1164. Their bodies lay interred there for more than 600 years, until their remains were transferred to Père-Lachaise Cemetery in Paris (**Fig. 10.19**).

Most of university life was tied to the church. Most masters were clerics (except at Bologna), and most students depended on ecclesiastical *benefices* (pensions) to support them. There were exceptions. There seem to have been women in universities in both Italy and Germany. At Salerno, famous for its faculty of medicine, there may have been women physicians who were attached to the faculty. By the 14th century Salerno was licensing women physicians. There is also a tradition that Bologna had a woman professor of law who, according to the story, was so beautiful that she lectured from behind a screen so as not to dazzle her students. It is well to remember that the universities were conservative and traditional institutions. It

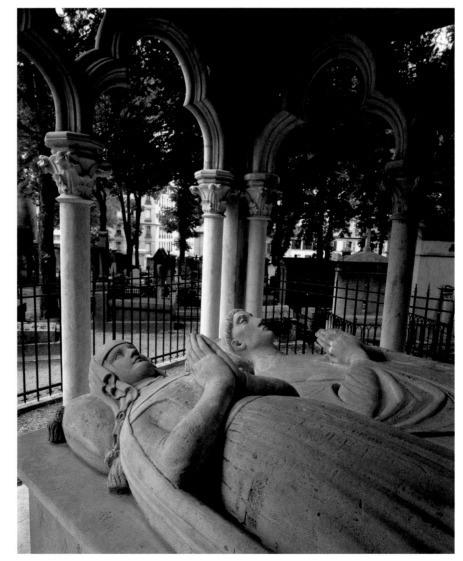

➤ 10.19 The resting place of Héloïse and Abelard, Père-Lachaise Cemetery, Paris, France. After their brief love affair was discovered, Héloïse was placed in a convent and Abelard sought refuge in a monastery. They rose to abbess and abbot and saw each other only rarely, but they exchanged letters that have become renowned, and they were buried together.

was not until the 20th century, for example, that provisions were made for women's colleges at Oxford that enjoyed the full privileges of university life. The discrimination against women at the university level was something, for example, that moved the bitter complaints of the English novelist Virginia Woolf as late as the 1920s.

STUDENT LIFE By the end of the 12th century, Paris was the intellectual center of Europe. Students flocked there from all over Europe. We do not have reliable statistics about their number, but an estimate of 5000 to 8000 students would probably not be far from the mark for the early 13th century. The students were organized into *nations* by their place of national origin. By 1294 there were four recognized nations in Paris: the French, the Picard, the Norman, and the Anglo-German. Student support came from families, pious benefactors, church stipends, or civic grants. Certain generous patrons provided funds for hospices for scholars, the most famous of which was that underwritten by Robert de Sorbon in 1258 for graduate students in theology; his hospice was the forerunner of the Sorbonne in Paris.

By our standards, student life in the 13th century was harsh. Food and lodging were primitive, heating scarce, artificial lighting nonexistent, and income sporadic. The daily schedule was rigorous, made more so by the shortage of books and writing material. An "ideal" student's day, as sketched out in a late medieval pamphlet for student use, now seems rather grim.

A master's lectures consisted of detailed commentaries on certain books the master intended to cover in a given term. Because books were expensive, emphasis was put on note taking and copying, so that students might build up their own collections of books. Examinations were oral, before a panel of masters. Students were also expected to participate in formal debates (called disputations) as part of their training.

Geoffrey Chaucer provides us an unforgettable, albeit idealized, portrait of the medieval student (the clerk or cleric—many of the students were members of the minor clerical orders of the church) in the Prologue to his *Canterbury Tales*.

A Student's Day at the University of Paris

4:00 A.M.	Rise
5:00–6:00	Arts lectures
6:00–8:00	Mass and breakfast
8:00–10:00	Lectures
11:00–12:00	Disputations before the noon meal
1:00–3:00 P.M.	Repetitions—study of morning lectures with tutors
3:00–5:00	Cursory lectures (generalized lectures on special topics) or disputations
6:00–7:00	Supper
7:00–9:00	Study and repetitions
9:00	Bed

Chaucer's portrait of the lean, pious, poor, zealous student was highly idealized to create a type. We probably get a far more realistic picture of what students were actually thinking and doing from the considerable amount of popular poetry that comes from the student culture of the medieval period. This poetry depicts a student life we are more familiar with: a poetry of wine, women, song, sharp satires at the expense of pompous professors or poor accommodations, and the occasional episodes of cruelty that most individuals are capable of only when banded into groups.

LITERATURE

Literature continued to develop in the High Middle Ages. Some would say that there was the beginning of a rebirth of literature that would reach fruition in the 13th century, with the magnificent epic poems of Chaucer and Dante, and in the Renaissance. The 12th and 13th centuries saw a continuation of the translation of Classical works and commentaries on them. There were writings on religion and philosophy, including works by the religious figures and scholars Moses Maimonides, Francis of Assisi, and Thomas

READING 10.1 GEOFFREY CHAUCER

The Canterbury Tales, General Prologue, lines 285–308

A young student from Oxford rode with us too,
Who'd begun his study of logic long ago.
As lean was his horse as is a rake,
And he himself was thin, I undertake;
He looked emaciated, burdened down with care,
His outer jacket was shabby and threadbare;
For he had not yet obtained a pulpit,
Nor for a worldly job would he be fit.
For he would rather have at his bed's head
Twenty books, each clad in black or red,
Of Aristotle and his philosophy,
Than rich robes, or fiddles, or gay psaltery.

Above all he was a philosopher;
With little money and abiding hunger.
But all that he might borrow from a friend
On books and learning he would surely spend.
And busily he'd pray God to keep the souls
Of patrons who supported him in schools.
Of study took he the utmost care and heed.
Not one word spoke he more than his need,
The style and reverence of his diction turning
Dignified, commanding, fraught with deepest meaning.
Thus flowing with moral virtue was his speech,
And gladly would he learn, and gladly teach.

The Medieval Parent and Student

The following letter was written by a parent to a son at the university in Orléans during the 14th century. Today the message might be communicated by telephone or email, but the content is hauntingly familiar.

> I have recently discovered that you live dissolutely and slothfully, preferring license to restraint and play to work and strumming a guitar while the others are at their studies, whence it happens that you have read but one volume of law while more industrious companions have read several. I have decided to exhort you herewith to repent utterly of your dissolute and careless ways that you may no longer be called a waster and that your shame may be turned to good repute.

The following letter is the answer of the student at Orléans to his father. The language might be a bit formal, but again, the content will be familiar. Notice the extremely common request: "Send money!"

> We occupy a good and comely dwelling, next door but one from the schools and market-place, so that we can go to school each day without wetting our feet. We have good companions in the house with us, well advanced in their studies, and of excellent habits—an advantage which we appreciate for, as the psalmist says "with an upright man thou wilt show thyself upright." Wherefore, lest production should cease for lack of material, we beg your paternity to send us by the bearer money for the purchase of parchment, ink, a desk, and the other things which we need, in sufficient amount that we may suffer no want on your account (God forbid!) but finish our studies and return home with honor. The bearer will also take charge of the shoes and stockings which you will send us, and any news at all.

Aquinas. We also had the birth of the modern love song and tales of the heroics of knights and kings, and of courtly love.

Troubadours and Trobairitz

Those who accede to the stereotype of the Middle Ages as dark may be surprised by the brilliance, elegance, and just plain fun that leaps from the written page. Nowhere is this more evident than in the *troubadours* (male) and *trobairitz* (female) who created the love song as we know it. The songs are accompanied by pleasant melodies, many of which we have. They have inspired poets and songwriters since the Middle Ages, from Dante and Chaucer to the Romantic poets to contemporary rock-and-roll lyricists. The themes are familiar enough. We saw them in the songs of ancient Egyptians, Greeks, and Romans: Why don't you love me as I love you? Why do you have all that clothing on? (And, Where is your clothing?) Why are women like that? Why are men like that? Love in springtime. Look what you've done to me. It is endless and very fresh, as new as the springtimes to which many of the songs refer. And some of them are quite raw.

GUILLEM DE PEITEUS Consider a couple of verses by Guillem de Peiteus (1071–1127), the first of the known troubadours. For a French nobleman, both a count and a duke, he was also a rebel. He feuded constantly with his underlings, the king, and the church. He joined Richard the Lion-hearted late on the First Crusade, and because of lack of coordination, Guillem's army was all but destroyed. Yet it is said of Guillem that he was a great gallant—"one of the most courtly men in the world and also one of the great deceivers of women; and he was a good knight-at-arms and generous in his gallantry; and he could write good poetry and sing well."[2] One of his "credentials" as a deceiver and a philanderer is that he was excommunicated by the church—twice. On one occasion, a

READING 10.2 GUILLEM DE PEITEUS

"A New Song for New Days," lines 1–6, 19–25

Such sweetness spreads through these new days:
As woods leaf out, each bird must raise
In pure bird-Latin of its kind
The melody of a new song.
It's only fair a man should find
His peace with what he's sought so long.

. . .

That morning comes to mind once more
We two made peace in our long war;
She, in good grace, was moved to give
Her ring to me with true love's oaths.
God grant me only that I live
To get my hands beneath her clothes.

2. Guillem de Peiteus, *A New Song for New Days*, quoted in Robert Kehew, ed., *Lark in the Morning: The Verses of the Troubadours*, trans. Ezra Pound, W. D. Snodgrass, and Robert Kehew (Chicago: University of Chicago Press, 2005), 23.

Chivalry and Courtly Love

You may have heard the expression "Chivalry is dead!" If so, what was the context? Why was it invoked? The context is almost always an interaction between men and women. The likely reason for the exclamation is that someone was behaving in a rude, uncaring, ungenerous way when it came to simple courtesy or a gesture of kindness. Picture a man and woman, 20 feet apart, hailing a taxi on a city street in the pouring rain. The car stops near the man who, seeing the woman nearby, offers the taxi to her and opens the door for her to climb in. "Chivalry is alive and well!" she might say. A similar scenario: the taxi stops and the man runs toward it, jumping in before the woman can even get near it; the taxi speeds off, splashing through a puddle of water and soaking the woman from head to toe. "Chivalry is dead," is her obvious retort. In our day, chivalrous behavior connotes graciousness, courtesy, generosity, and considerate behavior—particularly toward women. Our notion of chivalry has its roots in the Middle Ages, but the earliest use of the word was in connection with making war and not love.

The word *chivalry* derives from the French word for horse, *cheval*, and the practice was associated in the Middle Ages with knights—warriors in the heavy (armored) cavalry—who were expert horsemen. Knighthood was synonymous with valor and expert skills on the battlefield in sword-and-shield combat and with weapons like lances. Knights lived in castles or noble manors, or could be part of a royal court. When they were not off fighting battles for one lord attempting to wrest control from another within a fairly violent feudal structure, they kept their skills honed in competitive tournaments.

Feudalism, knighthood, and Christianity intersected with the church's attempt to limit violence and marauding on behalf of nobles and divert the knights' aggression to a higher purpose: protecting society's weak and defenseless and, as time passed, fighting "just wars" to defend the Christian faith in campaigns like the Crusades. It is in this intersection that our concept of the chivalrous knight was born: courageous and gallant; loyal to God, church, and feudal lord (in that order); protective of the poor and weak; and, perhaps most familiarly, dutiful and gentle in serving ladies. The ideal code of ethics and behavior for the chivalric knight was voiced in *The Song of Roland*, a poem written in the 11th century.

To fear God and maintain His Church
To serve the liege lord in valor and faith
To protect the weak and defenseless
To give succor to widows and orphans
To refrain from the wanton giving of offence
To live by honor and for glory
To despise pecuniary reward
To fight for the welfare of all
To obey those placed in authority
To guard the honor of fellow knights
To eschew unfairness, meanness and deceit
To keep the faith
At all times to speak the truth

shiny-headed bishop demanded that Guillem discontinue his adulterous relationship with a viscountess. Guillem retorted, "I will only repudiate her when your hair needs a comb." By his death, however, Guillem had apparently resolved his differences with the church.

BERNART DE VENTADORN Bernart de Ventadorn was a Celt who lived from ca. 1130 or 1140 to ca. 1190 or 1200. He has been referred to as the Master Singer, and he may have been in the

READING 10.3 BERNART DE VENTADORN

"When I See the Skylark Moving," lines 25–32

I've lost all my hope in women;
I'll place my faith in them no more;
Just as I used to support them,
From this point on I'll let them go.
Since I see none to help against
The one who ruins and confounds me,
I'll disbelieve and fear them all,
For I know well they're all alike.

READING 10.4 BEATRIZ, COMTESSA DE DIA

"My Heart Is Heavy," lines 17–24

Oh noble lover, most courtly knight,
If but once I could hold you as my jewel,
Lie with you just one night,
Share with you a single kiss—
How I long to be with you
Lying in my husband's bed;
If only you would promise me this,
That you would grant my heartfelt wish

Adapted from *La comtesse de Die*, Sernin Santy, 1893 by Spencer Rathus.

To persevere to the end in any enterprise begun
To respect the honor of women
Never to refuse a challenge from an equal
Never to turn one's back upon a foe.

Waiting for your "knight in shining armor," in modern-day parlance, suggests holding out for a relationship with a man who will treat you—well, like a knight would treat his lady. In the Middle Ages, this entailed the rules and rituals of courtly love that were established in Spain and spread to southern France and northern Europe in the 12th century. For the nobility and aristocracy, marriage was an arranged affair that brought material and political advantages but had little or nothing to do with love. Since marriage and love were, one could say, oxymoronic, husbands and wives might look for romance elsewhere, as did the knight Sir Lancelot and Queen Guinevere in the story of King Arthur and his Knights of the Round Table in the legendary court of Camelot. Minstrels and troubadours sang ballads about courtly love and recited long poems describing the valor and chivalry of knights. In the 12th century, Andreas Capellanus penned a treatise on courtly love, *De amore* (About Love)**, in which he cites 31 observations about true, ennobling love and guidelines on how to find it and hold onto it.

1. Marriage should not be a deterrent to love.
3. A double love cannot obligate an individual.
7. A lover must observe a two-year widowhood after his beloved's death.

8. Only the most urgent circumstances should deprive one of love.
11. A lover should not love anyone who would be an embarrassing marriage choice.
12. True love excludes all from its embrace but the beloved.
13. Public revelation of love is deadly to love in most instances.
14. The value of love is commensurate with its difficulty of attainment.
18. Good character is the one real requirement for worthiness of love.
22. Suspicion of the beloved generates jealousy and therefore intensifies love.
23. Eating and sleeping diminish greatly when one is aggravated by love.
24. The lover's every deed is performed with the thought of his beloved in mind.
26. Love is powerless to hold anything from love.
27. There is no such thing as too much of the pleasure of one's beloved.
30. Thought of the beloved never leaves the true lover.
31. Two men may love one woman or two women one man.

* From Alchin, L.K. The Middle Ages. Retrieved: April 20, 2012 from http://www.middle-ages.org.uk/knights-code-of-chivalry.htm.

** Appendix 1. *The Rules of Courtly Love*, based on the *De Amore* of Andreas Capellanus. "A Middle English Anthology," edited by Ann S. Haskell. Copyright 1985 by Wayne State University Press, Detroit, Michigan 48202, pp. 513–514.

court of Eleanor of Aquitaine. At times he portrayed women as pure, divine, above reproach. At other times he depicted them as Eve, who led man to what Saint Augustine called the "original sin" and thereby brought death into the world.[3] We have some 45 songs of Bernart, including "When I See the Skylark Moving." The skylark represents hope taking wing because the bird sings as it takes flight. This verse from the poem paints women as ruinous and impossible for men to understand.

BEATRIZ, THE COMTESSA DE DIA Troubadours (that is, men) had no monopoly on debauchery. The trobairitz Beatriz, the Comtessa de Dia, was married to one troubadour but apparently fell in love with another, about whom she wrote her love songs. We have some five of them, including "My Heart Has Been Heavy."

BERTRAN DE BORN We have a bitter satirical poem by Bertran de Born (ca. 1140–1215), a minor nobleman whose livelihood depended on the spoils of war. The song is directed against foolish heroism and Richard the Lion-hearted, who was not only a crusader but also himself a troubadour. Like Guillem de Peiteus, Bertran was a malcontent. Bertran joined a revolt against his duke, and as a result, his castle was burned to the ground and he was taken prisoner. However, he eventually received a pardon. Perhaps his greatest claim to fame is that Dante, in the Inferno, mentions Bertran as one of his "sowers of discord." See Reading 10.5 on page 328.

Carmina Burana

The student subculture of the High Middle Ages invented a mythical Saint Golias, who was the patron saint of wandering scholars. Verses (called **goliardic verse**) were written in honor of the "saint." The poems that have come down to us are a far

3. Elizabeth Aubrey, *The Music of the Troubadours* (Indianapolis: Indiana University Press, 1996).

READING 10.5 BERTRAN DE BORN

"I Love the Glad Time of Easter," lines 21–30, 37–40

And I love just as much the lord,
When he is first in the assault
Astride his horse, armed, unafraid;
Thus he emboldens his vassals
With valiant and lordly deeds.
And then when battle is joined,
Each man must hold himself ready

And follow him with a light heart,
For no man is of any worth,
Till he's given what he's received.

. . .

When the battle has been engaged,
Any truly noble man
Wants only to cleave heads and arms,
Better off dead than caught alive.

cry from the sober commentaries on Aristotle's *Metaphysics* that we usually associate with the medieval scholar.

One of the more interesting collections of these medieval lyrics was discovered in a Bavarian monastery in the early 19th century. The songs in this collection were written in Latin, Old French, and German and seem to date from the late 12th and 13th centuries. Their subject range is wide but, given the nature of such songs, predictable: there are drinking songs, laments over the loss of love or the trials of fate, hymns in honor of nature, salutes to the end of winter and the coming of spring, and cheerfully obscene songs of exuberant sexuality. The lyrics reveal a shift of emotions ranging from the happiness of love to the despair of disappointment, just as the allusions range from classical learning to medieval piety. One famous song, for example, praises the beautiful powerful virgin in language that echoes the piety of the church. The last line reveals, however, that the poem salutes not Mary but generous Venus.

In 1935 and 1936, German composer Carl Orff set some of these poems to music under the title *Carmina Burana*. His brilliant, lively blending of heavy percussion, snatches of ecclesiastical chant, strong choral voices, and vibrant rhythms have made this work a modern concert favorite. The listener gets a good sense of the vibrancy of these medieval lyrics from the use of the modern setting. Because the precise character of student music has not come down to us, Orff's new setting of these lyrics is a fine beginning for learning about the musicality of this popular poetry from the medieval university.

The Romance of the Rose

The *Romance of the Rose*[4] is a 13th-century love poem in two parts. It was written in Old French beginning in about 1230. The first part, containing 4058 lines, was penned by Guillaume de Lorris. Dreams were a popular topic in medieval days, so the poet begins with the tale of a 20-year-old man's dream vision, in which he falls in love with a rosebud in a perfumed springtime garden. The rosebud is a symbol of a beautiful woman or of sex. However, the rosebud is guarded, and the dreamer is thwarted in his efforts to secure it—making him want it more. The first part ends with the disconsolate lover yearning for his rosebud, which has become imprisoned in a castle of Jealousy. The second part, of 17,724

lines, was composed some 40 years later by a scholar at the University of Paris: Jean de Meun. It explores religion and philosophy, history, science, love and sex, marriage, and, of course, women. The lover's relationship with the rosebud is ultimately consummated in rather sexually explicit terms.

Along the way we come across many characters, whose names indicate that the poem is intended to be an **allegorical** account of the art of courtly love: Courtesy, Narcissus, Sir Mirth, Gladness, Beauty, Simplicity, Independence, Companionship, Fair Seeming, Pride, Jealousy, Villainy, Shame, Despair, Faithlessness. The young man falls in love at the Fountain of Narcissus; the poet is apparently saying that love, which may on the surface appear to be generous and selfless, suggests vanity and self-preoccupation lying underneath. The God of Love, Cupid, is sinister, and his darts are painful. There is an attempt by Reason to prevent love, but it fails. One of the characters is an Old Woman, La Vieille ("Old Woman" in French), whom we meet in the nearby Compare + Contrast box.

RELIGION, PHILOSOPHY, AND WRITING

Writers on religion and philosophy also made a great impact during the height of the Middle Ages. Among them are Moses Maimonides, Francis of Assisi, and Thomas Aquinas. Many consider Aquinas to be the most influential writer about Christianity since Augustine of Hippo.

Moses Maimonides

Moses Maimonides (1135–1204) was a physician and biblical scholar, and is considered to be the most important medieval Jewish philosopher. He was born and reared in Spain, during a period referred to as the golden age of Jewish culture. These were the centuries following Moorish rule and prior to the Inquisition (1492). Maimonides traveled extensively,

4. Guillaume de Lorris and Jean de Meun, *The Romance of the Rose*, trans. Harry W. Robbins. (New York: E. P. Dutton and Co., 1962).

settling in Egypt, where he served as court physician who treated the grand vizier of Egypt, Sultan Saladin, and—during the Crusades—Richard the Lion-Hearted. But at the end of the day, he treated the poor. He was well acquainted with the writings of the Greek, Christian, and Muslim scholars and philosophers as well as those in his own tradition, and his writings influenced philosophers beyond his tradition, including St. Thomas Aquinas.

One of his best-known works is *The Guide for the Perplexed*,[5] which was written in Arabic. It attempts to explain why people who are not interested in religion ought to be, and what the Hebrew Bible might truly mean. For example, Maimonides wrestles with the concept in Genesis that man was made in the image of God. He spends a chapter discussing translations and interpretations of the word "image" or "likeness," and he concludes that Genesis is not saying that people *look like* God, for God may have no bodily form at all. In the *Guide*, Maimonides discusses the reality of God, theories about the beginning of the universe and whether the universe is eternal, the celebration of the Sabbath, human intelligence, and why people are responsible for the evil that befalls them.

The *Guide* was translated by many people into many different languages. A contemporary of Maimonides, Shmuel ibn Tibbon, translated the work into Hebrew and wrote Maimonides that he would like to visit him to discuss some problems in translation. Maimonides's response provides some insight into the life he was leading in Egypt at the time.

READING 10.6 MOSES MAIMONIDES

A letter to Shmuel ibn Tibbon

I dwell at Fostat, and the sultan resides at Cairo [about a mile and a half away]. . . . My duties to the sultan are very heavy. I am obliged to visit him every day, early in the morning, and when he or any of his children or any of the inmates of his harem are indisposed, I dare not quit Cairo, but must stay during the greater part of the day in the palace. It also frequently happens that one of the two royal officers fall sick, and I must attend to their healing. Hence, as a rule, I leave for Cairo very early in the day, and even if nothing unusual happens, I do not return to Fostat until the afternoon. Then I am almost dying with hunger. . . . I find the antechamber filled with people, both Jews and gentiles, nobles and common people, judges and bailiffs, friends and foes—a mixed multitude who await the time of my return.

I dismount from my animal, wash my hands, go forth to my patients and entreat them to bear with me while I partake of some slight refreshment, the only meal I take in the twenty-four hours. Then I go forth to attend to my patients, and write prescriptions and directions for their various ailments. Patients go in and out until nightfall, and sometimes even, I solemnly assure you, until two hours or more in the night. I converse with and prescribe for them

while lying down from sheer fatigue; and when night falls I am so exhausted that I can scarcely speak.

In consequence of this, no Israelite can have any private interview with me, except on the Sabbath. On that day the whole congregation, or at least the majority of the members, come to me after the morning service, when I instruct them as to their proceedings during the whole week; we study together a little until noon, when they depart. Some of them return, and read with me after the afternoon service until evening prayers. In this manner I spend that day.

Maimonides also formulated 13 principles of Jewish faith that may strike you as quite familiar, because of the influence they achieved. They began with the idea that God exists, is one, and is eternal and spiritual in nature. God alone should be worshipped. God's will was revealed through prophets, and in Maimonides's eyes, Moses was the preeminent prophet. (Muslims include Jesus and Muhammad as prophets. Christians, of course, see Jesus as God.) Maimonides affirmed that God's law was given to humanity on Mount Sinai and is recorded accurately in the Hebrew Bible. God has foreknowledge of all events. God rewards virtue and punishes evil. There will be a Jewish Messiah (whom Christians believe is Jesus), and the dead will be resurrected. However, Maimonides also agreed with Aristotle that the intellect or soul—not the body—becomes immortal when it seeks virtue and godliness. Although bodily resurrection was an article of faith, Maimonides most often seemed to support the view that immortality is spiritual rather than physical. He also composed a code of Jewish law in his *Mishneh Torah*.

The *Guide* also teaches a "negative theology" that describes God in terms of what God is *not*. For example, it would be correct to say "God is not unintelligent" rather than "God is wise," or "God is not without existence" rather than "God exists." Maimonides was reluctant to describe God affirmatively, because he believed that people cannot understand the nature of God.

Maimonides' views on the problem of evil are similar to Augustine's. He believed that God was good and all-powerful but that evil could exist because evil is the lack of God, as shown, for example, by people who freely choose to reject belief in God or God's laws.

Francis of Assisi

In Italy at the end of the 12th century, a young man was born who would reshape medieval religious and cultural

5. Moses Maimonides, *The Guide for the Perplexed*, trans. M. Friedlander, 2nd ed., http://www.teachittome.com/seforim2/seforim/the_guide_for_the_perplexed.pdf.

The Old Woman in the *Romance of the Rose* and The Wife of Bath in *The Canterbury Tales*

As told by Jean de Meun, the sexual appetite of La Vieille, the Old Woman in *Romance of the Rose*, remains strong even as her beauty has vanished. And like the Wife of Bath in Chaucer's *Canterbury Tales*, the Old Woman has quite the sexual history in an era in which lustful sexual activity is roundly condemned—even if it is the preoccupation of the troubadours. La Vieille has traditionally been seen as an embodiment of Jean de Meun's misogyny, or hatred of women. She is sexually promiscuous and, as we shall see, she finds her use and deception of men appropriate. On the other hand, one could argue that she is ahead of her time in advocating the right of women to sexual pleasure and the mimicking of the philandering of men.

Chaucer tells briefly of the Wife of Bath in the General Prologue to *The Canterbury Tales*. He succinctly makes the point that her sexual history is extensive (lines 461–464).

> She was a worthy woman all of her life:
> Of husbands legally wed she had five,
> Not to mention other company in her youth,—
> But to speak of them might seem a bit uncouth.

Chaucer wrote his *Canterbury Tales* in Middle English in the 14th century, and scholars believe that the prologue to the Wife of Bath's Tale was heavily influenced by the *Romance of the Rose*. Both take place in the spring, a time of renewal and budding when the earth smells fresh and a "young man's fancy" turns to, well, sex and love. But with Jean de Meun and Chaucer, the fancies of older women also turn to sex and love. Chaucer's Wife of Bath has been married (and widowed) five times. She is on a pilgrimage—a religious journey—yet it seems that the social opportunities presented by the sojourn are at least as enticing to her as the quest for salvation.

The *Romance*'s Old Woman and Chaucer's Wife of Bath go on endlessly about their pasts, in what is partly a confession and partly a rationalization for a life led at the edge of morality. Both lament the passing of youth. The Old Woman explains, "And yet, by God, the memory of my heyday still gives me pleasure, and when I think back to the gay life that my heart so desires, my thoughts are filled with delight and my limbs with new vigor. The thought and the recollection of it rejuvenates my whole body; it does me all the good in the world to remember everything that happened, for I have at least had my fun."

The Wife of Bath comments on her youth in her own combative way (lines 473–482).

> "But Lord Christ! When it all comes back to me,
> When I think of my youth and of my jollity,
> It tickles me to the bottom of my heart.
> Even now it thrills me when the memories start
> Of the times that I have had; I've had my day
> But age, alas, will not be kept at bay.
> My beauty has faded—I cannot fake it—
> Let it go, then! Farewell! The devil take it!
> The flour is gone, there is no more to tell,
> The bran is left, it's what I have to sell;
> Yet will I be merry, finding what I may."

The Lover in the *Romance* desires the rosebud yet more fervently when it is withheld from him. The Old Woman also recounts the experience of loving most passionately that which is hardest to obtain: "Women have very poor judgment, and I was a true woman. I never loved a man who loved me. . . . And so he [one of her lovers] had me on the end of a rope, the false, thieving traitor, because he was so good in bed. I could not have lived without him and I would willingly have followed him everywhere. If he had run away, I would have gone in search of him as far as London in England, such was my love and affection for him."

The Wife of Bath has had similar experiences; she explains why she loved her fifth husband best (lines 507–525).

> "Now of my husband five, this is what I tell:
> God let his soul never rot in hell!
> And yet he was to me the most accursed;
> My ribs hurt as I think of it—the pain the worst—
> And ever they will until my ending day.
> But in our bed he was so fresh and gay,
> He knew the words, and knew he how to pose
> So that he won again my *belle chose*.**
> Although he beat me hard on every bone,

Once more he'd win my love when he was done.
I guess I loved him best, I now can see,
Because his love was dangerous to me.
We women have, and here I shall not lie,
In this matter the quaintest fantasy.
That thing we may not have so easily
Will make us cry and crave it endlessly.
Forbid us a thing and wildly we desire it,
Hand it to us and then we will despise it."

Both women seek to justify their extensive sexual histories, but in rather different ways. The Old Woman speaks of the licentiousness of men, suggesting—in twisting a saying—that what is sauce for the gander is sauce for the goose: "In short, [men] are all deceitful traitors, ready to indulge their lusts with everyone, and we should deceive them in our turn and not set our hearts upon just one of them. It is a foolish woman who gives her heart in this way: she ought to have several lovers and arrange, if she can, to be so pleasing that she brings great suffering upon all of them."

The Wife of Bath turns instead to hypocrisies and inconsistencies in biblical history for justification. The Christian Church, for example, condemns sex without marriage, but Jesus is reported to have told a woman entering her fifth marriage that her husband is not really her husband. Also consider the sexism—the apparently approved multiple wives and concubines of figures in the Hebrew Bible. The Wife argues her case at the outset of her prologue (lines 1–38).

"Experience, though not inscribed authority,
Were still enough to quite enlighten me,
To speak of all the woe that is in marriage,
Because, my lords, since I was twelve in age,
Thanks be to God, Who is eternally alive,
In vows at church, husbands took I five,
Yes, that often have I wedded been,
And all were in their way most worthy men.
But not so long ago was I for certain told
That since our Lord just once in days of old

Attended the wedding in Cana, Galilee,
That I should learn from His divine example
That being married once is more than ample.
Harken too to the pointed words that He
Beside a well, sweet Jesus, God and Man,
Spoke in reproof to the Samaritan.
'Thou hast had five husbands,' quoted He,
'Thus this, the man that now stands next to thee,
Is not thy husband.' So clearly that day
Spoketh he, yet what He meant I cannot say,
And even so I ask why that fifth man
Was not a husband to the Samaritan?
How many might she have in marriage?
Never have I heard in all my age
A definition of the proper number.
Men may divine and argue till December
But I would note for you without a lie
That God bid us to grow and multiply.
A noble text that well I understand.
And also well I know, He said, my husband
Should leave father and mother and stay with me,
But still no number was ever writ by He—
Nought I hear of bigamy or even of octogamy—
Why then should men speak of it as villainy?
And then there is the wise King Solomon;
Of wives I think he'd many more than one—
If only God would make it lawful for me
To be refreshed but half so oft as he!"

The *Romance of the Rose* and *The Canterbury Tales* were both written by men. French and English men placed these words in the mouths of women. Although the snippy banter could be seen as satirical of woman's perspectives, we may wonder if there are also some efforts to express an earnest empathy for those suffering from a double standard about sexuality.

* Jane E. Burns. *Courtly Love Undressed*. University Park, PA: University of Pennsylvania Press, 2002.

** French for "pretty thing."

READING 10.7 SAINT FRANCIS OF ASSISI

"The Canticle of Brother Sun"

Most high, omnipotent, good Lord
To you alone belongs praise and glory,
Honor and blessing.
No one is worthy to breathe your name.
Be praised, my Lord, for all your creatures.
In the first place for [per] the blessed Brother Sun
who gives us the day and enlightens us through You.
He is beautiful and radiant in his great splendor
Giving witness to You, most omnipotent One.
Be praised, my Lord, for Sister Moon and the stars
Formed by You so bright, precious, and beautiful.
Be praised, My Lord, for Brother Wind
and the airy skies so cloudy and serene.
For every weather, be praised because it is life giving.
Be praised, My Lord, for Sister Water
so necessary yet humble, precious, and chaste.
Be praised, my Lord, for Brother Fire

who lights up the night.
He is beautiful and carefree, robust and fierce.
Be praised, my Lord, for our sister, Mother Earth
who nourishes and watches over us
while bringing forth abundant fruits and colored
 flowers and herbs.
Be praised, my Lord, for those who pardon through Your love
and bear witness and trial.
Blessed are those who endure in peace
for they will be crowned by You, Most High.
Be praised, my Lord, for our sister, bodily death.
Whom no one living can escape.
Woe to those who die in sin.
Blessed are those who discover Thy holy will.
The second death will do them no harm.
Praise and bless the Lord.
Render Him thanks.
Serve Him with great humility.
Amen.

life. Giovanni di Bernadone, born in 1181 in the Umbrian hill town of Assisi, was renamed Francesco ("Little Frenchman") by his merchant father. The son of wealthy parents, Francis grew up as a popular, somewhat spendthrift and undisciplined youth. He joined the volunteer militia as a youth to do battle against the neighboring city of Perugia, only to be captured and put into solitary confinement until a ransom could be found.

That incident seems to have marked a turning point in his life. He dropped out of society and began to lead a life of prayer and self-denial. Eventually he concluded that the life of perfect freedom demanded a life of total poverty. He gave away all of his goods and began a life of itinerant preaching that took him as far away as the Middle East. His simple lifestyle attracted followers who wished to live in imitation of his life. By 1218 there were over 3000 Little Brothers (as he called them) who owed their religious allegiance to him. Francis died in 1226 when the movement he started was already a powerful religious order in the church.

If we know Francis of Assisi today, it is because of garden-shop statues of him with a bird on his shoulder. That he preached to the birds is a fact, but to think of him only as a medieval Doctor Dolittle speaking to animals is to trivialize a man

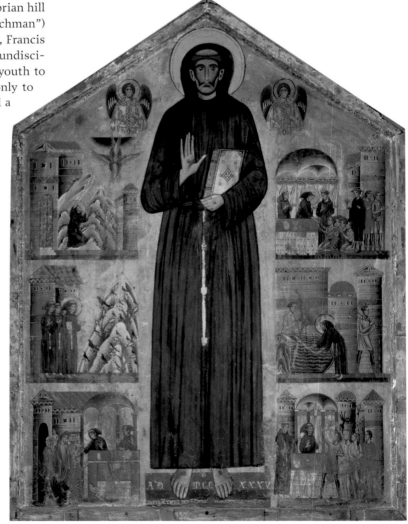

➤ **10.20** Bonaventura Berlinghieri, *Scenes from the Life of St. Francis*, 1235. Tempera on wood, predella panel of altarpiece, 63″ × 48⅜″ (160 × 123 cm). **San Francesco, Pescia, Italy.** Note that Francis looks forward to the viewer so that one could speak directly to the saint.

who altered medieval culture profoundly. First, his notion of a *mendicant* (begging) brotherhood that would be mobile and capable of preaching in the newly emerging cities of Europe was a worthy substitute for the more rural, land-bound monasteries of the past. Second, Francis believed that the Gospels could be followed literally, and this led him to identify closely with the humanity of Christ. It is said that in 1224, he had so meditated on the Passion of Christ that his own body bore the crucifixion marks of Christ (*stigmata*). This emphasis on Christ's humanity would have a powerful impact in making religious art more realistic and vivid. Finally, Francis's attitude toward religious faith was powerfully affirmative. He praised the goodness of God's creation; he loved the created world; he preached concern for the poorest of the poor; he felt that all creation was a gift and that everything in creation praised God in its own way. Some scholars have argued that the impact of the Franciscan vision on the imagination of European culture was a remote cause of the Renaissance preoccupation with the natural world and the close observation of nature.

Two years before he died, Francis—blind and in ill health—wrote "The Canticle of Brother Sun" with the hope that his brothers would sing it on their preaching journeys. It was one of the earliest poems written in Italian. It reflects the Franciscan love for nature.

The Berlinghieri altarpiece—one of the earliest depictions of Francis of Assisi—in the Franciscan church at Pescia has a central panel depicting the saint with scenes from his life on both sides (**Fig. 10.20**). Such altarpieces were not only tributes to the saint but also ways of reminding viewers of incidents of his life, which would have been read out to congregations to reinforce stories about him. These early sacred biographies were known as legends (from the Latin *legere*, "to read") because they were read aloud. Such altarpieces served the double purpose of teaching about the saint's life and providing devotional aids for the people.

Thomas Aquinas

The golden age of the University of Paris was the 13th century, since in that period Paris could lay fair claim to being the intellectual center of the Western world. It is a mark of the international character of medieval university life that some of its most distinguished professors did not come from France: Albert the Great (from Germany), Alexander of Hales (England), Bonaventure and Thomas Aquinas (Italy).

Thomas Aquinas (1225–1274) is one of the 33 doctors of the Roman Catholic Church. He was a priest in the Dominican order, whose best-known works are the *Summa theologica* and the *Summa contra gentiles*. He was born to wealth in his father's castle in Sicily and related, through his mother, to Holy Roman emperors. His family expected that he would follow his uncle as abbot of the Benedictine abbey, but at school he was recruited by a Dominican preacher to follow that order. His family was displeased by his decision and, in effect, kidnapped him and brought him home in an effort to change his mind. His brothers hired a prostitute to seduce him and overcome his stubbornness, but he is said to have turned her away with a burning stick. Angels are said to have

6. Many at the time of Aquinas taught that the earth was flat.

7. Separating or dividing in thought; considering individually; isolating.

READING 10.8 THOMAS AQUINAS

From *Summa Theologica*, Part I, Question 1, Article 1

It was necessary for man's salvation that there should be a knowledge revealed by God besides philosophical science built up by human reason. Firstly, indeed, because man is directed to God, as to an end that surpasses the grasp of his reason: "The eye hath not seen, O God, besides Thee, what things Thou hast prepared for them that wait for Thee" (Is. 66:4). . . . Hence it was necessary for the salvation of man that certain truths which exceed human reason should be made known to him by divine revelation. Even as regards those truths about God which human reason could have discovered, it was necessary that man should be taught by a divine revelation; because the truth about God such as reason could discover, would only be known by a few, and that after a long time, and with the admixture of many errors. Whereas man's whole salvation, which is in God, depends upon the knowledge of this truth. Therefore, in order that the salvation of men might be brought about more fitly and more surely, it was necessary that they should be taught divine truths by divine revelation. It was therefore necessary that besides philosophical science built up by reason, there should be a sacred science learned through revelation.

Reply to Objection 1: Although those things which are beyond man's knowledge may not be sought for by man through his reason, nevertheless, once they are revealed by God, they must be accepted by faith. Hence the sacred text continues, "For many things are shown to thee above the understanding of man" (Ecclus. 3:25). And in this, the sacred science consists.

Reply to Objection 2: Sciences are differentiated according to the various means through which knowledge is obtained. For the astronomer and the physicist both may prove the same conclusion: that the earth, for instance, is round: the astronomer by means of mathematics (i.e., abstracting from matter), but the physicist by means of matter itself. Hence there is no reason why those things which may be learned from philosophical science, so far as they can be known by natural reason, may not also be taught us by another science so far as they fall within revelation. Hence theology included in sacred doctrine differs in kind from that theology which is part of philosophy.

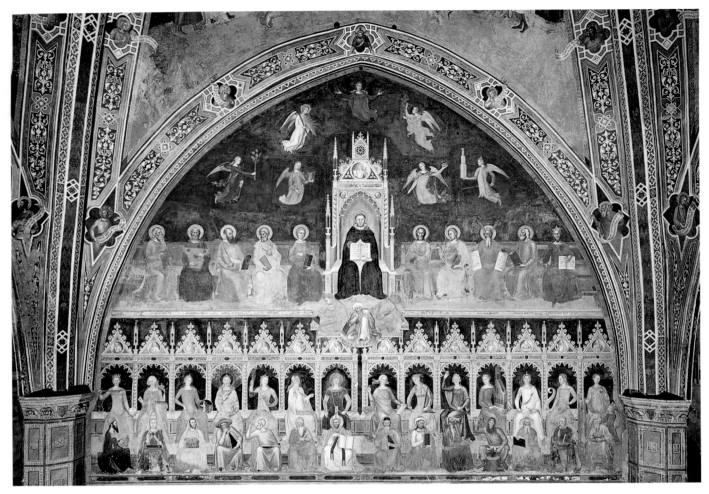

∧ 10.21 Andrea di Buonaiuto, *The Triumph of St. Thomas Aquinas*, ca. 1365. Fresco, Church of Santa Maria Novella, Florence, Italy. The saint is enthroned between figures of the Old and New Testaments with the personification of the virtues, sciences, and liberal arts below. This Florentine church had a school of studies attended by Dante Alighieri in his youth.

then appeared to him in his sleep, reinforcing his vow to remain celibate. His mother eventually admitted defeat and arranged for him to escape so that it would not appear that she had acceded to his wishes.

Aquinas became the most famous and influential of the Parisian masters of the 13th century (**Fig. 10.21**). His intellectual influence went far beyond the lecture halls of Paris and is felt to the present. He joined the Preaching Friars of Saint Dominic (the Dominicans) in 1243. From 1245 to 1248, he studied with Albert the Great at both Paris and Cologne. He was made a *magister* of theology in 1258 after completing his doctoral studies. During this same period (roughly 1256 to 1259), Aquinas lectured on theology in Paris. From 1259 to 1268, he was back in Italy, where he lectured and wrote at Orvieto (the papal court for a time), Rome, and Naples. From 1268 to 1272, he again held a chair of theology, when he returned to Naples to teach there. He died two years later on his way to a church council at Lyons in France.

Thomas Aquinas's life ended before he was 50, but in that span he produced a vast body of writings (they fill 40 folio volumes) on theology, philosophy, and biblical studies. It is a mark of his mobility that his masterpiece—the *Summa theologica*—was composed at Rome, Viterbo, Paris, and Naples, although it was unfinished at his death. Although his writings touched on a wide variety of subjects, at root Aquinas was interested in, and made a lifetime study of, a basic problem: how does one harmonize those things that are part of human learning (reason) with those supernatural truths revealed by God in the Bible and through the teaching of the church (revelation)? Aquinas's approach was to steer a middle path through two diametrically opposed opinions, both of which had avid supporters in the Middle Ages: the position of *fideism*, which held that religious faith as an absolute is indifferent to the efforts of human reason (*credo quia absurdum est*, "I believe because it is absurd") and *rationalism*, which insists that everything, revelation included, must meet the test of rational human scrutiny. Aquinas wanted to demonstrate that the liberal arts, the things and seasons of the world, and the mysteries revealed by God could be brought into some kind of intellectual harmony based on a single criterion of truth.

For Aquinas, reason finds truth when it sees evidence of truth. The mind judges something true when it has observed a sufficient number of facts to compel it to make that judgment. The mind gives assent to truth on the basis of evidence. Aquinas was convinced that there was a sufficient amount of observable evidence in the world to conclude the existence of God. He proposed five arguments in support of such a position. Still, he recognized that such argumentation yields only a limited understanding of God. Aquinas did not believe that the naked use of reason could ever discover or prove the mysteries about God revealed in the Bible: that God became a man in Jesus Christ or that there was a Trinity of persons in God. God had to tell us that. Our assent to it is not based on evidence, but on the authority of God who reveals it to us. If we could prove the mysteries of faith, there would have been no need for revelation and no need of faith.

Thus, for Aquinas there is an organic relationship between reason and revelation. Philosophy perfects the human capacity to know and revelation perfects one beyond the self by offering salvation and eternal life. Aquinas stated this relationship between reason and revelation at the beginning of his great work of theology, the *Summa theologica*.

When we read Aquinas today, we get some sense of his stark and rigorous attempt to think things through. For one thing, he offers no stylistic adornment to relieve his philosophical and rational discourse. For another, he makes clear that philosophical and theological reasoning is difficult; it is not a pastime for the incompetent or the intellectually lazy. Yet Aquinas was not a mere machine for logic. He had the temperament of a mystic. Some months before he died, he simply put down his pen; when his secretary asked him why he had stopped writing, he said that in prayer and quiet he had had a vision and that what he had written "seemed as straw." Aquinas was a rare combination of intellectual and mystic.

The intellectual tradition Aquinas used in his writing was that of the Greek philosopher Aristotle. He first knew Aristotle's work in Latin translations, based on Arabic texts, done by Muslim scholars in the south of Spain and North Africa. Later, Aquinas was able to use texts translated directly out of Greek by a Flemish friar and sometime companion, William of Moerbeke. Aquinas's use of Aristotle was certainly not a novelty in the Middle Ages. Such Arabic scholars as Avicenna (980–1036) and Averröes of Córdoba (1126–1198) commented on Aristotle's philosophy and its relationship to the faith of Islam.

Two other characteristics of the thought of Aquinas should be noted. First, his worldview was strongly hierarchical. Everything has its place in the universe, and that place is determined in relation to God. A rock is good because it *is* (to Aquinas, existence itself was a gift), but an animal is more nearly perfect because it has life and thus shares more divine attributes. In turn, men and women are better still because they possess mind and will. Angels are closer yet to God because they, like God, are pure spirit.

This hierarchical worldview explains other characteristics of Aquinas's thought in particular and medieval thought in general: It is wide-ranging, it is encyclopedic, and in interrelating everything it is synthetic. Everything fits and has its place, meaning, and truth. That a person would speak on psychology, physics, politics, theology, and philosophy with equal authority would strike us as presumptuous, just as any building decorated with symbols from the classics, astrology, the Bible, and scenes from everyday life would now be considered a hodgepodge. Such was not the case in the 13th century, because it was assumed that everything ultimately pointed to God.

Although Aquinas is often thought of as a philosopher, he understood himself to be a commentator on the Bible—"Master of the Sacred Page." Like all such lecturers he was charged by the university with three tasks: reading (of the Bible), disputing (using logic and argument to solve theological problems), and preaching. While attention is often given to his great *Summas*, it is well to remember that he also wrote long commentaries on specific books of the Bible, as well as compiled anthologies of early commentators on biblical material. In addition, he composed hymns that are still sung today.

The 13th century saw the rise of two complementary impulses that would energize late medieval culture: the affective and emotional religion of Francis of Assisi and the intellectualism of the schools epitomized in someone like Thomas Aquinas. Those two impulses would be best synthesized in the masterpiece that summed up high medieval culture: the *Divine Comedy* of Dante Alighieri, which we see in the following chapter.

GLOSSARY

Allegory (p. 328) The expression by means of symbolic figures and actions of a hidden or emblematic meaning, often spiritual in nature.

Ambulatory (p. 306) In a church, a continuation of the side aisles into a passageway that extends behind the choir and **apse** and allows traffic to flow to the chapels, which are often placed in this area (from *ambulare*, Latin for "to walk").

Apse (p. 306) A semicircular or polygonal projection of a building with a semicircular dome, especially on the east end of a church.

Archivolt (p. 313) An ornamental molding around an arched wall opening.

Censer (p. 313) A container carrying incense that is burned, especially during religious services.

Choir (p. 305) In architecture, the part of a church occupied by singers, usually located between a **transept** and the major **apse**.

Contrapposto (p. 315) A position in which a figure is obliquely balanced around a central vertical axis. The body weight rests on one foot, shifting the body naturally to one side; the body becomes curved like a subtle S.

Crypt (p. 305) An underground vault or chamber, particularly beneath a church, that is used as a burial place.

Dialectics (p. 322) Intellectual techniques involving rigorous reasoning to arrive at logical conclusions.

Flying buttress (p. 307) In architecture, an arched masonry support which carries the thrust of a roof or a wall away from the main structure of a building to an outer pier or buttress.

Gargoyle (p. 314) A grotesque carved beast that funnels water away from the roofs and sides of a church while also signifying that evil flees the church.

Gothic style (p. 305) A style of architecture that flourished during the High and Late Middle Ages, characterized by pointed arches, rib vaulting, and a visual dissolving of stone walls to admit light into a building.

Horarium (p. 316) The daily schedule of members of a religious community, such as a monastery.

Mullion (p. 313) In architecture, a slender vertical piece that divides the units of a window or door.

Narthex (p. 306) A church vestibule that leads to the **nave**, constructed for use by individuals preparing to be baptized.

Nave (p. 306) The central aisle of a church, constructed for use by the congregation at large.

Organum (p. 320) An early form of **polyphony** using multiple melodic lines.

Pilgrimage church (p. 308) A church on the route of a pilgrimage.

Polyphony (p. 320) A form of musical expression characterized by many voices.

Relic (p. 317) In this usage, a part of a holy person's body or belongings used as an object of reverence.

Scholasticism (p. 304) The system of philosophy and theology taught in medieval European universities, based on Aristotelian logic and the writings of early church fathers; the term has come to imply insistence on traditional doctrine.

Sexpartite rib vault (p. 308) In architecture, a rib vault divided into six parts and formed by the intersection of barrel vaults.

Triforium (p. 308) A gallery or arcade above the arches of the **nave**, **choir**, or **transept** of a church.

Universitas (p. 322) A corporation; a group of persons associated in a guild, community, or company.

THE BIG PICTURE THE HIGH MIDDLE AGES

Language and Literature

- European languages in use today developed from Old French and Middle English.
- The 12th century was the golden age of the University of Paris under scholastic masters.
- Peter Abelard began teaching in Paris in 1113 and met Héloïse.
- Troubadours and *trobairitz* composed songs, many of which had to do with courtly love, some with debauchery, and others with political matters.
- The 13th century was an era of writing of secular poetry, including goliardic verse.
- The allegorical *Romance of the Rose* was begun ca. 1230 by Guillaume de Lorris and completed some 40 years later by Jean de Meun.
- Villard de Honnecourt wrote his notebooks on construction of cathedrals ca. 1235.

Art, Architecture, and Music

- The Gothic style began with Abbot Suger's undertaking of the construction of Saint-Denis in 1140.
- The Cathedral of Notre-Dame was constructed in Paris ca. 1163–1250.
- Chartres Cathedral was destroyed by fire in 1194, and rebuilding in the Gothic style began.
- The *Notre Dame de Belle Verrière*, a stained-glass window, was installed at Chartres Cathedral.
- The Christ blessing trumeau was sculpted at the south porch of Chartres Cathedral ca. 1215.
- Guild windows were set in place at Chartres Cathedral ca. 1215–1250.
- The Cathedral at Amiens was constructed ca. 1220–1269.
- The Saint Francis of Assisi altarpiece was constructed at San Francesco, Pescia, Italy in 1235.
- Organum developed in the 10th century.
- Guido d'Arezzo invented the musical notation used today in the 11th century.
- Troubadours and trobairitz created the love song as we know it today.
- The Notre-Dame school of Paris was the center of music study and composition.
- German minnesingers flourished during the 13th century.
- Polyphonic motets were the principal form of composition ca. 1250.

Philosophy and Religion

- Scholasticism was born in the early 12th century.
- Moses Maimonides wrote his *Guide for the Perplexed* ca. 1190.
- Saint Francis of Assisi wrote his "Canticle of Brother Sun" ca. 1224.
- Thomas Aquinas wrote his *Summa theologica* ca. 1267–1273.

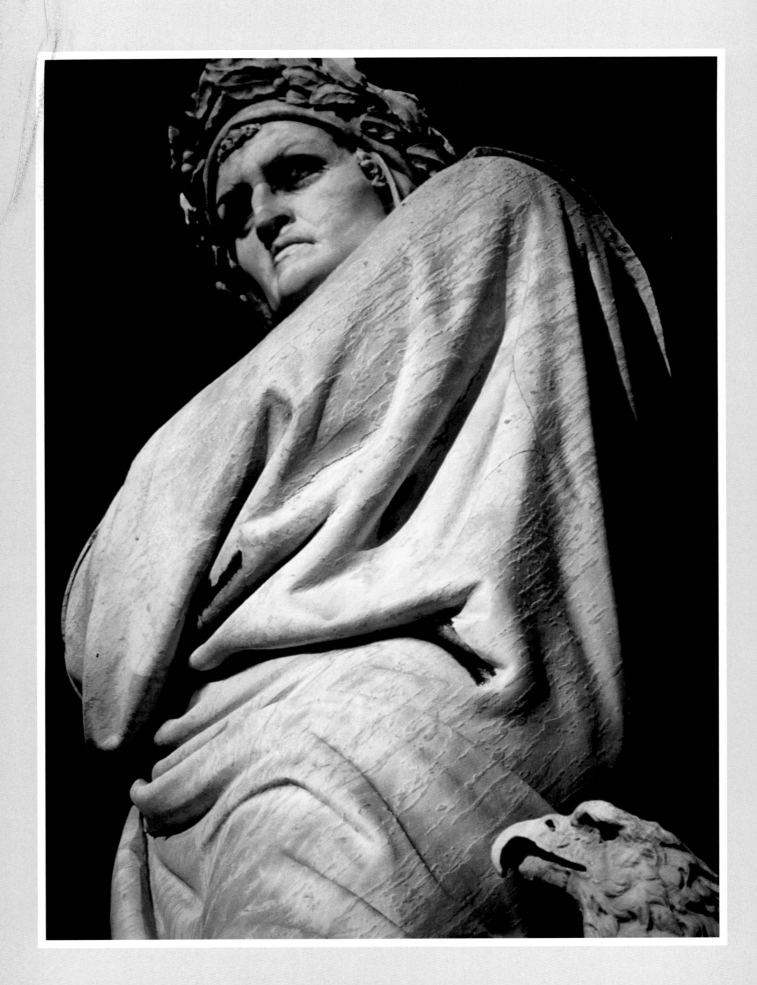

The Fourteenth Century: A Time of Transition

11

PREVIEW

On a wall in the Chapel of the Bargello Palace in Florence, there is a portrait of the famed poet Dante by his friend Giotto, the most famous Italian artist of the 14th century. The man is instantly recognizable to us as Dante. We have seen this image in countless iterations—an aquiline nose and strong, jutting chin, a signature red robe and head covering. The portrait dates to the 1300s, Dante's lifetime, and Giorgio Vasari—author of the 16th-century art-historical landmark Lives of the Artists*—tells us that Giotto painted it. In his life of Giotto, Vasari documents the relationship between the poet and painter, recounting a meeting between the two in Padua, where Dante saw Giotto's work in progress. Dante then went on to immortalize Giotto in his renowned poetic narrative* The Divine Comedy, *in which he contrasts the success and fame of the young painter with that of his older teacher, Cimabue, whose work had lost its luster. Just as Dante preserved Giotto's name in the poem, Giotto preserved Dante's likeness in the painting.*

This is the story that any tour guide in Florence might tell, but almost none of it is true. In a scholarly essay entitled "Giotto's Portrait of Dante?", art historian E. H. Gombrich writes, "Dante is the first person for almost a thousand years whose name immediately evokes a vivid image of his physical presence."[1] As Gombrich constructs his refutation of the authenticity of the portrait, he postulates that the Bargello image that gave rise to centuries of imitators who iconized Dante's portrait based on its features, was not Dante at all, and was likely not by Giotto's hand. It was a case of mistaken identities. Gombrich juxtaposes the legend that history has long embraced with the facts we know about Giotto, Dante, and Florence in in the first few decades of the 14th century. It is not even clear that Dante and Giotto ever knew one another.

What do we know about these men and their place in history, whether or not they can be yoked together by this painting? Giotto indeed was the most eminent painter in Florence, if not all of Italy, at the time that Dante was writing. His innovative approach to art, based on a close observation of the everyday natural world, laid the groundwork for the masterful illusions of three-dimensionality on a two-dimensional surface that would raise the art of painting to unimaginable heights in the two centuries that followed. Dante, whose *Divine Comedy* was written in Italian, the everyday language of his fellow citizens, would be seen as the greatest poet in the history of Florence, if not all of Italy. Giotto's talents would become so sought after and jealously guarded that the city of Florence would appoint him *capomaestro* (head master), overseeing all of its artistic and civic projects. They were afraid that Giotto might leave town and seek work elsewhere. And although Dante became enmeshed in a political struggle that led to his exile from the city in 1301 (his *Divine Comedy* was written in exile and may have been intended to bring him back into the good graces of the city fathers), the city would

◄ **11.1** Enrico Pazzi, *Dante Alighieri*, 1865. Piazza Santa Croce, Florence, Italy.

1. E. H. Gombrich, "Giotto's Portrait of Dante?," *The Burlington Magazine* 121, no. 917 (Aug. 1979): 471.

eventually decree public readings of the poem and create a "poets' corner" in the Florence Cathedral to honor its literary masters—Dante among them.

All signs point to this conclusion about the portrait in the Bargello: it is not a painting of Dante by Giotto. Now the questions are these: Why does this iconic image persist? What purpose does it serve for us? Gombrich quotes Pliny the Elder's *Natural History* on the practice of hanging the portraits of authors in libraries in his own time: "Our desires bring forth even the images which have not come down to us, as was the case with Homer. For I think there can be no greater happiness than the perpetual desire to know what someone was like."[2]

THE FOURTEENTH CENTURY

The 14th century (often called the **trecento**,[3] Italian for "300") is usually described by historians as the age that marks the end of the medieval period and the beginning of the Renaissance in Western Europe. If we accept this characterization, we should expect to see strong elements of the medieval sensibility as well as some stirrings of the "new birth" (*renaissance*) of culture that was the hallmark of 15th-century European life. But we must be cautious about expecting the break between the Middle Ages and the Renaissance to be clean and dramatic. History does not usually work with the precision employed by historians. Neither should we expect to see cultural history moving in a straight line toward greater modernity or greater perfection. We can see many of the cultural events of the 14th century as progressive. They are also transitional, combining elements of history, tradi-

tion, and rebellion. But there was also institutional decay, violence, and natural calamity.

The Great Schism

The medieval Roman Catholic Church, that most powerful and permanent large institution in medieval life, underwent convulsive changes in the 14th century—changes that issued distant warning signals of the Reformation to come at the beginning of the 16th century.

A glance at some dates suggests the nature of these changes. In 1300 Pope Boniface VIII celebrated the first Jubilee year at Rome. It brought pilgrims and visitors from all over the Christian West to pay homage to the papacy and the church it represented and headed. This event was one of the final symbolic moments of papal supremacy over European life and culture. Within the next three years, Philip the Fair of France imprisoned and abused that same pope at the papal palace of Anagni. The pope was beaten and almost executed, but he was released within days. He soon died from kidney stones and, it was said, as a result of his humiliation. Even Dante's implacable hatred of Boniface could not restrain his outrage at the humiliation of the office of the pope. In 1309 the papacy, under severe pressure from the French, was removed to Avignon in southern France, where it was to remain for nearly 70 years. In 1378 the papacy was further weakened by the **Great Schism**, which saw the Roman Catholic Church divided into hostile camps, each of whom pledged allegiance to a rival claimant

2. Quoted in Gombrich, "Giotto's Portrait of Dante?," 483.

3. Pronounced tray-CHEN-toe.

The Fourteenth Century

1299 CE	1309 CE	1378 CE	1417 CE
	CAPTIVITY OF THE PAPACY	**THE GREAT SCHISM**	
The Ottoman Turk dynasty is founded	The captivity of the papacy at Avignon begins	Reign of Richard II in England	
Pope Boniface VIII proclaims the first Jubilee year ("Holy Year")	Earliest known use of cannon	The Great Schism in the Roman Catholic Church begins	
Philip the Fair of France imprisons and abuses Pope Boniface VIII	Hundred Years' War between France and England	Peasants' Revolt in England	
	Reign of Charles IV, Holy Roman emperor	Reign of Henry IV in England	
	Bubonic plague devastates Western Europe	The English defeat the French at Agincourt	
	The English defeat the French at Poitiers	The Council of Constance ends the Great Schism with the election of Pope Martin V	
	The lower classes in France revolt		
	Reign of Philip the Bold, Duke of Burgundy		
	The papacy returns to Rome from Avignon		

to the papacy. Not until 1417 was this breach in church unity healed; a church council had to depose three papal pretenders to accomplish the reunification of the church.

The disarray of the church spawned ever more insistent demands for church reforms. Popular literature (such as the works of Boccaccio in Italy and Chaucer in England) unmercifully satirized the decadence of the church. Great saints like the mystic Catherine of Siena (1347–1380) wrote impassioned letters to the popes at Avignon in their "Babylonian Captivity," demanding that they return to Rome free from the political constraints of the French monarchy. In England, John Wycliffe's cries against the immorality of the higher clergy and the corruption of the church fueled indignation at all levels. The Peasants' Revolt of 1381 in England was aided by the activism of people aroused by the ideas of Wycliffe and his followers.

The 1381 revolt was only the last in a series of lower-class revolutions that occurred in the 14th century. The frequency and magnitude of these revolts (like that of the French peasants beginning in 1356) highlight the profound dissatisfactions with the church and the nobility in the period. Perhaps it is no accident that the story of Robin Hood, with its theme of violence toward the wealthy and care for the poor, was born in the 14th century.

of all they saw. According to their report it appeared that eighty banners, the bodies of eleven princes, twelve hundred knights, and thirty thousand common men were found dead on the field." As a result of events such as this, Barbara Tuchman's history of life in 14th-century France, *A Distant Mirror* (1978), is subtitled "The Calamitous Fourteenth Century."

But worse tragedy was to befall Europe two years after Crécy.

The Black Death

Midway through the century, in 1348, bubonic plague—also known as the Black Death—swept through Europe. Analysis of genetic material from victims suggests that the plague began in China and traveled westward along the Silk Road, carried into Europe by fleas on black rats that were regular stowaways on merchant vessels. The epidemic may have killed half the population of Europe. It upset trade, culture, and daily life in ways that are difficult for us to imagine. It has been estimated that some cities in Italy lost as much as two-thirds of their population in that year alone (see **Map 11.1**).

The prominent Italian writer Giovanni Boccaccio (1313–1375) lived through the devastation. His great collection

The Hundred Years' War

The violence of the 14th century was caused not only by the alienation of the peasants but also by the Hundred Years' War between France and England. While the famous battles of the period—Poitiers, Crécy, Agincourt—now seem distant and may even sound vaguely romantic, they brought unrelieved misery to France. Between battles, roaming bands of mercenaries pillaged the landscape to compensate for their lack of pay.

The battles were terrible in themselves. According to Jean Froissart's *Chronicles*, the English king Edward III sent a group of his men to examine the battlefield after the Battle of Crécy (1346), in which English longbowmen slaughtered more traditionally armed French and mercenary armies: "They passed the whole day upon the field and made a careful report

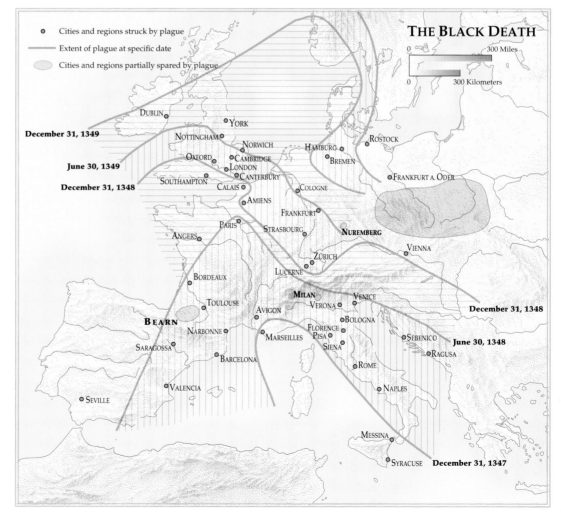

➤ **MAP 11.1** The Black Death.

Giovanni Boccaccio, Witness to the Black Death

Boccaccio's account of the **Black Death** is the prologue to the tales that make up the *Decameron*. It reflects the personal experience of the writer through the plague year of 1348 and his reflections on the psychological effects of the plague on the population. He wrote that some sought boundless pleasures as death approached the door, whereas others turned to God for solace. The very whisper of plague destroyed public order and familial bonds.

Preface to the Ladies

. . .

In the year then of our Lord 1348, there happened at Florence, the finest city in all Italy, a most terrible plague; which, whether owing to the influence of the planets, or that it was sent from God as a just punishment for our sins, had broken out some years before in the Levant, and after passing from place to place, and making incredible havoc all the way, had now reached the west. There, spite of all the means that art and human foresight could suggest, such as keeping the city clear from filth, the exclusion of all suspected persons, and the publication of copious instructions for the preservation of health; and notwithstanding manifold humble supplications offered to God in processions and otherwise; it began to show itself in the spring of the aforesaid year, in a sad and wonderful manner. Unlike what had been seen in the east, where bleeding from the nose is the fatal prognostic, here there appeared certain tumors in the groin or under the armpits, some as big as a small apple, others as an egg; and afterwards purple spots in most parts of the body; in some cases large and but few in number, in others smaller and more numerous—both sorts the usual messengers of death. To the cure of this malady, neither medical knowledge nor the power of drugs was of any effect; whether because the disease was in its own nature mortal, or that the physicians (the number of whom,

taking quacks and women pretenders into the account, was grown very great) could form no just idea of the cause, nor consequently devise a true method of cure; whichever was the reason, few escaped; but nearly all died the third day from the first appearance of the symptoms, some sooner, some later, without any fever or accessory symptoms. What gave the more virulence to this plague, was that, by being communicated from the sick to the hale, it spread daily, like fire when it comes in contact with large masses of combustibles. Nor was it caught only by conversing with, or coming near the sick, but even by touching their clothes, or anything that they had before touched. . . . Such, I say, was the quality of the pestilential matter, as to pass not only from man to man, but, what is more strange, it has been often known, that anything belonging to the infected, if touched by any other creature, would certainly infect, and even kill that creature in a short space of time. . . .

These facts, and others of the like sort, occasioned various fears and devices amongst those who survived, all tending to the same uncharitable and cruel end; which was, to avoid the sick, and every thing that had been near them, expecting by that means to save themselves. And some holding it best to live temperately, and to avoid excesses of all kinds, made parties, and shut themselves up from the rest of the world; eating and drinking moderately of the best, and diverting themselves with music, and such other entertainments as they might have within doors; never listening to anything from without, to make them uneasy. Others maintained free living to be a better preservative, and would baulk no passion or appetite they wished to gratify, drinking and reveling incessantly from tavern to tavern, or in private houses (which were frequently found deserted by the owners, and therefore common to every one), yet strenuously avoiding, with all this brutal indulgence, to come near the infected. And such, at that time, was the public

of stories, the *Decameron*, has a plague setting. A group of young men and women flee Florence to avoid the plague. During their two-week sojourn in the country, they amuse each other by telling stories. Each of the ten young people tells a story on each of the weekdays (*decameron* is Greek

for "10 days"). The resulting 100 stories constitute a brilliant collection of folktales, **fabliaux** (ribald fables), **exempla** (moral stories), and romances that Boccaccio culled from the oral and written traditions of Europe. Because of its romantic elements, earthiness, and somewhat shocking bawdiness,

distress, that the laws, human and divine, were no more regarded; for the officers, to put them in force, being either dead, sick, or in want of persons to assist them, every one did just as he pleased. . . .

. . . I pass over the little regard that citizens and relations showed to each other; for their terror was such, that a brother even fled from his brother, a wife from her husband, and, what is more uncommon, a parent from his own child. Hence numbers that fell sick could have no help but what the charity of friends, who were very few, or the avarice of servants supplied; and even these were scarce and at extravagant wages, and so little used to the business that they were fit only to reach what was called for, and observe when their employer died; and this desire of getting money often cost them their lives. . . .

It had been usual, as it now is, for the women who were friends and neighbors to the deceased, to meet together at his house, and to lament with his relations; at the same time the men would get together at the door, with a number of clergy, according to the person's circumstances; and the corpse was carried by people of his own rank, with the solemnity of tapers and singing, to that church where the deceased had desired to be buried. This custom was now laid aside, and, so far from having a crowd of women to lament over them, great numbers passed out of the world without a witness. . . . With regard to the lower sort, and many of a middling rank, the scene was still more affecting; for they staying at home either through poverty or hopes of succor in distress, fell sick daily by thousands, and, having nobody to attend them, generally died: some breathed their last in the streets, and others shut up in their own houses, where the stench that came from them made the first discovery of their deaths to the neighborhood. And, indeed, every place was filled with the dead. . . . [M]en's lives were no more regarded than the lives of so many beasts. Thus it plainly appeared, that what the wisest

in the ordinary course of things, and by a common train of calamities, could never be taught, namely, to bear them patiently, this, by the excess of calamity, was now grown a familiar lesson to the most simple and unthinking. The consecrated ground no longer containing the numbers which were continually brought thither, especially as they were desirous of laying every one in the parts allotted to their families, they were forced to dig trenches, and to put them in by hundreds, piling them up in rows, as goods are stored in a ship, and throwing in a little earth till they were filled to the top.

. . . The oxen, asses, sheep, goats, swine, and the dogs themselves, ever faithful to their masters, being driven from their own homes, were left to roam at will about the fields, and among the standing com, which no one cared to gather, or even to reap; and many times, after they had filled themselves in the day, the animals would return of their own accord like rational creatures at night.

What can I say more, if I return to the city? Unless that such was the cruelty of Heaven, and perhaps of men, that between March and July following, according to authentic reckonings, upwards of a hundred thousand souls perished in the city only; whereas, before that calamity, it was not supposed to have contained so many inhabitants. What magnificent dwellings, what noble palaces were then depopulated to the last inhabitant I what families became extinct! What riches and vast possessions were left, and no known heir to inherit them! What numbers of both sexes, in the prime and vigor of youth, . . . breakfasted in the morning with their living friends, and supped at night with their departed friends in the other world!

Edward Hugele, trans. Giovanni Boccaccio, *The Decameron.* The Bibliophilist Library, 1903.

the *Decameron* has often been called the "Human Comedy" to contrast it with the lofty moral tone of Dante's epic work, *The Divine Comedy.* However delightful and pleasing these stories may be, they stand in sharp contrast to the horrific picture Boccaccio draws of the plague in his introduction to the *Decameron.* Boccaccio's eyewitness account has the ring of authenticity. His vivid prose gives some small sense of what the plague must have been like for people who possessed only the most rudimentary knowledge of medicine and no knowledge about the source of the disease.

LITERATURE

When we look back upon the 14th century, it is easy to be overwhelmed by the many tragedies that befell humankind in Europe—natural, political, and religious. Similarly, when we regard the 20th century, we can focus on the world wars, the Great Depression, HIV/AIDS, and the like. But in both centuries there were cultural advances and islands of brilliance. The greatest literary figure of the 14th century, the Florentine Dante Alighieri, wrote at its beginning and took his readers on a journey that parallels some of the experiences of the century to come—from the pits of hell to the radiance of heaven. Dante's literary eminence was secure at the time of his death (1321), and the reputation of Italian letters was further enhanced by two other outstanding Tuscan writers: the poet Francesco Petrarch and Giovanni Boccaccio, famed for the *Decameron*. In England, one of the greatest authors in the history of English letters was active: Geoffrey Chaucer. His life spanned the second half of the 14th century; he died, almost symbolically, in 1400.

Dante Alighieri

Dante Alighieri (1265–1321) was a Florentine. He was nonetheless deeply influenced by the intellectual currents that emanated from the Paris of his time. As a comfortably fixed young man he devoted himself to a rigorous program of philosophical and theological study in order to enhance his burgeoning literary talent. His published work gives evidence of a deep love for study. He wrote on the origin and development of language (*De vulgari eloquentia*), political theory (*De monarchia*), and generalized knowledge (*Convivio*) as well as his own poetic aspirations (*La vita nuova*). His masterpiece is *La Divina Commedia* (*The Divine Comedy*). Dante's conceptualization of hell, purgatory, and paradise is outlined in **Figure 11.2**.

Dante was exiled from Florence for political reasons in 1300. In his bitter wanderings in the north of Italy he worked on—and finally brought to conclusion—a long poem to which he gave a bitingly ironical title: *The Comedy of Dante Alighieri, a Florentine by Birth but Not in Behavior*. Dante called his poem a comedy because, as he noted, it had a happy ending and was written in the popular language of the people—Italian—rather than literary Latin. The adjective *divine* was added later, some say by Boccaccio, who in the next generation lectured on the poem in Florence and wrote one of the first biographies of Dante.

The Divine Comedy relates a symbolic journey that the poet begins on Good Friday, 1300—through hell, purgatory, and heaven (**Fig. 11.3**). In the first two parts of his journey, Dante is guided by the ancient Roman poet Virgil. The *Aeneid* was a great inspiration to Dante, and he borrowed especially from book 6, which tells of Aeneas's own journey to the underworld. From the border at the top of the mountain of Purgatory to the pinnacle of heaven where Dante glimpses the "still point of light" that is God, Dante's guide is Beatrice, a young woman he loved passionately, if platonically, in his youth.

▼ **11.2 The Structure of Dante's *Divine Comedy***

HELL

The Anteroom of the Neutrals

Circle 1	The Virtuous Pagans (Limbo)
Circle 2	The Lascivious
Circle 3	The Gluttonous
Circle 4	The Greedy and the Wasteful
Circle 5	The Wrathful
Circle 6	The Heretical
Circle 7	The Violent against Others, Self, God, Nature, and Art
Circle 8	The Fraudulent (subdivided into 10 classes, each of which dwells in a separate ditch)
Circle 9	The Lake of the Treacherous against kindred, country, guests, lords, and benefactors. Satan is imprisoned at the center of this frozen lake.

PURGATORY

Ante-Purgatory: The Excommunicated, The Lazy, The Unabsolved, and Negligent Rulers

The Terraces of the Mount of Purgatory

The Proud

The Envious

The Wrathful

The Slothful

The Avaricious

The Gluttonous

The Lascivious

The Earthly Paradise

PARADISE

The Moon	The Faithful who were inconstant
Mercury	Service marred by ambition
Venus	Love marred by lust
The Sun	Wisdom; the theologians
Mars	Courage; the just warriors
Jupiter	Justice; the great rulers
Saturn	Temperance; the contemplatives and mystics
The Fixed Stars	The Church Triumphant
The Primum Mobile	The Order of Angels
The Empyrean Heavens	Angels, Saints, the Virgin, and the Holy Trinity

The organization of the *Comedy* is precise. The poem is made up of 100 **cantos**. The first canto of the *Inferno* serves as an introduction to the entire poem. There are then 33 cantos for each of the three major sections (*Inferno, Purgatorio,*

and *Paradiso*). The poem is written in a form called **terza rima** (*aba*, *bcb*, *cdc*, and so on) that is difficult to duplicate in English because of the relative shortage of rhyming words. Each group of three lines is called a **tercet**. Consider the first tercets in Italian. *Vita* rhymes with *smarrita* in the first tercet (*aba*). Then, *oscura* in the first tercet rhymes with *dura* and *paura* in the second tercet (*bcb*). We expect the first and third lines of the third tercet will rhyme with *forte*, propelling us forward.

When you listen to the poem in Italian, even without understanding the language, you quickly come to see that its unique form of beauty may not be translatable into English. But its ideas are.

The number three and its multiples, symbols of the Trinity, occur over and over. Hell is divided into nine regions plus a vestibule, and the same number is found in purgatory. Paradise contains the nine heavens of the Ptolemaic system plus the empyrean, the highest heaven. This scheme mirrors the whole poem's of 99 cantos plus one. The sinners in hell are arranged according to whether they sinned by incontinence, violence, or fraud (a division Dante derived from Aristotle's *Ethics*), while the yearning souls of purgatory are divided in three ways according to how they acted or failed to act in relation to love. The saved souls in paradise are divided into the layfolk, the active, and the contemplative. Nearest the throne of God, but reflected in the circles of heaven, are the nine categories of angels.

Dante's interest in the symbolic goes beyond his elaborate manipulation of numbers. Sinners in hell suffer punishments that have symbolic value; their sufferings instruct as well as punish. The gluttonous live on heaps of garbage under driving storms of cold rain; the flatterers are immersed in pools of sewage, and the sexually perverse walk burning stretches of sand in an environment as sterile as their attempts at love.

Canto 3 tells of the poet's entrance into hell—the Inferno—and includes inscriptions carved in stone above the gate. Line 9 of the canto is one of the best known in the history of poetry.

▼ **11.3** Domenico di Michelino, *Dante Illuminated the City of Florence with His Book* The Divine Comedy, 1465. Fresco 91″ high × 114″ (232 × 290 cm) wide. Cathedral of Santa Maria del Fiore (the Duomo), Florence, Italy. Dante's significance to the city of Florence was memorialized in a monument in the Florence Cathedral. He stands with his book open between hell, to which he gestures, and the city walls, behind which the Florence Cathedral and the tower of the Palazzo della Signoria can be seen. The mountain of Purgatory, with its seven terraces that symbolize the seven deadly sins, is in the middle distance. Its prominent place in the fresco refers to Dante's climb in the *Purgatorio* toward Paradise and Florence's ascent to spiritual enlightenment.

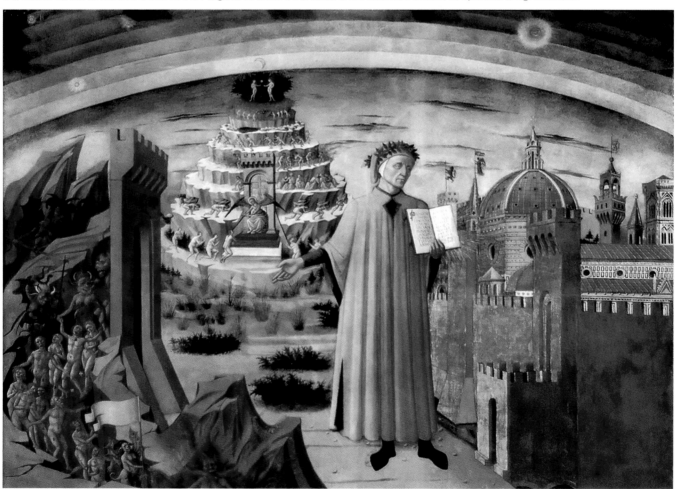

READING 11.1 DANTE

***The Divine Comedy, Inferno*, canto 1, The Dark Wood of Error, lines 1–6**

Nel mezzo del cammin di nostra vita
mi ritrovai per una selva oscura,
ché la diritta via era smarrita.

Ahi quanto a dir qual era è cosa dura
esta selva selvaggia e aspra e forte
che nel pensier rinova la paura!

An English translation by a fine 20th-century American poet, John Ciardi, finds the Italian rhyme scheme incompatible with English, and instead uses the scheme *aba*, *cdc*, and so on. Each tercet stands alone.

Midway in our life's journey, I went astray
from the straight road and woke to find myself
alone in a dark wood. How shall I say

what wood that was! I never saw so drear,
so rank, so arduous a wilderness!
Its very memory gives a shape to fear.

From *The Divine Comedy* by Dante Alighieri, translated by John Ciardi. Copyright 1954, 1957, 1959, 1960, 1961, 1965, 1967, 1970 by the Ciardi Family Publishing Trust. Used by permission of W. W. Norton & Company, Inc.

READING 11.2 DANTE

***The Divine Comedy, Inferno*, canto 3, The Vestibule of Hell, lines 1–9**

I AM THE WAY INTO THE CITY OF WOE.
I AM THE WAY TO A FORSAKEN PEOPLE.
I AM THE WAY INTO ETERNAL SORROW.

SACRED JUSTICE MOVED MY ARCHITECT.
I WAS RAISED HERE BY DIVINE OMNIPOTENCE,
PRIMORDIAL LOVE AND ULTIMATE INTELLECT.

ONLY THOSE ELEMENTS TIME CANNOT WEAR
WERE MADE BEFORE ME, AND BEYOND TIME I STAND.
ABANDON ALL HOPE YE WHO ENTER HERE.

From *The Divine Comedy* by Dante Alighieri, translated by John Ciardi. Copyright 1954, 1957, 1959, 1960, 1961, 1965, 1967, 1970 by the Ciardi Family Publishing Trust. Used by permission of W. W. Norton & Company, Inc.

that to hide the guilt of her debauchery
she licensed all debauchery alike,
and lust and law were one in her decree.

She is Semiramis of whom the tale is told
how she married Ninus and succeeded him
to the throne of that wide land the Sultans hold.

The other is Dido; faithless to the ashes
of Sichaeus, she killed herself for love.
The next whom the eternal tempest lashes

is sense-drugged Cleopatra. See Helen there,
from whom such ill arose. And great Achilles,
who fought at last with love in the house of prayer.

And Paris. And Tristan." As they whirled above
he pointed out more than a thousand shades
of those torn from the mortal life by love.

From *The Divine Comedy* by Dante Alighieri, translated by John Ciardi. Copyright 1954, 1957, 1959, 1960, 1961, 1965, 1967, 1970 by the Ciardi Family Publishing Trust. Used by permission of W. W. Norton & Company, Inc.

Conversely, in paradise, the blessed dwell in the circles symbolic of their virtue. The theologians are in the circle of the sun because they enlightened the world, and the holy warriors dwell in the sphere of Mars.

The Divine Comedy is replete with mythological and historic figures. We find people in the second circle of hell who abandoned themselves to the tempest of their passions. Their punishment, therefore, is to be perpetually lashed by the tempest. Dante asks his guide, Virgil, to explain what is happening.

READING 11.3 DANTE

***The Divine Comedy, Inferno*, canto 5, Circle Two, lines 49–69**

And watching their shadows lashed by wind, I cried:
"Master, what souls are these the very air
lashes with its black whips from side to side?"

"The first of these whose history you would know,"
he answered me, "was Empress of many tongues.
Mad sensuality corrupted her so

Dante then sees the lovers Paolo and Francesca tempest tossed.[4] Francesca da Rimini (1255–1285) was a contemporary of Dante whose father Guido, at war with the Malatesta family, sought to bring peace by marrying her to Giovanni Malatesta. Giovanni was deformed and Guido knew Francesca would not consent to the marriage. Therefore, he had her marry Giovanni's handsome brother, Paolo, by proxy. Francesca fell in love with Paolo, and they became so impassioned reading the love story of Lancelot and Guinevere that they made love. They were discovered by Giovanni and murdered before they could repent, and thus were consigned to the second circle of hell. In the following passage, Dante manages to speak with Francesca as she and Paolo are swirling around, "one in Hell," Francesca says, "as we were above." The passage is noted for its poetic narrative of the couple's love.

4. "Tempest-tossed" is a phrase from Shakespeare's *Macbeth*.

READING 11.4 DANTE

The Divine Comedy, Inferno, canto 5, Circle Two, lines 124–140

"On a day for dalliance we read the rhyme
of Lancelot, how love had mastered him.
We were alone with innocence and dim time.

Pause after pause that high old story drew
our eyes together while we blushed and paled;
but it was one soft passage overthrew

our caution and our hearts. For when we read
how her fond smile was kissed by such a lover,
he who is one with me alive and dead

breathed on my lips the tremor of his kiss.
That book, and he who wrote it, was a pander.
That day we read no further." As she said this,

the other spirit, who stood by her, wept
so piteously, I felt my senses reel
and faint away with anguish. I was swept

by such a swoon as death is, and I fell,
as a corpse might fall, to the dead floor of Hell.

We learn more of the density and complexity of Dante's symbolism by looking at Satan, "the Emperor of the Universe of Pain" (*Inferno*, canto 34, Cocytus, line 28). Our common image of Satan is that of a sly tempter (in popular art he is often in formal dress whispering blandishments in a willing ear, with just a whiff of sulfur about him) after the manner of Milton's proud, perversely tragic, heroic Satan in *Paradise Lost*. For Dante, Satan is a huge, stupid beast, frozen in a lake of ice in the pit of hell. He beats six bat-like wings (a demonic leftover from his angelic existence; see Isaiah 6:1–5) in an ineffectual attempt to escape the frozen lake that is watered by the four rivers of hell. He is grotesquely three-headed (a parody of the Trinity), and his slavering mouths remorselessly chew the bodies of three infamous traitors from sacred and secular history (Judas, Cassius, and Brutus).

Why does Dante portray Satan so grotesquely? It is clear that he borrowed from Byzantine mosaics, with which he would have been familiar, in the baptistery of Florence. Beyond that, the whole complex of Satan is heavily weighted with symbolic significance. Satan lies in frozen darkness at a point in the universe farthest from the warmth and light of God. He is the fallen angel of light (*Lucifer*—another name for the archangel Satan—means "light bearer"), now encased in a pit in the center of the earth excavated by the force of his own fall from heaven. Satan is immobile, in contrast to God, who is the mover of all things. Satan is inarticulate because he represents the souls of hell who have lost what Dante calls "the good of intellect." Satan and all the souls in hell will remain unfulfilled as created rational beings, because they are cut off from the ultimate source of rational understanding and fulfillment: God. Intellectual estrangement from God is for Dante, as it was for Thomas Aquinas, the essence of damnation. This estrangement is most evident in the case of Satan, whose very being symbolizes the loss of rationality.

Dante, following a line of thought already developed by Abbot Suger and Thomas Aquinas, conceived the human journey as a slow ascent to the purity of God by means of the created things of this world. To settle for less than God was, in essence, to fail to return to the natural source of life. Light is a crucial motif in *The Divine Comedy*. Neither light nor the source of light (the sun) is ever mentioned in the *Inferno*. The overwhelming visual impression of the *Inferno* is darkness—a darkness that begins when Dante is lost in the "dark wood" of canto 1 and continues until he climbs from hell and sees the stars (the word *stars* ends each of the three major parts of the poem) of the Southern Hemisphere. In the ascent of the Mountain of Purgatory, daylight and sunset are controlling motifs to symbolize the reception and rejection of divine light. In the *Paradiso*, the blessed are bathed in the reflected light that comes from God. At the climax of the *Paradiso*, the poet has a momentary glimpse of God as a point of light and rather obscurely understands that God, the source of all intelligibility, is the power that also moves the "sun and the other stars." Yet the experience is ineffable; it cannot be communicated.

READING 11.5 DANTE

The Divine Comedy, Paradiso, canto 33, The Empyrean, lines 97–108

My tranced being
stared fixed and motionless upon that vision,
ever more fervent to see in the act of seeing,

Experiencing that Radiance, the spirit
is so indrawn it is impossible
even to think of ever turning from it.

For the good which is the will's ultimate object
is all subsumed in It; and, being removed,
all is defective which in It is perfect.

Now in my recollection of the rest
I have less power to speak than any infant
wetting its tongue yet at its mother's breast.

Within the broad reaches of Dante's philosophical and theological preoccupations, the poet still has the concentrated power to sketch unforgettable portraits: the doomed lovers Paolo and Francesca—each of the tercets that tell their story starts with the word *amore* ("love"); the haughty political leader Farinata degli Uberti; the pitiable suicide Pier delle Vigne; and the gluttonous caricature Ciacco the Hog. Damned, penitent, or saved, the characters are by turns symbols and people. Saint Peter represents the church in the *Paradiso* but also explodes with ferociously human anger at its abuses. Brunetto Latini in the *Inferno* with "his brown-baked features" is a condemned sodomite anxious that posterity remember his literary accomplishments.

The comprehensiveness of *The Divine Comedy* has often been its major obstacle for the modern reader. Beyond that hurdle is the strangeness of the intellectual world in which Dante dwelled, so at variance with our own: earth-centered, manageably small, sure of its ideas of right and wrong, orthodox in its theology, prescientific in its outlook, Aristotelian in its philosophy. For all that, Dante is to be read not only for his store of medieval lore but because he is, as T. S. Eliot once wrote, the most universal of poets. He had a deeply sympathetic appreciation of human aspiration, love and hate, and the meaning of nature and history.

Francesco Petrarch

Petrarch's life spanned the better part of the century (1304–1374), and in that life we can see the conflict between medieval and Early Renaissance ideals being played out.

Petrarch (Petrarca in Italian) was born in Arezzo, a small town in Tuscany southeast of Florence. As a young man, in obedience to parental wishes, he studied law for a year in France and for three years at the law faculty in Bologna. He abandoned his legal studies immediately after his father's death to pursue a literary career. To support himself he accepted some minor church offices, but he was never ordained to the priesthood.

Petrarch made his home at Avignon, but for the greater part of his life he wandered from place to place. Some have referred to him as the first known tourist. He could never settle down; his restlessness prevented him from accepting lucrative positions that would have made him a permanent resident of any one place. He received invitations to serve as a secretary to various popes in Avignon and, through the intercession of his close friend Boccaccio, was offered a professorship in Florence. He accepted none of these positions.

Petrarch was insatiably curious. He fed his love for the classics by searching out and copying ancient manuscripts that had remained hidden and unread in the various monasteries of Europe. It is said that at his death he had one of the finest private libraries in Europe. He wrote volumes of poetry and prose, carried on a vast correspondence, advised the rulers of the age, took a keen interest in horticulture, and kept a wide circle of literary and artistic friends. We know that at

his death he possessed pictures by both Simone Martini and Giotto, two of the most influential artists of the time. In 1348 Petrarch was crowned poet laureate of Rome, the first artist so honored since the ancient days of Rome.

One true mark of the Renaissance sensibility was a keen interest in the self and an increased thirst for personal glory and fame. Petrarch surely is a 14th-century harbinger of that spirit. Dante's *Divine Comedy* is totally oriented to the next life; the apex of Dante's vision is that of the soul rapt in the vision of God in eternity. Petrarch, profoundly religious, never denied that such a vision was the ultimate goal of life. At the same time, his work exhibits a tension between that goal and his thirst for earthly success and fame. In his famous prose work *Secretum* (*My Secret*), written in 1343, the writer imagines himself in conversation with Saint Augustine. In a dialogue extraordinary for its sense of self-confession and self-scrutiny, Petrarch discusses his moral and intellectual failings, his besetting sins, and his tendency to fall into fits of depression. He agrees with his great hero Augustine that he should be less concerned with his intellectual labors and the fame that derives from them, and more with salvation and the spiritual perfection of his life. However, Petrarch's argument has a note of ambivalence: "I will be true to myself as far as it is possible. I will pull myself together and collect my scattered wits, and make a great endeavor to possess my soul in patience. But even while we speak, a crowd of important affairs, though only of this world, is waiting for my attention."

The inspiration for the *Secretum* was Augustine's *Confessions*, a book Petrarch loved so much that he carried it with him everywhere. It may well have been the model for his "Letter to Posterity," one of the few examples of autobiography we possess after the time of Augustine. That Petrarch would have written an autobiography is testimony to his strong interest in himself as a person. The Letter was probably composed in 1373, the year before his death. Petrarch reviews his life up until 1351, where the text breaks off abruptly. The unfinished work is clear testimony to Petrarch's thirst for learning, fame, and self-awareness. At the same time, it is noteworthy for omitting any mention of the Black Death of 1348, which carried off the woman he loved. The Letter is an important primary document of the sensibility of the 14th-century proto-Renaissance.

Petrarch regarded as his most important works the Latin writings over which he labored with devotion and in conscious imitation of his most admired classical masters: Ovid, Cicero, and Virgil. Today, however, only a literary specialist or an antiquarian is likely to read his long epic poem in Latin called *Africa* (written in imitation of the *Aeneid*), or his prose work in praise of the past masters of the world (*De viris illustribus*), or his meditation on the benefits of the contemplative life (*De vita solitaria*). What has assured Petrarch's literary reputation is his incomparable vernacular poetry, which he considered somewhat trifling but collected carefully into his **Canzoniere** (*Songbook*). The *Canzoniere* contains more than 300 **sonnets** (14-line poems) and 49 **canzoni** (songs) written in Italian during the span of Petrarch's adult career.

The subject of a great deal of Petrarch's poetry is his love for Laura, a woman with whom he fell in love in 1327 after seeing her at church in Avignon. Laura died in the plague of 1348. The poems in her honor are divided into those written during her lifetime and those mourning her untimely death. Petrarch poured out his love for Laura in more than 300 sonnets, which he typically broke into an octave and a sestet. Although they were never actually lovers (Petrarch says in the *Secretum* that this was due more to her honor than to his; Laura was a married woman), his Laura was no mere literary abstraction. She was a flesh-and-blood woman whom Petrarch truly adored. One of the characteristics of his poetry, in fact, is the palpable reality of Laura as a person; she never becomes (as Beatrice does for Dante) a symbol without earthly reality.

The interest in Petrarch's sonnets did not end with his death. Petrarchianism, which means the Petrarchan form of the sonnet and particularly the poet's attitude toward his subject matter—praise of a woman as the perfection of human beauty and the object of the highest expression of love—was introduced into other parts of Europe before the century was over. In England, Petrarch's sonnets were first imitated in form and subject by Sir Thomas Wyatt in the early 16th century. Although the Elizabethan poets eventually developed their own English form of the sonnet, the English Renaissance tradition of poetry owes a particularly large debt to Petrarch, as shown by the poetry of Sir Philip Sidney (1554–1586), Edmund Spenser (1552–1599), and William Shakespeare (1564–1616). Their sonnet sequences follow the example of Petrarch in linking together a series of sonnets in such a way as to indicate a development in the relationship of the poet to his love.

READING 11.6 **PETRARCH**

Canzoniere, Sonnet XIV

As when some poor old man, grown pale and gray,
　Sets out from where he lived his whole life-tide,
　And from his little household terrified,
　Foreseeing their dear father's quick decay,
Whilst his last time elapses, day by day,
　He still drags on from home his ancient side
　As best he can, with strong will fortified,
　Broken by years and weary of the way,
And following to Rome his guiding love
　Sees there the holy countenance of One,
　Whom he hopes yet to see in heaven above.
So I, outworn, hunt round at ties to view,
　Lady, elsewhere, so far as can be dome,
　The very features, that I love in you.

Source: *Translations from Dante, Petrarch, Michael Angelo, and Vitoria Colonna*. London, Kegan Paul & Co.: 1879.

Note the rhyme scheme *abba, abba, cdc, efe*. Petrarch's sonnets all have the same rhyme scheme for the octave. The scheme for the sestet varies. The first three lines (or tercet) of the sestet usually reflect on the themes of the poem, and the second tercet forms a conclusion.

READING 11.7 **PETRARCH**

Canzoniere, Sonnet XVIII

Ashamed at times, that your fair qualities,
　Lady, are still unsaid by me in rhyme,
　I think of when I saw you first, yon time,
　Such that from thenceforth none beside can please,
But find the weight too heavy for my knees,
　The work for my poor brushes too sublime;
　Therefore the mind, that knows its power to climb,
　In trying at the task, begins to freeze.
Of times ere now, I oped my lips to say,
　But then my breath stopped short without effect,
　Indeed, what voice could rise to such a height!
Of times I have begun to write some lay,
　But then the pen, the hand, the intellect
　Stopped, conquered at the entrance on the fight.

Source: *Translations from Dante, Petrarch, Michael Angelo, and Vitoria Colonna*. London, Kegan Paul & Co.: 1879.

Geoffrey Chaucer

While it is possible to see the beginning of the Renaissance spirit in Petrarch and other Italian writers of the 14th century, some scholars believe that the greatest English writer of the century, Geoffrey Chaucer (1340–1400), still reflects the culture of his immediate past. It could be argued that the new spirit of individualism discernible in Petrarch is less evident in Chaucer, although readers of the Wife of Bath's Tale might find a most finely etched individual. In the latter part of the 15th century, largely under the influence of Italian models, we can speak of a general movement toward the Renaissance in England.

Scholars have met with only partial success in reconstructing Chaucer's life. We know that his family had been fairly prosperous wine merchants and vintners and that he entered royal service early in his life, eventually becoming a squire to King Edward III. After 1373 he undertook various diplomatic tasks for the king, including at least two trips to Italy to negotiate commercial contracts. During these Italian journeys, Chaucer came into contact with the writings of Dante, Petrarch, and Boccaccio. There has been some speculation that he actually met Petrarch, but the evidence is tenuous. Toward the end of his life Chaucer served as the customs agent for the port of London on the river Thames. He was thus never a leisured man of letters; his writing had to be done amid the hectic round of public affairs that engaged his attention as a high-placed civil servant.

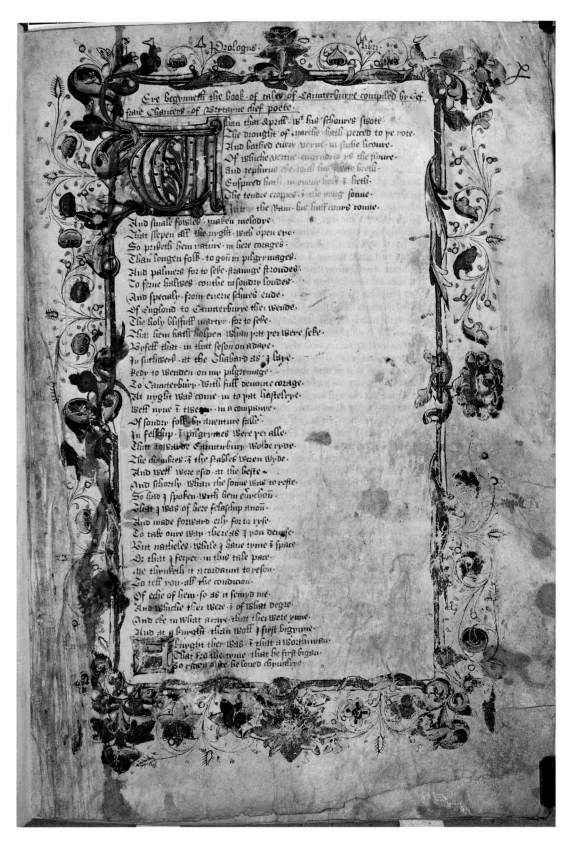

◄ **11.4** Geoffrey Chaucer, *Canterbury Tales*, General Prologue, manuscript page, ca. 1450–1460. British Library, London, United Kingdom. All copies of Chaucer's work were handwritten, as the printing press would not be invented for another 50 years. In this copy, fanciful painted borders of brilliant color surround the calligraphic text.

Like many other successful writers of the Late Middle Ages, Chaucer could claim a widespread acquaintance with the learning and culture of his time. This was still an age when it was possible to read most of the available books. Chaucer spoke and wrote French fluently, and his poems show the influence of many French allegories and dream visions. That he also knew Italian literature is clear from his borrowings from Dante and Petrarch, and from his use of stories and tales in Boccaccio's *Decameron* (although it is not clear that he knew that work directly). Chaucer also had a deep knowledge of Latin literature, both classical and ecclesiastical. Furthermore, his literary output was not limited to the composition of original works of poetry. He made a translation from Latin (with an eye on an earlier French version) of Boethius's *Consolation of Philosophy* as well as a translation from French of the 13th-century allegorical erotic fantasy *Romance of the Rose*. He also composed a short treatise on the astrolabe and its relationship to the study of astronomy and astrology (two disciplines not clearly distinct at that time).

The impressive range of Chaucer's learning pales in comparison to his most memorable and noteworthy talents: his profound feeling for the role of the English language as a vehicle for literature, his efforts to extend the range of the language (the richness of Chaucer's vocabulary was not exceeded until Shakespeare), and his incomparable skill in the art of human observation. Chaucer's characters are so finely realized that they have become standard types in English literature: his pardoner is an unforgettable villain, his knight the essence of courtesy, his wife of Bath a paradigm of rollicking bawdiness.

These characters, and others, are from Chaucer's masterpiece, *The Canterbury Tales*, begun sometime after 1385. To unify this vast work, a collection of miscellaneous tales, Chaucer used a typical literary device: a narrative frame—in this case a journey during which people amuse one another with tales. As we noted earlier, Boccaccio had used a similar device in the *Decameron*.

Chaucer's plan was to have a group of 30 pilgrims travel from London to the shrine of Saint Thomas à Becket at Canterbury and back. After a general introduction, each pilgrim would tell two tales on the way and two on the return trip in order to pass the long hours of travel more pleasantly. Between tales they might engage in perfunctory conversation or prologues of their own to cement the tales further into a unified whole.

Chaucer never finished this ambitious project; he died before half of it was complete. The version we possess has a General Prologue (**Fig. 11.4**), in which the narrator, Geoffrey Chaucer, describes the individual pilgrims, his meeting with them at the Tabard Inn in London, and the start of the journey. Only 23 of the 30 pilgrims tell their tales (none tells two tales), and the group does not reach Canterbury. There is even some internal evidence that the material we possess was not meant for publication in its present form.

Although *The Canterbury Tales* is only a draft of what was intended to be Chaucer's masterwork, it is of incomparable literary and social value. A close reading of the General Prologue, for instance—with its representative, although limited, cross section of medieval society (no person lower in rank than a plowman or higher in rank than a knight appears)—affords an effortless entry into the complex world of Late Medieval England. With quick, deft strokes Chaucer not only creates verbal portraits of people who at the same time seem both typical and uniquely real, but he also introduces us to a world of the gradual decline of chivalry—a world filled with such contrasts as clerical foibles, the desire for knowledge, the ribald taste of the lower social classes, and an appetite for philosophical conversation.

The General Prologue follows the literary convention we saw with the troubadours, among others, of beginning in the spring, when the world is reborn and aromas from the dampened earth invigorate the senses. *The Canterbury Tales* is written in rhyming couplets in **iambic pentameter**, a meter in poetry consisting of five feet, each one containing an unaccented syllable followed by an accented syllable. Chaucer often ends a line with an extra unaccented syllable. Note, for example, the structure of the accents in line 2 (we have updated the spelling to make the structure of the line clearer):

The dróught of Márch hath píerc-ed tó the róot-eh.

The first line skips the initial soft syllable, beginning the poem with an accented syllable. Because modern translations do not capture the sounds and cadences of the original, let us begin the General Prologue in Middle English as we see in Reading 11.8. We will translate some words and unfamiliar ideas.

After the General Prologue, the various members of the pilgrim company begin to introduce themselves and proceed to tell their tales. Between the tales they engage in small talk or indulge in lengthy prologues of their own. In the tales that he completed, we see that Chaucer drew on the vast treasury of literature—both written and oral—that was the common heritage of medieval culture. The Knight's Tale is a courtly romance; the miller and reeve tell stories that spring from the ribald fabliau tradition of the time; the pardoner tells an exemplum such as any medieval preacher might employ; the prioress draws from the legends of the saints; the nun's priest uses an animal fable; and the parson characteristically enough provides a somewhat tedious example of a medieval prose sermon.

At places, as in the prologue to the Wife of Bath's Tale, we get from Chaucer an extended meditation on some of the problems of the age. As we saw in Chapter 10, the Wife of Bath introduces her tale with a discourse explaining why the

READING 11.8 CHAUCER

The Canterbury Tales, General Prologue, lines 1–10,
16–18, in Middle and Modern English

In Middle English:

Whan that Aprill with his shoures soote
The droghte of march hath perced to the roote,
And bathed every veyne in swich licour
Of which vertu engendred is the flour;
Whan Zephirus eek with his sweete breeth
Inspired hath in every holt and heeth
The tendre croppes, and the yonge sonne
Hath in the Ram his halve cours yronne,
And smale foweles maken melodye,
That slepen al the nyght with open ye . . .

 In the springtime people long to go on pilgrimages, and

. . . to Caunterbury they wende,
The hooly blissful martir for to seke
That hem hath holpen, whan that they were seeke.

In Modern English:

When that April with his showers soft
The drought of March has pierced to the root,
And bathed every vein[5] in such moisture
By whose power is engendered the flower;
When Zephyrus[6] also with his sweet breath
Has inspired in every hill and field
The tender crops, and the young sun
Has in the Ram[7] his half course run
And small birds make melody,
That sleep all night with open eye . . .

 When these springtime events are afoot, people long
to go on pilgrimages.
. . . to Canterbury they travel,
The holy blessed martyr there to seek
Who had helped them when they were sick.

persistent tradition against women (misogyny) is unjust and contrary to authentic Christian theology. She also makes a passionate plea for seeing sexual relations as a good given by God. This may strike us as unnecessary in the 21st century, but in an age that prized celibacy (for example, for monks, nuns, priests), it was a fascinating and courageous poke in the eye of authority.

Christine de Pisan

Christine de Pisan (1365–1428) is an extraordinary figure in Late Medieval literature if for no other reason than her pioneering role as one of Europe's first female professional writers to make her living with the power of her pen.

Born in Venice, Christine accompanied her father Thomas de Pizzano to the French court of Charles V when she was still a small child. Thomas was the king's physician, astrologer, and close adviser. He evidently gave his daughter a thorough education: she was able to write in both Italian and French and probably knew Latin well enough to read it. At 15 she married Étienne du Castel, a young nobleman from Picardy. That same year (1380), the king died and the family fell on hard times with the loss of royal patronage. Five years later her father and her husband were both dead, leaving Christine the sole supporter of her mother, niece, and three young children. To maintain this large family, Christine hit on an almost unheard-of solution for a woman of the time: she turned to writing and the patronage such writing could bring to earn a living.

Between 1399 and 1415, Christine composed 15 books, which, as one of her translators has noted, is a staggering record in an age that had neither typewriters nor word processors. In 1399 she entered a famous literary debate about the *Romance of the Rose*. The *Romance*, a long and rather tedious poem, had been written in the preceding century and was immensely popular (Chaucer did an incomplete English translation of it). In 1275 Jean de Meun had written an addition to it that was violently critical of women. Christine attacked this misogynistic addition in a treatise called "The Letter to the God of Love." In 1404 she wrote her final word on this debate in a long work titled *The Book of the City of Ladies*.

The Book of the City of Ladies is indebted for its structure to Augustine's *The City of God*, and for its sources to a Latin treatise by Boccaccio titled *De claris mulieribus*. Through use of stories of famous women (*clarae mulieres*), Christine demonstrates that they possessed virtues precisely opposite to those vices imputed to women by Jean de Meun.

In *The Book of the City of Ladies*, Pisan presents an argument against the antifeminine writers of the day who condemned women as the snare of Satan and inferior to men. In the following extracts she speaks of the accomplishments of the ancient poet Sappho, and of the daughter of a professor at the University of Bologna.

5. A vessel within a plant that transports moisture.

6. The Greek god of the west wind; used poetically.

7. The constellation Aries, the Ram.

READING 11.9 CHRISTINE DE PISAN

From *The Book of the City of Ladies*, chapters 30 and 36

30 This Sappho had a beautiful body and face and was agreeable and pleasant in appearance, conduct, and speech. But the charm of her profound understanding surpassed all the other charms with which she was endowed, for she was expert and learned in several arts and sciences, and she was not only well-educated in the works and writings composed by others but also discovered many new things herself and wrote many books and poems. Concerning her, Boccaccio has offered these fair words couched in the sweetness of poetic language: "Sappho, possessed of sharp wit and burning desire for constant study in the midst of bestial and ignorant men, frequented the heights of Mount Parnassus, that is, of perfect study. Thanks to her fortunate boldness and daring, she kept company with the Muses, that is, the arts and sciences, without being turned away. She entered the forest of laurel trees filled with may boughs, greenery, and different colored flowers, soft fragrances and various aromatic spices, where Grammar, Logic, noble Rhetoric, Geometry, and Arithmetic live and take their leisure. She went on her way until she came to the deep grotto of Apollo, god of learning, and found the brook and conduit of the fountain of Castalia, and took up the plectrum and quill of the harp and played sweet melodies, with the nymphs all the while leading the dance, that is, following the rules of harmony and musical accord." From what Boccaccio says about her, it should be inferred that the profundity of both her understanding and of her learned books can only be known and understood by men of great perception and learning, according to the testimony of the ancients. Her writings and poems have survived to this day, most remarkably constructed and composed, and they serve as illumination and models of consummate poetic craft and composition to those who have come afterward. She invented different genres of lyric and poetry, short narratives, tearful laments and strange lamentations about love and other emotions, and these were so well made and so well ordered that they were named "Sapphic" after her.

36 Giovanni Andrea, a solemn law professor in Bologna not quite sixty years ago, was not of the opinion that it was bad for women to be educated. He had a fair and good daughter, named Novella, who was educated in the law to such an advanced degree that when he was occupied by some task and not at leisure to present his lectures to his students, he would send Novella, his daughter, in his place to lecture to the students from his chair. And to prevent her beauty from distracting the concentration of his audience, she had a little curtain drawn in front of her.

 Not all men (and especially the wisest) share the opinion that it is bad for women to be educated. But it is very true that many foolish men have claimed this because it displeased them that women knew more than they did. Your father, who was a great scientist and philosopher, did not believe that women were worth less by knowing science; rather, as you know, he took great pleasure from seeing your inclination to learning. The feminine opinion of your mother, however, who wished to keep you busy with spinning and silly girlishness, following the common custom of women, was the major obstacle to your being more involved in the sciences.

Pisan shows that victims often do not realize they are victims. Many victims, in fact, strive to maintain the social order that prevents them from rising in the belief that it is right and proper. Some, of course, do not want others of their kind to share in the benefits that they are denied.

The year after *The Book of the City of Ladies* (1405) Pisan wrote *The Treasure of the City of Ladies*, a book of etiquette and advice to help women survive in society. What is remarkable about this book is the final section, in which the author pens advice for every class of women—from young brides and wives of shopkeepers to prostitutes and peasant women.

Around 1418, Pisan retired to a convent in which her daughter was a nun and continued to write. Besides a treatise on arms and chivalry and a lament about the horrors of civil war, she also composed prayers and seven allegorical psalms. Of more enduring interest was *The Book of Peace*, a handbook of instruction for the dauphin who was to become Charles VII, and a short hymn in honor of Joan of Arc. Whether Pisan lived to see the bitter end of Joan is uncertain, but her hymn is one of the few extant works written while Joan was alive.

Although Pisan was immensely popular in her own time (the duc de Berry owned copies of every book she wrote), her reputation waned in the course of time, to be revived recently as scholars have tried to do justice to the forgotten heroines of our common history.

VOICES

John Ball

The priest John Ball was a leader in the Peasant's Revolt of 1381 in England. Here is an excerpt from a sermon of his, recorded in the *Chronicles* of Jean Froissart.

Good people: things cannot go right in England and never will, until goods are held in common and there are no more villeins [peasants] and gentlefolk. . . . In what way are those whom we call lords greater masters than ourselves? How have they deserved it? If we all spring from a common mother and father, Adam and Eve, how can they claim or prove that they are lords more than us except by making us produce and grow the wealth which they spend?

They are clad in velvet and camlet lined with squirrel and ermine, while wev go dressed in coarse cloth.

They have the wines, the spices, and the good bread; we have the rye, the husks, and the straw and we drink water.

They have shelters and ease in their fine manors and we have hardship and toil, the winds and the rains in the fields.

And from us must come, from our labor, the things which keep them in luxury.

We are called serfs and beaten if we are slow in service to them, yet we have no sovereign lord we can complain to; none to hear us and do us justice.

Let us go to the king—he is young—and show him how we are oppressed and tell him how we want things changed or else we will change them ourselves. If we go in good earnest and all together, very many people who are called serfs and are held in subjection will follow us to get their freedom.

When the king hears us he will remedy the evil, willingly or otherwise!

ART IN ITALY

Giorgio Vasari wrote the earliest historical account of Italian art during the Renaissance. He begins his story of artistic evolution with the life of Cimabue, but he claims that Giotto di Bondone, the 13th-century Florentine painter, was the first Renaissance artist—the one who set painting, once again, on its proper course. That proper course was classicism, from which Vasari claims art had strayed during the Middle Ages. When we use the word *Renaissance* to describe Italian art of the 14th through 16th centuries, the rebirth to which we refer is the revival of classical art; the first step was the observation of the natural world.

Italo-Byzantine Style

The first stirrings of a classical revival date to the mid-12th century, yet the style of that period can be though of as a hybrid of Gothic and classical elements. Artists were still rooted in the Byzantine pictorial traditions, and Italian churches were generally decorated not with lifelike sculptural groups like those we saw on the portals of Reims Cathedral (see **Fig. 10.14**), but with solemn and stylized frescoes and mosaics in what is called the

➤ **11.5 Nicola Pisano, pulpit of the baptistery, 1259–1260. Marble, 15′ (4.6 m) high. Pisa, Italy.** Details of the pulpit, an elevated liturgical platform, combine medieval and classical references. The trefoil arches are a bow to the French Gothic, but the Corinthian column capitals and rectangular reliefs are in the Greek tradition.

Italo-Byzantine style. This style would remain an important component in the development of 14th-century art.

PISANO, FATHER AND SON There are notable exceptions to the generally conservative character of Italian art in the 13th century. Nicola Pisano (ca. 1220/1225–1284) and his son Giovanni (ca. 1245/1250–1314), who took their names after the city of Pisa in which they worked, have been described as the creators of modern sculpture. Nicola's first major work was a marble pulpit for the baptistery in Pisa, completed in 1260 (**Fig. 11.5**), in which he married some trace of Gothic motifs (the trefoil visible in the arches supporting the pulpit) with clear references to classicism (the rounded rather than pointed arch, the Corinthian-style column capivtals). His reliefs are crowded with figures and the space is filled with lively detail, capturing much of the vitality and realism of late Roman art, along with its restraint (**Fig. 11.6**). For his son Giovanni, Classical models were less influential than was contemporary art in northern Europe, particularly the French Gothic style. In a pulpit that Giovanni carved, the figures are more elegant and less crowded than those of his father; the naturalism of the gestures and expression of intense emotion find their counterpart in late Gothic sculpture (**Fig. 11.7**).

Both father and son foreshadowed major characteristics of Renaissance art, Nicola by his emphasis on Classical models and Giovanni by the naturalism and emotionalism of his figures. While they both responded to outside influences, most painting in Italy at the time that they were working remained firmly grounded in the Byzantine tradition.

Painting in Florence: A Break with the Past

Although elements of the Byzantine style remained in paintings of the late 13th and early 14th centuries, a new naturalism began to appear—a consequence of artists' observing the natural world and devising techniques to suggest volume and three-dimensional space. For the next two centuries, painters would

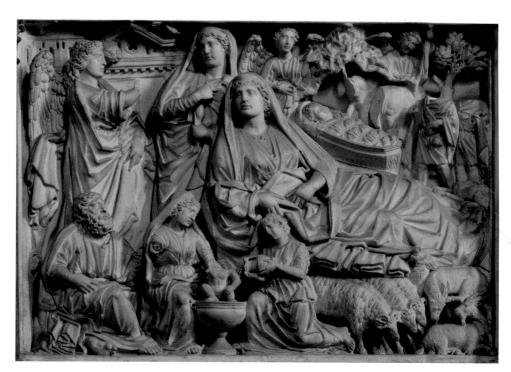

▲ **11.6** Nicola Pisano, *Annunciation, Nativity, and Adoration of the Shepherds*, **relief panel on the pulpit, 1259–1260. Marble, 34″ × 45″ (85 x 114 cm). Baptistery, Pisa, Italy.** The reliefs of the baptistery pulpit bear striking similarity to carvings on Roman sarcophagi, with which Pisano certainly would have been familiar.

▼ **11.7** Giovanni Pisano, *Annunciation, Nativity, and Adoration of the Shepherds*, **relief panel on pulpit, 1297–1301. Marble, 34″ × 40″ (85 × 101 cm). Sant'Andrea, Pistoia, Italy.** Whereas Nicola Pisano embraced Classical art, his son Giovanni had a taste for the French Gothic. The brisk, lively movement in Giovanni's Nativity contrasts with the repose in Nicola's. A bit of trivia: an asteroid observed in 1960 was named 7313 Pisano after the two sculptors.

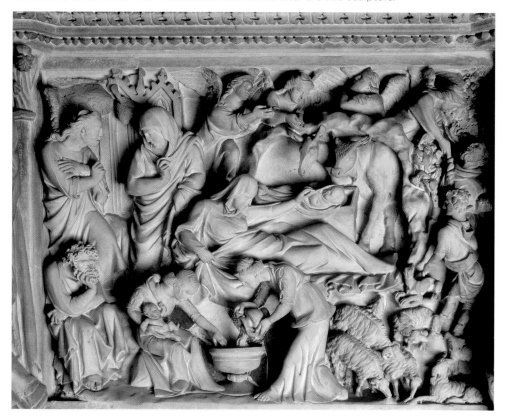

work toward creating the illusion of reality on a two-dimensional surface.

CIMABUE Vasari rightfully begins his *Lives of the Most Excellent Painters, Sculptors, and Architects* with Cimabue (ca. 1240–1302), a Florentine painter who was the first to make a true break with the past. His *Madonna Enthroned with Angels and Prophets* (**Fig. 11.8**), while it retains the otherworldly gold background of Byzantine predecessors, departs from them significantly in several important ways. Compare the drapery of Cimabue's Madonna with that of Saint Francis in Berlinghieri's altarpiece (see **Fig. 10.20**). The Madonna's veil and cloak fall over her head, shoulders, and arm in realistic folds that correspond to the shape of her body beneath. Her knees are spread slightly to balance the baby Jesus on her lap, and between them the drapery falls in a subtle pattern of U-shaped folds. She sits squarely on a substantial throne, the sides of which converge and recede toward the background, creating a sense of space in the composition. Adoring angels to either

side of the throne overlap, further enhancing depth, although the stacking of their heads one on top of the other has somewhat of a flattening effect.

Dante memorialized Cimabue in canto 11 of his *Purgatorio*:

> O vanity of human powers,
> how briefly lasts the crowning green of glory,
> unless an age of darkness follows!
>
> In painting Cimabue thought he held the field
> but now it's Giotto has the cry,
> so that the other's fame is dimmed.

Although these lines may seem to diminish Cimabue's achievements, they tell us two important things: first, that Cimabue's position in the Florentine art world of the 13th century was significant, and second, that individual artists were creating names for themselves and garnering fame for their work.

▲ **11.8** Cimabue, *Madonna Enthroned with Angels and Prophets*, from Santa Trinità, ca. 1280–1290. Tempera and gold leaf on wood on panel, 151″ × 88″ (325 × 203 cm). **Galleria degli Uffizi, Florence, Italy.** As a transitional artist in the late 13th century, Cimabue relied on Byzantine models yet reached for more naturalism in his depiction of three-dimensionality—both in his figures and in his suggestion of space.

▲ **11.9** Giotto di Bondone, *Madonna Enthroned*, from the Church of Ognissanti, ca. 1310. Tempera and gold leaf on wood, 128″ × 80″ (381 × 224 cm). **Galleria degli Uffizi, Florence, Italy.** Giotto based his approach to painting on the observation of the natural world and its successful translation to a two-dimensional surface. His Madonna has weight and occupies space; her drapery falls in natural folds, and light and shadow are used to great effect in the modeling of her face.

GIOTTO DI BONDONE Like everyone else around him, Giotto (ca. 1267–1337) was influenced by his mentors and contemporaries. He certainly knew the work of Giovanni Pisano and Cimabue and probably contributed to the discourse on Classical art. But Giotto's preeminent contribution to the history of painting was his realism. He acquired it through a close observation of the world around him—not only the natural world, but also human behavior. The Byzantine style was defined by rich, glowing surfaces, with elaborate linear designs. Now, for the first time, figures seemed truly three-dimensional, a sense of volume created by a careful manipulation of light and shadow known as **modeling** or **chiaroscuro**. Painted figures had the same palpable presence as sculpture carved in stone; for the 13th-century viewer, they even seemed to live and breathe. Compared to the Madonna in Cimabue's painting, Giotto's Madonna Enthroned **(Fig. 11.9)** has a majestic solidity. Cimabue's delicate drapery folds embellished with gold, which appeared so much more realistic than the drapery on Byzantine figures, now seem to be overly emphasized in comparison to the simple, unfussy drapery on Giotto's Madonna. Giotto also recreates textures in his contrast between the more delicate white fabric of the Madonna's dress and the heavier blue cloth of her mantle. The throne, which bears some vestiges of the Gothic style in its pointed arches, convincingly occupies space. The groups of angels, who now stand on roughly the same ground line and overlap one another, enhance the depth of the throne. The halos of some of the angels obscure parts of those behind them; this is exactly how a crowd of people would look to us if we were standing in front of the throne.

Each of these aspects of the composition contributes to its overall naturalism. But our true connection with the subject is made possible by Giotto's signature subtle gestures and specific realistic details. Mary looks like and behaves like a mother. She lightly grasps the baby's knee, almost as if she is trying to keep him from wiggling off her lap. Baby Jesus's face may look a bit mature, but his tiny, plump, and dimpled hands look as though the artist has sketched them directly from a child—maybe one of his own. One of the most enjoyable things about studying Giotto's paintings is searching for these human touches.

Giotto's greatness lay not so much in his technical ability to create realistic images—although he was unsurpassed in his day in imitating nature—as in his use of realism to dramatic effect in religious narratives rendered from a very human perspective. Giotto's most famous work is a fresco cycle for the Arena Chapel in Padua **(Fig. 11.10)**, commissioned by Enrico Scrovegni. The walls of the small, barrel-vaulted chapel are divided into four registers: the three upper ones illustrate scenes from the life of Christ and the life of the Virgin Mary, and the lowest register depicts virtues and vices painted in a palette of gray tones to imitate relief sculpture. Specific events are painted in rectangular segments separated by ornate borders. The chronologies progress from left to right, with visual elements (such as shape and line) leading our eyes from one rectangle to the next.

The Arena Chapel frescoes illustrate Giotto's extraordinary ability to portray three-dimensional figures in three-dimensional space—figures that have weight and occupy

▲ **11.10 Giotto di Bondone, Arena Chapel (Capella Scrovegni). Padua, Italy. View of the interior, looking toward the altar.** The chapel, dedicated in 1303, was built by Enrico Scrovegni, who made his fortune through banking. Giotto was commissioned to paint a fresco cycle showing scenes from the life of Christ. He completed 38 framed scenes by 1305.

space. An almost inexhaustible range of emotions and dramatic situations further enhances the sense of realism. One of the most vivid examples is the *Lamentation* **(Fig. 11.11)**, a scene of almost cosmic drama that describes the mourning over the dead Christ before he is laid to rest in the tomb. Angels reel overhead, wailing in grief, while below, Mary supports her dead son's head in her arms and stares desperately into his face. Around her are the other mourners, each a fully characterized individual. If the disciple John—who thrusts his body forward and his arms back—is the most passionate in the expression of his sorrow, no less moving are the silent hunched figures in the foreground and the hopeless Mary Magdalene who caresses Jesus's feet.

Giotto's masterful composition is also worth noting. Composition is the arrangement of the elements of art (line, shape, color, texture) using the design principles of art (for example, unity, variety, balance, focal point, scale, and proportion). It is good to keep in mind that Giotto's first and most basic goals for composition were two: to move the viewer's eye from one place to another in a logical flow, so that all parts of the composition will be seen; and to move the viewer from one rectangular composition to the one next to it so that the entire cycle will be seen. Consider the *Lamentation*. The space is divided into upper and lower regions

by a strong diagonal line formed by a rocky ledge. The endpoints of this line are a barren, leafless tree on the upper right and a crowd of mourners surrounding Mary and Jesus on the lower left.

In the center of the composition is the figure of Saint John, the apostle whom Jesus charged with caring for Mary as Jesus was dying on the cross. John's strange pose is an important one in the composition; in effect, he leads our eye everywhere it needs to go. We notice him because he is in the center of the painting and because his action is so dramatic. He leans and stares in the direction of Mary and Jesus, bringing our eyes with him to the all-important image of a mother mourning her son; he flings his arms behind him, one hand leading our eyes to the heavens and the other to two standing figures on the right side of the composition. The vertical folds of their drapery lead our eye downward to the hunched-over figure of Mary Magdalene at Jesus's feet and then along a horizontal line back in the direction of the mourning Mary. The seated figures whose backs are turned toward us provide a secure frame, so to speak, around Mary and Jesus. As you look at paintings, challenge yourself to analyze their formal structures. An artist places things in a composition as a director might arrange actors and scenery in a play; things are where they are for very specific reasons. Giotto's narrative paintings have been related to popular contemporary *mystery plays* that featured actors in tableaus based on biblical stories.

Giotto's work was a major influence on Italian Renaissance painting. Copying nature, observing the world, trying to reproduce exactly what the eye sees on a two-dimensional surface, and capturing the nuances of human behavior and emotion to add authenticity to this illusion of reality—these were Giotto's legacy to the history of Western art.

Painting in Siena

Nicola Pisano traveled from his hometown of Apulia to Pisa, where wealthy patrons held out the promise of fame and fortune—or at least practical circumstances for making a living as an artist. Florence and Siena were both wealthy republics with thriving art markets and opportunities for any number of commissions. As their Florentine counterparts were, early Sienese painters continued to be influenced by Byzantine traditions, but they too would make a break with the past.

DUCCIO DI BUONINSEGNA Giotto's contemporary in Siena, an artist who matched him in renown, was Duccio di Buonisegna (active ca. 1278–1318). His greatest achievement was an enormous multipanel painting for the high altar of the Siena Cathedral, for which he signed a contract on October 9, 1308; he completed it within three years. The principal

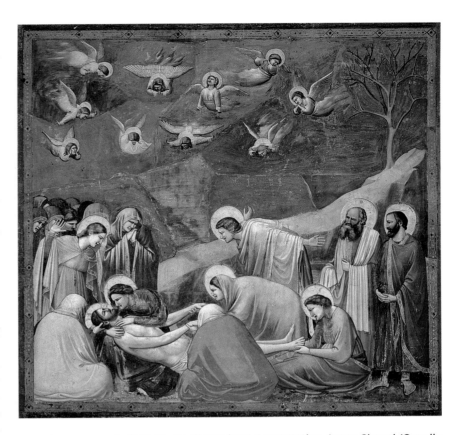

▲ **11.11** Giotto di Bondone, *Lamentation*, Arena Chapel (Capella Scrovegni), ca. 1305. Fresco, 78³⁄₄" × 72³⁄₄" (231 × 236 cm). **Padua, Italy.** Giotto arranged elements and principles of art—line, shape, color, focal point, and emphasis—to create a composition that would lead a viewer's eyes around the painting and heighten the dramatic narrative. The patchy quality of the blue background shows us that the *Lamentation* was painted in sections over the course of many days.

panel of the altarpiece (**Fig. 11.12**), which faced the congregants, follows the formula for a **maestà**: it features the Virgin Mary and Christ Child enthroned and surrounded by angels and saints. Duccio's composition begs comparison with the maestàs we have examined by Cimabue and Giotto (**Figs. 11.8 and 11.9**). The face of Duccio's Madonna retains a Byzantine quality, as does Cimabue's, but her physical presence more resembles that of Giotto's Madonna. She sits squarely on her throne, the arms of which splay out toward the viewer as if to present her or to welcome the viewer into her presence. The drapery of Duccio's Madonna is realistically handled, devoid (as with Giotto's) of the gold striations that appear more decorative than natural. The figures in the foreground to either side of the throne have distinct facial features and their gestures are animated, adding to the naturalism of the painting. They are situated in depth, in distinct rows arranged in such a way that each face is clearly visible—almost like a yearbook photograph.

The back of the altarpiece consisted of a grid of smaller panels, although not all of them can be seen together in one place today. Some of these panels have made their way into museum collections around the world. The portion that is illustrated here (**Fig. 11.13**) shows scenes from the Passion of

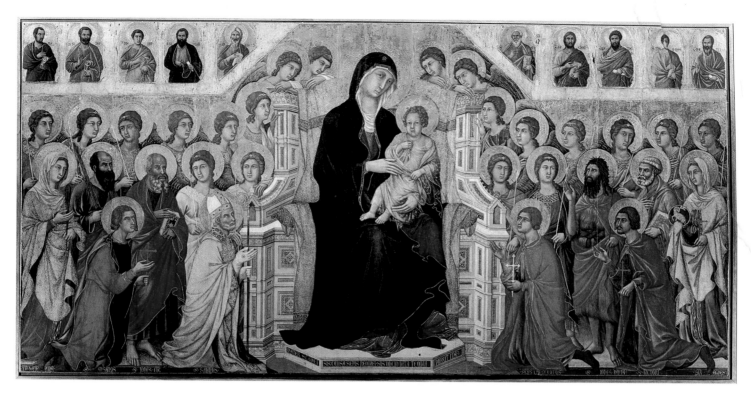

▲ **11.12** Duccio di Buoninsegna, *Virgin and Child Enthroned with Saints*, ca. 1308–1311. Principal panel of the Maestà altarpiece from Siena Cathedral. Tempera and gold leaf on wood, 84″ × 156″ (213 × 396 cm). Museo dell'Opera Metropolitana del Duomo, Siena, Italy. The Maestà altarpiece was commissioned for the high altar of the Siena Cathedral. When it was completed in 1311, a grand celebration was held throughout the city as the altarpiece was carried in an elaborate candlelit procession, led by the bishop, from Duccio's studio to its place of honor.

▼ **11.13** Duccio di Buoninsegna, *Life of Jesus*, ca. 1308–1311. Fourteen panels from the back of the Maestà altarpiece, from Siena Cathedral. Tempera and gold leaf on wood, 83½″ × 167¼″ (212 × 425 cm). Museo dell'Opera Metropolitana del Duomo, Siena, Italy. The back of the Maestà altarpiece consisted of 43 separate scenes of the life of the Virgin Mary and the life of Christ. Some of the panels are now in museum collections and others have been lost. The altarpiece was intact until 1711, when it was sawn up to divide the panels between two altars.

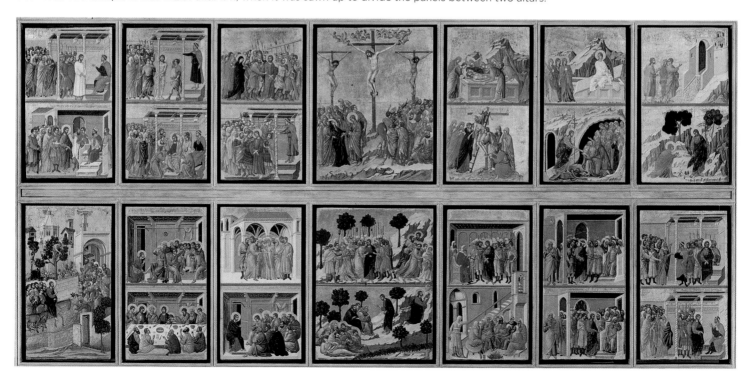

Scenes from the Passion of Christ by Giotto and Duccio

Florence and Siena were rival republics, and their "favorite sons"—Giotto and Duccio—were the most famous artists of their time and place. Their two big commissions, the Arena Chapel fresco cycle and the Maestà altarpiece for the Siena Cathedral, were created within a few years of each other, and both depict scenes from the lives of Mary and Jesus. Examining scenes from each of the works on the same theme offers an excellent opportunity to consider the artistic choices that each painter made, their stylistic differences, and the impact of their emotional content.

Christ's entry into the city of Jerusalem through one of the gates of its ancient fortification is mentioned in all four of the canonical Gospels, those that were accepted as part of the New Testament or Christian Bible. All four evangelists

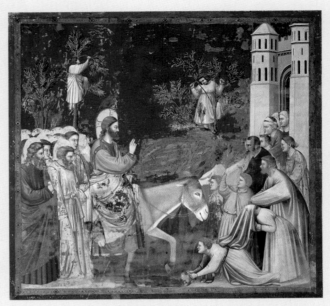

▲ 11.15 Giotto di Bondone, *Entry of Christ into Jerusalem*, ca. 1305. Fresco, 78 3/4" x 72 3/4" (200 x 185 cm). Arena Chapel (Capella Scrovegni), Padua, Italy.

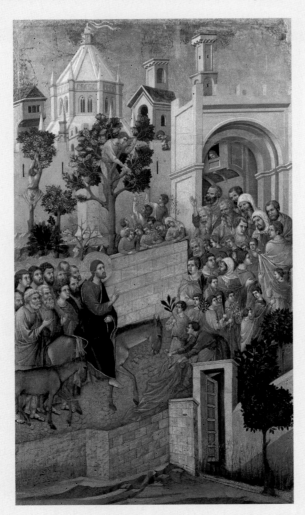

▲ 11.14 Duccio di Buoninsegna, *Entry into Jerusalem*, 1308–1311. Tempera on wood, 39 3/8" × 22 3/8" (100 x 57 cm). Panel from the back of the Maestà altarpiece. Museo dell'Opera del Duomo, Siena, Italy.

wrote that this arrival took place after Jesus's miracle of raising a man named Lazarus from the dead and a few days before the Last Supper. Throngs of people were said to have greeted Jesus and his apostles upon their arrival at the gate. This is the scene depicted here by both Duccio (Fig. 11.14) and Giotto (Fig. 11.15). In both paintings, Jesus rides a donkey—a symbol of peace—and blesses the onlookers; some of them lay down their cloaks before him and a couple others climb trees to get a better look. But beyond these few narrative pieces, the works are very different. In Duccio's painting there is a distinction between Jesus and his followers and the crowd that spills—almost literally through the city gate. Jesus's group processes calmly, looking forward; their heads are all visible and they are placed side by side in two distinct, regimented lines. The crowd, much larger than the one in Giotto's painting, is active and noisy; onlookers' positions vary and they all seem to be talking. There is energy in Duccio's composition that conveys a sense of genuine excitement. In Giotto's painting, the apostles also follow behind Jesus in a group, but only the ones nearest to us are visible; their halos obscure the apostles behind them.

A close look reveals that the perspective, or point of view, each artist has chosen is different: we look down on the scene in Duccio's painting, whereas in Giotto's we look straight ahead, and the proximity of the figures creates the sensation that we are there, on the same path, walking with them. As in many of the scenes in the fresco cycle, Giotto

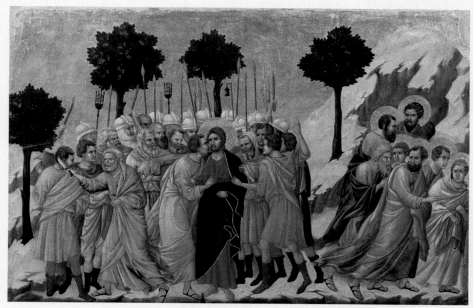

Yet the apostles are relegated to the background, focusing our attention on only a few players. As in the *Lamentation*, Giotto includes a figure with his back turned toward us; rather than blocking us from entering the scene, his placement makes us feel as if we are close behind him. The most dramatic point of the narrative, of course, is the actual kiss, to which Giotto draws our attention by stretching the diagonal folds of Judas's bright-yellow cloak up to the head of Christ. As Judas embraces him, Jesus does not remain expressionless. He stares directly and deeply into Judas's eyes as if he means for Judas to understand what he has done. Judas's kiss is not the only gesture that constitutes this bitter betrayal: he envelops Jesus in his cloak—a false, hypocritical gesture of comfort and protection.

How do these artistic choices affect the narrative? How do they impact your emotional connection to these characters and their stories?

▼ **11.17** Giotto di Bondone, *The Betrayal of Jesus*, ca. 1305. Fresco, 78 ³/₄″ × 72 ³/₄″ (200 × 185 cm). Arena Chapel (Capella Scrovegni), Padua, Italy.

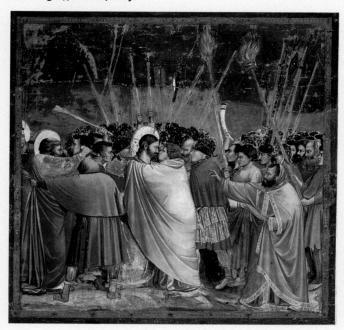

incorporates the results of his close observation of nature—and human nature. Consider how the people in the lower right corner are spreading their cloaks on the ground—or trying to. In the rush to do so before the honoree passes by, one person struggles with a cloak that has gotten stuck over his head and another is fumbling with his sleeve. When we see elements such as these, we understand that Giotto could have included these actions only if he had seen them before—in reality—and copied them. It is fun to imagine him walking through a crowd at a parade with his sketchbook.

According to the Gospels of Matthew, Mark, and Luke, one of Jesus's apostles—Judas—betrayed him to priests of the Sanhedrin (ancient Israel's supreme court) in the garden of Gethsemane after he dined with the apostles at the Passover meal that would become known as the Last Supper. Judas identified Jesus as the one among them by a kiss. The scene depicted by Duccio (**Fig. 11.16**) and Giotto (**Fig. 11.17**) is called the betrayal of Jesus.

In Duccio's composition, havoc has broken loose. Jesus stands at the center, surrounded by helmeted soldiers and bearded men with angry expressions on their faces. To the left, Peter attacks a soldier with a knife to protect Jesus, cutting off his ear; this action was reported in the Gospels along with Jesus's healing of the wound in the last miracle he would perform before his crucifixion. To the right, Jesus's apostles flee the scene, leaving him alone with Judas, whose face touches Jesus's as he plants his deadly kiss. Jesus stares ahead, expressionless.

Some of the same narrative components are present in Giotto's version of the scene, but they are handled quite differently—particularly when it comes to defining space. The crowd is much larger and much denser in Giotto's composition; Jesus and his apostles are greatly outnumbered.

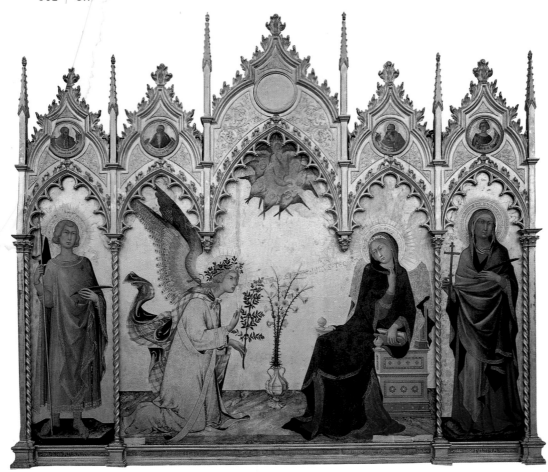

**11.18** Simone Martini and Lippo Memmi, *Annunciation* altarpiece, 1333. Siena Cathedral, Italy. Tempera and gold leaf on wood, center panel 121″ × 96″ (305 × 254 cm). Galleria degli Uffizi, Florence, Italy. The courtly elegance and delicacy of Martini's figures were a hallmark of the International Style. Speaking to the Virgin, the Angel Gabriel proclaims, "Ave gratia plena dominus tecum" (Hail thou that are full of grace, the Lord is with you). It is the moment when Mary becomes aware that she will bear the Christ child.

Jesus Christ, beginning (in the lower left) with his entry into Jerusalem (an event commemorated on Palm Sunday of the Christian liturgical calendar) and ending with scenes from his resurrection in the upper right.

The style of Duccio's painting appears more conservative—perhaps a bit more old-fashioned than Giotto's—but that is probably because of the iconic function of the altarpiece itself, placed on the high altar of the cathedral. The gold background of Duccio's work certainly limits the credibility of the scenes; on the other hand, it contributes to its splendor. Duccio's colors gleam like jewels; his fabrics glisten.

SIMONE MARTINI AND THE INTERNATIONAL STYLE Giotto's appeal was direct and immediate, and at Florence his pupils and followers continued to work under his influence for most of the 14th century, content to explore the implications of the master's ideas rather than devise new styles. As a result, the scene of the most interesting new developments in the generation after Giotto was Siena, where Duccio's influence (although considerable) was less overpowering. Among Duccio's pupils was Simone Martini (ca. 1285–1344), a close friend of Petrarch, who worked for a time at Naples for the king Robert of Anjou and spent the last years of his life at the papal court of Avignon. In Martini's work we find the last great development of Gothic art, the so-called *International Style* that swept Europe in the 14th and 15th

centuries. The elegant courts of France and the French kingdoms of Italy had developed a taste for magnificent colors, fashionable costumes, and richly embellished fabrics. Martini painted his *Annunciation* altarpiece (**Fig. 11.18**) with his pupil and assistant Lippo Memmi. The Annunciation is the angel Gabriel's announcement to Mary that she will bear the Christ child. The figures in the piece have an insubstantial grace and sophistication that contrast strongly with Giotto's solid and earthy realism (see **Fig. 11.9**). The resplendent robe and mantle of the angel Gabriel and the deep-blue dress of the Virgin, edged in gold, produce an impression of great splendor, while their willowy figures approach the ideal of courtly elegance.

AMBROGIO LORENZETTI If Simone Martini subordinated naturalism to the decorative lines and shapes of the International Style, two of his fellow Sienese artists— the Lorenzetti brothers—were more interested in applying Giotto's innovations to their own work. Ambrogio was granted an important commission for the Palazzo Pubblico, Siena's city hall (*palazzo pubblico* means "public palace"). Unusual for us in our study of Italian art thus far is this secular—rather than religious—commission. The the three large frescoes on the walls of the Sala della Pace (the Hall of Peace) are the *Allegory of Good Government, Bad Government and the Effects of Bad Government in the City*, and *Effects of Good Government in the City and in the Country* (**Figs. 11.19**

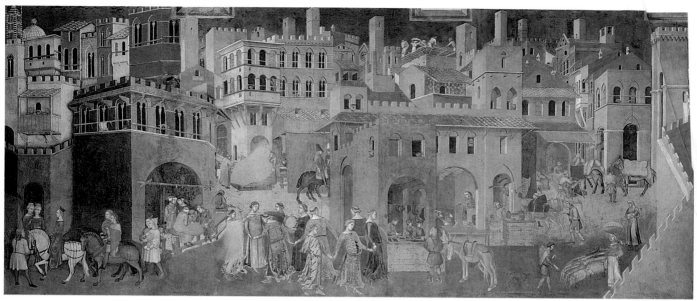

▲ **11.19 Ambrogio Lorenzetti,** *Peaceful City*, **detail of** *Effects of Good Government on the City and the Country*, **1338–1339. Fresco, 47′ × 10′ (14.3 × 3 m). Sala della Pace, Palazzo Pubblico, Siena, Italy.** The panoramic fresco in the Siena city hall is a tribute to the quality of life made possible by prevailing peace and a just and nurturing government. Citizens profit, commerce is congenial, and all are content, relaxed, and joyful. To the left is a shoe shop, in the center a school lesson is in progress, and to the right a tavern keeper is selling wine.

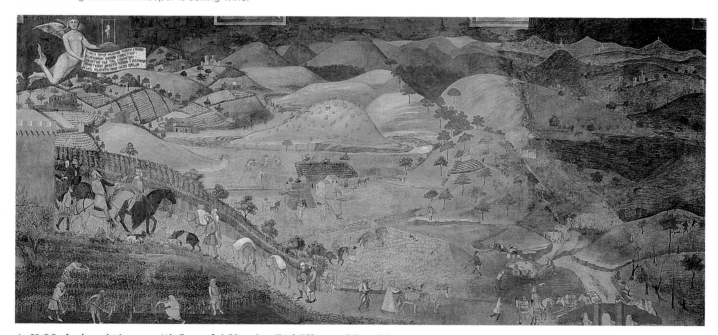

▲ **11.20 Ambrogio Lorenzetti,** *Peaceful City*, **detail of** *Effects of Good Government on the City and the Country*, **1338–1339. Fresco, 47′ × 10′ (14.3 × 3 m). Sala della Pace, Palazzo Pubblico, Siena, Italy.** Peace spills out of the city and into the countryside in one of the first examples of pure landscape painting since Roman times. The allegorical in the top left corner is Securitas (Security), whose scroll reads, "The people will be safe as long as justice rules." She also holds a gallows with a hanged man as a warning to those who might contemplate disturbing the peace.

and **11.20**). In a panoramic view of Siena, buildings are rendered in elaborate perspective; streets and squares are filled with scenes of daily life. Richly dressed merchants with their wives, craftsmen at work, and graceful girls who dance in the street preserve for us a vivid picture of a lifestyle that was to be abruptly ended by the Black Death. The scenes in the country, on the other hand, illustrate the bounty that attends a republic at peace. They show a world that survives even today in rural Tuscany: peasants at work on farms and in orchards and vineyards.

LATE MEDIEVAL ARCHITECTURE

Architecture in Europe of the late 13th and 14th centuries—regardless of where it was built—showed the influence of the **French Gothic style** from vaulting techniques to decorative details. Even buildings constructed in Italy during this period, whose lower profiles and basilican plans reach back to the country's Classical roots, bore motifs and embellishments that bespoke familiarity with the prevailing Gothic fashion. Cathedrals remained at the center of society—literally and figuratively—but to varying degrees. Civic pride, reborn in these transitional years, led to the creation of secular centers of city life and, in them, government buildings such as the Palazzo Pubblico in Siena and the Palazzo della Signoria in Florence (also known as the Palazzo Vecchio or "Old Palace")—both city halls.

Secular Architecture

The Palazzo della Signoria (begun 1298) and the Palazzo Pubblico (begun 1288; **Fig. 11.21**) convey the sense of strong government and civic pride that emerged in these rival republics during the trecento. Both buildings were constructed on city squares and were designed as fortresslike blocks with single tall towers that could be used to spot trouble from invading forces on the horizon or to defend the city authorities from threats by their own disenchanted citizens. The uppermost section of the tower of the Palazzo Pubblico, which served as a belfry, was also constructed in such a way that boiling liquid could be poured through holes in the floor onto enemy troops. From a distance, the building may look imposing and inaccessible, but from the ground level on the square, it feels much more inviting. The contrasting white stonework is light and more airy in appearance, and the entrances have a more human scale. The design of the Palazzo Pubblico broadcasts, at the same time, Siena's power as a city-centered republic—a

force to be reckoned with—and its inclusivity regarding its common citizens.

Both Florence and Siena were wealthy cities, having successfully established themselves in banking and commerce. So too was Venice wealthy; its location on the Adriatic coast of Italy positioned it for strong economic development as it thrived from all sorts of trade relationships. As a city on the water—whose "streets" are water—it was more easily defensible against aggression by other Italian cites than were Siena or Florence. Although the republic of Venice did not shy from its own military campaigns, it called itself the Serenisima Republica Veneta the Most Serene Republic of Venice. The Doges' (Dukes') Palace (**Fig. 11.22**) is the city hall of Venice; it is probably the most beautiful of all government centers in Italy, if not all of Europe. It was constructed ca. 1340–1345 and expanded and remodeled from 1424 to 1438. In the bright sunlight that reflects from the sea, the overall effect of the building is ethereal. An arcade with pointed arches marches along the lowest level of the building, providing an open and airy foundation for

> **11.21 Palazzo Pubblico, 1288–1309. Siena, Italy.** The tower of the Siena city hall is visible from miles around, its height necessitated by the hilly topography of the city and countryside. It served as a lookout as well as a symbol of power.

⌃ 11.22 Doges' Palace, begun ca. 1340–1345, expanded and remodeled 1424–1438. Venice, Italy. The palace was the most resplendent Italian public building of its day. The creamy white and rose-colored marbles, patterned surfaces, and ornate arches contribute to this unique and elegant interpretation of French Gothic architecture.

➤ 11.23 Gloucester Cathedral, 1089–1420, choir, 1332–1357. Gloucester, United Kingdom. The cathedral was constructed in the Perpendicular style, so called for its emphasis on verticality and proliferation of ribs in the vaulting.

a more delicate arcade with twice the number of columns and arches. The upper half of the building is solid, with only a few windows puncturing the plane of the façade. From a distance the Doges' Palace may seem top-heavy, but the delicately patterned brickwork—visible from a closer perspective—has the effect of dematerializing the surfaces, almost like bits of daubed color in an Impressionist painting (see **Chapter 18**).

Cathedral Architecture

Architects who designed cathedrals outside of Italy in the 14th century continued to embrace the lessons of French Gothic architecture. Nave walls continued to aspire to the great heights made possible by elaborate fan vaulting. The upward striving and extreme vertical emphasis in English cathedral architecture became known as the **Perpendicular style**. The choir of Gloucester Cathedral (**Fig. 11.23**) can be described as a harmony of vertical lines of different lengths and widths; the thicker, unbroken lines of the column clusters in the nave elevation culminate in a sprays of "branches" whose thin stalks spread and interweave into a delicate and intricate pattern of stonework that covers the vault and makes it seem weightless.

On the other hand, Gothic architecture never really crossed the Alps into Italy. Although some of the most important Italian buildings of the 14th century may be labeled

Gothic, their style differs markedly from that of their northern counterparts. The cathedral of the city of Florence, Santa Maria del Fiore (better known as the Duomo after the imposing dome that was completed in the 15th century), is weighty,

⌃ 11.24 Cathedral of Santa Maria del Fiore (the Duomo), 1296–1436. Florence, Italy. The Duomo was designed in the Late Medieval period by Arnolfo di Cambio and completed in the Early Renaissance when Filippo Brunelleschi constructed the great dome (although the façade was still being worked on in the 19th century). Giotto, the most famous Florentine painter of the 14th century, designed the freestanding campanile, or bell tower. The baptistery, located in a square across from the entrance of the cathedral, was built between 1059 and 1128; it is famous for relief sculpture on its bronze doors, one set of which was created by Giovanni Pisano.

not ethereal (**Fig. 11.24**). Its outer walls are not occluded by a screen of flying buttresses and do not dissolve into planes of colored glass; the floor plan of the cathedral is clearly visible from the outside. Excepting the dome, the profile of the building is low, horizontal; it does not reach heavenward but rather remains earthbound. The embellishment of the stone surfaces is not carved, for the most part, but consists of geometric patterns of green and white marble. And the bell tower—designed by Giotto—is separate from the façade, unlike the twin towers that are typical of French Gothic architecture and its imitators. When we look at cathedrals such as Notre-Dame or Chartres, the complex structures that surround the exterior, through which we must peer to see the walls, preserve a sense of mystery; the Duomo, with its clear components, has the feeling of rational order. This important difference will impact the nature of Renaissance architecture.

The Cathedral of Santa Maria del Fiore, begun in 1296, would not be completed until 1436. The commission for the massive dome, which has given the cathedral its affectionate moniker (*duomo* means "dome"), went to Filippo Brunelleschi in the opening decades of the 15th century.

A NEW MUSICAL STYLE— ARS NOVA

While Giotto was laying the foundations for a new naturalistic style of painting and writers like Petrarch and Chaucer were breathing fresh life into literary forms, composers in France and Italy were changing the style of music. To some extent this was the result of social changes. Musicians had begun to break away from their traditional role as servants of the church and to establish themselves as independent creative figures; most of the music that survives from the 14th century is secular. Much of it was written for singers and instrumentalists to perform at home for their own pleasure (**Fig. 11.25**) or for the entertainment of aristocratic audiences. The texts composers set to music were increasingly varied—ballads, love poems, even descriptions of contemporary events—in contrast to the religious settings of the preceding century.

As the number of people who enjoyed listening to music and performing it began to grow, so did the range of musical expression. The term generally used to describe the sophis-

ticated musical style of the 14th century is **Ars Nova**, derived from the title of a treatise written by the French composer Philippe de Vitry (1291–1361) ca. 1325. The work was written in Latin and called *Ars nova* (*The New Art*). Although it is really concerned with only one aspect of composition and describes a new system of rhythmic notation, the term *Ars Nova* has taken on a wider use and is applied to the new musical style that began to develop in France in the early 14th century and soon spread to Italy.

The chief characteristic of Ars Nova is a much greater richness and complexity of sound than before. This is partly achieved by the use of richer harmonies; thirds and sixths are increasingly employed and the austere sounds of parallel fifths, unisons, and octaves are generally avoided. Elaborate rhythmic devices are also introduced, including the method of construction called **isorhythm** (from the Greek word *isos*, which means "equal"). Isorhythm consists of allotting a repeated single mel-ody to one of the voices in a **polyphonic** composition. The voice is also assigned a repeating rhythmic pattern. Because the rhythmic pattern is of a different length from the melody, different notes are stressed on each repetition. The purpose of this device is twofold: it creates a richness and variety of texture, and it imparts an element of unity to the piece.

Guillaume de Machaut

The most famous French composer of this period was Guillaume de Machaut (ca. 1304–1377), whose career spanned the worlds of traditional music and the Ars Nova. He was trained as a priest and took holy orders, but much of his time was spent traveling throughout Europe in the service of the kings of Bohemia, Navarre, and France. Toward the end of his life he retired to Reims, where he spent his last years as a

◄ **11.25** Flemish school, *Romance of the Rose*, the Lover and Dame Oyseuse (Lady Idleness) in a garden. Manuscript illumination, 14″ × 10″ (35.6 × 25.4 cm). British Library, London, United Kingdom. In a vision of courtly love, a knight sings to a lady, accompanying himself on a mandolin. The romantic interlude is enhanced by the idyllic surroundings; the serenity of the lush, walled garden is shown punctuated by the sounds of music and the fountain's rushing water.

canon. Is most famous composition, and the most famous piece of music from the 14th century, is the *Messe de Notre Dame*. A four-part setting of the Ordinary of the Mass (discussed shortly), it is remarkable chiefly for the way in which Machaut gives unity to the five sections that make up the work by creating a similarity of mood and even using a single musical motif that recurs throughout.

Machaut's *Messe de Notre Dame* is the first great example of the entire Ordinary of the Mass set to polyphonic music by a single composer. The Ordinary of the Mass refers to those parts of the Roman Catholic liturgy that do not change from day to day, in contrast to the Propers (the readings from the Gospels or Epistles), which do change daily. The parts of the Ordinary are as follows.

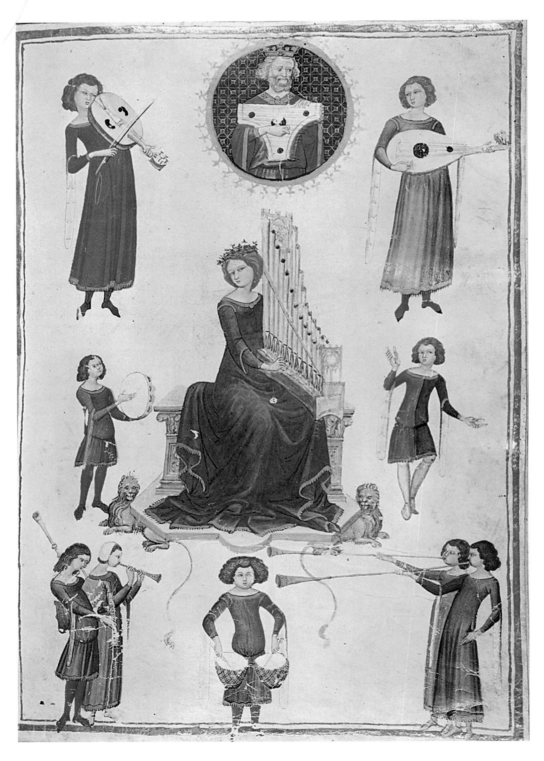

◄ **11.26 Fourteenth-century musicians and instruments, *De musica I*. Manuscript illumination. Biblioteca Nationale, Naples, Italy.** The goddess Music is enthroned in the center, playing a small organ and surrounded by musicians in contemporary dress playing stringed, percussion, and wind instruments. Above, King David of Israel is shown in a in a round inset plucking a psaltery, a stringed instrument in the harp family. The Hebrew book of Psalms—sacred verses recited or sung—was attributed to King David.

1. The **Kyrie Eleison**: the repeated Greek phrases that mean "Lord have mercy on us!" and "Christ have mercy on us!"
2. The **Gloria**: a hymn of praise sung at all masses except funerals and masses during Lent and Advent.
3. The **Credo**: the profession of faith sung after the Gospel.
4. The **Sanctus and Benedictus**: a short hymn based on the angelic praise found in Isaiah 6, sung at the beginning of the Eucharistic prayer.
5. The **Agnus Dei**: the prayer that begins "Lamb of God," sung before Communion.

GO LISTEN! GUILLAUME DE MACHAUT

Messe de Notre Dame, Credo

With the music of Machaut, we begin to approach the main characteristics of Western music. After a single voice has intoned the opening words of the Credo, the other voices enter to provide the elements absent from Gregorian chant and, to a lesser extent, Léonin's organum: **harmony** (the sounding together of several lines or voices in a pleasing arrangement) and a recognizable rhythmic structure. The rhythm is varied and uses melodic motifs as its basis. Although rooted in the principles laid out in Philipe de Vitry's *Ars nova musicae*, the free flow of the Credo is truly novel.

The four voices move simultaneously so that it is easy for the listener to follow the words, which remain clear but are given a new vigor by the freedom of their treatment. In his rhythmic inventiveness and sense of the structural importance of harmony (note the satisfying way in which the listening selection comes to rest at its conclusion), Machaut points the way to the next stage in the development of Western music.

Machaut's Messe de Notre Dame stands at the head of a long tradition of musical composition in which composers use the Ordinary of the Mass to express the timeless words of the liturgy in their own cultural idiom. In that sense Machaut's Mass is the ancestor of the Renaissance compositions of Palestrina in the 16th century, the Baroque masses of Johann Sebastian Bach in the 18th century, and the frenetically eclectic modern Mass of Leonard Bernstein.

Machaut is also one of the earliest musicians to leave a substantial body of secular music, contributing to another great musical tradition: secular song. With the increasing use of polyphony, composers began to turn their attention to the old troubadour songs and write new settings that combined several different voices. Machaut's polyphonic secular songs took several forms. His **ballades** were written for two or three voices, the top voice carrying the melody while the others provided the accompaniment. These lower voices were

probably sometimes played on instruments rather than sung. As in the ballades of earlier times, the poems consisted of three stanzas, each of seven or eight lines with the last one or two lines identical in all the stanzas to provide a refrain.

Many of these secular songs, both by Machaut and by other composers, deal with amorous topics, and they are often addressed to the singer's beloved. The themes are predictable—the sorrow of parting, as in Machaut's "Au dèpartir de vous," reproaches for infidelity, protestations of love, and so on—but the freshness of the melodies and Machaut's constant inventiveness prevent them from seeming artificial.

Francesco Landini

The other important composer of the 14th century was the Italian Francesco Landini (1325–1397), who lived and worked in Florence. Blinded in his youth by smallpox, he was famous in his day as a virtuoso performer on the organ, lute, and flute. Among his surviving works are several **madrigals**, a song for two or three voices unaccompanied by instruments. In addition, he wrote a large number of *ballate* (ballads), including many for solo voice and two accompanying instruments. The vocal lines are often elaborate, and Landini uses rich, sonorous harmonies. But in the case of these and other works of the period, there is no specification of the instruments intended or of the general performance style Landini would have expected (**Fig. 11.26**). We know from contemporary accounts that in some cases performers would have changed the written notes by sharpening or flattening them, following the convention of the day. This practice of making sounds other than those on the page was called **musica ficta** (fictitious music), but no systematic description of the rules followed has been handed down to us. As a result, modern editors and performers often have only their own historical research and instincts to guide them. Although the Ars Nova of the 14th century marks a major development in the history of music, our knowledge of it is far from complete.

The 14th century was a time of stark contrast between the horrors of natural and social disasters and the flowering of artistic and cultural movements that were the harbingers of the 15th-century Renaissance in Italy. Chaucer, as noted, died in 1400, the year that may be taken as the close of the medieval period. By that time, some of the prime figures of the Italian Renaissance—Donatello, Fra Angelico, and Ghiberti—were already in their teens. The great outburst of cultural activity that was to mark Florence in the 15th century was near, even though it would not make a definite impact on England until the end of the century. The "calamitous" 14th century was also the seedbed for rebirth and human renewal.

GLOSSARY

Agnus Dei (p. 369) Latin for "lamb of god."

Ars Nova (p. 367) A 14th-century style of music characterized by freedom and variety of melody, as contrasted with stricter 13th-century music.

Ballade (p. 369) In music, a composition with the romantic or dramatic quality of a narrative poem.

Black Death (p. 342) The epidemic form of the bubonic plague, which killed as much as half the population of Western Europe in the mid-14th century.

Canto (p. 344) A principal division of a long poem.

Canzone (p. 349) A song (plural *canzoni*).

Canzoniere (p. 348) A songbook.

Chiaroscuro (p. 357) An artistic technique in which subtle gradations of value create the illusion of rounded three-dimensional forms in space; also termed *modeling* (from Italian for "light-dark").

Credo (p. 369) The profession of faith sung after the Gospel in the Ordinary of the Mass.

Exemplum (p. 342) In literature, a tale intended as a moral example (plural *exempla*).

Fabliau (p. 342) A medieval tale told in verse and having comic, ribald themes (plural *fabliaux*).

French Gothic style (p. 364) A style of architecture that originated in 12th-century France and is characterized by pointed arches, ribbed vaults, and flying buttresses, which enable the use of ample fenestration.

Gloria (p. 369) A hymn of praise from the Ordinary of the Mass.

Great Schism (p. 340) The division in the Roman Catholic Church during which rival popes reigned at Avignon and Rome.

Harmony (p. 369) In music, a pleasing combination of lines or voices; in art and architecture, a balanced or unified composition arranged in a pleasing manner.

Iambic pentameter (p. 351) A meter in poetry consisting of five feet, each one containing an unaccented syllable followed by an accented syllable.

Isorhythm (p. 367) Alloting a repeated single melody to one of the voices in a composition.

Kyrie Eleison (p. 369) Repeated phrases in the Ordinary of the Mass that translate as "Lord, have mercy on us."

Madrigal (p. 369) A song for two or three voices unaccompanied by instrumental music.

Maestà (p. 358) From the word for "majesty," a work of art that features the Virgin Mary and Christ child enthroned and surrounded by angels and saints.

Modeling (p. 357) In two-dimensional works of art, the creation of the illusion of depth through the use of light and shade (*chiaroscuro*).

Musica ficta (p. 369) Literally "fictitious music"; the practice of making sounds not written on the page of music.

Perpendicular style (p. 365) A form of Gothic architecture developed in England and characterized by extreme vertical emphasis and fan vaulting.

Polyphonic (p. 367) Of a form of musical expression characterized by many voices.

Sanctus and Benedictus (p. 369) A hymn in the Ordinary of the Mass based on the angelic praise found in Isaiah 6.

Sonnet (p. 348) A 14-line poem usually broken into an octave (a group of eight lines) and a sestet (a group of six lines); rhyme schemes can vary.

Tercet (p. 345) A group of three lines of verse; characterized in *The Divine Comedy* by the **terza rima** scheme.

Terza rima (p. 345) A poetic form in which a poem is divided into sets of three lines (**tercets**) with the rhyme scheme *aba*, *bcb*, *cdc*, etc.

Trecento (p. 340) Literally, "300"; the Italian name for the 14th century.

THE BIG PICTURE THE FOURTEENTH CENTURY

Language and Literature

- Dante wrote *The Divine Comedy* ca. 1303.
- Boccaccio wrote the *Decameron*, set in the plague year, ca. 1348–1352.
- Petrarch compiled his collection of poems in the *Canzoniere* after 1350.
- Petrarch wrote his autobiography, "Letter to Posterity," in 1373.
- Chaucer wrote *The Canterbury Tales* ca. 1385–1400.
- Christine de Pisan wrote *The Book of the City of Ladies* in 1404.

Art, Architecture, and Music

- Nicola and Giovanni Pisano, father and son, "created" modern sculpture ca. 1259–1310.
- Secular music flourished in the 14th century.
- The Florentine painter Cimabue broke with Byzantine predecessors as in his *Madonna Enthroned with Angels and Prophets*, ca. 1280–1290.
- The Palazzo Pubblico was constructed in Siena in fortresslike fashion, with a tall tower, in 1288–1309.
- The Cathedral of Santa Maria del Fiore (the Duomo) in Florence was begun in 1296.
- Giotto painted the Arena Chapel frescoes, which displayed his ability to represent three-dimensional figures in a two-dimensional medium, ca. 1305.
- Giotto brought a new realism to painting, as can be seen in a comparison of his Madonna Enthroned (ca. 1310) to that of Cimabue.
- Duccio painted his multipanel altarpiece featuring the Virgin and Child with angels and saints in 1308–1311.
- Vitry penned *Ars nova musicae*, describing a new system of musical notation, ca. 1325.
- The Gloucester Cathedral choir was built in the Perpendicular Style in 1332–1357.
- Martini painted in the International Style—the final development of Gothic art—in 1333.
- Machaut composed his polyphonic Messe de Notre Dame after 1337.
- Ambrogio Lorenzetti applied Giotto's innovations in their allegory on good government for Siena's Palazzo Pubblico in 1338–1339.
- The Doges' Palace was constructed in Venice ca. 1345–1438.
- Landini composed madrigals and ballades in Florence ca. 1350.

Philosophy and Religion

- Pope Boniface VIII proclaimed the first Jubilee year ("Holy Year") in 1300.
- The captivity of the papacy in Avignon began in 1309.
- Saint Catherine of Siena urged an end of the Babylonian Captivity of the pope ca. 1370.
- The papacy returned from Avignon to Rome in 1376.
- The Great Schism of the Roman Catholic Church began in 1378.

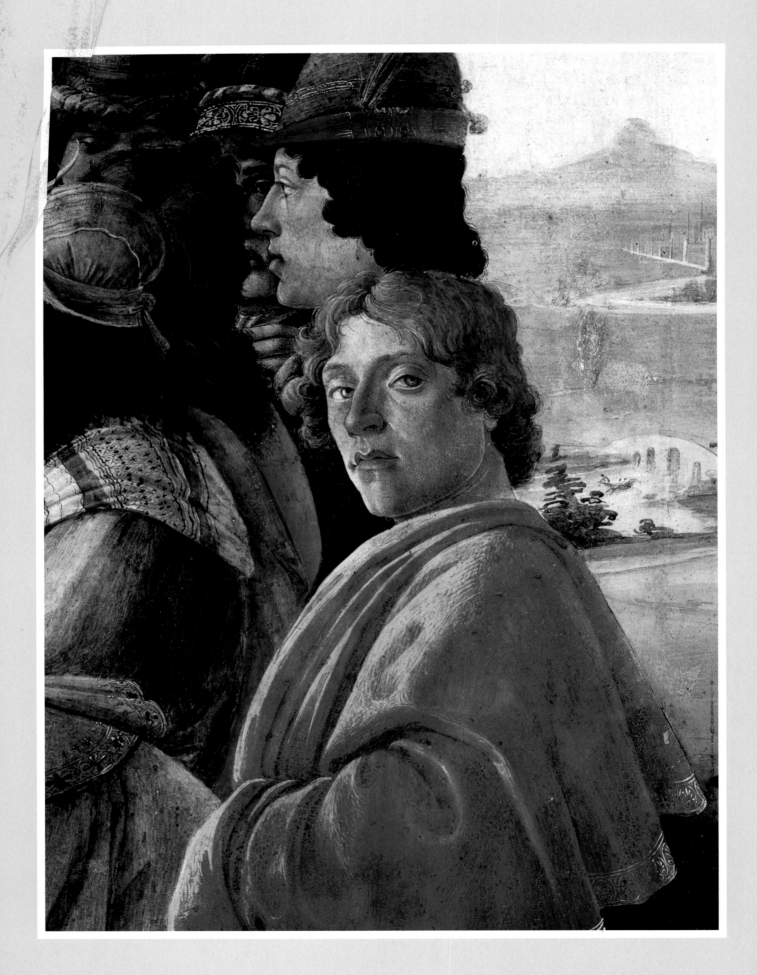

The Fifteenth Century

12

PREVIEW

Lorenzo de' Medici and Alessandro Filipepi—a prince and a pauper—were born within five years of each other in the middle of the 15th century. One to the manor born and the other on the backstreets, their paths may never have crossed except for fortuitous timing. The city of Florence, the crucible of the Renaissance, was in the midst of its most glorious historical moment. Lorenzo de' Medici, who would be called "the Magnificent," was the grandson of the man who founded the Medici political dynasty in the Republic of Florence and was called "Cosimo, Pater Patriae"—the Father of the Nation. Alessandro Filipepi, who would be called Botticelli, was the son of a tanner. Medici, whose wealth was immense and who patronized the arts and letters unstintingly, would gather around him in a tight circle the most talented and influential humanists of his day. Not only would Botticelli become one of them, he would also become one of Medici's closest and most trusted friends.

By 1475, the date that scholars roughly assign to Botticelli's *Adoration of the Magi* (see Fig. 12.29), the painter had already established himself in the Medici court, as evidenced by the family portraits that appear in that scene. The artist and historian Giorgio Vasari (1511–1574) praises the technique and verisimilitude with which Botticelli depicts them; included among them are Cosimo, who kneels closest to the Madonna and child; his son, Piero (father of Lorenzo), in a red cape, who genuflects in the center foreground; and Piero's sons Lorenzo and Giuliano, to the far left, who focus not on the religious scene but on the words of the famous Renaissance philosopher Giovanni Pico della Mirandola, shown in a red cap. In the *Adoration of the Magi*, Botticelli pays homage to the beneficence of the Medici—who saw themselves as kings and princes—and codifies the reconciliation of Christian belief and humanist thought that marked the discourse of Medici Florence. Botticelli was at the center of it all. In this painting, however, he places himself discreetly to the far right in what scholars believe may be a self-portrait (Fig. 12.1). Dressed not in finery but in a simple ochre cloak, he looks directly at us. Once a son of the poor working class, he moves in the company of princes, his head held high, his confidence and self-worth assured.

◄ **12.1 Sandro Botticelli, *Adoration of the Magi*, ca. 1475, detail showing self-portrait. Galleria degli Uffizi, Florence, Italy.**

TOWARD THE RENAISSANCE

The 14th century was a period of social strife and political turmoil—as well as a time of new stirrings in Europe. It was the century of Dante, Petrarch, Boccaccio, and Chaucer, and the birth of humanism. In art, the long-cherished Byzantine style was challenged by the new naturalism of Cimabue and Giotto in Florence and Duccio and the Lorenzetti brothers in Siena. A new focus on the natural world—the world that is visible—had its roots in the teaching of Saint Francis of Assisi, whose worship of God began with the contemplation of beauty in the world and its creatures.

In the 15th century, Europe's recovery in the aftermath of the plague that had struck ca. 1348 was aided by political changes and new economic developments. A class of wealthy families emerged, whose claim to eminence was based less on noble blood than on the ability to make money through **capitalism**—commercial trade, banking, and monetary-exchange systems. Centers of international trade sprang up in Northern Europe and in Italy; Bruges in Flanders and Florence in Italy emerged as two of the wealthiest cities. With capitalism came prosperity, and with prosperity came patronage.

The interconnected nature of European finance in the 15th century is encapsulated in the story of Jan van Eyck's double portrait *Giovanni Arnolfini and His Wife* (**Fig. 12.2**). Arnolfini was an Italian financier working in Bruges on behalf of the powerful Medici family of Florence, and a man who was prosperous enough to afford to commission a painting from an internationally famous artist. The purpose of the painting is not known for certain; it may have been intended to document the exchange of marriage vows between the couple or, as scholars have recently suggested, represent the transference of legal rights from Arnolfini to his wife to act on his behalf during his absence. Witnesses to the transaction, one of whom is probably the artist himself, are seen in the reflection in the convex mirror that hangs on the wall behind the couple. Van Eyck signed the painting (as one might a legal document) in what appears as an inscription above the framed circular mirror: *Johannes van Eyck fuit hic* (Latin for "Jan van Eyck was here"). The signature also asserts van Eyck's self-importance as an artist; pride and ownership of one's accomplishments, and the acknowledgement of fame, are new notions associated with Renaissance thought.

The Arnolfini portrait not only carries sociological meaning, it also shows us something of what was important to Northern European artists in the 15th century. The subject is a secular one, and as prosperity grew in the merchant class there was more of a demand for secular work alongside religious paintings; meticulous realism and symbolism were characteristic of both genres. The extraordinary

The Fifteenth Century

1400 CE	1434 CE	1494 CE	1520 CE
15th century Florence is the center of the European banking system	Cosimo de' Medici becomes de facto ruler of Florence	Medici faction goes into exile; Savonarola becomes de facto ruler of Florence; Charles VIII of France invades Italy	
Council of Constance ends Great Schism	The printing press is invented	Vasco da Gama begins first voyage to India	
Florentines defeat the Sienese at San Romano	Constantinople falls to the Turks; scholarly refugees bring Greek manuscripts to Florence	Savonarola is burned at the stake	
	The Hundred Years' War ends	Medici power is restored in Florence	
	Piero de' Medici takes power in Florence after the death of Cosimo	Machiavelli is exiled	
	Lorenzo de' Medici rules Florence after the death of Piero		
	Spain is united under Ferdinand and Isabella		
	Pazzi conspiracy against the Medici fails		
	The Spanish Inquisition begins		
	Savonarola begins sermons against Florentine immorality		
	Lorenzo de' Medici dies		
	Christopher Columbus sets sail to find a western passage to India		

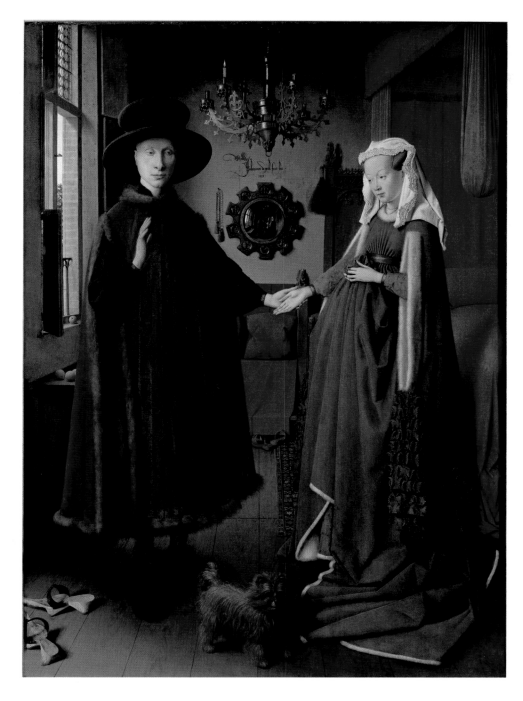

◀ **12.2** Jan van Eyck, *Giovanni Arnolfini and His Wife*, 1434. Oil on wood, 33″ × 22½″(81.3 × 59.7 cm). **National Gallery, London, United Kingdom.** In a Flemish painting, ordinary objects are often invested with symbolic meaning. In the Arnolfini portrait, which represents a sacred vow, the tiny dog symbolizes fidelity (Fido is a name that captures the loyalty of "man's best friend"), the stockinged feet symbolize the holy ground on which the marriage takes place, and the green of the bride's dress is associated with fertility.

detail of which Northern European artists were fond reveals much about contemporary life, its customs, fashions, and environs. Whatever the purpose of the Arnolfini portrait, we are offered a glimpse of a 15th-century Flemish interior and what the best-dressed men and women in Bruges were wearing at the time. The painting is replete with ordinary objects that carry meaningful symbolism: the small dog represents fidelity; the oranges by the windowsill and the green of the bride's apparel, fertility; and the chandelier with its single candle, the unity of a man and woman in marriage. In religious art as well, objects that might appear usual fare for secular paintings are invested with complex symbolism. We should assume that everything in a Northern European painting is there for a purpose and carries some sort of allusion or meaning.

Late Medieval and Early Renaissance Art in Northern Europe

A glimpse at a map of Europe in the 15th century (see **Map 12.1**) shows the territory of the Holy Roman Empire stretching

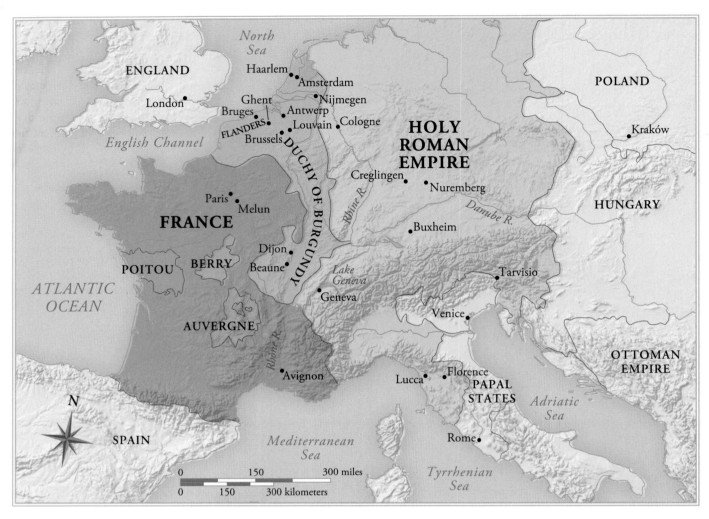

▲ **MAP 12.1. Europe in the mid-fifteenth century with France, the duchy of Burgundy, and the Holy Roman Empire.**

from the North Sea into parts of Italy, and the region of France with various territories controlled by dukes. The largest and most powerful of these territories, created by the political instability of the Hundred Years' War, was the duchy of Burgundy. The region of Burgundy bordering on the North Sea was called Flanders (art and culture from this region is called *Flemish*), and its most prosperous cities were Bruges, Ghent, Brussels, and Antwerp.

BURGUNDY AND FRANCE The Duke of Burgundy, Philip the Bold (reigned 1363–1404) was an important patron of the arts, and the cities of Dijon (in present-day France) and Bruges (in present-day Belgium) are associated with his court and his patronage. His brother John, the duc de Berry, was also an important patron of artists working in Paris and Bourges.

Claus Sluter At Dijon, Philip the Bold financed the construction of the Chartreuse de Champmol, a monastery that was also to be the burial site of the dukes of Burgundy. The cloister of the monastery featured the *Well of Moses*

(**Fig. 12.3**)—the source of water for the monks—by Claus Sluter (active ca. 1380–1406), the artist appointed to oversee the entire sculptural program for the monastery. The piece was imposing and elaborate, although not all of it survives. Six statues of Old Testament prophets (Moses, David, Daniel, Isaiah, Jeremiah, and Zachariah) encircle a base that served as a platform for a crucifixion group including Christ, the Virgin Mary, Saint John the Evangelist, and Mary Magdalene. Between the prophets and the heavy cornice at the top of the base are four weeping angels, their wings spread and touching, creating a continuous decorative band. At first glance, the style of the figures may seem reminiscent of sculpture on portals of French Gothic cathedrals, but a closer look reveals a significant departure from stylization. There is much variety in the costumes of Sluter's prophets; while each has distinctive characteristics, all have a sense of weight and mass beneath their drapery. In the figure of Moses the contrasting textures of the heavy cloth, the coarse, flowing beard, and the wrinkled face are differentiated skillfully, and the expression has the vividness of a

portrait. Some traces of pigment remain on the figures (it is possible to see tinges of blue here and there) that no doubt added to their realism.

Limbourg Brothers Philip the Bold's brother, John the duc de Berry, commissioned what may be the most famous illuminated manuscript in the history of art, from the Limbourg brothers, who were born in the Netherlands but worked in France—*Les Très riches heures du duc de Berry* (*The Very Sumptuous Hours of the duc de Berry*). Books of

hours, used by nobility as prayer books, included psalms, litanies, and liturgical passages that were to be recited at certain hours of the day. They also featured calendars of religious feast days; in the *Très riches heures*, these calendar pages are richly embellished with finely detailed scenes of activities and tasks associated with certain months and seasons of the year—from the ordinary to the splendid. In May (**Fig. 12.4**) we witness a parade of aristocratic gentlemen and ladies who have come in their colorful, bejeweled costumes hues to celebrate the first day of May. Complete

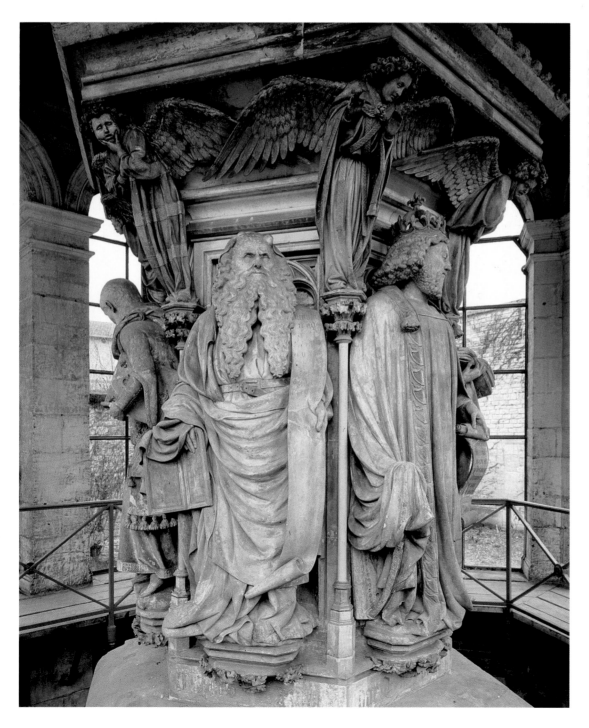

◄ **12.3** Claus Sluter, *The Well of Moses*, 1395–1406. Limestone, painted and gilded by Jean Malouel, Moses 72″ (180 cm) high. Chartreuse de Champmol, Dijon, France. Monumental figures are clustered to form a pedestal for a much larger work that included the crucified Christ, Virgin Mary, Saint John, and Mary Magdalene.

with glittering regalia and festive song, the entourage romps through a woodland clearing on carousel-like horses. In the background looms the medieval palace of the Louvre—remnants of which can be seen today under the present-day Louvre Museum in Paris. On the page representing February (**Fig. 12.5**), peasant women gather to warm themselves by a roaring fire in a small cottage while nearby, sheep too huddle against the elements. A young girl in a pink dress and a shawl, bracing against the cold, stumbles through the snow toward home, her icy breath hanging in the air; a man and a donkey trudge up a snow-laden hillside toward the frozen village in the far distance. Each of the calendar pages features a rectangular painted scene of this sort, on top of which is a semicircular *lunette* with Zodiac signs associated with the particular month. The illustration for February shows Aquarius and Pisces; May shows Aries and Taurus.

Although these calendar pages illustrated a holy book, the themes were secular; the *Très riches heures* is another example of the melding of religious and secular matters in Northern Europe that would find its richest expression in Flemish art.

FLANDERS Johan Huizinga, the modern cultural historian, wrote, "All [Flemish] life was saturated with religion to such an extent that the people were in constant danger of losing sight of the distinction between things spiritual and things temporal." In painting, this distinction was a particularly narrow one, as artists filled their compositions with objects that had symbolic significance—just as van Eyck had in his portrait *Giovanni Arnolfini and His Wife*. Chances are that museumgoers today might not be able to decipher all of the meaning behind ordinary objects in Flemish paintings. Yet they can enjoy the warm feeling of being invited into someone's home and be all the more enriched knowing that there is something more there than meets the eye.

The overwhelming realism of Flemish religious painting results from several factors: the situating of religious

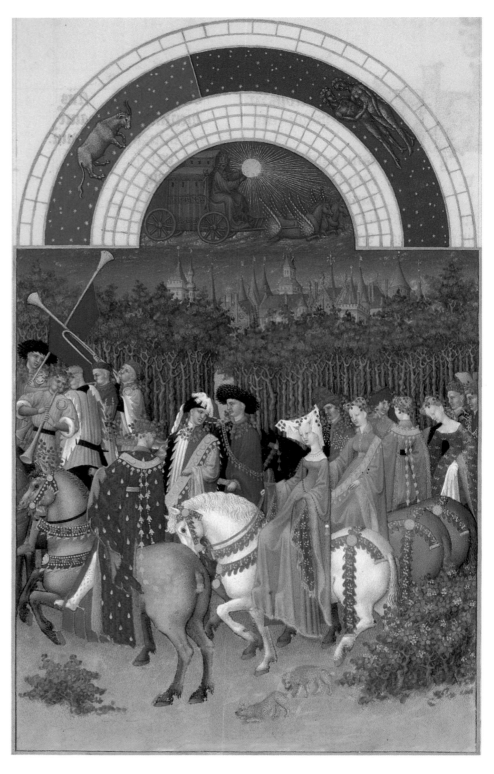

▲ **12.4** Limbourg brothers (Pol, Herman, and Jean), *May*, from *Les Très riches heures du duc de Berry*, 1413–1416. Colors from minerals, plants, or chemicals and ink on vellum, 8 7/8″ × 5 1/8″ (22 × 14 cm). Musée Condé, Chantilly, France. Books of hours were prayer books with liturgical passages that were to be recited at certain times of the day. The exquisite paintings in this book illustrate scenes and tasks connected with months of the calendar year, along with their astrological signs.

narratives in commonplace, secular environments; detailed portrait likenesses and the use of real models for the faces of religious figures; the expression of human emotion; and the illusionistic rendering of textures and surfaces. The finely wrought detail in Flemish paintings was made possible by the development of oil painting, which allowed for controlled, meticulous brushwork and brilliant, enamel-like colors.

Robert Campin, the Master of Flémalle

The character of Flemish painting—including its pervasive use of symbolism—is well represented in the Mérode altarpiece (**Fig. 12.6**) by Robert Campin, also known as the Master of Flémalle (ca. 1378–1444). The central panel of the three-panel altarpiece (called a triptych) features the subject of the Annunciation. The archangel Gabriel has just alighted, bringing the news to the Virgin Mary that she will bear a son. His wings are still aflutter and Mary not yet aware of his presence. She sits by the fireplace of her comfortable, well-appointed home, reading the bible. The objects in the room are all typical of what might be found in a Flemish household but they are also chosen for their symbolic references: a sprig of lilies signifies purity, as do the gleaming copper kettle in a niche on the back wall, the screened window, and the crisp white linen towels. To the left, a narrower panel contains full-length portraits of the donors of the altarpiece, who are seen kneeling in a garden outside the Virgin's home; the tiny plants and flowers are specifically associated with Mary. To the right of the Annunciation is Saint Joseph in his carpenter's workshop. Jesus's earthly father is building two mousetraps with woodworking tools authentic to the era, ordinary objects symbolizing Christ as the bait with which the devil would be trapped.

The symbolism in the altarpiece is a fascinating web for the observer to untangle and interpret, yet it does not overpower the down-to-earth realism. Flemish religious painting is accessible to the worshipper precisely because the characters can be seen as ordinary people who found themselves in extraordinary circumstances.

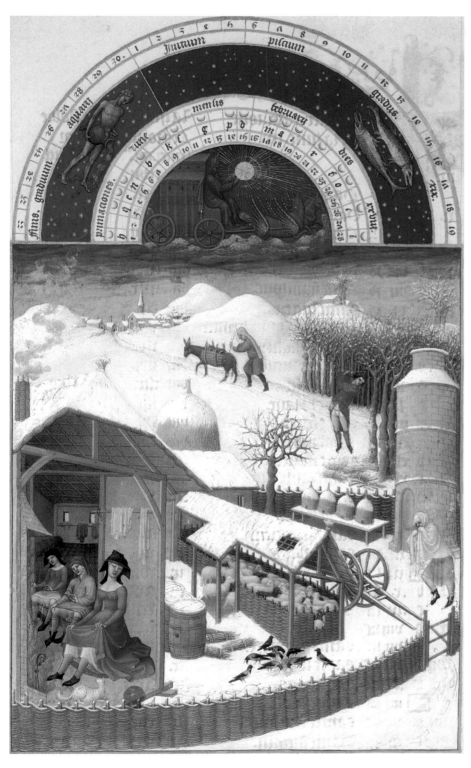

⌃ 12.5 Limbourg brothers (Pol, Herman, and Jean), *February*, from *Les Très riches heures du duc de Berry*, 1413–1416. Colors from minerals, plants, or chemicals and ink on vellum, 8⅞″ × 5⅛″ (22 × 14 cm). Musée Condé, Chantilly, France.

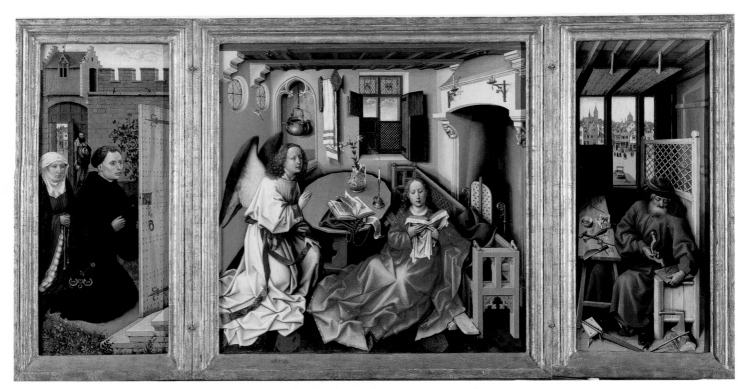

▲ **12.6** Robert Campin (Master of Flémalle), Mérode altarpiece (open), ca. 1428. Oil on wood, center panel 25³⁄₈″ × 24⁷⁄₈″ (64.5 × 63.2 cm), each wing 25³⁄₈″ × 10⁷⁄₈″ (64.5 × 27.6 cm). Metropolitan Museum of Art (The Cloisters Collection), New York, New York. The realistic detail of the scenes in the altarpiece tell us a great deal about the character of the Flemish home in the early 15th century. The interior is arrayed with objects that have symbolic meaning.

Jan van Eyck The painter of the Arnolfini portrait enjoyed a fame unsurpassed in his time and place. Van Eyck worked in the court of Philip the Good, Duke of Burgundy, and received important commissions from wealthy patrons for religious paintings and portraits. The Ghent altarpiece (**Fig. 12.7**) is one of the largest and most spectacular religious paintings of the 15th century in Northern Europe, a **polyptych** that was some 12 feet tall and had multiple panels, some of which could be closed over others. The exterior of the altarpiece (top, right) is divided into two zones: the upper zone features the Annunciation and the lower zone depicts two sculptures of saints bracketed by portraits of the donors of the altarpiece kneeling in prayer. Van Eyck skillfully contrasts the vibrant (living) colors of the donors' clothing with white used for the drapery on all four of the religious figures. Gabriel and the Virgin Mary are painted in warm tones but wear abundant garments whose folds have a chiseled, geometric look. In that sense, they are visually similar to the sculptural figures of John the Baptist and John the Evangelist between the donors. The juxtapositions and connections among these figures are a play on tangible and intangible realities.

When the Ghent altarpiece is fully open (bottom), 12 panels are displayed. In the center, presiding over all, is Jesus, enthroned and wearing a papal tiara. To his right is his mother, the Virgin Mary, resplendent in her crown that honors her as the Queen of Heaven. Saint John the Baptist, in a green cloak, sits at Jesus's left hand; his death was seen as a prefiguration of the sacrifice of Jesus. Below these three figures is a scene that represents the salvation of humankind through Jesus's sacrifice and its ongoing commemoration during the sacrifice of the Holy Mass. Crowds of figures representing the apostles, saints, martyrs, prophets, and others converge on a small altar on which a lamb is standing; a chalice—a golden cup—collects the blood that flows from its chest. The lamb symbolizes Jesus Christ (the Lamb of God) and the chalice with the blood alludes to the wine that is shared in memory of the blood of Jesus that was spilled to fulfill the promise of the salvation of the world. The figures of Adam and Eve on the outermost upper panels remind worshippers of the original sin that necessitated Jesus's sacrifice and also assure them that sinners, however grave their transgressions, can be forgiven.

The extraordinary detail, textural contrasts, and jewel-like colors combine to create a luxurious, glowing surface. Van Eyck represents the epitome of the Flemish artist. With him, Flemish painting reached the height of symbolic realism in both religious and secular subject matter. No one ever quite followed in his footsteps.

Florence and the Renaissance

At the beginning of the 15th century, Florence had every reason to be a proud city. It stood on the main road connecting Rome with the North. Its language—known at the time

as the Tuscan dialect or the Tuscan idiom—was the strongest and most developed of the Italian dialects; its linguistic power had been demonstrated more than a century earlier by Dante Alighieri and his literary successors, Petrarch and Boccaccio. The 12 great *arti* (trade guilds) of Florence were commercially important for the city; in addition, representatives of the seven senior **guilds** formed the body of magistrates that ruled the city from the fortresslike town hall, the Palazzo della Signoria. This "representative" government, limited though it was to the prosperous guilds, preserved Florence from the rise of the city tyrants who plagued so many other Italian cities.

Florence had been one of the centers of the wool trade since the Late Middle Ages. In the 15th century it was also the center of the European banking system. In fact, our modern banks (the word *bank* is from the Italian *banco*, which means "counter" or "table"—the place where money is exchanged) and their systems of handling money are based largely

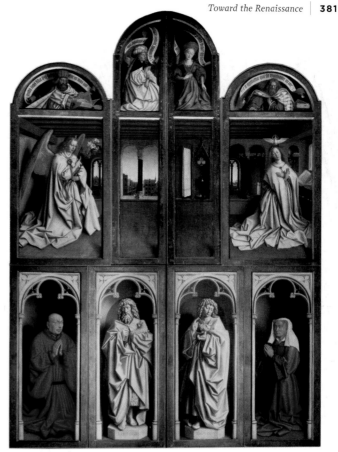

⌄➤ 12.7 Jan van Eyck, Ghent altarpiece, completed 1432. Oil on wood, closed at right, 11′5″ × 7′6″ (347 × 229 cm), open below, 11′5″ × 15′1″ (347 × 460 cm). Saint Bravo Cathedral, Ghent, Belgium. The theme of salvation is the subject of van Eyck's brilliantly conceived and meticulously rendered painting. The figures of Adam and Eve are reminders of the original sin that set into motion the events leading to Christ's sacrifice and resurrection.

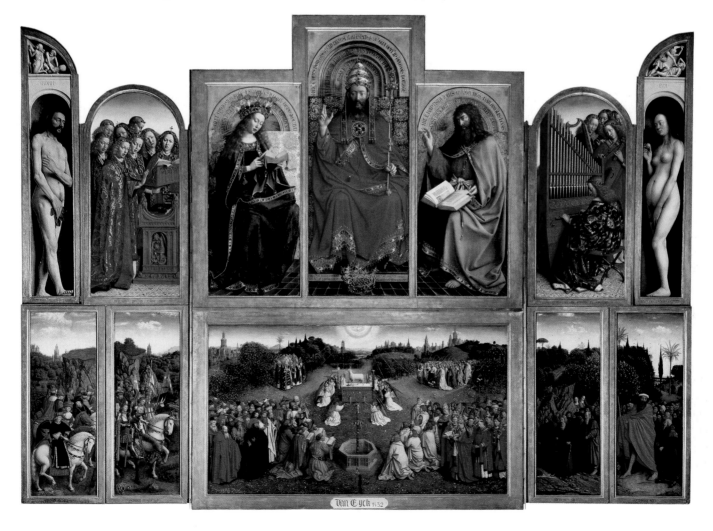

Intellectual Synthesis

It would be a bit misleading to see the Renaissance as a naïve recovery of the Classical past. What actually occurred was a desire for *synthesis*, which is to say, a recovery of the inherited past of Greece and Rome in order to use that recovery for the needs and aspirations of the time. The first step in this synthesis required a study of the past. It is worthwhile noting how extensive that study was. It ranged from the careful observation and measurement of ancient buildings to the close study of archaeological remains from Rome—such as coins, carved gems, and sculpture—to the humanistic work of editing texts, translating them, and providing aids such as dictionaries that would permit this work to continue. The synthesis came when people took what they had recovered from the past (a process called in French *ressourcement*, "going back to the sources") and transformed it to meet the needs of their contemporary situation.

That process of synthesis needs emphasis if one is to understand what happened in, say, 15th-century Florence. Filippo Brunelleschi, the architect of the dome of the Florence Cathedral, did not study Rome's Pantheon to rebuild it but as an exercise in order to better create church architecture. Ficino loved Plato but he thought that in Plato he could explain the Christian faith better than the scholars of an earlier period could. The authors Niccolò Machiavelli and Desiderius Erasmus loved the classics for their own sake, but they also saw in them pragmatic clues that would help in understanding contemporary problems, ranging from how politics ought to be ordered to how church reform might be effected.

If one is to understand the Renaissance, it is crucial to see that the Classical past was not merely ancient history but a source for new and innovative ideas and concepts that addressed real and pertinent issues.

on practices developed by the Florentines. They devised advanced accounting methods, letters of credit, and a system of checks; they were the first to emphasize the importance of a stable monetary system. The gold florin minted in Florence was the standard coin in European commerce for centuries.

Great Florentine banking families made and lost fortunes in trading and banking. These families—the Strozzi, Bardi, Tornabuoni, Pazzi, and Medici—were justly famous in their own time. They, in turn, were justly proud of their wealth and their city. A visitor to Florence today walks on streets named for these families and past palaces built for them. They combined a steady sense of business conservatism with an adventuresome pursuit of wealth and fame. No great Florentine banker would have thought it odd that one of this group began his will with the words "In the name of God and profit. Amen."

For all their renown and wealth, it was not the bankers who really gave Florence its lasting fame. By some mysterious stroke of good fortune, Florence and its immediate surroundings produced, in the 15th century, a group of artists who revolutionized Western art to such an extent that later historians refer to the period as a time of *renaissance* (rebirth) in the arts.

The Medici Era

Florence was governed by representatives of the major trade guilds. This control by a select group of people who wielded commercial power and wealth inevitably led to domination by the wealthiest of the group. From 1434 until 1492, Florence was under the control of one family: the Medici.

The Medici family had old, though until then undistinguished, roots in the countryside around Florence. Their prosperity in the 15th century rested mainly on their immense banking fortune. By the middle of that century, there were Medici branch banks in London, Naples, Cologne, Geneva, Lyons, Basel, Avignon, Bruges, Antwerp, Lübeck, Bologna, Rome, Pisa, and Venice.

COSIMO DE' MEDICI Cosimo de' Medici (de facto ruler of Florence from 1434 to 1464) was an astute banker and a cultivated man of letters. His closest friends were professional humanists, collectors of books, and patrons of the arts. Cosimo spent vast sums on collecting and copying ancient manuscripts. He had his copyists work in a neat cursive hand that would later be the model for the form of letters we call *italic*. His collection of books (together with those added by later members of his family) formed the core of the great humanist collection housed today in the Laurentian Library in Florence.

Although Cosimo never mastered the Greek language, he was intensely interested in Greek philosophy and literature. He financed the chair of Greek at the Studium of Florence (*studium* is a word for a for-profit university established first during the Middle Ages). When Greek prelates visited Florence during the ecumenical council held in 1439 (the council sought a union between the Greek and Latin churches), Cosimo took the opportunity to seek out scholars from Constantinople in the retinue of the prelates. He was particularly struck with the brilliance of Gemistos Plethon (c. 1355–1452), who lectured on Plato. Cosimo persuaded Plethon to remain in the city to continue his lectures.

THE PLATONIC ACADEMY Cosimo's most significant contribution to the advancement of Greek studies was the foundation and endowment of an academy for the study of Plato. For years, Cosimo and his heirs supported a priest, Marsilio Ficino, in order to allow him to translate and comment on the works of Plato. In the course of his long life (he died in 1499), Ficino translated into Latin all of Plato, Plotinus, and other Platonic thinkers. He wrote his own compendium of Platonism called the *Theologia Platonica*. These translations and commentaries had an immense influence on art and intellectual life in Italy and beyond the Alps.

Cosimo often joined his friends at a suburban villa to discuss Plato under the tutelage of Ficino. This elite group embraced Plato's ideas of striving for the ideal good and persistently searching for truth and beauty. This idealism became an important strain in Florentine culture. Ficino managed to combine his study of Plato with his own understanding of Christianity. He coined the term *Platonic love* for the spiritual bond between two people who were joined together in the contemplative search for the true, the good, and the beautiful. Cosimo, a pious man in his own right, found great consolation in this Christian Platonism of Ficino. "Come and join me as soon as you possibly can and be sure to bring with you Plato's treatise *On the Sovereign Good*," Cosimo once wrote his protégé: "There is no pursuit to which I would devote myself more zealously than the pursuit of truth. Come then and bring with you the lyre of Orpheus."

A fiercely patriotic Florentine known to his contemporaries as Pater Patriae (Father of the Nation), Cosimo lavished his funds on art projects to enhance the beauty of the city, at the same time glorifying his family name and atoning for his sins—especially usury (taking interest on money)—by acts of generous charity. He befriended and supported many artists. He was an intimate friend and financial supporter of the greatest Florentine sculptor of the first half of the 15th century, Donato di Niccolò di Betto Bardi (1386–1466), known as Donatello. Donatello was an eccentric genius who cared for little besides his work; it was said that he left his fees in a basket in his studio for the free use of his apprentices or whoever else might be in need.

Cosimo's last years were racked with chronic illness and depression brought on by the premature deaths of his son Giovanni and a favorite grandson, as well as the physical illnesses of another son, Piero. Toward the end of his life, Cosimo's wife once found him in his study with his eyes closed. She asked him why he sat in that fashion. "To get them accustomed to it," he replied. Cosimo de' Medici died on August 1, 1464.

Cosimo's position as head of the family and as first citizen of the city was assumed by his son Piero, called "the Gouty" in reference to the affliction of gout from which he suffered all his life. Piero's control over the city lasted only five years. It was a time beset by much political turmoil but continued artistic activity. Piero continued his father's patronage of the sculptor Donatello and the humanist philosopher Marsilio Ficino, who was at work on a translation

of Plato's works into Latin. Piero also generously supported religious and civic architectural projects in Florence. He died in 1469. His two sons, Lorenzo and Giuliano, succeeded their father as corulers of Florence.

THE PAZZI CONSPIRACY On April 26, 1478, during High Mass at the Cathedral of Florence, Francesco de' Pazzi and Bernardo Bandi attacked Giuliano and Lorenzo de' Medici in front of 10,000 people. Giuliano was killed and Lorenzo managed to escape with a stab wound. The Pazzi family, longtime rivals of the Medici, had designs on replacing them as the rulers of Florence—a coup supported by Pope Sixtus IV in Rome. With Lorenzo alive, their efforts failed; the murderers, Pazzi family coconspirators, and others who were complicit were executed. The mantle of power thus settled on the shoulders of Lorenzo, who accepted the responsibility with pragmatic resignation, saying, "It bodes ill for any wealthy man in Florence who doesn't control political power."

Lorenzo de' Medici ("The Magnificent")

Lorenzo il Magnifico ("the magnificent") ruled Florence until his death in 1492. His accomplishments were so many and varied that the last half of the 15th century in Florence is often called the Laurentian Era.

Lorenzo continued the family tradition of art patronage by supporting various projects and by adding to the Medici collection of ancient gems, other antiquities, and books. He was also more directly involved in the arts. Lorenzo was an accomplished poet, but his reputation as a political and social leader has made us forget that he was an important contributor to the development of vernacular Italian poetry. He continued the sonnet tradition begun by Petrarch. One of his most ambitious projects—done in conscious imitation of Dante's *La vita nuova*—was a long work that alternated his own sonnets with extended prose commentaries; this was the *Commento ad alcuni sonetti d'amore* (*Commentary on Some Love Sonnets*, begun ca. 1476–1477). In addition to this ambitious work, Lorenzo wrote hunting songs, poems for the carnival season, religious poetry, and occasional burlesque poems with a cheerfully bawdy tone.

The poem for which Lorenzo is best known is "The Song of Bacchus." Written in 1490, its opening stanzas echo the old Roman dictum of living for the present because life is short and the future is uncertain (Reading 12.1 on p. 384).

Lorenzo's interests in learning were deep. He had been tutored as a youth by Ficino, and as an adult continued the habit of spending evenings with an elite group of friends (including Ficino). He often took with him his friend the painter Sandro Botticelli, and a young sculptor who worked in a Medici-sponsored sculpture garden, Michelangelo Buonarroti.

The Laurentian patronage of learning was significant and widespread. Lorenzo contributed the funds necessary to rebuild the University of Pisa and designated it the principal

READING 12.1 LORENZO DE' MEDICI

"The Song of Bacchus"

Youth is sweet and well
But doth speed away!
Let who will be gay,
To-morrow, none can tell.
　　Bacchus and his Fair,
Contented with their fate,
Chase both time and care,
Loving soon and late;
High and low estate
With the nymphs at play;
Let who will be gay,
To-morrow, none can tell.
　　Laughing satyres all
Set a hundred snares,
Lovelorn dryads fall
In them unawares:
Glad with wine, in pairs
They dance the hours away:
Let who will be gay,
To-morrow, none can tell.

university of Tuscany (Galileo taught there in the next century). He continued to underwrite the study of Greek at the Studium of Florence.

The Greek faculty at Florence attracted students from all over Europe. This center was a principal means by which Greek learning was exported to the rest of Europe, especially to countries beyond the Alps. English scholars such as Thomas Linacre, John Colet, and William Grocyn came to Florence to study Greek and other Classical disciplines. Linacre was later to gain fame as a physician and founder of the Royal College of Physicians of London. Grocyn returned to England to found the chair of Greek at Oxford. Colet used his training to become a biblical scholar and a founder of Saint Paul's School in London.

The two greatest French humanists of the 16th century, as young men, came under the influence of Greek learning from Italy. Guillaume Budé (died 1540) founded, under the patronage of the French kings, a library at Fontainebleau that was the beginning of the Bibliothèque Nationale of Paris. He also founded the Collège de France, still the most prestigious center of higher learning in France. Jacques Lefèvre d'Étaples also studied in Florence, and became the greatest intellectual church reformer of 16th-century France.

Girolamo Savonarola

The notion that the Renaissance spirit marked a clean break with the Middle Ages must take into account the life and career of the Dominican preacher and reformer Fra Girolamo Savonarola (1452–1498). Savonarola lived at the Convent of San Marco in Florence from 1490 until his execution in 1498. His urgent preaching against the vanities of Florence in general and the degeneracy of its art and culture in particular had an electric effect on the populace. His influence was not limited to the credulous masses or workers in the city. Lorenzo called him to his own deathbed in 1492 to administer the last sacraments, even though Savonarola had been a bitter and open enemy of Medici control over the city. Savonarola, in fact, wanted a restored republic with a strong ethical and theocratic base. Giovanni Pico della Mirandola (1463–1494), one of the most brilliant humanists of the period, turned from his polyglot studies of Greek, Hebrew, Aramaic, and Latin to a devout life under the direction of the friar; only Pico's early death prevented him from joining Savonarola as a friar at San Marco. The humanist painter Botticelli was so impressed by Savonarola that he burned some of his worldlier paintings, and scholars see in his last works a more profound religiosity derived from the contact with the reforming friar. Michelangelo, when an old man in Rome, told a friend that he could still hear the words of Savonarola ringing in his ears.

Savonarola's hold over the Florentine political order (for a brief time he was the de facto ruler of the city) ended in 1498 when he defied papal excommunication and was then strangled and burned in the public square before the Palazzo della Signoria (**Fig. 12.31**). By that time Lorenzo had been dead for six years, and the Medici family had lost power in Florence. They were to return in the next century, but the Golden Age of Lorenzo had ended with a spasm of Medieval piety. The influence of the city and its ideals had, however, already spread far beyond its boundaries.

RENAISSANCE HUMANISM

Jules Michelet, a 19th-century French historian, coined the word *Renaissance* specifically to describe the cultural period of 15th-century Florence. The broad outline of this rebirth is described by the Swiss historian Jakob Burckhardt in his massive *Civilization of the Renaissance in Italy*, published in 1860, a book that remains the foundation for most discussions of the topic. Burckhardt's thesis is simple and persuasive. European culture, he argues, was reborn in the 15th century after a long dormant period that extended from the fall of the Roman Empire until the beginning of the 14th century.

The characteristics of this new birth, Burckhardt says, were first noticeable in Italy and were the building blocks of the modern world. It was in late-14th- and 15th-century Italy that new ideas about the nature of the political order developed—of which the republican government of Florence is an example—as well as the consciousness of the artist as an individual seeking personal fame. This pursuit of glory and fame was in sharp contrast to the self-effacing and world-denying attitude of the Middle Ages. Burckhardt also saw the thirst for Classical learning, the desire to construct a humanism from that learning, and an emphasis on the good life as an intellectual repudiation of Medieval religion and ethics.

Fra Savonarola

This excerpt comes from a sermon by Fra Savonarola to a congregation in the Cathedral of Florence.

Creatures are beautiful insofar as they share in and approach the beauty of the soul. Take two women of like bodily beauty, and if one is holy and the other is evil, you will notice that the holy one is more loved by everyone than the evil one, so all eyes will rest on her.

The same is true of men. A holy man, however deformed bodily, pleases everyone because, no matter how ugly he may be, his holiness shows itself and makes everything he does gracious.

Think how beautiful the Virgin was, who was so holy. She shines forth in all she does. Saint Thomas [Aquinas] says that no one who saw her ever looked on her with evil desire, so evident was her sanctity.

But now think of the saints as they are painted in the churches of the city. Young men go about saying "This is the Magdalen and that is Saint John," and only because the paintings in the church are modeled on them. This is a terrible thing because the things of God are undervalued.

You fill the churches with your own vanity.

Do you think that the Virgin Mary went about dressed as she is shown in paintings? I tell you she went about dressed like a poor person with simplicity and her face so covered that it was hardly seen. The same is true of Saint Elizabeth.

You would do well to destroy pictures so unsuitably conceived. You make the Virgin Mary look like a whore. How the worship of God is mocked!

Burckhardt's ideas have provoked strong reactions from historians and scholars, many of whom reject his theory as simplistic. Charles Homer Haskins, an American scholar, attacked Burckhardt's ideas in 1927 in a book whose title gives away his line of argument: *The Renaissance of the Twelfth Century*. Haskins points out that everything Burckhardt says about Florentine life in the 15th century could be said with equal justification about Paris in the 12th century. Scholars have also spoken of a Carolingian Renaissance identified with the court of Emperor Charlemagne.

Something new was happening in the intellectual and cultural life of 15th-century Italy, and contemporaries were conscious of it. "May every thoughtful spirit thank God that it has been given to him to be born in this new age, so filled with hope and promise, which already enjoys a greater array of gifted persons than the world has seen in the past thousand years," wrote Matteo Palmieri, a Florentine businessman, in 1436. Yet this "new age" of which Palmieri spoke did not spring up overnight. Its roots must be traced to Italy's long tradition of lay learning, the Franciscan movement of the 13th century, the relative absence of feudalism in Italy, and the long maintenance of Italian city life. In short, something new was happening precisely because Italy's long historical antecedents permitted it.

The question remains, however: what was new in the Renaissance? The Renaissance was surely more than a change in artistic taste or an advance in technological artistic skill. We need to go deeper. What motivated the shift in artistic taste? What fueled the personal energy that produced artistic innovation? What caused flocks of foreign scholars to cross the Alps to study in Florence and in other centers where they could absorb the new learning?

The answer to these questions, briefly, is this: There arose in Italy, as early as the time of Petrarch (1304–1374) but

clearly in the 15th century, a strong conviction that humanist learning not only would ennoble and perfect the individual but could also serve as a powerful instrument for social and religious reform. Very few Renaissance humanists denied the need for God's grace, but all felt that human intellectual effort should be the first concern of anyone who wished truly to advance the good of self or society. The career of Pico della Mirandola, one of the most brilliant and gifted Florentine humanist scholars, illustrates this humanist belief.

Giovanni Pico della Mirandola

Giovanni Pico della Mirandola was an intimate friend of Lorenzo de' Medici and a companion of the Platonic scholar Marsilio Ficino. Precociously brilliant, Pico was deeply involved with the intellectual life of his day. He once bragged, not totally implausibly, that he had read every book in Italy.

Pico was convinced that all human learning could be synthesized in such a way as to yield basic and elementary truths. To demonstrate this, he set out to master all the systems of knowledge that then existed. He thoroughly mastered the Latin and Greek classics. He studied medieval Aristotelianism at the University of Paris and learned Arabic and the Islamic tradition. He was the first Christian in his day to take an active interest in Hebrew culture; he learned Hebrew and Aramaic and studied the **Talmud** with Jewish scholars. At the age of 20, Pico proposed to defend at Rome his 900 *theses* (intellectual propositions), which he claimed summed up all current learning and speculation. Church leaders attacked some of his propositions as unorthodox; Pico left Rome and the debate was never held.

The preface to these theses, called the *Oration on the Dignity of Man* (1486), has often been cited as the first and

most important document of Renaissance humanism. The following reading from the introduction to the *Oration* argues that humans stand at the apex of the world in such a way such as to create the link between the world of God and that of the creation, thereby expressing the core of Renaissance humanism.

READING 12.2 GIOVANNI PICO DELLA MIRANDOLA

From *Oration on the Dignity of Man*, introduction

1. I have read in the records of the Arabians, reverend Fathers, that Abdala the Saracen, when questioned as to what on this stage of the world, as it were, could be seen most worthy of wonder, replied: "There is nothing to be seen more wonderful than man." In agreement with this opinion is the saying of Hermes Trismegistus: "A great miracle, Asclepius, is man." But when I weighed the reason for these maxims, the many grounds for the excellence of human nature reported by many men failed to satisfy me—that man is the intermediary between creatures, the intimate of the gods, the king of the lower beings, by the acuteness of his senses, by the discernment of his reason, and by the light of his intelligence the interpreter of nature, the interval between fixed eternity and fleeting time, and (as the Persians say), the bond, nay, rather, the marriage song of the world, on David's testimony but little lower than the angels. Admittedly great though these reasons be, they are not the principal grounds, that is, those which may rightfully claim for themselves the privilege of the highest admiration. For why should we not admire more the angels themselves and the blessed choirs of heaven? At last it seems to me I have come to understand why man is the most fortunate of creatures and consequently worthy of all admiration and what precisely is that rank which is his lot in the universal chain of Being—a rank to be envied not only by brutes but even by the stars and by minds beyond this world. It is a matter past faith and a wondrous one. Why should it not be? For it is on this very account that man is rightly called and judged a great miracle and a wonderful creature indeed.

Pico brings his wide learning to bear on this fundamental proposition: humanity is a great miracle. He not only calls on the traditional biblical and Classical sources but also cites, from his immense reading, the opinions of the great writers of the Jewish, Arabic, and Neo-Platonic traditions. The enthusiasm of the youthful Pico for his subject is as apparent as his desire to display his learning.

Even so, some scholars disagree on Pico's originality as a thinker and argue that his writings are a hodgepodge of knowledge without any genuine synthesis. There is no disagreement, however, about Pico's immense ability as a student of languages and culture to open new fields of study and, in that way, contribute much to the enthusiasm for

learning in his own day. His reputation attracted students. The most influential of these was a German named Johannes Reuchlin (1455–1522), who came to Florence to study Hebrew with Pico. After mastering that language and Greek as well, Reuchlin went back to Germany to pursue his studies and to apply them to biblical scholarship. In the early 16th century he came under the influence of Martin Luther (see Chapter 14) but he never joined the Reformation. Reuchlin passionately defended the legitimacy of biblical studies oriented to the original languages. When his approach was attacked in one of those periodic outbursts of anti-Semitism so characteristic of European culture of the time, Reuchlin, true to his humanist impulses, not only defended his studies as a true instrument of religious reform but also made an impassioned plea for toleration that was *not* characteristic of the time.

A High-Tech Revolution: The Export of Humanist Learning

We take for granted the technology that goes into printing the books that we hold in our hands, but before the invention of the printing press, they would have been handwritten and would have cost the equivalent of thousands of dollars apiece. Very few could afford them—or even copy them.

It was Johannes Gutenberg who published the first printed Bible, in 1454 in Mainz, Germany (**Figs. 12.8** and

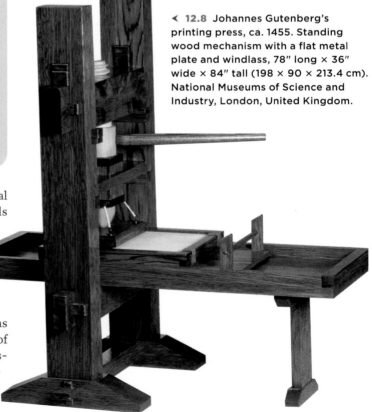

◄ **12.8** Johannes Gutenberg's printing press, ca. 1455. Standing wood mechanism with a flat metal plate and windlass, 78" long × 36" wide × 84" tall (198 × 90 × 213.4 cm). National Museums of Science and Industry, London, United Kingdom.

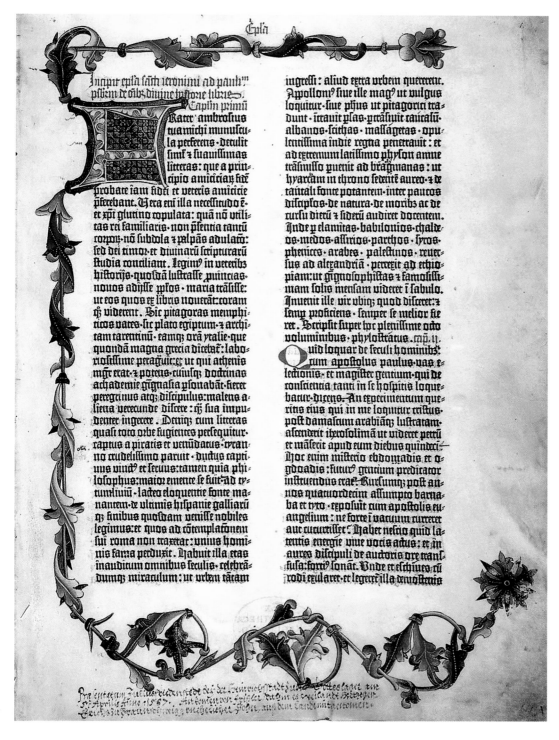

◄ **12.9** Page from the *Biblia latina* (Latin Bible), Johann Gutenberg, printer, Mainz, Germany, 1455. Oil-based ink on vellum, 17″ × 12″ (43.2 × 30.5 cm). Otto Vollbehr Collection, Rare Book and Special Collections Division, Library of Congress, Washington, DC. The Gutenberg Bible was the first major book to be printed using a moveable-type press. Only 48 copies have survived, one of which is in the Library of Congress.

12.9). He produced about 145 copies of the Latin Vulgate Bible on paper and another 35 copies on much more expensive parchment, made of animal skin. Each page had 42 lines of print. Not all the work was done by his workshop: Gutenberg printed the pages; another workshop colored in the initial letters and made the illuminations, and a third workshop did the binding. His Bibles appeared in two volumes and, by modern standards, were enormous. Those printed on paper weigh about 30 pounds, while the **vellum** (animal skin) or parchment Bibles weigh close to 50 pounds.

About 48 copies of that original printing have survived, although many single pages remain extant. Those Bibles were not meant for private use. They were "pulpit Bibles," meant to be read from a lectern (reading desk) either during church services or in religious houses of monks or nuns. A few were purchased for the private collections of the nobility.

Gutenberg's invention of moveable type coincided with the emerging technology of papermaking. Muslims had learned papermaking from their contacts with China, where paper was invented. The first European paper mill was

founded in the early 12th century near Valencia in Spain, and by around 1400 papermaking became common in parts of Italy and Germany. Paper made woodblock prints possible, but later in the 15th century Gutenberg took advantage of its availability for the printing of books. As that technology improved, reading became democratized as the production of books, pamphlets, and broadsheets brought them within the economic reach of vast numbers of people.

As with computers and word processing today, the costs dropped dramatically, making books more accessible to the educated classes. The most famous humanist printer and publisher of the fifteenth century was Aldus Manutius (1449–1515), whose Aldine Press was in Venice, his native city. Manutius was a scholar in his own right; he learned Greek from refugee scholars who settled in Venice after the fall of Constantinople in 1453. Recognizing the need for competent and reliable editions of the Classical authors, he employed professional humanists to collate and correct manuscripts. Erasmus, the greatest of the Northern European humanists, was, for a time, in his employ.

Manutius was also a technical innovator. He designed fonts for Greek and italics modeled after the scribal hand used for copying Florentine manuscripts, developed new inks, and obtained new paper from the nearby town of Fabriano, still today a source of fine papers for artists and printmakers. His books were nearly pocket size, portable and inexpensive.

The scope of the Aldine Press's activities was wide: after 1494, Manutius (and later his son) published, in about 20 years, the complete works of Aristotle and the works of Plato, Pindar, Herodotus, Sophocles, Aristophanes, Xenophon, and Demosthenes. Manutius reissued the Latin classics in better editions and published vernacular writers like Dante and Petrarch as well as contemporary poets like Poliziano, a Florentine friend of Lorenzo de' Medici.

The Aldine Press was not an isolated phenomenon. Germany, where Western printing started, already had an active printing and publishing tradition. Johannes Gutenberg (ca. 1395–1468) originated the method of printing from movable type that continued to be used with virtually no change until the late 19th century. Gutenberg finished printing a Bible at Mainz in 1454–1456. The first book printed in English, *The Recuyell* [collection] *of the Historyes of Troye*, was published by William Caxton in 1475. Historians have estimated that before 1500, European presses produced between six and nine million books in 13,000 different editions. Nearly 50,000 of these books survive in libraries throughout the world.

This conjunction of pride in humanist learning and technology of printing had profound consequences for European cultures. It permitted the wide diffusion of ideas to large numbers of people in a relatively short time. There is no doubt that vigorous intellectual movements—one thinks immediately of the Protestant Reformation—benefited immensely from printing. This communications revolution was as important for the Renaissance period as radio, film, television, and the Internet have been for our own.

READING 12.3 LAURA CERETA

From Letter to Bibulus Sempronius: A Defense of the Liberal Education of Women

My ears are wearied by your carping. You brashly and publicly not merely wonder but indeed lament that I am said to possess as fine a mind as nature ever bestowed upon the most learned man. You seem to think that so learned a woman has scarcely before been seen in the world. You are wrong on both counts, Sempronius, and have clearly strayed from the path of truth and disseminate falsehood. I agree that you should be grieved, indeed, you should be ashamed, for you have ceased to be a living man, but have become an animated stone; having rejected the studies which make men wise, you rot in torpid leisure. Not nature but your own soul has betrayed you, deserting virtue for the easy path of sin.

. . .

Only the question of the rarity of outstanding women remains to be addressed. The explanation is clear: women have been able by nature to be exceptional, but have chosen lesser goals. For some women are concerned with parting their hair correctly, adorning themselves with lovely dresses, or decorating their fingers with pearls and other gems. Others delight in mouthing carefully composed phrases, indulging in dancing, or managing spoiled puppies. Still others wish to gaze at lavish banquet tables, to rest in sleep, or, standing at mirrors, to smear their lovely faces. But those in whom a deeper integrity yearns for virtue, restrain from the start their youthful souls, reflect on higher things, harden the body with sobriety and trials, and curb their tongues, open their ears, compose their thoughts in wakeful hours, their minds in contemplation, to letters bonded to righteousness. For knowledge is not given as a gift, but [is gained] with diligence. The free mind, not shirking effort, always soars zealously toward the good, and the desire to know grows ever more wide and deep. It is because of no special holiness, therefore, that we [women] are rewarded by God the Giver with the gift of exceptional talent. Nature has generously lavished its gifts upon all people, opening to all the doors of choice through which reason sends envoys to the will, from which they learn and convey its desires. The will must choose to exercise the gift of reason.

Excerpt by Laura Cereta from *Her Immaculate Hand: Selected Works by and about the Women Humanists of Quattrocento Italy*, by Margaret L. King and Albert Rabil (Eds.), Second Revised Edition. © 1997 Pegasus Press, Asheville, NC 28803. Used with permission.

Women and the Renaissance in the 15th Century

As Europe engaged in its transition from feudalism to capitalism, the roles of women—noblewomen, in particular—changed, but not necessarily for the better. Joan Kelly-Gadol, in her essay "Did Women Have a Renaissance?," concludes that "all the advances of Renaissance Italy, its proto-capitalist economy, its states, and its humanistic culture, worked to mold the noblewoman into an aesthetic object; decorous, chaste, and doubly dependent—on her husband as well as the prince." Art historian Wendy Slatkin notes that the design of the Renaissance palazzo—a splendid building such as a palace or a museum—with (see **Fig. 12.34**), its interior courtyard closed off from the life of the city, separated the public from the private sphere and confined women within the nuclear family.

Humanism in the 15th century, however, brought with it an emphasis on knowledge and formal education, maintaining that these should be the privilege of women as much as they were of men. Thus it was possible for a young woman from a noble family to study Latin, philosophy, Classical literature, geometry, and other subjects previously available only to men. Slatkin notes that some women, who were educated in the humanist tradition, wound up writing spirited defenses of the intellectual capabilities of their gender. These were typically directed toward men, although they also found themselves arguing against female peers who thought that they had gone too far in assuming the mantle of scholar or writer or artist. In addition to opportunities for formal study, noblewomen had access to texts (as did literate men), made possible by the invention of the printing press and moveable type. Still, literacy was far from universal, and humanist writings by women uniformly reflect an upper-class culture.

Anthologies of texts by women humanists in Italy demonstrate that most came from the more illustrious families of the time. Ippolita Maria Sforza (1446–1484) was educated in the palace school established by her father, the Duke of Milan. As a teenager, she delivered an oration before the Renaissance humanist Pope Pius II. When she married Duke Alfonso of Calabria, son of the king of Sicily, her trousseau included 12 books, among them works by Cicero; and we are told that on the journey from her native Milan to her husband's home in Sicily, she stopped to buy manuscripts. Isotta Nogarola (1418–1466) became one of the most renowned Renaissance humanists of her day and, through her example, inspired other female writers, poets, and artists. Her most famous work is a performance piece framed around a dialogue between the characters Isotta and Ludovico on the relative guilt of Adam and Eve for original sin. Nogarola's intellectual argument springs from the basic tenet that Adam and Eve were equals; both possessed the essential goodness of human nature and both acted out of free will. Nogarola, who was educated in Greek and Latin,

also wrote an oration on Saint Jerome, one of the doctors of the church, whose own writings on Christianity were grounded in Classical literature. Nogarola secured her place in the male-dominated humanist circle before influential Renaissance authors of the 16th century began to sing the praises of female potential.

LAURA CERETA Laura Cereta (1469–1499), whose writings we see in Readings 12.3–12.5, was born in Brescia, Italy, the oldest of six children, and was sent to a convent the age of seven—the best place for a young girl to begin her education. At the age of nine she was brought back home to help care for her siblings; her father, an attorney and judge, taught her Greek and Latin. As a determined humanist, Cereta maintained a scholarly lifestyle against a tide of criticism both from men who were her peers and from women. Out of those struggles came many letters penned to

READING 12.4 LAURA CERETA

From Letter to Lucilia Vernacula: Against Women Who Disparage Learned Women (1487)

I thought their tongues should have been fine-sliced and their hearts hacked to pieces—those men whose perverted minds and inconceivable hostility [fueled by] vulgar envy so flamed that they deny, stupidly ranting, that women are able to attain eloquence in Latin. [But] I might have forgiven those pathetic men, doomed to rascality, whose patent insanity I lash with unleashed tongue. But I cannot bear the babbling and chattering women, glowing with drunkenness and wine, whose impudent words harm not only our sex but even more themselves. Empty-headed, they put their heads together and draw lots from a stockpot to elect each other [number one]; but any women who excel they seek out and destroy with the venom of their envy. A wanton and bold plea indeed for ill-fortune and unkindness! Breathing viciousness, while she strives to besmirch her better, she befouls herself; for she who does not yearn to be sinless desires [in effect] license to sin. Thus these women, lazy with sloth and insouciance, abandon themselves to an unnatural vigilance; like scarecrows hung in gardens to ward off birds, they tackle all those who come into range with a poisonous tongue. Why should it behoove me to find this barking, snorting pack of provocateurs worthy of my forbearance, when important and distinguished gentlewomen always esteem and honor me? I shall not allow the base sallies of arrogance to pass, absolved by silence, lest my silence be taken for approval or lest women leading this shameful life attract to their licentiousness crowds of fellow-sinners. Nor should anyone fault me for impatience, since even dogs are permitted to claw at pesty flies.

answer critics, including a defense of learning aimed at male humanists ("All human beings, women included, are born with the right to an education") and a defense of her vocation directed toward her female critics. She also fostered the concept of a community of women intended for scholarship, and critiqued housework as a barrier to women's intellectual development.

In the letter we find in Reading 12.3, Cereta not only assails men who would criticize her lifestyle, but also upbraids women who pride themselves on playing the pampered siren.

In a letter to Lucilia Vernacula (Reading 12.4)—a recipient who may well be fictitious, as *vernacula* can be translated as "hussy" or "common slave"—Cereta roundly criticizes women who attacked her learning and scholarly lifestyle.

Cereta married Pietro Serina when she was 15, but he died within 18 months, apparently from plague. She wrote of his passing, and in this prose, a more sensitive and pained side of the writer emerges. We also see that the concept of moral awareness—the knowledge of a self that requires us to take responsibility for our thoughts and actions—is a theme in her letters. The following is a prose poem.

READING 12.5 LAURA CERETA

On the death of her husband

We have soiled our grieving faces enough. Enough has the sickness of a grieving heart afflicted this mournful life. And although no one can escape the ineluctable law of death; although she, the avenger, strikes down even the Gods; and although all things grow old and die, nonetheless it is not wrong to mourn the things we love, nor does the reason for mourning easily leave the heart.

I know: he had lived on the brink of dying, for death—the end of nature—unmakes all things. We are all dust and shadow, but the days of men are unlike one another; unlike are their misfortunes, and unlike their ends. While I have lived, my prayers have come to naught. This life will ever be the nurse of my misery, I believe. But let the injury, forgotten for a short while, be restored to its place in history—the injury which, because of one man's death, has cruelly and unjustly pried up, lacerated, and dismembered my life, once quiet as though selected in safety.

Surely my husband's spirit now lies among the shades; and now unspeakable marble kisses his limbs. Now that ashy dust sighs in my ears, now one cave awaits me who lives among the living. For the dead, this life is a dream, whose course hangs over all humans like a brief watch in the night. And so, if I thought that it was completely unclear how the events of my life would proceed and in what order, and if you cared about these things, I would describe them more fully and at greater length—if my mind should ever become conscious of itself.

A couple of years after Serina's death, Cereta is said to have embarked on a teaching career of seven years at the University of Prada, but records on the issue are unclear. She died, of unknown causes, at the age of 30.

Humanism in Italy and the North: Two Sides of a Single Coin

In the generation after the death of Lorenzo de' Medici, humanism spread from Italy into Northern Europe, where its principles were applied to Christian belief and became part of the discourse of church reform. At the same time, it remained a core philosophy with regard to secular matters in Italy. The distinctions between the applications of humanist thought in Italy and in Northern Europe are embodied in the writings of Niccolò Machiavelli and Desiderius Erasmus.

NICCOLÒ MACHIAVELLI After Lorenzo de' Medici died, his son Piero—called Piero the Unfortunate—took over as the de facto ruler of Florence, but with none of his father's political gifts and alliances. The Medici family lost control of the city in 1494. During their absence, Niccolò Machiavelli (1469–1527)—humanist, philosopher, and founder of modern political science—was employed as a civil servant for the Florentine Republic, rising to the position of secretary of war. When the Medici came back to power in 1512, Machiavelli was banished from Florence and its politics. It was then that he wrote his famed treatise on politics titled *The Prince* (1513), dedicated first to Giuliano de' Medici (who ruled Florence from 1512–1518) and then, after Giuliano's premature death, to his nephew and successor Lorenzo de' Medici—an attempt to get back into the good graces of the ruling family. It is not clear whether any member of the Medici family ever read the treatise.

The Prince is often considered the first purely secular study of political theory in the West. Machiavelli's inspiration was the government of Republican Rome; he believed that the church's role in politics destroyed the power of the state to govern. For that reason, Machiavelli asserts, the state must restrict the power of the church, allowing it to exercise its office only in the spiritual realm. The prince, as ruler of the state, must understand that the key to success in governing is in the exercise of power. Power is to be used with wisdom and ruthlessness. The prince, in a favorite illustration of Machiavelli, must be as sly as the fox and as brutal as the lion.

Above all, says Machiavelli, the prince must not be deterred from his tasks by any consideration of morality beyond that of power and its ends. In this sense, cruelty or hypocrisy is permissible; judicious cruelty consolidates power and discourages revolution. Senseless cruelty is,

READING 12.6 NICCOLÒ MACHIAVELLI

From *The Prince*, chapter 18, "Concerning The Way In Which Princes Should Keep Faith"

Every one admits how praiseworthy it is in a prince to keep faith, and to live with integrity and not with craft. Nevertheless our experience has been that those princes who have done great things have held good faith of little account, and have known how to circumvent the intellect of men by craft, and in the end have overcome those who have relied on their word. You must know there are two ways of contesting, the one by the law, the other by force; the first method is proper to men, the second to beasts; but because the first is frequently not sufficient, it is necessary to have recourse to the second. Therefore it is necessary for a prince to understand how to avail himself of the beast and the man.

. . .

A prince, therefore, being compelled knowingly to adopt the beast, ought to choose the fox and the lion; because the lion cannot defend himself against snares and the fox cannot defend himself against wolves. Therefore, it is necessary to be a fox to discover the snares and a lion to terrify the wolves. Those who rely simply on the lion do not understand what they are about. Therefore a wise lord cannot, nor ought he to, keep faith when such observance may be turned against him, and when the reasons that caused him to pledge it exist no longer. If men were entirely good this precept would not hold, but because they are bad, and will not keep faith with you, you too are not bound to observe it with them. Nor will there ever be wanting to a prince legitimate reasons to excuse this nonobservance. Of this endless modern examples could be given, showing how many treaties and engagements have been made void and of no effect through the faithlessness of princes; and he who has known best how to employ the fox has succeeded best.

But it is necessary to know well how to disguise this characteristic, and to be a great pretender and dissembler; and men are so simple, and so subject to present necessities, that he who seeks to deceive will always find someone who will allow himself to be deceived.

Excerpt from *The Prince* by Niccolo Machiavelli. Translated by W. K. Marriott, 1908. http://www.constitution.org/mac/prince18.htm.

READING 12.7 NICCOLÒ MACHIAVELLI

Concerning Cruelty and Clemency, And Whether It Is Better To Be Loved Than Feared

Upon this a question arises: whether it be better to be loved than feared or feared than loved? It may be answered that one should wish to be both, but, because it is difficult to unite them in one person, is much safer to be feared than loved, when, of the two, either must be dispensed with. Because this is to be asserted in general of men, that they are ungrateful, fickle, false, cowardly, covetous, and as long as you succeed they are yours entirely; they will offer you their blood, property, life and children, as is said above, when the need is far distant; but when it approaches they turn against you. . . . [Men] have less scruple in offending one who is beloved than one who is feared, for love is preserved by the link of obligation which, owing to the baseness of men, is broken at every opportunity for their advantage; but fear preserves you by a dread of punishment which never fails.

Nevertheless a prince ought to inspire fear in such a way that, if he does not win love, he avoids hatred; because he can endure very well being feared whilst he is not hated, which will always be as long as he abstains from the property of his citizens and subjects and from their women. . . . But when a prince is with his army, and has under control a multitude of soldiers, then it is quite necessary for him to disregard the reputation of cruelty, for without it he would never hold his army united or disposed to its duties.

Excerpt from *The Prince* by Niccolo Machiavelli. Translated by W. K. Marriott, 1908. http://www.constitution.org/mac/prince17.htm.

however, counterproductive. Note Machiavelli's views on whether it is better for the prince to be loved or feared.

The basic theme of *The Prince* is the pragmatic use of power for state management of a populace that Machiavelli characterizes as selfish, shortsighted, devious, and treacherous. Previously the tradition of political theory had always invoked the transcendent authority of God to ensure the stability and legitimacy of the state. For Machiavelli it is power, not the moral law of God, that provides the state with its ultimate sanction. The final test of the successful ruler is a willingness to exercise power judiciously and a freedom from the constraints of moral suasion. "A wise ruler . . . cannot and should not keep his word when such an observance would be to his disadvantage," Machiavelli says in one of the most famous passages from his book. His justification is, "If men were all good, this precept would not be

good. But since men are a wicked lot and will not keep their promises to you, you likewise need not keep yours to them." This bold pragmatism explains why the Roman Catholic Church put *The Prince* on its index of prohibited books and why the adjective *Machiavellian* means, in English, "devious or unscrupulous in political dealings." Machiavelli had such a bad reputation that many 16th-century English plays had a stock evil character—an Italian called "Old Nick." The English phrase "filled with the Old Nick," meaning "devilish," derives from Machiavelli's reputation as an immoral man. But Machiavelli's realistic pragmatism also explains why Catherine the Great of Russia and Napoléon read him with great care.

In the final analysis, however, the figure of the prince best defines a view of politics that looks to a leader who understands that power is what keeps a political person as a strong ruler. Such a leader uses a simple rule of thumb: how does one exercise power in order to retain power? Such a ruler does not appeal to eternal rules but to simple calculations: Will the exercise of power in this or that particular fashion guarantee the stability of the state? If ruthlessness or violence is needed, let there be ruthlessness or violence (or terror!). Machiavelli did not want to create a monster, and he certainly did not want violence for its own sake. He did favor, however, whatever means it took to keep the state intact and powerful. That is the deepest meaning of the adjective *Machiavellian*.

DESIDERIUS ERASMUS Desiderius Erasmus (1469–1536; Fig. 12.10) has been called the most important Christian

◄ **12.10** Quentin Matsys, *Portrait of Erasmus*, 1517. Oil on panel, transferred to canvas, 23 ¼″ × 18 ½″ (59 × 47 cm). Galeria Nazionale d'Arte Antica, Rome, Italy. This portrait of Desiderius Erasmus, drawn from life, was the prototype for a coin bearing his profile and for an engraving by the German artist Albrecht Dürer. He is shown standing at his writing desk in a confined cell, spare save for two narrow shelves of scholarly, leather-bound volumes.

READING 12.8 DESIDERIUS ERASMUS

From *The Praise of Folly* (on theologians)

Perhaps it would be better to pass silently over the theologians. Dealing with them, since they are hot-tempered, is like . . . eating poisonous beans. They may attack me with six hundred arguments and force me to retract what I hold; for if I refuse, they will immediately declare me a heretic. . . . These theologians are happy in their self-love, and as if they were presently inhabiting a third heaven, they look down on all men as though they were animals that crawled along the ground, coming near to pity them. They are protected by a wall of scholastic definitions, arguments, corollaries, and implicit and explicit propositions. . . . They come forth with newly invented terms and monstrous sounding words. Furthermore, they explain the most mysterious matters to suit themselves, for instance, the method by which the world was set in order and began, through what channels original sin has come down to us through generations, by what means, in what measure, and how long the Omnipotent Christ was in the Virgin's womb, and how accidents subsist in the Eucharist without their substance.

. . .

And furthermore, they draw exact pictures of every part of hell, as though they had spent many years in that region. They also fabricate new heavenly regions as imagination dictates, adding the biggest of all and the finest, for there must be a suitable place for the blessed souls to take their walks, to entertain at dinner, or even to play a game of ball.

The Praise of Folly, from The Essential Erasmus by Erasmus, translated by John P. Dolan.

humanist in Europe. Born in Holland, he was educated in Latin as a young boy and in his mid-20s entered a monastery to avert poverty. He was ordained a Roman Catholic priest but did not practice for any length of time. Rather, in 1495 he enrolled in the University of Paris, where he came into contact with humanist thought at the time it was entering the academy. He was further engaged with humanism during visits to England, where he met men like John Colet and Thomas More. Fired by their enthusiasm for the new learning, Erasmus traveled to Italy in 1506, where he had lengthy stays in both Rome and Venice. Thereafter he led the life of a wandering scholar, gaining immense fame as a learned thinker and author.

Erasmus's many books attempted to combine Classical learning and a simple interiorized approach to Christian living. In the *Enchiridion militis Christiani* (1502), he attempts to spell out this Christian humanism in practical terms. The title has a typical Erasmus-style pun: the word *enchiridion* can mean either "handbook" or "short sword"; thus the title can mean the handbook or the short sword of the Christian knight. His *Greek New Testament* (1516) was the first attempt to edit the Greek text of the New Testament by a comparison of extant manuscripts. Because Erasmus used only three manuscripts, his version is not technically perfect, but it was a noteworthy attempt and a clear indication of how a humanist felt he could contribute to ecclesiastical work.

The most famous book written by Erasmus, *The Praise of Folly* (1509), was dashed off almost as a joke while he was a houseguest of Sir Thomas More in England. Again, the title is a pun; *Encomium Moriae* can mean either "praise of folly" or "praise of More"—Thomas More, his host. *The Praise of Folly* is a humorous work, but beneath its seemingly lighthearted spoof of the foibles of the day there are strong denunciations of corruption, evil, ignorance, and prejudice in society.

Erasmus flails away at the makers of war (he had a strong pacifist streak), venal lawyers, and fraudulent doctors, but above all, he bitterly attacks religious corruption: the sterility of religious scholarship and the superstitions in religious practice. In the following passage from *The Praise of Folly*, Erasmus comments on theologians.

Reading *The Praise of Folly* makes one wonder why Luther never won Erasmus over to the Protestant Reformation (Erasmus debated Luther, in fact). Erasmus remained in the old church, but as a bitter critic of its follies and an indefatigable proponent of its reform. Some have said that Erasmus laid the egg that Luther hatched.

This sweeping social criticism struck an obvious nerve. The book delighted not only the great Sir Thomas More (who was concerned enough about religious convictions to die for them later in the century) but also many sensitive people of the time. *The Praise of Folly* went through 27 editions in the lifetime of Erasmus and outsold every other book except the Bible in the 16th century.

Comparing Machiavelli and Erasmus is a bit like comparing apples and potatoes, but a few points of contact can be noted that help us generalize about the meaning of the Renaissance. Both men were heavily indebted to the new learning coming out of 15th-century Italy. Both looked back to the great Classical heritage of the past for their models of inspiration. Both were elegant Latinists who avoided the style and thought patterns of the Medieval world. Machiavelli's devotion to the Roman past was total. He saw the historic development of Christianity as a threat and stumbling block to the fine workings of the state. Erasmus, by contrast, felt that learning from the past could be wedded to the Christian tradition to create an instrument for social reform. His ideal was a Christian humanism based on this formula. It was a formula potent enough to influence thinking throughout the 16th century.

RENAISSANCE ART IN ITALY

By some stroke of good fortune, Florence and its surroundings produced, in the 15th century, a group of artists who revolutionized Western art to such an extent that later historians would refer to the period as a time of *renaissance* (rebirth) in the arts. But talent was not the whole story. Ambitious art projects require wealthy patrons and a nurturing cultural and intellectual environment. It all came together in Florence: great artists, great wealth, and the humanist thought that valued the aspirations of the individual and rewarded them with fame.

Although Florence can rightfully be termed the epicenter of the Early Renaissance, there were other powerful city-states that became cultural centers. Rome, Urbino, Mantua, and others revolved around princely courts established by wealthy dukes, counts, and even popes and cardinals who were major patrons of the arts.

Florence

At the dawn of the 15th century in Florence, the Early Renaissance began, not with a commission but with a competition—for the right to decorate the bronze doors of the Florence Baptistery. Sponsored by the guild of wool merchants, it was announced in 1401 in the midst of a military standoff between Florence and Milan that saw the Duke of Milan's armies surrounding the city. The subject that was chosen for the competition relief was the biblical story of Abraham's sacrifice of Isaac (Genesis 22:1–14). It would have seemed an inspirational one, as the Florentine Republic was on the verge of defeat by the superior forces of the Duke of Milan; Florence could be likened to Isaac and, as such, was in need of some divine intervention. It came in 1402 when the Duke of Milan died unexpectedly.

Sculpture

It is not so often that we can connect specific historical events with the beginning of a new period in art history. In ancient Greece, we saw that a decisive naval battle in 480 BCE launched the Classical period. The outcome of the conflict between the Republic of Florence and the Duchy of Milan coincided with the birth of the Renaissance in Florence.

THE BAPTISTERY COMPETITION: FILIPPO BRUNELLESCHI AND LORENZO GHIBERTI The competition for the high-profile commission for a new set of bronze doors for the Baptistery of San Giovanni drew proposals from many artists, some of whom already had significants reputation in the city. The two finalists, whose submissions survive, were Filippo Brunelleschi (1377–1446) and Lorenzo Ghiberti

(1378–1455). A comparison between them illustrates the stylistic and technical differences and allows us to infer the criteria used to judge the winner.

There were specific criteria for the competition panels to which all submissions had to conform. In addition to the Abraham and Isaac story, complete with all of its figures and props, the artists had to arrange all of the imagery within a four-lobed (quatrefoil) frame. One set of doors had already been fashioned by the sculptor Andrea Pisano in the 1330s, and the idea was to match the new to the old. Brunelleschi's version (**Fig. 12.11**) has a vigor and expressiveness that seem barely contained by the Gothic-style frame. Abraham lunges for Isaac's throat with a knife and at the same moment an angel comes into the scene, grasping Abraham's arm to stop him from slaying his son. Isaac's head has been wrenched to the side to expose his neck and his whole body is compressed between the harsh stone of the sacrificial altar on which he kneels and the strength of his father bearing down upon him. Two compositional triangles—one implied and one actual—add to the tension in the scene: the faces of Isaac, Abraham, and the angel are connected along implied diagonal lines with piercing stares; the triangular configuration of Abraham's shoulders, arms and head leads our eye to the most violent section in the composition.

In Brunelleschi's panel, the scattered figures keep the eye moving and underscore a feeling of agitation. By contrast, Ghiberti's panel on the same subject (**Fig. 12.12**) is divided dramatically by a slashing diagonal line separating the two sets of actors into clearly designated planes of action. The sway of Abraham's body echoes the shape of the rock up to the shoulders and then lunges toward Isaac in a dynamic counterthrust. Isaac, in turn, pulls reflexively away from the knife in his father's hand. His body arches as he looks at the angel overhead, which is drastically foreshortened and appears to be flying into the scene from deep space. It appears that Isaac is aware of his rescue before Abraham even sees the angel. All of the shapes seem to move rhythmically, and although Ghiberti's version is not as graphic and emotionally intense as Brunelleschi's, the impact of his narrative is just as strong. Of special note is the reference to nude Classical sculpture in Ghiberti's portrayal of Isaac. It may be the first such type of figure since antiquity.

Ghiberti's experience as a skilled goldsmith produced a panel that was a technical tour de force—cast only in two pieces. His victory in the competition may have come because his technique was assessed as superior to Brunelleschi's, but there may have been another reason. In Brunelleschi's panel, Isaac looks like a victim; in Ghiberti's, he seems strong, almost defiant. Given that the subject may have been intended to inspire Florentines to rally and defend their city, Ghiberti's Isaac would have better captured a spirit of resistance.

Ghiberti's response to his success speaks volumes about the growing sense in the Early Renaissance that human beings were entitled to the honor bestowed upon them for their achievements:

To me was conceded the palm of victory by all the experts and by all ... who had competed with me. To me the honor was conceded universally and with no exception. To all it seemed that I had at that time surpassed the others without exception, as was recognized by a great council and an investigation of learned men ... highly skilled from the painters and sculptors of gold, silver, and marble.

Ghiberti worked for almost a quarter of a century on the north doors, completing 20 panels. Just as he was finishing, the cathedral authorities commissioned him to create another set of panels for the east doors, those facing the cathedral. This project occupied the next quarter of a century (1425–1452), and the results of these labors were so striking that Michelangelo later in the century declared Ghiberti's east doors worthy to be called the Gates of Paradise. They are so called to this day.

The east doors (**Fig. 12.13**) differ dramatically in style and composition from the north-door panels. Rectangular frames replace the Gothic-style quatrefoils, and each is treated as a defined pictorial space not unlike a painting. By the time Ghiberti was at work on this project, his rival Brunelleschi had developed *linear perspective*—a

scientific method used for creating the illusion of three-dimensionality on a two-dimensional surface; Ghiberti used it in the Gates of Paradise. Linear perspective was the most important development in the history of Western painting and its inventor, the man who lost the Baptistery competition, went on to be the most important architect of the Early Renaissance.

DONATELLO The sculptor Donato di Niccolò di Betto Bardi—known simply as Donatello—was a close friend of Brunelleschi. After the competition, the two went off to Rome to study the architecture and sculpture of antiquity. In fact, Giorgio Vasari tells us that the pair were reputed to be treasure hunters because of their incessant prowling amid the ruins of the Roman Forum. For Brunelleschi, these intensive studies led to the development of linear perspective as well as construction methods and motifs that he would employ in his own architectural projects. For Donatello, the close encounter with antique reliefs and statuary would lead to the revival of Classical principles in his sculpture.

Donatello's *Saint George* (**Fig. 12.14**) was created originally for a niche on the exterior of the Or San Michele church in Florence, the site of the headquarters of the city's guilds. Each of the guilds had been assigned a niche in which

▼ **12.11** Filippo Brunelleschi, *Sacrifice of Isaac*, 1401–1402. Competition panel for the east doors of the Baptistery of San Giovanni, Florence, Italy. Gilded bronze, 21″ × 17½″ (53 × 44 cm). Museo Nazionale del Bargello, Florence, Italy. The nervous energy and scattering of figures in Brunelleschi's panel recalls Giovanni Pisano's relief for the pulpit at Sant'Andrea; both were influenced by the expressionism of the Late Gothic Style.

▼ **12.12** Lorenzo Ghiberti, *Sacrifice of Isaac*, 1401–1402. Competition panel for the east doors of the Baptistery of San Giovanni, Florence, Italy. Gilded bronze, 21″ × 17½″ (53 × 44 cm). Museo Nazionale del Bargello, Florence, Italy. Ghiberti's Isaac, inspired by sculpture from Greece and Rome, may be the first example of a fully nude, Classically modeled since antiquity.

◄ **12.13** Lorenzo Ghiberti, east doors (Gates of Paradise), 1425–1452 (modern replica, 1990). Baptistery of San Giovanni, Florence, Italy. Gilded bronze, 17′ (5.18 m) high. Original panels in the Museo dell'Opera del Duomo, Florence, Italy. Brunelleschi's innovations for creating the illusion of three-dimensionality on a two-dimensional surface using systematic mathematical laws of perspective were employed by Ghiberti to create the illusion of deep space in the square panels of his east doors of the Florence Baptistery. Michelangelo called them the Gates of Paradise.

to place a sculpture representing their patron saint; Saint George was the patron saint of armorers and sword makers. Donatello's figure exudes intelligence and courage in his piercing gaze and confident pose, but there is an element of tension—even worry—in Saint George's facial expression. This bit of agitation is, overall, balanced by serenity and control, and thus harkens to the Classical ideal. Donatello's sculpture was carved at the same time that Florence was under attack by the troops of King Ladislas of Naples. Just as the *Sacrifice of Isaac* had meaning to the Florentines when the Duke of Milan besieged their city, so too did the saintly knight George have meaning at a time when the city again was defending itself against threats to its independence. And once again, victory against the Florentines was thwarted by fortuitous circumstances: Ladislas died abruptly in 1414. Donatello's *Saint George*, begun in 1410, was completed in 1415.

Donatello's most Classically inspired work is his *David* (see **Fig. 12.15**), commissioned for the garden of the Medici palace; it is the first life-size, freestanding statue of a nude figure since antiquity. The sinuous **contrapposto** stance and body proportions are reminiscent of Greek prototypes that were mimicked by Roman artists. What is different—and new—here is that Donatello used the Classical style, one that focused on the beauty of the male form, to portray a Christian biblical subject. David, destined to become the second king of Israel, slew the Philistine giant Goliath—felling him with his slingshot and then decapitating him. For this, Donatello did not choose a godlike figure or heroic nude as a model, but rather what appears to be preadolescent peasant boy, whose long, soft curls still fall down to his shoulders and whose arms are still thin and muscles undeveloped. David rests his sword on the ground after cutting off Goliath's head, as if it is too heavy for him to hold. He glances downward at the head—and his own body—as if incredulous at what he has accomplished. Herein lies the humanity and thus the power of Donatello's sculpture. He has achieved the perfect reconciliation of idealism and realism.

ANDREA DEL VERROCCHIO One of the most important and versatile artists of the mid-15th century in Florence was Andrea del Verrocchio (1435–1488). Trained as a goldsmith, Verrocchio was also a painter and sculptor who ran an active studio shop; the young Leonardo da Vinci was one of the artists who apprenticed there. Verrocchio's *David* (**Fig. 12.16**), also commissioned by the Medici family, is quite different from Donatello's. Although both represent David as an adolescent, Verrocchio's hero is somewhat older (his muscles are better-developed, although wiry) and has a look of pride and self-confidence rather than a dreamy gaze of disbelief. Donatello's David is introspective; Verrocchio's looks bold. Both sculptures feature David after the fight, but the

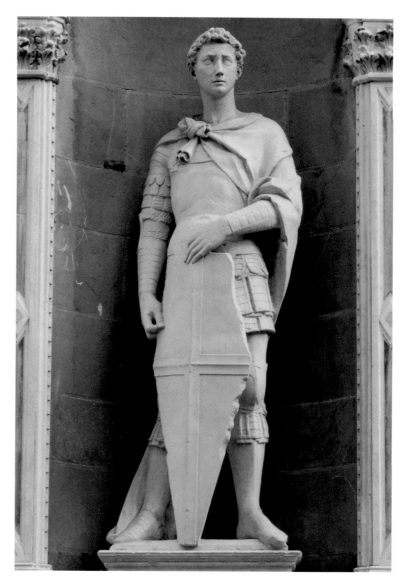

▲ **12.14** Donatello, *Saint George*, ca. 1410–1415. Or San Michele, Florence, Italy (modern copy in exterior niche). Marble, 82″ (208 cm) high. Original statue in the Museo Nazionale del Bargello, Florence, Italy. Saint George was a Roman soldier and early Christian martyr who was renowned for a legend in which he slew a dragon and saved a pagan princess from certain death, thus winning the gratitude and respect of her people—along with their conversion to Christianity. The legend of Saint George was a popular subject in romance literature.

long sword in Donatello's piece seems unwieldy, as if David can barely manage it, whereas in Verrocchio's sculpture the shorter blade, aimed outward, seems a still-threatening extension of David's arm. The most significant difference, of course, is that Donatello draws attention to David's body in his nudity, whereas Verrocchio tries to communicate something of David's personality though his sharp and cocky demeanor. The increasing sense of realism in Renaissance art was the result not only of imitating nature but also of recording aspects of human nature.

The *David*s of Donatello, Verrocchio, Michelangelo, and Bernini

Sometime soon after the year 1430, a bronze statue of *David* (Fig. 12.15) stood in the courtyard of the house of the Medicis. The work was commissioned from Donatello by Cosimo de' Medici himself, the founding father of the Republic of Florence. It was the first freestanding, life-size nude since Classical antiquity, poised in the same contrapposto stance as the victorious athletes of Greece and Rome—but soft, and somehow oddly unheroic. And the incongruity of the heads: David's boyish, expressionless face, framed by soft tendrils of hair and shaded by a laurel-crowned peasant's hat; Goliath's tragic, contorted expression, made sharper by the pentagonal helmet and coarse, disheveled beard.

Innocence and evil; the weak triumphing over the strong; perhaps even the Republic of Florence triumphing over the aggressive dukes of Milan? This is David as a civic monument.

In the year 1469, Ser Piero from the Tuscan town of Vinci moved to Florence to become a notary. He rented a house on the Piazza San Firenze, not far from the Palazzo Vecchio. His son, who was a mere 17 years old upon their arrival, began an apprenticeship in the Florentine studio of the well-known artist Andrea del Verrocchio. At that time, Verrocchio was at work on a bronze sculpture of the young *David* (Fig. 12.16). Might the head of this fine piece be a portrait of Leonardo da Vinci?

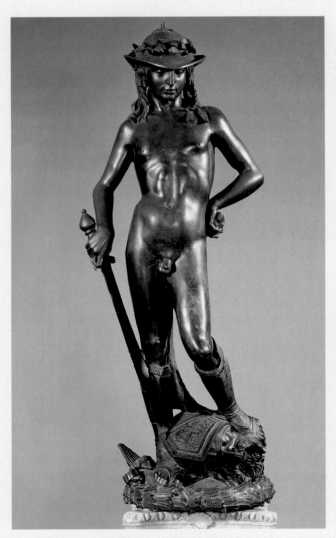

▲ 12.15 Donatello, *David*, ca. 1440–1460. Bronze, 62¼" (158 cm) high. Museo Nazionale del Bargello, Florence, Italy.

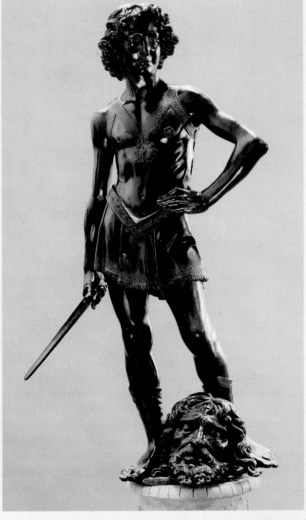

▲ 12.16 Andrea del Verrocchio, *David*, ca. 1465–1470. Bronze, 49¼" (125 cm) high. Museo Nazionale del Bargello, Florence, Italy.

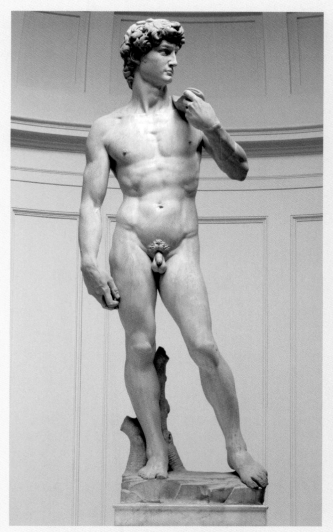

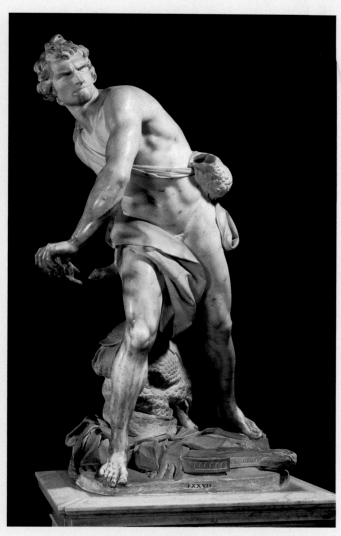

▲ **12.17** Michelangelo, *David*, 1501–1504. Marble, 17' (5.17 m) high. Gallerie dell'Accademia, Florence, Italy.

▲ **12.18** Gian Lorenzo Bernini, *David*, 1623. Marble, 66 ¼" (170 cm) high. Galleria Borghese, Rome, Italy.

For many years, a block of marble lay untouched, tossed aside as unusable, irretrievable evidence of a botched attempt to carve a human form. It was 18 feet high. A 26-year-old sculptor, riding high after the enormous success of his figure of the Virgin Mary holding the dead Christ, decided to ask for the piece. The wardens of the city in charge of such things let the artist have it. What did they have to lose? Getting anything out of it was better than nothing. So this young sculptor named Michelangelo measured and calculated. He made a wax model of David with a sling in his hand. And he worked on his *David* (**Fig. 12.17**) continually for some three years until, Vasari tells us, he brought it to perfect completion—without letting anyone see it.

A century later, a 25-year-old sculptor stared into a mirror at his steeled jaw and determined brow. A contemporary source tells us that on this day, perhaps, the mirror was being held by Cardinal Maffeo Barberini (who

would become Pope Urban VIII) while Bernini transferred what he saw in himself to the face of his *David* (**Fig. 12.18**). Gian Lorenzo Bernini, sculptor and architect, painter, dramatist, and composer—who centuries later would be called the undisputed monarch of the Roman High Baroque— identifying with David, whose adversary is seen only by him.

The great transformation in style that occurred between the Early Renaissance and the Baroque (see Chapter 15) can be followed in the evolution of David. Look at them: A boy of 12, perhaps, looking down incredulously at the physical self that felled an unconquerable enemy; a boy of 14 or 15, confident and reckless, with enough adrenaline pumping through his body to take on an army; an adolescent on the brink of adulthood, captured at that moment when, the Greeks say, sound mind and sound body are one; and another full-grown youth, caught in the midst of action, at the threshold of his destiny as king.

Painting

The International Style, originated by Simone Martini in Siena in the mid-14th century (see **Fig. 11.18**), continued to have a presence throughout Italy in the 15th century, when the lure of lush possibilities of the courtly manner in painting coexisted with efforts to revive Classicism and to seek ways to express the doctrine of humanism in art.

GENTILE DA FABRIANO Complete mastery of the International Style in the 15th century is most evident in the work of Gentile da Fabriano (ca. 1370–1427). His altarpiece *Adoration*

▾ **12.19** Gentile da Fabriano, *Adoration of the Magi*, 1423. Altarpiece from the Strozzi Chapel, Santa Trinità, Florence, Italy. Tempera on wood, 119″ × 111″ (302 × 281 cm). Galleria degli Uffizi, Florence, Italy. This sumptuous painting straddles the Gothic style, with its sinuous lines and lushly decorated surfaces, and that of the Early Renaissance, with its attention to realistic detail based on an observation of the natural world and human behavior.

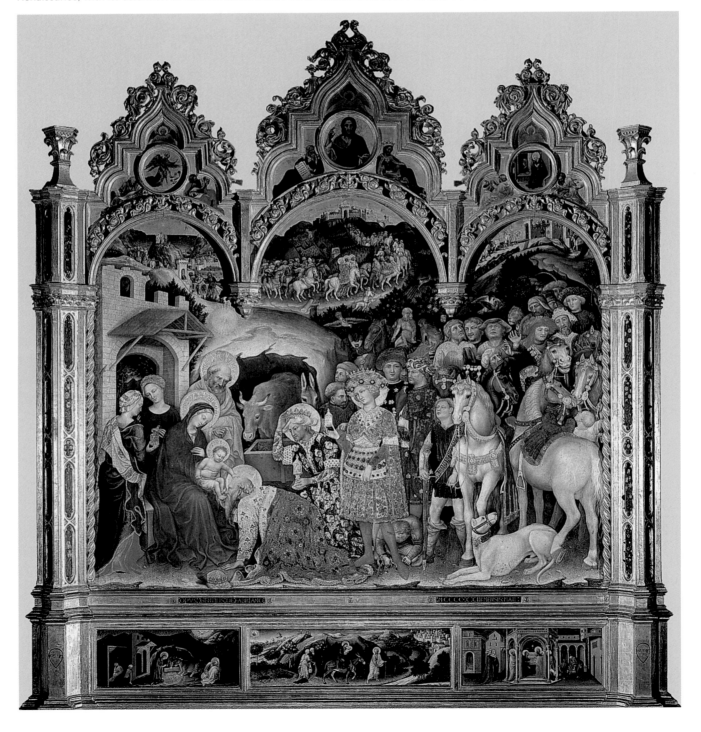

of the Magi (**Fig. 12.19**) is brimming with exquisite detail that gleams golden, from lavish costumes to bejeweled crowns and richly embossed halos. The figures have the courtly bearing and graciousness of nobility. The splendor of the painting—its brilliant color and elaborate gold frame—seems fit for a king—in this case, Palla Strozzi, a banker and one of the wealthiest men in Florence.

Although elements of the Gothic style dominate the *Adoration of the Magi*, the observation of the natural world that is central to the new aesthetic can also be seen in some of the detail—the individualized, expressive faces of the crowd, the hunched-over man at the feet of the red-stockinged king who removes his spurs, the twisting, turning positions of the animals, and the squirming legs of the baby Jesus. Gentile achieved balance between the ornamental and the naturalistic in a painting that dazzles.

MASACCIO Only five or so years after Gentile completed his altarpiece, Tomasso di Giovanni di Simone Cassai (1401–1428), known as Masaccio, painted his *Holy Trinity* (**Fig. 12.20**) for the church of Santa Maria Novella in Florence. It is a strikingly different approach by a precocious young artist who transformed contemporary painting by melding the innovations of Giotto with Brunelleschi's mathematical systems of perspective. *The Holy Trinity* is only one of several important fresco commissions Masaccio received between 1424 and 1427. Within a year after they were completed, he died, at the age of 27. *The Holy Trinity* is our first best example of linear perspective in Renaissance painting, begun at around the same time as Ghiberti was working on the Gates of Paradise. Both artists were experimenting with the illusion of deep space on a two-dimensional surface and both were applying mathematics to do so.

Linear perspective is a way of structuring pictorial space so that the figures and objects therein mimic the real-world perception of three-dimensional space from a single, fixed vantage point (**Fig. 12.21**). (In *The Holy Trinity*, that vantage point is outside of the painting, below the figures, at a spectator's eye level.) From that fixed point, one looks into the distance (for example, the background of the painting) to a horizon line on which is placed a single point (the vanishing point). Lines are then drawn from the edges of the picture frame in such a way that they all converge at this single point; these lines are called *orthogonals*. A perspectival grid is created through the intersection of the orthogonals and *transversals*, lines that are parallel to the horizon line and appear to come closer together as they approach it. The spaces of the grid (larger in the foreground, smaller at the horizon line) are used to determine the relative scale of figures and objects. This mathematical system

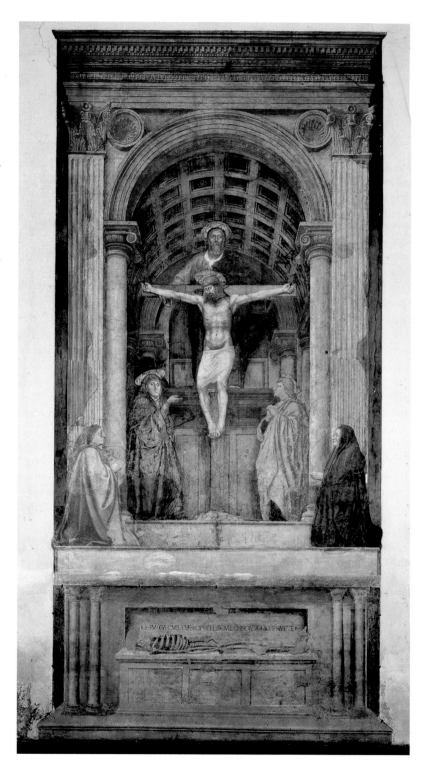

▲ **12.20** Masaccio, *The Holy Trinity*, ca. 1424–1427. Fresco, 21'10⁵/₈" × 10'4³/₄" (6.7 × 3.2 m). Santa Maria Novella, Florence, Italy. Altarpieces and other monumental paintings for church interiors were frequently funded by wealthy donors, whose generosity was acknowledged and recorded for posterity by the inclusion of their portraits in the work. Here, Masaccio shows Lorenzo Lenzi and his wife kneeling in prayer outside the chapel; Peter Inglebrecht and his wife, Margarete Scrynmakers, kneel in a garden outside the home in which the Annunciation takes place in the Mérode altarpiece.

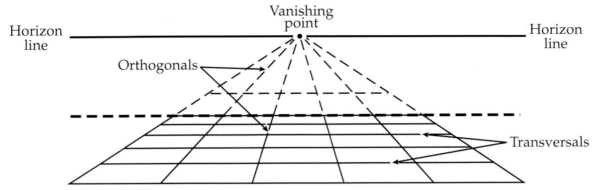

▲ **12.21 Diagram of one-point linear perspective.**

reflects what the eye sees in nature: things that are closer to us appear larger and those that are farther away, smaller.

In *The Holy Trinity*, Masaccio uses these laws of perspective to construct the spatial illusion of a barrel-vaulted chapel in which God the Father supports the arms of a cross with the crucified Christ. The Virgin Mary and Saint John are at Jesus's feet, where the orthogonals of the coffered ceiling converge. Between the heads of Jesus and God the Father, the Holy Spirit—a dove—spreads its wings and hovers in place. Outside of the space, the donors—Lorenzo Lenzi and his wife—kneel in prayer. The plane that they occupy sits between the mystical scene of the painted chapel and the concrete space of the spectator.

The illusion of three-dimensional space in *The Holy Trinity* is dramatic, but the painting's realism can be attributed also to the way that Masaccio rendered the figures—they have weight and occupy space. The carefully painted drapery folds and the modeling of the flesh are a further extension of Giotto's technique of chiaroscuro, the foundation of Masaccio's style. To this he would add psychological depth to his figures by capturing the spectrum of human emotion.

In this single fresco appear many of the characteristics of Florentine Renaissance painting that separate it from earlier styles: clarity of line, a concern for mathematically precise perspective, close observation of real people, concern for psychological states, and an uncluttered arrangement that rejects the earlier tendency to crowd figures into all of the painting's available space.

Masaccio's fresco paintings for the Brancacci Chapel of the Church of Santa Maria del Carmine in Florence are startling in their realism, in terms of both his convincing rendering of three-dimensional figures in a two-dimensional space and his expression of human behavior and feelings. In *Tribute Money* (**Fig. 12.22**), a three-part narrative that takes

▼ **12.22 Masaccio, *Tribute Money*, ca. 1424–1427. Fresco, 8'4 1/8" × 19'7 1/8" (2.5 × 5.9 m). Brancacci Chapel, Church of Santa Maria del Carmine, Florence, Italy.** Masaccio suggests the passage of time by showing, simultaneously, three moments in the story of Jesus and the Roman tax collector found in Matthew 17:24–27.

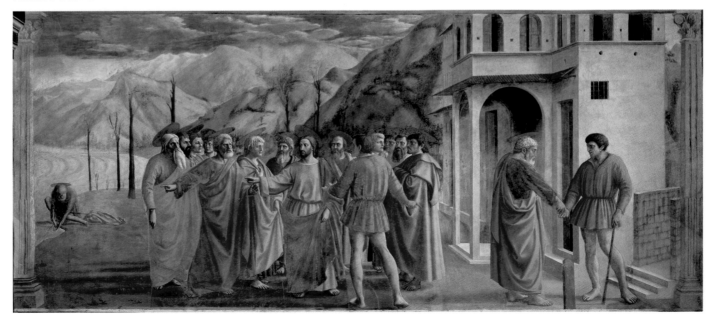

place in a single, continuous landscape, a Roman tax collector (in a short tunic) approaches Jesus and his apostles for payment (Matthew 17: 24–27). Jesus, in the center of the group, motions to Peter (with gray hair and a short gray beard) to go to the shore of Lake Galilee in the distance on the left, where a fish will swim to him with a coin in its mouth. Peter takes off his orange cloak and crouches to receive it. On the right side of the composition, we see Peter again, this time forcing the coin into the tax collector's hand.

The space in the painting is defined by the figures themselves, who cluster in a half-circle around Jesus as he speaks; the architecture, the lines of which converge at Jesus's head; the diminishing scale of the barren trees as they march toward the background; and the misty, atmospheric perspective used to suggest the distant hills and sky. The figures, as in *The Holy Trinity*, are weighty and corporeal beneath their drapery, and the expressions on their faces show their reactions to the circumstance: Jesus is serene and resigned but Peter is peeved and confused. The individualized facial features of all of the characters contribute to the overall sense of authenticity.

The fresco *Expulsion of Adam and Eve from Eden* (**Fig. 12.23**) illustrates Masaccio's exceptional command of the human form and his profound sense of human emotion—here the utter despair of the first couple as they are driven from the Garden of Paradise into a barren and unforgiving landscape. Eve covers her nakedness, her head thrown back in anguish; Adam brings his hands to his head and weeps, distraught. The shame associated with original sin is embodied in Eve, who, unlike Adam, hides her breasts and pubic area. In this representation of Adam and Eve, as in most, Eve bears the guilt for the Fall that would lead to the sacrifice of Jesus for the salvation of their descendants.

The revolutionary character of Masaccio's work was recognized in his own time, and his influence on Florentine painters who worked later in the century is clear. Two generations after Masaccio's death, the young Michelangelo often crossed the river Arno to sketch the frescoes in the Brancacci Chapel. In the next century, Giorgio Vasari in his *Lives of the Artists* would judge Masaccio's influence as basic and crucial: "The superb Masaccio . . . adopted a new manner for his heads, his draperies, buildings, and nudes, his colors, and foreshortening. He thus brought into existence the modern style which, beginning during his period, has been employed by all of our artists down to the present day."

FRA ANGELICO The works of Masaccio were ambitious in many ways: complex spatial illusion, believable physicality, authenticity of human emotion, and the visual correlate to humanist thought. The results had monumentality. How different, then, is the quiet, unassuming, quality of the art of Fra Angelico (ca. 1400–1455), a Dominican friar who devoted his life to religious painting. His *Annunciation* (**Fig. 12.24**) was commissioned for the Dominican monastery of San Marco and was executed in a corridor in the friars' dormitory. The pronounced linear aspect of the fresco, and its clear and simple shapes, construct a humble scene for quiet

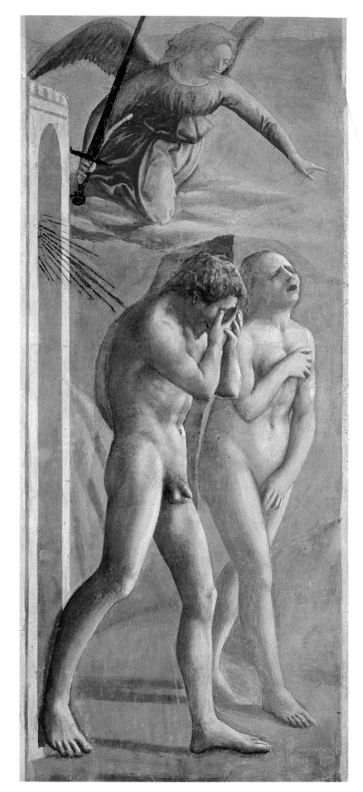

▲ **12.23** Masaccio, *Expulsion of Adam and Eve from Eden*, ca. 1424–1427. Fresco, 84″ × 35″ (214 × 90 cm). Brancacci Chapel, Church of Santa Maria del Carmine, Florence, Italy. Eve covers her body in shame, drawing our focus to her sexuality and its implication in the original sin that led to the Fall of humanity; Adam, on the other hand, holds his head in his hands but his genitals are not covered. Thus, Eve's guilt seems connected to a sin of the flesh, Adam's to a sin of intellectual misjudgment.

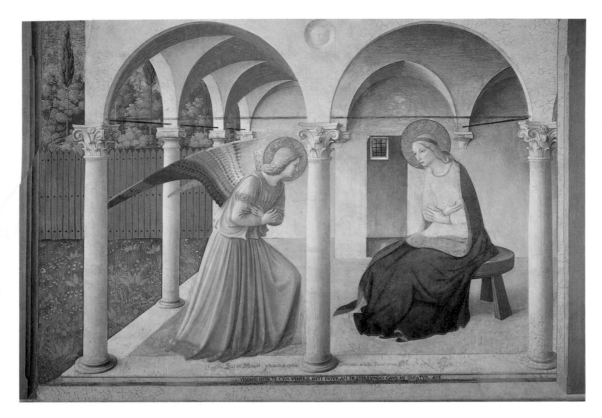

◄ **12.24** Fra Angelico, *The Annunciation*, ca. 1438–1447. Fresco, 85″ × 126″ (216 × 320 cm). San Marco, Florence, Italy. Though a simple, devotional painting, *The Annunciation* is not without small details derived from a close observation of nature: botanists have identified the flowers strewn amid the grasses of the sheltered garden.

▼ **12.25** Paolo Uccello, *The Battle of San Romano*, ca. 1456. Tempera on wood, 72″ × 126″ (182 × 320 cm). **National Gallery, London, United Kingdom.** Uccello's obsession with mathematical systems of perspective is conspicuous in the unnatural, grid-like placement of broken lances and spears along the ground. The painting, which represents a battle between the Florentines and the Sienese, once hung in Lorenzo de' Medici's bedroom.

contemplation. Although Fra Angelico seems far removed from the humanist discourse of Florence, the graceful arches of the covered terrace that spring from Corinthian capitals illustrate an awareness of the fashion for Classical motifs in architecture. The setting for *The Annunciation* may have been inspired by Brunelleschi's design for the loggia of the Ospedale degli Innocenti (see **Fig. 12.32**).

PAOLO UCCELLO Linear perspective swept Florence and found one of its most literal proponents in Paolo Uccello (1397–1475), a painter who married elements of the International Style with the new approach based on Brunelleschi's mathematical systems. *The Battle of San Romano* (**Fig. 12.25**) was one of three paintings commissioned to commemorate Florence's defeat of Siena in 1432, all of which illustrate Uccello's fascination with perspective. The jousting combatants engage on a battlefield littered with broken lances that have fallen in a near-grid pattern and are aimed toward a vanishing point somewhere in the distance. The foreshortened body of a fallen soldier, his feet touching the left front edge of the painting, parallels the orthogonals of the lances. Uccello depicts the clash and confusion of heated battle but, in the end, the paintings seem as much a vehicle for the artist's study of perspective as anything else.

PIERO DELLA FRANCESCA The artists of the Renaissance, along with the philosophers and scientists, shared a sense of the universe as an orderly place that was governed by natural laws and could be expressed in mathematical terms. Piero della Francesca (ca. 1420–1492) was trained in mathematics and geometry and is credited with writing the first theoretical treatise on the construction of systematic perspective in art. Piero's art, like his scientific thought, was based on an intensely rational construction of forms and space.

His *Resurrection* (**Fig. 12.26**), a fresco painted for the town hall of Borgo San Sepolcro, reveals the artist's

◄ **12.26** Piero della Francesca, *Resurrection*, ca. 1463–1465. Fresco, 88 5/8″ × 78 1/4″ (225 × 199 cm). Palazzo Comunale, Sansepolcro, Italy. The precise drawing, emphasis on geometry, and overall serenity of the scene characterize all of Piero's compositions. The figure of Christ the Savior, draped and nude from the waist up, undeniably suggests a familiarity with Graeco-Roman sculpture.

obsessions with order and geometry. Christ, transcendent in his expressionlessness, steps out of his tomb, grasping a flag in his right hand that signifies his victory over death. Beneath him are the sleepy soldiers who were charged with guarding the burial site. The figures are contained within a triangle—what would become a frequent compositional device in Renaissance painting—with Christ's head at the apex. The sleeping figures and the marble sarcophagus provide a strong and stable base for the upper two-thirds of the composition. Regimented trees are arranged in procession behind Jesus in a landscape whose juxtaposed elements are anything but serendipitous; the branches in the grove on the left are barren and the ones on the right in leaf, symbolizing death and resurrection, or rebirth. The feeling of restraint that pervades the painting is a by-product of Piero's geometrization.

SANDRO BOTTICELLI The prevailing trend in 15th-century art was the realistic representation of the natural world, buttressed by order, geometry, and references to classical style. Sandro Botticelli (1445–1510), however, bucked this trend. Seminal to the tradition of Giotto and Masaccio

in painting was the illusion of roundness in figures modeled by subtle gradations of *value*, that is tonal contrasts of light and shade. Botticelli's principle element of art, by contrast, was *line*—line that delimits and therefore flattens form, line that plays across figures and surfaces and seems to have a life of its own. His art relied primarily on drawing. As distinct as Botticelli's style was from those of other artists of his day, he shared with them a strong feeling for humanism and, with that, a penchant for Classical art and subjects.

Botticelli painted *Primavera* (*Springtime*) (**Fig. 12.27**) for a cousin of Lorenzo the Magnificent named Lorenzo di Pierfrancesco de' Medici on the occasion of his wedding. One of the most popular paintings in Western art, *Primavera* is an elaborate allegory of love, presided over by the figure of Venus in the center of the composition standing beneath her son, Cupid. To the right, the god of the wind, Zephyrus, abducts the nymph Chloris—who, after the two are wed, is transformed into Flora, the graceful figure who tosses petals from the bunched up folds of her floral-patterned dress. To the right, three maidens—the Three Graces—dance while nearby, the god Mercury lifts his staff toward the floating strata of a gloomy cloud. Cupid hovers and aims his love arrow in the direction of the Graces. The

▼ **12.27** Sandro Botticelli, *Primavera*, ca. 1482. Tempera on wood, 80″ × 124″ (203 × 314 cm). **Galleria degli Uffizi, Florence, Italy.** This work is one of the best examples of Botticelli's fusion of pagan symbolism and Christian humanism.

painting has been interpreted as a symbolic representation of the joining of physical love (desire) and spiritual love (the love of God) in the sacred bond of matrimony.

Botticelli's most famous painting, perhaps, is *The Birth of Venus* (**Fig. 12.28**), a work that may have been inspired by a poem by the humanist Angelo Poliziano on the same subject:

> You could swear that the goddess had emerged
> from the waves, pressing her hair with her right
> hand, covering with the other her sweet mound
> of flesh; and where the strand was imprinted by
> her sacred and divine step, it had clothed itself
> in flowers and grass; then with happy, more than
> mortal features, she was received in the bosom
> of the three nymphs and cloaked in a starry garment.
>
> —From "La Giostra," Angelo Poliziano, 1475–1478

Poliziano was a scholar and member of the Neo-Platonist circle around Lorenzo the Magnificent, and *The Birth of Venus* was painted for the Medici. Venus, born of the foam of the sea, drifts along on a large scallop shell to the shore of her sacred island of Cyprus, aided by the sweet breaths of entwined zephyrs. The nymph Pomona, wearing a billowing, flowered dress, awaits her with a luxurious patterned mantle. Venus was derived from an antique sculpture of the type Venus Pudica (the modest Venus), similar to the Aphrodite of Knidos (see **Fig. 3.18**); her face may have been based on a portrait of Simonetta Vespucci, a cousin of Amerigo Vespucci, the navigator and explorer after whom the continents of North and South America are named. The graceful rhythms in the composition are evoked through a plethora of lines, from the V-shaped ripples in the sea and the radiating pattern of the seashell to the subtle curves and vigorous arabesques that caress the figures; shading is confined to areas within the sculptural contours of the figures.

Neo-Platonic references to spiritual fulfillment made possible by the contemplation of ideal beauty were evident in Botticelli's painting, just as they were in Lorenzo de' Medici's poetry (see page 376). As a kindred spirit, Botticelli remained closely allied with the Medici for decades, although he did have other wealthy patrons. The *Adoration of the Magi* (**Fig. 12.29**)

▼ **12.28** Sandro Botticelli, *The Birth of Venus*, ca. 1484–1486. Tempera on canvas, 69″ × 110″ (172 × 277 cm). **Galleria degli Uffizi, Florence, Italy.** The statuesque quality of Venus was likely inspired by a classical sculpture, the Aphrodite of Knidos (see Fig.3.18), although the narrative that unfolds in the composition takes some of its details from a poem by one of Botticelli's fellow humanists.

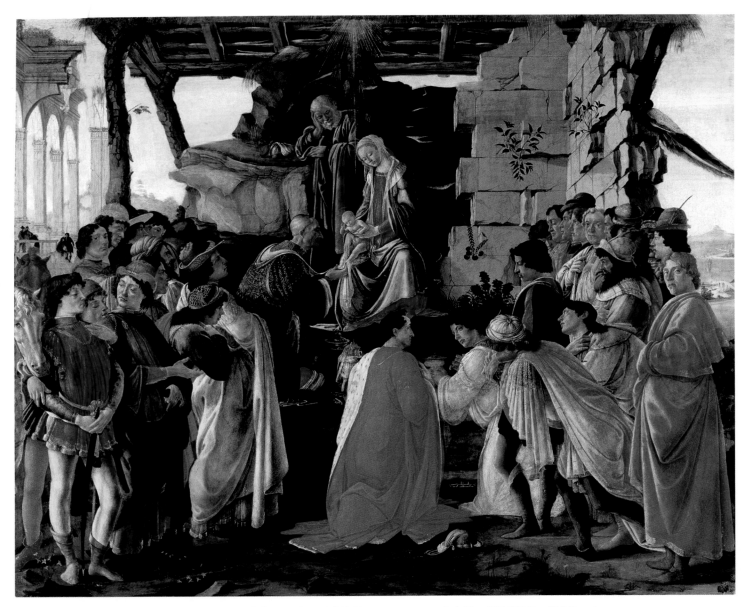

▲ 12.29 Sandro Botticelli, *Adoration of the Magi*, ca. 1475. Tempera on panel, 44″ × 53″ (111.8 × 134.6 cm). **Galleria degli Uffizi, Florence, Italy.** The painting reads as a veritable who's who of Florence's rich and famous. Many scholars believe that the young blond man in an ochre cloak in the extreme right foreground is Botticelli himself.

was commissioned by the Florentine banker Gaspare di Zanobi del Lama for a private chapel in Santa Maria Novella (now destroyed) and includes a portrait of the donor (in the right-hand group in a blue cape, looking out toward the viewer) in the midst of the city's most cultured and powerful. Botticelli, as if upstaging him, stands even closer to us in the right foreground.

Architecture

In a way, Brunelleschi's loss to Ghiberti in the competition for the bronze doors of the Florence Baptistery was

fortuitous for the history of Renaissance architecture. His intensive study of the structures and engineering techniques of Classical antiquity altered the way architects thought about and constructed buildings. His drawings and precise measurements, particularly of ruins in the Roman Forum, created a template for Renaissance architecture that reached deeper than the simple appropriation of classically inspired motifs.

FILIPPO BRUNELLESCHI AS ARCHITECT The Cathedral of Florence, begun by Arnolfo di Cambio at the end of the 14th century, was still unfinished in the opening decades of

⌃ 12.30 Drawings illustrating the Florence Cathedral before and during the construction of Brunelleschi's dome, 1420–1436. These artist's reconstructions depict the church of Santa Maria del Fiore: (A) as it stood without its eastern end—before Brunelleschi began construction of the dome—and (B) showing the progress on the transept, apse, and crossing square as of 1418. The tambour (drum) is complete and the domed vault is under construction.

the 15th century. The nave was completed but no one had quite figured out how to span the great area of the crossing square without immense buttresses on the exterior of the building and supporting armatures within. Brunelleschi worked on a design for the dome between 1417 and 1420, trying both to solve the complicated engineering puzzle of its construction and to convince skeptical cathedral overseers that it could be done. He won the day eventually—ironically beating out Ghiberti for the commission—but work on the dome was not completed until 1436 (**Fig. 12.30;** see also **Fig. 11.24**).

His solution, briefly, was to combine the buttressing methods of the Gothic cathedral with Classical vaulting techniques that he had mastered from his careful study of the Roman Pantheon and other buildings from antiquity. By putting a smaller dome within the larger dome to support the greater weight of the outside dome, he could not only cover the great tambour (drum, or base) but he could free the inside of the dome of the need for elaborate armatures or supporting structures. This dome was strong enough to support the lantern that eventually crowned the whole construction (**Fig. 12.31**). It was a breathtaking technical achievement, as well as an aesthetic success, as any person viewing Florence from the surrounding hills can testify. Years later, writing about his own work on the dome of Saint Peter's in

the Vatican, Michelangelo had Brunelleschi's dome in mind when he said, "I will create your sister; bigger but no more beautiful."

The technical brilliance of Brunelleschi's dome cannot be overpraised, but his real architectural achievement lies in building designs that break entirely from vestiges of the Medieval tradition. His loggia for the Ospedale degli Innocenti (Hospital of the Innocents) in Florence (**Fig. 12.32**), considered by some to be the first structure in a pure Renaissance style, is a light and airy sheltered gallery with an arcade that runs the length of the building. The Ospedale was a home for abandoned children supported by the guild of silk manufacturers and goldsmiths; the commission for the project was given to Brunelleschi, who was one of its members. The loggia is defined by hemispherical arches supported by Corinthian columns on street level; above, rectangular windows crowned with small triangular pediments are placed directly over the center of each arch. The horizontal progression of arches is reiterated in the gray stone moldings that separate the two levels of the façade. Despite its simple appearance, the building's intricate proportions and relationships were calculated with mathematical precision: the height of the columns is equal to the space between them and to the distance between them and the wall of the loggia.

◄ **12.31** *The Execution of Savonarola*, Italian School, ca. 1498. Tempera on panel, 39³/₄" x 46" (101 x 117 cm). Museo di S. Marco, Florence, Italy. The hanging and burning of Girolamo Savonarola in Florence's main square was painted by an anonymous artist who took great pains to record the architectural setting: the dark stone and crenelated tower of the Palazzo Vecchio, the curved arches of the Loggia dei Lanzi to its right, and, along the left edge of the painting, a sliver of the dome of the cathedral of Florence. Even though Brunelleschi's dome would not have been so visible from this specific perspective, its inclusion unmistakably identifies the location as Florence. His Duomo was synonymous with the city.

This same concern with mathematical proportion, order, and harmony can be seen in Brunelleschi's finest work—a chapel for the Pazzi family (**Fig. 12.33**) next to the Franciscan church of Santa Croce in Florence. The arched and columned portico and classicizing motifs are reminiscent, overall, of the Roman triumphal arches Brunelleschi sketched in and around the Forum (see **Fig. 4.8**). The chapel's unimposing façade leads to a central-plan interior in which a hemispherical dome, resting on massive piers and arches, is the central focus. Brunelleschi's decoration is spare, but dramatic; the combination of white stucco with gray stone accents, seen also in the Ospedale degli Innocenti, was his signature design element.

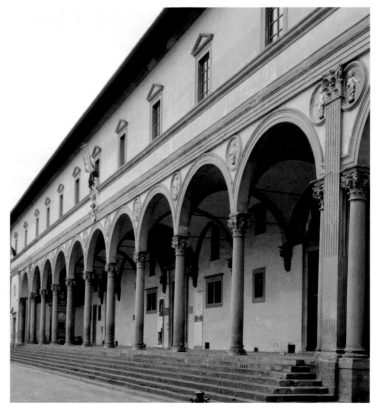

➤ **12.32** Filippo Brunelleschi, loggia of the Ospedale degli Innocenti ("Hospital of the Innocents" Foundling Hospital), begun 1419. Florence, Italy. The sheltered gallery of the Ospedale degli Innocenti was a place where abandoned children and those placed in the orphanage could be dropped off. The mission of the Ospedale—to care for unwanted children—is reinforced by the images of swaddled children in glazed terra-cotta medallions above the columns. They were a later addition to the façade by artists working in the della Robbia ceramics workshop in Florence.

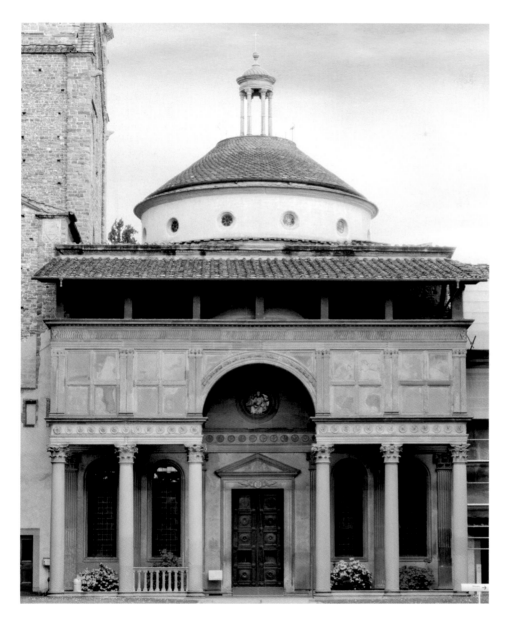

◄ **12.33** Filippo Brunelleschi, Pazzi Chapel, begun 1433. Santa Croce, Florence, Italy. Brunelleschi spent countless hours sketching and measuring ancient structures in Rome, particularly in the Forum. The façade of the Pazzi Chapel is an adaptation of a Roman triumphal arch. The Pazzi family is infamous for the conspiracy that led to the murder of Giuliano de' Medici and wounding of his brother, Lorenzo. In spite of their heinous deed, the Pazzi were allowed to bury their dead family members in the chapel.

LEON BATTISTA ALBERTI Some of the purest examples of Classical revival in Renaissance architecture are found in the work of Leon Battista Alberti (1404–1472). Among the first to study the treatises of Roman architects—the most famous of whom was Vitruvius—he combined his knowledge of antique buildings with innovative designs in his grand opus, *Ten Books on Architecture*. Alberti is also credited with canonizing Brunelleschi's principles of mathematical perspective in an essay on painting (*Della pittura*). One of Alberti's most pristine and harmonious designs in the Classical tradition is the Palazzo Rucellai (**Fig. 12.34**) in Florence, an atrium-style palatial residence built around an interior courtyard. The building has three stories, separated by horizontal entablatures and crowned by a heavy cornice. Within each story, pilasters with capitals of different orders frame the fenestration; they provide a vertical counterpoint to the strong horizontals, as does the vertical alignment of the windows. As the elevation rises

from ground level toward the roof, the pattern of the masonry becomes more delicate—smaller-cut stones, placed closer together. The palazzo's design, with its clear articulation of parts, rhythmic repetition, and overall balance and harmony of shape and line, illustrates the degree to which Alberti internalized Classical design and adapted it successfully to the contemporary nobleman's needs.

In analyzing the art and architecture of 15th-century Italy, certain recurring words and themes offer a clear description of what the Renaissance style reflects: a rejection of the ethereal otherworldliness of Medieval artistic traditions in favor of a focus on the natural world; a technical ability to handle space and volume in a credible way; a studious approach to the artistic models of antiquity, especially ancient Rome; and a greater concern for realism in the depiction of human behavior and emotion. The Florentine artistic temperament in particular

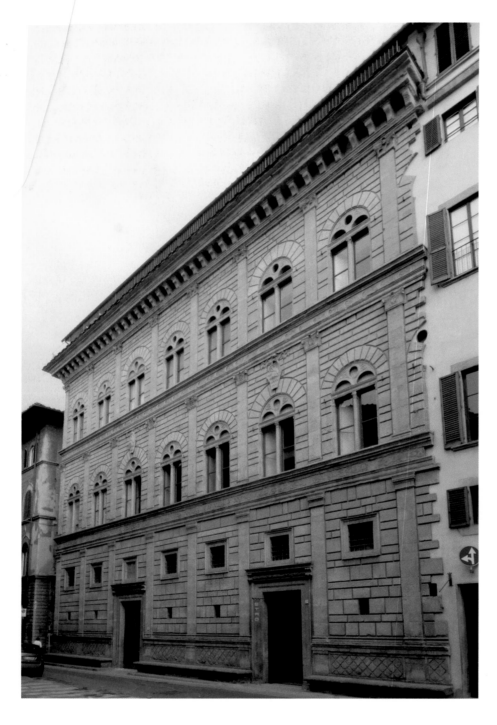

◄ **12.34** Leon Battisa Alberti and Bernardo Rossellino, Palazzo Rucellai, ca. 1452–1470. Florence, Italy. A palazzo is a palace, or palatial residence, for a prominent Italian family. This one was designed by Alberti for Giovanni Rucellai, the son-in-law of the powerful Florentine Pala Strozzi, who commissioned Gentile da Fabriano's *Adoration of the Magi*. The Rucellai family fortune came from the wool trade and banking.

leaped over its Medieval heritage (although not completely) to reaffirm the power of the Classical ideals of the ancients.

MUSIC

By the early 15th century, the force of the Italian Ars Nova movement in music had spent itself. The principal composers of the early Renaissance were from Northern Europe.

Strong commercial links between Florence and the North ensured the exchange of ideas, and a new musical idiom that had been developed to please the ear of the prosperous merchant families of the North soon found its way to Italy.

GUILLAUME DUFAY Guillaume Dufay (ca. 1400–1474), the most famous composer of the century, perfectly exemplifies the tendency of music to cross national boundaries. As a young man, Dufay spent several years in Italy studying

music and singing in the papal choir at Rome. He later served as music teacher in the French (Burgundian) court of Charles the Good. The works he composed there included masses and motets; he was one of the first composers after Machaut to write complete settings of the Mass. His secular works include several charming **chansons** (songs) that are free in form and expressive in nature.

Among the changes introduced into music by Dufay and his Burgundian followers (many of whom went to Italy for employment) was the secularization of the motet, a choral work that had previously used a religious text. Motets were now written for special occasions like coronations or noble marriages and the conclusions of peace treaties. Composers who could supply such motets on short notice found welcome in the courts of Renaissance Italian city-states.

Dufay was also one of the first composers to introduce familiar folk tunes into the music of the Mass, the best-known example being his use of the French folk tune "L'homme armé" ("The Man in Armor") in a mass that is now named for it. Other composers followed suit, and the so-called *chanson masses* were composed throughout the 15th and 16th centuries. "L'homme armé" alone was used for more than 30 different masses. The intermingling of secular with religious elements is thoroughly in accordance with Renaissance ideals.

Among Dufay's most prominent pupils was the Flemish composer Johannes Ockeghem (ca. 1410–1497), whose music was characterized by a smooth-flowing but complex web of contrapuntal lines generally written in a free style (the lines do not imitate one another). The resulting mood of the music is more serious than Dufay's, partly because of the intellectual complexity of the counterpoint and partly because Ockeghem sought a greater emotional expression. The combination of intellect and feeling is characteristic of the Renaissance striving for Classical balance. Ockeghem's Requiem Mass is the oldest of the genre to survive (Dufay wrote one, but it has not survived).

Music in Medici Florence

The fact that Italian composers were overshadowed by their Northern contemporaries did not in any way stifle Italian interest in music. Lorenzo de' Medici founded a school of harmony that attracted musicians from many parts of Europe, and he had some skill as a lute player. Musical accompaniment enlivened the festivals and public processions of Florence. Popular dance tunes for the *saltarello* and the *pavana* have survived in lute transcriptions.

We know that the Neo-Platonist writer Marsilio Ficino played the lyre before admiring audiences, although he had

intentions more serious than mere entertainment. Unlike the visual artists, who had models from Classical antiquity for inspiration, students of music had no Classical models to follow: no Greek or Roman music had survived in any significant form. Still, the ideas about music expressed by Plato and other writers fascinated Ficino and others. Greek music had been patterned after the meter of verse and its character carefully controlled by the mode in which it was composed. The Greek doctrine of ethos is still not fully understood today, but Ficino and his friends realized that Plato and Aristotle regarded music as of the highest moral (and hence political) significance. The closest they could come to imitating ancient music was to write settings of Greek and Roman texts in which they tried to follow the meter as closely as possible. Among the most popular works was Virgil's *Aeneid*: the lament of Dido was set to music by no fewer than 14 composers in the 15th and 16th centuries.

A more popular music form was the **frottola**, probably first developed in Florence, although the earliest surviving examples come from the Renaissance court of Mantua. The frottola was a setting of a humorous or amorous poem for three or four parts consisting of a singer and two or three instrumentalists. Written to be performed in aristocratic circles, the frottola often had a simple folk quality. The gradual diffusion of frottole throughout Europe gave Italy a reputation for good simple melody and clear vigorous expression.

The **canto carnascialesco** (carnival song) was a specifically Florentine form of the frottola. Written to be sung during the carnival season preceding Lent, such songs were very popular. Even the great Flemish composer Heinrich Isaac wrote some during his stay with Lorenzo de' Medici around 1480. With the coming of the Dominican reformer Savonarola, however, the carnivals were abolished because of their alleged licentiousness. The songs also disappeared. After the death of Savonarola, the songs were reintroduced, but they died out again in the 16th century.

The tug of war between Classicism and Christianity may be one key to understanding the Renaissance. It may even help us understand something about the character of almost everything we have discussed in this chapter. The culture of the 15th century often was, in fact, a dialectical struggle: At times Classical ideals clashed with biblical ideals; at other times, the two managed to live either in harmony or in a temporary marriage of convenience. The strains of Classicism and Christianity interacted in complex and subtle ways. This important fact helps us understand a culture that produced, in a generation, an elegant scholar like Ficino and a firebrand like Savonarola, a pious artist like Fra Angelico and a precocious genius like Masaccio; a Machiavelli and an Erasmus.

GLOSSARY

Cantocarnascialesco (p. 413) A carnival song, written for the carnial season before Lent.

Captalism (p. 374) A way of organizing the economy so that the manufacture and distribution of goods—and the exchange of wealth—is in the hands of individuals rather than the government.

Chanson (p. 413) Song.

Contrapposto (p. 397) A position in which a figure is obliquely balanced around a central vertical axis; also known as the *weight-shift principle.*

Frottola (p. 413) A humorous or amorous poem set to music for a singer and two or three instrumentalists.

Guild (p. 381) Generally, an association of people with common interests; in medieval times, typically a group of merchants or artisans who sought to maintain their standards and protect their interests.

Polyptych (p. 380) An arrangement of four or more painted or carved panels that are hinged together.

Talmud (p. 385) A collection of Jewish law and tradition created ca. fifth century CE.

Vellum (p. 387) Calfskin, kidskin, or lambskin used as a surface for writing.

THE BIG PICTURE THE FIFTEENTH CENTURY

Language and Literature

- Gutenberg invented moveable printing type in 1446–1450.
- The Gutenberg Bible was printed at Mainz in 1455–1456.
- William Caxton published the first book printed in English, *The Recuyell of the Historyes of Troye*, in 1475.
- Lorenzo de' Medici began *Comento ad alcuni sonetti* ca. 1476–1477.
- Laura Cereta's humanist writings appeared in the latter 1400s.
- Giovanni Pico della Mirandola published *Oration on the Dignity of Man* in 1486.
- Lorenzo de' Medici published "The Song of Bacchus" in 1490.
- Aldus Manutius established the Aldine Press in Venice ca. 1494.
- Niccolò Machiavelli published *The Prince* in 1513.

Art, Architecture, and Music

- Claus Sluter created *The Well of Moses* ca. 1395–1406.
- Lorenzo Ghiberti won the competition for the commission to create the north doors of the Florence Bapistery in 1401.
- Donatello sculpted *Saint George* ca. 1415 and the façade of the Pazzi Chapel in 1433.
- The Limbourg brothers created manuscript illuminations for *Les Très riches heures du duc de Berry* ca. 1413–1416.
- Filippo Brunelleschi designed and began construction of the dome of the Florence Cathedral ca. 1417–1420.
- Brunelleschi began the loggia of the Ospedale degli Innocenti in 1419.
- Gentile da Fabriano painted *Adoration of the Magi* at the Strozzi Chapel in 1423.
- Masaccio painted *The Holy Trinity, Tribute Money,* and *Expulsion of Adam and Eve from Eden* ca. 1424–1427.
- Robert Campin painted the Mérode altarpiece ca. 1428.
- Guillaume Dufay, teacher and composer, secularized the motet and popularized chanson masses in the 1430s.
- Ghiberti created the Gates of Paradise in 1425–1452.
- Jan van Eyck painted his Ghent altarpiece in 1432 and *Giovanni Arnolfini and His Wife* in 1434.
- Paolo Uccello painted *The Battle of San Romano* ca. 1456.
- Fra Angelico painted his *Annunciation* ca. 1438–1447.
- Donatello sculpted his *David* ca. 1440–1460.
- Johannes Ockeghem composed his Missa pro Defunctis, the earliest known requiem mass, ca. 1450–1500.
- Leon Battista Alberti built the Palazzo Rucellai ca. 1452–1470.
- Piero della Francesca created his *Resurrection* ca. 1463–1465.
- Andrea del Verrocchio created his sculpture of *David* ca. 1465–1470.
- Sandro Botticelli painted *Adoration of the Magi* ca. 1475, *Primavera* ca. 1482, and *The Birth of Venus* ca. 1484–1486.

Philosophy and Religion

- Marsilio Ficino published *Theologia Platonica* in 1482.
- Girolamo Savonarola began sermons against Florentine immorality in the late 1480s.
- Erasmus published *Enchiridion militis Christiani* in 1502.
- Erasmus published *The Praise of Folly* in 1509.
- Erasmus published the *Greek New Testament* in 1516.

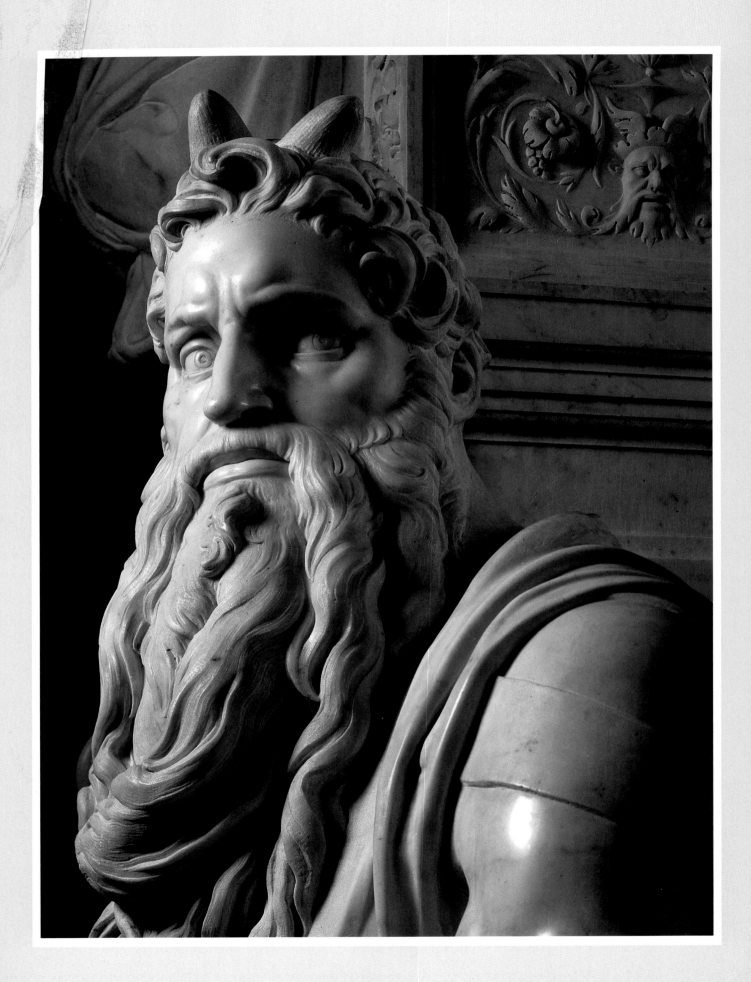

The High Renaissance and Mannerism in Italy

PREVIEW

The Italians had a word for awe-inspiring power and grandeur, overwhelming emotional intensity, intractable will, and incalculable rage: *terribilità*. That they used the word to describe two outsized personalities—Pope Julius II and Michelangelo Buonarroti—whose intertwined destinies shaped both history and the history of art gives us insight into the Renaissance papacy, patronage of the arts, and the lust for legacy.

On his fourth attempt to secure the papacy, Giuliano della Rovere, called "il Terribilis," was elected almost unanimously in 1503 by a conclave of cardinals, several of whom he most certainly bribed—heavily. He took the name Julius II, not in honor of the canonized fourth-century pope by the same name but in emulation of Julius Caesar, the great Roman statesman, conqueror, and architect of the future empire. Julius II would become known as the Warrior Pope who brought the Papal States back under control of Rome after the Avignon papacy, and who waged military campaigns against the Republic of Venice in partnership with the Holy Roman emperor and the kings of France and Aragon.

Like Caesar, Julius II would aim to glorify Rome, using art and architecture conspicuously to assert his power and wealth and to ensure his legacy. He directed his energies—and funds from the papal treasury—toward several pet projects that would reflect his authority, influence, and personal taste. They included the construction of a new Saint Peter's on the site of Constantine's fourth-century basilica and major works of art for the Vatican. An advocate for and patron of contemporary artists, Julius II was, in the words of the author R. A. Scotti, "a one-man MoMA."[1] In every way, he was larger than life. A Venetian ambassador to the Vatican said: "No one has any influence over him, and he consults few or none. . . . It is almost impossible to describe how strong and violent and difficult to manage he is. . . . Everything about him is on a magnificent scale, both his undertakings and his passions."[2] As it happened, Julius II might have spoken those very words in describing Michelangelo, for their relationship was anything but smooth.

By the time he was 30, the Florentine sculptor Michelangelo had secured his position as the hottest artistic commodity in Italy. With at least two significant, attention-getting works under his belt—the *Pietà* in a chapel in Old Saint Peter's Basilica and the *David* in the Piazza della Signoria in Florence—Michelangelo was destined for work in Rome. That was where power and the money were. And that is where Julius II would use him to realize his grand plans—beginning with his own funerary monument, a massive freestanding pyramidal

◄ **13.1** Michelangelo, *Moses*, detail, 1513–1515. Marble, 92½" (235 cm) high. San Pietro in Vincoli, Rome, Italy.

1. MoMA is the acronym for the Museum of Modern Art in New York City.

2. Quoted in R. A. Scotti, *Basilica: The Splendor and the Scandal; Building St. Peter's* (New York: Penguin, 2006), 4.

structure with 40 carved figures to be placed in none other than the basilica of Saint Peter's. It was the commission of a lifetime, and Michelangelo threw himself into the project with passion and zeal. But while the sculptor was away from Rome choosing perfect, creamy-white marble from the quarries in Carrara (his favorite material), Julius turned his attention to something even grander: a new Saint Peter's. Julius's choice of the architect Donato Bramante—a longtime bitter rival of Michelangelo—and sporadic provision of adequate funds for the tomb project caused tension and, eventually, outright conflict. Worst, perhaps, was the fact that Michelangelo was not getting the attention from the pope to which he was accustomed, and Julius II made a habit of adding insult to injury by granting several important commissions to his competitors. Michelangelo's rage, obstinacy, and moodiness—and the legendary temper of Julius II—amounted to a clash of titans.

Completion of the tomb plagued Michelangelo throughout Pope Julius II's reign (Julius's other "side projects" for the artist included the Sistine Chapel ceiling fresco), and things would not improve after the pontiff's death. Subsequent popes wanted to harness Michelangelo's talent for their own projects and purposes; very few were interested in glorifying their dead predecessor, particularly with a mammoth monument-tomb in as high profile a place as Saint Peter's. In the end, a completed work—much diminished from its first, grand design—was erected in the church of San Pietro in Vincoli (that is, "Saint Peter in Chains"). where it can still be seen today. Julius, who always intended to have his remains interred in Saint Peter's, is indeed buried there—alas, beneath the floor, his grave marked by a simple inscription carved in marble.

The masterwork of the monument to Pope Julius II is Michelangelo's *Moses* (**Fig. 13.1**), a portrait of the great Hebrew prophet and lawgiver fresh from his communion with God, gripping the tablets inscribed with the Ten Commandments, glowering in fury at the idolaters about to be destroyed. A figure of awesome might, uncompromising will, fearsome temperament, and unwavering belief—he is the artistic embodiment of *terribilità*. In his face, we see Julius; we see Michelangelo.

THE 16TH CENTURY IN ITALY: OF POLITICS, POPES, AND PATRONAGE

Culturally, one could argue that the Renaissance in Italy affected the daily lives of only the few. Northern Italy, especially Milan, was a major urban center. The papacy had returned to Rome in 1478, but much of the city was poor and in ruins from its history of invasions. The 16th century was part of the era of the warring city-states, the most prominent among these being Milan, Florence, Siena, Genoa, Venice, Naples, and the Papal States.

Although all of Italy was Roman Catholic, the Papal States were territories directly held by the pope. The head of the Roman Catholic Church held not only ecclesiastical power (as the leader of the religion) but also temporal power (as the head of state). The papacy governed territories in central Italy from the Middle Ages (756) through the middle of the 19th century. **Map 13.1** shows the city-states of Italy at the end of the 15th century. The outline would remain reasonably stable through most of the 16th century, despite a series of martial efforts to change it in every which way. The last papal state, which we know as Vatican City, was established in 1929. Although it is located in the city of Rome, it is a

The High Renaissance and Mannerism in Italy

1471 CE	1501 CE	1520 CE	1600 CE
Reign of Pope Sixtus IV (della Rovere)	Michelangelo sculpts *David*	Reign of Pope Clement VII (de' Medici)	
Columbus lands in the Americas	Leonardo da Vinci paints *Mona Lisa*	Sack of Rome by Charles V	
Foreign invasions of Italy begin	Reign of Pope Julius II (della Rovere)	Churches of Rome and England separate	
Leonardo da Vinci paints *The Last Supper*	Michelangelo paints the ceiling of the Sistine Chapel	Titian paints *Venus of Urbino*	
	Venetian trade declines as a result of new geographic discoveries	Council to reform the Catholic Church begins at Trent	
	Reign of Pope Leo X (de' Medici)		
	Reformation begins in Germany with Luther's 95 Theses challenging the practice of granting indulgences		

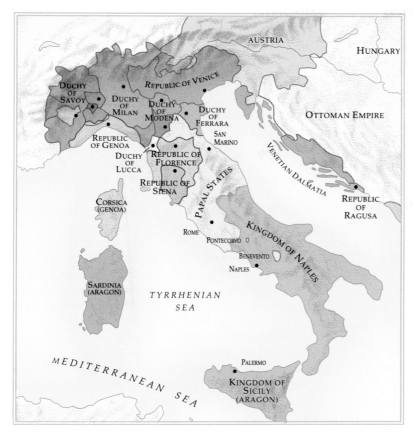

◄ **MAP 13.1** Italy in 1494

the Holy Roman emperor, sacked Rome. The Holy Roman Empire, formerly in league with the Papal States under Julius, was now at war with the Papal States, which were allied with France and the Italian states of Florence, Milan, and Venice. The pope at the time, Clement VII, escaped, but he eventually surrendered and was compelled to cede some territories.

The Medici family of Florence, although not quite what they were in the 15th century, also supported the arts during the 16th century. The family had amassed their wealth from banking and had become the de facto rulers of Florence. They became royalty—the dukes of Florence—in the 16th century (1531). They expanded the territory of Florence; it became the Grand Duchy of Tuscany—the surrounding region of Italy—in 1569. The Medici dynasty, like Julius II, had been a major inspiration of the Renaissance in Italy, along with some other families, such as the Sforza and Visconti families of Milan and the Gonzaga family of Mantua. During the 16th century, the Medici family consolidated their exalted position by producing four popes and a queen of France (Catherine de' Medici, who reigned from 1547 to 1559).

separate country. **Figure 13.2** shows some of the popes of the 16th century.

In the 15th century, artists had found rewarding work at the Vatican. Pope Sixtus IV (reigned 1471–1484) had commissioned many artists who were famous in Florence—among them Ghirlandaio, Botticelli, and Perugino—to fresco the side walls of the Sistine Chapel, named for himself, as well as work on other projects that caught his artistic fancy. Not the least of these projects was the enlargement and systematization of the Vatican Library. Florence in the 15th century, shaped by the generous and refined **patronage** of the Medici and others, was an extremely congenial place for the talented artist.

But it can be said that the High Renaissance began in 1503 when a nephew of Sixtus IV, Julius II, ascended to the papacy. Both Sixtus and Julius were members of the della Rovere family. Julius was a fiery man who did not hesitate to don full military armor over his vestments and lead his papal troops into battle. Thanks to the influence of his papal uncle, he appreciated the fine arts, indulging his artistic tastes with the same single-mindedness that characterized his military campaigns. It was Pope Julius—called by his contemporaries *il papa terribile* ("the awesome pope")—who summoned both Raphael Sanzio and Michelangelo Buonarroti to Rome. Julius II ruled the Papal States until his death in 1513.

It was a time like many other times, when alliances were readily formed and broken. In 1508 Julius entered alliances with the kings of France and Aragon and the Holy Roman emperor to fight the Republic of Venice. But by 1513, Venice had allied with France. In the year 1527, troops of Charles V,

▼ **13.2 Some Popes of the 16th Century**

Leo X (1513–1521)	Son of Lorenzo the Magnificent; patronized Michelangelo and excommunicated Martin Luther.
Hadrian VI (1522–1523)	Born in the Netherlands; a ferocious reformer and the last non-Italian pope until the 1970s.
Clement VII (1523–1534)	Grandson of Lorenzo the Magnificent; commissioned the Medici tombs in Florence, and *The Last Judgment* for the Sistine Chapel just before his death; excommunicated Henry VIII.
Paul III (1534–1549)	Commissioned Michelangelo to build the Farnese Palace in Rome; called the reform Council of Trent, which first met in 1545.
Julius III (1550–1555)	Patron of the composer Palestrina; confirmed the constitutions of the Jesuits in 1550; appointed Michelangelo as chief architect of Saint Peter's.
Marcellus II (1555)	Reigned as pope for 22 days; honoree of Palestrina's *Missa Papae Marcelli*.
Paul IV (1555–1559)	A fanatical reformer; began the papal reaction against the Renaissance spirit; encouraged the Inquisition and instituted the Index of Forbidden Books in 1557.

Their second queen of France, Marie de' Medici, reigned at the beginning of the 17th century, from 1600 to 1610. The Medici family competed with the Papal States, other Italian states, and foreign lands such as France for the services of the greatest artists. In mid-century, the Boboli Gardens in Florence, brought to full fruition by the Medici family, became a model for royal gardens throughout Europe. But the twin gravitational fields of patronage and the Church were inexorably pulling the center of the art world toward Rome.

Music was first printed in 1516, making it less expensive for choirs and orchestras to be literally on the same page. Julius II patronized his own choir as well as his monumental undertakings. Peasants farmed. Bankers and the church raked in cash. The Americas were explored. Painters painted. Sculptors sculpted. Architects architected. Artisans and laborers realized the grand schemes of the movers and the shakers. Despite the turmoil, the Renaissance reached its height.

THE VISUAL ARTS

At the dawn of the 16th century, the three artists who were in greatest demand—the masters of the High Renaissance in Italy—were Leonardo da Vinci, a painter, scientist, inventor, and musician; Raphael, the Classical painter thought to have rivaled the works of the ancients; and Michelangelo, the painter, sculptor, architect, poet, and enfant terrible. Donato Bramante is deemed to have made the most significant architectural contributions of this period. These are the stars of the Renaissance, the artistic descendants of Giotto, Donatello, and Alberti—who, because of their earlier place in the historical sequence of artistic development, are sometimes portrayed as but stepping-stones to the greatness of the 16th-century artists rather than as masters in their own right.

LEONARDO DA VINCI If the Italians of the High Renaissance could have nominated a counterpart to what the Classical Greeks referred to as the "four-square man," it most assuredly would have been Leonardo da Vinci (1452–1519). He came from a small Tuscan town near Florence by the name of Vinci. He lived in Florence until the 1480s, when he left for Milan; from there he moved restlessly from place to place until his death in France.

His capabilities in engineering, the natural sciences, music, and the arts seemed unlimited, as he excelled in everything from solving drainage problems (a project he undertook

▾ **13.3** Leonardo da Vinci, *The Last Supper*, 1495–1498. Fresco (oil and tempera on plaster), 15′1″ × 28′10″ (460 × 880 cm). Refectory, Santa Maria delle Grazie, Milan, Italy. There had been many paintings on the subject of the Last Supper, but the people in Leonardo's composition are individuals who display real emotions. They converse with one another animatedly, yet most heads are turned toward Jesus, focusing the viewer's attention of the center of the composition.

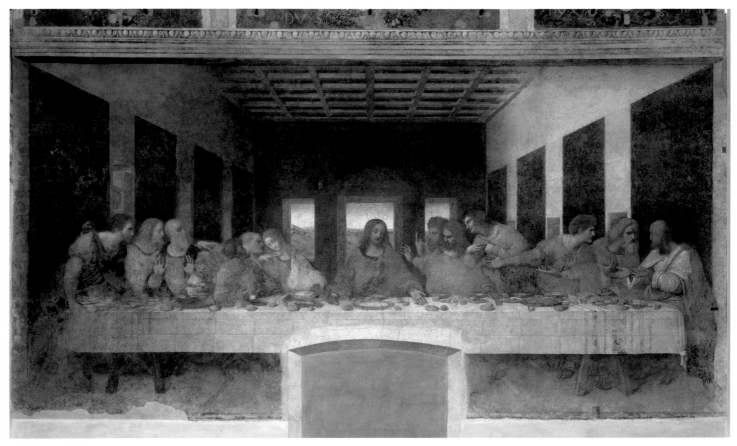

READING 13.1 LEONARDO DA VINCI

Letter of Application to Ludovico Sforza (ca. 1481)

Most Illustrious Lord, Having now sufficiently considered the specimens of all those who proclaim themselves skilled contrivers of instruments of war, and that the invention and operation of the said instruments are nothing different from those in common use: I shall endeavor, without prejudice to any one else, to explain myself to your Excellency, showing your Lordship my secrets, and then offering them to your best pleasure and approbation to work with effect at opportune moments on all those things which, in part, shall be briefly noted below.

1. I have a sort of extremely light and strong bridge, adapted to be most easily carried, and with it you may pursue, and at any time flee from the enemy; and others, secure and indestructible by fire and battle, easy and convenient to lift and place. Also methods of burning and destroying those of the enemy.

2. I know how, when a place is besieged, to take the water out of the trenches, and make endless variety of bridges, and covered ways and ladders, and other machines pertaining to such expeditions.

3. If, by reason of the height of the banks, or the strength of the place and its position, it is impossible, when besieging a place, to avail oneself of the plan of bombardment, I have methods for destroying every rock or other fortress, even if it were founded on a rock, etc.

4. Again, I have kinds of mortars; most convenient and easy to carry; and with these I can fling small stones almost resembling a storm; and with the smoke of these cause great terror to the enemy, to his great detriment and confusion.

5. And if the fight should be at sea I have kinds of many machines most efficient for offense and defense; and vessels which will resist the attack of the largest guns and powder and fumes.

6. I have means by secret and tortuous mines and ways, made without noise, to reach a designated spot, even if it were needed to pass under a trench or a river.

7. I will make covered chariots, safe and unattackable, which, entering among the enemy with their artillery, there is no body of men so great but they would break them. And behind these, infantry could follow quite unhurt and without any hindrance.

8. In case of need I will make big guns, mortars, and light ordnance of fine and useful forms, out of the common type.

9. Where the operation of bombardment might fail, I would contrive catapults, mangonels, trabocchi, and other machines of marvelous efficacy and not in common use. And in short, according to the variety of cases, I can contrive various and endless means of offense and defense.

10. In times of peace I believe I can give perfect satisfaction and to the equal of any other in architecture and the composition of buildings public and private; and in guiding water from one place to another.

11. I can carry out sculpture in marble, bronze, or clay, and also I can do in painting whatever may be done, as well as any other, be he who he may.

 Again, the bronze horse may be taken in hand, which is to be to the immortal glory and eternal honor of the prince your father of happy memory, and of the illustrious house of Sforza.

 And if any of the above-named things seem to anyone to be impossible or not feasible, I am most ready to make the experiment in your park, or in whatever place may please your Excellency—to whom I commend myself with the utmost humility, etc.

Jean Paul Richter. (Ed. & trans.). *The Literary Works of Leonardo da Vinci.* 2 vols. London: S. Low, Marston, Searle & Rivington, 1883.

in France just before his death) to designing prototypes for airplanes and submarines to creating some of the most memorable Renaissance paintings. In about 1481, Leonardo looked for work with Ludovico Sforza, the son of the ruler of Milan. Just as we sometimes tailor our résumés to coincide with the job we are seeking, so too did Leonardo write his letter of introduction stressing those qualities that he felt might be of greatest interest to Sforza, mentioning his artistic abilities only briefly. He assumed that Sforza was more concerned with making war—or defending against it.

Leonardo's application was accepted.

Leonardo left us about 30 paintings. *The Last Supper* (**Fig. 13.3**), a fresco painting executed for the dining hall of a Milan monastery, stands as one of his greatest works. The condition of the work is poor, because of Leonardo's experimental fresco technique—although the steaming of pasta for centuries on the other side of the wall may also have played a role. Nonetheless, we can still observe the Renaissance ideals of Classicism, humanism, and technical perfection now coming to full fruition. The composition is organized through the use of one-point linear perspective. Solid volumes are constructed from a masterful contrast of light and shadow. A hairline balance is struck between emotion and restraint.

The viewer is first attracted to the central triangular form of Jesus sitting among his apostles by **orthogonals** that converge at his head. His figure is silhouetted against a triple window that symbolizes the Holy Trinity and pierces the otherwise dark back wall. The viewer's attention is held at this center point by Christ's isolation, which results from the leaning away of the apostles. Leonardo has chosen to depict the moment when Jesus says, "One of you will betray me." The apostles fall back reflexively at this accusation; they gesture expressively, deny personal responsibility, and ask, "Who can

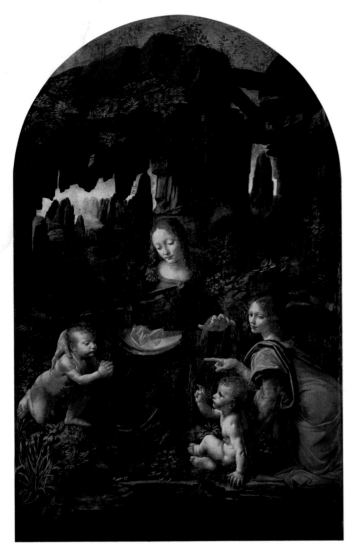

▲ **13.4A** Leonardo da Vinci, *Madonna of the Rocks*, 1483. Oil on panel, transferred to canvas, 78¼" × 48" (199 × 122 cm). Museé du Louvre, Paris, France. The *Madonna of the Rocks* was commissioned as the central painting for an altarpiece for a church in Milan. Leonardo did not comply with the deadline, and lawsuits followed.

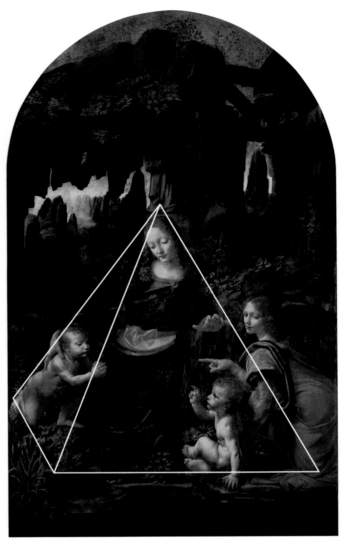

▲ **13.4B** The pyramidal structure of Leonardo da Vinci's *Madonna of the Rocks*.

this be?" The guilty one, of course, is Judas, who is shown clutching a bag of silver pieces at Jesus' left, with his elbow on the table. The two groups of apostles, who sweep dramatically away from Jesus along a horizontal line, are subdivided into four smaller groups of three that tend to moderate the rush of the eye out from the center. The viewer's eye is wafted outward and then coaxed back inward through the "parenthetic" poses of the apostles at either end. Leonardo's use of strict rules of perspective and his graceful balance of motion and restraint underscore the artistic philosophy and style of the Renaissance.

Although Leonardo does not allow excessive emotion in his *Last Supper*, the reactions of the apostles seem genuinely human. This spirit is also captured in *Madonna of the Rocks* (Fig. 13.4A). Mary is no longer portrayed as the queen of heaven, as she had been during the Middle Ages and the early

years of the Renaissance. Leonardo shows her as a mother. She is human; she is "real."

One of the hallmarks of Renaissance paintings is the use of implied lines to create or echo the structure of the composition. Geometric shapes such as triangles and circles are suggested through the use of linear patterns created by the position and physical gestures of the participants and, often, glances between them. These shapes often serve as the central focus and the main organizational device of the compositions. In the *Madonna of the Rocks*, Leonardo da Vinci places the head of the Virgin Mary at the apex of a rather broad, stable pyramid formed not by actual lines but by the extension of her arms and the direction of her glance. The base of the pyramid is suggested by an implied line that joins the "endpoints" of the baby Jesus and the infant John the Baptist. **Figure 13.4B** highlights the pyramidal structure of the composition.

The soft, hazy atmosphere and dreamy landscape of the *Madonna of the Rocks*, and the **chiaroscuro** that so realistically defines the form of the subtly smiling Virgin Mary,

were still in Leonardo's pictorial repertory when he created what is arguably the most famous portrait in the history of art—the *Mona Lisa* (**Fig. 13.5**). An air of mystery pervades the work—from her entrancing smile and intense gaze to her real identity and the location of the landscape behind her. With the *Mona Lisa*, Leonardo altered the nature of portrait painting for centuries, replacing the standard profile view of a sitter with one in which a visual dialogue could be established between the subject and the observer.

If we had been bequeathed nothing but Leonardo's *Notebooks*, we would still say that he had one of humanity's most fertile minds. By means of his sketches, one could say that he "invented" flying machines, submarines, turbines, elevators, ideal cities, and machines of almost every description. His knowledge of anatomy was unsurpassed (he came close to discovering the circulatory path of blood), and his interest in the natural worlds of geology and botany was keen. The *Notebooks*, in short, reflect a restlessly searching mind that sought to understand the world and its constituent parts. Its chosen fields of inquiry are dominated by many of the characteristics common to the period: a concern with mathematics, a deep respect for the natural world, and a love for

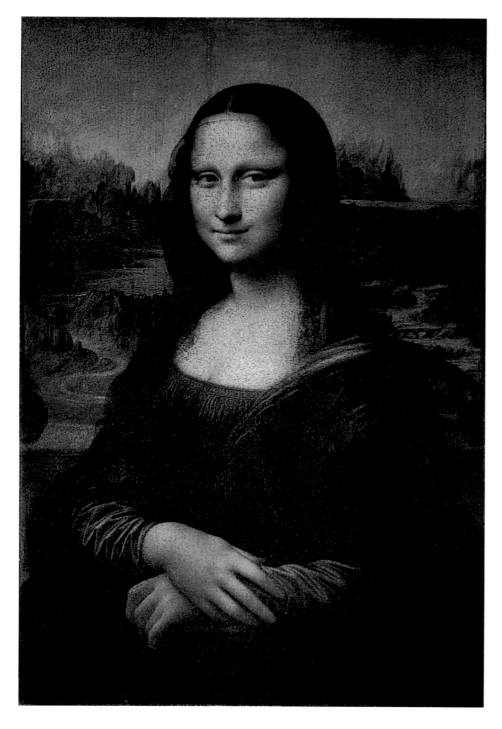

◀ **13.5** Leonardo da Vinci, *Mona Lisa*, ca. 1503–1505. Oil on wood panel, 30¼" × 21" (77 × 53 cm). **Museé du Louvre, Paris, France.** *Mona Lisa* has been called the most famous portrait in the world, even the most famous painting. The sitter's face, subtly modeled with gradations of color, has been called inscrutable. Is her gaze engaging the viewer, or perhaps the artist? The gentle repose of her hands has been considered exquisite. The scenic backdrop is fantasy.

beauty. A page from Leonardo's *Notebooks* (**Fig. 13.6**) shows one of the first drawings of a human fetus within the uterus.

RAPHAEL SANZIO Raphael Sanzio (1483–1520) was born in Urbino, a center of humanist learning east of Florence dominated by the court of the duke of Urbino. His precocious talent was first nurtured by his father, a painter, whose death in 1494 cut short the youth's education. The young Raphael then went to Perugia as an apprentice to the painter Perugino. There

his talents were quickly recognized. In 1505, at the age of 22, he moved on to Florence, where he worked for three years.

During his stay in Florence, Raphael painted many Madonnas in a style that has become almost synonymous with his name. The *Madonna of the Meadow* (**Fig. 13.7**) is typical. In this painting Raphael arranged his figures in a pyramidal configuration similar to the one we find in Leonardo's *Madonna of the Rocks*. This configuration was congenial to the Renaissance preoccupation with rationally ordered

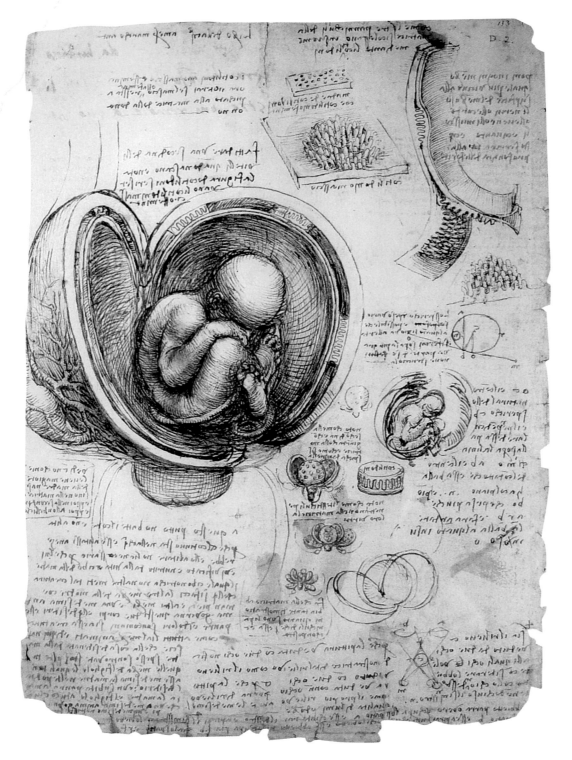

◄ **13.6 Leonardo da Vinci, anatomical drawing, medical studies of the human body, 1509–1514.** Black and red chalk, pen and ink wash on paper, 12″ × 8⅝″ (30.5 × 22 cm). Royal Library, Windsor Castle, London, United Kingdom. Leonardo's anatomical drawings show great drafting skill, but the slight scientific inaccuracies reflect the state of knowledge of his day.

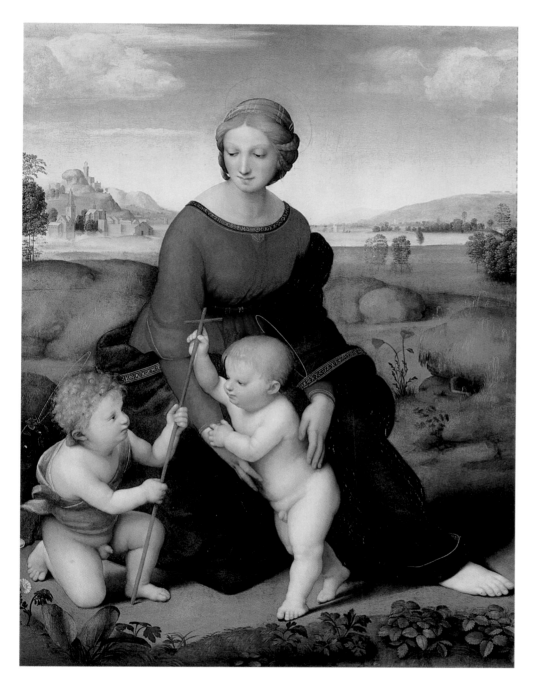

◀ **13.7** Raphael, *Madonna of the Meadow*, 1508. Oil on panel, 44½″ × 34⅝″ (113 × 88 cm). **Kunsthistorisches Museum, Vienna, Austria.** Raphael's painting, in contrast to that of Leonardo, places the Madonna and the infants John the Baptist and Jesus in a well-lit setting. Instead of a mysterious rockbound setting, we have red flowers and blue skies with fair-weather clouds above. Yet Raphael's painting maintains a pyramidal structure.

composition. But with Raphael, we also find a beautiful modeling of the human forms, especially in the figures of the two children and the genuine sweetness and warmth conveyed by the faces. The head of the Madonna is peaceful and luminous, while the infant Christ and John the Baptist convey a somewhat more playful mood. The human quality of the divine figure is Raphael's trademark. Note, too, that the background is rural and naturalistic, made of light, uplifting hues and values. Leonardo's Madonna and the other characters are shown surrounded by rock in darkness, with barely enough light shining through to illuminate the people. Because of the contest between light and dark, the Leonardo shows high contrasts. The Raphael is more concerned with subtle shadings, harmony, grace, and sweetness.

Raphael left Florence for Rome in 1508. By the following year, Pope Julius, whom Raphael later captured in an unforgettably fine portrait, had him working in the Vatican on various projects. The pope commissioned him to decorate various rooms of his palace. To add fuel to Michelangelo's fire, the commission was granted at the same time Michelangelo was at work on the Sistine Chapel ceiling. Raphael spent the rest of his brief life working on these projects and filling assorted administrative posts for the papacy, including at one time the office of architect of Saint Peter's Basilica and at another time that of superintendent of the Vatican's collection of antiquities.

One of Raphael's most outstanding works—and certainly one of the most important for defining the meaning

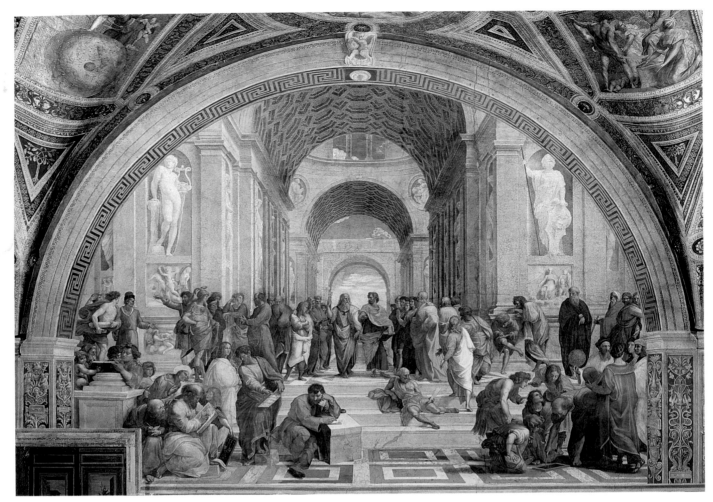

▲ **13.8A** Raphael, *Philosophy (The School of Athens)*, 1509–1511. Fresco, 25'3" × 18' (770 × 548 cm). **Stanza della Segnatura, Stanze di Raffaello, Vatican Palace, Vatican City State, Italy.** The central figures represent Plato and Aristotle. The in the forefront is believed to be Michelangelo resting his head on his fist. This is no static portrait: people move about in all directions, some with their backs turned to the viewer. One tries to scribble in a notebook held precariously on his raised knee.

of the 16th-century Renaissance in Rome—is a large fresco executed in 1509–1511 on the wall of the Stanza della Segnatura, an office in the Vatican Palace where documents requiring the pope's signature were prepared. Now called *Philosophy (The School of Athens)* (Fig. 13.8A), the fresco is a highly symbolic homage to philosophy that complements Raphael's similar frescoes in the same room symbolizing poetry, law, and theology.

Philosophy (The School of Athens) portrays the great philosophers of antiquity in an immense illusionistic architectural framework that must have been at least partially inspired by the impressive ruins of Roman baths and basilicas, and perhaps by the new Saint Peter's then under construction. Raphael's fresco depicts Roman barrel vaulting, coffered ceilings, and broad expanses not unlike those in the still-existing baths of ancient Rome. The figures symbolize philosophy, one of the four subjects deemed most valuable for a pope's education. The members of the gathering are divided into two camps, representing opposing philosophies, and

are led on the right by Aristotle and on the left by his mentor, Plato. Corresponding to these leaders are the Platonists, whose concerns are the more lofty realm of ideas (notice Plato pointing upward), and the Aristotelians, who are more in touch with matters of the earth, such as natural science. Some of the figures have been identified: Diogenes, the Cynic philosopher, sprawls out on the steps, while Pythagoras calculates on a slate and Ptolemy holds a globe. At the right, the idealized figure of Euclid with his compass is actually a portrait of Raphael's Roman protector, the architect Bramante. Heraclitus, a founder of Greek metaphysics, sits pensively just left of center. Of more interest is the fact that Raphael included a portrait of himself, staring out toward the viewer, in the far right foreground. He is shown in a group surrounding the geometrician Euclid. Raphael clearly saw himself as important enough to be commemorated in a Vatican mural as an ally of the Aristotelian camp.

Raphael's *Philosophy (The School of Athens)* reflects a high degree of sensitivity to ordered space, a complete ease with

Classical thought, obvious inspiration from the Roman architectural past, a brilliant sense of color and form, and a love for intellectual clarity—characteristics that could sum up the Renaissance ideal. **Figure 13.8B** shows how perspective works in the painting. As evidence of the ability of Renaissance artists to portray depth, all orthogonal lines lead to a single point, called a **vanishing point**, which sits squarely between the two central philosophers. Ever smaller and less textured vaults continue behind them. The **horizon line**— the line which represents the vantage point of the viewer— cuts through their bodies left and right. Converging on this point are orthogonals that can be traced from the patterns of the marble flooring below the horizon line and the horizontal entablatures sitting atop the piers that recede dramatically toward the rear of the arcade.

That such a fresco should adorn a room in the Vatican, the center of Christian authority, is not difficult to explain. The papal court of Julius II shared the humanist conviction that philosophy is the servant of theology and that beauty, even if derived from a pagan civilization, is a gift from God and not to be despised. To underscore this point, Raphael's homage to theology across the room, his fresco called the *Disputà*, shows in a panoramic form similar to *Philosophy (The School of Athens)* the efforts of theologians to penetrate divine mystery.

In the lower center of Raphael's *Philosophy (The School of Athens)* is a lone figure leaning an elbow on a block of marble and scribbling, taking no notice of the exalted scene about him. Strangely isolated in his stonecutter's smock, the figure has recently been identified, at least tentatively, as Michelangelo. If this identification is correct, this is the younger artist's act of homage to the solitary genius who was working just a few yards away from him in the Sistine Chapel.

MICHELANGELO BUONARROTI Of the three great Renaissance masters, Michelangelo Buonarroti (1475–1564) is probably most familiar to us. During the 1964 World's Fair in New York City, hundreds of thousands of culture seekers and devout pilgrims were trucked along a conveyor belt for a brief glimpse of his *Pietà* at the Vatican Pavilion. A year later, actor Charlton Heston (who seems to bear a striking resemblance to the artist) reprised the tumultuous relationship between artist and patron and the traumatic physical experience surrounding the painting of the Sistine ceiling in the Hollywood film *The Agony and the Ecstasy*. The two works stand as symbols of the breadth and depth of Michelangelo's talents as an artist.

Michelangelo spent his early days in the sculpture garden of Lorenzo de' Medici in Florence but fled when the Medici regime fell, moving first to Bologna and then to Rome. He

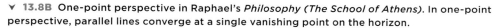

▼ **13.8B** One-point perspective in Raphael's *Philosophy (The School of Athens)*. In one-point perspective, parallel lines converge at a single vanishing point on the horizon.

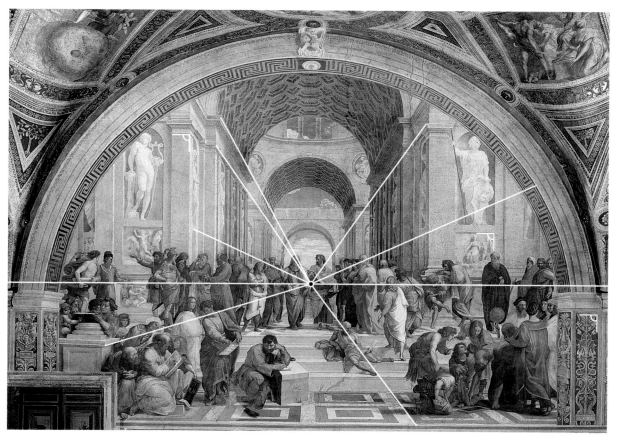

sculpted the **Pietà** (Fig. 13.9), which many observers consider to be his first masterpiece, in 1498 for a French cardinal living in Rome. The subject, Mary holding the dead son in her lap, was a common theme in French and German art. Yet Michelangelo's rendering of the subject shows a deep sensitivity. The composition is pyramidal. The imitation of flesh and drapery in marble is masterly. An exacting observer might wonder how Mary can cradle a fully grown man in her lap as she might hold a sleeping child. The answer is that the lower part of Mary's body, which is implied to exist beneath the drapery, is larger than would be possible in the flesh. Yet the lines of the figures carry our gaze along the body of Jesus and along the torso and arms of Mary.

If Leonardo's *Mona Lisa* is one of the best-known paintings in Western art, Michelangelo's *David* (Fig. 13.10) is certainly one of the best-known sculptures—if not the best-known. It was commissioned upon Michelangelo's return to Florence in 1501, and the artist worked from a massive piece of Carrara marble that had lain behind the cathedral in Florence since the middle of the preceding century—marble from an abandoned project. Michelangelo saw his figures' shapes as residing within the marble and himself as liberating them from their stone embrace; after much study, he freed David, whose victory against all logic, all odds, came to represent Florence's unlikely withstanding of attacks from a stronger Milan.

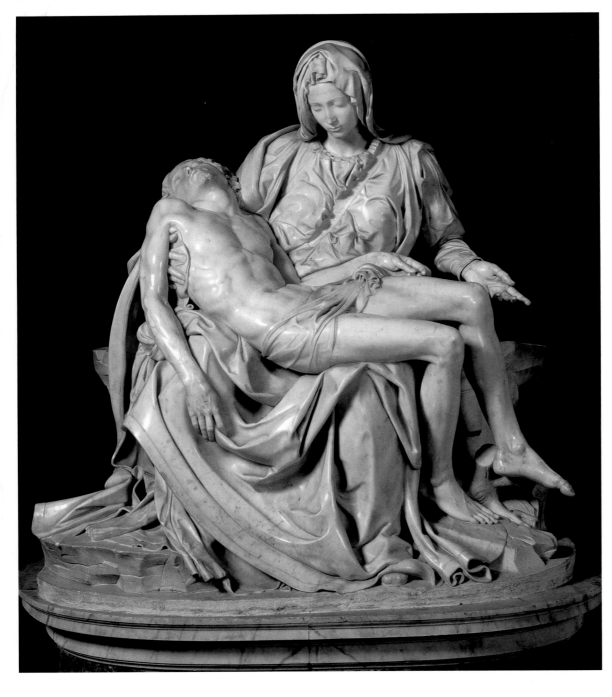

◄ **13.9** Michelangelo, *Pietà*, 1498–1499. Marble, 69″ (175 cm) high. Saint Peter's, Vatican City State, Italy. Michelangelo's *Pietà*, like those that preceded it, shows the Virgin Mary holding her dead son, Jesus, in her lap. Although it is an intensely religious work, it stirred controversy because Mary is portrayed as beautiful and not mature enough to have an adult son. Michelangelo countered that her beauty represented her purity. Julius II endorsed the sculpture by commissioning Michelangelo to create several other works after viewing the *Pietà*.

At the time Michelangelo crafted his *David*, earlier *David*s had generally shown the youthful hero with the head of the slain giant, as do the *David*s by Donatello (ca. 1440–1460; see **Fig. 12.15**) and Verrocchio (ca. 1470; see **Fig. 12.16**). Donatello and Verrocchio's figures are slimmer and perhaps more youthful than Michelangelo's; it seems clear that a miracle, as recounted in the Hebrew Bible, has occurred. Michelangelo's *David* may seem sturdy enough to fulfill his destiny, yet the artist does not show him victorious, but rather intense and contemplative—apparently strategizing his assault on Goliath. The sling rests over his shoulder. Tension is communicated in the muscles in David's arms, in the veins on the backs of his hands, in his furrowed brow. Most of his weight is on his back leg—his shoulders and hips are at opposing angles, imparting an S curve to the torso. Michelangelo catches him in the moment between choice and action, just before he springs forth.

The statue was placed outside the Palazzo Vecchio as a symbol of the civic power of the city, where it remained until weathering and damage required its removal to a museum in 1873. It has been said that Botticelli's paintings, the *David*s of Donatello and Michelangelo, and the general skepticism of a mind like Leonardo's are all symptoms of the general pagan tone of Florence during the High Renaissance—that Athens and Rome, in short, seemed far more important to Florence than did Jerusalem. There is no doubt that the Classical revival was central to Florentine culture.

Michelangelo was called back to Rome in 1505 by Pope Julius II to create a monumental tomb for him. It was to have three levels; the bottom level was to have sculpted figures representing Victory and bound slaves. The second level was to have statues of Moses and Saint Paul as well as symbolic figures of the active and contemplative life—representative of the human striving for, and reception of, knowledge. The third level, it is assumed, was to have an effigy of the deceased pope.

The tomb of Pope Julius II was never finished. Michelangelo was interrupted in his long labors by Julius himself and, after the pope's death, the Medici popes, who were more concerned with projects glorifying their own family. What was completed of the tomb represents a 20-year span of frustrating delays and revised schemes. Even those finished pieces provide no sense of the whole, but they do represent some of the highest achievements of world art.

One of the finished pieces is the *Moses*, begun after the death of Julius in 1513. We easily sense both the bulky physicality of Moses and the carefully modeled particulars of musculature, drapery, and hair. The fiercely inspired look on the

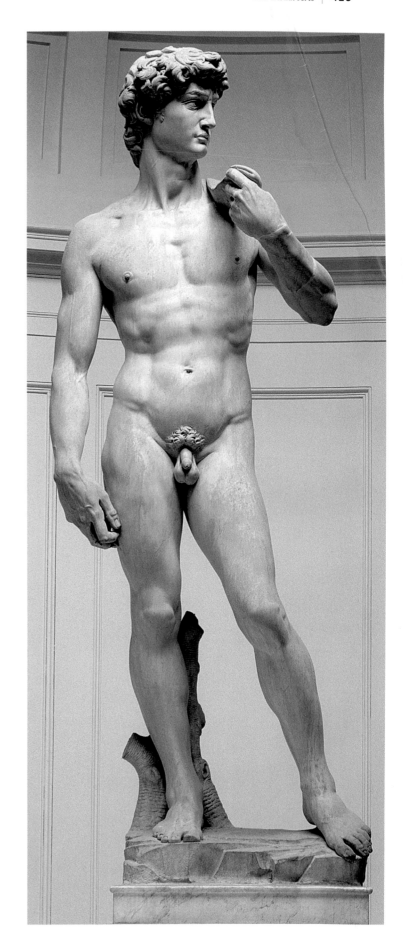

> **13.10** Michelangelo, *David*, 1501–1504. Marble, 14'3″ (434 cm) high. Galleria dell'Accademia, Florence, Italy. David's weight is shifted to his right leg, causing a realignment of his body and lending to the realism of the sculpture. True, he stands there, but he is certainly not inert. He is contemplating his attack on the giant Goliath, and we imagine him pulling the sling from his shoulder and unleashing its missile.

Donna Vittoria Colonna and Michelangelo

Donna Vittoria Colonna was Michelangelo's friend and spiritual adviser. She was the recipient of a number of his poems, and according to Vasari, he made several small sculptures and drawings for her.

Donna Vittoria Colonna to Michelangelo: She wrote to Michelangelo on the transitory nature of fame.

Most honored Master Michelangelo, your art has brought you such fame that you would perhaps never have believed that this fame could fade with time or through any other cause. But the heavenly light has shone into your heart and shown you that, however long earthly glory may last, it is doomed to suffer the second death.

Michelangelo replied with a poem on this theme.

I know full well that it was a fantasy
That made me think that art could be made into
An idol or a king. Though all men do
This, they do it half-unwillingly.
The loving thoughts, so happy and so vain,
Are finished now. A double death comes near—
The one is sure, the other is a threat.

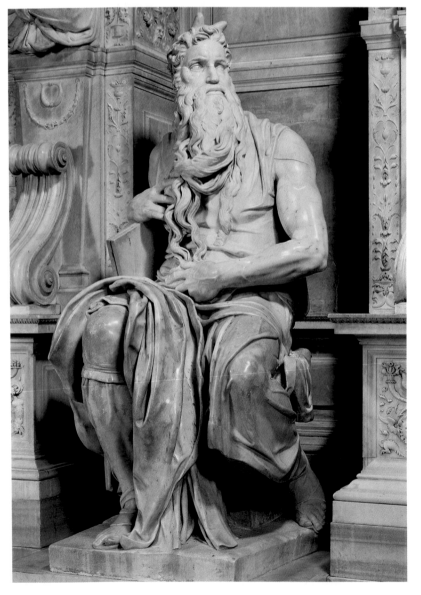

face of Moses is appropriate for one who has just seen God on Mount Sinai. His face radiates divine light but also divine fury toward the idolaters he spies when he comes down from the mountain. It is often said of Michelangelo that his work can overwhelm the viewer with a sense of awesomeness; Italians speak of his *terribilità*. If any single statue has this awesomeness, it is the *Moses*. A viewer may have the feeling that it will rise and judge the unrighteous (Fig. 13.11).

Michelangelo had hardly begun work on the pope's tomb when Julius commanded him to fresco the ceiling of the Sistine Chapel to complete the work done in the previous century under Sixtus IV. But Michelangelo resisted the project (he actually fled Rome and had to be ordered back by papal edict). He considered himself a sculptor, and there were technical problems presented by the shape of the ceiling. Nevertheless, he relented and in three years (1508–1511) finished the ceiling (Fig. 13.12A). He signed it "Michelangelo, Sculptor" to remind Julius of his reluctance and his own true vocation.

That famed ceiling is the vault of the chapel of Pope Sixtus IV, known as the Sistine Chapel. The ceiling is some 5,800 square feet and

◁ **13.11** Michelangelo, *Moses*, 1513–1515. Marble, 92 ½" (235 cm) high. San Pietro in Vincoli, Rome, Italy. Moses has brought the commandments from Mount Sinai and now he sits—momentarily—with his face twisting into a terrible wrath as he views idolaters. The "horns" on his head represent rays of light; the use of horns instead of rays is based on a mistranslation in the Latin Vulgate Bible.

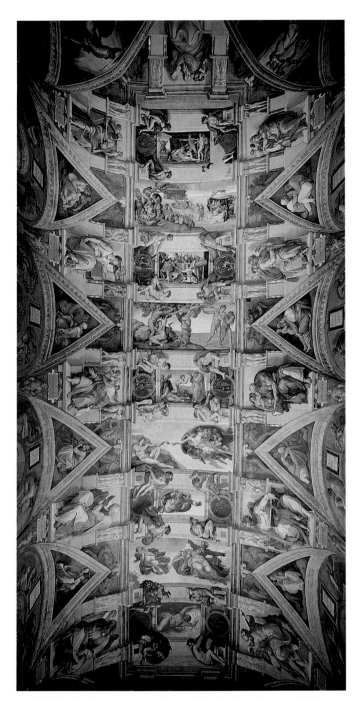

∧ 13.12A Michelangelo, ceiling of the Sistine Chapel, 1508–1511. Fresco, 44′ × 128′ (13.44 × 39.01 m). Sistine Chapel, Vatican Palace, Vatican City State, Italy. The more than 300 figures painted by Michelangelo contain biblical scenes of the creation and fall of humankind. The fresco cycle took the artist some four years. Michelangelo would suffer the physical effects of working on the project for the rest of his life.

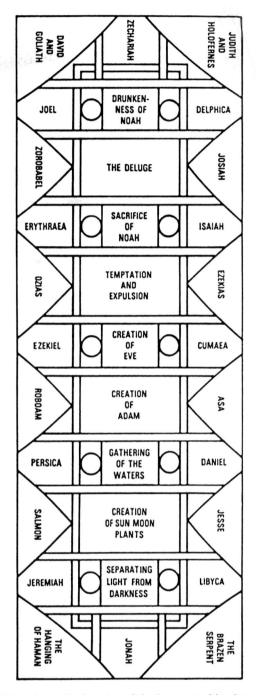

∧ 13.12B Schematic drawing of the iconographic plan of the Sistine Chapel ceiling. Michelangelo progressed on the ceiling from the panel depicting the Drunkedness of Noah above the chapel door to the earliest scenes in Genesis above the altar. As he worked, his technique and composition improved.

is almost 70 feet above the floor. After much anguish and early attempts to populate the vault with a variety of religious figures (eventually more than 300 in all), Michelangelo settled on a division of the ceiling into geometrical "frames" housing biblical prophets, mythological soothsayers, and biblical scenes from Genesis to the Flood. The

overall organization consists of four large triangles at the corners; a series of eight triangular spaces on the outer border; an intermediate series of figures; and nine central panels (four larger than the other five), all bound together with architectural motifs and nude male figures (**Fig. 13.12B**). The corner triangles depict heroic action in the

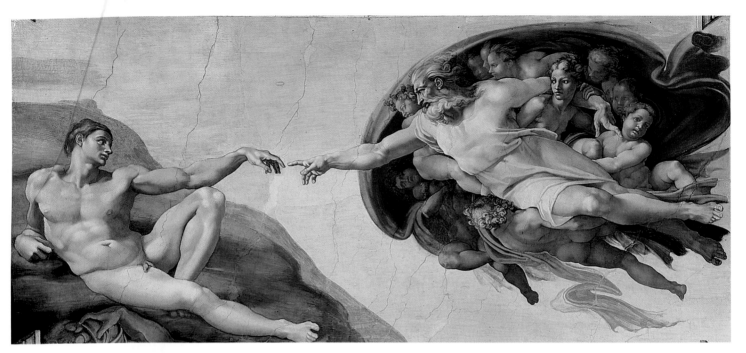

▲ **13.13** Michelangelo, *The Creation of Adam*, 1508–1512. Fresco (detail), ca. 9′2″ × 18′8″ (280 × 570 cm). Sistine Chapel, Vatican Palace, Vatican City State, Italy. The spark of life is passed from God to Adam. The composition of the work unifies the figures, but they do not actually touch.

Hebrew Bible (Judith beheading Holofernes, David slaying Goliath, Haman being punished for his crimes, and the rod of Moses changing into a serpent), whereas the other eight triangles depict the biblical ancestors of Jesus Christ. The 10 major intermediate figures are alternating portraits of pagan sibyls (female prophets) and Hebrew prophets. The central panels are scenes from the Book of Genesis. The one closest to the altar shows God dividing darkness from light, and the one at the other end shows the drunkenness of Noah (Genesis 9:20–27).

The most famous of these scenes is *The Creation of Adam* (**Fig. 13.13**). As Leonardo does in *The Last Supper*, Michelangelo chooses to communicate the event's most dramatic moment. Adam lies on the earth, listless for lack of a soul, while God the Father rushes toward him amidst a host of angels, who wrap him in a billowing cloak. The contrasting figures lean toward the left, separated by an illuminated diagonal that provides a backdrop for the Creation. Amidst an atmosphere of sheer electricity, the hand of God reaches out to spark spiritual life into Adam—but does not touch him! In some of the most dramatic negative space in the history of art, Michelangelo has left it to the spectator to complete the act. In terms of style, Michelangelo integrates chiaroscuro with Botticelli's extensive use of line. His figures are harshly drawn and muscular with almost marble-like flesh. In translating his sculptural techniques to a two-dimensional surface, the artist has conceived his figures in the round and has used the tightest, most

expeditious line and modeling possible to render them in paint. The fresco, demonstrating Michelangelo's ability to combine physical bulk with linear grace and a powerful display of emotion, well exemplifies the adjective *Michelangelesque*, applied to many later artists who were influenced by his style.

The full force of that Michelangelesque style can be seen in the artist's second contribution to the Sistine Chapel: *The Last Judgment*, which he painted on the wall behind the main altar between the years 1534 and 1541 (**Fig. 13.14**). A huge fresco marking the end of the world when Christ returns as judge, *The Last Judgment* shows Christ standing in the upper center of the scene, with the world being divided into the Dantean damned at the bottom and those who are called to glory above. Into that great scene Michelangelo poured both his own intense religious vision and a reflection of the troubled days during which he lived. It was, after all, a Rome that had already been sacked in 1527 and a church that had been riven by the Protestant Reformation in the north.

Under the patronage of popes Leo X and Clement VII— both from the Medici family—Michelangelo worked on another project, the Medici Chapel in the Florentine Church of San Lorenzo. This chapel is particularly interesting because Michelangelo designed and executed both the sculptures and the chapel in which they were to be placed. Although Michelangelo first conceived the project in 1519, he worked on it only in fits and starts from 1521 to 1534. He never completely

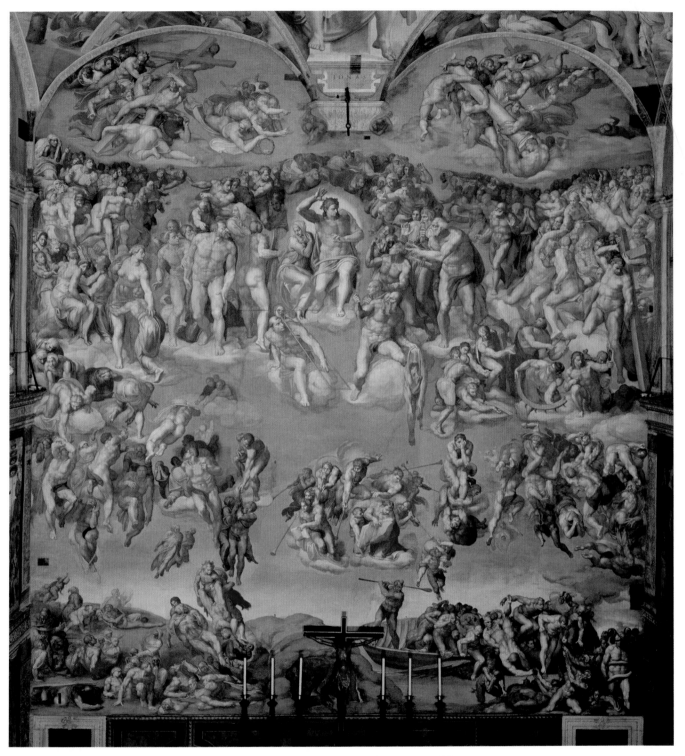

▲ **13.14** Michelangelo, *The Last Judgment*, 1534–1541. Fresco (restored), 44'11" × 40' (13.7 × 12.2 m). Sistine Chapel, Vatican Palace, Vatican City State, Italy. The loincloths on the figures were added later to appease the prudish sensibilities of post-Reformation Catholicism. The in the flayed skin of Saint Bartholomew below and to the right of Christ is a self-portrait of the painter.

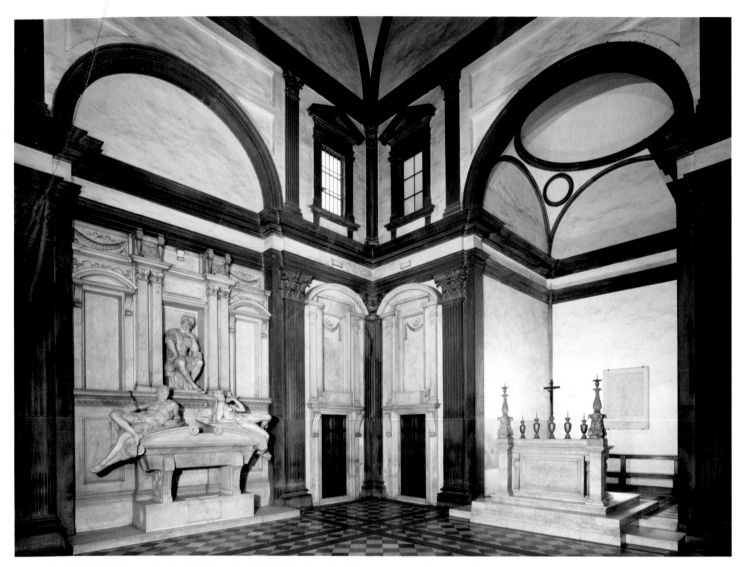

▲ **13.15** Michelangelo, Medici Chapel, 1519–1534. Church of San Lorenzo, Florence, Italy.
Inside of the New Sacristy, showing the tomb of Lorenzo the Magnificent and altar.

finished the chapel. In 1545 some of Michelangelo's students set the statues in place.

The interior of the Medici Chapel (**Fig. 13.15**) echoes Brunelleschi's Pazzi Chapel with its dome, its use of a light grayish stone called *pietra serena* (serene stone), its Classical decoration, and its chaste and severe style. The plan envisioned an altar at one end of the chapel and at the other end, statues of the Madonna and child with Saints Cosmas and Damian. The saints were the patrons of physicians, an allusion to the name Medici, which means "the doctor's family." At the base of these statues are buried in utter simplicity the bodies of Lorenzo the Magnificent and his brother Giuliano. On opposite walls are niches with idealized seated figures of relatives of Lorenzo the Magnificent, the dukes Lorenzo and Giuliano de' Medici in Roman armor. Beneath each are two symbolic figures resting on a **sarcophagus**: *Night* and *Day*, and *Dawn* and *Dusk*. (**Fig. 13.16**)

This great complex, unfinished like many of Michelangelo's projects, is a brooding meditation on the shortness of life, the inevitability of death, and the Christian hope for resurrection. Both the stark decoration of the chapel and the positioning of the statues (Duke Lorenzo seems always turned to the dark with his head in shadow, whereas Duke Giuliano seems more readily to accept the light) form a mute testament to the rather pessimistic and brooding nature of their creator. When Michelangelo had finished the figure of Night, a Florentine poet named Strozzi wrote a poem in honor of the statue, with a pun on the name Michelangelo:

Night, whom in shape so sweet thou here may'st see
 Sleeping, was by an Angel sculpted thus
 In marble, and since she sleeps hath life like us:
Thou doubt'st? Awake her: she will speak to thee.

Michelangelo, an accomplished poet in his own right, answered Strozzi's lines with a pessimistic rejoinder:

Sleep likes me well, and better yet to know
 I am but stone. While shame and grief must be,
 Good hap is mine, to feel not, nor to see:
Take heed, then, lest thou wake me: ah, speak low.

The New Saint Peter's

In 1506 Pope Julius II commissioned the architect Donato Bramante (1444–1514) to rebuild Saint Peter's Basilica in the Vatican. Old Saint Peter's had stood on Vatican Hill since it was first constructed more than 1000 years earlier, during the time of the Roman emperor Constantine. By the early 16th century it had suffered repeatedly from roof fires, structural stresses, and the general ravages of time. In the minds of the Renaissance "moderns" it was a shaky anachronism.

BRAMANTE'S PLAN Bramante's design envisioned a central-domed church with a floor plan in the shape of a Greek cross with four equal arms (**Fig. 13.17**). The dome would have been set on a columned arcade with an exterior colonnaded arcade, called a **peristyle**, on the perimeter of the building. Any of the four main doors was to be directly across from a *portal* (door) on the opposite side. This central plan was not executed in Bramante's lifetime, but a small chapel he built in 1502 next to the Church of San Pietro in Montorio, Rome, may give us a clue to what Bramante had in mind. This *tempietto* ("little temple") is believed to have been done in a style similar to what Bramante wanted later for Saint Peter's.

▼ **13.16** Michelangelo, *Night*, 1519–1531. Marble, 76½" (194 cm) long. Detail of the tomb of **Giuliano de' Medici, Church of San Lorenzo, Florence, Italy.** The owl and mask under the recumbent are emblems of night and dreams.

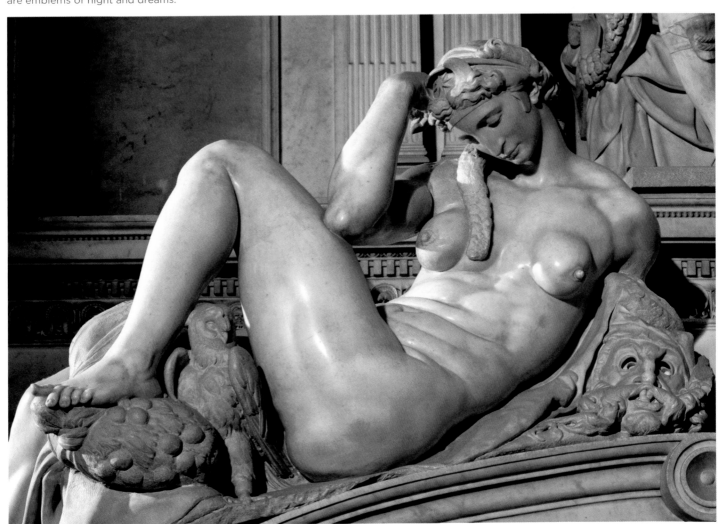

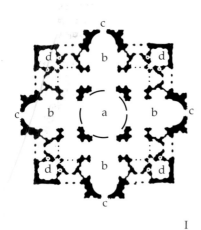

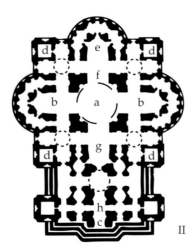

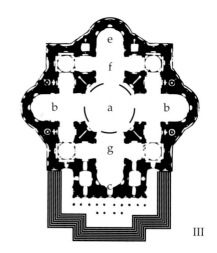

I

II

III

▲ ▶ 13.17 Floor plans for the new Saint Peter's Basilica, Rome, Italy, 1506–1666. (I) Bramante's plan, 1506–1514, shows a compact plan of a Greek cross with arms or transepts (b) of equal length meeting at a central altar (a) set under a dome, with each arm ending in a semicircular apse (e) opening to a portal or entrance (c), and including several chapels (d) for smaller services. (II) Antonio da Sangallo's plan, 1516–1546, imposed a Latin cross, adding Raphael's choir (f) to surround the altar on three sides, closing the portals in favor of a formal entrance (c), and forming a nave (g) from the arm proceeding from a huge vestibule or narthex (h). (III) Michelangelo's plan, 1547–1564, rejected Sangallo's design and returned to a centralized domed Greek cross inscribed within a square but retained the vestibule (c), now fronted by a portico with giant columns. (IV) Carlo Maderna's plan, 1606–1615, returned to a Latin cross with elongated nave (g), narthex (h), portico (c), and Baroque façade. This plan also shows Gian Lorenzo Bernini's piazza (j) with colonnades, 1656–1667. Maderna's final additions, especially the elongated nave, narthex, and large façade, obscured Michelangelo's original design. Artwork by Cecilia Cunningham.

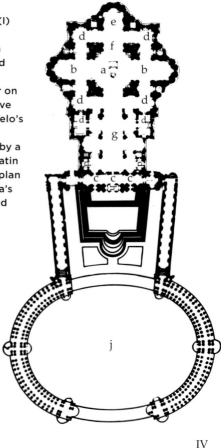

IV

MICHELANGELO'S PLAN After Bramante's death, other architects—including Raphael and Sangallo—worked on the massive project. Both of these architects added a nave and aisles. In 1547 Michelangelo was appointed architect, because the plans previously drawn up seemed unworkable. Michelangelo returned to Bramante's plan for a central-domed church in the shape of a Greek cross and envisioned a ribbed, arched dome somewhat after the manner of the cathedral in Florence, but on a far larger scale.

The present Saint Peter's, seen from the front, gives us no clear sense of what Michelangelo had in mind when he drew up his plans. From the back, we can appreciate the undulating façade and immense pilasters (**Fig. 13.18**). Michelangelo's church had a long nave and a façade added by Carlo Maderna in the early 17th century. The colonnaded piazza was completed under the direction of Gian Lorenzo Bernini in 1656–1667, almost a century after Michelangelo's death. Michelangelo lived to see the completion of the drum that was to support his dome, which was itself raised some 25 years after his death by Giacomo della Porta.

The High Renaissance in Venice

The brilliant and dramatic outbreak of artistic activity in 16th-century Rome and Florence does not diminish the equally creative art being done in the Republic of Venice to the north. While Rome excelled in fresco, sculpture, and architecture, Venice (and its territory) was famous for its revival of Classical architecture and for its tradition of easel painting. Venice's impressive cosmopolitanism derived from its position as a maritime port and its trading tradition.

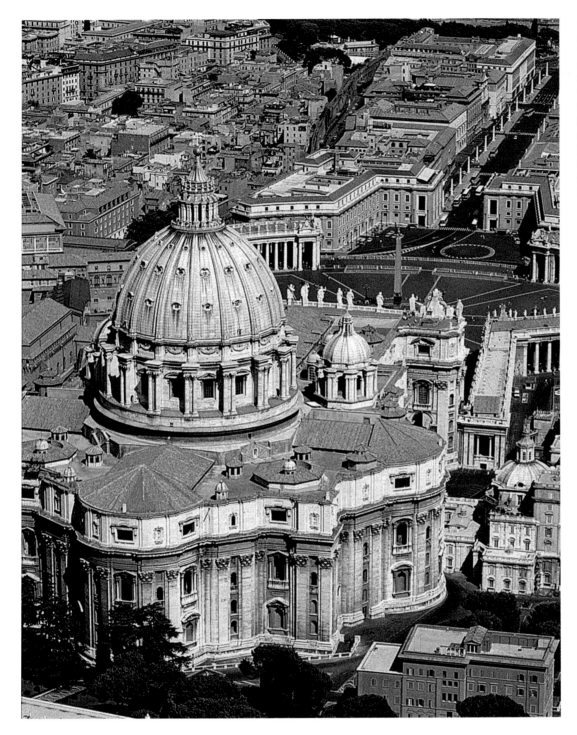

ANDREA PALLADIO The leading architect of the whole of northern Italy in the High Renaissance, the only one to rival the achievements of Tuscan architects of the caliber of Alberti and Michelangelo, was Andrea di Pietro della Gondola (1508–1580)—better known by his nickname Palladio. Coined by his first patron, Gian Giorgio Trissino of Vicenza, the name derives from that of the ancient Greek goddess Pallas Athena and indicates the main source of Palladio's inspiration: the architecture of Classical Greece as he saw it reflected in the buildings of ancient Rome. The young Palladio and his patron made several visits to Rome, studying both High Renaissance buildings and the ruins of the ancient city. His designs for villas, churches, and palaces stressed the harmonic proportions and Classical symmetry that the Romans had inherited from the Greeks. His *Four Books of Architecture* (1570) helped to spread his style throughout Europe. The Palladian style became particularly popular in 18th-century England and in due course was exported to North America, where it inspired much of the "Greek Revival" architecture of the Southern United States.

Whether Palladio was born in Padua or Vicenza is uncertain, but it is the latter city that contains the largest number of his buildings, both public and private. As a result, Vicenza is one of the most beautiful and architecturally interesting cities of Renaissance Venetian territory, and indeed of Italy as a whole. One of the finest of Palladio's works there is the Palazzo Chiericati (**Fig. 13.19**). The building is set on a large piazza, and Palladio took advantage of this to create one of his most imaginative façades.

Using strictly Classical forms, the architect managed to add his own contribution. The façade is divided into two parts horizontally: the lower open loggia has Doric columns, while the upper level is supported by Ionic columns (note the difference in the capitals at the top of the columns). By adding a wall to the central part of the upper story, however, Palladio has created three vertical divisions. He emphasizes this by having this central section stand out from the rest of the building on both levels, with columns bunched at each end. Thus it seems to float above the columns below.

Other Classical features include the **triglyphs** above the lower level of columns, which are placed in a strict rhythmic pattern—one over each column and two over the gaps between columns. The windows of the second level have triangular and semicircular pediments in strict alternation.

The result is a building that combines the elegance and clarity of Classical architecture with Palladio's own imaginative ideas. The sense of harmony and balance of proportion is a perfect example of the Renaissance revival of Classical ideals.

Painting in Venice

Venetian painters quickly adopted oil painting, which had first been popularized in the north. Oil painting gave the artist unparalleled opportunities to enrich and deepen color by the application of many layers of paint. Oil painting in general, and Venetian painting in particular, placed great emphasis on the brilliance of its color and the subtlety of its light. The sunny environment of Venice, with light reflecting off the ever-present waterways, further inspired the Venetian feel for color and light. Although the generalization is subject to refinement, there is truth in the observation that Venetian painters emphasized color, whereas painters in the south were preoccupied with line. Venetian painters, like their counterparts in Northern Europe, had an eye for close detail

▼ **13.19 Andrea Palladio, Palazzo Chiericati, begun 1550s. Vicenza, Italy.** Palladio's roof decorations consist of Classical-style statues alternating with fantastical architectural forms called balusters.

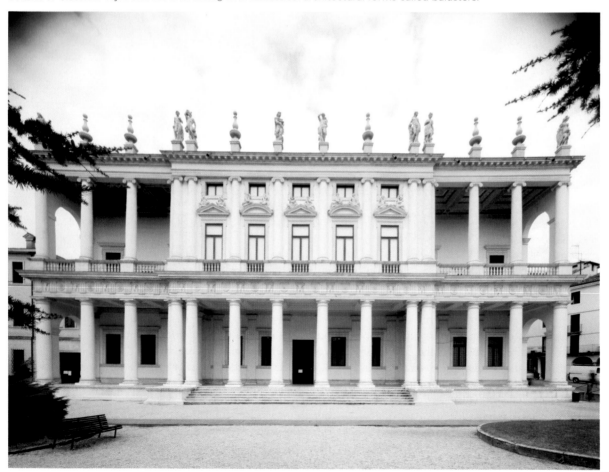

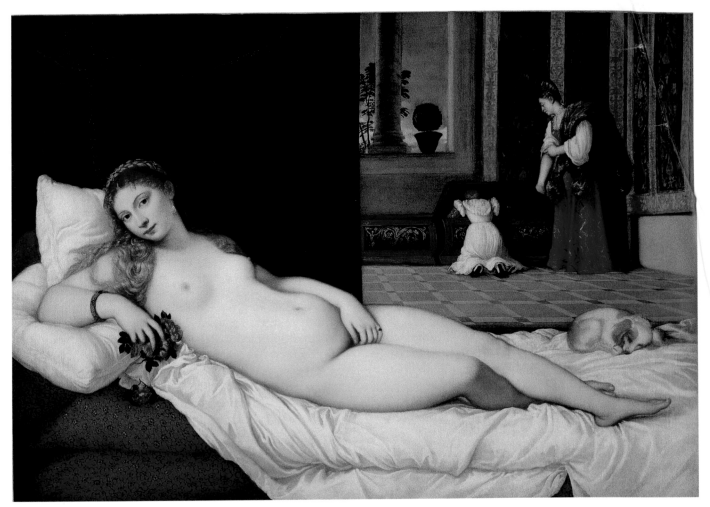

▲ **13.20** Titian, *Venus of Urbino*, 1538. Oil on canvas, ca. 47" × 65" (119 × 162 cm). Galleria degli Uffizi, Florence, Italy. The artist created the radiant golden tones of Venus's body through the application of multiple glazes over pigment.

and a love for landscape (an ironic interest, since Venice had so little land).

TITIAN Although he died almost a quarter century before the birth of the Baroque era, the Venetian master Tiziano Vecellio (ca. 1488/1490–1576), called Titian, had more in common with the artists who would follow him than with his Renaissance contemporaries in Florence and Rome. Titian's pictorial method differed from those of Leonardo, Raphael, and Michelangelo in that he was foremost a painter and colorist rather than a draftsman or sculptural artist. He constructed his compositions by means of colors and strokes of paint and layers of varnish rather than by line and chiaroscuro. A shift from painting on wood panels to painting on canvas occurred at this time, and with it a change from tempera to oil paint as the preferred medium. The versatility and lushness of oil painting served Titian well, with its vibrant, intense hues and its more subtle, semitransparent **glazes**.

Titian's artistic output during 70 years of activity was enormous. His reputation was such that he was lionized by popes and princes. He was a particular favorite of Holy Roman Emperor Charles V, who granted him noble rank after having summoned him on several occasions to work at the royal court. From his tremendous body of work two representative paintings, emblematic of the wide range of his abilities, provide a focus.

Titian's *Venus of Urbino* (**Fig. 13.20**) provides a beautiful example of the glazing technique. The composition was painted for the duke of Urbino, from which its title derives. Titian adopted the figure of the reclining Venus from his teacher Giorgione, and it has served as a model for many compositions since that time. In the foreground, a nude **Venus pudica** rests on voluptuous pillows and sheets spread over a red-brocade couch. Her golden hair, complemented by the delicate flowers she grasps loosely in her right hand, falls gently over her shoulder. A partial drape hangs in the middle ground, providing a backdrop for her upper torso and revealing a view of her boudoir. The background of the composition includes two women looking into a trunk—presumably handmaidens—and a more distant view of a

sunset through a columned veranda. Rich, soft tapestries contrast with the harsh Classicism of the stone columns and inlaid marble floor.

Titian appears to have been interested in the interaction of colors and the contrast of textures. The creamy white sheet complements the radiant golden tones of the body of Venus, built up through countless applications of glazes over pigment. Her sumptuous roundness is created by extremely subtle gradations of tones in these glazes rather than the harshly sculptural chiaroscuro that Leonardo or Raphael might have used. The forms evolve from applications of color instead of line or shadow. Titian's virtuoso brushwork allows him to define different textures: the firm yet silken flesh, the delicate folds of drapery, the servant's heavy cloth dress, the dog's soft fur. The pictorial dominance of these colors and textures sets the work apart from so many examples of Florentine and Roman painting. It appeals primarily to the senses rather than to the intellect.

Titian's use of color as a compositional device is significant. We have already noted the drape, whose dark color forces our attention on the most important part of the composition—Venus's face and upper torso. It also blocks out the left background, encouraging viewers to narrow their focus on the vista in the right background. The forceful diagonal formed by the looming body of Venus is balanced by three elements opposite her: the little dog at her feet and the two handmaidens in the distance. They do not detract from her because they are engaged in activities that do not concern her or the spectator. The diagonal of her body is also balanced by an intersecting diagonal that can be visualized by integrating the red areas in the lower left and upper right corners. Titian thus subtly balances the composition in his placement of objects and color areas.

TINTORETTO Perhaps no other Venetian artist anticipated the Baroque style so strongly as Jacopo Robusti, called Tintoretto (1518–1594). Tintoretto was a pupil of Titian and emulated the master's love of color, although he combined it with a more linear approach to constructing forms. This interest in draftsmanship was culled from Michelangelo, but the younger artist's compositional devices went far beyond those of the Florentine and Venetian masters. His dynamic structure and passionate application of pigment provide a sweeping, almost frantic, energy within compositions of huge dimensions.

Tintoretto's technique involved arranging doll-like figures on small stages and hanging flying figures by wires, in order to copy them in correct perspective on sheets of paper. He then used a grid to transcribe the figures onto much larger canvases. Tintoretto primed the entire canvas with dark colors. Then he quickly painted in the lighter sections. Thus, many of his paintings appear very dark except for bright patches of radiant light. The artist painted extremely quickly, using broad areas of loosely swathed paint. John Ruskin, a 19th-century art critic, is said to have suggested that Tintoretto painted with a broom.[3] Although this is unlikely, Tintoretto had certainly come a long way from the sculptural, at times marble-like, figures of the High Renaissance and the painstaking finish of Titian's glazed *Venus of Urbino*. His loose brushwork and dramatic white spotlighting on a dark ground anticipate the Baroque style.

The Last Supper (**Fig. 13.21**) seals his relationship to the later period. A comparison of this composition with Leonardo's *Last Supper* (**Fig. 13.3**) will illustrate the dramatic

3. Frederick Hartt, *History of Italian Renaissance Art*, 2nd ed. (Englewood Cliffs, NJ: Prentice-Hall, 1979), 615.

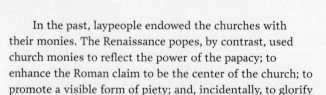

VALUES

Patronage

We have noted the role of patronage in Renaissance art. The question is, to what end did people and organizations spend lavish funds to sustain the arts? The answer to that question helps us understand the social value of art.

In the earlier Renaissance, many wealthy laypeople patronized the arts to "pay back" money earned from taking interest, which was considered a sinful practice. A more common motive was a combination of desires to memorialize the family name (a common custom even today), promote civic pride, and solidify one's standing in the community. Wealthy cities like Venice underwrote lavish art projects as a projection of civic pride and as a demonstration of power and wealth. The enormous papal expenditures in the 15th and 16th centuries reversed an earlier trend.

In the past, laypeople endowed the churches with their monies. The Renaissance popes, by contrast, used church monies to reflect the power of the papacy; to enhance the Roman claim to be the center of the church; to promote a visible form of piety; and, incidentally, to glorify the reign of the pope and his family. Visitors to the Vatican can still see the coats of arms of the families from which the popes came.

The patronage impulses of the past are not all that different from our own (although the church is hardly a central source of artistic patronage today), except that the monies that make art patronage possible come from different sources. This patronage is also the source of much social debate as our contemporaries argue the merits of government funding for the arts.

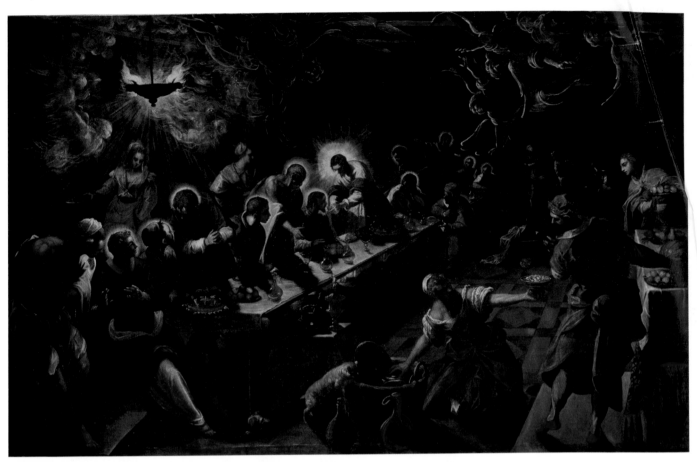

∧ **13.21** Tintoretto, *The Last Supper*, 1592–1594. Oil on canvas, 12′ × 18′8″ (366 × 569 cm). Chancel, San Giorgio Maggiore, Venice, Italy. Tintoretto's impassioned application of pigment lends energy to the painting. Although Tintoretto was a student of Titian, he constructed his forms in a more linear fashion, foregoing layer upon layer of glazing. A comparison with Leonardo's *Last Supper* quickly reveals Tintoretto's creation of a sense of motion and his dramatic use of light—both characteristics of the Baroque era to come.

changes that had taken place in both art and the concept of art over almost a century. The interests in motion, space, and time; the dramatic use of light; and the theatrical presentation of subject matter are all present in Tintoretto's *Last Supper*. We are first impressed by the movement. Everything and everyone is set into motion: People lean, rise up out of their seats, stretch, and walk. Angels fly and animals dig for food. The space, sliced by a sharp, rushing diagonal that goes from lower left to upper right, seems barely able to contain all of this commotion, but this cluttered effect enhances the energy of the event.

Leonardo's obsession with symmetry, along with his balance between emotion and restraint, yields a composition that appears static in comparison to the asymmetry and overpowering emotion in Tintoretto's canvas. Leonardo's apostles seem posed for the occasion when contrasted with Tintoretto's spontaneously gesturing figures. A particular moment is captured. We feel that if we were to look away for a fraction of a second, the figures would have changed position by the time we looked back! The timelessness of Leonardo's figural poses has given way to a seemingly temporary placement of characters. The moment that Tintoretto has chosen to depict

also differs from Leonardo's. The Renaissance master chose the point at which Jesus announced that one of his apostles would betray him. Tintoretto, on the other hand, chose the moment when Jesus shared bread, which symbolized his body as the wine stood for his blood. This moment is commemorated to this day during the celebration of Mass in the Roman Catholic faith. Leonardo chose a moment signifying death, Tintoretto a moment signifying life, depicted within an atmosphere that is teeming with life.

Mannerism

During the Renaissance, the rule of the day was to observe and emulate nature. Toward the end of the Renaissance and before the beginning of the 17th century, this rule was suspended for a while, during a period of art that historians have named **Mannerism**. Mannerist artists abandoned copying directly from nature and copied art instead. Works thus became "secondhand" views of nature. Line, volume, and color no longer duplicated what the eye saw but were derived instead from what other artists had already seen. Several

characteristics separate Mannerist art from the art of the Renaissance and the Baroque periods: distortion and elongation of figures; flattened, almost two-dimensional space; lack of a defined focal point; and discordant pastel hues.

JACOPO DA PONTORMO A representative of early Mannerism, Jacopo da Pontormo (1494–1557) used most of its stylistic principles. In *Entombment* (**Fig. 13.22**), we witness a strong shift in direction from High Renaissance art, even though the painting was executed during Michelangelo's lifetime. The weighty sculptural figures of Michelangelo, Leonardo, and Raphael have given way to less substantial, almost weightless, forms that balance on thin toes and ankles. The limbs are long and slender in proportion to the torsos, and the heads are dwarfed by billowing robes. There is a certain innocent beauty in the arched eyebrows of the haunted faces and in the nervous glances that dart this way and that past the boundaries of the canvas. The figures are pressed against the picture plane, moving within a very limited space. Their weight seems to be thrust outward toward the edges of the composition and away from the almost void center. The figures' robes are composed of odd hues, departing drastically in their soft pastel tones from the vibrant primary colors of the Renaissance masters.

The weightlessness, distortion, and ambiguity of space create an almost otherworldly feeling in the composition, a world in which objects and people do not come under an earthly gravitational force. The artist accepts this strangeness and makes no apologies for it to the viewer. The ambiguities are taken in stride. For example, note that the character in a turban behind the head of the dead Jesus does not appear to have a body—there is really no room for it in the composition. And even though a squatting figure in the center foreground appears to be balancing Christ's legs on his shoulders, having taken him down from the cross a moment before, there is no cross in sight! Pontormo seems to have been most interested in

elegantly rendering the high-pitched emotion of the scene. Iconographic details and logical figural stances are irrelevant.

IL BRONZINO Agnolo di Cosimo di Mariano Tori (1503–1572), known as Bronzino, was a student of Pontormo. Bronzino's 16th-century masterpiece *Venus, Cupid, Folly, and Time (The Exposure of Luxury)* (**Fig. 13.23**) is a classic example of a work in which there is much more than meets the eye. On the

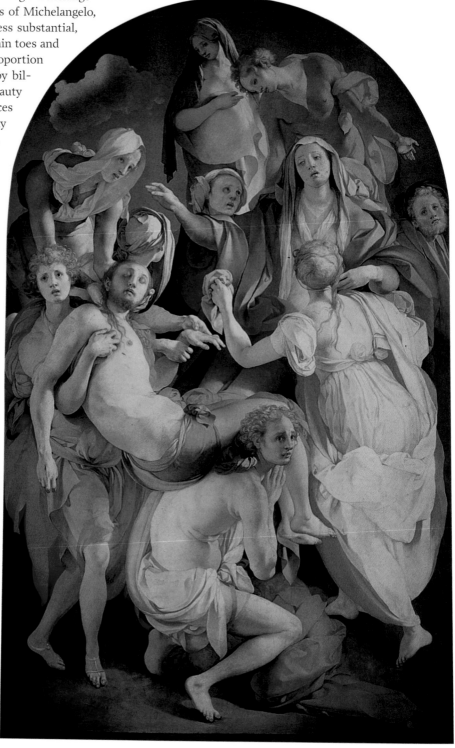

➤ **13.22** Jacopo Pontormo (born Carucci), *Entombment*, 1525-1528. Oil on panel, 123″ × 76″ (312.4 × 193 cm). Capponi Chapel, Santa Felicità, Florence, Italy. The figures do not possess the substantial realism of those of Michelangelo and Raphael. Instead we find nearly weightless figures with elongated limbs.

◀ **13.23** Bronzino, *Venus, Cupid, Folly, and Time (The Exposure of Luxury)*, ca. 1546. Oil on wood, 57½″ × 45⅝″ (146.1 × 116.2 cm). National Gallery, London, United Kingdom. Along with its eroticism, the painting has the ambiguity of meaning and obscurity of imagery that are considered characteristic of Mannerism.

surface, it is a fascinating jumble of mostly pallid figures, some of whom possess body proportions that, as in the Parmigianino, do little to convince us that they would exist in the real world. Over the years the work has alternately titillated and intrigued viewers because of the manner in which it weaves an intricate allegory, with many actors, many symbols. Venus, undraped by Time and spread in a languorous diagonal across the front plane, is fondled by her son Cupid. Folly prepares to cast roses on the couple, while Hatred and Inconstancy (with two left hands) lurk in the background. Masks, symbolizing falseness, and other objects, with meanings known or unknown, complete the scene.

Works such as these offer an intricate puzzle in **iconography.** Is Bronzino saying that love in an environment of hatred and inconstancy is foolish or doomed? Is something being suggested about incest? Self-love? Can one fully appreciate Bronzino's painting without being aware of its iconography? Is it sufficient to respond to the elements and composition, to the figure of a woman being openly fondled before an unlikely array of onlookers? No simple answer is

possible, and a Mannerist artist such as Bronzino would have intended this ambiguity. Certainly one could appreciate the composition and the subject matter for their own sake, but awareness of the symbolism enriches the viewing experience.

LAVINIA FONTANA The daughter of an accomplished painter in Bologna, Lavinia Fontana (1552–1614) traveled to Rome, where she gained patronage even at the level of the papal court. Like her father she adopted the Mannerist style of painting. She had a successful career, mainly as a portrait painter, both in Bologna and later in Rome. Her work shows the technical skill gained not only in her father's studio but also in her own careful study of the works of Raphael, Michelangelo, and Parmigianino. Her husband, Gian Paolo Zappi, gave up his own career after they married in 1577 to aid and manage her prolific one.

In viewing Fontana's religious painting *Noli Me Tangere* (*Do Not Touch Me*) (**Fig. 13.24**), we need to keep in mind that women of the era were discouraged from making religious paintings. Yet Fontana was commissioned to paint altarpieces as well as portraits. *Noli Me Tangere* is named according to the words attributed to the risen Christ in the Gospel of John (20:11–18). During a surprise encounter, Mary Magdalene suddenly realizes the identity of the gar-

◄ 13.24 Lavinia Fontana, *Noli Me Tangere*, 1581. Oil on canvas, 31½″ × 25¾″ (80 × 65.5 cm). Galleria degli Uffizi, Florence, Italy. Fontana was an important portrait artist in Bologna whose father Prospero, himself a painter, had taught her to paint in the Mannerist style. But Fontana also made a number of religious paintings, with *Noli Me Tangere* considered to be among her best.

▲ **13.25** Sofonisba Anguissola, *A Game of Chess*, 1555. Oil on canvas, 28¼″ × 38¼″ (72 × 97 cm). National Museum in Poznań, Poland. Anguissola was one of the earliest women artists to be internationally renowned. Her father was influenced by Castiglione's *The Book of the Courtier* and saw to it that Anguissola attained a proper education.

dener and naturally tries to touch him, but he prevents her from doing so. The scriptural passage reads that Mary at first believed that the man she saw was the gardener. Most artists who painted the subject had Christ holding some sort of garden tool. Fontana, perhaps looking for deeper meaning in the gardening of the Savior—attempting to plant virtue? Plucking evil weeds at the Last Judgment?— places Christ in full horticultural garb, with a coarse smock, a straw hat with a brim to protect him from the sun, and a shovel that is large and sturdy enough to do some real digging.

SOFONISBA ANGUISSOLA In 1556 Giorgio Vasari traveled to Cremona to see the "marvels" of six sisters, children of the Anguissola family, who were "excellent in painting, music, and *belles artes*." The beneficiary of a humanist education at home, the most famous of these sisters was Sofonisba

(ca. 1532–1625), who enjoyed a great degree of fame in her own lifetime. She studied art with a minor master in Cremona. As a young woman she traveled with her father to Rome, where she most likely met Michelangelo. Anguissola also spent time in Milan and, in 1560, traveled to Spain on the invitation of King Philip II to serve as a court portraitist. She remained in Spain for most of the next decade, moving back to Italy after her marriage to a Sicilian nobleman. She died in Palermo in 1625.

Anguissola was enormously successful. Most of her large body of work reflects the regional, realistic style of Cremona rather than the Mannerist stylizations that were popular elsewhere in Italy. The taste for meticulous detail was certainly influenced by Flemish portrait painters, including Anthony van Dyck, who painted Anguissola's portrait. *A Game of Chess* (**Fig. 13.25**), painted in 1555 when the artist was only 23, is a group portrait of three of the artist's sisters

playing chess while a nanny-servant looks on. The brocade fabric of their elaborate dresses and the patterned tablecloth attest to the family's affluence and gentility, although the girls are anything but stilted in their behavior. The oldest, Lucia, looks up from the game to meet our gaze, self-assured and poised. Her sister Minerva seems to try to catch her attention, her hand raised and her lips slightly parted as if about to speak. The youngest looks on, her face brimming with joy, it seems, that Minerva appears to be losing the game. Animated gestures and facial expressions combine to create a work that is less a formal portrait than an absolutely natural and believable scene. Anguissola pushes beyond mere representation to suggest the personalities of her sister and the relationship among them. This easy, conversational quality will become a familiar characteristic of group portraiture in the 17th century, particularly in the north.

GIOVANNI DA BOLOGNA Sculptors and architects as well as painters explored the Mannerist style. One such sculptor was Giovanni da Bologna (1529–1608). He was born Jean Boulogne in the Netherlands, under Spanish rule at the time, and moved to Italy, where he assumed the Italian form of his name. He settled in Florence in 1552 and attracted the attention of Francesco de' Medici, who gave him many commissions. He became one of the most significant court sculptors of the Medici family, who in effect held him against his will in Florence for the remainder of his life, fearful that another royal family would employ him.

His *Abduction of the Sabine Women* (**Fig. 13.26**) has a complex spiral composition that is intended to be viewed from any side or angle with equal effect. The surface of the marble has a beauty and cool elegance that belies the desperation of the female victim and the old man underneath who would protect her if he could.

Interestingly, the statue was not named nor its subject specified until after it was completed and set in place in the Loggia dei Lanzi in Florence's Piazza della Signoria. It may be that the artist was more concerned about solving artistic problems related to the movement of intertwined bodies in space than illustrating an episode in ancient Roman history.

EL GRECO The Late Renaissance brought many different styles. Spanish art polarized into two stylistic

➤ **13.26** Giovanni da Bologna, *Abduction of the Sabine Women*, ca. 1581–1583. Marble, 13′5″ (409 cm) high. **Loggia dei Lanzi, Florence, Italy.** The work was sculpted in the *figura serpentina* style—an upward spiral movement intended to be viewed from all sides.

groups of religious painting: the mystical and the realistic. One painter was able to pull these opposing trends together in a unique pictorial method. El Greco (1541–1614), born Domenikos Theotokopoulos in Crete, integrated many styles into his work. As a young man, he traveled to Italy, where he encountered the works of the Florentine and Roman masters, and he was for a time affiliated with Titian's workshop. The colors that El Greco incorporated into his paintings suggest a Venetian influence, and the distortion of his figures and use of an ambiguous space speak for his interest in Mannerism.

These pictorial elements can clearly be seen in one of El Greco's most famous works, *The Burial of the Count of Orgaz* (**Fig. 13.27**). In this single work, El Greco combines mysticism and realism. The canvas is divided into two halves by a

▲ **13.27** El Greco, *The Burial of the Count of Orgaz*, 1586. Oil on canvas. 15′9″ × 11′10″ (480 × 360 cm). **Santo Tomé, Toledo, Spain.** A horizontal line formed by the progression of white-collared heads separates "heaven" and "earth."

horizontal line of white-collared heads, separating "heaven" and "earth." The figures in the lower half of the composition are somewhat elongated, but well within the bounds of realism. The heavenly figures, by contrast, are extremely attenuated and seem to move under the influence of a sweeping, dynamic atmosphere. It has been suggested that the distorted figures in El Greco's paintings might have been the result of astigmatism in the artist's eyes, but there is no convincing proof of this.

For example, at times El Greco's figures appear no more distorted than those of other Mannerists. Heaven and earth are disconnected psychologically but joined convincingly in terms of composition. At the center of the rigid, horizontal row of heads that separates the two worlds, a man's upward glance creates a path for the viewer into the upper realm. This compositional device is complemented by a sweeping drape that rises into the upper half of the canvas from above his head, continuing to lead the eye between the two groups of figures, left and right, up toward the image of the resurrected Christ. El Greco's color scheme also complements the worldly and celestial habitats. The colors used in the costumes of the earthly figures are realistic and vibrantly Venetian, but the colors of the upper half of the composition are of discordant hues, highlighting the otherworldly nature of the upper canvas. The emotion is high pitched and exaggerated by the tumultuous atmosphere. This emphasis on emotionalism links El Greco to the onset of the Baroque era. His work contains a dramatic, theatrical flair, one of the hallmarks of the 17th century.

MUSIC

Much of the painting, sculpture, and architecture we see during the Renaissance was intended for the service of Roman Catholic worship. Fine music was also subsidized and nurtured in Rome at the papal court.

Music at the Papal Court

The patronage of the popes for the creation and the performance of music dates back to the earliest centuries of the papacy. Gregorian chant, after all, is considered a product of the interest of Pope Gregory and the school of Roman chant. In 1473 Pope Sixtus IV established a permanent choir for his private chapel, which came to be the most important center of Roman music. Sixtus's nephew Julius II endowed the choir for Saint Peter's, the Julian Choir.

The Sistine Choir used only male voices. Preadolescent boys sang the soprano parts, while older men—chosen by competition—sang the alto, tenor, and bass parts. The number of voices varied then from 16 to 24 (the choir eventually became, and still is, much larger). The Sistine Choir sang a cappella (without accompaniment), although we know that the popes enjoyed instrumental music outside the confines of the church. Benvenuto Cellini, for example, mentions that he played instrumental motets for Pope Clement VII.

JOSQUIN DES PREZ While Botticelli and Perugino were decorating the walls of the Sistine Chapel, the greatest composer of the age, Josquin des Prez (ca. 1450–1521), was in the service of the Sistine Choir, composing and directing music for its members from 1486 to 1494. From his music we can get some sense of the quality and style of the music of the time.

Josquin, who was Flemish, spent only those eight years in Rome, but his influence was widely felt in musical circles. He has been called the bridge figure between the music of the Middle Ages and the Renaissance. Although he wrote **madrigals** and many masses in his career, it was in the motet for four voices—a form not held to traditional usage in the way masses were—that he showed his true genius for creative musical composition. Josquin has been most praised for homogeneous musical structure, a sense of balance and order, and a feel for the quality of the lyrics. These are all characteristics common to the aspirations of the 16th-century Italian humanists. In that sense, Josquin combined the considerable musical tradition of Northern Europe with the new intellectual currents of the Italian south.

The Renaissance motet uses a sacred text sung by four voices in **polyphony**. Josquin split his texts into clear divisions but disguised them by using overlapping voices, so that one does not sense any break in his music. He also took considerable pains to marry his music to the obvious grammatical sense of the words while still expressing their emotional import by the use of the musical phrase.

PALESTRINA The 16th-century composer most identified with Rome and the Vatican is Giovanni Pierluigi da Palestrina (1525–1594). He came from the Roman hill town of Palestrina as a youth and spent the rest of his life in the capital city. At various times in his career, he was the choirmaster of the choir of Saint Peter's (the Julian Choir), a singer in the Sistine Choir, and choirmaster of two other Roman basilicas (Saint John Lateran and Saint Mary Major). Finally, from 1571 until his death, he directed all music for the Vatican.

Palestrina flourished during the rather reactionary period in which the Catholic Church, in response to the Protestant Reformation, tried to reform itself by returning to the simpler ways of the past. It should not surprise us, then, that the more than 100 masses he wrote were conservative. His polyphony, while a model of order, proportion, and clarity, is closely tied to the musical tradition of the ecclesiastical past. Rarely does Palestrina move from the Gregorian roots of church music. For example, amid the polyphony of his Missa Papae Marcelli (Mass in Honor of Pope Marcellus), one can detect the traditional melodies of the Gregorian Kyrie, Agnus Dei, and so on. Despite that conservatism, he was an extremely influential composer whose work is still regularly heard in the Roman basilicas. His music was consciously imitated by the Spanish composer Vittoria (or Vic-

toria, ca. 1548–1611), whose motet "O Vos Omnes" is almost traditional at Holy Week services in Rome, and by William Byrd (ca. 1539/40–1623), who brought Palestrina's style to England.

GO LISTEN! PALESTRINA

Missa Papae Marcelli, Credo

In this listening selection, we hear Palestrina's successful return to earlier traditions of church music, a return that satisfies the Counter-Reformation requirement of keeping the text clearly audible. Indeed, he may have composed the mass to illustrate the musical seriousness and textual intelligibility laid down as requirements by the Council of Trent.

Nevertheless, for all Palestrina's conservatism, his work is clearly more complex and advanced than that of Machaut (see Chapter 11). The richness of harmony and the perfect balance of the voices produce a smoothness of texture and beauty and a variety of line that break new ground in the history of Western music. Note the entrance of one voice immediately after another, and the decorative ornamentation of many of the phrases that by the addition of shorter notes adds musical interest without blurring the text.

In the purity of his style, his return to the ideal values of the past, and the inventiveness of his own musical contributions, Palestrina is a perfect example of a Renaissance artist. His music has remained widely admired, and a 19th- and 20th-century composer, Hans Pfitzner (1869–1949), wrote the opera *Palestrina* to pay homage to the inner certainties of artistic genius.

Venetian Music

The essentially conservative character of Palestrina's music can be contrasted with the far more adventuresome situation in Venice, a city less touched by the ecclesiastical powers of Rome. In 1527 a Dutchman—Adriaan Willaert—became choirmaster of the Saint Mark's Basilica. He in turn trained Andrea Gabrieli and his more famous nephew, Giovanni Gabrieli, who became the most renowned Venetian composer of the 16th century.

The Venetians pioneered the use of multiple choirs for their church services. Saint Mark's regularly used two choirs, called split choirs, which permitted greater variation of musical composition in that the choirs could sing to and against each other in increasingly complex patterns. The Venetians were also more inclined to add instrumental music to their liturgical repertoire. They pioneered the use of the organ for liturgical music. The independent possibilities of the organ gave rise to innovative compositions that highlighted the organ. These innovations in time became standard organ pieces: the prelude, the music played before the services

began (called in Italy the *intonazione*), and the virtuoso prelude called the toccata (from the Italian *toccare*, "touch"). The toccata was designed to feature the range of the instrument and the dexterity of the performer.

Both Roman and Venetian music were deeply influenced by the musical traditions of the north. Josquin des Prez and Adriaan Willaert were, after all, both from the Low countries. In Italy their music came in contact with the intellectual tradition of Italian humanism. Without pushing the analogy too far, it could be said that Rome gave musicians the same Renaissance sensibility that it gave painters: a sense of proportion, Classicism, and balance. Venetian composers, much like Venetian painters of the time, were interested in color and emotion.

LITERATURE

The High Renaissance in Italy not only marked the achievement of some of the most refined artistic accomplishments, but, as in other times and in other places, it was also a period of great upheaval. The lives of Raphael and Leonardo ended at precisely the time Luther was struggling with the papacy. In 1527 Rome was sacked by Emperor Charles V's soldiers in an orgy of rape and violence the city had not seen since the days of the Vandals in the fifth century.

Writing continued. Some of it was in the form of notebooks, as we see with Leonardo da Vinci. Some was in the form of poetry, as we see in the sonnets of Michelangelo and Vittoria Colonna. Some of it was philosophizing, as in Castiglione's fictionalized dialogues in *The Book of the Courtier*. And some of it was autobiography, as we find in the self-serving work of Cellini.

LEONARDO DA VINCI When we think of Leonardo da Vinci, paintings such as the *Mona Lisa* and *The Last Supper* may spring into mind. And they should. But so ought we to contemplate his 13,000 pages of notes, replete with well-known drawings. They were made throughout his travels and daily undertakings, mostly written from right to left, as seen through a mirror. Leonardo was left-handed, and it has been speculated that it might have been easier for him to write "backwards."

Some of the notes were published, or intended for publication, during his lifetime: notes on mathematics with geometric drawings; treatises on anatomy, focusing on the skeleton, muscle, and sinews; observations on landscape and the nature of light. Many of his writings and illustrations seem as though they would be the science fiction of his day: fanciful inventions that presage our own times with just enough detail to suggest that they were, in fact, plausible. Included among these are helicopters and hang gliders, submarines, a 720-foot-long bridge, and war machines such as the tank, which would resist defensive measures and protect land forces following behind. (In 2006, the Turkish government decided to build the bridge.)

MICHELANGELO BUONARROTI If Leonardo had never held a paintbrush, we would know him today because of the richness of his written works. It is difficult to know whether we would know of Michelangelo's poetry if he had never held a brush or a chisel. The poems have received a mixed review, yet many of them show the vitality of an artist more than occasionally at odds with his patrons and society.

The following sonnet, written to his longtime (platonic) friend Vittoria Colonna, compares the artist's quest for forms residing in dumb blocks of stone to his search for certain properties in the woman—"Lady, divinely proud and fair." It is of interest that Michelangelo's poems to Tomasso de'Cavalieri, a male friend, are more erotically charged—one of the suggestions that Michelangelo might have been gay.

READING 13.2 MICHELANGELO

The master-craftsman hath no thought in mind
That one sole marble block may not contain
Within itself, but this we only find When the hand serves
the impulse of the brain;
The good I seek, the harm from which I fly,
Lady, divinely proud and fair, even so
Are hid in thee, and therefore I must die
Because my art is impotent to show
 My heart's desire; hence love I cannot blame,
Nor beauty in thee, nor thy scorn, nor ill
Fortune, nor good for this my pain, since life
Within thy heart thou bearest at the same
Moment as death, and yet my little skill
Revealeth death alone for all its strife.

Lorna de' Lucchi, trans. *An Anthology of Italian Poems 13th-19th Century.* New York: Alfred A. Knopf, 1922, p. 127.

VITTORIA COLONNA Colonna (1492—1547) was a member of an affluent Roman family that patronized Petrarch, so it is fitting that she wrote mainly in Petrarchan sonnets (see Chapter 11). She numbered Michelangelo and the epic poet Ludovico Ariosto among her friends. Her social life seems to have largely come to a halt when her husband died in battle in 1525. Nearly all of the more than 400 poems which have come down to us idealize her husband. They look back to love and the promise of a rich life; they look forward to emptiness and darkness. Although her writings became reasonably predictable, Michelangelo refers to them as composed in "sacred ink." Ariosto said of her poetry that it "rescued her triumphant spouse from the dark shore of the Styx." Her spouse was triumphant in seizing the poet's heart unto perpetuity, not on the battlefield.

READING 13.3 VITTORIA COLONNA

Sonnet IX

Once I lived here in you, my now blest Light,
 With your soul joined to mine, for you were kind;
 Each, to the dearer one, had life resigned,
 And dead to self, there only lived aright.
Now that, you being in that heavenly height,
 I am no longer graced such joy to find,
 Your aid deny not to a faithful mind,
 Against the World, which arms with us to fight.
Clear the thick mists, which all around me lie,
 That I may prove at flying freer wings,
 On your already travelled heavenward way.
The honour yours, if here, midst lying things,
 I shut my eyes to joys which soon pass by,
 To ope them there to true eternal day.

Translations from Dante, Petrarch, Michael Angelo, and Vitoria Colonna. London, Kegan Paul & Co.: 1879, p. 317.

⌃ 13.28 Raphael, *Baldassare Castiglione*, ca. 1514. Oil on panel, transferred to canvas, 32¼″ × 26¼″ (82 × 67 cm). **Museé du Louvre, Paris, France.** Raphael would have known the famous humanist through family connections in his native Urbino.

BALDASSARE CASTIGLIONE Baldassare Castiglione (1478–1529) served in the diplomatic corps of Milan, Mantua, and Urbino. He was a versatile man—a person of profound learning, equipped with physical and martial skills, and possessed of a noble and refined demeanor. Raphael's portrait of Castiglione (**Fig. 13.28**) faithfully reflects Castiglione's aristocratic and intellectual qualities.

While serving at the court of Urbino from 1504 to 1516, Castiglione decided to write *The Book of the Courtier*, a task that occupied him for a dozen years. It was finally published by the Aldine Press in Venice in 1528, a year before the author's death. Castiglione's work was translated into English by Sir Thomas Hoby in 1561. It exerted an immense influence on what the English upper classes thought an educated gentleman should be. We can detect echoes of Castiglione in some of the plays of Ben Jonson as well as in Shakespeare's *Hamlet*.

Oh, what a noble mind is here o'erthrown!
The courtier's, soldier's, scholar's eye, tongue, sword:
The expectancy and rose of the fair state,
The glass of fashion and the mould of form,
The observed of all observers . . .

The most common criticism of Castiglione's courtier is that he reflects a world that is overly refined, too aesthetically sensitive, and excessively preoccupied with the niceties of decorum and decoration. The courtier's world, in short, i

READING 13.4 BALDASSARE CASTIGLIONE

From *The Book of the Courtier*, book 3, "The Perfect Lady"

"Leaving aside, therefore, those virtues of the mind which she must have in common with the courtier, such as prudence, magnanimity, continence and many others besides, and also the qualities that are common to all kinds of women, such as goodness and discretion, the ability to take good care, if she is married, of her husband's belongings and house and children, and the virtues belonging to a good mother, I say that the lady who is at Court should properly have, before all else, a certain pleasing affability whereby she will know how to entertain graciously every kind of man with charming and honest conversation, suited to the time and the place and the rank of the person with whom she is talking. And her serene and modest behavior, and the candor that ought to inform all her actions, should be accompanied by a quick and vivacious spirit by which she shows her freedom from boorishness; but with such a virtuous manner that she makes herself thought no less chaste, prudent and benign than she is pleasing, witty and discreet. Thus she must observe a certain difficult mean, composed as it were of contrasting qualities, and take care not to stray beyond certain fixed limits."

. . .

The Magnifico laughed and said:

"You still cannot help displaying your ill-will towards women, signor Gaspare. But I was truly convinced that I had said enough, and especially to an audience such as this; for I hardly think there is anyone here who does not know, as far as recreation is concerned, that it is not becoming for women to handle weapons, ride, play the game of tennis, wrestle or take part in other sports that are suitable for men."

Then the Unico Aretino remarked: "Among the ancients women used to wrestle naked with men; but we have lost that excellent practice, along with many others."

Cesare Gonzaga added: "And in my time I have seen women play tennis, handle weapons, ride, hunt and take part in nearly all the sports that a knight can enjoy."

The Magnifico replied: "Since I may fashion this lady my own way, I do not want her to indulge in these robust and manly exertions, and, moreover, even those that are suited to a woman I should like her to practice very circumspectly and with the gentle delicacy we have said is appropriate to her. For example, when she is dancing I should not wish to see her use movements that are too forceful and energetic."

. . .

The Magnifico Giuliano . . . remarked:

"It appears to me that you have advanced a very feeble argument for the imperfection of women. And, although this is not perhaps the right time to go into subtleties, my answer, based both on a reliable authority and on the simple truth, is that the substance of anything whatsoever cannot receive of itself either more or less; thus just as one stone cannot, as far as its essence is concerned, be more perfectly stone than another stone, nor one piece of wood more perfectly wood than another piece, so one man cannot be more perfectly man than another; and so, as far as their formal substance is concerned, the male cannot be more perfect than the female, since both the one and the other are included under the species man, and they differ in their accidents and not their essence. You may then say that man is more perfect than woman if not as regards essence then at least as regards accidents; and to this I reply that these accidents must be the properties either of the body or of the mind. Now if you mean the body, because man is more robust, more quick and agile, and more able to endure toil, I say that this is an argument of very little validity since among men themselves those who possess these qualities more than others are not more highly regarded on that account; and even in warfare, when for the most part the work to be done demands exertion and strength, the strongest are not the most highly esteemed. If you mean the mind, I say that everything men can understand, women can too; and where a man's intellect can penetrate, so along with it can a woman's."

COMPARE + CONTRAST

Courtesans, East and West

Baldassare Castiglione's most famous work, *The Book of the Courtier*, was written one year before he died, at age 50, from the plague. The funerary monument dedicated to him informs posterity that he was "endowed by nature with every gift and the knowledge of many disciplines" and that "he drew up the *Book of the Courtier* for the education of the nobility." Castiglione's book lays out the model for the perfect Renaissance gentleman—a virtuous, noble, and devoted public servant, educated in the classics, skilled in

rhetoric, able to converse knowledgeably on all subjects including the humanities and history, and gifted in poetry, music, drawing, and dance. Above all, these wide-ranging talents ought to come naturally to the ideal courtier, or at least give the appearance of authenticity; this is the quality Castiglione calls *sprezzatura*—an apparent effortlessness, or "art that conceals art."

Although the setting that inspires *The Book of the Courtier* is the court of the duke of Urbino, the philosophical conversation "recorded" by Castiglione offers a good barometer of the social climate in early-16th-century Italy—including contemporary views on the role of women, their capabilities and gender disadvantages, and their contribution to the life and intellectual discourse of the court. In fact, Elisabetta Gonzaga, the duchess of Urbino, was the moderator of the four-day-long salon (a gathering meant to educate and inspire participants through conversation on subjects such as politics, art, literature, poetry, and scholarship) described by Castiglione in his book. Gonzaga was an educated noblewoman and was regarded as one of the most cultured and virtuous women (she remained loyal to her invalid husband) in Renaissance courtly circles.

The role of courtier was not, then, exclusive to males. On the contrary, in some places where less rigid and more tolerant views prevailed—like the Republic of Venice—female courtesans were an important part of the social fabric. The most renowned courtesan of Renaissance Venice was Veronica Franco (1546–1591), a complex woman of great prestige

◄ **13.29** Tintoretto, *Veronica Franco*, late 16th century. Oil on canvas, 18" × 24" (46 × 61 cm). Worcester Museum of Art, Worcester, Massachusetts.

and many talents whose mantle as a public servant included the creation of a charitable institution for women involved in prostitution and their children.

Franco (**Fig. 13.29**) was the daughter of what Venetians called a *cortigiana onesta* (an honest, upstanding, virtuous courtesan), trained by her mother to be a proper consort of nobility and princes. She was well educated, a skilled musician, a poet, and a brilliant conversationalist. Courtesans like Franco were sought-after companions and entertainers who may or may not have engaged in sexual liaisons. In Venice, a lower class of courtesans—the *cortigiane di lume*—comprised women for whom prostitution was a means of financial survival or security. *Cortigiane oneste* could rise from modest backgrounds to the upper rungs of society, their profession providing one way to gain influence within a patriarchal oligarchy that otherwise suppressed the status of women.

Versions of courtesanship have existed in many cultures, including Japan (**Fig. 13.30**), China, and Turkey, but physical beauty is certainly a common denominator (it is also an important quality of the ideal woman in Castiglione's book). The history of Japanese courtesans, like their European counterparts, has run the gamut from poor young women selling sexual services and high-class prostitutes to *geisha*—erudite companion-entertainers (*geisha* means "entertainer" in Japanese) trained in classical music, dance, vocal performance, conversation, and traditional Japanese rituals such as serving tea.

Although the term *geisha girl* entered common parlance after World War II among American soldiers stationed in Japan to describe women working as prostitutes, these women were not geisha in the true definition of the term. In geisha society, which was highly structured and cloistered, authentic geisha were not associated with clients paying for sex; their business lives and love lives were entirely separate.

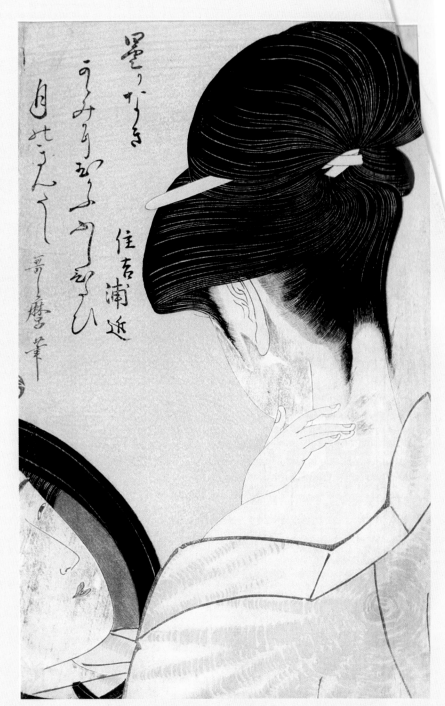

▲ **13.30** Kitagawa Utamaro, *White make-up*, 1795–1796. Color woodblock print, 14 ¹⁄₂″ × 8 ³⁄₄″ (37.0 × 22.3 cm). Musée national des arts asiatiques Guimet, Paris, France.

the world the wealthy, the aristocratic, and the most select of the elite

In *The Book of the Courtier*, cast in the form of an extended dialogue, Castiglione has his learned friends discuss a range of topics: the ideals of chivalry, Classical virtues, the character of the true courtier. Castiglione insistently pleads that the true courtier should be a person of humanist learning, impeccable ethics, refined courtesy, physical and martial skills, and fascinating conversation. He should not possess any of these qualities to the detriment of any other. The *uomo universale* (well-rounded person) should do all things with *sprezzatura*, or effortless mastery. The courtier, unlike the pedant, wears learning lightly, while his mastery of sword and horse has none of the fierce clumsiness of the common soldier in the ranks. The courtier does everything equally well but with an air of unhurried and graceful effortlessness.

Book 3 deals with the position of women in the courtly life of Renaissance Italy. We find one strikingly modern note in this selection when the Magnifico argues that women imitate men not because of masculine superiority but because they desire to "gain their freedom and shake off the tyranny that men have imposed on them by their one-sided authority."

The Magnifico argues that women are as capable as men of understanding worldly affairs. Signor Gaspare counters with the "wisdom" of various philosophers and says that he is astonished that the Magnifico would allow that women are capable of understanding social and political issues as are men.

There follows a discussion of what Nature "intended" with women and men, and how neither can be perfect in the absence of the other. The Magnifico jests that philosophers believe that those who are weak in body will be able in mind. Therefore, if women are in fact weaker than men, they should have greater intellectual capability. Signor Gaspare, intent on winning the argument that men are superior to women, finally responds "without exception every woman wants to be a man," which leads the Magnifico to reply with what we would now see as a feminist point of view.

READING 13.5 BALDASSARE CASTIGLIONE

From *The Book of the Courtier*, book 3, "The Perfect Lady," continued

The Magnifico Giuliano at once replied:

"The poor creatures do not wish to become men in order to make themselves more perfect but to gain their freedom and shake off the tyranny that men have imposed on them by their one-sided authority."

"On Women" from *The Book of the Courtier* by Baldesar Castiglione, translated by George Bull (Penguin Classics, 1967). Copyright © George Bull, 1967. Reprinted by permission of the publisher Penguin Books, Ltd.

VERONICA FRANCO Veronica Franco (1546–1591), the most famous courtesan in Venice, was schooled in Classical literature, knew the ins and outs of politics, played various musical instruments, and was renowned for her learned and scintillating conversation. She wrote letters to the elite of Venice and Europe, letters that have survived because the recipients valued them. She also wrote poems in **terza rima**, the difficult verse used by Dante in his *Divine Comedy*. Franco's collected poems in terza rima include pieces that are seductive, poetic dialogues with her suitors, and many that challenge the patriarchal status quo in Venice.

READING 13.6 VERONICA FRANCO

From *Poems in Terza Rima*, chapter 2, lines 34–39, 154–171

Since I will not believe that I am loved,
nor should I believe it or reward you
for the pledge you have made me up to now,
win my approval, sir, with deeds:
prove yourself through them, if I, too,
am expected to prove my love with deeds.

. . .

So sweet and delicious do I become,
when I am in bed with a man
who, I sense, loves and enjoys me,
that the pleasure I bring excels all delight,
so the knot of love, however tight
it seemed before, is tied tighter still.
Phoebus, who serves the goddess of love,
and obtains from her as a sweet reward
what blesses him far more than being a god,
comes from her to reveal to my mind
the positions that Venus assumes with him
when she holds him in sweet embraces;
so that I, well taught in such matters,
know how to perform so well in bed
that this art excels Apollo's by far,
and my singing and writing are both forgotten
by the man who experiences me in this way,
which Venus reveals to people who serve her.

Franco's efforts to help and protect Venetian women who were working as prostitutes through her charitable institution, Casa del Soccorso, acknowledged the dangers and indignities of life as a courtesan—particularly among the *cortigiane di lume*. Franco warns the mother of a young woman of the sordid side of courtesan life in a letter.

READING 13.7 VERONICA FRANCO

From letter 22, "A Warning to a Mother Considering Turning Her Daughter into a Courtesan"

Where once you made [your daughter] appear simply clothed and with her hair arranged in a style suitable for a chaste girl, with veils covering her breasts and other signs of modesty,

suddenly you encouraged her to be vain, to bleach her hair and paint her face. And all at once, you let her show up with curls dangling around her brow and down her neck, with bare breasts spilling out of her dress, with a high, uncovered forehead, and every other embellishment people use to make their merchandise measure up to the competition.

. . .

I'll add that even if fate should be completely favorable and kind to her, this is a life that always turns out to be a misery. It's a most wretched thing, contrary to human reason, to subject one's body and labor to a slavery terrifying even to think of. To make oneself prey to so many men, at the risk of being stripped, robbed, even killed, so that one man, one day, may snatch away from you everything you've acquired from many over such a long time, along with so many other dangers of injury, and dreadful contagious diseases; to eat with another's mouth, sleep with another's eyes, moving according to another's will, obviously running toward the shipwreck of your mind and your body—what greater misery? What wealth, what luxuries, what delights can outweigh all this? Believe me, among all the world's calamities, this is the worst. And if to worldly concerns you add those of the soul, what greater doom and certainty of damnation could there be?

BENVENUTO CELLINI Benvenuto Cellini (1500–1571) was a talented Florentine goldsmith and sculptor whose life, frankly chronicled, was a seemingly never-ending panorama of violence, intrigue, quarrel, sexual excess, egotism, and political machination. His autobiography, much of it dictated to a young apprentice who wrote while Cellini worked, is a vast and rambling narrative of Cellini's life from his birth to the year 1562. We read vignettes about popes and commoners, artists and soldiers, cardinals and prostitutes, assassins and artists, as well as a gallery of other characters from the Renaissance demimonde of Medicean Florence and papal Rome.

Above all, we meet Benvenuto Cellini, who makes no bones about his talent, his love of life, or his taste for violence. Cellini is not one of Castiglione's courtiers. He fathered eight children in and out of marriage; was banished from Florence for sodomy; was imprisoned for assault; fled Rome after murdering a man; and fought on the walls of the Castel Sant'Angelo in Rome during the siege of 1527, in defense of the Medici pope Clement VII. Anyone who thinks of the Renaissance artist solely in terms of proportion, love of the classics, Neo-Platonic philosophy, and genteel humanism is in for a shock when encountering Cellini's autobiography.

One particular part of Cellini's book is interesting not for its characteristic bravado or swagger, but for its insight into the working methods of an artist. In a somewhat melodramatic account, Cellini describes the process of casting the bronze statue of Perseus that turned out to be his most famous work (**Fig. 13.31**). It now stands in the Loggia dei Lanzi along with Bologna's *Abduction of the Sabine Women*

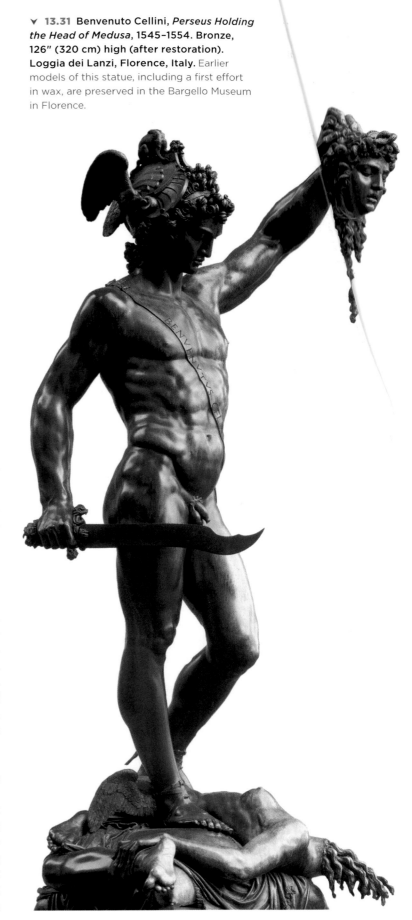

▼ 13.31 Benvenuto Cellini, *Perseus Holding the Head of Medusa*, 1545–1554. Bronze, 126″ (320 cm) high (after restoration). Loggia dei Lanzi, Florence, Italy. Earlier models of this statue, including a first effort in wax, are preserved in the Bargello Museum in Florence.

READING 13.8 BENVENUTO CELLINI

From The Autobiography, Casting Perseus

I had of the Medusa [whose severed head is held high by the victorious Perseus]—and it came out very well—and then very hopefully I brought the Perseus towards completion. I had already covered it in wax, and I promised myself that it would succeed in bronze as well as the Medusa had. The wax Perseus made a very impressive sight, and the Duke thought it extremely beautiful. It may be that someone had given him to believe that it could not come out so well in bronze, or perhaps that was his own opinion, but anyhow he came along to my house more frequently than he used to, and on one of his visits he said:

"Benvenuto, this figure can't succeed in bronze, because the rules of art don't permit it."

I strongly resented what his Excellency said.

"My lord," I replied, "I'm aware that your Most Illustrious Excellency has little faith in me, and I imagine this comes of your putting too much trust in those who say so much evil of me, or perhaps it's because you don't understand the matter."

He hardly let me finish before exclaiming: "I claim to understand and I do understand, only too well."

"Yes," I answered, "like a patron, but not like an artist. If your Excellency understood the matter as you believe you do, you'd trust in me on the evidence of the fine bronze bust I made of you: that large bust of your Excellency that has been sent to Elba. And you'd trust me because of my having restored the beautiful Ganymede in marble; a thing I did with extreme difficulty and which called for much more exertion than if I had made it myself from scratch: and because of my having cast the Medusa, which is here now in your Excellency's presence; and casting that was extraordinarily difficult, seeing that I have done what no other master of this devilish art has ever done before. Look, my lord, I have rebuilt the furnace and made it very different from any other. Besides the many variations and clever refinements that it has, I've constructed two outlets for the bronze: that was the only possible way of ensuring the success of this difficult, twisted figure. It only succeeded so well because of my inventiveness and shrewdness, and no other artist ever thought it possible.

"Be certain of this, my lord, that the only reason for my succeeding so well with all the important and difficult work I did in France for that marvelous King Francis was because of the great encouragement I drew from his generous allowances and from the way that he met my request for workmen—there were times when I made use of more than forty, all of my own choice. That was why I made so much in so short a time. Now, my lord, believe what I say, and let me have the assistance I need, since I have every hope of finishing a work that will please you. But if your Excellency discourages me and refuses the assistance I need, I can't produce good results, and neither could anyone else no matter who."

The Duke had to force himself to stay and listen to my arguments; he was turning now one way and now another, and, as for me, I was sunk in despair, and I was suffering agonies as I began to recall the fine circumstances I had been in [when] in France.

All at once the Duke said: "Now tell me, Benvenuto, how can you possibly succeed with this beautiful head of Medusa, way up there in the hand of the Perseus?"

Straight away I replied: "Now see, my lord: if your Excellency understood this art as you claim to then you wouldn't be worried about that head not succeeding; but you'd be right to be anxious about the right foot, which is so far down."

At this, half in anger, the Duke suddenly turned to some noblemen who were with him and said:

"I believe the man does it from self-conceit, contradicting everything."

. . .

Seeing that the work was so successful I immediately went to Pisa to find my Duke. He welcomed me as graciously as you can imagine, and the Duchess did the same. Although their majordomo had sent them news about everything, it seemed to their Excellencies far more of a stupendous and marvelous experience to hear me tell of it in person. When I came to the foot of the Perseus which had not come out—just as I had predicted to his Excellency—he was filled with astonishment and he described to the Duchess how I had told him this beforehand. Seeing how pleasantly my patrons were treating me I begged the Duke's permission to go to Rome.

From *The Autobiography of Benvenuto Cellini*, translated by George Bull (Penguin Classics, 1956). Copyright © George Bull, 1956. Reprinted by permission of Penguin Books, Ltd.

(see **Fig. 13.28**) and a number of other sculptures. *Perseus Holding the Head of Medusa*, finished in 1554 for Duke Cosimo I de' Medici, is a highly refined work made more interesting because of Cellini's record of its genesis.

In the following portion of his autobiography, Cellini recalls his casting of the statue. The casting of bronze statues is a complex process in which a model of the statue, made of a material such as wax or clay, is translated into the more durable bronze. Bronze has been used most frequently because of its appealing surface and color characteristics. It involves the use of a kiln, and accidents occur quite often. Cellini's casting of the bronze Perseus involved a series of such accidents, some of which could have been quite dangerous. As the reader encounters the process, she or he comes across much more than delays, illness, masterly skill, and perseverance the ego of the artist is also inescapable. Here the artist is attempting to explain the difficulties of the process to the duke—his patron.

Despite his skepticism of the process and his impatience with the manner of the artist, the duke asks Cellini explain matters to him, which he does, at the same time asking for more money. We are then led through the complicated casting process, including an illness during which Cellini certain he will die. But upon hearing that his work is in danger of being destroyed, the "selfless" Cellini springs out of bed and summons all of his assistants and all of his skills to the achievement of the task. Once the statue is complete, Cellini journeys to Pisa to inform his patron, in effect, that he—the artist—was correct in his predictions.

GLOSARY

Chiaroscu *(p. 422)* From the Italian for "light–dark"; an artistic te lique in which subtle gradations of value create the illusion c ounded, three-dimensional forms in space; also called *modeling*

Glaze (439) In painting, a semitransparent coating on a painted urface that provides a glassy or glossy finish.

Horiz line *(p. 427)* In linear perspective, the imaginary line (frequ tly where the earth seems to meet the sky) along which conv ing lines meet; also see **vanishing point**.

Ico graphy *(p. 443)* A set of conventional meanings attached to ages; as an artistic approach, representation or illustration th uses the visual conventions and symbols of a culture. Also, th study of visual symbols and their meaning (often religious).

M drigal *(p. 448)* A song for two or three voices unaccompanied instrumental music.

Mannerism *(p. 441)* A style of art characterized by distortion and elongation of figures; a sense of flattened space rather than depth; a lack of a defined focal point; and the use of clashing pastel colors.

Orthogonal *(p. 421)* In perspective, a line pointing to the vanishing point.

Patronage *(p. 419)* In the arts, the act of providing support for artistic endeavors.

Peristyle *(p. 435)* A series of columns enclosing a court or surrounding a building.

Pietà *(p. 428)* In artistic tradition: a representation of the dead Christ, held by his mother, the Virgin Mary (from the Latin word for "pity").

Polyphony *(p. 448)* Music with two or more independent melodies that harmonize or are sounded together.

Sarcophagus *(p. 434)* A coffin; usually cut or carved from stone, although Etruscan sarcophagi were made of terracotta.

Terza rima *(p. 454)* A poetic form in which a poem is divided into sets of three lines (*tercets*) with the rhyme scheme *aba*, *bcb*, *cdc*, etc.

Triglyph *(p. 438)* In architecture, a panel incised with vertical grooves (usually three, hence, *tri-*) that serve to divide the scenes in a *Doric frieze*.

Vanishing point *(p. 427)* In linear perspective, a point on the horizon where parallel lines appear to converge.

Venus pudica *(p. 439)* A representation of a nude Venus with her hand held over her genitals for modesty.

THE BIG PICTURE THE HIGH RENAISSANCE IN ITALY

Language and Literature

- Leonardo da Vinci began to write his treatises on art and science ca. 1490–1495.
- The Aldine Press was established in Venice ca. 1494.
- Strozzi wrote his poem on Michelangelo's *Night* ca. 1531.
- Vittoria Colonna began writing poems in memory of her husband in 1525.
- Martin Luther translated the Bible into German in 1527.
- Castiglione published *The Courtier* in 1528.
- Michelangelo and Colonna began exchanging letters and poems in 1538.
- Cellini wrote his autobiography ca. 1558–1566.
- Sir Thomas Hoby translated *The Book of the Courtier* into English in 1561.

Art, Architecture, and Music

- Sixtus IV establishes the Sistine Choir in 1473.
- Leonardo da Vinci painted his *Madonna of the Rocks* in 1483,
 The Last Supper in 1495–1498, and *Mona Lisa* ca. 1503–1505.
- Josquin des Prez composed masses and motets for the Sistine Choir ca. 1486–1494.
- Raphael painted *Madonna of the Meadow* in 1508 and *Philosophy*
 (The School of Athens) in 1509–1511.
- Michelangelo sculpted the *Pietà* in 1498–1499, *David* in 1501–1504,
 Moses in 1513–1515, and *Night* ca. 1519–1531.
- Michelangelo painted the ceiling of the Sistine Chapel in 1508–1511
 and *The Last Judgment* ca. 1534–1541.
- Pope Julius II established the Julian Choir for Saint Peter's Basilica in 1512.
- Adriaan Willaert became the choirmaster of Saint Mark's in Venice in 1527.
- Palladio began construction of the Palazzo Chiericati in the 1550s.
- Titian painted *Assumption of the Virgin* in 1516–1518 and *Venus of Urbino* in 1538.
- Tintoretto painted his *Last Supper* in the Mannerist style in 1592–1594.
- Pontormo painted *Entombment* in 1525–1528.
- Parmigianino painted *Madonna of the Long Neck* ca. 1535.
- Bronzino painted *Venus, Cupid, Folly, and Time (The Exposure of Luxury)* ca. 1546.
- Palestrina composed Missa Papae Marcelli in 1567.
- Fontana painted *Noli Me Tangere* in 1581.
- Anguissola painted *A Game of Chess* in 1555.
- Bologna sculpted *Abduction of the Sabine Women*{{AU: The chapter and caption have
 Abduction of the Sabine Women; please reconcile.}} ca. 1581–1583.
- El Greco painted *The Burial of the Count of Orgaz* in 1586.
- Cellini sculpted *Perseus Holding the Head of Medusa* ca. 1545–1554.

Philosophy and Religion

- Luther presented his 95 Theses, triggering the Reformation in Germany in 1517.
- Luther was excommunicated by Pope Leo X in 1521.
- Castiglione published *The Book of the Courtier*, a philosophical treatise on the courtly life in 1528.
- Luther published his translation of the Bible in 1527.
- The churches of Rome and England separated in 1534.
- The Council of Trent initiated the Counter-Reformation in 1545–1564.

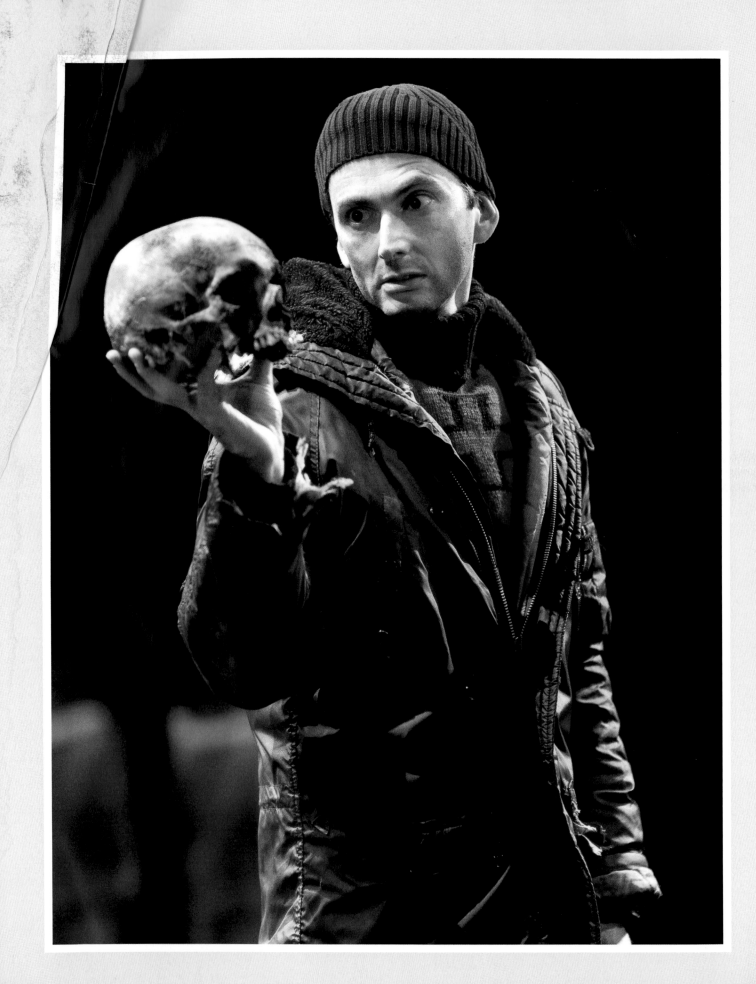

The High Renaissance in the North

14

PREVIEW

The website of London's Royal Shakespeare Company cites Hamlet as the most often performed of William Shakespeare's plays. Its earliest documented performance took place in 1607 on a ship called *The Dragon* anchored off the coast of Sierra Leone in West Africa; some 400 years later, the actor David Tennant (Fig. 14.1) played the title role in a production that included a human skull that had been bequeathed in a will for use as a prop in a play.

It is estimated that every minute of every day, *Hamlet* is staged somewhere in the world. To what does the play owe such fascination, such relevance, such longevity as a work of art? Why have Shakespeare's writings outlived many of "the gilded monuments of princes" of which he wrote? Steven Greenblatt, in his important book, *Will in the World: How Shakespeare Became Shakespeare,* observed:

> One of the prime characteristics of Shakespeare's art is the touch of the real. As with any other writer whose voice has long ago fallen silent and whose body has moldered away, all that is left are words on a page, but even before a gifted actor makes Shakespeare's words come alive, those words contain the vivid presence of actual, lived experience. The poet who noticed that the hunted trembling hare was "dew-bedabbled" or who likened his strained reputation to the "dyer's hand," the playwright who has a husband tell his wife that there is a purse in the desk "That's covered o'er with Turkish tapestry," or who has a prince remember that his poor companion owns only two pairs of silk stockings, one of them peach-colored—this artist was unusually open to the world and discovered the means to allow the world into his works.[1]

This careful observation of the mundane, the stuff of everyday life rendered vivid, against which unfold symbolic narratives, describes Shakespeare's plays just as it does the visual art of Northern Renaissance painters. The illusion of reality based on mimicking the experience of the physical world on a two-dimensional surface, made more convincing by the depiction of the psychological states of the characters—this was the contribution of the Italian Renaissance artist; it finds its analogy in Shakespeare's haunting realism on stage

◄ **14.1** British actor David Tennant as Hamlet, 2008. Royal Shakespeare Company, The Courtyard Theatre.

1. Stephen Greenblatt. *Will in the World: How Shakespeare Became Shakespeare.* New York: W. W. Norton & Company, 2004, pp. 13–14.

and his penetration into the hearts and anguishes of his characters. He knew psychology before there was a science called psychology.

Self-knowledge and self-reflection are also key components of humanist thought, and in Shakespeare's famed soliloquies they are explored to great dramatic effect. In what is perhaps the most familiar of these speeches, "To be or not to be," Hamlet confronts the fear of death and dilemmas of conscience that plague him—and humankind. In another, recited in a graveyard where he comes upon the skull of his father's court jester, he ponders the transitory nature of human existence and the fate of death that knows no privilege. He asks his confidante, Horatio, "Dost thou think Alexander looked o' this fashion?" and muses on the inglorious ends of two of history's most famed figures: "Alexander was buried, Alexander returneth into the dust; the dust is earth; of earth we make loam; and why of that loam, whereto he was converted, might they not stop a beer-barrel" (that is, use the mix of dirt and human remains to stop it from leaking); and "Imperious Caesar, dead and turn'd to clay, Might stop a hole to keep the wind away: O, that the earth, which kept the world in awe, Should patch a wall to expel the winter flaw!"

In the 16th century, the spirit of humanism spread from Italy to Northern Europe, including England, where William Shakespeare was born in 1564—the same year that the High Renaissance master, Michelangelo, died in Rome. Shakespeare would become the most famous of Elizabethan writers, his work a hallmark of an era of great cultural achievement that accompanied the almost half-century-long reign of Queen Elizabeth I.

HUMANISM TRAVELS NORTH

The ideas and artistic styles that developed in Italy during the 15th and 16th centuries produced immense changes in the cultural life of England, France, Germany, and the Netherlands. As the Renaissance spread beyond the Alps, the new humanism roused Northern Europe from its conservative intellectual patterns and offered an alternative to traditional religious doctrines. The infusion of Italian ideas produced a breadth of vision that contributed not only to a humanist aesthetic in Northern Renaissance painting and to important developments in music, but also to a more global enthusiasm for Classical literature and philosophy, which led to considering the tenets of Christianity from a humanist perspective.

France

The spread of Italian Renaissance ideas to the North was in many respects political rather than cultural. Throughout most of the 16th century, the monarchs of Northern Europe vied with one another for political and military control over the states of Italy. In the process, they came in contact with the latest developments in Italian artistic and intellectual life and often based their own courts on Italian models. Francis I, who ruled France from 1515 to 1547, made a deliberate attempt to expose French culture to Italian influences; he attracted Italian artists to the French court, among them Leonardo da Vinci, Andrea del Sarto, and Benvenuto Cellini. Francis and his successors also esteemed literature and

The Renaissance in the North

1500 CE	1525 CE	1550 CE	1575 CE	1620 CE
GENESIS OF THE REFORMATION	**SPREAD OF THE REFORMATION**	**GROWTH OF THE COUNTER-REFORMATION**	**RELIGIOUS AND NATIONALISTIC UNREST**	
Reign of Henry VIII in England	Charles V defeats Francis I at Pavia	Lutheran and Catholic wars in Germany end with the Peace of Augsburg	The Netherlands declares independence from Spain	
Reign of Francis I in France	Charles V sacks Rome	Charles V abdicates	England sends troops to support the Netherlands against Spain	
Luther presents his 95 theses, triggering the Reformation in Germany	Execution of Thomas More	Reign of Philip II in Spain and the Netherlands	Philip II's Spanish Armada is defeated by England	
Reign of Charles V as Holy Roman emperor	Execution of Anne Boleyn	Reign of Mary Tudor in England	The English found the East India Company	
Peasants' War in Germany	Copernicus publishes *On the Revolution of Celestial Bodies* and Vesalius publishes *Seven Books on the Structure of the Human Body*	Reign of Elizabeth I in England	The English found the colony of Jamestown	
		St. Bartholomew's Day Massacre in France	Spain recognizes the independence of the Netherlands	
			Francis Bacon publishes *Novum Organum*	

scholarship. Francis's sister, Marguerite of Navarre, was a writer of considerable gifts and became the center of an intellectual circle that included many of the finest minds of the age.

Germany

The history of Germany is intimately bound up with that of the Hapsburg family. In the first half of the 16th century, the same Hapsburg king who ruled Germany (under the old name of the Holy Roman Empire) as Charles V ruled Spain as Charles I. Charles was the principal competitor of Francis I for political domination of Italy, and although his interest in the arts was less cultivated than that of his rival, his conquests brought Italian culture to both Spain and the North. On his abdication (1556) he divided his territories between his brother Ferdinand and his son Philip. The Austrian and Spanish branches of the Hapsburg family remained the principal powers in Europe until the 1650s.

The Netherlands

Spain reached the height of its power in the 16th century, controlling territories in the Americas, parts of France and Germany, and the Netherlands. Catholic Spain came into conflict with Northern Europe not only because of a desire to increase and maintain wealth and power, but also because Northern Europe was turning Protestant. In 1566, there were Calvinist-led riots in the Spanish Netherlands, which caused the Spanish to militarily restore order and conduct a reign of terror. The Eighty Years' War followed, leading to the eventual independence of the Netherlands. In 1586, Queen Elizabeth I of England supported the Protestant Netherlands. (In 1587, the English admiral Sir Francis Drake attacked the Spanish port of Cádiz, destroying many of the harbored **galleons** and delaying the Spanish Armada from attacking England for a year.) Despite all the turmoil, excellent art was produced in the Nether-

lands—as it apparently is in many or most societies undergoing transformations.

England

For most of the Renaissance, England remained under the dominion of a single family—the Tudors—whose last representative was Elizabeth I. The Tudor family came into power after the War of the Roses, which destroyed the previous royal family. The Tudor dynasty began with Henry VII, who rose to power after defeating Richard III of the house of York in 1485. Henry married Elizabeth of York to try to cement the relationship between the conflicting families and extended Tudor power to Wales and Ireland. He is credited with restoring England's financial security following ruinous wars.

Henry VIII ascended to the throne in 1509 and reigned until his death in 1547. When we picture Henry VIII, we are likely to think of the portrait by Hans Holbein the Younger (**Fig. 14.2**), showing a corpulent but confident king with a

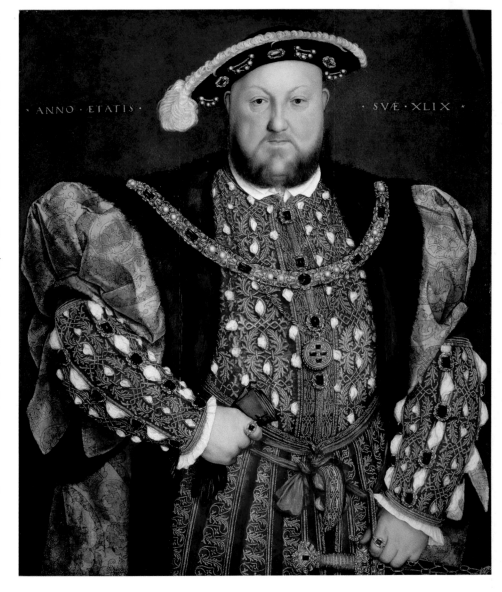

> **14.2** Hans Holbein the Younger, *Henry VIII in Wedding Dress*, 1540. Oil on panel, 32½" × 29" (83 × 74 cm). Galleria Nazionale d'Arte Antica, Rome, Italy. Weddings were not uncommon events in Henry's life. The wedding he is dressed for here—to his fourth wife, Anne of Cleves (see Fig. 14.18)—took place in his 49th year (as the inscription reads) and was annulled within the year.

rakish demeanor and a flattering beard. He is wearing wedding apparel, attired for a not-uncommon event in his life. He is remembered for having six wives and disposing of them in one way or another, but he also beheaded tens of thousands of actual and potential political opponents. Nor did matchmakers fare well; Henry also beheaded a couple of ministers who had recommended failed marital unions—albeit for different reasons.

Henry VIII's marriage to his first wife, Catherine of Aragon, failed because the couple could not produce a male heir to the throne. The king sought a papal dispensation that would permit divorce, but the pope refused the petition. Parliament enacted laws breaking ties with the pope and establishing Henry VIII as the governor of the Church of England, along with his secular title as king. He then married Anne Boleyn, who gave birth in 1533 to Elizabeth, who would become Queen Elizabeth I. Thomas Cromwell, a minister of

the king from 1532 to 1540, accused Anne of adultery. She was tried for treason, witchcraft, and incest, found guilty, and executed in 1536. (Cromwell was executed four years later.) Henry married again, and again, and again—and again.

Elizabeth I became queen after much intrigue and rivalry in claims to the throne. Her predecessor and half-sister, Mary Tudor—nicknamed Bloody Mary because of her burning of Protestant dissenters at the stake—had sought to return England to the Catholic faith from which Henry VIII had broken. But Elizabeth was a Protestant, and when she assumed the throne she required clergy to swear an oath recognizing the independence of the Church of England from the Catholic Church.

The question of marriage for Elizabeth was a problem without an easy solution. Had Elizabeth married an English nobleman, she would have disturbed the delicate balance of power that maintained the loyalty of England's leading aris-

▼ **14.3** Lucas Cranach the Elder, *Martin Luther and His Wife Katherina von Bora* (double portrait), 1529. Oil on wood, 14³/₈″ × 9″; 14⁵/₈″ × 9″ (36.5 × 23; 37 × 23 cm). **Galleria degli Uffizi, Florence, Italy.** Luther and von Bora, a former nun, were married at about the time this portrait was painted. They had six children.

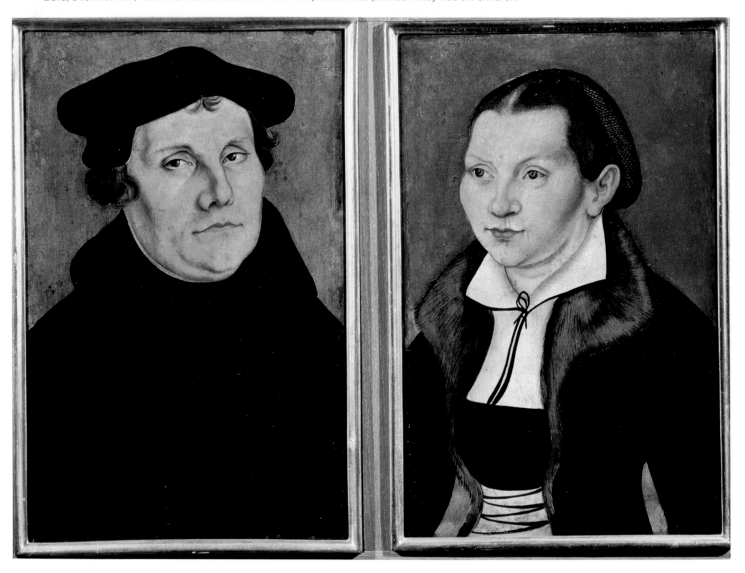

READING 14.1 MARTIN LUTHER

From *Disputation on the Power and Efficacy of Indulgences* (1517)

Out of love for the truth and the desire to bring it to light, the following propositions will be discussed at Wittenberg, under the presidency of the Reverend Father Martin Luther, Master of Arts and of Sacred Theology, and Lecturer in Ordinary on the same at that place. Wherefore he requests that those who are unable to be present and debate orally with us, may do so by letter.

. . .

32. They will be condemned eternally, together with their teachers, who believe themselves sure of their salvation because they have letters of pardon.

33. Men must be on their guard against those who say that the pope's pardons are that inestimable gift of God by which man is reconciled to Him;

34. For these "graces of pardon" concern only the penalties of sacramental satisfaction, and these are appointed by man.

35. They preach no Christian doctrine who teach that contrition is not necessary in those who intend to buy souls out of purgatory or to buy confessionalia.

36. Every truly repentant Christian has a right to full remission of penalty and guilt, even without letters of pardon.

37. Every true Christian, whether living or dead, has part in all the blessings of Christ and the Church; and this is granted him by God, even without letters of pardon.

. . .

43. Christians are to be taught that he who gives to the poor or lends to the needy does a better work than buying pardons;

44. Because love grows by works of love, and man becomes better; but by pardons man does not grow better, only more free from penalty.

45. Christians are to be taught that he who sees a man in need, and passes him by, and gives [money] for pardons, purchases not the indulgences of the pope, but the indignation of God.

. . .

50. Christians are to be taught that if the pope knew the exactions of the pardon-preachers, he would rather that St. Peter's church should go to ashes, than that it should be built up with the skin, flesh and bones of his sheep.

51. Christians are to be taught that it would be the pope's wish, as it is his duty, to give of his own money to very many of those from whom certain hawkers of pardons cajole money, even though the church of St. Peter might have to be sold.

52. The assurance of salvation by letters of pardon is vain, even though the commissary, nay, even though the pope himself, were to stake his soul upon it.

. . .

75. To think the papal pardons so great that they could absolve a man even if he had committed an impossible sin and violated the Mother of God—this is madness.

76. We say, on the contrary, that the papal pardons are not able to remove the very least of venial sins, so far as its guilt is concerned.

tocratic families. Marriage to a foreign ruler could have compromised England's status as a leading European power, just at the moment when she was intent on strengthening it. Elizabeth avoided the dilemma by choosing to remain the "Virgin Queen," although gossips during her reign and since have questioned the accuracy of the moniker.

In the course of her long reign (1558–1603) Elizabeth established her court as a center of art and learning. Although the influence of Italian models on the visual arts was less marked in England than elsewhere, revived interest in Classical antiquity and the new humanism it inspired is reflected in the works of Shakespeare and other Elizabethan writers.

Toward the end of her life, a protracted war with Spain and a series of poor harvests weakened England's economy. For a while Elizabeth's authority seemed to falter, but by the end of her reign she had regained the love of her people. As she proclaimed in 1601, "Though God hath raised me high, yet this I count the glory of my crown, that I have reigned with your love, and you never shall have any on this throne who will love you better."

Although the art of the great Northern centers drew heavily on Italy for inspiration, the 16th century was also a period of intellectual tumult in which traditional ideas on religion and the nature of the universe were shaken and changed. Many of the revolutionary movements of the age were Northern in origin, and they had a profound effect on the arts. While Northern artists were being influenced by the styles of their fellow artists south of the Alps, their cultural world was also being shaped by theologians and scientists closer to home.

THE REFORMATION

On the eve of All Saints' Day in 1517, a German Augustinian friar, Martin Luther (1483–1546; **Fig. 14.3**), tacked on the door of the collegiate church of Wittenberg a parchment containing 95 **theses** (academic propositions) written in Latin—the usual procedure for advertising an academic debate. Luther's theses challenged the Roman Catholic doctrine of **indulgences** (forgiveness of punishment for sins, usually obtained either through good works or prayers along with the payment of an appropriate sum of money). This was a timely topic because an indulgence was currently being preached near Wittenberg to help raise funds for the rebuilding of Saint Peter's in Rome.

Consequences of Luther's Challenge

Luther's challenge touched off a controversy that extended far beyond academia. For the next few years theologians debated, and Luther received emissaries and directives from the Vatican as well as official warnings from the pope. Luther did not waver in his criticisms. He also advocated the abolition of statues and images and the right of the clergy to marry (abolishing celibacy). On June 15, 1520, Pope Leo X (Giovanni de' Medici, son of Lorenzo the Magnificent) condemned Luther's teaching as heretical; and, on January 3, 1521, he excommunicated him from the Catholic Church, unintentionally birthing the Protestant Reformation.

ANABAPTISM Luther's reformation principles began to be applied in churches throughout Germany, and a rapid and widespread outbreak of other reforming movements was touched off by his example. By 1523, reformers called **Anabaptists**, who were more radical than Luther, agitated for a purer Christianity, one free of any trace of "popery." *Anabaptism* means being baptized again, reflecting the group's insistence on adult baptism even if baptism had been performed in infancy. Anabaptists believed that baptismal candidates must be able to understand and make their own declarations of faith. Many of these Anabaptist groups had radical social and political ideas, including pacifism and the refusal to take oaths or participate in civil government, which appealed to the discontent of the lower classes. One outcome was the Peasants' War in Germany, which was put down with ferocious bloodshed in 1525.

The Amish, Hutterites, and Mennonites are descendants of the Anabaptist movement. The Baptist churches in the United States arose independently, but Baptists share the belief that only people who understand the meaning of baptism are candidates for the ceremony. The concept of being "born again" refers to the experience of conversion to Christianity by means of water and one's confession of faith.

CALVINISM In 1523, Zürich, Switzerland, accepted the reformation ideal for its churches. Under the leadership of Ulrich Zwingli (1484–1531), Zürich—and later Berne and Basel—adopted Luther's reforms, including the abolition of statues and images and the abolition of clerical celibacy. The list of **sacraments** was reduced and modified to include only baptism and **communion** (the Lord's Supper).

In Geneva, John Calvin (1509–1564) preached a brand of Protestantism that has come to be seen as more extreme than that of Luther or Zwingli, but one could argue that it develops logically enough from certain beliefs about the nature of God. The Judeo-Christian God is defined as **omnipotent** (all-powerful) and **omniscient** (all-knowing). God, seeing the past, present, and future, knows what people will do and who will be saved. In that sense, one's selection for salvation is predestined; God knows who will be saved before they are born. Therefore, life on earth is not an opportunity to earn salvation by good deeds, as it is in Lutheranism. Nevertheless, Calvin and his followers preached that it is essential to live as though one is among the elect (those who are to be saved).

Consider the core beliefs of Calvinism. The first is *total depravity*, the idea that all people are depraved because of the original fall into sin. Second is *unconditional election*, the idea that God will save some through mercy, despite all of humanity's fall into sin. Third is *limited atonement*, the view that Jesus's atonement serves to save only those who are among the elect. Fourth is *irresistible grace*, a saving grace instilled

READING 14.2 JOHN CALVIN

From *Institutes of the Christian Religion*, on predestination

[Many] consider nothing more unreasonable, than that, of the common mass of mankind, some should be predestinated to salvation, and others to destruction. . . . But [we] shall never be clearly convinced as we ought to be, that our salvation flows from the fountain of God's free mercy, till we are acquainted with His eternal election, which illustrates the grace of God . . . Ignorance of this principle evidently detracts from the Divine glory, and diminishes real humility. But according to Paul, what is so necessary to be known, never can be known, unless God, without any regard to works, chooses those whom He has decreed. "At this present time also, there is a remnant according to the election of grace. And if by

grace, then it is no more of works; otherwise, grace is no more grace. But if it be of works, then it is no more grace; otherwise, work is no more work. . . ." In ascribing the salvation of the remnant of the people to the election of grace, Paul clearly testifies, that it is then only known that God saves whom upon which there can be no claim. They who shut the gates to prevent anyone from presuming to approach and taste this doctrine, do no less injury to man than to God; for nothing else will be sufficient to produce in us suitable humility, or to impress us with a due sense of our great obligations to God.

Jerome S. Arkenberg, "Modern History Sourcebook: John Calvin: On Predestination," Fordham University. http://www.fordham.edu/halsall/mod/calvin-predest.asp. From: Oliver J. Thatcher, ed., *The Library of Original Sources* (Milwaukee: University Research Extension Co., 1907), Vol. V: 9th to 16th Centuries, pp. 141–150.

READING 14.3 JONATHAN EDWARDS

From "Sinners in the Hands of an Angry God," 1741

The God that holds you over the pit of hell, much as one holds a spider, or some loathsome insect, over the fire, abhors you, and is dreadfully provoked; his wrath towards you burns like fire; he looks upon you as worthy of nothing else, but to be cast into the fire; he is of purer eyes than to bear to have you in his sight; you are ten thousand times so abominable in his eyes as the most hateful venomous serpent is in ours. You have offended him infinitely more than ever a stubborn rebel did his prince: and yet 'tis nothing but his hand that holds you from falling into the fire every moment; 'tis to be ascribed to nothing else, that you did not go to hell the last night; that you was suffered to awake again in this world, after you closed your eyes to sleep: and there is no other reason to be given why you have not dropped into hell since you arose in the morning, but that God's hand has held you up; there is no other reason to be given why you han't gone to hell since you have sat here in the house of God, provoking his pure eyes by your sinful wicked manner of attending his solemn worship: yea, there is nothing else that is to be given as a reason why you don't this very moment drop down into hell.

. . .

It would be dreadful to suffer this fierceness and wrath of almighty God one moment; but you must suffer it to all eternity: there will be no end to this exquisite horrible misery. When you look forward, you shall see a long forever, a boundless duration before you, which will swallow up your thoughts, and amaze your soul; and you will absolutely despair of ever having any deliverance, any end, any mitigation, any rest at all; you will know certainly that you must wear out long ages, millions of millions of ages, in wrestling and conflicting with this almighty merciless vengeance; and then when you have so done, when so many ages have actually been spent by you in this manner, you will know that all is but a point to what remains. So that your punishment will indeed be infinite.

by God among the elect. Fifth is *perseverance of the saints*—the maintenance of faith among the elect despite hardship or temptation. Among those who bear some conceptual lineage from Calvinism are members of the Reformed Church in America, Presbyterians, and the Puritans who settled the shores of Massachusetts.

Calvin's major theological work is the *Institutio Christianae religionis* (*Institutes of the Christian Religion*) in which he declares the tenets of his belief system. Reading 14.2 describes some of his views on **predestination**. The conflict about predestination essentially has to do with whether humankind obtains salvation through works—that is, good deeds and righteous living—or by the grace of God. Calvin expresses the view that it must be one or the other; it cannot be both.

Calvin's doctrine spread north to the British Isles, especially Scotland, under the Calvinist John Knox, and west to the Low Countries, especially Holland. It also crossed the Atlantic to Massachusetts in the 17th century and flavored the beliefs of the Puritans.

Reading 14.3 is one of the most famous, or infamous, sermons ever delivered. The preacher, Jonathan Edwards, was a Puritan; he gave this sermon two centuries after Calvin's lifetime to what he saw as a resistant congregation in Enfield, Massachusetts. Edwards's goal was to convince the congregation to live more righteously. The theological justification for the sermon is the Calvinist tenet that all humankind is totally depraved and deserving of eternal damnation. The irony, of course, is that within that denomination, only God's grace can save people, and the outcome is predestined. What then, one might ask, could congregants really do on their own to deliver themselves from hellfire? Because of this problem, such sermons are rare, and Calvin-

ists "in large numbers have drifted away from [attempting to frighten congregations]."[2]

THE CHURCH OF ENGLAND In England, King Henry VIII broke with Rome in 1534 because the pope refused to grant an annulment of his first marriage, to Catherine of Aragon. In that same year, Henry issued the *Act of Supremacy*, declaring the English sovereign head of the Church of England, also known as the Anglican Church. In 1559, Parliament made Elizabeth I the supreme governor of the church, and a new Book of Common Prayer was introduced in the same year. Elizabeth I was excommunicated from the Catholic Church in 1570, possibly because the papacy had finally surrendered any expectation of reunion. After ascending to the throne in 1603, James I commissioned English scholars to translate the Bible into English and free it from papal and Calvinist influences. The King James version of the Bible is still considered authoritative by many millions.

The church created a threefold order of clergy: bishops, priests, and deacons. The term *Anglican Communion* refers to the worldwide congregation of Anglican churches. However, unlike in Catholicism, there is no central authority. The archbishop of Canterbury is the titular head of the Church of England and the worldwide Anglican Communion, but the position holds more symbolic than actual authority. The Episcopalian and Methodist churches have their ancestry in the Church of England.

By the middle of the 16th century, Europe—for centuries solidly under the authority of the Church of Rome—was

2. Benjamin B. Warfield, Princeton, NJ. "Calvinism Today." http://www.the-highway.com/caltoday_Warfield.html.

divided in a way that has remained essentially unaltered. Spain and Portugal, Italy, most of France, southern Germany, Austria, parts of Eastern Europe (Poland, Hungary, and parts of the Balkans), and Ireland remained Catholic, whereas most of Switzerland, Great Britain, all of Scandinavia, northern and eastern Germany, and other parts of Eastern Europe gradually switched to Protestantism (see **Map 14.1** on page 470).

Causes of the Reformation

What conditions permitted this rapid and revolutionary upheaval in Europe? The standard answer is that the medieval church was so riddled with corruption and incompetence that it was like a house of cards waiting to be toppled. However, this answer does not explain why the Reformation did not occur a century earlier, when similar or worse conditions prevailed. Why did the Reformation not take place during the 14th century, a time of plague, schisms, and wars as well as reformers clamoring for change? The exact conditions that gave birth to the Reformation are difficult to pinpoint, but any explanation must take into account several elements that were emerging in the 16th century.

First, there was a rising sense of nationalism in Europe, but many of the economic and political demands of the papacy ignored the rights of individual countries. Thus Luther's insistence that the German rulers reform the church because the church was impotent to do so appealed to both economic and nationalistic self-interests.

Second, the idea of reform in the church had been maturing for centuries, with outcries against abuses. Some of the great humanists who were contemporaries of Luther—including Desiderius Erasmus of Rotterdam, Thomas More

in England, and Jacques Lefèvre d'Étaples in France—had also pilloried the excesses of the church. Their followers and devoted readers yearned for a deeper, more interior piety, free from the excessive pomp and ceremony that characterized medieval religion. Luther's emphasis on personal conversion and his rejection of much of the ecclesiastical superstructure of Catholicism thus appealed to many people.

Third, the low moral and intellectual condition of much of the clergy was a scandal; the wealth and lands of the monastic and episcopal lords were envied.

In 1528, with the Reformation underway, Luther toured villages in Saxony (a region of Germany) and was appalled at the people's lack of knowledge about their religion. In response he wrote *The Small Catechism*, which was meant for ordinary people to read as a handbook of the tenets and rituals of their faith. Reading 14.4 is from the preface to the catechism and reveals Luther's concerns.

Renaissance Humanism and the Reformation

The relationship between Renaissance humanism and the Protestant Reformation is significant, if complex. Luther had no early contact with the "new learning," even though he utilized its fruits. Nevertheless, humanism as far back as the time of Petrarch shared many intellectual and cultural sentiments with the Reformation.

The reformers and the humanists shared several religious aversions. They were both fiercely critical of monasticism, the decadent character of popular devotion to the saints, the low intellectual preparation of the clergy, and the general

Katherine Zell

Many of the Reformation's most active figures were women. Katherine Zell (1497–1562) was the wife of Matthias Zell, one of the first priests to demonstrate his break from the church by marrying. When he died, Katherine continued his teaching and pastoral work. She wrote this letter in 1558 to an old friend who was suffering from leprosy.*

> My dear Lord Felix, since we have known each other for a full thirty years I am moved to visit you in your long and frightful illness. I have not been able to come as often as I would like, because of the load here for the poor and the sick, but you have been ever in my thoughts. We have often talked of how you have been stricken, cut off from rank, office, from your wife and friends, from all dealings with the world which recoils from your loathsome disease and

leaves you in utter loneliness. At first you were bitter and utterly cast down till God gave you strength and patience, and now you are able to thank him that out of love he has taught you to bear the cross. Because I know that your illness weighs upon you daily and may easily cause you again to fall into despair and rebelliousness, I have gathered some passages which may make your yoke light in the spirit, though not in the flesh. I have written meditations on the 51st Psalm: "Have mercy upon me, O God, according to thy loving-kindness," and the 130th, "Out of the depths have I cried unto thee, O Lord." And then on the Lord's Prayer and the Creed.

* Letter by Katherine Zell reprinted from *Women of the Reformation in Germany and Italy* by Roland H. Bainton.

READING 14.4 MARTIN LUTHER

From *The Small Catechism*, preface

Grace, mercy, and peace in Jesus Christ, our Lord, from Martin Luther to all faithful, godly pastors and preachers.

The deplorable conditions which I recently encountered when I was a visitor constrained me to prepare this brief and simple catechism or statement of Christian teaching. Good God, what wretchedness I beheld! The common people, especially those who live in the country, have no knowledge whatever of Christian teaching, and unfortunately many pastors are quite incompetent and unfitted for teaching. Although the people are supposed to be Christian, are baptized, and receive the holy sacrament, they do not know the Lord's Prayer, the Creed, or the Ten Commandments, they live as if they were pigs and irrational beasts, and now that the Gospel has been restored they have mastered the fine art of abusing liberty.

How will you bishops answer for it before Christ that you have so shamefully neglected the people and paid no attention at all to the duties of your office? May you escape punishment for this! You withhold the cup in the Lord's Supper and insist on the observance of human laws, yet you do not take the slightest interest in teaching the people the Lord's Prayer, the Creed, the Ten Commandments, or a single part of the Word of God. Woe to you forever!

. . .

In the first place, the preacher should take the utmost care to avoid changes or variations in the text and wording of the Ten Commandments, the Creed, the Lord's Prayer, the sacraments, etc. On the contrary, he should adopt one form, adhere to it, and use it repeatedly year after year. Young and inexperienced people must be instructed on the basis of a uniform, fixed text and form. They are easily confused if a teacher employs one form now and another form—perhaps with the intention of making improvements—later on. In this way all the time and labor will be lost.

Martin Luther's Basic Theological Writings, ed. Timothy L. Lull, Augsburg Fortress, 1989.

venality and corruption of the higher clergy, especially the papal **curia**—the body of tribunals and assemblies through which the pope governed the church.

Both the humanists and the reformers felt that the scholastic theology of the universities had degenerated into quibbling arguments, meaningless discussions, and dry academic exercises bereft of intellectual or spiritual significance. They preferred Christian writers of an earlier age. John Calvin's reverence in the 16th century for the writings of Saint Augustine (354–430) echoed the devotion of Petrarch in the 14th century.

Humanists and reformers alike spearheaded a move toward a better understanding of the Bible—one based not on the authority of theological interpretation, but on close, critical scrutiny of the text, preferably in the original Hebrew and Greek. Mastery of the three biblical languages (Latin, Greek, and Hebrew) was considered so important in the 16th century that schools—including Corpus Christi College, Oxford; the University of Alcalá, Spain; and the Collège de France in Paris—were founded for instruction in them. Luther's own University of Wittenberg emphasized the study of biblical languages.

We can see the connection between humanist learning and the Reformation more clearly by noting some aspects of Luther's translation of the Bible into German. Although there had been many earlier vernacular translations into German, Luther's, which he began in 1521, was the first produced entirely from the original languages; and the texts he used illuminate the contribution of humanist learning. For the New Testament, he used the critical Greek edition prepared by Erasmus. For the Book of Psalms, he used a text published in Hebrew by the humanist printer Froben at Basel in 1516. The other Hebrew texts were rendered from a Hebrew version published by Italian Jewish scholars who worked in the Italian cities of Soncino and Brescia. His translations of the Apocrypha (books not found in the Hebrew canon) utilized the Greek edition of the Apocrypha printed in 1518 by Aldus Manutius at his press in Venice. As an aid for his labors, Luther made abundant use of grammars and glossaries published by the humanist scholar Johannes Reuchlin.

Luther's achievement was possible only because much of the groundwork had been laid by a generation of humanist **philologists**. Similarly, in 1611, when the translators of the King James Bible wrote their preface, they noted that they had consulted commentaries and translations as well as translations or versions in Chaldee, Hebrew, Syriac, Greek, Latin, Spanish, French, Italian, and Dutch.

Although there were similarities and mutual influences between humanists and reformers, there were also differences. For example, the humanist program was rooted in the notion of human perfectibility. This was as true of the Florentine humanists with their strong Platonic bias as it was of Northern humanists such as Erasmus. The humanists emphasized the Greek (or, more accurately, Socratic) notion that education can produce a moral person. Humanist learning and humanist education had a strong ethical bias: learning improves and ennobles. The reformers, by contrast, felt that humanity was hopelessly mired in sin and could only be raised from that condition by the freely offered grace of God. For the reformers, the humanists' position that education could perfect a person undercut the notion of a sinful humanity in need of redemption.

LUTHER AND ERASMUS The contrast between these two points of view is evident in a debate between Luther and

Erasmus on the nature of the human will. In a 1524 treatise called *De libero arbitrio* (*On Free Will*), Erasmus defended the notion that human effort cooperates in the process of sanctification and salvation. Luther answered in 1525 with a tract denying free will—*De servo arbitrio* (*On the Bondage of the Will*).

Many humanists also believed that a universal truth underlay all religious systems and could be detected by a careful study of religious texts. Pico della Mirandola, for example, believed that the essential truth of Christianity could be detected in Talmudic, Platonic, Greek, and Latin authors. He felt that a sort of universal religion could be constructed from a close application of humanist scholarship to all areas of religion. The reformers, on the other hand, held to a simple yet unshakable dictum: *Sola Scriptura* ("the Bible alone"). While the reformers were ready to use humanist methods to investigate the sacred text, they were adamant in their conviction that only the Bible held God's revelation to humanity.

As a result of the translation of the Bible into the vernacular languages of Northern Europe, Reformation theologians were able to stress the scriptures as the foundation of their teachings. Luther and Calvin further encouraged lay education, urging their followers to read the Bible for themselves and find there—and only there—Christian truth. In interpreting what they read, individuals were to be guided not by religious authorities but by their own judgments on what they read, and by their own consciences. This doctrine is known as "universal priesthood," because it denies a special authority to the clergy. All of these teachings, although primarily theological, were to have profound and long-range cultural impacts.

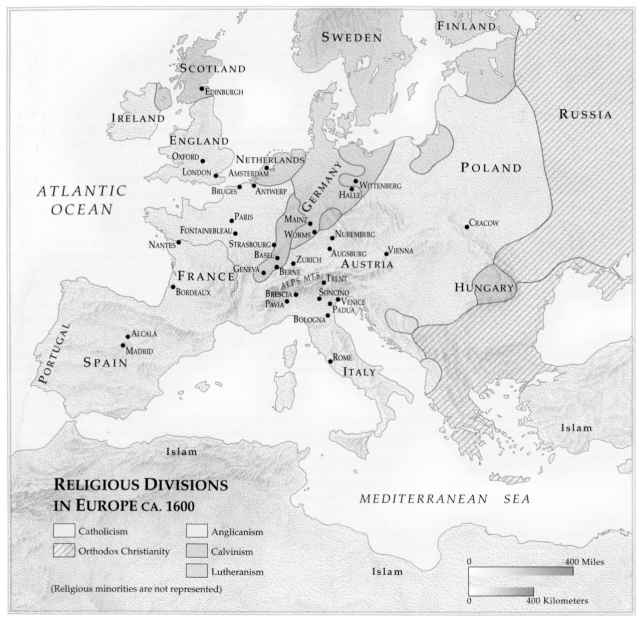

∧ **MAP 14.1** Religious Divisions in Europe ca. 1600.

Reform

The predominant value that energized Western Europe in the first half of the 16th century was the desire for religious reform. This impulse was manifested in different ways, but the acting out of the reform impulse would have great sociopolitical effects in Europe and in the newly discovered lands of the New World.

This desire for reform motivated Northern humanists who believed that their scholarly labors of biblical translation and the recovery of early Christian classics would invigorate Christian life in Europe. They believed in reform by scholarship.

The Protestant reformers did not undertake to found new churches. They sought to return to an earlier, less corrupt, Christianity. The Catholic response to Protestantism is often called the Counter-Reformation, but it was also an internal reformation in which the Church clarified its own beliefs and experienced religious impulses anew. The reactive strategies of Catholicism to the rise of Protestantism derived from the sense that the church itself needed reformation.

Early 16th-century reforming impulses solidified into discrete church bodies: the Anglicans in England; Presbyterians in Scotland; Calvinists in parts of Switzerland and Holland; Catholicism in the Mediterranean countries; and Lutheranism in parts of Germany and Scandinavia.

Also evident in this period was a new spirit in scientific investigation, which would sweep away the older authority-based approach to scientific questions in favor of an empirical, investigative mode. In the rise of the experimental sciences we find another kind of reformation, of intellectual life.

There was an intense positive and negative interaction between humanism and the Reformation—a movement energized by books in general and the Bible in particular. The intensely literary preoccupations of 14th- and 15th-century humanism provided a background and impetus for the 16th-century Reformation. As a philosophical and cultural system, however, humanism was in general too optimistic and ecumenical for the more orthodox reformers. In the late 16th century, humanism as a worldview found a congenial outlook in the Christian humanism of Cervantes and the gentle skepticism of Montaigne, but in Reformation circles it was used as an intellectual instrument for other ends.

The Cultural Significance of the Reformation

Cultural historians have attributed a great deal of significance to the Reformation. Some have argued, for example, that with its strong emphasis on individuals and their religious rights, the Reformation was a harbinger of the modern political world. (However, with equal plausibility one could make the case that with its strong emphasis on social discipline and its biblical authoritarianism, the Reformation was the last great spasm of the medieval world.) Likewise, in a famous thesis developed in the early 20th century by the German sociologist Max Weber, Calvinism was seen as the seedbed and moving force of modern capitalism. Weber's proposition has lingered in our vocabulary in phrases such as "the work ethic" and "the Puritan ethic."

The Reformation also gave impetus to the already growing use of books in Europe. The emphasis on Bible study suggested a need for more widespread literacy. Luther wanted free education for children of all classes in Germany. Luther's Bible in Germany and the King James Bible in England exercised an inestimable influence on the very shape of the languages spoken by their readers. In other countries touched by the Reformation, the literary influence of the translated Bible was fundamental. In the Scandinavian countries, vernacular literature began with translations of the Bible. Finnish was used as a written language for the first time in translating the Bible.

The Bible was not the only book to see widespread diffusion in this period. Books, pamphlets, and treatises crisscrossed Europe as theological battles were waged on one position or another. It is not accidental that the Council of Trent (1545–1564), a prime instrument of the Catholic Counter-Reformation, legislated the manner in which copies of the Bible were to be translated and distributed. The fact that the infamous index of forbidden books was instituted by the Catholic Church at this time is evidence that the clerical leadership recognized the power of books. The number of books circulating during this period is staggering. Between 1517 and 1520 (even before his break with Rome), Luther's various writings sold about 300,000 copies in Europe.

None of this would have been possible before the Reformation because printing did not exist in Europe. The invention of the printing press and moveable type revolutionized Renaissance culture north and south of the Alps in the same way that film, radio, television, and the Internet changed the 20th century. There were important side effects. The availability of "book learning" undermined the dominance of universities, which had been the principal gatekeepers and disseminators of knowledge. Latin began to lose its position

as the sole language for scholarship, because many new readers could not read or write it. Luther grasped the implications of the spread of literacy and used it to advance his cause.

The reformers also placed great emphasis on the word. Besides reading and listening there was also singing, and the reformers—especially Luther—stressed vernacular hymns. Hymns were seen as a means of praise and as an instrument of instruction. Luther was a hymn writer of note. The famous "Ein' feste Burg ist unser' Gott" ("A Mighty Fortress Is Our God"), one of the best-loved hymns in Christianity, is generally attributed to him.

On the other hand, the 16th-century reformers had little need or sympathy for painting and sculpture. They were in fact militantly **iconoclastic**. One of the hallmarks of the first reformers was their denunciation of paintings, statues, and other visual representations as forms of papist idolatry. The net result of this iconoclastic spirit was that, by the beginning of the 17th century, patronage for the sacred visual arts had virtually died out in countries where the Reformation was strong. With the exception of Rembrandt, it is difficult to name any first-rate painter or sculptor who worked from a Reformation religious perspective after the 16th century, although much secular art was produced.

The attitude of the 16th-century reformers toward the older tradition of the visual arts may best be summed up by the Church of Saint Peter in Geneva, Switzerland. Formerly a Romanesque Catholic cathedral of the 12th century, Saint Peter's became Calvin's own church. The stained glass was taken out, the walls whitewashed, the statues and crucifixes removed, and a pulpit placed where the high altar once stood. The Church of Saint Peter is a thoroughly reformed church, a building for hearing the Word of God preached and read. Gone is the older notion (represented, for example, by the Chartres Cathedral) of the church as reflecting the otherworldly vision of heaven in the richness of its art. Reformation culture was in short an *aural*, not a *visual*, culture.

THE GROWTH OF SCIENCE

The period of the Renaissance in the North was not merely a turning point in the history of religion.

It was also a decisive age in the history of science. In earlier times a scientist was likely enough to be an ingenious tinkerer with elaborate inventions who dabbled in alchemy, astrology, and magic. The new Renaissance scientist, a person of wide learning with a special interest in mathematics and philosophy, would develop bold and revolutionary ideas but subject them to the test of practical experience.

The age produced many advances in science. In England, William Gilbert (1544–1603) discovered that the earth was a large magnet whose pole points approximately north. William Harvey (1578–1657) solved the problem of how the blood could circulate—get from the arteries to the veins and return to the heart—by postulating the existence of the then-undiscovered channels we now call capillaries. John Napier

➤ **14.4 Andreas Vesalius, Third Musculature Table from *De humani corporis fabrica libri septem*, 1543. Published in Basel, Switzerland. National Library of Medicine, Bethesda, Maryland.** Although the work was chiefly intended to have a scientific value, Vesalius has set his into a scene showing a landscape and, in the distance, evidence of human construction. By placing the human in the foreground, towering over the rest of the scene, Vesalius emphasizes the humanists' view of the central importance of humanity.

(1550–1617) discovered the practical mathematical tool called the *logarithm*, which reduced the time and effort needed to solve difficult equations.

Elsewhere in Europe, the German Paracelsus (1493–1541) laid the foundations of modern medicine by his rejection of traditional practices. Although his own theories were soon rejected, his insistence on observation and inquiry had important consequences, one of which can be seen in the work of Andreas Vesalius (1514–1564), who was born in Brussels and studied in Padua. Vesalius's *De humani corporis fabrica libri septem* (*Seven Books on the Structure of the Human Body*), published in 1543, comprises a complete anatomical treatise, illustrating the human form with minute detail and impressive accuracy (**Fig. 14.4**).

The philosophical representative of the "new science" was Francis Bacon (1561–1626), who combined an active and somewhat disreputable political career with the writing of works intended to demolish traditional scientific views. The chief of these books was the *Novum Organum* (*New Organon*, 1620), which aimed to free science from the 2000-year-old grasp of Aristotle while at the same time warning against the unrestrained use of untested hypotheses. Science and religion came into direct conflict in the work of the Polish astronomer Nicolaus Copernicus (1473–1543), who studied at the universities of Kraków and Bologna. In 1543, the same year Vesalius's work appeared, Copernicus published *De revolutionibus orbium coelestium* (*On the Revolutions of Celestial Bodies*), a treatise in which he denies that the sun and the planets revolve around the Earth, and reverts to a long-dead Greek theory that the Earth and planets orbit the sun. Catholic and Protestant theologians for once found themselves united in their refusal to accept an explanation of the universe that seemed to contradict the teaching of the Bible, but Copernicus's work provided stimulus for Galileo's astronomical discoveries in the following century.

Additionally, the general principle behind Copernicus's method had important repercussions for the entire history of science. Up until his time, scientists had taken the position that, with certain exceptions, reality was as it appeared to be. If the sun appeared to revolve about the Earth, that appearance was a "given" in nature, not to be questioned. Copernicus showed that it was equally plausible to take the Earth's mobility as a given, because his view explained why it might seem that the Earth lay in the center of the solar system and also explained other astronomical events more powerfully and extensively.

THE VISUAL ARTS IN NORTHERN EUROPE

The conflict between religion and humanism—and the attempt to reconcile them in the North—affected the outcomes of developments in the visual arts. Some artists traveled to Italy and absorbed themselves in the art of antiquity as well as its interpretation by Italy's contemporary artists.

▼ **14.5 Principal Discoveries and Inventions in the 16th Century**

1486	Diaz rounds the Cape of Good Hope
1492	Columbus discovers North America
1513	Balboa sights the Pacific Ocean
1516	Portuguese ships reach China
1520–1522	First circumnavigation of globe by Magellan
Ca. 1530s	Paracelsus pioneers the use of chemicals to treat disease
1530–1543	Copernicus refutes the geocentric view of universe
1533	Gemma Frisius invents the principle of triangulation in surveying
1542	Leonhard Fuchs publishes an herbal guide to medicine
1543	Vesalius publishes his anatomical treatise
1546	Agricola publishes a guide to metallurgy
1569	Mercator devises his system of mapmaking
1572–1598	Tycho Brahe observes a supernova (1572) and produces the first modern star catalog (1598)
1582	Pope Gregory XIII reforms the calendar
ca. 1600	The first refracting telescope is constructed in Holland
1600	William Gilbert publishes his treatise on magnetism

Some were influenced by the writings of Martin Luther, others by the Christian humanism of Erasmus. The art of the 16th century in the North reflected, as it always does, the current streams of thought as well as the market for commissions. Of particular importance, however, was the role that the invention of the printing press played in the dissemination of international styles and of copies of works.

Painting in Germany

It might be said that the intellectual and religious battles of the era stimulated German art to its highest achievements, for both Albrecht Dürer (1471–1528) and Matthias Grünewald (ca. 1470–1528) are, in very different ways, towering figures in the development of Northern European painting. Despite his sympathy with Luther's beliefs, Dürer was strongly influenced by Italian artistic styles and, through Italian models, by Classical ideas. Grünewald, on the other hand, rejected almost all Renaissance innovations and turned instead to traditional Northern religious themes, treating them with new passion and emotion. Other artists, it seems, chose not to wrestle with these theological and cultural problems. Albrecht Altdorfer (1480–1538), for example, stood apart from the dueling ideological discourses and created a worldview of his own.

ALBRECHT DÜRER Dürer was born in Nürnberg, the son of a goldsmith who trained him in the craft and also arranged

for him an apprenticeship with a wood engraver. This technical background accounts for Dürer's proficiency in handling the printmaking medium as well as for his reputation as a printmaker; in his day he was more famous for his prints than his paintings. Dürer's education as an artist expanded with two visits to Italy. There he saw for the first time the new technique of **linear perspective** (in which parallel lines converge at vanishing points as they recede from the viewer) and came into contact with artists studying human anatomy. As important as these technical discoveries were to his own art, what truly impressed him in Italy was the reshaping of artistic identity by humanist thought. The traditional German—indeed, medieval—view of the artist was as an artisan whose task was to humbly, if expertly, reproduce God's creations. Dürer would adopt the humanist view that the artist is an inspired genius endowed with potential by God but whose exceptional achievements reflect conscientious work and study and the will to excel.

It is not by chance that a first glance at Dürer's *Self-Portrait* of 1500 (**Fig. 14.6**) suggests a Christlike figure rather than a prosperous German painter of the turn of the century. The effect is intentional. The lofty gaze underlines the solemn, almost transcendent nature of the artist's vision, while the positioning of the fingers of his hand vaguely recall the sign of blessing seen in icons and other representations of Christ (see **Fig. 7.6** and **Fig. 7.16**). Our focus is drawn to the artist's penetrating eyes and his hand, symbolizing the important connection between the artist's vision and his skill.

In his paintings, Dürer shows a fondness for capturing form with precise detail and strong, linear draftsmanship rather than the suppler modeling using light and shade that was characteristic of Italian art. This reflects his training as a goldsmith and his commitment to printmaking. One of his most accomplished works in the medium is *Adam and Eve* (**Fig. 14.7**), an **engraving** that combines an admiration for the Classical style with the attention to realistic detail that is the signature of Northern art. Dürer's Adam and Eve arise from the idealism of Greek and Roman prototypes; Adam's young, muscular body could have been drawn from a live model or from Classical statuary. Eve reflects a standard of beauty very different from that associated with representations of the female nude in works by other Northern artists: the familiar slight build and refined facial features are replaced with a plumper, more well-rounded figure and a classical profile. Elsewhere in the composition, however, Dürer's Northern roots are visible in the carefully drawn trees with their leaves and hanging fruit, detailed

◀ **14.6** Albrecht Dürer, *Self-Portrait*, 1500. Oil on lime panel, 25 ⁵/₈" × 18 ⁷/₈" (65 × 47.9 cm). Alte Pinakothek, Munich, Germany. The frontal pose and solemn gaze convey Dürer's belief in the seriousness of his calling. The artist's characteristic monogram stands to the upper left, with the date, 1500, above it.

◄ **14.7** Albrecht Dürer, *Adam and Eve*, 1504. Engraving, 9⁷/₈″ × 7⁵/₈″ (25.1 × 19.4 cm). Metropolitan Museum of Art, New York, New York. The engraving reveals Dürer's fascination with the ideal human form. Adam and Eve are depicted in symmetrical poses. Each is supported on one leg; each bends an arm upward. The fig held by Eve represents the Tree of Knowledge; Adam holds a branch representative of the Tree of Life. Four animals symbolize the basic temperaments of the ancient Greek physician Hippocrates: the elk, melancholic; the cat, choleric; the rabbit, sanguine; and the ox, phlegmatic.

renderings of the animals, and symbolism. The ox, cat, rabbit, and elk are associated with the four humors, or fluids of the body, associated with medieval medical theories about human temperament: phlegm, yellow bile, blood, and black bile.

Dürer brought unsurpassed subtlety and expressiveness to engraving, a challenging printmaking medium in which the artist incises lines into a metal plate (such as copper or zinc) with a sharp-pointed steel instrument called a *burin*. When the drawing is complete, the plate is smeared with a paste-like ink that is forced into the crevices made by the burin. The excess ink is wiped away, a damp piece of paper is laid on top of the plate, and both are passed through a press. The fibers of the paper, under many pounds of pressure, sink into the ink-filled crevices and pick up the ink. The resulting print is a mirror image of the drawing that was made on the plate.

Knight, Death, and the Devil (**Fig. 14.8**) is one of three prints Dürer made during 1513 and 1514, known collectively as his *Meisterstiche*—master engravings (in German, *stechen* means "to stab" or "to prick"). The theme of the work is moral virtue, symbolized by the Christian knight who remains stalwart despite the temptation toward sin (the devil with a pig snout follows closely behind) and the recognition of the brevity of life (Death, holding an hourglass, stares directly into the knight's face). We do not know whether Dürer had read Erasmus's *Instructions for the Christian Soldier* (1503), but the content of the print seems to be inspired by his

➤ **14.8** Albrecht Dürer, *Knight, Death, and the Devil*, 1513. Engraving, 9 5/8″ × 7 5/8″ (24.4 × 8.1 cm). **British Museum, London, United Kingdom.** The knight's steadfast sense of purpose may have been inspired by Erasmus's *Instructions for the Christian Soldier*.

words[3]: "In order that you may not be deterred from the path of virtue because it seems rough and dreary . . . and because you must constantly fight three unfair enemies—the flesh, the devil, and the world—this third rule shall be proposed to you: all of those spooks and phantoms which come upon you as if you were in the very gorges of Hades must be deemed for naught after the example of Virgil's Aeneas. . . . Look not behind thee." Indeed, the knight, beset by "spooks and phantoms" looks neither behind nor to the side—rather, steadfastly straight ahead.

Dürer was acknowledged as one of the great artists of his era during his lifetime. Like Luther, he used the new possibilities of the printing press to disseminate his ideas. At the time of his death, Dürer was working on *Libri IV De Humani*

Corporis Proportionibus (*Four Books on Human Proportions*). This work (in Latin) aimed to accomplish for art what Vesalius's did for medicine. It was inspired by two of the great intellectual concerns of the Renaissance: a return to Classical ideals of beauty and proportion, and a new quest for knowledge and scientific precision.

MATTHIAS GRÜNEWALD If Dürer's art illustrates the impact that humanist thought, imported from Italy, had on the North, the work of Matthias Grünewald exposes the Northern

3. "Albrecht Dürer: *Knight, Death, and the Devil* (43.106.2)." *Heilbrunn Timeline of Art History*, Metropolitan Museum of Art, October 2006, http://www.metmuseum.org/toah/works-of-art/43.106.2.

artists' characteristic synthesis of realism, religion, symbolism, and passionate emotion. Grünewald, whose actual name was Matthias Neithardt, worked for a while at the court of the archbishops of Mainz, important figures in the Holy Roman Empire. Some scholars believe that he sided with the peasants in their complaint against the Catholic Church—which contributed to the Peasants' War of 1524–1525—and embraced some of the teachings of Martin Luther. In any event, Grünewald moved northeast from Mainz to Halle, where he stayed until his death.

What we know about his political and religious sympathies—his support for the oppressed and for the ideals of the Reformation—is borne out by the characteristics of his paintings. Grünewald did not share the Renaissance quest for ideal beauty and the humanist interest in Classical antiquity. Instead, he turned repeatedly to the traditional religious themes of German medieval art, bringing to them a passionate, almost violent intensity.

Grünewald's Isenheim altarpiece (completed in 1515) was commissioned for the church of a hospital run by members of the monastic Order of Saint Anthony. The folding panels are painted with scenes and figures appropriate to its location, including saints associated with the curing of disease and events in the life of Saint Anthony. In particular, the patients who contemplated the altarpiece were expected to meditate on Christ's Crucifixion and Resurrection and derive from them comfort for their own sufferings.

In his painting of Christ in the *Crucifixion* panel (**Fig. 14.9**), Grünewald uses numerous details to depict the intensity of Christ's anguish—from his straining hands frozen in the agony of death, to the thorns stuck in his festering body, to the huge iron spike that pins his feet to the cross. It is difficult to imagine anything further from the Italian Renaissance and its concepts of ideal beauty than this tortured image. Nor does Grünewald adhere to Renaissance or Classical theories of proportion or perspective. The figure of Christ, for example, is not related in size to the other figures—it dominates the panel—as a glance at the comparative size of his gnarled hands will reveal. Those hands reach painfully upward, stretching or

▼ **14.9** Matthias Grünewald, *Crucifixion*, center panel of the Isenheim altarpiece (closed), ca. 1510–1515. Oil on panel, 106″ × 121″ (269 × 307 cm). Musée d'Unterlinden, Colmar, France. Mary Magdalene kneels, wringing her hands in grief, as Mary and John the Evangelist stand behind her. John the Baptist points to Jesus while the sacrificial lamb pours its blood into the chalice.

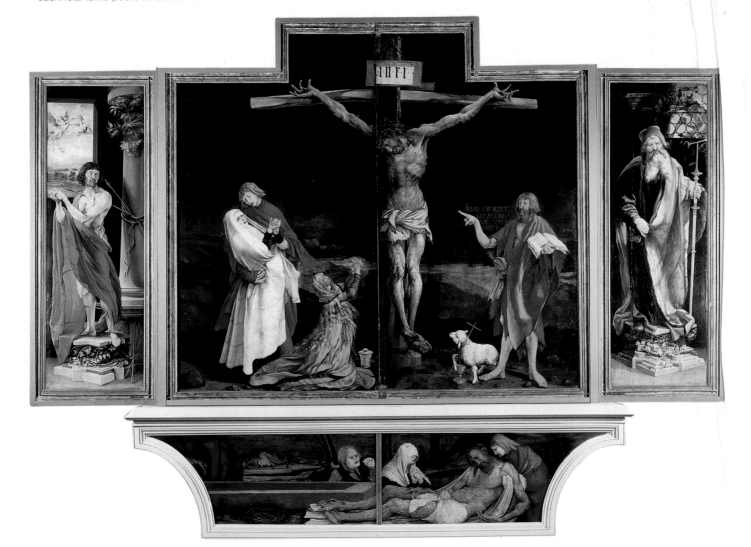

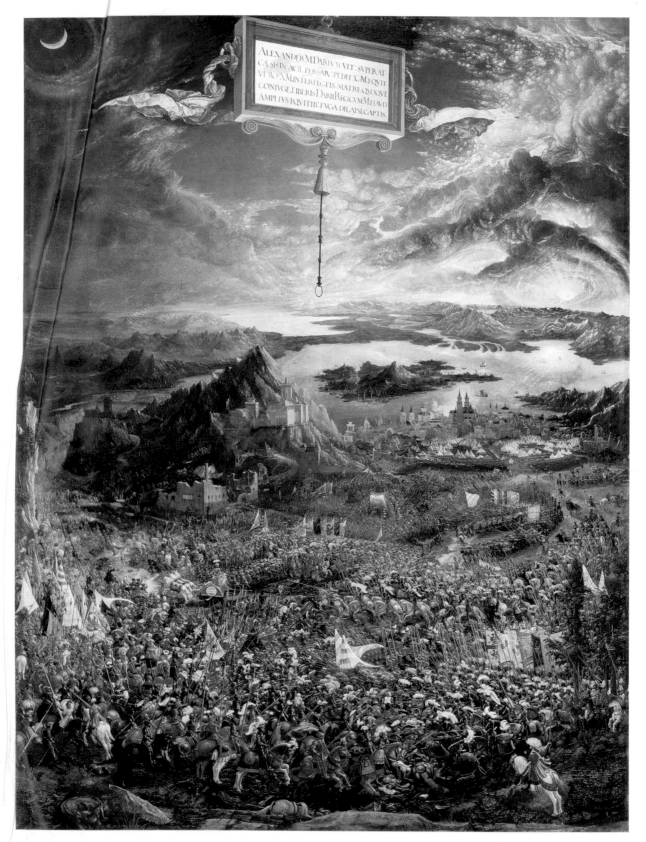

∧ **14.10** Albrecht Altdorfer, *Battle of Alexander at Issus*, 1529. Oil on wood, 62″ × 47″ (158 × 120 cm), Alte **Pinakothek, Munich, Germany.** Although the cavalry is appareled in 16th-century armor, the title of the painting—and the inscription in the sky—refers to Alexander the Great's defeat of the Persians at the town of Issus in 333 BCE. Wilhelm IV of Bavaria had just undertaken a campaign against invading Turks and wished, as Alexander before him, to drive the enemy back across the seas. The panorama takes the eye as far as Cyprus, the mouth of the Nile, and the Red Sea.

salvation from the blackened sky. We do not find such impassioned portrayals outside Germany during the Renaissance.

With the Protestant Reformation, the market for works like the Isenheim altarpiece would change as reformers like Luther and Calvin equated prayer before images of Christ, the Virgin Mary, and saints with idol worship.

ALBRECHT ALTDORFER Like his contemporaries, Albrecht Altdorfer painted his share of religious subjects, but in his case, landscape elements dominated the compositions, sometimes to the point that they seem to be the main subject. Such is the case in his *Battle of Alexander at Issus* (**Fig. 14.10**), a history painting commissioned by Wilhelm IV, the duke of Bavaria (from 1508 to 1550). The subject is Alexander the Great's defeat of the Persian king Darius III on the battlefield at Issus in 333 BCE. The sweeping panorama is a study in creating depth within pictorial space. Like a river wending and surging toward the horizon, the cavalries of both armies clash along a similar path; Alexander's troops drive their enemy toward the encampment adjacent to a town on the Pinarus River. Across the water are the island of Cyprus, the Nile River, and the Red Sea farther beyond. A brilliant sunset represents the reward that awaits the victorious troops, while the vanquished are met by the crescent of a waxing moon; the contrast of the celestial bodies symbolizes Alexander (who was represented as the sun god) and Persia (whose symbol was the crescent moon). The Latin inscription suspended in the sky declares

the subject as the Battle of Issus as well as the names of the victor and vanquished; the armor that is worn by the soldiers, however, is of the 16th century rather than the fourth century BCE. The occasion for the commission was the duke's military campaign against invading Turks; the subject was clearly chosen because it resonated with the Duke's own ambitions.

Almost half of the area of the painting of the *Battle of Alexander at Issus* is given over to landscape elements—craggy mountains, serene seas, and a turbulent sky that seems, only at this moment in the battle, to be calming. Masses of humanity—and their squabbles—are dwarfed by the awesome power of nature.

Painting in the Netherlands

The numerous provinces of the Netherlands (including present-day Holland and Belgium), under the rule of the Spanish crown during the second half of the 16th century, rebelled in 1579 and formed two separate unions: one to the south, closer to France, remained Catholic and the other, to the north, was Protestant. Art commissions in the two territories reflected these religious differences.

HIERONYMUS BOSCH Hieronymus Bosch (ca. 1450–1516) was a Dutch painter known for using fantastic and erotic imagery to illustrate moral concepts. His *Garden of Earthly Delights* (**Fig. 14.11**) is one of the most intriguing works of art

▼ **14.11** Hieronymus Bosch, *Garden of Earthly Delights*, 1505–1510. Oil on wood, center panel 86″ × 76¼″ (220 × 194 cm), each wing 86″ × 38¼″ (220 × 97 cm). Museo del Prado, Madrid, Spain. God presents Eve to an apparently questioning Adam in the left panel. The center panel is an orgy of sex and procreation. The right panel shows hellfire and punishment for sinners. The overall meaning of the triptych is somewhat puzzling, but the impression is fascinating.

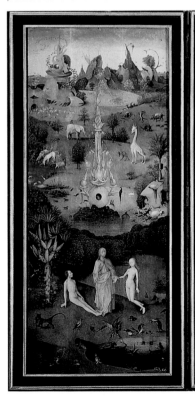
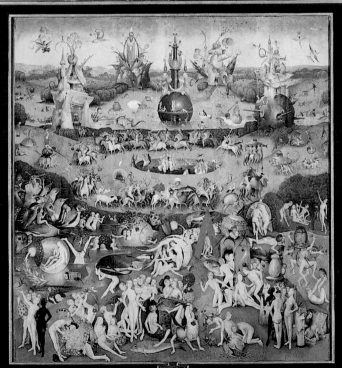
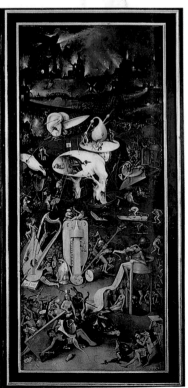

that a reader will encounter in this book; it is certainly one of the most ambiguous in terms of meaning and purpose. On the one hand, its form—a triptych—likens it to an altarpiece; on the other, some of the content, which is quite sexually explicit, would suggest that the work was a secular rather than religious commission. Some scholars have suggested that it might have been painted as a wedding picture because of imagery relating to sex and procreation. The *Garden of Earthly Delights* may never be accurately deciphered, but it will always be mesmerizing.

Reading the triptych from left to right, the first panel features a fanciful landscape with plants, animals, and landforms generated not from the observation of nature but from the mind. It is an imagined Eden in which, at the bottom in the extreme foreground, God introduces Adam and Eve to one another. The central panel continues the theme of the garden, this time populated by the generations who seem to have inherited the bliss of Adam and Eve in their state of innocence before the Fall. They live, cavort, and love freely; nothing they do causes shame. An outright joyousness, however bizarre, permeates the panel, enhanced by the vibrant colors, frolicking nudes, and fantastic hybrid structures along the horizon. How grim then, by contrast, is the last panel. Here all the light and air evaporates and we are left with the murky darkness of a forbidding, perverted, hellish

scene in which, as in Dante's *Inferno*, punishment is meted out to souls (or here, people) according to their sins. The most prominent image is of a creature with a cracked, egg-shaped body and a man's head, crowned with a bagpipe—a symbol of lust—to the left of which is a cannon-like object assembled from two severed ears and a knife blade poised like a phallus. Elsewhere a glutton retches up his excesses and a miser excretes coins. Lust, gluttony, and greed are three of the seven deadly sins.

The sources of Bosch's inspiration in this and his other work are unknown. Many of his demons and fantastic animals seem related to similar manifestations of evil depicted in medieval art, but no medieval artist ever devised a vision such as this or possessed the technique—or the courage—to execute it. To modern eyes some of Bosch's creations, like the human-headed monster on the right-hand panel turning both face and rear toward us, seem to prefigure the Surrealist art of the 20th century. Bosch stands as one of the great originals in the history of painting.

PIETER BRUEGEL THE ELDER With increased prosperity in the Netherlands, a more diverse market of art buyers took shape. The church and nobility did not alone define patronage, and religious art was only one of many genres in which artists were working. Landscape emerged as an important genre, even

▼ **14.12** Pieter Bruegel the Elder, *The Triumph of Death*, ca. 1562–1564. Oil on panel, 46″ × 63 ¾″ (117 × 162 cm). Museo del Prado, Madrid, Spain. Note the huge coffin on the right into which the dead are being piled, guarded by rows of skeleton soldiers. Nobody is spared, not even the king in the lower left-hand corner.

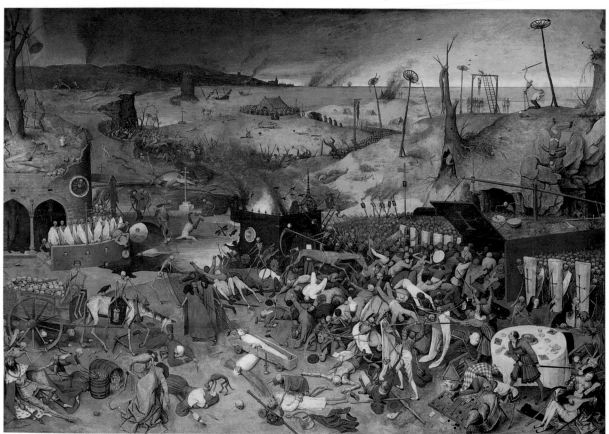

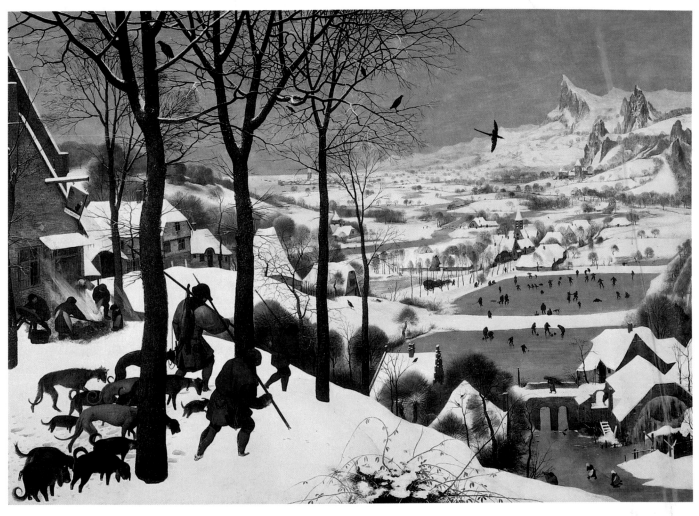

▲ **14.13** Pieter Bruegel the Elder, *Hunters in the Snow*, 1565. Oil on wood, 46″ × 64″ (116.8 × 162.6 cm). **Kunsthistorisches Museum, Vienna, Austria.** Note Bruegel's careful use of color to suggest a cold, clear, sunless day. From his first crossing of the Alps in the 1530s, Bruegel was inspired by mountain scenery, and it reappeared throughout his work. In this painting, the panoramic sweep from the foreground to the lofty peaks behind makes the scene appear a microcosm of human existence. Thus Bruegel's "world landscapes" or *Weltlandsschaften* are both literal depictions of scenes from nature and symbolic representations of the relationship between human beings and the world around them.

as it served as a backdrop for other subjects. Portraiture also became popular, as did scenes of daily life. As with Northern art in general, Dutch painting often harbored symbolism and continued to be chock-full of realistic detail.

Pieter Bruegel the Elder (ca. 1525–1569), the most important Netherlandish painter of the second half of the 16th century, combined a love of landscape and genre scenes (slice-of-life subjects), occasionally with moralizing tales or proverbs. In *The Triumph of Death* (**Fig. 14.12**), Bruegel looks with uncompromising honesty at the indiscriminate nature of death, which comes eventually to all: rich and powerful, poor and hopeless. Like the hell panel in Bosch's *Garden of Earthly Delights*, *The Triumph of Death* is rife with horrific passages. An army of skeletons besieges all living things, from a king (in the lower left corner) and nobles to soldiers and peasants; nothing is spared. The animals are emaciated or dead and the landscape is burning or scorched. It is about

as grim and eerie a picture as is imaginable. Bruegel offers no escape, no hope.

How serene and benign then, by contrast, is *Hunters in the Snow* (**Fig. 14.13**), one of a series of paintings by Bruegel depicting scenes associated with the seasons of the year. We join the painting among hunters and their hounds on a hillside overlooking a snow-covered town, our eyes following an imaginary path down toward a frozen pond full of skaters and back up again toward the icy peaks of distant mountains. The minimal palette of white, browns, and cool blues communicates the essence of winter, a bleak backdrop against which humans huddle, work, and play. There is inevitability—even beauty—in the way that people and nature are bound together by a sense of order and purpose. Humanism—encountered by Bruegel during his trip to Italy and reinforced by philosophers active in Antwerp—seems to have inspired him to create works that have a similar regard for human dignity.

CATERINA VAN HEMESSEN The Northern European art market was kinder to women artists than was Italy's. A burgeoning middle class became almost as likely as the nobility to commission paintings, and their taste was for portraits, still-life compositions, and genre paintings. As opportunities for formal training were minimal for women who aspired to be artists, the best path to success was through one's father's studio; for women artists who were not daughters of painters, getting started at all was difficult if not impossible. Very successful women artists acquired court patrons, as did Caterina van Hemessen—who was painter to Mary of Hungary—and Levina Teerlinc, listed as the "king's paintrix" in the account books of the court of England's Henry VIII.

van Hemessen was trained by her father, one of Antwerp's most sought-after painters, and it is believed that she worked on some of his commissions. Realistically rendered detail and sensitive, thoughtful expressions are a hallmark of her portraiture, arguably the genre in which she was most prolific. Her *Portrait of a Lady* (**Fig. 14.14**) is a fine example. The three-quarter-profile, three-quarter-length format provides a more complete, poised, and natural portrait likeness. The sitter's head is subtly cocked and her expression is warm and open, as if she is listening with interest to a conversation. The tiny dog, lush, crimson velvet sleeves, heavy brocade dress, and delicate lace inset over the lady's shoulders provide a vehicle for van Hemessen's virtuoso brushwork.

The first self-portrait of a Northern woman artist shown working at her profession was created by van Hemessen. In that work—in a collection in Basel, Switzerland—she sits before an easel on which we see a portrait in progress. Her right hand holds a fine brush—the bristles of which touch the surface of the canvas—and in her left she deftly manages a selection of brushes and a painter's palette. It is worth noting that women painters frequently used the self-portrait to assert their authenticity as practicing artists. As if to be doubly sure to convey her authorship, van Hemessen inscribed her portrait thus: "Caterina van Hemessen painted me/1548/her age 20."

Art and Architecture in France

French art of the 16th century was strongly influenced by the Italianate style due in part to the presence of Italian artists, including Leonardo da Vinci, at the French court. Leonardo had entered the service of Francis I in 1516, one year after the king captured Milan, and remained in the country for the rest of his life. The great Italian Renaissance artist was buried by the French king in the chapel of his royal residence, the Château d'Amboise.

JEAN CLOUET Francis I was an avowed patron of the arts, setting the standard for French taste in art and architecture for generations of successors. He retained as his official portrait painter Jean Clouet (ca. 1485–1541). In Clouet's portrait of Francis (**Fig. 14.15**), the king fills the space, indeed spilling beyond

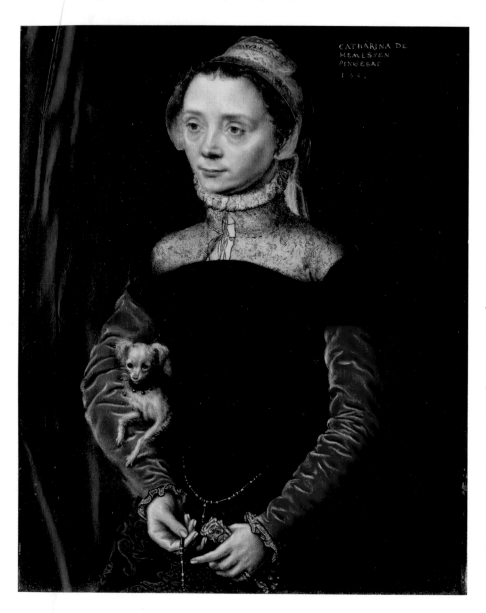

◀ **14.14** Caterina van Hemessen, *Portrait of a Lady*, 1551. Oil on oak, 9″ × 7″ (22.9 × 17.8 cm). National Gallery, London, United Kingdom. The sitter is unidentified, but the painting is one of a pair of signed portraits. van Hemessen moved to Spain with the court of Mary of Hungary after Mary abdicated her regency of the Low Countries. When Mary died, she bequeathed van Hemessen and her husband enough money to live on for the rest of their lives.

the frame as if his greatness cannot be contained. Francis's facial expression is at the same time imperious and suave, supporting his dual reputation as a man of uncompromising authority (he declared Protestantism illegal in France and persecuted adherents to the faith) and a legendary lover (he was known as the "merry monarch"). Clouet's attention to detail, particularly the illusionistic rendering of surfaces and textures, gives visual prominence to the king's costume and suggests his flair for fashion. Francis's face and neck, disproportionally small, are defined by strong lines; as in Botticelli's figures (see **Fig. 12.27** and **Fig. 12.28**), chiaroscuro is virtually absent.

CHÂTEAU DE CHAMBORD During the reign of Francis I, a number of luxurious châteaus were built along the valley of the Loire River, combining the airiness of the earlier French Gothic style with decorative motifs imported from Italian Renaissance architecture. The châteaus were castle-like country residences, sometimes complete with moats, built as hunting lodges for the royalty and nobility (the famed palace at Versailles—see **Fig. 15.33**—began as such a getaway). The Château de Chambord (**Fig. 14.16**) is a good example of a hybrid design. An assortment of Gothic-style spires, turrets, chimneys, and other structures rise at the roofline over a large, square, central module marked by cylindrical towers at the corners. Assertive horizontal moldings that run the length of the building balance the bit of Gothic verticality in the center and in the conical roofs that serve as endpoints for the château's symmetrical wings. The precise delineation of the floors and the rhythmic placement of windows—one aligned atop the other—are reminiscent of the design of Italian palazzi (see **Fig. 12.34**).

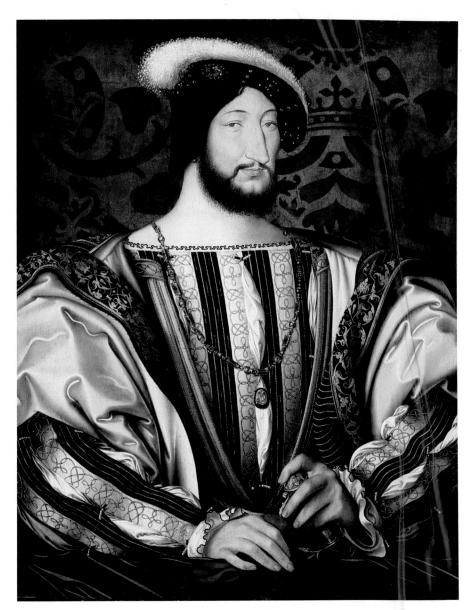

▲ **14.15** Jean Clouet, *Francis I*, ca. 1523–1530. Tempera and oil on wood, 37³/₄" × 29" (96 × 74 cm). Musée du Louvre, Paris, France. The portrait reveals a sophisticated and calculating king in a nation aspiring to great wealth. The silken brocade is sumptuous, and the hat provides a rakish air.

THE LOUVRE The palace seen in the distance on the painted page *May* in the *Très riches heures du duc de Berry* (see **Fig. 12.4**) is not at all the building we associate with the Louvre, perhaps the world's foremost repository of art. The foundation walls of that medieval-style palace-fortress can be seen beneath the museum today; its renowned courtyard (the Cour Carrée, or Square Court), however, was a central piece of the redesign of the palace by Pierre Lescot (ca. 1510–1578) for Francis I. The king died in 1547, a year after the renovation began, but it was continued by his successor, Henry II (who reigned from 1547 to 1559). Lescot's design synthesized aspects of Italian Renaissance architecture with characteristi-

cally Northern elements. The result created the foundation for a signature French Classical style. The façade of the west wing (**Fig. 14.17**) is a compendium of Classical references—from the arcade on the lowest level and curved and triangular pediments over the windows to engaged columns and pilasters with Corinthian capitals. As in the Château de Chambord (and its Italian precedents), the three stories are accentuated by strong horizontals, but the steep roofline (also seen at Chambord) and the tall windows counterbalance the earthbound quality with their vertical thrust. Also uniquely French are the two-story pavilions that project from the plane of the façade as well as the sculptural ornamentation.

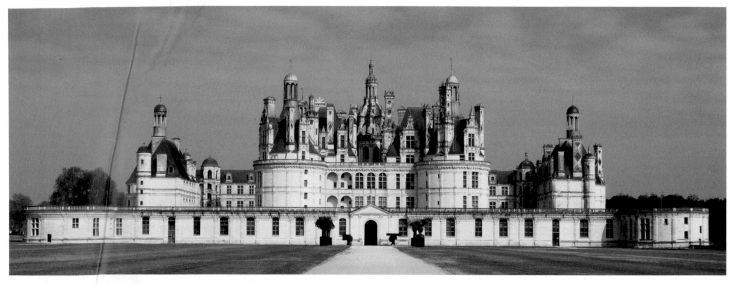

∧ **14.16 Château de Chambord, Loire Valley, France, begun 1519.** The turrets and pinnacles are reminiscent of French medieval architecture, but the central block and much of the decorative detail suggest Italian Renaissance models.

∨ **14.17 Pierre Lescot, west wing of the Cour Carrée (Square Court) of the Louvre, Paris, France, begun 1546.** The architectural and sculptural decoration are Italian in origin but used here as typically French elaborate ornamentation. On the first floor, the use of arches is reminiscent of ancient Roman architecture.

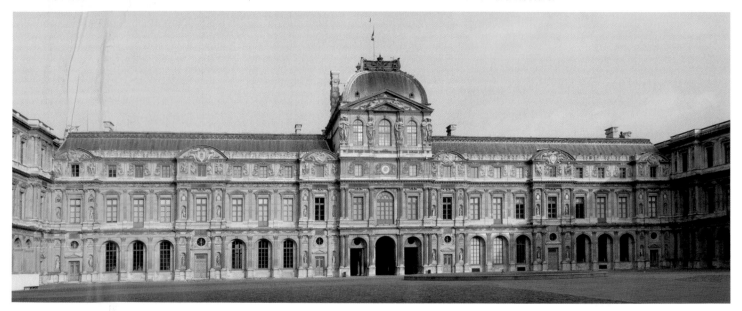

Elizabethan England

Throughout the 16th century, English political and cultural life followed a path notably different from that of continental Europe, as it had done so often in its previous history. The social unrest that had marked the Late Middle Ages in England was finally ended in 1485 by the accession of Henry VII, the first king of the Tudor dynasty. For the entire 16th century, England enjoyed stability and commercial prosperity, on the basis of which it began to play an increasingly active role in international politics. Henry VIII's final break with the Catholic Church in 1534 led to the development of ties between England and the other countries of the Reformation, particularly the Netherlands. When years of tension between the Netherlanders and their Spanish rulers finally broke out into open rebellion, England (then ruled by Queen Elizabeth I) supplied help secretly. Relations between Elizabeth and the Spanish king Philip II were already strained—in part because Philip had been briefly married to Elizabeth's predecessor, Mary—and English interference in the Spanish Netherlands was unlikely to help. In 1585 a new Spanish campaign of repression in the Netherlands, coupled with the threat of a Spanish invasion of England, drove the queen to resort to more open action— she sent 6000 troops to fight alongside the Netherlanders. Their presence proved decisive.

Philip's anger at his defeat and at the progress of the campaign for an independent Netherlands was converted to fury against England. The massive Spanish Armada—the largest fleet the world had ever seen—was ready early in 1588 and sailed majestically north, only to be met by a fleet of lighter, faster English ships commanded by Sir Francis Drake. The rest is part history, part legend. Even before the expedition sailed, Drake had "singed the beard of the King of Spain"[4] by sailing into Cádiz harbor and setting fire to some of the Spanish galleons anchored there. What was left of the Armada reached the English Channel, where it was destroyed, partly by superior English tactics and partly by a huge storm promptly dubbed (by the victors, at least) the Protestant Wind. The subsequent tales of English valor and daring brought a new luster to the closing years of the Elizabethan Age.

In view of England's self-appointed position as the bulwark of Protestantism against the Catholic Church in general and Spain in particular, it is hardly surprising that Renaissance ideas that developed south of the Alps took some time to affect English culture.

Art in Elizabethan England

Few Italian artists were tempted to work at the English court or, for that matter, were likely to be invited. Furthermore, England's geographic position inevitably cut it off from intellectual developments in continental Europe and produced a kind of psychological insularity that was bolstered in the late 16th century by a wave of national pride. The finest expression of this is probably to be found in the lines William Shakespeare put into the mouth of John of Gaunt in *Richard II*, a play written some six years after the defeat of the Spanish Armada.

> **READING 14.5 WILLIAM SHAKESPEARE**
>
> *Richard II*, act 2, scene 1, lines 39–50
>
> This royal throne of kings, this sceptered isle,
> This earth of majesty, this seat of Mars,
> This other Eden, demi-Paradise,
> This fortress built by Nature for herself
> Against infection and the hand of war,
> This happy breed of men, this little world,
> This precious stone set in the silver sea,
> Which serves it in the office of a wall
> Or as a moat defensive to a house
> Against the envy of less happier lands—
> This blessed plot, this earth, this realm, this England. . . .

On the other hand, the same spirit of nationalism was bound to produce a somewhat narrow-minded rejection of new ideas from outside. In comparison to those of Italy and the Netherlands, English sculpture and painting remained provincial.

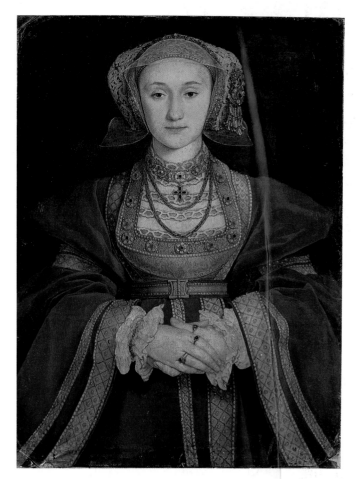

▲ **14.18** Hans Holbein the Younger, *Anne of Cleves*, ca. 1539–1540. Vellum applied to canvas, 25⅝″ × 18⅞″ (65 × 48 cm). **Musée du Louvre, Paris, France.** After viewing this portrait, Henry VIII sent for Anne of Cleves and made her his fourth queen. Note the formal pose and suitably modest downturned gaze.

NETHERLANDISH ARTISTS IN THE TUDOR COURT: HANS HOLBEIN THE YOUNGER AND LEVINA TEERLINC One of the few foreign painters to work in England was the Northerner Hans Holbein the Younger (1497/98–1543), a court painter to Henry VIII who was enlisted to travel to prospective brides and paint their likenesses for the king's approval. Holbein's *Anne of Cleves* (**Fig. 14.18**) is an example; after viewing the portrait (and that of her sister, Amalia), Henry sent for Anne and made her his fourth queen. Six months later, the marriage between Henry and the woman he called his "Flanders Mare" was annulled. The formal frontal pose and exquisite though understated detail of Anne's costume convey her poise. A French ambassador to the English court described her as "of middling beauty, and of very assured and resolute countenance."

For the most part, women artists of the era, both in the North and in Italy, earned their reputations locally by

4. From a poem by Henry Wadsworth Longfellow.

working steadily on small private commissions. As such, they were able to earn a living in their professions. Some, however, like Levina Teerlinc (1515–1576) were held in such high esteem that they garnered international attention. Henry VIII brought Teerlinc to his court as his official portrait miniaturist, and she stayed in England to serve three Tudor monarchs who succeeded him, including Elizabeth I, the daughter of Henry VIII and Anne Boleyn (executed by Henry's order when Elizabeth was not yet three years old). Attributions of Teerlinc's portraits are not definitive, although it is believed that she created nine of Elizabeth alone. Her miniature portrait of Elizabeth's cousin Lady Catherine Grey (**Fig. 14.19**), only one and three-eighths inches in diameter, shows us Teerlinc's extraordinary skill, the level of which is matched only by the court portraits by her contemporary (and, some say, rival) Holbein.

Like Caterina van Hemessen, Teerlinc came from a family of practicing artists: her grandfather and father were portrait miniaturists and her father trained her. As far as we know, she was the only female artist working in England from 1550 to 1576.

NICHOLAS HILLIARD English artists were virtually cut off from contemporary art on the European continent. The only English-born painter of note during the 16th century was Nicholas Hilliard (1547–1619), best known for his miniature portraits, often painted in watercolor. Hilliard's *Ermine Portrait of Queen Elizabeth I* (**Fig. 14.20**), as sumptuous and meticulously detailed as it is, was intended to symbolize the queen's wealth and power rather than to accurately record her appearance. Her diminutive, delicate hands seem to hover against a constellation of beads that embellish an inky black gown; the stiff pleats of her starched lace collar appear to emanate, as the rays of the sun, from her luminous complexion and flame-red hair. As queen of England and Ireland in her own right, Elizabeth is the picture of transcendent authority.

MUSIC

As in the visual arts, the Renaissance produced major stylistic changes in the development of music, but in general, musical development in the Renaissance was marked by a less severe break with medieval custom than was the case with the visual

◄ **14.19** Levina Teerlinc, *Lady Catherine Grey*, ca. 1555–60. Watercolor on vellum mounted on plain card, 1³⁄₈″ (3.49 cm) diameter. Victoria and Albert Museum, London, United Kingdom. Teerlinc was a renowned miniaturist.

arts. Although 16th-century European composers began to increase the complexity of their style, frequently using polyphony, they continued to use forms developed in the High Middle Ages and the Early Renaissance. In religious music, the motet remained popular, set to a religious text. Composers also continued to write *madrigals* (songs for three or more solo voices based generally on secular poems). For the most part these were intended for performance at home, and elaborate, interweaving polyphonic lines often tested the skill of the singers. The difficulty of the parts often made it necessary for the singers to be accompanied instrumentally. This increasing complexity produced a significant change in the character of madrigals, which were especially popular in Elizabethan England. Nonetheless, 16th-century musicians were recognizably the heirs of their 13th- and 14th-century predecessors.

Music in France and Germany

The madrigal form was originally devised in Italy for the entertainment of courtly circles. By the early 16th century, French composers, inspired by such lyric poets as Clément Marot (1496–1544), were writing more popular songs known as **chansons**. The best-known composer of chansons was Clément Janequin (ca. 1485–ca. 1560), who was famous for building his works around a narrative program. In "La Guerre" ("The War") the music imitates the sound of shouting soldiers, fanfares, and rattling guns; other songs feature street cries and birdsong. Frequently repeated notes and the use of nonsense syllables help give Janequin's music great rhythmic vitality, although it lacks the harmonic richness of Italian madrigals.

The tendency to appeal to a general public also characterized German and Flemish songs of the period, with texts that were romantic, military, or sometimes even political in character. Among the great masters of the period was the Flemish composer Heinrich Isaac (ca. 1450–1517), who composed songs in Italian and French as well as in German. His style ranges from simple chord-like settings to elaborately interweaving lines that imitate one another. Isaac's pupil, the Swiss Ludwig Senfl (ca. 1486–ca. 1542), was, if anything,

JOHN DOWLAND The most melancholy works of all Elizabethan music are the **ayres** (simple songs for one voice accompanied by either other voices or instruments) of John Dowland (1562–1626)—the rare example of an Elizabethan musician who traveled widely. Irish by birth, Dowland visited France, Germany, and Italy, and even worked for a while at the court of King Christian IV of Denmark and Norway; ultimately, he settled in England.

Dowland was the greatest virtuoso of his day on the lute (a plucked stringed instrument that is a relative of the guitar), and he used it to accompany his ayres. Dowland's gloomy temperament was given full expression both in the ayres and in his solo pieces for lute, most of which are as obsessively depressed and woeful as Morley's madrigals are determinedly cheerful. Popular in his own day, Dowland's music has undergone in more recent times something of a revival, with the growth of interest in the guitar and other similar instruments.

LITERATURE

Renaissance literature in the North took religious and secular turns. There were the writers of the Reformation, such as Martin Luther and John Calvin. There were also essayists, poets, and dramatists who dealt with nonreligious matters, such as the Frenchman Montaigne, with his critique of barbarous behavior in Europe; More, with his *Utopia*; Spenser, in poetry; and Christopher Marlowe and William Shakespeare in drama.

MICHEL EYQUEM DE MONTAIGNE Michel Eyquem de Montaigne (1533–1592) came from a wealthy Bordeaux family. His father, who had been in Italy and was heavily influenced by Renaissance ideas, provided him with a fine early education. Montaigne spoke nothing but Latin with his tutor when he was a child, so that when he went to school at age six, he spoke Latin not only fluently but with a certain elegance. His later education (he studied law for a time) was a keen disappointment to him because of its pedantic narrowness. After a few years of public service, in 1571 Montaigne retired with his family to a rural estate to write and study. He remained there, with the exception of a few years traveling and some further time of public service, until his death.

The times were not happy. France was split over the religious issue, as was Montaigne's own family. He remained a Catholic, but his mother and sisters became Protestants. Only a year after his retirement came the terrible Saint Bartholomew's Day Massacre (August 24, 1572), in which thousands of French Protestants were slaughtered in a bloodbath unequaled in France since the days of the Hundred Years' War. In the face of this violence and religious bigotry, Montaigne returned to a study of the classics and wrote out his ideas for consolation.

Montaigne's method was to write on a widely variegated list of topics gleaned either from his readings or from his own experiences. He called these short meditations *essays*. Our modern form of the essay is rooted in Montaigne's first use of the genre in Europe. The large numbers of short essays Montaigne wrote share certain qualities characteristic of a mind wearied by the violence and religious bigotry of the time: a sense of stoic calmness (derived from his study of Cicero and Seneca), a tendency to moralize (in the best sense of that abused word) from his experiences, a generous nondogmatism, and a vague sense of world-weariness.

During the period when Montaigne's essay "On Cannibals" was written, reports of native peoples were pouring into Europe from explorers who wrote of their adventures in the New World. As Montaigne contrasts so-called primitive people to the so-called civilized people of his own time and place, he reflects his horror at the lack of civility in a European culture warring incessantly over religion. Montaigne's somewhat romantic view of cannibals reminds us of the tendency of European culture—especially in the century to follow—to praise the "noble savage" as a vehicle for social and political criticism.

The following reading explores the meaning of the word *barbarous,* as applied to the various "nations" discovered by explorers.

READING 14.6 MICHEL DE MONTAIGNE

From "On Cannibals," the meaning of *barbarous*

These nations, then, seem to me barbarous in this sense, that they have been fashioned very little by the human mind, and are still very close to their original naturalness. The laws of nature still rule them, very little corrupted by ours; and they are in such a state of purity that I am sometimes vexed that they were unknown earlier, in the days when there were men able to judge them better than we. I am sorry that Lycurgus and Plato did not know of them; for it seems to me that what we actually see in these nations surpasses not only all the pictures in which poets have idealized the golden age and all their inventions in imagining a happy state of man, but also the conceptions and the very desire of philosophy.

. . .

This is a nation, I should say to Plato, in which there is no sort of traffic, no knowledge of letters, no science of numbers, no name for a magistrate or for political superiority, no custom of servitude, no riches or poverty, no contracts, no successions, no partitions, no occupations but leisure ones, no care for any but common kinship, no clothes, no agriculture, no metal, no use of wine or wheat. The very words that signify lying, treachery, dissimulation, avarice, envy, belittling, pardon—unheard of. How far from this perfection would he find the republic that he imagined: "Men fresh sprung from the gods" (Seneca).

The following passage discusses warfare among "nations" that practice cannibalism. Montaigne does not view the practice in a positive light, but notes that these people are somewhat innocent in their outlook, whereas supposedly civilized Europeans have been just as barbaric.

READING 14.7 MICHEL DE MONTAIGNE

From "On Cannibals," on warfare, cannibalism, and other barbaric acts

They have their wars with the nations beyond the mountains, further inland, to which they go quite naked, with no other arms than bows or wooden swords ending in a sharp point, in the manner of the tongues of our boar spears. It is astonishing what firmness they show in their combats, which never end but in slaughter and bloodshed; for as to routs and terror, they know nothing of either.

Each man brings back as his trophy the head of the enemy he has killed, and sets it up at the entrance to his dwelling. After they have treated their prisoners well for a long time with all the hospitality they can think of, each man who has a prisoner calls a great assembly of his acquaintances. He ties a rope to one of the prisoner's arms, by the end of which he holds him, a few steps away, for fear of being hurt, and gives his dearest friend the other arm to hold in the same way; and these two, in the presence of the whole assembly, kill him with their swords. This done, they roast him and eat him in common and send some pieces to their absent friends.

. . .

I am not sorry that we notice the barbarous horror of such acts, but I am heartily sorry that, judging their faults rightly, we should be so blind to our own. I think there is more barbarity in eating a man alive than in eating him dead; and in tearing by tortures and the rack a body still full of feeling, in roasting a man bit by bit, in having him bitten and mangled by dogs and swine (as we have not only read but seen within fresh memory, not among ancient enemies, but among neighbors and fellow citizens, and what is worse, on the pretext of piety and religion), than in roasting and eating him after he is dead.

English Literature

English literature in the 16th century, unlike the visual arts and to a greater extent even than music, was strongly affected by new currents of Renaissance thought. One reason for this is purely practical. Soon after the invention of printing in Germany, William Caxton (ca. 1421–1491) introduced the printing press into England, and during the first half of the 16th century, books became increasingly plentiful and cheap.

With the spread of literature an increased literacy developed, and the new readers were anxious to keep in touch with the latest ideas of the day. The development of humanism in England undoubtedly influenced Erasmus of Rotterdam, who was brought into contact with humanist ideas during his visits there. In addition to teaching at Cambridge, Erasmus formed a warm personal friendship with the English statesman Sir Thomas More, who became lord chancellor in 1529.

SIR THOMAS MORE More (1478–1535) was an English philosopher, lawyer, author, and statesman. He was a councilor to King Henry VIII and served for three years as lord chancellor. He was an opponent of Martin Luther and did not accept the Reformation in England, which he saw as the king's excuse for divorcing his wives and taking new ones. More accepted Henry VIII as king of England, but not as supreme head of the Church of England (the Protestant Anglican Church), a title given the king by Parliament in 1534. More was imprisoned in 1534 because of his refusal to take an oath that disparaged papal power and made the unborn daughter of the king and Anne Boleyn the successor to the throne. That successor, of course, would become Queen Elizabeth I. More was beheaded in 1535 for treason. (There were two more succession acts, one which removed Elizabeth from succession, and the other which placed both Princesses Mary—daughter of Catherine of Aragon—and Elizabeth in line for the throne.)

More's execution stunned European statesmen and intellectuals. Erasmus wrote that More's soul was purer than snow, and that he possessed a genius heretofore unseen in England and unlikely to be seen again. In the 18th century, Jonathan Swift would write that More was "the person of the greatest virtue this kingdom ever produced." It is not surprising that More became a saint of the Catholic Church, but the Church of England now considers More to have been a Reformation martyr. More also became the tragic hero of Robert Bolt's 1960 play *A Man for All Seasons*, which was made into a film of the same name in 1966.

More's *Utopia*—a term he coined—is a philosophical romance, written in Latin in 1516, about an ideal island nation resembling Plato's *Republic*. *Utopia*, in Greek, means "not a (real) place." It was written under Erasmus's influence and was firmly based on humanistic ideals. Once introduced, these ideas caught on, and so did the use of Classical or Italian models to express them. Sir Philip Sidney (1554–1586), the dashing youth who has been described as Castiglione's courtier come to life, wrote a series of sonnets in imitation of Petrarch, and a romance, *Arcadia*, of the kind made popular in Italy by Ludovico Ariosto (1474–1533).

THOMAS WYATT Thomas Wyatt (1503–1542) was the poet who is credited with bringing the **sonnet** into the English language. His father was a close advisor to King Henry VII and remained in the position when Henry VIII ascended to the throne in 1509. Wyatt attended Cambridge and can be said to then have inherited his father's position, serving Henry VIII as an advisor and an ambassador. One of the perquisites of being

in the court at the time was meeting Anne Boleyn. Wyatt was tall and powerfully built, unhappily married, and Boleyn was a red-haired beauty. There is speculation that the two had an affair, and Wyatt was sent to the Tower of London in 1536 on charges of adultery. During his imprisonment in the tower, it is further speculated that he might have witnessed Boleyn's execution from his window, along with those of several other men with whom she was accused of having affairs. These charges were likely trumped up, and the executions were more likely to have been political than personal. In any event, Wyatt managed to be freed due to his father's connections. Wyatt's sister was mother to a man named Henry Lee, from whom descended the Lees of Virginia, including Robert E. Lee.

Following is a sonnet that critics believe was written about Boleyn. "Whoso list to hunt" means "whoever leans toward hunting," as a boat lists to port or starboard when the cargo shifts. A hind is a female red deer. The sense of the poem is that the poet cannot erase the deer from his mind. The English sonnet has three **quatrains** (four lines of verse) and a concluding **couplet**. The couplet here begins with the Latin "Noli me tangere," which translates as "Do not touch me" and represents the words spoken by Jesus to Mary Magdalene (John 20:17) when she recognizes him following his resurrection. Jesus may have been saying that he now dwelled somewhere in between the human and the divine; the poem may be suggesting that Anne, for Wyatt, also dwelled somewhere beyond natural reality—that perhaps he was spending "his time in vain" if he sought to touch her. The reference to Caesar may be to the king.

READING 14.8 THOMAS WYATT

"Whoso List to Hunt?"

Whoso list to hunt? I know where is an hind!
But as for me, alas! I may no more,
The vain travail hath wearied me so sore;
I am of them that furthest come behind.
Yet may I by no means my wearied mind
Draw from the deer; but as she fleeth afore
Fainting I follow; I leave off therefore,
Since in a net I seek to hold the wind.
Who list her hunt, I put him out of doubt
As well as I, may spend his time in vain!
And graven with diamonds in letters plain,
There is written her fair neck round about;
"Noli me tangere; for Caesar's I am,
And wild for to hold, though I seem tame."

EDMUND SPENSER Edmund Spenser (1552–1599), considered the greatest nondramatic poet of Elizabethan England, was also influenced by Ariosto and by Torquato Tasso (1544–1595), Ariosto's Italian successor in the production of massive epic poems. In *The Faerie Queene*, Spenser combined the romance of Ariosto and the Christian allegory of Tasso

to create an immensely complex epic. Its chivalrous hero, the Knight of the Red Cross, represents both Christianity and, through his resemblance to Saint George, England. At the same time, the tests he undergoes make him a Renaissance version of the medieval figure of Everyman. The epic takes place in the imaginary land of Faerie, where the knight's path is frequently blocked by dragons, witches, wizards, and other magical creatures. All of this fantastical paraphernalia not only advances the plot but also provides a series of allegorical observations on moral and political questions of the day.

Spenser also wrote other poems, including sonnets, such as the love poem that is sonnet 79 in his *Amoretti*.

READING 14.9 EDMUND SPENSER

Amoretti, sonnet 79

Men call you fair, and you do credit it,
For that yourself you daily such do see:
But the true fair, that is the gentle wit,
And virtuous mind, is much more praised of me:
For all the rest, however fair it be,
Shall turn to nought and lose that glorious hue;
But only that is permanent and free
From frail corruption, that does flesh ensue.
That is true beauty: that does argue you
To be divine, and born of heavenly seed;
Derived from that fair Spirit, from whom all true
And perfect beauty did at first proceed:
　　He only fair, and what he fair has made;
　　All other fair, like flowers, untimely fade.

QUEEN ELIZABETH I Queen Elizabeth I could read Greek and Latin and spoke French, Italian, and Spanish as well as her native English. In addition to her talents of state, she was also an accomplished poet. "On Monsieur's Departure" apparently memorializes her reaction to a heart-wrenching leave-taking. The "monsieur" of the poem may be the French Duke of Alençon and Anjou, with whom Elizabeth had contemplated marriage. It may also be the Earl of Essex, a loyal companion of the queen with whom she may have had a romantic—or nearly romantic—relationship. Elizabeth chose not to reveal his identity. The poem is written in **iambic pentameter**.

READING 14.10 QUEEN ELIZABETH I

"On Monsieur's Departure," ca. 1582

I grieve, and yet dare not shew my discontent;
I love, and yet am forced to seem to hate;
I dote, but dare not say I ever meant;
I seem stark mute, but inwardly do prate.
I am, and not; —I freeze, and yet am burned,
Since from myself my other self I turned.

My care is like my shadow in the sun,
Follows me flying; flies when I pursue it;
Stands, and lies by me; does what I have done;
This too familiar care doth make me rue it.
No means I find to rid him from my breast,
Till by the end of things it be suppresst.
Some gentler passion steals into my mind,
(For I am soft, and made of melting snow);
Or be more cruel, love, and so be kind;
Let me, or float or sink, be high or low;
Or let me live with some more sweet content,
Or die, and so forget what love e'er meant.

Drama in Elizabethan England

The greatest English cultural achievements in the Renaissance were in drama. The Classical models of English drama were the Latin tragedies of Seneca and the comedies of Plautus and Terence, which, with the introduction of printing, became more frequently read and performed. These ancient Roman plays created a taste for the theater that English dramatists began to satisfy in increasing quantities. At the same time, the increasing prosperity and leisure that created a demand for new madrigals produced a growing audience for drama. To satisfy this audience, traveling groups of actors began to form, often attaching themselves to the household of a noble who acted as their patron. These companies gave performances in public places, especially the courtyards of inns. When the first permanent theater buildings were constructed, their architects imitated the form of the inn courtyards, with roofs open to the sky and galleries around the sides. The stage generally consisted of a large platform jutting out into the center of the open area known as the **pit** or **ground** (Fig. 14.22).

The design of these theaters allowed—indeed encouraged—people of all classes to attend performances regularly, because the price of admission varied for different parts of the theater. The more prosperous spectators sat in the galleries, where they had a clear view of the stage, while the poorer spectators stood on the ground around the stage. Dramatists

▼ **14.22 Replica of Globe Theater, London, United Kingdom.** The theater has 900 seats arranged in tiers and space for 700 groundlings. It is built from what is known of the original Globe Theater, in which Shakespeare's plays were performed.

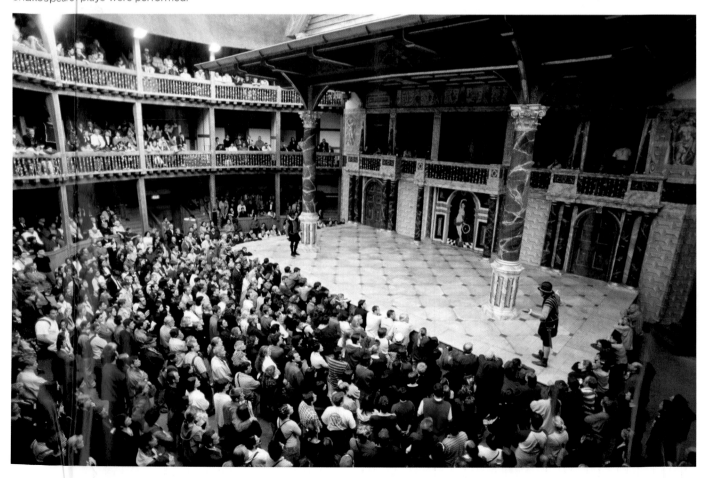

and actors soon learned to please these so-called **groundlings** by appealing to their taste for noise and spectacle.

Not all performances were given in public before so democratic an audience. The most successful companies were invited to entertain Queen Elizabeth and her court. The plays written for these state occasions were generally more sophisticated in both content and style than those written for the general public. The works written for the court of James I, Elizabeth's successor, are among the most elaborate of all. In general, English drama developed from a relatively popular entertainment in the mid-16th century to a more formal, artificial one in the early 17th century. It is probably no coincidence that the greatest of all Elizabethan dramatists, Shakespeare and Marlowe, wrote their best works at about the midpoint in this development, from about 1590 to 1610. Their plays reflect the increasing appreciation and demand for real poetry and high intellectual content without losing the "common touch" that has given their work its continual appeal.

CHRISTOPHER MARLOWE Born two months before Shakespeare, Christopher Marlowe (1564–1593)—had he not been killed in a fight over a tavern bill at age 29—might well have equaled Shakespeare's mighty achievements. It is certainly true that by the same age Shakespeare had written relatively little of importance, whereas Marlowe's works include the monumental two-part *Tamburlaine the Great*, a vast tragic drama that explores the limits of human power. It contains some wonderful **blank verse**, nonrhyming lines of iambic pentameter; each of the five feet in a line has two syllables, with the second syllable in each foot generally bearing the accent. Marlowe's use of blank verse for dramatic expression was imitated by virtually every other Elizabethan playwright, including Shakespeare. Marlowe's masterpiece *The Tragicall History of the Life and Death of Doctor Faustus* may reflect the passion and violence of his own life, with heroes striving to achieve the unachievable by overcoming all limits, only to be defeated by destiny.

We know from the title of *Doctor Faustus* that it will not end well. Faustus, a German professor at Wittenberg University, seeks ultimate wisdom and power, and makes a pact with the devil to achieve them. In return for these ends, Faustus will give the devil his body and soul. There are stock allegorical characters, including the seven deadly sins and Faustus's good and bad angels. In the play, Faustus travels to the Vatican, to the emperor's palace, and through the heavens, and he meets with the beauteous Helen of Troy (who is called Helen of Greece in the play) in a dumb show; that is, she does not speak. When Faustus meets Helen, we hear some of the most beautiful—and familiar—lines that have ever graced the English language.

Toward the end, Faustus tries to make his peace with God, but there is no turning back. The devil's collection of that which is due is gruesome.

Marlowe was also a fine lyric poet, as we see in some verses from the beloved "The Passionate Shepherd to His Love," which is written in rhyming lines of **iambic tetrameter**.

READING 14.11 CHRISTOPHER MARLOWE

***The Tragicall History of the Life and Death of Doctor Faustus*, scene 14, lines 87–94**

Was this the face that launched a thousand ships
And burnt the topless towers of Ilium[5]?
Sweet Helen, make me immortal with a kiss. [*Kisses her.*]
Her lips suck forth my soul; see where it flies!—
Come, Helen, come, give me my soul again.
Here will I dwell, for Heaven is in these lips,
And all is dross[6] that is not Helena.

READING 14.12 CHRISTOPHER MARLOWE

"The Passionate Shepherd to His Love," lines 1–4, 9–12, and 17–20

Come live with me and be my love,
And we will all the pleasures prove
That valleys, groves, hills, and fields,
Woods or steepy mountain yields.

. . .

And I will make thee beds of roses
And a thousand fragrant posies,
A cap of flowers, and a kirtle
Embroidered all with leaves of myrtle;

. . .

A belt of straw and ivy buds,
With coral clasps and amber studs:
And if these pleasures may thee move,
Come live with me and be my love.

WILLIAM SHAKESPEARE Regret at the loss of what Marlowe might have written had he lived is balanced by gratitude for the many works William Shakespeare (1564–1616) bequeathed us. Shakespeare is universally acknowledged as the greatest writer in the English language and one of the greatest in any tongue. His stature is well summarized in the words of his leading contemporary and rival, playwright Ben Jonson (1572–1637): "He was not of an age, but for all time!" A century and a half after the passing of Shakespeare, Doctor Samuel Johnson, a literary critic and an inventor of the dictionary, would further recognize the playwright's humanism and write:[7]

5. That is, Troy—as in the *Iliad*.

6. Waste, worthless matter.

7. From *Preface to the Plays of William Shakespeare*, 1765.

Shakespeare is above all writers, at least above all modern writers, the poet of nature; the poet that holds up to his readers a faithful mirrour of manners and of life. His characters are not modified by the customs of particular places, unpractised by the rest of the world; by the peculiarities of studies or professions, which can operate but upon small numbers; or by the accidents of transient fashions or temporary opinions: they are the genuine progeny of common humanity, such as the world will always supply, and observation will always find. His persons act and speak by the influence of those general passions and principles by which all minds are agitated, and the whole system of life is continued in motion. In the writings of other poets a character is too often an individual; in those of *Shakespeare* it is commonly a species.[8]

There are gaps in our knowledge of Shakespeare's life. He was born at Stratford-upon-Avon, the son of a successful businessman who also dabbled in local politics; his mother was the daughter of a wealthy man. Stratford was enjoying the economic boom of the Elizabethan Age, and the town hired fine teachers for the grammar school, where Shakespeare presumably began the "armchair travels" that would acquaint him with much of the known Western world, past and present. He left the grammar school in 1578 and married Anne Hathaway in 1582. Over the following three years the couple had three children. By 1592 Shakespeare had achieved astounding success in London, both as an actor and a budding playwright. Exactly how he became involved in the theater and what he did from 1585 to 1592 remain unclear. From the beginning of his time in London, Shakespeare was associated with the leading theatrical company of the day—the Lord Chamberlain's Men—which changed its name to the King's Men at the accession of James I in 1603. Public records show that Shakespeare would purchase the largest house in Stratford.

Shakespeare's earliest plays follow the example of Classical models in being carefully constructed, although their plots sometimes seem unnecessarily complicated. In *The Comedy of Errors* (1592–1593), for example, Shakespeare combines two plays by the Roman comic writer Plautus (ca. 254–184 BCE) to create a series of situations replete with mistaken identities and general confusion. Some would argue that the careful manipulation of plot in the early plays is achieved at the expense of characterization, and that the poetry tends to use artificial literary devices. Even Shakespeare's first great tragedy, *Romeo and Juliet* (1595), is not altogether free from an excessive use of puns and plays on words, although the psychological depiction of the young lovers is convincing and the play contains magnificent passages—including the balcony scene, in which Juliet alludes to the feud between the Montague and Capulet families.

The comedies of the next few years, including both *The Merchant of Venice* (ca. 1596) and *Twelfth Night* (ca. 1600), are more lyrical. *The Merchant of Venice* has been consid-

READING 14.13 WILLIAM SHAKESPEARE

Romeo and Juliet, act 2, scene 2, lines 2–6, 33–44

ROMEO: But, soft! what light through yonder window
 breaks?
 It is the east, and Juliet is the sun.
 Arise, fair sun, and kill the envious moon,
 Who is already sick and pale with grief,
 That thou her maid art far more fair than she.

 . . .

JULIET: O Romeo, Romeo, wherefore art thou Romeo?
 Deny thy father and refuse thy name;
 Or if thou wilt not, be but sworn my love
 And I'll no longer be a Capulet.
ROMEO: [*Aside*] Shall I hear more, or shall I speak at this?
JULIET: 'Tis but thy name that is my enemy:
 Thou art thyself, though not a Montague.
 What's Montague? It is nor hand nor foot,
 Nor arm nor face, nor any other part
 Belonging to a man. O be some other name!
 What's in a name? That which we call a rose
 By any other word would smell as sweet.

ered Shakespeare's first mature play. The characters are well-drawn, and the play is a comedy in the sense that it ends with the union of the young lovers—despite obstacles. Yet the portrayal of the Jewish merchant Shylock, who plans to exact his "pound of flesh" from a youthful lover because of a bad loan, is complex; yes, his demands are troubling, but he also has bitter and real grievances against the social order in which he dwells. Actors over the centuries have feasted on the role, searching out its nuances. And the answer to the question of whether Shakespeare was anti-Semitic seems elusive, since he wrote the play at a time when Jewish characters were typically portrayed as monsters. Despite Shylock's vindictiveness, some find that he is the one character of value in a society of dubious worth.

Twelfth Night is often regarded as Shakespeare's supreme achievement in comedy. Although the plot hinges on a series of well-worn comic devices—mistaken identities, separated twins, and so on—the characters are vivid and individualized. Furthermore, the work's principal subject, romantic love, is shown from an almost infinite number of viewpoints. Yet at the same time Shakespeare was attracted to historical subjects—generally drawn from English history, as in *Henry IV*, Parts 1 and 2 (1597–1598), but also from Roman history, as in *Julius Caesar* (1599).

Henry IV, Part 1 has a flamboyant comic character, Sir John Falstaff (**Fig. 14.23**). One tradition has it that Queen Elizabeth herself petitioned the playwright to author another

8. Representative of all humankind.

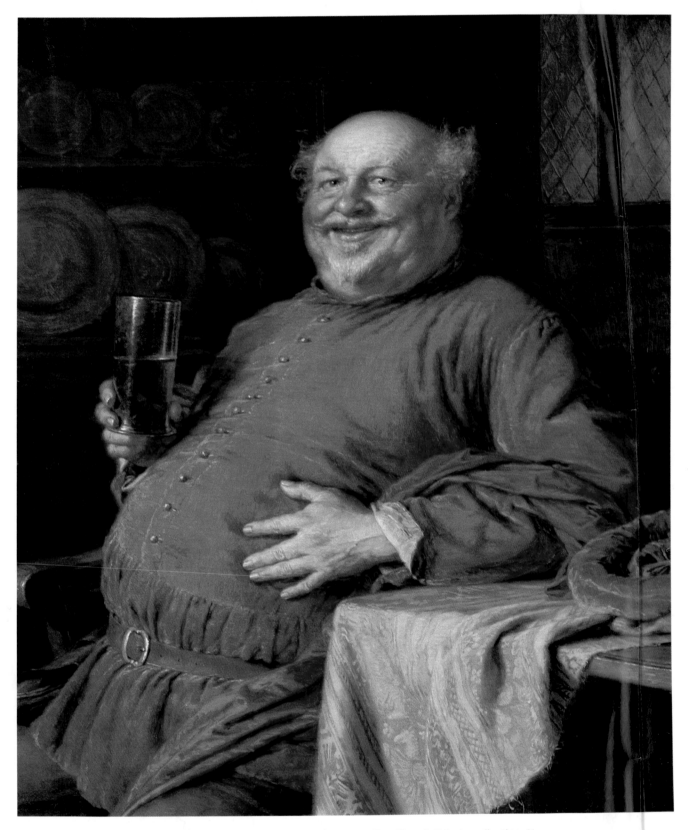

▲ **14.23** Eduard Grützner, *Falstaff*, 1910. Oil on canvas, 17³/₄″ × 15″ (45 × 38 cm). **Private collection.** Sir John Falstaff, a fictional character in *Henry IV, Part 1* imagined here by a German artist, has been one of the more popular characters in Shakespeare's plays. He is a knight of questionable moral character, given to drink, "bawds," overeating, and—as it turns out on the battlefield—betrayal. Nevertheless, Shakespeare was urged to write a play with Falstaff as the central character, and Falstaff has inspired many artistic works since, including a 19th-century opera by Giuseppe Verdi.

play to continue the ribald nonsense of Falstaff. The "sequel" became *The Merry Wives of Windsor*, set in a town not unlike Stratford. But we meet Falstaff for the first time in act 1, scene 2 of *Henry IV, Part 1*. Prince Hal (Henry) and Sir John enter a London apartment of the prince. Falstaff, portrayed as jolly, rotund, bearded, and often inebriated, asks the prince the time of day. The answer is one of the more jocular retorts in the history of drama and immediately establishes the character, or lack of character, of Falstaff.

READING 14.14 WILLIAM SHAKESPEARE

Henry IV, Part 1, act 1, scene 2, lines 1–13

FALSTAFF: Now, Hal, what time of day is it, lad?
PRINCE: Thou art so fat-witted, with drinking of old sack[9]
 and unbuttoning thee after supper and sleeping upon
 benches after noon, that thou hast forgotten to demand
 that truly which thou wouldst truly know. What a devil
 hast thou to do with the time of the day? Unless hours
 were cups of sack and minutes capons and clocks the
 tongues of bawds and dials the signs of leaping-houses[10]
 and the blessed sun himself a fair hot wench in flame-
 coloured taffeta, I see no reason why thou shouldst be
 so superfluous to demand the time of the day.

READING 14.15 WILLIAM SHAKESPEARE

Julius Caesar, extracts

In act 1, scene 2, line 18, a soothsayer warns Caesar of what is to come.

 Beware the ides of March.

The ides of March is March 15, the date of the assassination. Later, in the same scene, we see Cassius convincing Brutus to join in the assassination for the good of Rome, preventing Caesar from becoming dictator (lines 135-141).

 Why man, he doth bestride the narrow world
 Like a Colossus; and we petty men
 Walk under his huge legs, and peep about
 To find ourselves dishonourable graves.
 Men at some time are masters of their fates:
 The fault, dear Brutus, is not in our stars,
 But in ourselves, that we are underlings.

In lines 192-195, Caesar sees Cassius standing by and speaks to Antonius.

 Let me have men about me that are fat;
 Sleek-headed men and such as sleep o' nights;
 Yond' Cassius has a lean and hungry look;
 He thinks too much: such men are dangerous.

The night before Caesar's death, there are warnings enough in the turbulence of nature. Caesar is advised to remain at

Julius Caesar (1599) is notable for several reasons. It shows that Shakespeare shared the renewed interest of his contemporaries in Classical antiquity. It is, in fact, based directly on the accounts of Caesar, Brutus, and Mark Antony in the *Parallel Lives* of the Greek historian Plutarch (ca. 46– after 119 CE), which had appeared in a new translation by Sir Thomas North in 1579. In the play, Mark Antony is identified by his Latin name, Marcus Antonius. The play illustrates Shakespeare's growing interest in psychological motivation rather than simple sequencing of events. The plot, briefly, covers Caesar's assassination and some of the civil wars that follow, ending with the deaths of the plotters, Brutus and Cassius. Like many of the plays, it mixes the supernatural with the natural world.

In *Julius Caesar* and many other plays, Shakespeare explains his characters' feelings and motives by using the **soliloquy**—that is, by having the characters utter their thoughts aloud, facing the audience, rather than addressing them to another character in the drama. Antonius's exclamation "let slip the dogs of war" occurs during a soliloquy. The use of this device becomes increasingly common in Shakespeare's supreme achievements, the series of tragedies he

9. A strong, dry wine.
10. Brothels.

home on the ides, but he insists to his wife, Calpurnia, that he will venture forth (act 2, scene 2, lines 32–37).

 Cowards die many times before their deaths;
 The valiant never taste of death but once.
 Of all the wonders that I yet have heard,
 It seems to me most strange that men should fear;
 Seeing that death, a necessary end,
 Will come when it will come.

During the assassination in act 3, scene 1, despite knife wounds from others, Caesar sees his loyal and trusted Brutus participating. Caesar says "Et tu, Brute? Then fall, Caesar!" (line 77). (*Et tu* is "and you" in Latin.) Later in the scene, when he is alone, Antonius declares his outrage and utters the rallying cry that gave birth to the expression "the dogs of war": "Cry, 'Havoc!' and let slip the dogs of war" (line 273).

In the following scene we have the well-known conflicting speeches to the Roman crowd by Brutus and Antonius. Brutus shows how Caesar was ambitious. Antonius ironically refers to Brutus repeatedly as "an honorable man," yet he shows the crowd the bloody garments of Caesar and reads to them from Caesar's will, which has an inheritance for every Roman to show that Caesar had his subjects' best interests at heart. Antonius's speech begins (lines 74-77)

 Friends, Romans, countrymen, lend me your ears;
 I come to bury Caesar, not to praise him.
 The evil that men do lives after them;
 The good is oft interred with their bones.

wrote between 1600 and 1605: *Hamlet* (ca. 1600), *Othello* (ca. 1604), *King Lear* (ca. 1605), and *Macbeth* (ca. 1605). In dramatic truth, poetic beauty, and profundity of meaning, these four plays achieve an artistic perfection found only in the tragic dramas of Classical Greece. Through his protagonists, Shakespeare explores the great problems of human existence—the many forms of love, the possibilities and consequences of human error, the mystery of death—with a subtlety and yet a directness that remain miraculous through countless readings or performances and continue to provide inspiration to artists and writers.

In *Hamlet,* what could be more in keeping with the humanistic ideal of man as the measure of all things than the following extract from act 2?

READING 14.16 **WILLIAM SHAKESPEARE**

Hamlet, act 2, scene 2, lines 315–319

What a piece of work is a man! How noble in Reason! How infinite in faculty! In form and moving how express and admirable! In action how like an Angel! In apprehension how like a god! The beauty of the world! The paragon of animals.

Yet Hamlet adds that in his present mood—and that is much of what the drama is about: Hamlet's moodiness, his reasons for it, and his inability to extricate himself from it—he cannot appreciate the perfection of man nor, for that matter, woman. The problem is that his mother, Gertrude, has participated in the murder of his father, the king of Denmark, so that she can marry her lover, Hamlet's uncle Claudius, who, through the marriage and the tradition of succession, has become the new king. Hamlet seems to be based on a true story—the pre-Christian story of Horwendil, who was married to Queen Gemuth and had a son with her named Hamlet. Horvendile was killed by his brother, Fengon, who then married the queen, and Hamlet, to escape the wrath of Fengon, pretended to be insane.

At the beginning of the drama we again find the interweaving of the supernatural and the natural, with the ghost of the murdered king claiming "murder most foul" and crying out for vengeance. "What a falling off was there," the ghost tells Hamlet of the queen's virtue. The balance of the play has to do with Hamlet's obtaining what he considers solid evidence that Gertrude and Claudius indeed bear the guilt, and whether he is really going to avenge his father's murder. One of the core concepts of Elizabethan drama is that the world has an order, and when that order is broken, it must be reestablished. Hamlet finally acts (a spoiler?[11]) and everyone winds up dead—including Hamlet (another spoiler). A prince from Norway then enters the scene to restore order.

In between the complaint of the ghost and the ghastly scene at the end, we have what many critics refer to as the greatest play ever written. There are plays within the play, which lend a greater sense of reality to the surrounding drama besetting Hamlet. Hamlet observes an actor simulating the grief felt by Hecuba when her husband, Priam, king of Troy, is killed. He is astounded by the apparently true emotions portrayed by the actor, which, one might think, is also a commentary on the power of Shakespeare's own works.

Some of this language is unclear to the modern audience. Hamlet has been witness to the invention (the "conceit") of the actor. The actor's face has paled ("his visage wann'd") as fits his role. What would this actor be capable of with Hamlet's true passion? Hamlet argues with himself as to whether his indecision reflects cowardice. He then decides to put on a play which parallels his suspicions about Gertrude and Claudius so that he can observe their

11. That is, a piece of information that gives away the plot.

READING 14.17 **WILLIAM SHAKESPEARE**

Hamlet, act 2, scene 2, lines 555–581

O, what a rogue and peasant slave am I!
Is it not monstrous that this player here,
But in a fiction, in a dream of passion,
Could force his soul so to his own conceit
That from her working all his visage wann'd,
Tears in his eyes, distraction in's aspect,
A broken voice, and his whole function suiting
With forms to his conceit? and all for nothing!
For Hecuba!
What's Hecuba to him, or he to Hecuba,
That he should weep for her? What would he do,
Had he the motive and the cue for passion
That I have? He would drown the stage with tears
And cleave the general ear with horrid speech,
Make mad the guilty and appal the free,
Confound the ignorant, and amaze indeed
The very faculties of eyes and ears. Yet I,
A dull and muddy-mettled rascal, peak,
Like John-a-dreams, unpregnant of my cause,
And can say nothing; no, not for a king,
Upon whose property and most dear life
A damn'd defeat was made. Am I a coward?
Who calls me villain? breaks my pate across?
Plucks off my beard, and blows it in my face?
Tweaks me by the nose? gives me the lie i' the throat,
As deep as to the lungs? who does me this?
Ha!

READING 14.18 WILLIAM SHAKESPEARE

Hamlet, act 3, scene 1, lines 55–87

To be, or not to be: that is the question:
Whether 'tis nobler in the mind to suffer
The slings and arrows of outrageous fortune,
Or to take arms against a sea of troubles,
And by opposing end them? To die: to sleep;
No more; and by a sleep to say we end
The heartache and the thousand natural shocks
That flesh is heir to, 'tis a consummation
Devoutly to be wish'd.[12] To die, to sleep;
To sleep: perchance to dream: ay, there's the rub;
For in that sleep of death what dreams may come
When we have shuffled off this mortal coil,[13]
Must give us pause: there's the respect
That makes calamity of so long life;
For who would bear the whips and scorns of time,
The oppressor's wrong, the proud man's contumely,[14]
The pangs of despised love, the law's delay,
The insolence of office and the spurns
That patient merit of the unworthy takes,
When he himself might his quietus make
With a bare bodkin?[15] who would fardels[16] bear,
To grunt and sweat under a weary life,
But that the dread of something after death,
The undiscover'd country from whose bourn[17]
No traveller returns, puzzles the will
And makes us rather bear those ills we have
Than fly to others that we know not of?
Thus conscience does make cowards of us all;
And thus the native hue of resolution
Is sicklied o'er with the pale cast of thought,
And enterprises of great pith and moment
With this regard their currents turn awry,
And lose the name of action.

reactions for signs of guilt. At the end of the scene Hamlet voices this couplet:

> "The play's the thing
> Wherein I'll catch the conscience of the King." (lines 604–605)

In act 3, scene 1, we find what is probably Shakespeare's best-known soliloquy, which represents more inner conflict over whether Hamlet should act. In this passage we find familiar expressions such as "to be or not to be," "the slings and arrows of outrageous fortune," "to take arms against a sea of troubles," "the thousand natural shocks that flesh is heir to," "to die, to sleep; to sleep: perchance to dream," "there's the rub," death as "the undiscovered country," and on and on. The passage has been a feast for poets, novelists, dramatists, filmmakers, and professors for four centuries. Note, too, that these plays are written in five acts, and act 3 is the climax—not the end, but the high point, the place to which the earlier story has ascended and from which the final actions fall into place.

There is no end to the riches in *Hamlet*. We could also speak of the romance with Ophelia and her suicide. We could speak of Polonius's fabled advice to his son, which includes axioms such as "Give every man thine ear, but few thy voice," "Neither a borrower nor a lender be," and

> This above all: to thine own self be true,
> And it must follow, as the night the day,
> Thou canst not then be false to any man. (lines 78–81)

As Hamlet's final line is "The rest is silence," our discussion of the play must end here.

Shakespeare's later plays explore new directions. *Antony and Cleopatra* (ca. 1603–1608) returns to Plutarch and to ancient Rome but with a new richness and magnificence of language. The conciseness of Shakespeare's great tragedies is replaced by a delight in the sound of words, and the play contains some of the most musical of all Shakespearean verse. His last works examine the borderline between tragedy and comedy with a sophistication that was perhaps intended to satisfy the new aristocratic audience of the court of King James I. *The Tempest* (1611), set on an enchanted island, blends high romance and low comedy to create a world of fantasy unlike that of any of Shakespeare's other plays.

SHAKESPEARE'S SONNETS Shakespeare's early successes on the stage were interrupted by legal restrictions banning actors due to socially unruly behavior and recurrent plague. During these pauses Shakespeare wrote poetry, including 154 sonnets that were published in 1609. Sonnet

12. If by dying one could end heartache, one might then wish to die.
13. Cast off the concerns of life.
14. Insults.
15. Dagger.
16. Burdens.
17. Boundary.

18 may be the most popular and beloved of Shakespeare's sonnets, with straightforward language that gradually elevates the object of the poet's love into a perfect being—a summer that remains eternal despite the onslaughts of nature. He also asserts that the poem will endure and "give life" to his friend or lover as long as people exist and are capable of reading it.

READING 14.19 WILLIAM SHAKESPEARE

Sonnet 18

Shall I compare thee to a summer's day?
Thou art more lovely and more temperate:
Rough winds do shake the darling buds of May,
And summer's lease hath all too short a date:
Sometime too hot the eye of heaven shines,
And often is his gold complexion dimm'd;
And every fair from fair sometime declines,
By chance or nature's changing course untrimm'd;
But thy eternal summer shall not fade
Nor lose possession of that fair thou owest;
Nor shall Death brag thou wander'st in his shade,
When in eternal lines to time thou growest:
So long as men can breathe or eyes can see,
So long lives this and this gives life to thee.

In sonnet 29, the poet writes that regardless of his moments of despair, his financial reversals, and the disapproval he may find in the eyes of others, his spirits rise when he thinks about his friend or lover. To paraphrase the poet: "Despite all, the memory of your love brings me such psychological wealth that I would not wish to trade my position with those of kings."

READING 14.20 WILLIAM SHAKESPEARE

Sonnet 29

When, in disgrace with fortune and men's eyes,
I all alone beweep my outcast state
And trouble deaf heaven with my bootless cries
And look upon myself and curse my fate,
Wishing me like to one more rich in hope,
Featured like him, like him with friends possess'd,
Desiring this man's art and that man's scope,
With what I most enjoy contented least;
Yet in these thoughts myself almost despising,
Haply I think on thee, and then my state,
Like to the lark at break of day arising
From sullen earth, sings hymns at heaven's gate;

For thy sweet love remember'd such wealth brings
That then I scorn to change my state with kings.

In sonnet 55, Shakespeare asserts that "this powerful rhyme," his poem, will outlive monuments made of stone and adorned with gold to grant the object of the poem a form of immortality.

READING 14.21 WILLIAM SHAKESPEARE

Sonnet 55

Not marble nor the gilded monuments
Of princes shall outlive this powerful rhyme;
But you shall shine more bright in these contents
Than unswept stone, besmear'd with sluttish time.
When wasteful war shall statues overturn,
And broils[18] root out the work of masonry,
Nor Mars his sword nor war's quick fire shall burn
The living record of your memory.
'Gainst death and all-oblivious enmity
Shall you pace forth; your praise shall still find room,
Even in the eyes of all posterity
That wear this world out to the ending doom.
So, till the judgment[19] that yourself arise,
You live in this, and dwell in lovers' eyes.

Sonnet 116 is in effect a vow of love based on the marriage of minds. In one interpretation, the sonnet recognizes that there are disagreements and conflicts enough between lovers, but the marriage of "true minds" is not broken by argument or even by the toll taken by time. In another interpretation, the sonnet is a confession of love—presumably platonic[20] for Shakespeare's mysterious aristocratic male friend.

14.22 WILLIAM SHAKESPEARE

Sonnet 116

Let me not to the marriage of true minds
Admit impediments.[21] Love is not love
Which alters when it alteration finds,
Or bends with the remover to remove:

18. Disturbances.

19. Judgment Day.

20. Without sexual activity.

21. During a traditional wedding ceremony, the congregations is asked, "If any of you know cause or just *impediment* as to why these persons should not be joined together, speak now or forever hold your peace."

Plutarch and Shakespeare's Description of Cleopatra on the Barge

Plutarch (ca. 46–after 119 CE) was born into a wealthy Greek family and became a citizen of Rome. He was a philosopher in the tradition of Plato, and attempted to tease out Plato's basic doctrines from his writings and develop them into a more coherent system. Yet he is best known for his historical tome, *Parallel Lives,* a work of epic proportions that compares and contrasts the lives of important Greeks and Romans. In his recounting of the life and assassination of Julius Caesar, we find much of the source of the Shakespearean play *Julius Caesar.*

Parallel Lives was translated into French by Jacques Amyot in 1559, and from the French into English by Sir Thomas North 20 years later. Shakespeare's play *Antony and Cleopatra* was written about 1603–1608 and is based on the North translation. One of the most stirring passages of *Antony and Cleopatra* describes the arrival of Cleopatra, queen of Egypt, on her riverboat, or barge, as she comes to meet with Antony, the Roman general who avenged Caesar's death and who will ultimately confront Octavian—the great-nephew of Julius Caesar—for control of the Roman Empire. North translates the passage as follows.

Plutarch
*From Parallel Lives, "Marcus Antonius" (XXVI)**

> Therefore when she was sent unto by diverse letters, both from Antonius himself and also from his friends, she made so light of it and mocked Antonius so much that she disdained to set forward otherwise but to take her barge in the river of Cydnus, the poop** whereof was of gold, the sails of purple, and the oars of silver, which kept stroke in rowing after the sound of the music of flutes . . . , cithernes,*** viols, and such other instruments as they played upon in the barge. And now for the person of herself: she was laid under a pavilion of cloth of gold of tissue, appareled and attired like the goddess Venus commonly drawn in picture; and hard by her, on either hand of her, pretty fair boys appareled as painters do set forth the god Cupid, with little fans in their hands, with the which they fanned wind upon her. Her ladies and gentlewomen also, the fairest of them were appareled like the nymphs Nereides (which are the mermaids of the waters) and like the Graces, some steering the helm, others tending the tackle and ropes of the barge, out of which there came a wonderful passing sweet savour of perfumes, that perfumed the wharf's side, pestered with innumerable multitudes of people.

Shakespeare put his own poetic stamp on the scene, writing in blank verse and imbuing the winds and waters with life.

Antony and Cleopatra, act 2, scene 2, lines 192–206

> The barge she sat in, like a burnished throne,
> Burned on the water: the poop was beaten gold;
> Purple the sails, and so perfumèd, that
> The winds were lovesick with them; the oars were silver,
> Which to the tune of flutes kept stroke, and made
> The water which they beat to follow faster,
> As amorous of their strokes. For her own person,
> It beggared all description: she did lie
> In her pavilion, cloth-of-gold of tissue,
> O'erpicturing that Venus where we see
> The fancy outwork nature. On each side her
> Stood pretty dimpled boys, like smiling Cupids,
> With diverse-coloured fans, whose wind did seem
> To glow the delicate cheeks which they did cool,
> And what they undid did.

Note the alliteration in the first two lines of the Shakespeare: *barge, burnished, burned, beaten. Purple* and *perfumèd* are found in the third line. Also consider the barge "burning" on the water—a metaphor for reflecting the brilliance of the Egyptian sun. Consider the fanciful metaphor that the winds were lovesick with the perfumed sails, and the metaphor that chases it—that the water pushed back by the oars moved faster to try to catch up, as if jealous of ("as amorous of") the strokes. Note the play on words—that the fanning of Cleopatra's cheeks, meant to cool her in the Egyptian heat, made her cheeks glow, such that what it "undid [it] did"—that is, in deflecting heat, it created heat. Read the passage aloud, reading *perfumèd* as three syllables, and the rhythms thrust it forward as the oars propel the barge.

* *Shakespeare's Plutarch,* ed. T. J. B. Spencer, trans. Sir Thomas North (Location: Penguin Books, 1968).

** An enclosed structure at the back of a boat or ship.

*** A stringed instrument similar to a guitar.

O no! it is an ever-fixed mark
That looks on tempests and is never shaken;
It is the star to every wandering bark,
Whose worth's unknown, although his height be taken.
Love's not Time's fool, though rosy lips and cheeks
Within his bending sickle's compass come:
Love alters not with his brief hours and weeks,
But bears it out even to the edge of doom.
If this be error and upon me proved,
I never writ, nor no man ever loved.

Sonnet 130 is a playful expression of the old adage that love is blind. The speaker's love is actually far from blind in this case, but it is deep and steady. Shakespeare admits that the features of his lover cannot be compared to the wonders of nature. Yet he so adores her that reality matters not.

READING 14.23 WILLIAM SHAKESPEARE

Sonnet 130

My mistress' eyes are nothing like the sun;
Coral is far more red than her lips' red;
If snow be white, why then her breasts are dun[22];
If hairs be wires, black wires grow on her head.
I have seen roses damasked, red and white,
But no such roses see I in her cheeks;
And in some perfumes is there more delight
Than in the breath that from my mistress reeks.
I love to hear her speak, yet well I know
That music hath a far more pleasing sound;

I grant I never saw a goddess go;
My mistress when she walks treads on the ground.
And yet, by heaven, I think my love as rare
As any she belied with false compare.

In the year he wrote *The Tempest*, Shakespeare left London and retired to Stratford to live out the remaining years of his life in comparative prosperity. Although he continued to write, it is tempting to see in lines he gave to Prospero toward the end of *The Tempest* his own farewell to the theater and to the world he created for it:

READING 14.24 WILLIAM SHAKESPEARE

The Tempest, act 4, scene 1, lines 148–158

Our revels now are ended. These our actors,
As I foretold you, were all spirits, and
Are melted into air, into thin air.
And, like the baseless fabric of this vision,
The cloud-capped towers, the gorgeous palaces,
The solemn temples, the great globe itself—
Yea, all which it inherit—shall dissolve
And, like this insubstantial pageant faded,
Leave not a rack behind. We are such stuff
As dreams are made on, and our little life
Is rounded with a sleep.

22. A dull brownish color.

GLOSSARY

Anabaptist (p. 466) A member of a radical 16th-century reform movement that viewed baptism solely as a witness to the believer's faith; therefore, Anabaptists denied the usefulness of baptism at birth and baptized people mature to enough to understand their declaration of faith.

Anthem (p. 487) The English term for a *motet*; a choral work having a sacred or moralizing text; more generally, a song of praise.

Ayre (p. 489) A simple song for one voice accompanied by other voices or by instruments.

Blank verse (p. 493) Unrhymed **iambic pentameter**.

Chanson (p. 486) A song that is free in form and expressive in nature; A French word meaning *song*.

Communion (p. 466) A Christian **sacrament** in which consecrated bread and wine are consumed as memorials to the death of Christ or in the belief that one is consuming the body and blood of Christ.

Counterpoint (p. 487) In music, the relationship between two or more voices that are harmonically interdependent but combine in a harmonic manner.

Couplet (p. 491) A pair of rhyming lines of poetry.

Curia (p. 469) The tribunals and assemblies through which the pope governed the church.

Engraving (p. 474) An image created by cutting into or corroding with acid the surface of a metal plate or wooden block, such that a number of prints of the image can be made by pressing paper or paperlike materials against the plate or block.

Galleon (p. 463) A ship with three or more masts used as a trader or warship from the 15th through 18th centuries.

Ground (p. 492) In drama, an open area in front of the stage.

Groundling (p. 493) The name given an audience member at a dramatic event who stands in the pit or ground rather than being seated (because admission is generally less expensive).

Iambic pentameter (p. 491) A poetic metrical scheme with five feet, each of which consists of an unaccented syllable followed by an accented syllable.

Iambic tetrameter (p. 493) A poetic metrical scheme with four feet, each of which consists of an unaccented syllable followed by an accented syllable.

Iconoclastic (p. 472) Having to do with the destruction or removal of sacred religious images.

Indulgence (p. 465) According to Roman Catholicism, removal or remission of the punishment that is due in purgatory for sins; the forgiving of sin upon repentance.

Linear perspective (p. 474) A system of organizing space in two-dimensional media in which lines that are in reality parallel and horizontal are represented as converging diagonals; the method is based on foreshortening, in which the space between the lines grows smaller until it disappears, just as objects appear to grow smaller as they become more distant.

Omnipotent (p. 466) All-powerful.

Omniscient (p. 466) All-knowing.

Philologist (p. 469) A person who studies the history of language in written sources; a scholar of the changes in language over time.

Pit (p. 492) In drama, an open area in front of the stage.

Quatrain (p. 491) A verse of poetry with four lines.

Sacrament (p. 466) A visible sign of inward grace, especially a Christian rite believed to symbolize or confer grace.

Soliloquy (p. 496) A passage in a play spoken directly to the audience, unheard by other characters, and often used to explain the speaker's motives.

Sonnet (p. 490) A 14-line poem usually broken into an octave (a group of eight lines) and a sestet (a group of six lines); rhyme schemes can vary.

Thesis (p. 465) An academic proposition; a proposition to be debated and proved or disproved (plural *theses*).

Virginal (p. 488) An early keyboard instrument small enough to be held in the lap of the player.

THE BIG PICTURE THE RENAISSANCE IN THE NORTH

Language and Literature

- Thomas More published *Utopia* in 1516.
- Thomas Wyatt brought the sonnet into the English language ca. the 1530s.
- Montaigne published his first essays in 1580.
- Queen Elizabeth I penned "On Monsieur's Departure" ca. 1582.
- Marlowe wrote *Tamburlaine the Great* ca. 1587 and staged *Doctor Faustus* ca. 1593.
- Spenser worked on *The Faerie Queene* ca. 1590–1596.
- Shakespeare's plays were written and first performed ca. 1590–1610; *Romeo and Juliet*, ca. 1595; *Julius Caesar*, ca. 1599; *Hamlet*, ca. 1600; *Antony and Cleopatra*, ca. 1603–1608.
- The King James Version of the Bible was translated ca. 1604–1611.

Art, Architecture, and Music

- Bosch painted the *Garden of Earthly Delights* ca. 1505–1510.
- Isaac and Senfl were active ca. 1510.
- Dürer painted a self-portrait ca. 1500 and produced his *Meisterstiche* in 1513 and 1514.
- Grünewald completed the Isenheim altarpiece in 1515.
- The Château de Chambord was begun in 1519.
- Marot and Janequin composed chansons ca. 1520.
- Altdorfer painted the *Battle of Alexander at Issus* in 1529.
- Clouet painted his portrait of Francis I ca. 1523–1530.
- Hans Holbein the Younger painted his wedding portrait of King Henry VIII in 1540; he painted the portrait of Anne of Cleves at about the same time.
- The first English-language litany, based on Gregorian chant, appeared in 1544.
- The renovation of the Louvre into the structure we see today was begun in 1546.
- Bruegel painted his major works ca. 1562–1567.
- Tallis composed *Lamentations of Jeremiah* ca. 1570.
- Hilliard painted his *Ermine Portrait of Queen Elizabeth I* in 1585 and *Portrait of a Youth* ca. 1590.
- English madrigals by Byrd, Morley, and Weelkes were sung at the end of the century.

Philosophy and Religion

- Luther presented his 95 theses, triggering the Reformation in Germany, in 1517.
- Luther was excommunicated by Pope Leo X in 1521.
- Erasmus published *De libero arbitrio* (*On Free Will*) in 1524.
- Luther published *De servo arbitrio* (*On the Bondage of the Will*) in 1525.
- Luther published his translation of the Bible in 1534.
- Henry VIII founded the Church of England in 1534.
- Calvin published *Institutes of the Christian Religion* in 1536.
- Saint Ignatius of Loyola founded the Society of Jesus (Jesuits) in 1539.
- The Council of Trent initiated the Counter-Reformation under Jesuit guidance 1545–1564.
- Queen Elizabeth I was excommunicated from the Catholic Church in 1570.
- The Edict of Nantes established religious toleration in France in 1598.

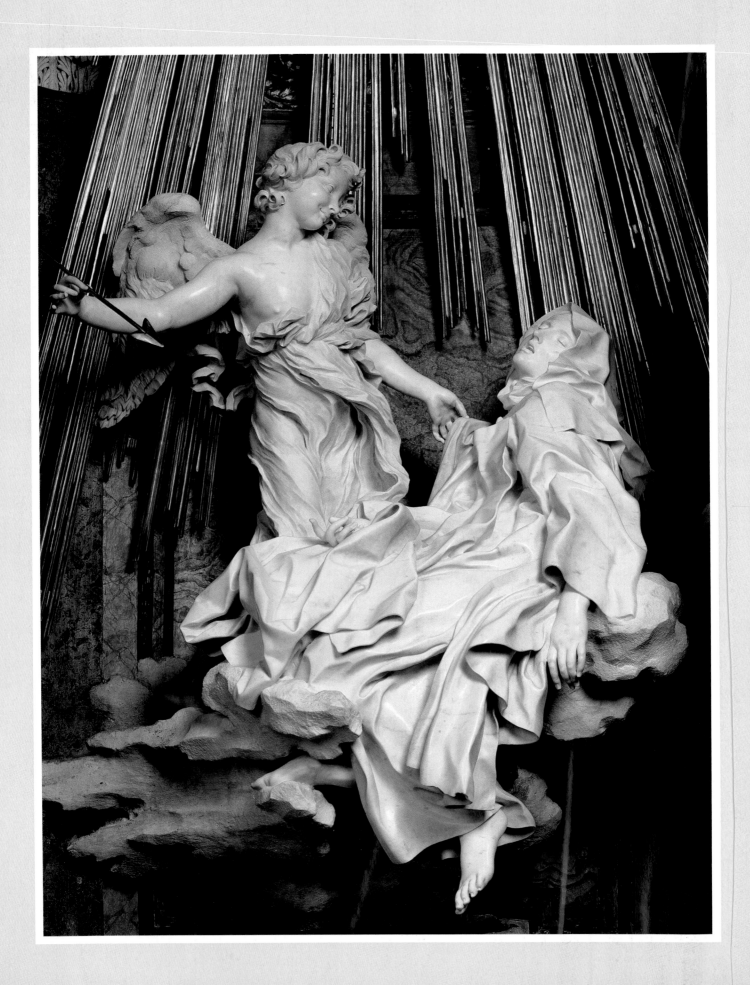

The Seventeenth Century: The Baroque Era

15

PREVIEW

Teresa Sánchez de Cepeda y Ahumada was born in the province of Ávila, Spain, on March 28, 1515, just two years before Martin Luther's 95 Theses laid the groundwork for the Protestant Reformation. When she was 30 years old, Pope Paul III convened the Council of Trent in Rome to address Luther's grievances (widespread corruption among the church's elite and the scandal of indulgences) and to reaffirm the basic tenets of Catholic dogma (transubstantiation, the sacraments, veneration of the Virgin Mary and saints, salvation through faith and good works). With these reforms came the institution of new religious orders—the Jesuits, Capuchins, and the Discalced Carmelites among them. They would provide a support system for the Catholic Reformation, or Counter-Reformation, through teaching and missionary work as well as ministries that emphasized personal and private spiritual communion with Jesus Christ achieved through internal prayer. By the time the Council of Trent disbanded in 1563, Teresa of Avila would be 48 years old and would have become one of the most forceful instruments of the Counter-Reformation—a theologian, mystic, writer, and Carmelite nun. The grandchild of a Spanish Jew who had been forced to convert to Christianity during the Inquisition, Teresa Sánchez de Cepeda y Ahumada—Teresa of Ávila—was canonized by Pope Gregory XV in 1622, just 40 years after her death. In 1970, Pope Paul VI bestowed upon her the honor of doctor of the church—a title granted to only two women in the history of Catholicism.

The central theme of Teresa's writings is the soul's mystical union with God—a process that begins with contemplative mental prayer, followed by progressive states of being in which control of human will and faculties is overtaken by the supernatural, rapturous experience of divine love. The final state in the ascent of the soul and its complete absorption in God was described by Teresa as *ecstasy*, in which the body and the spirit—in a trance sometimes accompanied by levitation—experience sensations of pain and pleasure, stimulation and unconsciousness. Teresa described one particular ecstatic event in her autobiography.

I saw in his hand a long spear of gold, and at the iron's point there seemed to be a little fire. He appeared to me to be thrusting it at times into my heart, and to pierce my very entrails; when he drew it out, he seemed to draw them out also, and to leave me all on fire with a great love of God. The pain was so great, that it made me moan; and yet so surpassing was the sweetness of this excessive pain, that I could not wish to be rid of it. The soul is satisfied now with nothing less than God. The pain is not bodily, but spiritual; though the body has its share in it. It is a caressing of love so sweet which now takes place between the soul and God, that I pray God of His goodness to make him experience it who may think that I am lying.[1]

< **15.1** Gian Lorenzo Bernini, *The Ecstasy of Saint Teresa*, 1645–1652. Marble group, 138″ (350 cm) high. Cornaro Chapel, Santa Maria della Vittoria, Rome, Italy.

1. In *The Wonders of the Heart of St. Teresa of Jesus*. Translated by David Lewis. Baltimore: John B. Piet & Co., 1882. Chapter XXIX, Part 17, Teresa's *Autobiography*.

Thirty years after Teresa's canonization, just as the Counter-Reformation was drawing to a close, Gian Lorenzo Bernini—the most sought-after sculptor in Baroque Italy—captured her words in stone (Fig. 15.1). After the Renaissance, during which teachings of the church were viewed through a humanist, rationalist lens, Teresa's mystical writings reaffirmed the drama and mystery of faith. The re-creation in art of such extremes of emotion as she described fit hand in glove with the Counter-Revolution theory that contemplation of these spiritual experiences would inspire fervent devotion. The new style of the **Baroque** era—a style that embraced theatricality, passion, and human drama—would prove to be a perfect match.

THE SPIRIT OF THE COUNTER-REFORMATION

By about 1600, the intellectual and artistic movements of the Renaissance and Reformation had taken a new turn. Although the cultural activity of the following 150 years was the natural outgrowth of earlier developments, the difference in spirit—already signaled by the middle of the 16th century—was striking.

The chief agent of this new spirit was the Roman Catholic Church. After its initial shock at the success of Protestantism, the church decided that the best defense was a well-planned offense. It relied in great measure on new religious orders such as the Jesuits to lead the movement known as the **Counter-Reformation**. Putting behind the anxieties of the past, the chief representatives of the Counter-Reformation gave voice to a renewed spirit of confidence in the universality of the church and the authority of its teachings.

The official position of the church was newly stated at the Council of Trent, which met sporadically from 1545 to 1563. Under the leadership of Pope Paul III, the council redefined Catholic doctrines and reaffirmed those dogmas that Protestantism had challenged. Transubstantiation, the apostolic succession of the priesthood, the belief in purgatory, and the rule of celibacy for the clergy were all confirmed as basic to the Catholic system of faith. The pope remained as the monarchical ruler of the church. At the same time, the council tried to eliminate the abuses by the clergy that had fueled Martin Luther and the Reformation, and to tighten discipline. Bishops and priests could no longer hold more than one benefice, and theological seminaries were set up in every diocese to improve the level of education of priests.

One of the key instruments in the campaign to reestablish the authority of the church was the Society of Jesus, an order—founded in 1534 by Ignatius Loyola (1491–1556)—of priests and brothers called Jesuits who dedicated themselves to the defense of the faith. Loyola was a Spanish nobleman and a career soldier who embraced a life of religious devotion after suffering a serious wound. His Spiritual Exercises (begun 1522–1523) express a mystical, even morbid spirit of introspection, inspired by visions of Satan, Jesus, and the Trinity. A similarly heightened spiritual sense and attempt

The Seventeenth Century

1600 CE	1621 CE	1648 CE	1682 CE	1700 CE
The Dutch dominate global trade	Philip IV is king of Spain	The Peace of Westphalia ends Thirty Years' War; the Counter-Reformation ends	Louis XIV moves the French court from Paris to Versailles	
James VI, king of Scotland, ascends the English throne as James I	Teresa of Ávila is canonized by Pope Gregory XV	England is ruled by Oliver Cromwell	Isaac Newton publishes a monograph describing his laws of motion	
Holland and Flanders achieve independence from Spain in the Twelve Years' Truce	New Saint Peter's is consecrated by Pope Urban VIII, who patronizes the arts on a grand scale	The rings of Saturn are discovered	William of Orange invades England, leading to the deposition of James II; William and his wife Mary become joint sovereigns of England, Ireland, and Scotland	
Galileo invents and improves telescopes	Louis XIV, the Sun King, ascends the French throne at the age of five and reigns until 1715	Cromwell dies and the English monarchy is restored under Charles II		
Louis XIII of France ascends to throne at the age of nine; the country is ruled by his mother, Marie de Medici, for seven years as regent	Charles I of England, a supporter of the divine right of kings, rules without Parliament	Most of London is destroyed by a fire that lasts for five days	The Bill of Rights establishes English constitutional government and limits the sovereign's power	
Thirty Years' War	Galileo is found guilty of heresy and forced to recant his discovery that the sun is the center of the solar system	Van Leeuwenhoek discovers bacteria with a microscope	The Salem Witch Trials begin in Massachusetts	
Kepler reveals his laws of planetary motion				
Puritans set sail for North America on the *Mayflower*				

to describe mystical experiences occurs in the writings of other Spanish Catholics of the Counter-Reformation, most notably, as we saw at the outset of this chapter, Saint Teresa of Ávila (1515–1582) and Saint John of the Cross (1542–1591). Saint John wrote powerfully of the soul's emergence from the "dark night" to attain union with God.

Loyola's Jesuits soon became the most militant of the religious movements to appear during the 16th century. The members were organized on the model of a military company, led by a general as their chief commander and required to exercise iron discipline. The Jesuits led their charge not with swords or guns, but with eloquence and the power of persuasion. Their duty was simple: to promote the teachings of the church unquestioningly. Loyola taught that if the church ruled that black was white, its followers were obliged to believe it. They reinforced this position by their vigorous missionary work throughout Europe, the Americas, and Asia, while improving educational institutions throughout Catholic Europe.

At the same time, the Council of Trent called on artists to remind Catholics of the power and splendor of their religion by commissioning a massive quantity of works of art dedicated to underlining the chief principles of Counter-Reformation teachings. Now it was the task of religious leaders and, under their guidance, of artists to make this position known to the faithful. New emphasis was placed on clarity and directness. The impression of the church's triumphant resurgence was further reinforced by a new emphasis on material splendor and glory.

Il Gesù

The Jesuits were key figures in the Counter-Reformation strategy of the Catholic Church, so it stands to reason that they would desire worship spaces to accommodate their growing influence and to showcase the spectacle of Counter-Reformation art and ceremony. The Church of Most Holy Name of Jesus in Rome, called il Gesù, is on a familiar basilican plan, designed to accommodate large crowds in its very wide and long nave (**Fig. 15.2**).

▾ **15.2** Giacomo della Porta, central nave of il Gesù, ca. 1575–1584. Rome, Italy.

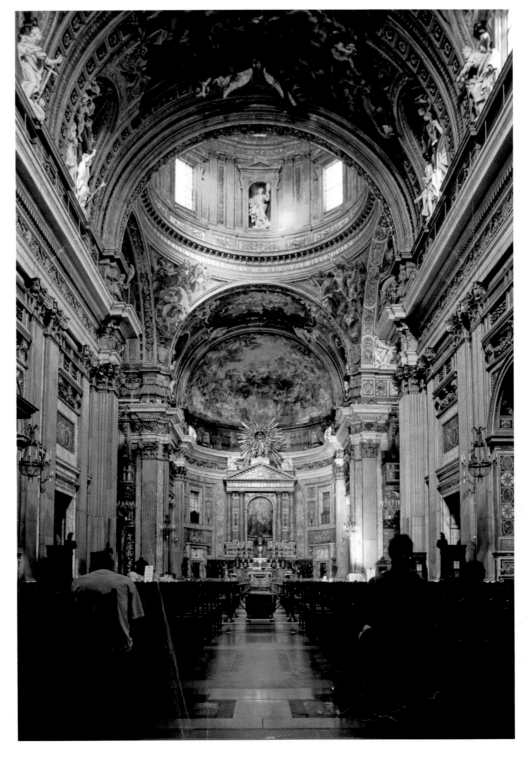

One can imagine the elaborate processions of exquisitely clothed clergymen passing through throngs of worshippers as they pressed toward the altar carrying gold and silver liturgical objects studded with precious stones, music rising around them, incense filling the air. Above it all, a spectacular ceiling whose illusion was so complete that the boundaries between heaven and earth seem to be erased (**Fig. 15.3**). It is as if the gilded vault of the church is literally open, creating the sensation that the devout worshipper might be transported to another realm. Within a mesmerizing, brilliant, yellow-white light, a monogram for the Holy Name of Jesus—IHS—hovers, venerated by a host of angels and saints buoyed by clouds. This sublime realm is accessible only to the devout, however. At the same time that the faithful's eyes are drawn heavenward to salvation in Christ, sinners are cast out, their tangled and writhing bodies painted on stucco panels that jut outside the painting's lozenge-shaped frame. Painting, sculpture, and architecture were conjoined in the service of maximum drama and theatricality, enhanced by the compelling strains of organ music. Not only were interiors such as these dazzling to the eyes; they were intended to fire all of the human senses.

The architect of Il Gesù was Giacomo Barozzi da Vignola. After da Vignola's death, the project was continued by Giacomo della Porta, who designed many features of the church, including the façade. (Della Porta also completed the dome of Saint Peter's during the late years of the Renassion (1568–1584). The ceiling frescoes, including the *Triumph of the Name of Jesus* by Giovanni Battista Gaulli, were painted 100 years later, during the Baroque era. The Jesuit church is synonymous with the spirit of the Counter-Reformation, but the artistic style of the interior is wholly Baroque.

THE BAROQUE

The origins of the word *baroque* are obscure. It may be related to the Portuguese *barroco*—an irregularly shaped pearl—or to the Italian *baroco*—a term used to describe a complicated problem in medieval logic. The catchall term does convey the multiplicity of artistic styles of the era; the 17th century was filled with artists working all over Europe whose art would be described as anything but uniform. Yet their work reveals some common characteristics: complexity, spontaneity, drama, theatricality, virtuosity, opulence, and monumentality.

Perhaps the most striking, though, is the primacy of emotion. Renaissance art, for example, revisited the perfect balance between emotion and restraint that was central to Classical philosophy and art; Baroque artists, on the other hand, placed extremes of human behavior and emotion front and center. The dramatic nature of their often violent subjects was reinforced by theatrical spotlighting, sanguine palettes, and exaggerated gestures; artists gravitated to such subjects because they provided an opportune vehicle for the artists' edgy, unrestrained styles.

This concern with emotion produced in its turn an interest in what came to be called *psychology*. Baroque artists attempted to analyze how and why their subjects felt as strongly as they did by representing emotional states as vividly as possible. This psychological exploration is also evident in 17th-century opera and drama, in which musical or spoken passages convey the precise frame of mind of the characters. Baroque writers often used elaborate imagery and complicated grammatical structure to express intense emotional states.

New and daring techniques accompanied these dramatic changes in artistic expression, and Baroque artists gained attention for their unconventional styles and virtuoso handling of their media or instruments. In the hands of Baroque sculptors, stone was transformed into extraordinary illusions of flesh and fabric; composers wrote pieces of increasing complexity whose challenging notes inaugurated the tradition of the virtuoso performer that reached its climax in the 19th century.

Although the term *Baroque* is applied mainly to the visual and performing arts, it is also used to describe the entire cultural achievement of the age. Baroque culture and values were astonishingly diverse, affected by different religious, political, and social pressures in very different parts of Europe. They comprise, indeed, an irregularly shaped pearl. And much of it, at least in the arts, was inspired by the Counter-Reformation of the Catholic Church.

THE BAROQUE PERIOD IN ITALY

Saint Peter's

The Baroque era was born in Rome, where a series of powerful popes—Paul V, Gregory XV, Urban VIII, Innocent X, and Alexander VII—wielded power and influence in the realms of religion, politics, and art. This is perhaps nowhere more evident than in the expansion and renovation of Saint Peter's in Vatican City, Rome (**Fig. 15.4** on page 510).

Constantine's basilica, Old Saint Peter's, was consecrated in November of 326 CE and was only half the size of the structure as it stands today. Its interior was decorated with mosaics and frescoes and was the site of monuments dedicated to popes and emperors; Charlemagne was crowned Holy Roman emperor in Old Saint Peter's by Pope Leo III in 800 CE. As the most important pilgrimage destination for Christians, the old basilica was deemed inadequate, yet the impetus to do something about it came only in the mid-15th century with Pope Nicholas V. The first significant changes to Old Saint Peter's, however, came with his successor, Julius II—patron of Michelangelo and Raphael. Julius decided on a complete reconstruction of the old basilica and put the architect Bramante in charge of demolishing parts of the old structure and replacing them with a much grander vision. After

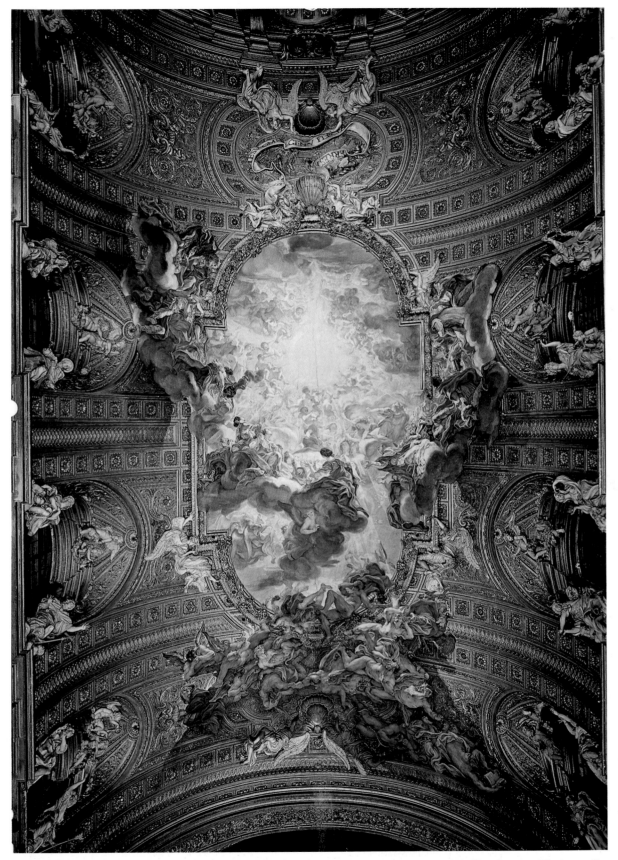

▲ **15.3** Giovanni Battista Gaulli, *Triumph of the Name of Jesus*, 1676–1679. Nave vault ceiling fresco with stucco figures. **The Church of Most Holy Name of Jesus (il Gesù), Rome, Italy.** Baroque ceiling decorations were not partitioned as Renaissance ceilings were. Figures painted on plaster seem to spill out beyond the gilded frame, heightening the illusion of reality.

Julius's death, the "new" Saint Peter's proceeded in fits and starts over a succession of popes—some who supported the arts, at least one who despised them, and some who were so overwhelmed by political disturbances that they were incapable of doing anything else.

It was Pope Paul V who ordered dismantled whatever remained of Old Saint Peter's—and even some parts that were new and just not workable—and hired the architect Carlo Maderno to design a long-nave for a Latin-cross plan as well as a new façade. On November 18, 1626—the 1300th anniversary of the consecration of Old Saint Peter's by Constantine—the new Saint Peter's was consecrated by Paul V's successor, Urban VIII. From the beginning of the redesign of St. Peter's in the mid-15th century to its completion, 27 popes had come and gone and almost every Renaissance artist of note was associated in some way with the build-

ing: Alberti, Bramante, Raphael, Michelangelo, Giacomo della Porta, and many more. Urban VIII would be known as the first of the Baroque builder-popes. He was also the grand patron of the era's most prolific and accomplished sculptor—Gian Lorenzo Bernini.

Baroque Sculpture and Architecture in Rome

GIAN LORENZO BERNINI Before a visitor encounters the spectacular scale of the nave of Saint Peter's, or stands beneath Michelangelo's breathtaking dome over the massive piers of its crossing square, or has an intimate encounter with the heart-rending scene of a mother and her dead child in Michelangelo's *Pietà*—that visitor has passed through an elliptical piazza in

▼ **15.4 Saint Peter's Basilica and Piazza. Façade 147′ high × 374′ (44.8 × 114 m) long. Vatican City State, Italy.** The building combines Renaissance and Baroque elements. The nave and façade were finished by Carlo Maderna (1556–1629) between 1606 and 1612, and the colonnades around the square were built between 1656 and 1663 to Bernini's design.

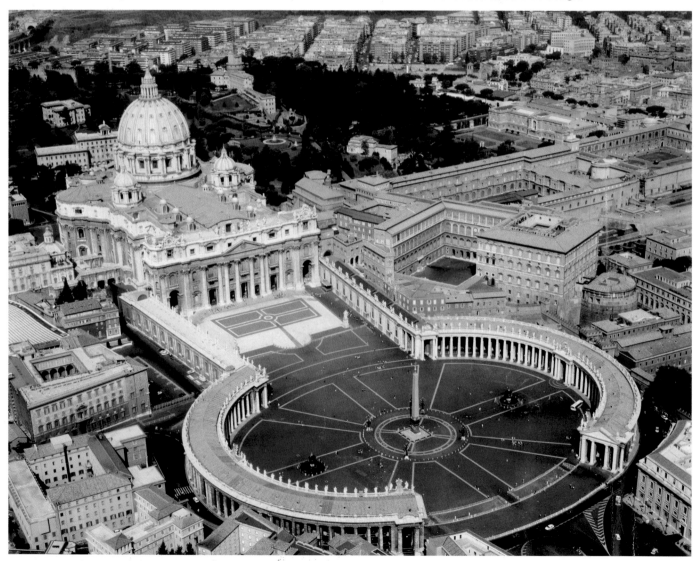

◀ **15.5** Alberto Hamerani, Papal medal showing a bust of Alexander VII wearing a tiara and cope; reverse showing the colonnade and Piazza San Pietro, 1666. Cast-lead, 1⅝″ (42 mm). Private Collection.

front of the basilica and has been caressed by the arms of colonnades that extend from the façade and seem to draw one into the spiritual comfort of the bosom of the church. This is Bernini's piazza—and but one of his many theatrical creations. His seemingly unlimited range of expression and unparalleled technical virtuosity as a sculptor represented one of his artistic dimensions; as the chief architect of Counter-Reformation Rome, he also permanently changed the face of that venerable city.

Bernini's patron for the colonnades was Pope Alexander VII, whose profile can be seen on one side of a commemorative coin marking the construction; the other side of the coin bears an image of a diminutive Saint Peter's against the exaggerated scale (and importance, in Alexander's mind) of the colonnades and piazza (**Fig. 15.5**).

The coin shows that a third, center section of the colonnade, which would have obscured a full-frontal view of Maderno's façade, was never built. Commemorative coins of this type—but with different images—provide a veritable timeline of progress on Saint Peter's and, importantly, connect specific popes with the significant projects they sponsored in Vatican City and in Rome. Another such coin, for example, commemorates the building of Bernini's **baldacchino**, the glorious bronze-columned canopy

that stands approximately 100 feet high over the main altar of Saint Peter's, above the saint's tomb and beneath Giacomo della Porta's dome (**Fig. 15.6**). In the apse, visible through the

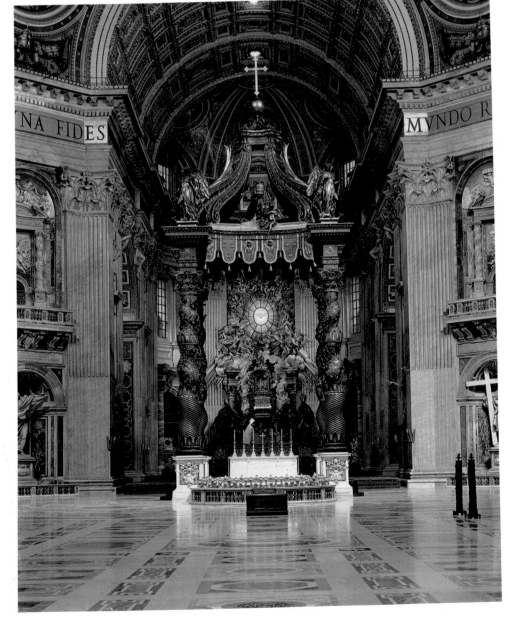

> **15.6** Gian Lorenzo Bernini, Baldacchino, Saint Peter's, 1624–1633. Vatican City State, Italy. The canopy stands nearly 100 feet (30.5 m) above the main altar of Saint Peter's.

baldacchino, Bernini combined architecture, sculpture, and stained glass in a brilliant gold setting for the Cathedra Petri, or Throne of Saint Peter. Pope Urban VIII commissioned both of these projects. Bernini also designed the tombs of Urban VIII and Alexander VII in Saint Peter's.

Bernini had another, earlier patron in the upper echelons of the Vatican—Cardinal Scipione Borghese, the nephew of Pope Paul V. Many of Bernini's famed secular sculptures of mythological subjects were created for the Villa Borghese, as was his version of *David* (**Fig. 15.7**)—at once homage to those of his Florentine predecessors and a sharp departure from them. Bernini's *David* illustrates two of the most dramatic characteristics of Baroque sculpture: time and motion. Bernini does not depict David before or after the fight, but during. We do not look upon David; we are swept up in the action that unfolds around us with David as the eye of the storm. From his furrowed brow, clenched jaw, and pressed lips to the muscular tension of his arms and the grasping toes of his right foot, this David personifies energy, almost exploding through space. The expressive power of the action is enhanced by deep cuts in the stone that create strong contrasts of light and shadow; slashing diagonals draw the eye around the work along a spiral path. David's body is like a coiled spring. In its violent emotion—a young man on the physical and psychological brink—and its virtuoso technique, Bernini's *David* epitomizes the Baroque style.

The dynamism and drama that we see in the *David* would reach its fullest and most radical expression in works like *The Ecstasy of Saint Teresa* for the Cornaro family chapel in the church of Santa Maria della Vittoria in Rome. Bernini combined architecture, sculpture, and natural light (from a concealed window above the figures) to drama-

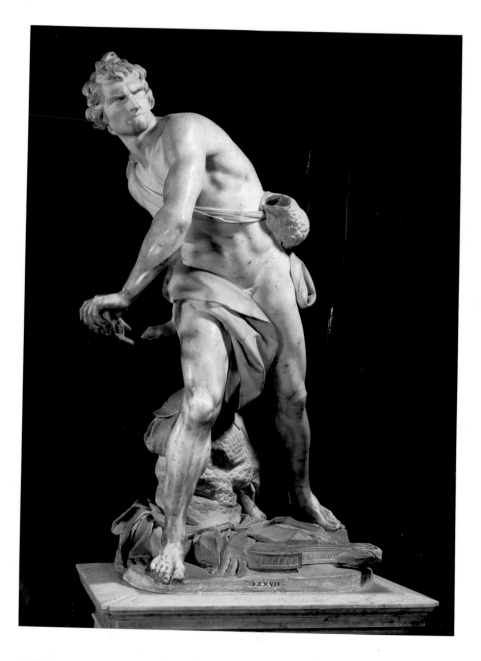

◀ **15.7** Gian Lorenzo Bernini, *David*, 1623. Marble, 66¼" (170 cm) high. Galleria Borghese, Rome, Italy. Bernini's David captures the in action. The facial expression reinforces the tension of the pose with straining leg and foot muscles.

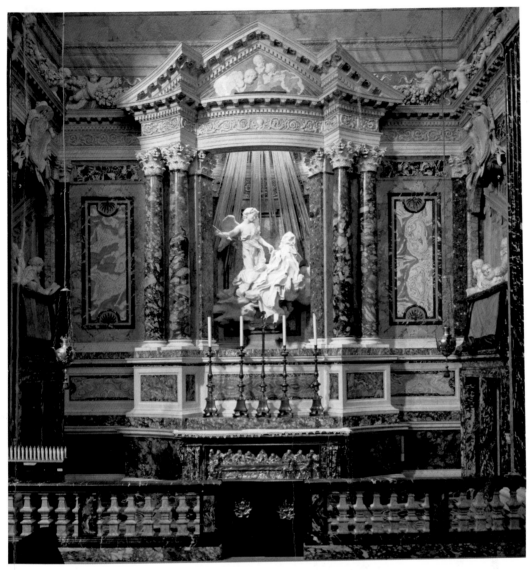

△ 15.8 Gian Lorenzo Bernini, Cornaro Chapel, the altar with *The Ecstasy of Saint Teresa*. Santa Maria della Vittoria, Rome, Italy. To the left and the right, members of the Cornaro family observe the ecstasy from "box seats."

tize the saint's ecstatic vision, which is framed as if on a shallow stage. On the walls of the chapel, left and right, Bernini portrayed members of the Cornaro family observing the event from "box seats" (**Fig. 15.8**). The entire space of the chapel is treated as a theatrical tableau. Perhaps it is not surprising to learn that Bernini also wrote plays and designed stage sets.

We may liken the difference between, say, Michelangelo's *David* and Bernini's *David* to that between Classical and Hellenistic Greek sculpture, the latter of which was marked by an extension of the figure into surrounding space, a strong sense of movement, exaggerated expression, and a large degree of theatricality. The time-honored balance between emotion and restraint coveted by the Classical Greek artist—and adapted in Renaissance works—gave way in the Hellenistic and Baroque periods to unbridled passion.

FRANCESCO BORROMINI Bernini's mother once said of him, "He acts as if he were master of the world." His expansive personality and his resounding success in obtaining high-profile commissions combined to make him the dominant force in the Roman Baroque, but he met stiff competition in Francesco Borromini (1599–1667). Both have been called "stage managers of Baroque theater," and their contentious relationship and obsession with outdoing one another can be described as its own version of theater. They were born within a year of each other but could not have been more different in personality: Bernini was the ultimate insider and showman, a gregarious family man and multifaceted artist, whereas Borromini was a reclusive outsider, a loner, and an "architect's architect." Bernini lived to be 82 and worked up until his death; Borromini committed suicide at the age of 68 (see the Voices feature).

◄ **15.9** Francesco Borromini, San Carlo alle Quattro Fontane, begun 1638, façade finished 1667. Exterior façade 38' (11.58 m) wide. Rome, Italy. The curves and countercurves of the façade, together with the rich decoration, mark a deliberate rejection of the classical style.

Although the element of motion may seem anathema to architecture, Borromini introduced it as a component in several of his buildings. Combined with intricately framed space and dramatic lighting, this familiar Baroque characteristic found its equivalent in architectural design. The façade of Borromini's San Carlo alle Quattro Fontane (**Fig. 15.9**), completed the year of his death, undulates with sinuous curves and countercurves. Light plays across the surfaces, bouncing off the projections and plunging the recessed areas into darkness. The stone seems to pulse and breathe, at once joyous and tormented. This organic feeling echoes the interior of the small church, whose rippling concave and convex walls stretch up to an oval-shaped dome with a honeycomb pattern of coffering (**Fig. 15.10** on page 516). Perhaps for the first time since the Parthenon (see **Fig. 3.4**), a building is seen first as sculpture and only second as architecture.

Baroque Painting in Rome

The Baroque interest in combining the arts of painting, sculpture, and architecture found its home in the naves and domes of churches and cathedrals, as artists used the three media to create unsurpassed illusionism. Unlike Renaissance ceiling frescoes, exemplified by Michelangelo's decoration for the Sistine Chapel, the space of Baroque ceilings was not divided into small frames, each with individual scenes. Rather, the space was conceived as a whole, with the center of the vault "open" to the heavens and figures "migrating" from the actual space of the vault to the illusion of space beyond. Giovanni Battista Gaulli's *Triumph of the Sacred Name of Jesus* (**Fig. 15.3**) is an energetic display of figures that spill out beyond the gilded frame of the ceiling's illusionistic opening. The trompe l'oeil effect was achieved by combining these

painted figures with white stucco-modeled sculptures and a gilded stucco ceiling. Attention to detail is remarkable, from the blinding light of the heavens to the deep shadows painted on the gilded vault that would be there if the figures were indeed real. Artists like Gaulli and their patrons spared no device—no trick of the eye—to create an utterly believable, mystical atmosphere.

The foundations of Baroque painting were laid around 1600 by two artists whose works, at first glance, have little or nothing in common: Michelangelo Merisi, known as Caravaggio (1571–1610), and Annibale Carracci (1560–1609). That both artists exerted an immense influence on their successors says something about the extreme range of Baroque style. Caravaggio explored the darker aspects of life in some of the most naturalistic and dramatic religious pictures ever painted; Carracci delighted the senses with elegant, colorful, and brilliantly lit landscapes and mythological paintings.

ANNIBALE CARRACCI At first glance, it would seem that the ceiling fresco *The Loves of the Gods* (**Fig. 15.11** on page 517) by Annibale Carracci followed the model of Michelangelo's Sistine Chapel with its individually framed paintings, but a closer look reveals a distinct difference. Michelangelo's

frames were painted to look like an architectural framework for the vault; his narrative scenes take place within the rectangular bays, and numerous extra figures inhabit assorted spaces between and among the architectural elements. Carracci's ceiling, on the other hand, consists of discrete pictures of the kind that would be painted on an easel, complete with their decorative frames. The sections in the center on either side of the vault feature what appear to be actual separate paintings, with their own internal lighting scheme, propped up on the ledge of a delicately carved entablature. This particular form of illusionism was called *quadro riportato* (transferred frame painting) and was popularized by Carracci. Other figures—the ones outside the frames—are lit differently, creating the illusion that they are separate and three-dimensional. The many scenes in the gallery (formal reception hall) of the Palazzo Farnese were based on Greek and Roman mythology and depict amorous encounters among the gods; Carracci was commissioned by Cardinal Odoardo Farnese to decorate the ceiling on the occasion of the marriage of his brother.

The Loves of the Gods was painted between 1597 and 1601, at the precise moment when another Italian Baroque painter, Caravaggio, was at work on his paintings for the Contarelli

VOICES

Giambattista Passeri

In this passage the 17th-century painter and biographer Giambattista Passeri describes the suicide of Francesco Borromini, who in the summer of 1667 was tormented by Bernini's triumphant successes.[*]

[Borromini] was assailed again with even greater violence by hypochondria which reduced him within a few days to such a state that nobody recognized him any more for Borromini, so haggard had his body become, and so frightening his face. He twisted his mouth in a thousand horrid ways, rolled his eyes from time to time in a fearful manner, and sometimes would roar and tremble like an irate lion. His nephew [Bernardo] consulted doctors, heard the advice of friends, and had him visited several times by priests. All agreed that he should never be left alone, nor be allowed any occasion for working, and that one should try to make him sleep at all costs, so that his spirit might calm down. This was the precise order which the servants received from his nephew and which they carried out. But instead of improving, his illness grew worse. Finding that he was never obeyed, as all he asked for was refused him; he imagined that this was done in order to annoy him rather than for his good, so that his restlessness increased and as time passed his hypochondria changed into pains in his chest, asthma, and a sort of intermittent frenzy. One evening,

during the height of summer, he had at last thrown himself into his bed, but after barely an hour's sleep he woke up again, called the servant on duty, and asked for a light and writing material.

Told by the servant that these had been forbidden him by the doctors and his nephew, he went back to bed and tried to sleep. But unable to do so in those hot and sultry hours, he started to toss agitatedly about as usual, until he was heard to exclaim "When will you stop afflicting me, O dismal thoughts? When will my mind cease being agitated? When will all these woes leave me? . . . What am I still doing in this cruel and execrable life?" He rose in a fury and ran to a sword which, unhappily for him and through carelessness of those who served him, had been on a table, and letting himself barbarously fall on the point was pierced from front to back. The servant rushed in at the noise and seeing the terrible spectacle called others for help, and so, half-dead and covered in blood, he was put back to bed. Knowing then that he had really reached the end of his life, he called for the confessor and made his will.

[*] By Giambattista Passeri, translated by Rudolf and Margot Wittkower, and included in their book *Born Under Saturn*.

◀ **15.10** Francesco Borromini, the dome of San Carlo alle Quattro Fontane, 1638–1641. Rome, Italy. Borromini used an oval dome rather than a traditional round dome to crown the interior of the church. Some light enters the church from unseen windows around the base of the dome.

Chapel in the Church of San Luigi dei Francesi in Rome. The brilliant, colorful, and idealized world of Annibale Carracci was diametrically opposed to the dark, haunting, emotional world of the Baroque era's most notorious artist.

CARAVAGGIO Caravaggio was an extremely controversial figure in his day—and not just because of his painting. His own lifestyle did little to recommend him to the aristocratic and ecclesiastical patrons on whom he depended. From his arrival in Rome in 1592 until his forced exile in 1606, Caravaggio was in and out of trouble with the law—prone to street brawls, violent outbursts, and a savage temper that alienated potential friends. Although by 1600 his reputation in Rome as a painter had soared, garnering important commissions,

any chances that he had for establishing himself there permanently came to an abrupt end when he (perhaps accidentally) killed a man in 1606. He avoided punishment only by fleeing to Naples and then to Malta, where he was thrown into prison for attacking a police officer. Escaping, he made his way to Sicily and then back again to Naples, where he was involved in yet another violent quarrel, which left him seriously wounded. While in Naples, Caravaggio became aware of the possibility of a papal pardon for the murder in Rome and headed back to that city on a ship with three paintings that he probably thought he could use to seal the pardon. He was detained at a port along the way and his paintings went on without him; all we know is that Caravaggio died before he could reach Rome. The pardon from the pope arrived a few days later.

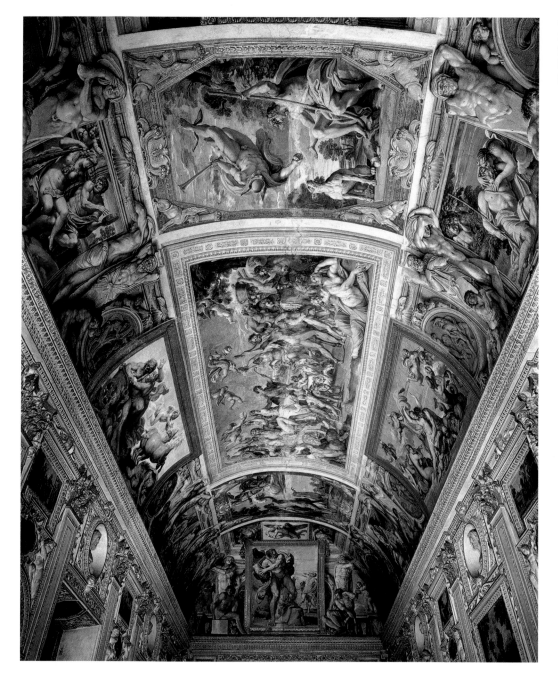

◀ **15.11** Annibale Carracci, *The Loves of the Gods*, 1597–1601. Ceiling frescoes in the gallery of the Palazzo Farnese, Rome, Italy.

The details of Caravaggio's life read like a novel, but nonetheless offer important clues to unlocking the nature of his style. Whereas Bernini could move in the company of popes and princes, Caravaggio had an affinity for what the French would call the *demimonde*, literally the "half-world"—people who drink, gamble, and live on the edge. After all, he was one of them. Just as he rejected the artifice of decorum and moralistic societal values, so too did he reject traditional, idealized portrayals of religious subjects in favor of something more earthy, more real, more believable. The characters in his stories are not lost amid the splendor of elaborate settings as in so many Counter-Reformation works. Rather,

the emphasis is on them—their human anxieties, simple piety, quiet sorrow. Their faces are not the generic, standardized, and often idealized versions typical of other artists; his models were ordinary people—the people around him.

Our attention is drawn to their humanness and individuality, both physical and emotional, as they grapple with their circumstances. As Caravaggio's backgrounds are almost always spare and dark, the atmosphere is close and intimate, and lighting is used to dramatic effect. This technique is called **Tenebrism**, which can be translated as a "dark manner." The effect is harsh and theatrical and was mimicked widely by contemporary Baroque artists in Italy and throughout Europe.

▼ **15.12** Caravaggio, *The Calling of Saint Matthew*, ca. 1600–1602. Oil on canvas, 120⅝" × 132⅞" (322 cm × 340 cm). Contarini Chapel, Church of San Luigi dei Francesi, Rome, Italy. A bright light comes from a mysterious source to the right of the canvas. Jesus, half-hidden on the right, points at Matthew. The artist dramatically directs the light at Matthew's head, and Matthew draws back in fear.

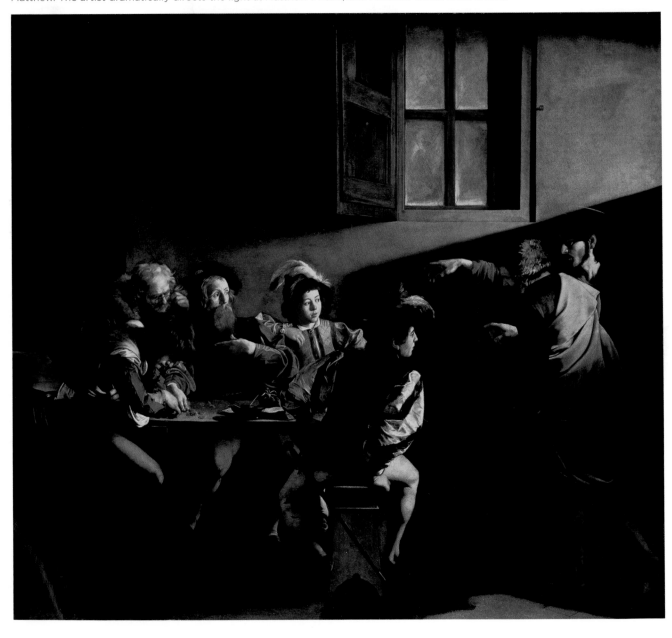

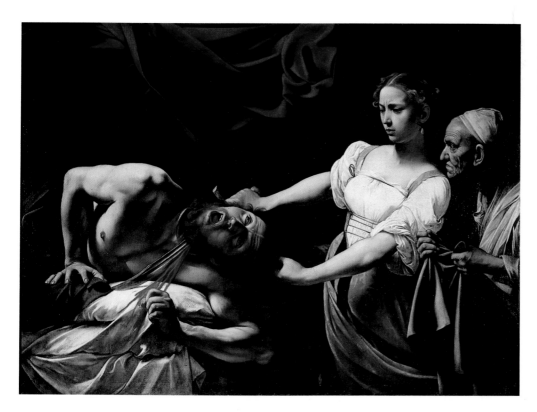

◄ 15.13 Caravaggio, *Judith and Holofernes*, ca. 1598. Oil on canvas, 57" × 77" (145 cm × 195 cm). Galleria Nazionale d'Arte Antica, Palazzo Barberini, Rome, Italy. Caravaggio's painting shows a strangely removed, delicate executioner.

Just five years after Caravaggio came to Rome, he was commissioned by the Contarelli family to paint two works for their chapel in the Church of San Luigi dei Francesi. *The Calling of Saint Matthew* (**Fig. 15.12**) and *The Martyrdom of Saint Matthew* hang on walls opposite one another and thus are connected both spatially and temporally. In one painting, we see Matthew as a young man being called by Jesus to follow him; in the other he is older, about to be slain for his beliefs. The saint's life story is relayed in two distinct but related dramatic moments. In *The Calling of Saint Matthew*, Jesus enters the room from the right and points in the direction of Matthew, who is surrounded by men and is hunched over the table. It is not clear whether Matthew sees Jesus yet, or hears him, or awed and fearful, tries to shrink back into the darkness—to instinctually preserve himself from the destiny that we know will unfold for him. Of course, Matthew will go.

ARTEMISIA GENTILESCHI One of Caravaggio's foremost contemporaries was Artemisia Gentileschi (1593–ca. 1652). Her father—the painter Orazio Gentileschi, who enjoyed much success in Rome, Genoa, and London—recognized and supported Artemisia's talents. Although one of Orazio's choices for her ended in disaster—an apprenticeship with a man who ultimately raped her—Gentileschi came to develop a personal, dramatic, and impassioned Baroque style. Her work bears similarities to that of Caravaggio, her own father, and others working in Italy at that moment, but it often stands apart in the emphatic rendering of its content or in

its reconsideration and revision of subjects commonly represented by 16th- and 17th-century artists.

Consider the roughly contemporary paintings of *Judith and Holofernes* by Caravaggio (**Fig. 15.13**) and *Judith Decapitating Holofernes* by Gentileschi (**Fig. 15.14** on page 520). Both works reference a biblical story of the heroine Judith, who rescues her oppressed people by decapitating the tyrannical Assyrian general Holofernes. She steals into his tent under the cover of night and pretends to respond to his seductive overtures. When he is besotted, with her and with drink, she uses his own sword to cut off his head. Both paintings are prime examples of the Baroque style—vibrant palette, dramatic lighting, an impassioned subject heightened to excess by our coming face-to-terrified-face with a man at the precise moment of his bloody execution. Judith is determined, strong, physically and emotionally committed to the task. In Caravaggio's painting, Holofernes is caught unaware and falls victim in his compromised, drunken state. Gentileschi's tyrant snaps out of his wine-induced stupor and struggles for his life. He pushes and fights and is ultimately overpowered by a righteous woman. What gender differences, if any, can you interpret in these renderings?

Gentileschi's *Judith Decapitating Holofernes* is one of her most studied and violent paintings. She returned to the subject repeatedly in many different versions, leading some historians to suggest that her seeming obsession with the story signified her personal struggle in the wake of her rape and subsequent trial of her accuser, during which she was tortured in an attempt to verify the truth of her testimony. As

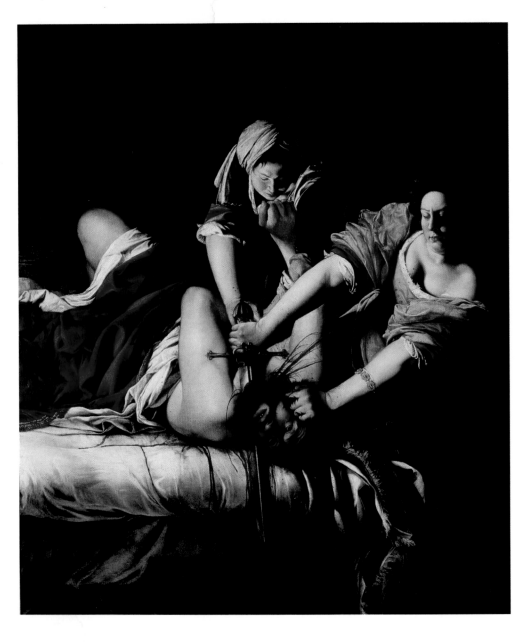

◄ **15.14** Artemisia Gentileschi, *Judith Decapitating Holofernes*, ca. 1620. Oil on canvas, 72½" × 55¾" (199 × 162 cm). Galleria degli Uffizi, Florence, Italy. Gentileschi's Judith is a visually powerful woman who tackles her gruesome task with alacrity.

from south of the Alps. Throughout Northern Europe the rise of the middle class continued to create a new public for the arts, which in turn affected the development of painting, architecture, and music.

The irregularity of styles across and even within regions suggested by the term *Baroque* is again apparent. Artists of Spain and Flanders adopted the Venetian love of color and application of paint in loosely brushed swaths. Northern artists had always been interested in realism, and during the Baroque period they carried this emphasis to an extreme. Paintings of everyday life and activities became the favorite subjects of Dutch artists, who followed in Bruegel's footsteps and perfected the art of genre painting. The Baroque movement also extended into France and England, but there it often manifested in a strict adherence to classicism. For the first time, European culture began to spread across the Atlantic, carried to the Americas by Counter-Reformation missionaries.

with Caravaggio's life and art, do you think that this context is essential to understanding Gentileschi's work?

THE BAROQUE PERIOD OUTSIDE ITALY

During the Renaissance, Italy was the center of virtually all artistic development. Despite the impact of the Counter-Reformation, the Reformation began an irreversible process of decentralization. By the beginning of the 17th century, although Rome was still the artistic capital of Europe, important cultural changes were taking place elsewhere. The economic growth of countries like Holland and England, and the increasing power of France, produced a series of artistic styles that developed locally rather than being imported wholesale

Spain

Spain was one of the wealthiest countries in Europe during the Baroque era—partly because of the influx of riches from the New World—and the Spanish court was lavish in its support of the arts. Painters and sculptors were imported from different parts of Europe for royal commissions, and native talent was cultivated and treasured.

DIEGO VELÁZQUEZ Diego Velázquez (1599–1660) was born in Spain and rose to the position of court painter and confidant of King Philip IV. Although Velázquez relied on Baroque techniques in his use of Venetian colors, highly

contrasting lights and darks, and a deep, illusionistic space, he had contempt for the idealized images that accompanied these elements in the Italian art of the period. Like Caravaggio, Velázquez preferred to use common folk as models to assert a harsh realism in his canvases. Velázquez brought many a mythological subject down to earth by portraying ordinary facial types and naturalistic attitudes in his principal characters. Nor did he restrict this preference to paintings of the masses. Velázquez adopted the same genre format in works involving the royal family, such as *Las Meninas* (**Fig. 15.15**).

▼ **15.15** Diego Velázquez, *Las Meninas* (The Maids of Honor), 1656. Oil on canvas, 125″ × 108¾″ (318 cm × 276 cm). **Prado Museum, Madrid, Spain.** The artist boldly shows himself on the left side of the painting, palette in hand, standing before a huge canvas that is ironically almost lost because of its placement in the composition. The Infanta (princess) stands in the center, surrounded by her maids in waiting. A large dog, a favored symbol of loyalty, occupies the foreground.

The huge canvas is crowded with figures engaged in different tasks. *Las meninas*, the maids of honor, are attending the little princess Margarita, who seems dressed for a portrait-painting session. She is being entertained by the favorite members of her entourage, including two little people and an oversized dog. We suspect that they are keeping her company while the artist, Velázquez, paints before his oversized canvas.

Is Velázquez, in fact, supposed to be painting exactly what we see before us? Some have interpreted the work in this way. Others have noted that he would not be standing behind the princess and her attendants if he were painting them. Moreover, on the back wall of his studio we see what appears to be the mirror images of the king and queen standing next to one another, with a red drape falling behind. Because we do not actually see them in the flesh, we may assume that they are standing in the viewer's position, before the canvas and the artist. Is the princess being given a few finishing touches before joining her parents in a family portrait? We cannot know for sure. The reality of the scene has been left a mystery by Velázquez, as has the identity of the gentleman observing the scene from an open door in the rear of the room. It is interesting to note the prominence of the artist in this painting of royalty. It makes us aware of his importance to the court and to the king in particular. Recall the portrait of Raphael in *Philosophy (The School of Athens)* (see **Fig. 13.8**). Raphael's persona is almost furtive by comparison.

Velázquez pursued realism in technique as well as in subject matter. Building upon the Venetian method of painting, Velázquez constructed his forms from a myriad of strokes that capture light exactly as it plays over a variety of surface textures. Upon close examination of his paintings, we find small, distinct strokes that hover on the surface of the canvas, divorced from the very forms they are meant to describe. Yet from a few feet away, the myriad brushstrokes evoke an overall impression of silk or fur or flowers. This method would be the foundation of a movement called Impressionism some two centuries later. In his pursuit of realism, Velázquez truly was an artist before his time.

Flanders

After the dust of the Reformation settled, the region of Flanders was divided. The northern sections, now called the Dutch Republic (present-day Holland), accepted Protestantism, whereas the southern sections, still called Flanders (present-day Belgium), remained Catholic. This separation more or less dictated the subjects that artists rendered in their works. Dutch artists painted scenes of daily life, carrying forward the tradition of Bruegel, whereas Flemish artists continued painting the religious and mythological scenes already familiar to us from Italy and Spain.

PETER PAUL RUBENS Even the great power and prestige held by Velázquez were exceeded by the Flemish artist Peter Paul Rubens (1577–1640). One of the most sought-after artists of his time, Rubens was an ambassador, diplomat, and court painter

◀ **15.16** Peter Paul Rubens, *The Rape of the Daughters of Leucippus*, 1617. Oil on canvas, 88¼" × 72⅞" (224 × 211 cm). Alte Pinakothek, Munich, Germany. Rubens's canvas is flooded with action. As is typical with Rubens, the women have ample, delicately colored flesh.

to dukes and kings. He ran a bustling workshop with numerous assistants to help him complete commissions. Rubens's style combined the sculptural qualities of Michelangelo's figures with the painterliness and coloration of the Venetians. He also emulated the dramatic **chiaroscuro** and theatrical presentation of subject matter we found in the Italian Baroque masters. Much as Dürer had, Rubens admired and adopted from his southern colleagues. Although Rubens painted portraits, religious subjects, and mythological themes, as well as scenes of adventure, his canvases were always imbued with the dynamic energy and unleashed passion we link to the Baroque era.

In *The Rape of the Daughters of Leucippus* (**Fig. 15.16**), Rubens recounts a tale from Greek mythology in which two mortal women were seized by the twin sons of Zeus, Castor and Pollux. The action in the composition is described by the intersection of strong diagonals and verticals that stabilize the otherwise unstable composition. Capitalizing on the Baroque "stop-action" technique, which depicts a single moment in an event, Rubens placed his struggling, massive forms within a diamond-shaped structure that rests in the foreground on a single point—the toes of a man and a woman. Visually, we grasp that all this energy cannot be supported on a single point, so we infer continuous movement. The action has been pushed up to the picture plane, where the viewer is confronted with the intense emotion and brute strength of the scene. Along with these Baroque devices, Rubens used color and texture much in the way the Venetians used it. The virile, suntanned arms of the abductors contrast strongly with the delicately colored flesh of the women. The soft blond braids that flow outward under the influence of all of this commotion correspond to the soft, flowing manes of the overpowering horses.

ANTHONY VAN DYCK Paintings on a large scale required the help of assistants, and there is no doubt that in Rubens's workshop much of the preliminary work was done by his staff. One of the many artists employed for this purpose eventually became as much in demand for portraits of the aristocracy as his former master. Anthony van Dyck (1599–1641) spent two years (1618–1620) with Rubens before beginning his career as an independent artist. Although from time to time he painted

religious subjects, his fame rests on his formal portraits, many of which were produced during the years he spent in Italy and England.

Van Dyck's refined taste equipped him for satisfying the demands of his noble patrons that they be shown as they thought they looked, rather than as they actually were. It is certainly difficult to believe that any real-life figure could have had quite the haughty bearing and lofty dignity of Marchesa Cattaneo in van Dyck's portrait of her (**Fig. 15.17**),

> **15.17** Anthony van Dyck, *Marchesa Elena Grimaldi, Wife of Marchese Nicola Cattaneo*, ca. 1623. Oil on canvas, 84⁷⁄₈″ × 48½″ (242.9 × 138.5 cm). National Gallery of Art, Washington, DC. The portrait uses generally somber colors and an artificial setting to accentuate the grandeur of van Dyck's subject.

although the Genoese nobility of which she was a member was known for its arrogance.

International celebrities like Rubens and van Dyck, at home at the courts of all Europe, were far from typical of northern artists. Painters in the Dutch Republic in particular found themselves in a very different situation from their colleagues elsewhere. The two most lucrative sources of commissions—the church and the aristocracy—were unavailable to them because the Dutch Calvinist Church followed the post-Reformation practice of forbidding the use of images in church, and because the Dutch Republic had never had its own powerful hereditary nobility. Painters therefore depended on the tastes and demands of the open market.

The Dutch Republic (Holland)

The grandiose compositional schemes and themes of action executed by Rubens could not have been further removed from the concerns and sensibilities of most 17th-century Dutch artists. Whereas mysticism and religious naturalism flourished in Italy, Flanders, and Spain amid the rejection of Protestantism and the invigorated revival of Catholicism, artists of the Dutch Republic turned to secular art, abiding by the Protestant mandate that humans not create false idols. Artists turned to scenes of everyday life, and the collectors of art were everyday folk. In the Dutch quest for the establishment of a middle class, aristocratic patronage was lost and artists were forced to peddle their wares in the free market. Landscapes, still lifes, and genre paintings were the favored canvases, and *realism* was the word of the day. Although the subject matter of Dutch artists differed radically from that of their colleagues elsewhere in Europe, the spirit of the Baroque, along with many if not most of its artistic characteristics, was present in their work.

FRANS HALS One highly profitable source of income for Dutch artists in the 17th century was the group portrait, in particular that of a militia or civic-guard company. These bands of soldiers had originally served a practical purpose in the defense of their country, but their regular reunions tended to be social gatherings, chiefly for the purpose of eating and drinking. A group of war veterans today would hire a photographer to commemorate their annual reunion; the militia companies engaged the services of a portrait painter. If they were lucky or rich enough, they might even get Frans Hals (ca. 1581–1666), whose group portraits capture the individuality of each of the participants while conveying the general convivial spirit of the occasion, as in *Banquet of the Officers of the Civic Guard of Saint George at Haarlem* (Fig. 15.18). Hals was certainly not the most imaginative or inventive of artists, but his sheer ability to paint, using broad, dynamic brushstrokes and

▼ **15.18** Frans Hals, *Banquet of the Officers of the Civic Guard of Saint George at Haarlem*, 1616. Oil on canvas, 60⅞" × 96⅜" (179 × 257.5 cm). Frans Hals Museum, Haarlem, The Netherlands. The "action" of the sitters thrusts from lower left to upper right as the viewer's eye follows the diagonals made by the flag. The sitters are spread out evenly across the canvas and, interestingly, do not all appear to be posing for the painting.

cleverly organized compositions, makes his work some of the most attractive of that period.

REMBRANDT VAN RIJN The golden-toned, subtly lit canvases of Rembrandt van Rijn (1606–1669) possess a certain degree of timelessness. Rembrandt concentrated on the personality of the sitter or the psychology of a particular situation rather than on surface characteristics. This introspection is evident in all of his works, whether religious or secular in subject, landscapes or portraits, drawings, paintings, or prints.

Rembrandt painted many self-portraits that offer us an insight into his life and personality. In a self-portrait at age 46 (**Fig. 15.19**), Rembrandt paints an image of himself as a self-confident, well-respected, and sought-after artist who stares almost impatiently out toward the viewer. It is as if he had been caught in the midst of working and has but a moment for us. It is a powerful image, with piercing eyes, thoughtful brow, and determined jaw that betray a productive man who is more than satisfied with his position in life. All of this may seem obvious, but notice how few clues he gives us to reach these conclusions about his personality. He stands in an undefined space with no props that reveal his identity. The figure is cast into darkness; we can hardly discern his torso and hands resting in the sash around his waist.

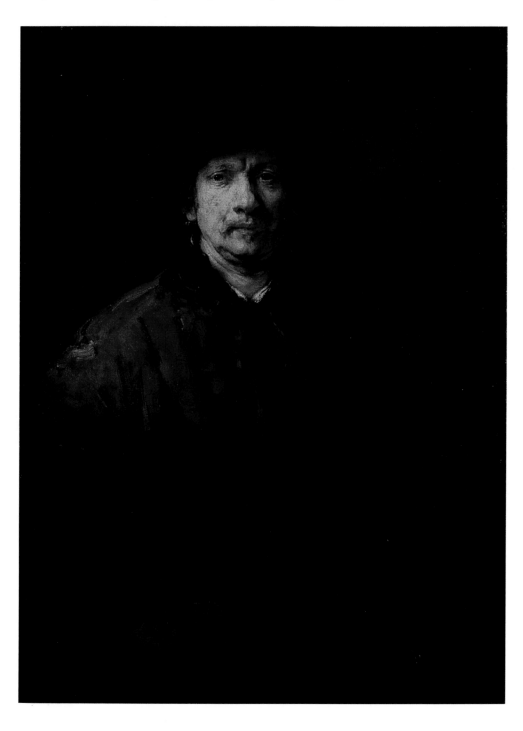

◄ 15.19 Rembrandt van Rijn, *Self-Portrait*, 1652. Oil on canvas, 44″ × 32″ (112 × 81.5 cm). Kunsthistorisches Museum, Vienna, Austria. This particular self-portrait, painted in early middle age, shows the artist as confident and respected, satisfied with his position in life.

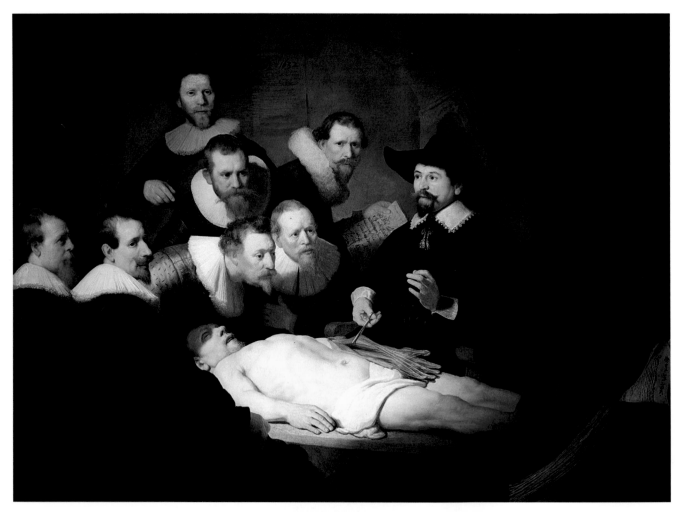

▲ **15.20** Rembrandt van Rijn, *The Anatomy Lesson of Dr. Nicolaes Tulp*, 1632. Oil on canvas, 67″ × 85¼″ (170 × 217 cm). **The Royal Picture Gallery Mauritshuis, The Hague, The Netherlands.** The painting, commissioned by the surgeon's guild, groups the onlookers at the left, some pressing in for a better view.

The penetrating light in the canvas is reserved for just a portion of the artist's face. Rembrandt gives us a minute fragment with which he beckons us to complete the whole. It is at once a mysterious and revealing portrayal that relies on a mysterious and revealing light.

Rembrandt also painted large group portraits, such as *The Anatomy Lesson of Dr. Nicolaes Tulp* (**Fig. 15.20**). In *Banquet of the Officers of the Civic Guard of Saint George at Haarlem* (see again **Fig. 15.18**), Frans Hals chose to spread his group evenly across his portrait. Rembrandt, however, clustered the doctor's students—members of the surgeon's guild that had commissioned the work—on the left side of the painting. Some of them are caught in the moment of pushing inward for a better view. The doctor gestures with his left hand; he is holding forth. The color of the cadaver makes it look as dead as can be. The student at the center top gazes directly out of the painting, at the viewer, as if to say "We're really here." The cadaver's feet are mercifully shaded so they will not protrude from the painting. The "spotlight" is on

his body, especially his dissected arm. Rembrandt, master of light and shade, has much of the outer parts of the painting disappear into blackness. We see what Rembrandt wants us to see.

The Night Watch (**Fig. 15.21**), along with Leonardo da Vinci's *Mona Lisa, (La Gioconda)* is one of the most famous and familiar works in the history of Western art. The Rijksmuseum in Amsterdam, where it hangs today, writes on its website that this is the best-known painting in its collection. But its name is not *The Night Watch*. It is actually called *The Company of Frans Banning Cocq and Willem van Ruytenburch*, and it is a militia painting—that is, another group portrait, this time of a part of the civic guard. In Baroque fashion, Rembrandt did not paint the group in a row or sitting for their annual banquet. Instead, he painted a moment in time, when Cocq has issued the order for the militia to march and they are being organized for action. Rembrandt emphasized movement through a masterful use of foreshortening in which Cocq's left hand seems to leap out of the painting.

Rembrandt used light and shade to focus the viewer's attention on the key figures in the forefront of the painting, Cocq and his lieutenant van Ruytenburch. Although the recesses of implied depth in the painting fall into shade, they are darker than the artist intended, which is how the painting became dubbed *The Night Watch*. Much of the darkness results from layers of varnish that were applied to the surface.

The militiamen in the painting are the Arquebusiers, so named after the arquebus (or *harquebus*), a long-barreled gun of the day. Rembrandt worked the emblem of the group into the painting by having the girl in the foreground carry the symbols of the group, including chicken claws. The painting of the militia was to be hung in the Arquebusiers hall. It was hung alongside other canvases, and since then has been moved a couple of times. It has not gone without being damaged: it was first moved from the militia's hall to the town hall, where it was cut down, especially on the left side, because it was too large to be hung as it was.

As we saw in the painterly technique of Velázquez, Rembrandt's images are more easily discerned from afar than from up close. As a matter of fact, Rembrandt is reputed to have warned viewers to keep their noses out of his paintings because the smell of paint was bad for them. We can take this to mean that the technical devices Rembrandt used to create certain illusions of realism are all too evident from the perspective of a few inches. Above all, Rembrandt was capable of manipulating light. His is a light that alternately constructs and destroys, bathes and hides from view. It is a light that can be focused as unpredictably, and that shifts as subtly, as the light we find in nature.

▼ **15.21** Rembrandt van Rijn, *The Company of Frans Banning Cocq and Willem van Ruytenburch* (*The Night Watch*), 1642. Oil on canvas, 141½" × 170½" (363 × 437 cm). Rijksmuseum, Amsterdam, The Netherlands. Recent cleaning has revealed that the painting's popular name, though conveniently brief, is inaccurate. Far from being submerged in darkness, the principal figures were originally bathed in light and painted in glowing colors.

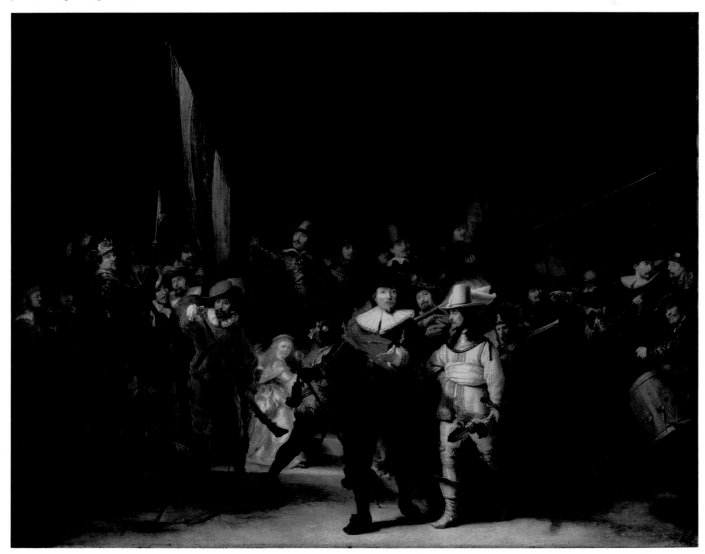

COMPARE + CONTRAST

Vision and Difference: Three Paintings Entitled *Susanna and the Elders*

Artemisia Gentileschi once said, in reaction to being cheated out of a potentially lucrative commission, "If I were a man, I can't imagine it would have turned out this way." The statement might as easily be applied to an analysis—and gendered interpretation—of the subject of Susanna and the Elders, painted by three different artists: Tintoretto, Artemisia Gentileschi, and Rembrandt.

The story of Susanna is found in the book of Daniel. Susanna was the wife of Joachim, a wealthy Babylonian Jew whose home was frequented by judges and elders of the community. Susanna was as pious as she was enchantingly beautiful. One day, while she was bathing in her garden, two of these elders surreptitiously observed her and then made sexual advances, warning her that if she refused them, they would accuse her publicly of having an affair with a young man. When Susanna did not comply, they made good on their threat and she was put on trial for the fictitious accusations. Just as she was about to be found guilty, Daniel appeared in the court of justice and suggested that the elders be cross-examined out of earshot of one another to determine whether their individual testimonies corroborated each other. They did not. Susanna was found innocent and her accusers were stoned to death for bearing false witness. Justice was served and good triumphed over evil.

How might an artist visualize this story? What impression does an artist wish to convey about the protagonists and what types of pictorial devices might an artist use to skew a narrative? The paintings of Susanna and the Elders offer some contrasting and illuminating answers to these questions. Tintoretto's rendering of Susanna (**Fig. 15.22**) befits her status as the wife of a wealthy man but also suggests that she likes beautiful things. Her hair is elaborately braided, and she is adorned with pearl earrings and golden bracelets. At her feet, which she dries with a sensuous silken cloth, are a silver perfume bottle and a strand of pearls that look as though they have been thoughtlessly tossed aside. Bathing in the surrounds of a sumptuous, fertile garden, Susanna admires herself in a mirror propped up against a privacy screen covered in vines and flowers. Our focus is drawn entirely to her, as are the prying eyes of one of the lecherous old men, peeping around the screen in the lower left. Susanna, as represented by Tintoretto, seems anything but pious. On the contrary, in her wanton display of vanity, it appears as though Susanna may have enticed seduction.

In Rembrandt's *Susanna and the Elders* (**Fig. 15.23**), one of the leering elders grabs at the white cloth wrapped around Susanna's body, pulling it toward him and revealing her naked torso. The physical act, as it unfolds so close to us, is menacing, disturbing. But what first appears to be an empathic rendering of Susanna's plight and a condemning view of her assailants is partially vitiated by other details. We are drawn into the painting by Susanna's eye contact with us, but her facial expression does not beseech us to help her. She perhaps looks surprised, but not distressed. Her cowering body position may lead us to view Susanna

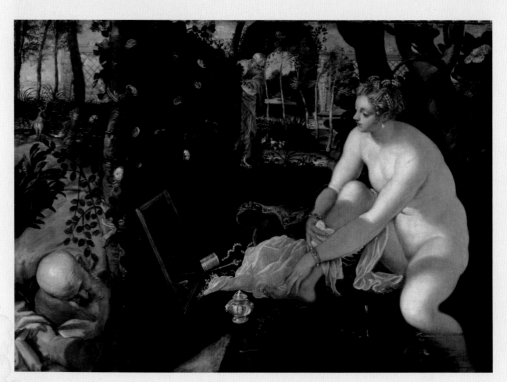

◀ **15.22** Tintoretto, *Susanna and the Elders*, 1555–1556. Oil on canvas, 57 ³/₄" × 76 ¹/₄" (146 × 193.6 cm). Kunsthistorisches Museum, Vienna, Austria.
Tintoretto's Susanna is surrounded by jewelry and other stereotypical ornaments of feminine vanity.

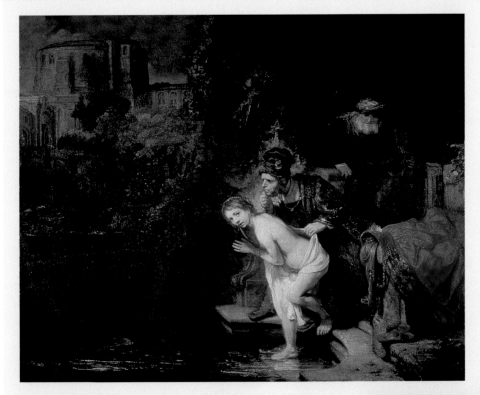

◄ **15.23** Rembrandt van Rijn, *Susanna and the Elders*, 1647. Oil on mahogany panel, 30¼″ × 36⅝″ (77 × 93 cm). Gemäldegalerie der Staatlichen Museum, Berlin, Germany. In Rembrandt's mysterious version of Susanna's plight, the victim looks surprised but not necessarily distressed. A severe light shows her garment being torn from her.

▼ **15.24** Artemisia Gentileschi, *Susanna and the Elders*, 1610. Oil on canvas, 66⅞″ × 46⅞″ (170 × 119 cm). Kunstsammlungen Graf von Schönborn, Wiesentheid, Germany. Gentileschi's Susanna is a victim, a victim who cannot be blamed for the voyeurs' crimes.

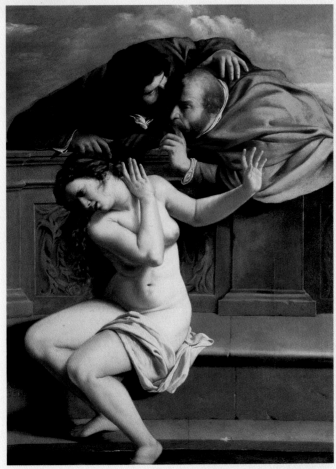

as innocent, discreet, ashamed, but Rembrandt placed other things in the painting that may lead us to draw another conclusion about her. She has pearls in her hair and wears a gold bracelet; off to the side are small, satin slippers and a sumptuous red cloak embellished with gold detail.

Artemisia Gentileschi tells the same story, but from a dramatically different perspective (**Fig. 15.24**). Her Susanna does not lounge at leisure in a lush garden or dip delicately into a secluded pool. She is trapped in a claustrophobic space, her naked flesh set against hard, cold stone. The men whisper to each other and swoop down on her, threatening her with their proposition. Her body position—a twisting, turning Z shape—is uncomfortable and awkward, even painful to behold. The expression on Susanna's face is undeniably tormented as she pushes them away from her ears. Gentileschi's Susanna wears no jewelry, has no luxurious trappings surrounding her. The cloth draped over her thigh is not a sensuous prop; it simply looks like a towel.

Faced with a narrative to be rendered, artists always make choices. We can assume that the particular elements of a painting are there for a reason. Ask yourself: What are those choices? Why might the artist have made them? Aside from the story, or *text*, of the work of art, is the artist trying to convey some other message (that is, a *subtext*)? What do these choices say about the artist, or the patron, or the gender ideology of the day? And in these works in particular, are there interpretations to be made that reveal gender differences in the representation of familiar subjects?

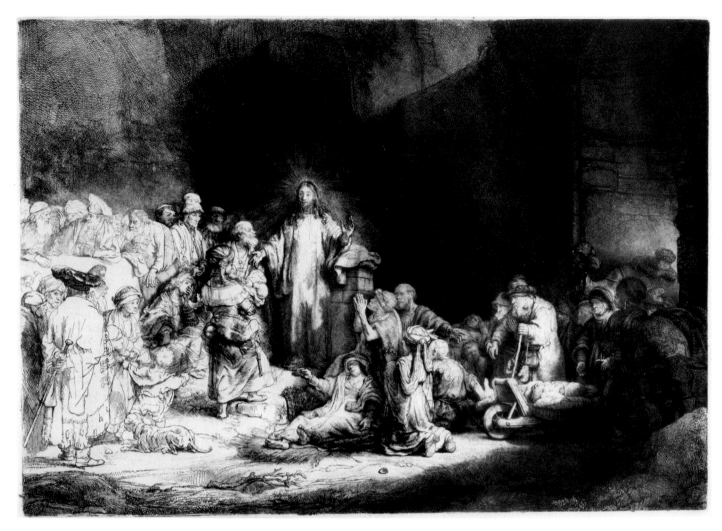

▲ **15.25** Rembrandt van Rijn, *Christ with the Sick around Him, Receiving the Children* (the Hundred-Guilder Print), ca. 1649. Etching, 11″ × 15¼″ (27.9 × 38.8 cm). Pierpont Morgan Library, New York, **New York.** In this small print, the lame and the blind are scattered all around the Messiah, some bleached in powerful light and others lost in shade.

We find similar shifts in light in Rembrandt's etching *Christ with the Sick around Him, Receiving the Children* (the Hundred-Guilder Print) (**Fig 15.25**). Despite the details in the etching, it is a small work, only fifteen inches wide. The name Hundred-Guilder Print has stuck because that amount of money—the price for which the etching sold—was 10% of the price of a decent house in mid-17th-century Holland. The etching shows that Rembrandt also had an interest in religious subjects, which increased as he passed the years. But Rembrandt's piety reveals a human and humane Jesus, preaching to and comforting those most in need—the lame, the blind, and the young. The composition shows a striking arrangement of figures—some standing, some kneeling, some lying down—and a dog who is apparently unconcerned with matters of the soul, because he has presented his behind to the Messiah. Dazzling divine light bathes the figures on the left, so much so that many individual features are bleached out. In contrast, figures in or before the archway on the right are partly lost in shade.

Although Rembrandt was sought after as an artist for a good many years and was granted many important commissions, he fell victim to the whims of the free market. The grand master of the Dutch Baroque died at age 63, out of fashion and penniless.

JAN VERMEER If there is a single artist who typifies the Dutch interest in painting scenes of daily life, the commonplace narratives of middle-class men and women, it is Jan Vermeer (1632–1675). Although he did not paint many pictures, and never strayed from his native Delft, his precisely sketched and pleasantly colored compositions made him well respected and influential in later centuries.

Young Woman with a Water Jug (**Fig. 15.26**) exemplifies Vermeer's subject matter and technique. In a tastefully underfurnished corner of a room in a typical middle-class household, a woman stands next to a rug-covered table, grasping a water jug with one hand and, with the other, opening a stained-glass window. A blue cloth has been thrown

over a brass-and-leather chair, a curious metal box sits atop the table, and a map adorns the wall. At once we are presented with opulence and simplicity. The elements in the composition are perfectly balanced and serene. One senses that their positions could not be moved a fraction of an inch without disturbing the composition. Crisp lines grace the space in the painting rather than interrupt it. The shadows in the painting are rendered in color, displaying the artist's recognition that objects in shadow display a complexity of hues; they are not featureless and black. Every item in the painting is of a simple, almost timeless form and corresponds to the timeless tranquility of the porcelainlike image of the woman. Her simple dress and starched collar and bonnet epitomize grace and peace.

We might not see this as a Baroque composition if it were not for three things: the single source of light bathing the elements in the composition, the genre subject, and the sense of mystery captured by Vermeer. What is the woman doing? She has opened the window and taken a jug into her hand at the same time, but we will never know for what purpose. Some have said that she may intend to water flowers at a window box. Perhaps she was in the midst of doing something else and paused to investigate a noise in the street. Vermeer gives us a curious combination of the momentary and the eternal in this almost photographic glimpse of everyday Dutch life.

France

During the Baroque period, France, under the reign of the Sun King, Louis XIV, began to replace Rome as the center of

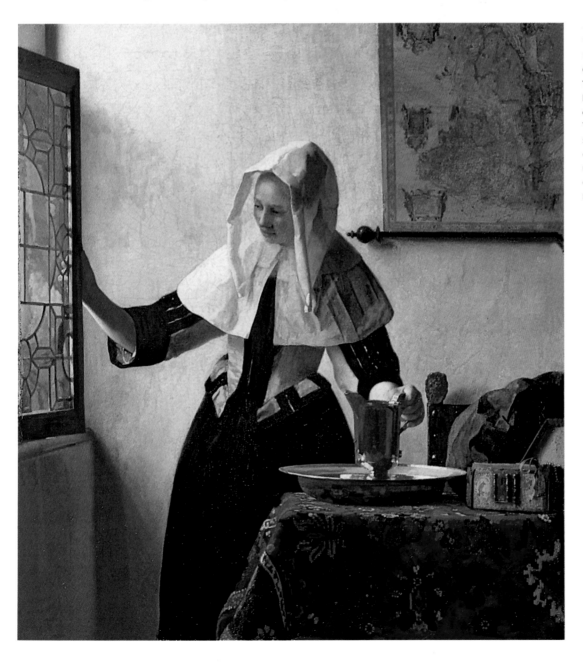

◄ **15.26** Jan Vermeer, *Young Woman with a Water Jug*, ca. 1665. Oil on canvas, 18″ × 16″ (45.7 × 40.6 cm). Metropolitan Museum of Art, New York, New York. The setting is securely upper middle class. Everything is under control. The box on the table lends a minor air of mystery.

the art world. The king preferred classicism; thus too did the country, and painters, sculptors, and architects alike created works in this vein. Louis XIV guaranteed adherence to classicism by forming academies of art that perpetuated this style. These academies were art schools of sorts, run by the state, whose faculties were populated by leading proponents of the classical style. When we examine European art during the Baroque period, we thus perceive a strong stylistic polarity. On the one hand, we have the exuberant painterliness and high drama of Rubens and Bernini, and on the other hand, a reserved classicism that hearkens back to Raphael.

NICOLAS POUSSIN The most renowned French painter of the 17th century, Nicolas Poussin (ca. 1594–1665), echoed this French preference for restraint when he decisively rejected the innovations of Caravaggio, whose works he claimed to detest. He saw his own work as a kind of protest against the excesses of the Baroque; but a strong dislike of his Roman contempo-

raries did not prevent Poussin from spending most of his life in Rome. It may seem strange that so French an artist should have chosen to live in Italy, but what drew him there was the art of ancient, not Baroque, Rome. Poussin's only real and enduring enthusiasm was for the world of Classical antiquity. His friends in Rome included the leading antiquarians of the day, and his paintings often expressed a nostalgic yearning for a long-vanished past.

Poussin's *Rape of the Sabine Women* (**Fig. 15.27**) was painted four years before he was summoned back to France by the king. It illustrates the Baroque classicism that Poussin would bring back to his native country. The flashy dynamism of Bernini and Rubens gives way to a more static, almost staged motion in the work of Poussin. Harshly sculptural, Raphaelesque figures thrust in various directions, forming a complex series of intersecting diagonals and verticals. The initial impression is one of chaos, of unrestrained movement and human anguish. But as was the case with the Classical Greek

▾ **15.27** Nicolas Poussin, *The Rape of the Sabine Women*, ca. 1636–1637. Oil on canvas, 60 ⅞″ × 82 ⅝″ (154.6 × 209.9 cm). Metropolitan Museum of Art, New York, New York. At the time of this painting, Poussin was strongly influenced by the ancient sculptures he had studied in Rome, most notably the careful depiction of the musculature of the figures.

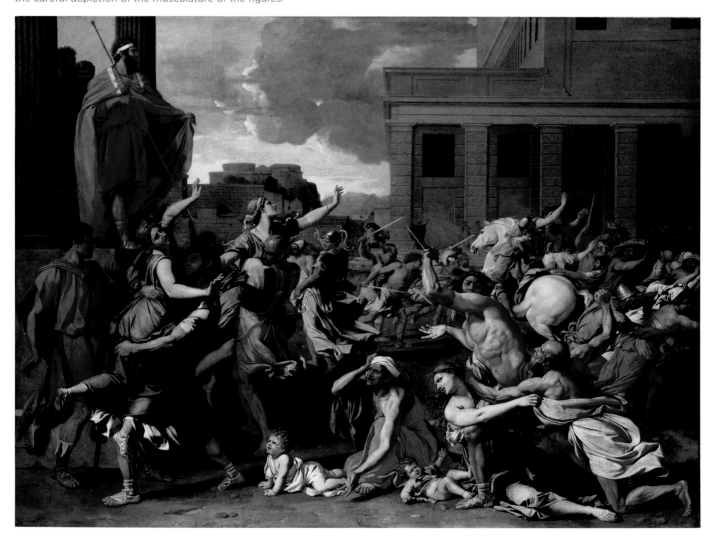

sculptors and Italian Renaissance artists, emotion is always balanced carefully with restraint. For example, the pitiful scene of the old woman in the foreground, flanked by crying children, forms part of the base of a compositional triangle that stabilizes the work and counters excessive emotion. If one draws a vertical line from the top of her head upward toward the top border of the canvas, one encounters the apex of this triangle, formed by the swords of two Roman abductors. The sides of the triangle, then, are formed by the diagonally thrusting torso of the muscular Roman man in the right foreground and the arms of the Sabine women on the left, reaching hopelessly into the sky. This compositional triangle, along with the Roman temple in the right background that prevents a radically receding space, are Renaissance techniques for structuring a balanced composition. Poussin used these, along with a stagelike, theatrical presentation of his subjects, to reconcile the divergent styles of the harsh Classical and the vibrant Baroque.

Even had Poussin been prepared to leave Rome and return to the French court, the austere nature of his art would hardly have served to glorify that most autocratic and magnificent of monarchs, Louis XIV (born 1638, reigned 1643–1715). For the most part, the king had only second-rate artists available to him at court.

GEORGES DE LA TOUR France was a Catholic country during the Baroque period, and some 17th-century French painters were occupied with religious themes. Among them was Georges de La Tour (1593–1652), whose paintings suggest a familiarity with Caravaggio's depiction of light, particularly Tenebrism. La Tour's works frequently display a single source of light, such that those parts of his subjects who were bereft of that light would disappear into the shadows. His *Penitent Magdalen* (**Fig. 15.28**) shows Mary Magdalene in a pensive mood, reflecting, perhaps, on her carnal sins or on the passing of her beloved Jesus. The symbolism in the painting suggests inner conflict—the mirror symbolizing vanity, the skull symbolizing mortality, and the candle, perhaps, symbolizing spiritual enlightenment. What is signified by the reflection of the candle in the mirror? Although the lighting in the piece may recall Caravaggio, the feeling tone with La Tour here is reflective, not passionate.

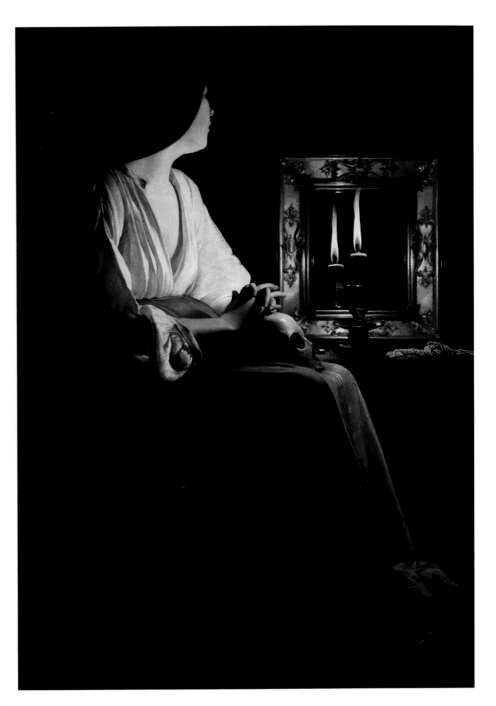

⋀ **15.28** Georges de La Tour, *The Penitent Magdalen*, ca. 1640. **Oil on canvas, 52¹⁄₂″ × 40¹⁄₄″ (133.4 × 102.2 cm). Metropolitan Museum of Art, New York, New York.** The symbols in the painting represent a meditation upon loss and death.

VERSAILLES Louis XIV's taste for the Classical extended to architecture, as seen in the Palace of Versailles (**Fig. 15.29**). Originally the site of the king's hunting lodge, the palace and surrounding area just outside Paris were converted by a host of artists, architects, and landscape designers into one of the grandest monuments to the French Baroque. In their tribute to Classicism, the architects Louis Le Vau (1612–1670) and Jules Hardouin-Mansart (1646–1708) divided the horizontal

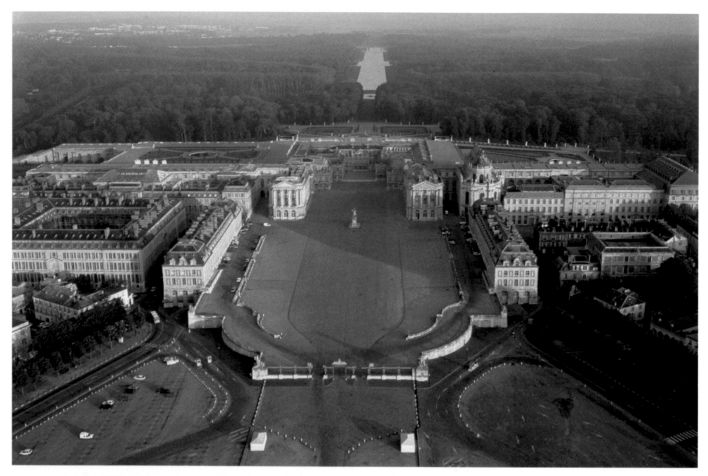

▲ **15.29 Palace of Versailles, begun 1669, and a small portion of the surrounding park. Versailles, France.** The chief architects for the last stage of construction at Versailles were Louis Le Vau and Jules Hardouin-Mansart. Although the external decoration of the palace is Classical in style, the massive scale (1935' wide) is characteristic of Baroque architecture.

sweep of the façades into three stories. The structure was then divided vertically into three major sections, and these were in turn subdivided into three additional sections. The windows march along the façade in a rhythmic beat, accompanied by rigid pilasters that are wedged between the strong horizontal bands delineating the floors. A balustrade tops the palace, further emphasizing the horizontal sweep while restraining any upward movement suggested by the building's vertical members. The divisions into classically balanced threes and the almost obsessive emphasis on the horizontal echo the buildings of Renaissance architects. The French had come a long way from the towering spires of their glorious Gothic cathedrals!

THE HALL OF MIRRORS The Palace of Versailles was conceived by the king in political terms. The architects' task, both inside and out, was to create a building that would illustrate Louis XIV's symbolic concept of himself as the Sun King. Thus, each morning the king would rise from his bed, make his way past the assembled court through the Hall of Mirrors (**Fig. 15.30**), where the 17 huge mirrors reflected both the daylight and his own splendor, and enter the gardens along the

main wing of the palace—laid out on an east–west axis to follow the path of the sun. At the same time, both the palace and its gardens, which extend behind it for some two miles, were required to provide an appropriate setting for the balls, feasts, and fireworks displays organized there.

Given the grandiose symbolism of the ground plan and interior decorations, the actual appearance of the outside of the Palace of Versailles, with its rows of Ionic columns, is surprisingly modest. The simplicity of design and decoration is another demonstration of the French ability to combine the extremes of Baroque art with a more Classical spirit.

New England

During the 17th century, European powers were continuing to colonize the Western Hemisphere and competing for land, resources, and influence. Europeans were also emigrating to the New World. English, Dutch, German, French, Spanish—all these peoples came to populate parts of the Americas. Much of the early European settlement in what is now the United States occurred in New England, and New England-

ers brought their language, customs, religions, and cultural talents and preferences with them across the ocean.

ANNE BRADSTREET Poetry was written in New England. Anne Bradstreet (1612–1672) and her husband Simon, whom she had married at age 16, journeyed across the Atlantic from England in 1630. They lived in Massachusetts, with its biting winters, where Simon became governor in 1679, after Anne's death. They were Puritans, a name which has been somewhat misunderstood. Their intention was to purify their Protestant religion by taking their instruction directly from the Bible and no other source. There were occasional humorous results, as in attempting to find Biblical sources to prove that women should wear their hair long.

Puritans are painted as fleeing England because of religious oppression, although the extent of their danger has been questioned. It is also possible that their foremost intention

was to establish a society in which their religious views could flourish unchallenged. The Puritan brand of Protestantism was Calvinistic. The Frenchman John Calvin (1509–1564) had taught that since God was omniscient (all-knowing) and omnipotent (all powerful), the entire panoply of human existence was laid out before him with his approval. Therefore, all was predestined, including the election of those who would ascend to heaven and those who would fall into the fiery pit of hell. Why, then, bother to be good, when one's own behavior would not determine one's fate? The Puritan answer was that by living a righteous life, one could develop a personal conviction of salvation. Puritans thus sought to build the perfect, and austere, "city on a hill." (Psychologically speaking, however, it is difficult to believe that many Puritans did not secretly harbor the hope that God would show them mercy if their demeanor was upright, even if they had not made the list.)

▼ **15.30 Hall of Mirrors (Galerie des Glaces), begun 1676, Palace of Versailles. Versailles, France.** Seventeen arches, each with 21 mirrors, reflect the arcaded windows that overlook the gardens as they descend toward and around a human-made lake.

Bradstreet, though a Calvinist, when still in England confessed, "as I grew up to be about 14 or 15, I found my heart more carnal, and sitting loose from God." She developed smallpox just before her marriage, which she—possibly tongue in cheek—attributed to divine retribution.

Bradstreet has been considered the first American poet and a key figure in the history of American literature. Much of her work recounts her struggles with New England colonial life and with her own illnesses. Even so, her first collection of poems, *The Tenth Muse Lately Sprung Up in America, By a Gentlewoman of Those Parts* (1650) is also the first book authored by a woman and published in America.

She begins her poem "The Prologue" with an apology for writing, which was common among writers, including male writers, of the day.

READING 15.1 ANNE BRADSTREET

"The Prologue," lines 1–6

To sing of wars, of captains, and of kings,
Of cities founded, commonwealths begun,
For my mean[2] pen are too superior things:
Or how they all or each their dates have run,
Let poets and historians set these forth;
My obscure lines shall not so dim thy worth.

Following are lines from a lyric poem she wrote to her husband, when he was called away on business.

READING 15.2 ANNE BRADSTREET

"A Letter to Her Husband, Absent upon Public Employment," lines 1–8

My head, my heart, mine eyes, my life, nay, more,
My joy, my magazine[3] of earthly store,
If two be one, as surely thou and I,
How stayest thou there, whilst I at Ipswich[4] lie?
So many steps, head from the heart to sever,
If but a neck, soon should we be together.
I, like the Earth this season, mourn in black,
My Sun[5] is gone so far in's zodiac.[6]

THOMAS SMITH We know little about Thomas Smith (died ca. 1691) except that he was a sea captain of some wealth who also painted portraits in and around Boston. His self-portrait (**Fig. 15.31**) is the earliest known self-portrait in the American colonies and the first one we know of to be painted by an identified artist. Smith's financial means are confirmed by an account book at Harvard College (established in 1636) and by his attire in the painting. The naval battle which seems to be in progress outside the window would appear to represent a historic union of British and Dutch naval powers—according to the flags depicted—in combat with Islamic Barbary states on the North African coast. The battle would have occurred a century or so before Americans were thinking about declaring independence from England, and Smith would have participated in it as an Englishman. He would have seen fighting Muslims as his Christian duty, a continuation of the intermittent clashes of Christians and Muslims that had been proceeding for a millennium. Except for occasional cooperation, as apparently depicted in the painting, the British and the Dutch were at each other's throats competing for ownership and influence in the Americas.

2. Humble.

3. Storehouse.

4. A town to the north of Boston.

5. Her husband.

6. Travels through the heavens.

◀ **15.31** Thomas Smith, *Self-Portrait*, ca. 1680. Oil on canvas, 24 5/8″ × 23 5/8″ (62.8 × 60 cm). Worcester Art Museum, Worcester, Massachusetts. The battle scene outside the window may be the artist's recollection of a campaign off the north coast of Africa.

The portrait shows familiarity with European portraiture. There is, for example, the contemplation of the skull as a symbol of mortality, as in La Tour's *Penitent Magdalen* (see again **Fig. 15.28**). The poem held in place by the skull confirms the religious purpose of the painting. It begins, "Why why should I the World be minding/therein a World of Evils Finding?" It then affirms his Protestant faith. Despite his piety, he is quite the fashion plate. He sports a fancy lace *jabot*—the ornamental cascade of frills fronting his shirt. Jabots became popular in about 1650 and Smith, although geographically removed from Europe, is clearly up to date. As in European paintings of the time, that which is not illuminated by the source of light fades into black. Smith's hair, needless to say, is expertly coiffed, although the tone of the painting denies any desire for self-representation as a dandy—perhaps.

BAROQUE MUSIC

Although the history of music is as long as that of the other arts, the earliest music with which most modern music lovers are on familiar ground is that of the Baroque period. It is safe to say that many thousands of listeners have tapped their feet to the rhythm of a Baroque concerto without knowing or caring anything about its historical context, and with good reason: Baroque music, with its strong emphasis on rhythmic vitality and attractive melody, is easy to respond to with pleasure. Furthermore, in the person of Johann Sebastian Bach, the Baroque period produced one of the greatest geniuses in the history of music, one who shared Rembrandt's ability to communicate profound experience on the broadest level.

The qualities that make Baroque music popular today were responsible for its original success. Composers of the Baroque period were the first since Classical antiquity to write large quantities of music intended for the pleasure of listeners as well as the glory of God. The polyphonic music of the Middle Ages and the Renaissance, with its interweaving of many musical lines, had enabled composers like Machaut and Palestrina to praise the Lord on the highest level of intellectual achievement, but the result was a musical style far above the heads of most of their contemporary listeners. The Council of Trent, in accordance with Counter-Reformation principles, had even considered prohibiting polyphony in religious works in order to make church music more accessible to the average congregation, before finally deciding that this would be too extreme a measure. For once, the objectives of the Reformation and Counter-Reformation coincided, for Luther had already simplified the musical elements in Protestant services for the same reason (see Chapter 14).

The time was therefore ripe for a general move toward sacred music with a wider and more universal appeal. Since at the same time the demand for secular music was growing, it is not surprising that composers soon developed a style sufficiently attractive and flexible not only for the creation of masses and other liturgical works, but also of instrumental and vocal music that could be played and listened to at home (**Fig. 15.32**).

The Birth of Opera

Perhaps the major artistic innovation of the 17th century was a new form of musical entertainment that appeared at the

➤ 15.32 Pieter de Hooch, *Portrait of a Family Playing Music*, 1683. Oil on canvas, 39" × 47" (98.7 × 116.7 cm). Cleveland Museum of Art, Cleveland, Ohio. This group portrait of a prosperous Dutch family seems to symbolize the harmonious nature of family, as the mother and father lead their children in a musical performance.

beginning of the Baroque period: **opera**. This consisted of a play in which the text was sung rather than spoken. Throughout the 17th century the taste for opera and operatic music swept Europe, attracting aristocratic and middle-class listeners alike. In the process, the public appetite for music with which it could identify grew even greater. Small wonder that 21st-century listeners have found pleasure and delight in music written to provide our Baroque predecessors with precisely these satisfactions.

Like much else of beauty, opera was born in Florence. Ironically enough, an art form that was to become so popular in so short a time was originally conceived of in lofty intellectual terms. Toward the end of the 16th century, a group of thinkers, poets, and musicians began to meet regularly at the house of a wealthy Florentine noble, Count Giovanni Bardi. This group, known as the Florentine *Camerata*, objected strongly to the way in which the polyphonic style in vocal music reduced the text to incomprehensible nonsense. They looked back nostalgically to the time of the Greeks, when almost every word of Greek tragedy was both sung and accompanied by instruments, yet remained perfectly understandable to the spectators. Greek music was lost forever, but at least the group could revive what they considered its essence.

The result was the introduction of a musical form known as **monody**, or **recitative**, which consisted of the free declamation of a single vocal line with a simple instrumental accompaniment for support. Thus listeners could follow the text with ease. The addition of music also gave an emotional intensity not present in simple spoken verse, thus satisfying the Baroque interest in heightened emotion.

Although in theory monody could be used for either sacred or secular works, its dramatic potential was obvious. In the winter of 1594–1595 the first play set to music, Jacopo Peri's *Dafne*, was performed in Florence. Its subject was drawn from Classical mythology and dealt with Apollo's pursuit of the mortal girl Daphne, who turned into a laurel tree to elude him. In the words of a spectator, "The pleasure and amazement of those present were beyond expression." *Dafne* is now lost, but another of Peri's works, *Euridice*, has survived as the earliest extant opera. It too was based on a Greek myth, that of Orpheus and Eurydice. The first performance took place in 1600, again in Florence, at the wedding of Henry IV of France to Marie de' Medici.

It is no coincidence that both of Peri's works, as well as many that followed, were written on Classical subjects, because the Camerata had taken its initial inspiration from Greek drama. The story of Orpheus and Eurydice, furthermore, had a special appeal for composers, because it told how the musician Orpheus was able to soften the heart of the King of the Underworld by his music and thereby win back his wife Eurydice from the dead. The theme was treated many times in the music of the following 400 years, yet no subsequent version is more moving or psychologically convincing than that of Claudio Monteverdi (1567–1643).

CLAUDIO MONTEVERDI Monteverdi's *L'Orfeo*, considered by many critics to be the first great opera, was first performed in 1607. Its composer brought to the new form not only a complete understanding of the possibilities of monody but in addition an impressive mastery of traditional polyphonic forms such as the madrigal. Equally important for the success of his work was Monteverdi's dramatic instinct and his ability to transform emotion into musical terms. The contrast between the pastoral gaiety of the first act of *L'Orfeo*, depicting the happy couple's love, and the scene in the second act in which Orpheus is brought the news of his wife's death is achieved with marvelous expressive power.

L'Orfeo was written for his noble employer, the Duke of Mantua, and intended for a limited aristocratic public. Monteverdi lived long enough to see the new dramatic form achieve widespread popularity at all levels of society throughout Europe. A taste for Italian opera spread to Germany and Austria and then to England, where, by the end of the century, Italian singers dominated the London stage.

The leading composer of opera at the court of Louis XIV was a Florentine who changed his name from Giovanni Battista Lulli to the French form: Jean Baptiste Lully (1632–1687). His stately tragedies, which were performed throughout Europe, incorporated long sections of ballet, a custom continued by his most illustrious successor, Jean-Philippe Rameau (1683–1764).

Opera won its largest public in Italy. In Venice alone, where Monteverdi spent the last 30 years of his life, at least 16 theaters were built between 1637—when the first public opera house was opened—and the end of the century. As in the Elizabethan theater (see **Fig. 14.22**), the design of these opera houses separated the upper ranks of society, who sat in the boxes, from the ordinary citizens—the groundlings.

There is a notable similarity, too, between Elizabethan drama and opera in the way these forms of art responded to growing popularity. Just as the groundlings of Shakespeare's day demanded ever more sensational and melodramatic entertainment, so the increasingly demanding and vociferous opera public required new means of satisfaction. The two chief means by which these desires were met became a feature of most operas written during the following century. The first was the provision of lavish stage spectacles involving mechanical cloud machines that descended from above and disgorged singers and dancers, complex lighting effects that gave the illusion that the stage was being engulfed by fire, apparently magical transformations, and so on; it was Baroque extravagance at its most extreme. The second was a move away from the declamatory recitative of the earliest operas to self-contained musical pieces known as **arias**. In the case of opera and many other musical forms, we continue to use technical terms like *aria* in their Italian form—a demonstration of the crucial role played by Italy, and in particular Florence, in the history of music. The function of music as servant of the drama was beginning to change. Beauty of melody and the technical virtuosity of the singers became the glory of Baroque opera, although at the expense of dramatic truth.

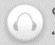

GO LISTEN! CLAUDIO MONTEVERDI

"Quel Sguardo Sdegnosetto"

In addition to his operas, Monteverdi wrote religious works, madrigals, and—as here—songs. "Quel Sguardo Sdegnosetto" was one of three *scherzi musicali* (musical jokes) composed in 1632 and shows a characteristically Baroque love of virtuosity and emotion. Unlike Morley's madrigal (Chapter 14), it is certainly not written for an amateur performer: the soloist is required to perform feats of brilliant singing (involving considerable breath control) while conveying the feeling behind a somewhat conventional anonymous Baroque poem.

The words deal with the joys and dangers of physical love (a new and typically Baroque subject: compare Bernini's *Ecstasy of Saint Teresa*, **Fig. 15.1**). Note the change of mood in the central section of the song's three parts. Much of the effect of the song comes from the way in which Monteverdi constructs a solid bass line, above which the singer seems to weave her line at random (although, of course, everything is carefully calculated).

Thus, in miniature, Monteverdi constructs a subtle and varied picture of erotic delights. The middle verse contains the words "Bombard my heart with a shower of sparks, but let not your lips be slow to revive me when I die." The singer here is Emma Kirkby, whose purity of voice (musicians would describe it as "without vibrato") is regarded as highly appropriate for Baroque vocal music.

Baroque Instrumental and Vocal Music

The development of opera permitted the dramatic retelling of mythological or historical tales. Sacred texts as stories derived from the Bible were set to music in a form known as the **oratorio**, which had begun to appear toward the end of the 16th century. One of the Baroque masters of the oratorio was the Italian Giacomo Carissimi (1605–1674), whose works, based on well-known biblical episodes, include *The Judgment of Solomon* and *Job*. By the dramatic use of the chorus, simple textures, and driving rhythms, Carissimi created an effect of strength and power that 21st-century listeners have begun to rediscover.

HEINRICH SCHÜTZ The concept of the public performance of religious works, rather than secular operas, appealed especially to Protestant Germans. Heinrich Schütz (1585–1672) wrote a wide variety of oratorios and other sacred works. In his early *Psalms of David* (1619), Schütz combined the choral technique of Renaissance composers like Gabrieli with the vividness and drama of the madrigal. His setting of *The Seven Last Words of Christ* (1645–1646) uses soloists, chorus, and instruments to create a complex sequence of narrative sections (recitatives), vocal ensembles, and choruses. Among his

last works are three settings of the Passion, the events of the last days of the life of Jesus, in the accounts given by Matthew, Luke, and John. Written in 1666, these works revert to the style of a century earlier, with none of the instrumental coloring generally typical of Baroque music, both sacred and secular.

Schütz is, in fact, one of the few great Baroque composers who, so far as is known, never wrote any purely instrumental music. The fact is all the more striking because the Baroque period was notable for the emergence of independent instrumental compositions unrelated to texts of any kind. Girolamo Frescobaldi (1583–1643), the greatest organ virtuoso of his day—he was organist at Saint Peter's in Rome—wrote a series of rhapsodic fantasies known as toccatas that combined extreme technical complexity with emotional and dramatic expression. His slightly older Dutch contemporary Jan Pieterszoon Sweelinck (1562–1621), organist at Amsterdam, built sets of variations out of different settings of a chorale melody or hymn tune. The writing of **chorale variations**, as this type of piece became known, became popular throughout the Baroque period.

DIETRICH BUXTEHUDE The Danish Dietrich Buxtehude (1637–1707), who spent most of his career in Germany, combined the brilliance of the toccata form with the use of a chorale theme in his chorale fantasies. Starting with a simple hymn melody, he composed free-form rhapsodies that are almost improvisational in style. His suites for **harpsichord** (the keyboard instrument that was a primary forerunner of the modern piano) include movements in variation form, various dances, slow lyric pieces, and other forms; like other composers of his day, Buxtehude used the keyboard suite as a kind of compendium of musical forms.

DOMENICO SCARLATTI One of the greatest composers of the Late Baroque period was Domenico Scarlatti (1685–1757). The greatest virtuoso of his day on the harpsichord, Scarlatti wrote hundreds of **sonatas** (short instrumental pieces) for it and laid the foundation for modern keyboard techniques.

GEORG FRIDERIC HANDEL Scarlatti's contemporary Georg Frideric Handel (1685–1759) was born in Halle, Germany, christened with the name Georg Friedrich Händel, which he changed to George Frederick Handel when he settled in England and became a naturalized citizen. London was to prove the scene of his greatest successes, among them *Messiah*, first performed in Dublin in 1742. This oratorio is among the most familiar of all Baroque musical masterpieces, and its most famous section is the "Hallelujah Chorus."

GO LISTEN! GEORG FRIDERIC HANDEL

"Hallelujah Chorus" from *Messiah*

From the time of its first performance, Handel's "Hallelujah Chorus," which ends the second part of his oratorio

Messiah, has been recognized as one of the great masterpieces of Baroque splendor and fervor. With its hammering drums and triumphant trumpets soaring, it epitomizes the grandeur and religious conviction of the Baroque era.

It uses the typical Baroque device of light and shade to achieve its effect, with the music changing volume in order to dramatize the text. The chorus begins vigorously and fervently, repeating the word *hallelujah* with increasing emphasis and volume. Then the music suddenly drops to a lower level as the chorus sings, "For the Lord God omnipotent reigneth." The music becomes even quieter with the next section, beginning "The Kingdom of this world," as if the sound were about to fade away.

But Handel has a final punch up his sleeve. As the singers launch at top volume into the final section, "And He shall reign for ever and ever," the voices pile up into a massive and increasingly complex texture, urged on by trumpets and drums, until they reach their triumphant climax. Thus the "Hallelujah Chorus" combines the emotionalism, spirituality, light and shade, and religious fervor that are all typical of Baroque art.

Handel also wrote operas, including a series of masterpieces in Italian for performance in England. Among their greatest glories are the arias, which are permeated by Handel's rich melodic sense; one of the best-known is "Ombra mai fu" from *Xerxes*, often called the "Largo." Among his best-known orchestral works are the *Water Music* and the *Music for the Royal Fireworks*, both originally designed for outdoor performance. Written for numerous instruments, they were later rearranged for regular concerts.

Johann Sebastian Bach

In the year that saw the births of both Scarlatti and Handel, Johann Sebastian Bach (1685–1750) was born in Eisenach, Germany, into a family that had already been producing musicians for more than a century. With the exception of opera—which, as a devout Lutheran, he was not interested in—Bach mastered every musical form of the time, pouring forth some of the most intellectually rigorous and spiritually profound music ever created.

It is among the more remarkable achievements in the history of the arts that most of Bach's music was produced under conditions of grinding toil as organist and choir director in relatively provincial German towns. Even Leipzig—where Bach spent 27 years (from 1723 to his death) as **kantor** (music director) at the school attached to Saint Thomas's Church (*Thomaskirche* in German)—was far removed from the glittering centers of European culture where most artistic developments were taking place. As a result, Bach was little known as a composer during his lifetime and virtually forgotten after his death. Only in the 19th century did his body of work become known and published. He has since taken his place at the head of the Western musical tradition as the figure who raised the art of polyphony to its highest level.

If the sheer quantity of music Bach wrote is stupefying, so is the complexity of his musical thought. Among the forms he preferred was the fugue (derived from the Latin word for "flight"). In the course of a **fugue** a single theme is passed from voice to voice or instrument to instrument (generally four in number), each imitating the principal theme in turn. The theme thus becomes combined with itself and, in the process, the composer creates a web of sound in which each musical part is equally important; this technique is called *counterpoint* (*contrapunctus* in Latin). Bach's ability to endow this highly intellectual technique with emotional power is little short of miraculous. The range of emotions Bach's fugues cover can best be appreciated by sampling his two books of 24 preludes and fugues each, known collectively as *The Well-Tempered Clavier*. Each of the 48 preludes and fugues creates its own mood while remaining logically organized according to contrapuntal technique.

Many of Bach's important works are permeated by a single concern: the expression of his deep religious faith. A significant number were written in his capacity as director of music at Saint Thomas's for performance in the church throughout the year. Organ music, masses, oratorios, motets—in all of these he could use music to glorify God and to explore the deeper mysteries of Christianity. His **chorale preludes** consist of variations on chorales and use familiar and well-loved songs as the basis for a kind of musical improvisation. He wrote some two hundred **cantatas** (short oratorios), made up of sections of declamatory recitative and lyrical arias, which contain an almost inexhaustible range of religious emotions, from joyful celebrations of life to profound meditations on death. Most overwhelming of all is his setting of the *Saint Matthew Passion*, the story of the trial and crucifixion of Jesus as recorded in the Gospel of Matthew. In this immense work, Bach asserted his Lutheranism by using the German rather than the Latin translation of the gospel and by incorporating Lutheran chorales. The use of self-contained arias is Italian, though, and the spirit of deep religious commitment and dramatic fervor can only be described as universal.

It would be a mistake to think of Bach as somehow unworldly and touched only by religious emotions. Certainly his personal life had its share of domestic happiness and tragedy. His parents died when he was 10, leaving him to be brought up by an older brother who treated him with less than complete kindness. At the age of 15, Bach jumped at the chance to leave home and become a choirboy in the little town of Lüneberg. He spent the next few years moving from place to place, perfecting his skills as organist, violinist, and composer.

In 1707 Bach married his second cousin, Maria Barbara, who bore him seven children, of whom three died in infancy. Bach was devoted to his family, and the loss of these children, followed by the death of his wife in 1720, made a deep impression on him. It may have been to provide a mother for his surviving sons that he remarried in 1721. His new wife, Anna Magdalena, proved a loving companion, bearing him

13 more children and helping him with the preparation and copying of his music. One of the shortest but most touching of Bach's works is the little song "Bist du bei mir," which has survived, copied out in her notebook. The words are "As long as you are with me, I could face my death and eternal rest with joy. How peaceful would my end be if your beautiful hands could close my faithful eyes." (Some scholars now believe that the song may have originally been written by G. H. Stölzel, a contemporary musician whom Bach much admired.)

The move to Leipzig in 1723 was dictated at least in part by the need to provide suitable schooling for his children, although it also offered the stability and security Bach seems to have required. The subsequent years of continual work took their toll, however. Bach's sight had never been good, and the incessant copying of manuscripts produced a continual deterioration. In 1749, Bach was persuaded to undergo two disastrous operations, which left him blind. A few months later his sight was suddenly restored, but within 10 days he died of apoplexy (stroke).

Although most of Bach's works are on religious themes, the best known of all, the six Brandenburg Concertos, were written for the private entertainment of a minor prince, the Margrave of Brandenburg. Their form follows the Italian *concerto grosso*, an orchestral composition in three **movements** (sections): fast (**allegro**)—slow (**adagio** or **largo**)—fast (**allegro**).

THE "BRANDENBURG CONCERTOS" Four of Bach's six "Brandenburg Concertos" use a group of solo instruments, although the grouping differs from work to work. The whole set forms a kind of compendium of the possibilities of instrumental color, a true virtuoso achievement requiring equal virtuosity in performance. The musical mood is light, as befits works written primarily for entertainment, but Bach was incapable of writing music without depth, and the slow movements in particular are strikingly beautiful.

The second "Brandenburg Concerto" is written for a solo group of trumpet, recorder, oboe, and violin accompanied by a string orchestra. The first movement combines all of these to produce a brilliant rhythmic effect as the solo instruments now emerge from the orchestra, now rejoin it. The melodic line avoids short themes. Instead, as in much Baroque music, the melodies are long, elaborate patterns that seem to spread and evolve, having much of the ornateness of Baroque visual art. The opening theme forms an unbroken line of sound, rising and falling and doubling back as it luxuriantly spreads itself out.

The slow second movement forms a tranquil and meditative interlude. The brilliant tone of the trumpet would be inappropriate here, and Bach therefore omits it, leaving the recorder, oboe, and violin to quietly intertwine in a delicate web of sound. After its enforced silence, the trumpet seems to burst out irrepressibly at the beginning of the third movement, claiming the right to set the mood of limitless energy that carries the work to its conclusion.

GO LISTEN! JOHANN SEBASTIAN BACH

Third movement, Allegro assai, from Brandenburg Concerto No. 2 in F Major

Bach expects every one of his performers to be capable of extraordinary feats of virtuosity and movement. Listen to the opening trumpet solo, with its difficult trills: the player barely has time to breathe. And the oboist who picks up the tune has an even longer passage before the solo violin breaks in. With the entry of the flute, the texture becomes more complex but always remains crystal clear, as the four principal instruments play with fragments of the opening theme, breaking them up and putting them back together with the typical sense of Baroque unity in variety. The arrival of the other instruments provides a background for the continuous display of virtuosity, as the trumpet seems to reach ever higher.

Other works of Bach illustrate a broader range of Baroque characteristics: religious fervor, illusionism, emotionalism. We hear this last feature in this work, where the music seems to express boundless joy. In two other respects the work is typical of the Baroque period. It is written for a group of performers playing together—a technique that was to develop into the Classical orchestra—and, more importantly perhaps, the music's purpose is to give pleasure to performers and listeners alike: music as entertainment.

Antonio Vivaldi

The **concerto grosso** was pioneered by the Venetian composer Antonio Vivaldi (ca. 1676–1741), who delighted in strong contrasts between the orchestra, generally made up of string instruments, and a solo instrument—often a violin, but sometimes a flute, bassoon, or other wind instrument. Vivaldi's most often performed work is a set of four violin concertos known as "The Four Seasons," which illustrate in sound a set of four poems describing the characteristics of the annual cycle of the seasons. The one for spring, for example, describes the happy songs and dances with which the season is celebrated.

GO LISTEN! ANTONIO VIVALDI

First movement from "Spring" (*La Primavera*), Concerto No. 1 in E major, "The Four Seasons"

Written according to typical Baroque practice, each movement of Vivaldi's concertos is based on a single, strongly rhythmic theme, heard right at the beginning of the section. The fast tempo of the first movement of the "Spring" concerto indicates in the work a delight at the return of the season of flowers. Two further Baroque devices

help Vivaldi characterize the specific season: virtuosity (on the part of the solo violinist) and illusionism. Shortly after the opening, the violin imitates the trilling of the birds who have returned, and the music suddenly becomes quiet as all the instruments imitate the sound of the gentle spring breezes.

A sudden plunge announces the arrival of a spring storm, with upward leaps portraying lightning. The solo violin expresses the violence of the abrupt gusts of wind, while the lower strings seem to hint at not-so-distant thunder. Then the storm passes, the birdsong is heard again, and all ends with the joyful music of the opening.

In a matter of a few minutes, and with only a handful of instruments, Vivaldi has used Baroque techniques to illustrate human emotions evoked by natural events.

PHILOSOPHY AND SCIENCE IN THE BAROQUE PERIOD

Throughout the 17th century, philosophy—like the visual arts—continued to extend and intensify ideas first developed in the Renaissance. With the spread of humanism, the 16th century had seen a growing spirit of philosophical and scientific inquiry. In the Baroque period, that fresh approach to the world and its phenomena was expressed in clear and consistent terms for the first time since the Greeks. It might be said, in fact, that if the Renaissance marked the birth of modern philosophy, the 17th century signaled its coming of age.

The chief difference between the intellectual attitudes of the Middle Ages and those inaugurated by the Renaissance was a turning away from the contemplation of the absolute and eternal to a study of the particular and the perceivable. Philosophy ceased to be the preserve of theologians and instead became an independent discipline, no longer prepared to accept a supernatural or divine explanation for the world and human existence.

The importance of objective truth, objectively demonstrated, continues to lie at the heart of all scientific method and most modern philosophy. Yet great thinkers before the Renaissance, such as Thomas Aquinas (1225–1274), had also asked questions in an attempt to understand the world and its workings. How did 17th-century scientists and philosophers differ from their predecessors in dealing with age-old problems? The basic difference lay in their approach. When, for example, Aquinas was concerned with the theory of motion, he discussed it in abstract, metaphysical terms. Armed with his copy of Aristotle, he claimed that "motion exists because things which are in a state of potentiality seek to actualize themselves." When Galileo wanted to study motion and learn how bodies move in time and space, he climbed to the top of the Leaning Tower of Pisa and dropped weights to watch them fall. It would be difficult to imagine a more dramatic rejection of abstract generalization in favor of objective demonstration (see **Fig. 15.33**).

▼ **15.33 Principal Scientific Discoveries of the 17th Century**

1609	Kepler announces his first two laws of planetary motion
1614	Napier invents logarithms
1632	Galileo publishes *Dialogue Concerning the Two Chief World Systems*
1643	Torricelli invents the barometer
1662	Boyle formulates his law of gas pressure
1675	The Royal Observatory is founded at Greenwich, England
1684	Leibniz publishes his first paper employing new notations of calculus
1687	Isaac Newton publishes his account of the principle of gravity
1724	Fahrenheit proposes his scale for measuring temperature

Galileo Galilei

The life and work of Galileo Galilei (1564–1642) are typical both of the progress made by science in the 17th century and of the problems it encountered. Galileo changed the scientific world in two ways: first, as the stargazer who claimed that his observations through the telescope proved Copernicus right, for which statement he was tried and condemned by the Inquisition; and second, as the founder of modern physics. Although he is probably better known for his work in astronomy, from the scientific point of view his contribution to physics is more important.

Born in Pisa, Galileo learned from his father, Vincenzo—who had been one of the original members of the Florentine Camerata—a lively prose style and a fondness for music. As a student at the University of Padua from 1581 to 1592, he began to study medicine, but he soon changed to mathematics. After a few months back in Pisa, he took a position at the University of Padua as professor of mathematics, remaining there from 1592 to 1600.

In Padua, Galileo designed and built his own telescopes (**Fig. 15.34**) and saw for the first time the craters of the moon, sunspots, the phases of Venus, and other phenomena that showed that the universe is in a constant state of change, as Copernicus had claimed. From the time of Aristotle, however, it had been widely believed that the heavens were unalterable, representing perfection of form and movement. Galileo's discoveries thus disproved what had been a basic philosophical principle for 2000 years and so outraged a professor of philosophy at Padua that he refused to shake his own prejudices by having a look through a telescope for himself.

The more triumphantly Galileo proclaimed his findings, the more he found himself involved in something beyond mere scientific controversy. His real opponent was the church, which had officially adopted the Ptolemaic view of the universe: that the Earth formed the center of the universe around which the

sun, moon, and planets circled. This theory accorded well with the Bible, which seemed to suggest that the sun moves rather than the Earth; for the church, the Bible naturally took precedence over any reasoning or speculation independent of theology. Galileo, however, considered ecclesiastical officials incompetent to evaluate scientific matters and refused to give way. When he began to claim publicly that his discoveries had proved what Copernicus had theorized but could not validate, the church initiated a case against him on the grounds of heresy.

Galileo had meanwhile returned to his beloved Pisa, where he found himself in considerable danger from the Inquisition. In 1615 he left for Rome to defend his position in the presence of Pope Paul V. He failed and, as a result, was censured and prohibited from spreading the Copernican theory either by teaching or publication.

In 1632, Galileo returned to the attack when a former friend was elected pope. He submitted to Pope Urban VIII a *Dialogue Concerning the Two Chief World Systems*, having carefully chosen the dialogue form so that he could put ideas into the mouths of other characters and thereby claim that they were not his own. Once more, under pressure from the Jesuits, Galileo was summoned to Rome. In 1633 he was put on trial after spending several months in prison. His pleas of old age and poor health won no sympathy from the tribunal. He was made to recant and humiliate himself publicly and was sentenced to prison for the rest of his life. (It might well have appealed to Galileo's sense of bitter irony that 347 years later, in 1980, Pope John Paul II—a fellow countryman of the Polish Copernicus—ordered the case to be reopened so that belated justice might be done.)

Influential friends managed to secure Galileo a relatively comfortable house arrest in his villa just outside Florence, and he retired there to work on physics. His last and most important scientific work, *Dialogues Concerning Two New Sciences*, was published in 1638. In it he examined many long-standing problems, including that of motion, always basing his conclusions on practical experiment and observation. In the process he established the outlines of many areas of modern physics.

In all his work, Galileo set forth a new way of approaching scientific problems. Instead of trying to understand the final cause or cosmic purpose of natural events and phenomena, he tried to explain their character and the manner in which they came about. He changed the question from why to what and how.

René Descartes

Scientific investigation could not solve every problem of human existence. While it could try to explain and interpret objective phenomena, there remained other, more subjective areas of experience involving ethical and spiritual questions. The Counter-Reformation on the one hand and the Protestant churches on the other claimed to have discovered the answers. The debates nevertheless continued, most notably in the writings of the French philosopher René Descartes (1596–1650), often called the Father of Modern Philosophy.

In many ways Descartes's philosophical position was symptomatic of his age. He was educated at a Jesuit school but found traditional theological teaching unsatisfactory. Turning to science and mathematics, he began a lifelong search for reliable evidence in his quest to distinguish truth from falsehood. Attacking philosophical problems, his prime concern was to establish criteria for

◄ **15.34 Telescope and lens of Galileo, 1609. Museo della Scienza, Florence, Italy.** After his death near Florence in 1642, many of Galileo's instruments, including this telescope, were collected and preserved. The Museo della Scienza (Museum of Science) in Florence, Italy, where they can now be seen, was one of the earliest museums to be devoted to scientific rather than artistic works.

READING 15.3 RENÉ DESCARTES

From *Discourse on the Method of Rightly Conducting the Reason and Seeking the Truth in the Sciences*, part 4, book 4

I attentively examined what I was, and as I observed that I could suppose that I had no body, and that there was no world nor any place in which I might be; but that I could not therefore suppose that I was not; and that, on the contrary, from the very circumstance that I thought to doubt of the truth of other things, it most clearly and certainly followed that I was; while, on the other hand, if I had only ceased to think, although all the other objects which I had ever imagined had been in reality existent, I would have had no reason to believe that I existed; I thence concluded that I was a substance whose whole essence or nature consists only in thinking, and which, that it may exist, has need of no place, nor is dependent on any material thing; so that "I," that is to say, the mind by which I am what I am, is wholly distinct from the body, and is even more easily known that the latter, and is such, that although the latter were not, it would still continue to be all that it is.

defining reality. His chief published works, the *Discourse on the Method* (1637) and the *Meditations* (1641), contain a step-by-step account of how he arrived at his conclusions.

According to Descartes, the first essential in the search for truth was to make a fresh start by refusing to believe anything that could not be decisively proved to be true. This required that he doubt all of his previously held beliefs, including the evidence of his own senses. By stripping away all uncertainties he reached a basis of indubitable certainty on which he could build: that he existed. The very act of doubting proved that he was a thinking being. As he put it in a famous phrase in his second Meditation, "Cogito, ergo sum" ("I think, therefore I am").

From this foundation Descartes proceeded to reconstruct the world he had taken to pieces by considering the nature of material objects. He was guided by the principle that whatever is clearly and distinctly perceived must exist. He was aware at the same time that our perceptions of the exact nature of these objects are extremely likely to be incorrect and misleading. When, for example, we look at the sun, we see it as a very small disk, although the sun is really an immense globe. We must be careful, therefore, not to assume that our perceptions are bound to be accurate. All that they demonstrate is the simple existence of the object in question.

If the idea of the sun comes from the perception, however inaccurate, of something that actually exists, what of God? Is the idea of a divine being imagined or based on truth? Descartes concluded that the very fact that we who are imperfect and doubting can conceive of a perfect God proves that our conception is based on a reality. In other words, who could ever have imagined God unless God existed? At the center of the Cartesian philosophical system, therefore, lay a belief in a perfect being—not necessarily to be identified with the God of the Old and New Testaments—who had created a world permeated by perfect (that is, mathematical) principles.

At first, this may seem inconsistent with Descartes' position as the founder of modern rational thought. It may seem even stranger that, just at the time when scientific investigators like Galileo were explaining natural phenomena without recourse to divine intervention, Descartes succeeded in proving to his own satisfaction the undeniable existence of a divine being. Yet a more careful look at Descartes's method reveals that both he and Galileo shared the same fundamental confidence in the rational powers of human beings.

Thomas Hobbes

Although Galileo and Descartes represent the major trends in 17th-century thought, other important figures made their own individual contributions. Descartes's fellow countryman Blaise Pascal (1623–1662), for example, launched a strong attack on the Jesuits while providing his own somewhat eccentric defense of Christianity. A more mystical approach to religion was that of the Dutch philosopher Baruch Spinoza (1632–1677), whose concept of the ideal unity of nature later made a strong appeal to 19th-century Romantics.

The English philosopher Thomas Hobbes (1588–1679), however, had little in common with any of his contemporaries—as he was frequently at pains to make plain. For Hobbes, truth lay only in material things: "All that is real is material, and what is not material is not real." Hobbes was thus one of the first modern proponents of **materialism**, and like many of his materialist successors, he was interested in solving political rather than philosophical problems. Born in the year of the Spanish Armada, Hobbes lived through the turbulent English Civil War, a period marked by constant instability and political confusion. Perhaps in consequence, he developed an enthusiasm for the authority of the law, as represented by the king, that verged on totalitarianism.

Hobbes's political philosophy finds its fullest statement in his book *Leviathan*, first published in 1651. The theory of society that he describes there totally denies the existence in the universe of any divinely established morality. (Hobbes never denied the existence of God, not wishing to outrage public and ecclesiastical opinion unnecessarily, although he might as well have.) According to Hobbes, all laws are created by humans to protect themselves from one another—a necessary precaution, in view of human greed and violence. Organized society in consequence is arrived at when individuals give up their personal liberty in order to achieve

security. As a result, the ideal state is that in which there is the greatest security, specifically one ruled by an absolute ruler.

From its first appearance, *Leviathan* created a scandal; it has been subjected to continual attack ever since. Hobbes managed to offend both of the chief groups of participants in the intellectual debates of the day: the theologians by telling them that their doctrines were irrelevant and their terminology "insignificant sound," and the rationalists by claiming that human beings, far from being capable of the highest intellectual achievements, are dangerous and aggressive creatures who need to be saved from themselves.

READING 15.4 THOMAS HOBBES

From *Leviathan*, part 1, chapter 13

Hereby it is manifest, that during the time men live without a common power to keep them all in awe, they are in that condition which is called war; and such a war is of every man, against every man. For war consisteth not in battle only or the act of fighting; but in a tract of time, wherein the will to contend by battle is sufficiently known.

Whatsoever therefore is consequent to a time of war, where every man is enemy to every man, the same is consequent to the time wherein men live without other security than what their own strength and their own invention shall furnish them withal. In such condition there is no place for industry, because the fruit thereof is uncertain; and consequently no culture of the earth; no navigation, nor use of the commodities that may be imported by sea; no commodious building; no instruments of moving and removing such things as require much force; no knowledge of the face of the earth; no account of time; no arts; no letters; no society; and, which is worst of all, continual fear, and danger of violent death; and the life of man, solitary, poor, nasty, brutish, and short.

Hobbes's pessimism and the extreme nature of his position have won him few wholehearted supporters in the centuries since his death. Yet many modern readers, like others in the time since *Leviathan* first appeared, must reluctantly admit that there is at least a grain of truth in his picture of society, which can be attested to by personal experience and observation. At the very least, his political philosophy is valuable as a diagnosis and a warning of some aspects of human potential that virtually all of his contemporaries, and many of his successors, preferred to ignore.

John Locke

The leading English thinker of the generation following Hobbes was John Locke (1632–1704), whose work helped pave the way for the European Enlightenment. The son of a country attorney, his education followed traditional Classical lines, but the young Locke was more interested in medicine and the new experimental sciences. In 1666 he became physician and secretary to the future Earl of Shaftesbury, who encouraged his interest in political philosophy.

In his first works, Locke explored the subjects of property and trade and the role of the monarch in a modern state. He then turned to more general questions: What is the nature of ideas? How do we get them? What are the limitations of human knowledge? His most influential work, *An Essay Concerning Human Understanding*, appeared in 1690. In it he argued against a theory of innate (or *inborn*) ideas, proposing instead that our ideas derive from our perceptions. Thus, our notions and characters are based on our own individual sense impressions and on our reflections on them, not on inherited values.

READING 15.5 JOHN LOCKE

From *An Essay Concerning Human Understanding*, book 1, "Of Innate Notions," chapter 2: No Innate Principles in the Mind

It is an established opinion amongst some men, that there are in the understanding certain *innate principles*; some primary notions, . . . characters, as it were stamped upon the mind of man; which the soul receives in its very first being, and brings into the world with it.

It would be sufficient to convince unprejudiced readers of the falseness of this supposition, if I should only show (as I hope I shall in the following parts of this Discourse) how men, barely by the use of their natural faculties, may attain to all the knowledge they have, without the help of any innate impressions; and may arrive at certainty, without any such original notions or principles. For I imagine any one will easily grant that it would be impertinent to suppose the ideas of colors innate in a creature to whom God hath given sight, and a power to receive them by the eyes from external objects; and no less unreasonable would it be to attribute several truths to the impressions of nature, and innate characters, when we may observe in ourselves faculties fit to attain as easy and certain knowledge of them as if they were originally imprinted on the mind.

For his successors in the 18th century, Locke seemed to have set human nature free from the control of divine authority. Humans were no longer perceived as the victims of innate original sin or the accidents of birth, but instead derived their ideas and personalities from their experiences. Like many of the spokesmen of the Enlightenment, Voltaire acknowledged the importance of Locke's ideas; few modern students of education or theory of knowledge have escaped being influenced by him.

LITERATURE IN THE 17TH CENTURY

French Baroque Comedy and Tragedy

It is hardly surprising that the Baroque age, which put so high a premium on the expression of dramatic emotion, should have been an important period in the development of the theater. In France in particular, three of the greatest names in the history of drama were active simultaneously, all of them benefiting at one point or another from the patronage of Louis XIV.

Molière was the stage name of Jean-Baptiste Poquelin (1622–1673), who was the creator of a new theatrical form: French Baroque comedy. Having first made his reputation as an actor, he turned to the writing of drama as a means of deflating pretense and pomposity. In his best works, the deceptions or delusions of the principal characters are revealed for what they are with good humor and considerable understanding of human foibles, but dramatic truth is never sacrificed to mere comic effect. Unlike so many comic creations, Molière's characters remain believable. Jourdain, the good-natured social climber of *Le Bourgeois Gentilhomme*, and Harpagon, the absurd miser of *L'Avare*, are by no means mere symbols of their respective vices, but victims of those vices, albeit willing ones. Even the unpleasant Tartuffe in the play of the same name is a living character with his own brand of hypocrisy.

Tartuffe is something of a hedonist but presents himself to the world as a religious ascetic. He has managed to convince a wealthy Parisian, Orgon, that he is pious—so pious that Orgon will leave his fortune to Tartuffe. Tartuffe becomes Orgon's houseguest, but Orgon's family, who see through Tartuffe and wish to protect their own interests, attempt to expose him to Orgon, leading to a variety of humorous complications. In lines from act 3, we see the hypocrite referring to his hair-shirt (an instrument designed to mortify the flesh and used by some of the pious) and his scourge (an instrument with which he would flagellate himself, again to mortify the flesh). Then he approaches Orgon's maid Dorine and shows an interest in her—before he attempts to seduce Orgon's wife.

Classical motifs play a strong part in the works of the two greatest tragic dramatists of the age: Pierre Corneille (1606–1684) and Jean Racine (1639–1699). Corneille created, as a counterpart to Molière's comedy, French Baroque tragedy. Most of his plays take as their theme an event in Classical history or mythology, which is often used to express eternal truths about human behavior. The themes of patriotism, as in *Horace*, or martyrdom, as in *Polyeucte*, are certainly as relevant today as they were in 17th-century France or in ancient Greece or Rome. However, most people's response to Corneille's treatment of subjects such as these is probably conditioned by the degree to which they enjoy the cut and thrust of rhetorical debate.

Racine may well provide for many modern readers an easier entry into the world of French Baroque tragedy. Although for the most part he followed the dramatic form and framework established by Corneille, he used it to explore different areas of human experience. His recurrent theme is self-destruction: the inability to control one's own jealousy, passion, or ambition and the resulting inability, as tragic as it is inevitable, to survive its effects. Furthermore, in plays like *Phèdre*, he explored the state of mind of his principal characters, probing for the same kind of understanding of motivation that Monteverdi tried to achieve in music.

Cervantes and the Spanish Novel

By the middle of the 16th century, the writing of fiction in Spain had begun to take a characteristic form that was to influence future European fiction. The **picaresque** novel (in Spanish *pícaro* means "rogue" or "knave") was a Span-

READING 15.6 MOLIÈRE

***Tartuffe*, act 3, scene 2, lines 1–16**

TARTUFFE: *[Observing Dorine, and calling to his manservant offstage]* Hang up my hair-shirt, put my scourge in place,
 And pray, Laurent, for Heaven's perpetual grace.
 I'm going to the prison now, to share
 My last few coins with the poor wretches there.
DORINE: *[Aside]* Dear God, what affectation! What a fake!
TARTUFFE: You wished to see me?
DORINE: Yes . . .
TARTUFFE: *[Taking a handkerchief from his pocket]* For mercy's sake,
 Please take this handkerchief before you speak.
DORINE: What?
TARTUFFE: Cover that bosom, girl, the flesh is weak,
 And unclean thoughts are difficult to control.
 Such sights as that can undermine the soul.
DORINE: Your soul, it seems, has very poor defenses,
 And flesh makes quite an impact on your senses,
 It's strange that you're so easily excited;
 My own desires are not so soon ignited,
 And if I saw you naked as a beast,
 Not all your hide would tempt me in the least.

Tartuffe by Moliere, English translation by Richard Wilbur.

VALUES

Scientific Truth

Nature, and Nature's laws lay hid in night.
God said: "Let Newton be!" and all was Light!

—Alexander Pope

Many factors contributed to the growth of science in the 17th century. Among them were the spread of education, the discovery of the Americas, explorations in Asia and Africa, and the development of urban life. Perhaps the most important of all was a growing skepticism toward traditional religious beliefs, induced by the violent wars of religion provoked by the Reformation and Counter-Reformation.

One of the leading figures in the scientific revolution, Francis Bacon (1561–1626), wrote that scientists should follow the example of Columbus and think all things possible until all things could be tested. This emphasis on the "empirical faculty"—learning based on experience—is a method of drawing general conclusions from particular observations. Medieval thinkers, relying on the examples of Aristotle and Ptolemy, had devised general theories and then looked for specific examples to confirm them. Scientific truth sought to reason in the opposite way: start from the specific and use it to establish a general theory, a process known as **induction**. Above all, the new scientists took nothing for granted and regarded no opinion as "settled and immovable."

The search for objective, scientific truth required the invention of new instruments. Galileo's telescope allowed him to study the sky and revolutionize astronomy. Other researchers used another form of optical instrument—the microscope—to analyze blood and describe bacteria. The invention of the thermometer and barometer made it possible to perform atmospheric experiments.

With the increasing circulation of knowledge, scientists could spread and test their ideas. An international scientific community began to develop, stimulated by the formation of academies and learned societies. The most influential were the Royal Society of London for Improving Natural Knowledge, founded in 1662, and the French Académie des Sciences, founded in 1666. By means of published accounts and private correspondence, scientists were able to see how their own discoveries related to other fields.

Although the study of natural science does not involve questions of theology or philosophy, the growing interest in finding rational explanations for natural phenomena led to a change in views of religion. Most early scientists continued to believe in God but abandoned the medieval view of the deity as incomprehensible creator and judge. Rather, they saw God as the builder of a world-machine, which he then put into motion. Humans could come to understand how the machine worked, but only if they used their powers of reason to establish scientific truth.

ish invention; books of this genre tell a story that revolves around a rogue or adventurer. The earliest example is *Lazarillo de Tormes*, which appeared anonymously in 1554. Its hero, Lazarillo, is brought up among beggars and thieves, and many of the episodes serve as an excuse to satirize priests and church officials—so much so, in fact, that the Inquisition ordered parts omitted in later printings. Unlike prose being written elsewhere at the time, the style is colloquial, even racy, and heavy with irony.

Although *Don Quixote*, by general agreement the greatest novel in the Spanish language, has picaresque elements, its style and subject are both far more subtle and complex. Miguel de Cervantes Saavedra (1547–1616), its author, set out to satirize medieval tales of chivalry and romance by inventing a character—Don Quixote—who is an amiable elderly gentleman looking for the chivalry of storybooks in real life. This apparently simple idea takes on almost infinite levels of meaning, as Don Quixote pursues his ideals, in general without much success, in a world with little time for romance or honor. In his adventures, which bring him into contact with all levels of Spanish society, he is accompanied by his squire

Sancho Panza, whose shrewd practicality serves as a foil for his own unworldliness.

In part 2 of *Don Quixote*, Don Quixote and Sancho are searching for Don Quixote's ideal (and imaginary) mistress, Dulcinea. Sancho, who realizes the absurdity of the quest, pretends to recognize a passing peasant girl as the beloved Dulcinea. Don Quixote sees that the girl is plain, poorly dressed, and riding on a donkey, yet his own need to be convinced persuades him to greet her as his beautiful mistress.

The structure of the novel is as leisurely and seemingly as rambling as the Don's wanderings. Yet the various episodes are linked by the constant confrontation between reality and illusion, the real world and that of the imagination. Thus at one level the book becomes a meditation on the relationship between art and life. By the end of his life, Don Quixote has learned painfully that his noble aspirations cannot be reconciled with the realities of the world, and he dies disillusioned. In the last part of the book, where the humor of the hero's mishaps does not conceal their pathos, Cervantes reaches that rare height of artistry where comedy and tragedy are indistinguishable.

READING 15.7 MIGUEL DE CERVANTES SAAVEDRA

From *Don Quixote*, part 2, chapter 10

By this time Don Quixote had fallen on his knees beside Sancho, and was staring, with his eyes starting out of his head and a puzzled look on his face, at the person whom Sancho called Queen and Lady. And as he could see nothing in her but a country girl, and not a very handsome one at that, she being round-faced and flat-nosed, he was bewildered and amazed, and did not dare to open his lips. The village girls were equally astonished at seeing these two men, so different in appearance, down on their knees and preventing their companion from going forward. But the girl they had stopped broke the silence by crying roughly and angrily: "Get out of the way, confound you, and let us pass. We're in a hurry."

To which Sancho replied: "O Princess and world-famous Lady of El Toboso! How is it that your magnanimous heart is not softened when you see the column and prop of knight errantry kneeling before your sublimated presence?"

On hearing this, one of the two others exclaimed: "Wait till I get my hands on you, you great ass! See how these petty gentry come and make fun of us village girls, as if we couldn't give them as good as they bring! Get on your way, and let us get on ours. You had better!"

"Rise, Sancho," said Don Quixote at this; "for I see that Fortune, unsatisfied with the ill already done me, has closed all roads by which any comfort may come to this wretched soul I bear in my body. And you, O perfection of all desire! Pinnacle of human gentleness! Sole remedy of this afflicted heart, that adores you! Now that the malignant enchanter persecutes me, and has put clouds and cataracts into my eyes, and for them alone, and for no others, has changed and transformed the peerless beauty of your countenance into the semblance of a poor peasant girl, if he has not at the same time turned mine into the appearance of some specter to make it abominable to your sight, do not refuse to look at me softly and amorously, perceiving in this submission and prostration, which I make before your deformed beauty, the humility with which my soul adores you."

"Tell that to my grandmother!" replied the girl. "Do you think I want to listen to that nonsense? Get out of the way and let us go on, and we'll thank you."

From *The Adventures of Don Quixote* by Miguel de Cervantes Saavedra, translated by J. M. Cohen.

English Literature

In England, the pinnacle of dramatic expression had been reached by the turn of the century in the works of Shakespeare. The literary form that proved most productive during the 17th century was that of lyric poetry, probably because of its ability to express personal emotions—although most scholars would agree that the single greatest English work of the age was John Milton's epic poem *Paradise Lost*. Yet another achievement of the era was not an original work at all, but rather a translation.

THE KING JAMES BIBLE An important English-language literary achievement of the 17th century was not an original artistic creation, but rather a new translation. It is difficult to know precisely how to categorize the Authorized Version of the Bible, commissioned by King James I and first published in 1611, often called the only great work of literature ever produced by a committee. The 54 scholars and translators who worked on the task deliberately tried to create a biblical style that would transcend the tone of English as it was then generally used. Their success can be measured by the immense influence the King James Bible has had on speakers and writers of English ever since (see Chapter 14). It remained the Authorized Version for English-speaking people until the late 19th century, when it was revised in light of new developments in biblical studies.

JOHN DONNE Of all 17th-century literary figures writing in English, the group known as the Metaphysical poets, whose poetry sought to give intellectual expression to emotional experience, make a particular appeal to modern readers. As is often pointed out, the label **metaphysical** is misleading for two reasons. In the first place, it suggests an organized group of poets consciously following a common style. While it is true that the earliest poet to write in the metaphysical style, John Donne (1572–1631), exerted a strong influence on a whole generation of younger poets, a unified group or school never existed. (Some scholars would, in fact, classify Donne's style as *Mannerist*.)

Second, *metaphysical* seems to imply that the principal subject of their poetry was philosophical speculation on the nature of reality. While it is certainly true that the Metaphysical poets were interested in ideas and that they used complex forms of expression and a rich vocabulary to express them, the chief subject of their poems was not philosophy, but themselves—particularly their own emotions.

Yet this concern with self-analysis should not suggest a limitation of vision. Some critics have ranked Donne's sonnets second only to Shakespeare's in their range and depth of expression. Donne's intellectual brilliance and his love of paradox and ambiguity make his poetry sometimes difficult to follow. Donne always avoided the conventional, both in word and thought, and the swift changes of mood within a single short poem from light banter to the utmost seriousness can confuse careless readers. Although it sometimes takes patience to unravel his full meaning, the effort is more than amply rewarded by contact with one of the most daring and honest of poets.

Donne's poems took on widely differing areas of human experience, ranging from some of the most passionate and frank discussions of sexual love ever penned to profound meditations on human mortality and the nature of the soul. Born a Catholic, he traveled widely as a young man and seems to have led a hectic and exciting life. He abandoned Catholicism, perhaps in part to improve his chances of success in Protestant England, and in 1601, on the threshold of a successful career in public life, he entered Parliament. The same year, however, he secretly married his patron's 16-year-old niece, Anne More. Her father had him dismissed and even imprisoned for a few days, and Donne's career never recovered from the disgrace.

Donne's "The Canonization" has its religious elements, but as we see in the first verse, it could also have been an argument against his wife's father.

READING 15.8 JOHN DONNE

"The Canonization," lines 1–9

For Godsake, hold your tongue, and let me
 Love,
 Or chide my palsy, or my gout,
My five gray hairs, or ruined fortune flout.
 With wealth your state, your mind with
 Arts improve.
 Take you a course, get you a place,
 Observe his honor, or his grace,
Or the king's real, or his stamped face
 Contemplate; what you will, approve,
 So you will let me love.

Although Donne's marriage proved a happy one, its early years were clouded by debt, ill health, and frustration. In 1615, at the urging of friends, he finally joined the Anglican Church and entered the ministry. As a preacher he soon became known as among the greatest of his day. By 1621, Donne was appointed to one of the most prestigious positions in London: dean of Saint Paul's. During his last years he became increasingly obsessed with death. After a serious illness in the spring of 1631, he preached his own funeral sermon and died within a few weeks.

Thus the successful worldliness of the early years gave way to the growing somberness of his later career. We might expect a similar progression from light to darkness in his work, yet throughout his life the two forces of physical passion and religious intensity seem to have been equally dominant, with the result that in much of his poetry each is sometimes used to express the other.

RICHARD CRASHAW The poems of Donne's younger contemporary Richard Crashaw (1613–1649) blend extreme emotion and religious fervor in a way that is completely typi-

cal of much Baroque art. Yet Crashaw serves as a reminder of the danger of combining groups of artists under a single label, because although he shares many points in common with the other Metaphysical poets, his work as a whole strikes a unique note.

There can be little doubt that Crashaw's obsessive preoccupation with pain and suffering has more than a touch of masochism, or that his religious fervor is extreme even by Baroque standards. Some of the intensity is doubtless a result of his violent rejection of his father's Puritanism and his own enthusiastic conversion to Catholicism. Stylistically, Crashaw owed much to the influence of the flamboyant Italian Baroque poet Giambattista Marino (1569–1625), whose virtuoso literary devices he imitated. Yet the eroticism that so often tinges Crashaw's spiritual fervor gives a highly individual air to his work.

READING 15.9 RICHARD CRASHAW

"On the Wounds of Our Crucified Lord," lines 1–8

O these wakeful wounds of thine!
 Are they Mouthes? or are they eyes?
Be they Mouthes, or be they eyne,
 Each bleeding part some one supplies.
Lo! a mouth, whose full bloom'd lips
 At too dear a rate are roses.
Lo! a blood-shot eye! that weeps
 And many a cruell teare discloses.

ANDREW MARVELL Marvell (1621–1678) was the son of a pastor and attended Cambridge. Through his studies and his travels, he learned Latin, Greek, Dutch, French, Spanish, and Italian—all of which served him well as an ambassador during his career. That career was largely political; he served in in the Cromwell government and then in parliament for many years. His poetry, like that of other metaphysical poets, contains some far-fetched similes, metaphors, and **hyperbole**—that is, poetic exaggeration. We find such exaggeration in his ever-popular "carpe diem"[7] poem "To His Coy Mistress," which is written in rhyming couplets of iambic tetrameter. His phrasing "if you please, refuse/Till the conversion of the Jews" refers to one Christian belief that Jews will convert to Christianity just before the end of time. Or consider the simile, "the youthful hue/Sits on thy skin like morning dew." Other phrasings of note include "thy marble vault" as your sepulcher or grave; if you persevere in protecting your honor, "then worms shall try/That long preserved virginity."

7. "Seize the day."

READING 15.10 ANDREW MARVELL

To His Coy Mistress (ca. early 1650s)

"Had we but world enough, and time,
This coyness, Lady, were no crime.
We would sit down and think which way
To walk and pass our long love's day.
Thou by the Indian Ganges' side
Shouldst rubies find: I by the tide
Of Humber would complain. I would
Love you ten years before the Flood,
And you should, if you please, refuse
Till the conversion of the Jews.
My vegetable love should grow
Vaster than empires, and more slow;
An hundred years should go to praise
Thine eyes and on thy forehead gaze;
Two hundred to adore each breast;
But thirty thousand to the rest;
An age at least to every part,
And the last age should show your heart;
For, Lady, you deserve this state,
Nor would I love at lower rate.

But at my back I always hear
Time's wingèd chariot hurrying near;
And yonder all before us lie
Deserts of vast eternity.
Thy beauty shall no more be found,
Nor, in thy marble vault, shall sound
My echoing song: then worms shall try
That long preserved virginity,
And your quaint honour turn to dust,
And into ashes all my lust:
The grave's a fine and private place,
But none, I think, do there embrace.
Now therefore, while the youthful hue
Sits on thy skin like morning dew,
And while thy willing soul transpires
At every pore with instant fires,

Now let us sport us while we may,
And now, like amorous birds of prey,
Rather at once our time devour
Than languish in his slow-chapt power.
Let us roll all our strength and all
Our sweetness up into one ball,
And tear our pleasures with rough strife
Thorough the iron gates of life:
Thus, though we cannot make our sun
Stand still, yet we will make him run.

JOHN MILTON'S HEROIC VISION While the past hundred years have seen a growing appreciation for Donne and his followers, the reputation of John Milton has undergone some notable ups and downs. Revered in the centuries following his death, Milton's work came under fire in the early years of the 20th century from major poets such as T. S. Eliot and Ezra Pound, who claimed that his influence on his successors had been pernicious and had led much of subsequent English poetry astray. Now that the dust of these attacks has settled, Milton has resumed his place as one of the greatest of English poets. The power of his spiritual vision, coupled with his heroic attempt to wrestle with the great problems of human existence, seems in fact to speak directly to the uncertainties of our own time.

Milton's life was fraught with controversy. An outstanding student with astonishing facility in languages, he spent his early years traveling widely in Europe and composing relatively lightweight verse—lightweight, that is, when compared to what was to come. Among his most entertaining early works are the companion poems "L'Allegro" and "Il Penseroso," which compare the cheerful and the contemplative character to appropriate scenery. They were probably written in 1632, following his graduation from Cambridge.

By 1640, however, he had become involved in the tricky issues raised by the English Civil War and the related problems of church government. He launched into the fray with a series of radical pamphlets that advocated, among other things, divorce on the grounds of incompatibility. (It is presumably no coincidence that his own wife had left him six weeks after their marriage.) His growing support for Oliver Cromwell and the Puritan cause won him an influential position at home but considerable enmity in continental Europe, where he was seen as the defender of those who had ordered the execution of King Charles I in 1649. The strain of his secretarial and diplomatic duties during the following years destroyed his eyesight, but although completely blind, he continued to work with the help of assistants.

When Charles II was restored to power (in 1660), Milton lost his position and was fortunate not to lose his life or liberty. Retired to private life, he spent his remaining years in the composition of three massive works: *Paradise Lost* (1667), *Paradise Regained* (1671), and *Samson Agonistes* (1671).

By almost universal agreement, Milton's most important, if not most accessible, work is *Paradise Lost*, composed in the early 1660s and published in 1667. It was intended as an account of the fall of Adam and Eve, and its avowed purpose was to "justify the ways of God to man." The epic is in 12 books (originally 10, but Milton later revised the divisions), written in blank verse.

Milton's language and imagery present an almost inexhaustible combination of biblical and Classical reference.

READING 15.11 JOHN MILTON

Paradise Lost, book 1, lines 1–27

Of Man's first disobedience, and the fruit
Of that forbidden tree whose mortal taste
Brought death into the World, and all our woe,
With loss of Eden, till one greater Man
Restore us, and regain the blissful seat,
Sing, Heavenly Muse, that, on the secret top
Of Oreb, or of Sinai, didst inspire
That shepherd who first taught the chosen seed
In the beginning how the heavens and earth
Rose out of chaos: or, if Sion hill
Delight thee more, and Siloa's brook that flowed
Fast by the oracle of God, I thence
Invoke thy aid to my adventurous song,
That with no middle flight intends to soar
Above the Aonian mount, while it pursues
Things unattempted yet in prose or rhyme.
And chiefly Thou, O Spirit, that dost prefer
Before all temples the upright heart and pure,
Instruct me, for Thou know'st; Thou from the first
Wast present, and, with mighty wings outspread,
Dove-like sat'st brooding on the vast Abyss,
And mad'st it pregnant: what in me is dark
Illumine, what is low raise and support;
That, to the height of this great argument,
I may assert Eternal Providence,
And justify the ways of God to men.

Charles W Eliot, ed., *The Complete Poems of John Milton*, Volume 4, The Harvard Classics, New York: PF Collier & Son, 1909, p. 90.

READING 15.12 JOHN MILTON

Paradise Lost, book 1, lines 84–94

If thou beest he but Oh how fallen! How changed
From him!—who, in the happy realms of light,
Clothed with transcendent brightness, didst outshine
Myriads, though bright if he whom mutual league,
United thoughts and counsels, equal hope
And hazard in the glorious enterprise,
Joined with me once, now misery hath joined
In equal ruin; into what pit thou seest
From what height fallen: so much the stronger proved
He with his thunder: and till then who knew
The force of those dire arms?

Charles W Eliot, ed., *The Complete Poems of John Milton*, Volume 4, The Harvard Classics, New York: PF Collier & Son, 1909, p. 92.

From the very first lines of book 1, where the poet calls on a Classical Muse to help him tell the tale of the Fall, the two great Western cultural traditions are inextricably linked. Like Bach, Milton represents the summation of these traditions. In his work, Renaissance and Reformation meet and blend to create the most complete statement in English of Christian humanism, the philosophical reconciliation of humanist principles with Christian doctrine. To the Renaissance Milton owed his grounding in the Classics. In composing *Paradise Lost*, an epic poem that touches on the whole range of human experience, he was deliberately inviting comparison to Homer and Virgil. His language is also Classical in inspiration, with its long, grammatically complex sentences and preference for abstract terms. Yet his deeply felt Christianity and his emphasis on human guilt and repentance mark him as a product of the Reformation. Furthermore, although he may have tried to transcend the limitations of his own age, he was as much a child of his time as any of the other artists discussed in this chapter. The dramatic fervor of Bernini, the spiritual certainty of Bach, the psychological insight of Monteverdi, the humanity of Rembrandt—all have their place in Milton's work and mark him, too, as an essentially Baroque figure.

Paradise Lost is written in iambic pentameter (five feet, each with a soft syllable followed by an accented syllable), with occasional variations. It begins as shown in Reading 15.11—note that Milton reveals no false modesty about his ability to pen "things unattempted yet in prose or rhyme."

A bit later Milton paints Satan (in Reading 5.12), who has been expelled from Paradise along with his entourage of fallen angels. They are immortal and therefore cannot die, but Satan bemoans their situation to Beelzebub, who to Satan was "next himself in power, and next in crime."

There will be no "greater Man" who will ever restore the fallen angels to "regain the blissful seat." But for humans, there is hope.

GLOSSARY

Adagio (*p. 541*) Slow, as in a passage or piece of music.

Allegro (*p. 541*) Fast, as in a passage or piece of music.

Aria (*p. 538*) A solo song in an opera, oratorio, or cantata, which often gives the singer a chance to display technical skill.

Baldacchino (*p. 511*) An ornamental canopy for an altar, supported by four columns and often decorated with statuary.

Baroque (*p. 506*) A 17th- century European style characterized by ornamentation, curved lines, irregularity of form, dramatic lighting and color, and exaggerated gestures.

Cantata (*p. 540*) A short oratorio composed of sections of declamatory recitative and lyrical arias.

Chiaroscuro (*p. 523*) From the Italian for "light−dark"; an artistic technique in which subtle gradations of value create the illusion of rounded, three-dimensional forms in space; also called *modeling*.

Chorale prelude (*p. 540*) A variation on a chorale that uses familiar songs as the basis for improvisation.

Chorale variations (*p. 539*) Instrumental music consisting of a set of variations upon melodies taken from a familiar hymn or sacred song.

Concerto grosso (*p. 541*) An orchestral composition in which the musical material is passed from a small group of soloists to the full orchestra and back.

Counter-Reformation (*p. 506*) The effort of the Catholic Church to counter the popularity of Protestantism by reaffirming basic values but also supporting a proliferation of highly ornamented Baroque churches.

Fugue (*p. 540*) A musical piece in which a single theme is passed from voice to voice or instrument to instrument (generally four in number), repeating the principal theme in different pitches.

Harpsichord (*p. 539*) A keyboard instrument; a forerunner of the modern piano.

Hyperbole (*p.549*) Poetic exaggeration.

Induction (*p. 547*) A kind of reasoning that constructs or evaluates propositions or ideas on the basis of observations of occurrences of the propositions; arriving at conclusions on the basis of examples.

Kantor (*p. 540*) Music director, as at a school.

Largo (*p. 541*) Slow, as in a passage or piece of music.

Materialism (*p. 544*) In philosophy, the view that everything that exists is either made of matter or—in the case of the mind, for example—depends on matter for its existence.

Metaphysical (*p. 548*) Pertaining to a group of British lyric poets who used unusual similes or metaphors.

Monody (*p. 538*) From the Greek *monoidia*, meaning an ode for one voice or one actor; in early opera, a single declamatory vocal line with accompaniment.

Movement (*p. 541*) A self-contained section of a larger musical work; the Classical symphony, for example, has four distinct movements.

Opera (*p. 538*) A dramatic performance in which the text is sung rather than spoken.

Oratorio (*p. 539*) A sacred drama performed without action, scenery, or costume, generally in a church or concert hall.

Picaresque (*p. 546*) Of a form of fiction having an engaging, roguish hero who is involved in a series of humorous or satirical experiences.

Recitative (*p. 538*) The free declaration of a vocal line, with only a simple instrumental accompaniment for support.

Sonata (*p. 539*) A kind of short piece of instrumental music.

Tenebrism (*p. 518*) A style of painting in which the artist goes rapidly from highlighting to deep shadow, using very little modeling.

Toccata (*p. 539*) A free-form rhapsody composed for an instrument with a keyboard, often combing extreme technical complexity and dramatic expression.

THE BIG PICTURE THE SEVENTEENTH CENTURY

Language and Literature

- King James I commissioned a new English translation of the Christian Bible.
- Three playwrights transformed French dramatic literature—the tragedians Pierre Corneille and Jean Racine and the comedic satirist Jean-Baptiste Poquelin (stage name: Molière).
- In Spain, Miguel de Cervantes Saavedra wrote *Don Quixote*, weaving keen perceptions of human nature with satire and comedy.
- John Donne, Richard Crashaw, and other English Metaphysical poets gave intellectual expression to emotional experience.
- In England, the blind poet John Milton composed his blank-verse epic poem *Paradise Lost* "to justify the ways of God to men."

Art, Architecture, and Music

- To counter the Protestant Reformation, the Roman Catholic Church constructed Baroque churches in Italy characterized by splendor, opulence, and theatricality. The portrayal of spiritual experiences in painting and sculpture was seen as a vehicle for promoting devotion and piety.
- Carlo Maderno was appointed chief architect of Saint Peter's by Pope Paul V. He enlarged the nave, fixing the Latin Cross plan of the basilica, and completed the façade.
- Gian Lorenzo Bernini, the foremost sculptor and architect of the Baroque era, succeeded Maderno at Saint Peter's. He designed the colonnaded piazza in front of the basilica and worked on interior projects for some 50 years.
- Bernini created his *David*, and other sculptures, for Cardinal Scipione Borghese, launching his lucrative and high-profile career.
- Pope Urban VIII, Bernini's unwavering supporter, patronized the arts on a grand scale.
- Caravaggio pioneered Tenebrism in painting—an exaggerated use of light and shade that heightens the drama of the narrative. He rejected standard, idealized versions of saints and biblical figures and turned to ordinary people for models in the search for naturalism and accessibility.
- Artemisia Gentileschi, stylistic heir to Caravaggio, was the most successful female artist in Italy. Many of her works focused on biblical heroines and offered a distinct woman's perspective on commonly painted themes.
- Diego Velázquez, the leading painter in the court of the Spanish king Philip IV, painted *Las Meninas*, an enigmatic portrait of the artist and the royal family.
- Peter Paul Rubens transformed northern art with his dissemination of the Italian Baroque style. The greatest Flemish painter of his era, Rubens ran a large workshop to keep pace with his international commissions.
- Rembrandt van Rijn became the leading painter in the Dutch Republic. His unique handling of light and shadow are evident in portraits and biblical scenes; he also became a renowned printmaker and famously sold one of his etchings for the stunning price of 100 Dutch guilders.
- King Louis XIV of France built his immense palace at Versailles, with its glorious gardens and famed Hall of Mirrors.
- Opera, a new musical genre, combined performances of orchestral musicians and vocalists into a single, theatrical art form. The medium's complexity raised singers to new levels of virtuosity.
- Domenico Scarlatti, a harpsichord virtuoso, wrote hundreds of sonatas that laid the foundation for modern keyboard techniques.
- George Frederick Handel composed *Water Music* and *Messiah*, with its famed "Hallelujah Chorus."
- Johann Sebastian Bach, born in the late 17th century, composed fugues, chorale preludes, and cantatas.

Religion and Philosophy

- The Roman Catholic Church continued its Counter-Reformation against Protestantism by reaffirming basic Catholic doctrines such as transubstantiation, the papacy, and the rule of celibacy for the clergy.
- New religious orders—among them the Jesuits, Capuchins, and Discalced Carmelites—helped support the Counter-Reformation with their ministries and missionary work.
- Jesuits sought worship spaces to showcase the spectacle of Counter-Reformation art and ceremony.
- The French skeptic René Descartes, the Father of Modern Philosophy, sought scientific evidence to sort out truth from falsehood.
- In England, Thomas Hobbes, an early materialist, published *Leviathan*, a profoundly pessimistic work that speaks of the need to control human avarice and violence.
- The English philosopher and physician John Locke argued against the idea of inborn knowledge or understanding in his best-known work, *An Essay Concerning Human Understanding*.

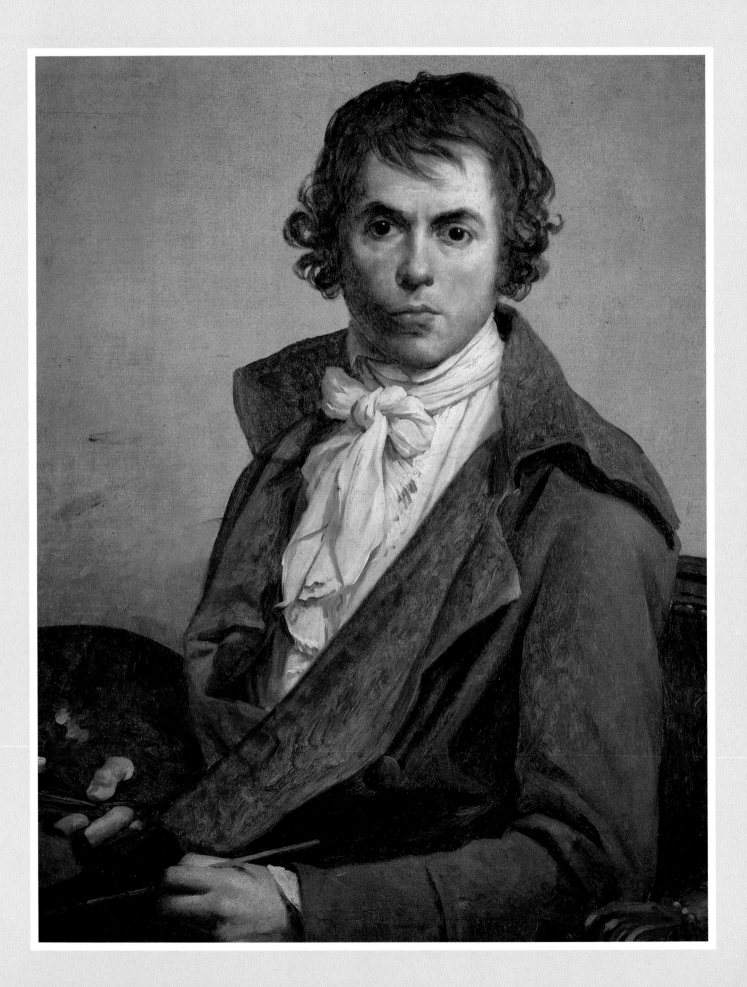

The Eighteenth Century

16

PREVIEW

Jacques-Louis David—by any art historical account—was a giant of 18th-century art. He was a pillar of the Neo-Classical style of painting in France. He was a recipient of the *Prix de Rome*—the coveted study-abroad scholarship for promising art students funded by the French monarchy. He had royal patrons. His paintings, inspired by themes from antiquity, were visual manifestations of the lofty ideals of the Enlightenment era: selflessness, courage, morality, and pure reason. Yet as we look into his eyes in a self-portrait from 1794 (**Fig. 16.1**), we might wonder: who was David the man?

David was a Jacobin—a member of a fairly exclusive political club of mostly well-off men who supported individual and collective rights for the citizens of France—and a rabid supporter of the revolution against the monarchy. As a member of the Committee of Public Safety of the National Convention, the first postrevolution government assembly, David cast a vote for the death by guillotine of King Louis XVI. In the bloody years that followed, David participated in the Reign of Terror, spearheaded by his friend Maximilien de Robespierre. Tens of thousands of so-called enemies of the Revolution were executed, more than 16,000 by guillotines erected throughout the country; David himself may have signed execution orders for more than 300 people. When Robespierre fell from power and was sentenced to death, David was arrested. He painted this portrait from his "prison cell" in the Luxembourg Palace—looking in a mirror but idealizing himself nonetheless.

On October 16, 1793, David had sketched Marie-Antoinette, the deposed queen of France, as she was led to her execution. David himself might have gone to the guillotine if not for the ironic intervention of his ex-wife, a supporter of the monarchy, who divorced him after he voted for Louis's execution. They remarried in 1796. David was the ultimate survivor, and for him, fate continued to twist and turn.

One of the nobles for whom David signed a death warrant was the husband of the woman who would become the wife of Napoléon Bonaparte—Joséphine. After Napoléon crowned himself emperor in 1804, David became *his* official court painter. Ten years later, after Napoléon had conquered much of Europe, his enemies led campaigns against him that would lead to his abdication of the throne and the restoration of the monarchy under Louis XVIII. The king wanted the services of David too. Even though the painter had been a revolutionary, a regicide, and a Bonapartist, Louis pardoned him and offered him the position of court painter. This time David said no. He left France for Belgium, where he lived, worked, and taught until he was run over by a carriage and died from his injuries.

◀ **16.1** Jacques-Louis David, *Self-Portrait*, 1794. Oil on canvas, 31⁷⁄₈″ × 25¼″ (81 × 64 cm). Musée du Louvre, Paris, France. In a time of political turmoil, David (pronounced dah-VEED) survived by switching his political allegiances several times. He painted this self-portrait in a prison cell, looking in a mirror. He spent his final years in Belgium. He had escaped the guillotine, but was run over by a carriage and died of his injuries.

THE AGE OF ENLIGHTENMENT

Like other artists, architects, writers, musicians, and philosophers of his day, Jacques-Louis David espoused the rejection of the ideologies of church and state that promoted superstition and maintained the status quo of social inequity. He believed, as did his contemporaries at the forefront of the movement called the **Enlightenment**, that *reason* would unseat these age-old and repressive traditions and lead to scientific knowledge and societal reforms.

The Enlightenment, or the Age of Reason, originated in the second half of the 17th century when Louis XIV presided over his royal court at Versailles, although it really took hold as a cultural movement in the next century. The main figures associated with the Enlightenment in France were Voltaire, Denis Diderot, and Jean-Jacques Rousseau; John Locke in England; Francis Hutcheson, Adam Smith, and David Hume in Scotland; and, in America, Benjamin Franklin and Thomas Jefferson.

The Age of Enlightenment was an age of diverse intellectual developments beyond the humanities. Toward the end of the 17th century, Cesare Beccaria (1738–1794), an important Enlightenment figure in Italy, published *On Crimes and Punishments* (1764), the first application of rationalist principles to the study of criminal punishment; it led to reforms in the criminal-justice systems of many European countries. Beccaria argued that prison sentences should fit the crime, and should be used to deter crime and rehabilitate criminals rather than to exact retribution. He also spoke vehemently against the death penalty for reasons that echo in opponents' voices even today: no one (and no state) has the right to take the life of another, and the death penalty does not deter crime any more than do other forms of punishment.

At the same time in Scotland, Adam Smith (1723–1790) adapted a central Enlightenment theme—individual liberty—for his new economic theory in *The Wealth of Nations*; it was published in 1776, the year that the American colonies declared independence from Britain. Smith promoted an economic approach called **laissez-faire**—"let it be." He believed that if market forces were allowed to operate without state intervention, an "invisible hand" would guide self-interest for the benefit of all. He further postulated that open competition would place a ceiling on prices and lead to the improvement of products. He is often called the Father of Capitalism.

Smith's theories were optimistic, and from one perspective, the whole 18th century was an age of optimism. It had trust in science and in the power of human reason,

▼ **16.2 European Rulers in the 18th Century**

Enlightened Despots

Frederick II of Prussia	1740–1786[a]
Catherine the Great of Russia	1762–1796
Gustav III of Sweden	1771–1792
Charles III of Spain	1759–1788
Joseph II of Austria	1780–1790

Rulers Bound by Parliamentary Government[b]

George I of the United Kingdom	1714–1727
George II of the United Kingdom	1727–1760
George III of the United Kingdom	1760–1820

Aristocratic Rulers

Louis XV of France	1715–1774
Louis XVI of France	1774–1792

[a] All dates are those of reigns.

[b] British political life was dominated not by the kings but by two powerful prime ministers, Robert Walpole and William Pitt, the Elder.

The Eighteenth Century

1700 CE	1774 CE	1783 CE	1794 CE	1814 CE
The rise of Russia and Prussia	Reign of Louis XVI and Marie-Antoinette	The French Revolution begins; the Declaration of the Rights of Man is promulgated	Napoléon rules France as consul	
Excavation of Herculaneum begins	Americans declare independence from Britain	Wollstonecraft writes *A Vindication of the Rights of Women*	Napoléon crowns himself emperor	
Death of Louis XIV	Adam Smith publishes *The Wealth of Nations*	Execution of Louis XVI and Marie-Antoinette	Napoléon rules France as emperor	
Reign of Louis XV	The American Revolutionary War	The French Reign of Terror		
Reign of King Frederick the Great of Prussia		Execution of Robespierre		
Excavation of Pompeii begins				
Reign of Catherine the Great of Russia				

belief in a natural order, and an overriding faith in the theory of progress that the world was better than it had ever been and was bound to get better still. From another perspective, however, the 18th century was one of pervasive resentment of, and dissatisfaction with, establishment rule and social conditions—particularly in urban centers with large populations (see **Map 16.1**). By the closing decades of the century, the desire for reform had grown into an irrepressible demand for change—if necessary, by violent means—leading to both the American and French Revolutions. The 18th century may have opened with Louis XIV still strutting down the Hall of Mirrors at the Palace of Versailles, but his death in 1715 marked the beginning of the end of absolute monarchy.

Although most of Europe continued to be ruled by hereditary monarchs (see **Fig. 16.2**), the former emphasis on splendor and privilege was leavened with a new concern for the welfare of the ordinary citizen. Rulers such as King Frederick the Great of Prussia (ruled 1740−1786) and Empress Catherine the Great of Russia (ruled 1762−1796) were no less determined than their predecessors to retain all power in their own hands, but they no longer thought of their kingdoms as private possessions to be manipulated for personal

ˇ **MAP 16.1** Eighteenth-Century Europe

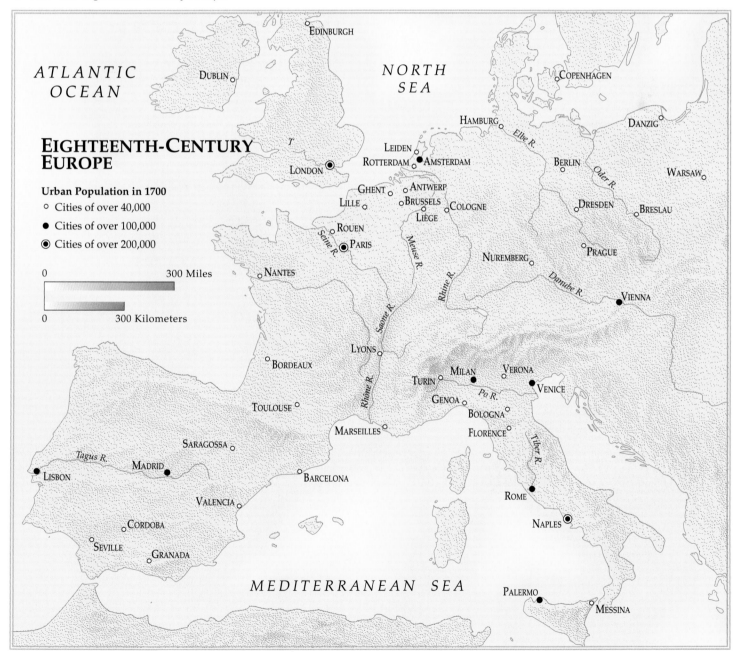

pleasure. Instead, they regarded them as trusts, which required them to show a sense of duty and responsibility. They built new roads, drained marshes, and reorganized legal and bureaucratic systems. In reflecting their greater concern for the welfare of their people, these new, more liberal monarchs, often known as "enlightened despots," undoubtedly braked the growing demands for change—for a while. Inevitably, however, by drawing attention to the injustices of the past, they stimulated an appetite for reform that they were in no position to satisfy. Furthermore, for all their claims— Frederick the Great, for example, described himself as "first servant of the state"—their regimes remained essentially autocratic. These enlightened despots, however, brought Enlightenment philosophers, scientists, writers, artists, and intellectuals into their royal circle and supported their endeavors.

In some countries in the second half of the 18th century, a conscious engagement with social issues cut across political hierarchies. Yet this concern was not univer-

sal; France remained under the control of aristocratic rulers until the French Revolution in 1789. The French kings and their courts insulated themselves from the widespread discontent of the citizenry in what amounted to a fantasy world of denial, pleasure, and escape from social unrest. This "fairy tale" lifestyle is evident in French Rococo paintings. It was also satirized by composers, writers, and artists: for example, Wolfgang Amadeus Mozart's **opera** *The Marriage of Figaro* (premiered in 1786) is a spoof on the aristocracy, and William Hogarth's series of paintings *Marriage à la Mode* (1743–1745) satirized the marital ethics of the British upper class.

THE VISUAL ARTS IN THE 18TH CENTURY

At the beginning of the century, two divergent styles of art competed for influence in France's Royal Academy of Paint-

∨ 16.3 Jean-Antoine Watteau, *Return from Cythera*, 1717. Oil on canvas, 51″ × 76½″ (130 × 194 cm). Musée du Louvre, Paris, France. One ancient Greek tradition claimed the isle of Cythera as the birthplace of Aphrodite (Venus), goddess of love. Thus the island became symbolic of ideal, tender love. Note that the mood of nostalgia and farewell is conveyed not only by the autumnal colors but also by the late-afternoon light that washes over the scene.

ing and Sculpture, which was established during the reign of Louis XIV. The king had a taste for the classical, and as we saw in the previous chapter, artists like Nicolas Poussin gravitated toward Classical themes and subjects and focused on form in their compositions. Some of the leading artists in the French academy continued along the classical model, with Poussin as their inspiration. Others, by contrast, emphasized color, harking back to Peter Paul Rubens as a model. These conflicting approaches led to a categorization of artists as Poussinistes and Rubenists. The colorists—the Rubenists—were also characterized by vigorous, textural brushstrokes, whereas the Poussinistes created surfaces with a smooth, mirrorlike finish. In the early part of the 18th century, the colorists were on top; their style is called **Rococo**.

The Rococo

Despite the changing social climate, most 18th-century artists still depended on aristocratic patronage; but tastes had changed, and so had the messages that monarchs wished to communicate through the works they commissioned. The desire to portray grandeur, glory, and, pomp—connected to absolute monarchy and captured so convincingly by the Baroque style—had faded. Enlightened despots liked beautiful things, but they had qualms about surrounding themselves with symbols of unchecked power.

The Rococo style developed to meet these less grandiose tastes and first reached maturity in France. The name *Rococo* is derived from the French *rocaille*, the elaborate encrustation of rocks and shells that often adorned grottoes of Baroque gardens. In its lightness and delicacy, Rococo art was conceived of as anti-Baroque, a contrast to the weighty grandeur and flamboyant, dramatic effects of 17th-century art. It might be said that whereas Baroque artists preached to their audiences, Rococo artists engaged them in civilized and lighthearted conversation. Among the wealthy and highborn, the 18th century was an age of polite society, a time of letter writing, chamber music, dancing, and intimate liaisons. Having abandoned the formality of court life at Versailles, many nobles moved back to Paris and lived in elegant urban châteaus refurbished in the latest fashion.

The Rococo style was, for the most part, aimed at aristocratic audiences; its grace and charm shielded them psychologically from the burgeoning stresses of the real world. The elegant picnics, the graceful lovers, the triumphant Venuses represent an almost frighteningly unrealistic view of life, and one that met with disapproval from Enlightenment thinkers who sought to promote social change. Yet even the sternest moralist can hardly fail to respond to the enticing fantasy world of the best of Rococo art. The knowledge that the whole Rococo world was soon to be so swept away imparts an unintentional poignancy to its art. The existence of all those

fragile ladies and their refined suitors was to be cut short by the guillotine.

Rococo Painting in France

With its delicate embellishments such as scrolls, ribbons, and gold-gilt leaves—and, in painting, a pastel-hued palette—the overall impression of Rococo art is one of lightness and gaiety. The subject matter seems frivolous and often features romantic dalliances and the pursuit of pleasure.

JEAN-ANTOINE WATTEAU The first and probably most exemplary French Rococo painter, Jean-Antoine Watteau (1684–1721), seems to have felt instinctively the transitory and impermanent world he depicted. Watteau is best known for his paintings of *fêtes galantes* (elegant outdoor festivals attended by courtly figures dressed in the height of fashion). Yet the charming scenes are sometimes touched with a mood of nostalgia that can verge on melancholy. In *Return from Cythera* (**Fig. 16.3**), for instance, handsome young couples in silken fabrics either embark or return home from a visit to Cythera, the island sacred to Venus and to love. A few gaze wistfully over their shoulders at the idyllic setting they leave behind. Watteau's colorful palette and feathery brushstrokes, along with flourishes of thick paint that create the illusion of folds in lush, shimmery fabric, correspond in feeling to the sensuality of his subject.

JEAN-HONORÉ FRAGONARD Jean Honoré Fragonard (1732–1806), the last of the great French Rococo painters, lived long enough to see all demand for Rococo art disappear with the coming of the French Revolution. Fragonard often used landscape to accentuate an erotic or romantic mood. His painting *The Happy Accidents of the Swing* (**Fig. 16.4**) is a prime example of the aims and accomplishments of the Rococo artist. In the midst of a lush green park, whose opulent foliage was no doubt inspired by the Baroque, we are offered a glimpse of the love games of the leisure class. A young, though not so innocent maiden, with petticoats billowing beneath her sumptuous pink dress, is being swung by an unsuspecting chaperone high over the head of her reclining gentleman friend, who seems delighted with the view. The subjects' diminutive forms and rosy cheeks make them doll-like, an image reinforced by the idyllic setting. This is 18th-century life at its finest—pampered by subtle hues, embraced by lush textures, and bathed by the softest of lights. Unfortunately, this is also life at its most clueless. As the ruling class continued to ignore the needs of the common people, the latter were preparing to rebel.

The end of Fragonard's career is a reminder of the ways in which artists are affected by social developments. When his aristocratic patrons died or fled France during the Revolution, Fragonard was reduced to poverty. It was perhaps because

∧ **16.4 Jean-Honoré Fragonard, *The Swing*, 1767. Oil on canvas, 31⁷⁄₈″ × 25³⁄₈″ (81.8 × 64.8 cm). The Wallace Collection, London, United Kingdom.** The landscape is lush and all-encompassing, clearly symbolizing fecundity.

Fragonard supported the ideals of the Revolution, despite the fact that it would eliminate his patronage, that Jacques-Louis David, one of the Revolution's chief artistic arbiters, found him a job related to art. Even so, the last representative of the Rococo tradition died in obscurity.

ROSALBA CARRIERA Fragonard's ill fortune could not have been farther removed from Rosalba Carriera's (1675–1757) success. Born in Venice and trained as a lace maker and painter of miniature ivory portraits, Carriera first came to Paris in 1720. In the same year, she painted a portrait of Louis XV as a boy (**Fig. 16.5**). Louis, who became king at the age of five, was moved from Versailles to the Tuileries Pal-

ace in Paris until his coronation in 1722, at the age of twelve; Carriera painted this small portrait just two years before that date. The arresting detail of the face, contrasted with a freer handling of the materials in the jacket and lace cravat, illustrated her virtuosity in an unusual medium—colored chalk. She was unparalleled in the technique, and her achievement was recognized with a membership to the French Academy. Carriera traveled widely throughout Europe, where her portraits were in high demand and where she counted kings and aristocrats among her patrons. Hers was a talent to find the "sweet spot" between the portrait likeness and some degree of flattery that captured sitters as the best possible version of themselves.

◄ **16.5** Rosalba Carriera, *Louis XV as a Boy*, 1720. Pastel on paper, 19 ⁷/₈″ × 15 ¹/₈″ (50.5 × 38.5 cm). Gemaeldegalerie Alte Meister, Staatliche Kunstsammlungen, Dresden, Germany. The pale elegance of the subject is typical of most of Carriera's aristocratic sitters. The delicate colors of the pastels reproduce the tones of his skin.

▲ 16.6 Giovanni Battista Tiepolo, *Allegory of Merit Accompanied by Nobility and Virtue*, 1757–58.
Fresco, 32'10" × 20'8" (10 x 6 m). Museo del Settecento Veneziano, Ca' Rezzonico, Venice, Italy.

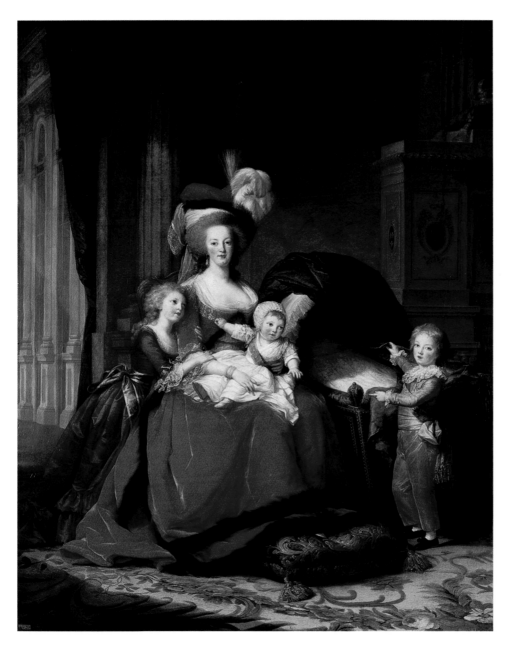

◀ **16.7** Élisabeth Vigée-Lebrun, *Marie Antoinette and Her Children*, 1781. Oil on canvas, 106 ³/₄" × 76 ³/₄" (271 × 195 cm). Palace of Versailles, Versailles, France. The queen's hat and skirts create a richness to which the common person could not reasonably aspire, but the triangular composition and the child on the lap are reminiscent of Renaissance images of the Madonna and Child.

dip and glide and hover around the throne of Merit, buoyed by billowy clouds. The palace was the residence of a wealthy family of Italian merchants who may have wanted to suggest to their guests (or convince themselves) that all this luxury was made possible through earnest accomplishment.

ÉLISABETH VIGÉE-LEBRUN

During the late years of the 18th century, the forces of the Enlightenment and the decline of support for the maintenance of the monarchy and nobility led to a style among many of these patrons that was less frivolous, less saccharine, and much more natural. These stylistic changes were a reflection of Jean-Jacques Rousseau's association of moral values and human virtue with the innocence and unadulterated simplicity of peasant life. Carrying these views to an almost bizarre conclusion, Marie-Antoinette oversaw the construction of a mock peasant village on the grounds of Versailles where she could tend sheep in the simple clothes of a shepherdess, pretend to milk cows, and, with her attendants, engage in other activities associated with peasant life. In the end, this dalliance with the life of a commoner did not change the queen's image among her people; nor did the essentially propagandistic portrait that the her court painter Élisabeth Vigée-Lebrun (1755–1842) created just two years before the French Revolution. *Marie Antoinette and Her Children* (**Fig. 16.7**) was intended to counteract the queen's declining popularity by portraying her not as an entitled, indifferent spendthrift but as a loving mother who had had her share of heartbreak. The elegant dress and elaborate hat—both bright red—convey her regal stature, as does the

GIOVANNI BATTISTA TIEPOLO Carriera's Venetian contemporary Giovanni Battista Tiepolo (1696–1770) shared with her a remarkable sense of how to use color to create luminous effects. But unlike Carriera, whose commissions consisted of life-size portraits, Tiepolo worked on a grand scale. Many of Tiepolo's most ambitious and best-known works are decorations for the ceilings of churches and palaces, such as his fresco painting for the Ca' Rezzonico palazzo in Venice, painted in 1757–1758. The *Allegory of Merit Accompanied by Nobility and Virtue* (**Fig. 16.6**) seems a quite a lofty subject for a sumptuous Rococo interior that speaks more about the frivolous lifestyles of the rich and famous in 18th-century Italy than any aspirations they might have for such ideals. The entire ceiling seems to open up to reveal a vast, blue, and luminous sky in which beautiful creatures

setting adjacent to the famed Hall of Mirrors, which can be seen to the left. Her figure is imposing as the centerpiece of a grouping reminiscent of Madonna and Child compositions typical of the Italian Renaissance. Marie-Antoinette bounces a child on her lap; her eldest daughter leans on her shoulder affectionately. The queen's eyes look out of the canvas as if searching for sympathy as the dauphin— the boy who would be king—points to an empty cradle shrouded in black. Her fourth child, a girl named Marie Sophie Hélène Béatrice de France, died of tuberculosis when she was 11 months old. Neither this nor any other public-relations efforts to paint the royal family as accessible and sympathetic persuaded the French populace, in spite of Vigée-Lebrun's best efforts and personal loyalty to

the monarchy. When Louis XVI and Marie-Antoinette were imprisoned, the painter left France and traveled to Italy, Austria, and Russia, where she had ready patrons among royalty and nobility. Her career was as successful as any; she lived to be 87 and painted some 800 works. Her style epitomized the tendency toward naturalism that characterized late-18th-century painting.

England and America

THOMAS GAINSBOROUGH English art in the 18th century was also notable for its aristocratic portraits in what can best be described as a hybrid style, featuring both Rococo characteristics (color and light; vigorous, delicate brushwork) and more naturalistic elements (the sitters appear more thoughtful, confident, and less artificially perfect in appearance). Thomas Gainsborough (1727–1788) dominated English portraiture in his day, despite the fact that he was more interested in painting landscapes. One of the initiators of the so-called *Grand Manner* in portraiture, Gainsborough created an air of elegance and importance in his sitters by using several pictorial devices—a deep, lush landscape; a relatively large figure in relation to its surroundings; a simple pose and a dignified gaze. *Mary, Countess Howe* (**Fig. 16.8**) shows the subject dressed in a costume reminiscent of Watteau in its soft, feathery strokes, but her dignified pose and cool gaze suggest that she had other than thoughts of romance in mind. Yet there is a visual poetry to the scene—the resplendent shimmer of the countess's refined dress set off by the rustic landscape elements and more somber tones of the sky.

JOSHUA REYNOLDS Sir Joshua Reynolds (1723–1792) painted numerous portraits of military figures (although not exclusively), using the Grand Manner to convey Classical values of heroism and patriotism (**Fig. 16.9**). He counted among his clientele military commanders who

◄ **16.8** Thomas Gainsborough, *Mary, Countess Howe*, ca. 1765. Oil on canvas, 96″ × 60″ (244 × 152.4 cm). Kenwood House, London, United Kingdom. The wild background and threatening sky set off the subject, but their artificiality is shown by her shoes—hardly appropriate for a walk in the country. Gainsborough was famous for his ability to paint fabric: note the contrast between the heavy silk dress and the lacy sleeves.

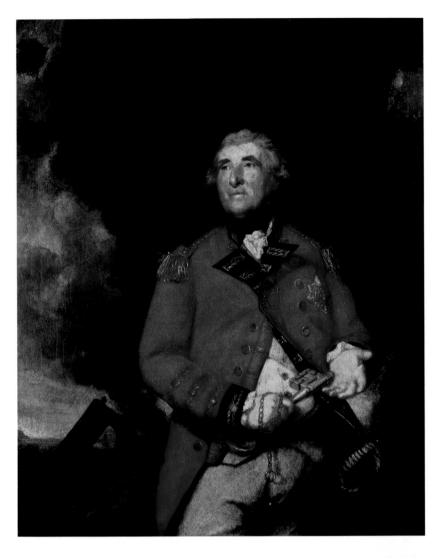

ough's painterly touch contrasts with Copley's exacting linear style. The lighting is dramatic rather than subtle, and the textures, softly blended in Gainsborough's portrait, are purposely distinct and different from one another (the soft folds of Revere's shirtsleeves against his sculptural arms; the warm wood surface of his worktable compared to the gleaming metal of his teapot). It is tempting to read Copley's approach as one that reflects American values and sensibilities. Like some other American-born artists of his generation, however, he moved to London, where he adapted his style to British tastes.

WILLIAM HOGARTH William Hogarth (1697–1764) stands dramatically apart from other portrait painters in that rather than portraying the lifestyle of the upper echelons of society, he focused with a rapier wit on the English middle class, satirizing their

◄ **16.9** Sir Joshua Reynolds, *Lord Heathfield*, 1787. Oil on canvas, 56″ × 44³/₄″ (142 × 113.5 cm). National Gallery, London, United Kingdom.

▼ **16.10** John Singleton Copley, *Portrait of Paul Revere*, 1768. Oil on canvas, 35¹/₈″ × 28¹/₂″ (89.2 × 72.4 cm). Museum of Fine Arts, Boston, Massachusetts. Copley combined English naturalism with an American taste for realism and simplicity.

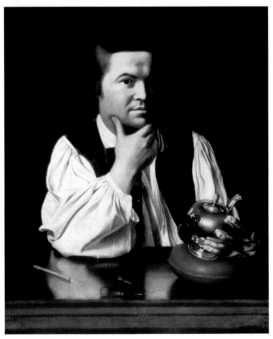

were associated with seminal historical events in England; in his portraits, their stature was sometimes reinforced by their commanding presence in a landscape that contained references to their courageous deeds. He also painted portraits of the writer Samuel Johnson and of James Boswell, Johnson's biographer, who penned what some scholars believe to be the greatest biography ever written in the English language.

JOHN SINGLETON COPLEY America offered a new twist in portraiture, perhaps best represented by John Singleton Copley (1738–1815) of Massachusetts. Whereas Gainsborough combined naturalism with elements of French Rococo, Copley combined English naturalism with an American taste for realism and simplicity. His *Portrait of Paul Revere* (**Fig. 16.10**), which shows the silversmith-turned-revolutionary-hero, has a directness of expression and unpretentious gaze that undertakes an assertive visual dialogue with the viewer. Tools at hand, Revere ponders the teapot on which he is working and raises his head momentarily from the task to acknowledge the visitor, the patron, the observer. Gainsbor-

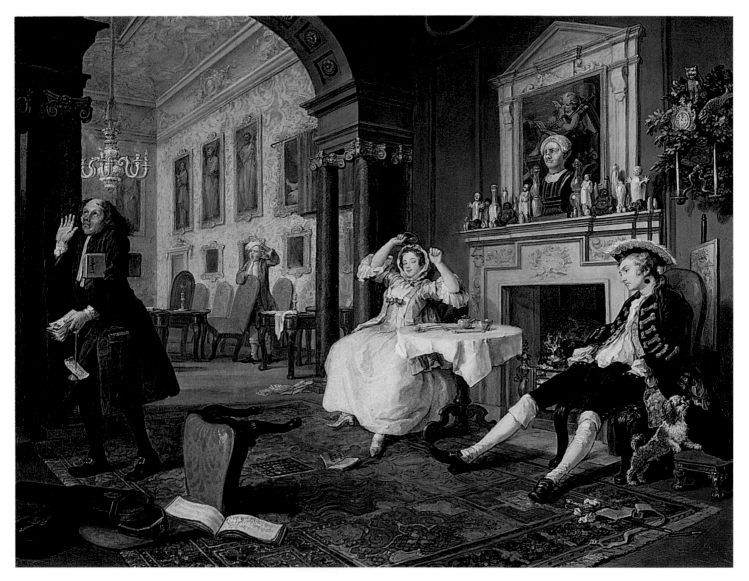

▲ **16.11** William Hogarth, *Breakfast Scene* from *Marriage à la Mode*, ca. 1745. Oil on canvas, 26 ¾″ × 35″ (68 × 89 cm). National Gallery, London, United Kingdom. Hogarth satirized the frequent marital indiscretions among the English.

pretensions to the upper class. In his series of paintings called *Marriage à la Mode*, Hogarth illustrated the consequences of a loveless marriage between an impoverished earl and the daughter of a wealthy city merchant who wants to improve his social position. In one of the series, *Breakfast Scene* (**Fig. 16.11**), matters have already begun to deteriorate. Even though it is morning, both the husband and wife appear to be exhausted from the events of the night before—events that they did not share. She spent the evening at home entertaining herself while he went out on the town. It is not clear what he was up to, but a small dog is sniffing a piece of lace that is sticking out of his pocket. The other adult in the room laments, holding a stack of bills in his hand. The environments in which Hogarth's characters are placed and the backdrop against which these

comedic melodramas unfold cast an unforgiving light on the moral turpitude of the age.

Rococo Architecture

Rococo architecture was principally concerned with delighting the eye rather than inspiring noble sentiments. One region of Europe in which the Rococo style exerted a powerful influence on religious architecture was southern Germany and Austria. Throughout the 17th century, a series of wars in that area had discouraged the construction of new churches or public buildings; with the return of relatively stable conditions in the German states, new building again became possible. By one of those fortunate chances in the history of the arts, the fantasy and complexity of the Rococo style provided

a perfect complement to the new mood of exuberance. The result is a series of churches that is among the happiest of all Rococo achievements.

BALTHASAR NEUMANN The leading architect of the day was Balthasar Neumann (1687–1753), who had begun his career as an engineer and artillery officer. Among the many palaces and churches he designed, none is more spectacular than the Vierzehnheiligen ("fourteen saints") near Bamberg, Germany. The relative simplicity of the exterior deliberately leaves the visitor unprepared for the spaciousness and elaborate decoration of the interior (**Fig. 16.12**), with its rows of

▼ **16.12** **Balthasar Neumann, Vierzehnheiligen pilgrim church, 1743–1772. Near Bamberg, Germany.** This interior view shows the high altar at the back of the nave (back left) and the oval altar in the middle of the church (center). The oval altar, the Gnadenaltar ("Mercy Altar"), is the work of Johann Michael Feuchtmayer and Johann Georg Übelherr and dates to 1763; its central location is characteristic of the pilgrimage churches of southern Germany and Austria, while its shape is echoed in the oval ceiling paintings. Neumann deliberately rejected the soaring straight lines of Gothic architecture and the symmetrical balance of the Renaissance style in favor of an intricate interweaving of surfaces, solid volumes, and empty spaces.

windows and irregularly placed columns. As in the Hôtel de Soubise, the joint between the ceiling and walls is hidden by a fresco that, together with its border, spills downward in a series of gracious curves. It is not difficult to imagine what John Calvin would have said of such an interior, but if a church can be allowed to be a place of light and joy, Neumann's design succeeds admirably.

Neo-Classicism

For all its importance, the Rococo style was not the only one to influence 18th-century artists. The other principal artistic movement of the age was **Neo-Classicism**, which increased in popularity as the appeal of the Rococo declined.

There were good historical reasons for the rise of Neo-Classicism. The excavation of the buried cities of Herculaneum and Pompeii, beginning in 1711 and 1748, respectively, evoked immense interest in the art of Classical antiquity in general and of Rome in particular. The wall paintings from Pompeian villas of the first century CE were copied by countless visitors to the excavations, and reports of the finds were published throughout Europe. The German scholar Johannes Winckelmann (1717–1768), who is sometimes called the Father of Archaeology, played a major part in creating a new awareness of the importance of Classical art; in many of his writings he encouraged his contemporaries not only to admire ancient masterpieces but also to imitate them (see **Fig. 16.13**).

▾ **16.13 The Rediscovery of Classical Antiquity in the Eighteenth Century**

1711	First excavations take place at Herculaneum
1734	Society of Dilettanti is formed in London to encourage exploration
1748	First excavations take place at Pompeii
1753	Robert Wood and James Dawkins publish *The Ruins of Palmyra*
1757	Wood and Dawkins publish *The Ruins of Baalbek*
1762	James Stuart and Nicholas Revett publish the first volume of *The Antiquities of Athens*
1764	Robert Adam publishes *The Ruins of the Palace of the Emperor Diocletian at Spalatro*; Johannes Winckelmann publishes *History of Ancient Art*
1769	Richard Chandler and William Pars publish the first volume of *The Antiquities of Ionia*
1772	The Hamilton collection of Greek vases is purchased by the British Museum
1785	Richard Colt Hoare explores Etruscan sites in Tuscany
1801	Lord Elgin receives Turkish permission to work on the Parthenon in Athens

Neoclassical Painting and Sculpture

JACQUES-LOUIS DAVID The aims and ideals of the Roman Republic—freedom, opposition to tyranny, valor—held a special appeal for 18th-century republican politicians, and the evocation of Classical models became a characteristic of the art of the French Revolution. The painter who best represents the official revolutionary style is Jacques-Louis David (1748–1825). His *Oath of the Horatii* (**Fig. 16.14**) draws not only on a story of ancient Roman civic virtue but also on a knowledge of ancient dress and armor derived from excavations of Pompeii and elsewhere. The simplicity of its message—the importance of united opposition to tyranny—is expressed by the austerity of its style and composition, a far cry from the lush, self-indulgent, indifferent world of Watteau and Fragonard.

David restored the Classical ideal of balance between emotion and restraint in the *Oath*; the atmosphere of the scene is highly charged but the cool precision of David's brushwork and the harsh lines of the setting counteract it. The palette consists mostly of muted blues, grays, and browns, but these subtleties are punctuated with vibrant, strategically placed reds that heighten the tension in the painting. The figures occupy the extreme foreground, resembling a Classical relief sculpture in their placement. The three groupings are each arranged in a roughly triangular configuration and each is visually related to a corresponding heavy arch in the background. The most dramatic moment in the action—the swearing of an oath on the swords clasped in the center—is brightly lit and silhouetted against darkness.

Knowing something of the historical circumstances under which *The Oath of the Horatii* was created, and understanding what is new about it in terms of style and composition, helps us appreciate its significance. But our full comprehension and appreciation of the work can occur only with our consideration and interpretation of the subject matter. The subject of David's *Oath of the Horatii* is, on the face of things, fairly easy to read. In a bow to Classical themes, three brothers—the Horatii—swear their allegiance to Rome on swords held high by their father. They pledge to come back victorious from the fight or not at all. The sharp, unwavering gestures and stable stances convey strength,

commitment, and bravery—male attributes associated with action. By contrast, the women have been pushed to the side in this painting; overwhelmed by emotion, they have collapsed. They have much to be upset about: one of the Horatii sisters is betrothed to one of the enemy—the Curatii—and one of the Horatii brothers is married to a Curatii sister. In David's world, not only are women incapable of action, but aggressive or assertive behavior would be viewed as unbecoming of ladies. The contrast between the women's posture and the men's represents, according to historian Linda Nochlin, "the clear-cut opposition between masculine strength and feminine weakness offered by the ideological discourse of the period." That ideological discourse was ingrained in Enlightenment principles, particularly the influential ideas

of Rousseau, whose "social contract" enunciated specific gender roles.

David used the same lofty grandeur to depict Napoléon soon after his accession to power (see **Fig. 16.15**), although there is considerable, if unintentional, irony in the use of the Revolutionary style to represent the military dictator.

ANGELICA KAUFFMANN Angelica Kauffman (1741–1807) was another leading Neo-Classical painter, an exact contemporary of David. Born in Switzerland and educated in the Neo-Classical circles in Rome, Kauffman was responsible for the dissemination of the style in England. She is known for her portraiture, history painting, and narrative works such as *The Artist in the Character of Design Listening to the Inspiration*

▼ **16.14** Jacques-Louis David, *The Oath of the Horatii*, 1784–1785. Oil on canvas, 130″ × 167 ¼″ (330 × 425 cm). Musée du Louvre, Paris, France. The story of the Horatii, three brothers who swore an oath to defend Rome even at the cost of their lives, is used here to extol patriotism. Painted only five years before the French Revolution, David's work established the official style of Revolutionary art.

(Re)framing History: The Assertion and Subversion of Power in Iconic Imagery

When the French painter, Jacques-Louis David went to work for Napoleon Bonaparte, one his foremost tasks would be PR, or more precisely, to create a public relations image for the famous general—one that would exude power, authority, heroism, and accomplishment. In so doing, David would not only have a role in shaping public opinion of Napoleon, but also in securing the leader's place in history. That David would sometimes "fudge" accurate historical detail to re-frame events in such a way as to aggrandize his subject, or comply with his patron's legacy agenda, however, is well-known. (David's painting of Napoleon's coronation, for example, includes a prominent portrait of his mother even though she refused to attend the ceremony [see **Fig. 17.6**]).

David's painting of Napoleon Crossing the Alps (**Fig. 16.15**) was a feat of propaganda, glorifying and romanticizing the general's military prowess by utilizing a format—the equestrian portrait—that had deep historical roots in the ancient world (see **Fig. 4.39**, the equestrian portrait of the Emperor Marcus Aurelius). Napoleon commands his troops, his magnificent steed, even, one might say, the landscape around him, to rise up and move forward as the horse and its rider cut a vigorous, powerful diagonal swath across the canvas. The general's eyes meet ours, urging us to join the ascent to greatness; beneath the hooves of his rampant Arabian stallion, the names of his illustrious predecessors who also crossed the Alps are inscribed in stone: Hannibal and Charlemagne. As students of history, from David's awe-inspiring image of Napoleon we

would never know that the general did not, in fact, lead his troops through the perilous St. Bernard Pass and up over the Alps himself but, rather, followed them the next day on a donkey. It is also worth noting that Napoleon did not pose for the painting; David used a previously sketched portrait of the general for his head and had one of his own sons climb a ladder (not mount a horse) to serve as a body-double.

From David's Napoleon and countless other paintings that ensconce historical figures, we would also never know that ordinary people play a role in the course of human

> **16.15** Jacques-Louis David, *Napoleon Crossing the Alps*, 1800. Oil on canvas, 96″ × 91″ (244 × 231 cm). Chateau de Versailles, Versailles, France. After he took his army across the Alps, Napoléon surprised and defeated an Austrian army. His calm, controlled guiding of a wildly rearing horse is symbolic of his own vision of himself as bringing order to postrevolutionary France.

events—women, workers, and people of color. It is to this point that Kehinde Wiley speaks in his witty and thought-provoking revision of David's iconic portrait (**Fig. 16.16**). Many of the details of the original have been copied by Wiley to the letter: the rearing horse, swirling cloak, and the rider's pose and gesture. But the unmistakable figure of Napoleon has been replaced with an anonymous African-American man, the general's dashing military trappings with contemporary camouflage fatigues, Magnum work boots, and a handkerchief sweatband—recognizable hip-hop culture attire.

Wiley also replaces the natural setting of David's painting with an opulent, red and gold patterned wallpaper suggesting that the backdrop for his present-day "warrior" is no more decorative and contrived than the one that David conceived for his hero. The craggy rocks are reduced to stage props in Wiley's painting, reiterating the etched names of Hannibal and Charlemagne in David's version but adding two more: Napoleon and Williams. The addition of the ordinary name drives home the point that the role of ordinary "others" in shaping history has largely gone unnoticed. Wiley's specific use of the name "Williams" also calls attention to the historic roles of slaves—often assigned new, "slave names"—in white society, imagined reversals of those roles and, with them, a subversion of power relationships.

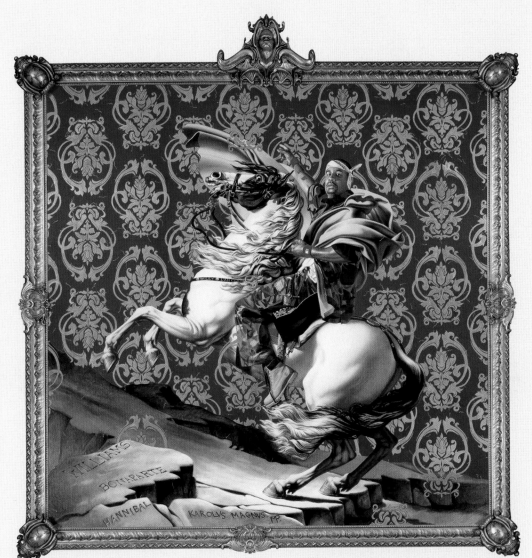

▲ **16.16** Kehinde Wiley, *Napoleon Leading the Army Over the Alps*, 2005. Oil on canvas, 108″ × 108″ (274 × 274 cm). Brooklyn Museum, Brooklyn, New York. © Kehinde Wiley. Courtesy of Sean Kelly Gallery, New York, Roberts & Tilton, Culver City, California, Rhona Hoffman Gallery, Chicago, and Galerie Daniel Templon, Paris. Digital image courtesy of the artist. Used by permission. Wiley once asked, "How can we make art that matters?" His works would seem to suggest that part of the answer is to reaffirm the place of African Americans in our predominantly Eurocentric culture.

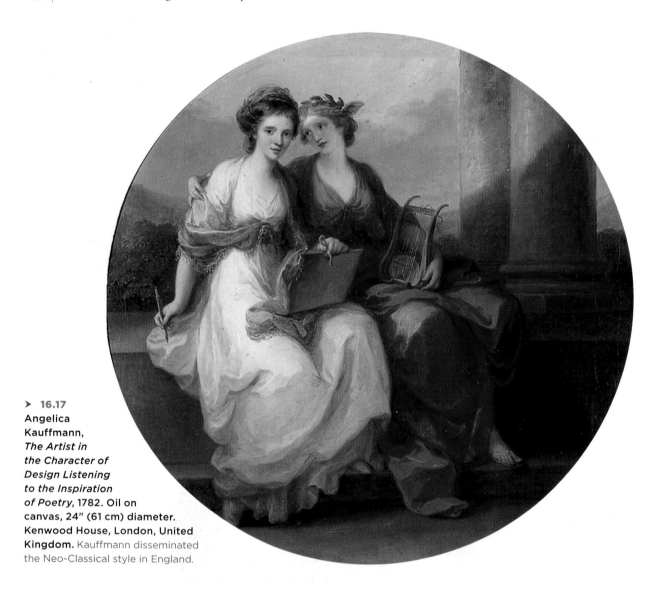

> **16.17**
Angelica
Kauffmann,
*The Artist in
the Character of
Design Listening
to the Inspiration
of Poetry*, 1782. Oil on
canvas, 24″ (61 cm) diameter.
Kenwood House, London, United
Kingdom. Kauffmann disseminated
the Neo-Classical style in England.

of Poetry (**Fig. 16.17**). In this allegorical work, Kauffman paints her own features in the person of the Muse of Design, who is listening attentively with paper and pencil in hand to her companion, the Muse of Poetry. Poetry's idealized facial features, along with the severe architecture, Classically rendered drapery, and rich palette, place the work firmly in the Neo-Classical style.

ANTONIO CANOVA The principal Neo-Classical sculptors—the Italian Antonio Canova (1757–1822) and the Frenchman Jean-Antoine Houdon (1741–1829)—succeeded in using Classical models with real imagination and creativity. Canova's portrait *Pauline Bonaparte Borghese as Venus Victorious* (**Fig. 16.18**) depicts Napoléon's sister with an idealized Classical beauty as she reclines on a couch modeled on one found at Pompeii. The cool worldly elegance of the figure, however, is Canova's own contribution.

Neo-Classical Architecture

For serious projects such as major public buildings, architects tended to follow Classical models, as in the portico of the Panthéon in Paris (**Fig. 16.19**), the design of which uses Classical proportions in the colonnade, pediment, and dome. England's most significant contribution to the arts in the 17th and early 18th centuries was in the realm of Neo-Classical architecture. Two architects in particular—Inigo Jones (1573–1652) and Sir Christopher Wren (1632–1723)—were responsible for the architectural profile of London during this time. Both were heavily influenced by Italian Baroque architecture, which combined the regimentation and clarity of Classical elements with occasional unpredictable shapes or rhythms.

INIGO JONES Inigo Jones's Banqueting House at Whitehall (**Fig. 16.20**) in London illustrates a certain symmetry and repetition of Classical elements (for example, regularly spaced

windows separated by engaged columns, and an overall balance of horizontal and vertical lines). But the rigidity of the design scheme is subtly challenged by the use of pilasters in a different rhythm at the corners and by the mix-up of architectural orders—Ionic capitals on the lower floor and more ornate, Corinthian-style capitals on the second floor. The alternating pattern of vertical elements is not unlike that of the façade of Saint Peter's in Rome.

SIR CHRISTOPHER WREN Sir Christopher Wren began his career at age 25, although not as an architect. He was an engineer and professor of astronomy, whose developing interest in mathematics led him to architecture. He was solicited by King Charles II to renovate Saint Paul's Cathedral—a Gothic structure—and his plans for the project were in place when the 1666 Great Fire of London consumed the old building.

The new Saint Paul's (**Fig. 16.21**) stands as Wren's masterpiece and the most beloved structure in London. Influenced by Italian and French Baroque architecture, Wren reconciled the problematic relationship of the classical **pedimented** facade to the hemispherical dome that we first encountered in the Baroque expansion of Saint Peter's in Rome. He did this by placing tall bell towers on either side of the façade to soften the visual transition from the horizontal emphasis of the two-storied elevation to the vertical rise of the massive dome a nave's length away. Wren's design stands midway between the organic, flowing designs of the Italian Baroque and the strict classicism of the French Baroque, integrating both in a reserved, but not rigid, composition. The double-columned, two-tiered **portico** is French Baroque in style (see the Palace of Versailles, **Fig. 15.29**), and the upper level of the bell towers (topped by pineapples—symbols of peace and prosperity) is

▼ **16.18** Antonio Canova, *Pauline Bonaparte Borghese as Venus Victorious*, 1808. Marble, life size, 78" (198 cm) long. Galleria Borghese, Rome, Italy. Canova's blend of simplicity and grace was widely imitated by European and American sculptors throughout the 19th century. The apple that Venus holds in her left hand is the apple of discord, inscribed "to the fairest." According to legend, the goddesses Aphrodite (Venus), Hera, and Athena each offered a tempting bribe to the Trojan Paris, who was to award the apple to one of them. Paris chose Venus, who had promised him the most beautiful of women. The result was the Trojan War, which began when Paris abducted his prize—Helen, the wife of a Greek king.

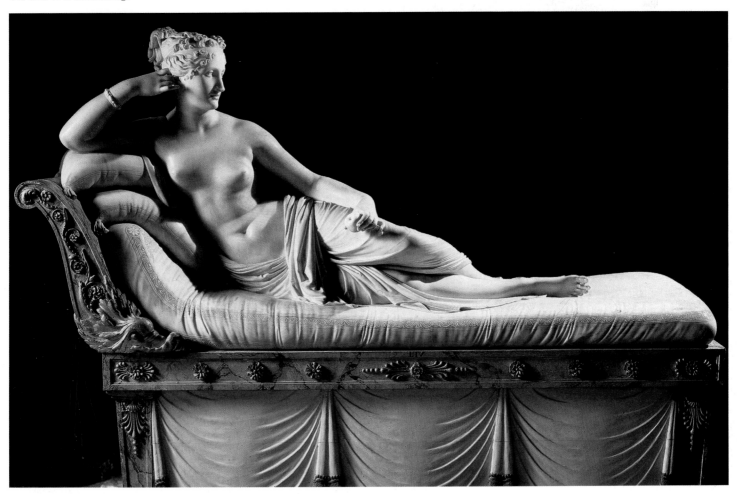

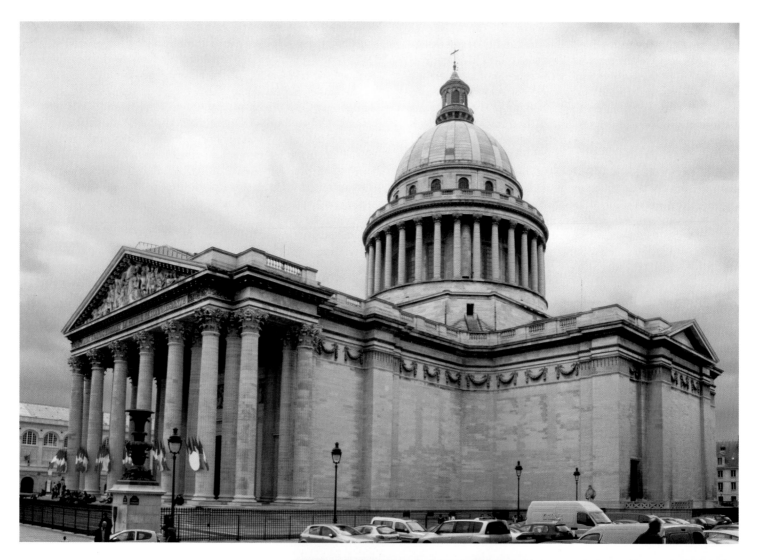

▲ **16.19** Jacques-Germain Soufflot, **Panthéon (Church of Sainte-Geneviève), 1755–1792. Paris, France.** Originally built as the Church of Sainte-Geneviève, the building was converted into a memorial to the illustrious dead at the time of the French Revolution. The architect studied in Rome; the columns and pediment were inspired by ancient Roman temples.

➤ **16.20** Inigo Jones, **Banqueting House at Whitehall, 1619–1622. London, United Kingdom.** The design repeats Classical elements such as windows separated by engaged columns and an overall balance of horizontal and vertical lines.

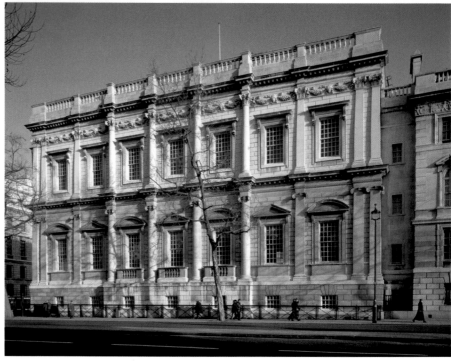

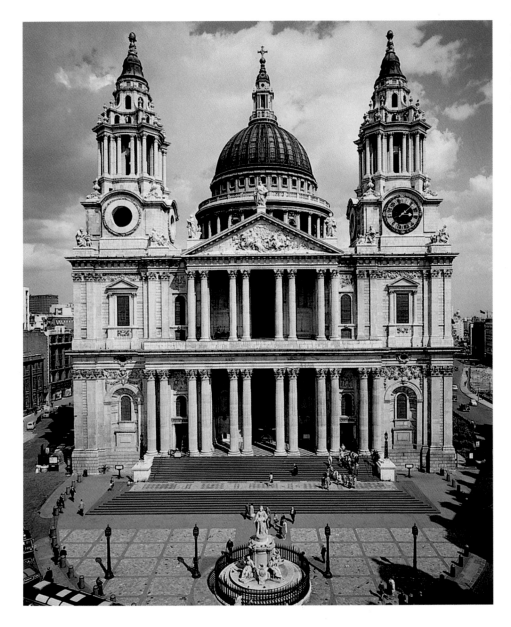

◄ **16.21** Sir Christopher Wren, Saint Paul's Cathedral, 1675–1710. London, United Kingdom. Wren reconciled the architectural relationship between the classical facade and the dome by placing tall bell towers on either side of the façade.

similar to those found on Borromini's churches, such as San Carlo alle Quattro Fontane (see **Fig. 15.9**) in Rome.

The dome of Saint Paul's is the world's second-highest, at 361 feet (Saint Peter's is higher). Inside the dome is the so-called Whispering Gallery; the acoustics enable visitors who whisper against its walls to be heard on the opposite side of the dome. The interior is richly embellished with marble inlays, frescoes, mosaics, and wrought iron. Aside from its stature as an architectural masterpiece, Saint Paul's holds a valuable place in British memory. Winston Churchill took extraordinary measures to protect it from the Nazi bombing raids of World War II. The church survived amidst a virtually ruined city.

CLASSICAL MUSIC

For the most part, music in the 18th century followed the example of literature in retaining a serious purpose and was relatively untouched by the mood of the Rococo style. At the French court, however, there was a demand for elegant, light-hearted music to serve as entertainment. The leading composer in this *style galant* was François Couperin (1668–1733), whose many compositions for keyboard emphasized grace and delicacy at the expense of the rhythmic drive and intellectual rigor of the best of Baroque music. Elsewhere in Europe, listeners continued to prefer music that expressed emotion. At the court of Frederick the Great (himself an accomplished performer and composer), for example, a musical style known as *Empfindsamkeit* ("sensitiveness") developed.

The chief exponent of this expressive style was Carl Philipp Emanuel (C. P. E.) Bach (1714–1788), a son of Johann Sebastian Bach. His works have considerable emotional range and depth; their rich harmonies and contrasting moods opened up new musical possibilities. Like all his contemporaries, C. P. E. Bach was searching for a formal structure with which to organize the expression of emotion. A single piece

or movement from a Baroque work first established a single mood and then explored it fully, whether it be joyful, meditative, or tragic. Now composers were developing a musical organization that would allow them to place different emotions side by side, contrast them, and thereby achieve expressive variety.

By the middle of the 18th century, a musical style developed that made possible this new range of expression. It is usually called **Classical**, although the term is also used in a more general sense, which can be confusing. It would be as well to begin by carefully distinguishing between these two usages.

In its general sense, the term *classical* is frequently used to distinguish so-called serious music from popular music, such that all music likely to be presented in a concert hall or opera house, no matter its age, is classical. One reason this distinction is confusing is that for many composers before our own time, there was essentially no difference between serious and popular music. They used the same musical styles and techniques for a formal composition to be listened to attentively by an audience of music lovers as for a religious work to be performed in church, or for dance music or background music for a party or festive occasion. Furthermore, used in this sense, *classical* tells us nothing significant about the music itself or its period or form. It does not even describe its mood, because many pieces of classical or serious music were in fact deliberately written to provide light entertainment.

The more precise and technical meaning of *Classical* as it relates to music denotes a musical style that was in use from the second half of the 18th century and reached its fulfillment in the works of Franz Joseph Haydn (1732–1809) and Wolfgang Amadeus Mozart (1756–1791). It evolved in answer to new musical needs the Baroque style could not satisfy and lasted through the early years of the 19th century, when it in turn gave way to the Romantic style. The figure chiefly responsible for the change from Classical to Romantic music was Ludwig van Beethoven (1770–1827). Although his musical roots were firmly in the Classical style, he is more appropriately seen as a representative of the new Romantic age (see Chapter 17).

It is no coincidence that the Classical style in music developed at much the same time as painters, architects, and poets were turning to Greek and Roman models, because the aims of Classical music and Neo-Classical art and literature were similar. After the almost obsessive exuberance and display of the Baroque period, the characteristic qualities of ancient art—balance, clarity, intellectual weight—seemed especially appealing. Eighteenth-century composers, however, faced a problem that differed from that of artists and writers. Unlike literature or the visual arts, ancient music has disappeared almost without trace. As a result, the Classical style in music had to be newly invented to express ancient concepts of balance and order. In addition, it had to combine these intellectual principles with the no-less-important ability to express a wide range of emotion. Haydn and Mozart were the two supreme masters of the Classical style because

of their complete command of the possibilities of the new idiom within which they wrote.

The Classical Symphony

The most popular medium in the Classical period was instrumental music. In extended orchestral works—symphonies—divided into several self-contained sections called *movements*, composers were most completely able to express Classical principles.

THE ORCHESTRA One reason for this was the new standardization of instrumental combinations. In the Baroque period, composers such as Bach had felt free to combine instruments into unusual groups that varied from composition to composition. Each of Bach's Brandenburg Concertos was written for a different set of solo instruments. By about 1750, however, most instrumental music was written for a standard orchestra (**Fig. 16.22**), the nucleus of which was formed by the string instruments: violins (generally divided into two groups known as first and second), violas, cellos, and double basses. To the strings were added wind instruments, almost always the oboe and bassoon and fairly frequently the flute; the clarinet began to be introduced gradually and, by about 1780, had become a regular member of the orchestra. The only brass instrument commonly included was the French horn. Trumpets, along with the timpani or kettledrums, were reserved for reinforcing volume or rhythm. Trombones were never used in classical symphonies until Beethoven did so.

Orchestras made up of these instruments were capable of rich and varied sound combinations ideally suited to the new Classical form of the symphony. In general, the Classical symphony has four movements (as opposed to the Baroque concerto's three): a first, relatively fast one, usually the most complex in form; then a slow, lyrical movement, often songlike; a third movement in the form of a **minuet** (a stately dance); and a final movement, which brings the entire work to a spirited and usually cheerful conclusion. As time went on, the length and complexity of the movements grew; many of Haydn's later symphonies last for nearly half an hour. In most cases, however, the most elaborate musical argument was always reserved for the first movement, presumably because during it the listeners were freshest and most able to concentrate.

SONATA FORM The structure almost invariably chosen for the first movement of a Classical symphony was called **sonata form**. Because sonata form was not only one of the chief features of Classical style but also a principle of musical organization that remained popular throughout the 19th century, it merits our attention in some detail. The term is actually rather confusing, because the word *sonata* is used to describe a work in several movements (like a symphony) but written for one or two instruments rather than for an orchestra. Thus, a piano sonata is a piece for solo piano, a violin sonata is a piece for violin and an accompanying instrument,

almost always a piano, and so on. A symphony is, in fact, a sonata for orchestra.

The term *sonata form*, however, does not, as might be reasonably expected, describe the form of a sonata, but rather a particular kind of organizing principle frequently found in the first movement of both symphonies and sonatas, as well as other instrumental combinations like string quartets (two violins, viola, and cello). Because first movements are generally played at a fast tempo (speed), the term sonata **allegro** form is also sometimes used. (The Italian word *allegro* means "fast"; Italian terms are traditionally used in music, as we have seen.)

Unlike Baroque music, with its unity based on the use of a single continually expanding theme, sonata form is dominated by the idea of contrasts. The first of the three main sections of a sonata form movement is called the exposition, because it sets out, or exposits, the musical material. This consists of at least two themes, or groups of themes, that differ from one another in melody, rhythm, and key. They represent, so to speak, the two principal characters in the drama. If the first theme is lively, the second may be thoughtful or melancholy; or a strong marchlike first theme may be followed by a gentle, romantic second one. The first of these themes (or subjects, as they are often called) is stated, followed by a linking passage leading to the second subject and a conclusion that rounds off the exposition.

During the course of the movement, it is of the utmost importance that listeners be able to remember these themes and identify them when they reappear. To help make this task easier, classical composers replaced the long, flowing lines of Baroque melodies with much shorter tunes, often consisting of only a few notes, comparatively easy to recognize when they recur. Just in case their listeners were still not perfectly familiar with the basic material of a movement, composers reinforced it by repeating the entire exposition note for note.

In the second section of a movement in sonata form—the development—the themes stated in the exposition are changed and varied in whatever way the composer's imagination suggests. One part of the first subject is often detached and treated on its own, passed up and down the orchestra, now loud, now soft, as happens in the first movement of Mozart's Symphony No. 40. Sometimes different themes will be combined and played simultaneously. In almost all cases, the music passes through a wide variety of keys and moods. In the process, the composer sheds new light on what have by now become familiar ideas.

At the end of the development, the original themes return to their original form for the third section of the movement, the recapitulation (repeated theme). The first section is recapitulated with both first and second subjects now in the same key. In this way the conflict implicit in the development section is resolved. A final coda (or tailpiece; *coda* is

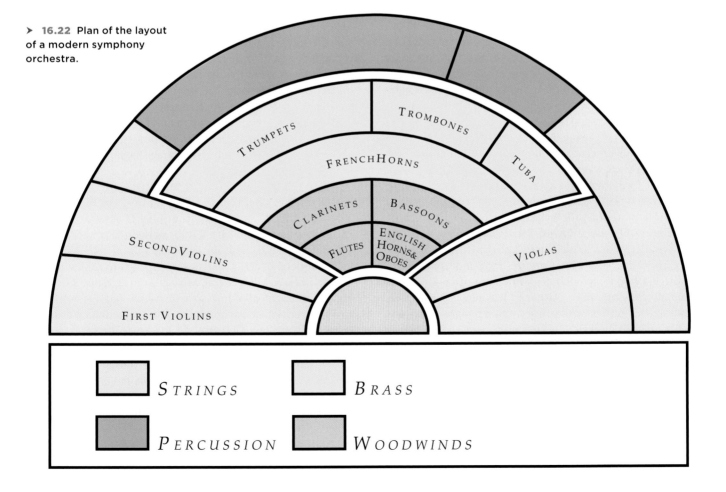

➤ **16.22 Plan of the layout of a modern symphony orchestra.**

the Italian word for "tail") is sometimes added to bring the movement to a suitably firm conclusion.

Sonata form embodies many of the Classical principles of balance, order, and control. The recapitulation, which carefully balances the exposition, and the breaking down of the material in the development and its subsequent reassembling both emphasize the sense of structure behind a sonata-form movement. Both the first and last movements of Mozart's Symphony No. 40 demonstrate how the sonata form can be used to create music of extreme dramatic power.

Franz Joseph Haydn

The long and immensely productive career of Franz Joseph Haydn spanned a period of great change in both artistic and social terms. Born in Rohrau on the Austro-Hungarian border, he sang as a child in the choir of Saint Stephen's Cathedral in Vienna. After scraping together a living for a few precarious years, in 1761 he entered the service of a wealthy nobleman, Prince Esterházy.

Haydn began work for the prince on the same terms as any carpenter, cook, or artisan in his master's employ. That he was a creative artist was irrelevant, because social distinctions were made on grounds of wealth or birth, not talent. By the time he left the Esterházy family almost 30 years later, the aristocracy was competing for the privilege of entertaining him! The world was changing; in the course of two visits to London, Haydn found himself feted and honored, and during his last years in Vienna he was among the most famous figures in Europe. Thus Haydn was one of the first musicians to attain a high social position solely on the strength of his genius. His success signaled the new relationship between the artist and society that was to characterize the 19th century.

In personal terms, Haydn seems to have been little affected by his fame. During the long years of service to Prince Esterházy and his descendants, Haydn used the enforced isolation of the palace where he lived to experiment with all of the musical forms available to him. In addition to operas, string quartets, piano sonatas, and hundreds of other pieces, Haydn wrote more than 100 symphonies that exploit almost every conceivable variation on sonata and other classical forms, winning him the nickname Father of the Symphony. During his visits to London (in 1791–1792 and 1794–1795), he wrote his last 12 symphonies, which are often known as the "London" Symphonies. Although less obviously experimental than his earlier works, they contain perhaps the finest of all his orchestral music; the slow movements in particular manage to express the greatest seriousness and profundity without tragedy or gloom.

Wolfgang Amadeus Mozart

In 1781, in his 50th year and at the height of his powers, Haydn met a young man about whom he was to say a little while later to the young man's father: "Before God and as an honest man, I tell you that your son is the greatest composer known to me either in person or by name." Many of us for whom the music of Wolfgang Amadeus Mozart represents a continual source of inspiration and joy, and a comforting reminder of the heights the human spirit can attain, would see no reason to revise Haydn's judgment.

Although Mozart's life, in contrast to Haydn's, was to prove to be one of growing disappointments and setbacks, his early years were comparatively happy. During his childhood he showed extraordinary musical ability. By age six he could already play the violin and piano and had begun to compose. His father Leopold—a professional musician in the service of the archbishop of Salzburg, where the family lived—took Wolfgang on a seemingly never-ending series of trips throughout Europe to exhibit his son's musical prowess. The effects of constant travel on the boy's health and temperament can be imagined, but during these trips he was exposed to the most sophisticated and varied musical ideas of the day; the breadth of his own musical style must in part be the result of the wide range of influences he was able to assimilate, from the style galant of the Rococo to the Renaissance **polyphonies** he heard in Rome. From time to time father and son would return to Salzburg, where by this time they both held appointments at the court of the archbishop.

In 1772 the old archbishop died. His successor, Hieronymus Colloredo, was far less willing to allow his two leading musicians to come and go as they pleased. Artistic independence of the kind Haydn was to achieve was still in the future, and the following 10 years were marked by continued quarreling between Mozart and his aristocratic employer. Finally, in 1781, when Mozart could take no more and asked the archbishop for his freedom, he was literally kicked out the palace door. Mozart spent the last years of his life (from 1781 to 1791) in Vienna, trying in vain to find a permanent position while writing some of the most sublime masterpieces in the history of music. When he died at age 35, he was buried in a pauper's grave.

The relationship between an artist's life and work is always fascinating. In Mozart's case it raises particular problems. We might expect that continual frustration, poverty, and depression would have left its mark on his music, yet it is a grave mistake to look for autobiographical self-expression in the work of an artist who devoted his life to achieving perfection in his art. In general, Mozart's music reflects only the highest and noblest of human aspirations. Perhaps more than any other artist in any medium, Mozart combines ease and grace with profound learning in his art to come as near to ideal beauty as anything can. Nevertheless, his music remains profoundly human. We are reminded many times not of Mozart's own suffering but of the tragic nature of life itself.

A year before his death, Mozart wrote the last of his great series of concertos for solo piano and orchestra, the Piano Concerto No. 27 in B Flat, K. 595 (Mozart's works are generally listed according to the catalog first made by Köchel; hence the letter *K* that precedes the catalogue numbers). The

wonderful slow movement of this work expresses, with a profundity no less moving for its utter simplicity, the resignation of one for whom the beauty of life is perpetually tinged with sadness.

MOZART'S LAST THREE SYMPHONIES In the summer of 1788, living in Vienna and with no regular work or source of income, Mozart wrote his last three symphonies, numbers 39, 40, and 41. He composed without a commission or even the possibility of hearing his own works; he may have died without ever hearing any of them performed.

The range of the three symphonies discourages us from making any easy connection between the composer's outward misery (some begging letters to friends from the same period have survived) and the spirit of his music. No. 39 is a serene and genial work. Some details—the major key, the writing for woodwind instruments, and some phrases in the first movement—suggest a Masonic connection in their sense of fellowship and kindness (Mozart himself was a Freemason and a firm believer in their ideas). The minuet forming the third movement is even festive in character, and the finale positively cheerful.

Symphony No. 41, generally known as the "Jupiter" Symphony, is Mozart at his most Classical, combining elegance of ideas with a powerfully intellectual treatment. In the last movement, he builds excitement by combining themes into a massive but elegant texture of sound. Nothing could be more triumphant than the splendor and power of the overwhelming structure he builds, leaving us stunned by his brilliance and exhilarated by the music's drive. This is surely one of the high points of musical genius.

If we are to look for a darker side to the composer's state of mind, however, it can be found in Symphony No. 40, a work almost entirely written in a minor key. The first movement opens with an inexorable drive. Even a brief moment of relief is soon cut short, and the movement ends with the hopelessness of its beginning. The slow movement has a tentative melancholy that breaks into occasional outbursts of passion. The minuet, normally an occasion for relaxation, is stern and forceful, with only its wistful trio section to bring some relief.

GO LISTEN! WOLFGANG AMADEUS MOZART

Fourth movement from Symphony No. 40

The final movement, far from bringing us any light, is, from its very opening, the culmination of the tragedy. A short string passage leads upwards, only to be beaten down again no less than four times. Two powerful chords from the whole orchestra discourage the strings when they try to repeat their escape. From then on, the music hurtles to the end of the exposition, with only a brief, wan attempt to lighten the mood. The development section is brusque and in places vio-

lent, and when the opening returns, it does so with no resolution of the tension. While all of this emotion is subject to clear, Classical forms, the movement—and the symphony—storms to a close offering no grounds for optimism or hope.

There is no real parallel in the Classical period for the almost unrelieved gloom of Mozart's Symphony No. 40. It would be easy to read it as the emotional expression of a desperate man. And yet it is flanked by the serenity and fellowship of number 39 and the magisterial grandeur of number 41. All three were written between June 26 and August 10, 1788.

The need to earn a living, coupled with the inexhaustibility of his inspiration, drew from Mozart works in almost every conceivable category. Symphonies, concertos, masses, sonatas, and string quartets are only some of the forms he enriched. Many admirers of Mozart would choose his operas, however, if faced with a decision as to what to save if all else were to be lost. Furthermore, his operas provide the clearest picture of his historical position.

MOZART AND OPERA Mozart wrote many operas, including *The Magic Flute*, *Così fan tutte*, and the monumental *Don Giovanni*. His highly popular *Marriage of Figaro* is based on a play of the same name by the French dramatist Pierre-Augustin de Beaumarchais (1732–1799). Although a comedy, the play, which was first performed in 1784, contains serious overtones. The plot is too complicated to permit even a brief summary, but among the characters are a lecherous and deceitful, though charming, count; his deceived wife, the countess; her maid Susanna, who puts up a determined resistance against the count's advances; and Susanna's husband-to-be, Figaro, who finally manages to outwit and embarrass the would-be seducer, who is also his own employer. In other words, the heroes of the play are the servants and the villain their master. Written as it was on the eve of the French Revolution, Beaumarchais's play was interpreted rightly as an attack on the morals of the ruling classes and a warning that the lower classes would fight back. Beaumarchais was firmly associated with the moves toward social and political change; he was an early supporter of the American Revolution and helped organize French support for the insurgent colonists.

Mozart's opera was first performed in 1786. It retains the spirit of protest in the original but adds a sense of humanity and subtlety perhaps only music can bring. No one suffered more than Mozart from the high-handedness of the aristocracy, yet when *The Marriage of Figaro* gives voice to the growing mood of revolution, it does so as a protest against the abuse of human rights rather than in a spirit of personal resentment. In the first act, Figaro's aria "Se vuol ballare" expresses the pent-up frustration of generations of men and women who had endured injustices and who could take no more. The musical form and expression is still restrained, indeed Classical, but Mozart pours into it the feelings of the age.

Mozart's ability to create characters who seem real, whose feelings we can identify with, reaches its height in the countess. Ignored and duped by her husband, the laughingstock of those around her, she expresses the conflicting

emotions of a woman torn between resentment and deep attachment. Her third-act aria "Dove sono" begins with a recitative in which she vents her bitterness. Gradually it melts into a slow and meditative section in which she asks herself what went wrong: "Where are those happy moments of sweetness and pleasure, where did they go, those vows of a deceiving tongue?" The poignant theme to which these words are set returns toward the end of the slow section to provide one of the most affecting moments in opera. Mozart's gift for expressing human behavior at its most noble is conveyed in the aria's final section, where the countess decides, despite everything, to try to win back her husband's love. Thus, in seven or eight minutes, we have been carried from despair to hope, and Mozart has combined his revelation of a human heart with music that by itself is of extraordinary beauty.

The opera as a whole is far richer than discussion of these two arias can suggest. For instance, among the other characters is one of the composer's most memorable creations, the pageboy Cherubino, whose aria "Non so più" epitomizes the breathless, agonizing joy of adolescent love. An accomplishment of another kind is exemplified by the **ensembles** (groups of supporting singers and actors). Here Mozart combines clarity of musical and dramatic action while advancing the plot at a breakneck pace.

The Marriage of Figaro expresses at the same time the spirit of its age and the universality of human nature, a truly Classical achievement. Equally impressively, it illuminates the personal emotions of individual people, and through them teaches us about our own reactions to life and its problems. As one distinguished writer has put it, in this work Mozart has added to the world's understanding of people—of human nature.

LITERATURE IN THE 18TH CENTURY

Intellectual Developments

While painters, poets, and musicians were reflecting the changing moods of the 18th century in their art, social and political philosophers were examining the problems of contemporary society more systematically. Individual thinkers frequently alternated between optimism and despair, because awareness of the greatness of which human beings were capable was always qualified by the perception of the sorry state of the world. The broad range of diagnoses and proposed solutions makes it difficult to generalize on the nature of 18th-century intellectual life, but two contrasting trends can be discerned. A few writers, notably Jonathan Swift, reacted to the problems of the age with deep pessimism, bitterly opposing the view that human nature is basically good.

Others, convinced that progress was possible, sought to devise new systems of intellectual, social, or political organization. Rational humanists like Diderot and political philosophers like Rousseau based their arguments on an optimistic view of human nature. However, Voltaire, the best known of all 18th-century thinkers, fitted into neither of these two categories—rather, he moved from one to the other. The answer he finally proposed to the problems of existence is as applicable to the world of today as it was to that of the 18th century, although perhaps no more welcome.

The renewed interest in Classical culture, visible in the portraits by Sir Joshua Reynolds and buildings like the Panthéon, also made a strong impression on literature. French writers such as Jean Racine (1639–1699) had already based works on Classical models, and the fables of Jean de La Fontaine (1621–1695) drew freely on Aesop and other Greek and Roman sources. Elsewhere in Europe throughout the 18th century, poets continued to produce works on Classical themes, from the plays of Pietro Metastasio (1698–1782) in Italy to the lyric poetry of Friedrich von Schiller (1759–1805) in Germany.

The appeal of Neo-Classical literature was particularly strong in England, where major Greek and Roman works like Homer's *Iliad* and *Odyssey* or Virgil's *Aeneid* had long been widely read and admired. In the 17th century, Milton's *Paradise Lost* had represented a deliberate attempt to create an equally monumental epic poem in English. Before the 18th century, however, several important works, including the tragedies of Aeschylus, had never been translated into English.

The upsurge of enthusiasm for Classical literature that characterized the 18th-century English literary scene had two chief effects: poets and scholars began to translate or retranslate the most important Classical authors; and creative writers began to produce original works in Classical forms, deal with Classical themes, and include Classical references. The general reading public was by now expected to understand and appreciate both the ancient masterpieces and modern works inspired by them.

THE AUGUSTANS The principal English writers formed a group calling themselves Augustans. The name reveals the degree to which these writers admired and modeled themselves on the Augustan poets of ancient Rome. In 27 CE the victory of the first Roman emperor Augustus ended the chaos of civil war in Rome and brought peace and stability to the Roman world. The principal poets of Rome's Augustan Age, writers like Virgil and Horace, subsequently commemorated Augustus's achievement in works intended for a sophisticated public. In the same way in England, the restoration to power of King Charles II (in 1660) seemed to some of his contemporaries a return to order and civilization after the tumultuous English Civil War. The founders of the English Augustan movement, writers like John Dryden (1631–1700), explored not only the historical parallel, by glorifying English achievement under the monarchy, but also the literary one, by imitating the highly polished style of the Roman Augustan poets in works intended for an aristocratic audience. Dryden also translated the works of Virgil, Juvenal, and other Roman poets into English.

A Visit to the Court of Louis XV

The English writer and connoisseur Horace Walpole (1717–1797) was presented to the king and queen of France and described the encounter to a friend.*

You perceive that I have been presented. The Queen took great notice of me; none of the rest said a syllable.

You are let into the king's bedchamber just as he has put on his shirt; he dresses and talks good-humoredly to a few, glares at strangers, goes to mass, to dinner, and a-hunting. The good old Queen, who is like Lady Primrose in the face, and Queen Caroline in the immensity of her cap, is at her dressing-table, attended by two or three old ladies, who are languishing to be in Abraham's bosom, as the only man's bosom to whom they can hope for admittance. Thence you go to the Dauphin, for all is done in an hour. He scarce stays a minute; indeed, poor creature; he is a ghost, and cannot possibly last three months. The Dauphiness is in her bedchamber, but dressed and standing; looks cross, is not civil, and has the true Westphalian grace and accents.

The four Mesdames, who are clumsy, plump old wenches, with a bad likeness to their father, stand in a bedchamber in a row, with black cloaks and knitting-bags, looking good-humored, not knowing what to say, and wriggling as if they wanted to make water. This ceremony too is very short; then you are carried to the Dauphin's three boys, who you may be sure only bow and stare. The Duke of Berry looks weak and weakeyed: the Count de Provence is a fine boy; the Count d'Artois well enough. The whole concludes with seeing the Dauphin's little girl dine, who is as round and as fat as a pudding.

* *The Letters of Horace Walpole*, ed. P. Cunningham (London: Publisher, 1892).

ALEXANDER POPE'S ROCOCO SATIRES Alexander Pope (1688–1744), the greatest English poet of the 18th century, was one of the Augustans, yet the lightness and elegance of his wit reflect the Rococo spirit of the age. His genius lay precisely in his awareness that the dry bones of Classical learning needed to have life breathed into them. The spirit that would awaken art in his own time, as it had done for the ancient writers, was that of nature—not in the sense of the natural world but of that which is universal and unchanging in human experience. Pope's conception of the vastness and truth of human experience given form and meaning by rules first devised in the ancient past represents 18th-century thought at its most constructive.

Pope suffered throughout his life from ill health. When he was 12, an attack of spinal tuberculosis left him permanently crippled. Perhaps in compensation, he developed the passions for reading and the beauty of the world around him that shine through his work. A Catholic in a Protestant country, he was unable to establish a career in public life or obtain public patronage for his literary work. As a result, he was forced to support himself entirely by writing and translating. Pope's literary reputation was first made by the *Essay on Criticism*, but he won economic independence by producing highly successful translations of Homer's *Iliad* (1713–1720) and *Odyssey* (1725–1726) and an edition of the works of Shakespeare (1725). With the money he earned from these endeavors, he abandoned commercial publishing and confined himself, for the most part, to his house on the river Thames at Twickenham, where he spent the rest of his life writing, entertaining friends, and indulging his fondness for gardening.

Pope's range as a poet was considerable, but his greatest achievements were in the characteristically Rococo medium of satire. Like his fellow countryman Hogarth, Pope's awareness of the heights to which humans can rise was coupled with an acute sense of the frequency of their failure to do so. In the long poem *An Essay on Man* (1733–1734), for example, Pope combines Christian and humanist teachings in a characteristically 18th-century manner to express his philosophical position with regard to the preeminent place occupied by human beings in the divine scheme of life. Early in the poem, Pope strikes a chord that will resonate remarkably with contemporary astronomers seeking planets revolving around other stars.

READING 16.1 ALEXANDER POPE

An Essay on Man, lines 17–28

> Say first, of God above, or Man below,
> What can we reason, but from what we know?
> Of Man what see we, but his station here,
> From which to reason, or to which refer?
> Thro' worlds unnumber'd tho' the God be known,
> 'Tis ours to trace him only in our own.
> He, who thro' vast immensity can pierce,
> See worlds on worlds compose one universe,
> Observe how system into system runs,
> What other planets circle other suns,
> What vary'd being peoples ev'ry star,
> May tell why Heav'n has made us as we are.

The poem is divided into four epistles (letters written in verse) to a friend, Henry Bolingbroke. The first of these discusses that part that evil plays in a world created by God. The conclusion of the epistle powerfully expresses the view that a belief that God has erred in permitting evil to invade the world is illusion, that humans cannot perceive the overall design of things.

READING 16.2 ALEXANDER POPE

***An Essay on Man*, lines 289–294**

All Nature is but Art, unknown to thee;
All Chance, Direction, which thou canst not see;
All Discord, Harmony, not understood;
All partial Evil, universal Good:
And, spite of Pride, in erring reason's spite,
One truth is clear, "Whatever is, is RIGHT."

Pope is at his best when applying his principles to practical situations and uncovering human folly. Pope's reverence for order and reason made him the implacable foe of those who in his eyes were responsible for the declining political morality and artistic standards of the day. It is sometimes said that Pope's satire is tinged with personal hostility. In fact, a series of literary and social squabbles marked his life, suggesting that he was not always motivated by the highest ideals; nonetheless, in his poetry he nearly always based his moral judgments on what he described as "the strong antipathy of good to bad," a standard he applied with courage and wit.

JONATHAN SWIFT'S SAVAGE INDIGNATION Perhaps the darkest of all visions of human nature in the 18th century was that of Jonathan Swift (1667–1745). In a letter to Alexander Pope he made it clear that, whatever his affection for individuals, he hated the human race as a whole. According to Swift, human beings were not to be defined automatically as rational animals, as so many 18th-century thinkers believed, but as animals capable of reason. It was precisely because so many of them failed to live up to their capabilities that Swift turned his "savage indignation" against them into bitter satire, never more so than when the misuse of reason served "to aggravate man's natural corruptions" and provide new ones.

Swift was in a position to observe at close quarters the political and social struggles of the times. Born in Dublin, for much of his life he played an active part in supporting Irish resistance to English rule. After studying at Trinity College, Dublin, he went to England and (in 1694) was ordained a priest in the Anglican Church. For the next few years he moved back and forth between England and Ireland, taking a leading role in the political controversies of the day by publishing articles and pamphlets that, in general, were strongly conservative.

A fervent supporter of the monarchy and of the Anglican Church, Swift had good reason to hope that his advocacy of their cause would win him a position of high rank. In 1713 this hope was partially realized with his appointment as dean of Saint Patrick's Cathedral in Dublin. Any chances he had of receiving an English bishopric were destroyed in 1714 by the death of Queen Anne and the subsequent dismissal of Swift's political friends from power.

1. The Pretender, who claimed the English throne, was James Stuart, son of James II of England, who was thrown off the throne during the Glorious Revolution.

2. Slaves sold to the Barbadoes, paralleled with the Irish, whom the English exploited for cheap labor.

READING 16.3 JONATHAN SWIFT

From *A Modest Proposal for Preventing the Children of Poor People from Being a Burthen to Their Parents or Country, and for Making Them Beneficial to the Publick*

It is a melancholy object to those, who walk through this great town, or travel in the country, when they see the streets, the roads and cabin doors crowded with beggars of the female sex, followed by three, four, or six children, all in rags, and importuning every passenger for an alms. These mothers instead of being able to work for their honest livelihood, are forced to employ all their time in strolling to beg sustenance for their helpless infants who, as they grow up, either turn thieves for want of work, or leave their dear native country, to fight for the Pretender in Spain,[1] or sell themselves to the Barbadoes.[2]

I think it is agreed by all parties, that this prodigious number of children in the arms, or on the backs, or at the heels of their mothers, and frequently of their fathers, is in the present deplorable state of the kingdom, a very great additional grievance; and therefore whoever could find out a fair, cheap and easy method of making these children sound and useful members of the commonwealth, would deserve so well of the public as to have his statue set up for a preserver of the nation.

But my intention is very far from being confined to provide only for the children of professed beggars: it is of a much greater extent, and shall take in the whole number of infants at a certain age, who are born of parents in effect as little able to support them, as those who demand our charity in the streets.

. . .

There is likewise another great advantage in my scheme, that it will prevent those voluntary abortions, and that horrid practice of women murdering their bastard children, alas! too frequent among us, sacrificing the poor innocent babes, I doubt, more to avoid the expense than the shame, which would move tears and pity in the most savage and inhuman breast.

Swift spent the remainder of his life in Ireland, cut off from the mainstream of political and cultural life. Here he increasingly emerged as a publicist for the Irish cause. During his final years his mind began to fail, but not before he had composed the epitaph under which he lies buried in Saint Patrick's Cathedral: *Ubi saeva indignatio ulterius cor lacerare nequit* ("He has gone where savage indignation can tear his heart no more").

During his years in Ireland, Swift wrote his best-known work, *Gulliver's Travels*, which was first published in 1726. In a sense, *Gulliver's Travels* has been a victim of its own popularity, because its surprising success as a work for young readers has distracted attention from the author's real pur-

pose: to satirize human behavior. (It says much for the 18th century's richness that it could produce two writers working in the same genre—the satirists Swift and Pope—with such differing results.) The first two of Gulliver's four voyages, to the miniature land of Lilliput (**Fig. 16.23**) and to Brobdingnag, the land of giants, are the best known. In these sections the harshness of Swift's satire is to some extent masked by the charm and wit of the narrative. In the voyage to the land of the Houyhnhnms, however, Swift draws a bitter contrast between the Houyhnhnms, a race of horses whose behavior is governed by reason, and their slaves the **Yahoos**, human in form but bestial in behavior. As expressed by the Yahoos, Swift's vision of the depths to which human beings can sink

◄ **16.23** Gulliver's Voyage to Lilliput, 1860s. Colored print from *Gulliver's Travels*, published by Nelson & Sons, United Kingdom. This color plate from *Gulliver's Travels* shows Gulliver ingratiating himself with the tiny populace of Lilliput by disabling an enemy fleet.

is profoundly pessimistic. His insistence on their deep moral and intellectual flaws is in strong contrast to the rational humanism of many of his contemporaries, who believed in the innate dignity and worth of human beings.

Yet even the Yahoos do not represent Swift's most bitter satire. It took his experience of the direct consequences of "man's inhumanity to man" to draw from his pen a short pamphlet, *A Modest Proposal for Preventing the Children of Poor People from Being a Burthen to Their Parents or Country, and for Making Them Beneficial to the Publick*, the title of which is generally abbreviated to *A Modest Proposal*. First published in 1729, this brilliant and shocking work was inspired by the poverty and suffering of a large sector of Ireland's population. Even today the nature of the supposedly benevolent author's "modest proposal" can take the reader's breath away, both by the calmness with which it is offered and by the devastatingly quiet logic with which its implications are explained. All the irony of which this master satirist was capable is here used to express anger and disgust at injustice and the apparent inevitability of human suffering. Although Swift was writing in response to a particular historical situation, the deep compassion for the poor and oppressed that inspired him transcends its time. Our own world has certainly not lost the need for it.

Swift's modest proposal for managing the problem of overpopulation and undernourishment turns out to be simple: the rich should eat the poor.

ROBERT BURNS The Scotsman Robert Burns (1759–1796) had a troubled life and died young, possibly from excessive drinking. Much of his work expresses Scottish nationalism,

but his most beloved poem is likely "To a Mouse," which is addressed to an animal he turns up, accidentally, with his shovel. The poem contains a couple of the best-known lines in poetry, here translated as: "The best laid schemes of mice and men go oft awry." Burns concludes in expressing his envy of the mouse who cannot contemplate the disappointments of the past or the uncertainties of the future.

MARY WOLLSTONECRAFT Mary Wollstonecraft (1759–1797) is a towering figure of the Enlightenment, although in her day, she was seen as more of a brilliant, erudite rabble-rouser. Not only did she criticize the concept of private property as a sort of oppression of the have-nots, she also was among the first to offer a sustained argument for women's rights and equality. (Incidentally, she was also the mother of Mary Wollstonecraft Shelley, who would write one of the most famed novels of all time: *Frankenstein*.) Wollstonecraft was the second of five siblings, born into a family with a drunken, brutal father and a submissive mother. More than once Wollstonecraft slept on the landing outside her parents' bedroom, futilely hoping to protect her mother. Even so, her mother favored a brother.

In spite of this background—or due to it—Wollstonecraft would obtain a Classical education and bear a biting pen, as in *A Vindication of the Rights of Women*.

READING 16.4 ROBERT BURNS

"To a Mouse," lines 1–6, 37–48

Wee, sleeket, cow'rin',[3] tim'rous beastie,
O, what a panic's in thy breastie!
Thou need na start awa sae hasty,
 Wi' bickering brattle![4]
I wad be laith[5] to rin an' chase thee,
 Wi' murd'ring pattle![6]

 . . .

But Mousie, thou art no thy lane[7]
In proving foresight may be vain:
The best laid schemes o' mice an' men,
 Gang aft a-gley,[8]
An' lea'e us nought but grief and pain,
 For promis'd joy.
Still, thou art blest, compar'd wi' me!
The present only toucheth thee:
But Och! I backward cast my e'e,
 On prospects drear!
An' forward, tho' I canna see,
 I guess an' fear.

READING 16.5 MARY WOLLSTONECRAFT

From *A Vindication of the Rights of Women*, Introduction

After considering the historic page, and viewing the living world with anxious solicitude, the most melancholy emotions of sorrowful indignation have depressed my spirits, and I have sighed when obliged to confess, that either nature has made a great difference between man and man, or that the civilization which has hitherto taken place in the world has been very partial. I have turned over various books written on the subject of education, and patiently observed the conduct of parents and the management of schools; but what has been the result?—a profound conviction that the neglected education of my fellow-creatures is the grand source of the misery I deplore; and that women, in particular, are rendered weak and wretched by a variety of concurring causes, originating from one hasty conclusion. The conduct and manners of women, in fact, evidently prove that their minds are not in a healthy state; for, like the flowers that are planted in too rich a soil, strength and usefulness are

3. Cowering.
4. Scurrying.
5. Loath; reluctant.
6. A small shovel.
7. Not alone.
8. Often go awry.

sacrificed to beauty; and the flaunting leaves, after having pleased a fastidious eye, fade, disregarded on the stalk, long before the season when they ought to have arrived at maturity.—One cause of this barren blooming I attribute to a false system of education, gathered from the books written on this subject by men, who considering females rather as women than human creatures, have been more anxious to make them alluring mistresses than affectionate wives and rational mothers; and the understanding of the sex[9] has been so bubbled[10] by this specious homage, that the civilized women of the present century, with a few exceptions, are only anxious to inspire love, when they ought to cherish a nobler ambition, and by their abilities and virtues exact respect.

. . .

I wish to persuade women to endeavor to acquire strength, both of mind and body, and to convince them that the soft phrases, susceptibility of heart, delicacy of sentiment, and refinement of taste, are almost synonymous with epithets of weakness, and that those beings who are only the objects of pity and that kind of love, which has been termed its sister, will soon become objects of contempt.

Later, Wollstonecraft comments on the failure of education to teach people to think as individuals, with the consequence that they swallow the false ideas of the age.

READING 16.6 MARY WOLLSTONECRAFT

From *A Vindication of the Rights of Women*, chapter 2

Men and women [are] educated, in a great degree, by the opinions and manners of the society they live in. In every age there has been a stream of popular opinion that has carried all before it, and given a family character, as it were, to the century. It may then fairly be inferred, that, till society be differently constituted, much cannot be expected from education.

As she proceeds, Wollstonecraft challenges the misogynist view of the likes of John Milton, Alexander Pope, Jean-Jacques Rousseau, Cervantes, and a certain "Dr. Gregory"—that is, Dr. John Gregory, who had written a popular book on the education of women: *A Father's Legacy to His Daughters* (1774). Gregory, for example, urged his daughters to "dance with spirit" but never to allow themselves to be so transported by joy as to forget the "delicacy" of their gender. Gregory, writes Wollstonecraft, goes so far as to advise his daughters "to cultivate a fondness for dress, because a fondness for dress, he asserts, is natural to them." Wollstonecraft steadily demolishes the opposition and presents ideas for education that will defeat stereotypes and enhance the mental faculties of the individual.

Rational Humanism: The Encyclopedists

DENIS DIDEROT Belief in the essential goodness of human nature and the possibility of progress, as expressed by the humanists of the Renaissance, continued to find supporters throughout the 18th century. The enormous scientific and technical achievements of the two centuries since the time of Erasmus tended to confirm the opinions of those who took a positive view of human capabilities. It was in order to provide a rational basis for this positive humanism that the French thinker and writer Denis Diderot (1713–1784) conceived the preparation of a vast encyclopedia that would describe the state of contemporary science, technology, and thought and provide a system for the classification of knowledge.

Work on the *Encyclopédie*, as it is generally called, began in 1751; the last of its 17 volumes appeared in 1772. By its conclusion, what had begun as a compendium of information had become the statement of a philosophical position: that the extent of human powers and achievements conclusively demonstrates that humans are rational beings. The implication of this position is that any political or religious system seeking to control the minds of individuals is to be condemned. It is hardly surprising, therefore, that some years before the conclusion of the project, the *Encyclopédie* had been banned by decree of Louis XV; the last volumes were published clandestinely.

CHARLES-LOUIS MONTESQUIEU In religious terms, the *Encyclopédie* took a position of considerable skepticism, advocating freedom of conscience and belief. Politically, however, its position was less extreme and less consistent. One of the most distinguished philosophers to contribute political articles was Charles-Louis Montesquieu (1689–1755), whose own aristocratic origins may have helped mold his relatively conservative views. Both in the *Encyclopédie* and in his own writings, Montesquieu advocated the retention of a monarchy, with powers divided between the king and a series of "intermediate bodies" that included parliament, aristocratic organizations, the middle class, and even the church. By distributing power in this way, Montesquieu hoped to achieve a workable system of checks and balances, thereby eliminating the possibility of a central dictatorial government. His ideas proved particularly interesting to the authors of the Constitution of the United States.

JEAN-JACQUES ROUSSEAU A very different point of view was espoused by another contributor to the *Encyclopédie*, Jean Jacques Rousseau (1712–1778), whose own quarrelsome and neurotic character played a considerable part in influencing his political philosophy. Diderot had originally

9. That is, female.

10. Deceived by insubstantial nonsense.

commissioned Rousseau to produce some articles on music, since the latter was an accomplished composer (his opera *Le Devin du village* is still performed occasionally). After violently quarreling with Diderot and others, however, Rousseau spent much of an unhappy and restless life writing philosophical treatises and novels that expressed his political convictions. Briefly stated, Rousseau believed that the natural goodness of the human race had been corrupted by the growth of civilization and that the freedom of the individual had been destroyed by the growth of society. For Rousseau, humans were good and society was bad.

Rousseau's praise of the simple virtues like unselfishness and kindness and his high regard for natural human feelings have identified his philosophy with a belief in the "noble savage," but this phrase is misleading. Far from advocating a return to primitive existence in some nonexistent Garden of Eden, Rousseau passionately strove to create a new social order. In *The Social Contract* (1762), he tried to describe the basis of his ideal state in terms of the general will of the people, which would delegate authority to individual organs of government, although neither most of his readers nor Rousseau himself seemed clear on how this general will should operate.

Although Rousseau's writings express a complex political philosophy, most of his readers were more interested in his emphasis on spontaneous feeling than in his political theories. His contempt for the superficial and the artificial, and his praise for simple and direct relationships between individuals, did a great deal to help demolish the principles of aristocracy, and continue to inspire believers in human equality.

Voltaire's Philosophical Cynicism: *Candide*

It may seem extravagant to claim that the life and work of François-Marie Arouet (1694–1778), best known to us as Voltaire (one of his pen names), can summarize the events of a period as complex as the 18th century. That the claim can be not only advanced but also supported is some measure of the breadth of his genius. A writer of poems, plays, novels, and history; a student of science, philosophy, and politics; a man who spent time at the courts of Louis XV and Frederick the Great but also served a prison sentence; a defender of religious and political freedom who simultaneously supported enlightened despotism, Voltaire was above all a man engagé—one committed to the concerns of his age.

After being educated by the Jesuits, Voltaire began to publish writings in the satirical style he was to use throughout his life. His belief that the aristocratic society of the times was unjust must have received strong confirmation when his critical position earned him first a year in jail and then, in 1726, exile from France. Voltaire chose to go to England, where he found a system of government that seemed to him far more liberal and just than that of the French. He returned home in 1729 and published his views on the advantages of English political life in 1734, in his *Lettres philosophiques*. He averted the scandal and possibility of arrest that his work created by living the next 10 years in the countryside.

In 1744 Voltaire was finally tempted back to the French court, but he found little in its formal and artificial life to stimulate him. He discovered a more congenial atmosphere

READING 16.7 JEAN JACQUES ROUSSEAU

From *The Social Contract*, book 1, section 4: Slavery

Since no man has a natural authority over his fellow, and force creates no right, we must conclude that conventions form the basis of all legitimate authority among men.

. . .

It will be said that the despot assures his subjects civil tranquility. Granted; but what do they gain, if the wars his ambition brings down upon them, his insatiable avidity, and the vexatious conduct of his ministers press harder on them than their own dissensions would have done? What do they gain, if the very tranquility they enjoy is one of their miseries? Tranquility is found also in dungeons; but is that enough to make them desirable places to live in? The Greeks imprisoned in the cave of the Cyclops lived there very tranquilly, while they were awaiting their turn to be devoured.

To say that a man gives himself gratuitously, is to say what is absurd and inconceivable; such an act is null and illegitimate, from the mere fact that he who does it is out of his mind. To say the same of a whole people is to suppose a people of madmen; and madness creates no right.

Even if each man could alienate himself, he could not alienate his children: they are born men and free; their liberty belongs to them, and no one but they has the right to dispose of it. Before they come to years of discretion, the father can, in their name, lay down conditions for their preservation and well-being, but he cannot give them irrevocably and without conditions: such a gift is contrary to the ends of nature, and exceeds the rights of paternity.

. . .

To renounce liberty is to renounce being a man, to surrender the rights of humanity and even its duties. . . . From whatever aspect we regard the question, the right of slavery is null and void, not only as being illegitimate, but also because it is absurd and meaningless. The words *slave* and *right* contradict each other, and are mutually exclusive. It will always be equally foolish for a man to say to a man or to a people: "I make with you a convention wholly at your expense and wholly to my advantage; I shall keep it as long as I like, and you will keep it as long as I like."

Book I, Section 4, "Slavery" from *The Social Contract or Principles of Political Right*, by Jean Jacques Rousseau (1762), translated by G. D. H. Cole.

VALUES

Revolution

O wild West Wind, thou breath of Autumn's being,
Thou, from whose unseen presence the leaves dead
Are driven, like ghosts from an enchanter fleeing,
Yellow, and black, and pale, and hectic red,
Pestilence-stricken multitudes: O thou,
Who chariotest to their dark wintry bed
The winged seeds, where they lie cold and low,
Each like a corpse within its grave, until
Thine azure sister of the Spring shall blow
Her clarion o'er the dreaming earth, and fill
(Driving sweet buds like flocks to feed in air)
With living hues and odours plain and hill:
Wild Spirit, which art moving everywhere;
Destroyer and preserver; hear, oh, hear!

—"Ode to the West Wind," stanza 1,
Percy Bysshe Shelley (1819)

Shelley's ode was written 19 years after the 18th century had passed, and on its surface, it is a pastoral description of changing seasons. Symbolically, many analysts find reference to the Age of Revolution which had just passed, ushering in new regimes in America and France, industry, and a the Enlightenment, in which intellectuals sought to lift reason and science above a sea of superstition. Perhaps the wind of freedom blows eastward from the Americas. Perhaps the leaves are peoples of different colors.

Indeed, the 18th century saw a series of vast upheavals in patterns of European life that had remained constant since the Late Middle Ages. The Renaissance and the subsequent Reformation and Counter-Reformation had laid the intellectual bases for the change. The 18th century was marked by their consequences. One revolution was in economic affairs. As a result of exploration and colonization, international trade and commerce increased, which enriched ever-growing numbers of middle-class citizens and their families. On the other hand, the endless wars of the 17th century left national governments deeply in debt. In England, the state introduced paper money for the first time in an attempt to restore financial stability. The transfer of wealth from the public sector to private hands encouraged speculation. Spectacular financial collapses of private companies—the most notorious being that of the South Sea Company—produced panic and revolutionary changes in banking systems.

Another revolution, perhaps in the long run the most important of all, was the development of industry. The Industrial Revolution, which reached its climax in the mid-19th century, had its origins a century earlier. The invention of new machines, particularly in the textile industry, led to the establishment of factories, which in turn produced the growth of urban life. New mining techniques turned coal into big business. New technologies revolutionized modes of travel that had been virtually unchanged since Roman times.

At the same time, the complex structure of international diplomatic relations that had existed for centuries began to collapse. Although France remained the leading European power, its economy and internal stability were undermined by the refusal of its ruling class to admit change, and Britain became the richest country in the world. The dominant powers of Renaissance Europe and the Age of Exploration—Spain, Portugal, the city-states of Italy—were in decline, while important new players appeared on the scene: Prussia under the Hohenzollerns, the Russia of Peter the Great.

Impatience with the ways of the Old Regime, together with the desire for revolutionary political and social change, found expression in the writings of Enlightenment figures such as Voltaire. By the end of the 18th century, many people throughout Europe were increasingly frustrated with living in continual political and social deprivation. As a result, they took to the streets in direct physical action.

The American Revolution undermined the power of the monarchy in Britain, and speeded up the collapse of the Old Regime in France. The French Revolution petered out in the years of Napoleonic rule but marked a watershed in Western history and culture: ever since the late 18th century, governments have had to reckon with intellectual protest and direct political action by their citizens.

at the court of Frederick the Great at Potsdam, where he spent the years from 1750 to 1753. Frederick's warm welcome and considerable intellectual stature must have come as an agreeable change from the sterile ceremony of the French court, and the two men soon established a close friendship. It seems, however, that Potsdam was not big enough to contain two such powerful intellects and temperaments. After a couple of years, Voltaire quarreled with his patron and once again abandoned sophisticated life for that of the country.

In 1758 Voltaire finally settled in the village of Ferney, where he set up his own court. Here the greatest names in Europe—intellectuals, artists, politicians—made the pilgrimage to talk and, above all, listen to the sage of Ferney, while he published work after work, each of which was distributed throughout Europe. Only in 1778, the year of his death, did Voltaire return to Paris, where the excitement brought on by a hero's welcome proved too much for his failing strength.

It is difficult to summarize the philosophy of a man who touched on so many subjects. Nevertheless, one theme recurs continually in Voltaire's writings: the importance of freedom of thought. Voltaire's greatest hatred was reserved for intolerance and bigotry; in letter after letter he ended with the phrase he made famous, "Écrasez l'infâme" ("Crush the infamous thing"). The infamous thing is superstition, which breeds fanaticism and persecution. Those Voltaire judged chiefly responsible for superstition were the Christians— Catholic and Protestant alike.

Voltaire vehemently attacked the traditional view of the Bible as the inspired word of God. He claimed that it contained a mass of anecdotes and contradictions totally irrelevant to the modern world and that the disputes arising from it, which had divided Christians for centuries, were absurd and pointless. Yet Voltaire was far from being an atheist. He was a firm believer in a God who had created the world, but whose worship could not be tied directly to one religion or another: "The only book that needs to be read is the great book of nature." Only natural religion and morality would end prejudice and ignorance.

Voltaire's negative criticisms of human absurdity are more convincing than his positive views on a universal natural morality. It is difficult not to feel at times that even Voltaire had only the vaguest ideas of what natural morality really meant. In fact, in *Candide* (1759), his best-known work, he reaches a much less optimistic conclusion. *Candide* was written with the avowed purpose of ridiculing the optimism of the German philosopher Gottfried Wilhelm Leibniz (1646–1716) who believed that "everything is for the best in the best of all possible worlds." The premise of Leibniz's argument is that God is good, God is all-knowing (omniscient) and all-powerful (omnipotent); therefore, we live in the best of all possible worlds. What appears to be evil or unfortunate is actually for the best. Because both intellect and experience teach that this is far from the case, Voltaire chose to demonstrate the folly of unreasonable optimism, as well as the cruelty and stupidity of the human

11. "God's wounds"—a form of curse.

12. All foreigners were expelled from Japan after a conspiracy of Christians had been found out. Only the Dutch, who had revealed the plot to the emperor, were allowed to remain, on the condition that they gave up Christianity and stamped on the crucifix.

READING 16.8 **VOLTAIRE**

From *Candide*, chapter 5

[Candide, Pangloss, and a sailor] walked toward Lisbon; they had a little money by the help of which they hoped to be saved from hunger after having escaped the storm. [They] had scarcely set foot in the town when they felt the earth tremble under their feet; the sea rose in foaming masses in the port and smashed the ships which rode at anchor. Whirlwinds of flame and ashes covered the streets and squares; the houses collapsed, the roofs were thrown upon the foundations, and the foundations were scattered; thirty thousand inhabitants of every age and both sexes were crushed under the ruins. Whistling and swearing, the sailor said: "There'll be something to pick up here." "What can be the sufficient reason for this phenomenon?" said Pangloss. "It is the last day!" cried Candide. The sailor immediately ran among the debris, dared death to find money, found it, seized it, got drunk, and having slept off his wine, purchased the favours of the first woman of good-will he met on the ruins of the houses and among the dead and dying. Pangloss, however, pulled him by the sleeve. "My friend," said he, "this is not well, you are disregarding universal reason, you choose the wrong time." "Blood and 'ounds!"[11] he retorted, "I am a sailor and I was born in Batavia; four times have I stamped on the crucifix[12] during four voyages to Japan; you have found the right man for your universal reason!" Candide [lay] lay in the street covered with debris. He said to Pangloss: "Alas! Get me a little wine and oil; I am dying." "This earthquake is not a new thing," replied Pangloss. "The town of Lima felt the same shocks in America last year; similar causes produce similar effects; there must certainly be a train of sulfur underground from Lima to Lisbon." "Nothing is more probable," replied Candide; "but, for God's sake, a little oil and wine." "What do you mean, probable?" replied the philosopher; "I maintain that it is proved." . . . Next day they found a little food as they wandered among the ruins and regained a little strength. Afterwards they worked like others to help the inhabitants who had escaped death. Some citizens they had assisted gave them as good a dinner as could be expected in such a disaster; . . . but Pangloss consoled them by assuring them that things could not be otherwise. "For," said he, "all this is for the best; for, if there is a volcano at Lisbon, it cannot be anywhere else; for it is impossible that things should not be where they are; for all is well." A little, dark man . . . politely took up the conversation, and said: "Apparently you do not believe in original sin; for, if everything is for the best, there was neither fall nor punishment." "I most humbly beg your excellency's pardon," replied Pangloss still more politely, "for the fall of man and the curse necessarily entered into the best of all possible worlds."

Haskell M. Block, ed. *Candide and Other Writings* by Voltaire, 1956 (Random House, Inc.).

READING 16.9 FRENCH NATIONAL ASSEMBLY

From the Declaration of the Rights of Man and of the Citizen

The representatives of the French people, organized in National Assembly, considering that ignorance, forgetfulness, or contempt of the rights of man are the sole causes of public misfortunes and of the corruption of governments, have resolved to set forth in a solemn declaration the natural, inalienable, and sacred rights of man, in order that such declaration, continually before all members of the social body, may be a perpetual reminder of their rights and duties; in order that the acts of the legislative power and those of the executive power may constantly be compared to the aim of every political institution and may accordingly be more respected; in order that the demands of the citizens, founded henceforth upon simple and incontestable principles, may always be directed toward the maintenance of the Constitution and the welfare of all.

Accordingly, the National Assembly recognizes and proclaims, in the presence and under the auspices of the Supreme Being, the following rights of man and citizen.

- Men are born and remain free and equal in rights; social distinctions may be based only on general usefulness.
- The aim of every political association is the preservation of the natural and inalienable rights of man; these rights are liberty, property, security, and resistance to oppression.
- The source of all sovereignty resides essentially in the nation; no group, no individual may exercise authority not emanating expressly therefrom.
- Liberty consists of the power to do whatever is not injurious to others; thus the enjoyment of the natural rights of every man has for its limits only those that assure other members of society the enjoyment of those same rights; such limits may be determined only by law.
- The law has the right to forbid only actions which are injurious to society. Whatever is not forbidden by law may not be prevented, and no one may be constrained to do what it does not prescribe.
- Law is the expression of the general will; all citizens have the right to concur personally, or through their representatives, in its formation; it must be the same for all, whether it protects or punishes. All citizens, being equal before it, are equally admissible to all public offices, positions, and employments, according to their capacity, and without other distinction than that of virtues and talents.

race, by subjecting his hero Candide to a barrage of disasters and suffering.

In chapter 5 of *Candide*, Candide and his tutor, Dr. Pangloss, are involved in an actual event, the earthquake that destroyed most of Lisbon in 1755. When called upon to help the injured, the learned doctor meditates instead on the causes and effects of the earthquake and duly comes to the conclusion that if Lisbon and its inhabitants were destroyed, it had to be so, and therefore was all for the best.

THE LATE 18TH CENTURY: TIME OF REVOLUTION

Throughout the 18th century, Europe continued to prosper economically. The growth of trade and industry, particularly in Britain, France, and Holland, led to several significant changes in the lifestyles of increasing numbers of people. Technological improvements in coal mining and iron casting began to lay the foundations for the Industrial Revolution of the 19th century. The circulation of more books and newspapers increased general awareness of the issues of the day. As states began to accumulate more revenue, they increased both the size of their armies and the number of those in government employ. The Baroque period had seen the exploitation of imported goods and spices from Asia and gold from Latin America; the 18th century was marked by the development of trade with North America and the Caribbean.

Amid such vast changes, it was hardly possible that the systems of government should remain unaffected. Thinkers like Rousseau and Voltaire began to question the hitherto unquestioned right of the wealthy aristocracy to rule throughout Europe. In Britain, both at home and in the colonies, power was gradually transferred from the king to Parliament. Prussia, Austria, and Russia were ruled by so-called enlightened despots, as we have seen.

The French Revolution

In France, however—the center of much of the intellectual pressure for change—the despots were not even enlightened. Louis XV, who ruled from 1715 to 1774, showed little interest in the affairs of his subjects or the details of government. The remark often attributed to him, "Après moi le déluge" ("After me the flood"), suggests that he was fully aware of the consequences of his indifference. Subsequent events fully justified his prediction, yet throughout his long reign he remained either unwilling or unable to follow the examples of his fellow European sovereigns and impose some order on government. By the time his grandson Louis XVI succeeded him in 1774, the damage was done. Furthermore, the new king's continued reliance on the traditional aristocratic class, into whose

hands he put wealth and political power, offended both the rising middle class and the peasants.

When in 1788 the collapse of the French economy was accompanied by a disastrous harvest and consequent steep rise in the cost of food in the first phase of the revolution, riots broke out in Paris and in rural districts. In reaction to the ensuing violence, the Declaration of the Rights of Man and of the Citizen, which asserted the universal right to "liberty, property, security, and resistance to oppression," was passed on August 26, 1789. Its opening section clearly shows the influence of the American Declaration of Independence.

Declarations alone hardly sufficed, however; after two and a half years of continual political bickering and unrest, the revolution entered its second phase. On September 20, 1792, the National Convention was assembled. One of its first tasks was to try Louis XVI, now deposed and imprisoned for treason. After unanimously finding him guilty, the convention was divided on whether to execute him. He was finally condemned to the guillotine by a vote of 361 to 360 and beheaded forthwith. The resulting Reign of Terror lasted until 1795. During it, utopian theories of a republic based on liberty, equality, and fraternity were ruthlessly put into practice. The revolutionary leaders cold-bloodedly eliminated all opponents, real or potential, and created massive upheaval throughout all levels of French society.

The principal political group in the convention, the Jacobins, was at first led by Maximilien de Robespierre (1758–1794). One of the most controversial figures of the revolution, Robespierre is viewed by some as a demagogue and bloodthirsty fanatic, by others as a fiery idealist and ardent democrat; his vigorous commitment to revolutionary change is disputed by no one. Following Rousseau's belief in the virtues of natural human feelings, Robespierre aimed to establish a "republic of virtue," made up democratically of honest citizens.

In order to implement these goals, revolutionary courts were established, which tried and generally sentenced to death those perceived as the enemies of the revolution. The impression that the Reign of Terror was aimed principally at the old aristocracy is incorrect. Only nobles suspected of political agitation were arrested, but the vast majority of the guillotine's victims—some 70 percent—were rebellious peasants and workers. Neither were revolutionary leaders immune. Georges-Jacques Danton (1759–1794), one of the earliest spokesmen of the revolution and one of Robespierre's principal political rivals, was executed in March 1794 along with some of his followers.

Throughout the rest of Europe, events in France were followed with horrified attention. Austria and Prussia were joined by England, Spain, and several smaller states in a war against the Revolutionary government. After suffering initial defeat, the French enlarged and reorganized their army and succeeded in driving back the allied troops at the Battle of Fleurus in June 1794. Paradoxically, the military victory, far from reinforcing Robespierre's authority, provided his opponents the strength to eliminate him; he was declared an outlaw on July 27, 1794, and guillotined the next day.

By the spring of the following year, the country was in economic chaos and Paris was torn by street rioting. Many of those who had originally been in favor of revolutionary change, including businessmen and landowning peasants, realized that whatever the virtues of democracy, constitutional government was essential. In reply to these pressures, the convention produced a new constitution, which specified a body of five directors—the Directory—that held executive power. This first formally established French republic lasted only until 1799, when political stability returned to France with the military dictatorship of Napoléon Bonaparte.

READING 16.10 PROBABLE PRINCIPAL AUTHOR: THOMAS JEFFERSON

From *The Declaration of Independence* (1776)

When in the Course of human events, it becomes necessary for one people to dissolve the political bonds which have connected them with another, and to assume among the Powers of the earth, the separate and equal station to which the Laws of Nature and of Nature's God entitle them, a decent respect to the opinions of mankind requires that they should declare the causes which impel them to the separation.

We hold these truths to be self-evident, that all men are created equal, that they are endowed by their Creator with certain unalienable Rights, that among these are Life, Liberty and the pursuit of Happiness. That to secure these rights, Governments are instituted among Men, deriving their just powers from the consent of the governed. That whenever any Form of Government becomes destructive of these ends, it is the Right of the People to alter or to abolish it, and to institute new Government, laying its foundation on such principles and organizing its powers in such form, as to them shall seem most likely to effect their Safety and Happiness. Prudence, indeed, will dictate that Governments long established should not be changed for light and transient causes; and accordingly all experience hath shown, that mankind are more disposed to suffer, while evils are sufferable, than to right themselves by abolishing the forms to which they are accustomed. But when a long train of abuses and usurpations, pursuing invariably the same Object, evinces a design to reduce them under absolute Despotism, it is their right, it is their duty, to throw off such Government, and to provide new Guards for their future security. Such has been the patient sufferance of these Colonies; and such is now the necessity which constrains them to alter their former Systems of Government. The history of the present King of Great Britain is a history of repeated injuries and usurpations, all having in direct object the establishment of an absolute Tyranny over these States.

Revolution in America

Although the French Revolution was an obvious consequence of extreme historical pressures, many of its leaders were additionally inspired by the successful outcome of another revolution: that of the Americans against their British rulers. More specifically, the Americans had rebelled against not the British king but the British parliament. In 18th-century England the king was given little chance to be enlightened or otherwise, because supreme power was concentrated in the legislative assembly, which ruled both England and, by its appointees, British territories abroad. A series of economic measures enacted by Parliament succeeded in thoroughly rousing American resentment. The American Revolution followed the Declaration of Independence of July 4, 1776. Although the Declaration of Independence was certainly not intended as a work of literature, its author, generally assumed to be Thomas Jefferson, was as successful as any of the literary figures of the 18th century in expressing the more optimistic views of the age. The principles enshrined in the document assume that human beings are capable of achieving political and social freedom. Positive belief in equality and justice is expressed in universal terms like *man* and *nature*—universal for their day, that is—typical of 18th-century enlightened thought

The Constitution of the United States further underscores the beliefs in equality and freedom by delineating a balance of power between the various branches of government and between the government and the people. The Constitution has been a living document in the sense that it specifies ways in which it can be amended, lessening the need to "overthrow" it as times change. For example, the Constitution has been modified over the generations to grant freedom to slaves and full voting rights to people of all ethnic and racial backgrounds and to women.

The first ten amendments to the Constitution (Reading 16.11) are known as the Bill of Rights, and they grant individuals freedoms that lie at the heart of the American experience, such as freedom of speech, freedom of religion, the right to bear arms, the right to "due process" of law when crimes are suspected, and the illegality of the use of "cruel and unusual punishments." They also, to some degree, reverse the weight of power between the people and the government by specifying that the states and the people bear all those powers not specifically given to the federal government. However, the states may not abridge the lawful powers of the federal government.

READING 16.11 **THE BILL OF RIGHTS**

The following text is a transcription of the first ten amendments to the Constitution in their original form. These amendments were ratified December 15, 1791, and form what is known as the "Bill of Rights."

The Preamble to The Bill of Rights

Amendment I: Congress shall make no law respecting an establishment of religion, or prohibiting the free exercise thereof; or abridging the freedom of speech, or of the press; or the right of the people peaceably to assemble, and to petition the Government for a redress of grievances.

Amendment II: A well regulated Militia, being necessary to the security of a free State, the right of the people to keep and bear Arms, shall not be infringed.

Amendment III: No Soldier shall, in time of peace be quartered in any house, without the consent of the Owner, nor in time of war, but in a manner to be prescribed by law.

Amendment IV: The right of the people to be secure in their persons, houses, papers, and effects, against unreasonable searches and seizures, shall not be violated, and no Warrants shall issue, but upon probable cause, supported by Oath or affirmation, and particularly describing the place to be searched, and the persons or things to be seized.

Amendment V: No person shall be held to answer for a capital, or otherwise infamous crime, unless on a presentment or indictment of a Grand Jury, except in cases arising in the land or naval forces, or in the Militia, when in actual service in time of War or public danger; nor shall any person be subject for the same offence to be twice put in jeopardy of life or limb; nor shall be compelled in any criminal case to be a witness against himself, nor be deprived of life, liberty, or property, without due process of law; nor shall private property be taken for public use, without just compensation.

Amendment VI: In all criminal prosecutions, the accused shall enjoy the right to a speedy and public trial, by an impartial jury of the State and district wherein the crime shall have been committed, which district shall have been previously ascertained by law, and to be informed of the nature and cause of the accusation; to be confronted with the witnesses against him; to have compulsory process for obtaining witnesses in his favor, and to have the Assistance of Counsel for his defence.

Amendment VII: In Suits at common law, where the value in controversy shall exceed twenty dollars, the right of trial by jury shall be preserved, and no fact tried by a jury, shall be otherwise re-examined in any Court of the United States, than according to the rules of the common law.

Amendment VIII: Excessive bail shall not be required, nor excessive fines imposed, nor cruel and unusual punishments inflicted.

Amendment IX: The enumeration in the Constitution, of certain rights, shall not be construed to deny or disparage others retained by the people.

Amendment X: The powers not delegated to the United States by the Constitution, nor prohibited by it to the States, are reserved to the States respectively, or to the people.

GLOSSARY

Allegro (p. 577) In music, a quick, lively tempo.

Classical (p. 576) A term for music written during the 17th and 18th centuries; more generally, referring to serious music as opposed to popular music.

The Enlightenment (p. 556) A philosophical movement of the late 17th and 18th centuries that challenged tradition, stressed reason over blind faith or obedience, and encouraged scientific thought.

Ensemble (p. 580) A group of musicians, actors, or dancers who perform together.

Laissez-faire (p. 556) French for "let it be"; in economics, permitting the market to determine prices.

Minuet (p. 576) A slow, stately dance for groups of couples.

Neo-Classicism (p. 568) An 18th-century revival of Classical Greek and Roman art and architectural styles, generally characterized by simplicity and straight lines.

Opera (p. 558) A dramatic performance in which the text is sung rather than spoken.

Pediment (p. 573) In architecture, any triangular shape surrounded by *cornices*, especially one that surmounts the *entablature* of the *portico facade* of Greek temple.

Polyphony (p. 578) A form of musical expression characterized by many voices.

Portico (p. 573) A roofed entryway, like a front porch, with columns or a colonnade.

Rococo (p. 559) An 18th-century style of painting and of interior design that featured lavish ornamentation. Rococo painting was characterized by light colors, wit, and playfulness. Rococo interios had ornamental mirrors, small sculptures and reliefs, wall paintings, and elegant furnishings.

Sonata form (p. 576) A musical form having three sections: exposition (in which the main theme or themes are stated), development, and recapitulation (repetition) of the theme or themes.

***Style galant* (p. 575)** A style of elegant, lighthearted music that was popular in France during the early part of the 18th century.

Yahoo (p. 583) In *Gulliver's Travels*, a crude, filthy, and savage creature, obsessed with finding "pretty stones" by digging in mud—Swift's satire of the materialistic and elite British.

THE BIG PICTURE THE EIGHTEENTH CENTURY

Language and Literature

- Pope wrote his "Essay on Criticism" in 1711, followed by successful translations of Homer's *Iliad* (1713–1720) and *Odyssey* (1725–1726).
- Swift wrote *Gulliver's Travels* in 1726 and *A Modest Proposal* in 1729.
- Diderot published 17 volumes of the *Encyclopédie* between 1751 and 1772, with contributions from Montesquieu and Rousseau.
- Voltaire wrote *Candide* in 1759.
- Rousseau wrote *The Social Contract* in 1762.
- Burns wrote "To a Mouse" in 1785.

Art, Architecture, and Music

- Watteau, Boucher, Fragonard, Carriera, Lebrun, Gainsborough, and Tiepolo painted in the Rococo style.
- Neumann designed buildings in the Rococo style.
- David painted in the Neo-Classical style, creating *The Oath of the Horatii* in 1784 and *Napoleon Crossing the Alps* in 1800.
- Canova sculpted *Pauline Bonaparte Borghese as Venus Victorious* in the Neo-Classical style in 1808.
- Soufflot's Panthéon in Paris, Jones's Banqueting House in London, and Wren's Saint Paul's Cathedral, also in London, were constructed in the Neo-Classical style.
- Symphonies were written and the orchestra came to include most of the instruments used today, with separate sections for string instruments, brass, percussion instruments, and clarinets and flutes.
- Classical music reached a new height with the works of Haydn in the 1790s and Mozart in the 1760s through to 1791.
- Mozart wrote 22 operas, including *The Marriage of Figaro* (1786), *Don Giovanni* (1787), *Così fan tutte* (1790), and *The Magic Flute* (1791).

Philosophy and Religion

- Locke argued for religious tolerance and a separation of church and state.
- Pope wrote his *Essay on Man* in 1733–1734.
- Voltaire wrote *Lettres philosophiques* in 1734.
- Rousseau wrote *The Social Contract* in 1762.
- Adam Smith published *The Wealth of Nations* in 1776.
- Paine published a series of pamphlets called *Common Sense* in 1776, followed by *The Rights of Man* in 1792.
- Wollstonecraft wrote *A Vindication of the Rights of Women* in 1792.

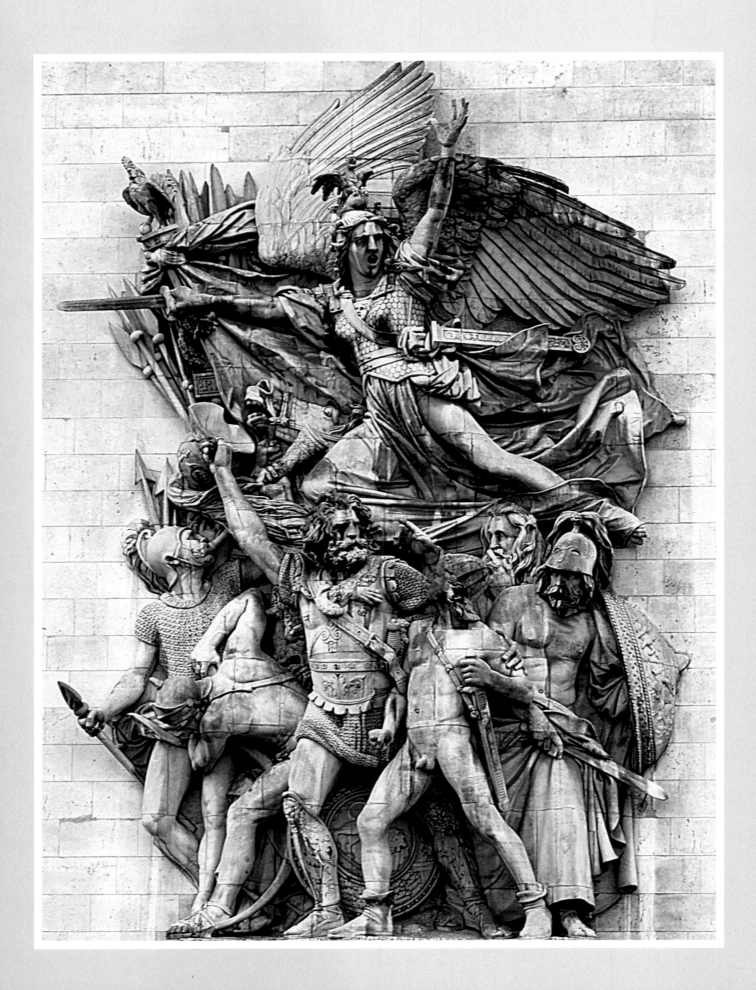

Romanticism, Realism, and Photography

PREVIEW

"It was the best of times, it was the worst of times, it was the age of wisdom, it was the age of foolishness, it was the epoch of belief, it was the epoch of incredulity, it was the season of Light, it was the season of Darkness, it was the spring of hope, it was the winter of despair, we had everything before us, we had nothing before us, we were all going direct to heaven, we were all going direct the other way . . ."

Thus begins Charles Dickens's novel *A Tale of Two Cities* set in the year 1775. It is the same year that the American colonists engaged with British troops in the Battle of Lexington and Concord after the "shot heard round the world" incited the armed struggle of the American Revolution against the United Kingdom, and just 14 short years before the storming of the Bastille prison sparked the beginning of the French Revolution against the ancien régime in 1789.

The intertwining human dramas of *A Tale of Two Cities*, which was published in 1859, unfold against the cities of Paris and London in the late 18th century. Almost 70 years after the event that inspired Dickens, it remained vivid in the minds of his readers, whose nostalgia for the glories of the not-so-recent past drove the novel's success. Dickens published its 45 chapters in a periodical called *All the Year Round* over the course of 30 weeks, enthralling readers who waited impatiently for the next installment. To what did this piece of historical fiction owe its popularity?

The Romantic poet William Wordsworth, who died in 1850, lived in England at the time of the French Revolution. He wrote, "Bliss was it in that dawn to be alive, / But to be young was very heaven!" In spite of the violence and bloodshed of the tumultuous era of revolutions, the memory of human resolve, the lust for freedom, and uncompromising heroism lingered. They also continued to inspire.

On one of the large pillars of the Napoleonic Arc de Triomphe (Arch of Triumph) in Paris, an inset relief over 40 feet high commemorates the heroism of volunteers who defended the French border along the Rhine River from foreign forces hostile to the revolution: men armed in Classically inspired costumes including greaves, helmets, and shields are roused by the battle cry of the personification of liberty (**Fig. 17.1**). She leads them to victory with an unsheathed sword, protecting them under her wings and cloak. The figural group, entitled *Departure of the Volunteers of 1792*, was created between 1833 and 1836, in the midst of the Romantic era; it is also known as *La Marseillaise*, after a war song written by Claude-Joseph Rouget de Lisle in 1792. "La Marseillaise" was adopted as the first anthem of the nation of France and is played and sung to this day.

◄ **17.1** François Rude, *Departure of the Volunteers of 1792 (La Marseillaise)*, 1833–1836. Limestone, 41'8" (12.7 m) high. Arc de Triomphe, Paris, France.

GO LISTEN! "LA MARSEILLAISE"

THE 19TH CENTURY

The industrial development and scientific progress of the 19th century overthrew centuries-old ways and saw vast changes in the lives of millions of people. The railroad, using engines powered by steam, first appeared in 1825 between Stockton and Darlington in England. By 1850, there were 6000 miles of track in the United Kingdom, 3000 in Germany, 2000 in France, and the beginnings of a rail system in Austria, Italy, and Russia. The economic impact was overwhelming. The railroad industry provided jobs, offered opportunities for capital investment, and increased the demand for coal and iron.

Industry soon overtook agriculture as the source of national wealth. With the growth of mass production in factories, the cities connected by rail became vast urban centers, attracting migration from the countryside. The number of people living in cities rose dramatically. The population of Turin, in northern Italy, was 86,000 by 1800, 137,000 by 1850, and more than 200,000 by 1860. Half of the United Kingdom's inhabitants lived in cities by 1850, the first time in social history that so large a percentage of a population was concentrated in an urban center; one Londoner described his city in the 1820s as "a wilderness of human beings."

Crowds of provincials flocked to great cities like London, Paris, and Vienna for employment and better wages, but also to enjoy metropolitan life and culture. One visitor to Paris described it as "a glass beehive, a treat to the student of humanity." Cities were seductive: they had public gardens, dance halls, fireworks, concerts, and other attractions for the ever-expanding working class and the rising bourgeoisie. Cities also fed the social and material desires of the very rich, whose world of glittering balls and A-list parties were the subject of Giuseppe Verdi's opera, *La traviata*. Based on the life story of the Parisian courtesan Marie Duplessis, who died of tuberculosis, the opera's main protagonists—the courtesan Marguerite and her provincial lover Armand—embody the tension between the allure of city life (even with its perils of disease tied to overcrowded and unsanitary conditions) and the return to nature for physical and spiritual repair. This tension also would be the subject of much Romantic art and literature. The truth was that the life expectancy of a male living in mid-19th-century London was less than half that of one living in the country.

What follows is a snapshot of events in the mid-19th century in two of Europe's most populous cities, as well as a glimpse of history across the Atlantic in the United States.

London

Vast social change in cities outstripped societies' abilities to keep pace; this was nowhere truer than in London. As people crowded into the densely packed city, housing burst at the seams. Many who arrived from farms in search of their fortunes drifted into marginal and disagreeable jobs (rag picking, collecting excrement), and public welfare programs sprang into being to address poverty. Some migrants turned to crime. In 1829, circumstances led Sir Robert Peel to establish the first British police force; its members became known as bobbies, after their founder.

Romanticism, Realism, and Photography

1789 CE	1815 CE	1848 CE	1870 CE
French Revolution	Napoléon escapes Elba and is defeated at the Battle of Waterloo	Revolutionary uprisings throughout Europe	
French Reign of Terror	Industrialization of England	Transatlantic cable is begun	
Napoléon rules France as consul	Faraday discovers the principle of the electric dynamo	Darwin publishes *On the Origin of Species*	
Napoléon's Russian campaign fails	Greek War of Independence from the Ottoman Empire	Unification of Italy	
Stephenson's first locomotive	Industrialization of France and Belgium	American Civil War	
Congress of Vienna	Reign of Queen Victoria in the United Kingdom (1837–1901)	Unification of Germany	
	Industrialization of Germany	United Kingdom grants Canada dominion status	
	Morse perfects the telegraph in 1844	First transcontinental railroad is completed in United States	

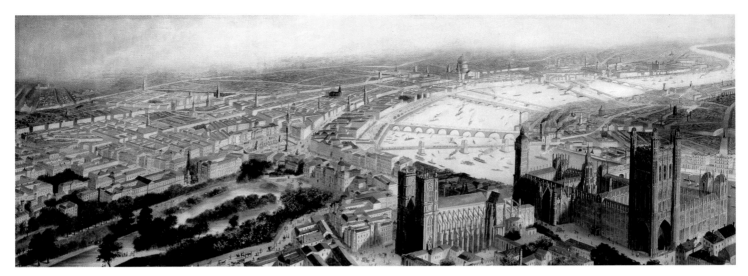

▲ **17.2** *A Panoramic View of London*, ca. 1858. Oil on canvas, 21½″ × 59″ (54.6 × 149.8 cm). Private collection.
This view of London, looking northeast from Westminster, shows the course of the river Thames. In the foreground are Westminster Abbey, with the Houses of Parliament on the right (1840–1870) showing the completed Clock and Victoria Towers, and St. James's Park to the left.

A lack of an adequate sewage system and street cleaning led to cholera and typhoid fever, the result of water polluted with human and animal waste and the flies it attracted, as well as the spread of lice among humans. By the middle of the 19th century, London was at a breaking point; in 1858, the "Great Stink" emanating from the polluted Thames River forced the British Parliament to take legislative measures to stop the crisis. This is the London that features so prominently in stories by Charles Dickens like *Hard Times* and *Oliver Twist*, even though London also had Westminster Abbey, the Gothic Revival Houses of Parliament, and St. James's Park and many other parks (**Fig. 17.2**). By the end of the century, a sewer system was in place, public health had improved, and more and better housing had been constructed. By 1900, it was just about as safe and healthy to live in the city as it was in the countryside.

Another response to the ills of the industrialized city was the design and construction of public parks, which served both hygienic and humanitarian purposes. In his essay on 19th-century public parks, particularly in London, Frank Clark quotes the British social reformer Francis Place on the benefits of a bit of country in the city: public parks can "instill a hallowed calm, and a spirit of reverence into the mind and heart." Clark further cites the words of one of the bishop of London's priests: "they, who might otherwise have been absolutely pent up and stifled in the smoke and din of their enormous prison may take breath in our parks . . . to satisfy that inextinguishable love for nature and fresh air and the bright face of the sun."[1]

The arrival in London of the railways, including the underground railway system, and public transportation connected the inner city with the outer suburbs in a more efficient manner and thus offered the best of both worlds. It was possible for individuals to separate their living quarters from the workplace, and by the early 20th century, posters advertising the convenience and health benefits of suburban living papered London. The city reoriented itself around railway stations and terminals. Train travel was both mundane and exotic, carrying people from home to work and from the city to adventures beyond.

Paris

One of the grandest 19th-century urbanization projects in the West was the modernization of the city of Paris. The *Haussmann Plan*, named after Georges-Eugène Haussmann (1809–1891, known as Baron Haussmann) was commissioned by Louis-Napoléon (Napoléon III) following the 1848 Revolution, a series of rebellions that essentially pitted the working and lower middle classes against the privileged and wealthy. "Modernization" was begun in 1853, ostensibly for the benefit of the masses. Yet a primary motive was to replace the Parisian warren of streets and alleyways with straight, wide boulevards, so that revolutionaries could not readily conceal themselves for attack and retreat. Paris today retains many of these smaller passageways that open into the boulevards and are dotted with shops and cafés. But Haussmann had many homes and neighborhoods *condemned*—that is, the city paid owners and took possession of them—and razed; he replaced them with apartments with pristine stone façades, wrought-iron balconies, and mansard roofs. Haussmann created a coding system that governed all aspects of the designs of

1. Frank Clark, "Nineteenth-Century Public Parks from 1830," *Garden History* 1, no. 3 (Summer 1973): 31.

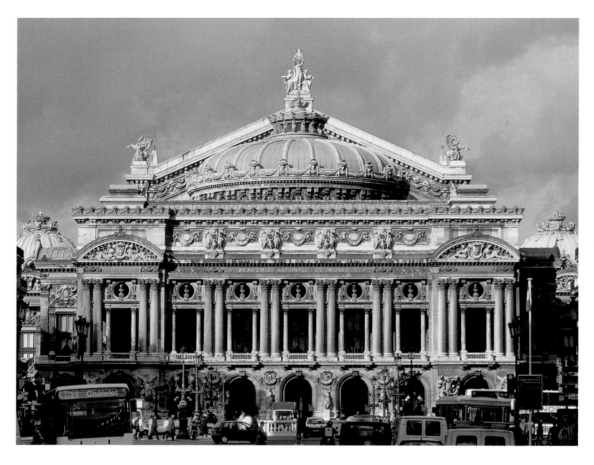

◄ **17.3** Charles Garnier,
Palais Garnier, 1860–1875.
The Paris National Opera
House, Paris, France.
The beaux art building
is dramatically staged
at the end of an opulent
boulevard—the Avenue de
l'Opéra—which connects it
with the Musée du Louvre.
The Palais Garnier—also
known as the Opera
Garnier—was not only a
venue for music, but also
a place for fashionable
Parisians who sought to see
and be seen.

buildings—including height—so as to create beauty through consistency. His boulevards, with their sweeping vistas, often culminated with something spectacular to look at, such as a splendid monument or building (**Fig. 17.3**). The effects were stunning and Haussmann's aesthetic became synonymous with the city of Paris. He also built parks, new sewers, and water works.

The United States

The mid-19th century in the United States brought a grave challenge to the union with the secession of a block of 11 Southern states that formed the Confederate States of America. From 1861 to 1865, the American Civil War was fought between the North (the Union forces consisting of 23 states) and the South (the Confederacy). It is estimated that as many as 620,000 lost their lives during the war, although more died from diseases and collateral damage than were killed in action. The right to own slaves was the reason for the secession of the Southern states, which maintained that the system was necessary to support the agrarian economy—

► **17.4** Mathew Brady, Abraham Lincoln, 1864. Albumen print
2¼″ × 3¾″ (5.7 × 9.5 cm) on carte de visite mount 2½″ × 4″
(6.4 × 10.2 cm). Library of Congress, Prints and Photographs
Division, Washington, DC.

VOICES

Charles Baudelaire: A View of the Modernization of Paris

For all of its renowned urban beauty, the mid-19th century modernization of Paris came with a price. Georges-Eugène Haussmann, the major architect of change, was seen as both creator and destroyer. In 1861 the French poet Charles Baudelaire, who felt alienated in his own city, wrote that Paris had been despoiled—just as the ancient Greeks had despoiled Troy.

From "The Swan,"* in *Flowers of Evil* ("Parisian Scenes," 1861)

Andromache,** I think of you! That stream,
and sometimes witness to your widowhood's
enormous majesty of mourning—that
mimic Simoïs salted by your tears,
suddenly inundates my memory
as I cross the new Place du Carrousel.***
Old Paris is gone (no human heart
changes half so fast as a city's face)
and only in my mind's eye can I see
the junk laid out to glitter in the booths
among the weeds and splintered capitals,
blocks of marble blackened by the mud;
there used to be a poultry market here,
and one cold morning—with the sky swept clean,
the ground, too, swept bay garbage men who raised
clouds of soot in the icy air—I saw
a swan that had broken out of its cage,
webbed feet clumsy on the cobblestones,

white feathers dragging in the uneven ruts,
and obstinately pecking at the drains,
drenching its enormous wings in the filth
as if in its own lovely lake, crying
"Where is the thunder, when will it rain?"
I see it still, inevitable myth,
like Daedalus dead-set against the sky****—
the sky quite blue and blank and unconcerned
that straining neck and that voracious beak,
as if the swan were castigating God!
Paris changes . . . But in sadness like mine
nothing stirs—new buildings, old
neighborhoods turn to allegory,
and memories weigh more than stone.
One image, near the Louvre, will not dissolve:
I think of that great swan in its torment,
silly, like all exiles, and sublime,
endlessly longing . . .

* Richard Howard, trans. *Les Fleurs du Mal*. Published by David Godine, 1983, pp. 90−92. Translation © 1982 by Richard Howard. Reprinted by permission of Richard Howard, Professor of Practice, School of the Arts—Writing Division, Columbia University.

** Hector's widow in the *Iliad*.

*** An area of Paris that was constructed to replace the bohemian artists' quarter where Baudelaire had lived.

**** The mythical Greek inventor who escaped from imprisonment with his son Icarus on wax wings that melted in the sun.

particularly the cotton industry. Abraham Lincoln—an antislavery president—was elected in 1860, prompting action on the part of the Southern states. Secession, viewed as treason, became the *casus belli*, or justification for war. The war concluded with a Union victory upon the surrender of the Confederacy on April 9, 1865. Consequently, slavery was outlawed throughout the nation. John Wilkes Booth, who sympathized with the Confederacy, assassinated Lincoln five days later. Because of the invention of photography, we have documentary photographs of the Civil War battlefields, as well as many images of Abraham Lincoln (**Fig. 17.4**).

THE INTELLECTUAL BACKGROUND

For many philosophers in the middle of the 18th century, *reason* was the guiding principle of human thought and existence. A banner for the Enlightenment era may well have quoted Immanuel Kant's definition of the philosophy in his 1784 essay "Answering the Question: What Is Enlightenment?" For Kant, it was the freedom to use one's own *intelligence*. Implicit in "one's own intelligence" was the rejection of the blind authority of established institutions (of the church and state), the pursuit of knowledge and scientific truths (as opposed to a belief in dogma and a life in the grip of superstition and fear), and the potential of the individual to achieve great things and to employ reason to effect the betterment of society. The ideals of the Enlightenment era shaped historical events in the late 18th century—including the revolutions in North America and France and the nature of their postmonarchy constitutions.

As the century came to a close, there was a dramatic shift in the intellectual and cultural discourse from reason to *feeling*. Kant questioned the validity of reason as the exclusive path to understanding the real, positing that feeling may offer an equally valuable guide to knowledge. The central

role of feeling—and its expression—drew the focus on the uniqueness of the individual and the inner self and the human capacity for self-fulfillment.

Romanticism as a cultural movement was multifaceted. The emphasis on innate feeling led to an interest in the *primitive*—that is, in the simple life unmediated by the authority of established institutions, and nature untouched, unspoiled by human presence. Romanticism also put a premium on *imagination* as a creative force—that intangible, powerful bit of consciousness that bridges the intellect and the emotions.

IMMANUEL KANT The ideas that proved most attractive to the Romantic imagination developed in Germany at the end of the 18th century. Their chief spokesman was Immanuel Kant (1724–1804), whose *Critique of Judgment* (1790) defined the pleasure we derive from art as "disinterested satisfaction." Kant conceived of art as uniting opposite principles. It unites the general with the particular, for example, and reason with the imagination. For Kant, the only analogy for the way in which art is at the same time useless and yet useful was to be found in the world of nature.

Kant also taught that the apparent characteristics of objects in the world are products of our minds. He noted that prior to Copernicus, people believed that the apparent motion of the sun around the earth was its actual motion. Copernicus showed that the sun's apparent motion was a product of our perception of the earth's motion. Kant further argued that the human mind imposes an order on the outside world, including concepts such as space and time. This order also requires our continuous consciousness. Whatever is "out there"—in the world beyond the person—must be filtered through the mind to become meaningful. So did Romantic artists and writers believe that experience was made meaningful by filtering it through their artistic minds.

GEORG WILHELM FRIEDRICH HEGEL Even more influential than Kant was Georg Wilhelm Friedrich Hegel (1770–1831), whose ideas continued to affect approaches to art criticism into the 20th century. Like Kant, Hegel stressed art's ability to reconcile and make sense of opposites—to provide a **synthesis** of the two opposing components of human existence, called **thesis** (an idea or pattern of behavior) and **antithesis** (the direct opposite). This process, he held, applied to the workings of the mind and also to the workings of world history, through the development and realization of what he called the World Spirit. Hegel's influence on his successors lay less in the details of his philosophical system than in his acceptance of divergences and his attempt to reconcile them. The search for a way to combine differences, to permit the widest variety of experience, still stimulates much contemporary thinking about the arts.

ARTHUR SCHOPENHAUER Both Kant and Hegel developed their ideas in the relatively optimistic intellectual climate of the late 18th and early 19th centuries, and their approach to art and to existence is basically positive. But in his major work, *The World as Will and Idea* (1819), Arthur Schopenhauer (1788–1860) expressed the belief that people are selfish and rarely rational, and that the sciences and the humanities both create the false impression that the world is a reasonable place. At the time of its appearance, Schopenhauer's work made little impression, largely because of the popularity of Kant's and Hegel's idealism. Schopenhauer did not help matters by launching a bitter personal attack on Hegel. But the failure of mid-century nationalist uprisings in many parts of Europe produced a growing mood of pessimism and gloom, against which background Schopenhauer's vision of a world condemned to be ravaged perpetually by strife and misery seemed more convincing. Thus, his philosophy, if it did not mold the Romantic movement, came to reflect its growing despondency.

KARL MARX Many of the developments in 19th-century thought had little direct impact on the arts. Perhaps the most influential of 19th-century philosophers, because of his effect on the 20th century to come, was Karl Marx (1818–1883), whose belief in the inherent evil of capitalism and in the historical inevitability of a proletarian revolution was powerfully expressed in his *Communist Manifesto* (1848).

Marx's belief that revolution was both unavoidable and necessary was based at least in part on his own observation of working conditions in industrial England, where his friend and fellow communist Friedrich Engels (1820–1895) had inherited a textile factory. Marx and Engels both believed that the factory workers, although creating wealth for the middle classes, derived no personal benefit. Living in overcrowded, unsanitary conditions, the workers were deprived of any effective political power and kept quiet only by the drug of religion, which offered them the false hope of rewards in a future life. The plight of the working classes seemed to Marx to transcend all national boundaries and create a universal proletariat who could only achieve freedom through revolution: "Workers of the world, unite!" Marx asserted. "You have nothing to lose but your chains!" The drive to political action was underpinned by Marx's economic philosophy, with its emphasis on the value of labor and, more generally, on the supreme importance of economic and social conditions as the true moving forces behind historical events. This so-called materialist concept of history was to have worldwide repercussions in the century that followed Marx's death. More recent writers, such as Bertolt Brecht (1898–1956), have embraced Marxist principles, and Marxist critics have developed a school of aesthetic criticism that applies standards based on Marxist doctrines. During the 19th and early 20th centuries, however, Marx's influence was exclusively social and political.

Marx clearly delineated his views on the arts: Art can contribute to important social and political changes, and is thus a determining factor in history. Neither is artistic output limited to the upper or more prosperous social

classes; according to the "principle of uneven development," a higher social order does not necessarily produce a correspondingly high artistic achievement. Capitalism is, in fact, hostile to artistic development, because of its obsession with money and profit. As for styles, the only one appropriate for the class struggle and the new state is Realism, which would be understood by the widest audience. Vladimir Lenin, the Russian Revolutionary who led the October Revolution of 1917—which overthrew the tsarist regime—developed this doctrine further in the Soviet Union when he ordered that art should be a specific "reflection" of reality, and used the Communist party to enforce the official cultural policy.

The Communist Manifesto—from which is reproduced here the famous preface and part 2 with its ringing final exhortation—was written jointly by Marx and Engels to serve as a program for a secret workingmen's society, the Communist League, but subsequently became the core of all communist doctrine. The translation that appears here was done by Samuel F. Moore under the supervision of Engels. *Bourgeois* defines the class of modern capitalists, owners of the means of social production and employers of wage labor.

In a note to the 1888 English edition, Engels defined the proletariat as the "class of modern wage laborers who, having no means of production of their own, are reduced to selling their labor power in order to live."

CHARLES DARWIN

"My nose had spoken falsely."

—Charles Darwin

No single book affected 19th-century readers more powerfully than *On the Origin of Species by Means of Natural Selection* by Charles Robert Darwin (1809–1882), which appeared in 1859. As a student at Cambridge, in 1831 Darwin volunteered to serve as the scientist for an expeditionary voyage to the Galápagos Islands on the HMS *Beagle*. Darwin's adventure would lead to the development of his theory of evolution, but it might never have happened at all. The ship's captain, Robert Fitzroy, was concerned about having Darwin along on account of the shape of his nose. Fitzroy placed credence in *physiognomy*, a practice of assessing character by the facial features, and Darwin's nose worried him. He relented,

READING 17.1 KARL MARX AND FRIEDRICH ENGELS

From *The Communist Manifesto* (1848)

Preface

A spectre is haunting Europe—the spectre of communism. All the powers of old Europe have entered into a holy alliance to exorcise this spectre: Pope [Vatican] and Tsar [Russia], Metternich [Austria] and Guizot [France], French Radicals, and German police-spies.

Where is the party in opposition that has not been decried as communistic by its opponents in power? Where is the opposition that has not hurled back the branding reproach of communism, against the more advanced opposition parties, as well as against its reactionary adversaries?

Two things result from this fact:

1. Communism is already acknowledged by all European powers to be itself a power.
2. It is high time that Communists should openly, in the face of the whole world, publish their views, their aims, their tendencies, and meet this nursery tale of the spectre of communism with a manifesto of the party itself.

To this end, Communists of various nationalities have assembled in London and sketched the following manifesto, to be published in the English, French, German, Italian, Flemish and Danish languages.

. . .

II. Proletarians and Communists

In what relation do the Communists stand to the proletarians as a whole?

The Communists do not form a separate party opposed to other working-class parties.

They have no interests separate and apart from those of the proletariat as a whole.

They do not set up any sectarian principles of their own, by which to shape and mould the proletarian movement.

The . . . immediate aim of the Communists is the same as that of all the other proletarian parties; formation of the proletariat into a class, overthrow of the bourgeois supremacy, conquest of political power by the proletariat.

The theoretical conclusions of the Communists . . . [express] actual relations springing from an existing class struggle, from a historical movement going on under our very eyes. . . . The distinguishing feature of Communism is not the abolition of property generally, but the abolition of bourgeois property. . . .

In short, the Communists everywhere support every revolutionary movement against the existing social and political order of things.

In all these movements they bring to the front, as the leading question in each, the property question, no matter what its degree of development at the time.

Finally, they labor everywhere for the union and agreement of the democratic parties of all countries.

The Communists disdain to conceal their views and aims. They openly declare that their ends can be attained only by the forcible overthrow of all existing social conditions. Let the ruling classes tremble at a Communistic revolution. The proletarians have nothing to lose but their chains. They have a world to win.

Working men of all countries, unite!

however, and Darwin undertook the historic voyage that would change science.

Darwin studied geological formations, fossils, and the distribution of plant and animal types. On examining his material, he became convinced that species were not fixed categories, as had always been held, but were instead capable of variation. Drawing on the population theories of Thomas Malthus and the geological studies of Sir Charles Lyell, Darwin developed his theory of evolution as an attempt to explain the extinction of old species and the development of new species.

According to Darwin, animals and plants evolve by a process of **natural selection** (as opposed to artificial selection, which is used by farmers and animal breeders). Over time, some variations of each species survive while others die out. Those likely to survive are those best suited to prevailing environmental conditions—a process called survival of the fittest. Changes in the environment would lead to adjustments within the species. The first publication of this theory appeared in 1858, in the form of a short scientific paper; *On the Origin of Species* appeared a year later.

In 1871 Darwin published *The Descent of Man*, which claimed that humans and apes descended from a common ancestor, even though the fossil record had thus not far provided evidence of the links. In the past few decades, however, anthropologists have been literally unearthing many of those links.

The impact of both books was spectacular. Their author quietly continued his research and tried to avoid the popular controversy surrounding his work. Church leaders thundered their denunciations of a theory that utterly contradicted the notion that humans, along with everything else, had been created by God in their current form in accordance with a divine plan. An example of the reaction against Darwin is shown in the Thomas Nast cartoon in **Figure 17.5**. On the other hand, scientists and freethinkers stoutly defended Darwin, often enlarging his claims. One hundred fifty years later, the debate continues in the United States, with some school districts demanding that creationism be taught alongside Darwinism, or even that evolution not be taught at all.

Other Intellectual Developments

In other sciences, research brought a host of new discoveries. Experiments in magnetism and electricity advanced physics. Using new chemical elements, the French chemist Louis Pasteur (1822–1895) explored the process of fermentation and invented pasteurization—a procedure that helped improve the safety of food. Equally beneficial was Pasteur's demonstration that disease is spread by living but invisible (to the naked eye, at least) germs, which can be combated by vaccination and the sterilization of medical equipment.

READING 17.2 **CHARLES DARWIN**

From *On the Origin of Species*, Ch. 14, "Recapitulation and Conclusion" (1859)

Under domestication we see much variability. This seems to be mainly due to the reproductive system being eminently susceptible to changes in the conditions of life so that this system, when not rendered impotent, fails to reproduce offspring exactly like the parent-form. Variability is governed by many complex laws,—by correlation of growth, by use and disuse, and by the direct action of the physical conditions of life.

. . .

Man does not actually produce variability; he only unintentionally exposes organic beings to new conditions of life, and then nature acts on the organisation, and causes variability. But man can and does select the variations given to him by nature, and thus accumulate them in any desired manner. He thus adapts animals and plants for his own benefit or pleasure. He may do this methodically, or he may do it unconsciously by preserving the individuals most useful to him at the time, without any thought of altering the breed. It is certain that he can largely influence the character of a breed by selecting, in each successive generation, individual differences so slight as to be quite inappreciable by an uneducated eye.

. . .

There is no obvious reason why the principles which have acted so efficiently under domestication should not have acted under nature. In the preservation of favoured individuals and races, during the constantly-recurrent Struggle for Existence, we see the most powerful and ever-acting means of selection. The struggle for existence inevitably follows from the high geometrical ratio of increase which is common to all organic beings. . . . More individuals are born than can possibly survive. A grain in the balance will determine which individual shall live and which shall die,—which variety or species shall increase in number, and which shall decrease, or finally become extinct. As the individuals of the same species come in all respects into the closest competition with each other, the struggle will generally be most severe between them; . . . the slightest advantage in one being, at any age or during any season, over those with which it comes into competition, or better adaptation in however slight a degree to the surrounding physical conditions, will turn the balance.

With animals having separated sexes there will in most cases be a struggle between the males for possession of the females. The most vigorous individuals, or those which have most successfully struggled with their conditions of life, will generally leave most progeny. But success will often depend on having special weapons or means of defence, or on the charms of the males; and the slightest advantage will lead to victory.

MR. BERGH TO THE RESCUE.

THE DEFRAUDED GORILLA. "That *Man* wants to claim my Pedigree. He says he is one of my Descendants."

Mr. BERGH. "Now, Mr. DARWIN, how could you insult him so?"

◀ **17.5** Thomas Nast, cartoon from *Harper's Weekly*, August 19, 1871. Woodcut (colorized), 5″ × 4″ (12.7 × 10.2 cm). Private collection. Thomas Nast satirizes Charles Darwin's theory of evolution by showing a gorilla seeking the protection of Henry Bergh, the founder of the American Society for the Prevention of Cruelty to Animals while Darwin looks on. This is one of the less ugly cartoons that was used to denigrate Darwin.

Achievements in science and technology are reflected to a certain extent in Romantic art, although often from a negative point of view. The growing mechanization of life in the great cities, and the effect of inventions like the railway train on urban architecture stimulated a "back to nature" movement, as Romanticism provided an escape from the grim realities of urbanization and industrialization. Furthermore, at a time when many people felt submerged and depersonalized in overcrowded cities, the Romantic emphasis on the individual and on self-analysis found an appreciative audience. Many artists contrasted the growing problems of urban life with an idyllic (and highly imaginative) picture of rustic bliss.

Scientific ideas had something of the same negative effect on 19th-century artists. The English Victorian writers (so called after Queen Victoria, who reigned from 1837 to 1901) responded to the growing scientific materialism of the age. Although few were, strictly speaking, Romantics, much of their resistance to progress in science and industry and their portrayal of its evil effects has its roots in the Romantic tradition.

FROM NEO-CLASSICISM TO ROMANTICISM: ART UNDER NAPOLÉON

Napoléon Bonaparte crowned himself emperor in 1804 and enlisted Jacques-Louis David (1748–1825) as First Painter

▲ **17.6** Jacques-Louis David, *The Consecration of Emperor Napoleon I and Coronation of the Empress Josephine in the Cathedral of Notre-Dame de Paris, 2 December, 1804*, 1806–1807. Oil on canvas, 20'4½" × 32'1¾" (621 × 979 cm). **Musée du Louvre, Paris, France.** In the painting, Napoléon is about to crown his wife, Joséphine, as Empress. The painting also shows Napoléon's mother as present, although she was not.

of the Empire, granting the artist (perhaps literally) a new lease on life. David was present at the coronation and afterward crafted—with the input of his patron—an enormous composition recording, in detail, the glory and politics of the event (Fig. 17.6). Napoléon chose the focal point of the painting: after crowning himself, rather than allowing the pope to crown him, he bestows the crown of empress on the head of his wife, Joséphine. The pope sits behind Napoléon and Joséphine kneels and bows before her husband. In that exact moment, Napoléon's supreme authority and power are represented as unchallenged.

David's **Neo-Classical** style underscored this air of authority, bolstered by its association with the Classical past—especially the Roman Republic and Empire. The coronation took place in the Gothic cathedral of Notre-Dame in Paris, but the site was transformed to reflect Napoléon's taste for Neo-Classicism; architects were hired to create a stage set of sorts, featuring sweeping arches and thick piers inlaid with patterned stone. Napoléon knew well the potential power of images and used David to exploit it, even, as in *The Consecration of Emperor Napoleon I*, micromanaging the content to

serve his own purpose. Napoléon insisted that David portray the pope with a gesture of blessing (not originally recorded in the artist's drawings of the event) and include the emperor's mother (in a seat of honor in the center middle ground of the painting), even though she refused to attend the event. Although the composition was intended to record the details of the coronation, some of those details rewrote history.

David remained a prominent figure in the French art world and a mentor of students in the Neo-Classical style. For all of his own strict adherence to Classical models and his belief that students should be learned in Classical studies, his respect for individual interests and talents and his flexibility as a master teacher are evident in the work of two of his most well-known students—Anne-Louis Girodet-Trioson (1767–1824) and Jean-Auguste-Dominique Ingres (1780–1867). While their styles were inspired by David and while they were committed to Classical form, their subjects pointed in a different direction—toward exoticism and emotion, eroticism and fantasy. We can consider both of these artists transitional figures between Neo-Classicism and Romanticism.

ANNE-LOUIS GIRODET-TRIOSON *The Entombment of Atala* (**Fig. 17.7**) depicts a Romantic narrative set in the American wilderness, acted out, as it were, by Classical figures. Drawn from a popular work by the French Romantic novelist François-Auguste-René de Chateaubriand (1768–1848), it is the tragic story of a young Native American man and woman—Chactas and Atala—who have fallen in love but are from different tribes. Atala has taken a vow of chastity and, rather than break it, commits suicide. A hooded priest helps Chactas lower her gently into her grave; his arms and torso are wrapped tightly around her legs, as he cannot bring himself to part with her.

David's Neo-Classical hand can be felt in Girodet-Trioson's painting by its idealism, linearity and sculptural forms, attention to detail, and frieze-like placement of the dramatic narrative in the foreground plane. But the painting also contains just about every conceivable element of Romanticism: an exotic location, eroticism, unfulfilled love, and the pain and emotion of the individual. Girodet-Trioson's setting, with its lush, tropical plants, is intended to evoke the New World—specifically the Louisiana wilder-

ness. Atala's wan, feminine beauty, more delicate and sensual even in death, contrasts strongly with Chactas's rough, knotty musculature and the long, dark, curly hair that flows from his head, over her thighs, and into her lap. Chactas mourns Atala deeply, movingly, but privately. Despite larger references to Christianity, primitivism, and social mores, it is the intimacy of Chactas's emotional suffering that moves the viewer.

JEAN-AUGUSTE-DOMINIQUE INGRES David's most prodigious student, Jean-August-Dominique Ingres created pristine compositions in an even purer style of Neo-Classicism that was inspired specifically by Greek art. Ingres's work is a combination of precise linearity and sculptural smoothness on the one hand, and delicacy and sensuality on the other. Like David's, Ingres's forms are flawless and his painted surfaces as smooth as glass. But as did Girodet-Trioson, Ingres tapped into the early-19th-century audience's appeal for the exotic in his themes. His *Grande Odalisque* (see **Fig. 17.8** in the nearby Compare + Contrast feature), although very much in the tradition of

▼ **17.7** Anne-Louis Girodet-Trioson, *The Entombment of Atala*, 1808. Oil on canvas, 83″ × 105″ (207 × 267 cm). Musée du Louvre, Paris, France. The anti-Classical nature of the subject is emphasized by the Christian symbolism of the two crosses, one leaning on the cave wall behind Atala and the other rather improbably placed high in the jungle outside the cave.

Women, Art and Power: Ideology, Gender Discourse, and the Female Nude

We often use Compare + Contrast features to stimulate students' powers of visual recognition and discrimination, to test students' ability to characterize and categorize, and to encourage students to think critically about the content and context of literature and visual works of art.

You can write paragraphs on the stylistic differences alone between the odalisque paintings by Ingres (**Fig. 17.8**) and Delacroix (**Fig. 17.9**). They are archexamples of the contrast between a linear and a painterly approach to the same subject; they offer clear evidence of the "battle" between the Poussinistes and the Rubenists during the Romantic period (those whose draftsmanship was inspired by the Classical Baroque artist Nicolas Poussin versus those who "went to school" on the Flemish Baroque painter Peter Paul Rubens). On the other hand, they have one important element in common: both bespeak a fascination with the exotic, with "the Orient," with the *other*; a seemingly insatiable fascination not only with the trappings of an exotic *sensuality*—turbans, silken scarves, peacock feathers, opium pipes— but with what was perceived as an unrestrained and exotic *sexuality*. These two works are in abundant company in 19th-century France. Can you do a bit of research to discover what circumstances (historical, political, sociological, and so on) prevailed at this time and might have created a market for such paintings? Why did these very different artists find the same subject so captivating, so fashionable?

Linda Nochlin, a historian of 19th-century art and a feminist scholar, has suggested that such

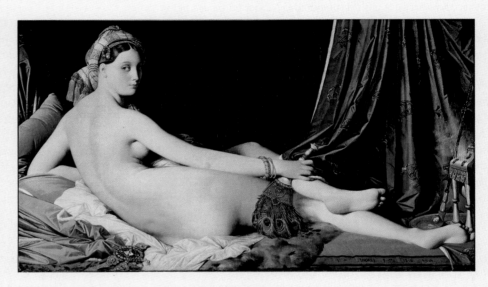

▲ **17.8** Jean-Auguste-Dominique Ingres, *La Grande Odalisque*, 1814. Oil on canvas, 35¼" × 63¾" (91 × 162 cm). Musée du Louvre, Paris, France.

▼ **17.9** Eugène Delacroix, *Odalisque Reclining on a Divan*, ca. 1825. Oil on canvas, 14⅞" × 18¾" (38.0 × 46.7 cm). Fitzwilliam Museum, Cambridge, United Kingdom.

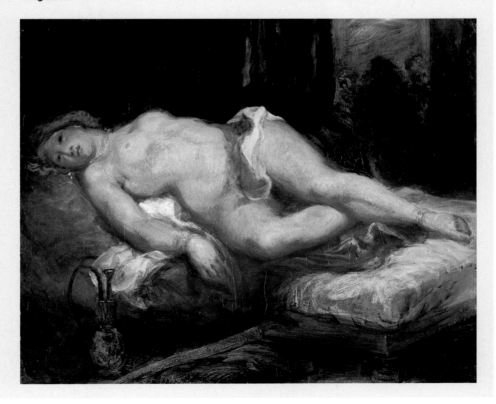

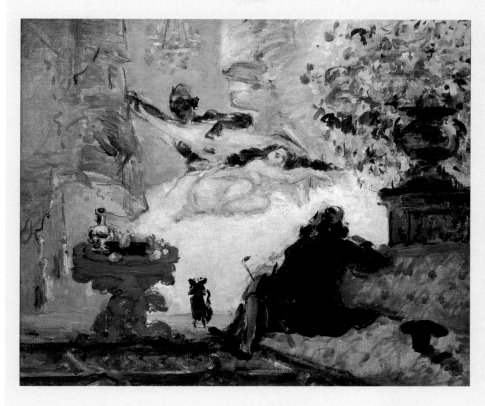

◀ **17.10** Paul Cezanne, *A Modern Olympia*, 1873–1874. Oil on canvas, 18¼" × 21⅞" (46.0 × 55.5 cm). Musée d'Orsay, Paris, France.

the viewer and the viewed in art, literature, and film this way: Men are in the position of looking, and women are "passive, powerless objects of their controlling gaze."

Paul Cézanne's *Modern Olympia* (**Fig. 17.10**) and Sylvia Sleigh's *Philip Golub Reclining* (**Fig. 17.11**) seem to address the issue of the male gaze straight on, but in quite different ways. Cézanne was surely commenting on Édouard Manet's *Olympia* (see **Fig. 18.7**), which was painted just 10 years earlier and made quite a splash when exhibited. What are the similarities in content? What are the differences? Note, among other things, that Cézanne has placed himself in the picture—owning up, as it were, to the male gaze.

Sleigh attacks the issue by reversing the power relationship in painting. The artist is seen in the background, in a mirror reflection, painting the nude Philip Golub from the rear. Does the work raise questions such as "Is this also what women really want to paint?" or "Is this what women want to gaze upon?" Or do you think the main purpose of this painting is to call our attention to a tradition in the arts of perpetuating ideological gender attitudes?

paintings speak volumes about contemporary ideology and gender discourse:

> The ways in which representations of women in art are founded upon and serve to reproduce indisputably accepted assumptions held by society in general, artists in particular, and some artists more than others about men's power over, superiority to, difference from, and necessary control of women, assumptions which are manifested in the visual structures as well as the thematic choices of the pictures in question.

Among several that Nochlin lists are assumptions about women's weakness and passivity and sexual availability for men's needs.

The works in this feature speak to the tradition of the reclining nude in Western art. For whom—for whose "gaze"—do you think they were intended? The concept of the *male gaze* has been central to feminist theory for more than four decades. In a landmark article written in 1973, the filmmaker Laura Mulvey explained the roles of

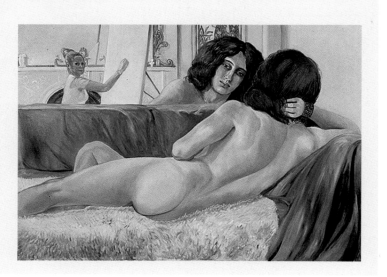

▶ **17.11** Sylvia Sleigh, *Philip Golub Reclining*, 1971. Oil on canvas, 42" × 62" (106.7 × 157.5 cm). Private collection, Dallas, Texas. © Sylvia Sleigh.

the art-historical reclining nude, presents a twist: a Turkish harem mistress has replaced the Venus figure.

In *La Grande Odalisque*, line has a prominent role, from the languid curve of the woman's spine to the staccato folds of the rumpled bed linens. Ingres tilts the Classically rendered body toward Mannerism in the attenuation of the torso and limbs, the fullness of the lower body, and the smallish turbaned head. The creamy flesh of the odalisque is set off by subtle hues and brilliantly rendered sheens and textures, all of which contribute to the lush, sensuous atmosphere. The odalisque turns her head toward the viewer and fixes her gaze, yet her sultry, relaxed pose remains undisturbed; she is unfazed by our presence. In Romantic art, eroticism in the context of exoticism was a socially acceptable form of fantasy.

Ingres's version of Neo-Classicism was radical (even deviant) to many who still associated David with defining and perfecting the style. Although Ingres parted company with David, he would ultimately become the self-appointed defender of his legacy against a group of artists—including Théodore Géricault and Eugène Delacroix—whose style seemed barbarous in contrast to cultured Classicism. Ingres would wage a war against Romantic painting—against its brash color and bravado brushwork, its unchained emotion and extreme subjects.

ROMANTICISM

The tide of revolution that swept away much of the old political order in Europe and North America in the late 1700s had momentous consequences for the arts. The essence of **Romanticism** is difficult to describe because the movement is more concerned with broad general attitudes than with specific stylistic features. Painters, writers, and musicians in the 19th

century shared several concerns in their approach to their art, such as an emphasis on the expression of personal feelings. Focus on emotion rather than intellect led artists to use their works to explore and dissect their own personal hopes and fears rather than to arrive at some general truth. Romanticism's love of the fantastic and the exotic made it possible to probe more deeply into an individual's creative imagination. The suppression of reason—deliberate intellectual dissection of experience—held the danger of releasing monsters to wing forth from the mind: the symbols of ignorance (bats) and folly (owls) revealed in the Spanish artist Francisco de Goya's etching *The Sleep of Reason Produces Monsters* (**Fig. 17.12**).

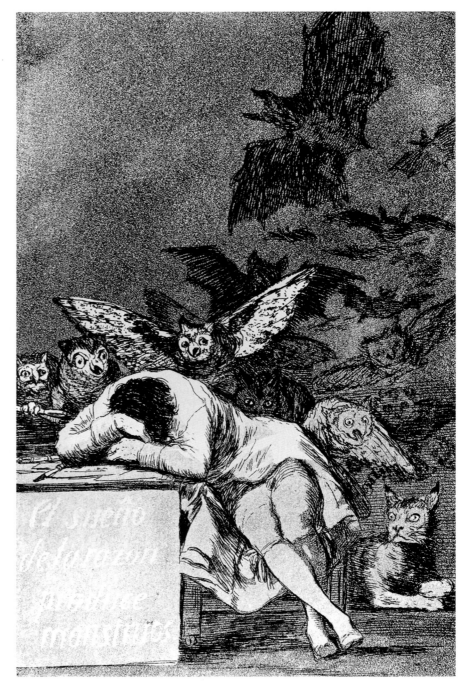

> **17.12** Francisco de Goya, *The Sleep of Reason Produces Monsters* (*El sueño de la razón produce monstruos*), 1797–1798. Plate 43 from *Los Caprichos*. Etching and aquatint, 8½″ × 6″ (21.5 × 15.0 cm). Victoria and Albert Museum, London, United Kingdom. The etching suggests that the suppression of reason might release monsters from the mind—monsters that symbolize ignorance (bats) and folly (owls). The title of the piece is written on the desk below the student, who—not unlike some contemporary students?—sleeps with his head on his textbooks.

> **MAP 17.1** **Europe in 1848.**

Romantic art frequently embraced a mystical attachment to the world of nature. Painters turned increasingly to landscape, composers evoked the rustling of leaves in a forest or the noise of a storm, and poets expressed their sense of union with the natural world. Most 18th-century artists had turned to nature in search of order and reason. In the 19th century, the wild unpredictability of nature was emphasized—the mirror of the artist's emotions. At the same time, the Romantic communion with nature expressed a rejection of the Classical notion of a world centered on human activity.

These attitudes and the creative power they unleashed sometimes alienated creative artists from their public. Whereas artists had once provided entertainment or satisfied political and religious demands, Romantic artists' works might meet no needs other than their own. Even so, an increasing number of artists sought to depict the national characteristics of their people—if one could say there were such things. Abandoning the common artistic language of earlier periods and developing local styles that incorporated traditional folk elements enabled artists to stimulate (and in some cases to initiate) the growth of national consciousness and the demand for national independence (see **Map 17.1**). Even as some artists were retreating into private worlds of their own creation, others were at the forefront of the social and political movements of their age.

▼ **17.13** **Principal Characteristics of the Romantic Movement**

Expression of Personal Feelings

Chopin, preludes

Goya, *The Family of Charles IV* (Fig. 17.15)

Goethe, *The Sorrows of Young Werther*

Self-Analysis

Berlioz, *Symphonie fantastique*

Keats, poetry

Whitman, *Leaves of Grass*

Love of the Fantastic and Exotic

Paganini, musical compositions and performances

Girodet-Trioson, *The Entombment of Atala* (Fig. 17.7)

Delacroix, *The Death of Sardanapalus* (Fig. 17.18)

Interest in Nature

Beethoven, "Pastoral" Symphony

Constable, *The Hay Wain* (Fig. 17.20)

Wordsworth, poetry

Emerson, "The American Scholar"

Nationalism and Political Commitment

Verdi, *Nabucco*

Smetana, *Má vlast* (*My Fatherland*)

Goya, *The Third of May, 1808* (Fig. 17.14)

Byron's support of the Greeks

Erotic Love and the Eternal Feminine

Goethe, *Faust, Part Two*

Wagner, *Tristan and Isolde*

Romantic Art in Spain and France

At the start of the Romantic era, artists began to abandon the lofty, idealized, remote world of Neo-Classical art for more vivid images intended to communicate intense personal feelings. The depiction of nature as unpredictable and uncontrollable—in the words of the French philosopher, art critic, and writer Denis Diderot, as stunning the soul and imprinting feelings of terror—was also a favorite theme of the romantic artist.

FRANCISCO DE GOYA In Francisco de Goya's (1746–1828) painting *The Third of May, 1808* (**Fig. 17.14**), nothing is idealized. The horror and the terror of the victims, their faceless executioners, and the blood streaming in the dust all combine to create an almost unbearable image of protest against human cruelty. Goya's painting is Romantic because it conveys to us his own personal emotions at the thought of the executions and because, great artist that he was, his emotions become our own.

As the composer Beethoven by his own passionate commitment convinces us of the necessity to struggle against the injustices of human beings and of fate, so Goya by his intensity urges us to condemn the atrocities of war. Furthermore, both Beethoven and Goya shared a sympathy with the oppressed and a hatred of tyranny. The soldiers firing their bayoneted guns in Goya's painting were serving in the army of Napoléon; the event shown took place some four years after Beethoven had seen the danger Napoléon presented to the cause of liberty and erased his name from the "Eroica" Symphony.

It was easier for an artist outside France to abandon the artistic language of Neo-Classicism for more direct ways of communication. Although from 1824 to his death Goya lived in France, he was born in Spain and spent most of his working life there. Removed from the mainstream of artistic life, he seems never to have been attracted by the Neo-Classical style. Some of his first paintings were influenced by the Rococo style of Tiepolo (see **Fig. 16.6**), who was in Spain from 1762 until 1770, but his own introspective nature

▼ **17.14** Francisco de Goya, *The Third of May, 1808*, 1814. Oil on canvas, 104³/₄″ × 135³/₄″ (266 × 345 cm). **Museo del Prado, Madrid, Spain.** The painting shows the execution of a group of citizens of Madrid, Madrileños, who had demonstrated against the French occupation by Napoléon's troops. The Spanish government commissioned the painting after the expulsion of the French army.

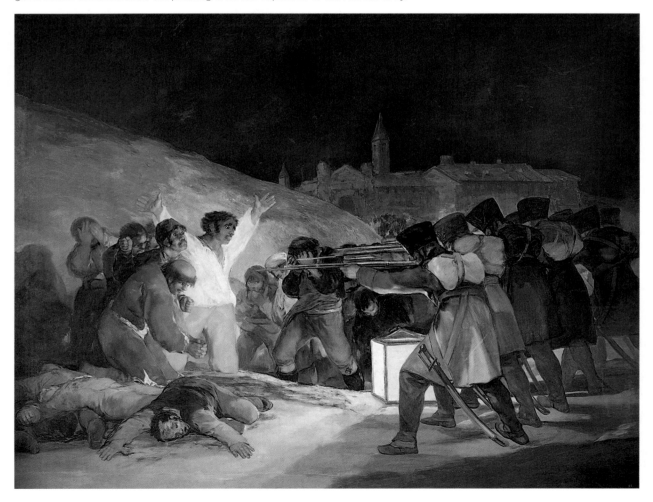

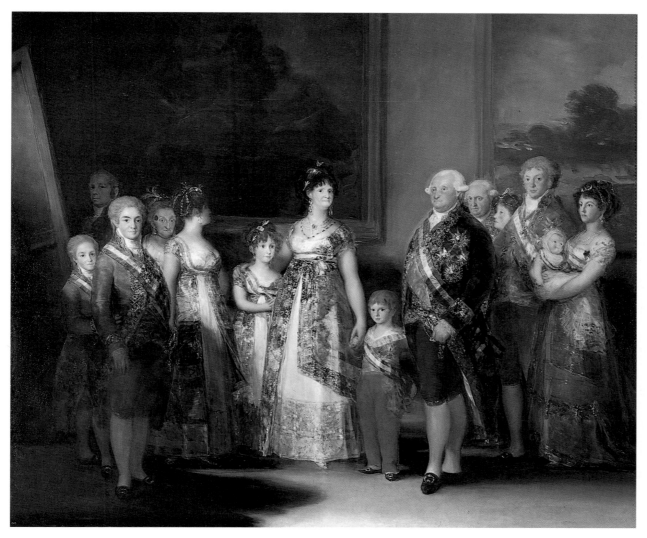

▲ **17.15** Francisco de Goya, *The Family of Charles IV*, 1800. Oil on canvas, 110″ × 132″ (280 × 336 cm). **Museo del Prado, Madrid, Spain.** In this scathing portrayal of the Spanish royal family, the artist depicts himself working quietly at the far left. The French writer Alphonse Daudet said the painting showed "the grocer and his family who have just won top prize in the lottery."

and the strength of his feelings seem to have driven Goya to find more direct means of expression. Personal suffering may have played a part also, because Goya, like Beethoven, became totally deaf.

In 1799 Goya became official painter to King Charles IV of Spain and was commissioned to produce a series of formal court portraits. The most famous of these, *The Family of Charles IV* (Fig. **17.15**), was deliberately modeled on Velázquez's *Las Meninas* (see Fig. **15.15**). Goya shows us the royal family—king, queen, children, and grandchildren—in the artist's studio, where they have come to visit. The comparison he intends us to make between his own painting and that of his distinguished predecessor is devastating. At first glance, Goya's painting may seem just another official portrait, but it does not take a viewer long to realize that something is wrong at the court of Spain. Instead of grace and

elegance, Goya's patrons radiate arrogance, vanity, and stupidity. The king and queen are especially unappealing.

The effect of Goya's painting is not so much one of realism as of personal comment, although there is every reason to believe that the queen was in fact as ugly as she appears here. The artist is communicating his own feelings of disgust at the emptiness—indeed the evil—of court life. That he does so through the medium of an official court portrait that is itself a parody of one of the most famous of all court portraits is an intentional irony.

Even at the time of his official court paintings, Goya was obsessed by the darker side of life. His engraving *The Sleep of Reason Produces Monsters* (see Fig. **17.12**) foreshadowed the work of his last years. Between 1820 and 1822, Goya covered the walls of his own house with paintings that depict a nightmare world of horror and despair.

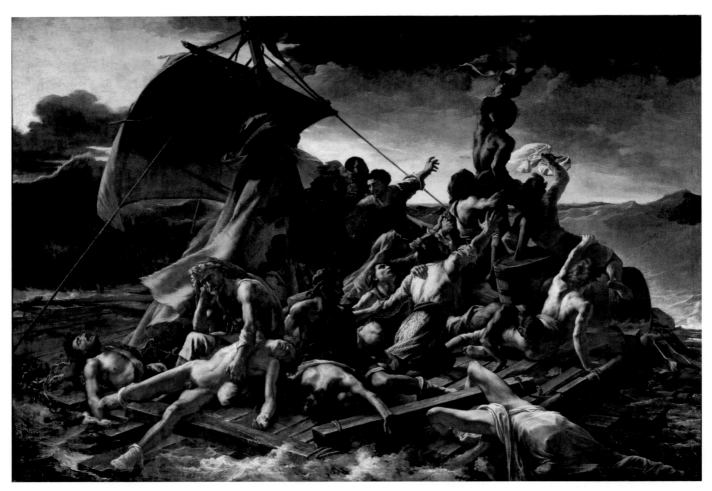

▲ **17.16** Jean-Louis-André-Théodore Géricault, *The Raft of the Medusa*, 1818. Oil on canvas, 16′1¼″ × 23′6″ (491 × 716 cm). Musée du Louvre, Paris, France. Note the careful composition of this huge work, built around a line that leads from the bottom left corner to the top right, where a survivor desperately waves his shirt.

JEAN-LOUIS-ANDRÉ-THÉODORE GÉRICAULT Many French and British paintings of the period reveal a particular fascination with the destructive power of nature at sea, perhaps none as intensely as Théodore Géricault's *Raft of the Medusa* (**Fig. 17.16**). Based on an actual event—a shipwreck off the coast of West Africa in 1816—during which a makeshift raft laden with Algerian immigrants was set adrift by the captain and crew of the crippled French ship *Medusa*, it is viewed as Géricault's most controversial and political work.

Like many of his liberal peers, Géricault (1791–1824) opposed the French monarchy and used the tragedy of the *Medusa* to call attention to the mismanagement and ineffectual polities of the French government, as well as the practice of slavery. The plight of the survivors and victims of the *Medusa* became a national scandal, and Géricault's authentic documentation, based on interviews with the rescued survivors and visits to the morgue, was intended as a direct indictment of the government. The powerful composition is full of realistic detail and explores the full gamut of human emotion under extreme hardship and duress. Much of the drama in the scene takes place along a diagonal grouping of figures, from the corpse in the lower left that will soon slip into the ocean's roiling currents upward in a crescendo that culminates in the muscular torso of a man waving a shirt toward a rescue ship that is but a speck on the horizon. The fractured raft is tossed about mercilessly by the winds and waves; humans battle against nature, and one another,for sheer survival.

FERDINAND-EUGÈNE-VICTOR DELACROIX When Géricault died from falling off a horse, the cause of Romanticism was taken up by his young friend and admirer, Eugène-Victor Delacroix (1798–1863), whose name has become synonymous with Romantic painting. Although the subjects of many of his paintings involve violent emotions, Delacroix seems to have been aloof and reserved. He never married or for that matter formed any lasting relationship. His journal reveals him as a man constantly stimulated by ideas and experience, but he preferred to live his life through his art—a true Romantic. Among his few close friends was the composer Frédéric François Chopin; his portrait (see **Fig. 17.25**) seems to symbolize the introspective creative vision of the romantic artist.

Like his mentor Géricault, Delacroix supported the liberal movements of the day. His painting *The Massacre at Chios* (**Fig. 17.17**) depicts a particularly brutal event in the Greek War of Independence. In 1824, the year in which the poet Lord Byron died while supporting the Greek cause, the Turks massacred some 90 percent of the population of the Greek island of Chios. Delacroix's painting on the subject was intended to rouse popular indignation. It certainly roused the indignation of the traditional artists of the day, one of whom dubbed it "the massacre of painting," principally because of its revolutionary use of color. Whereas David and other Neo-Classical painters had drawn their forms and then filled them

▼ **17.17** Ferdinand-Eugène-Victor Delacroix, *The Massacre at Chios*, 1824. Oil on canvas, 13′7″ × 11′10″ (419 × 354 cm). Musée du Louvre, Paris, France. Rather than depict a single scene, the painter chose to combine several episodes, contrasting the static misery of the figures on the left with a swirl of activity on the right.

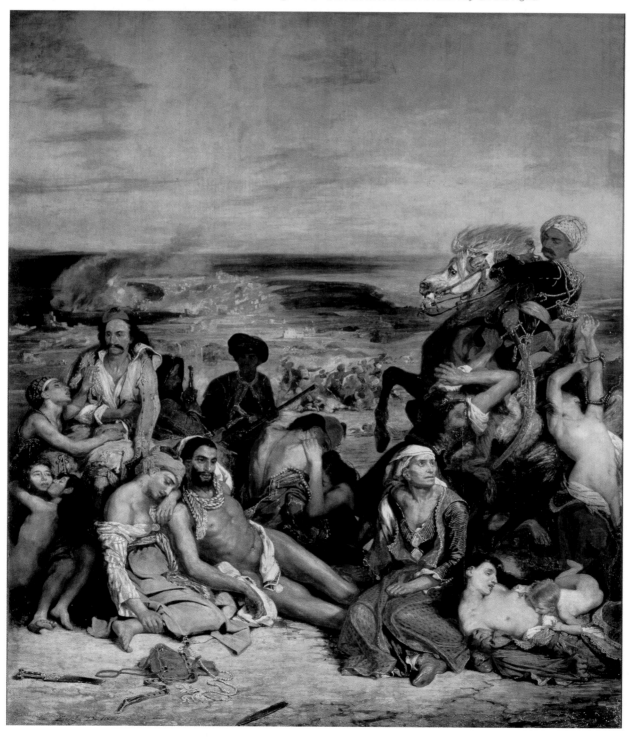

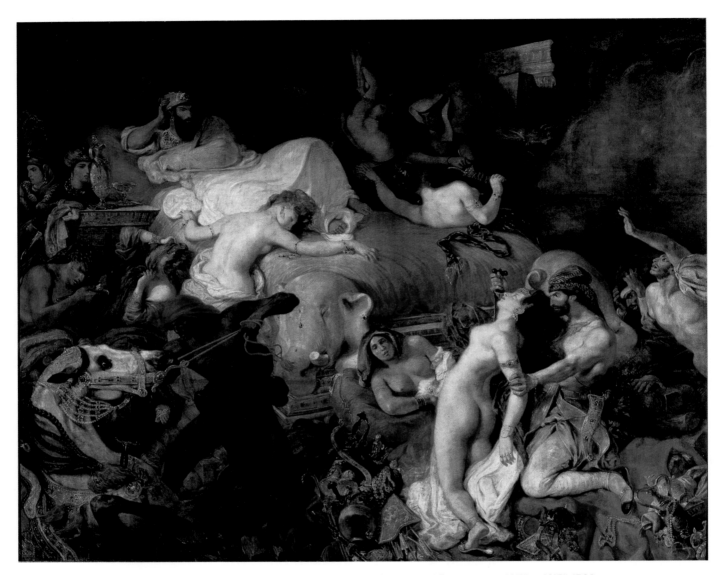

∧ 17.18 Ferdinand-Eugène-Victor Delacroix, *The Death of Sardanapalus*, 1826. Oil on canvas, 12'1" × 16'3" (368 × 495 cm). Musée du Louvre, Paris, France. This painting makes no attempt to achieve historical accuracy but instead concentrates on exploiting the violence and cruelty of the story. Delacroix called this work *Massacre No. 2*, a reference to his earlier painting *The Massacre at Chios* (Fig. 17.17). Although this suggests a certain detachment on the artist's part, there is no lack of energy or commitment in the free, almost violent, brushstrokes.

in with color, Delacroix used color to create form. The result is a much more fluid use of paint.

Byron figures again in another of Delacroix's best-known paintings, because it was on one of the poet's works that the artist based *The Death of Sardanapalus* (**Fig. 17.18**). The Assyrian king, faced with the destruction of his palace by the Medes, decided to prevent his enemies from enjoying his possessions after his death by ordering that his wives, horses, and dogs be killed and their bodies piled up, together with his treasures, at the foot of the funeral pyre he intended for himself. The opulent, violent theme is treated with appropriate drama; the savage brutality of the foreground contrasts with the lonely, brooding figure of the king reclining on his couch above. Over the entire scene, however, hovers an air of unreality, even of fantasy, as if Delacroix is trying to convey not so

much the sufferings of the victims as the intensity of his own imagination.

Romantic Art in the United Kingdom and Germany

Although Romantic art was mainly a 19th-century movement, it began toward the end of the 18th century.

WILLIAM BLAKE William Blake's (1757–1827) imagination when he was a child was filled with spiritual visions, yet he was far from a devotee of the Church of England. Rather, he interpreted the Bible for himself and came to believe in liberty for all people, including women. His artworks show his dis-

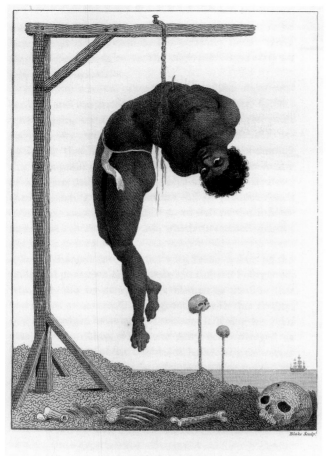

A Negro hung alive by the Ribs to a Gallows.

gust with the practice of slavery and England's participation in the slave trade. His graphic *Black Slave on Gallows*, which he developed from a description of the punishment of resistant slaves in Surinam, speaks for itself (**Fig. 17.19**).

Blake spent his early years as an apprentice in engraving before entering the Royal Academy, where he clashed with the founders, who endorsed a Neo-Classical style. He left the academy and established himself as an illustrator and an engraver, and he framed his poetry with his own illustrations.

JOHN CONSTABLE The English painter John Constable (1776–1837) expressed a deep and warm love of nature. His paintings convey not only the physical beauties of the landscape but also a sense of the less tangible aspects of the natural world. In *The Hay Wain* (**Fig. 17.20**), for example, we not only see the peaceful rustic scene, with its squat, comforting house on the left, but we also can even sense the light

◀ **17.19** William Blake, *Black Slave on Gallows*, 1796. Copper engraving, original coloring, 7⅝" × 10" (19.5 × 25.4 cm). **British Library, London, United Kingdom.** Blake was outraged by the practice of slavery.

▼ **17.20** John Constable, *The Hay Wain*, 1821. Oil on canvas, 51" × 73" (128 × 185 cm). **National Gallery, London, United Kingdom.** Note Constable's bold use of color, which impressed Delacroix.

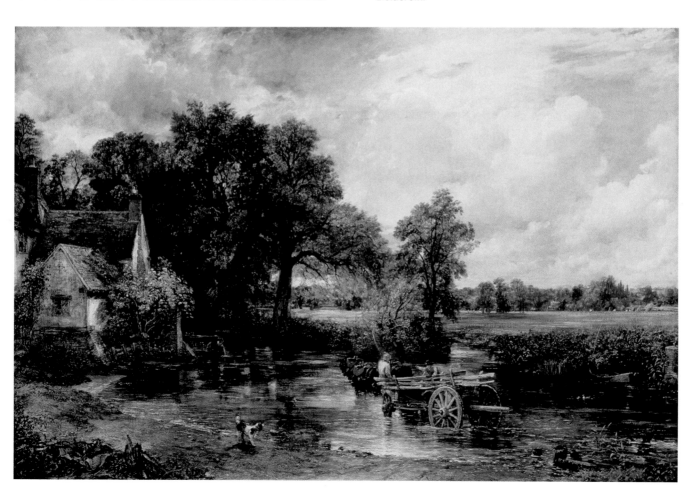

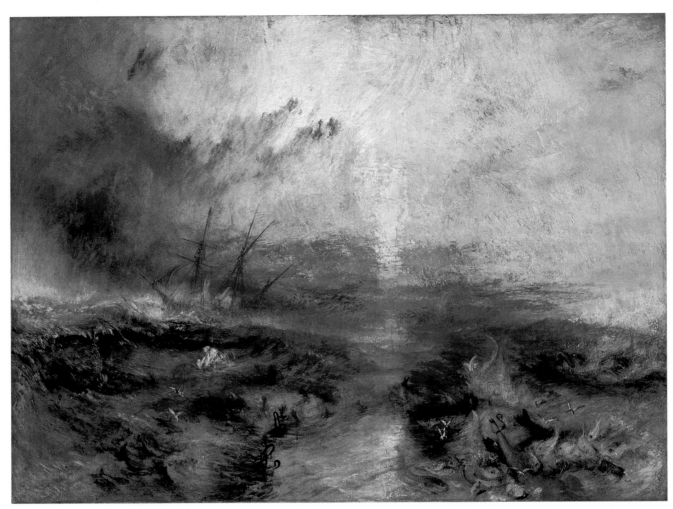

▲ **17.21** **Joseph Mallord William Turner,** *The Slave Ship*, 1840. **Oil on canvas, 35³/₄″ × 48¹/₄″ (90.8 × 122.6 cm).** **Museum of Fine Arts, Boston, Massachusetts.** The title of this painting is an abbreviation of the longer *Slavers Throwing Overboard the Dead and Dying; Typhoon Coming On.* At the lower center, Turner includes the horrifying detail of the chains that still bind the slaves whose desperate hands show above the water.

and quality of atmosphere, prompted by the billowing clouds that, responsible for the fertility of the countryside, seem about to release their moisture.

JOSEPH MALLORD WILLIAM TURNER Constable's use of color pales besides that of his contemporary Joseph Mallord William Turner (1775–1851). In a sense, the precise subjects of Turner's paintings are irrelevant. All his mature works use light, color, and movement to represent a cosmic union of the elements in which earth, sky, fire, and water dissolve into one another and every trace of the material world disappears. His technique is seen at its most characteristic in *The Slave Ship* (**Fig. 17.21**).

Like Géricault's *Raft of the Medusa* (see **Fig. 17.16**), Turner's *Slave Ship* deals with a social disgrace of the time; in this case, the horrifyingly common habit of the captains of slave ships to jettison their entire human cargo if an epidemic broke out. Turner only incidentally illustrates his specific subject—the detail of drowning figures in the lower right

corner seems to have been added as an afterthought—and concentrates instead on conveying his vision of the grandeur and mystery of the universe.

CASPAR DAVID FRIEDRICH Romantic artists in both Germany and England were particularly attracted by the possibilities offered by landscape painting. *Wanderer Above a Sea of Mist* (**Fig. 17.22**) is German painter Caspar David Friedrich's (1774–1840) best-known painting. Inspired by ice-topped mountains in Central Europe, it was completed in the studio, where its content was filtered through the mind of the artist.

The wanderer, having reached the pinnacle of a rocky promontory, finds himself agaze in wonderment at the vastness and splendor of nature. He has ascended to the summit, perhaps has lost his way, and finds distant peaks reaching farther yet into the sky. Claiming the center of the composition, however, the wanderer is as prominent as the vista. If a divine spirit animates nature, it also circulates through the wanderer, con-

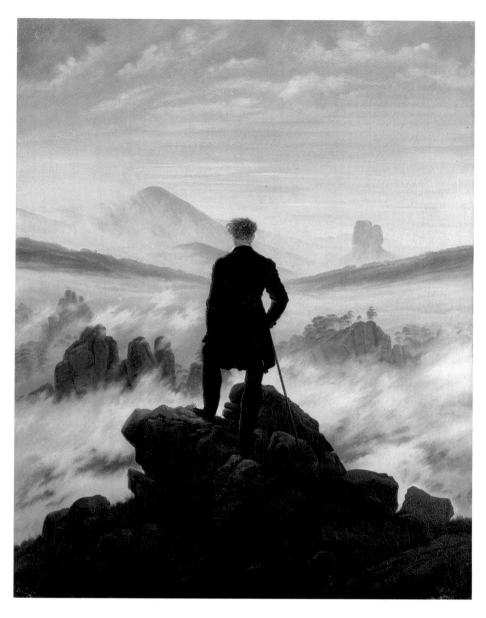

◄ **17.22** Caspar David Friedrich, *Wanderer Above a Sea of Mist*, 1817–1818. Oil on canvas, 37³/₄" × 29³/₈" (94.8 × 74.8 cm). Hamburger Kunsthalle, Hamburg, Germany. The painting expresses the ideal of nature as sublime.

necting the two. Moreover, we the viewers join the wanderer, standing directly behind him, perhaps on another promontory but more likely impossibly suspended in midair. Because of our vantage point, we participate in his sublime experience.

ROMANTIC LITERATURE

Romantic literature developed throughout Europe and, as we shall see, it had its counterparts in the nascent United States.

JOHANN WOLFGANG VON GOETHE Johann Wolfgang von Goethe (1749–1832) spanned the transition from Neo-Classicism to Romanticism in literature. In the course of a long and productive life, he wrote in a bewildering variety of disciplines. One of the first writers to rebel against the principles of Neo-Classicism, Goethe used both poetry and prose to express the most turbulent emotions; yet he contin-

ued to produce work written according to Neo-Classical principles of clarity and balance until his final years, when he expressed in his writing a profound if abstruse symbolism.

Although the vein of Romanticism is only one of many that runs through Goethe's work, it is an important one. As a young man he studied law, first at Leipzig and then at Strassburg, where by 1770 he was already writing lyric poetry of astonishing directness and spontaneity. By 1773, he was acknowledged as the leader of the literary movement known as **Sturm und Drang** ("Storm and Stress"). This German manifestation of Romanticism rebelled against the formal structure and order of Neo-Classicism, replacing it with an emphasis on originality, imagination, and emotion. Its chief subjects were nature, primitive emotions, and protest against established authority. Although the **Sturm und Drang** movement was originally confined to literature, its precepts were felt elsewhere. For instance, it was partly under the inspiration of this movement that Beethoven developed his fiery style.

The climax of this period in Goethe's life is represented by his novel *The Sorrows of Young Werther* (1774), which describes how an idealistic young man comes to feel increasingly disillusioned and frustrated by life, develops a hopeless passion for a happily married woman, and ends his agony by putting a bullet through his head. All of these events but the last were autobiographical. Instead of committing suicide, Goethe left town and turned his life experiences into the novel that won him international fame. Not surprisingly, it became a key work of the Romantic movement. Young men began to dress in the blue jacket and yellow trousers Werther is described as wearing, and some, disappointed in love, even committed suicide with copies of the book in their pockets—a dramatic if regrettable illustration of Goethe's ability to communicate his own emotions to others.

The years around the turn of the century found Goethe extending the range of his output. Along with such plays as the Classical drama *Iphigenia in Tauris*, which expressed his belief in purity and sincere humanity, were stormy works like

Egmont, inspired by the idea that human life is controlled by demonic forces. The work for which Goethe is probably best known, *Faust*, was begun at about the turn of the century, although its composition took many years. Part One was published in 1808, and Part Two was only finished in 1832, shortly before Goethe's death.

The subject of Dr. Faustus and his pact with the devil had been treated before in literature, notably in the play by Christopher Marlowe. The theme was guaranteed to appeal to Romantic sensibilities, with its elements of the mysterious and fantastic. The play begins with Mephistopheles making a bet with God—as Satan challenges God in the Book of Job. In Job, the devil takes Job's livestock, kills his children, and gives him boils simply to test his love for God. In Goethe's *Faust*, Mephistopheles bets that he can lure Faust away from righteousness by offering him knowledge and worldly pleasures.

In Part One (1808), the pure and innocent Marguerite (also called by the diminutive of the name, Gretchen) becomes deranged and then is executed. Gretchen is the chief victim of Faust's lust for experience and power; he callously calls on Mephistopheles's help to seduce her and then—his lust satisfied—abandons her. She goes mad. She is accused of the murder of her child, which was fathered by Faust, condemned to death, and executed. Following the execution, voices from heaven intone that Gretchen has been saved ("Sie ist gerettet"), but this device only defuses some of the angst of the audience; it does nothing to ameliorate the "hero's" guilt. At a point in the play that presages this heartrending ending, Faust recognizes how his quest has led to misery—but even here, he focuses on his own suffering.

READING 17.3 JOHANN WOLFGANG VON GOETHE

From *Faust, Part One*, Night, lines 266–274 (1808)

I, God's own image, from this toil of clay
Already freed, with eager joy who hail'd
The mirror of eternal truth unveil'd,
Mid light effulgent and celestial day:—
I, more than cherub, whose unfetter'd soul
With penetrative glance aspir'd to flow
Through nature's veins, and, still creating, know
The life of gods,—how am I punished now!
One thunder-word hath hurl'd me from the goal!

In perhaps the most poetic passage of *Faust*, Gretchen, who has become enamored with Faust's intellect, asks him whether he believes in God. His response is Romantic in that he answers that the divine—howsoever one might name it—is found in the beauty of the everlasting stars which "climb on high," rather than falling to earth (nature), in gazing into the eyes of one's lover, in rapture and bliss (passion). For all this Faust has no name—it is to experience, not to name: "Names are but sound and smoke."

READING 17.4 JOHANN WOLFGANG VON GOETHE

From *Faust, Part One*, Martha's Garden, lines 3089–3115 (1808)

Him who dare name?
And who proclaim,
Him I believe?
Who that can feel,
His heart can steel,
To say: I believe him not?
The All-embracer,
All-sustainer,
Holds and sustains he not
Thee, me, himself?
Lifts not the Heaven dome above?
Doth not the firm-set earth beneath us lie?
And beaming tenderly with looks of love,
Climb not the everlasting stars on high?
Do we not gaze into each other's eyes?
Nature's impenetrable agencies,
Are they not thronging on thy heart and brain,
Viewless, or visible to mortal ken,
Around thee weaving their mysterious chain?
Fill thence thy heart, how large soe'er it be;
And in the feeling when thou utterly art blest,
Then call it, what thou wilt,—
Call it bliss! Heart! Love! God!
I have no name for it!
'Tis feeling all;
Name is but sound and smoke

Part Two of *Faust* is very different. Its theme, expressed symbolically through Faust's pact with the devil, is nothing less than the destiny of Western culture. Western civilization's unceasing activity and thirst for new experiences inevitably produces error and suffering; at the same time, it is the result of the divine spark within us and will, in the end, guarantee our salvation. In his choice of the agent of this salvation, Goethe established one of the other great themes of Romanticism: the Eternal Feminine. Faust is finally redeemed by the divine love of Gretchen, who leads him upward to salvation.

Romantic Poetry

William Wordsworth (1770–1850) and Samuel Taylor Coleridge (1772–1834) are usually credited with founding the Romantic movement in English poetry. They met in 1795 and developed a close friendship during which they published *Lyrical Ballads*, which included Coleridge's *Rime of the Ancient Mariner* and is considered a key work in the Romantic movement. Wordsworth described his aims and ideals in his critical writings. He sought purposefully to create a new approach to poetry, one that preferred to portray intuition and emo-

tion rather than reason, and to use rural or pastoral settings rather than urban ones. The Romantic movement, as we see in Wordsworth, also used a more colloquial language. Wordsworth emphasized the value of meter, a feature that differentiates between poetry and prose. Romantic poetry also aspires to feel spontaneous, to apparently gush forth in the passion of the moment, although Romantic poets, including Wordsworth, recognized that pure emotion must be shaped into poetry by the mind. For Wordsworth, the poet was a person with special gifts, "endowed with more lively sensibility, more enthusiasm and tenderness, who has a greater knowledge of human nature, and a more comprehensive soul" than other people. Wordsworth described his view of the Romantic in poetry in his preface to the *Lyrical Ballads*. Along with an explanation of his principles of composing poetry in the language of people in "rural occupations," you will note his caustic comment that the poet nevertheless needs to have colloquial language "purified indeed from what appear to be its real defects."

READING 17.5 WILLIAM WORDSWORTH

From "Preface to Lyrical Ballads" (1800)

The principal object, then, proposed in these Poems was to choose incidents and situations from common life, and to relate or describe them, throughout, as far as was possible in a selection of language really used by men, and, at the same time, to throw over them a certain colouring of imagination, whereby ordinary things should be presented to the mind in an unusual aspect; and, further, and above all, to make these incidents and situations interesting by tracing in them, truly though not ostentatiously, the primary laws of our nature: chiefly, as far as regards the manner in which we associate ideas in a state of excitement. Humble and rustic life was generally chosen, because, in that condition, the essential passions of the heart find a better soil in which they can attain their maturity, are less under restraint, and speak a plainer and more emphatic language; because in that condition of life our elementary feelings coexist in a state of greater simplicity, and, consequently, may be more accurately contemplated, and more forcibly communicated; because the manners of rural life germinate from those elementary feelings, and, from the necessary character of rural occupations, are more easily comprehended, and are more durable; and, lastly, because in that condition the passions of men are incorporated with the beautiful and permanent forms of nature. The language, too, of these men has been adopted (purified indeed from what appear to be its real defects, from all lasting and rational causes of dislike or disgust).

English Romantic poetry of the first half of the 19th century remains a peak in the history of English literature. It touches on several themes characteristic of the age. Wordsworth's deep love of the country led him to explore the relationship between human beings and the world of nature;

Percy Bysshe Shelley and George Gordon, also known as Lord Byron, probed the more passionate, even demonic aspects of existence; and John Keats expressed his own sensitive responses to the eternal problems of art, life, and death.

WILLIAM BLAKE There are several writers whom we might call "doubly-gifted," that is, who are accomplished in both the realms of literature and the visual arts. Among the Romantic poets, Edgar Allan Poe and William Blake stand out as particularly noteworthy examples. Poe created pen and ink drawings and Blake illustrated his collections of poetry, including his *Songs of Innocence and Experience*.

"The Lamb" is one of 19 poems from Blake's *Songs of Innocence* published in 1789; together with "The Tyger" from his 1794 collection, *Songs of Experience*, it is among the most widely read poems in the English language. Although "The Lamb" stands alone as a children's song, with its repetition and simple rhythm and rhyme scheme, as the poem progresses it becomes more complex in allusion and suggestion. Blake begins his first, pastoral verse with a question posed to a "little lamb"—one that cannot yield a reply. Rather, the question is used as a rhetorical device that is intended to lead the reader to reflect, in the second verse, on something larger and more significant. It is in this part of the poem that the lamb alludes to Jesus Christ, who is referred to in the Christian Bible as the "Lamb of God." Jesus enjoined his followers to be meek and mild, to "turn the other cheek" rather to than resist an evil person. The lamb symbolizes purity and innocence.

READING 17.6 WILLIAM BLAKE

"The Lamb," from *Songs of Innocence* (1789)

Little Lamb who made thee
Dost thou know who made thee
Gave thee life & bid thee feed
By the stream & o'er the mead;

Gave thee clothing of delight,
Softest clothing woolly bright;
Gave thee such a tender voice,
Making all the vales rejoice:

Little Lamb who made thee
Dost thou know who made thee
Little Lamb, I'll tell thee,
Little Lamb, I'll tell thee;

He is called by thy name,
For he calls himself a Lamb:
He is meek & he is mild,
He became a little child:

I a child & thou a lamb,
We are called by his name.
Little Lamb, God bless thee.
Little Lamb, God bless thee.

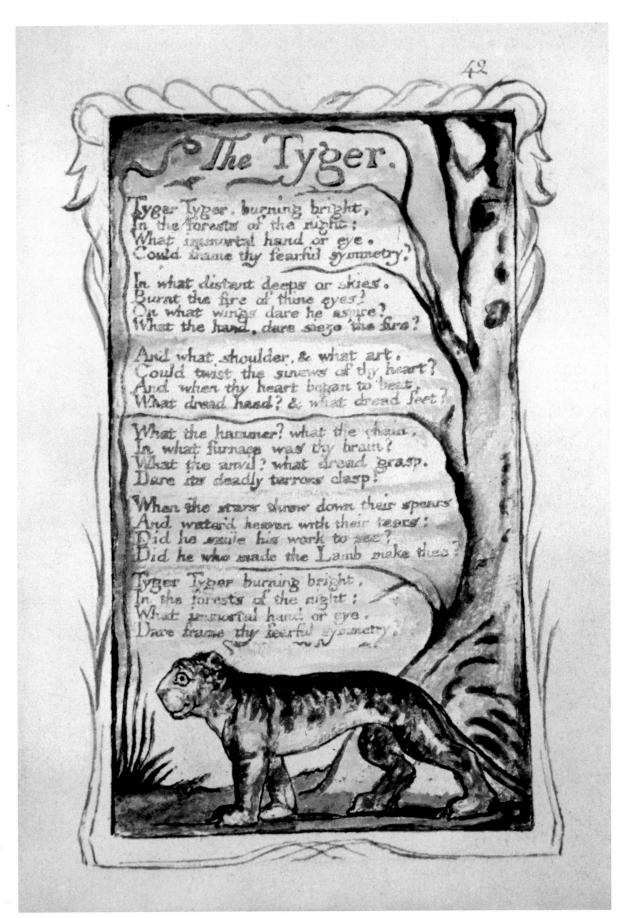

◄ 17.23 William Blake, "The Tyger," 1794. From *Songs of Experience*. Relief etching with watercolor, 4 ¾" × 7 ¼" (12.1 × 18.4 cm). Private collection. The poem itself shows that Blake was keenly aware of the potentially vicious nature of the tiger, leaving us to wonder why his etching shows an animal that looks rather domesticated and friendly.

"The Tyger" can be seen as the antithesis of "The Lamb" just as experience is the antithesis of innocence. In "The Tyger" Blake again asks questions, but here they are sustained throughout the poem and, in the end, have no answers. The poem would seem to be Blake's commentary—or at least an outlet for his religious and philosophical questions—on the duality of God and the relationship between good and evil. Is it conceivable that the same God who created the meek and gentle lamb is also willing and capable of instilling violence in the tiger? Has this God also created good and evil in human beings? An illustrated poem, "The Tyger" (**Fig. 17.23**) continues to mystify with its pulsating rhythms, brilliant imagery, and incongruity between the verbal and visual descriptions of the familiar jungle animal. Blake's drawing of a docile, wide-eyed, smiling cat set in a delicate, decorative frame is inconsistent with phrases such as "fearful symmetry," "dread head," "dread grasp," and twisted "sinews of the heart." One possible interpretation of this deliberate visual-verbal contrast is that "the immortal hand or eye" that "framed" the "fearful symmetry" of the tiger must (or perhaps cannot) be reconciled with our singular notion of a benevolent God.

READING 17.7 **WILLIAM BLAKE**

"The Tyger," from *Songs of Experience* **(1794)**

Tyger Tyger, burning bright,
In the forests of the night;
What immortal hand or eye,
Could frame thy fearful symmetry?

In what distant deeps or skies
Burnt the fire of thine eyes?
On what wings dare he aspire?
What the hand, dare seize the fire?

And what shoulder, & what art,
Could twist the sinews of thy heart?
And when thy heart began to beat,
What dread hand? & what dread feet?

What the hammer? what the chain,
In what furnace was thy brain?
What the anvil? what dread grasp,
Dare its deadly terrors clasp!

When the stars threw down their spears
And water'd heaven with their tears:
Did he smile his work to see?
Did he who made the Lamb make thee?

Tyger Tyger burning bright,
In the forests of the night:
What immortal hand or eye,
Dare frame thy fearful symmetry?

WILLIAM WORDSWORTH Although Wordsworth's poetry is filled with beautiful visions of nature, his personal life had its share of tragedies. His parents died while he was still a child. Even though he managed to graduate from St. John's College at Cambridge University, he and his four siblings had financial difficulties. Rejecting artificiality and stylization, Wordsworth aimed to make his poetry communicate directly in easily comprehensible terms. His principal theme was the relation between human beings and nature, which he explored by thinking back calmly on experiences that had earlier produced a violent emotional reaction: his famous "emotion recollected in tranquility."

The relation between humans and nature emerges in the following extract from "Lines Composed a Few Miles Above Tintern Abbey on Revisiting the Banks of the Wye During a Tour" (see **Fig. 17.24**). They describe the poet's reactions on his return to the place he had visited five years earlier. After painting the scene in lines 1–22, he recalls the joy its memory has brought to him in the intervening years. This in turn brings to mind the passage of time in his own life and the importance that the beauty of nature has always had for him. The last part of the poem shows how his love of nature has illuminated his relationships with other human beings, in this case his beloved sister.

READING 17.8 **WILLIAM WORDSWORTH**

"Lines Composed a Few Miles Above Tintern Abbey on Revisiting the Banks of the Wye During a Tour" (1798), lines 1–22

Five years have past: five summers, with the length
Of five long winters! and again I hear
These waters, rolling from their mountain-springs
With a soft inland murmur.—Once again
Do I behold these steep and lofty cliffs,
That on a wild secluded scene impress
Thoughts of more deep seclusion; and connect
The landscape with the quiet of the sky.
The day is come when I again repose
Here, under this dark sycamore, and view
These plots of cottage-ground, these orchard-tufts,
Which at this season, with their unripe fruits,
Are clad in one green hue, and lose themselves
'Mid groves and copses. Once again I see
These hedge-rows, hardly hedge-rows, little lines
Of sportive wood run wild: these pastoral farms,
Green to the very door; and wreaths of smoke
Sent up, in silence, from among the trees!
With some uncertain notice, as might seem
Of vagrant dwellers in the houseless woods,
Or of some Hermit's cave, where by his fire
The Hermit sits alone.

The following brief poem also expresses the poet's relationship with nature and holds the well-known line "The Child is father of the Man."

⌃ **17.24** **Joseph Mallord William Turner**, *Transept of Tintern Abbey*, 1794. Watercolor, 12⁵⁄₈″ × 9⁷⁄₈″ (32.2 × 25.1 cm). **Victoria and Albert Museum, London, United Kingdom.** The small watercolor speaks nostalgically of a collective past we find, perhaps, in dreams. Human endeavors, no matter how beautiful, no matter how majestic, are transient.

READING 17.9 WILLIAM WORDSWORTH

"My Heart Leaps Up" (1802)

My heart leaps up when I behold
 A rainbow in the sky:
So was it when my life began;
So is it now I am a man;
So be it when I shall grow old,
 Or let me die!
The Child is father of the Man;
And I could wish my days to be
Bound each to each by natural piety.

SAMUEL TAYLOR COLERIDGE Coleridge was the youngest of the 14 children of a rural clergyman. He attended Jesus College at Cambridge, but he left without a degree. He joined the cavalry as a way of escaping the mundane life, but found himself more suited to cleaning stables and writing love letters for his comrades than to riding.

He met Wordsworth in 1795 and the poets influenced one another's work. Although we may think of *Lyrical Ballads* as Wordsworth's because of Wordsworth's preface to the revised edition in 1800, Coleridge's works, including *The Rime of the Ancient Mariner*, account for about one-third of the volume's length.

In *The Rime of the Ancient Mariner*, an old sailor—the mariner—is apparently doomed to repeat his rime—his story—endlessly to those who will listen. In brief, his ship is penned in among floats of ice as lofty as its masts, until an albatross flies in and the ice melts, turning to fog. The mariner kills the albatross with his crossbow without cause, thus triggering events that bring about the death of his mates. The mariner wears the albatross around his neck in penance for his misdeed. The ship's course becomes aimless and the mariner curses water snakes and other creatures of nature. Eventually, although the mariner is suffering from painful thirst, he is somehow transformed and recognizes beauty in the water snakes. The albatross drops off him and seraphs—winged angels—bring the ship to port.

The following lines in part 1 describe the ill turn of weather, the ice, and the coming of the albatross.

READING 17.10 SAMUEL TAYLOR COLERIDGE

From *The Rime of the Ancient Mariner* (1797), part 1, lines 51–66

And now there came both mist and snow,
And it grew wondrous cold:
And ice, mast-high, came floating by,
As green as emerald.
And through the drifts the snowy clifts
Did send a dismal sheen:
Nor shapes of men nor beasts we ken—

The ice was all between.
The ice was here, the ice was there,
The ice was all around:
It cracked and growled, and roared and howled,
Like noises in a swound!
At length did cross an Albatross,
Thorough the fog it came;
As it had been a Christian soul,
We hailed it in God's name.

Although the albatross appears to save the crew from its fate in the ice, the mariner kills it. At first his mates are outraged because they think the bird had brought the winds that saved them from the ice, but then they cheer the mariner, thinking that the bird had brought the fog that surrounded them. In part 2, perhaps because of the crew's change of heart, the ship is once more dead in the water. The crew are without drinkable water, and the mariner notices "slimy" life atop the water. You may notice familiar phrases in these lines—"a painted ship upon a painted ocean," "Water, water, every where, / Nor any drop to drink."

READING 17.11 SAMUEL TAYLOR COLERIDGE

***The Rime of the Ancient Mariner* (1797), part 2, lines 115–126**

Day after day, day after day,
We stuck, nor breath nor motion;
As idle as a painted ship
Upon a painted ocean.
Water, water, every where,
And all the boards did shrink;
Water, water, every where,
Nor any drop to drink.
The very deep did rot: O Christ!
That ever this should be!
Yea, slimy things did crawl with legs
Upon the slimy sea.

Later, when all are dead but the mariner, he apparently saves himself from their fate by recognizing the beauty of these creatures. One of the messages of the poem would seem to be that one must appreciate all of God's creatures—nature—and safeguard their lives. The symbolic meaning of the albatross has been debated. The bird has been interpreted as an omen of good fortune and of ill. The phrase "wearing an albatross around one's neck" can be interpreted to mean bearing a burden or undergoing penance—or both. In any event, the tale would seem to illustrate the Romantic theme of humankind's powerlessness in the face of the majesty of nature.

GEORGE GORDON, LORD BYRON Wordsworth's emotion recollected in tranquility is in strong contrast to the

poetry of Lord Byron (1788–1824), who filled both his life and work with the same moody, passionate frenzy of activity. Born with a lame foot, he nevertheless pressed his body such that he became a championship swimmer. A woman whom he had spurned, Lady Caroline Lamb, wrote in her diary that he was "mad, bad, and dangerous to know." Their passionate affair began *after* this assessment of his character.

Much of Byron's time was spent wandering throughout Europe, where he became a living symbol of the unconventional, homeless, tormented Romantic hero who has come to be called Byronic. Much of his flamboyant behavior was no doubt calculated to produce the effect it did, but his personality must have been striking for no less a figure than Goethe to describe him as "a personality of such eminence as has never been before and is not likely to come again." Byron's sincere commitment to struggles for liberty—like the Greek war of independence against the Ottoman Empire—can be judged by the fact that he died while on military duty in Greece.

Byron's lyrical "She Walks in Beauty" is one of his most popular poems. The meter is iambic tetrameter (four feet, each with an unaccented and then an accented syllable). The rhyme scheme for each of the three verses is simple: ABA-BAB. The alliteration—repetition of consonant sounds—is something of a lesson in poetic methodology: "cloudless climes," "starry skies," or "gaudy day denies."

READING 17.12 GEORGE GORDON, LORD BYRON

"She Walks in Beauty" (1814)

She walks in beauty, like the night
Of cloudless climes and starry skies;
And all that's best of dark and bright
Meet in her aspect and her eyes:
Thus mellowed to that tender light
Which heaven to gaudy day denies.

One shade the more, one ray the less,
Had half impaired the nameless grace
Which waves in every raven tress,
Or softly lightens o'er her face;
Where thoughts serenely sweet express
How pure, how dear their dwelling place.

And on that cheek, and o'er that brow,
So soft, so calm, yet eloquent,
The smiles that win, the tints that glow,
But tell of days in goodness spent,
A mind at peace with all below,
A heart whose love is innocent!

Childe Harold's Pilgrimage is a more mature work, one that took Byron many years to write, as he continued to add and revise verses. The following verse speaks of the poet's struggle with death and his desire to achieve an imperishable fame—to become the "Byronic hero."

READING 17.13 GEORGE GORDON, LORD BYRON

Childe Harold's Pilgrimage (1812–1818), canto 4, verse 137

But I have lived, and have not lived in vain:
My mind may lose its force, my blood its fire,
And my frame perish even in conquering pain;
But there is that within me which shall tire
Torture and Time, and breathe when I expire;
Something unearthly, which they deem not of,
Like the remember'd tone of a mute lyre,
Shall on their soften'd spirits sink, and move
In hearts all rocky now the late remorse of love.

Critics have referred to such verses in *Childe Harold's Pilgrimage* as set pieces, meaning that they stand by themselves, as do so many of the songs in a musical or arias in an opera. The following verse, in which Byron imagines himself at a gladiator contest, achieves a particular poignancy.

READING 17.14 GEORGE GORDON, LORD BYRON

Childe Harold's Pilgrimage (1812–1818), canto 4, verse 140

I see before me the Gladiator lie:
He leans upon his hand—his manly brow
Consents to death, but conquers agony,
And his droop'd head sinks gradually low—
And through his side the last drops, ebbing slow
From the red gash, fall heavy, one by one,
Like the first of a thunder-shower; and now
The arena swims around him—he is gone,
Ere[2] ceased the inhuman shout which hail'd the wretch who won.

PERCY BYSSHE SHELLEY Like Lord Byron, Percy Bysshe Shelley (1792–1822) spent many of his most creative years in Italy. He lived a life of continual turmoil. After being expelled from Oxford for publishing his atheistic views, he espoused the cause of anarchy and eloped with the daughter of one of its chief philosophical advocates—Mary Wollstonecraft Godwin. The consequent public scandal, coupled with ill health and critical hostility toward his work, gave him a sense of bitterness and pessimism that lasted until his death by drowning.

Shelley's brilliant mind and restless temperament produced poetry that united extremes of feeling, veering from the highest pitch of exultant joy to the deepest despondency. His belief in the possibility of human perfection is expressed in what many critics believe to be his greatest work, *Prometheus Unbound* (1820), where the means of salvation is the love of human beings for one another. His most accessible

2. Before.

works, however, are probably the short lyrics in which he seized a fleeting moment of human emotion and captured it by his poetic imagination.

The following sonnet is titled "Ozymandias," which is the Greek name for the mighty Egyptian pharaoh Ramses II. Shelley uses the image of his shattered statue to symbolize the impermanence of human achievement.

READING 17.15 PERCY BYSSHE SHELLEY

"Ozymandias" (1818)

I met a traveler from an antique land
Who said: "Two vast and trunkless legs of stone
Stand in the desert. Near them, on the sand,
Half sunk, a shattered visage lies, whose frown,
And wrinkled lip, and sneer of cold command,
Tell that its sculptor well those passions read
Which yet survive, stamped on these lifeless things
The hand that mocked them and the heart that fed:
And on the pedestal these words appear:
'My name is Ozymandias, king of kings:
Look on my works, ye Mighty, and despair!'
Nothing beside remains. Round the decay
Of that colossal wreck, boundless and bare
The lone and level sands stretch far away."

Following is the final stanza of *Adonais*, a lament for John Keats. Shelley learned in April of 1821 that Keats had died, and he published *Adonais* that July. The poem also alludes to Shelley's concerns about the possibility of his own passing. The metaphor that his "spirit's bark is driven / Far from the shore" places his imagination in the vastness of the sea that would eventually take him.

READING 17.16 PERCY BYSSHE SHELLEY

Adonais (1821), verse 55, lines 487–495

The breath whose might I have invoked in song
Descends on me; my spirit's bark[3] is driven
Far from the shore, far from the trembling throng
Whose sails were never to the tempest given;
The massy earth and sphered skies are riven!
I am borne darkly, fearfully, afar;
Whilst, burning through the inmost veil of Heaven,
The soul of Adonais, like a star,
Beacons from the abode where the Eternal are.

JOHN KEATS In John Keats (1795–1821), whose life was clouded by unhappy love and the tuberculosis that killed him so tragically young, we find a poet of rare poignancy and sensitivity. When we examine his works, we cannot help but be bewildered that he wrote nearly all of his major poems in one

year—between the ages of 23 and 24. In his odes (lyric poems of strong feeling), in particular, he conveys both the glory and the tragedy of human existence and dwells almost longingly on the peace of death.

Keats wrote "Ode to a Nightingale," on the next page, while living in Hampstead (London). His companion, Charles Brown, left an account of the circumstances of its composition:

> In the spring of 1819 a nightingale had built her nest near my house. Keats felt a tranquil and continual joy in her song; and one morning he took his chair from the breakfast table to the grass plot under a plum-tree where he sat for two or three hours. When he came into the house, I perceived he had some scraps of paper in his hand.

The song of the bird serves as inspiration for a meditation on the nature of human experience. It comes to represent an enduring beauty beyond human grasp. The sensuous images, the intensity of emotion, and the flowing rhythm join to produce a magical effect. Yet the poem begins in despondency as Keats, at age 24, broods on life's sorrows. As he muses, the immortal song consoles him, bringing comfort and release, and he accepts his tragic fate. He died less than two years later.

The Romantic Novel

During the 19th century, increases in literacy and a rise in the general level of education resulted in a European and American public that was eager for entertainment and instruction, and the success of such writers as Charles Dickens and Leo Tolstoy was largely the result of their ability to combine the two. The best of 19th-century novels were those rare phenomena: great works of art that achieved popularity in their own day. Many of these are still able to enthrall modern readers with their humanity and insight.

There was more to the 19th-century novel than we find in the movements of Romanticism and Realism, notably beginning with two British women who achieved recognition that has spanned two centuries and shows no signs of fading. We are speaking of Jane Austen and Mary Wollstonecraft Shelley.

JANE AUSTEN

It is a truth universally acknowledged, that a single man in possession of a good fortune must be in want of a wife.

—JANE AUSTEN, *PRIDE AND PREJUDICE*

So begins one of the most popular and beloved novels in the history of fiction. Of course, it is clearly *not* universally acknowledged that financially secure men are in want of a wife—although many characters in novels by Jane Austen (1775–1817), and even contemporary romance novels, would like to think they are. But therein lies much of the charm of

3. A ship with three or more masts; often spelled *barque*.

READING 17.17 JOHN KEATS

"Ode to a Nightingale" (1819)

I

My heart aches, and a drowsy numbness pains
 My sense, as though of hemlock I had drunk,
Or emptied some dull opiate to the drains
 One minute past, and Lethe-wards[4] had sunk:
'Tis not through envy of thy happy lot,
 But being too happy in thine happiness.—
 That thou, light-wingèd Dryad[5] of the trees,
 In some melodious plot
Of beechen green, and shadows numberless,
 Singest of summer in full-throated ease.

II

O, for a draught of vintage! that hath been
 Cool'd a long age in the deep-delved earth,
Tasting of Flora and the country green,
 Dance, and Provençal song, and sunburnt mirth!
O for a beaker full of the warm South,
 Full of the true, the blushful Hippocrene,
 With beaded bubbles winking at the brim,
 And purple-stainèd mouth;
That I might drink, and leave the world unseen,
 And with thee fade away into the forest dim:

III

Fade far away, dissolve, and quite forget
 What thou among the leaves hast never known,
The weariness, the fever, and the fret
 Here, where men sit and hear each other groan;
Where palsy shakes a few, sad, last gray hairs,
 Where youth grows pale, and spectre-thin, and dies;
 Where but to think is to be full of sorrow
 And leaden-eyed despairs,
 Where Beauty cannot keep her lustrous eyes,
 Or new Love pine at them beyond tomorrow.

IV

Away! away! for I will fly to thee,
 Not charioted by Bacchus and his pards,[6]
But on the viewless wings of Poesy,
 Though the dull brain perplexes and retards:
Already with thee! tender is the night,[7]
 And haply the Queen-Moon is on her throne,
 Cluster'd around by all her starry Fays;
 But here there is no light,
Save what from heaven is with the breezes blown
 Through verdurous glooms and winding mossy ways.

V

I cannot see what flowers are at my feet,
 Nor what soft incense hangs upon the boughs,
But, in embalmed darkness, guess each sweet

Wherewith the seasonable month endows
The grass, the thicket, and the fruit-tree wild;
 White hawthorn, and the pastoral eglantine;
 Fast fading violets cover'd up in leaves;
 And mid-May's eldest child,
 The coming musk-rose, full of dewy wine,
 The murmurous haunt of flies on summer eves.

VI

Darkling I listen: and, for many a time
 I have been half in love with easeful Death,
Call'd him soft names in many a musèd rhyme,
 To take into the air my quiet breath;
Now more than ever seems it rich to die,
 To cease upon the midnight with no pain,
 While thou art pouring forth thy soul abroad
 In such an ecstasy!
 Still wouldst thou sing, and I have ears in vain—
 To thy high requiem become a sod.

VII

Thou wast not born for death, immortal Bird!
 No hungry generations tread thee down;
The voice I hear this passing night was heard
 In ancient days by emperor and clown:
Perhaps the self-same song that found a path
 Through the sad heart of Ruth,[8] when, sick for home,
 She stood in tears amid the alien corn;
 The same that oft-times hath
 Charm'd magic casements, opening on the foam
 Of perilous seas, in faery lands forlorn.

VIII

Forlorn! the very word is like a bell
 To toll me back from thee to my sole self!
Adieu! the fancy cannot cheat so well
 As she is fam'd to do, deceiving elf.
Adieu! adieu! thy plaintive anthem fades
 Past the near meadows, over the still stream.
 Up the hill-side; and now 'tis buried deep
 In the next valley-glades.
 Was it a vision, or a waking dream?
 Fled is that music:—Do I wake or sleep?

4. Toward the river Lethe, in Greek mythology the river of forgetfulness.

5. A divinity presiding over trees and flowers.

6. Leopards.

7. *Tender Is the Night* would become the title of a 20th-century novel by F. Scott Fitzgerald.

8. From the Book of Ruth in the Hebrew Bible.

Austen's witty works—*Northanger Abbey* (1798–1799), *Sense and Sensibility* (1811), *Pride and Prejudice* (1811–1812), *Mansfield Park* (1814), *Emma* (1814–1815), and *Persuasion* (1815–1816). Not only are these books widely read today, they have also been made into movies—several times. On a superficial level, they are about manners and dress. If this were all they were, they might fit the category of what George Eliot would later call "silly novels by lady novelists." But on a deeper level they satirize the British evolution of mating strategies; they certainly do not necessarily adhere to paths that might be preferred by a moralist. Austen also shared an aversion, with Mary Wollstonecraft, to the view that women are driven about whimsically by their emotions. And in *Mansfield Park,* she expresses concern about the stereotyped education of women.

Although her fiction became popular, Austen herself led a rather secluded and brief life. She was one of eight children of an Anglican clergyman. Although most of the leading novelists of the 19th century wrote within a tradition of Romanticism or Realism, Austen fit only within a category of her own. In 1816, the year before her death from a fatal illness, she satirized the perfect novel expected of a British woman in her letter "Plan of a Novel, According to Hints from Various Quarters."

READING 17.18 JANE AUSTEN

From "Plan of a Novel, According to Hints from Various Quarters'" (1816)

Scene to be in the Country, Heroine the Daughter of a Clergyman, one who after having lived much in the World had retired from it and settled in a Curacy, with a very small fortune of his own.—He, the most excellent Man that can be imagined, perfect in Character, Temper, and Manners—without the smallest drawback or peculiarity to prevent his being the most delightful companion to his Daughter from one year's end to the other.—Heroine a faultless Character herself,—perfectly good, with much tenderness and sentiment, and not the least Wit—very highly accomplished, understanding modern Languages and (generally speaking) everything that the most accomplished young Women learn, but particularly excelling in Music—her favourite pursuit—and playing equally well on the PianoForte and Harp—and singing in the first stile. Her Person quite beautiful—dark eyes and plump cheeks.—Book to open with the description of Father and Daughter—who are to converse in long speeches, elegant Language—and a tone of high serious sentiment.

. . .

From this outset, the Story will proceed, and contain a striking variety of adventures.

MARY WOLLSTONECRAFT SHELLEY Percy Bysshe Shelley dedicated his poem *Laon and Cythna* to his young wife:

They say that thou wert lovely from thy birth,
Of glorious parents, thou aspiring Child.

The "aspiring child" was Mary Wollstonecraft Godwin (1797–1851), the daughter of William Godwin, a liberal-leaning philosopher who argued in favor of **free love**, and Mary Wollstonecraft, the author of *A Vindication of the Rights of Women* (see Chapter 16). Percy Shelley was an adherent of the philosophy of Godwin, and at the age of 21 he met 16-year-old Mary at her father's house in London. The couple fell in love and ran off to France, Switzerland, and Germany. At the time, Mary Shelley probably had no idea that she would pen perhaps the most renowned **Gothic novel** of all time—a genre that shares Romantic roots with tales of horror. Gothic novels, like other Romantic novels, dwell on the relationship between humans and nature, but in the Gothic novel it is nature gone wrong—in the case of Shelley's novel, there is a misuse of the natural; a scientist creates a monster in his attempt to rival the divine and conquer nature.

With another journey to the continent (of Europe), the year 1816 saw a grouping of genius in Geneva, Switzerland. The poet Byron and his friend John William Polidori were in attendance, along with Mary and Percy. They regaled each other with stories and fantasies, including a ghost-story competition that got their creative juices flowing against the blackness of the lake at night.

Mary Shelley tells of the ghost stories in the preface to her immortal novel *Frankenstein, or The Modern Prometheus* (1818). Why "the modern Prometheus"? In Greek mythology, the Titan Prometheus stole fire from the god of gods, Zeus, and gave it to humankind. His punishment was being bound to a rock where an eagle every day ate his liver, which regrew and was eaten again. Dr. Victor Frankenstein, in the novel, steals the ability to create life from the gods, and he too gets his just deserts.

Frankenstein creates life and then, finding his creation grotesque, abandons him, leading to endless tragedies, including the monster's murder of Frankenstein's brother and his beloved Elizabeth. The pathway to the killings seems inevitable. The monster asks Frankenstein to create a bride for him so that the couple can depart humanity and live in peace as recluses, consoling one another. Frankenstein does not comply. In chapter 18 of the novel, he rationalizes that "I feared the vengeance of the disappointed fiend, yet I was unable to overcome my repugnance to the task which was enjoined me. I found that I could not compose a female without again devoting several months to profound study." We witness the consequences. In perhaps the novel's saddest episode, Frankenstein allows a young family friend, Justine, to be convicted by circumstantial evidence of the killing of his brother and to be hanged for it—all because he doubts that anyone would believe him if he were to come forth with the truth. Yet amid the horror the Romantic spirit rises to the sublime, at one with the painting of Caspar David Friedrich (see **Fig. 17.22**), as in Dr. Frankenstein's descriptions of the lakes of Switzerland.

READING 17.19 MARY WOLLSTONECRAFT SHELLEY

From *Frankenstein, or The Modern Prometheus*, chapter 18

We travelled at the time of the vintage, and heard the song of the laborers, as we glided. . . . Even I, depressed in mind, and my spirits continually agitated by gloomy feelings, even I was pleased. I lay at the bottom of the boat, and, as I gazed on the cloudless blue sky, I seemed to drink in a tranquility to which I had long been a stranger. And if these were my sensations, who can describe those of Henry [Dr. Frankenstein's close friend, Henry Clerval]? He felt as if he had been transported to Fairyland, and enjoyed a happiness seldom tasted by man. "I have seen," he said, "the most beautiful scenes of my own country; I have visited the lakes of Lucerne and Uri, where the snowy mountains descend almost perpendicularly to the water, casting black and impenetrable shades, which would cause a gloomy and mournful appearance, were it not for the most verdant islands that relieve the eye by their gay appearance; I have seen this lake agitated by a tempest, when the wind tore up whirlwinds of water, and gave you an idea of what the waterspout must be on the great ocean; and the waves dash with fury the base of the mountain, where the priest and his mistress were overwhelmed by an avalanche, and where their dying voices are still said to be heard amid the pauses of the nightly wind; I have seen the mountains of La Valais, and the Pays de Vaud: but this country, Victor, pleases me more than all those wonders. The mountains of Switzerland are more majestic and strange; but there is a charm in the banks of this divine river, that I never before saw equaled. Look at that castle which overhangs yon precipice; and that also on the island, almost concealed amongst the foliage of those lovely trees; and now that group of laborers coming from among their vines; and that village half hid in the recess of the mountain. Oh, surely, the spirit that inhabits and guards this place has a soul more in harmony with man than those who pile the glacier, or retire to the inaccessible peaks of the mountains of our own country."

At the time she wrote *Frankenstein*, Shelley was familiar with Coleridge's poetry. When she was eight years old, Coleridge recited *The Rime of the Ancient Mariner* in her family's home. She mentions the poem in *Frankenstein*. Moreover, the final passages of the novel play out against threatening floes of ice in the polar sea—the floes that trapped the mariner and his crew until the albatross flew into their lives.

We noted that John William Polidori was in attendance at the ghostly soiree in Geneva where *Frankenstein* was born. There was another birth. Polidori published his own Gothic novel a year after Frankenstein came into being: *The Vampyre* (1819), which became another literary landmark and one of the progenitors of Bram Stoker's *Dracula*, which was published in 1897.

VICTOR HUGO In some cases, writers were able to combine the Romantic style with a social conscience, as in the case of the French novelist Victor Hugo (1802–1885), whose *Les Misérables* (1862) describes the plight of the miserable victims of society's injustices, as suggested in the following extract, in which a righteous bishop implores a congregation to help the needy.

READING 17.20 VICTOR HUGO

From *Les Misérables*, volume 1, book 1, chapter 4

"My very dear brethren, my good friends, there are thirteen hundred and twenty thousand peasants' dwellings in France which have but three openings; eighteen hundred and seventeen thousand hovels which have but two openings, the door and one window; and three hundred and forty-six thousand cabins besides which have but one opening, the door. And this arises from a thing which is called the tax on doors and windows. Just put poor families, old women and little children, in those buildings, and behold the fevers and maladies which result! Alas! God gives air to men; the law sells it to them. I do not blame the law, but I bless God. In the department of the Isere, in the Var, in the two departments of the Alpes, the Hautes, and the Basses, the peasants have not even wheelbarrows; they transport their manure on the backs of men; they have no candles, and they burn resinous sticks, and bits of rope dipped in pitch. That is the state of affairs throughout the whole of the hilly country of Dauphiné. They make bread for six months at one time; they bake it with dried cow-dung. In the winter they break this bread up with an axe, and they soak it for twenty-four hours, in order to render it eatable. My brethren, have pity! Behold the suffering on all sides of you!"

The hero of the novel, Jean Valjean, is an ex-convict who is rehabilitated through the agency of human sympathy and pity. Hugo provides graphic descriptions of the squalor and suffering of the poor, but his high-flown rhetorical style is essentially Romantic. *Les Misérables*, of course, has given birth to numerous movies of the name and to one of the most popular musicals in the history of musical theater.

Most of the leading novelists of the mid-19th century wrote within a tradition of Realism that came gradually to replace Romanticism. Instead of describing an imaginary world of their own creation, they looked outward to find inspiration in the day-to-day events of real life. The increasing social problems produced by industrial and urban development produced not merely a lament for the spirit of the times but also a passionate desire for the power to change them as well.

ROMANTIC MUSIC

For many of the Romantics, music was the supreme art. Free from the intellectual concepts involved in language and the

physical limits inherent in the visual arts, it was capable of the most wholehearted and intuitive expression of emotion.

Romantic Musicians

Among the Romantic musicians, we find many familiar names: Ludwig van Beethoven, Hector Berlioz, Franz Schubert, Johannes Brahms, Anton Bruckner, Frédéric Chopin, Franz Liszt, and Niccolò Paganini.

LUDWIG VAN BEETHOVEN Ludwig van Beethoven (1770–1827), widely regarded as the pioneer of Romanticism in music, also manifested many characteristically Romantic attitudes—a love of nature, a passionate belief in the freedom of the individual, and a fiery temperament—so it is not surprising that he has come to be regarded as the prototype of the Romantic artist. When Beethoven wrote proudly to one of his most loyal aristocratic supporters, "There will always be thousands of princes, but there is only one Beethoven," he spoke for a new generation of creators. When he used the last movement of his Symphony No. 9 to preach the doctrine of universal brotherhood, he inspired countless ordinary listeners by his fervor. Even today, familiarity with Beethoven's music has not dulled its ability to give dramatic expression to the noblest of human sentiments.

Although Beethoven's music served as the springboard for the Romantic movement in music, his own roots were deep in the Classical tradition. He pushed Classicism to the limits through use of the sonata allegro form. In spirit, furthermore, his work is representative of the Age of Enlightenment and the revolutionary mood of the turn of the century, as seen in the words and music of his opera *Fidelio*. A complex and many-sided genius, Beethoven transcended the achievements of the age in which he was born and set the musical tone for the 19th century.

Beethoven was born in Bonn, Germany, where he received his musical training from his father, an alcoholic. Beethoven's father saw the possibility of producing a musical prodigy in his son and forced him to practice hours at the keyboard, often locking him in his room and beating him on returning from drinking bouts. All possibilities of a happy family life were brought to an end in 1787 when Beethoven's mother died and his father descended into advanced alcoholism. Beethoven sought compensation in the home of the von Breuning family, where he acted as private tutor. It was there that he met other musicians and artists and developed a lifelong love of literature. He also struck up a friendship with a local minor aristocrat, Count von Waldstein, who remained his devoted admirer until the composer's death.

In 1792 Waldstein was one of the aristocrats who helped Beethoven go to Vienna to study with Haydn, who was then regarded as the greatest living composer; but although Haydn agreed to give him lessons, the young Beethoven's impatience and suspicion, and Haydn's deficiencies as a teacher, did not make for a happy relationship. Nevertheless, many of the works Beethoven wrote during his first years in Vienna are essentially Classical in both form and spirit; only by the end of the century had he begun to extend the emotional range of his music.

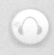

GO LISTEN! LUDWIG VAN BEETHOVEN

Piano Sonata No. 8 ("Pathétique") in C Minor, Op. 13

One of the first pieces to express the characteristically Beethovenian spirit is his Piano Sonata No. 8 in C Minor, Op. 13, generally known as the "Pathétique." Beethoven's sonata is characteristic of Romantic music in its strong expression of personal feelings. Its three movements, of which we hear the last, tell a continuous story in which the hero (the composer) fights an increasingly desperate battle against what seems his certain destiny. Unlike the Classical, tragic resignation of Mozart's Symphony No. 40 (see Chapter 16), Beethoven's Romantic spirit drives him to fight.

In the first movement, grim resistance gives way to forceful, turbulent struggle; after a second movement with a serene vision of beauty that offers hope of relief, Beethoven returns to the battle. The final movement appears to arrive at a synthesis between the drama of the opening and the hushed beauty of the slow movement. The music opens in a fragile, reflective mood. The composer has not yet recovered from the solemn beauty of the slow movement, and we hear his changes of mood echoed in the music, as if he hesitates to prepare himself for further combat. His repeated instruction to the performer is *tranquillo* (peacefully). Yet the mood darkens and the music is marked *agitato* (agitatedly). The strife-ridden mood of earlier sweeps away the sense of resignation. There are brief moments of respite, and just before the very end, the opening theme returns quietly and with simplicity. Yet the conclusion is both decisive and sudden. The piano hurtles down a violent scale, and a final brutal chord puts an end to the piece, with its alternating moods of faint hope and despair. Before the Romantics, no one had used music for such frank expression of the most fluctuating emotions, and Beethoven's use of abrupt changes of volume, his hesitations, and his sense of self-revelation are all typical of the new musical era.

It is important to understand precisely how Beethoven used music in a new and revolutionary way. Other composers had written music to express emotion long before Beethoven's time, from Bach's outpouring of religious fervor to Mozart's evocation of human joy and sorrow. What is different about Beethoven is that his emotion is autobiographical. His music tells us how he feels, what his succession of moods is, and what conclusion he reaches. It does other things at the same time, and at this early stage in his career for the most part it self-consciously follows Classical principles of construction, but the vivid communication of personal emotions is its prime concern. That Beethoven's

range was not limited to anger and frustration is immediately demonstrated by the beautiful and consoling middle (slow) movement of the "Pathétique," with its lyrical main theme—but the final movement returns to passion.

Parallels for the turbulent style of the "Pathétique" can be found in other contemporary arts, especially literature, but although to some extent Beethoven was responding to the climate of the times, there can be no doubt that he was also expressing a personal reaction to the terrible tragedy that had begun to afflict him as early as 1796. In that year the first symptoms of his deafness began to appear; by 1798, his hearing had grown very weak; and by 1802, he was virtually totally deaf.

Nonetheless, although obviously affected by his condition, Beethoven's music was not exclusively concerned with his own fate. The same heroic attitude with which he faced his personal problems was also given universal expression, never more stupendously than in the Symphony No. 3 in E-flat, Op. 55, subtitled the "Eroica" (Heroic) Symphony. As early as 1799, the French ambassador to Vienna had suggested that Beethoven write a symphony in honor of Napoléon Bonaparte. At the time, Napoléon was widely regarded as a popular hero who had triumphed over his humble origins to rise to power as a champion of liberty and democracy. Beethoven's own democratic temperament made him one of Napoléon's many admirers. The symphony was duly begun, but in 1804—the year of its completion—Napoléon had himself crowned emperor. When Beethoven heard the news, he angrily crossed out Napoléon's name on the title page. The first printed edition, which appeared in 1806, bore only the dedication "to celebrate the memory of a great man."

The "Eroica" is not merely a portrait of Napoléon. Rather, inspired by what he saw as the heroic stature of the French leader, Beethoven created his own heroic world in sound, in a work of vast dimensions. The first movement alone lasts for almost as long as many a Classical symphony. Its complex structure requires considerable concentration by the listener. The form is basically the Classical sonata allegro form (see Chapter 16), but on a much grander scale and with a wealth of musical ideas. Yet the principal theme of the movement, which the cellos announce at the beginning after two hammering, impatient chords demand our attention, is of a rock-like sturdiness and simplicity.

Beethoven's genius emerges as he uses this and other similarly straightforward ideas to build his mighty structure. Throughout the first movement his use of harmony and, in particular, discord adds to the emotional impact, especially in the middle of the development section, where slashing dissonances seem to tear apart the orchestra. His Classical grounding emerges in the recapitulation, where the infinite variety of the development section gives way to a restored sense of unity; the movement ends triumphantly with a long and thrilling coda. The formal structure is recognizably Classical, but the intensity of expression, depth of personal commitment, and heroic defiance are all totally Romantic.

The second movement of the "Eroica" is a worthy successor to the first. A funeral march on the same massive scale, it alternates a mood of epic tragedy—which has been compared, in terms of impact, with the works of the Greek playwright Aeschylus—with rays of consolation that at times achieve a transcendental exaltation. Although the many subtleties of construction deserve the closest attention, even a first hearing will reveal the grandeur of Beethoven's conception.

The third and fourth movements relax the tension. For the third, Beethoven replaces the stately minuet of the classical symphony with a **scherzo**—the word literally means "joke" and is used to describe a fast-moving, lighthearted piece of music. Beethoven's introduction of this kind of music, which in his hands often has something of the crude flavor of a peasant dance, is another illustration of his democratization of the symphony. The last movement is a brilliant and energetic series of variations on a theme Beethoven had composed a few years earlier for a ballet he had written about Prometheus.

Many of the ideas and ideals that permeate the "Eroica" reappear throughout Beethoven's work. His love of liberty and hatred of oppression are expressed in his only opera, *Fidelio*, which describes how a woman rescues her husband, who has been unjustly imprisoned for his political views. A good performance of *Fidelio* is still one of the most uplifting and exalting experiences music has to offer.

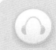

GO LISTEN! **LUDWIG VAN BEETHOVEN**

Symphony No. 5 in C Minor

The first notes of Beethoven's Fifth Symphony are probably the best known of any symphony. Nothing could be further from the Classical balance of Haydn and Mozart than Beethoven's Romantic drive and passion. The mood of pathos and agitation is present from the opening hammering motive that permeates the entire movement and eventually drives it to its fatal conclusion.

The careful listener will hear that Beethoven constructs his torrent of sound according to the principles of traditional sonata form (this performance does not repeat the opening section, the exposition). The first section ends with a pause, and the middle, development section concentrates almost exclusively on the opening motive, which is passed around the orchestra. We then hurtle into the recapitulation, which repeats the opening section with one important addition: a pathetic, almost weeping solo passage for the oboe. Then, as the recapitulation comes to its stormy end, Beethoven plunges into an extended coda (conclusion), which builds up to new heights of tension and violence before its abrupt conclusion.

Never before in the history of music had any composer maintained such emotional intensity and concentration throughout a symphonic movement. It is difficult for us today to realize the revolutionary impact of his music on Beethoven's contemporaries as an expression of personal feelings. When the French composer Hector Berlioz took his old teacher of composition to the first Paris performance of

the Fifth Symphony, the old man was so bewildered that, on leaving, he could not put on his hat—because, Berlioz tells us, he could not find his head.

Beethoven's Symphony No. 6, Op. 68, called the "Pastoral," consists of a Romantic evocation of nature and the emotions it arouses, while his Symphony No. 9, Op. 125, is perhaps the most complete statement of human striving to conquer all obstacles and win through to universal peace and joy. In it Beethoven introduced a chorus and soloists to give voice to the "Ode to Joy" by his compatriot Johann Christoph Friedrich von Schiller (1759–1805). The symphony is one of the most influential works of the Romantic movement.

HECTOR BERLIOZ After Beethoven, music could not return to its former mood of Classical objectivity. Although Beethoven's music may remain unsurpassed for its universalization of individual emotion, his successors tried—and in large measure succeeded—to find new ways to express their own feelings. Among the first to follow Beethoven was Hector Berlioz (1803–1869), the most distinguished French Romantic composer, who produced, among other typically Romantic works, *The Damnation of Faust* (a setting of Part One of Goethe's work) and the *Symphonie fantastique* ("Fantastic Symphony"), which describes the hallucinations of an opium-induced dream. In both of these, Berlioz used the full Romantic apparatus of dreams, witches, demons, and the grotesque to lay bare the artist's innermost feelings.

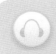

GO LISTEN! HECTOR BERLIOZ

Symphonie fantastique, V, "Dream of a Witches' Sabbath"

In 1830 (three years after the death of Beethoven) Berlioz presented to an astonished Parisian public his *Symphonie fantastique*, subtitled "Episode in the Life of an Artist." Clearly this was self-confessed expression of personal feelings and self-analysis at its most Romantic.

Berlioz himself provides the background. A young musician of extraordinary sensibility, in the depths of despair because of hopeless love, has poisoned himself with opium. The drug is too feeble to kill him, but plunges him into a heavy sleep accompanied by weird visions. His sensations, emotions, and memories become transformed into musical images and ideas. The beloved herself becomes a melody—what Berlioz calls the *idée fixe* (fixed idea)—that recurs throughout all five movements of the work. The writing for the orchestra introduces new sound colors and combinations in order to render the horror of the scene, in particular through Berlioz's highly unusual use of the woodwinds.

The last movement, from which we hear the opening section, depicts the funeral of the dreamer, who has seen his own execution in the preceding movement. The scene is that of a witches' Sabbath, and the music begins with a series of muffled groans and cries that convey a gradual assembly of

cackling old witches. The theme that earlier represented the dreamer's beloved appears in a horribly distorted form played by the woodwinds, and at the climax of the tumult, the brass instruments hurl out the traditional Gregorian-chant theme of the **Dies Irae** (day of wrath), as in a Roman Catholic requiem mass for the dead. The brass blare combines with the witches' dance to form what the composer calls a "diabolical orgy."

It only remains for the historian to add that the beloved in question was the Irish actress Harriet Smithson, whom Berlioz married in 1833 and from whom he separated in 1842.

FRANZ SCHUBERT A highly intimate and poetic form of Romantic self-revelation is the music of Franz Schubert (1797–1828), who explored in the few years before his premature death the new possibilities opened up by Beethoven in a wide range of musical forms. In general, Schubert was happiest when working on a small scale, as evidenced by his more than 600 **lieder** (songs), which are an inexhaustible store of musical and emotional expression.

On the whole, the more rhetorical nature of the symphonic form appealed to Schubert less, although the wonderful Symphony No. 8 in B Minor, called the "Unfinished" because he completed only two movements, combines great poetic feeling with a sense of drama. His finest instrumental music was written for small groups of instruments. The two trios for piano, violin, and cello are rich in the delightful melodies that seemed to come to him so easily; the second, slow movement of the Trio in E-flat, Op. 100, touches profound depths of Romantic expression. Like the slow movement of Mozart's Piano Concerto No. 27 in B-flat (see Chapter 16), its extreme beauty is tinged with an unutterable sorrow.

JOHANNES BRAHMS Most 19th-century composers followed Beethoven in using the symphony as the vehicle for their most serious musical ideas. Robert Schumann (1810–1856) and his student Johannes Brahms (1833–1897) regarded the symphonic form as the most lofty means of musical expression, and each as a result wrote only four symphonies. Brahms did not even dare to write a symphony until he was 44 and is said to have felt the presence of Beethoven's works "like the tramp of a giant" behind him. When it finally appeared, Brahms' Symphony No. 1 in C Minor, Op. 68, was inevitably compared to Beethoven's symphonies. Although Brahms's strong sense of form and conservative style won him the hostility of the arch-Romantics of the day, other critics hailed him as the true successor to Beethoven.

Both responses were, of course, extreme. Brahms's music certainly is Romantic, with its emphasis on warm melody and a passion no less present for being held in check—but far from echoing the stormy mood of many of the symphonies of his great predecessor, Brahms was really more at home in a relaxed vein. Although the Symphony No. 1 begins with a gesture of defiant grandeur akin to Beethoven's, the first movement ends by fading dreamily into a glowing tranquility. The lovely slow movement is followed not by a scherzo but by

a quiet and graceful **intermezzo** (interlude), and only in the last movement are we returned to the mood of the opening.

ANTON BRUCKNER Closer to the more cosmic mood of the Beethoven symphonies are the nine symphonies of the Austrian Anton Bruckner (1824–1896). A deeply religious man imbued with a Romantic attachment to the beauties of nature, Bruckner combined his Catholicism and vision in music of epic grandeur. It has often been remarked that Bruckner's music requires time and patience on the listener's part. His pace is leisurely and he creates huge structures in sound that demand our full concentration if we are to appreciate their architecture. There is no lack of incidental beauty, however, and the rewards are immense, especially in the slow movements of his last three symphonies. The **adagio** movement from the Symphony No. 8 in C Minor, for instance, moves from the desolate Romanticism of its opening theme to a mighty, blazing climax.

The Instrumental Virtuosos

Some composers were also known for their performance expertise. Beethoven's emphasis on the primacy of the artist inspired another series of Romantic composers to move in a different direction from that of the symphony. Beethoven had first made his reputation as a brilliant pianist, and much of his music—both for piano and for other instruments—was of considerable technical difficulty. As composers began to demand greater and greater feats of virtuosity from their performers, performing artists came to attract more attention. Singers had already in the 18th century commanded high fees and attracted crowds of fanatical admirers, and they continued to do so. Now, however, they were joined by instrumental virtuosos, some of whom were also highly successful composers.

FRÉDÉRIC CHOPIN The life of Frédéric Chopin (1810–1849) seems almost too Romantic to be true (**Fig. 17.25**). Both in his piano performances and in the music he composed, he united the aristocratic fire of his native Poland with the elegance and sophistication of Paris, where he spent much of his life. His concerts created a sensation throughout Europe, while his piano works exploited (if they did not always create) new musical forms like the **nocturne**—a short piano piece in which an expressive, if often melancholy, melody floats over a murmuring accompaniment. Chopin is characteristically Romantic in his use of music to express his own personal emotions. The structure of works like the 24 **preludes** of Op. 28 is dictated not by formal considerations but by the feeling of the moment. Thus the first three take us from excited agitation to brooding melancholy to bubbling high spirits in just over three minutes.

In private, Chopin's life was dominated by a much-talked-about liaison with the leading French woman author of the day, George Sand (1804–1876). His early death from tuberculosis put the final Romantic touch to the life of a composer who has been described as the soul of the piano.

FRANZ LISZT Franz Liszt (1811–1886) shared Chopin's brilliance at the keyboard and joined it with his robust temperament. A natural Romantic, Liszt ran the gamut of Romantic themes and experiences. After beginning his career as a handsome, impetuous rebel, the idol of the salons of Paris, he conducted several well-publicized affairs and finally turned to the consolation of religion. His vast musical out-

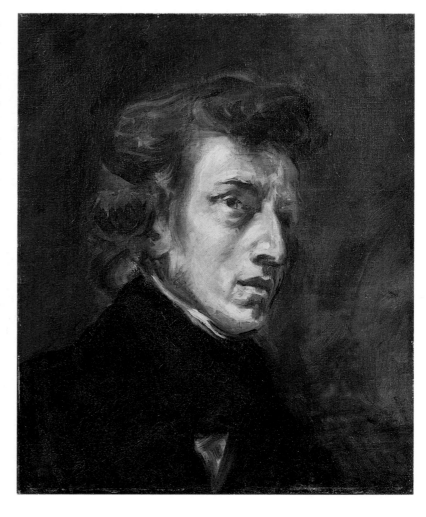

➤ **17.25** Ferdinand-Eugène-Victor Delacroix, *Frédéric Chopin*, 1838. Oil on canvas, 18″ × 15″ (45 × 38 cm). Musée du Louvre, Paris, France. Delacroix's portrait of his friend captures Chopin's Romantic introspection. Delacroix was a great lover of music, although perhaps surprisingly the great Romantic painter preferred the Classical Mozart to Beethoven.

Culture and Nationalism

One of the consequences of the rise of the cities and growing political consciousness was the development of nationalism: the identification of individuals with a nation-state, with its culture and history. In the past, the units of which people felt a part were either smaller (a local region) or larger (a religious organization or a social class). In many cases, the nations with which people began to identify either were broken up into separate small states, as in the case of the future Germany and Italy, or formed part of a larger state: Hungary, Austria, and Serbia were all under the rule of the Austro-Hungarian Empire, with Austria dominating the rest.

In the period from 1848 to 1914, the struggle for national independence marked political and social life and left a strong impact on European culture. The arts became one of the chief ways in which nationalists sought to stimulate peoples' awareness of their national roots. One of the basic factors that distinguished the Hungarians or the Czechs from their Austrian rulers was their language, and patriotic leaders fought for the right to use their own language in schools, government, and legal proceedings. In Hungary, the result was the creation by Austria of the Dual Monarchy in 1867, which allowed Hungarian speakers to have their own systems of education and public life. A year later, the Hapsburgs granted a similar independence to Hungarian minorities—Poles, Czechs, Slovaks, Romanians, and others.

In Germany and Italy, the reverse process operated. Although most Italians spoke one or another dialect of the same language, they had been ruled for centuries by a bewildering array of outside powers. In Sicily alone, Arabs, French, Spaniards, and English were only some of the occupiers who had succeeded one another. The architects of Italian unity used the existence of a common language, which went back to the poet Dante, to forge a sense of national identity.

The arts also played their part. Nationalist composers used folk tunes, sometimes real and sometimes invented, to underscore a sense of national consciousness. In the visual arts, painters illustrated historical events and sculptors portrayed patriotic leaders. While the newly formed nations aimed to create independent national cultures, the great powers reinforced their own identities. Russian composers turned away from Western models to underline their Slavic roots, while in the United Kingdom the artists and writers of the Victorian Age depicted the glories (and, in some cases, the horrors) of their nation.

The consequences of the rise of national consciousness dominated the 20th century and are still with us today. The age of world war was inaugurated by competition between nation-states, and the last half of the 20th century saw the collapse and regrouping of many of the countries created in the first half. Among the casualties are the former Czechoslovakia and Yugoslavia. The struggle of minorities to win their own nationhood remains a cause of bloodshed, as with the Basques of northern Spain and the Corsican separatists. In both cases, language and the arts continue to serve as tools in the struggle.

put includes some of the most difficult piano works (many of them inspired by the beauties of nature), two symphonies on the characteristically Romantic subjects of Faust and Dante (with special emphasis, in the latter case, on the *Inferno*), and a host of pieces that are infused with the folk tunes of his native Hungary.

NICCOLÒ PAGANINI The greatest violinist of the age was Niccolò Paganini (1782–1840). Like Chopin and Liszt, Paganini also composed, but his public performances secured his reputation. So apparently impossible were the technical feats he "casually" executed that rumor spread that, like the fictional Faust, he had sold his soul to the devil. This Romantic exaggeration was assiduously encouraged by Paganini, who cultivated a suitably ghoulish appearance to enhance his public image. Nothing more clearly illustrates the 19th century's obsession with music as emotional expression (in this case, diabolical) than the fact that Paganini's concerts earned him honors throughout Europe and a considerable fortune.

Music and Nationalism

Both Chopin and Liszt introduced the music of their native lands into their works, Chopin in his **mazurkas** and **polonaises** (traditional Polish dances) and Liszt in his *Hungarian Rhapsodies*. For the most part, however, they adapted their musical styles to the prevailing international fashions of the day.

Other composers placed greater emphasis on their native musical traditions. In Russia, a group of five composers—Mussorgsky, Balakirev, Borodin, Cui, and Rimsky-Korsakov (known collectively as the "Big Five")—purposefully set out to exploit their rich musical heritage. For example, Modest Mussorgsky's (1839–1881) opera *Boris Godunov* (1874) is based on an episode in Russian history. It makes full use of Russian folksongs and religious music in telling the story of Tsar Boris Godunov, who rises to power by killing the true heir to the throne. Although Boris is the opera's single most important character, the work is dominated by the chorus, which represents the Russian people. Mussorgsky powerfully depicts their changing emotions, from bewilderment to awe to fear to

rage, and in so doing voices the feelings of his nation. The pulsating rhythms of Nikolai Rimsky-Korsakov's (1844–1908) symphonic suite *Scheherazade* (1888) retell the Arabic *One Thousand and One Nights* with colorful orchestration, combining Russian music with a Russian fascination with the East.

Elsewhere in Eastern Europe composers were finding similar inspiration in national themes and folk music. The Czech composer Bedřich Smetana (1824–1884), who aligned himself with his native Bohemia in the uprising against Austrian rule in 1848, composed a set of six pieces for orchestra under the collective title of *Má vlast* (*My Fatherland*). The best known, *Vltava* (*The Moldau*), depicts the course of the river Vltava as it flows from its source through the countryside to the capital city of Prague. His fellow countryman Antonín Dvořák (1841–1904) also drew on the rich tradition of folk music in works like his *Slavonic Dances*, colorful settings of Czech folk tunes.

Opera

Throughout the 19th century, opera achieved new heights of popularity in Europe, and "opera mania" spread to the United States, where opera houses opened in New York (1854) and Chicago (1865). Early in the century, the Italian operagoing public was interested in beautiful and brilliant singing rather than realism of plot or action.

BEL CANTO OPERA Composers such as Gaetano Donizetti (1797–1848) and Vincenzo Bellini (1801–1835) used their music to express sincere and deep emotions, even drama, but the emotional expression was achieved primarily by means of **bel canto** (beautiful singing) and not by the unfolding of a convincing plot. The story lines of their operas apparently serve as "excuses" for the performance of their music; characters in bel canto operas are thus frequently given to fits of madness in order to give musical expression to deep emotion.

The revival and subsequent popularity of much early-19th-century opera is largely the result of the performances and recordings of Maria Callas (1923–1977), whose enormous talent showed how a superb interpreter could bring such works to life. Following her example, other singers turned to bel canto opera, with the result that performances of Bellini's *Norma* (1831) and of Donizetti's best-known opera, *Lucia di Lammermoor* (1835), have become a regular feature of modern operatic life, while lesser-known works are revived in increasing numbers.

Under the inspiration of the Italian Giuseppe Verdi and the German Richard Wagner, however, opera began to move in a different direction. Their subjects remained larger than life, but dramatic credibility became increasingly important. On both sides of the Atlantic, opera-house stages are still dominated by the works of the two 19th-century giants.

GIUSEPPE VERDI Giuseppe Verdi (1813–1901) showed a new concern for dramatic and psychological truth. Even in his early operas like *Nabucco* (1842) and *Luisa Miller* (1849), Verdi

was able to give convincing expression to human relationships. At the same time, his music became associated with the growing nationalist movement in Italy. *Nabucco*, for example, deals ostensibly with the captivity of the Jews in Babylon and their oppression by Nebuchadnezzar, but the plight of the Jews became symbolic of the Italians' suffering under Austrian rule. The chorus the captives sing as they think of happier days, "Va, pensiero" ("Fly, thought, on golden wings, go settle on the slopes and hills where the soft breezes of our native land smell gentle and mild"), became a kind of theme song for the Italian nationalist movement, the Risorgimento, largely because of the inspiring yet nostalgic quality of Verdi's tune.

Verdi's musical and dramatic powers reached their first great climax in three major masterpieces—*Rigoletto* (1851), *Il trovatore* (1853), and *La traviata* (1853)—that remain among the most popular of all operas. They are very different in subject and atmosphere. *Il trovatore* is perhaps the most traditional in approach, with its gory and involved plot revolving around the troubadour Manrico and its abundance of superb melodies. In *Rigoletto*, Verdi achieved one of his most convincing character portrayals in the title character, a hunchbacked court jester who is forced to suppress his human feelings and play the fool to his vicious and lecherous master, the Duke of Mantua. With *La traviata*, based on Dumas's play *La dame aux camélias* (*The Lady of the Camellias*), Verdi broke new ground in the history of opera by dealing with contemporary life rather than a historical or mythological subject.

GO LISTEN! GIUSEPPE VERDI

Violetta's aria "Ah, fors' è lui" from *La traviata*

Act 1 of *La traviata* takes place at a party given by Violetta Valéry. She is used to being admired and flattered, but during the course of the party a naïve young man from the provinces, Alfredo Germont, confesses that he feels a real and sincere love for her. Violetta is amused but moved, and when the guests have gone and she finds herself alone, she sings the aria "Ah, fors' è lui": perhaps this is the man who can offer her the joy of loving and being loved, a joy she has never known but for which she yearns. In typical Romantic fashion, she explores and analyzes her own feelings, repeating the phrase "croce e delizia" (torment and delight).

Her conflicting emotions are expressed by a melody that at first is broken and unsure, but as her confidence grows, it breaks out into glowing, soaring phrases. Note that at the end, the unaccompanied vocal line serves to display not the excellent technique of the singer (although it certainly requires that) but the innermost personal feelings of the character—another Romantic characteristic. Equally Romantic is the way in which her fluctuating emotions reflect the illness that proves fatal at the end of the opera.

As the opera progresses, Violetta falls in love with Alfredo and decides to give up her sophisticated life in the capital for country bliss. Her reputation follows her, however, in the

form of Alfredo's father. In a long and emotional encounter, he persuades her to abandon his son and put an end to the disgrace she is bringing on his family. Violetta, who is aware of her fatal illness, returns alone to the cruel glitter of her life in Paris. By the end of the opera, her money gone, she lies dying in poverty and solitude. At this tragic moment Verdi gives her one of his most moving arias, "Addio del passato" ("Goodbye, bright dreams of the past"). Alfredo, learning of the sacrifice she has made for his sake, rushes to find her, only to arrive for a final farewell—Violetta dies in his arms.

Throughout the latter part of his career, Verdi's powers continued to develop and grow richer, until in 1887 he produced in *Otello*—a version of Shakespeare's tragedy—perhaps the supreme work in the entire Italian operatic tradition. From the first shattering chord that opens the first act to Otello's heartbreaking death at the end of the last, Verdi rose to the Shakespearean challenge with music of unsurpassed eloquence. In a work that is so consistently inspired, it seems invidious to pick out highlights, but the ecstatic love duet of act 1 between Otello and Desdemona deserves mention as one of the noblest and most moving of all depictions of Romantic passion.

RICHARD WAGNER The impact of Richard Wagner (1813–1883) on his times went far beyond the opera house. Not only did his works change the course of the history of music, but many of his ideas also had a profound effect on writers and painters. He became involved with the revolutionary uprisings of 1848 and spent several years in exile in Switzerland.

It is difficult to summarize the variety of Wagner's ideas, which ranged from art to politics to vegetarianism and are not noted for their tolerance. Behind many of his writings on opera and drama lay the concept that the most powerful form of artistic expression was one that united all the arts—music, painting, poetry, movement—in a single work of art, the **Gesamtkunstwerk** (total artwork). To illustrate this theory, Wagner wrote both the words and music of what he called "music dramas" and even designed and built a special theater for their performance at Bayreuth, Germany, where they are still performed every year at the Bayreuth Festival.

Several characteristics link Wagner's mature works. He abolished the old separation between *recitatives* (in which the action was advanced) and arias, duets, or other individual musical numbers (which held up the action). Wagner's music flows continuously from the beginning to the end of each act with no pauses. He eliminated the vocal display and virtuosity that had been traditional in opera. Wagnerian roles are not easy to sing, but their difficulties are for dramatic reasons and not to display a singer's skill. He also placed new emphasis on the orchestra, which not only accompanies the singers but also provides a rich musical argument of its own. This orchestral innovation is enhanced by his device of the **leitmotiv** (leading motif), which gives each principal character, idea, and even object a theme of his, her, or its own. By recalling these themes and combining them or changing them, Wagner achieves complex dramatic and psychological effects.

Wagner generally drew his subjects from German mythology. By peopling his stage with heroes, gods, giants, magic swans, and the like, he aimed to create universal dramas with universal emotions. In his most monumental achievement, *The Ring of the Nibelung*, written between 1851 and 1874, he even represented the end of the world. The Ring cycle consists of four separate music dramas—*The Rhine Gold*, *The Valkyrie* (**Fig. 17.26**), *Siegfried*, and *Twilight of the*

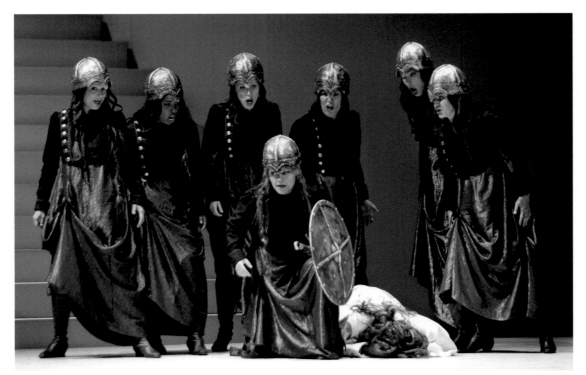

◄ **17.26** Scene from *The Valkyrie*, the second work in Richard Wagner's *Ring of the Nibelung*, June 24, 2007. Grand Théâtre de Provence, Aix-en-Provence, France. Following the famous "Ride of the Valkyries," the warrior maidens surround their fellow Valkyrie Brünnhilde (played here by Eva Johannson), center stage. The woman dressed in white, lying prostrate, is Sieglinde, who is destined to give birth to Siegfried, the cycle's eventual hero.

Gods—the plot of which defies summary. With rich music, Wagner depicted not only the actions and reactions of his characters but also the wonders of nature. In *Siegfried*, for example, we hear the rustling of the forest and the songs of wood birds, while throughout the Ring cycle and especially in the well-known "Rhine Journey" from *Twilight of the Gods*, the mighty river Rhine reverberates throughout the score. At the same time, *The Ring of the Nibelung* has several philosophical and political messages, many of which are derived from Schopenhauer. One of its main themes is that power corrupts; Wagner also adopted Goethe's idea of redemption by a woman in the final resolution of the drama.

GO LISTEN! RICHARD WAGNER

"The Ride of the Valkyries" from act 3 of *The Valkyrie*

The second opera of Wagner's Ring cycle, *The Valkyrie*, introduces us to the work's hero, Brünnhilde, who is one of the nine Valkyries, warrior daughters of Wotan, father of the gods. Their task is to roam the battlefields and carry the bodies of dead heroes to Valhalla (the home of the gods).

At the beginning of the third act of *The Valkyrie*, Brünnhilde's sisters gather on a mountaintop, and Wagner's stormy music describes their ride through the clouds. Note how the composer sets the scene by his use of the orchestra. The woodwinds begin with a series of wild trills, the strings play scales that rush up and down, and then the heavy brass enter with the rhythmic motive of the Valkyries (a theme that returns many times during the rest of the Ring cycle). As each warrior maid arrives with her fallen hero, the music subsides, only to rise again to ever greater peaks of excitement as another rides in.

The version heard on the CD is orchestral, prepared for performance in the concert hall rather than in the opera house, so that no voices are heard. In the original we hear the Valkyries calling to one another. The ending of the selection is also modified for concert performance; in the opera, the scene continues unbroken.

The wild and exotic nature of the music is typical of fully developed Romanticism, as is the extended development of the plot of *The Ring of the Nibelung*, with its emphasis on erotic love and the role of Wotan as eventual redeemer at the very end of the cycle, while the use of Norse and Germanic mythology (rather than biblical or Classical background) illustrates the Romantics' love of nationalism.

No brief discussion can begin to do justice to so stupendous a work as the Ring cycle. It is probably easier to understand Wagner by looking at a work on smaller scale, a single self-contained music drama—albeit one of some four hours' duration. *Tristan and Isolde* was first performed in 1865, and its first notes opened a new musical era. Its subject is the overwhelming love of the English knight Tristan and the Irish princess Isolde: so great that the pair betray his dearest friend and lord and her husband, King Mark of Cornwall, and so overpowering that it can achieve its complete fulfillment only in death.

Wagner's typically Romantic preoccupation with love and death may seem morbid and far-fetched, but under the sway of his intoxicating music it is difficult to resist. The sense of passion awakened but unfulfilled is expressed in the famous opening bars of the prelude. The music imparts no sense of settled harmony or clear direction. This lack of **tonality**, used here for dramatic purpose, was to have a considerable influence on modern music.

The core of *Tristan and Isolde* is the long love scene at the heart of the second act, where the music reaches heights of erotic ecstasy too potent for some listeners. Whereas Verdi's love duet in *Otello* presents two noble spirits responding to one another with deep feeling but with dignity, Wagner's characters are racked by passions they cannot begin to control. If ever music expressed what neither words nor images could depict, it is in the overwhelming physical emotion of this scene. The pulsating orchestra and surging voices of the lovers build up an almost unbearable tension that Wagner suddenly breaks with the arrival of King Mark. Once again, as in the prelude, fulfillment is denied both to the lovers and to us.

That fulfillment is reached only at the end of the work in Isolde's "Liebestod" (love death). Tristan has died, and over his body Isolde begins to sing a kind of incantation. She imagines she sees the spirit of her beloved, and in obscure, broken words describes the bliss of union in death before sinking lifeless upon him. Although the "Liebestod" does make its full effect when heard at the end of the entire work, even out of context the emotional power of the music as it rises to its climax can hardly fail to affect the sensitive listener.

REALISM

If Neo-Classical artists sought a visual counterpart to the primacy of reason based in Enlightenment philosophy, and the Romanticists emphasized feeling, imagination, and intuition, the driving force behind Realism was science. The emphasis in contemporary scientific thought on *empiricism*—the direct observation of natural phenomena and experience as the foundation of knowledge—found its equivalent among artists and writers subscribing to **Realism.**

Realist Art

The major proponent of Realism in the visual arts, Gustave Courbet, stated, "Painting is an essentially concrete art and can only consist of the representation of real and existing things. It is a completely physical language, the words of which consist of all visible objects. An object which is abstract, not visible, non-existent is not within the realm

of painting." Realists painted what they saw; anything else, they believed, did not represent the real world. Courbet also said, "I have never seen angels. Show me an angel and I will paint one." Realist writers approached their subjects from the same perspective: they too portrayed real-life situations without idealization or sentiment. For the Realists, human drama was human-scaled and therefore believable and knowable.

GUSTAVE COURBET Courbet's (1819–1877) Realism had a political tinge. He was a fervent champion of the working class whose ability to identify with ordinary people won him the label of Socialist. Yet Courbet did not fully accept this characterization of his artistic and philosophical positions and painted *The Artist's Studio: A Real Allegory Summing Up Seven Years of My Artistic and Moral Life* (**Fig. 17.27**), partly to respond to this misimpression. We find a self-portrait of the artist placed firmly in the center of the picture, engrossed in the creation of a landscape and inspired by a nude female model—a muse—who would appear to represent Realism or Truth. The various other figures symbolize the forces that made up Courbet's world. On the right side we recognize his friends, other artists, and art lovers, including Baudelaire, a bearded art collector, and a philosopher (Proudhon). On the left side we find what Courbet termed the "world of everyday life," including a merchant, a priest, a hunter, an unemployed worker, and a female beggar. There are also a guitar, dagger, and hat which, along with the male model, constitute a symbolic condemnation of traditional art. The painter stands in the middle as a mediator between these social types, affirming his view of the artist's cultural role in a scene painted on a grand scale. The work was intended to be shown at the 1855 Universal Exhibition, but Courbet got wind of the fact that it was going to be rejected. He therefore constructed, out of his own pocket, a "Pavilion of Realism" outside the official exhibition that would enable society at large to view his work.

HONORÉ DAUMIER The French Realists of the second half of the 19th century used everyday events to express their views. One of the first Realist artists was the printmaker and caricaturist Honoré Daumier (1808–1879), who followed the example of Goya in using his work to criticize the evils of

▼ 17.27 Gustave Courbet, *The Artist's Studio: A Real Allegory of the Last Seven Years of My Life*, 1855. Oil on canvas, 11′9 ¾″ × 19′6″ (360 × 596 cm). Musée d'Orsay, Paris, France. Although most of the figures can be convincingly identified as symbols of real people, no one has ever satisfactorily explained the small boy admiring Courbet's work or the cat at his feet.

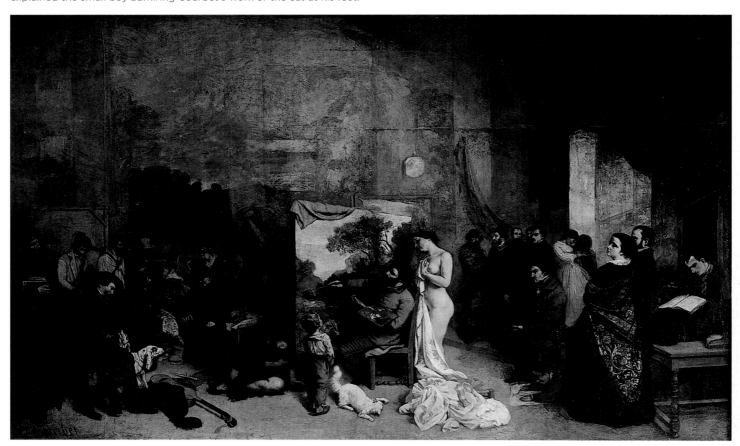

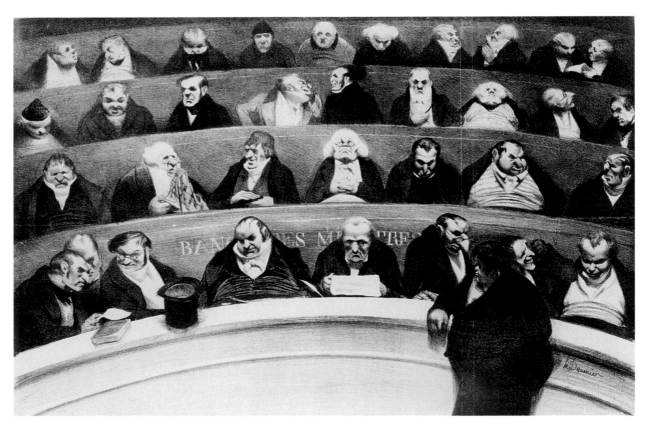

▲ 17.28 Honoré Daumier, *Le Ventre Legislatif* (*The Legislative Belly*), 1834. Lithograph, 11″ × 17″ (28.1 × 43.2 cm). Bibliothèque Nationale, Paris, France. Although obviously caricatures, the politicians arranged in tiers were recognizable as individual members of the legislative assembly of the time.

society in general and government in particular. In *Le Ventre Legislatif* (*The Legislative Belly*) (Fig. 17.28), Daumier produced a powerful image of the greed and corruption of political opportunists that has, over time, lost nothing of its bitterness nor, unfortunately, its relevance. The characters in the print are individually recognizable as members of the Chamber of Deputies. They are hilariously depicted as bloated and nodding off. The government censored such subjects a year after the print was made, resulting in fines. Daumier's publisher managed to pay the fines by selling the prints.

Realist Literature

GUSTAVE FLAUBERT Increasingly, writers found that they could best do justice to the problems of existence by adopting a more naturalistic style and describing their characters' lives in realistic terms. One of the most subtle attacks on contemporary values is *Madame Bovary* (1856) by Gustave Flaubert (1821–1880). Flaubert's contempt for bourgeois society finds expression in his portrait of Emma Bovary, who tries to discover in her own provincial life the romantic love she reads about in novels. Her shoddy affairs and increasing debts lead to an inevitably dramatic conclusion. Flaubert is at his best when portraying the banality and futility of Emma's everyday existence.

READING 17.21 GUSTAVE FLAUBERT

From *Madame Bovary*, part 1, chapter 9

Every day at the same time the schoolmaster in a black skullcap opened the shutters of his house; and the rural policeman, wearing his sabre over his blouse, passed by. Night and morning the post-horses, three by three, crossed the street to water at the pond. From time to time the bell of a public house door rang, and when it was windy one could hear the little brass basins basins that served as signs for the hairdresser's shop creaking on their two rods. This shop had as a decoration an old engraving of a fashion-plate stuck against a window-page and the wax bust of a woman with yellow hair. He, too, the hairdresser, lamented his wasted his wasted calling, his hopeless future, and dreaming of some shop in a big town—perhaps at Rouen, for example, overlooking the harbor, near the theatre—he walked up and down all day from the mairie to the church, somber and awaiting customers. When Madame Bovary looked up, she always always saw him there, like a sentinel on duty, with his skullcap over his ears and his vest of lasting.

HONORÉ DE BALZAC Honoré de Balzac (1779–1850) was the most versatile of all French novelists. He created a series

of some 90 novels and stories, under the general title of *The Human Comedy*, in which many of the same characters appear more than once. Above all a Realist, Balzac depicted the social and political currents of his time while imposing on them a sense of artistic unity. His novels are immensely addictive. The reader who finds in one of them a reference to characters or events described in another novel hastens there to be led on to a third, and so on. Balzac thus succeeds in creating a fictional world that seems more real than historical reality.

His novel *Le Père Goriot* (*Father Goriot*) is set in Paris of 1819 and traces the intertwined lives of three people: the kindly and elderly Goriot, a criminal, and a law student. The book is noted for the use of characters from Balzac's other works and, as with Flaubert's *Madame Bovary*, for its attention to minute detail. The story is an adaptation of Shakespeare's *King Lear*, in which the elderly Lear, like Father Goriot, is troubled by his children's selfishness. Goriot's daughters marry into the aristocracy but leave their father penniless. Lear said

How sharper than a serpent's tooth it is
To have a thankless child.

In the passage above early in the novel, we find a character in the novel, Monsieur M. Poiret, ambling down the streets of Paris. Balzac comments on his appearance in detail and asks the reader to contemplate the indifference of the city of Paris—perhaps of the universe—which can squash individuality and drown its denizens in financial and psychological need.

GEORGE SAND Among the leading literary figures of Balzac's Paris—and a personal friend of Balzac—was Aurore

Dupin (1804–1876), better known by her pseudonym George Sand. This redoubtable defender of women's rights and assailant of male privilege used her novels to wage war on many of the conventions of society. In her first novel, *Lélia* (1833), she attacked, among other targets, the church, marriage, the laws of property, and the double standard of morality, whereby women were condemned for doing what was condoned for men.

Translator Maria Espinosa commented on the questions troubling Lélia:

How can I make sense of the universe? Is there a God, and if so, what is His nature? Why must I be a slave to the artificially defined role of a woman? What is the nature of sensuality, and is it compatible with spiritual love? Are love relationships between the sexes designed to be transitory? Lélia craves sexual variety in her fantasies—despite or because of her inability to achieve satisfaction through physical love. She asks how to deal with this. Should she live as a nun or as a courtesan? (She never considers the role of wife!) These are the queries of an intense, passionate, and singularly courageous woman.[9]

In the following extract from the Espinosa translation, one of Lélia's lovers writes to her of his passion for her and his idealization of her—idealization being one of the "symptoms" of romantic love. It is evident that Sand is writing a prose poem.

9. George Sand, *Lélia*, trans. Maria Espinosa. (Bloomington: Indiana University Press, 1978), xv.

READING 17.23 GEORGE SAND

From *Lélia* (1833), II [Sténio to Lélia]

Yesterday when the sun set behind the glacier, drowned in vapors of a bluish rose, the warm winter evening glided through your hair, and the church bell threw its melancholy echoes into the valley. Lélia, I tell you that then you were truly the daughter of heaven. The soft light of the setting sun caressed you. Your eyes burned with a sacred fire as you looked up at the first timid stars. As for me, poet of woods and valleys, I listened to the mysterious murmur of the water, and I watched the slight undulations of the pines. I breathed the sweet perfume of wild violets which open beneath dried moss on the first warm, sunlit day. But you scarcely noticed all this—neither the flowers, the trees, the rushing stream, nor any object on earth aroused your attention. You belonged entirely to the sky. And when I showed you this enchanted spectacle at your feet, you raised your hand toward the heavens and cried, "Look at that!" Oh, Lélia, you long for your native land, don't you? Do you ask God why he has left you so long among us? And why He doesn't give you back your wings to return to Him?

In another passage, Lélia tells her sister, also a courtesan, of the experiences that led her to the point at which she cannot love a man.

READING 17.24 GEORGE SAND

From *Lélia* (1833), XXXIV

Oh, I remember the burning nights I passed pressed against a man's flanks in close embrace with him. During those nights I thoroughly studied the revolts of pride against the vanity of abnegation. I sensed one could simultaneously love a man to the point of submitting to him and love oneself to the point of hating him because he subjugates us. . . . What was cruelest for me . . . is that he failed to appreciate the extent of my sacrifices. . . . He pretended to believe me abused by a sentiment of hypocritical modesty. He affected to take for signs of rapture the moanings torn from me by suffering and impatience. He laughed harshly at my tears. . . . When he had broken me in ferocious embraces, he slept brusque and uncaring at my side, while I devoured my tears so as not to awaken him. . . . What caused me to love him a long time (long enough to weary my entire soul) was without doubt the feverish irritation produced in me by the absence of personal satisfaction. . . . I felt my bosom devoured by an inextinguishable fire, and his kisses shed no relief. . . . When he was drowsy, satisfied, and at rest, I would lie motionless beside him. I passed many hours watching him sleep. . . . I was violently tempted to awaken him, to hold him in my arms, and to ask for his caresses from which I hadn't yet known how to profit.

. . .

One day I felt so worn out with loving that I stopped suddenly. When I saw how easily this bond was broken, I was astonished at having believed in its eternal duration for so long.

Unconventional in her own life, Sand became the lover of Chopin, with whom she lived from 1838 to 1847. Her autobiographical novel *Lucrezia Floriani* (1846) chronicles as thinly disguised fiction the remarkable course of this relationship, albeit very much from its author's point of view.

The riches of mid-19th-century English literature include the profoundly intellectual and absorbing works of George Eliot—the pen name of Mary Ann Evans (1819–1880)—and *Wuthering Heights* (1847), the only novel by Emily Brontë (1818–1848) and one of the most dramatic and passionate pieces of fiction ever written. The book's brilliant evocation of atmosphere and violent emotion produces a shattering effect. Like the two already mentioned, many of the leading novelists of the time were women, and the variety of their works soon puts to flight any facile notions about the feminine approach to literature. Elizabeth Gaskell (1810–1865), for example, was one of the leading social critics of the day; her novels study the effects of industrialization on the poor.

LEO TOLSTOY The Russian Leo Tolstoy (1828–1910) produced, among other works, two huge novels of international stature: *War and Peace* (1863–1869) and *Anna Karenina* (1873–1877). The first is mainly set against the background of Napoléon's invasion of Russia in 1812. Among the vast array of characters is the Rostov family, aristocratic but far from wealthy, who, together with their acquaintances, have their lives permanently altered by the great historical events through which they live. Tolstoy even emphasizes the way in which the course of the war affects his characters by combining figures he created for the novel with real historical personages, including Napoléon, and allowing them to meet.

At the heart of the novel is the young and impressionable Natasha Rostov, whose own confused love life seems to reflect the confusion of the times. Yet the novel's philosophy is profoundly optimistic, despite the tragedies of Natasha's own life and the horrors of war that surround her. Her final survival and triumph represent the glorification of the irrational forces of life, which she symbolizes as the "natural person," over sophisticated and rational civilization.

Toward the end of his life, Tolstoy gave up his successful career and happy family life to undertake a mystical search for the secret of universal love. Renouncing his property, he began to wear peasant dress and went to work in the fields, although at the time of his death he was still searching in vain for peace. Russia's other great novelist, Fyodor Dostoyevsky (1821–1881), although he died before Tolstoy, had far more in common with the late 19th century than with the Romantic movement, so he is discussed in Chapter 18.

CHARLES DICKENS The Englishman Charles Dickens (1812–1870) was immensely popular during his lifetime and has been widely read ever since. One of his best-known novels, *A Tale of Two Cities*, is set during the French Reign of Terror, in which thousands are sent to the guillotine; some observers, including Madame Defarge, knit while they observe the day's "entertainment." In the final chapter, Dickens describes the progress of the "death carts" through the Parisian streets.

> ### READING 17.25 CHARLES DICKENS
>
> **From *A Tale of Two Cities*, chapter 15 (1859)**
>
> As the sombre wheels of the six carts go round, they seem to plough up a long crooked furrow among the populace in the streets. Ridges of faces are thrown to this side and to that, and the ploughs go steadily onward. So used are the regular inhabitants of the houses to the spectacle, that in many windows there are no people, and in some the occupation of the hands is not so much as suspended, while, the eyes survey the faces in the tumbrils. Here and there, the inmate has visitors to see the sight; then he points his finger, with something of the complacency of a curator or authorised exponent, to this cart and to this, and seems to tell who sat here yesterday, and who there the day before.
>
> Of the riders in the tumbrils, some observe these things, and all things on their last roadside, with an impassive stare; others, with a lingering interest in the ways of life and men. Some, seated with drooping heads, are sunk in silent despair; again, there are some so heedful of their looks that they cast upon the multitude such glances as they have seen in theatres, and in pictures. Several close their eyes, and think, or try to get their straying thoughts together. Only one, and he a miserable creature, of a crazed aspect, is so shattered and made drunk by horror, that he sings, and tries to dance. Not one of the whole number appeals by look or gesture, to the pity of the people.

Dickens campaigned against social injustice and used his books to focus on individual institutions and their evil effects. In *Hard Times* (1854) he turned, like Gaskell, to the evils of industrialization and pointed out some of the harm that misguided attempts at education can do. Yet better known today is *Oliver Twist* (1837–1839)—or at least the name "Oliver," because it, like *Les Misérables*, is the title of an extremely successful musical. The novel attacks the treatment of the poor in the workhouses and reveals Dickens's view of crime as the manifestation of a general failing in society. It is filled with unforgettable characters: Fagin, the conniving criminal who teaches orphaned children how to pick pockets for him but does not expose himself to danger; Nancy, the soft-hearted woman of the streets; Bill Sikes, the tough burglar who is Nancy's pimp, lover, and, ultimately, murderer; and, with typically Dickensian names, Mr. Bumble, the Artful Dodger, Mr. and Mrs. Sowerberry (undertaker and wife), and Mr. Grimwig. The novel was first serialized in a British literary magazine. It would not be an exaggeration to say that many readers became (psychologically) addicted to Dickens's works and could barely wait for the next installment. The beginning of *Oliver Twist* reveals Dickens at his ironic best.

> ### READING 17.26 CHARLES DICKENS
>
> **From *Oliver Twist* (1837–1839), chapter 1**
>
> Among other public buildings in a certain town, which for many reasons it will be prudent to refrain from mentioning, and to which I will assign no fictitious name, there is one anciently common to most towns, great or small; to wit, a workhouse: and in this workhouse was born: on a day and date which I need not trouble myself to repeat, inasmuch as it can be of no possible consequence to the reader, in this stage of the business at all events: the item of mortality whose name is prefixed to the head of this chapter [Oliver Twist].
>
> For a long time after it was ushered into this world of sorrow and trouble, by the parish surgeon, it remained a matter of considerable doubt whether the child would survive to bear any name at all, in which case it is somewhat more than probable that these memoirs would never have appeared; or, if they had, that being comprised within a couple of pages, they would have possessed the inestimable merit of being the most concise and faithful specimen of biography, extant in the literature of any age or country.
>
> Although I am not disposed to maintain that the being born in a workhouse, is in itself the most fortunate and enviable circumstance that can possibly befall a human being, I do mean to say that in this particular instance, it was the best thing for Oliver Twist that could by possibility have occurred. The fact is, that there was considerable difficulty in inducing Oliver to take upon himself the office of respiration—a troublesome practice, but one which custom has rendered necessary to our easy existence; and for some time he lay gasping on a little flock mattress, rather unequally poised between this world and the next: the balance being decidedly in favor of the latter. Now, if, during this brief period, Oliver had been surrounded by careful grandmothers, anxious aunts, experienced nurses, and doctors of profound wisdom, he would most inevitably and indubitably have been killed in no time.

THE HUMANITIES IN THE UNITED STATES

The early history of the arts in colonial North America was intimately linked to developments in Europe. The United Kingdom, in particular, by virtue of its common tongue and

political connections, exerted an influence on literature and painting that even the American Revolution did not end. U.S. writers sought publishers and readers there and modeled their style on that of English writers. U.S. painters went to London to study. The earliest U.S. composers confined their attention to settings of hymns and patriotic songs. A recognizably U.S. musical tradition of composition did not develop before the end of the 19th century, although European performers had much earlier found a vast and enthusiastic musical public in the course of their U.S. tours.

In the case of literature and the visual arts, the French Revolution provided a change of direction, for revolutionary ties inevitably resulted in the importation of Neo-Classicism into the United States. With the dawning of the Romantic era, however, U.S. artists began to develop for the first time an authentic voice of their own. In many cases they still owed much to European examples. The tradition of the expatriate North American artist who left home to study in Europe and remained there had been firmly established by the 18th century. Throughout the 19th century, writers like Washington Irving and painters like Thomas Eakins continued to bring back to the United States themes and styles they had acquired during their European travels. Something about the nature of Romanticism, however, with its emphasis on the individual, seemed to fire the U.S. imagination. The Romantic love of the remote and mysterious reached a peak in the macabre stories of Edgar Allan Poe. For the first time, in the Romantic era U.S. artists began to produce work that was both a genuine product of their native land and at the same time of international stature.

U.S. Literature

In a land where daily existence was lived so close to the wildness and beauty of nature, the Romantic attachment to the natural world was bound to make a special appeal. The Romantic concept of the transcendental unity of humans and nature was quickly taken up in the early 19th century by a group of U.S. writers who even called their style **Transcendentalism**. Borrowing ideas from Kant and from his English followers such as Coleridge and Wordsworth, they developed notions of an order of truth that transcends what we can perceive by our physical senses and that unites the entire world.

RALPH WALDO EMERSON One of the leading Transcendentalist representatives, Ralph Waldo Emerson (1803–1882), underlined the particular importance of the natural world for American writers in his essay "The American Scholar," first published in 1837. In calling for the development of a national literature, Emerson laid down as a necessary condition for its success that his compatriots should draw their inspiration from the wonders of their own country. A few years later he was to write: "America is a poem in our eyes; its ample geography dazzles the imagination, and it will not wait long for metres."

READING 17.27 **RALPH WALDO EMERSON**

From "Self-Reliance" (1841)

To believe your own thought, to believe that what is true for you in your private heart is true for all men,—that is genius.

. . .

Whoso would be a man must be a nonconformist. He who would gather immortal palms must not be hindered by the name of goodness, but must explore if it be goodness. Nothing is at last sacred but the integrity of your own mind.

. . .

[Do] not tell me, as a good man did today, of my obligation to put all poor men in good situations. Are they *my* poor? I tell thee, thou foolish philanthropist, that I grudge the dollar, the dime, the cent, I give to such men as do not belong to me and to whom I do not belong. There is a class of persons to whom by all spiritual affinity I am bought and sold; for them I will go to prison, if need be; but your miscellaneous popular charities; the education at college of fools; the building of meeting-houses to the vain end to which many now stand; alms to sots; and the thousandfold Relief Societies;—though I confess with shame I sometimes succumb and give the dollar, it is a wicked dollar which by and by I shall have the manhood to withhold.

. . .

A foolish consistency is the hobgoblin of little minds, adored by little statesmen and philosophers and divines. With consistency a great soul has simply nothing to do. He may as well concern himself with his shadow on the wall. Speak what you think now in hard words, and tomorrow speak what tomorrow thinks in hard words again, though it contradict every thing you said today.

. . .

Insist on yourself; never imitate. . . . Where is the master who could have taught Shakespeare? Where is the master who could have instructed Franklin, or Washington, or Bacon, or Newton? Every great man is a unique. . . . Shakespeare will never be made by the study of Shakespeare.

. . .

The civilized man has built a coach, but has lost the use of his feet. He is supported on crutches, but lacks so much support of muscle. He has a fine Geneva watch, but he fails of the skill to tell the hour by the sun. A Greenwich nautical almanac he has, and so being sure of the information when he wants it, the man in the street does not know a star in the sky.

. . .

Nothing can bring you peace but yourself. Nothing can bring you peace but the triumph of principles.

VALUES

Transcendentalism

Transcendentalism, a U.S. and European philosophical movement of the 1830s and 1840s, was largely a reaction against the rationalism of the 18th century and, in the United States, the austerity of New England Calvinism. Transcendentalists believed that organized religion and political parties corrupted humankind and that people rose to the height of their potential when they were self-reliant and listened to nature rather than books. They were in this sense religious: they believed that God was in us all, not a "person"—as defined by established religions—who demanded worship and would respond to human prayer.

Transcendental thought was partially rooted in the work of the German philosopher Immanuel Kant, who was himself skeptical of rationalism, as he explained in his *Critique of Pure Reason*. Kant appreciated the Latin motto of the Enlightenment, *Sapere aude* ("dare to know"); however, he challenged the idea that humans could perceive things as they are in reality. We only know reality as organized by limited human understanding. But society and its political and religious institutions corrupt the individual by coming between the individual and the perceived world. From this observation, Transcendentalists argue that people must be self-reliant, depending on their inner mental or spiritual essence. And people begin to reach their potential as individuals when they shed society and its institutions.

Ralph Waldo Emerson's essay "Nature"* (1836) describes the Transcendental protest and also shows the way in which he and many of his fellow Transcendentalists opened themselves to that which is divine in nature and in themselves.

> Crossing a bare common, in snow puddles, at twilight, under a clouded sky, without having in my thoughts any occurrence of special good fortune, I have enjoyed a perfect exhilaration. I am glad to the brink of fear. In the woods too, a man casts off his years, as the snake his slough, and at what period soever of life, is always a child. In the woods, is perpetual youth. Within these plantations of God, a decorum and sanctity reign, a perennial festival is dressed, and the guest sees not how he should tire of them in a thousand years. In the woods, we return to reason and faith. There I feel that nothing can befall me in life,—no disgrace, no calamity, (leaving me my eyes,) which nature cannot repair. Standing on the bare ground,—my head bathed by the blithe air, and uplifted into infinite space,— all mean egotism vanishes. I become a transparent eye-ball; I am nothing; I see all; the currents of the Universal Being circulate through me; I am part or particle of God.

* Ralph Waldo Emerson. Nature. Originally published 1836. In Ralph Waldo Emerson, *Nature: Addresses and Lectures*, 1849.

Emerson always tried to make his own work "smell of pines and resound with the hum of insects," and his ideas have exerted a profound effect on the development of American culture. His essay "Self-Reliance" (1841) could be considered something of a manifesto for the rugged individualist. Perhaps the best-known comments within the essay are: "Whoso would be a man must be a nonconformist" and "A foolish consistency is the hobgoblin of little minds." The first is self-explanatory. The second means to do what you believe is right and to speak your heart as you feel it, without worrying that it might contradict something you said yesterday. You will notice in the extracts that Emerson speaks against charity—alms for the poor. Is it simple selfishness, or do his comments emanate from the conviction that charity belittles the recipient and prevents him or her from becoming self-reliant? Even so, Emerson admits, "I sometimes succumb and give the dollar."

HENRY DAVID THOREAU

I went to the woods because I wished to live deliberately, to front only the essential facts of life, and see if I could not learn what it had to teach, and not, when I came to die, discover that I had not lived. I did not wish to live what was not life, living is so dear; nor did I wish to practise resignation, unless it was quite necessary. I wanted to live deep and suck out all the marrow of life, to live so sturdily and Spartan-like as to put to rout all that was not life, to cut a broad swath and shave close, to drive life into a corner, and reduce it to its lowest terms, and, if it proved to be mean, why then to get the whole and genuine meanness of it, and publish its meanness to the world; or if it were sublime, to know it by experience, and be able to give a true account of it in my next excursion.

—Henry David Thoreau, *Walden* (1854), chapter 2

Thus the best-known literary practitioner of Transcendentalist principles, Henry David Thoreau (1817–1862), explains why he left "civilization" to sojourn in solitude in the woods. In his masterpiece *Walden*, he uses his experiences and his observations on the shore of Walden Pond, in Massachusetts, to draw

general conclusions about the nature of human beings and the nature of . . . nature. People still go on pilgrimages to Walden Pond, now in the suburbs of Boston, to try to commune with the spirit that drove Thoreau. *Walden* is truly a prose poem.

Thoreau's passionate support of the freedom of the individual led him to be active in the antislavery movement; by the end of his life, he had moved from belief in passive resistance to open advocacy of violence against slavery.

EDGAR ALLAN POE Edgar Allan Poe (1809–1849) occupies a unique place in the U.S. imagination, both for his tales of the macabre and for his poems with their pulsating rhythms. Every schoolchild in the United States is likely to have read him. Stories such as "The Tell-Tale Heart," "The Cask of Amontillado," and "The Pit and The Pendulum" all share the Gothic horror of something terrible that is going to happen and cannot be prevented. In "The Tell-Tale Heart" (1843), an unnamed narrator murders an old man, not for money or from the heat of passion, but because he cannot abide the victim's pale blue eye. He dismembers the body and conceals the parts beneath the floorboards. A neighbor reports the victim's shrieking to the police, who then drop by to investigate. The narrator imagines that he hears his victim's heart beating louder and louder, until he is certain that the police must hear it too, and he confesses.

Poe wrote an article, "The Philosophy of Composition" (1846), in which he expounds his theory of good writing: length must be controlled, there must be a unity of effect,

and development of the narrative must be logical. He also asserts that the death of a beautiful woman is "unquestionably the most poetical topic in the world"; that is the subject of poems such as "Annabel Lee," "Ulalume," and "The Raven." "The Raven" is noted for its alliteration, assonance (repetition of vowel sounds), and rhyming within lines, not just at the ends of lines. The basic rhyme scheme is *trochaic octameter*; that is, eight feet, each with an accented syllable followed by an unaccented syllable. The stressed beginnings lend the lines their pounding rhythms. Following are the first two verses.

> And each separate dying ember wrought its ghost upon the
> floor.
> Eagerly I wished the morrow;—vainly I had sought to borrow
> From my books surcease of sorrow—sorrow for the lost
> Lenore—
> For the rare and radiant maiden whom the angels name
> Lenore—
> Nameless here for evermore.

The raven—an omen of misfortune—visits the narrator and quotes incessantly the word *nevermore*, which rhymes with *door* and *floor* and *Lenore* and *evermore*—and still more. The narrator implores the bird to bustle back into the bleakness beyond, but it takes up residence upon a "pallid bust of Pallas" (a pale statue of the Greek goddess of wisdom, Pallas Athena) and unfalteringly utters the one word in its vocabulary, nagging the narrator. The narrator does all the emotional work; the bird merely recites "nevermore" at intervals that accommodate the rhyme scheme.

Critic Harold Bloom condemns Poe's work: "Poe is a bad poet, a poor critic, and a dreadful prose stylist in his celebrated tales."[10] Yet he admits that "Poe is inescapable"—the most widely read U.S. writer—and he includes two of Poe's poems in his anthology *The Best Poems of the English Language*: "Israfel" and "The City in the Sea." *Inescapable.*

WALT WHITMAN Ideas of freedom, tolerance, and spiritual unity reached the height of poetic expression in the works of Walt Whitman (1819–1892), who many think of as the United States's first great poet. His first important collection of poems was published in 1855 under the title *Leaves of Grass*. From then until his death he produced edition after edition, retaining the title but adding new poems and revising old ones. The central theme of most of his work was the importance of the individual, reminding us of the essentially Romantic character of Whitman's mission. By describing the details of his own feelings and reactions, he communicated a sense of the unity of the human condition. Much of the time the sheer vitality and flow of his language helps make his experiences our own, although many of his earlier readers were horrified at the implied and explicit sexual content of some of his poems. Above all, Whitman was a fiery defender of freedom and democracy. His vision of the human race united with itself and with the universe seems to continue to have significance for our own time.

Whitman's **free verse** was quite new in his day. He wrote at the time of the Romantic poets in the United Kingdom, yet he poured out his ideas—one after another, related but distinct—in a fashion that ignored the need for regular meter and, often, even sentence structure. Still you catch glimpses of rhythms, as when he refers to grass as "the flag of my disposition, out of hopeful green stuff woven." (He did *not* write "woven out of hopeful green stuff.") It gushes out, but certainly not at random. Whitman divided "Song of Myself," the

main poem in his *Leaves of Grass*, into 52 numbered sections, some of which are reproduced here.

READING 17.30 WALT WHITMAN

From "Song of Myself," *Leaves of Grass* (1881–1882 edition)

1

I celebrate myself, and sing myself,
And what I assume you shall assume,
For every atom belonging to me as good belongs to you.
I loafe and invite my soul,
I lean and loafe at my ease observing a spear of summer
grass.
My tongue, every atom of my blood, form'd from this soil,
this air,
Born here of parents born here from parents the same, and
their parents the same,
I, now thirty-seven years old in perfect health begin,
Hoping to cease not till death.
Creeds and schools in abeyance,
Retiring back a while suffic'd at what they are, but never
forgotten,
I harbor for good or bad, I permit to speak at every hazard,
Nature without check with original energy.

2

Houses and rooms are full of perfumes, the shelves are
crowded with perfumes,
I breathe the fragrance myself and know it and like it,
The distillation would intoxicate me also, but I shall not let it.
The atmosphere is not a perfume, it has no taste of the
distillation, it is odorless,
It is for my mouth forever, I am in love with it,
I will go to the bank by the wood and become undisguised
and naked,
I am mad for it to be in contact with me.

. . .

6

A child said *What is the grass?* fetching it to me with full
hands;
How could I answer the child? I do not know what it is any
more than he.
I guess it must be the flag of my disposition, out of hopeful
green stuff woven.
Or I guess it is the handkerchief of the Lord,
A scented gift and remembrancer designedly dropt,
Bearing the owner's name someway in the corners, that we
may see and remark, and say *Whose?*
Or I guess the grass is itself a child, the produced babe of the
vegetation.

10. Harold Bloom, *The Best Poems of the English Language* (New York: Harper Perennial, 2004), 517.

Or I guess it is a uniform hieroglyphic,
And it means, Sprouting alike in broad zones and narrow zones,
Growing among black folks as among white,
Kanuck, Tuckahoe, Congressman, Cuff, I give them the same,
I receive them the same.
And now it seems to me the beautiful uncut hair of graves.
Tenderly will I use you curling grass,
It may be you transpire from the breasts of young men,
It may be if I had known them I would have loved them,
It may be you are from old people, or from offspring taken soon out of their mothers' laps,
And here you are the mothers' laps.

Leaves of Grass (6e), Boston, MA: James R. Osgood and Company, 1881/Philadelphia, PA: David McKay, 1882

EMILY DICKINSON Emily Dickinson (1830–1886) was as private in her life and work as Whitman was public in his. She remained single, which was not all that uncommon, but she also secluded herself in her house in Amherst, Massachusetts, with few acquaintances. Her grave is to be seen in Amherst; carved into the stone is "Called Back."

Only seven of her poems appeared in print during her lifetime; the first complete edition was published in 1958. Yet today, few American poets are better known or better loved. Her work tries to create a balance between passion and the prompting of reason, while her interest in psychological experience appeals to modern readers. Many, too, are attracted by her desire for a secure religious faith, equaled only by her stubborn skepticism.

Followers of Dickinson feel an intimacy with her and usually refer to her by her first name. Of her body of 1,800 works, the following two are considered to be among her greatest and address a recurrent theme: death. In reading Dickinson, you must picture the words—"a certain slant of light" breaking through glass in winter. And consider the **metaphor** and the **simile**: That slant of light *oppresses*—light as oppressing, the metaphor. And how does it oppress? Here is the simile: "like the Heft / of Cathedral Tunes." She uses short lines and rhyme. There is also **personification**: *He*—Death—"kindly stopped for me." The carriage held "Ourselves—/ And Immortality"; that is poetry.

NATHANIEL HAWTHORNE Nathaniel Hawthorne (1804–1864) was born in Salem, Massachusetts, and was descended from John Hathorne, a judge who had presided over the Salem witch trials at the end of the 17th century. Upturning his Calvinist and Puritan heritage, Hawthorne and his future wife joined Brook Farm in 1841, a Transcendentalist utopian community. The couple left after a year, but the experience gave birth to the novel *The Blithedale Romance* (1852).

READING 17.31 EMILY DICKINSON

Poems 258 (ca. 1861) and 712 (ca. 1863)

258

There's a certain Slant of light,
Winter Afternoons—
That oppresses, like the Heft
Of Cathedral Tunes—
Heavenly Hurt, it gives us—
We can find no scar,
But internal difference,
Where the Meanings are—
None may teach it—Any—
'Tis the Seal Despair
An imperial Affliction
Sent us of the Air—
When it comes, the Landscape listens—
Shadows—hold their breath—
When it goes, 'tis like the Distance
On the look of Death—

712

Because I could not stop for Death—
He kindly stopped for me—
The Carriage held but just Ourselves—
And Immortality.
We slowly drove—He knew no haste
And I had put away
My labor and my leisure too,
For His Civility—
We passed the School, where Children strove
At Recess—in the Ring—
We passed the Fields of Gazing Grain—
We passed the Setting Sun—
Or rather—He passed Us—
The Dews drew quivering and chill—
For only Gossamer, my Gown—
My Tippet—only Tulle—
We paused before a House that seemed
A Swelling of the Ground—
The Roof was scarcely visible—
The Cornice—in the Ground—
Since then—'tis Centuries—and yet
Feels shorter than the Day
I first surmised the Horses' Heads
Were toward Eternity—

Hawthorne is best known as the author of *The Scarlet Letter* (1850), which tells the story of a young woman, Hester

Prynne, who becomes pregnant through an adulterous affair with the Rev. Arthur Dimmesdale and bears a daughter, Pearl, who is something of a wild creature. Perhaps the sin of the mother is visited upon the child, along with the mother's punishment—ostracism and expulsion from society. Hester is compelled by her community to wear a red letter *A* upon her dress, a symbol that broadcasts her adultery to the world. The novel plays out with themes of sin, pride, guilt, vengeance—and love and passion.

In the passage below from chapter 2, Hester steps literally into the daylight from prison, carrying her three-month-old infant. If the townspeople, especially women who dress and think austerely, expect to see penitence written across her face and upon her breast, they will be disappointed with Hester's demeanor. The child squints in the sun.

HERMAN MELVILLE Herman Melville (1819–1891), like Hawthorne, dealt with profound moral issues. His subjects and style are very different, however. *Moby-Dick* (1851), his masterpiece, is often hailed as the greatest of all U.S. works of fiction. It shares with Goethe's *Faust* the theme of the search for truth and self-discovery, which Melville works out by using the metaphor of the New England whaling industry. Both Melville and Hawthorne were at their greatest when using uniquely North American settings and characters to shed light on universal human experience.

The novel begins with the narrator offering a name: "Call me Ishmael." Ishmael, in the Hebrew Bible, is the son of Abraham and the servant Hagar, who is cast with his mother into the wilderness when Sarah becomes pregnant with Isaac. Ishmael in *Moby-Dick* is sent into the "wilderness" of the ocean aboard a whaling vessel captained by Ahab, the

READING 17.32 NATHANIEL HAWTHORNE

From *The Scarlet Letter* (1850), chapter 2

When the young woman—the mother of this child—stood fully revealed before the crowd, it seemed to be her first impulse to clasp the infant closely to her bosom; not so much by an impulse of motherly affection, as that she might thereby conceal a certain token, which was wrought or fastened into her dress. In a moment, however, wisely judging that one token of her shame would but poorly serve to hide another, she took the baby on her arm, and with a burning blush, and yet a haughty smile, and a glance that would not be abashed, looked around at her townspeople and neighbours. On the breast of her gown, in fine red cloth, surrounded with an elaborate embroidery and fantastic flourishes of gold thread, appeared the letter A. It was so artistically done, and with so much fertility and gorgeous luxuriance of fancy, that it had all the effect of a last and fitting decoration to the apparel which she wore, and which was of a splendour in accordance with the taste of the age, but greatly beyond what was allowed by the sumptuary regulations of the colony.

The young woman was tall, with a figure of perfect elegance on a large scale. She had dark and abundant hair, so glossy that it threw off the sunshine with a gleam; and a face which, besides being beautiful from regularity of feature and richness of complexion, had the impressiveness belonging to a marked brow and deep black eyes. She was ladylike, too, after the manner of the feminine gentility of those days; characterised by a certain state and dignity, rather than by the delicate, evanescent, and indescribable grace which is now recognised as its indication. And never had Hester Prynne appeared more ladylike, in the antique interpretation of the term, than as she issued from the prison. Those who had before known her, and had expected to behold her dimmed and obscured by a disastrous cloud, were astonished, and even startled, to perceive how her

beauty shone out, and made a halo of the misfortune and ignominy in which she was enveloped. It may be true that, to a sensitive observer, there was some thing exquisitely painful in it. Her attire, which indeed, she had wrought for the occasion in prison, and had modelled much after her own fancy, seemed to express the attitude of her spirit, the desperate recklessness of her mood, by its wild and picturesque peculiarity. But the point which drew all eyes, and, as it were, transfigured the wearer—so that both men and women who had been familiarly acquainted with Hester Prynne were now impressed as if they beheld her for the first time—was that SCARLET LETTER, so fantastically embroidered and illuminated upon her bosom. It had the effect of a spell, taking her out of the ordinary relations with humanity, and enclosing her in a sphere by herself.

"She hath good skill at her needle, that's certain," remarked one of her female spectators; "but did ever a woman, before this brazen hussy, contrive such a way of showing it? Why, gossips, what is it but to laugh in the faces of our godly magistrates, and make a pride out of what they, worthy gentlemen, meant for a punishment?"

"It were well," muttered the most iron-visaged of the old dames, "if we stripped Madame Hester's rich gown off her dainty shoulders; and as for the red letter which she hath stitched so curiously, I'll bestow a rag of mine own rheumatic flannel to make a fitter one!"

"Oh, peace, neighbours—peace!" whispered their youngest companion; "do not let her hear you! Not a stitch in that embroidered letter but she has felt it in her heart."

The grim beadle now made a gesture with his staff. "Make way, good people—make way, in the King's name!" cried he. "Open a passage; and I promise ye, Mistress Prynne shall be set where man, woman, and child may have a fair sight of her brave apparel from this time till an hour past meridian. A blessing on the righteous colony of the Massachusetts, where iniquity is dragged out into the sunshine! Come along, Madame Hester, and show your scarlet letter in the market-place!"

namesake of an evil idol worshipper in the Book of 1 Kings. The plot of *Moby-Dick* follows Ahab's obsession with killing the white whale, who had maimed him on an earlier voyage. White is normally a symbol of innocence and purity; yet this whale kills the crew and sinks the ship, apparently with purposeful intent. Looking at it from the whale's perspective, of course, the whalers had initially attacked the whale—an innocent creature. We see humans tackling the immense forces of nature at a time when there was somewhat more of an even match between hunter and hunted (today's whaling vessels are larger and made of steel, and the harpoons are deadlier).

As the story concludes, Ahab thrusts his final harpoon at the whale, proclaiming "to the last I grapple with thee; from hell's heart I stab at thee; for hate's sake I spit my last breath at thee." As we see in the final moments of the novel, Ahab is caught up in a loop of rope from the harpoon, and the whale drags him down to his watery death. Only Ishmael survives. The story is about much more than how the thirst for revenge harms the vengeful. The whale has complex meanings, as does the "tyger" in William Blake's poem.

U.S. Art and Architecture

During the 19th century, U.S. artists turned, for the first time, from the tradition of portraiture to landscape and genre painting. From the 1830s to the 1860s, railways were laid all over the country, eventually linking the East and West. Rail travel overtook other forms of transportation; the movement of goods, for example, shifted from the waterways to railways. It became possible to observe the wonders and variety of the North American topography, no matter how far afield they might be. With the expansion of the rail system came the belief that the United States had a mandate to expand across the continent—that is was destiny. In U.S. history, this point of view is called *manifest destiny*; it is another aspect of nationalism.

11. Ahab laments that he will not be able to go down with his ship, the *Pequod*.

READING 17.33 HERMAN MELVILLE

From *Moby-Dick* (1851), chapter 135

From the ship's bows, nearly all the seamen now hung inactive; hammers, bits of plank, lances, and harpoons, mechanically retained in their hands, just as they had darted from their various employments; all their enchanted eyes intent upon the whale, which from side to side strangely vibrating his predestinating head, sent a broad band of overspreading semicircular foam before him as he rushed. Retribution, swift vengeance, eternal malice were in his whole aspect, and spite of all that mortal man could do, the solid white buttress of his forehead smote the ship's starboard bow, till men and timbers reeled. Some fell flat upon their faces. Like dislodged trucks, the heads of the harpooneers aloft shook on their bull-like necks. Through the breach, they heard the waters pour, as mountain torrents down a flume.

"The ship! The hearse!—the second hearse!" cried Ahab from the boat. . . .

Diving beneath the settling ship, the whale ran quivering along its keel; but turning under water, swiftly shot to the surface again, far off the other bow, but within a few yards of Ahab's boat, where, for a time, he lay quiescent.

"I turn my body from the sun. What ho, Tashtego! Let me hear thy hammer. Oh! ye three unsurrendered spires of mine; thou uncracked keel; and only god-bullied hull; thou firm deck, and haughty helm, and Pole-pointed prow,—death-glorious ship! must ye then perish, and without me?

Am I cut off from the last fond pride of meanest shipwrecked captains?[11] Oh, lonely death on lonely life! Oh, now I feel my topmost greatness lies in my topmost grief. Ho, ho! from all your furthest bounds, pour ye now in, ye bold billows of my whole foregone life, and top this one piled comber of my death! Towards thee I roll, thou all-destroying but unconquering whale; to the last I grapple with thee; from hell's heart I stab at thee; for hate's sake I spit my last breath at thee. Sink all coffins and all hearses to one common pool! and since neither can be mine, let me then tow to pieces, while still chasing thee, though tied to thee, thou damned whale! Thus, I give up the spear!"

The harpoon was darted; the stricken whale flew forward; with igniting velocity the line ran through the groove;—ran foul. Ahab stooped to clear it; he did clear it; but the flying turn caught him round the neck, and . . . he was shot out of the boat, ere the crew knew he was gone. Next instant, the heavy eye-splice in the rope's final end flew out of the stark-empty tub, knocked down an oarsman, and smiting the sea, disappeared in its depths.

For an instant, the tranced boat's crew stood still; then turned. "The ship? Great God, where is the ship?" Soon they through dim, bewildering mediums saw her sidelong fading phantom . . . only the uppermost masts out of water; while fixed by infatuation, or fidelity, or fate, to their once lofty perches, the pagan harpooneers still maintained their sinking lookouts on the sea. And now, concentric circles seized the lone boat itself, and all its crew, and each floating oar, and every lance-pole, and spinning, animate and inanimate, all round and round in one vortex, carried the smallest chip of the *Pequod* out of sight.

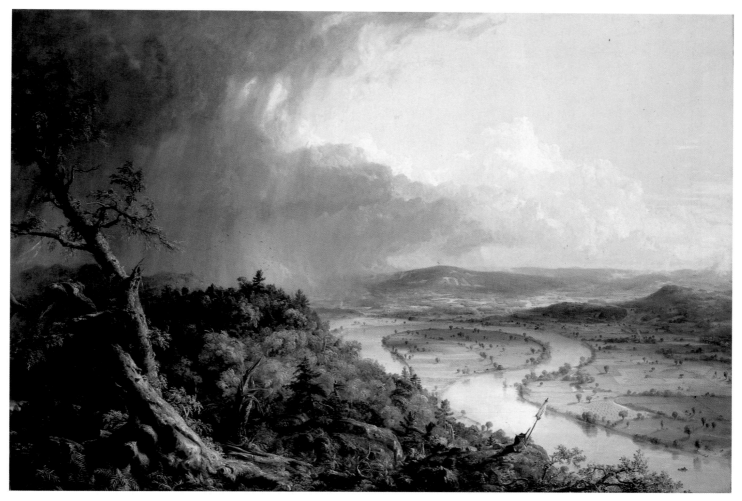

▲ **17.29** Thomas Cole, *View from Mount Holyoke, Northampton, Massachusetts, after a Thunderstorm—The Oxbow*, 1836. Oil on canvas, 51½" × 76" (130.8 × 193.0 cm). Metropolitan Museum of Art, New York, New York. This painting shows a meticulous care for detail that is never allowed to detract from the broad sweep of the view. Note the shape of the river, its characteristic turns known as the Oxbow.

HUDSON RIVER SCHOOL The earliest painters of landscapes that were intended to glorify nature are known collectively as the Hudson River school. The foundations of their style were laid by Thomas Cole (1801–1848), born in England, whose later paintings combine the effect of grandeur with an accurate rendering of detail based on close observation. His *View from Mount Holyoke, Northampton, Massachusetts, after a Thunderstorm—The Oxbow* (**Fig. 17.29**) is particularly representative work in its bird's-eye perspective, dramatic sky, and contrast between raw nature and human presence. The scene features an oxbow—a bend in the Connecticut River so called because of its resemblance to a U-shaped wooden yoke used for oxen. Half of the canvas space is devoted to the sky, whose storm clouds roll back to reveal bright white light. There is a contrast in mood, created both by the sky's shifting atmosphere and the juxtaposition of the still waters of the river, and the smooth lines of its banks, with the rough bark and snapped tree trunk of the dense hillside above it. The parallel lines of the river and the tree complement one another and reinforce their connection—almost as two aspects of a Janus-faced nature.

The painters of the Hudson River school were certainly influenced by U.S. Transcendentalist writers such as Thoreau, Whitman, and Emerson. In his "Thoughts on Art," Emerson reminds the artist who sets out to paint a nature scene that "landscape has a beauty for his eye because it expresses a thought which to him is good, and this because the same power which sees through his eyes is seen in that spectacle." Art was perceived as a way to connect the individual to the universal (to nature and the divine) and "an agent of moral and spiritual transformation."

The entirety of this philosophy is symbolized in Asher B. Durand's *Kindred Spirits* (**Fig. 17.30**), a self-portrait with his

▲ **17.30** Asher B. Durand, *Kindred Spirits*, 1849. Oil on canvas, 44″ × 36″ (111.8 × 91.4 cm). Crystal **Bridges Museum of American Art, Bentonville, Arkansas.** Durand places himself in the pristine forest with fellow painter Thomas Cole. Who are the "kindred spirits"?

▲ 17.31 George Caleb Bingham, *The Jolly Flatboatmen*, 1846. Oil on canvas, 38 1/8″ × 48 1/2″ (96.8 × 123.2 cm). **Private collection.** Bingham is best known for his genre paintings of daily life on the Western frontier.

comrade in spirit, Thomas Cole. Perched on an outcropping of rock that juts over a deep gorge, the two artists contemplate the glories of nature. The title of the work has a double meaning: it refers to the mutual goals and respect between the two artists as well as to their relationship to nature and the presence of the divine believed to be revealed therein.

U.S. GENRE PAINTING Visual parallels to Walt Whitman's poetry can be found in the work of U.S. genre painters whose subjects featured narrative scenes and portraits of ordinary people at work and play. George Caleb Bingham (1811–1879) focused a great deal of his career on painting life on the American frontier, notably along the Mississippi and Missouri Rivers. *The Jolly Flatboatmen* (**Fig. 17.31**), painted in 1846, was already becoming a scene of the past. Flatboats were used to carry freight along rivers and canals but, as we saw, by mid-century other modes of transportation were being developed and deployed to meet the demands of what was becoming a highly industrialized society. Paddle-wheel steamboats would replace the flatboat, a human-powered vessel. Perhaps Bingham's painting was intended to reflect this transition: the boat seems devoid of cargo and the men to be looking for ways to entertain each other and pass the time.

ARCHITECTURE Two works of architecture—the United States Capitol in Washington, DC, and Saint Patrick's Cathedral in New York City—offer case studies in the United States's assimilation of contemporary European philosophical thought and its embodiment in architecture. The ground-breaking ceremonies for these monuments took place 43 years apart (the Capitol in 1793 and Saint Patrick's in 1836), and the two buildings reflect changing contemporary European styles that span the Neo-Classicism of the Enlightenment era and the Gothic Revival of the Romantic era.

Thomas Jefferson, the third president of the United States, proposed a competition for a design for the Capitol

▲ **17.32 The United States Capitol. Washington, DC.** As of this writing, the U.S. Capitol Building has had 11 architects, beginning with Dr. William Thornton, who was appointed by President George Washington. The building is a study in bilateral symmetry: everything in the composition to either side of an actual or imaginary line is the same. The regularity and predictability of symmetry cannot help but conjure a sense of peace, calm, comfort, and order. Repetition and symmetry can imply rationality and decorum, tying the structure of the building to a certain symbolic ideal. There are also obvious references to Golden Age Greek architecture.

in 1792, and he was inclined toward French models. He had lived in Paris for a number of years, having served as a diplomat and then the minister to France, and was a great admirer of Neo-Classicism. The design of the Capitol would undergo many revisions, and its signature dome was not constructed until the mid-19th century (**Fig. 17.32**), but its relationship to Enlightenment architecture always remained central to the design concept.

Saint Patrick's Cathedral (**Fig. 17.33**), by contrast, was created in the Gothic Revival style, one of the dominant strains of architectural design associated with Romanticism. The architect, James Renwick, was also inspired by European travel and exposure to historic monuments, and designed several important build-

➤ **17.33 James Renwick, Saint Patrick's Cathedral, 1858–1878. New York, New York.** Saint Patrick's is a Gothic cathedral, with its pointed arches and walls of richly ornamented fenestration. However, it was built in the mid-1800s, and is an example of the Gothic Revival style.

ings in the style, including Grace Church in New York City (1843–1846) and the Smithsonian Institution Building (The Castle) (1847–1855). The Gothic Revival movement in architecture originated in the mid-19th century in England and can also be seen in the design of Westminster Palace (the Houses of Parliament) in London. The Gothic Revival was used to reinforce a philosophical separation between rationalism (and liberal values) linked to the Neo-Classical style on the one hand and spiritualism (Christian values) that was evoked by medieval traditions in architecture on the other.

PHOTOGRAPHY

Photography leapt into being at about the time when Courbet was testing the limits of representing reality with oil on canvas. The word *photography* is derived from Greek roots meaning "to write with light," and the scientific aspects of photography concern the ways in which images of objects are captured on a **photosensitive** surface, such as film, by light that passes through a **lens**. Today, of course, digital cameras translate the visual images that pass through the lens into bits of digital information, which are recorded onto an electronic storage device such as a disks or flash memory card, not on film.

Although the ability to record images with a camera seemed to burst onto the scene in the mid-19th century, some of the principles of photography can be traced back another 300 years, to the camera obscura, which was used by Renaissance artists to help them accurately portray depth, or perspective, on two-dimensional surfaces. The camera obscura could be a box or a room with a small hole that admitted light through one wall. The beam of light projected the outside scene upside down on a surface within the box. The artist then simply traced the scene to achieve proper perspective—to accurately imitate nature.

The next developments in photography concerned the search for photosensitive surfaces that could permanently affix images. These developments came by bits and pieces. In 1727, the German physicist Johann Heinrich Schulze discovered that silver salts had light-sensitive qualities, but he never tried to record natural images. In 1802, Thomas Wedgwood, son of the well-known English potter, reported his discovery that paper soaked in silver nitrate did take on projected images as a chemical reaction to light. However, the images were not permanent. But then in 1826, the Frenchman Joseph-Nicéphore Niépce invented **heliography**. *Bitumen*, or asphalt residue, was placed on a pewter plate to create a pho-

tosensitive surface. Niépce used a kind of camera obscura to expose the plate for several hours, and then he washed the plate in lavender oil. The pewter showed through where there had been little or no light, creating the image of the darker areas of the scene. The bitumen remained where the light had struck, leaving lighter values.

The **daguerreotype** resulted from a partnership formed in 1829 between Niépce and another Frenchman, Louis-Jacques-Mandé Daguerre. The daguerreotype used a thin sheet of chemically treated silver-plated copper, placed it in a camera obscura, and exposed it to a narrow beam of light. After exposure, the plate was treated chemically once more. Figure 17.34 shows the first successful daguerreotype, taken in 1837. In this work, called *Nature morte: Intérieur d'un cabinet de curiosités* (*Still Life: Cabinet of Curiosities*), Daguerre, a landscape painter, sensitively assembled deeply textured objects and sculptures. The contrasting light and dark values help create an illusion of depth. Remarkably clear images could be recorded. The first daguerreotypes required exposure to light from 5 to 40 minutes—quite some time for a human subject to sit still. But within a decade, the exposure time had been reduced to about 30 to 60 seconds, and the process had become so inexpensive that families could purchase two portraits for a quarter. Daguerreotype studios opened all across Europe and the United States, and families began to collect the rigid, stylized pictures that now seem to reflect days gone by.

The negative was invented in 1839 by British scientist William Henry Fox Talbot. Talbot found that sensitized paper, coated with emulsions, could be substituted for the copper plate of the daguerreotype. He would place an object, such as a sprig of a plant, on the paper and expose the arrangement to light. By the 1850s, photographic technology and the demands of a growing middle class came together to create a burgeoning business in portrait photography. Having a likeness of oneself was formerly reserved for the wealthy, who

> **17.34** Louis-Jacques-Mandé Daguerre, *Nature morte: Intérieur d'un cabinet de curiosités* (*Still Life: Cabinet of Curiosities*), 1837. Daguerreotype, 6½″ × 8″ (16.5 × 20.3 cm). Société Française de Photographie, Paris, France. This is the first successful daguerreotype.

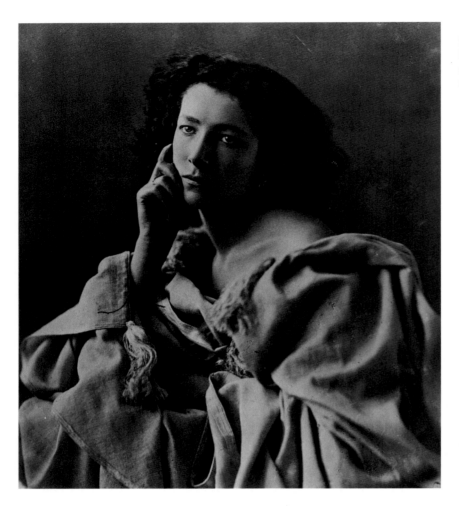

◀ **17.35** Nadar, *Sarah Bernhardt*, 1869. **Photograph. 8¼″ × 6⅜″ (21.4 × 17.2 cm). Bibliothèque Nationale, Paris, France.** The photographer had the actress assume a dreamlike pose.

could afford to commission painters. Photography became the democratic equalizer. The rich, the famous, and average bourgeois citizens could now become memorable, could now make their presence known long after their flesh had rejoined the elements from which it was composed.

Photographic studios spread like wildfire, and many photographers, such as Julia Margaret Cameron and Gaspard-Félix Tournachon—called "Nadar"—vied for famous clientele. Cameron's impressive portfolio included portraits of Charles Dickens; Alfred, Lord Tennyson; and Henry Wadsworth Longfellow. Nadar's 1859 portrait of the actress Sarah Bernhardt (**Fig. 17.35**) was printed from a glass plate, which could be used several times to create sharp copies. Early portrait photographers such as Nadar imitated both nature and

the arts, using costumes and props that recalled Romantic paintings or sculpted busts caressed by flowing drapery. The photograph is soft and smoothly textured, with middle-range values predominating; Bernhardt is sensitively portrayed as pensive and intelligent.

Prior to the 19th century, there were few illustrations in newspapers and magazines. Those that did appear were usually engravings or drawings. Photography revolutionized the capacity of the news media to bring realistic representations of important events before the eyes of the public. Pioneers such as Mathew Brady and Alexander Gardner first used the camera to record major historical events such as the U.S. Civil War. The photographers and their crews trudged down the roads alongside the soldiers, horses drawing their equip-

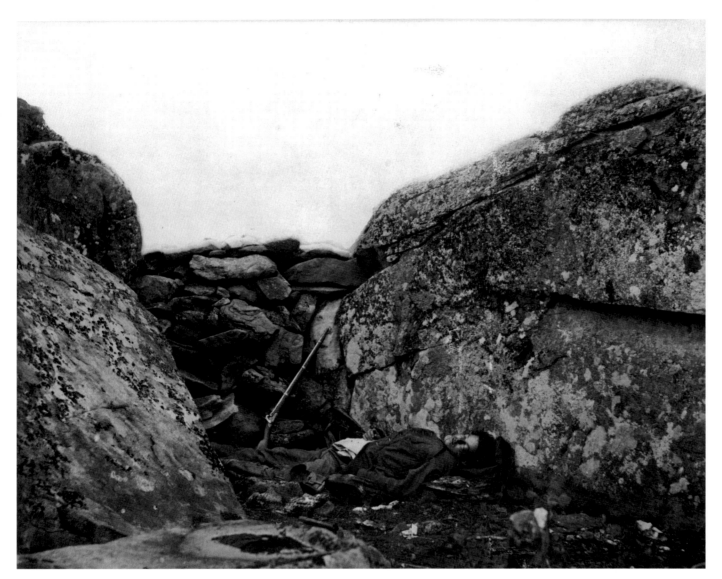

▲ **17.36** Alexander Gardner, *Home of a Rebel Sharpshooter, Gettysburg*, July 1863. Glass, wet collodion, 7″ × 9″ (17.8 × 22.9 cm). Library of Congress Prints and Photographs Division, Washington, DC.

ment behind them in wagons referred to by the soldiers as "whatsits."

Equipment available to Brady and Gardner did not allow them to capture candid scenes, so there is no direct record of the bloody to-and-fro of the battle lines, no photographic record of each lunge and parry. Instead, they brought home photographs of officers and of life in the camps along the lines. Although battle scenes would not hold still for Gardner's cameras, the litter of death and devastation caused by the war and pictured in Gardner's *Home of a Rebel Sharpshooter, Gettysburg* (**Fig. 17.36**) most certainly did. Ever since, graphic images of distant conflicts have been brought into the homes of the citizenry, often influencing public support for a war in one direction or another.

GLOSSARY

Adagio (p. 632) Slow, as in a passage or piece of music.

Antithesis (p. 600) An idea or pattern of behavior that is the direct opposite of another (the **thesis**).

Bel canto (p. 634) An Italian term for opera that is defined by "beautiful singing."

Daguerreotype (p. 653) A 19th-century form of photography in which a thin sheet of chemically treated, silver-plated copper is placed in a camera obscura and exposed to a narrow beam of light.

Dies Irae (p. 631) A medieval Latin hymn describing Judgment Day, used in some Roman Catholic requiems for the dead. (Latin for "day of wrath.")

Free love (p. 627) A social movement that originally sought to separate the state from matters such as sex, marriage, birth control, and adultery; more generally, sexual activity without legal sanction.

Free verse (p. 645) Poetry without rhyme or a consistent meter pattern.

Gesamtkunstwerk (p. 635) An artistic creation that combines several mediums, such as music, drama, dance, and spectacle, as in the operas of Wagner. (German for "total artwork.")

Gothic novel (p. 627) A kind of novel that shares Romantic roots with tales of horror, as in the novels *Frankenstein* and *Dracula*.

Heliography (p. 653) A 19th-century form of photography in which bitumen, or asphalt residue, is placed on a pewter plate to render the plate sensitive to light.

Intermezzo (p. 632) In music, an interlude.

Leitmotiv (p. 635) A leading motif; a recurring theme or idea in a literary, artistic, or musical work.

Lens (p. 653) A transparent object with two opposite surfaces, at least one of which is curved, used to magnify or focus rays of light.

Lieder (p. 631) German art songs. (The German word for "songs" [singular *lied*]).

Mazurka (p. 633) A traditional Polish dance similar to a polka.

Natural selection (p. 602) The means by which organisms with genetic characteristics and traits that make them better adjusted to their environment tend to survive, reach maturity, reproduce, and increase in number, such that they are more likely to transmit those adaptive traits to future generations.

Neo-Classicism (p. 604) An 18th-century revival of Classical Greek and Roman art and architectural styles, generally characterized by simplicity and straight lines.

Nocturne (p. 632) A short piano piece in which a melancholy melody floats over a murmuring accompaniment.

Photosensitive (p. 653) Responsive to light.

Polonaise (p. 633) A traditional Polish dance that is marchlike and stately.

Prelude (p. 632) In music, a brief instrumental composition; a piece that precedes a more important movement.

Realism (p. 636) A movement in art directed toward the accurate representation of real, existing things.

Romanticism (p. 608) An intellectual and artistic movement that began in Europe in the late 18th century and emphasized rejection of Classical (and Neo-Classical) forms and attitudes, interest in nature, the individual's emotions and imagination, and revolt against social and political rules and traditions.

Scherzo (p. 630) A fast-moving, lighthearted piece of music. (Italian for "joke" or "monkey business.")

Sturm und Drang (p. 617) German for "storm and stress"; the German manifestation of Romanticism, which emphasized originality, imagination, and emotion.

Synthesis (p. 600) In Hegelian philosophy, the reconciliation of mutually exclusive propositions—the thesis and the antithesis; more generally, the combining of separate substances or ideas into a single unified object or concept.

Thesis (p. 600) A proposition that is stated for consideration.

Tonality (p. 636) The sum of melodic and harmonic relationships between the tones of a scale or a musical system.

Transcendentalism (p. 642) A 19th century New England literary movement that sought the divine in nature. More generally, the view that there is an order of truth that goes beyond what we can perceive by means of the senses and that it unites the world.

Language and Literature

- William Blake wrote Romantic poetry from the late 1700s through the early 1800s, publishing *Songs of Experience*, with the poem "The Tyger," in 1794.
- Wordsworth wrote his "Preface to Lyrical Ballads," explaining some principles of Romantic poetry, in 1800; *Lyrical Ballads* also contained Coleridge's *Rime of the Ancient Mariner*.
- Goethe published the first part of *Faust* in 1808.
- English Romantic poets working in the early 19th century included Byron, Percy Bysshe Shelley, and Keats.
- English novelists in the early 19th century included Austen (e.g., *Pride and Prejudice*) and Mary Wollstonecraft Shelley (*Frankenstein*).
- Early- and mid-19th-century U.S. poets included Poe, Whitman, and Dickinson.
- Emerson wrote "Self-Reliance" in 1841; Thoreau published *Walden* in 1854.
- U.S. novelists included Hawthorne (*The Scarlet Letter*) and Melville (*Moby-Dick*).
- Realist writers included Flaubert (*Madame Bovary*), Balzac (*Le Père Goriot*), Sand (*Lélia*), Tolstoy (*War and Peace*), and Dickens (*A Tale of Two Cities, Hard Times, Oliver Twist*).
- Hugo published *Les Misérables* in 1862.

Art, Architecture, and Music

- William Blake worked as an illustrator from the late 1700s through the early 1800s and illustrated his own poetry.
- Ground was broken for the Neo-Classical U.S. Capitol in 1793.
- Beethoven composed his Romantic symphonies and other works in the late 1700s and early 1800s.
- Other Romantic composers working in the first half of the 19th century included Berlioz, Schubert, Brahms, Bruckner, and Chopin.
- Bel canto opera developed during the Romantic era.
- The operas of Verdi showed a new concern for dramatic and psychological truth.
- Goya etched *The Sleep of Reason Produces Monsters* in 1798–1798 and painted politically oriented works, including *The Third of May, 1808*, in the 1800s.
- David painted *The Consecration of Emperor Napoleon I and Coronation of the Empress Josephine* in 1806–1807.
- Ingres painted *La Grande Odalisque* in 1814.
- Géricault painted *The Raft of the Medusa* in 1818.
- Delacroix painted the politically charged *Massacre at Chios* in 1824 and *The Death of Sardanapalus* in 1826.
- Daumier and Courbet produced art in the Realist style beginning in the 1830s.
- Turner painted *The Slave Ship* in 1840.
- U.S. painters of the Hudson River school included Cole (*The Oxbow*) and Durand (*Kindred Spirits*).
- Wagner composed *The Ring of the Nibelung* between 1851 and 1874.
- Haussmann began the modernization of Paris in 1853.
- Saint Patrick's Cathedral was constructed in New York between 1858 and 1878.

Philosophy and Religion

- Romanticism as a movement began in the 1790s.
- Hegel stressed the ability of art to reconcile and make sense of opposites.
- Schopenhauer published *The World as Will and Idea* in 1819.
- Transcendentalism developed in the United States in the early 19th century.
- Marx and Engels published *The Communist Manifesto* in 1848.

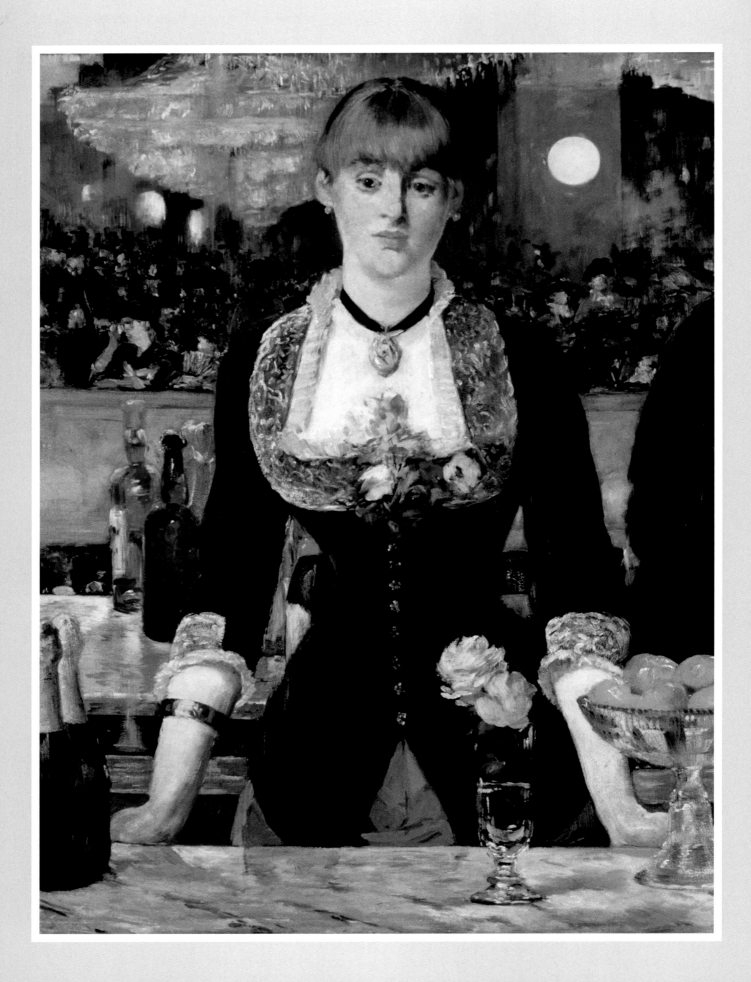

Toward the Modern Era: 1870–1914

<div style="text-align:right">18</div>

PREVIEW

In 1863, the poet and art critic Charles Baudelaire published "The Painter of Modern Life," a groundbreaking treatise on art, beauty, fashion, and the role of the artist in modern times. That was the same year that the painter Édouard Manet presented his own groundbreaking work *Le Déjeuner sur l'Herbe*, shocking the critics and public with an otherwise ordinary Parisian picnic scene in which one of the guests has removed all of her clothes. The coincidence was an important one—for art and for friendship. Baudelaire's essay presaged Manet's artistic message; the poet's definition of modernity—of being of one's time—found its visual counterpart in the work of the painter. The two men were close friends for over a decade.

In 1866, the writer Émile Zola published an article on Manet defending the painter against harsh criticism; a year later he wrote again, in support of Manet's bold decision to create a private exhibition of his own outside the Exposition Universelle in Paris. In 1868, Manet painted a portrait of Zola in a gesture of gratitude. The two developed a lasting, loyal friendship.

Baudelaire, Manet, and Zola form a fascinating triangle, at the center of which is the concept of *modernity*. In "The Painter of Modern Life," Baudelaire defines modernity as "the transitory, the fugitive," and the role of the artist as that of an outsider, a flâneur, or a "passionate spectator." The artist, he says, is to be "a man of the crowd" who faded into the crowd, observing everything unnoticed and hastily sketching the mood and social conditions of his time. The "modern life" that the painter passively records, Baudelaire tells us, is one of desires (what he called artificial desires) satiated by commodities, such as fashion, cosmetics, pleasure, and entertainment (including prostitution).

These desires drive Zola's *Au Bonheur des Dames*, a novel about material consumption and what art historian Ruth E. Iskin calls the "selling, seduction, and soliciting of the eye" at the center of a new phenomenon in 19th-century France—the department store. Desire and consumption, seduction and selling—according to Iskin—are also at the center of *A Bar at the Folies-Bergère* (Figs. 18.1 and 18.5), Manet's painting of the legendary Parisian music hall. Her compelling argument derives from an examination of what she labels the historically specific discourses of mass consumption, the changing roles of women, and the development of the modern crowd or public. Zola's novel, first in serial form, and Manet's painting appeared in the same year—1882.

In Manet's painting, a man approaches a bar arrayed with consumables, displayed to titillate the eye as much as does the attractively attired barmaid or, as some have identified her, *marchande* (salesgirl). The large mirror behind her reflects the customer, a dandy bourgeois in a top hat, but also reflects a quickly sketched crowd of spectators—consumers of entertainment. The barmaid's gaze is blank, disinterested, as she seems to look past her customer in our direction. We too are spectators seduced by her spell and her wares.

◄ **18.1** Édouard Manet, *A Bar at the Folies-Bergère* (detail), 1882. Oil on canvas, 37³/₄" × 51" (96 × 130 cm). Courtauld Institute and Galleries, London, United Kingdom.

THE BIRTH OF THE MODERN ERA

Distance lends perspective in human experience. The more intimately we are affected by events, the more difficult it is to evaluate them objectively. Looking back, we can see that the world in which we live—with its great hopes and fears—began to take its present political shape in 1870, with Otto von Bismarck's (1815—1898) creation of the German Empire—the incorporation of smaller German states into Prussia through a series of brief wars. As minister president of a unified Germany, he warred with Denmark, Austria, and France to assure his new nation's dominance over continental Europe. But he then worked to engineer a balance of power in Europe, which managed to keep the peace from the early 1870s through 1890, when he was dismissed from office.

Social and Political Developments

Bismarck was a social and political conservative who abhorred the growth of the socialist movement in Europe, including the development of his country's Social Democratic Party. Therefore, it might strike you as quite strange that Bismarck also promoted the development of what we would now call the welfare state. He instituted old-age pensions (the forerunner of Social Security in the United States), government-sponsored medical care, unemployment insurance, and accident insurance. The socialists voted against all of these programs.

The British Empire reached its zenith in the 1880s (despite its loss of a few American colonies toward the end of the 18th century), with colonies stretching across the globe. It became said that "the sun never set on the British Empire." Other European nations, especially France, also had colonies, and Germany under Bismarck took some small steps in that direction as well, all of which heightened competition and tensions between Germany, the United Kingdom, and France. Despite hundreds of years of warfare, the United Kingdom and France signed a treaty designed, essentially, to protect themselves from this troublesome emerging Germany, and both sides gathered additional allies. The jockeying for position and power would eventually lead to World War I in 1914, but between the Franco-Prussian War of 1870—1871 and that time, Europe remained mostly at peace.

The Spirit of the Age

By the last quarter of the 19th century, there was a widespread if somewhat unfocused feeling in Europe that life would not and could not continue as it had been. Social and political revolutions had replaced the old monarchies with relatively more equitable forms of government. Scientific and technological developments had affected millions of ordinary people, bringing them improved standards of living and a more congenial existence. As a result, a new mood of cheerfulness began to make itself felt in the great cities of Europe, especially for those with resources; in Paris, for example, the period became known as the **belle époque** ("beautiful age").

UNCERTAIN TIMES For other people, perhaps most people, the belle époque did not really exist. Despite peace, most of the leading countries in Europe were maintaining huge armies and introducing compulsory military service. Long before 1914,

Toward the Modern Era 1870—1914

1870 CE	1885 CE	1900 CE	1906 CE	1914 CE

Bismarck creates the German Empire in 1870	International League of Socialist Parties is founded	Marconi sends first transatlantic message via wireless telegraph in 1901	Social insurance and parliamentary reform are enacted in England
Bismarck uses balance-of-power diplomacy to keep peace in Europe	Russia industrializes	Wright brothers make first powered flight in 1903	Ford introduces the Model T automobile
Germans found the Social Democratic Party	French Dreyfus Affair reveals anti-Semitism and leads to separation of church and state	Pankhurst founds Women's Social and Political Union in 1903	Ford produces automobiles via the assembly line
Bell invents the telephone in 1876	Roentgen discovers X-rays	Russo-Japanese War is fought in 1904	Revolution in China establishes republic
Edison patents the light bulb in 1879	Marconi invents wireless telegraphy in 1895	First revolution breaks out in Russia in 1905	Rutherford formulates "planetary model" of the atom
Pasteur and Koch prove the germ theory of disease	Second Boer War leads to British control of all South Africa and tension with Germany	Einstein formulates theory of relativity in 1905	World War I begins in 1914
Social insurance is initiated in Germany		First motion-picture theater opens in Pittsburgh in 1905	

many people thus assumed that sooner or later war would break out—a belief that did not help to avert it. The growth of democratic systems of government had taught increasing numbers of people that they had a right to share in the material benefits made possible by the Industrial Revolution. In the richest countries in Europe—France, England, and Germany—the poor compared their lot to that of the more affluent. Simultaneously, in the poorer European countries, including Ireland, Spain, Portugal, and almost all of Eastern Europe, people looked with envy—and resentment—upon their wealthier neighbors.

MIGRATION TO THE UNITED STATES The disparity in wealth between classes and between nations led to the greatest period of European migration to the United States, where it was rumored—fancifully, to be sure—that the streets were paved with gold. In 1907, the peak year, more than 1.25 million European immigrants came to the United States, most of them from Southern and Eastern Europe. Between 1870 and 1914, millions upon millions of Europeans came. They came by ship, in crowded holds (steerage was the least expensive and most densely populated accommodations); and on some voyages, many passengers became sick and died. On one transatlantic voyage, the photographer Alfred Stieglitz was struck by the chance grouping of people he immortalized in a photograph

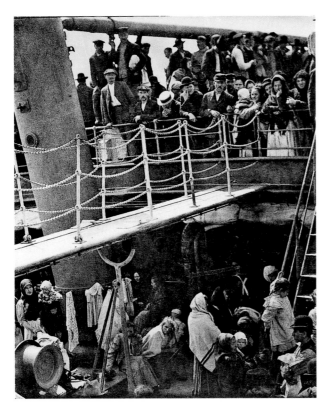

▲ **18.2** Alfred Stieglitz, *The Steerage*, 1907. Photogravure, 13″ × 10″ (33 × 25.4 cm). Library of Congress, Prints and Photographs Division, Washington, DC. The photographer wrote, "I stood spellbound for a while, looking and looking. Could I photograph what I felt, looking and looking and still looking?"

titled *The Steerage* (**Fig. 18.2**), taken aboard the *Kaiser Wilhelm II*. He rushed to his cabin for his camera, hoping that the upper and lower masses of humanity would maintain their balanced relationships to one another, to the drawbridge that divides the scene, to the stairway, the funnel, and the horizontal beam of the mast. In the steerage, the "huddled masses" seem suspended in limbo by machinery and by symbolic as well as actual bridges. Yet the tenacious human spirit which impelled these people to cross the ocean may best be symbolized by the jaunty patch of light that strikes the straw hat of one passenger on the upper deck.

MORE UNCERTAINTIES There was certainly good news: Medical advances reduced the rate of infant mortality, cured hitherto fatal diseases, and prolonged life expectancy. But as a result, populations in most of Europe soared to record levels, creating shortages of food and housing. New forms of transport and industrial processes brought vast numbers of workers to the cities. New electronic forms of communication were making it possible for people to communicate instantaneously over vast distances. But looking at it from another perspective, the lives of many people were uprooted, and their daily existence became anonymous and impersonal.

The growth of a world financial market, primarily dependent on the value of gold, gave new power to the forces of big business. In turn, the rise of capitalism, fiercely opposed by the growing forces of socialism, provoked the development of trade unions to protect the workers' interests. Fortunes were being made and people wanted what they saw as their share.

At a time when so many political and social forces were pitted against one another, there seemed to be no certainty on which to fall back. Religion had lost its hold over intellectual circles by the 18th century, and by the end of the 19th century, strong religious faith and its manifestation in church attendance began to fall drastically at all levels of society. The newly developing fields of anthropology and psychology, far from replacing religion, provided fresh controversy with their radically different explanations of human life and behavior.

FRIEDRICH WILHELM NIETZSCHE In a state of such potential explosiveness, a collapse of the fabric of European civilization seemed likely. Events were moving so rapidly that few thinkers were able to detach themselves from their times and develop a philosophical basis for dealing with them. One of the few who did was Friedrich Wilhelm Nietzsche (1844–1900), whose ominous diagnosis of the state of Western civilization in *Thus Spoke Zarathustra* (1883–1892) and other works led him to propose drastic remedies.

For Nietzsche, Christianity was a slave religion, extolling feeble virtues such as compassion and self-sacrifice: the greatest curse of Western civilization. He viewed democracy as little better, calling it the rule of the mediocre masses. The only valid life force, according to Nietzsche, is the "will to power"—that energy that casts off all moral restraints in its pursuit of independence. Anything that contributes to power is good. Society can only improve if strong and bold individuals, who can

Imperialism

The transition from the world of the Late Middle Ages to the dawn of the modern era was largely the result of European expansion overseas and the economic developments that it brought. By the mid-19th century, the European search for new territories in which to engage in trade had solidified into a competitive drive to conquer and colonize them. Imperialism became one of the chief motivating forces in 19th-century politics and culture.

Imperialism arose in response to economic, political, and psychological goals. Economically, conquests of overseas territories and peoples provided sources of raw materials and abundant cheap labor. As the capitalist system grew, the colonies became centers for investment and thereby absorbed accumulating surplus capital—a point made by Lenin, one of the fiercest opponents of both capitalism and imperialism.

Politically, imperialism provided a means whereby the leading European powers could continue their rivalries outside Europe. At the beginning of the 19th century, the delegates at the Congress of Vienna in 1815 had created a political balance of power under which no European nation was able to dominate the others. By conquering more and richer territory in Africa and Asia, however, Western European colonizers could try to surpass one another.

No less important were the psychological factors inherent in nationalism. National pride became a powerful factor in determining political and military decisions. As European possessions abroad began to accumulate, the conquest of a well-located port or island could open up new territories, allow a nation to hold on to territories, or effectively block a rival nation. At the patriot's level, heroic achievement abroad, particularly military prowess, brought personal glory and offered avenues of advancement to the less advantaged.

At least some of the drive for imperialism also rested on the claim—expressed by many imperialists and surely believed by some—that colonizers were spreading civilization, in its European form at least. Missionaries accompanied most colonial expeditions, and colonial governments tried to outlaw those local customs that appalled their administrators: cannibalism, child marriage, nakedness. While in some cases the physical conditions and education of the local populations improved, colonizers nevertheless resisted calls for self-government.

The eventual result was that the colonized peoples slowly began to fight for their own independence. In the course of the 20th century, struggles for independence reversed colonialism. In the process, European dominance gave way to a global culture that links the destinies of all parts of the world. Technological changes, weapons of mass destruction, and rapid progress in electronic communication have all helped build a global environment in which imperialism is now seen as arrogant and self-serving.

survive the loss of illusions, by the free assertion of the will establish new values of nobility and goodness. Nietzsche called these superior individuals **Übermenschen** (literally "supermen"). Like Schopenhauer in the early 19th century (see Chapter 17), Nietzsche is valuable principally for the way in which he anticipated future ideas rather than for being the leader of a movement himself. Unfortunately, his concepts were later taken up and distorted by many would-be world rulers of the 20th century, most notoriously the leaders of Nazi Germany.

The Women's Movement

The rise of new political movements during the 19th century, of which socialism was perhaps the most prominent, drew upon a section of society new to political activism: women. Indeed, the first use of the term *feminism* dates to this period. Women campaigned for a wide variety of causes—divorce reform, property ownership—but the issue that united most women across barriers of class or nationality was suffrage: the right to vote.

British women could vote in local elections from 1868, and they could vote for local governments in Finland and Sweden in the 1870s. In the 1890s, some U.S. states granted women the vote, but only single women who owned property. By the eve of World War I, with the exception of Finland, no Western country (including the United States) allowed women to vote in national elections.

In France, feminists began to organize protest groups, refusing to pay taxes and overturning voting urns. The best known British group was the Women's Social and Political Union, founded in 1903 by Emmeline Pankhurst. Pankhurst and her daughters believed that only direct, violent action would secure women the vote. Her organization campaigned against political candidates who were opposed to women's suffrage. When leading politicians, including British prime minister Herbert Asquith and his minister David Lloyd George, refused to back women's right to vote, her supporters smashed the windows of London's most exclusive shops, assaulted leading politicians, and chained themselves to the railings of official buildings. When sent to prison, they staged hunger strikes (only to be gruesomely force-fed). One of their activists, Emily Wilding Davison, threw herself in front of the king's horse on Derby day, 1913, and was trampled to death. Only after World War I, in 1918, did the suffragettes

in Britain win the right to vote. U.S. women voted in national elections for the first time in 1920.

The Arts

Cut adrift from the security of religion or philosophy, the arts responded to the restless mood of the times by searching for new subjects and styles, which often challenged principles that had been accepted for centuries. In music, traditional concepts of harmony and rhythm were first radically extended and then, by some composers at least, discarded. In literature, new areas of experience were explored, including the impact of the subconscious on human behavior, and traditional attitudes like the role of women were examined afresh. In the visual arts, movement followed movement in rapid succession. The formative years of the modern world were certainly not dull with respect to the arts.

THE VISUAL ARTS

Something of the feverish activity in the visual arts during this period can be gauged by the sheer number of movements and styles that followed one another in rapid succession: Impressionism, Postimpressionism, Fauvism, Expressionism, Cubism, and Futurism, culminating at about the beginning of World War I. But we begin with traditional Academic art.

Academic Art

Ironically, the style of painting that had the least impact on the development of modernism was Academic art, so called because its style and subject matter were derived from conventions established by the Académie Royale de Peinture et de Sculpture (the Royal Academy of Painting and Sculpture) in Paris, established in 1648. Artists educated in the academy painted traditional subjects (history, nudes, mythological subjects) rendered with precise drawing and highly polished surfaces. The academy maintained

a firm grip on artistic production for more than two centuries and pretty much controlled the art scene by sponsoring annual juried exhibitions (salons) that featured only the work of artists whose style complied with academy standards. Many of these artists were followers rather than innovators, and because of the pedantic nature of their work, they often never rose above the level of mediocrity.

One of the more popular and accomplished Academic painters was William-Adolphe Bouguereau (1825–1905). Included among his oeuvre are religious and historical paintings in a grand Classical manner, although he is most famous for his meticulously painted nudes and mythological subjects. *Nymphs and Satyr* (**Fig. 18.3**) is nearly photographic in its refined technique and attention to detail. Four sprightly and sensuous wood nymphs corral a hesitant satyr and tug him into the water. Their innocent playfulness would have

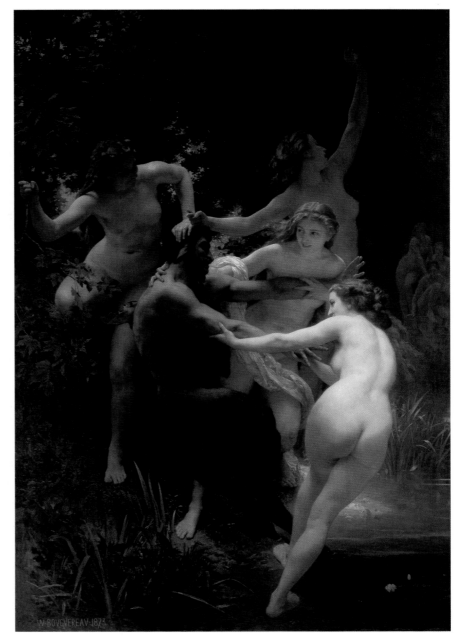

➤ **18.3** Adolphe Bouguereau, *Nymphs and Satyr*, 1873. Oil on canvas, 102³/₈″ × 70⁷/₈″ (260 × 179.8 cm). Sterling and Francine Clark Art Institute, Williamstown, Massachusetts. Bouguereau's work, though accomplished, epitomized the traditional standards that sparked rebellion among younger artists.

appealed to the French man on the street, although the saccharine character of the subject matter and the extreme light-handedness with which the work was painted served only as a model against which the new wave of painters rebelled.

From Realism Toward Impressionism

ÉDOUARD MANET Édouard Manet (1832–1883) was arguably the most influential painter to emerge in Paris between the movements of Realism and Impressionism, bridging the two styles and, with his subjects, soundly rejecting the conventions of the French Academy. Ten years before Bouguereau painted *Nymphs and Satyr*, Manet exhibited a work that would become legend in the history of modern art—*Le Déjeuner sur l'Herbe* (Luncheon on the Grass) (**Fig. 18.4**)—in what was called the Salon des Refusés (an alternative exhibition for artists who were rejected from the academy's official salon). To say that the painting raised a stir is an understatement; it met with disapproval from critics and the public alike. Why? It was the shock of the new.

The juxtaposition of nude women and clothed men was *not* new; the Venetian artists of the Renaissance had painted such compositions before. Also, Manet lifted the poses and placement of his figural group from an engraving after a painting by Raphael. Beyond these deliberate, perhaps tongue-in-cheek references, everything else *was* new, radically new. A Venetian pastoral scene by Titian would have featured mythological women—for whom nudity was standard—juxtaposed with courtier-type men playing musical instruments or waxing philosophical. But in lieu of these personages, which had become the standard fare of the Academic artists, Manet offered ordinary—identifiable—mortals from the French middle class on a picnic in the park. Manet's brother Eugène extends a pointed finger in a gesture of conversation with a man identified by some historians as a sculptor friend

▼ **18.4** Édouard Manet, *Le Déjeuner sur l'Herbe* (Luncheon on the Grass), 1863. Oil on canvas, 93⅞" × 104" (208 × 264.5 cm). Musée d'Orsay, Paris, France. There are many mysteries about this painting: What are the women doing there? Why are they undressed? What, exactly, is the meaning of the expression on the face of the nude woman?

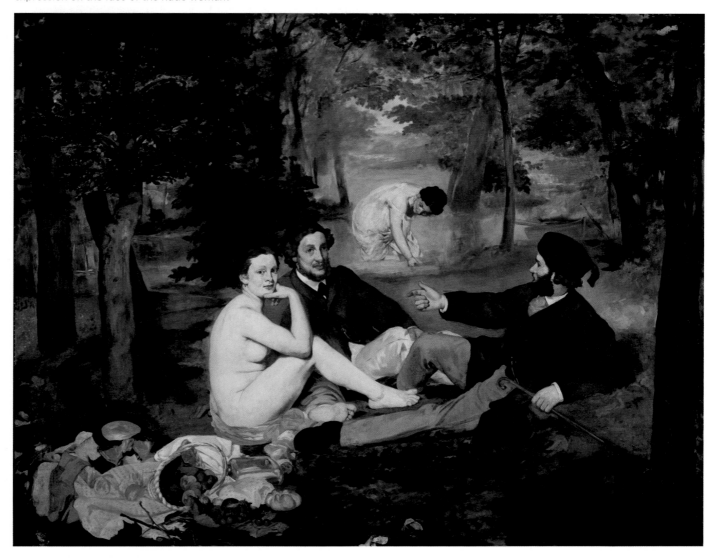

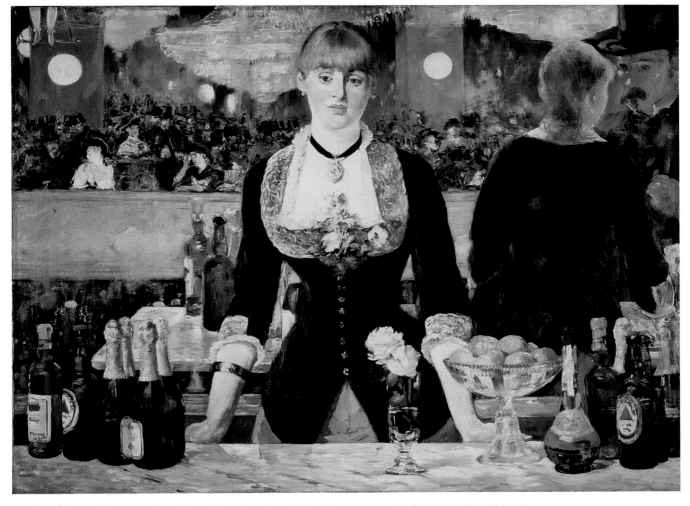

▲ **18.5** Édouard Manet, *A Bar at the Folies-Bergère*, 1882. Oil on canvas, 37 ³/₄" × 51" (96 × 130 cm). **Courtauld Institute and Galleries, London, United Kingdom.** The barmaid is inaccurately reflected in the mirror. Why do you think the artist chose to paint her this way? What "consumables" do you find in the painting?

of the artist; the seated nude who engages the viewer with her gaze is Victorine Meurent, a model who appears in several of Manet's paintings. Her eyes meet the viewer's and the viewer is transformed into voyeur, an unsettling relationship to be sure. Perhaps even more unsettling were the unanswered questions that likely ran through the minds of the audience: Why has the woman removed her clothes? Why are the men uninterested in her nudity? Has she caught me staring?

Manet's painting technique was also unconventional, building on the innovations of Realist artists. In lieu of the smooth, highly polished technique that was the signature of the Academic style, Manet applied barely modeled pigment in thick, broad brushstrokes; he prioritized the physical presence of the materials and evidence of the painting process over illusionism. Manet also introduced a luminous quality in his canvases by reversing painting methods developed by Renaissance artists: rather than beginning with a dark underpainting and adding highlights in successive layers, Manet began with a white background to which he added darker tones. It is this luminosity that paved the way for the Impressionists. Modernism was on its way.

Déjeuner was not Manet's only subversive composition. In *Olympia* (see **Fig. 18.7** in the nearby Compare + Contrast

feature) he also sardonically referenced Old Masters as the role models of the Academically trained artist. The painting he "revised" this time was Titian's *Venus of Urbino*, replacing the reclining nude in the Venetian work with another "goddess of love"—a prostitute (Olympia was a contemporary name for women who sold sexual favors in the red-light districts of Paris)—and the sleeping dog at her feet, which symbolized fidelity, with a black cat. Just as the seated nude in *Dejeuner* ruffled the public's feathers, the prostitute in *Olympia* created her own outcry. She, too, stares directly out of the canvas, creating the uncomfortable impression that a transaction is being made between her and the viewer-as-client. Gone are the Old Master delicate glazes that create the illusion of supple, glowing flesh. Manet replaces them with a pasty white pigment that a critic described as "the tint of a cadaver in a morgue." The representation of a contemporary prostitute, the raw application of paint, and the juxtaposition of races (the maid who presents Olympia with flowers from a potential client is black) comprised a recipe for scandal. Yet a quarter of a century after *Olympia* was painted, only 17 years after his death, Manet's works were shown at the prestigious Louvre Museum.

We may respond to Manet's *A Bar at the Folies-Bergère* (**Figs. 18.1** and **18.5**) on many different levels. Superficially, it

The Politics of Sexuality: The Female Body and the Male Gaze

"We never encounter the body unmediated by the meanings that cultures give to it." Right out of the starting gate, can you challenge yourself to support or contest this statement with reference to the four works in this feature? The words are Gayle Rubin's, and they can be found in her essay "Thinking Sex: Notes for a Radical Theory of the Politics of Sexuality."* Which of these works, in your view, are about "thinking sex"? Which address the "politics of sexuality"?

Titian's reclining nude (**Fig. 18.6**) was commissioned by the Duke of Urbino for his private quarters. There was a considerable market for erotic paintings in the 16th century. One point of view maintains that many of the "great nudes" of Western art were, in essence, created for the same purpose as pinups. Yet there is also no doubt that this particular reclining nude has had an undisputed place in the canon of great art. This much, at least, has been reaffirmed by the reinterpretations and revisions the work has inspired into current times.

One of the first artists to use Titian's *Venus* as a point of departure for his own masterpiece was Édouard Manet. In his *Olympia* (**Fig. 18.7**), Manet intentionally mimicked the Renaissance composition as a way of challenging the notion that modern art lacked credibility when brought face-to-face with the Old Masters. In effect, Manet seemed to be saying, "You want a Venus? I'll give you a Venus." And just where do you find a Venus in 19th-century Paris? In the bordellos of the demimonde. What do these paintings have in common? Where do they depart? What details does Titian use to create an air of innocence and vulnerability? What details does Manet

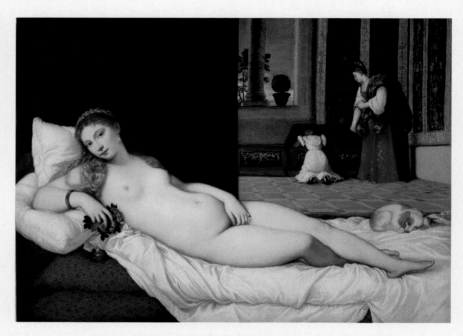

▲ **18.6** Titian, *Venus of Urbino*, 1538. Oil on canvas, 47" × 65" (119 × 165 cm). Galleria degli Uffizi, Florence, Italy.

▼ **18.7** Édouard Manet, *Olympia*, 1863–1865. Oil on canvas, 51³⁄₈" × 74³⁄₄" (130 × 190 cm). Musée d'Orsay, Paris, France.

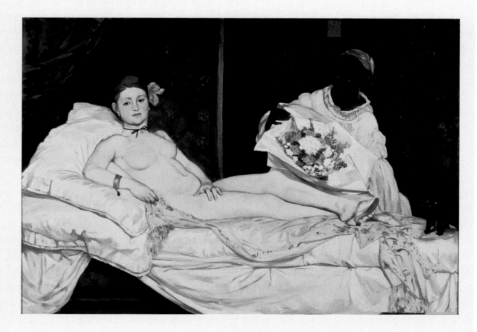

use to do just the opposite? For example, Titian placed a dog on the couch of his reclining nude in *Venus of Urbino*. Manet placed a black cat on the couch with Olympia. What are the meanings of these symbols?

Paul Gauguin, the 19th-century French painter who moved to Tahiti, was also inspired by the tradition of the Western reclining nude in the creation of *Te Arii Vahine* (The Noble Woman) (**Fig. 18.8**). The artist certainly knew Manet's revision of the work; in fact, he had a photograph of *Olympia* tacked on the wall of his hut. How does this Tahitian Venus fit into the mix? All three of these works have a sense of self-display. In which do the women solicit our gaze? Refuse it? How do the stylistic differences influence our interpretation of the women and our relationship to them? How is the flesh modeled in each work? What overall effects are provided by the different palettes? And: Are these paintings intended for the male gaze, the female gaze, or both?

Suzanne Valadon would probably have said that such images do *not* appeal equally to men and women. More to the point, Valadon would have argued that the painting of such subjects is not at all of interest to women artists. Perhaps this belief was the incentive behind her own revision of the reclining nude: *The Blue Room* (**Fig. 18.9**). With this work, she seems to be informing the world that when women relax, they really *don't* look like the Venuses of Titian, or Manet, or Gauguin. Instead, they get into their loose-fitting clothes, curl up with a good book, and sometimes treat themselves to a bit of tobacco.

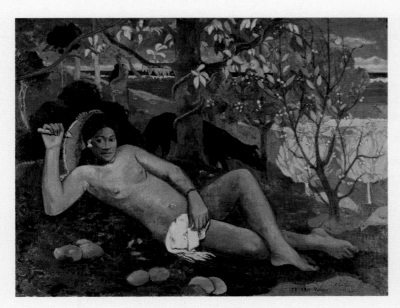

▲ **18.8** Paul Gauguin, *Te Arii Vahine* (The Noble Woman), 1896. Oil on canvas, 38⅛" × 51¼" (97 × 130 cm). The National Pushkin Museum, Moscow, Russia.

▼ **18.9** Suzanne Valadon, *The Blue Room*, 1923. Oil on canvas, 35½" × 45⅝" (90 × 116 cm). Musée National d'Art Moderne, Centre Georges Pompidou, Paris, France.

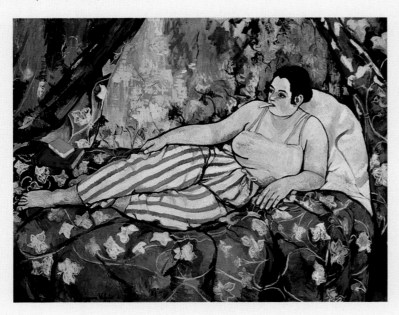

*Gayle Rubin, "Thinking Sex: Notes for a Radical Theory of the Politics of Sexuality," in *Pleasure and Danger: Exploring Female Sexuality*, ed. Carole S. Vance (London: Pandora, 1992), 267–293.

is what has been called "a feast for the eye." There is a splendid array of alcoholic beverages, fruit, and flowers before us, along with a beautiful young woman. Might a male viewer identify with the reflection of the man in the mirror on the right? That man is engaging the barmaid in conversation; is he propositioning her? Might a female viewer identify with the barmaid—the object of the man's interest? We might note her disengaged expression. Although there is an overload of visual stimulation for the viewer, even a powerful suggestion of perfume, the barmaid has seen it all and is, perhaps, weary of it.

Impressionism

In the late 1800s, a group of artists were banding together against the French art establishment. Suffering from little

recognition and much vicious criticism, many of them lived in abject poverty for lack of commissions. Yet they stand today as some of the most significant, and certainly among the most popular, artists in the history of art. They were called the **Impressionists**. The very name of their movement was coined by a hostile critic and intended to malign their work. The word *impressionism* suggests a lack of realism, and realistic representation was the standard of the day.

The Impressionist artists had common philosophies about painting, although their styles differed widely. They all reacted against the constraints of the Academic style and subject matter. They advocated painting out of doors and chose to render subjects found in nature. They studied the dramatic effects of atmosphere and light on people and

▼ **18.10** Claude Monet, *Impression, Sunrise*, 1872. Oil on canvas, 19" × 24 ³/₄" (48 × 63 cm). **Musée Marmottan, Paris, France.** This is the canvas that inspired the epithet *impressionist*. Impressionist artists appropriated the term and gave it a positive meaning.

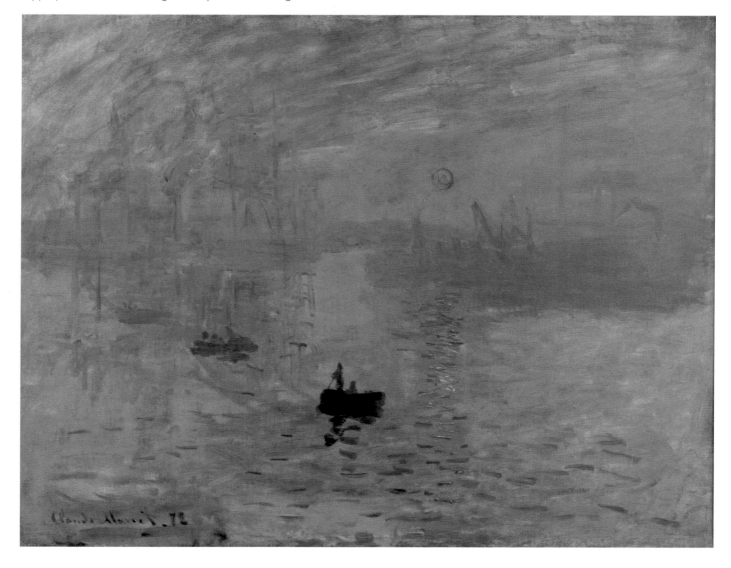

objects and, through a varied palette, attempted to duplicate these effects on canvas.

Through intensive investigation, they arrived at awareness of certain visual phenomena. When bathed in sunlight, objects are optically reduced to facets of pure color. The actual color—or local color—of these objects is altered by different lighting effects. Solids tend to dissolve into color fields. Shadows are not black or gray, but a combination of colors.

Technical discoveries accompanied these revelations. The Impressionists duplicated the glimmering effect of light bouncing off the surface of an object by applying their pigments in short, choppy strokes. They juxtaposed complementary colors such as red and green to reproduce the optical vibrations perceived when one is looking at an object in full sunlight. Toward this end, they also juxtaposed primary colors such as red and yellow to produce, in the eye of the spectator, the secondary color orange. We shall discuss the work of the Impressionists Claude Monet, Pierre-Auguste Renoir, Berthe Morisot, and Edgar Degas.

CLAUDE MONET The most fervent practitioner of Impressionist techniques was the painter Claude Monet (1840–1926). His canvas *Impression, Sunrise* (**Fig. 18.10**) inspired the epithet *impressionist* when it was shown at the first Impressionist exhibition in 1874. Fishing vessels sail from the port of Le Havre toward the morning sun, which rises in a foggy sky to cast its copper beams on the choppy, pale-blue water. The warm blanket of the atmosphere envelops the figures, their significance having waned in the wake of nature's beauty.

The dissolution of surfaces and the separation of light into its spectral components remain central to Monet's art. They are dramatically evident in a series of canvases depicting Rouen Cathedral (**Fig. 18.11**) from a variety of angles, during different seasons and times of day. The harsh stone façade of the cathedral dissolves in a bath of sunlight, its finer details obscured by the bevy of brushstrokes crowding the surface. Dark shadows have been transformed into patches of bright blue and splashes of yellow and red. With these delicate touches, Monet has recorded for us the feeling of a single moment in time. He offers us his impressions as eyewitness to a set of circumstances that will never be duplicated.

Throughout his long career, Monet retained a total fidelity to visual perception. His fellow painter Paul Cézanne (1839–1906) is said to have called him "only an eye, but my God what an eye!" Monet's preoccupation with the effects of light and color reached its most complete expression in his numerous paintings of water lilies in his garden. In version

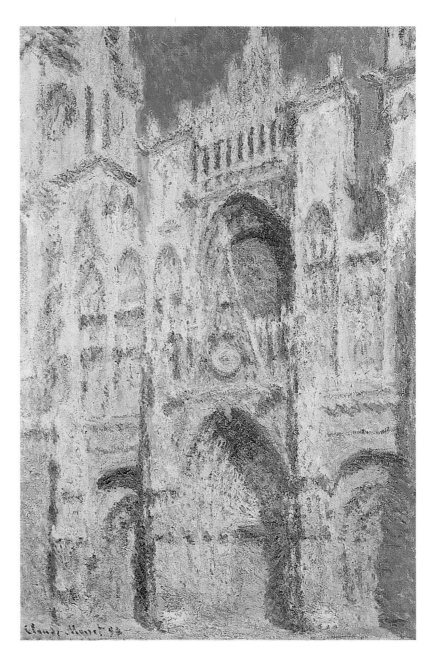

▲ **18.11** Claude Monet, *Rouen Cathedral*, The Portal (in Sun), 1894. Oil on canvas, 39¼″ × 25⅞″ (99.7 × 65.7 cm). Metropolitan Museum of Art, New York, New York. This painting is one of a series, each of which captures the cathedral in a different light.

after version he tried to capture in paint the effect of the shimmering, ever-changing appearance of water, leaves, and blossoms. The result, as in the *Nymphéas (Water lilies, water study, morning)* of 1914–1918 (**Fig. 18.12**), reproduces not so much the actual appearance of Monet's lily pond as an abstract symphony of glowing colors and reflecting lights. Paradoxically, the most complete devotion to naturalism was to pave the way for abstraction and for what we know as "modern art."

> **18.12** Claude Monet, *Nymphéas (Water lilies, water study, morning)*, ca. 1914–1918. Oil on canvas, 83 3/4" × 78 3/4" (200 × 212.5 cm). Musée de l'Orangerie, Paris, France. This is one of several large paintings that Monet produced in the garden of his house in Giverny.

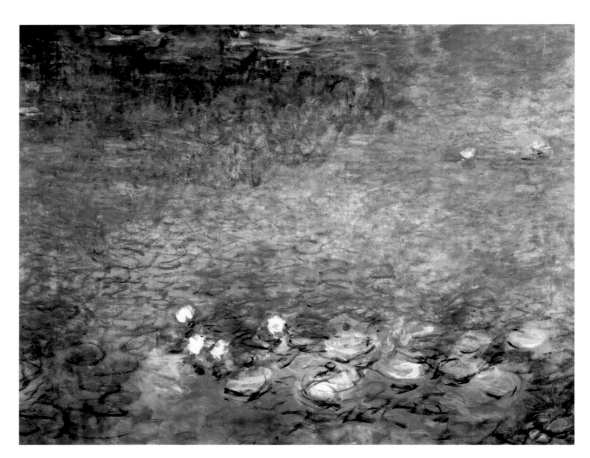

∨ **18.13** Pierre-Auguste Renoir, *Le Moulin de la Galette*, 1876. Oil on canvas, 51 1/2" × 69" (131 × 175 cm). Musée d'Orsay, Paris, France. Renoir, like other Impressionists, was fascinated by the play of light on various surfaces. Note the dappling of the sun on the straw hats.

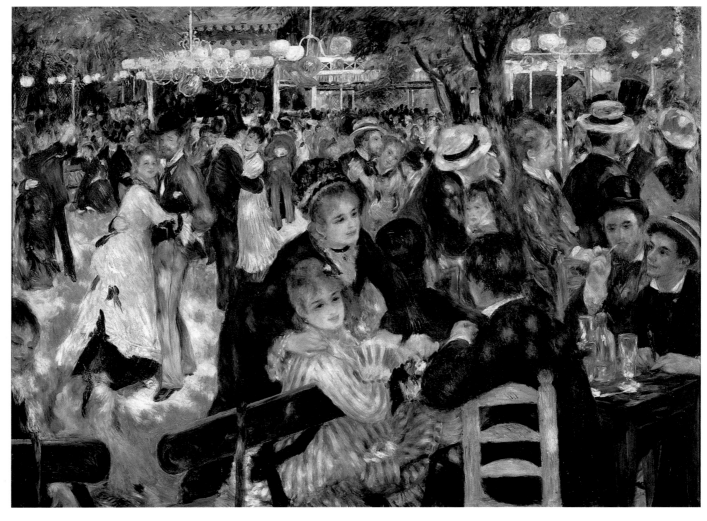

PIERRE-AUGUSTE RENOIR Most Impressionists counted among their subject matter landscape scenes or members of the middle class enjoying leisure-time activities. Of all the Impressionists, however, Pierre-Auguste Renoir (1841–1919) was perhaps the most significant figure painter. Like his peers, Renoir was interested primarily in the effect of light as it played across the surface of objects. He illustrated his preoccupation in one of the most wonderful paintings of the Impressionist period, *Le Moulin de la Galette* (**Fig. 18.13**). With characteristic feathery strokes, Renoir communicated all of the charm and gaiety of an afternoon dance. Men and women caress and converse in frocks that are dappled with sunlight filtering through the trees. All of the spirit of the event is as fresh as if it were yesterday. From the billowing skirts and ruffled dresses to the rakish derbies, top hats, and skimmers,

Renoir painted all of the details that imprint such a scene on the mind forever.

BERTHE MORISOT Like other Impressionists, Berthe Morisot (1841–1895) exhibited at the Salon—the prestigious official art exhibition of the French Académie des Beaux-Arts—early in her career, but she surrendered the safe path as an expression of her allegiance to the new. Morisot was a granddaughter of the 18th-century painter Jean-Honoré Fragonard (see **Fig. 16.4**) and the sister-in-law of Édouard Manet. Manet painted her quite often; in fact, Morisot is the seated figure in his painting *The Balcony*.

In Morisot's *Young Girl by the Window* (**Fig. 18.14**), surfaces dissolve into an array of loose brushstrokes, applied, it would seem, at a frantic pace. The vigor of these strokes

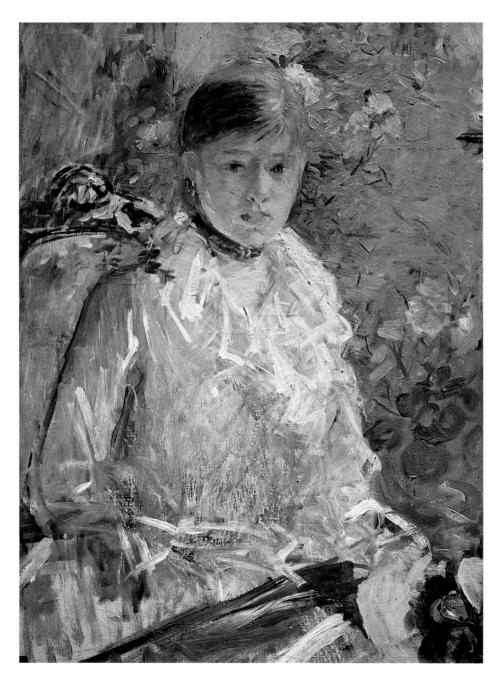

◄ **18.14** Berthe Morisot, *Young Girl by the Window*, 1878. Oil on canvas, 30″ × 24″ (76.2 × 61 cm). Musée Fabre, Montpellier, France. Morisot uses a few strokes of pigment to suggest forms.

contrasts markedly with the tranquility of the woman's face. The head is strongly modeled, and several structural lines, such as the back of the chair, the contour of her right arm, the blue parasol across her lap, and the vertical edge of drapery to the right, anchor the figure in space. Yet in this, as in most of Morisot's works, we are most impressed by her ingenious ability to suggest complete forms through a few well-placed strokes of pigment.

EDGAR DEGAS We can see the vastness of the aegis of Impressionism when we look at the work of Edgar Degas (1834–1917), whose approach to painting differed considerably from those of his peers. Degas, like Morisot, had exhibited at the Salon for many years before joining the movement. He was a superb draftsman who studied under Ingres. While in Italy, he copied the Renaissance masters. He was also intrigued by Japanese prints and the new art of photography.

The Impressionists, beginning with Manet, were strongly influenced by Japanese woodcuts, which were becoming readily available in Europe; Oriental motifs appeared widely in their canvases. They also adopted certain techniques of spatial organization found in Japanese prints, including the use of line to direct the viewer's eye to different sections of the work and to divide areas of the essentially flattened space. They found that the patterning and flat forms of Oriental woodcuts complemented similar concerns in their own painting. Throughout the Impressionist period, and even more so in the Postimpressionist period, the influence of Japanese artists remained strong.

Degas was strongly influenced by the developing art of photography, and the camera's exclusive visual field served as a model for the way in which he framed his own paintings. *The Rehearsal (Adagio)* **(Fig. 18.15)** contains elements both of photographs and of Japanese prints. Degas draws us into the composition with an unusual and vast off-center space that curves around from the viewer to the background of the canvas. The diagonals of the floorboards carry our eyes briskly from outside the canvas to the points at which the groups of dancers congregate. The imagery is placed at eye level so that we feel we are part of the scene. This feeling is enhanced by the fact that our "seats" at the rehearsal are less than adequate; a spiral staircase to the left blocks our view of

▼ **18.15** Edgar Degas, *The Rehearsal (Adagio)*, 1877. Oil on canvas, 23″ × 33″ (58.4 × 83.8 cm). **Burrell Collection, Glasgow, United Kingdom.** The borders of the canvas slice through figures as if this were an imperfectly centered photograph.

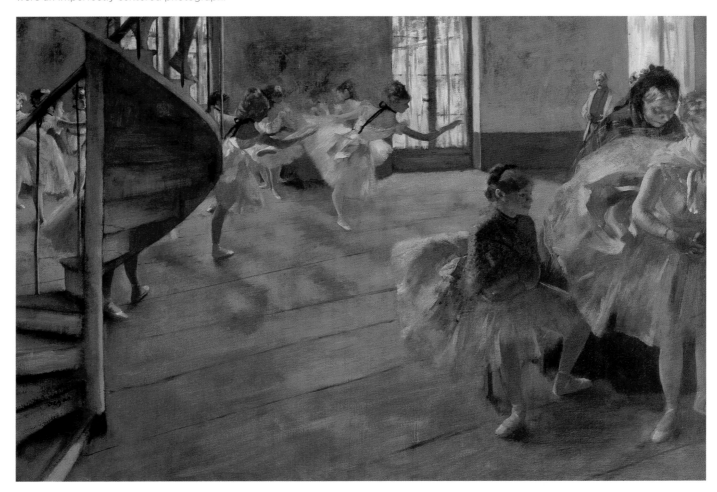

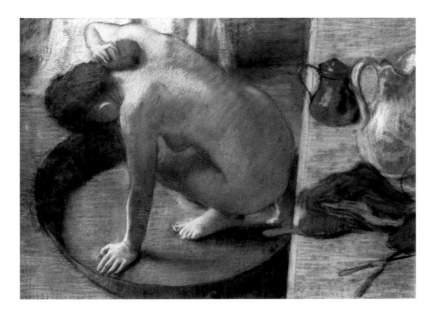

◄ **18.16** Edgar Degas, *The Tub*, 1886. Pastel on card, 23 ⅝″ × 32 ⅝″ (60 × 83 cm). Musée d'Orsay, Paris, France. The simplicity of Degas's drawing gives an impression of action glimpsed momentarily, as if in passing by. As in *The Rehearsal*, Degas chooses to visualize the scene from an unusual angle. Here we view from above the crouching and still life of toilet articles on a shelf.

the ballerinas. In characteristic camera fashion, the borders of the canvas slice off the forms and figures in a seemingly arbitrary manner. Although it appears as if Degas has failed to frame his subject correctly or has accidentally cut off the more important parts of the scene, he carefully planned the placement of his imagery. These techniques are what render his asymmetrical compositions so dynamic and, in the spirit of Impressionism, so immediate.

Degas won the reputation of being a misogynist because many of his representations of female nudes lack the idealizing qualities of Renoir's and other painters' works. In a series of pastels he shows women caught unawares in simple, natural poses. *The Tub* (**Fig. 18.16**), with its unusual angle of vision, shows why these were sometimes called "keyhole visions." Far from posing, his subjects seem to be spied on while they are engrossed in the most intimate and natural activities.

American Expatriates

Until the 20th century, art in the United States remained fairly provincial. Striving artists of the 18th and 19th centuries would go abroad for extended pilgrimages to study the Old Masters and mingle with the avant-garde. In some cases, they emigrated to Europe permanently. These artists, among them Mary Cassatt and James Abbott McNeill Whistler, are called the American Expatriates.

MARY CASSATT Mary Cassatt (1844–1926) was born in Pittsburgh but spent most of her life in France, where she was part of the inner circle of Impressionists. Cassatt's early career was influenced by Manet and Degas, photography, and Japanese. She was a figure painter whose subjects centered on women and children.

A painting such as *The Boating Party* (**Fig. 18.17**), with its flat planes, broad areas of color, and bold lines and shapes, illustrates Cassatt's interest and skill in merging French Impressionism with elements of Japanese art. Like many of her contemporaries in Paris, she became aware of Japanese prints and art objects after trade was established between Japan and Europe in the mid-19th century. In their solidly constructed compositions and collapsed space, Cassatt's lithographs in particular stand out from the more ethereal images of other Impressionists.

➤ **18.17** Mary Cassatt, *The Boating Party*, 1893–1894. Oil on canvas, 14″ × 18¼″ (35.5 × 46.1 cm). National Gallery of Art, Washington, DC. Cassatt's friend Edgar Degas said, "I will not admit that a woman can draw so well."

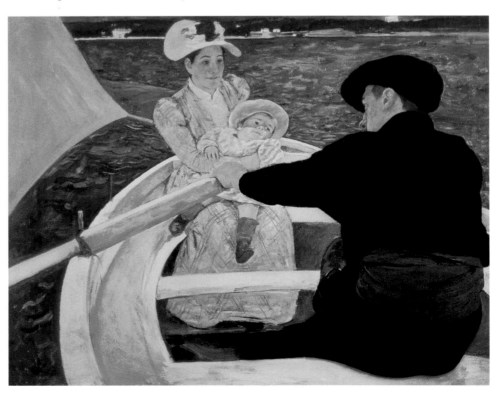

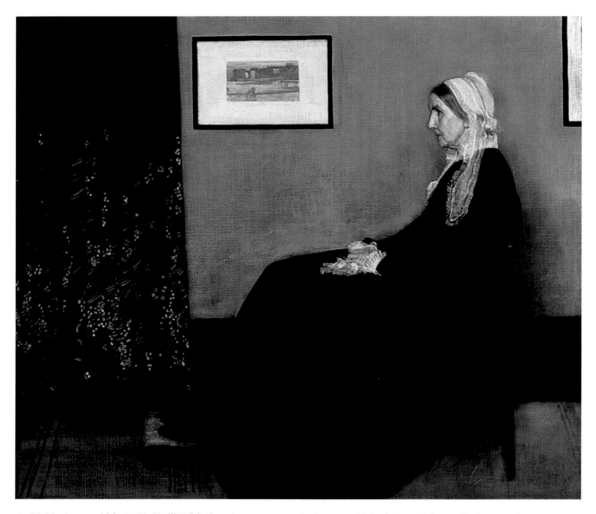

▲ **18.18** James Abbott McNeill Whistler, *Arrangement in Grey and Black No. 1* (also called *Portrait of the Artist's Mother*), 1871. Oil on canvas, 56 ³/₄″ × 64″ (144.3 × 162.5 cm). Musée d'Orsay, Paris, **France.** This is the painting that has become known as "Whistler's Mother."

JAMES ABBOTT MCNEILL WHISTLER In the same year that Monet painted his *Impression, Sunrise* and launched the movement of Impressionism, the U.S. artist James Abbott McNeill Whistler (1834–1903) painted one of the best-known compositions in the history of art. Who among us has not seen "Whistler's Mother," whether on posters, on billboards, or in television commercials? *Arrangement in Grey and Black No. 1* (also called *Portrait of the Artist's Mother*) (**Fig. 18.18**) exhibits a combination of candid realism and abstraction that indicates two strong influences on Whistler's art: Courbet (see Chapter 17) and Japanese prints. Whistler's mother is silhouetted against a quiet backdrop in the right portion of the composition. The strong contours of her black dress are balanced by an Asian drape and a simple rectangular picture on the left. The subject is rendered with a harsh realism reminiscent of northern Renaissance portrait painting. However, the composition is seen first as a logical and pleasing arrangement of shapes in tones of black, gray, and white that work together in pure harmony.

Americans in America

While Whistler and Cassatt were working in Europe, several U.S. artists of note remained at home working in the Realist tradition. This realism can be detected in figure painting and landscape painting, both of which were tinted with Romanticism.

THOMAS EAKINS The most important U.S. portrait painter of the 19th century was Thomas Eakins (1844–1916). Although his early artistic training took place in the United States, his study in Paris with painters who depicted historical events provided the major influence on his work. The penetrating realism of a work such as *The Gross Clinic* (**Fig. 18.19**) stems from Eakins's endeavors to become fully acquainted with human anatomy by working from live models and dissecting corpses. Eakins's dedication to these practices met with disapproval from his colleagues and ultimately forced his resignation from a teaching post at the Pennsylvania Academy of the Fine Arts.

The Gross Clinic—no pun intended—depicts the surgeon Dr. Samuel Gross operating on a young boy at the Jefferson Medical College in Philadelphia. Eakins thrusts the brutal imagery to the foreground of the painting, spotlighting the surgical procedure and Dr. Gross's bloody scalpel, while casting the observing medical students in the background into darkness. The painting was deemed so shockingly realistic that it was rejected by the jury for an exhibition. Part of the impact of the work lies in the contrast between the matter-of-fact discourse of the surgeon and the torment of the boy's mother. She sits in the lower left corner of the painting, shielding her eyes with whitened knuckles. In brush technique, Eakins is close to the fluidity of Courbet, although his compositional arrangement and dramatic lighting are surely indebted to Rembrandt.

Eakins devoted his career to increasingly realistic portraits. Their haunting veracity often disappointed sitters who would have preferred more flattering renditions. The artist's passion for realism led him to use photography extensively as a point of departure for his paintings as well as an art form in itself. Eakins's style and ideas influenced U.S. artists of the early 20th century who also worked in a Realist vein.

Postimpressionism

The Impressionists were united in their rejection of many of the styles and subjects of the art that preceded them. These included Academic painting, the emotionalism of Romanticism, and even the depressing subject matter of some of the Realist artists. During the latter years of the 19th century, a group of artists who came to be called **Postimpressionists** were also united in their rebellion against that which came before them—in their case, Impressionism. The Postimpressionists were drawn together by their rebellion against what they considered an excessive concern for fleeting impressions and a disregard for traditional compositional elements.

Although they were united in their rejection of Impressionism, their individual styles differed considerably. Postimpressionists fell into two groups that in some ways paralleled the stylistic polarities of the Baroque period as well as the Neoclassical–Romantic period. On the one hand, the work of Georges Seurat and Paul Cézanne had at its core a more systematic approach to compositional structure, brushwork, and color. On the other hand,

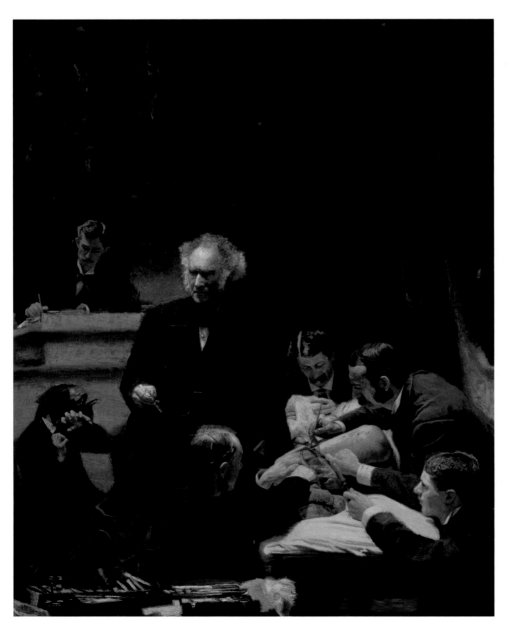

◄ **18.19** Thomas Eakins, *The Gross Clinic*, 1875. Oil on canvas, 96″ × 78″ (243.8 × 198.1 cm). Philadelphia Museum of Art, Philadelphia, Pennsylvania. With this painting, Eakins intended to make an international impression in 1876, at the Centennial Exhibition, which was scheduled to coincide with the "birthday" of the nation in 1776. However, the jury rejected the work as being too gruesome for placement in an art gallery. It wound up at the Jefferson Medical College in 1878 but was purchased by the Pennsylvania Academy of the Fine Arts and the Philadelphia Museum of Art in 2007, with the help of more than 3,600 donors, and is now displayed at the museum.

the lavishly brushed canvases of Vincent van Gogh and Paul Gauguin coordinated line and color with symbolism and emotion.

HENRI DE TOULOUSE-LAUTREC Henri de Toulouse-Lautrec (1864–1901), along with van Gogh, is one of the best-known 19th-century European artists—both for his art and for the troubled aspects of his personal life. Born into a noble French family, Toulouse-Lautrec broke his legs during adolescence, and they failed to develop correctly. This deformity resulted in alienation from his family. He turned to painting and took refuge in the demimonde of Paris, at one point taking up residence in a brothel. In this world of social outcasts, Toulouse-Lautrec, the dwarflike scion of a noble family, apparently felt at home.

He used his talents to portray life as it was in this cavalcade of cabarets, theaters, cafés, and bordellos—somewhat seamy, but also vibrant and entertaining, and populated by "real" people. He made numerous posters to advertise cabaret acts, and numerous paintings of his world of night and artificial light. In *At the Moulin Rouge* (**Fig. 18.20**), we find something of the Japanese-inspired oblique perspective in his poster work. The extension of the picture to include the balustrade on the bottom and the heavily powdered entertainer on the right is reminiscent of those "poorly cropped snapshots" of Degas, who had influenced Toulouse-Lautrec.

The fabric of the entertainer's dress is constructed of fluid Impressionistic brushstrokes, as are the contents of the bottles, the lamps in the background, and the amorphous overall backdrop—lost suddenly in the unlit recesses of the Moulin Rouge. But the strong outlining, as in the entertainer's face, marks the work of a Postimpressionist.

The artist's palette is limited and muted, except for a few accents, as found in the hair of the woman in the center of the composition and the bright mouth of the entertainer. The entertainer's face is harshly sculpted by artificial light from beneath, rendering the shadows a grotesque but not ugly green. The green and red mouth clash, of course, as green and red are complementary colors, giving further intensity to the entertainer's masklike visage. But despite her powdered harshness, the entertainer remains human—certainly as human as her audience. Toulouse-Lautrec was accepting of all his creatures, just as he hoped that they would be accepting of him. The artist is portrayed within this work as well, his bearded profile facing left, toward the upper part of the composition, just left of center—a part of things, but not at the heart of things, certainly out of the glare of the spotlight. There, so to speak, the artist remained for many of his brief 37 years.

GEORGES SEURAT At first glance, the paintings by Georges Seurat (1859–1891)—such as *A Sunday Afternoon*

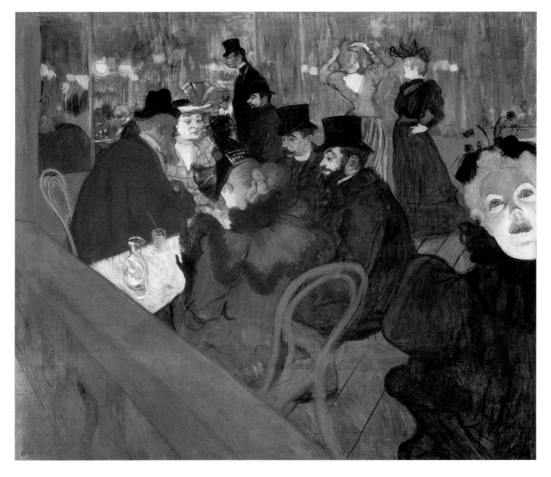

◄ **18.20** Henri de Toulouse-Lautrec, *At the Moulin Rouge*, 1892. Oil on canvas, 48½″ × 55½″ (123 × 141 cm). Art Institute of Chicago, Chicago, Illinois. Toulouse-Lautrec painted the nightlife—and the seamier side of life—in belle époque Paris.

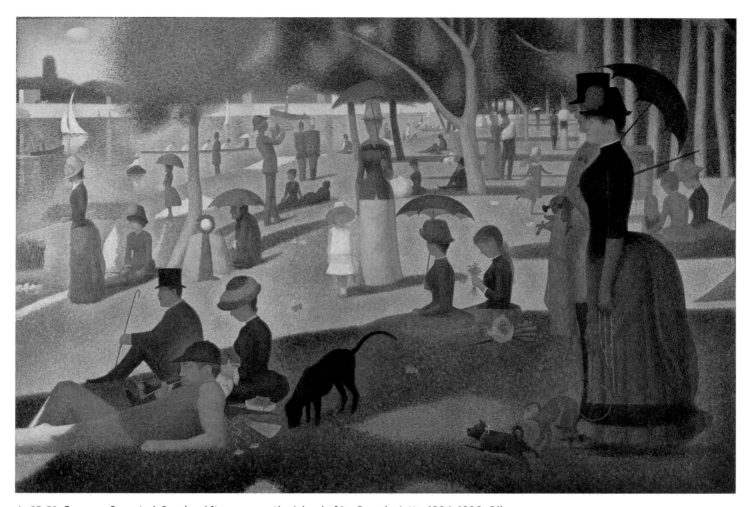

▲ **18.21** Georges Seurat, *A Sunday Afternoon on the Island of La Grande Jatte*, 1884–1886. Oil on canvas, 81¾" × 121¼" (207.5 × 308.1 cm). Art Institute of Chicago, Chicago, Illinois. Seurat constructed his forms from dots of color. When you move in for a closer look, every form dissolves.

on the Island of La Grande Jatte (**Fig. 18.21**)—have the feeling of Impressionism "tidied up." The small brushstrokes are there, as are the juxtapositions of complementary colors. The subject matter is entirely acceptable within the framework of Impressionism. However, the spontaneity of direct painting found in Impressionism is relinquished in favor of a more tightly controlled, "scientific" approach to painting.

Seurat's technique has also been called **pointillism**, after his application of pigment in small dabs, or points, of pure color. Upon close inspection, the painting appears to be a collection of dots of vibrant hues—complementary colors abutting one another, primary colors placed side by side. These hues intensify or blend to form yet another color in the eye of the viewer who beholds the canvas from a distance.

Seurat's meticulous color application was derived from the color theories and studies of color contrasts by the scientists Hermann von Helmholtz and Michel-Eugène Chevreul. He used these theories to restore a more intellectual approach to painting that countered nearly two decades of works focusing wholly on optical effects.

PAUL CÉZANNE

The same subject seen from a different angle gives a subject for study of the highest interest and so varied that I think I could be occupied for months without changing my place, simply bending a little more to the right or left.

—PAUL CÉZANNE

From the time of Manet, there was a movement away from a realistic representation of subjects toward one that was abstracted. Early methods of abstraction assumed different forms. Manet used a flatly painted form, Monet a disintegrating light, and Seurat a tightly painted and highly patterned composition. Paul Cézanne (1839–1906), a Postimpressionist who shared with Seurat an intellectual approach to painting, is credited with having led the revolution of abstraction in modern art from those first steps.

Cézanne's method for accomplishing this radical departure from tradition did not disregard the Old Masters.

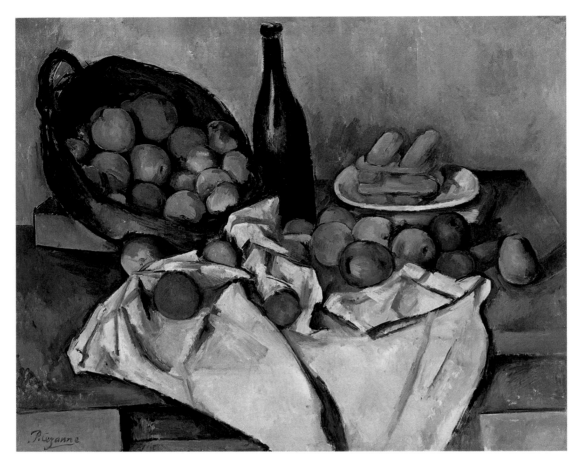

◄ **18.22** Paul Cézanne, *Still Life with Basket of Apples*, ca. 1893. Oil on canvas, 25 ½" × 31 ½" (65 × 80 cm). Art Institute of Chicago, Chicago, Illinois. A careful look will reveal that the tabletop does not align from left to right.

Although he allied himself originally with the Impressionists and accepted their palette and subject matter, he drew from Old Masters in the Louvre and desired somehow to reconcile their lessons with the thrust of Modernism, saying, "I want to make of Impressionism something solid and lasting like the art in the museums." Cézanne's innovations include a structural use of color and brushwork that appeals to the intellect, and a solidity of composition enhanced by a fluid application of pigment that delights the senses.

Cézanne's most significant stride toward Modernism, however, was a drastic collapsing of space, seen in works such as *Still Life with Basket of Apples* (**Fig. 18.22**). All of the imagery is forced to the picture plane. The tabletop is tilted toward us, and we simultaneously view the basket, plate, and wine bottle from front and top angles. Cézanne did not paint the still-life arrangement from one vantage point either. He moved around his subject, painting not only the objects but also the relationship among them. He focused on solids as well as on the void spaces between two objects. If you run your finger along the tabletop in the painting, you will see that it is not possible to trace a continuous line. This discontinuity follows from Cézanne's movement around his subject. Despite this spatial inconsistency, the overall feeling of the composition is one of completeness.

Cézanne's painting technique is also innovative. The sensuously rumpled fabric and lusciously round fruits are constructed of small patches of pigment crowded within dark outlines. The apples look as if they would roll off the table, were it not for the supportive folds of the tablecloth.

The miracle of Cézanne's paintings is that for all their concern with ideal order, they are still vibrantly alive. *Mont Sainte-Victoire* (**Fig. 18.23**) is one of several versions Cézanne painted of the same scene, visible from his studio window. Perhaps the contrast between the peaceful countryside and the grandeur of the mountain beyond partially explains the scene's appeal to him. He produced the transition from foreground to background and up to the sky by the wonderful manipulation of planes of pure color. It illustrates his claim that he tried to give the style of Impressionism a more solid appearance by giving his shapes a more continuous surface, an effect produced by broad brushstrokes. Yet the painting equally conveys the vivid colors of a Mediterranean landscape, with particular details refined away to leave behind the pure essence of all its beauty.

Cézanne can be seen as advancing the flatness of planar recession begun by David more than a century earlier. Cézanne asserted the flatness of the two-dimensional canvas by eliminating the distinction between foreground and back-

ground, and at times merging the two. This was perhaps his most significant contribution to future modern movements.

VINCENT VAN GOGH

I paint as a means to make life bearable. . . . Really, we can only speak through our paintings.

—VINCENT VAN GOGH,
IN A LETTER TO HIS BROTHER THEO

One of the most tragic and best-known figures in the history of art is the Dutch Postimpressionist Vincent van Gogh (1853–1890). We associate him with bizarre and painful acts, such as the mutilation of his ear and his suicide. With these events, as well as his tortured, eccentric painting, he typifies the impression of the mad, artistic talent. Van Gogh also epitomizes the cliché of the artist who achieves recognition only after death: just one of his paintings was sold during his lifetime.

"Vincent," as he signed his paintings, decided to become an artist only 10 years before his death. His most beloved canvases were created during his last 29 months. He began his career painting in the dark manner of the Dutch Baroque, only to adopt the Impressionist palette and brushstroke after he settled in Paris with his brother Theo. Feeling that he was a constant burden on his brother, he left Paris for Arles, where he began to paint his most significant Postimpressionist works. Both his life and his compositions from this

▾ **18.23** Paul Cézanne, *Mont Sainte-Victoire*, 1904–1906. Oil on canvas, 28 ³/₄″ × 36 ¹/₄″ (73.0 × 91.9cm). Philadelphia Museum of Art, Philadelphia, Pennsylvania. The reduction of the elements in the landscape to flat planes and the avoidance of the effect of perspective give the painting a sense of concentrated intensity.

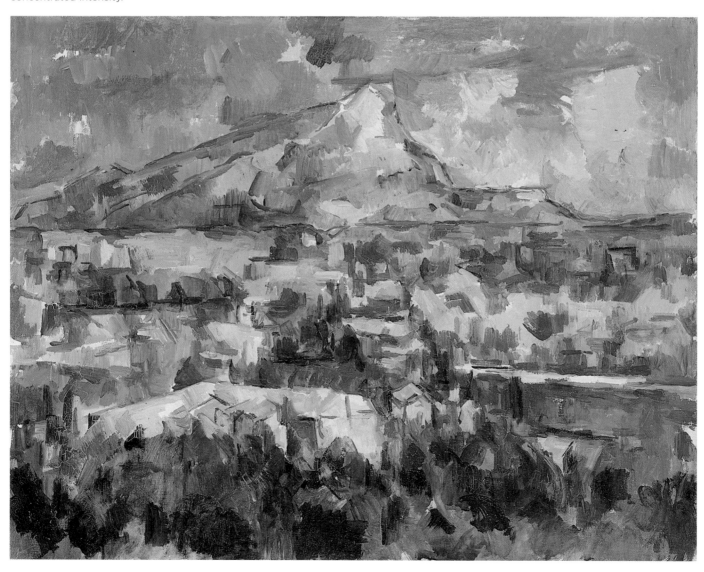

period were tortured, as he suffered from what may have been bouts of epilepsy and mental illness. He was eventually hospitalized in an asylum at Saint-Rémy, where he painted the famous *Starry Night* (**Fig. 18.24**).

In *Starry Night*, an ordinary painted record of a sleepy valley town is transformed into a cosmic display of swirling fireballs that assault the blackened sky and command the hills and cypresses to undulate to their sweeping rhythms. Van Gogh's palette is laden with vibrant yellows, blues, and greens. His brushstroke is at once restrained and dynamic. His characteristic long, thin strokes define the forms but also create the emotionalism in the work. He presents his subject not as we see it, but as he would like us to experience it. His is a feverish application of paint, an ecstatic kind of drawing, reflecting at the same time his joys, hopes, anxieties, and despair.

The momentum of swirling, flickering forms in *Starry Night* is intoxicating, but much of van Gogh's vision of the world was profoundly pessimistic. *The Night Café* (**Fig. 18.25**)

was described by the artist as "one of the ugliest I have done," but the ugliness was deliberate. Van Gogh's subject was "the terrible passions of humanity," expressed by the harsh contrasts between red, green, and yellow, which were intended to convey the idea that "the café is a place where one can ruin oneself, go mad, or commit a crime."

PAUL GAUGUIN Paul Gauguin (1848–1903) shared with van Gogh the desire to express his emotions on canvas. But whereas the Dutchman's brushstroke was the primary means to that end, Gauguin relied on broad areas of intense color to transpose his innermost feelings to canvas.

Gauguin, a stockbroker by profession, began his artistic career as a weekend painter. At age 35, he devoted himself full-time to his art, leaving his wife and five children to do so. Gauguin identified early with the Impressionists, adopting their techniques and participating in their exhibitions. But Gauguin was a restless soul. Soon he decided to leave France

▾ **18.24** Vincent van Gogh, *Starry Night*, 1889. Oil on canvas, 29″ × 36¼″ (73.7 × 92.1 cm). Museum of Modern Art, New York, New York. Van Gogh rendered his *Starry Night* with a thick application of paint.

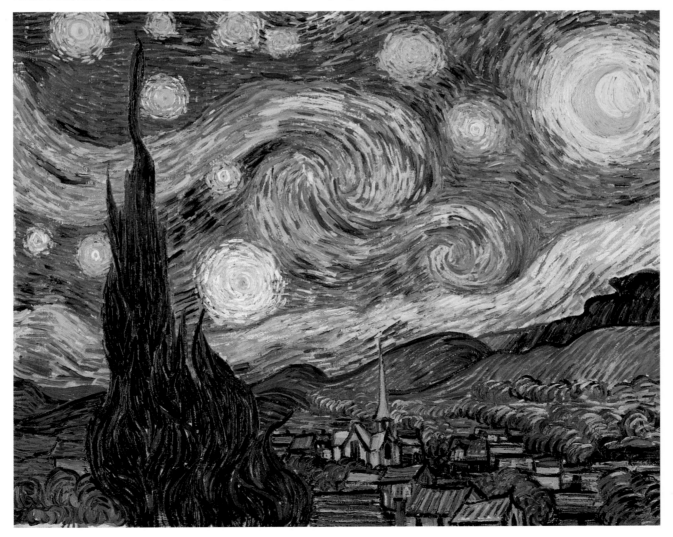

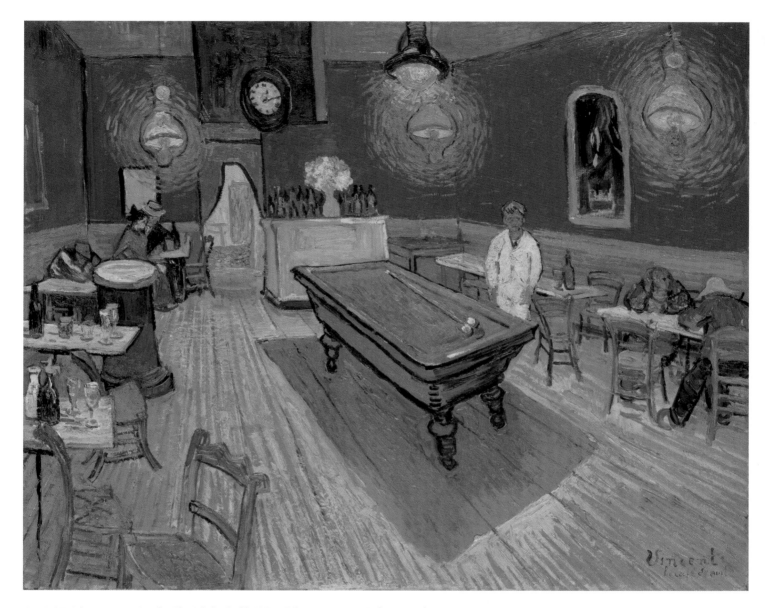

▲ **18.25** Vincent van Gogh, *The Night Café*, 1888. Oil on canvas, 28½" × 36¼" (72.39 × 92 cm). Yale University Art Gallery, New Haven, Connecticut. Compare the lack of perspective in Cézanne's *Mont Sainte-Victoire* (Fig. 18.24) to the highly exaggerated perspective used by van Gogh here to achieve a sense of violent intensity.

for Panama and Martinique, which he viewed as primitive places where he could purge civilization from his art and life. The years until his death were spent in France and the South Seas, where he finally died of syphilis five years after a failed attempt to take his own life.

Gauguin developed a theory of art called **Synthetism**, in which he advocated the use of broad areas of unnaturalistic color and "primitive" or symbolic subject matter. His *Vision After the Sermon (Jacob Wrestling with the Angel)* (**Fig. 18.26**), one of the first canvases to illustrate his theory, combines reality with symbolism. After hearing a sermon on the subject, a group of Breton women believed they had a vision of

Jacob, ancestor of the Israelites, wrestling with an angel. In a daring composition that cancels pictorial depth by thrusting all elements to the front of the canvas, Gauguin presents all details of the event, actual and symbolic. An animal in the upper left portion of the canvas walks near a tree that interrupts a bright vermilion field with a slashing diagonal. The Bible tells that Jacob wrestled with an angel on the banks of the Jabbok River in Jordan. Caught, then, in a moment of religious fervor, the Breton women may have imagined the animal's four legs to have been those of the wrestling couple, and the tree trunk might have been visually analogous to the river.

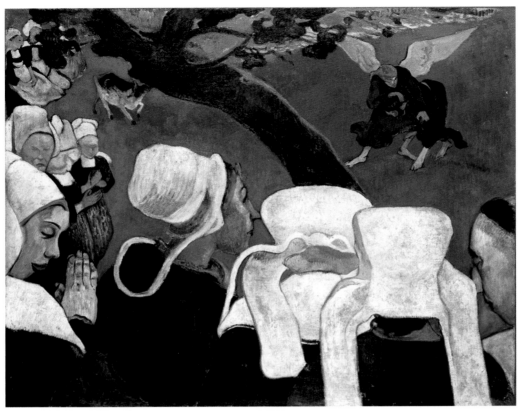

▲ **18.26** Paul Gauguin, *Vision After the Sermon (Jacob Wrestling with the Angel)*, 1888. Oil on canvas, 29 ³⁄₈″ × 36 ¹⁄₄″ (74.4 × 93.1 cm). National Gallery of Scotland, Edinburgh, United Kingdom. Gauguin painted broad areas of the canvas with unnatural color.

Gauguin's contribution to the development of modern art lay largely in his use of color. Writing on the subject, he said, "How does that tree look to you? Green? All right, then use green, the greenest on your palette. And that shadow, a little bluish? Don't be afraid. Paint it as blue as you can." He intensified the colors he observed in nature to the point where they became unnatural. He exaggerated his lines and patterns until they became abstract. He learned these lessons from the surroundings of which he was so fond. They were his legacy to art.

The Birth of Modern Sculpture

Some of the most notable characteristics of modern painting include a newfound realism of subject and technique; a more fluid, or impressionistic, handling of the medium; and a new treatment of space. Nineteenth-century sculpture, for the most part, continued stylistic traditions that artists saw as complementing the inherent permanence of the medium in which they worked. It would seem that working on a large scale with materials such as marble or bronze was not well

suited to the spontaneous technique that captured fleeting impressions. One 19th-century artist, however, changed the course of the history of sculpture by applying to his work the very principles on which modern painting was based, including Realism, Symbolism, and Impressionism—Auguste Rodin.

AUGUSTE RODIN Auguste Rodin (1840–1917) devoted his life almost solely to the representation of the human figure. His figures were imbued with a realism so startlingly intense that he was accused of casting the sculptures from live models. (It is interesting to note that casting of live models is used today without criticism.)

Rodin's *The Burghers of Calais* (**Fig. 18.27**) represents a radical break with the past and a search for new forms of expression in three dimensions. The work commemorates a historical event in which six prominent citizens of Calais offered their lives to the conquering English so that their fellow townspeople might be spared. They present themselves in coarse robes with nooses around their necks. Their psychological states range from quiet defiance to frantic desperation. The reality of the scene is achieved in part by the odd

placement of the figures. They are not a symmetrical or cohesive group. Rather, they are a scattered collection of individuals, who were meant to be seen at street level. Capturing them as he did, at a particular moment in time, Rodin ensured that spectators would partake of the tragic emotion of the scene.

The original name of Rodin's marble sculpture *The Kiss* (**Fig. 18.28**) was *Francesca da Rimini*, after the 13th-century noblewoman depicted in the second circle of hell in canto 5 of Dante's *Inferno*. She is half of the tempest-tossed couple who fell in love after reading of Lancelot and Guinevere. She married her lover—her husband's younger brother, Paolo—by proxy, but technically speaking, the couple committed adultery. Rodin shows the man holding the book of Lancelot

and Guinevere. The lips of the lovers do not actually touch, possibly suggesting that they were interrupted.

Rodin preferred modeling soft materials to carving because it enabled him to achieve highly textured surfaces that captured the play of light, much as in an Impressionist painting. As his career progressed, Rodin's sculptures took on an abstract quality. Distinct features were abandoned in favor of solids and voids that, together with light, constructed the image of a human being. Such works were outrageous in their own day—audacious and quite new. Their abstracted features set the stage for yet newer and more audacious art forms that would rise with the dawn of the 20th century.

▾ **18.27** Auguste Rodin, *The Burghers of Calais*, 1884–1895. Bronze, 85 ³⁄₈″ × 100 ³⁄₈″ × 69 ⁵⁄₈″ (217 × 255 × 177 cm). Musée Rodin, Paris, France. Each of the figures faces a different direction and expresses his own impassioned emotions.

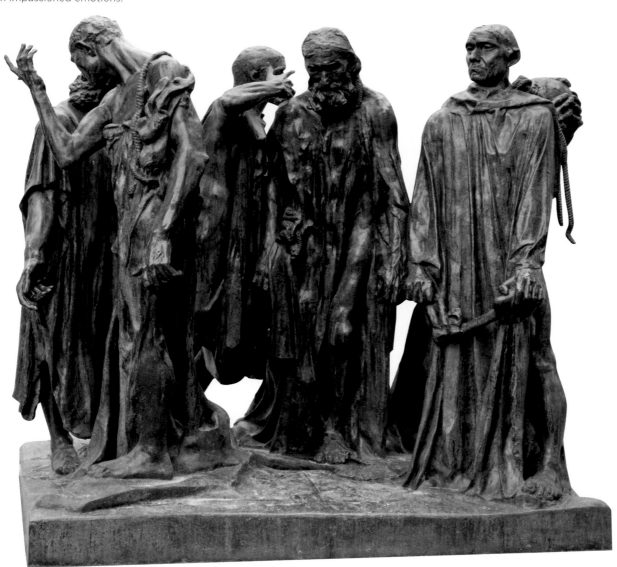

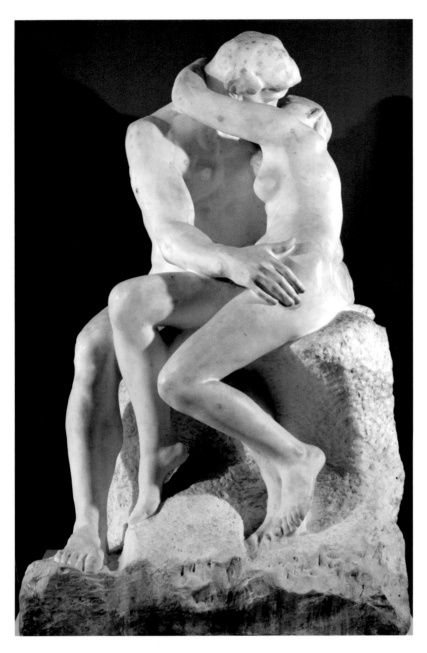

The sculpture is based on the story of Paolo and Francesca, who were portrayed in the second circle of Dante's *Inferno*.

emphatic lines grew out of their desire for a direct form of expression unencumbered by theory. Their skewed perspectives and distorted forms were also inspired by the discovery of ethnographic works of art from African, Polynesian, and other ancient cultures.

HENRI MATISSE

My choice of colors does not rest on any scientific theory; it is based on observation, on feeling, on the very nature of each experience.

—HENRI MATISSE

Henri Matisse (1869–1954) started law school at age 21, but when an illness interrupted his studies, he began to paint. Soon thereafter, he decided to devote himself totally to art. Matisse's early paintings reveal a strong and traditional compositional structure, which he gleaned from his first mentor, Bouguereau, and from copying Old Masters in the Louvre. His loose brushwork is reminiscent of Impressionism, and his palette is inspired by the color theories of the Postimpressionists. In 1905, he consolidated these influences and painted several Fauvist canvases in which he used primary color as a structural element. These canvases were exhibited with those of other Fauvists at the Salon d'Automne of that year.

In his post-Fauvist works, Matisse used color in a variety of other ways: structurally, decoratively, sensually, and expressively. In his *Harmony in Red (The Red Room)* (Fig. 18.29), all of these qualities of color are present. A vibrant palette and curvilinear shapes create the gay mood of the canvas. The lush red of the wallpaper and tablecloth absorb the viewer in their brilliance. The arabesques of the vines create an enticing surface pattern.

A curious contest between flatness and three dimensions in *Harmony in Red* characterizes much of Matisse's work. He crowds the table and wall with the same patterns. They seem to run together without distinction. This jumbling of patterns propels the background to the picture plane, asserting the flatness of the canvas. The two-dimensionality of the canvas is further underscored by the window in the upper left, which is rendered so flatly that it suggests a painting of a garden scene instead of an actual view of a distant landscape. Yet for all of these attempts to collapse space, Matisse

The Fauves

In some respects, **Fauvism** was a logical successor to the painting of van Gogh and Gauguin. Like these Postimpressionists, the Fauvists also rejected the subdued palette and delicate brushwork of Impressionism. They chose their color and brushwork on the basis of their emotive qualities. Despite the aggressiveness of their method, however, their subject matter centered on traditional nudes, still lifes, and landscapes.

What set the Fauves apart from their 19th-century predecessors was their use of harsh, nondescriptive color, bold linear patterning, and a distorted form of perspective. They saw color as autonomous, a subject in and of itself, not merely an adjunct to nature. Their vigorous brushwork and

counteracts the effect with a variety of perspective cues: the seat of the ladder-back chair recedes into space, as does the table; and the dishes are somewhat foreshortened, combining frontal and bird's-eye views.

Matisse used line expressively, moving it rhythmically across the canvas to complement the pulsing color. Although the structure of *Harmony in Red* remains assertive, Matisse's foremost concern was to create a pleasing pattern. Matisse insisted that painting ought to be joyous. His choice of palette, his lyrical use of line, and his brightly painted shapes are all means toward that end. He even said of his work that it ought to be devoid of depressing subject matter, that his art ought to be "a mental soother, something like a good armchair in which to rest."[1]

Although the colors and forms of Fauvism burst explosively on the modern art scene, the movement did not last very long. For one thing, the styles of the Fauvist artists were very different from one another, so the members never formed a cohesive group. After about five years, the Fauvist qualities began to disappear from their works as they pursued other styles. Their disappearance was, in part, prompted by a retrospective exhibition of Cézanne's paintings held in 1907, which revitalized an interest in this 19th-century artist's work. His principles of composition and constructive brush technique were at odds with the Fauvist manifesto.

While Fauvism was descending from its brief, colorful flourish in France, related art movements, termed *Expressionistic*, were ascending elsewhere.

1. Quoted in Robert Goldwater and Marco Treves, eds., *Artists on Art* (New York: Pantheon Books, 1972), 413.

▼ **18.29** Henri Matisse, *Harmony in Red (The Red Room)*, 1908. Oil on canvas, 71″ × 87″ (180.5 × 221 cm). Hermitage, St. Petersburg, Russia. Photo: Archives H. Matisse. © 2013 Succession H. Matisse/Artists Rights Society (ARS), New York. Matisse, like other Fauvists, used color expressively and sensually.

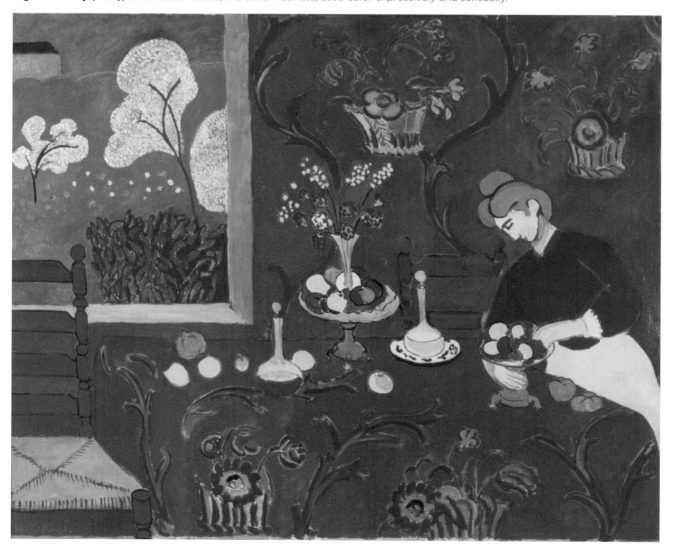

Expressionism

Expressionism is a style of art that departs from optical realism (the mimicking of the outward appearances of things) with the intent of communicating the inner emotions, anxieties, obsessions, rage, and outrage of the artist. Expressionism may serve as a vehicle for personal emotional catharsis, enabling an artist to express and "work through" inner conflict, but it may also serve as an instrument of social change by creating empathy toward a subject or condition in the viewer. Stylistic characteristics of expressionist works of art include figural distortion, vigorous or aggressive brushwork, and unnatural, exaggerated color.

Expressionism in in the first decade of the twentieth century was influenced by earlier artists whose work exhibited these same characteristics—in particular, Vincent Van Gogh and Paul Gauguin, Edvard Munch, and the French Fauves.

EDVARD MUNCH Munch (1863–1944), a Norwegian, had studied in Paris; his early work was Impressionistic, but during the 1890s he abandoned a light palette and lively subject matter in favor of a more somber style that reflected an anguished preoccupation with fear and death.

The Scream (**Fig. 18.30**) is one of Munch's best-known works, a portrayal of pain and isolation that became his central themes. A figure in black walks across a bridge toward the viewer, cupping his ears as if to buffer the sound of his own screaming. Two figures in the background stroll in the opposite direction, seemingly unaware of or uninterested in the sounds of desperation piercing the atmosphere. Munch transformed what might have been a placid scene into one that reverberates in waves the high-pitched tones that emanate from the skeletal head. We are reminded of the swirling forms of van Gogh's *Starry Night*, but the intensity and horror pervading Munch's composition speak of his view of humanity as being consumed by an increasingly dehumanized society.

ERNST LUDWIG KIRCHNER This mood of isolation and anxiety is also seen in Ernst Ludwig Kirchner's *Street, Dresden* (**Fig. 18.31**). Kirchner was one of the founding members of a group of German expressionists who called themselves **Die Brücke**, or The Bridge. Founded in 1905 in Dresden at the same time that Fauvism was afoot in France, the concept of the bridge was intended to symbolize the artists' desire to connect "all the revolutionary and fermenting elements" that rejected academic and other "fashionable" (socially or culturally acceptable) artforms. The inhabitants of Kirchner's crowded street do not interact, but rather seem lost in their own thoughts as they rush to and fro. In spite of their common circumstances, they are each alone in carrying the weight of their emotional lives. Kirchner portrays, with these masked "automatons," an acute sense of alienation gripping society at the start of the new century.

WASILY KANDINSKY Emotionally charged subject matter, often radically distorted, was the essence of Die Brücke art. Another German expressionist group, **Der Blaue Reiter**

◄ **18.30** Edvard Munch, *The Scream*, 1893. Oil, tempera, and pastel on cardboard, 35 3/4″ × 28 7/8″ (91 × 73.5 cm). National Gallery, Oslo, Norway. © 2013 The Munch Museum/The Munch-Ellingsen Group/Artists Rights Society (ARS), New York. A skeletal crosses a bridge in anguish.

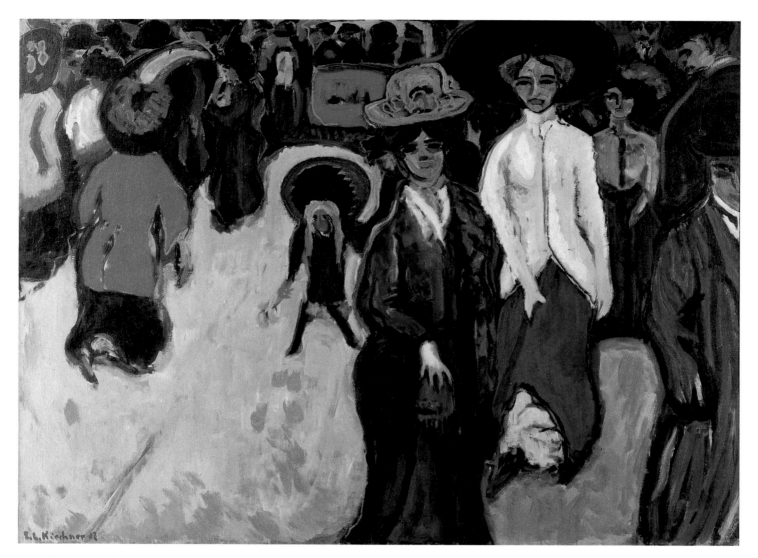

∧ 18.31 Ernst Ludwig Kirchner, *Street, Dresden*, 1908 (reworked 1919; dated on painting 1907). Oil on canvas, 59¼" × 78⅞" (150.5 × 200.4 cm). Museum of Modern Art, New York, New York. Many German Expressionist works feature themes of isolation and alienation. Agitated brushwork and unnatural color schemes suggest turbulence and uncertainty.

(the Blue Rider), depended less heavily on content to communicate feelings and evoke an emotional response from the viewer. Their work focused more on the contrasts and combinations of abstract forms and pure colors and at times made no reference to visible reality. Such works can be described as nonobjective, or abstract.

Kandinsky (1866–1944) was a Russian artist who left a career in law to become an influential abstract painter and art theorist. During numerous visits to Paris early in his career, Kandinsky was immersed in the works of Gauguin and the Fauves and was inspired to adopt the Fauvist idiom. The French experience opened his eyes to color's powerful capacity to communicate the artist's inmost psychological and spiritual concerns. In his seminal essay "Concerning the

Spiritual in Art," he examined this capability and discussed the psychological effects of color on the viewer. Kandinsky further analyzed the relationship between art and music in this study.

Early experiments with these theories can be seen in works such as *Sketch I for Composition VII* (**Fig. 18.32**), in which bold colors, lines, and shapes tear dramatically across the canvas in no preconceived fashion. The pictorial elements flow freely and independently throughout the painting, reflecting, Kandinsky believed, the free flow of unconscious thought. *Sketch I for Composition VII* and other works of this series underscore the importance of Kandinsky's early Fauvist contacts in their vibrant palette, broad brushstrokes, and dynamic movement, and they also

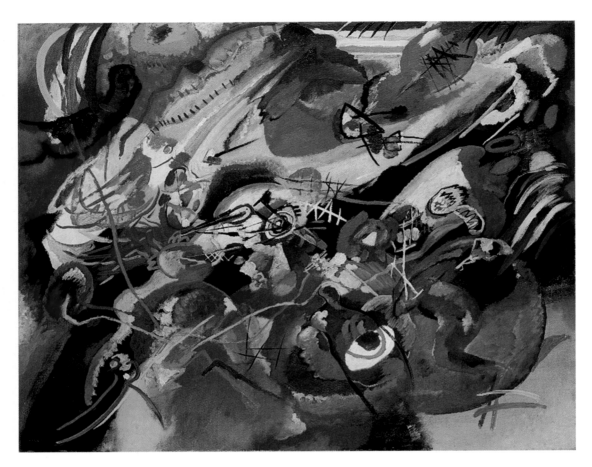

▲ **18.32** Wassily Kandinsky, *Sketch I for Composition VII*, 1913. Oil on canvas, 30 ³/₄" × 39 ³/₈" (78.1 × 100 cm). Private collection © 2013 Artists Rights Society (ARS), New York/ ADAGP, Paris, France. The painting is nonobjective—freed from the shackles of representation.

➤ **18.33** Käthe Kollwitz, *The Outbreak*, 1903. Plate no. 5 from *The Peasants' War*. Etching, dry point, aquatint, and softground, 20 ¹/₄" × 23 ¹/₈" (51.3 × 58.7 cm). Library of Congress, Prints and Photographs Division, Washington, DC. © 2013 Artists Rights Society (ARS), New York/VG Bild-Kunst, Bonn. Few works in the history of art are as impassioned.

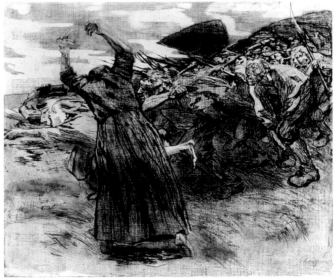

stand as harbingers of a new art unencumbered by referential subject matter.

For Kandinsky, color, line, and shape were subjects in themselves. They were often rendered with a spontaneity born of the psychological process of free association. At this time, free association was also being explored by the founder of psychoanalysis, Sigmund Freud, as a method of mapping the geography of the unconscious mind.

KÄTHE KOLLWITZ Whereas many artists in Germany used Expressionist techniques to represent their own inner forces and preoccupations, isolation, loneliness or themes of violence expressionists Käthe Kollwitz (1867-1945) sought

universal symbols for inhumanity, injustice, and humankind's self-destruction.

The Outbreak (**Fig. 18.33**) is one of a series of seven prints by Kollwitz representing the 16th-century Peasants' War. In this print, Black Anna, a woman who led the laborers in their struggle against their oppressors, incites an angry throng of

peasants to action. Her back is toward us, her head down, as she raises her gnarled hands in inspiration. The peasants rush forward in a torrent, bodies and weapons lunging at Anna's command. Although the work records a specific historical incident, it stands as an inspiration to all those who strive for freedom against the odds. There are few more forceful images in the history of art.

Kollwitz, along with most German artists who embraced some form of modernism in their work, fell victim in the 1930s to Nazi policies that aimed to put an end to their form of artistic expression. Her work was confiscated and hung in a propagandistic exhibition of so-called "degenerate art." Many of her compositions were destroyed. Kirchner's work also suffered the same fate. After being labeled a degenerate artist, he committed suicide in 1938.

▼ **18.34** Pablo Picasso, *The Old Guitarist*, 1903. Oil on canvas, 48³/₈″ × 32¹/₂″ (122.9 × 82.6 cm). Art Institute of Chicago, Chicago, Illinois. © 2013 Estate of Pablo Picasso/Artists Rights Society (ARS), New York. The guitarist is a haunting image from the artist's Blue Period.

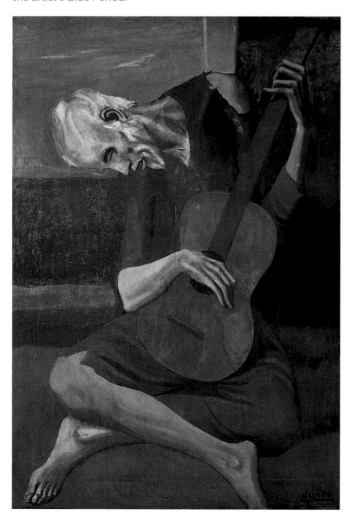

Cubism

The history of art is colored by the tensions of stylistic polarities within given eras, particularly the polarity of an intellectual versus an emotional approach to painting. Fauvism and German Expressionism found their roots in Romanticism and the emotional, Expressionistic work of Gauguin and van Gogh. The second major art movement of the twentieth century, **Cubism**, can trace its heritage to Neo-Classicism and the analytical and intellectual work of Cézanne.

Cubism is an offspring of Cézanne's geometrization of nature, his abandonment of scientific perspective, his rendering of multiple views, and his emphasis on the two-dimensional canvas surface. Picasso, the driving force behind the birth of Cubism and perhaps the most significant artist of the 20th century, combined the pictorial methods of Cézanne with formal elements from African, Oceanic, and Iberian sculpture.

PABLO PICASSO Pablo Ruiz y Picasso (1881–1973) was born in Spain, the son of an art teacher. As an adolescent, he enrolled in the Barcelona Academy of Art, where he quickly mastered the illusionistic techniques of the realistic Academic style. By age 19, Picasso was off to Paris, where he remained for more than 40 years—introducing, influencing, or reflecting the many styles of modern French art.

Picasso's first major artistic phase has been called his Blue Period. Spanning the years 1901 to 1904, this work is characterized by an overall blue tonality, a distortion of the human body through elongation reminiscent of El Greco and Toulouse-Lautrec, and melancholy subjects consisting of poor and downtrodden individuals engaged in menial tasks or isolated in their loneliness. *The Old Guitarist* (**Fig. 18.34**) is but one of these haunting images. A contorted, white-haired man sits hunched over a guitar, consumed by the tones that emanate from what appears to be his only possession. The eyes are sunken in the skeletal head, and the bones and tendons of his hungry frame protrude. We are struck by the ordinariness of poverty, from the unfurnished room and barren window view (or is he on the curb outside?) to the uneventfulness of his activity and the insignificance of his plight. The essentially monochromatic blue palette creates an unrelenting, somber mood. Tones of blue eerily echo the ghostlike features of the guitarist.

In between his Blue Period and his innovation of Cubism with Georges Braque, Picasso painted a portrait of Gertrude Stein (**Fig. 18.35**). Stein was an expatriate American living in Paris, along with her brother Leo. She was an important writer and supporter of the new movements in the arts, helping nurture artists such as Matisse, Braque, and Picasso. In the portrait, Stein wears her preferred brown coat and skirt, which cloak her massive body. As described in *The Autobiography of Alice B. Toklas* (1933), the painting of the portrait was also a massive undertaking.

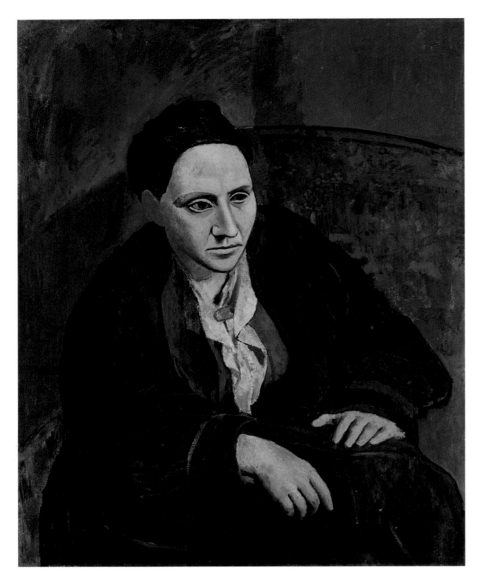

◀ **18.35** Pablo Picasso, *Gertrude Stein*, 1905–1906. Oil on canvas, 39 3/8″ × 32″ (100 × 81.3 cm). Metropolitan Museum of Art, New York, New York. © 2013 Estate of Pablo Picasso/Artists Rights Society (ARS), New York. The face of the sitter is more like an African mask than an accurate portrait. Her attire is reduced to abstract forms.

The painting was begun in 1905 and not completed until 1906. Picasso reduced Stein's body to simple masses and made the face, which he had drawn earlier and discarded, masklike. At about that time, Picasso also became aware of the formal properties of ethnographic art from Africa, Oceania, and Iberia, which he viewed at the Musée de l'Homme in Paris. In 1907 he would paint women whose features were still more masklike and who would literally change the face of modern art.

During Picasso's Rose Period, which followed the Blue Period, works became lighter both in palette and in spirit. Subjects were drawn primarily from circus life and rendered in tones of pink. During this second period, which dates from 1905 to 1908, Picasso was inspired by two very different sources—the ethnographic works that had influenced his portrait of Stein, and the Cézanne retrospective exhibition held at the Salon d'Automne in 1907. These two art forms, which at first glance might appear dissimilar, had in common a fragmentation, distortion, and abstraction of form that were adopted by Picasso in works such as *Les Demoiselles d'Avignon* (**Fig. 18.36**).

This startling, innovative work, still primarily pink in tone, depicts five women from Barcelona's red-light district. (Avignon was the name of a street in that city.) They line up for selection by a possible suitor who stands, as it were, in the position of the viewer of the painting. The faces of three of the women are primitive masks. The facial features of the other two have been radically simplified by combining frontal and profile views. The thick-lidded eyes stare stage front, calling to mind some of the Mesopotamian votive sculptures we saw in Chapter 1.

The bodies of the women are fractured into geometric forms and set before a background of similarly splintered drapery. In treating the background and the foreground

READING 18.1 GERTRUDE STEIN[2]

From *The Autobiography of Alice B. Toklas*

Picasso had never had anybody pose for him since he was sixteen years old. He was then twenty-four and Gertrude had never thought of having her portrait painted, and they do not know either of them how it came about. Anyway, it did, and she posed for this portrait ninety times. There was a large broken armchair where Gertrude Stein posed. There was a couch where everybody sat and slept. There was a little kitchen chair where Picasso sat to paint. There was a large easel and there were many canvases. She took her pose, Picasso sat very tight in his chair and very close to his canvas and on a very small palette, which was of a brown gray color, mixed some more brown gray and the painting began. All of a sudden one day Picasso painted out the whole head. I can't see you anymore when I look, he said irritably, and so the picture was left like that.

2. Stein is said to have penned a new genre of literature—writing another person's autobiography.

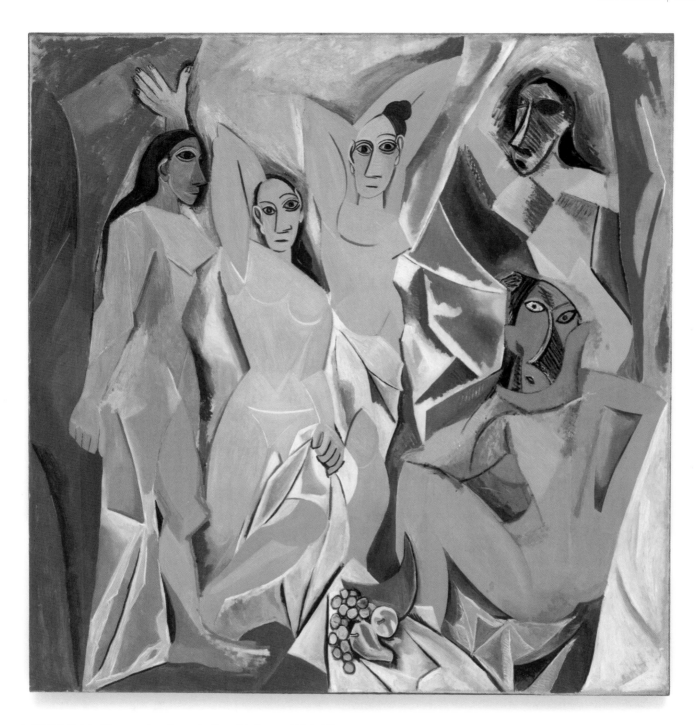

imagery in the same manner, Picasso collapses the space between the planes and asserts the two-dimensionality of the canvas surface in the manner of Cézanne. In some radical passages, such as the right leg of the leftmost figure, the limb takes on the qualities of drapery, masking the distinction between figure and ground. The extreme faceting of form, the use of multiple views, and the collapsing of space in *Les Demoiselles* together provided the springboard for **Analytic Cubism**, cofounded with the French painter Georges Braque in about 1910.

ANALYTIC CUBISM The term *Cubism*, like so many others, was coined by a hostile critic. In this case, the critic was responding to the predominance of geometrical forms in the works of Picasso and Braque. *Cubism* is a limited term in that it does not adequately describe the appearance of Cubist paintings, and it minimizes the intensity with which Cubist artists analyzed their subject matter. It ignores their most significant contribution—a new treatment of pictorial space that hinged upon the rendering of objects from multiple and radically different views.

The Cubist treatment of space differed significantly from that in use since the Renaissance. Instead of presenting an object from a single view, assumed to have been the complete view, the Cubists—as did Cézanne—realized that our visual comprehension of objects consists of many views

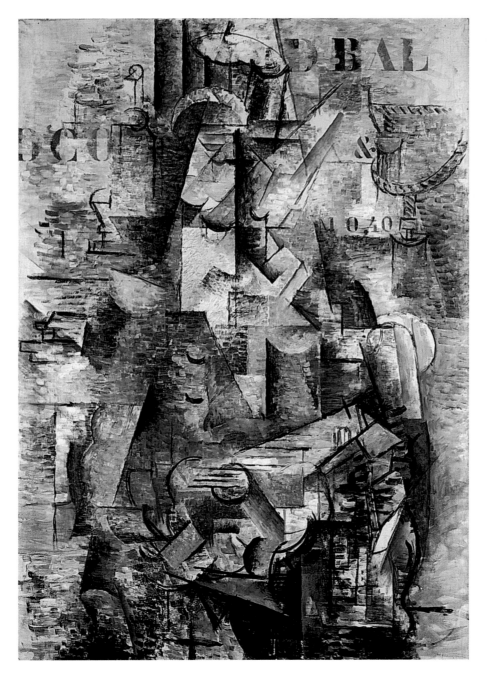

◄ **18.37** Georges Braque, *The Portuguese*, 1911. Oil on canvas, 46″ × 32¼″ (117 × 82 cm). Offentliche Kunstsammlung, Basel, Switzerland. © 2013 Artists Rights Society (ARS), New York/ADAGP, Paris, France. Braque and Picasso were cofounders of Analytic Cubism.

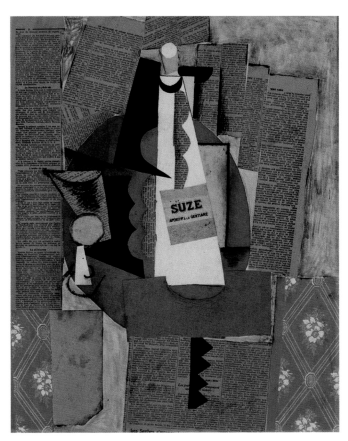

▲ **18.38** Pablo Picasso, *La Bouteille de Suze* (Bottle of Suze), 1912. Pasted paper, gouache, and charcoal, 25³/₄″ × 19³/₄″ (65.40 × 50.17 cm). Mildred Lane Kemper Art Museum, Washington University in St. Louis, St. Louis, Missouri. © 2013 Estate of Pablo Picasso/Artists Rights Society (ARS), New York. The work is completely composed, or synthesized, of found objects.

that we perceive almost at once. They tried to render this visual "information gathering" in their compositions. In their dissection and reconstruction of imagery, they reassessed the notion that painting should reproduce the appearance of reality. Now the very reality of appearances was being questioned. To Cubists, the most basic reality involved consolidating optical vignettes instead of reproducing fixed images with photographic accuracy.

GEORGES BRAQUE During the analytic phase of Cubism, which spanned the years from 1909 to 1912, the works of Picasso and Braque were very similar. The early work of Georges Braque (1882–1963) graduated from Impressionism to Fauvism to more structural compositions based on Cézanne. He met Picasso in 1907, and from then until about 1914, the artists worked together toward the same artistic goals.

The theory of Analytic Cubism reached the peak of its expression in 1911 in works such as Braque's *The Portuguese* (**Fig. 18.37**). Numerous planes intersect and congregate at the center of the canvas to form a barely perceptible triangular human figure, which is alternately constructed from

and dissolved into the background. There are only a few concrete signs of its substance: dropped eyelids, a mustache, the circular opening of a stringed instrument. The multifaceted, abstracted form appears to shift position before our eyes, simulating the time lapse that would occur in the visual assimilation of multiple views. The structural lines—sometimes called the *Cubist grid*—that define and fragment the figure are thick and dark. They contrast with the delicately modeled short, choppy brushstrokes of the remainder of the composition. The monochromatic palette, chosen so as not to interfere with the exploration of form, consists of browns, tans, and ochres.

Although the paintings of Picasso and Braque were almost identical at this time, Braque was the first to begin inserting words and numbers and using **trompe l'oeil** effects in portions of his Analytic Cubist compositions. These realistic elements contrasted sharply with the abstraction of the major figures and reintroduced the nagging question, "What is reality and what is illusion in painting?"

SYNTHETIC CUBISM Picasso and Braque did not stop with the inclusion of precisely printed words and numbers in their works. In the phase of their work known as **Synthetic Cubism**, they began to add characters cut from newspapers and magazines, other pieces of paper, and found objects such as labels from wine bottles, calling cards, theater tickets—even swatches of wallpaper and bits of rope. These items were pasted directly onto the canvas in a technique Picasso and Braque called *papier collé*—what we know as **collage**.

Some Synthetic Cubist compositions, such as Picasso's *La Bouteille de Suze* (Bottle of Suze) (**Fig. 18.38**), are constructed entirely of found elements. In this work, newspaper clippings and opaque pieces of paper function as the shifting planes that hover around the aperitif label and define the bottle and glass. These planes are held together by a sparse linear structure much in the manner of Analytic Cubist works. In contrast to Analytic Cubism, however, the emphasis is on the form of the object and on constructing instead of disintegrating that form. Color reentered the compositions, and much emphasis was placed on texture, design, and movement.

Futurism

Some years after the advent of Cubism, a new movement sprang up in Italy under the leadership of poet Filippo Marinetti (1876–1944). **Futurism** was introduced angrily by Marinetti in a 1909 manifesto that called for an art of "violence, energy, and boldness" free from the "tyranny of . . . harmony and good taste."[5]

3. F. T. Marinetti, "The Foundation and Manifesto of Futurism," in *Theories of Modern Art*, ed. Herschel B. Chipp (Berkeley: University of California Press, 1968), 284–288.

In theory, Futurist painting and sculpture were to glorify the life of today, "unceasingly and violently transformed by victorious science." In practice, many of the works owed much to Cubism.

UMBERTO BOCCIONI

Everything moves, everything runs, everything turns swiftly. The figure in front of us never is still, but ceaselessly appears and disappears. Owing to the persistence of images on the retina, objects in motion are multiplied, distorted, following one another like waves through space. Thus a galloping horse has not four legs; it has twenty.

—UMBERTO BOCCIONI

An oft-repeated word in the Futurist credo is **dynamism**, defined as the theory that force or energy is the basic principle of all phenomena. The principle of dynamism is illustrated in Umberto Boccioni's (1882–1916) *Dynamism of a Soccer Player*. Irregular, agitated lines communicate the energy of movement. The Futurist obsession with illustrating images in perpetual motion also found a perfect outlet in sculpture. In works such as *Unique Forms of Continuity in Space* (**Fig. 18.39**), Boccioni, whose forte was sculpture, sought to convey the elusive surging energy that blurs an image in motion, leaving but an echo of its passage. Although it retains an overall figural silhouette, the sculpture is devoid of any representational details. The flame-like curving surfaces of the striding figure do not exist to define movement; instead, they are a consequence of it.

GIACOMO BALLA The Futurists also suggested that their subjects were less important than the portrayal of the "dynamic sensation" of the subjects. This

> **18.39** Umberto Boccioni, *Unique Forms of Continuity in Space*, 1913 (cast 1931). Bronze, 43⅞" × 34⅞" × 15¾" (111.2 × 88.5 × 40 cm). Museum of Modern Art, New York, New York. Boccioni wrote, "The figure in front of us never is still, but ceaselessly appears and disappears."

declaration manifests itself fully in Giacomo Balla's (1871–1958) pure Futurist painting *Street Light* (**Fig. 18.40**). The light of the lamp pierces the darkness in reverberating circles; V-shaped brushstrokes simultaneously fan outward from the source and point toward it, creating a sense of constant movement. The palette consists of complementary colors that forbid the eye to rest. All is movement; all is sensation.

Cubist and Futurist works of art, regardless of how abstract they might appear, contain vestiges of representation, whether they be unobtrusive details like an eyelid or mustache, or an object's recognizable contours. Yet with Cubism, the seeds of abstraction were planted. It was just a matter of time until they would find fruition in artists who, like Kandinsky, would seek pure form unencumbered by referential subject matter.

In Chapter 21 we will see more of Picasso's work, including his great protest painting *Guernica*, which was painted when fascism arose in Europe and a Spanish town was used as a testing ground for new air-to-ground weaponry. We will also explore schools of art with names such as Surrealism and Dada.

Architecture

Architecture took new turns and literally reached new heights in the period between 1870 and 1914. A Parisian structure erected for an exhibition has remained in place for more than 100 years and become, perhaps, the defining symbol of that city. A simplified Modernist style that presaged the modern skyscraper was developing in the United States. In Barcelona, Spain, an architect-sculptor's mind ran free.

EIFFEL TOWER The Eiffel Tower, designed by Gustave Eiffel (1832–1923) and completed in 1889, is made of iron and stands 984 feet tall (**Fig. 18.41**). It is mainly openwork, although restaurants and a few other minor structures have been placed on its three levels and elevators run up along its curved supports. Its minimal function can be explained by its original purpose: it was built as the gateway to the 1889 World's Fair. It was not intended to be a permanent fixture in Paris, but the populace responded to it so positively that it has remained in place. However, it is built of iron, not of steel, which

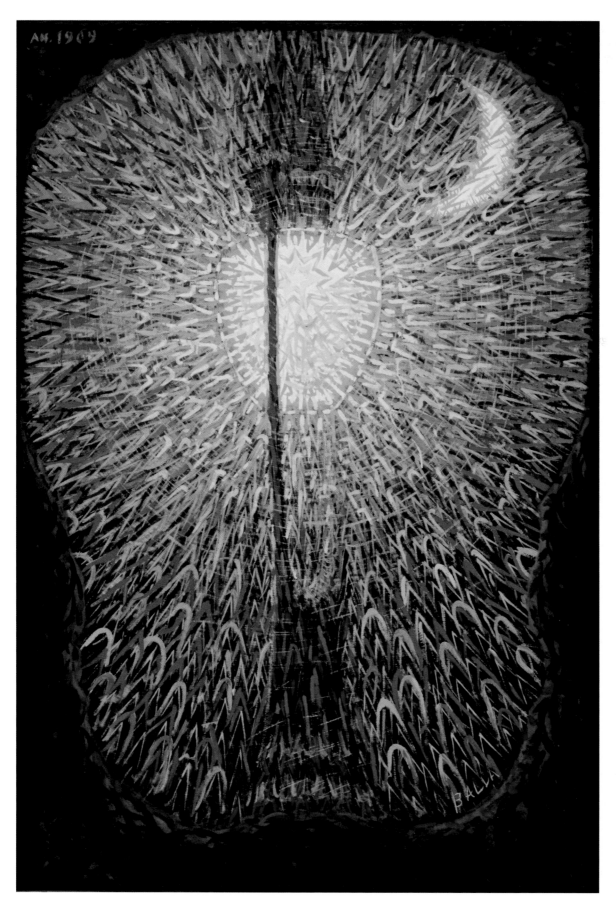

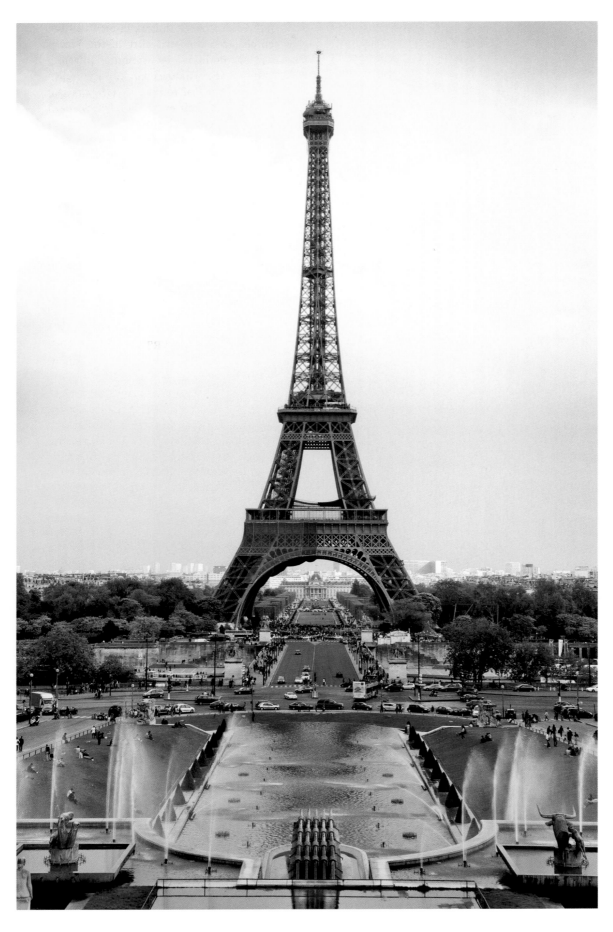

◀ **18.41** Gustave Eiffel, Eiffel Tower, 1889. Paris, France. Iron, 1050′ (320 m) high. To prevent rusting, the tower is repainted every seven years with 50 to 60 tons of paint.

fathers of modern American architecture, emphasized the verticality of the Wainwright Building by running pilasters between the windows through the upper stories. Many of today's skyscrapers run pilasters up their entire façades. Sullivan also emphasized the horizontal features of the Wainwright Building. Ornamented horizontal bands separate most of the windows, and a severe decorated cornice crowns the structure. Sullivan's motto was "form follows function," and the rigid horizontal and vertical processions of the elements of the façade suggest the regularity of the rectangular spaces within. Sullivan's early "skyscraper"—in function, in structure, and in simplified form—was a precursor of the 20th-century behemoths to follow.

CASA MILÀ APARTMENT HOUSE

Antoni Gaudí's (1852–1926) apartment house in Barcelona, Spain (**Fig. 18.44**), shows an obsessive avoidance of straight lines and flat surfaces. The material looks as if it had grown in place or hardened in malleable wood forms, as would cement; in actuality, it is cut stone. The rhythmic roof is wavelike, and the chimneys seem

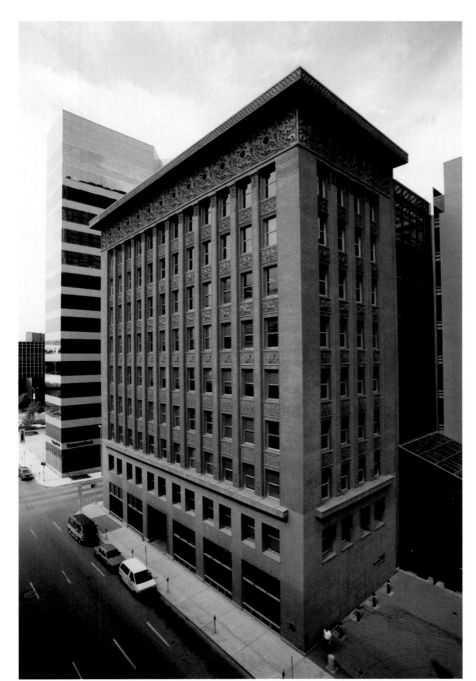

◀ **18.42 Louis Sullivan, Wainwright Building, 1890–1891. St. Louis, Missouri.** The building may not be impressively tall by today's standards, but its steel-cage construction set the pattern for modern skyscrapers.

▼ **18.43 Steel-cage construction.**

means that it is more prone to rusting. Therefore, the tower is repainted every seven years, with 50 to 60 tons of paint, at a current cost of more than $5 million. Even so, the tourists who visit the tower—about seven million each year, many of whom visit Paris at least in part because of the tower—bring in many times the maintenance costs.

WAINWRIGHT BUILDING The Wainwright Building (**Fig.18.42**)—erected in St. Louis, Missouri, in 1890–1891— is an early example of steel-cage construction. With steel-cage construction, the weight of the building is borne by its structural core and not its walls, allowing for an expansive use of glass—called a *curtain wall*—on the building's elevations (**Fig. 18.43**). Architect Louis Sullivan (1856–1924), one of the

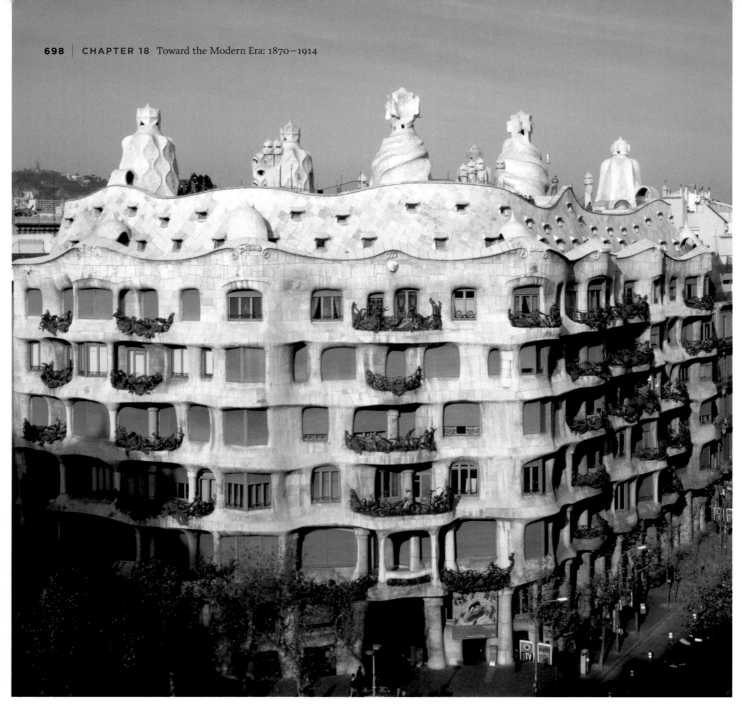

▲ **18.44** Antoni Gaudí, Casa Milà Apartment House, 1905–1907. Barcelona, Spain. A visitor will be hard-pressed to find a straight line in Gaudi's building.

dispensed like shaving cream or soft ice cream. Nor are any two rooms on a floor alike. This multistory organic hive is clearly the antithesis of the steel-cage construction that was coming into its own at the same time.

MUSIC

The latter 19th and early 20th centuries saw new beloved composers of opera whose works remain as compelling as they have ever been. Impressionism had forced both artists and public to think afresh about painting and seeing; by the early years of the 20th century, musicians and music lovers were also to have many of their preconceptions challenged. Not only were traditional forms like the symphony either discarded or handled in a radical new way, but even the basic ingredients of musical expression—melody, harmony, and rhythm—were subject to startling new developments. Few periods in the history of music are in fact more packed with change than that between 1870 and 1914, which saw a fresh approach to symphonic form, the rise of a musical version of Impressionism, and the revolutionary innovations of the two giants of modern music: Schönberg and Stravinsky.

Opera

Two of the most beloved opera composers of all time lived and composed during the era from 1870 to 1914. One was French and the other Italian.

GEORGES BIZET One of these is the French composer Georges Bizet (1838–1875), whose best-known work, *Carmen*, was completed in 1874 and apparently failed, leading Bizet to despair prior to his death in the following year. Yet *Carmen* has blossomed into one of opera's major success stories, with some fans ensuring that they see it once a year. The story is simple: A soldier in Seville, Don José, is seduced by a gypsy, Carmen, who works in a tobacco factory. She leads him into a life of crime, which for her is carefree but for him, deeply conflicted. But Carmen tires of him and takes up a relationship with a toreador. Don José cannot accept that he has been but a temporary plaything, and he kills Carmen. Morality in the opera is interesting: Carmen is a criminal yet she is always honest with Don José; in one of her arias she sings about the fact that she may love a man today, but what of tomorrow? At the end, she refuses to disavow her feelings for the toreador although she knows Don José will kill her for it. The opera is known for its "set pieces," including what we refer to as "The Toreador Song" and Carmen's "Habanera." The opera is in French, and the aria begins *"L'amour est un oiseau rebelle que nul ne peut apprivoiser,"* which translates as "Love is a rebellious bird that nobody can tame."

The habanera was a Cuban dance genre with African roots. It originated early in the 19th century, and its rhythms are also used in dances such as the *conga* and the *tango*. It became exported across the world, and was highly popular in France and Spain toward the latter part of the century, when Bizet composed *Carmen*. Carmen moves seductively as she sings the aria, "Habanera," which, of course, bears the name of the dance.

GO LISTEN! GEORGES BIZET

Carmen, Act One, "Habanera"

GIACOMO PUCCINI The Italian composer Giacomo Puccini (1858–1924) also emerged toward the turn of the century. His shimmering musical passages are part traditional Italian opera and part Impressionism, influenced by contemporaries such as Igor Stravinsky. Puccini also swept audiences on exotic journeys, for example, to Japan in *Madame Butterfly* (1904) and to the American West in *La Fanciulla del West* (1910). His most popular operas are *La Bohème* (1896), whose tragic plot revolving around impoverished artists set the stage for the rock musical *Rent*; *Madame Butterfly*, whose impossible love affair with an American is retold in the musical *Miss Saigon*; and *Tosca* (1900), which may have no precise present-day parallels but whose story, set in Rome in 1800, rushes poignantly to its dramatic conclusion—the deaths of an opera singer, Tosca, and her lover, the artist Mario Cavaradossi, at

the hands of a corrupt police chief, Scarpia. *Tosca*'s most compelling arias include Scarpia's "Va, Tosca" followed immediately by the Te Deum at the end of act 1—Scarpia's declaration that he will have Tosca followed ironically by a religious piece declaring, "Everlasting Father, all the earth worships thee"; Tosca's plaintive "Vissi d'arte" in act 2 ("I lived for art, I lived for love"); and Cavaradossi's all-too-brief "E lucevan le stele" ("And shone the stars") just prior to his execution in act 3.

Light Opera

Although opera was well attended during this era, light opera was more accessible to the masses. Dialogue and soliloquies were interspersed with songs of melodies that theater-goers could hum and sing on the way home.

GILBERT AND SULLIVAN Perhaps the most successful stagers of light opera were the librettist William S. Gilbert (1836–1911) and the composer Arthur Sullivan (1842–1900), known collectively as simply Gilbert and Sullivan. Sullivan had tried his hand at "heavier" opera and other musical pieces, but they never achieved renown. The duo's light operas, on the other hand, remain attended today, with the most popular—*The Mikado*, first staged in 1885 (**Fig. 18.45**)—turning up in the repertoire of opera companies throughout the English-speaking world at various intervals. Their other popular works include *H.M.S. Pinafore* (that is, Her Majesty's Ship *Pinafore*; staged in 1878), with an admiral who is appointed because of his social rank but suffers from seasickness.

The mikado is the ruler of Japan, and the opera—as does Puccini's *Madame Butterfly*—suggests the European fascination of its time with all things Oriental. Maidens parade in tiny steps, fluttering their fans. Men, similarly, open and slap fans closed as punctuation marks. Their dress mimics that found in Japanese prints of the period. Having said all this, the lyrics are fundamentally a satire of British society. The officious Pooh-Bah might represent any pompous and puffed-up minor government official—one of excellent "pedigree" who is nevertheless susceptible to bribes ("insults"). Ko-Ko, the Lord High Executioner who would never be able to bring himself to execute a fly, is a neurotic mess who aspires to a position in society. He sings "I've got them on my list"—a laundry list of society's worst offenders, especially among the upper crust. Current-day American stagers of the opera are likely to insert their own laundry lists of obnoxious politicians and reality TV icons.

In the lyrics on page 701 from *H.M.S. Pinafore*'s "Ruler of the Queen's Navy," the admiral, Sir Joseph, describes his rise to wealth and power. Without any self-insight, Sir Joseph actually mocks the absurdity of the British bureaucracy's delegation of power to people of established lineage, name, or nobility. Ability is all but irrelevant. In Parliament, for example, he simply voted the party line, never thinking for himself. (Might we have such politicians in the U.S. Congress today?) Since this is a rollicking comedy, the chorus repeats each verse with dancing and posturing. The queen is Queen

▲ **18.45** Cover of the score for *Airs from The Mikado*, by Gilbert and Sullivan, arranged by P. Bucalossi, 1885. Sheet music ca. 10″ × 13″ (25.4 × 33.0 cm). Royal Academy of Music, London, United Kingdom.

The Mikado suggested Europe's fascination with all things Oriental. Although the setting was exotic, the opera satirized British society.

Victoria, who reigned from 1837 to 1901—a span of time which was most or all of many Britishers' lifetimes.

"When I Was a Lad" is a *patter song*. Patter songs range in tempo from moderately rapid to extremely rapid. They are found mainly in light opera and *opera buffa* (comic opera). Many patter songs accelerate in pace as they proceed, and some performers repeat the lyrics ever faster, so fast that the audience may wonder how it is possible. Patter songs often have tongue-twisting lyrics, as in Gilbert & Sullivan's *Pirates of Penzance*, which has the song "I am the Very Model of a Modern Major General." Since "When I Was a Lad" is accompanied by a dancing chorus, the dancing accelerates with the music.

GO LISTEN! GILBERT & SULLIVAN

H.M.S. Pinafore "When I Was a Lad"

READING 18.2 W. S. GILBERT

From *H.M.S. Pinafore*, "When I Was a Lad"

When I was a lad I served a term
As office boy to an Attorney's firm.
I cleaned the windows and I swept the floor,
And I polished up the handle of the big front door.
I polished up that handle so carefully
That now I am the Ruler of the Queen's Navy!

. . .

Of legal knowledge I acquired such a grip
That they took me into the partnership.
And that junior partnership, I ween,
Was the only ship that I ever had seen.
But that kind of ship so suited me,
That now I am the Ruler of the Queen's Navy!

I grew so rich that I was sent
By a pocket borough into Parliament.
I always voted at my party's call,
And I never thought of thinking for myself at all.
I thought so little, they rewarded me
By making me the Ruler of the Queen's Navy!

Now landsmen all, whoever you may be,
If you want to rise to the top of the tree,
If your soul isn't fettered to an office stool,
Be careful to be guided by this golden rule—
Stick close to your desks and never go to sea,
And you all may be rulers of the Queen's Navy!

Orchestral Music

Although many extended orchestral works written in the last years of the 19th century and the early 20th century were called symphonies by their composers, they would hardly have been recognizable as such to Haydn or Beethoven. The custom of varying the traditional number and content of symphonic movements had already begun during the Romantic period; Berlioz wrote his *Symphonie fantastique* as early as 1830 (see Chapter 17). Nonetheless, by the turn of the century, so-called symphonies were being written that had little in common with one another, much less the Classical symphonic tradition.

The driving force behind many of these works was the urge to communicate something beyond purely musical values. From the time of the ancient Greeks, many composers attempted to write instrumental music that told a story or described some event, including Vivaldi in his "Four Seasons" and Beethoven in his curious work known as the "Battle" Symphony. By the mid-19th century, however, composers had begun to devise elaborate *programs* (plots), which their music would then describe. Music of this kind is generally known as **program music**; its first great exponent was Franz Liszt (see Chapter 17), who wrote works with titles such as *Hamlet, Orpheus*, and *The Battle of the Huns*, for which he invented the generic description *symphonic poem*.

The principle behind program music is no better or worse than many another. The success of any individual piece depends naturally on the degree to which narrative and musical interest can be combined. There are, to be sure, some cases where a composer has been carried away by eagerness for realism. Ottorino Respighi (1879–1936), for example, incorporated the sound of a nightingale by including a record player and a recording of live birdsong in *Pines of Rome* (1924).

RICHARD STRAUSS No one was more successful at writing convincing program symphonies and symphonic poems—**tone poems**, as he called them—than the German composer Richard Strauss (1864–1949). One of his first successful tone poems, *Don Juan* (begun in 1886), deals with the familiar story of the compulsive Spanish lover from a characteristically late-19th-century point of view. Instead of the unrepentant Don Giovanni of Mozart or Byron's amused (and amusing) Don Juan, Strauss presents a man striving to overcome the bonds of human nature, only to be driven by failure and despair to suicide. The music, gorgeously orchestrated for a vast array of instruments, moves in bursts of passion, from the surging splendor of its opening to a bleak and shuddering conclusion.

Strauss was not limited to grand and tragic subjects. *Till Eulenspiegel's Merry Pranks* tells the story of a notorious practical joker and swindler and is one of the most successful examples of humor in music. Even when Till goes too far in his pranks and ends up on the gallows (vividly depicted by Strauss's orchestration), the music returns to a cheerful conclusion.

One of Strauss's most remarkable works, and one that clearly demonstrates the new attitude toward symphonic form, is *An Alpine Symphony*, written between 1911 and 1915. In one huge movement lasting some 50 minutes, it describes a mountain-climbing expedition, detailing the adventures on the way (with waterfalls, cowbells, and glaciers all in the music) and, at its climax, the arrival on the summit. The final section depicts the descent, during which

a violent storm breaks out, and the music finally sinks to rest in the peace with which it opened. All this may sound more like a movie soundtrack than a serious piece of music, but skeptical listeners should try *An Alpine Symphony* for themselves. It is as far from conventional notions of a symphony as Cézanne's painting of Mont Sainte-Victoire (see **Fig. 18.23**) is from a conventional landscape, but genius makes its own rules. Strauss's work should be taken on its own terms.

Not surprisingly, a composer capable of such exuberant imagination was also fully at home in the opera house. Several of Strauss's operas are among the greatest of all 20th-century contributions to the repertoire. In some, he was clearly influenced by the prevailingly gloomy and morbid mood of German Expressionist art. His first big success, for example, was a setting of the Irish writer Oscar Wilde's play *Salome*, based on a biblical story, which was first performed to a horrified audience in 1905. After one performance (in 1907) at the Metropolitan Opera House in New York, it was banned in the United States for almost 30 years. The final scene provides a frightening yet curiously moving depiction of erotic depravity, as Salome kisses the lips of the severed head of John the Baptist.

Works such as *Don Juan* and *An Alpine Symphony* deal with stories we know or describe events with which we are familiar. In other cases, Strauss took as his subject his own life, and a few of his pieces—including the *Domestic Symphony* and the somewhat immodestly titled *Ein Heldenleben* (A Hero's Life)—are frankly autobiographical. In this he was following a custom that had become increasingly popular in the late 19th century—the composition of music concerned with the detailed revelation of its composer's inner emotional life.

PIOTR ILYCH TCHAIKOVSKY The late-Romantic composer Piotr Ilych Tchaikovsky (1840–1893) is best known for composing the ballets *Swan Lake* in 1875–1876 (**Fig. 18.46**) and *The Nutcracker* in 1892. *The Nutcracker* is surely the most beloved and familiar of Tchaikovsky's ballets. Performances around the world are a perpetual part of the Christmas tradition and the melodies accompanying the ballet numbers rings familiar to many an ear. *The Nutcracker Suite*, Op. 71a is a group of eight numbers chosen by Tchaikovsky for an orchestral performance before the ballet's premier in 1892. Among the six are the famous "Waltz of the Flowers" and a series of numbers for the "Danses Caracterisques," in which the composer appropriated what he deemed to be the "characteristic" musical styles of diverse cultures. The "Arabian Dance" is based on a lullaby from the Georgia that, in Tchaikovsky's time, was under control of the Russian tsar.

GO LISTEN! TCHAIKOVSKY

"Waltz of the Flowers"
"Arabian Dance"

Tchaikovsky was one of the first musicians to make his personal emotions the basis for a symphony. His Symphony No. 6 in B Minor, Op. 74, known as the "Pathétique," was written in the year of his death. An early draft outline of its "story" was found among his papers, describing its "impulsive passion, confidence, eagerness for activity," followed by love and disappointments, and finally collapse and death. It is now believed that the Russian composer did not die of cholera, as formerly thought, but by suicide. The reasons are still not clear, but they perhaps related to a potentially scandalous love affair. In the light of this information, the "Pathétique" takes on new poignancy. Its last movement sinks mournfully into silence after a series of climaxes that seem to protest bitterly, if vainly, against the injustices of life.

GUSTAV MAHLER The revelation of a composer's life and emotions through his music reached its most complete expression in the works of Gustav Mahler (1860–1911). Until around 1960, the centenary of his birth in Bohemia, Mahler's music was almost unknown, and those who did know it generally derided him as unoriginal and overambitious. Now that he has become one of the most frequently performed and recorded of composers, we can begin to appreciate his true worth and learn the danger of hasty judgments.

The world of Mahler's symphonies is filled with his own anxieties, triumphs, hopes, and fears, but it also illuminates our own problem-ridden age. It may well be that Mahler speaks so convincingly and so movingly to a growing number of ordinary music lovers because his music touches on areas of human experience that were unexplored before his time and increasingly significant to ours. In purely musical terms, however, Mahler can now be seen as a profoundly original genius. Like Rodin, Mahler stands as both the last major figure of the 19th century in his field and a pioneer in the modern world. Mahler's innovations won him the scorn of earlier listeners: his deliberate use of popular, banal tunes, for example, and the abrupt changes of mood in his music. A symphony, he once said, should be like the world; it should contain everything. His own nine completed symphonies (he left a tenth unfinished), and *Das Lied von der Erde* (The Song of the Earth), a symphony for two singers and orchestra, certainly contain just about every human emotion.

As early as the Symphony No. 1 in D, we can hear the highly individual characteristics of Mahler's music. The third movement of the symphony is a funeral march, but its wry, ironic tone is totally unlike any other in the history of music. The movement opens with the mournful sound of a solo double bass playing the old round "Frère Jacques," which is then taken up by the rest of the orchestra. There are sudden bursts of trite nostalgia and violent aggression until the mood gradually changes to one of genuine tenderness. After a gentle middle section, the movement returns to the bizarre and unsettling spirit of the opening.

By the end of his life, Mahler was writing far less optimistic music than his Symphony No. 1, which—despite its third-movement funeral march—concludes with a long finale

Gustav Mahler

Mahler wrote to his wife, Alma, after a meeting with Richard Strauss. Mahler had heard *Salome* and was impressed.[6]

Berlin, January 190-
My dear, good Almschili;

Yesterday afternoon I went to see Strauss. [His wife, Pauline,] met me at the door with pst! pst! Richard is sleeping, pulled me into her (very slovenly) boudoir, where her old mama was sitting over some mess (not coffee) and filled me full of nonsensical chatter about various financial and sexual occurrences of the last two years, in the meantime asking hastily about a thousand and one things without waiting for a reply, would not let me go under any circumstances, told me that yesterday morning Richard had had a very exhausting rehearsal in Leipzig, then returned to Berlin and conducted Götterdämmerung in the evening, and this afternoon, worn to a frazzle, he had gone to sleep, and she was carefully guarding his sleep. I was dumbfounded.

Suddenly she burst out: "Now we have to wake up the rascal!" Without my being able to prevent it, she pulled me with both her fists into his room and yelled at him in a very loud voice: "Get up, Gustav is here!" (For an hour I was Gustav—then suddenly Herr Direktor again.) Strauss got up, smiled patiently, and then we went back to a very animated discussion of all that sheer bilge. Later we had tea and they brought me back to my hotel in their automobile, after arranging for me to take lunch with them at noon Saturday.

There I found two tickets for parquet seats in the first row for *Salome* and I took Berliner along. The performance was excellent in every respect—orchestrally, vocally, and scenically it was pure Kitsch and Stoll, and again it made an extraordinary impression on me. It is an extremely clever, very powerful piece, which certainly belongs among the most significant of our time! Beneath a heap of rubbish an infernal fire lives and burns in it—not just fireworks.

That's the way it is with Strauss's whole personality and it's difficult to separate the wheat from the chaff. But I had felt tremendous respect for the whole manifestation and this was confirmed again. I was tremendously pleased. I go the whole hog on that. Yesterday Blech conducted—excellently. Saturday Strauss is conducting and I am going again. Destinn was magnificent; the Jochanaan [Berger] very fine. The others, so-so. The orchestra really superb.

*Letter of Gustav Mahler to his wife from *Letters of Composers* by G. Norman and M. L. Shrifte.

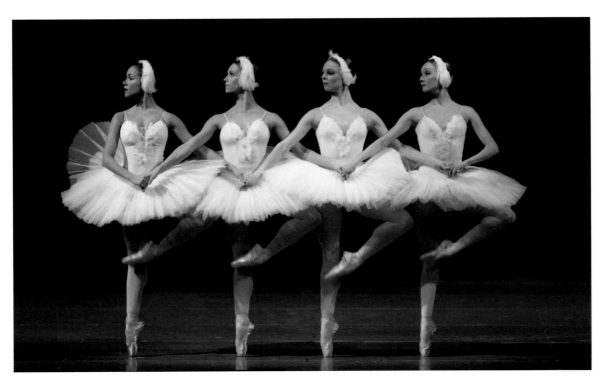

◀ **18.46** Yelizaveta Chaprasova, Svetlana Ivanova, Yelena Chmil, and Valeria Martynyuk as the Little Swans in a scene from the ballet *Swan Lake* by Piotr Tchaikovsky, choreographed by Marius Petipa and Lev Ivanov and adapted by Konstantin Sergeyev. St. Petersburg, Russia.

ending in a blaze of triumphant glory. Mahler's last completed works—*The Song of the Earth* and Symphony No. 9—composed under the shadow of fatal heart disease and impending death, express all of the beauty of the world together with the sorrow and ultimate resignation of one who has to leave it. The final movement of the Symphony No. 9, in particular, is a uniquely eloquent statement of courage in the face of human dissolution. Opening with a long, slow theme of great passion and nobility, the movement gradually fades away as the music dissolves into fragments and finally sinks into silence. Like all of Mahler's music, and like the paintings of van Gogh or Munch, the Symphony No. 9 does not turn its back on the ugliness and tragedy of life; but Mahler, unlike many of his contemporaries, was able to see beyond these realities and express something of the painful joy of human existence. Perhaps this is why his music has become so revered today.

CLAUDE DEBUSSY At about the same time painters in France were developing the style we call Impressionist, the young French composer Claude Debussy (1862–1918) began to break new musical ground. Abandoning the concept of the development of themes in a systematic musical argument, which lies behind Classical sonata form and Romantic symphonic structure, he aimed for a constantly changing flow of sound. Instead of dealing with human emotions, Debussy's music evoked the atmosphere of nature: the wind and the rain and the sea. The emphasis on shifting tone colors led inevitably to comparisons to Impressionist painting. Like Monet or Renoir, he avoided grand, dramatic subjects in favor of ephemeral, intangible sensations and replaced Romantic opulence with refinement.

These comparisons should nevertheless not be exaggerated. Debussy and the Impressionists shared a strong reaction against tradition in general and the Romantic tradition in particular, in response to which they created a radically new approach to their respective arts, but Impressionism permanently changed the history of painting, while the only really successful Impressionist composer was Debussy. Later musicians borrowed some of Debussy's musical devices, including his highly fluid harmony and frequent dissonances, but Debussy never really founded a school. The chief developments in 20th-century music after Debussy took a different direction, and were summed up rather unsympathetically by the French poet Jean Cocteau (1889–1963): "After music with the silk brush, music with the axe." These developments represent a more determined break with tradition than the refined style of Debussy. With the passing of time, Debussy's musical style appears increasingly to represent the last gasp of Romanticism rather than the dawn of a new era.

Whatever his historical position, Debussy was without doubt one of the great creative musical figures of his time. He is at his best and most Impressionist in orchestral works like *La Mer* (The Sea), composed in 1903–1905, which Debussy called symphonic sketches. This marine counterpart of Strauss's *An Alpine Symphony* is in three movements, the titles of which ("From Dawn to Noon on the Sea," "Play of the

Waves," and "Dialogue of the Wind and the Sea") describe the general atmosphere that concerned Debussy rather than literal sounds. There are no birdcalls or thunderclaps in the music; instead, the continual ebb and flow of the music suggest the mood of a seascape. The second movement, for example, depicts the sparkling sunlight on the waves by means of delicate, flashing violin scales punctuated by bright flecks of sound color from the wind instruments. It is scarcely possible to resist a comparison with the shimmering colors of Monet's *Nymphéas*, (see **Fig. 18.12**).

Elsewhere, Debussy's music is less explicitly descriptive. His piano music, among his finest compositions, shows an incredible sensitivity to the range of sound effects that instrument can achieve. Many of his pieces have descriptive titles—"Footsteps in the Snow," "The Girl with the Flaxen Hair," and so on—but these were often added after their composition as the obligatory touch of musical Impressionism. Sometimes they were even suggested by Debussy's friends as their own personal reactions to his music. His "Claire de Lune" (Moonlight) is a case in point. The tranquil calm of the music might well convey to some listeners the beauty of a moonlit night, but equally, the piece can be enjoyed as a musical experience in its own right.

 GO LISTEN! CLAUDE DEBUSSY

"Claire de Lune" (Moonlight)

"Claire de Lune" is one of Debussy's earliest piano works, written in 1890, at a time when he was closer to Impressionist art than he was to become as his style developed. Thus the peaceful descending scale that begins the piece might very well be intended to depict a calm, glowing night. Throughout the piece, interest is centered on the right hand and the higher, "celestial" notes of the piano. The music intensifies, although remaining within the limits of its placid opening.

Debussy's interest in French keyboard music of the Rococo period may be responsible for the slightly "antique" air of the piece. Like most of his music, it creates its own form, following neither Classical nor Romantic principles of organization and remaining the expression of a mood rather than a personal outpouring of feeling. Whether that mood is related to a peaceful scene under moonlight or is more generalized is up to the individual listener to decide. It is interesting to speculate on what our reactions to the piece would have been if we did not know its title.

JOSEPH-MAURICE RAVEL The only composer to make wholehearted use of Debussy's Impressionistic style was his fellow countryman Joseph-Maurice Ravel (1875–1937), who, however, added a highly individual quality of his own. Ravel was far more concerned with Classical form and balance than Debussy. His musical god was Mozart, and something of the limpidity of Mozart's music can be heard in many of his pieces,

although certainly not in the all-too-familiar *Boléro*. His lovely Piano Concerto in G alternates a Mozartian delicacy and grace with an exuberance born of Ravel's encounters with jazz. Even in his most overtly Impressionistic moments, like the scene in his ballet *Daphnis and Chloé* that describes dawn rising, he retains an elegance and verve that differ distinctly from the veiled and muted tones of Debussy.

The Search for a New Musical Language

In 1908 the Austrian composer Arnold Schönberg (1874–1951) wrote his Three Piano Pieces, Op. 11, in which he was "conscious of having broken all restrictions" of past musical traditions. After the first performance one critic described the pieces as "pointless ugliness" and "perversion." In 1913 the first performance of *The Rite of Spring*, a ballet by the Russian-born composer Igor Fyodorovich Stravinsky (1882–1971), was given in Paris, where he was then living. It was greeted with hissing, stamping, and yelling, and Stravinsky was accused of the "destruction of music as an art." Stravinsky and Schönberg are today justly hailed as the founders of modern music, but we can agree with their opponents in at least one respect: their revolutionary innovations permanently changed the course of musical development.

It is a measure of their achievement that today listeners find *The Rite of Spring* exciting, even explosive, but perfectly approachable. If Stravinsky's ballet score has lost its power to shock and horrify, it is principally because we have become accustomed to music written in its shadow. *The Rite of Spring* has created its own musical tradition, one without which present-day music at all levels of popularity would be unthinkable. Schönberg's effect has been less widespread, and subtler; nonetheless, no serious composer writing since his time has been able to ignore his music. It is significant that Stravinsky, who originally seemed to be taking music down a radically different "path to destruction," eventually adopted principles of composition based on Schönberg's methods.

As is true of all apparently revolutionary breaks with the past, Stravinsky and Schönberg were really only pushing to extreme conclusions developments that had been under way for some time. Traditional harmony had been collapsing since the time of Wagner, and Schönberg only dealt it a deathblow by his innovations. Wagner's *Tristan and Isolde* had opened with a series of chords that were not firmly rooted in any key and had no particular sense of direction (see Chapter 17), a device Wagner used to express the poetic concept of restless yearning. Other composers followed him in rejecting the concept of a fixed harmonic center from which the music might stray so long as it returned there, replacing it with a much more fluid use of harmony. (Debussy, in his attempts to go beyond the bounds of conventional harmony, often combined chords and constructed themes to avoid the sense of a tonal center; the result can be heard in the wandering, unsettled quality of much of his music.)

ARNOLD SCHÖNBERG Arnold Schönberg believed that the time had come to abandon a harmonic (or tonal) system that had served music well for more than 300 years but had simply become worn out. He therefore began to write **atonal** music, which deliberately avoided traditional chords and harmonies. Thus Schönberg's atonality was a natural consequence of earlier musical developments. At the same time, it was fully in accordance with the spirit of the times. The sense of a growing rejection of traditional values, culminating in a decisive and violent break with the past, can be felt not only in the arts but also in the political and social life of Europe; Schönberg's drastic abandonment of centuries of musical tradition prefigured by only a few years the far more drastic abandonment of centuries of tradition brought about by World War I.

There is another sense in which Schönberg's innovations correspond to contemporary developments. One of the principal effects of atonality is a mood of instability—even disturbance—that lends itself to the same kind of morbid themes that attracted Expressionist painters. In fact, many of Schönberg's early atonal works deal with such themes. (Schönberg was also a painter of some ability and generally worked in an Expressionist style.)

One of Schönberg's most extraordinary pieces is *Pierrot Lunaire* (finished in 1912), a setting of twenty-one poems for a woman's voice and small instrumental group. The poems describe the bizarre experiences of their hero, Pierrot, who is an Expressionist version of the eternal clown, and their mood is grotesque and at times demonic. The eighth poem, for example, describes a crowd of gigantic black moths flying down to block out the sunlight, while in the eleventh, titled "Red Mass," Pierrot holds his own heart in his bloodstained fingers to use as a "horrible red sacrificial wafer." Schönberg's music clothes these verses in appropriately fantastic and macabre music. The effect is enhanced by the fact that the singer is instructed to speak the words at specific pitches. This device of **Sprechstimme** ("speaking voice") is mainly associated with Schönberg in *Pierrot Lunaire*. Sprechstimme is a hybrid of speaking and singing in which the pitch of speech is raised or lowered according to musical notation. Sprechstimme is difficult to execute, but when it is done properly by a skilled performer, it imparts a wistfully dreamlike quality to the music. In the mid-20th century Sprechstimme was used in English by Sam Levene, the original Nathan Detroit in *Guys and Dolls*, and by Rex Harrison, who played Henry Higgins in *My Fair Lady*. Neither Levene nor Harrison could be accused of having had a singing voice, but their more-than-adequate Sprechstimme brought something unique to their songs.

GO LISTEN! ARNOLD SCHÖNBERG
"Mondestrunken" from *Pierrot Lunaire*

In this first number of Schönberg's *Pierrot Lunaire*, "Mondestrunken" (literally "Moondrunk"), the poet, his eyes drunk with wine and moonlight, seeks inspiration in the beauty of the night. The piece begins with brief piano scales before the voice enters, accompanied by the flute, later the violin and cello. Indeed, the flute dominates the setting, soaring and trilling, as if to express the ecstasy of the moment. The piece reaches a brief climax, with the flute in its highest register, and then fades away.

This first number sets the tone for the whole cycle. Schönberg uses a group of eight solo instruments to accompany his "reciter," varying the combination from piece to piece. The moon as a topic returns in several of the later pieces, most notably number seven, "The Sick Moon."

Of all the selections discussed so far, none is likely to seem more perplexing to first-time listeners or further from most people's musical experience. It may help to know that in an earlier work, his String Quartet No. 2, Schönberg included a setting of a poem by the German Symbolist poet Stefan George, which included the line "I feel the breath of another planet." Schönberg was indeed seeking to break with the long history of musical development and open up new worlds.

The freedom atonality permitted the composer became something of a liability, and by the 1920s Schönberg replaced it with a system of composition as rigid as any earlier method in the history of music. His famous **twelve-tone technique** uses the twelve notes of the chromatic scale (on the piano, all of the black and white notes in a single octave) carefully arranged in a row or series, the latter term having given rise to the name *serialism* to describe the technique. The basic row, together with variant forms, then serves as the basis for a movement or even an entire work, with the order of the notes remaining always the same.

Just as with program music, the only fair way to judge the twelve-tone technique is by its results. Not all works written using it are masterpieces, but we can hardly expect them to be. It is not a system that appeals to all composers or brings out the best in them, but few systems ever have universal application. Some of Schönberg's own twelve-tone works, including his unfinished opera *Moses and Aaron* and the Violin Concerto of 1934, demonstrate that serial music can be both beautiful and moving. The 21st century will decide whether the system has permanent and enduring value.

IGOR STRAVINSKY Like *Pierrot Lunaire*, Igor Stravinsky's *The Rite of Spring* deals with a violent theme. It is subtitled "Pictures from Pagan Russia" and describes a springtime ritual culminating in the sacrifice of a chosen human victim. Whereas Schönberg jettisoned traditional harmony, Stravinsky used a new approach to rhythm as the basis of his piece. Constantly changing, immensely complex, and frequently violent, his rhythmic patterns convey a sense of barbaric frenzy that is enhanced by the weight of sound obtained from the use of a vast orchestra. There are some peaceful moments, notably the nostalgic opening section, but in general the impression is of intense exhilaration.

GO LISTEN! IGOR STRAVINSKY

"Dance of the Adolescents" from *The Rite of Spring*

The Rite of Spring opens quietly, with no hint of the violence to come. The first outbreak occurs in this dance, with the strings hammering out a repeated dissonant chord, while wind instruments can be heard in the background, playing fragments of themes. Stravinsky creates a sense of excitement by repeating the same rhythm obsessively, while violently stressing some of the notes. When the heavy brass instruments enter, they bring an ominous tone, but soon we return to the hammering string chords. The mood grows quieter for a while, but as Stravinsky increases the tension, the dance moves to a frenzied climax, with rhythm and melodic fragments reaching a fever pitch before plunging into the next dance.

It is difficult to imagine a more complete break with the Romantic movement. Subject and style, the violence of contrasts, the sheer brute power of the music, all took Stravinsky's contemporaries by storm, and many accounts have survived of the scandalous scenes of protest that broke out at the ballet's first performance. In a way, *The Rite of Spring* marks both a beginning and an end: Stravinsky never returned to the work's style. Yet as an illustration of the collapse of traditional values on the eve of World War I (the ballet was first performed in 1913), Stravinsky's musical revolution, like Picasso's in the visual arts, was indeed prophetic of the troubled 20th century.

The Rite of Spring was the last of three ballets (the others were *The Firebird* and *Petrouchka*) that Stravinsky based on Russian folk subjects. In the years following World War I, he wrote music in a wide variety of styles, absorbing influences as varied as Bach, Tchaikovsky, and jazz. Yet a characteristically Stravinskian flavor pervades all of his best works, with the result that his music is almost always instantly recognizable. Short, expressive melodies and unceasing rhythmic vitality, both evident in *The Rite of Spring*, recur in works like the Symphony in Three Movements from 1945. Even when, in the 1950s, he finally adopted the technique of serialism, he retained his own unique musical personality. Stravinsky is a peculiarly 20th-century cultural phenomenon, an artist uprooted from his homeland, cut off (by choice) from his cultural heritage, and exposed to a barrage of influences and counterinfluences. That he never lost his sense of personal identity or his belief in the enduring value of art made him a 20th-century hero.

LITERATURE

At the end of the 19th century, many writers were still as concerned with exploring the nature of their own individual existences as they had been when the century began. In fact, the first years of the 20th century saw an increasing interest

in the effect of the subconscious on human behavior, a result largely of the work of the Austrian psychoanalyst Sigmund Freud (1856–1939), whose work is discussed in Chapter 21. In many ways his interest in the part played by individual frustrations, repressions, and neuroses (particularly sexual) in creating personality was prefigured in the writing of two of the greatest novelists of the late 19th century: Fyodor Dostoyevsky (1821–1881) and Marcel Proust (1871–1922).

FYODOR DOSTOYEVSKY Self-knowledge played a major part in Dostoyevsky's work, and his concern for psychological truth led him into a profound study of his characters' subconscious motives. His empathy for human suffering derived in part from his identification with Russian Orthodox Christianity, with its emphasis on suffering as a means to salvation. Although well aware of social injustices, he was more concerned with their effect on the individual soul than on society as a whole. His books present a vivid picture of the Russia of his day, with characters at all levels of society brought brilliantly to life. Nevertheless, he was able to combine realism of perception with a deep psychological understanding of the workings of the human heart. Few artists have presented so convincing a picture of individuals struggling between good and evil.

The temptation to evil forms a principal theme of one of his most powerful works, *Crime and Punishment* (1866). In it, Dostoyevsky tells the story of a poor student, Raskolnikov, whose growing feeling of alienation from his fellow human beings leads to a belief that he is superior to society and above conventional morality. To prove this to himself, Raskolnikov decides to commit an act of defiance: the murder of a defenseless old woman, not for gain but as a demonstration of his own power.

He murders the old woman and also her younger sister, who catches him in the act. Crime is followed immediately, however, by the punishment not of the law but of his own conscience. Guilt and remorse cut him off even farther from human contact until finally, in utter despair and on the verge of madness, he goes to the police and confesses to the murders. Here and in his other works, Dostoyevsky underlines the terrible dangers of intellectual arrogance. The world he portrays is essentially cruel, one in which simplicity and self-awareness are the only weapons against human evil, and suffering is a necessary price for victory.

MARCEL PROUST One of the most influential of all modern writers was the French novelist Marcel Proust. Proust's youth was spent in the fashionable world of Parisian high society, where he entertained lavishly and mixed with the leading figures of the day while writing elegant, if superficial, poems and stories. The death of his father in 1903 and of his mother in 1905 brought about a complete change. He retired to his house in Paris and rarely left his soundproofed bedroom, where he wrote the vast work for which he is famous, *Remembrance of Things Past*. The first volume appeared in 1913; the seventh and last volume was not published until 1927, five years after his death.

It is difficult to do justice to this amazing work. The lengthy story is told in the first person by a narrator who, though never named, obviously has much in common with Proust. The story's entire concern is to recall the narrator's past life—from earliest childhood to middle age—by bringing to mind the people, places, things, and events that have affected him. In the course of the narrator's journey back into his past, he realizes that all of it lies hidden inside him and that the tiniest circumstance—a scent, a taste, the appearance of someone's hair—can trigger a whole chain of memory associations.

The following extract contains the well-known episode involving a sensory memory: biting into the madeleine—a small cake—triggers a host of memories.

READING 18.3 MARCEL PROUST

From *Remembrance of Things Past, Vol. I: Swann's Way*

Many years had elapsed during which nothing of Combray,[4] save what was comprised in the theatre and the drama of my going to bed there, had any existence for me, when one day in winter, on my return home, my mother, seeing that I was cold, offered me some tea, a thing I did not ordinarily take. I declined at first, and then, for no particular reason, changed my mind. She sent for one of those squat, plump little cakes called "petites madeleines," which look as though they had been moulded in the fluted valve of a scallop shell. And soon, mechanically, dispirited after a dreary day with the prospect of a depressing morrow, I raised to my lips a spoonful of the tea in which I had soaked a morsel of the cake. No sooner had the warm liquid mixed with the crumbs touched my palate than a shudder ran through me and I stopped, intent upon the extraordinary thing that was happening to me. An exquisite pleasure had invaded my senses, something isolated, detached, with no suggestion of its origin. And at once the vicissitudes of life had become indifferent to me, its disasters innocuous, its brevity illusory—this new sensation having had on me the effect which love has of filling me with a precious essence; or rather this essence was not in me it *was* me.

By the end of the final volume the narrator has decided to preserve the recollection of his past life by making it permanent in the form of a book—the book the reader has just finished. Proust's awareness of the importance of the subconscious and his illustration of the way in which it can be unlocked have had a great appeal to modern writers, as has his **stream of consciousness** style, which appears to reproduce the narrator's thought processes as they actually occur rather than as edited by a writer for logical connections and development. Furthermore, as we follow Proust's (or the narrator's) careful and painstaking resurrection of his past, it is important to remember that his purpose is far more than a mere intellectual

4. The narrator's family home.

exercise. By recalling the past, we bring it back to life in a literal sense. Memory is our most powerful weapon against death.

ANTON CHEKHOV If Dostoyevsky used violence to depict his worldview, his contemporary and fellow Russian Anton Pavlovich Chekhov (1860–1904) used irony and satire to show the passivity and emptiness of his characters. In plays and short stories, Chekhov paints a provincial world whose residents dream of escape, filled with a frustrated longing for action. The three sisters who are the chief characters in the play of that name never manage to achieve their ambition to go "to Moscow, to Moscow!" In stories such as "The Lady with the Dog," Chekhov uses apparent triviality to express profound understanding, whereas in "The Bet" he ironically challenges most of our basic values.

MARK TWAIN Perhaps the most beloved U.S. writer toward the close of the 19th century and into the early part of the 20th was Mark Twain (1835–1910), the pen name of Samuel Langhorne Clemens. Twain was once a Mississippi River steamboat captain, and sailors would plumb the depths of the river by dropping in a weighted rope and calling out the numbers. "Mark twain" meant two fathoms deep, or 12 feet—safe sailing for the steamboat. Much of Twain's sailing as a writer and humorist was indeed safe. He told tall tales of the inner parts of the United States, capturing the rhythms and the sounds of local speech. The passage in Reading 18.4 is from a book called *Roughing It*, and it will give you the flavor. It is supposedly the story of Grandfather's old ram, but it is not easy for the narrator to get around to it.

Twain may be best known for his novels *The Adventures of Tom Sawyer* (1876) and *Adventures of Huckleberry Finn* (1885), with "Huck Finn" often referred to as "the great American novel." Most critics agree that Twain was the greatest humorist of the era, but as time went on his writings took a darker tone. Twain was very concerned about the hardships—including wanton murder—often inflicted upon natives in the era of imperialism and colonization. Colonization was supposed to bring "the light" to "people sitting in darkness," but it often brought deprivation, destruction, and disease. Twain was also horrified at what people did to one another in the name of their religion; whatever his personal beliefs about a god might have been, he developed a mistrust of "organized religion" and what he viewed as nonsensical beliefs.

He worked on and off over the last 20 years of his life on a short novel called *The Mysterious Stranger*. The stranger is Satan, but actually the nephew of the fallen archangel of the same name. He visits a bunch of youngsters in Austria in 1590 and points out their errors in logic. As the novel is drawing to a close, Satan offers them the diatribe in Reading 18.5.

READING 18.4 MARK TWAIN

From *Roughing It*, "The Story of Grandfather's Old Ram"

Every now and then, in these days, the boys used to tell me I ought to get one Jim Blaine to tell me the stirring story of his grandfather's old ram—but they always added that I must not mention the matter unless Jim was drunk at the time—just comfortably and sociably drunk.

. . .

His face was round, red, and very serious; his throat was bare and his hair tumbled; in general appearance and costume he was a stalwart miner of the period. On the pine table stood a candle, and its dim light revealed "the boys" sitting here and there on bunks, candle-boxes, powder-kegs, etc. They said:

"Sh-! Don't speak-he's going to commence."

I found a seat at once, and Blaine said:

I don't reckon them times will ever come again. There never was a more bullier old ram than what he was. Grandfather fetched him from Illinois—got him of a man by the name of Yates—Bill Yates—maybe you might have heard of him; his father was a deacon—Baptist—and he was a rustler, too; a man had to get up ruther early to get the start of old Thankful Yates; it was him that put the Greens up to jining teams with my grandfather when he moved west. Seth Green was prob'ly the pick of the flock; he married a Wilkerson—Sarah Wilkerson—good cretur, she was—one of the likeliest heifers that was ever raised in old Stoddard, everybody said that knowed her. She could heft a bar'l of flour as easy as I can flirt a flapjack. And spin? Don't mention it! Independent? Humph! When Sile Hawkins come a browsing around her, she let him know that for all his tin he couldn't trot in harness alongside of *her*. You see, Sile Hawkins was—no, it warn't Sile Hawkins, after all—it was a galoot by the name of Filkins—I disremember his first name; but he *was* a stump—come into pra'r meeting drunk, one night, hooraying for Nixon, becuz he thought it was a primary; and old deacon Ferguson up and scooted him through the window and he lit on old Miss Jefferson's head, poor old filly. She was a good soul—had a glass eye and used to lend it to old Miss Wagner, that hadn't any, to receive company in; it warn't big enough, and when Miss Wagner warn't noticing, it would get twisted around in the socket, and look up, maybe, or out to one side, and every which way, while t' other one was looking as straight ahead as a spy-glass. Grown people didn't mind it, but it most always made the children cry, it was so sort of scary. She tried packing it in raw cotton, but it wouldn't work, somehow—the cotton would get loose and stick out and look so kind of awful that the children couldn't stand it no way. She was always dropping it out, and turning up her old dead-light on the company empty, and making them oncomfortable, becuz *she* never could tell when it hopped out, being blind on that side, you see. So somebody would have to hunch her and say, "Your game eye has fetched loose, Miss Wagner dear"—and then all of them would have to sit and wait till she jammed it in again—

READING 18.5 **MARK TWAIN**

From *The Mysterious Stranger*

Strange, indeed, that you should not have suspected that your universe and its contents were only dreams, visions, fiction! Strange, because they are so frankly and hysterically insane—like all dreams: a God who could make good children as easily as bad, yet preferred to make bad ones; who could have made every one of them happy, yet never made a single happy one; who made them prize their bitter life, yet stingily cut it short; who gave his angels eternal happiness unearned, yet required his other children to earn it; who gave his angels painless lives, yet cursed his other children with biting miseries and maladies of mind and body; who mouths justice and invented hell—mouths mercy and invented hell—mouths Golden Rules, and forgiveness multiplied by seventy times seven, and invented hell; who mouths morals to other people and has none himself; who frowns upon crimes, yet commits them all; who created man without invitation, then tries to shuffle the responsibility for man's acts upon man, instead of honorably placing it where it belongs, upon himself; and finally, with altogether divine obtuseness, invites this poor, abused slave to worship him!

ÉMILE ZOLA The French writer Émile Zola (1840–1902) lived as an impoverished clerk in his early 20s but was determined to earn his living by writing only (**Fig. 18.47**). He had the rare capacity to bring symbols of modernity to life: the factory, the mine, and, as we see in this chapter, that new monster of merchandising we know as the department store. His work is emotional, ranging from the poignantly descriptive to the humorous. His first significant novel, *Thérèse Raquin*, appeared in 1867. He wrote a cycle of 20 novels intended to scientifically explore the effects of nature (genetics) and nurture (environmental experiences) on one family. He then wrote another cycle of novels that attack the Roman Catholic Church. His famous open letter of 1898, "J'accuse" (I Accuse) attacked the French government for being anti-Semitic because of its sentencing of army officer Alfred Dreyfus to a life sentence for espionage. Zola argued

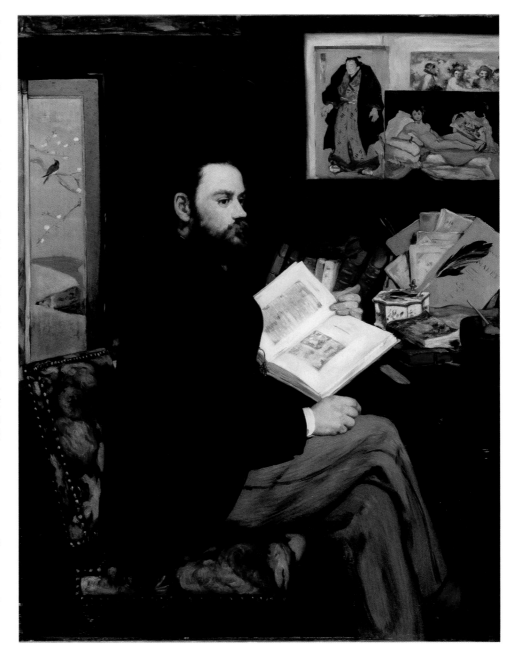

➤ **18.47** Edouard Manet, *Émile Zola*, 1868. Oil on canvas, 57⅝″ × 44⅞″ (146.5 × 114 cm). Musée d'Orsay, Paris, France. The pictures in the upper right include a sketch of *Olympia*, which Zola fiercely defended as Manet's best work, a Japanese print of a wrestler, and an engraving of Velazquez's Bacchus, suggesting Zola's appreciation of Spanish art. The Japanese screen on the left further attests to Zola's and Manet's shared interest in Japanese art.

that the government had trumped up the charges against Dreyfus and convicted him on flimsy evidence. Zola was then found guilty of libeling the government and given a prison sentence, causing him to flee to England. He returned to Paris a year later.

He published the novel *Au Bonheur des Dames* (*The Ladies' Delight*) in 1883. The title of the novel is also the name of the dazzling department store in belle époque Paris. The owner of the store, Octave Mouret, was one of the entrepreneurs who helped rip up the old Paris and shepherd in the new. "He belonged to his age," writes Zola. "Honestly you had to have something wrong in your make-up, some weakness in your head and limbs, to shrink from action at a time when so much was being done, when the whole century was thrusting forward into the future."[5]

In a theme that resonates today, Mouret (in effect, speaking for Zola) pontificates on how modern merchandising relies on the exploitation of women's appetites. The department store was set up just so—just so that women would be drawn to it like insects to a source of light and then open their purses.

READING 18.6 ÉMILE ZOLA

From *Au Bonheur des Dames* (*The Ladies' Delight*)

Here . . . emerged the exploitation of women. Everything led to this point: the capital which was constantly being renewed, the system of concentrating the merchandise, the low prices to attract the customers, the fixed prices to reassure them. Woman was what the shops were fighting over when they competed, it was woman whom they ensnared with the constant trap of their bargains, after stunning her with their displays. They had aroused new desires in her flesh, they were a huge temptation to which she must fatally succumb, first of all giving in to the purchases of a good housewife, then seduced by vanity and finally consumed. By increasing their sales tenfold and democratizing luxury they became a dreadful agent of expense, causing ravages in households and operating through the madness of fashion, which was constantly more expensive. And if in store woman was queen, adulated in herself, humoured in her weaknesses, surrounded by every little attention, she reigned as a queen in love, whose subjects were swindling her so that she paid for each of her whims with a drop of her own blood. [Mouret] raised a temple to her, had a legion of servants to perfume her with incense and devised the ritual of a new religion. He thought only of her and sought constantly to invent more powerful means of seduction; and, when her back was turned, when he had emptied her pockets and unhinged her nerves, he was filled with the secret contempt of a man whose mistress has just been stupid enough to give herself to him.

Emile Zola, *The Ladies' Delight*. (Translated by Robin Buss.) London: Penguin Books, originally published 1883.

OSCAR WILDE Oscar Fingal O'Flahertie Wills Wilde was born in Dublin in 1854 and died in Paris in 1900. He is best-known as a playwright, having penned the comedies *The Importance of Being Earnest* (1895) and *An Ideal Husband* (also 1895), among several others. He wrote one novel, *The Picture of Dorian Gray* (1891). He was a clever satirist of British society and truly a master of the one-liner. In *Earnest*, for example, Jack Worthing tells Lady Augusta Bracknell that he has lost both of his parents (that is, they have died). Her rejoinder is: "To lose one parent, Mr. Worthing, may be regarded as a misfortune. To lose both looks like carelessness." Wilde's first produced play was *Lady Windermere's Fan* (1892), which has the line "I can resist anything except temptation."

In his preface to *Dorian Gray*, Wilde shares some thoughts about art and criticism.

READING 18.7 OSCAR WILDE

From Preface to *The Picture of Dorian Gray*

The artist is the creator of beautiful things.

To reveal art and conceal the artist is art's aim.

The critic is he who can translate into another manner or a new material his impression of beautiful things.

The highest, as the lowest, form of criticism is a mode of autobiography.

Those who find ugly meanings in beautiful things are corrupt without being charming. This is a fault.

Those who find beautiful meanings in beautiful things are the cultivated. For these there is hope.

They are the elect to whom beautiful things mean only Beauty.

There is no such thing as a moral or an immoral book. Books are well written, or badly written. That is all.

MONA CAIRD Mona Caird (1854–1932) was a feminist author who wrote of women's lives and position in Victorian society. A typical plot is found in her novel *The Daughters of Danaus* (1894), in which a young woman's aspirations to pursue a career in music inevitably come into conflict with her responsibilities to her family. Her 1888 essay "Marriage" launched a series of hot debates about the role and destiny of women. Like many feminists before her and since, Caird equates a marriage that is not entered into freely with prostitution.

READING 18.8 MONA CAIRD

From "Marriage" *Westminster Review*

We come then to the conclusion that the present form of marriage—exactly in proportion to its conformity with orthodox ideas—is a vexatious failure. If certain people have

5. Émile Zola, *Au Bonheur des Dames* (*The Ladies' Delight*), trans. Robin Buss (London: Penguin Books, 2001), p. 66. © Robin Buss.

made it a success by ignoring those orthodox ideas, such instances afford no argument in favour of the institution as it stands. We are also led to conclude that modern "Respectability" draws its life-blood from the degradation of womanhood in marriage and in prostitution. But what is to be done to remedy these manifold evils? How is marriage to be rescued from a mercenary society, torn from the arms of "Respectability" and established on a footing which will make it no longer an insult to human dignity?

. . .

The ideal marriage, then, despite all dangers and difficulties, should be free. So long as love and trust and friendship remain, no bonds are necessary to bind two people together; life apart will be empty and colourless; but whenever these cease the tie becomes false and iniquitous, and no one ought to have power to enforce it.

. . .

The economical independence of woman is the first condition of free marriage. She ought not to be tempted to marry, or to remain married, for the sake of bread and butter.

A. E. HOUSMAN The Englishman Alfred Edward Housman (1859–1936) became a student of the Latin classics and led an academic life, teaching Classical literature at University College in London and then at Cambridge. During his career he wrote some poetry which has become quite familiar, including "When I was one-and-twenty" from his collection *A Shropshire Lad* (1896). In the poem, the narrator fails to heed good advice, either because he was too young to understand the wisdom of the sage or else because he was too young and feverishly in love to listen.

READING 18.9 A. E. HOUSMAN

"When I was one-and-twenty"

When I was one-and-twenty
 I heard a wise man say,
"Give crowns and pounds and guineas
 But not your heart away;
Give pearls away and rubies
 But keep your fancy free."
But I was one-and-twenty,
 No use to talk to me.
When I was one-and-twenty
 I heard him say again,
"The heart out of the bosom
 Was never given in vain;
'Tis paid with sighs a plenty
 And sold for endless rue."
And I am two-and-twenty,
 And oh, 'tis true, 'tis true.

RUDYARD KIPLING Rudyard Kipling (1865–1936) was born to Britons in India—at the time, the most important colony of the United Kingdom. He was schooled for a few years in the United Kingdom, but was unhappy there and returned to India. He spent part of his life married to a U.S. woman in Vermont, but then moved to England. Britishers were fascinated by his reporting on India, and he also wrote many stories, books, and poems. Generations of children have enjoyed his two-volume *Jungle Book* (1894, 1895). He also wrote the celebrated novel *Kim* (1901) and was awarded the Nobel Prize for Literature in 1907. His poems include "The Ballad of East and West," in which an Afghan horse thief and an Englishman develop mutual respect, and "If."

READING 18.10 RUDYARD KIPLING

"The Ballad of East and West," lines 1–4

Oh, East is East, and West is West, and never the twain shall
 meet,
Till Earth and Sky stand presently at God's great Judgment
 Seat;
But there is neither East nor West, Border, nor Breed, nor
 Birth,[6]
When two strong men stand face to face, tho' they come
 from the ends of the earth!

In the poem "If," we hear a father giving his son advice about how to live the decent life.

READING 18.11 RUDYARD KIPLING

"If," lines 1–8, 31–32

If you can keep your head when all about you
Are losing theirs and blaming it on you;
If you can trust yourself when all men doubt you,
But make allowance for their doubting too;
If you can wait and not be tired by waiting,
Or being lied about, don't deal in lies,
Or being hated don't give way to hating,
And yet don't look too good, nor talk too wise;

. . .

Yours is the Earth and everything that's in it,
And—which is more—you'll be a Man, my son!

The Role of Women

Not all writers in the late 19th and early 20th centuries devoted themselves to the kind of psychological investigation found in the works of Dostoyevsky and Proust. The larger

6. Family name or social standing.

question of the nature of society continued to attract the attention of more socially conscious writers, who explored the widening range of problems created by industrial life as well as a whole new series of social issues.

One of the most significant aspects of the development of the modern world has been the changing role of women in family life and in society at large. The issue of women's right to vote was bitterly fought in the early years of the 20th century, and not until 1918 in the United Kingdom and 1920 in the United States were women permitted to participate in the electoral process on a wide scale. On a more personal basis, the growing availability and frequency of divorce began to cause many women (and men) to rethink the nature of the marriage tie. The pace of women's emancipation from the stock role assigned to them over centuries was extremely slow, and the process is far from complete. A beginning had to be made somewhere, however, and it is only fitting that a period characterized by cultural and political change should also be marked by social change in this most fundamental of areas.

In the same way that Dickens had led the drive against industrial oppression and exploitation in the mid-19th century, writers of the late 19th and early 20th centuries not only reflected feminist concerns but actively promoted them as well. They tackled a range of problems so vast that we can do no more than look at just one area, marriage, through the eyes of two writers of the late 19th century. One of them, Henrik Ibsen (1828–1906), was the most famous playwright of his day and a figure of international renown. The other, Kate Chopin (1851–1904), was ignored in her own lifetime even in her native United States.

HENRIK IBSEN Ibsen was born in Norway, although he spent much of his time in Italy. Most of his mature plays deal with the conventions of society and their consequences, generally tragic. Although many are technically set in Norway, their significance was intended to be universal. The problems Ibsen explored were frequently ones regarded as taboo, including sexually transmitted infections, incest, and insanity. The realistic format of the plays brought issues like these home to his audience with shocking force. At first derided, Ibsen eventually became a key figure in the development of drama, particularly in the English-speaking world, where his work was championed by George Bernard Shaw (1856–1950), who inherited Ibsen's mantle as a progressive social critic.

In one of his first important plays, *A Doll's House* (1879), Ibsen deals with the issue of women's rights. The principal characters, Torvald Helmer and his wife Nora, have been married for eight years, apparently happily enough. Early in their marriage, however, before Helmer became a prosperous lawyer, Nora secretly borrowed some money from Krogstad, a friend, to pay for her husband's medical treatment; she told Torvald that the money came from her father, because he was too proud to borrow. As the play opens, Krogstad—to whom Nora is still in debt—threatens to blackmail her if she does not persuade Helmer to find him a job. When she refuses to

do so, Krogstad duly writes a letter to Helmer revealing the truth. Helmer recoils in horror at his wife's deception. The matter of the money is eventually settled by other means and Helmer eventually forgives Nora, but not before the experience has given her a new and unforgettable insight into her relationship with her husband. In the final scene, she walks out the door, slams it, and leaves him forever.

Nora decides to abandon her husband on two grounds. In the first place, she realizes how small a part she plays in her husband's real life. As she says, "Ever since the first day we met, we have never exchanged so much as one serious word about serious things." The superficiality of their relationship horrifies her. In the second place, Helmer's inability to rise to the challenge presented by the discovery of his wife's deception and prove his love for her by claiming that it was he who had borrowed and failed to repay the debt diminishes him in Nora's eyes. Ibsen tries to express what he sees as an essential difference between men and women when, in reply to Helmer's statement that "one doesn't sacrifice one's honor for love's sake," Nora replies, "Millions of women have done so." Nora's decision not to be her husband's childish plaything—to leave the doll's house in which she is the doll—was so contrary to accepted social behavior that one noted critic remarked, "That slammed door reverberated across the roof of the world."

The final scene of act 3 reveals Nora's controlled fury at the role society has assigned her.

READING 18.12 HENRIK IBSEN

A Doll's House, act 3, final scene, lines 1–38

[The action takes place late at night, in the Helmers' living room. Nora, instead of going to bed, has suddenly reappeared in everyday clothes.]

HELMER . . . What's all this? I thought you were going to bed. You've changed your dress?
NORA Yes, Torvald; I've changed my dress.
HELMER But what for? At this hour?
NORA I shan't sleep tonight.
HELMER But, Nora dear—
NORA [looking at her watch] It's not so very late—Sit down, Torvald; we have a lot to talk about.

[She sits at one side of the table.]
HELMER Nora—what does this mean? Why that stern expression?
NORA Sit down. It'll take some time. I have a lot to say to you.

[Helmer sits at the other side of the table.]
HELMER You frighten me, Nora. I don't understand you.
NORA No, that's just it. You don't understand me; and I have never understood you either—until tonight. No, don't

interrupt me. Just listen to what I have to say. This is to be a final settlement, Torvald.

HELMER How do you mean?

NORA *[after a short silence]* Doesn't anything special strike you as we sit here like this?

HELMER I don't think so—why?

NORA It doesn't occur to you, does it, that though we've been married for eight years, this is the first time that we two—man and wife—have sat down for a serious talk?

HELMER What do you mean by serious?

NORA During eight whole years, no—more than that—ever since the first day we met—we have never exchanged so much as one serious word about serious things.

HELMER Why should I perpetually burden you with all my cares and problems? How could you possibly help me to solve them?

NORA I'm not talking about cares and problems. I'm simply saying we've never once sat down seriously and tried to get to the bottom of anything.

HELMER But, Nora, darling—why should you be concerned with serious thoughts?

From Act III of *A Doll's House* by Henrik Ibsen

How, indeed, could Nora participate in solving Helmer's problems, and why, indeed, should she be concerned with serious thoughts? After all, she is just a woman. Helmer's befuddlement reflects traditional society's clueless degradation of women; marital satisfaction will require new attitudes on the part of men.

KATE CHOPIN In comparison to the towering figure of Ibsen, the U.S. writer Kate Chopin found few readers in her own lifetime; even today she is not widely known. Only recently have critics begun to do justice to the fine construction and rich psychological insight of her novel *The Awakening*, denounced as immoral—even banned—when it was first published in 1899. Its principal theme is the oppressed role women are forced to play in family life. Edna, its heroine, like Nora in *A Doll's House*, resents the meaninglessness of her relationship with her husband and the tedium of her daily existence. Her only escape is to yield to her sexual drives and find freedom not in slamming the door behind her but in throwing herself into a passionate if unloving affair.

In her short stories, Chopin deals with the same kind of problem, but with greater delicacy and often with a wry humor. Frequently on the smallest of scales, these stories examine the prison that marriage seems so often to represent. In the course of a couple of pages, Chopin exposes an all-too-common area of human experience and, like Ibsen, touches a chord that rings as true now as it did at the turn of the century.

In "The Story of an Hour" (1894), Mrs. Mallard learns that her husband has been killed in an accident. She cries at once, "with sudden, wild abandonment," but then goes to her room alone.

READING 18.13 KATE CHOPIN

From "The Story of an Hour"

There was something coming to her and she was waiting for it, fearfully. What was it? She did not know; it was too subtle and elusive to name. But she felt it, creeping out of the sky, reaching toward her through the sounds, the scents, the color that filled the air.

Now her bosom rose and fell tumultuously. She was beginning to recognize this thing that was approaching to possess her, and she was striving to beat it back with her will—as powerless as her two white slender hands would have been.

When she abandoned herself a little whispered word escaped her slightly parted lips. She said it over and over under her breath: "free, free, free!" The vacant stare and the look of terror that had followed it went from her eyes. They stayed keen and bright. Her pulses beat fast, and the coursing blood warmed and relaxed every inch of her body.

She did not stop to ask if it were or were not a monstrous joy that held her. A clear and exalted perception enabled her to dismiss the suggestion as trivial.

She knew that she would weep again when she saw the kind, tender hands folded in death; the face that had never looked save with love upon her, fixed and gray and dead. But she saw beyond that bitter moment a long procession of years to come that would belong to her absolutely. And she opened and spread her arms out to them in welcome.

TOWARD A WORLD AT WAR

As we will see in Chapter 21, the pessimists of the era of 1870–1914 turned out to be correct in their perceptions of what the future would hold. But not even they grasped the scale of the deluge of metal and gunpowder to come. Those who survived to look back upon the era would generally do so with nostalgia: in their bloodshot eyes, the belle époque would appear to be more beautiful than it ever was in reality. And as we think back on it today, the world of the *Bar at the Folies-Bergère* seems to recede father and farther—as if all the glitter were more a thing of the imagination than of the past.

GLOSSARY

Analytic Cubism (p. 692) The early phase of Cubism (1909–1912), during which objects were dissected or analyzed in a visual information-gathering process and then reconstructed on the canvas.

Atonal (p. 705) Referring to music that does not conform to the tonal character of European Classical music.

Belle époque (p. 660) French for "beautiful era"; a term applied to a period in French history characterized by peace and flourishing of the arts, usually dated as beginning in 1890 and ending with World War I in 1914.

Der Blaue Reiter (p. 687) German for "the blue rider"; a 20th-century German Expressionist movement that focused on the contrasts between, and combinations of, abstract form and pure color.

Die Brücke (p. 686) German for "the bridge"; a short-lived German Expressionist movement characterized by boldly colored landscapes and cityscapes and by violent portraits.

Collage (p. 693) An assemblage of two-dimensional objects to create an image; a work of art in which materials such as paper, cloth, and wood are pasted to a two-dimensional surface, such as a wooden panel or canvas.

Cubism (p. 689) A 20th-century style of painting developed by Picasso and Braque that emphasizes the two-dimensionality of the canvas, characterized by multiple views of an object and the reduction of form to cube-like essentials.

Dynamism (p. 694) The Futurist view that force or energy is the basic principle that underlies all events, including everything we see. Objects are depicted as if in constant motion, appearing and disappearing before our eyes.

Expressionism (p. 686) A modern school of art in which an emotional impact is achieved through agitated brushwork, intense coloration, and violent, hallucinatory imagery.

Fauvism (p. 684) From the French for "wild beast"; an early-20th-century style of art characterized by the juxtaposition of areas of bright colors that are often unrelated to the objects they represent, and by distorted linear perspective.

Futurism (p. 693) An early-20th-century style of art that portrayed modern machines and the dynamic character of modern life and science.

Impressionism (p. 668) A late-19th-century artistic style characterized by the attempt to capture the fleeting effects of light through painting in short strokes of pure color.

Pointillism (p. 677) A systematic method of applying minute dots of discrete pigments to the canvas; the dots are intended to be "mixed" by the eye when viewed.

Postimpressionism (p. 675) A late-19th-century artistic style that relied on the gains made by Impressionists in terms of the use of color and spontaneous brushwork but employed these elements as expressive devices. The Postimpressionists rejected the essentially decorative aspects of Impressionist subject matter.

Program music (p. 701) Music that describes elaborate programs or plots.

Sprechstimme (p. 705) Arnold Schönberg's term for "speaking voice," that is, speaking words at specific pitches.

Stream of consciousness (p. 707) A literary technique that is characterized by an uncensored flow of thoughts and images, which may not always appear to have a coherent structure.

Synthetic Cubism (p. 693) The second phase of Cubism, which emphasized the form of the object and constructing rather than disintegrating that form

Synthetism (p. 681) Paul Gauguin's theory of art, which advocated the use of broad areas of unnatural color and "primitive" or symbolic subject matter.

Tone poem (p. 701) Richard Strauss's term for a program symphony (see **program music**).

Trompe l'oeil (p. 693) Literally, French for "fool the eye." In works of art, trompe l'oeil can raise the question as to what is real and what is illusory.

Twelve-tone technique (p. 706) A musical method that uses the twelve notes of the chromatic scale—on the piano, all of the black and white notes in a single octave—carefully arranged in a row or series; also called *serialism*.

Übermensch (p. 662) Nietzsche's term for a person who exercises the will to power (plural *Übermenschen*).

Language and Literature

- Dostoyevsky published *Crime and Punishment* in 1866.
- Ibsen staged *A Doll's House* in 1879.
- Zola published *Au Bonheur des Dames (The Ladies' Delight)* in 1883.
- Twain published *Adventures of Huckleberry Finn* in 1885.
- Caird published *The Daughters of Danaus* in 1894.
- Chopin published "The Story of an Hour" in 1894.
- Kipling published his two-volume *Jungle Book* in 1894 and 1895.
- Wilde staged *The Importance of Being Earnest* in 1895.
- Housman published *A Shropshire Lad* in 1896.
- Proust published the first volume of *Remembrance of Things Past* in 1913.

Art, Architecture, and Music

- Bouguereau painted Academic works in the 1870s.
- Manet's paintings of the 1860s through the 1880s bridged Realism and Impressionism.
- Monet painted *Impression, Sunrise* in 1872.
- Bizet's opera *Carmen* was first performed in 1875.
- Tchaikovsky composed his ballets *Swan Lake* in 1875–1876 and *The Nutcracker* in 1892.
- Renoir painted *Le Moulin de la Galette* in 1876.
- Morisot painted *Young Girl by the Window* in 1878.
- Degas painted ballet dancers and nudes in the 1870s and 1880s.
- American Expatriates Cassatt and Whistler painted in Paris toward the turn of the century.
- Gilbert and Sullivan staged *H.M.S. Pinafore* in 1878 and *The Mikado* in 1885.
- Postimpressionsts Toulouse-Lautrec, Seurat, Cézanne, and van Gogh painted in Europe toward the turn of the century; Cézanne painted groundbreaking still lifes and landscapes; van Gogh created emotional works with feverish brushstrokes.
- Eiffel constructed the Eiffel Tower in Paris in 1889.
- Sullivan erected the Wainwright Building in St. Louis in 1890–1891.
- Munch painted *The Scream* in 1893, an early Expressionist work evoking anguish and dehumanization.
- Puccini composed the operas *La Bohème* in 1896, *Tosca* in 1900, and *Madame Butterfly* in 1904.
- Rodin created modern sculpture with works such as *The Burghers of Calais* (1884–1895) and *The Kiss* (1886).
- Matisse espoused Fauvism in the early 1900s by using color emotionally and sensually.
- Debussy composed *La Mer* in 1903–1905.
- Gaudi built the Casa Milà in Barcelona in 1905–1907.
- Nolde (Die Brücke), Kandinsky (Der Blaue Reiter), and Kollwitz developed German Expressionism.
- Picasso and Braque developed Analytic Cubism and then Synthetic Cubism early in the 20th century; Picasso painted his seminal *Les Demoiselles d'Avignon* in 1907.
- Mahler composed his Symphony No. 9 in 1910–1911.
- The futurists Boccioni and Balla sculpted and painted mainly between 1909 and 1914.
- Strauss composed *An Alpine Symphony* between 1911 and 1915.
- Ravel premiered *Daphnis and Chloé* in 1912.
- Schönberg composed *Pierrot Lunaire* in 1912.
- Stravinsky premiered *The Rite of Spring* in 1913.

Philosophy and Religion

- Nietzsche espoused the "will to power" as opposed to compassion and self-sacrifice in the 1880s.
- Anthropology and psychology brought new points of view into the debates over human origins and human nature.
- Zola wrote "J'accuse," assailing the French government for widespread anti-Semitism and leading, eventually, to separation of church and state.

India, China, and Japan: From Medieval to Modern Times

19

PREVIEW

The phenomenon of *globalization* is perhaps nowhere more evident than in the Eastern nations of India, China, and Japan. Phone calls for tech support when our electronics go awry, or for customer service when our credit cards go missing, are often fielded by teams in places like Bangalore, India. Chinese workers assemble iPhones and iPads that are disseminated worldwide. For decades, our preferred electronics have born the label "Made in Japan." Globalization has become a familiar catchall term that describes global communication, economic integration, and the exchange of ideas and popular culture across nations in the 21st century. By this definition, however, globalization is also a thing of the past.

Turn back the clock to the centuries-old and centuries-long era of the Silk Road—a web of ancient trade routes that ran some 4,000 miles through the Indian subcontinent and connected China to the Mediterranean Sea. Caravans of merchants on horses and Bactrian camels moved silk and other luxuries from East to West over perilous terrain—trading cotton, linen, pearls, ivory, spices, perfumes, and much more, for commodities such as copper, tin, wool, and wine. Ideas and customs, too, traveled along the Silk Road. Buddhism, for example, wended its way from India to China and had a profound impact on the history of Eastern religions; a relay-style messenger system was set up along the length of the route, employing the fastest horsemen to move documents and information efficiently over vast distances. But the sprawling network was also a conduit for the bubonic plague—history's first pandemic. The first reported case of the plague was in China in 224 BCE, at around the same time that the route was established by the Han dynasty; in the mid-1300s, roughly a century after the adventurer Marco Polo traveled from Venice to China and the court of the Mongol emperor Kublai Khan—and back again—one-half of the population of Europe succumbed to the disease.

The benefits, challenges, and fallout of globalization in our own time also bear reflection. Proponents believe that with cultural intermingling comes understanding and tolerance of difference, and that mass communications and the sharing of real-time information—made possible by social networking—provide knowledge and create empathy. Consumers have access to products from global markets, and the influx of capital into poor countries creates the conditions for development and democracy. Opponents, on the other hand, warn that globalization is a wolf in sheep's clothing, noting that laborers in poor countries are exploited and remain disadvantaged while the corporations for which they work—and their global investors—grow rich. Globalization has also been linked to the spread of communicable diseases such as HIV/AIDS. One thing seems certain: globalization is a force that shows no sign of stopping. People are connected like never before. The travelers along the Silk Road had to have been thinking the same thing.

Contemporary artist Subodh Gupta was born in 1964 in one of the poorest and most violent provinces in India and lives today in New Delhi, a city of economic extremes. Gupta taps into sacred symbols and ancient cultural identity, but his frequent use of found objects connects his work—and message—to 21st-century issues and realities. *Silk Route* (Fig. 19.1) emphasizes

◀ **19.1** Subodh Gupta, *Silk Route* (detail), 2007. Stainless-steel kitchen utensils, 78³⁄₄" × 189" × 189" (200 × 480 × 480 cm). Installation photograph by Colin Davison at the BALTIC Centre for Contemporary Art, Gateshead, United Kingdom. © Subodh Gupta. Courtesy of the artist.

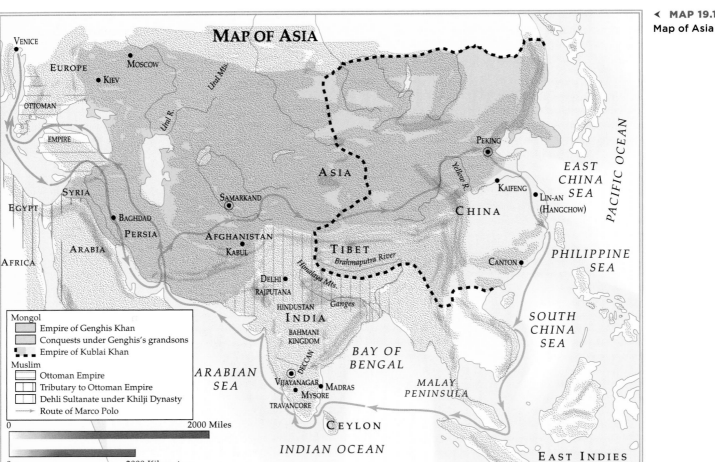

◄ **MAP 19.1**
Map of Asia

India, China, and Japan: From Medieval to Modern Times

780 CE	**1400** CE	**1700** CE	**1900** CE	**2000** CE

Heian (later Kyoto) becomes capital of Japan in 780

Song dynasty in China (r. 960–1279)

Period of feudal rule in Japan (r. 1185–1603)

Sultanate of Delhi establishes seat of Muslim power in India in 1192

Mongol invasions of Japan in 1274 and 1281

Mongol invasion of China in 1279

Ming dynasty in China (r. 1368–1644)

Age of Warring States in Japan (r. 1467–1568)

Mughal Empire in India (r. 1500–1700)

Muslim rule extends to most of India (r. 1556–1605)

Hideyoshi reunites Japan in 1590

Edo (Tokyo) becomes capital of Japan ca. 1603

Qing dynasty in China (r. 1644–1911)

Chinese treaty with Peter the Great in 1689

India falls under British rule in 1764

First Opium War in China (1839–1842)

Commodore Perry visits Japan in 1853

Japan begins modernization under the Meiji Emperor in 1868

National Congress Party is founded in India in 1885

Boxer Rebellion in China (1900–1901)

Japan defeats Russia in Russo-Japanese War in 1905

Republicans led by Sun Yat-sen defeat the Chinese monarchy in 1911

Gandhi leads Indian independence campaign via satyagraha in 1917

Chiang Kai-shek retreats from mainland China in 1928

World War II (1937–1945)

Mao Zedong leads Communist Party into power in China in 1949

End of British rule in India in 1950

End of U.S. occupation of Japan in 1952

India's key historic and contemporary role in globalization as an important economic conduit, at the same time illustrating the "current state of India's shifting society, migration, a sense of home and place and the effects and frictions caused by a rapidly globalizing society." Gleaming, highly polished silvery bowls and utensils conjure the sight of shimmery silken fabrics that so mesmerized the West from the time of Julius Caesar through the era of the Silk Road. Yet piled on top of one another and crowded into the space of a single tabletop, the same glittering objects evoke the overcrowding of cities. They call attention to the societal disconnect between poverty-stricken inner-city life and some of the most critically acclaimed works of contemporary architecture (much of it designed by Western architects) springing up in cities across the globe, particularly in the East. The stacks of utensils move along mechanized tracks carved into the steel table, almost as luggage on an airport conveyer belt. Is world travel in our own era of globalization—and the objects we bring back home to remind us of the people and places we have seen—an echo of the past?

INDIA

With the decline of Buddhism and the fall of the Gupta Empire, India separated into a series of kingdoms, many of which were ruled by **Rajputs**. For the most part, these local rulers were descendants of warriors from Central Asia who had converted to Hinduism and claimed membership in the warrior caste. (For general developments in Asia during this period, see **Map 19.1**.) Their constant feuding prevented the formation of a thriving economy or stable government and left India vulnerable to conquest by an outside force—that of the Muslims.

The first major seat of Muslim power was at Delhi, where Turkish forces established a *sultanate* (a Muslim kingdom ruled by a sultan) in 1192. Although it fell to successive waves of invaders, the Sultanate of Delhi established Islam as a new force in the subcontinent; it was strongest in the northwest—the Indus Valley—a region that centuries later, after World War II, broke away from India to become the Islamic Republic of Pakistan.

The Mughal Empire

In 1526, Babur (1483–1530), an Afghan chieftain, led his troops into India and in a short time won control over most of northern India. His grandson Akbar (1542–1605) further extended Muslim rule to most of India and Afghanistan. Akbar's kingdom was called the **Mughal** (the Persian word for "Mongol") Empire and lasted until the British took control of India in the 18th century (see **Map 19.2**).

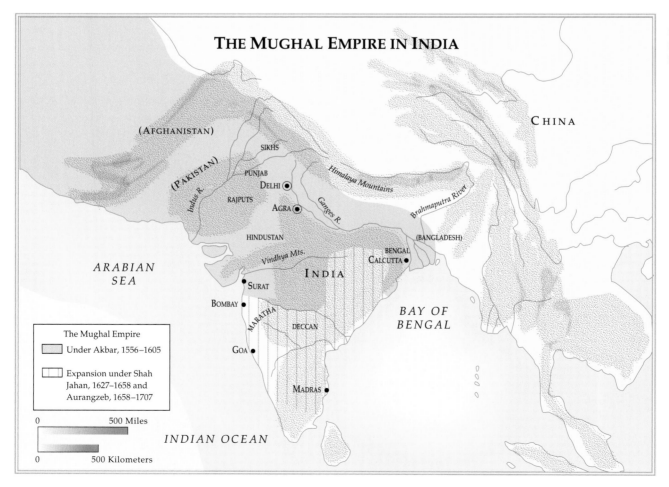

◄ **MAP 19.2**
Mughal Empire in India

Unlike earlier raiders bent on plunder, both Akbar and his grandfather intended from the outset that the land they conquered should become a center for civilization. Akbar was famous not only for his courage and military prowess, but also as a book collector and patron of the arts. Unlike Muslim rulers elsewhere, Akbar made no attempt to impose the Islamic faith on his subjects. He married a Hindu princess and allowed Hindu women at his court to practice their religion openly. In order to provide a common language for all his subjects, Akbar commissioned scholars to create a blend of Hindi (hitherto the most widely spoken language in India) with Arabic and Persian. The new language, called **Urdu**, is, together with Hindi and English, one of India's three official languages today, and spoken in Muslim areas.

Under Akbar's successors, the Mughal Empire expanded further to include all but the extreme southern tip of the subcontinent. During the first half of the 17th century, patronage of the arts reached new heights, as Mughal architects and painters devised a new style that, like the Urdu language, combined aspects of the Hindu tradition with Persian and other Muslim elements.

Mughal Art

The most visible remains of Mughal rule in India were left by Mughal architects. Mosques, palaces, walled cities, and forts all show traditional Indian techniques combined with new innovations from Arabic architecture. Among the most important of these innovations are the dome, pointed arch, and **minaret** (tower); this last feature formed a vital element in the construction of mosques, Islam's most important religious architectural form. The most famous of Mughal buildings—and one of the best-known anywhere in the world—is the Taj Mahal at Agra, built by order of Shah Jahan (1592–1666) during the years 1632–1649 (**Fig. 19.2**). The shah commissioned the Taj Mahal as a tomb and monument for his beloved wife Arjumand Banu Begum, the mother of 14 of his children, a woman as renowned for her charity as for her beauty. The dome, towers, and landscaping—in particular the use of water—are all typical Mughal features. Together with the elaborate decorations, or arabesques, they make the Taj Mahal seem an eternal symbol of the queen, "radiant in her youthful beauty, who still lingers on the riverbanks, at early morn, in the glowing midday sun, or in the silver moonlight."

Virtually all Mughal painting is in the form of book illustrations or miniature paintings that were collected in portfolios. Unlike earlier Hindu and Buddhist art, Mughal painting is secular. It shows scenes of courtly life, including—for the first time in Indian art—realistic portraits, and often depicts historical events (**Fig. 19.3**). As in the case of Mughal architecture, the overwhelming influence comes from Persian art of the period. A new art form in India also drew inspiration

▼ **19.2 The Taj Mahal, 1632–1649. Agra, India.** Built at the command of Shah Jahan as the tomb of his favorite wife, it eventually served as the shah's own tomb. Much of the building's visual effect comes from its proportions: the height of the central structure is equal to its width, and the dome and the central façade on which it sits are the same height.

◄ **19.3** Basawan and Chatar Muni, *Akbar and the Elephant Hawai*, ca. 1590. Folio 22 from the *Akbarnama* (History of Akbar) by Abu'l Fazl. Opaque watercolor on paper, 13⁷⁄₈″ × 8³⁄₄″ (32.5 × 22 cm). Victoria and Albert Museum, London, United Kingdom. The painting depicts an event that occurred when Akbar was 19. The elephant he was riding charged after another elephant and broke a bridge resting on boats. The emperor is shown successfully maintaining control over his beast—a symbol of his success in governing the state.

from Persian models, that of **calligraphy**, which was often combined with miniature paintings.

Literature and the production of fine books were highly esteemed by Mughal aristocrats. Babur, the founder of Mughal rule, wrote his autobiography, the *Baburnama*, in Chagatai, a now extinct Turkish language. It is still regarded as one of the finest examples of Turkish prose literature.

The following journal entry from the year 911 describes events following the death of Babur's mother and other relatives. He had been planning a military campaign against Kandahar in Afghanistan, but it was then interrupted by an illness and a great earthquake. But as we see, nothing can prevent Babur from returning to his aggressive ways as soon as possible.

From *The Memoirs of Babur*, "Events of the Year 911"

Our grief for the separations we had suffered was unbounded. After completing the period of mourning, food and victuals were dressed and doled out to the poor and needy. Having directed readings of the Koran, and prayers to be offered up for the souls of the departed, and eased the sorrows of our hearts by these demonstrations of love, I returned to my political enterprises which had been interrupted, and . . . led my army against Kandahar. We had marched as far as the meadow of Kush-Nadir . . . when I was seized with a fever. It came most unseasonably. Whatever efforts they made to keep me awake, my eyes constantly fell back into sleep. After four or five days, I got somewhat better.

At this period there was such an earthquake that many ramparts of fortresses, the summits of some hills, and many houses, both in the towns and villages, were violently shaken and leveled with the ground. Numbers of persons lost their lives by their houses and terraces falling on them. The whole houses of the village of Pamghan fell down, and seventy or eighty respectable householders were buried under the ruins. Between Pamghan and Bektut, a piece of ground, about a stone's throw in breadth, separated itself, and descended for the length of a bow-shot; and springs burst out and formed a well in the place that it had occupied. . . . In some places the ground was elevated to the height of an elephant above its old level, and in other places as much depressed; and in many places it was so split that a person might have hid himself in the gaps. During the time of the earthquake, a great cloud of dust rose from the tops of the mountains. Nur-allah . . . happened to be playing before me on the mandolin, and had also another instrument with him; he instantly caught up both the instruments in his hands, but had so little command of himself, that they knocked against each other. . . . That same day there were thirty-three shocks; and for the space of a month, the earth shook two or three times every day and night.

. . .

My expedition against Kandahar had been delayed by my sickness and the earthquake; but as soon as I had regained my health, and restored the defenses of the fortress, I immediately resumed my former plan.

Babur's successor, Humayun (ruled 1530–1540 and again 1555–1556), was so devoted to books that when he rode into battle he took with him part of his library, carried on camelback. Humayun also wrote poetry, using the Persian rather than the Turkish language. Mughal tolerance allowed Hindu writers to continue to write works in their own languages and on traditional themes. The poet Tulsidas (ca. 1532–1623), drawing on the Sanskrit epic the *Ramayana*, produced the *Ramcaritmanas* (*The Holy Lake of the Acts of Rama*), a work that combines monotheism with traditional Hindu polytheism and is still widely read.

The End of Mughal Rule and the Arrival of the British

The religious tolerance of the early Mughal rulers eroded over time. The last significant Mughal emperor, Aurangzeb (1618–1707), destroyed Hindu temples and increased his Hindu subjects' taxes. For the first time, Hindus serving in the imperial bureaucracy had to convert to Islam. Another factor contributing to the collapse of Mughal power was the rise of a new religion, related to Hinduism but with no caste system: Sikhism. The Sikhs combined Hindu rituals with a highly activist approach, forming a military brotherhood that succeeded in setting up an independent state of their own, which lasted until 1849. In that same year, British forces won control over the rest of India.

Throughout the 18th century, the British and French had fought their battle for colonial supremacy on Indian soil. The British East India Trading Company began its operations as early as 1600, and the superiority of British naval forces assured them victory over other European rivals—first Portugal, then France. By 1764, although India was theoretically made up of separate kingdoms including a Sikh state and a much reduced Mughal Empire, in practice the government was in British hands, first under the East India Company and then, by 1849, directly under the British government. For the next century and a half, India was the "jewel in the crown" of the British Empire.

The Rise of Nationalism

Throughout the early years of the 20th century, many of those colonized by the chief European powers began to strive for self-rule. In India, the battle began a little earlier—in 1885—with the founding of India's National Congress Party. During World War I, three million Indian soldiers fought in British armies. This brought about further impetus, and a postwar campaign for India's independence was led by Mahatma Gandhi (1869–1948). First in South Africa, and then, after 1915 in India, Gandhi developed the principle of **satyagraha** (nonviolent civil disobedience).

Although Gandhi was born a Brahmin (the highest Hindu caste), he would come to oppose the caste system. He studied law in London and began his legal career in South Africa, where he found brutal discrimination against Indian workers who had been imported by British employers. To draw attention to these injustices, he devised his strategy of peaceful protest marches and nonviolent resistance to police actions.

Mahatma Gandhi and Martin Luther King Jr.

The Indian Mahatma Gandhi (**Fig. 19.4**) and the American Martin Luther King Jr. (**Fig. 19.5**) both sought freedom for their people—the right to better their own lives. Both also preached nonviolence and civil disobedience as the means for achieving their goals.

However, the two leaders were very different in terms of their backgrounds and in terms of the forces that oppressed their people. Who were the oppressors of Indians in the mid-20th century? Who were the oppressors of African Americans? What did the oppressors have in common? How did they differ?

What were the personal and professional backgrounds of Gandhi and King? How did they each arrive at their methods of civil disobedience?

▼ **19.4 Mahatma Gandhi on the steps of 10 Downing Street in London, United Kingdom, 1931. Photograph.** What is the significance of the address 10 Downing Street?

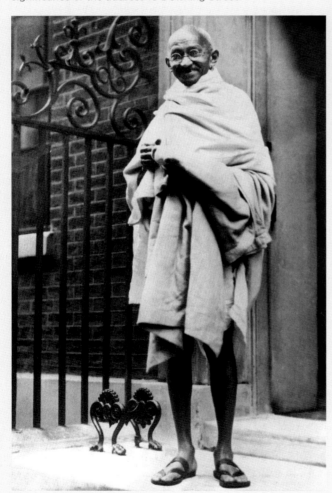

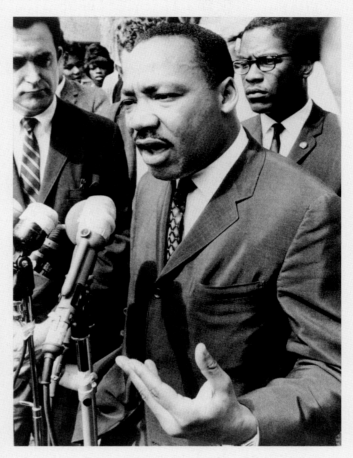

▲ **19.5 Martin Luther King Jr. speaking at a news conference in Selma, Alabama, 1965. Photograph.** What is the significance of Selma, Alabama?

Were there other "liberators" in their lands at they time they preached and practiced? Did they espouse different methods of throwing off the oppressors? Who were they, and what were their arguments?

What were the political outcomes for the followers of Gandhi and King? What are their legacies? Did they achieve their goals?

Satyagraha

The Sanskrit word *satya* means "truth." Mahatma Gandhi coined the term *satyagraha* to express his value upon "insistence on truth." He used the term to refer to nonviolent resistance to oppressive laws or governments, such as the British colonial rule of India. In his book Non-Violent Resistance (Satyagraha), Gandhi wrote:

> For the past thirty years I have been preaching and practicing Satyagraha. . . . Satyagraha differs from passive resistance as the North Pole from the South. The latter has been conceived as a weapon of the weak and does not exclude the use of force or violence for the purpose of gaining one's end, whereas the former has been conceived as a weapon of the strongest and excludes the use of violence in any shape or form.
>
> . . .
>
> [Satyagraha's] root meaning is holding on to truth, hence truth-force. I have also called it Love-force or Soul-force. In the application of Satyagraha I discovered in the earliest stages that pursuit of truth did not admit of violence being inflicted on one's opponent but that he must be weaned from error by patience

and sympathy. For what appears to be truth to the one may appear to be error to the other. And patience means self-suffering. So the doctrine came to mean vindication of truth not by infliction of suffering on the opponent but on one's self.

But on the political field the struggle on behalf of the people mostly consists in opposing error in the shape of unjust laws. When you have failed to bring the error home to the lawgiver by way of petitions and the like, the only remedy open to you, if you do not wish to submit to error, is to compel him by physical force to yield to you or by suffering in your own person by inviting the penalty for the breach of the law. Hence Satyagraha largely appears to the public as Civil Disobedience or Civil Resistance. It is civil in the sense that it is not criminal.

The lawbreaker breaks the law surreptitiously and tries to avoid the penalty, not so the civil resister. . . . But there come occasions, generally rare, when he considers certain laws to be so unjust as to render obedience to them a dishonor. He then openly and civilly breaks them and quietly suffers the penalty for their breach.

Returning to India, he soon acquired supporters both among sophisticated nationalist leaders and among the Hindu rural masses, who respected his austere way of life. In 1919, after hundreds of peaceful nationalist demonstrators had been gunned down by British-controlled forces at Amritsar, Gandhi—as leader of the Indian National Congress Party—campaigned for noncooperation and nonviolent civil disobedience. He encouraged the boycott of British products, urged the friendship of Hindus and Muslims, and spoke out against the terrible conditions of the lowest caste—the untouchables. During his numerous prison sentences between 1922 and 1942, he regularly went on hunger strikes.

Pressure for independence grew during the 1930s, and by the end of World War II, the British had no choice but to withdraw. Gandhi made efforts to unite Hindus and Muslims, a policy that led to his assassination in 1948 by a Hindu extremist. Britain had played its own part in encouraging tension between Hindus and Muslims, and the subcontinent split into the Republic of India (predominantly Hindu) and the Islamic Republic of Pakistan (mostly Muslim).

Modern Indian Arts

One of the effects of the struggle for self-rule was to create a generation of Indian authors who, writing in both their own languages and in English, sought to draw attention to their country's plight. They include the novelist and short-story writer Munshi Premchand (1880–1936), who wrote in both Hindi and Urdu. In his works he tried to describe to the outside world the grim life led by so many of India's poorest villagers.

> **READING 19.2 MUNSHI PREMCHAND**
>
> **From "The Shroud"**
>
> **I**
>
> Father and son were sitting silently at the door of their hut beside the embers of a fire. Inside, the son's young wife, Budhiya, was suffering the pangs of childbirth. Every now and then she gave such piercing cries that the hearts of both men seemed to stop beating. It was a winter night; all was silent and the whole village was plunged in darkness.

Gheesu said, "She may be dying. We've been out chasing around all day. You ought to go in now and see how she is."

Madhava answered peevishly, "If she has to die, then the sooner the better. What's there to see?"

"You're heartless. Such lack of consideration for the wife with whom you lived so pleasantly for a whole year!"

"I can't bear to watch her in pain and torment."

Theirs was a family of cobblers notorious throughout the village. Gheesu worked for a day, then rested for three days. His son, Madhava, tired so quickly that he needed an hour for a smoke after every half hour of work. Therefore they could find little work anywhere. If they had no more than a handful of grain in the house, they refused to stir themselves. After a couple of days' fasting, Gheesu would climb a tree and break off some branches for firewood. Madhava would take it to the bazaar and sell it. As long as they had any of the proceeds in their pockets, both of them lazed about. When it came to the fasting point once more, they again collected firewood or looked for work.

. . .

II

When Madhava entered the hut in the morning, his wife lay dead and cold. Flies swarmed over her face. Her eyes were fixed in a glassy stare. Her whole body was covered with dust. The child had died in the womb.

Rabindranath Tagore (1861–1941) won the Nobel Prize for Literature in 1913. He also painted and composed music, including India's first national anthem, and founded a school and a university. Tagore's writing and teaching stressed that national freedom was meaningless without personal freedom and that true authority comes only from basic humanity.

In Tagore's story "The Conclusion," young Apurba has returned from his B.A. examination in Calcutta to his village, where a marriage has been arranged for him. Yet his gaze falls upon a "madcap" girl, Mrinmayi. A struggle between custom and Apurba's heart ensues.

READING 19.3 RABINDRANATH TAGORE

From "The Conclusion"

Apurba knew much about this girl's reputation. The men of the village referred to her affectionately as Pagli—"Madcap"—but their wives were in a constant state of alarm at her wayward behavior. All her playmates were boys, and she had vast scorn for girls her own age. In the ranks of [easily led] children she was regarded as a scourge.

Being her father's favorite made her all the more unruly. Her mother never stopped grumbling about it to her friends. Yet because the father loved Mrinmayi, her tears would have hurt him deeply if he had been at home. That fact, and

natural deference to her absent husband, kept the mother from imposing too strict a discipline.

Mrinmayi was dark complexioned with wavy hair that had straggled over her shoulders. Her expression was boyish. Her enormous black eyes held no shame or fear, and not the slightest coyness. She was tall, well built, healthy, strong—but of an age people found hard to estimate; otherwise they would have criticized her parents because she was still unmarried. If the boat of some distant [tax collector] arrived at the [pier], the villagers became impressively alert. As if at a signal, the women pulled their veils down to the tips of their noses, thus concealing their faces like curtains on a stage. But Mrinmayi would arrive holding a naked child to her chest, her unbound hair hanging free. She would stand like a young doe gazing inquisitively in a land where there was neither hunger nor danger. Eventually she would return to her boy playmates and give them elaborate descriptions of the new arrival's manners and mores.

VISUAL ARTS The creator of many ready-made artworks, Subodh Gupta (b. 1964) was born in one of the poorest and most violent provinces in India and lives today in New Delhi. His work includes painting, sculpture, photography, installations, and video art. It taps into sacred symbols and ancient cultural identity but is connected to contemporary life realities through its found objects. A work like *Silk Route* (**Fig. 19.6**) is an example, composed of simple, mundane kitchen utensils. Just as India was once a key component of the Silk Route or Silk Road—a web of ancient trade routes that ran some 4,000 miles through the Indian subcontinent and connected China to the Mediterranean Sea—so is it in today's era of globalization an important economic conduit. Gupta's piece is intended to illustrate the "current state of India's shifting society, migration, a sense of home and place, and the effects and frictions caused by a rapidly globalizing society."

The Indian director Satyajit Ray (1921–1992) was born into a prosperous Bengali family and studied art as a young man. His films aim to show the lives of ordinary people and use the details of their everyday existence to give a more general impression of the culture of which they form a part. His best-known work is probably the Apu Trilogy, three films that tell the story of a young Bengali boy growing to maturity: *Song of the Little Road* (*Pather Panchali*) of 1955, *The Unvanquished* (*Aparajito*) of 1956, and *The World of Apu* (*Opur Shôngshar*) of 1959. Taken together, the three movies (with specially composed background music played by Ravi Shankar), provide an unforgettably moving impression of coming of age in both rural and urban India and point out the similarities between a culture that at first seems so remote and life in the West in the 21st century. A later Ray film, *The Home and the World* (*Ghare Baire*) (1984), sets a romantic love triangle against the background of the early years of the 20th century, with its scheming and treacherous British rulers.

▲ **19.6** Subodh Gupta, *Silk Route*, 2007. Stainless-steel kitchen utensils, 78³/₄″ × 189″ × 189″ (200 × 480 × 480 cm). Installation photograph by Colin Davison at the BALTIC Centre for Contemporary Art, Gateshead, United Kingdom. © **Subodh Gupta. Courtesy of the artist.** Gupta uses many found objects in his installations.

CHINA

China retained a central government for most of its history. A series of dynasties brought the country and its arts forward in various ways.

The Song Dynasty

The Song dynasty reigned from 960 to 1279. Song emperors, interestingly, discontinued much of the practice of populating important government positions with hereditary ministers; instead, they instituted the equivalent of the modern civil-service examination to create a meritocracy. Ability and education therefore became as important as birthright. Perhaps as a result of the meritocracy, the Song dynasty became the technological trailblazer of the world—creating printing with moveable type centuries before Gutenberg in Germany, gunpowder (which was eagerly adopted by Western visitors), and magnetic compasses as travel aids, particularly at sea when the stars were occluded by cloudy skies.

SONG DYNASTY ART Many consider the Song dynasty to be the height of landscape painting. Fan Kuan (ca. 960–1030) was born at the beginning of the dynasty and spent much of his life as a recluse, studying nature rather than the works of other artists. His *Travelers Among Mountains and Streams* (**Fig. 19.7**) was painted on a silk scroll during the early 11th century. Although Fan was an ardent observer of nature, the work reveals an escape into the landscapes of the imagination that constitute the so-called **Monumental style**. This style was often used to create a "perfection" that was meant to praise the supposed flawlessness of the Song government. The highest peak in such landscapes is often meant to represent the Song emperor.

Rocks in the foreground of the Fan Kuan scroll create a visual barrier that prevents the viewer from being drawn suddenly into the painting. But once the viewer is "in," his

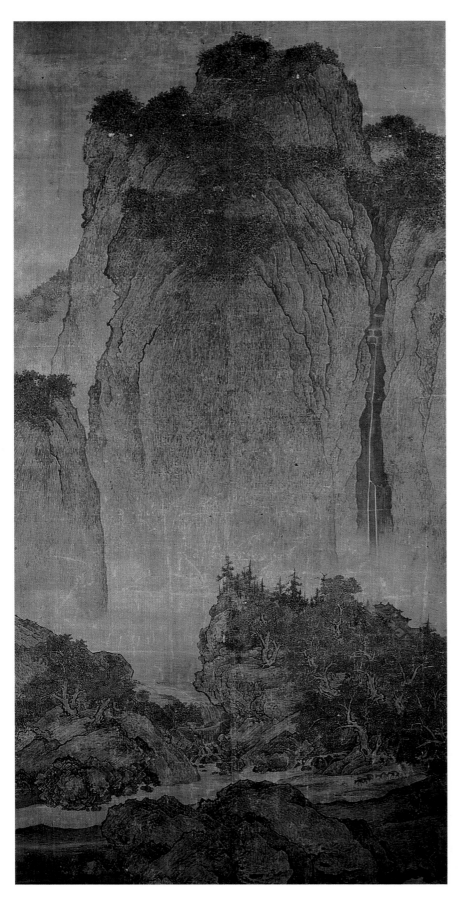

◄ **19.7** Fan Kuan, *Travelers Among Mountains and Streams*, ca. 1000 CE. Hanging scroll, ink and colors on silk, 81¼″ × 40¾″ (206.3 × 103.3 cm). National Palace Museum, Taipei, Taiwan, Republic of China. The scroll was painted in the Monumental style, which was used to create a sense of perfection that symbolized the supposedly flawless rule of the Song dynasty.

or her eye is lifted upward in a sort of mystical journey. Rounded forms rise in an orderly, rhythmic fashion from foreground through background. Sharp brushstrokes clearly delineate conifers, deciduous trees, and small temples on the cliff in the middle ground. The waterfall down the high cliffs to the right is balanced by the cleft to the left. A high contrast in **values**—dark and light—picks out the waterfall from the cliffs. The distance to the mountains is ambiguous, and possibly infinite; the remote and possibly unreachable mountains dwarf the human figures in the foreground. Those figures usually represent the governed masses in works such as these. In contrast to the perspective typical of Western landscapes, there is no single vanishing point or set of vanishing points. The perspective shifts, offering the viewer a freer journey back across the many paths and bridges.

About a century later, Zhou Jichang painted *Lohans Bestowing Alms on Suffering Human Beings* (**Fig. 19.8** on the following page), which represented a traditional Buddhist theme. Lohans were viewed as having obtained **nirvana**—freedom from the endless cycle of rebirth—through their reverence for the teaching of the Buddha. The scroll has a vertical organization, as does *Travelers Among Mountains and Streams* (see **Fig. 19.7**), but there the similarity ends. In using perspective, artists typically portray figures and objects higher in the picture as father from the viewer. Observation of nature would also dictate that more distant figures be smaller than those in the foreground, and perhaps less distinctly delineated. But Zhou's scroll places large, clearly defined and colorful figures in the center of the scroll, in conflict with their apparent greater remoteness from the picture plane than the figures at the bottom. It is all quite symbolic. The lohans are presented as being more important, given

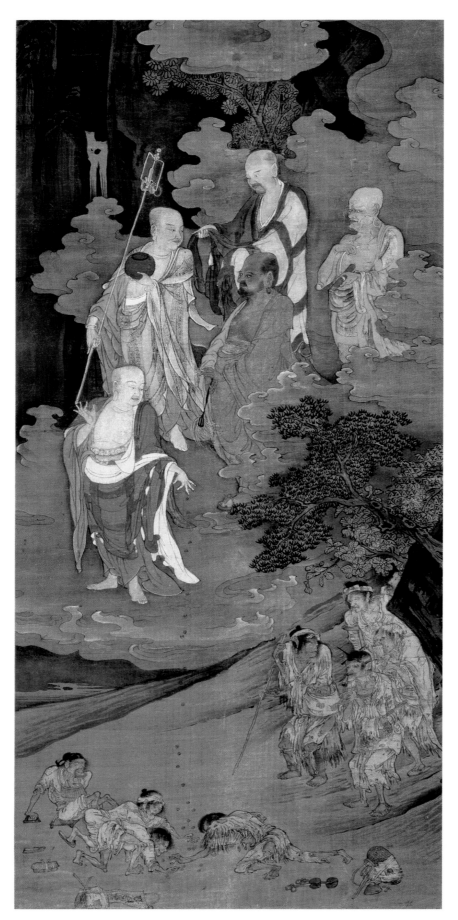

their spiritual attainments, than the beggars beneath them. They are shown as dwelling at a higher level of existence than the peasants—who scramble below for the descending coins—which explains the devices used to attract the eye, including the unnatural brightness of the colors.

The Ming Dynasty

In 1279, the urban society created in China under the Tang and Song dynasties fell under the control of Mongol invaders from Central Asia. It took almost a century for resentment of foreign occupation, coupled with a series of disastrous floods, to provoke a widespread peasants' revolt. One of the rebel leaders seized the Mongol capital, Beijing, and in 1368 declared himself the first emperor of the Ming dynasty (see **Map 19.3**).

For the period from 1368 to the Republican Revolution of 1911, two dynasties controlled Chinese political and cultural life: the Ming (1368–1644) and the Qing (1644–1911). As in India, European traders established operations in China—the British East India Company arrived in 1689. Portuguese Jesuit missionaries had been established in the preceding century, using Macao (leased by the emperor to Portugal) as their base. Unlike the Indian experience, however, where the European colonial powers fought out their wars on Indian soil, China remained virtually untouched by the West, and Macao remained the only port of entry for non-Chinese until the 19th century. Thus the central government was able to maintain tight control over the arrival of both people and ideas. This encouraged the stability of the state bureaucracy and the social structure but did little to encourage trade or manufacturing. As a result, the rapid increase in population between 1600 and 1800—from around 150 million to some 300 million—led to widespread poverty and political unrest, conditions that Western colonial powers were quick to exploit during the 19th century, culminating in the Republican Revolution of 1911.

◀ **19.8** Zhou Jichang, *Lohans Bestowing Alms on Suffering Human Beings*, ca. 1178 (Southern Song Period). Hanging scroll mounted as panel, ink and color on silk, 43$\frac{7}{8}$" × 20$\frac{7}{8}$" (111.5 × 53.1 cm). Museum of Fine Arts, Boston, Massachusetts.

Under the Ming emperors, China enjoyed an extended period of political and economic stability and cultural enrichment. The basis for all aspects of life was Confucianism, which argues that social behavior must be derived from sympathy for one's fellows. Confucianism also stressed loyalty within the family, headed by the father, and in the state as a whole, headed by the emperor—the Son of Heaven—who ruled as the father of his country. Despite the emphasis on the traditional, writers and visual artists experimented and invented new artistic forms.

MING DYNASTY LITERATURE The most popular new literary genres were the novel and the short story. The latter, known as **huaben**, were often based on the oral tales of professional traveling storytellers, or at any rate aimed to give that impression. They included verses inserted into the prose narrative, recording of audience responses, and the use of the speech of the streets. Traditional Buddhist subjects were combined with scenes from everyday life. The earliest collections of huaben date to the 16th century, although many of these had probably circulated for more than a century.

One of the first novels to focus on daily life rather than extraordinary events is the anonymous *Jinpingmei* (*The Plum in the Golden Vase*), attributed to the late Ming dynasty. This story chronicles the lurid career of the licentious Ximen and his six wives. The society it describes is driven mainly by lust, greed, and vanity, although the author makes no attempt to moralize. The book owed its immediate and continuing popularity to its openly erotic episodes. Note that the extract in Reading 19.4 on the next page from the book reads rather like a contemporary novel.

Another novel to achieve a large readership, this one primarily intended for children, is *Monkey*, written by Wu Cheng'en (ca. 1501–1580). Describing the journey to India of a Buddhist priest, Tripitaka, it uses centuries-old tales and legends. Tripitaka is a historical figure who actually made a pilgrimage to India in the seventh century. By the 10th century, his travels had already inspired an entire cycle of fantastic tales, which by the beginning of the Ming dynasty were the subject of stage plays. Wu thus had a mass of material to draw on for his long fairy tale. The real hero of the story is not Tripitaka but his assistant, Monkey, whose magical

◀ **MAP 19.3** The Ming Empire

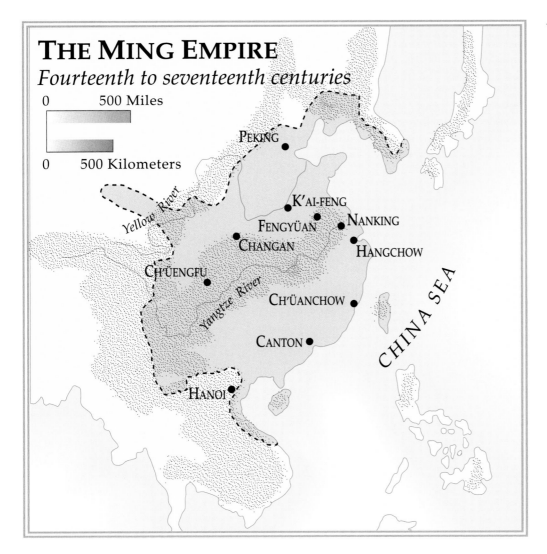

THE MING EMPIRE
Fourteenth to seventeenth centuries

0 500 Miles

0 500 Kilometers

Yellow River

PEKING

K'AI-FENG

FENGYÜAN NANKING

CHANGAN HANGCHOW

CH'UENGFU

Yangtze River

CH'UANCHOW

CANTON

HANOI

CHINA SEA

From *Jinpingmei*, chapter 28, "Beggar Ying startles a pair of Lovers in the Grotto"

Next morning Moon Lady was just sitting down to breakfast with the wife of her elder brother and the two nuns, when Hsi Men unexpectedly pushed the curtain aside and entered the room. Sister-in-law Wu quickly took the two nuns by the hand and retired with them to Sunflower's apartments.

"Was that Sister Pi?" Hsi Men inquired of Moon Lady, in a tone of surprise. "What is that accursed carrion, that female baldhead doing here?"

"You ought to control your tongue a little better," Moon Lady reproved him. "What has she done to you that you should speak of her so disgustingly? And how do you come to know her at all?"

"Don't I just know her! That's the old woman who fouls heaven and earth and turns her convent into a brothel. She once arranged for the youngest daughter of the Ministerial Councilor Chen to meet a young lover in the 'Cloister of Earthly Seclusion,' and took money for it. The affair became known afterwards and came up before me in court. I made the young couple husband and wife, but I had the old procuress's robe pulled off and gave her twenty strokes with the rod. Moreover, she had to revert to her lay status,[1] as being unworthy of holy orders. How is it she is wearing the nun's robe again today?"

"Oh, nonsense! She's a most orthodox person and lives a life of the greatest piety."

"Her piety consists in letting men through the convent gates at night!" he said, derisively.

powers and craftiness enable the two travelers to overcome all obstacles—both natural and supernatural—and complete their journey as we see in Reading 19.5.

Monkey springs up into the sky, looks around, sees no horse, and concludes that the dragon has eaten it. Struggles ensue, in which Monkey beats the dragon attempting to recover the horse. The story combines fantasy, folklore, and history, together with strong elements of satire. The absurd bureaucratic behavior of the gods is clearly intended to poke fun at the complexity of the Chinese state bureaucracy. Tripitaka represents a kind of Chinese Everyman, blundering along through the various problems he has to face, whereas Monkey represents the ingenuity of human intelligence. One of Tripitaka's other fellow pilgrims, Pigsy, personifies human physical desires and brute strength. None of these layers of meaning are allowed to interfere with the narrative drive and the richness of the various adventures encountered by the pilgrims.

MING DYNASTY ART AND ARCHITECTURE The Ming dynasty is known for its landscape painting, its use of calligraphy on the surfaces of paintings, and its use of calligraphic types of strokes to create leaves and other natural shapes. But the period is also renowned for its ceramics and for its furniture and other objects—called *lacquerware*—made of lacquered wood.

The blue-and-white porcelain vase in **Figure 19.9**, from the Ming dynasty, speaks eloquently of the refinement of Chinese ceramics. The crafting of vases such as these was a hereditary art, passed on from father to son over many generations. Labor was also frequently divided so that one craftsman made the vase and others glazed and decorated it. The vase has a blue underglaze decoration—that is, a decoration

1. That is, her status prior to becoming a nun and joining the convent.

From *Monkey*, chapter 15

It was mid-winter, a fierce north wind was blowing and icicles hung everywhere. Their way took them up precipitous cliffs and across ridge after ridge of jagged mountain. Presently Tripitaka heard the roaring of a torrent and asked Monkey what this river might be. "I remember," said Monkey, "that there is a river near here called the Eagle Grief Stream." A moment later they came suddenly to the river side, and Tripitaka reined in his horse. They were looking down at the river, when suddenly there was a swirling sound and a dragon appeared in mid-stream. Churning the waters, it made straight for the shore, clambered up the bank and had almost reached them, when

Monkey dragged Tripitaka down from the horse and turning his back to the river, hastily threw down the luggage and carried the master up the bank. The dragon did not pursue them, but swallowed the horse, harness and all, and then plunged once more into the stream. Meanwhile Monkey had set down Tripitaka upon a high mound, and gone back to recover the horse and luggage. The luggage was there, but the horse had disappeared. He brought the luggage up to where Tripitaka was sitting.

"The dragon has made off," he said. "The only trouble is that the horse has taken fright and bolted."

"How are we to find it?" asked Tripitaka.

Excerpt from *Monkey* by Wu Cheng-En, translated by Arthur Waley, chapter XV, p. 158-166, Allen & Unwin.

molded or incised beneath rather than on top of the glaze. A transparent **glaze** increases the brilliance of the piece. In many instances, the incising or molding was so subtle that it amounted to "secret" decoration. Chinese connoisseurs had always prized and collected painted ceramic ware, and potters of the Ming dynasty produced vases of exceptional quality. Pieces of decorated porcelain began increasingly to circulate in the West, taken there by traders and missionaries. These transported pieces added a new word to the English language for high-quality pottery: **china**.

Lacquer is derived from the sap or resin of the sumac tree. Lacquerware has a hard and durable finish that can vary from high gloss to matte, according to the desires of the artisan. It can also be polished further, providing an even greater sheen. Lacquer also prevents the wood beneath from rotting. The lacquerware table shown in **Figure 19.10**, on the next page, was produced during the Ming dynasty. It has intricate carvings as well as a lacquered finish. Because of the durability of the surface, it looks "good as new."

Li Kan's 14th-century ink painting *Bamboo* (**Fig. 19.11**), created during the period between the Song and Ming Dynasties, possesses an almost unbearable beauty. The entire composition consists of minor variations in line and tone. On one level, it is a realistic representation of bamboo leaves, with texture gradient providing a powerful illusion of depth. On another level, it is a nonobjective symphony of calligraphic brushstrokes. The mass of white paper showing in the background is a symbolic statement of purity, not a realistic rendering of natural elements such as haze.

In much of Chinese art, there is a type of reverence for nature in which people are seen as integral parts of the order of nature, neither its rulers nor its victims. In moments of enlightenment, we understand how we create and are of this order, very much in the way Li Kan must have felt that his spirit had both created and been derived from these leaves of bamboo and the natural order that they represent.

Beijing, as the imperial capital, was originally laid out during the 13th century in a rectangular plan with a north–south axis, by order of the Mongol emperor Kublai Khan (ca. 1216–1294). We have a description of how it then looked from perhaps the most famous travel writer of all time, Marco Polo (ca. 1254–1324), who arrived in China in 1275 and spent time there as an envoy of Kublai Khan. When the Chinese succeeded in driving out the Mongols, they retained Beijing as the imperial capital; the city was reconstructed at the beginning of the 15th century, early in the Ming dynasty.

◄ **19.9** Vase in *meiping* shape with phoenix, late 16th or early 17th century (Ming dynasty). Porcelain painted with cobalt blue under transparent glaze (Jingdezhen ware), 25 1/8″ (63.8 cm) high, 13 1/2″ (34.3 cm) maximum diameter. Metropolitan Museum of Art, New York, New York. Transparent glazing enhances the brilliance of the vase.

◀ **19.10** Lacquerware table with drawers, ca. 1426–1435 (Ming dynasty). Wood, lacquered red and carved 47" (119.38 cm) long. Victoria and Albert Museum, London, Great Britain. Lacquerware, along with ceramics, was a luxury art much appreciated by nobility during the Ming and Qing dynasties. Lacquered objects can be inlaid with metals, semiprecious stones, and precious jewels.

The chief buildings, including the emperor's residence—known as the Forbidden City—and the main government offices, or Imperial City, were constructed to the north of the city. The buildings faced south, with their backs to the direction that symbolized evil: the Mongol invasion. The Forbidden City stood to the extreme north of the complex, so that the emperor, like the northerly polestar, could overlook his subjects (**Fig. 19.12**). A series of gateways and courtyards led from the main entrance, the southern Gate of Heavenly Peace (which now gives its name, Tiananmen, to the vast square in front of the buildings), to the heart of the palace, the Hall of Supreme Harmony, where the emperor held audiences and performed special rituals. Thus the entire complex represented traditional symbolic values.

The Qing Dynasty

The general attitude toward cultural development during the Ming dynasty can be summed up in a phrase frequently used

▼ **19.11** Li Kan, *Ink Bamboo* (section), 1308 (Yuan dynasty). Hand scroll, ink on paper, 14¾" × 93½", (37.5 × 237.5 cm). The Nelson-Atkins Museum of Art, Purchase: William Rockhill Nelson Trust, 48-16, Kansas City, Missouri. There is no setting for the bamboo, just the stalks and leaves, apparently dashed out in loose calligraphic strokes.

▲ **19.12 Hall of Supreme Harmony, the Forbidden City, Beijing, China. 98′ 5″ (30 m) high.** The Forbidden City served as both the private residence for the emperor and the setting for his official appearances. The Hall of Supreme Harmony served as the throne room, set as it is on a high platform with marble staircases. The throne, inside, was set on another high dais.

by Ming scholars: "change within tradition." The result was to produce a culture—and also a society—that was stable but subject to internal decay. The preeminence of gentleman-scholars, artists, and bureaucrats, rather than professionals, led to economic decline. By the early 17th century, as the bureaucracy became increasingly corrupt and the emperors began to lose control, rebellions and banditry became rampant; in 1628, a popular uprising drove the last Ming emperor to hang himself. The resulting confusion attracted invaders from the south, who soon established a new dynasty—the Qing—the last royal house to rule China.

The new Qing rulers, who came from Manchuria, were foreigners in the eyes of most Chinese. Although they maintained their own army, they had to rely on the established bureaucracy for the day-to-day running of the empire. One of the early Qing emperors, Kangxi (1654–1722), set up a grand council to supervise the bureaucrats and succeeded in interweaving local and central administration. These measures strengthened the power of the emperor. Simultaneously, Kangxi began to make tentative contacts abroad. In 1689 he signed a treaty with Peter the Great of Russia, to set limits on

the expanding Russian Empire, and encouraged the introduction—carefully controlled—of Western arts and education. The Jesuit missionary Matteo Ricci (1552–1610) had already studied Chinese in order to familiarize some of those at court with Western mathematics, geography, and astronomy. Kangxi employed other Jesuits as mapmakers and took Jesuit physicians with him on his travels. Some Westerners even received appointments at court. The Flemish missionary and astronomer Ferdinand Verbiest (1623–1688) became head of Beijing's astronomical bureau in 1669 and played a part in helping to determine the Chinese–Russian border. When, however, the pope sent an ambassador to ask if a permanent papal legation could be set up in Beijing (in part, probably, to keep an eye on the Jesuits), the emperor refused permission and required all resident Jesuits to sign a declaration stating that they understood and accepted the definition of Confucianism and ancestral rituals as formulated by Kangxi.

QING DYNASTY LITERATURE The most popular book of the Qing dynasty is actually a compilation of poetry from the Tang period (618–907), 1000 years earlier, which has been

The Emperor of China Studies Western Mathematics

Chinese emperor Kangxi Muses on His Contacts with Western Ideas.

 I realized, too, that Western mathematics has its uses. I first grew interested in this subject shortly after I came to the throne, during the confrontations between the Jesuit Adam Schall and his Chinese critic, Yang Kuanghsien, when the two men argued the merits of their respective techniques by the Wumen gate, and none of the great officials there knew what was going on.

 Schall died in prison, but after I had learned something about astronomy I pardoned his friend Verbiest in 1669 and gave him an official position, promoting him in 1682. In 1687, I let the newly arrived Jesuit Fontaney and the others come to Beijing, although they had come to China illegally on a Chinese merchant vessel and the Board of Rites had recommended their deportation; and throughout the 1680s I discussed Western skills in Manchu with Verbiest, and I made Grimaldi and Pereira learn the language as well, so they could converse with me.

 After the treaty of Nerchinsk had been signed with the Russians, I ordered the Jesuits Thomas, Gerbillon, and Bouvet to study Manchu also, and to compose treatises in that language on Western arithmetic and the geometry of Euclid. In the early 1690s, I often worked several hours a day with them. With Verbiest I had examined each stage of the forging of cannons, and made him build a water fountain that operated in conjunction with an organ, and erect a windmill in the court.

called the Golden Age of Chinese poetry. The compilation is simply titled *300 Tang Poems*, and it was collected in 1763 by Sun Zhu. Sun's choices for the anthology included works that were popular and built character. The anthology has been so popular that even today most Chinese households have a copy.

 The following excerpts vividly portray sources of heartbreak. Their ability to cultivate character is obvious.

READING 19.6 WEI YINGWU

**"To My Daughter on Her Marriage into the Yang Family,"
lines 1–10**

My heart has been heavy all day long
Because you have so far to go.
The marriage of a girl, away from her parents,
Is the launching of a little boat on a great river. . . .
You were very young when your mother died,
Which made me the more tender of you.
Your elder sister has looked out for you,
And now you are both crying and cannot part.
This makes my grief the harder to bear;
Yet it is right that you should go.

READING 19.7 HE ZHIZHANG

"Coming Home"

I left home young. I return old;
Speaking as then, but with hair grown thin;
And my children, meeting me, do not know me.
They smile and say: "Stranger, where do you come from?"

▼ **19.13** Thousand Flowers vase, 1736–1795 (Qianlong period, Qing dynasty). Porcelain, color enamels, 18⅞″ × 14¼″ (48 × 36 cm). Musée national des arts asiatiques Guimet, Paris, France. Qing potters advanced the techniques of earlier potters by applying more complex glazes to their works, allowing for more brilliant and varied colors.

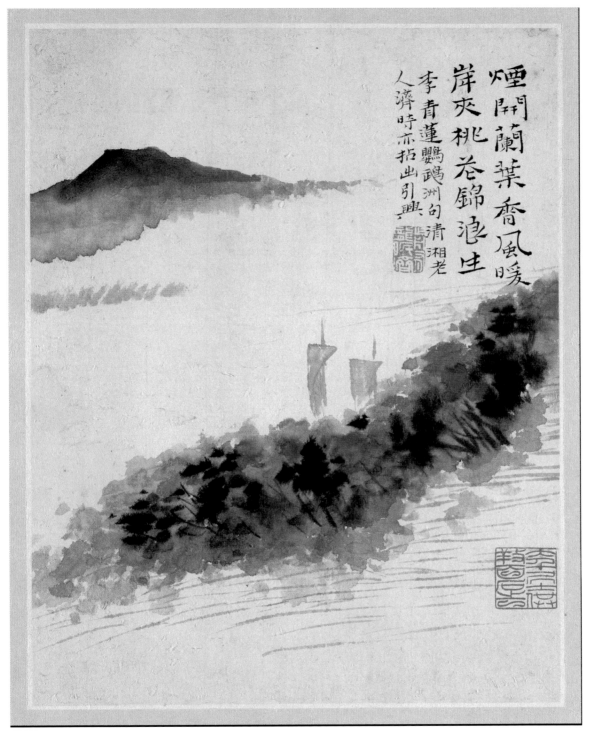

煙開蘭葉香風暖
岸夾桃花錦浪生
李青蓮鸚鵡洲句清湘老
人濟時亦拈出引興

◄ **19.14** Shitao, "Riverbank of Peach Blossoms," ca. 1700. Leaf C from *Wilderness Colors*, an album of 12 paintings. Ink and color on paper, 10 ⁷⁄₈″ × 8 ½″ (27.6 × 21.6 cm). The Metropolitan Museum of Art, New York, New York. The bank of blossoms and the distant mountains are both described by diagonals from lower left to upper right.

QING DYNASTY ART Qing potters advanced the achievements of Ming dynasty potters by further developing porcelain ceramics with **underglazes** and **overglazes**. The Thousand Flowers vase (**Fig. 19.13**) is more colorful and complex in design than the earlier Ming dynasty vases. The flowers overlap each other in an intricate, continuous pattern. Other vases of the era are partly covered with flowers or have other kinds of designs.

The Qing painter Shitao (1641–1707), who became a Buddhist monk at the age of 20, experimented with new approaches. In some cases, he boldly repeated lines with several strokes of ink, providing a massiveness to shapes. In other cases he created areas of color to suggest fields of blossoms or distant mountains reaching into the sky. *Riverbank of Peach Blossoms* (**Fig. 19.14**) has an abstract quality to it. Strokes of black suggest tree trunks and the blossoms

merge in a sea—or a riverbank—of spring finery. The water is barely suggested. We see what appear to be sails in the river. The upper right part of the work consists of calligraphic writing, a tradition not found in Western art of the time, and we see the stamp of the artist prominently displayed in the lower right. The writing and the stamp are parts of the composition, helping to define open areas in the piece.

By 1800 Chinese independence was beginning to come under threat. Western traders establishing themselves in India and other parts of Asia recognized the potential for profit at home as demand rose for Chinese tea, fine vases, silks, and works of art. Trade, however, depended on exchange, and foreign merchants could find little in the way of Western products to interest the Chinese. Silver and gold would have been acceptable, but the British, who were the chief traders, had no intention of damaging their balance of trade by incurring trade deficits. British merchants, therefore, began importing large quantities of opium from India into China. The Chinese, well aware of the harmful effects of the drug, made little use of it. The Chinese government, therefore, attempted to prevent its importation; the emperor even addressed a personal appeal to Queen Victoria, which she ignored.

When (in 1839) the Chinese tried to block the introduction of opium, the result was outright war. The first Opium War, of 1839–1842—in which the British used their vastly superior naval power to blockade the entire coast—forced the Chinese to open up a string of ports along their coast, including Canton and Shanghai, thereby ending their isolation. Quite apart from their bitter resentment at the introduction of a drug that soon became widely used (importation rose from 6000 cases in 1820 to 100,000 in 1880), the Chinese also had to face the arrival of other Westerners—from France and the United States, among others. One of the results of all this turmoil was a series of internal rebellions, which the Chinese authorities could only put down by humiliatingly having to ask the invading foreigners for help. During the Taiping Rebellion (1850–1864), a Franco-British force occupied Beijing, drove out the emperor, and burned down the Summer Palace.

The Collapse of Chinese Imperial Rule

When the central government grew increasingly ineffectual, the foreign trading powers benefited from a weak central authority that depended on them for the little influence it possessed. With the suppression of the bloody Boxer Rebellion of 1900–1901, the Western powers took virtual control, constructing railways and opening up river traffic to all parts of the interior.

In 1911, republicans led by Sun Yat-sen (1866–1925) finally brought down the monarchy, but the collapse of centuries-old institutions created decades of chaos, complicated by two world wars. Two chief movements struggled for power in China. The Kuomintang, led by Chiang Kai-shek (1887–1975), offered authoritarian rule, which was supposed to evolve into a form of democracy. The

▾ **19.15 "Women hold up half of heaven, and, cutting through mountains and rivers, change to a new attitude,"** 1970. Propaganda poster, color lithograph, ca. 30" × 21" (76 × 53 cm). Private collection. One of Mao's chief aims was to bring China's industrial strength to the level of Western powers, requiring the participation of women in the workforce.

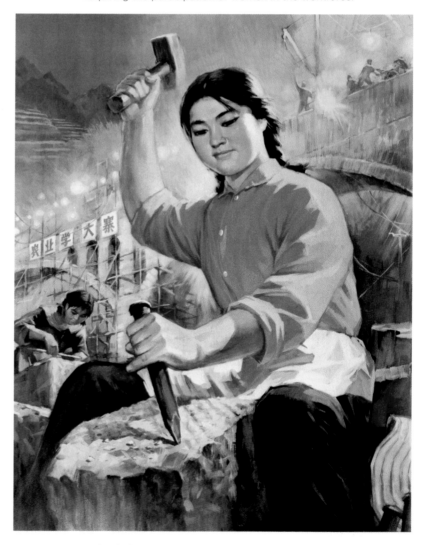

妇女能顶半边天　管教山河换新颜

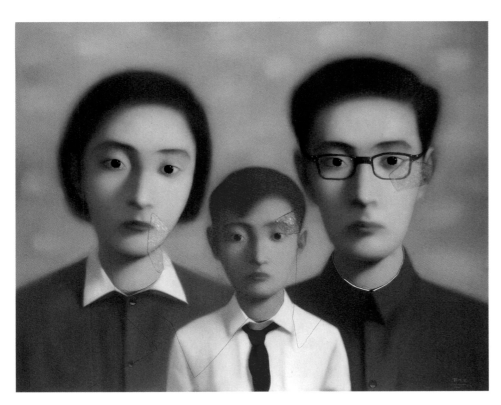

◀ **19.16** Zhang Xiaogang, *Bloodline: Big Family*, 1999. Oil on canvas, 59" × 74 ³/₄" (150 × 190 cm). © Zhang Xiaogang. Courtesy of Zhang Xiaogang Studio and Pace Beijing. The print is a comment on China's one-child policy. The child is a male—the preferred gender in China. Now that prenatal ultrasounds to determine gender are common in China, many couples are aborting female fetuses; there is a looming scarcity of women, with Chinese men often looking to neighboring countries to find wives.

other group, the Chinese Communist Party, aimed to follow the example of Russia's Bolshevik movement and was led by Mao Zedong (1893–1976). The Communists rose to power in 1949. Just as Western art for many centuries was devoted to Christian themes, Chinese art under communism has had to advance—or at least be consistent with—the social and political environment. Virtually all of the art produced under Communist rule exalts the party (under Mao especially) and the virtues of hard work—most notably in the posters produced at the time of the Cultural Revolution (1966–1976). We see a smiling worker in **Figure 19.15**. It is of interest that the worker is a woman, somewhat feminine in appearance despite burly arms. The Communist Party teaches that the genders are equal, denying that there is such a thing as men's work or women's work. The woman smiles to reveal her pleasure at working to be one of the people of the People's Republic of China. Things have changed—somewhat.

China Today

The China of the 21st century is an economic powerhouse with a significant emerging military. Its influence is felt around the world. Although communist China is officially atheistic, many again think of Confucius in their daily lives and there are those who practice Buddhism, Islam, and Christianity—although usually without overtly seeking converts. The China that abhorred capitalism in the mid-20th century now has a hybrid communist–capitalist system with more than a few billionaires. Contemporary Chinese art, produced in a variety of styles—and no longer necessarily progovernment—sells for millions. Chinese artists are represented by major galleries in London, New York, Paris, Rome, and, yes, Shanghai and Beijing. Some Chinese artists protest too loudly against the Communist Party and wind up with certain restrictions and lost privileges, but many "commute" freely between the major cities in China and the rest of the world.

Zhang Xiaogang's (b. 1958) *Big Family* (**Fig. 19.16**) features a passage of bright red in a sea of monotonous beige and gray tones. For this Chinese artist, the uniformity of a drab palette reflects the appearance—indeed the lives—of what he calls a typical revolutionary family: "asexual, dressed in Mao suits, their gaze glassy and dismal. . . . They could be clones." Red as a signifier of Chinese Communist culture creates points of narrative and visual emphasis, but there is more to the print than its design elements. The work addresses a truth of contemporary Chinese life: this "big" family is as big as a family is permitted to get in the overpopulated country, given its one-child policy. And because of sexism, abortion is not uncommon when an early sonogram reveals that a fetus is female. Chinese social critics note that the country has been developing a surplus of males; some have even suggested that women be permitted to have more than one husband.

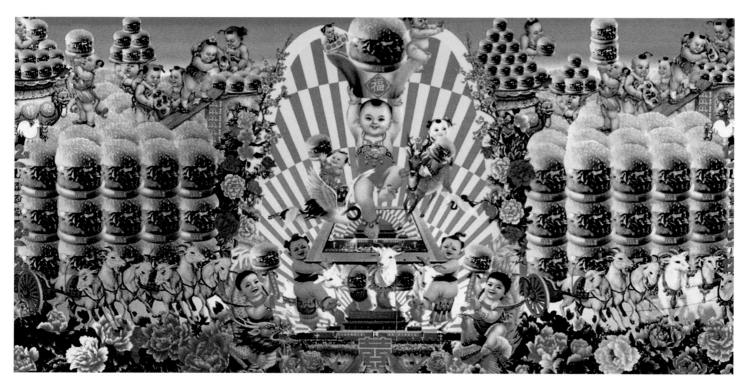

▲ **19.17** The Luo Brothers, *Welcome the World Famous Brand*, 2000. Collage and lacquer on wood, 49 ⅝" × 96 ⅞" × 1¼" (126 × 246 × 3 cm). © The Luo Brothers. Image courtesy of the artists. Compare the composition of this contemporary Chinese work to the paintings by Cimabue, Giotto, and others of the Madonna enthroned.

Welcome to the World Famous Brand (**Fig. 19.17**), by the Luo brothers, features their signature emphasis on the convergence of consumerism and globalism. It continues the theme of East meets West—or, in this case, West invades East—with Big Macs. Mimicking the garish packaging of Chinese merchandise, the Luo brothers' compositions are often overcrowded, intensely colored, and exuberant in mood. There is so much energy bound up in the imagery that it is almost impossible for the eyes to stop and focus. Emphasis through placement is an important device in this work, and to achieve it, once again, the Luo brothers use mimicry. The "enthroned" baby raising a McDonald's sandwich in the center of the piece becomes the focal point. It is emphasized by the red and yellow bands of lines that look like divine rays emanating from behind the baby, who in turn is bolstered on a floating rectangle by lesser, though no less jubilant, little ones. To the left and right are regimented stacks of burgers riding on chariots pulled by teams of lambs. Brightly colored peonies add to the outrageously festive atmosphere. This formula—enthroned central figure buoyed by devoted onlookers and flanked by symmetrical groups of regimented figures—is standard in religious altarpieces over centuries of art history. The Luo brothers appropriate this formula to sharpen their statement about what we "worship" in contemporary society.

Many Chinese cities have become boomtowns for contemporary architecture, although—at least for the time being—the principal architects involved in the designs for these cities are not Chinese, but European and American. Iraqi–British architect Zaha Hadid has called China "an incredibly empty canvas for innovation." American architect Anthony Fieldman has said that in China, "you're seeing things that no one in their right mind would build elsewhere." Looking at a piece of Shanghai's conglomerate Pudong New Area skyline (**Fig. 19.18**), it is no wonder that Wang Lu of Beijing-based *World Architecture* magazine has said, "Architecture in China has become like a kung fu film, with all of these giants trying to vanquish each other."

On the left we see the Oriental Pearl Broadcasting Tower, with its spherical components reminiscent of toys on a steel kabob. To the right we see the Jin Mao Tower, an integral part of the Pudong skyline since 1999, and behind it, the World Financial Center. A hybrid design by Skidmore, Owings and Merrill, the Jin Mao Tower combines Chinese pagoda architecture with the steel-cage postmodern architecture frequently seen in the West. Constructed to withstand typhoon winds and strong earthquakes, the design also makes whimsical reference to the number 8, associated with prosperity in China. An eight-sided core concrete structure supports the building and is surrounded by eight composite columns and eight exterior steel columns. Across the street from the Jin Mao Tower, and behind it in the figure, is the modernist World Financial Center, designed by Kohn Pedersen Fox

Associates. The 101-story structure is the tallest building in the People's Republic of China, but it will soon be eclipsed by the Shanghai Tower, which is under construction and will rise to 2073 feet (New York's One World Trade Center will be 1776 feet high). With the opening near the top, which aids the structure in channeling currents of wind, the Financial Center has been referred to, tongue-in-cheek, as the "bottle opener."

JAPAN

Japan is an island country off the eastern coast of Asia, holding more than 120 million people in an area not quite as large as California (whose population is about 37 million people). The islands were originally formed from porous volcanic rock, and thus they are devoid of hard stone suitable for sculpture and building. Therefore, Japan's sculptural tradition

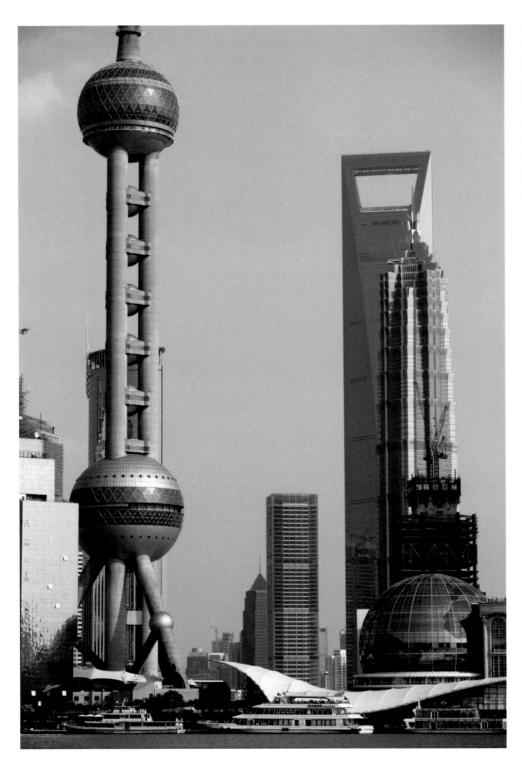

◀ **19.18 A view of Shanghai's bustling Pudong New Area, with the Oriental Pearl Broadcasting Tower on the left, the pagoda-style Jin Mao Tower on the right, and the modernist Shanghai World Financial Center behind it.** Three hundred office towers are planned for the Pudong New Area, China's financial hub, which constitutes most of the eastern part of Shanghai. Unsurprisingly, perhaps, a Disney theme park is also under development in Pudong. The World Financial Center is mainland China's tallest building, but it will soon be eclipsed in height by the Shanghai Tower, which is rising nearby to 2073 feet (632 m).

has focused on clay modeling and bronze casting, and its structures have been built from wood.

Ceramic figures and vessels date to the fourth millennium BCE. Archaeological evidence suggests that agricultural communities were developed by 200 CE. Each community had a tribal chief and its own god, thought of as an ancestor. Around 400 CE, one of these communities was sufficiently sophisticated to bring in scribes from Korea to keep records, because no system of writing as yet existed in Japan. In the fifth and sixth centuries CE the Japanese produced **haniwa**, hollow ceramic figures with tubular limbs modeled from slabs of clay. Haniwa were placed around burial plots, but their function is unknown.

The original chief city had been Nara, laid out in 706 CE in imitation of Chinese urban design. Less than a century later, however, the various settlements, now much expanded, came together in a new capital, Kyoto (then known as Heian), which remained a center of stable government and economic growth until 1185.

By the beginning of the seventh century, Buddhism had spread to Japan from China and been established as the state religion in Japan. Many sculptors produced wooden and bronze effigies of the Buddha, and Buddhist temples reflected the Chinese style. **Shintoism**, the native religion of Japan, teaches love of nature and the existence of many beneficent gods, who are never symbolized in art or any other visual form. Shintoism involved worship of the spirits of nature—including the all-important rice god—a complex series of rituals, and the imperial cult; that is, the ruling emperor and his ancestors were worshiped as divine. The tension between Shintoism and the influence of Chinese Buddhism always remained an important factor in Japanese religious life. The move from Nara to Heian (present-day Kyoto) was in part to escape from the domination of Nara's Buddhist priests.

During this period, the Japanese developed their own writing system, partly based on the Chinese system. Poetry was popular, and as urban centers grew, various forms of theater became common. Perhaps the best known is the **Noh** play, in which dancers enact dramatic stories combined with ritual and slapstick (**Fig. 19.19**). The most famous literary work of the age was *The Tale of Genji*, written by Lady Murasaki Shikibu (ca. 973–ca. 1014–1025). Murasaki lived during the so-called Fujiwara period, one dominated by members of

▼ 19.19 An actor in a Japanese Noh play. The pinned hairstyle suggests the actor is playing a female role. All performers in Noh plays are traditionally male; as here, they use traditional wooden masks. The plays combine speech, singing, dance, and mime.

that family; the most important, Fujiwara Michinaga, ruled as regent from 1017 to 1028.

Murasaki's father held a minor position at court. She married and had children, but when her husband died and her father was transferred to the provinces, Murasaki took a position in the service of Empress Akiko. The diary she wrote during her years at court gives precious insight into life there. Basically serious-minded, Murasaki had little time for the frivolity of many of her contemporaries. By a remarkable chance, another diary of the same period has also survived, kept by Sei Shonagon (active ca. 1000). Sei Shonagon's work takes the form of a **pillow book**—a collection of notes and observations on the day's events that are often malicious and sometimes indelicate, forming an interesting contrast with the more straitlaced Murasaki.

Murasaki's enduring fame is based on her novel *The Tale of Genji*. One of the great achievements of Japanese literature, the book describes the amorous adventures of Prince Genji, set against a court background very similar to that in which Murasaki herself moved. She writes with great delicacy and an underlying melancholy, often underlined by descriptions of nature. The autumnal winds, swift-flowing rivers, snow in winter—all serve as background to the book's more poignant scenes.

Genji is married to a somewhat older woman who dwells in a mansion at Sanjo. Yet he longs for his father's most beautiful consort, Fujitsubo, who resembles his own mother, who died years earlier.

READING 19.8 MURASAKI SHIKIBU

From *The Tale of Genji*, chapter 1

Constantly at his father's side, Genji spent little time at the Sanjō mansion of his bride. Fujitsubo was for him a vision of sublime beauty. If he could have someone like her—but in fact there was no one really like her. His bride too was beautiful, and she had had the advantage of every luxury; but he was not at all sure that they were meant for each other. The yearning in his young heart for the other lady was agony. Now that he had come of age, he no longer had his father's permission to go behind her curtains. On evenings when there was music, he would play the flute to her koto[2] and so communicate something of his longing, and take some comfort from her voice, soft through the curtains. Life at court was for him much preferable to life at Sanjō. Two or three days at Sanjō would be followed by five or six days at court. For the minister [his bride's father], youth seemed sufficient excuse for this neglect. He continued to be delighted with his son-in-law.

The minister selected the handsomest and most accomplished of ladies to wait upon the young pair and planned the sort of diversions that were most likely to interest Genji. At the palace the emperor [Genji's father]

assigned him the apartments that had been his mother's and took care that her retinue was not dispersed. Orders were handed down to the offices of repairs and fittings to remodel the house that had belonged to the lady's family. The results were magnificent. The plantings and the artificial hills had always been remarkably tasteful, and the grounds now swarmed with workmen widening the lake. If only, thought Genji, he could have with him the lady he yearned for.

One of the unintentional effects of Murasaki's psychological subtlety is to reveal the gulf between the aesthetic sensibilities of the aristocratic elite at court and the lives of the peasants, the overwhelming majority of the population. It seems that life at court consisted of music and love affairs, poetry recitations, and apt quotations from the classics.

The Period of Feudal Rule

As the increasingly remote court life of Kyoto led to internal rivalry, in 1185 a new, more aggressive center developed at Kakamura. The emperor now combined legal and administrative duties with military command, creating a new office—**samurai-dokoro**—which gave him control of all of Japan's warriors (**samurai** is the Japanese name for a professional warrior). His title was *seii taishogun* ("barbarian-suppressing commander-in-chief"), later shortened to **shogun**. This newly enhanced warrior class dominated Japanese culture sufficiently to defeat two waves of Mongol invaders (in 1274 and 1281). Bands of warriors followed their aristocratic leader, who was in turn bound to the emperor—a system not unlike the feudal system developing independently in Western Europe around the same period.

Over time, the local **daimyo** (warlords) began to assert their own authority against that of the shogun, and the years 1467 to 1568 are known as the Age of the Warring States. With the introduction of firearms, first obtained from Portuguese traders and then manufactured in Japan, individual daimyo began to build their own fortified centers, and the authority of the central government grew ever weaker. The Portuguese guns may have increased the influence of individual warriors, but they undercut the traditional samurai fighting style and raised the problem of outside influence in a society that had been virtually closed to the world for centuries. Fighting between the various warlords was finally ended under two powerful leaders, Toyotomi Hideyoshi (1537–1598), who united Japan once more by 1590, and Tokugawa Ieyasu (1543–1616), who created a new capital in 1603 at Edo

2. A Japanese stringed instrument resembling a zither, having a rectangular wooden sounding board and typically 13 strings made of silk. It is usually plucked with the fingers.

(present-day Tokyo). Members of the Tokugawa family ruled there until 1868.

The landscapes, portraits, and narrative scrolls produced by the Japanese during the late 12th through the early 14th centuries are highly original and Japanese in character. Some of them express the contemplative life of Buddhism, others express the active life of the warrior, and still others express the aesthetic life made possible by love of nature.

The *The Three Sacred Shrines at Kumano: Kumano Mandala* (**Fig. 19.20**), a scroll executed at the beginning of the 14th century, represents three Shinto shrines. For nearly 2000 years, wooden Shinto shrines such as those shown in the scroll have been razed every 20 years and replaced by duplicates. The shrines in the mandala are actually several miles apart in mountainous terrain, but the artist collapsed the space between them to permit the viewer an easier visual pilgrimage. The scroll pays homage to the unique Japanese landscape in its vivid color and rich detail. The several small figures of the seated Buddha portrayed within testify to the Japanese reconciliation of disparate spiritual influences. The repetition of forms within the shrines and the procession of the shrines afford the composition a wonderful rhythm and unity. A **mandala** is a religious symbol of the design of the universe. It seems as though the universe of the shrines of the *The Three Sacred Shrines at Kumano: Kumano Mandala* must carry on forever—as indeed it did in the minds of the Japanese.

The feudal period also gave rise to an extraordinary realism, as in the 13th-century wood sculpture *The Sage Kuya Invoking the Amida Buddha* (**Fig. 19.21**). From the stance of the figure and the keen observation of every drapery fold to the crystal used to create the illusion of actual eyes, this sculptor's effort to reproduce reality knew no bounds. The artist even went as far as to attempt to render speech: six tiny images of the Buddha come forth from the sage's mouth, representing the syllables of a prayer that repeats the name of the Buddha.

◄ **19.20** *The Three Sacred Shrines at Kumano: Kumano Mandala*, ca. 1300. Japan, Kamakura period (1185-1333). Hanging scroll; ink and color on silk, 53³/₄″ × 24³/₈″ (134 × 62 cm). **The Cleveland Museum of Art, John L. Severance Fund 1953.16, Cleveland, Ohio.** A mandala is an object to encourage meditation. The shrines in the scroll are miles apart, but the artist chose to collapse the space between them so that the viewer would be able to make a visual pilgrimage from one to the next.

A remarkable balance between the earthly and the spiritual is achieved through the use of extreme realism to portray a subject that refers to religion.

The Edo Period

Artists entering Edo period, such as Hasegawa Tohaku (1539–1610), produced a wide variety of work, catering to the needs of an increasingly urban and sophisticated population. Hasegawa painted his masterful *Pine Forest* (**Fig. 19.22** on page 744) on a pair of six-panel screens. It is reminiscent of Li Kan's study of bamboo in that the plant life stands alone. No rocks or figures occupy the foreground. No mountains press the skies in the background. Like *Bamboo*, it is monochromatic. The illusion of depth—and the illusion of dreamy mists—is evoked by subtle gradations in tone and texture. Overlapping and relative size also play their roles in the provision of perspective. Without foreground or background, there is no point of reference from which we can infer the scale of the trees. Their monumentality is implied by the power of the artist's brushstrokes. The groupings of trees to the left have a soft sculptural quality and the overall form of delicate ceramic wares. The groupings of trees within each screen balance one another, and the overall composition suggests the infinite directional strivings of nature to find form and express itself.

During the Edo period, the development of woodblock, a printmaking medium, made it possible to create multiple copies of works of art for a growing number of collectors. The best-known landscape artist to use woodblock was Katsushika Hokusai (1760–1849). His image of a monstrous wave crashing in the foreground while a diminutive but enduring Mount Fuji appears at the center of the background is one of the best-known Japanese works of art (**Fig. 19.23** on page 745). The ominous claws of the whitecap seem certain to capsize the trading boats below and drown the sailors, who bend to gouge their oars into the rough waters to try to propel themselves past the wave. The vantage point from which we observe the unfolding drama is low in the water, such that we may feel vulnerable to the wave ourselves.

Japanese writers of the Edo period made major contributions in poetry, fiction, and dramatic writing. The greatest poet of the age was Matsuo Basho

➤ **19.21** *The Sage Kuya Invoking the Amida Buddha,* **13th century. Painted wood, ca. 46¼″ (117.5 cm) high. Rokuharamitsu-ji Temple, Kyoto, Japan.** The artist spared no effort in the attempt to render the sage realistically. There is even a representation of speech in tiny Buddhas emerging from the statue's mouth.

READING 19.9 **MATSUO BASHO**

"An Old Pond"

Furu ike ya
kawazu tobikomu
mizu no oto

These three lines constitute the best-known Japanese haiku poem, composed by the Zen Buddhist Matsuo Basho in the 17th century. They have the standard haiku structure of five syllables, seven syllables, and five syllables, and they have been translated into English countless times.

In this poem, the first line creates the setting: *old pond*, with "old" possibly meaning ancient, settled, quiet, still, sleepy, serene, eternal, even overgrown with lilies, or all these and more. The second line expresses the action: *a frog jumps in*, with "jumps" sometimes translated as "leaps," making the action a bit more forceful and, perhaps, purposeful. The third line records the result of the action: *the sound of water*, which is sometimes translated as that phrase—that is, "the sound of water"—and sometimes into a single English word: "splash," "plop," "plunk," or even "kerplunk." Some translators have insisted that the English version also have five, seven, and five syllables; others have argued that you do not translate meaning with such verbal straitjackets.

The words and phrases in poems often have symbolic meanings. The pond, serene, might represent the pure mind of the meditating Buddhist who has cast out the worries of the world. Japanese poets have portrayed frogs as endearing, little creatures, and the frog, in this haiku, might represent the intrusion of reality or the sudden occurrence of an enlightening thought—"a flash of insight." The sound of water may be a disturbance in the eddies of the pond, as when a child tosses in a pebble and, in effect, says, "I am here and you will respond."

The poem could also be a simple record of an experience. But in the haiku, which is brief, little is simple.

(1644–1694), who developed one of the most important Japanese verse forms, the **haiku** (originally called *hokku*). This consists of three lines of five, seven, and five syllables, respectively. Haiku typically juxtapose images, often drawn from nature, to see things freshly, to evoke or suggest a feeling or mood—of being within the scene. Basho spent most of his life either in retreat or on solitary journeys, writing poems that evoke entire landscapes by the telling selection of the crucial details. In this way, he aimed to provide a poetic equivalent of the flash of enlightenment that a meditating Buddhist hoped to achieve. Basho was a devout Buddhist, with a special interest in Zen Buddhism. (Zen, which avoided images, rituals, and sacred texts and stressed contemplation and meditation, had a great influence on Japanese culture.)

Basho's contemporary Ihara Saikaku (1642–1693) also wrote poetry but was chiefly famous for his novels. Many of these follow the various adventures of their heroes and heroines rather in the manner of *The Tale of Genji*, to which they form a middle-class equivalent. *The Life of an Amorous Woman*, for example, is narrated by an old woman as she looks back over her life from the Buddhist retreat to which she has retired. Beginning as a high-class prostitute, she gradually declines to a mere streetwalker and eventually scrapes a living from the few occupations open to women. The overt eroticism

⌄ **19.22** Hasegawa Tohaku, *Pine Forest*, late 16th century. One of a pair of six-panel screens, ink on paper, 61³⁄₈″ × 136″ (156.8 × 356 cm). Tokyo National Museum, Tokyo, Japan. The picture elicits a meditative mood, inviting the viewer to consider those things that are beyond our vision yet suggest infinite beauty.

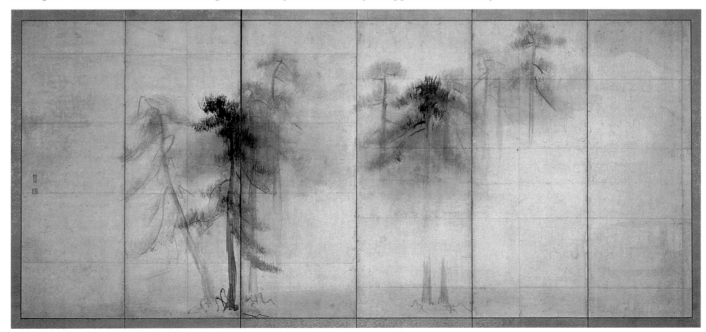

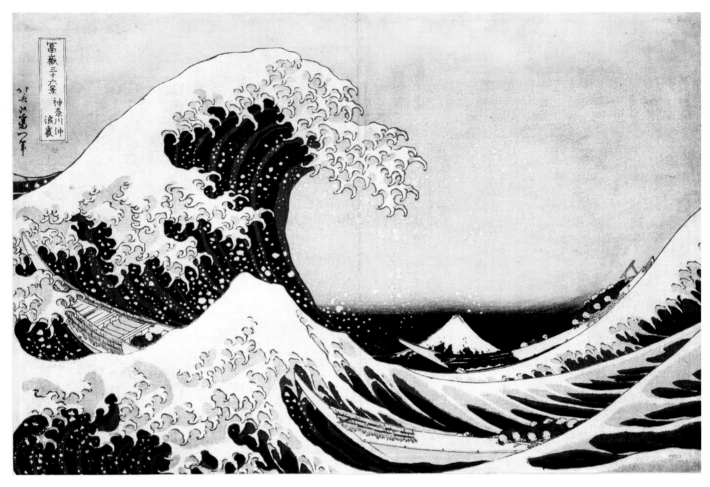

ᐱ 19.23 Katsushika Hokusai, *Under the Wave off Kanagawa* (also known as the "Great Wave"), ca. 1831 (Edo period). Polychrome woodblock print, 97³/₄″ × 145³/₄″ (25.5 × 37.1 cm). Musée national des arts asiatiques Guimet, Paris, France. This is one of a series of woodblocks called *Thirty-Six Views of Mount Fuji*; the mountain can be seen in the distance. Note the two boats, whose crews are trying desperately to negotiate the perilous seas.

is in strong contrast with Murasaki's delicacy and emerges in Saikaku's other writings, which include a collection of tales about male homosexual love. Similar themes of love among the bourgeois merchant classes inspire the plays of Chikamatsu Monzaemon (1653–1725). One of the most famous is *The Love Suicides at Amijima*, which describes the life and eventual death of a paper merchant, ruined by his hopeless love for a prostitute. The earlier Noh dramas had enacted traditional stories, passed down from generation to generation. This new form of drama, based on real-life incidents, is called **Kabuki**; it grew increasingly popular despite government opposition.

At the end of the Edo period, Japan was thrust into contact with the Western powers. In 1853 the famous American naval expedition of Commodore Matthew Calbraith Perry arrived in Edo Bay and insisted, under threat of bombardment, that Americans be allowed to trade. The United Kingdom, Russia, and the Netherlands soon followed. The ensuing contest between conservatives and reformers was soon won by the latter, when a new emperor ascended to the throne in 1867.

Modern Japan: The Meiji

The reign of the new emperor Mutsuhito (from 1867 to 1912), known as the Meiji ("enlightened government"), introduced a radical program of reform, abolished feudalism, and quickly built a strong central government. A new army, modeled on the German system, was formed. A parliament, consisting of an upper and a lower house, served under the emperor. Banks, railways, and a merchant marine all permitted Japan to industrialize at a speed that far outstripped India or China, and by 1905, Japan could claim military victory over a European opponent[3] in the Russo-Japanese War. Japan was also initially victorious over an underdeveloped China in World War II but eventually lost when the United States entered the war (1941–1945).

Although the tumultuous events of the 20th century brought ever-increasing globalization of culture and

3. Russia, of course, spans the continents of Europe and Asia.

economies, Japanese artists have continued to work in ways inherited from the past. As in China, high-quality ceramic manufacture has always been a feature of artistic production, and the tradition continues with contemporary artists adapting new styles and techniques to old art forms (**Fig. 19.24**).

Contemporary Japanese Arts

The Japanese director Akira Kurosawa (1910–1998) made films that many movie critics consider to be among the greatest ever produced. Influenced by American movies, in particular those of John Ford, Kurosawa brought his own insights to bear on a wide range of human situations and historical periods. The first of his films to catch international attention was *Rashomon* (1950). The film is based on two stories by the father of the Japanese short story, Ryunosuke Akutagawa (1892–1927). It is set in 12th-century Kyoto. In the opening scene three characters—a commoner, a woodcutter, and a Shinto priest—seek shelter from a rainstorm under the ruins of the once magnificent Rashomon gatehouse. The priest and woodcutter talk about the killing of a samurai and the rape of his wife by a bandit in the nearby woods. The priest is devastated by the self-serving ways in which the survivors tell their versions of the crime at the police court. Viewers see each story enacted on the screen, differentiated by tempo, editing, and camera shots. In one story, the bandit is honorable. In another, the wife is

◄ 19.24 Hamada Shoji, square bottle, 1965. Stoneware, 9¼″ × 4″ (23.5 × 10 cm). Mingei International Museum, San Diego, California. The Japanese have retained their love for traditional ceramics. This bottle is made of stoneware, rather than the finer porcelain of Chinese pottery, and its simple, apparently casual decoration emphasizes its relationship to folk art and craft.

victimized. Each version blames a different individual for the outcome. Who is telling the truth? We cannot know. Indeed, the film suggests that there may not *be* one completely true story of events, such as wars. (It is said that the first casualty of war is truth.)

Rashomon was followed by *Seven Samurai* (1954), which re-creates the lives—and deaths—of Japanese feudal warriors and has been listed as one of the 10 greatest films of all time.

In the visual arts, one of the effects of globalization is **hybridity**, or the mixing of the traditions of different cultures to create new blends and new connections. There is two-way hybridity with Kurosawa's films: *Seven Samurai* was remade as an American film, *The Magnificent Seven*. One critic writing of Kurosawa referred to the "Shakespearean cast of his genius"; two of his most dramatic films are based on works by Shakespeare: *Throne of Blood* (1957), based on *Macbeth*, and *Ran* (1985), Kurosawa's version of *King Lear*. The latter is a movie of immense power, profoundly pessimistic in tone.

Highly popular in the United States was Ishiro Honda and Terry O. Morse's *Godzilla: King of the Monsters!* (**Fig 19.25**). Godzilla began its life as a remake of Hollywood's *The Beast*

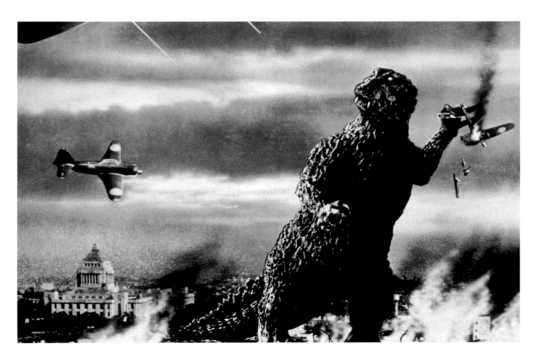

◄ 19.25 Film still from *Godzilla*, 1954. Godzilla is awakened in the depths of the Pacific by hydrogen bomb tests. Is he the monster unleashed by humankind?

Bushido: The Eight Virtues of the Samurai

Sixteenth-century Japan was wracked by civil war as warlords fought for control. Each warlord had an army drawn from the samurai caste. Samurai owed their loyalty to their warlords, but if their lord was killed or defeated, they were jobless. Unemployed samurai became wandering **ronin**, loners with the romantic aura of the gunfighter in an early Clint Eastwood Western.

We find seven such ronin in Akira Kurosawa's *Seven Samurai* (1954). They are swords for hire who defend a group of farmers against outlaws (**Fig. 19.26**). Many ronin became outlaws themselves in feudal Japan, but one of the seven samurai in the film, Kambei, personifies the **Bushido** code—the way of zthe warrior—in its purest form.

Bushido was not about stubbornly fighting to the death or committing suicide if one's lord was killed. Rather, the samurai were expected to evince the following traits.

Rectitude or justice: Making decisions on how to behave based on reason—striking the enemy when the time is right; dying when it is the proper thing to do.

Courage: Showing courage in the cause of righteousness.

Benevolence or mercy: Showing love, generosity, sympathy, and pity. Confucius lauded benevolence as the greatest virtue of the ruler.

Politeness: Showing courtesy and good manners, not for fear of offending but to express regard for the feelings of others.

Honesty and sincerity: Being thrifty, exercising abstinence.

Honor: Keeping a sense of personal dignity and worth; fearing disgrace but being able to overlook minor provocations.

Loyalty: Remaining loyal to those to whom one is indebted, as the seven samurai were expected to be to their lords and then to the farmers who employed them.

Character and self-control: Having a solid standard of what is right and wrong, and living up to it.

Rectitude, courage, and benevolence are shown by Kambei in the first scene of the film. A samurai's topknot is an emblem of Bushido, and losing it is considered a disgrace. However, Kambei maintains his sense of personal dignity, his loyalty, and his character when he shaves off his topknot to impersonate a priest so that he can rescue a kidnapped child.

▼ **19.26 Film still from Akira Kurosawa's** *Seven Samurai*, **1954.** Toshiro Mifune as the temperamental Kikuchiyo, who ultimately proves his worth defending villagers in the film.

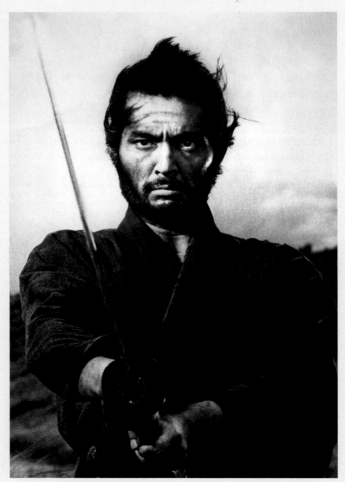

▲ **19.27** Takashi Murakami, *Tan Tan Bo*, 2001. Acrylic on canvas mounted on board, 141³/₄″ × 212⁵/₈″ × 212⁵/₈″ (360 × 540 × 6.7 cm). Private collection. © 2001 Takashi Murakami/Kaikai Kiki Co., Ltd.

from 20,000 Fathoms (1953) and was then recut to include the American actor Raymond Burr. Despite this humble origin, it captured the interest of viewers around the world, spawning 27 sequels, comic-book art, and tie-in products such as stuffed Godzillas and video games. *Godzilla* tells the story of a 400-foot prehistoric monster awakened from the depths of the Pacific by hydrogen-bomb tests. Provoked by depth charges, Godzilla uses his fiery breath to turn Tokyo to toast. Eventually he is killed by another weapon of mass destruction, one that destroys the oxygen in the water around him.

By today's standards *Godzilla*'s special effects are primitive, but the strength of this film lies in its portrayal of Japanese fears about weapons of mass destruction following World War II and in its personalization of the monster. Although humans must be saved from Godzilla, Godzilla is also a victim of the nuclear genie that humans have uncorked. The atomic devastation of Hiroshima and Nagasaki horrified the Japanese not only because of the immediate loss of

life but also because of the disfigurement of survivors and lingering radiation sickness. Was *Godzilla* a not-so-subtle protest film?

Another example of the ways in which globalization has led to an intermingling of the world's cultural icons is found in the work of Takashi Murakami (b. 1962), a creator of **Pop art** who draws on consumer culture for his imagery. Murakami is also vigorously self-promotional, exhibiting his paintings and sculpture at major museums around the world while creating mass-market products ranging from T-shirts and key chains to mouse pads and Louis Vuitton handbags.

As a boy, Murakami fantasized about illustrating Japanese graphic novels called manga, which are also hybrids. Though illustrated manuscripts have as long and distinguished a history in Japanese art as they do in Western art, their modern form is heavily influenced by American comic books, which infiltrated Japanese culture soon after the end

of World War II, when Japan was occupied by the United States and U.S. culture became popular. As a student, Murakami experimented with large-eyed cartoon figures in the popular **anime** style (a style of animation developed in Japan), but he was also trained in classical Japanese painting techniques. Consequently, his work often aims to reconcile "high art" and "low culture." *Tan Tan Bo* (**Fig. 19.27**) is filled with cartoonlike imagery rendered in simple, dark outlines filled in with bright colors. The overall shape may resemble a fierce Mickey Mouse, but the artist has dubbed his signature character Mr. DOB. Murakami has created a multimedia sensation of Mr. DOB in such objects as lithographs and inflatable balloons. Like some contemporary American Pop artists, he makes no distinction between art and merchandise.

The nations of India, China, and Japan have been insulated and isolated from each other by mountain ranges and seas, and they have connected with one another with trade, with religions that have crossed natural boundaries, and with styles in writing and the visual arts. They have also warred with one another from time to time, and each of them has warred with the West. Today mass media and electronic forms of communication such as the Internet are intertwining the cultures of India, China, and Japan with those of the West ever more deeply. It is a two-way street. Cultural works in many, perhaps most, areas of the world are becoming increasingly hybrid. The American artist Robert Mothwerwell said, "Every intelligent painter carries the whole culture of modern painting in his head." It is likely that no major writer or artist anywhere in the world now works without intimate knowledge of what is happening elsewhere on the globe.

GLOSSARY *(CONTINUED ON P. 750)*

(CONTINUED ON P. 750)

Anime *(p.749)* A Japanese style of animation characterized by colorful graphics and adult themes.

Bushido *(p. 747)* The behavioral or moral code of the samurai; a Japanese counterpart to chivalry.

Calligraphy *(p. 721)* A stylized form of elegant handwriting.

China *(p. 731)* A translucent ceramic material; porcelain ware.

Daimyo *(p. 741)* Japanese warlords.

Glaze *(p. 731)* A coating of transparent or colored material applied to the surface of a ceramic piece before it is fired in a kiln.

Haiku *(p. 741)* Three-lined Japanese verse, with a syllable structure of 5-7-5, which usually juxtaposes images, often drawn from nature, to achieve deeper meaning.

Haniwa *(p. 740)* Hollow ceramic figures modeled from slabs of clay that Japanese people placed around burial plots in the fifth and sixth centuries CE.

Huaben *(p. 729)* Chinese short stories of the Ming dynasty.

Hybridity *(p. 746)* In the arts, the mixing of the traditions of different cultures to create new blends and new connections.

Kabuki *(p. 745)* A type of drama begun during the Edo period of Japan that was based on real-life events.

Lacquer *(p. 731)* A hard, durable finish for furniture and other objects that is created from the sap of the sumac tree.

Mandala *(p. 742)* A religious symbol, often round, that represents the universe.

Minaret *(p. 720)* A tall, slender tower attached to a mosque, from which a *muezzin* or crier summons people to prayer.

Monumental style *(p. 726)* A style of painting during the Song dynasty that lauded the "perfection" of Song rule through symbols such as unreachable mountain peaks.

Mughal *(p. 719)* A Muslim dynasty in India, founded by the Afghan chieftain Babur in the 16th century.

Nirvana *(p. 727)* A state characterized by the absence of suffering.

Noh *(p. 740)* A type of Japanese drama in which actors wear wooden masks.

GLOSSARY
(CONTINUED FROM P. 749)

Overglaze (p. 735) The outer layer or **glaze** on a ceramic piece; a decoration applied over a glaze.

Pillow book (p. 741) Generally, a book of observations and musings, which reveal a period in a person's life.

Pop art (p. 748) An art style originating in the 1960s that uses ("appropriates") commercial and popular images and themes as its subject matter.

Rajput (p. 719) A member of a Hindu people claiming descent from the warrior caste during the Indian Heroic Age.

Ronin (p. 747) Unemployed samurai, who roamed about seeking employment.

Samurai (p. 741). Japanese professional warriors in medieval times.

Samurai-dokoro (p. 741) The official in feudal Japan who led legal and military affairs.

Satyagraha (p. 722) Nonviolent civil disobedience.

Shintoism (p. 740) The native Japanese religion, which teaches of many beneficent gods and love of nature.

Shogun (p. 741) Another term for the **samurai-dokoro**.

Underglaze (p. 735) A decoration applied to the surface of a ceramic piece before it is glazed.

Urdu (p. 720) The literary language of Pakistan; similar to Hindi when spoken, but written in the Arabic alphabet and influenced by Persian.

Value (p. 727) As an element of art, the relative lightness or darkness of a color.

THE BIG PICTURE INDIA, CHINA, AND

INDIA

Language and Literature

- Babur (1483–1530), the founder of the Mughal Empire, wrote his autobiography—the *Baburnama*—in Eastern Turkish.
- Humayun (1507–1556), Babur's son and successor, wrote poetry in Persian.
- The Mughal emperor Akbar (1542–1605), Babur's grandson, commissioned scholars to provide a common language for India; they created Urdu, which combines Hindi with Arabic and Persian.
- Calligraphy came into use during the Mughal Empire.
- The novelist and short-story writer Munshi Premchand (1880–1936), wrote in Hindi and Urdu to describe the lives of India's poorest villagers to the outside world.
- Rabindranath Tagore (1861–1941) won the Nobel Prize for Literature in 1913 for writing that stresses that true authority derives from basic humanity.

Art, Architecture, and Music

- Mughal architects and painters devised a style that combines Hindu tradition with Muslim elements in the early 17th century.
- The Taj Mahal, combining the dome, the pointed arch, and the minaret, was built at Agra between 1632 and 1649.
- Mughal painting consisted mainly of manuscript illuminations and miniatures, depicting courtly life, portraits, and historic events.
- Rabindranath Tagore (1861–1941) painted and composed music, including India's first national anthem.
- Indian director Satyajit Ray's (1921–1992) films, including the Apu Trilogy, portrayed the lives of ordinary people to provide a general impression of their culture.
- Subodh Gupta (b. 1964) creates ready-made works of art.

Philosophy and Religion

- The monotheistic religion of Sikhism was founded in the 15th century in the Punjab region.
- Babur, an Afghan chieftain, brought the Muslim religion into northern India in 1526.
- The poet Tulsidas (ca. 1532–1623) produced the *Ramcaritmanas* (*The Holy Lake of the Acts of Rama*), which combines monotheism with traditional Hindu polytheism.
- The Mughal emperor Aurangzeb (1618–1707) destroyed Hindu temples and compelled Hindus serving in the imperial bureaucracy to convert to Islam.
- Gandhi founded the movement of satyagraha—nonviolent civil resistance—in 1906.

JAPAN: FROM THE MEDIEVAL TO THE MODERN WORLD

CHINA

Language and Literature

- During the Ming dynasty, the most popular new literary genres were the novel and short story.
- Professional traveling tellers of short stories inserted verses into prose narratives, included past audience reactions, and employed street language.
- The anonymous and openly erotic novel *Jinpingmei* (*The Plum in the Golden Vase*) appeared late in the Ming dynasty; it is noted as a landmark in the history of narrative prose.
- The 16th-century novel *Monkey,* by Wu Cheng'en, used old supernatural legends to tell the tale of a Buddhist priest's pilgrimage to India.
- Sun Zhu compiled 300 poems from the Tang period during the Qing dynasty.

Art, Architecture, and Music

- Landscape painting reached new heights with the Monumental style during the Song dynasty.
- Chinese paintings of the Ming and Qing dynasties frequently included calligraphy.
- Ming potters produced vases of exceptional quality, including decorated porcelain, which became known as *china*.
- The imperial capital of Beijing, first constructed by the Mongols in the 13th century, was reconstructed during the Ming dynasty, including the emperor's residence, known as the Forbidden City.
- The Qing dynasty continued the development of fine pottery through developments in glazing.
- Lacquerware developed during the Ming and Qing dynasties.
- Qing painters experimented with new approaches such as the bold repetition of strokes.
- Modern Chinese visual arts frequently comment on Communist rule and globalization.
- Shanghai's Pudong area has a multitude of skyscrapers of various types of designs, where the new Shanghai Tower is rising to 2,073 feet.

Philosophy and Religion

- Confucianism served as the basis for all aspects of life under the Ming dynasty (1368–1644).
- Daoism preached that people should follow their own nature, not distinguishing between good and bad. Daoism taught passivity and resignation, particularly avoiding war because "every victory is a funeral rite."
- Buddhism was introduced into China during the Han Dynasty. Following the collapse of the Han rulers, Buddhist monasteries grew in wealth and power.

JAPAN

Language and Literature

- Ca. 400 CE, a Japanese community imported Korean scribes because Japan did not yet have a system of writing of its own.
- The Japanese developed their own writing system, partly based on the Chinese, before 1185.
- The Japanese developed the Noh play ca. 1185.
- *The Tale of Genji* was the best-known literary work of 11th century Japan.
- Sei Shonagon kept a noted pillow book early in the 11th century.
- Edo writers made major contributions to poetry, fiction, and drama, as shown in the 17th-century haiku of Basho.
- Ihara Saikaku wrote popular novels in the 17th century.

Art, Architecture, and Music

- Ceramic figures and vessels date to the fourth millennium BCE.
- In the fifth and sixth centuries CE the Japanese produced hollow ceramic figures—haniwa—from slabs of clay and placed them around burial plots.
- During the feudal period, the Japanese created highly original landscapes, portraits, and narrative scrolls.
- Woodblock, a printmaking method, was developed during the Edo period.
- The Japanese director Akira Kurosawa made *Rashomon* in 1950; *Seven Samurai* (the basis for the American *The Magnificent Seven*) in 1954; *Throne of Blood*, based on *Macbeth*, in 1957; and *Ran*, based on *King Lear*, in 1985
- Ishiro Honda and Terry O. Morse produced *Godzilla: King of the Monsters!* in 1956.
- Takashi Murakami (b. 1962) became Japan's best-known Pop artist.

Philosophy and Religion

- Buddhism was established as the state religion of Japan by the early seventh century.
- Shintoism, the native religion of Japan, developed in the seventh and eighth centuries.

Africa

PREVIEW

Everything we are began in Africa. The first human species—hominids—trod the African plains and scaled African trees several million years ago. Our species emerged there some 150,000 to 200,000 years ago, and the earliest bones we know of have been unearthed in Africa. From that cradle, we began to spread to the four corners of the earth. We moved northeast into what is now the Arabian Peninsula, still farther north into Europe, eastward into Asia, down into Oceania and Australia, and across a natural land bridge—now submerged—from present-day Siberia to the Americas. Human migrations over thousands of miles go back more than 50 millennia.

As we adapted to our new environments over untold generations, skin color and other features changed. In Africa, our dark black skin helped block out the searing rays of the sun. In Europe our skin paled to maximize our synthesis of vitamin D in lands where the sun was less intense. For thousands of years, those of us who stayed in Africa were relatively untouched by the ways and cultures of our migrant descendants—until they came back to the continent.

Greeks and Romans returned more than 2,000 years ago, establishing settlements along the northern coast of Africa. Cleopatra, who reigned as the last Egyptian pharaoh, was of Macedonian Greek descent. Arabs returned from the Middle East in the seventh century CE, introducing Islam to northern parts of Africa. Western and northern Europeans returned to Africa about 1,000 years later as colonial powers, bringing Christianity to many areas of the continent.

Africa is vast. Its land area is three times that of the continental United States and Alaska. Its climate and landforms are wildly diverse—from moderate Mediterranean conditions to humid rain forests, from grasslands to desert—and the cultures of African peoples that developed in these distinct zones were equally diverse. More than 2,000 ethnic groups have been identified, and over 1,000 languages are spoken in sub-Saharan Africa alone. Unlike in China or India, Africa's peoples never united under a single government; Western colonization, for the most part, determined the geographical and political boundaries of modern Africa. The cultural development of Africa is marked, then, by distinct indigenous traditions, sometimes blended with influences brought back from those humans who essentially made a round trip.

◀ **20.1 Neolithic arrowhead, ca. 4000 BCE. Sahara Desert, Africa.** This arrowhead is about 6000 years old, yet humans had existed for some 150,000 to 200,000 years before it was made and shot into the flesh of some unfortunate animal. The ancestors of us all evolved in Africa and only spread out from that continent in the past 50,000 to 60,000 years.

SOCIETY AND RELIGION IN EARLY AFRICA

The continent of Africa has been described in terms of two broad regions: North Africa (the territories along the Mediterranean Sea that are considered part of the Arab world and are now Islamic) and sub-Saharan Africa (see **Map 20.1**). The latter region consists of the area—or countries—south of the broad expanse of the Sahara Desert; the religion in sub-Saharan Africa is now primarily Christian. Given the topography, cultural diversity and separation come as no surprise, although signs of a common cultural inheritance are strong. Africa's many languages are related to only four or five basic tongues, and traditional religion is tied into the beliefs and practices of linguistic cultural groups. Common to most are ancestor worship, deification of rulers, respect for nature—the environment and living creatures—and worship of nature deities. **Animism**, the belief that the world is governed by the workings of nature, underscores most traditional African religion, and ritual and ceremony often pertain to managing illness, warding off death, and controlling natural disasters.

In the absence of written texts, practices and beliefs were memorized and passed on by word of mouth to younger generations by their elders, who were revered. A tradition of ancestor worship emerged that placed emphasis on the family and, more broadly, on the village community. Within the community, certain extended families, or kinship groups, specialized in functions such as hunting, farming, and trade. Social structure and religious beliefs reinforced one another and allowed for the slow evolution of increasingly powerful kingdoms.

Writing developed in Africa later than in Europe and Asia, and thus we have no consistent historic records prior to the 19th century. To reconstruct the earliest civilizations on African soil, we must rely on archaeological evidence and written accounts by the first outsiders to visit those kingdoms. The general picture is of a number of powerful and highly developed states.

THREE EARLY AFRICAN KINGDOMS: GHANA, BENIN, AND ZIMBABWE

The kingdoms of Ghana, Benin, and Zimbabwe flourished long before the Europeans entered Africa's interior. From the 16th century, with the beginning of the age of European colonization and the slave trade that accompanied it, Europeans began to settle in coastal regions, which served as bases for exploring and exploiting Africa's extraordinary natural resources. Muslim missionaries had carried their religion southward across the Sahara Desert centuries earlier. The arrival of the Europeans brought Christianity, and under the influence of both religions, traditional patterns of ritual and ancestor worship began to die out.

Africa

	1300 CE	1800 CE	1900 CE
BCE \| CE			

Modern humans emerge in Africa ca. 200,000–150,000 BCE	Beginnings of Ghana ca. 300 CE	Kingdom of Benin flourishes during the 14th–16th centuries	Prominence of Benin declines due to slave trade	Slave narratives based on interviews with former slaves are produced in the U.S. in the 1930s
Modern humans disperse from Africa to populate the earth ca. 60,000–50,000 BCE	Muslim missionaries bring Islam to Ghana in 8th century	Europeans settle in coastal religions in the 16th century	The European "Scramble for Africa" partitions Africa into regions ruled by European powers	Beginning of decolonization of Africa by European powers after 1945
North Africa is colonized by ancient Greeks, Phoenicians, and Romans (r. 6th century BCE–1st century CE)	Muslims begin to colonize North Africa	Slave trade by Europeans begins in the 16th century	Spirituals and quilting develop in the United States	Apartheid instituted in South Africa in 1948
	Arabs begin slave trade in Africa ca. 10th century			Apartheid ends in 1994
	Ghana becomes world's largest producer of gold			
	Ghana is defeated by Muslim Berbers ca. 1075			
	Huge stone buildings are erected in kingdom of Zimbabwe			

The Kingdom of Ghana

One of the earliest states to develop was Ghana, in West Africa. Caravan routes crossing the Sahara linked the region to Mediterranean cities, first by horse and ox and then, after 300 CE, by camel. Shortly after, the city of Ghana on the upper Niger River began to export gold, animal hides, pepper, ivory, and slaves in exchange for salt, cloth, pottery, and other manufactured goods. Ghana grew increasingly wealthy; at the height of its success (around 1000 CE), it was probably the world's largest gold producer. According to an Arab traveler who visited Ghana in 1065, the army numbered 200,000 men, of whom 40,000 were armed with bows and arrows. This formidable fighting force was defeated a decade later by a nomadic army of Muslim Berbers. The Berbers moved north after a few years to attack Morocco, but Ghana never fully recovered (in part because the gold mines were beginning to peter out), and by 1300 the great kingdom was only a memory.

Traders from North Africa in the eighth century CE brought Islam to Ghana, which, because of its wealth, became a vibrant center of Islamic culture. What emerged in terms of religious practice and art was a blend of both traditions. The plan of the Great Mosque at Djenné in present-day Mali (**Fig. 20.2**)—which was part of the Ghana Empire—like those of all early mosques, is based on the model of Muhammad's home in Medina. It has a walled courtyard in front of a wall that faces Mecca. Unlike the stone mosques of the

∨ **MAP 20.1** Africa, Early Twenty-First Century

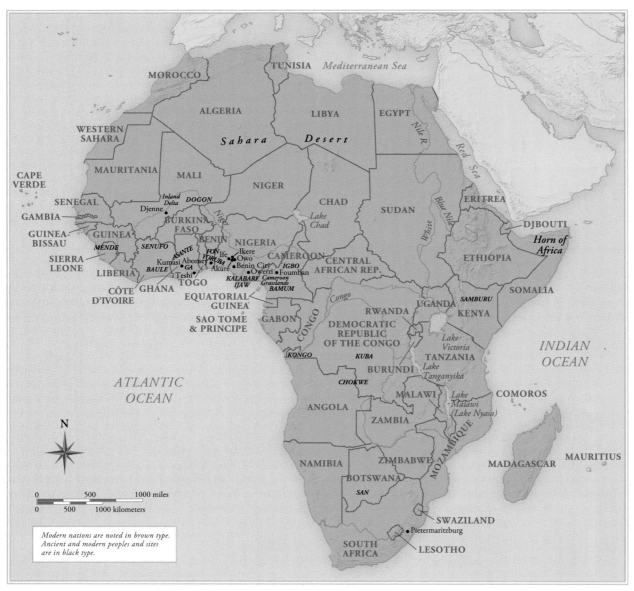

∧ 20.2 The Great Mosque, 14th century CE. Djenné, Mali. The mosque's design is based on that of Muhammad's home in Medina, but unlike mosques throughout the Arab world, it is constructed of puddled clay, adobe brick, and wooden poles.

Middle East, however, the mosque at Djenné is built of sun-dried bricks and puddled clay. Wooden poles jutting through the clay serve as a kind of scaffold support for workers who replaster the structure yearly to prevent complete erosion of the clay. They also provide a form of exterior ornamentation, an aspect of the highly decorative aesthetic of Islamic art and architecture.

The Kingdom of Benin

During the time of Ghana's slow decline, the kingdom of Benin was beginning to grow in what is now Nigeria (ancient Benin should not be confused with the modern African state of Benin). The period around 1000 CE saw the introduction of new food crops from East Asia and more sophisticated methods of metalworking, making larger communities possible. The kingdom of Benin flourished between the 14th and 16th centuries, trading widely in pepper and ivory. Its eventual decline was caused by the

massive deportation of its male population in the 19th century by Arab and European slave traders. The kingdom was ruled by a hereditary male absolute monarch with the title of *oba*, who had at his disposal a powerful army and an effective central government.

BENINESE CULTURE The oba's central palace was adorned with a series of bronze plaques showing the life of the court and military exploits. Among the sculptures was a small portrait of a royal woman with tribal markings and a conical headdress, which offers insight into life at the Beninese court. She is the Queen Mother Idia, to whose mystical powers her son, the oba Esigie, attributed his success in warfare. In gratitude, he allowed her to have her own palace and sacred altars, and this head was made to decorate one of the altars (**Fig. 20.3**). At the same time, the beauty of line and the balance between decoration and naturalism give some idea of how much we have lost with the disappearance of so much African art.

Another bronze from Benin throws light on religious practices at court (**Fig. 20.4**). It comes on an *ikegobo*, or

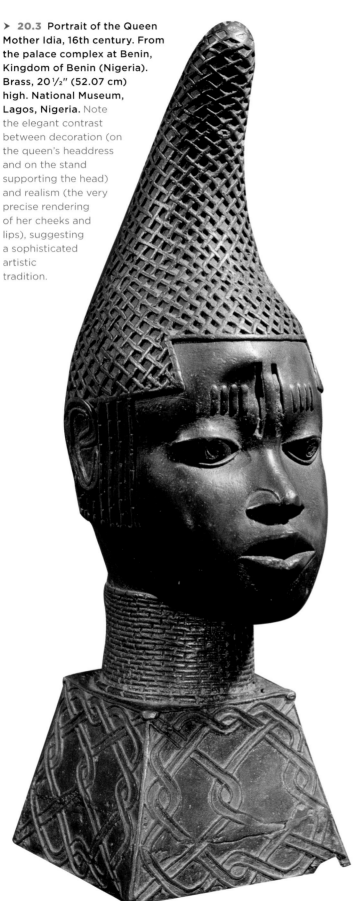

➤ **20.3** Portrait of the Queen Mother Idia, 16th century. From the palace complex at Benin, Kingdom of Benin (Nigeria). Brass, 20½″ (52.07 cm) high. National Museum, Lagos, Nigeria. Note the elegant contrast between decoration (on the queen's headdress and on the stand supporting the head) and realism (the very precise rendering of her cheeks and lips), suggesting a sophisticated artistic tradition.

royal shrine, at which the oba would have offered up sacrifices either for favors received from the gods or in the hope of receiving future ones. The oba appears both on the side and on the lid, again dominating the accompanying attendants. On the lid, two meek leopards crouch humbly at his feet. Even the creatures of the wild acknowledge the supreme power of their master, while other animals range around the base.

The Kingdom of Zimbabwe

The greatest ancient kingdom in South Africa was Zimbabwe. Bushmen's paintings and tools show that the earliest people to occupy the site settled there in the Stone Age. Around 1300, the rulers ordered the erection of huge stone buildings

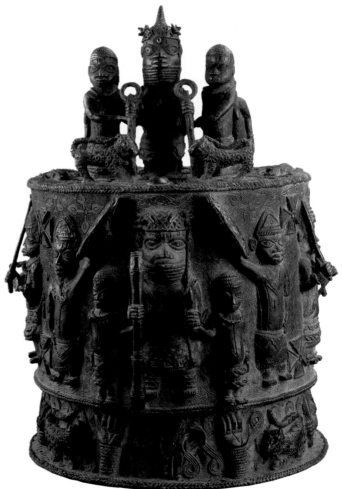

▼ **20.4** Altar of the Hand, late 19th century. Kingdom of Benin (Nigeria). Bronze, 17½″ (44.5 cm) high. British Museum, London, United Kingdom. Note the large size of the oba's head, both on the main body of the altar and on the lid: one of the standard terms used to praise the ruler was "great head," symbol of his power.

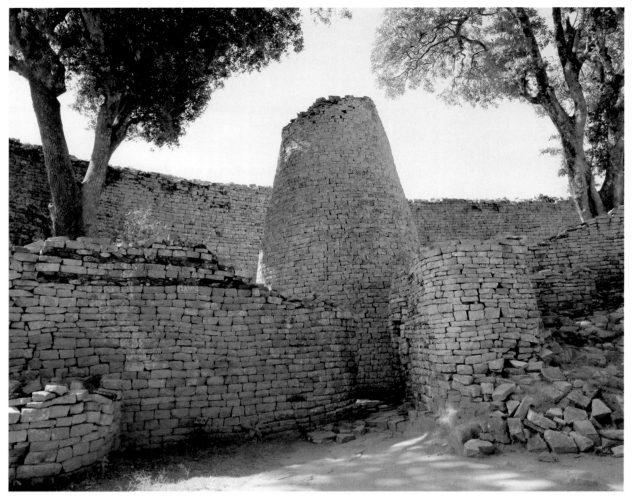

∧ 20.5 The ancient walls and one of the conical towers showing the inner passage of the Great Enclosure at Great Zimbabwe, 15th century. Zimbabwe. Built of granite during the African Iron Age, the surrounding walls probably enclosed a royal residence with private living quarters and an open area for ceremonial assemblies. Some of the larger towers may have been used to store grain.

surrounded by massive walls; the complex is now known as Great Zimbabwe (**Fig. 20.5**). Finds in the ruins include beads and pottery from the Near East, Persia, and even China, suggesting that the complex served as the base for a trading empire that must have been active well before the arrival of the Europeans, some two centuries later.

Attempts to understand the function of Great Zimbabwe's constructions are largely based on accounts of Portuguese traders who visited the site after its original inhabitants had abandoned it. The main building seems to have been a royal residence, with other structures perhaps for nobles, and a great open ceremonial court. It has been calculated that at the height of its power, the complex may have served as the center for a population of some 18,000 people, with the ruling class living inside and the remainder in less permanent structures on the surrounding land.

Portuguese documents describe Great Zimbabwe as "the capital of the god-kings called Monomotapa." In the 16th

century, Europeans used this name for two Shona rulers: Mutota and Matope. The original inhabitants may well have been ancestors of the Shona people, who are now among the groups living in modern Zimbabwe. Part of Shona beliefs is the idea that ancestral spirits take the form of birds, often eagles. In one of the enclosed structures, perhaps an ancestral shrine, archaeologists discovered a soapstone carving of an eagle that may represent one of these ancestral spirits, which were believed to carry messages between the human and divine worlds (**Fig. 20.6**).

SLAVERY AND COLONIALISM

Africa has been beset by human-made disasters from within and without. Some wounds were self-inflicted: Africa, like

other continents, saw its share of wars and the coercion of captives and their descendants into lives of servitude and **slavery**. Colonization by European powers may have brought with it some benefits, such as advanced technology and medicine, but these were outweighed by its destructive effect on African life and culture. But discussing the pros and cons of imperialism and **colonialism**, according to human-rights activist Arundhati Roy, "is a bit like debating the pros and cons of rape." It was physically brutal and psychologically humiliating.

Slavery

One of the worst tragedies to befall Africans was the transatlantic slave trade. Slavery was common in ancient Africa, as in many other parts of the world—including ancient Greece and ancient Rome—but a distinction must be made between slavery practices such as existed in these ancient cultures and the slave trade that affected Africa from the 16th through the early 19th century. In some areas of Africa, slaves were more like **indentured servants**, who were not necessarily considered property, worked the fields, were paid wages, and could obtain land of their own. Some slaves were able to buy their freedom and advance socially. In Greece and Rome, the slave class mainly comprised enemy soldiers and vanquished citizens taken back home by the victorious generals as plunder. Slaves could be bought, sold, or traded, but had certain rights and the potential for upward social mobility.

The slave trade in Africa was connected to European colonization. As new lands were explored, they were also exploited for their commodities through peaceful trade or outright seizure. This included human beings who were swept up in the system of the so-called triangular trade. The first leg began in Europe; factory goods including guns and ammunition were moved to Africa and then bartered or sold for slaves who had been captured by African rulers. The slaves were then shipped across the Atlantic Ocean (hence the term *transatlantic slave trade*) to the Caribbean islands and the Americas to work on sugar, tobacco, and cotton plantations. The commodities produced by the plantations were then shipped to Europe, sometimes on the very same vessels on which the slaves had arrived.

African slave trading became a business for foreigners, particularly Arabs (beginning in the 10th century CE) and Europeans (beginning with the Portuguese in the 15th century CE). African groups including the Imbangala of present-day Angola and the Nyamwezi of what is now

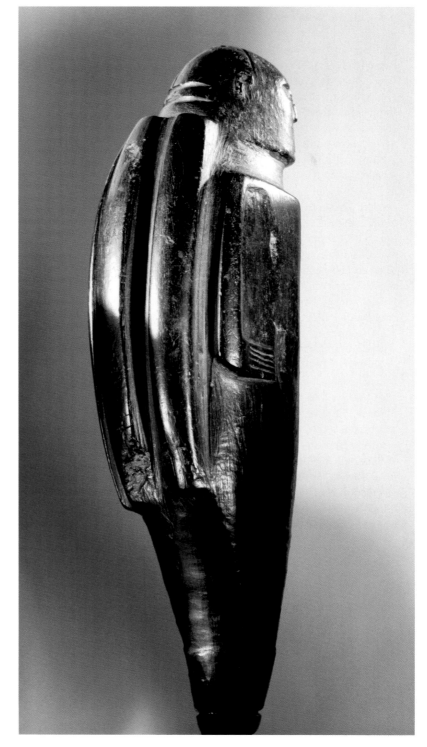

➤ **20.6** Sculpture of a bird, ca. 1200–1400. Great Zimbabwe, Zimbabwe. Soapstone (steatite) carving. **Private collection.** Thought to represent a mythical eagle that carries messages from human beings to the gods, the piece is remarkable for its elegant simplicity of form and beauty of line.

VALUES ||

From the Autobiography of Wangari Muta Maathai*

Wangari Muta Maathai (1940–2011), nicknamed "Forest Queen," was born in Kenya and spent her adult life as an environmental and political activist. She championed the values of spirituality, tradition and continuity, community, family, agrarian life, and environmentalism. In 1977 she began the Green Belt Movement, which involves (and thereby empowers) rural women who plant millions of indigenous trees—fig, blue gum, acacia—to replace those that were destroyed during the colonial period. So far over 20 million trees have been planted. Kenya is thus one of the few African countries to make strides against the problem of deforestation.

Most societies in traditional Africa have been, and remain, patriarchal, and women's rights are limited. Yet Maathai, against overwhelming odds, earned a doctorate, became a university professor, and served as an academic department chair—the first Kenyan woman to do so. Her husband, a businessman and politician, was ridiculed for his highly educated and influential wife, a woman "beyond his control." Social pressure may have led him to divorce her, but it did not deter Maathai from her mission to connect women's issues with environmental concerns. In the past, Africa was oppressed by colonial powers; today, Maathai asserted, the oppressors are the African elite, who are "no better than the world which colonized us." The political elite hit back; the government restricted her travel and she was beaten and teargassed by police. Nonetheless, her environmental work won national and international acclaim. Al Gore praised her accomplishments in his book *Earth in the Balance*, and in 2002 Maathai was elected to Kenya's parliament, serving as assistant minister for the environment and wildlife. In 2004 she was awarded the Nobel Peace Prize.

The following extract from her autobiography recounts the lush, rural circumstances of her birth, and is suggestive of the development of her values.

Beginnings

I was born the third of six children, and the first girl after two sons, on April 1, 1940, in the small village of Ihithe in the central highlands of what was then British Kenya. My grandparents and parents were also born in this region near the provincial capital of Nyeri, in the foothills of the Aberdare Mountain Range. To the north, jutting into the sky, is Mount Kenya.

Two weeks into *mbura ys njahi*, the season of the long rains, my mother delivered me at home in a traditional mud-walled house with no electricity or running water. She was assisted by a local midwife as well as women family members and friends. My parents were peasant farmers, members of the Kikuyu community, one of 42 ethnic groups in Kenya and then, as now, the most populous. They lived from the soil and also kept cattle, goats, and sheep.

At the time of my birth, the land around Ihithe was still lush, green, and fertile. The seasons were so regular that you could almost predict that the long, monsoon rains would start falling in mid-March. In July you knew it would be so foggy you would not be able to see ten feet in front of you, and so cold in the morning that the grass would be silvery-white with frost. In Kikuyu, July is known as *mworia nyoni*, the month when birds rot, because birds would freeze to death and fall from the trees.

We lived in a land abundant with shrubs, creepers, ferns, and trees, like the *mitundu mikeu*,

Tanzania were complicit in slave trading, waging war on other African peoples and states and exporting captives as slaves. In turn, Arabian and European slave traders supported the African rulers who were in league with them. The first enslaved Africans were brought to Portuguese and Spanish colonies in the Americas in the early 16th century,

primarily by Portuguese traders. In the 17th century, the Dutch imported slaves to the southern American colonies, where most worked in agriculture and domestic servitude. Half of all enslaved Africans were traded during the 18th century, when the system operated at its peak and the countries involved included the United Kingdom, France,

and *migumo*, some of which produced berries and nuts. Because rain fell regularly and reliably, clean drinking water was everywhere. There were large well-watered fields of maize, beans, wheat, and vegetables. Hunger was virtually unknown. The soil was rich, dark red-brown, and moist.

When a baby joined the community, a beautiful and practical ritual followed that introduced the infant to the land of the ancestors and conserved a world of plenty and good that came from that soil. Shortly after the child was born, a few of the women attending the birth would go to their farms and harvest a bunch of bananas, full, green, and whole. If any of the bananas had ripened and birds had eaten them, the women would have to find another full bunch. The fullness expressed wellness and wholeness, qualities the community valued. Along with the bananas, the women would bring to the new mother's house sweet potatoes from her and their gardens and blue-purple sugarcane (*kigwa kia nyanmuiru*). No ordinary sugarcane would do.

In anticipation of the birth, the expectant mother would fatten a lamb that slept and ate inside her home. While the women gathered the ritual foods, the child's father would sacrifice the lamb and roast a piece of the flesh. The bananas and the potatoes would also be roasted and along with the meat and the raw sugarcane given to the new mother. She would chew small pieces of each in turn and then put some of the juice in the baby's tiny mouth. This would have been my first meal. Even before breast milk, I would have swallowed the juice of green bananas, blue-purple sugarcane, sweet potatoes, and a fattened lamb, all fruits of the local land. I am as much a child of my native soil as I am of my father,

Muta Njugi, and my mother, Wanjiru Kibicho, who was more familiarly known by her Christian name, Lydia. Following the Kikuyu tradition, my parents named me for my father's mother, Wangari, an old Kikuyu name.

According to the Kikuyu myth of origin, God created the primordial parents, **Gikuyu**** and **Mumbi**, and from Mount Kenya showed them the land on which they were to settle: west from Mount Kenya to the Aberdares, on to Ngong Hills and Kilimambogo, then north to Garbatula. Together, Gikuyu and Mumbi had ten daughters—Wanjiru, Wambui, Wangari, Wanjiku, Wangui, Wangeci, Wanjeri, Nyambura, Wairimu, and Wamuyu—but they had no sons. The legend goes that, when the time came for the daughters to marry, Gikuyu prayed to God under a holy fig tree, *mugumo*, as was his tradition, to send him sons-in-law. God told him to instruct nine of his daughters—the tenth was too young to be married—to go into the forest and to each cut a stick as long as she was tall. When the daughters returned, Gikuyu took the sticks and with them built an altar under the *mugumo* tree, on which he sacrificed a lamb. As the fire was consuming the lamb's body, nine men appeared and walked out of the flames.

* From *Unbowed: A Memoir* by Wangari Muta Maathai, copyright © 2006 by Wangari Muta Maathai. Used by permission of Alfred A. Knopf, a division of Random House, Inc. Any third party use of this material, outside of this publication, is prohibited. Interested parties must apply directly to Random House, Inc. for permission. Published in the UK by William Heinemann and reprinted by permission of The Random House Group Limited.

** Another spelling of Kikuyu, the name of a people in Kenya and of their language.

and Portugal. The British parliament outlawed the trading of enslaved people in 1807. In the United States, slavery was abolished after the Civil War with the ratification of the 13th Amendment to the U.S. Constitution in 1865. It is estimated that four million enslaved Africans lived and died in the Americas.

SLAVE NARRATIVES In the United States between 1936 and 1938, journalists and writers employed by the federal government's Works Progress Administration (WPA) conducted interviews with 2,300 former slaves from the U.S. South. These slave narratives provide eyewitness testimony of life, work, relationships, and survival

on plantations and small farms and in cities through-out the so-called slave states. Many of these inter-views, with audio clips, are available on the U.S. Library of Congress's American Memory site (http://memory.loc.gov/ammem/collections/voices), including some songs.

THE SPIRITUAL The spiritual, a primarily Christian song, was created during the period of enslavement. Slave owners forbade traditional African worship, in addition to speaking in African tongues. Thus, enslaved Africans were converted to Christianity and learned to speak the language of their mas-ters. The spiritual has elements, however, that can be traced to African rhythms. In the United States, these traditions were combined with European ones—including Christian hymns—giving birth to a musical form that was unique to African Americans.

Spirituals had different components and purposes. These religious songs sometimes included *ring shouts*—probably derived from African ritual dance—during which participants moved in a circle, clapping and singing or pray-ing spontaneously. The listening selection "Good Lord (Run Old Jeremiah)" speaks of escaping the trials of a life of slavery. It was sung in connection with a West African dance pattern. Participants shuffled in single file, clapping the rhythm.

GO LISTEN! **SPIRITUAL**

"Good Lord (Run Old Jeremiah)"

Many spirituals make reference to Biblical events rel-evant to slave experiences, such as the Israelites' exodus from Egypt and freedom from their oppressors. "Michael, Row the Boat Ashore" is one such spiritual. Other songs may have contained hidden meaning known only to those who sang them. "Swing Low, Sweet Chariot," for example, may contain veiled references to the Underground Railroad—a secret route to freedom between the South and the North. The listening selection "Go Down Moses" is a spiritual that refers to Exodus 7:16 in the Hebrew Bible, in which God instructs Moses to go before Pharaoh and tell him, "Let my people go." The song predates the U.S. Civil War but was popularized by the deep, resonant voice of Paul Robeson in the 20th century. The Wil-liam Faulkner novel, *Go Down, Moses* is named after the song.

GO LISTEN! **SPIRITUAL**

"Go Down Moses" Paul Robeson

The influence of spirituals can be heard in gospel music that originated in the United States in the early 20th century. Both music forms became familiar through recordings, and performances of both could be heard throughout the country and abroad. During the U.S. civil-rights movement in the late

1950s and early 1960s, demonstrators sang spirituals (such as "We Shall Overcome") that would become familiar and uni-versal symbols of protest in the cause of freedom.

GO LISTEN! **SPIRITUAL**

"We Shall Overcome"

QUILTING The WPA slave narratives also revealed sto-ries of African American women creating quilts from scraps of fabric left over from the sewing they did for the plantation households, some of which were sold to white people. Quilt-ing parties—often large gatherings—were opportunities for storytelling and recollection, for music making, socializing, and more. Harriet Beecher Stowe, the author of the antislav-ery novel *Uncle Tom's Cabin*, described a quilting bee in a later work.

READING 20.1 HARRIET BEECHER STOWE

From *The Minister's Wooing*

The day was spent in friendly gossip as they rolled and talked and laughed . . . One might have learned in that instructive assembly how best to keep moths out of blankets; how to make fritters of Indian corn undistinguishable from oysters; how to bring up babies by hand; how to mend a cracked teapot; how to take grease from a brocade; how to reconcile absolute decrees with free will.

One of the finest and most completely preserved quilts, made by the freed slave Harriet Powers, features scenes from biblical stories in which she often juxtaposes cutouts of black and white figures (**Fig. 20.7**). These stories are stitched together with significant events that occurred in the artist's family and community.

Colonialism

In ancient times, Greeks and Phoenicians established colonies in North Africa, principally along the coast, as they left their congested home cities and sought new trade relationships. Alexander the Great, the Greek king of the state of Macedon, established a major city on the Mediterranean Sea in Egypt called Alexandria, which changed hands among the Greeks, Romans, and Vandals until the Arabs conquered North Africa in the seventh century. From these colonies, Arabs began to penetrate sub-Saharan Africa.

The first modern European expeditions to Africa were launched by the Portuguese in the 15th century, followed by conquest and colonization. Over time, other European rulers,

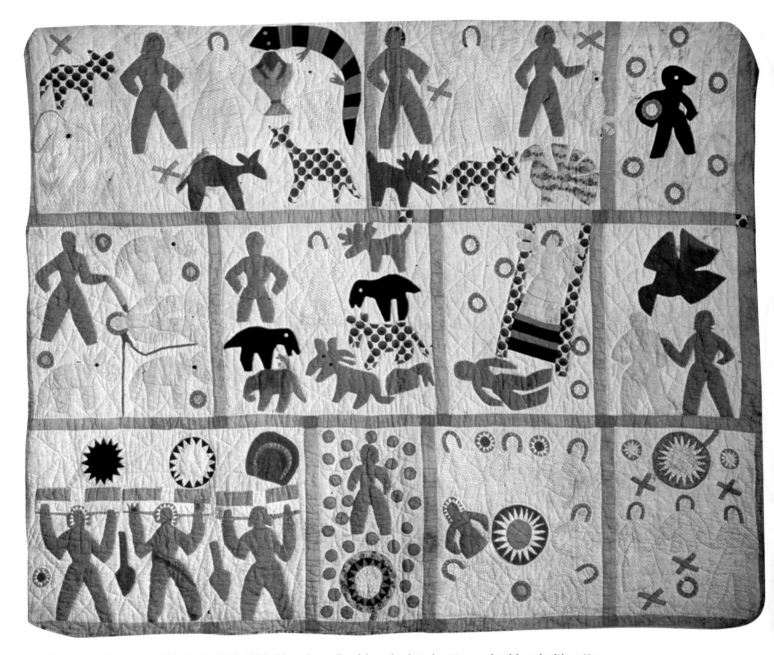

∧ **20.7** Harriet Powers, *Bible Quilt*, 1885–1886. Pieced, appliquéd, and printed cotton embroidered with cotton, 75″ × 89″ (191 × 227 cm). National Museum of American History, Smithsonian Institution, Washington, DC.

who vied among one another for power by accumulating and colonizing territories, saw Africa as fair game. Belgium took the Belgian Congo, now the Democratic Republic of the Congo. France took Algeria in North Africa and created colonial federations called French West Africa and French Equatorial Africa. The United Kingdom took Kenya, Rhodesia (now Zimbabwe), and eventually South Africa, among other territories, as imperial possessions. Power was one motivating factor in the explosion of European colonization in Africa, but there were others: the desire for exploration and the availability of raw materials for the taking; missionary zeal for the conversion of Africans from traditional religious beliefs to Christianity; a perceived obligation to "civilize" Africans; and lucrative markets for the sale or barter of European goods, most notoriously for African captives who would be enslaved and sent abroad.

European colonists were inconsistent in their policies regarding their African subjects. Ever committed to instilling patriotic loyalty and "brotherhood," the French accepted Africans as French, provided that they surrendered their native tongues and traditions and adopted French language and culture. The British embraced a policy of racial segregation that would lead to **apartheid** in South Africa, instituted in 1948.

South Africa became a country of a few million transplanted Europeans and their descendants with disproportionate authority over Africans, who far exceeded them in number. Apartheid continued in some form until multiracial elections were held in 1994.

Alan Paton's 1948 novel *Cry, the Beloved Country* highlights the lives of ordinary South Africans under an oppressive system. The story follows a Zulu parson who searches for his son in the criminal underworld of the big city (Johannesburg).

READING 20.2 **ALAN PATON**

From *Cry, the Beloved Country*

He is silent, his head aches, he is afraid. There is this railway station to come, this great place with all its tunnels under the ground. The train stops, under a great roof, and there are thousands of people. Steps go down into the earth, and here is the tunnel under the ground. Black people, white people, some going, some coming. So many that the tunnel is full. He goes carefully that he may not bump anybody, holding tightly on to his bag. He comes out into a great hall, and the stream goes up the steps, and here he is out in the street. The noise is immense. Cars and buses one behind the other, more than he has ever imagined. The stream goes over the street, but remembering Mpanza's son, he is afraid to follow. Lights change from green to red, and back again to green. He has heard that. When it is green, you may go. But when he starts across, a great bus swings along the path. There is some law of it that he does not understand, and he retreats again. He finds himself a place against the wall, he will look as though he is waiting for some purpose. His heart beats like that of a child, there is nothing to do or think to stop it. *Tixo*,[1] watch over me, he says to himself. *Tixo*, watch over me.

> *A poetic excerpt from Chapter 12 addresses the debilitating effects of fear on the individual and on the apartheid South African society.*
>
> Cry, the beloved country, for the unborn child that is the inheritor of our fear. Let him not love the earth too deeply. Let him not laugh too gladly when the water runs through his fingers, nor stand too silent when the setting sun makes red the veld[2] with fire. Let him not be too moved when the birds of his land are singing, nor give too much of his heart to a mountain or a valley. For fear will rob him of all if he gives too much.

Nelson Mandela (born 1918) began writing his autobiography, *Long Walk to Freedom*, while he was still in prison for "treason" for his efforts to end apartheid. Released in 1990 (after nearly 30 years), Mandela became the country's first black president in the election of 1994. A year earlier, he shared the Nobel Peace Prize with fellow countryman and state president Frederik Willem de Klerk, who had released Mandela from prison soon after he was elected. De Klerk lifted the ban on opposition political parties and ended apartheid with the institution of the democratic vote. The prize was awarded to both men "for their work for the peaceful termination of the apartheid regime, and for laying the foundations for a new democratic South Africa."

READING 20.3 **NELSON MANDELA**

From *Long Walk to Freedom*, chapter 1

Apart from life, a strong constitution, and an abiding connection to the Thembu royal house, the only thing my father bestowed upon me at birth was a name, Rolihlahla. In Xhosa, Rolihlahla literally means "pulling the branch of a tree," but its colloquial meaning more accurately would be "troublemaker." I do not believe that names are destiny or that my father somehow divined my future, but in later years, friends and relatives would ascribe to my birth name the many storms I have both caused and weathered. My more familiar English or Christian name was not given to me until my first day of school. But I am getting ahead of myself.

The decolonization of Africa began after World War II pursuant to the Atlantic Charter, which called for the autonomy of imperial territorial possessions. By 1980, Africa consisted of independent African nations. The former British colonies now have one-person-one-vote policies, in effect meaning majority rule.

AFRICAN LITERATURE

Although written African literature prior to the 20th century is scarce, there was a rich tradition of storytelling, often in verse. Much storytelling was passed down orally—in the same way as the Homeric epic poems, the *Iliad* and *Odyssey*—and a little has been preserved, written down by later generations using either the Arabic or Roman alphabet. Somalia had a rich poetic tradition. Raage Ugaas (18th century), of the Somali Ogaden clan, was popular for his wisdom and piety, whereas another Somali oral poet, Qamaan Bulxan (probably mid-19th century), was well-known for his philosophical and reflective verses, some of which have become proverbial expressions.

One area that did develop an earlier written tradition was the coastal region of East Africa, where Swahili (an African language strongly influenced by Arabic) was and remains spoken. Beginning in the 16th century, Muslim traders brought with them to the coastal trading centers

1. The name of the Xosa god, a god of the Zulu.

2. An open grazing area; Dutch for "field."

didactic and religious verse that was paraphrased in Swahili, with the Swahili version written between the lines of the Arabic text. Over time, poets used this Swahili-Arabic script to compose their own works, either recording traditional songs or creating new ones. Saiyid Abdallah (ca. 1720–1810) was born on the island of Lamu, now part of Kenya. In his long poem *Self-Examination*, he uses the decline of the great Arab trading cities on the East African coast, increasingly overshadowed during Abdallah's time by the new European colonial centers, as a symbol of the inevitability of death.

Léopold Sédar Senghor and Negritude

As African writers began to use the Roman alphabet, they also adopted Western languages, normally the one spoken by their colonial occupiers. The modern state of Senegal, which once formed part of the 11th-century kingdom of Ghana, fell under French rule in 1895. As a young boy, Léopold Sédar Senghor (1906–2001) was sent to a Catholic mission school, where he learned French and Latin. In due course he won a scholarship to study in Paris, where he became part of a group of talented black writers—some African, some West Indian, and some, including Langston Hughes, American. Angered by racism, particularly in the French colonies, Senghor found strength in his "blackness." Together with two other black writers living in Paris—Aimé Césaire (1913–2008) from Martinique and Léon-Gontran Damas (1912–1978) from French Guiana—Senghor created a literary and aesthetic movement called *Negritude*, articulated as "the sum total of the values of civilization of the black world." Césaire discussed the beginning of Negritude in an address in Geneva, Switzerland, in 1978.

> ### READING 20.4 **AIMÉ CÉSAIRE**
>
> #### From an address delivered in Geneva (1978)
>
> When it appeared, the literature of Negritude created a revolution: in the darkness of the great silence, a voice was rising up, with no interpreter, no alteration, and no complacency, a violent and staccato voice, and it said for the first time: "I, Negre."
> A voice of revolt
> A voice of resentment
> No doubt
> But also of fidelity, a voice of freedom, and first and
> foremost, a voice for retrieved identity.

Negritude as a philosophy reflected traditional African culture and values; as an aesthetic model in the visual arts, it emphasized African personality traits such as sensuality and emotional sensitivity. The literature of Negritude addresses themes of alienation (life as part of an uprooted minority subordinated by a more powerful group), revolt (against injustices of colonial rule), and rediscovery (what Nigerian Africanist Abiola Irele calls "an open and unashamed identification with the continent"). These themes are present in Senghor's foreword to an anthology of writings by the scholar, Leo Frobenius. Senghor refers to his experiences in early 20th century Paris and how his European professors did not understand that Africans, as well as Europeans, understood what was meant by civilization and its values. Then Senghor expresses his views that while there may be universals in the arts, every "race" also has its own *Paiduma*, or ways of creating meaning.

> ### READING 20.5 **LÉOPOLD SÉDAR SENGHOR**
>
> #### From Foreword to *Leo Frobenius (1873-1938): An Anthology*. Wiesbaden, Germany: F. Steiner, 1973.
>
> Had our [African] ancestors left us . . . the values of civilization? The Father Director of my college . . . denied that they had left us those. But Louis Armstrong's trumpet had already sounded across the French capital like a judgment, Josephine Baker's hips were vigorously shaking all its walls . . . Nevertheless, in our painstaking essays at the Lycée of Louis le Grand and the Sorbonne, where to the astonishment of our teachers we referred to "black values," we lacked not only "vision in depth," but also the basic philosophical explanation. . . . [Having] completed our studies, we were entering upon active militant life, with the concept and the idea of *Négritude* under our belts. . . .
>
> For every race possesses its own *Paideuma*, that is its own peculiar capacity for and manner of being moved: of being "possessed." Nevertheless, the artist, whether dancer, sculptor or poet, is not content to relive the Other; he recreates it in order to better live it and make it live. He recreates it by rhythm and thus makes of it a higher, truer reality, one that is more real than the factual reality.

Senghor went on to a political career in Africa, using Negritude as a foundation for an African socialist model that was derived from Marxist communism but at the same time inspired by "black spiritualities." Whatever the lasting value of his aesthetic theories, his influence on 20th-century African history is undeniable. One of his fellow countrymen called him "the myth that is endlessly discussed."

Yet not all African writers viewed Negritude in positive terms. One Senegalese contemporary described it as "mystification" that ignored the class struggle, as elitist, and out of touch with the masses. Younger African critics have attacked the concept of Negritude as a compromise with Neo-Colonialism, a refusal to complete the decolonization of the African mind. The Nigerian writer Wole Soyinka (who in 1986 was the first African to receive the Nobel Prize for

An Arab and a European Visit Africa

The Arab geographer al-Bakri (1014–1094) gives the following account of the kingdom of Ghana's capital (probably Kumbi Saleh).

> Ghana consists of two towns lying in a plain. One of these towns is inhabited by Muslims. It is large and possesses twelve mosques. . . . The town in which the king lives is six miles from the Muslim one and bears the name Al Gaba. The land between the two towns is covered with houses. The houses of the inhabitants are made of stone and acacia wood. The king has a palace and a number of dome-shaped dwellings, the whole surrounded by an enclosure like the defensive wall of a city. . . . The king adorns himself like a woman, wearing necklaces and bracelets, and when he sits before the people he puts on a high cap decorated with gold and wrapped in turbans of fine cotton.

A Dutch trader, writing in the late 1600s—long after the kingdom of Benin's heyday—gives the following description of the capital.

> The town is enclosed on one side by a wall ten feet high, made of a double palisade of trees, with stakes in between interlaced in the form of a cross, thickly lined with earth. On the other side a marsh, fringed with bushes, which stretches from one end of the wall to the other, serves as a natural rampart to the town. There are several gates, eight or nine feet high, and five feet wide. . . . The king's palace . . . is a collection of buildings which occupy as much space as the town of Haarlem [in the Netherlands], and which is enclosed within walls. There are numerous apartments for the king's ministers and fine galleries most of which are as big as those on the Exchange at Amsterdam.

Literature) has dismissed Negritude, stating that "tigers do not contemplate their 'tigritude' but just act naturally by pouncing."

African Novelists

THOMAS MOFOLO Other important African writers used their own languages, rather than those of the colonizers. The first African novelist, Thomas Mofolo (ca. 1875–1948), was born in Lesotho, a landlocked kingdom in the middle of South Africa, upon which it has always depended economically. While he was teaching in South Africa and Lesotho, Mofolo's passion for storytelling led friends to encourage him to write. In 1906 he published *The Traveler of the East*, writing in the Sesotho language. The book is considered both the first novel by an African and the first written in an African language. In his early work, Mofolo sought to combine Christian elements with traditional tales and poems.

By the time he came to write his most important and successful novel, *Chaka* (1912), Mofolo used African religion as the overriding influence in his characters' lives. The book describes the career of Zulu king Chaka (ca. 1787–1828), an actual historical figure who organized the hitherto weak Zulu warriors into a formidable fighting force. The real king was notorious for his cruelty and paranoia. In Mofolo's story, however, he begins as genuinely heroic and courageous. The tragic hero then declines into tyranny and eventual insanity

when, in an African version of Faust's pact with the devil, he sells his soul into sorcery. The missionary press that had published Mofolo's earlier books refused to publish *Chaka*, and it did not appear in print until 1925. It became an instant best seller and has been widely translated.

READING 20.6 THOMAS MOFOLO

From *Chaka*, chapter 19, "The Killing of the Cowards"

After Noliwa's death Chaka underwent a frightful change both in his external appearance and also in his inner being, in his very heart; and so did his aims and his deeds. Firstly, the last spark of humanity still remaining in him was utterly and finally extinguished in the terrible darkness of his heart; his ability to distinguish between war and wanton killing or murder vanished without a trace, so that to him all these things were the same, and he regarded them in the same light. Secondly, his human nature died totally and irretrievably, and a beast-like nature took possession of him; because although he had been a cruel person even before this, he had remained a human being, his cruelty but a human weakness. But a man who had spilt the blood of someone like Noliwa [a young woman beloved by Chaka's mother], would understandably regard the blood of his subjects exactly as if it were no different from that of mere animals which we slaughter at will.

CHINUA ACHEBE Chinua Achebe is one of the most widely read and acclaimed African novelists of the 20th century. He was born in Nigeria in 1930 to a family that belonged to the Igbo people of eastern Nigeria. When Nigeria became independent in 1960, the country (an artificial creation of the British) became divided. In 1967 the Igbo seceded to form the Republic of Biafra, and Achebe, a passionate supporter of the Igbo, became minister of information in the new state. The Igbo revolt was crushed in 1970, and the central Nigerian government seized control of the breakaway country. Achebe, overwhelmed by the death of many of his closest friends and the defeat of his people, chose to remain in Nigeria under the terms of the general amnesty for the rebels, and the war became a constantly recurring subject in much of his writing.

The central theme of Achebe's work is the conflict between two worlds: Western technology and values and traditional African society. In most of his novels, the chief character is torn by these opposing forces and is often destroyed in the process. His first book, *Things Fall Apart* (1958), forewarns us by its title—a quotation from W. B. Yeats's poem "The Second Coming"—that its story is tragic; the beginning of that poem is ominous.

READING 20.7 W. B. YEATS

"The Second Coming," lines 1–6 (1919)

Turning and turning in the widening gyre[3]
The falcon cannot hear the falconer;[4]
Things fall apart; the centre cannot hold;
Mere anarchy is loosed upon the world,
The blood-dimmed tide is loosed, and everywhere
The ceremony of innocence is drowned.

In Achebe's novel, the British intrude on a traditional Igbo society and undermine the values that have sustained it. Although the disaster is implicit from the beginning, Achebe's cool, laconic prose style somewhat distances the narrator from his tale.

Near the end of the novel, the clan of the black protagonist of the novel, Okonkwo, is holding a meeting to discuss how they can fend off the influences of the British. A messenger arrives to inform them that "the white man whose power you know too well has ordered this meeting to stop." Okokwo draws his machete "in a flash" and kills the messenger. His clan trembles with fear, and Okonkwo realizes that he will bring the wrath of the white man down on them. Learning of the killing, the district commissioner arrives at Okonkwo's compound with a band of soldiers to arrest him. Obierika, a village elder, says that Okonkwo is not there. The commissioner turns red in the face and demands that the men produce Okonkwo or they will be arrested themselves. Obierika says, somewhat mysteriously, "We can take you where he is, and perhaps your men will help us."

They find Okonkwo dangling dead from a tree. He has killed himself to avoid arrest or living in a world in which the traditional way of life has been destroyed—the "ceremony of innocence is drowned." Obierika asks whether the commissioner's men will take the body down and bury it. "Why can't you take him down yourselves?" the commissioner asks. Obierika explains that suicide is considered an abomination and that a man who kills himself must be buried by strangers, untouched by his clansmen. At the end of the novel, the commissioner refuses.

READING 20.8 CHINUA ACHEBE

From *Things Fall Apart*, chapter 25

"Take down the body," the Commissioner ordered his chief messenger, "and bring it and all these people to court."

"Yes, sah," the messenger said, saluting.

The Commissioner went away, taking three or four of the soldiers with him. In the many years in which he had toiled to bring civilization to different parts of Africa he had learned a number of things. One of them was that a District Commissioner must never attend to such undignified details as cutting a hanged man from the tree. Such attention would give the natives a poor opinion of him. In the book which he planned to write he would stress that point. As he walked back to the court he thought about that book. Every day brought him some new material. The story of this man who had killed a messenger and hanged himself would make interesting reading. One could almost write a whole chapter on him. Perhaps not a whole chapter but a reasonable paragraph, at any rate. There was so much else to include, and one must be firm in cutting out details. He had already chosen the title of the book, after much thought: The Pacification of the Primitive Tribes of the Lower Niger.

In Achebe's next novel, *No Longer at Ease* (1960), conflict becomes internalized. We meet a younger Obi Okonkwo. He has been sent by his community to England for his education, and on his return takes an uneasy position among the corrupt minor British bureaucrats governing local affairs. As the story unfolds, Achebe paints a bitter, if ironic, picture of the colonial ruling classes, the bewilderment of the Africans, and the disastrous effect of both forces on the innocent young man in the middle. Okonkwo's plight is made even more poignant by the impact on him of two powerful aspects of Western culture: Christianity and romantic love.

Achebe wrote his novels in English and, as in the case of Senghor, many of his fellow African writers have reproached him for writing in a colonial language. Achebe has always argued, however, that only Western languages can carry the

3. A rotating system of motion or currents.

4. A person who trains and hunts with falcons.

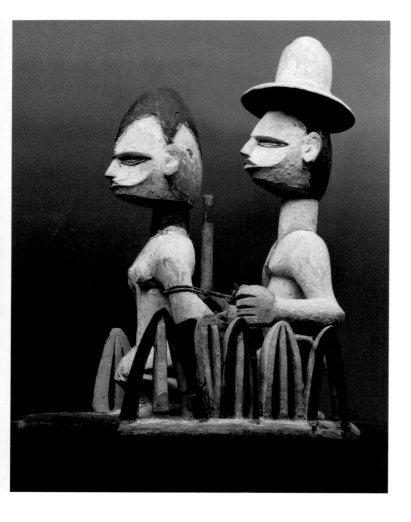

Whether it exalts the secular power of rulers or the force of the spirit world—and often the two overlap—a sculpture or mask must evoke age-old memories and associations. At the same time, African artists are as open to the influences of changing times and the world around them as are Western or Asian artists.

The conflict between Achebe's Igbo tradition and the newly arrived Western forces, which leads to tragedy in his novels, is made visible in a pair of wooden figures produced by an Igbo artist to crown a dancer's headdress (**Fig. 20.8**). The male figure, which wears a European-style hat, is a slave trader, while the woman, bound to him with rope, is his captive.

◀ **20.8** Headdress, Igbo culture. Nigeria, 1900s. Wood carving. American Museum of Natural History, New York, New York. Worn by a dancer in a ritual, this headdress shows a slave trader, wearing a European hat, with his captive woman.

▼ **20.9** A ritual dance mask representing a monkey, Dogon culture, ca. 1975–1995. Mali.

message to those who most need to hear it. Furthermore, by using European languages, Africans can prove that their work can stand and be acknowledged alongside Western literature. Above all, throughout his long career, Achebe has always believed that the retelling of the African experience is crucial. In one of his novels, an elder says, "It is the story that saves our progeny from blundering like blind beggars into the spikes of the cactus fence. The story is our escort; without it, we are blind."

TRADITIONAL AFRICAN ART IN THE MODERN PERIOD

In order to appreciate traditional African art, it is necessary to bear in mind its cultural context. Unlike most modern Western artists, African artists generally have not produced works as aesthetic objects to be viewed for pleasure, but rather to fulfill a precise function in society and religion. Until the commercialization of recent times, the notion of a museum or gallery was alien to African art. Also, far from following Western ideas of inspiration or progress, African art is firmly rooted in tradition. The identity of the individual creator is far less important than the authenticity of the object, and as a result, we know the names of very few African artists.

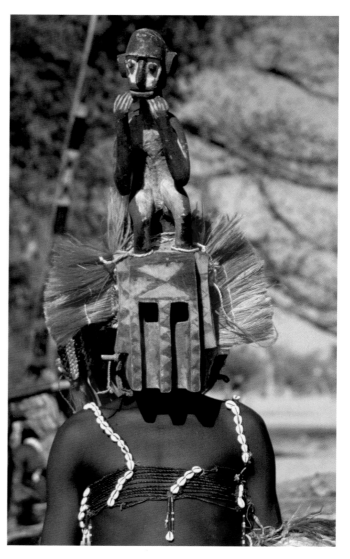

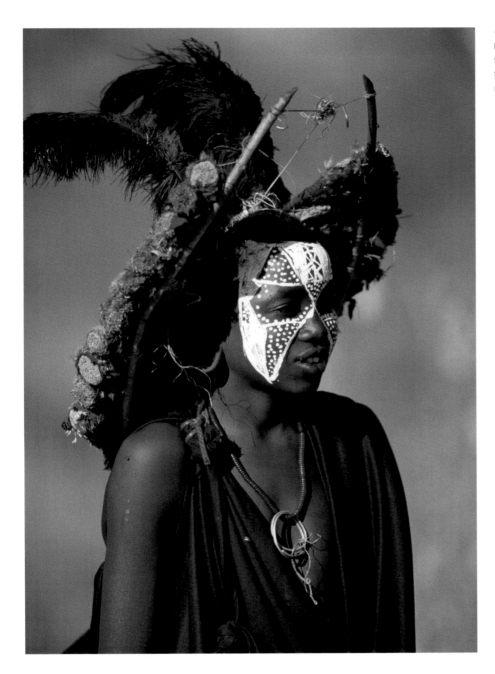

◄ **20.10 The bird headdress of a young Maasai warrior, 2006. Tanzania.** Note the designs painted on his face as well the multicolored headdress that marks his recent rite of passage.

The same conflict of influences can be seen in the customs of the Dogon people of the modern state of Mali. The coming of Islam to Africa produced a conflict between the strict Islamic ban on music, dancing, and the carving of realistic images, whether of humans or animals, and traditional African art, music, and dance. The Dogons reject the principles of Islam, and dance continues to play a central role in their culture, marking religious events, honoring ancestors, welcoming the rainy season, and, most importantly, accompanying funerals. On all these occasions, masks play an important role in the ceremonies. As the Dogon philosopher Ogotemmêli has said, "Masked dancers are the world, and when they dance in a public place, they are dancing the process of the world and the world order." At funerals the dancers wear masks representing animals, as they usher the dead from village life back to the bush, thereby restoring that natural world order (**Fig. 20.9**).

Many traditional African works of art are used in customs that celebrate the transitions of life and rites of passage. When a young man of the Maasai undergoes circumcision, he and his friends construct a special bird headdress to mark the occasion (**Fig. 20.10**). They hunt down a variety of birds—kingfishers, orioles, lovebirds, and others—clean them out, and stuff them with a mixture of ashes and dried grass. The birds, which may be as many as 40 in number, are then attached to a large horseshoe-shaped crown, which the young

COMPARE + CONTRAST

Out of Africa: The Enduring Legacy of the Ceremonial Mask

Masks of myriad designs and materials play an essential role in the rituals of the traditional peoples of sub-Saharan and West Africa. They typically have religious or spiritual meanings and are the focal piece of masquerades—ceremonial dances performed for events ranging from funerals and initiation rites to social gatherings and entertainment. Mask makers have special status in these societies, and their craft is usually passed down from father to son over the generations.

In the early 20th century, the mask became the quintessential object associated with traditional African culture and was widely collected by European artists, writers, and the intellectual elite (Fig. 20.11). Drawn to the simplicity, the directness of expression, the rustic carving, and the inherent power of the primitive forms—untouched and unmediated by

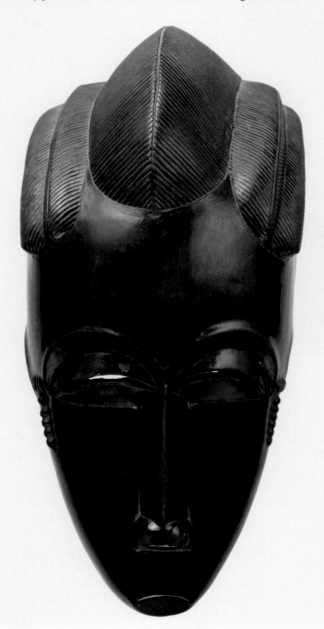

◄ 20.11 Portrait Mask (Gba gba), before 1913. Côte d'Ivoire. Wood, 10 1/4" × 4 7/8" × 4 1/8" (26 × 12.4 × 10.5 cm). Metropolitan Museum of Art, New York, New York. This mask was used as part of a theatrical tradition that combines dance and dramatic skits. As a portrait mask, it is an idealized version of the face of a prominent member of the community, by whom it was commissioned. Only the best dancers were permitted to wear such masks.

▼ 20.12 Pablo Picasso, *Head of a Sleeping Woman (Study for Nude with Drapery)*, 1907. Oil on canvas, 24 1/4" × 18 3/4" (61.4 × 47.6). Museum of Modern Art, New York, New York. © 2013 Estate of Pablo Picasso/Artist Rights Society (ARS), New York

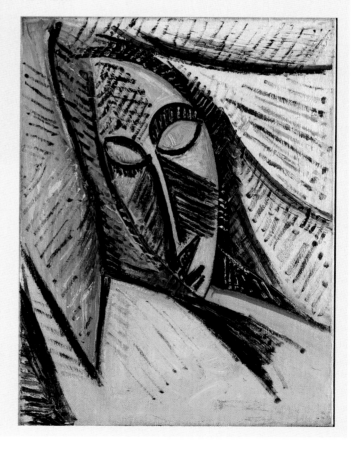

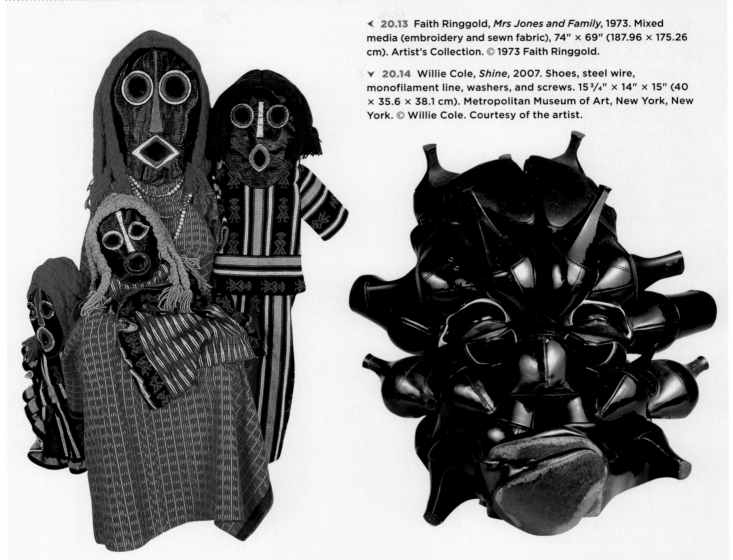

◄ **20.13** Faith Ringgold, *Mrs Jones and Family*, 1973. Mixed media (embroidery and sewn fabric), 74″ × 69″ (187.96 × 175.26 cm). Artist's Collection. © 1973 Faith Ringgold.

▼ **20.14** Willie Cole, *Shine*, 2007. Shoes, steel wire, monofilament line, washers, and screws. 15 ³/₄″ × 14″ × 15″ (40 × 35.6 × 38.1 cm). Metropolitan Museum of Art, New York, New York. © Willie Cole. Courtesy of the artist.

the West—young modern artists such as Pablo Picasso and Henri Matisse incorporated aspects of African masks and other objects in their own paintings and sculpture. In his *Head of a Sleeping Woman* (Fig. 20.12), Picasso mimicked the geometric rhythms and simplified features of African objects. He would return to these forms—which he first saw in an exhibition in Paris—throughout his long career.

Contemporary African American artists Faith Ringgold and Willie Cole have also referenced masks in many of their works. Ringgold's *Mrs Jones and Family* (Fig. 20.13) is constructed of stitched fabric of kente-cloth patterns with embroidered details. The wedge-shaped noses and open mouths on the heads of the soft-sculpture dolls evoke common features of African masks. In combination, these elements connect the artist to both her African heritage and artistic traditions—like needlework and quilting—among enslaved African women.

Willie Cole has created masklike sculptures from women's high-heeled shoes that, while captivating in their cleverness, are stocked with multiple references that elicit conflicting emotions. His mask called *Shine* (Fig. 20.14) has positive and negative associations. The use of the word *shine* as a derogatory expression for African Americans originated in the early 20th century, perhaps in reference to shoe shining or polishing, which was a common way for urban black men and boys to earn money. At the same time, the word connotes radiance, and indeed, the positioning of the shoes with the heels aimed outward from the central core of the mask can read as rays emanating from a spiritual object. Cole has said, "I want the [masks] to be links between worlds, . . . art that looks like it is from another culture and another time, even though the materials in the work are strictly American."

man proudly wears at ceremonies and public occasions until the healing process is completed.

Other rituals require different forms of ceremonial dress. The Yoruba Egungun masquerade ceremony is performed in long elaborate costumes that cover the performer from head to foot (**Fig. 20.15**). They often involve a variety of fabrics, which are then decorated with sequins, beads, and other materials, using traditional patterns.

Masks, headdresses, and costumes all serve as important elements in perhaps the most important of all artistic manifestations in Africa: the performance art of dance. Often religious or ceremonial, African dance is an integral part of cultural life, used to mark all important occasions.

THE IMPACT OF WESTERN CULTURE ON CONTEMPORARY AFRICAN ART

Contemporary African artists often work with traditional techniques and art forms or combine them with Western references. These hybrid works correspond to the melding of cultures—for better or for worse—that occurred in Africa as a result of European and Arab colonization and continues to factor into African life today.

El Anatsui lives and works in Nigeria, but he was born in Ghana, where kente cloth—a silk and cotton textile made of colorful, interwoven strips—originated. This sacred cloth is most certainly the inspiration for his many wall hangings, but rather than weaving pieces of fabric, Anatsui recycles the aluminum wrappings of liquor-bottle caps and other packaging and assembles it all into a facsimile of cloth using copper wire (**Fig. 20.16**). The wall hangings are immense, evoking tapestries

and mosaic murals as well. At the same time, they serve as a sociopolitical and economic commentary on globalization.

So too does **Figure 20.17**, a satirical riff on traditional African ceremonial masks from the "jerry can" series by Romuald Hazoumé. In this series of assemblages, Hazoumé is calling attention to the worldwide shortage of gasoline, the exploitation of Africa's resources, and the economic enslavement of Africans who are forced to ferry the fuel. Assemblages such as these begin with what early-20th-century Europeanartists called ready-mades—objects there for the taking which, with little to no manipulation, would take on a character that negated their original purpose. Like Anatsui, Hazoumé calls attention to the effects of global encounters on cultural traditions through the use of **ephemera**.

Many of the works of Kenyan artist Wangechi Mutu are also examples of hybridity. She juxtaposes contemporary print models and African objects in politically charged collages that feature women's bodies surrounded by rich, explosive colors, animal prints, botanical elements, and abstract patterns that evoke traditional textiles. In *Mask* (**Fig. 20.18** on page 774), the model becomes an exotic temptress who invokes the sexualized stereotype of the dominatrix and overturns the traditional male–female power relationship. Mutu shares Nobel laureate Wangari Muta Maathai's concerns about the place—and well-being—of women in patriarchal societies. Many of Mutu's works illustrate twisted female anatomy and conditions of deterioration that draw attention to what she describes as the sexualization and neglect of African women by oppressive men. Underneath the stereotype, women are suffering, and Mutu wants her viewers to challenge their assumptions about race, gender, and beauty.

> **20.15 Ceremonial costume for the Egungun masquerade ritual, Yoruba culture, 1900s. Benin. Mixed media, 68″ (172.7 cm) long. Indianapolis Museum of Art, Indianapolis, Indiana.** Representing the collective spirit of ancestors, the Egungun costume uses velvet, cotton, and wool, decorated with a mixture of sequins, beads, metallic threads, and cowrie shells.

AFRICAN MUSIC

Africa is a varied continent with different musical traditions. The music of North Africa is closely related to Islamic or Arabian music (see Chapter 8). There are a number of traditions in music in sub-Saharan Africa, but they are similar in rhythmic principles. Many of them use a cross beat or **cross-rhythm**, in which the pattern of accents of a measure of music is contradicted by the pattern in a subsequent meter. Familiar modern examples

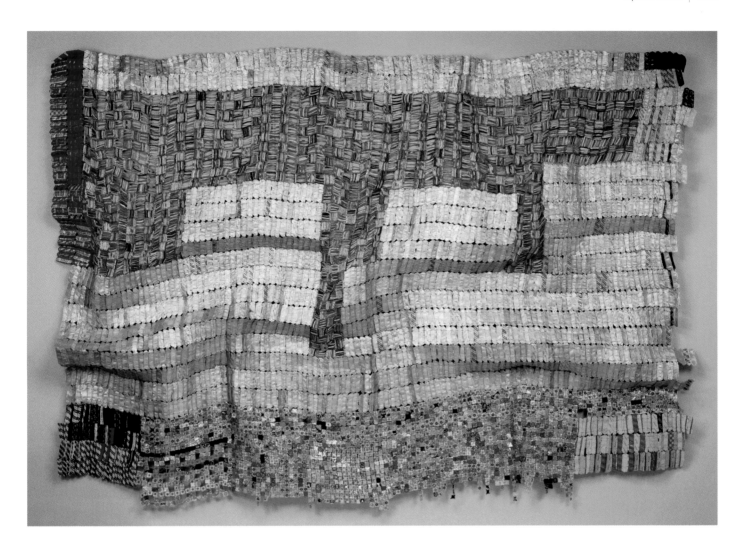

▲ **20.16** El Anatsui, *Between Earth and Heaven*, 2006. Nigeria. Aluminum, copper wire, 86³/₄" × 128" (220.3 × 325.1 cm). Metropolitan Museum of Art, New York, New York. © El Anatsui. Courtesy of the artist and Jack Shainman Gallery, New York. El Anatsui's wall hangings are reminiscent of Ghanaian works made of traditional kente cloth, but El Anatsui assembles his wall hangings from caps of liquor bottles.

➤ **20.17** Romuald Hazoumé, *Bagdad City*, 1992. Brush, speakers, and plastic can. © The Contemporary African Art Collection (C.A.A.C. The Pigozzi Collection), Geneva, Switzerland.

with cross-beats include "Carol of the Bells" and Radiohead's "Myxomatosis." **Vocal harmony**, in which consonant notes are sung along with the main melody, is another characteristic of African music. (Vocal harmony is also used in European choral music and opera.) Vocal harmony is frequently used in contemporary music, by backup singers whose pitches must be in harmony with those of the lead singer.

Some instruments, such as the iron bell, are found throughout sub-Saharan Africa. Some peoples use a drum

▲ **20.18** Wangechi Mutu, *Mask*, 2006. Mixed-media collage. © Wangechi Mutu. Courtesy of the artist.

➤ **20.19 A kora, a 21-stringed instrument that is plucked by hand.** One hand plays 11 strings, and the other hand plays 10. The instrument is made from a calabash cut in half. The calabash is a vegetable grown for use as a water container, not for eating.

similar to those used in Arabia, and stringed instruments. One is a lute similar to a banjo. Another is a single-stringed instrument played with a bow. Xylophones of various kinds are used in some regions. Xylophones are percussion instruments (as are drums) made of wood bars that are struck by

hammer-like sticks or mallets. Each bar sounds a different note when struck. The **kora** is a 21-stringed instrument, with 11 played by one hand and 10 by the other (**Fig. 20.19**). Instruments are usually accompanied by singing.

Music is used for initiations, coronations, weddings, funerals, hunting, working, other social functions, and just pleasure.

GLOSSARY

Animism (p. 754) A belief in spiritual beings; a belief that natural objects (such as plants, animals, or the sun) or natural events (such as wind, thunder, and rain) possess spiritual qualities or spiritual beings.

Apartheid (p. 763) In South Africa, the rigid former policy of segregation of the white and nonwhite populations.

Colonialism (p. 759) A political system in which one nation has control or governing influence over another nation; also known as *imperialism*.

Cross-rhythm (p. 772) A traditional African musical method in which the pattern of accents of a measure of music is contradicted by the pattern in a subsequent measure; also termed *cross beat*.

Ephemera (p. 772) Items not of lasting significance that were meant to be discarded.

Gikuyu (p. 761) In Kikuyu beliefs, the male primordial parent; the father of the Kikuyu people.

Indentured servant (p. 759) A person who is placed under a contract to work for another person for a period of time, often in exchange for travel expenses or an apprenticeship.

Kora (p. 774) A traditional African string instrument which is plucked; eleven strings are plucked by one hand, and ten strings by the other hand.

Mumbi (p. 761) In Kikuyu beliefs, the female primordial parent; the mother of the Kikuyu people.

Slavery (p. 759) A social system or practice in which one person is the property of, and wholly subject to the will of, another person.

Vocal harmony (p. 773) A traditional musical method in which consonant notes are sung along with the main melody.

THE BIG PICTURE THE PEOPLES AND CULTURES OF AFRICA

Language and Literature
- Prior to the 20th century, most African storytelling was done by word of mouth.
- About 1500 CE, Islamic religious verse was translated into Swahili; the Swahili-Arabic script became a new poetic tradition.
- Saiyid Abdallah (Somalia, ca. 1720–1810) wrote *Self-Examination*, a long poem using the decline of great Arab trading cities on the East African coast as a symbol of the inevitability of death.
- Oral poet Raage Ugaas (Somalia) became popular for his wisdom and piety.
- In 1906, Thomas Mofolo (Lesotho, ca. 1875–1948) wrote *Traveler of the East* in his native Sesotho language, becoming the first African novelist. In 1912, Mofolo wrote *Chaka*, his most celebrated book, but the missionary-run press that published his previous works refused to publish it.
- In 1929, poet Léopold Sédar Senghor (Senegal, 1906–1989), writing in French, created a literary movement known as Negritude that celebrates the unique traditions of African art.
- Alan Paton wrote *Cry, the Beloved Country* in 1948.
- Chinua Achebe (Nigeria) published his first novel, *Things Fall Apart*, in English in 1958. He published *No Longer at Ease* in 1960.
- In 1986, Wole Soyinka (Nigeria) became the first African to receive a Nobel Prize for Literature.

Art, Architecture, and Music
- Neolithic rock paintings and objects such as arrowheads are found throughout North Africa.
- Between 1000–1300, Bantu-speaking ancestors of the Shona erected Great Zimbabwe, with huge stone buildings surrounded by massive walls.
- Ca. 1200–1400, the people of Great Zimbabwe created soapstone carvings.
- Ca. 1300–1500, Benin artists (in modern-day Nigeria) created sculptures honoring their rulers and ancestors; Yoruba culture created ceremonial costumes for masquerades honoring Egungun (collective spirit of ancestors).
- The Great Mosque at Djenné was first built in the 14th century but took its present form in the early 20th century.
- In the 1700s the Dogon people (modern-day Mali) created masks for ceremony and dance.
- In the early 1900s, African artworks began to influence Western artists, such as Picasso.
- Contemporary African art continues to examine the conflict between traditional cultures and the West. Traditional art forms and rituals involving masks and headdresses continue to play a crucial role in African communities.
- Contemporary African and African American artists show bidirectional influences.

Philosophy and Religion
- Native African religions were largely animistic.
- Arabs brought Islam to North Africa beginning in the seventh century.
- Europeans brought Christianity to West, Central, and Southern Africa beginning in about the 16th century.
- Ca. 1805, Qamaan Bulhan (Somalia) became well-known for his philosophical and reflective verses, some of which have become proverbial expressions.

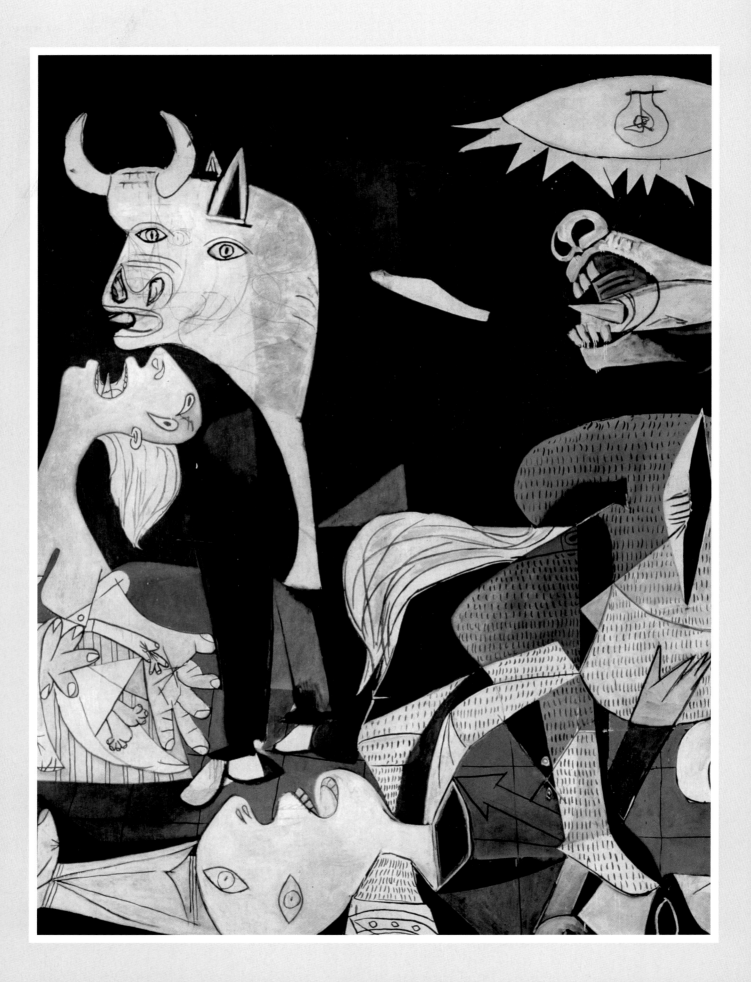

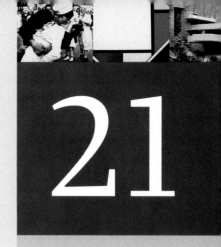

The World at War

<div style="text-align: right; font-size: 2em;">21</div>

PREVIEW

On April 26, 1937, volunteer aviators from German Nazi and Italian fascist air forces took to their bombers and flew toward Spain. Their destination was Guernica, a small town in the infamously independent Basque region that had sided against the country's right-wing Nationalist forces in their attempt to overthrow Spain's more left-leaning, duly elected Republican government in the Spanish Civil War. Both the fascists under Benito Mussolini and the Nazis under Adolf Hitler supported the Nationalist general, Francisco Franco, in his efforts to wrest control of the country by a military coup. What ensued was known as Operation Rügen (*Rügen* is German for "rebuke" or "harsh reprimand"), one of the earliest campaigns of *terror bombing* (bombs and missiles deployed from fighter or bomber aircraft) and *strafing* (attacks from low-flying planes with weapons like machine guns). The goal was complete destruction of villages and the massacre of civilians as a strategic tactic to demoralize the enemy. Operation Rügen began in the late afternoon on Guernica's market day and continued in waves until the town was taken three days later with little to no resistance reported. Some estimates put the number of dead at roughly 1700, with some 900 more wounded. The campaign was a test run for what would be similar actions by the Luftwaffe, the deadly air-warfare division of the German army, during World War II.

One month after the bombing of Guernica, the International Exposition of Art and Technology in Modern Life opened in Paris, a celebration of modern invention and ingenuity in the service of humanity. But a painting by Pablo Picasso, who had been commissioned by the Spanish Republican government to create a work for that country's pavilion, would become a potent symbol of the dark side of these technological advances: their potential for human destruction. Picasso's *Guernica* (**Figs. 21.1** and **21.3**), a vast canvas exhibited at this World's Fair that commemorates the brutal attack, comes down to us as one of the harshest vilifications of modern warfare and one of the most deeply moving antiwar messages put forth by an artist. Picasso's familiar Cubist idiom, in which multiple perspectives yield fractured forms, is used to disturbing effect—one that eerily reflects an eyewitness report of the carnage by a British journalist, Noel Monks:

> We were still a good ten miles away when I saw the reflection of Guernica's flames in the sky.... I was the first correspondent to reach Guernica, and was immediately pressed into service by some Basque soldiers collecting charred bodies that the flames passed over. Some of the soldiers were sobbing like children.... Houses were collapsing into the inferno.[1]

◄ **21.1** Pablo Picasso, *Guernica* (detail), 1937. Oil on canvas, 137 3/8″ × 305 1/2″ (349 × 776 cm). Museo Nacional Centro de Arte Reina Sofia, Madrid, Spain. © 2013 Estate of Pablo Picasso/Artists Rights Society (ARS), New York.

1. Monks, Noel, *Eyewitness* (1955); Thomas, Hugh, *The Spanish Civil War* (1977).

As a political statement, *Guernica* had—and still has—great power. After the close of the Paris Exposition, the painting traveled to several Scandinavian countries before coming back to France. When Franco came to power, Picasso sent *Guernica* to the United States to raise funds for Spanish refugees; in 1939, he placed it on loan in the Museum of Modern Art in New York. Although the painting traveled to various museums for special exhibition, the Museum of Modern Art was to remain its home base, at Picasso's request, until such time as Spain reverted to a democratic government. In 1974, Tony Shafrazi, a contemporary artist and art dealer, defaced *Guernica* with the words "Kill Lies All" spray-painted across the canvas (it was quickly cleaned with no lasting damage). Shafrazi used one of art history's most famous protest paintings as a billboard for his own protest against the much publicized My Lai village massacre by American soldiers during the Vietnam War. Franco died in 1975, two years after Picasso's death; free elections were held in Spain in 1977 and a year later a democratic constitution was adopted. On September 9, 1981, *Guernica* went back to Spain.

In 2003, just before the Iraq War, when Secretary of State Colin Powell was to meet the press standing before a tapestry reproduction of *Guernica* that hangs outside the United Nations Security Council chamber, United Nations officials hid the work behind a blue curtain—so potent a symbol of the atrocities and injustices of war is *Guernica*, even in recent times.

THE GREAT WAR (WORLD WAR I)

They called it the war to end all wars, but it didn't. Even so, the armed conflict that raged throughout Europe from 1914 until 1918 put to rest forever the notion that war was a heroic rite of passage conferring nobility and glory. The use of technology—especially artillery, poison gas, tanks, and airplanes—made slaughter possible on a scale previously only imagined by storytellers. Trench warfare took its toll. Soldiers dug deep, miles-long crevices in the earth, where they lived and prepared to assault or defend against enemy soldiers dug into trenches across from them. Intermittently they rose up from their trenches and ran toward the enemy's trenches, to be largely mowed down by artillery and machine-gun fire. The other side would attack and the slaughter would be repeated. By the end of the war, the Germans had lost three and a half million men and the Allies 5 million (see **Map 21.1**).

The World at War

1914 CE	1920 CE	1929 CE	1939 CE	1941 CE	1945 CE
World War I begins in 1914	Women receive the right to vote in the United States in 1920	The U.S. Stock market crashes in 1929	Hitler invades Poland in 1939	The United States defeats Japanese fleet at Midway in 1942	
Panama Canal opens	Fascists rise to power in Italy	The Great Depression begins	Einstein alerts Roosevelt of the need to develop an atom bomb in 1939	The Soviet Union defeats Germany at Stalingrad and Kursk in 1943	
Germans use poison gas and sink the *Lusitania*	Lindbergh makes the first solo flight from the United States to Europe in 1927	The analog computer is invented at the Massachusetts Institute of Technology in 1930	The Netherlands, Belgium, and France are all taken by German blitzkrieg in 1940	The Allies land in Normandy on June 6, 1944	
The October Revolution brings communism to Russia in 1917	Television images are transmitted from Washington, DC, to New York City in 1927	Franklin Delano Roosevelt is first elected president in 1932	Hitler invades Russia in 1941	Germany surrenders in 1945	
United States enters World War I in 1917	Fleming discovers penicillin in 1928	Roosevelt declares, "We have nothing to fear but fear itself"	Japan bombs Pearl Harbor, bringing the United States into the war on Dec. 7, 1941	The United States drops atom bombs on Hiroshima and Nagasaki in 1945	
The war ends in 1918	First sound movie is produced in 1928	Prohibition ends in 1933		World War II ends	
Women receive the right to vote in Britain in 1918		Nazis rise to power in Germany in 1933			
Prohibition begins in the United States in 1919		The Spanish Civil War (1936–1939)			
		Golden Gate Bridge opens in 1937			
		Japan invades China in 1937			

Territory lost by

Germany

Bulgaria

Russia

Austria-Hungary

EUROPE AFTER WORLD WAR I

∧ **MAP 21.1 Europe after World War I**

The immediate cause of the war was the assassination of Archduke Franz Ferdinand of Austria, heir to the Austro-Hungarian throne. But the war was actually a logical, if horrific, outcome of the tensions in Europe that had been brewing throughout the modern era and solidified via Otto von Bismarck's unification of Germany and the competition for territories and influence that followed. Britain was concerned about Germany's rising economic power, and there was a naval arms race between the two countries. France rebuilt its armed forces rapidly following the humiliation of the Franco-Prussian War of 1870–1871, and anger toward Germany simmered. By the early years of the 20th century, the efforts of Bismarck (who was relieved of his position in 1890) to maintain a balance of power were slipping away. Russia was also rearming after its defeat in the Russo-Japanese

War of 1904–1905. Britain, France, Italy, and Russia formed alliances to balance the strength of Germany and Austria-Hungary. In 1908 the Austro-Hungarian Empire annexed Bosnia and Herzegovina. There was a crisis in the Balkans in 1912 and 1913 as landlocked Serbia tested its growing military might by invading Albania, desirous of an Albanian seaport. The Russians—Slavs—supported Slavic Serbia, increasing tensions with nearby Austria-Hungary and its ally, Germany. The assassination might have been the spark, but years of warfare and competition were the powder keg.

The United States entered the war on the side of Britain, France, Italy, and Russia in 1917, although President Woodrow Wilson had sought to keep the country neutral. The United States was a "melting pot," composed of immigrants from all sides of the warring states. There were, of course, supporters

for the British despite U.S. wars with that country. But German Americans, Swedish Americans, and Irish Americans had no great love for Britain. Yet the United States was shipping supplies to Britain across the North Atlantic and German submarines (U-boats) were attacking them. A German U-boat also sank the passenger liner RMS *Lusitania*, incurring the wrath of the United States. Wilson asked Congress for a declaration of war against Germany and its allies, for "a war to end all wars" and "make the world safe for democracy." The United States tipped the balance, and Germany surrendered in 1918.

The sociopolitical consequences of the Great War were monumental. The geopolitical face of Europe was considerably altered. Europe demanded unreasonably high repara-

tions from Germany—so high that while the United States was experiencing the Roaring Twenties, Germany remained in economic despair for more than a decade, with such inflation that it was said, with some exaggeration, that one would have to bring a wheelbarrow full of marks (the German currency) to purchase a loaf of bread. Germany's miseries led to a decade of decadence, with Berlin known as a capital for drinking and womanizing, as suggested in the musical *Cabaret*.

The October Revolution of 1917 led by Vladimir I. Lenin toppled the tsarist regime and produced a communist government in Russia. The punitive attitude of the Allies and the stricken state of Germany's postwar economy provided the

▼ **21.2** Max Beckmann, *The Night*, 1918–1919. **Oil on canvas, 52³/₈″ × 60¹/₄″ (133 × 153 cm). Kunstsammlung Nordrhein-Westfalen, Düsseldorf, Germany. © 2013 Artists Rights Society (ARS), New York/VG Bild-Kunst, Bonn.** In this work, Beckmann abandons the Christian symbolism he had used in some earlier works. The torture and martyrdom, unlike in a religious painting, do not lead to justice or salvation.

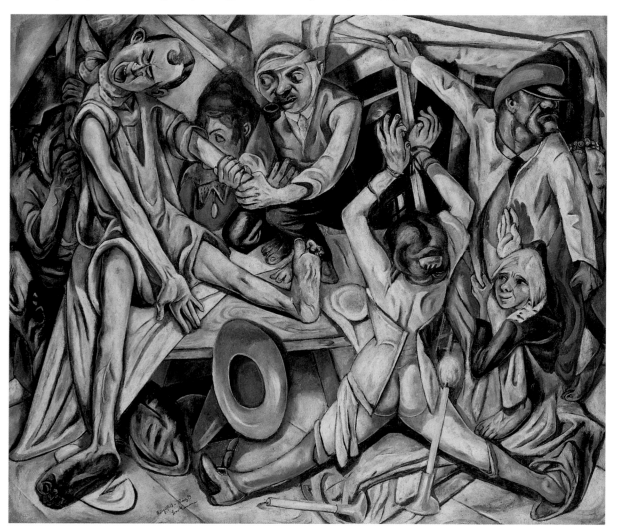

Disillusionment

The period between the two world wars has often been characterized as a time of disillusionment. The horrendous slaughter of World War I, the brief spasm of economic prosperity followed by the worldwide depression, the lack of trust in governments, and the questioning of traditional culture created a search for ways to fill the moral vacancy of the times. Responses ranged from a new hedonism reflected in the excesses of the Jazz Age to a renewed search for some kind of a center for culture in the works of the modernist writers.

The most dangerous reaction to this disillusioned spirit was the rise of the total state. From Lenin's Russia, Hitler's Germany, and Mussolini's Italy arose a totalitarianism that saw the state as the total center of power that would guide everything from economics and social policy to the arena of culture, arts, and propaganda. The distinction between public and private life was erased by the total state.

One lesson that can be learned from the rise of modern totalitarianism is the vigor with which the total state repressed all cultural alternatives to its own vision of reality. The suppression of free speech, independent media, toleration for the arts, and space for independent social groups, churches, or civic organizations was total in the Soviet Union, Germany, and Italy. The vigorous antifascist novelist Ignazio Silone once wrote that what the state feared more than anything else was one person scrawling "NO" on a wall in the public square.

seedbed from which Hitler's **National Socialism** (Nazism)— a form of **fascism**—sprang. Postwar turmoil led to Mussolini's ascendancy in Italy. Britain had lost many of its best young men in the war; those who survived leaned toward either frivolity or pacifism.

Art Out of the Ashes

The experience of war had searing effects on those who went through it—in art, in writing, in film. The direction of painting in Germany is a case in point.

MAX BECKMANN Beckmann (1884–1950) was born in Leipzig, Germany, and began his artistic career painting in a traditional manner. He enlisted in the army because of the belief that the chaos of war would plant the seeds of a superior society; moreover, Germany had proved itself to be invulnerable since its unification. Serving as a medic, then, he had not anticipated the massive destruction or the loss of life and limb. His art after the war took a direction that reflected what he saw as humankind's descent into cruelty and madness. His canvases now depicted a world in which the human figure, and the space occupied by the figure, became dramatically distorted.

His painting *Night* (**Fig. 21.2**) is not a depiction of the war, but it is surely a reflection of the emotional residue of the war. A family's home is invaded. The face of the husband is contorted as he is being hanged. The wife has apparently been raped; she is tied to a window frame that, like all the action, is pressed up against the picture plane. Her partial nudity is pathetic, not erotic, although it suggests the moti-

vation of the invaders. In the lower right, a girl, perhaps the daughter, is pulling the clothing of a man whose face is partly shielded by a hat—perhaps pleading for mercy.

Beckmann's style won the disapproval of Hitler in the 1930s. Hitler, the mass murderer, preferred a more traditional approach to art. Beckmann's works were displayed in an exhibition of **degenerate art,** and the artist fled to Amsterdam and later the United States, where he taught art until his death.

PABLO PICASSO Pablo Picasso lived a long life, from 1881 to 1973, and observed the world from the vantage point of France as it changed from a belle époque to a time of militarism and interminable warfare. We noted his innovation of Cubism in Chapter 18, but Picasso moved on while never quite discarding what was, for him, the past. He painted the renowned *Guernica* (**Fig. 21.3**) as a protest against the bombing of the town during the Spanish Civil War of 1936–1939. This mammoth painting, created for the Spanish Pavilion at the Paris International Exposition of 1937, broadcast to the world the carnage of the bombing of civilians in the Basque town. The painting captures the event in gruesome details, such as the frenzied cry of one woman trapped in rubble and fire and the pale fright of another woman who tries in vain to flee the conflagration. A terrorized horse rears over a dismembered body, while an anguished mother embraces her dead child and wails futilely. Innocent lives are shattered into Cubist planes that rush and intersect at myriad angles, distorting and fracturing the imagery. Confining himself to a palette of harsh blacks, grays, and whites, Picasso expressed, in his words, the "brutality and darkness" of the age.

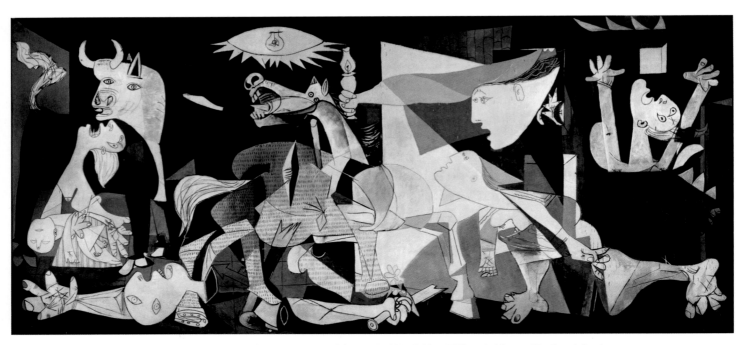

▲ **21.3** Pablo Picasso, *Guernica*, 1937. Oil on canvas, 137³/₈″ × 305¹/₂″ (349 × 776 cm). Museo Nacional Centro de Arte Reina Sofia, Madrid, Spain. © 2013 Estate of Pablo Picasso/Artists Rights Society (ARS), New York. By Picasso's specification, this monumental painting remained on extended loan in New York until after the death of the fascist dictator General Francisco Franco, when it was moved to his native Spain.

The Lost Generation

Culturally, World War I sounded the death knell for the world of settled values. The battle carnage and the senseless destruction—in no small part the result of callous and incompetent military leadership—made a mockery of patriotic slogans, appeals to class, and the metaphysical unity of nations. One result of this disillusionment was a spirit of frivolity, but another was bitterness and cynicism about anything connected with military glory.

In Britain the term *Lost Generation* referred generally to the loss of "the flower of youth," the nation's potential future leaders in government, industry, and the arts. In cultural terms, it referred to a whole school of poets, many of whom did not survive, but who had lived long enough to vent their disgust with this first modern war. Among them were poets like Rupert Brooke and Isaac Rosenberg, both of whom were lost in the war—but not before penning powerful poems about the stupidity, the carnage, and the waste of the battles.

RUPERT BROOKE The English poet Rupert Brooke (1887–1915) was known for his sonnets and also for his work as a travel journalist. He was a handsome young man, so appealing that Virginia Woolf boasted of going skinny-dipping with him when they were both students at Cambridge. During the war, he was aboard a vessel of the British Mediterranean Expeditionary Force when he developed blood poisoning and died. His poem "The Soldier" is remembered for its patriotism, its peace, and its opening lines.

READING 21.1 RUPERT BROOKE

"The Soldier"

If I should die, think only this of me:
That there's some corner of a foreign field
That is for ever England. There shall be
In that rich earth a richer dust concealed;
A dust whom England bore, shaped, made aware,
Gave, once, her flowers to love, her ways to roam,
A body of England's, breathing English air,
Washed by the rivers, blest by suns of home.

And think, this heart, all evil shed away,
A pulse in the eternal mind, no less
Gives somewhere back the thoughts by England given;
Her sights and sounds; dreams happy as her day;
And laughter, learnt of friends; and gentleness,
In hearts at peace, under an English heaven.

ISAAC ROSENBERG Isaac Rosenberg (1890–1918) worked as an engraver in London and aspired to be an artist. However, he began to write poetry and was encouraged to continue by those of the literary set, even though his work brought no income. He enlisted in the army in 1915 and was killed in action in 1918, the final year of the war. His literary reputation grew after his death because of his poetic innovations, but of course his pen had been stilled. We are left with a few verses and regrets about his

promise. In "Dead Man's Dump," the verse beginning "Maniac Earth!" captures the despair of humanity, metal, poison gas ("chemic smoke"), and earth intertwined in madness.

READING 21.2 ISAAC ROSENBERG

"Dead Man's Dump," lines 1–13, 39–54, 63–71

The plunging limbers[2] over the shattered track
Racketed with their rusty freight,
Stuck out like many crowns of thorns,
And the rusty stakes like sceptres old
To stay the flood of brutish men
Upon our brothers dear.
The wheels lurched over sprawled dead
But pained them not, though their bones crunched,
Their shut mouths made no moan.
They lie there huddled, friend and foeman,
Man born of man, and born of woman,
And shells go crying over them
From night till night and now.

. . .

The air is loud with death,
The dark air spurts with fire,
The explosions ceaseless are.
Timelessly now, some minutes past,
Those dead strode time with vigorous life,
Till the shrapnel called "An end!"
But not to all. In bleeding pangs
Some borne on stretchers dreamed of home,
Dear things, war-blotted from their hearts.
Maniac Earth! howling and flying, your bowel
Seared by the jagged fire, the iron love,
The impetuous storm of savage love.
Dark Earth! dark Heavens! swinging in chemic smoke,
What dead are born when you kiss each soundless soul
With lightning and thunder from your mined heart,
Which man's self dug, and his blind fingers loosed?

. . .

Here is one not long dead;
His dark hearing caught our far wheels,
And the choked soul stretched weak hands
To reach the living word the far wheels said,
The blood-dazed intelligence beating for light,
Crying through the suspense of the far torturing wheels
Swift for the end to break
Or the wheels to break,
Cried as the tide of the world broke over his sight.

The phrase Lost Generation means different things in different places, although it always refers to those who were born, say, between 1883 and 1900 and who thus came of age during World War I and the Roaring Twenties that followed. The expatriate U.S. author Ernest Hemingway also wrote of the Lost Generation, crediting the phrase to his mentor,

patron, and friend Gertrude Stein, whom we met in Chapter 18 as a supporter of artists such as Picasso and Matisse. But to Hemingway and many others, the word *lost* referred to people who had lost their way.

ERNEST HEMINGWAY Ernest Hemingway (1899–1961), a native of Illinois, was quite young to serve in World War I, but serve he did. Much of his fiction is set in that war and other wars of the period, such as the Spanish Civil War, a military revolt against the Republican Spanish government. The rebels, called Nationalists, were aided by Nazi Germany and fascist Italy. The Republicans, on the other hand, were supported by the communist Soviet Union and International Brigades made up of European and U.S. volunteers. Hemingway's experiences in reporting that war provided the backdrop for perhaps his greatest novel, *For Whom the Bell Tolls* (1940). His first important novel, *The Sun Also Rises* (1926), chronicles expatriates who are physically and psychologically damaged by World War I and who wander through Europe, particularly Spain. The characters in *The Sun Also Rises* are lost. Their lives go around in circles as they have some sexual liaisons, get into some minor trouble, and are rescued. In that novel, Hemingway sets up the bullfighter as a hero, because the bullfighter faces death with honor, with grace under pressure.

Hemingway did not settle in one place for long. He lived in Europe but also in Cuba and Key West, Florida. One of the great stories about Hemingway—which may or may not be accurate, but is in keeping with his persona as a formidable hunter, boxer, soldier, and raconteur—is that he personally entered and "liberated" Paris, by seizing the bars at the Ritz and Crillon Hotels, before the Free French army and the U.S. army formally liberated the city from the German occupation.

Reading 21.3 is from one of Hemingway's short stories, "In Another Country," published in 1927. It, too, is about World War I, during which a very young Hemingway served as an ambulance driver and was wounded by shrapnel. He fell in love with his Red Cross nurse, an event that inspired his novel *A Farewell to Arms* (1929).

The story provides a fine example of Hemingway's writing style, which one critic suggested might lead to a grade of F in a high school because of its use of small words and its repetition. But the language is purposeful. It builds and builds. Writers are generally taught to try to avoid using the same word twice in the same sentence or even the same paragraph. But notice Hemingway's repeated use of words such as *fall* (the season), *cold*, and *wind*. Moreover, if you read the first paragraph aloud, you will discover that several lines have a poetic meter. The story is about injured soldiers in a hospital. They will recover, supposedly, and the rehabilitation machines will help them—supposedly. What, the reader may ask, is the other country? Is it Italy, the hospital, or something else? The soldiers in the story, clearly, have lost their way as well as their limbs.

2. Carts.

READING 21.3 **ERNEST HEMINGWAY**

From "In Another Country"

In the fall the war was always there, but we did not go to it any more. It was cold in the fall in Milan and the dark came very early. Then the electric lights came on, and it was pleasant along the streets looking in the windows. There was much game hanging outside the shops, and the snow powdered in the fur of the foxes and the wind blew their tails. The deer hung stiff and heavy and empty, and small birds blew in the wind and the wind turned their feathers. It was a cold fall and the wind came down from the mountains.

We were all at the hospital every afternoon, and there were different ways of walking across the town through the dusk to the hospital. Two of the ways were alongside canals, but they were long. Always, though, you crossed a bridge across a canal to enter the hospital. There was a choice of three bridges. On one of them a woman sold roasted chestnuts. It was warm, standing in front of her charcoal fire, and the chestnuts were warm afterward in your pocket. The hospital was very old and very beautiful, and you entered through a gate and walked across a courtyard and out a gate on the other side. There were usually funerals starting from the courtyard. Beyond the old hospital were the new brick pavilions, and there we met every afternoon and were all very polite and interested in what was the matter, and sat in the machines that were to make so much difference.

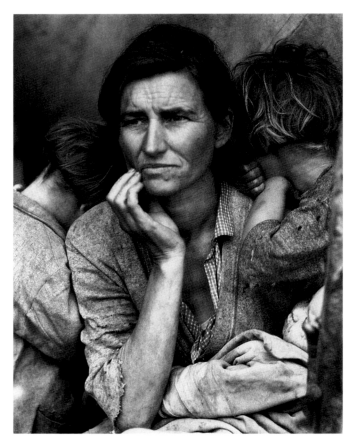

▲ **21.4** Dorothea Lange, *Migrant Mother, Nipomo, California*, 1936. Gelatin silver print, 12½″ × 9⅞″ (31.6 × 25.1 cm). Library of Congress, Prints and Photographs Division, FSA/OWI Collection, Washington, DC. Photographers such as Lange and Evans memorialized the hardships suffered by ordinary Americans during the Great Depression. They both worked for the Farm Security Administration. After 1935, she focused on the exploitation of sharecroppers.

Photography

For most of the West, the 1920s were a time of dramatic recovery. In the United States, alcohol flowed in clubs despite **Prohibition**. New dances such as the Charleston arrived on the scene. It was known as the Jazz Age or the Roaring Twenties. The stock market seemed to be able to move in only one direction: up, and further up. All bubbles burst and the market crashed in 1929, leading to the Great Depression of the 1930s.

In the United States between the world wars, the most powerful pictures produced for social purposes were those photographs made to show the terrible economic deprivations of the Great Depression. In the mid-1930s, the Farm Security Administration of the United States Department of Agriculture commissioned photographers to record the life of the country's rural poor. The resulting portfolios of these pictures taken by such photographers as Dorothea Lange, Arthur Rothstein, and Walker Evans have become classics of their kind. Lange and Evans portrayed the lifestyles of migrant farmworkers and sharecroppers. Lange's *Migrant Mother* (**Fig. 21.4**) is a heartrending record of a 32-year-old woman who is out of work but cannot move on because the

tires have been sold from the family car to purchase food for her seven children. The etching in her forehead is an eloquent expression of a mother's thoughts; the lines at the outer edges of her eyes tell the story of a woman who has aged beyond her years. Lange crops her photograph close to her subjects; they fill the print from edge to edge, forcing us to confront them rather than allowing us to seek comfort in a corner of the print not consigned to such an overt display of human misery. The migrant mother and her children, who turn away from the camera and heighten the futility of their plight, are constrained as much by the camera's viewfinder as by their circumstances.

LITERATURE

WILLIAM BUTLER YEATS At the end of World War I, the Irish poet William Butler Yeats (1865–1939), profoundly

moved by unrest in his own country (particularly the Easter Rising of 1916) and the growing militarism in Europe, wrote one of the most extraordinarily beautiful and prophetic poems of modern times, "The Second Coming." The title of the poem is deeply ironic because it refers not to the glorious promised return of the Christian Messiah but to an event the poet only hints at in an ominous manner. We already noted these lines in Chapter 19, because the Nigerian writer Chinua Achebe took the first phrase, "things fall apart," as the title of a novel that protests British colonialism. But the following lines from the poem also seem to sum up the catastrophe of the Great War and to look into the future. It seems to be as strikingly relevant for the era of the great wars, and perhaps for our own times, as it was for Yeats.

> Things fall apart; the centre cannot hold;
> Mere anarchy is loosed upon the world,
> The blood-dimmed tide is loosed, and everywhere
> The ceremony of innocence is drowned;
> The best lack all conviction, while the worst
> Are full of passionate intensity.

The themes are all there. Some kind of center—political, philosophical, social, artistic, even scientific—seems to be in perpetual jeopardy. There is a sense of anarchy as nations fail to act in responsible manners and groups within nations move viciously within and across borders, with or without government sanction. "Innocence is drowned"; disillusionment reigns. Blind trust in governments, religious institutions, even educational systems has evaporated because history has revealed us as the creators of "the blood-dimmed tide." Those who mean well are plagued by hesitation and indecision ("lack all conviction"), and those who would destroy ("the worst") harbor passion. The only surprise is that these words were penned nearly a century ago. Most of the literature of 1914 to 1945 touches on these themes in one way or another.

T. S. ELIOT The year 1922 was a turning point for literary modernism. In that year, T. S. Eliot (1888–1965), a U.S. expatriate living in England, published his poem *The Waste Land* and James Joyce, an expatriate Irish writer living on the Continent, published his novel *Ulysses*. In their respective works, Eliot and Joyce reflect some of the primary characteristics of what is called the *modernist temper* in literature. There is a fragmentation of line and image, an abandonment of traditional forms, an overwhelming sense of alienation and human homelessness (both authors were self-imposed exiles), an ambivalence about traditional culture, an intense desire to find some anchor in a past that seems to be escaping, a blurring of the distinction between reality "out there" and the world of subjective experience, and, finally, a straining and pushing of language to provide new meanings for a world the writer sees as exhausted.

Both Eliot and Joyce reflect the conviction that, in Yeats's phrase, "the centre cannot hold." For Joyce, only art would give people a new worldview that would provide meaning. Eliot felt that if culture was to survive, people had to recover a sense of cultural continuity through a linkage of the artistic and religious tradition of the past. That perceived need for past cultural links helps explain why Eliot's poems are filled with allusions to works of art and literature as well as fragments from Christian rituals.

The gradual shift from cultural despair in *The Waste Land* can be traced in Eliot's later poems, beginning with "The Hollow Men" (1925) and "Ash Wednesday" (1930) and culminating in *Four Quartets*, which were completed in the early 1940s. The *Quartets* were Eliot's mature affirmation of his Christian faith as a bulwark against the ravages of modernist culture. To read *The Waste Land* and the *Four Quartets* in tandem is to see one way in which a sensitive mind moved from chaos to stability in the period between the wars.

Eliot's "The Love Song of J. Alfred Prufrock," written in 1920, has one of the more interesting similes in English literature:

> . . . the evening is spread out against the sky
> like a patient etherized upon a table; . . .

JAMES JOYCE Before World War I, Joyce (1882–1941) had already published his collection of short stories under the title *Dubliners* (1914) and his *Portrait of the Artist as a Young Man* (1916). The former is a series of linked short stories in which people come to some spiritual insight (which Joyce called an **epiphany**), while the latter is a thinly disguised autobiographical memoir of Joyce's own youth before he left for the Continent in self-imposed exile after his graduation from college. With the 1922 publication of *Ulysses*, Joyce was recognized as a powerful innovator in literature. In 1939, two years before his death, Joyce published the dauntingly difficult *Finnegans Wake*. Joyce once said that *Ulysses* was a book of the day (the action takes place in one day) while *Finnegans Wake* was a haunting dream book of the night.

Joyce's blend of myth and personal story, his many-layered puns and linguistic allusions, his fascination with stream of consciousness, his sense of the artist alienated from his roots, and his credo of the artist as maker of the world have all made him one of the watershed influences on literature in the 20th century.

Ulysses's final episode (or chapter) chronicles the thoughts of the concert singer Molly Bloom, the spouse of Leopold Bloom, an advertising agent. The episode begins and ends with the word *yes*, which is also repeated throughout. Reading 21.4 shows the end of the novel, but begins with one of the yesses. Joyce had elsewhere written that *yes* is "the female word"—assuming, traditionally, that the male is the sexual aggressor and the female is the gatekeeper. The episode title "Penelope" refers to Ulysses's wife, Molly Bloom's

counterpart (Leopold Bloom is the ironic distorted mirror image of the heroic Ulysses). *Ulysses* is intended to portray the characters' **stream of consciousness**, as if they were lying on the couch of the psychoanalyst and uttering, uncensored, every thought that came into mind.

READING 21.4 JAMES JOYCE

From *Ulysses*, episode 18, "Penelope"

yes 16 years ago my God after that long kiss I near lost my breath yes he said was a flower of the mountain yes so we are flowers all a womans body yes that was one true thing he said in his life and the sun shines for you today yes that was why I liked him because I saw he understood or felt what a woman is and I knew I could always get round him and I gave him all the pleasure I could leading him on till he asked me to say yes and I wouldnt answer first only looked out over the sea and the sky I was thinking of so many things he didnt know of Mulvey and Mr Stanhope and Hester and father and old captain Groves and the sailors playing all birds fly and I say stoop and washing up dishes they called it on the pier and the sentry in front of the governors house with the thing round his white helmet poor devil half roasted and the Spanish girls laughing in their shawls and their tall combs and the auctions in the morning the Greeks and the jews and the Arabs and the devil knows who else from all the ends of Europe and Duke street and the fowl market all clucking outside Larby Sharans and the poor donkeys slipping half asleep and the vague fellows in the cloaks asleep in the shade on the steps and the big wheels of the carts of the bulls and the old castle thousands of years old yes and those handsome Moors all in white and turbans like kings asking you to sit down in their little bit of a shop and Ronda with the old windows of the posadas glancing eyes a lattice hid for her lover to kiss the iron and the wineshops half open at night and the castanets and the night we missed the boat at Algeciras the watchman going about serene with his lamp and O that awful deepdown torrent O and the sea the sea crimson sometimes like fire and the glorious sunsets and the figtrees in the Alameda gardens yes and all the queer little streets and pink and blue and yellow houses and the rosegardens and the jessamine and geraniums and cactuses and Gibraltar as a girl where I was a Flower of the mountain yes when I put the rose in my hair like the Andalusian girls used or shall I wear a red yes and how he kissed me under the Moorish wall and I thought well as well him as another and then I asked him with my eyes to ask again yes and then he asked me would I yes to say yes my mountain flower and first I put my arms around him yes and drew him down to me so he could feel my breasts all perfume yes and his heart was going like mad and yes I said yes I will Yes.

FRANZ KAFKA Perhaps the quintessential modernist in literature is the Czech writer Franz Kafka (1883–1924). A German-speaking Jew born and raised in Prague, Kafka was by heritage alienated from both the majority language of his city and its predominant religion. An obscure clerk for a major insurance company, he published virtually nothing during his lifetime. He ordered that his works be destroyed after his death, but a friend did not accede to his wish. What we have from Kafka's pen is so unique that it has contributed the adjective *Kafkaesque* to our language. A Kafkaesque experience is one in which a person feels trapped by forces that seem simultaneously ridiculous, threatening, and incomprehensible.

This is precisely the tone of Kafka's fiction. In *The Trial* (1925), Josef K. (note the near anonymity of the name) is arrested for a crime that is never named, by a court authority that is not part of the usual system of justice. At the end of the novel, the hero (if he can be called that) is executed in a vacant lot by two seedy functionaries of the court. In *The Castle* (1926), a land surveyor known merely as K., hired by the lord of a castle overlooking a remote village, attempts in vain to approach the castle, to communicate with its lord and learn of his duties. In time, he comes to the point where would be satisfied just to know if there actually is a lord who has hired him.

No critic has successfully uncovered the meaning of these novels—if in fact they should be called novels. Kafka's work might better be called extended parables that suggest, but do not explicate, a terrible sense of human guilt, a feeling of loss, and an air of oppression and muted violence.

The parable in Reading 21.5 from *The Trial*, told to Josef K. in a cathedral, is meant to be an enigma and a puzzle. As a parable it mirrors the confusion of the hero, who is pursued by the court for crimes he cannot identify, a guilt he recognizes, but whose source he cannot name.

VIRGINIA WOOLF Virginia Woolf (1882–1941) is one of the most important writers in the period of literary modernism. Novels like *Mrs. Dalloway* (1925), *To the Lighthouse* (1927), and *The Waves* (1931) have been justly praised for their keen sense of narrative, sophisticated awareness of time shifts, and profound feeling for the textures of modern life.

Woolf's reputation would be secure if she had been known only for her novels, but she was also an accomplished critic, a founder (with her husband Leonard Woolf) of the esteemed Hogarth Press, and a member of an intellectual circle in London known as the Bloomsbury Group. That informal circle of friends was at the cutting edge of some of the most important cultural activities of the period. Lytton Strachey, the biographer, was a member, as was John Maynard Keynes, the influential economist. The group also included the art critics Roger Fry and Clive Bell, who championed the new art coming from France, and had close contacts with mathematician-philosopher Bertrand Russell and poet T. S. Eliot.

Two small books, written by Woolf as polemical pieces, are of special contemporary interest. *A Room of One's Own* (1929) and *Three Guineas* (1938) were passionate but keenly

From *The Trial*, chapter 9, "In the Cathedral, Before the Law"

Before the Law stands a doorkeeper. To this doorkeeper there comes a man from the country who begs for admittance to the Law. But the doorkeeper says that he cannot admit the man at the moment. The man, on reflection, asks if he will be allowed, then, to enter later. 'It is possible,' answers the doorkeeper, 'but not at this moment.' Since the door leading into the Law stands open as usual and the doorkeeper steps to one side, the man bends down to peer through the entrance. When the doorkeeper sees that, he laughs and says: 'If you are so strongly tempted, try to get in without my permission. But note that I am powerful. And I am only the lowest doorkeeper. From hall to hall, keepers stand at every door, one more powerful than the other. And the sight of the third man is already more than even I can stand.' These are difficulties which the man from the country has not expected to meet, the Law, he thinks, should be accessible to every man and at all times, but when he looks more closely at the doorkeeper in his furred robe, with his huge pointed nose and long thin Tartar beard, he decides that he had better wait until he gets permission to enter. The doorkeeper gives him a stool and lets him sit down at the side of the door. There he sits waiting for days and years. He makes many attempts to be allowed in and wearies the doorkeeper with his importunity. The doorkeeper often engages him in brief conversation, asking him about his home and about other matters, but the questions are put quite impersonally, as great men put questions, and always conclude with the statement that the man cannot be allowed to enter yet. The man, who has equipped himself with many things for his journey, parts with all he has, however valuable, in the hope of bribing the doorkeeper. The doorkeeper accepts it all, saying, however, as he takes each gift: 'I take this only to keep you from feeling that you have left something undone.' During all these long years the man watches the doorkeeper almost incessantly. He forgets about the other doorkeepers, and this one seems to him the only barrier between himself and the Law. In the first years he curses his evil fate aloud; later, as he grows old, he only mutters to himself. He grows childish, and since in his prolonged study of the doorkeeper he has learned to know even the fleas in his fur collar, he begs the very fleas to help him and to persuade the doorkeeper to change his mind. Finally his eyes grow dim and he does not know whether the world is really darkening around him or whether his eyes are only deceiving him. But in the darkness he can now perceive a radiance that streams inextinguishably from the door of the Law. Now his life is drawing to a close. Before he dies, all that he has experienced during the whole time of his sojourn condenses in his mind into one question, which he has never yet put to the doorkeeper. He beckons the doorkeeper, since he can no longer raise his stiffening body. The doorkeeper has to bend far down to hear him, for the difference in size between them has increased very much to the man's disadvantage. 'What do you want to know now?' asks the doorkeeper, 'you are insatiable.' 'Everyone strives to attain the Law,' answers the man, 'how does it come about, then, that in all these years no one has come seeking admittance but me?' The doorkeeper perceives that the man is nearing his end and his hearing is failing, so he bellows in his ear: 'No one but you could gain admittance through this door, since this door was intended for you. I am now going to shut it.'

"Before the Law", edited by Nahum N. Glatzer, from *Franz Kafka: The Complete Stories* by Franz Kafka, edited by Nahum N. Glatzer, copyright 1946, 1947, 1948, 1949, 1954, 1958, 1971 by Schocken Books. Used by permission of Schocken Books, a division of Random House, Inc. and The Random House Group Ltd.

VOICES

Virginia Woolf

In this abridged version of her diary entry for January 15, 1941, Virginia Woolf describes the results of the German bombing of London. Shortly after writing this entry, Virginia Woolf committed suicide.

Then Joyce is dead: Joyce about a fortnight younger than I am. I remember Miss Weaver, in wool gloves, bringing *Ulysses* in typescript to our teatable at Hogarth House. . . . One day Catherine [sic] Mansfield came, and I had it out. She began to read, ridiculing: then suddenly said: But there's something in this: a scene that should figure I suppose in the history of literature. . . . Then I remember Tom [T. S. Eliot] saying: how could anyone write again after the immense prodigy of that last chapter?

We were in London on Monday. I went to London Bridge. I looked at the river; very misty; some tufts of smoke, perhaps from burning houses. There was another fire on Saturday. Then I saw a cliff of wall, eaten out, at one corner; a great corner all smashed: a bank; the monument erect; tried to get a bus; but such a block I dismounted; and the second bus advised me to walk. A complete jam of traffic; for streets were being blown up. So by Tube to the Temple; and there wandered in the desolate ruins of my old squares: gashed, dismantled; the old red bricks all white powder, something like a builder's yard. Grey dirt and broken windows. Sightseers; all that completeness ravished and demolished.

READING 21.6 VIRGINIA WOOLF

From *A Room of One's Own*

I could not help thinking, as I looked at the works of Shakespeare on the shelf, that . . . it would have been impossible, completely and entirely, for any woman to have written the plays of Shakespeare in the age of Shakespeare. Let me imagine, since facts are so hard to come by, what would have happened had Shakespeare had a wonderfully gifted sister, called Judith, let us say. Shakespeare himself went, very probably—his mother was an heiress—to the grammar school, where he may have learnt Latin—Ovid, Virgil and Horace—and the elements of grammar and logic. . . . He had, it seemed, a taste for the theatre; he began by holding horses at the stage door. Very soon he got work in the theatre, became a successful actor, and lived at the hub of the universe, meeting everybody, knowing everybody, practising his art on the boards, exercising his wits in the streets, . . . Meanwhile his extraordinarily gifted sister, let us suppose, remained at home. She was as adventurous, as imaginative, as agog to see the world as he was. But she was not sent to school. . . . She picked up a book now and then, one of her brother's perhaps, and read a few pages. But then her parents came in and told her to mend the stockings or mind the stew and not moon about with books and papers. . . . Perhaps she scribbled some pages up in an apple loft on the sly but was careful to hide them or set fire to them. Soon, however, before she was out of her teens, she was to be betrothed to the son of a neighbouring woolstapler.[3] She cried out that marriage was hateful to her, and for that she was severely beaten by her father. . . . How could she disobey him? How could she break his heart? The force of her own gift alone drove her to it. She made up a small parcel of her belongings, let herself down by a rope one summer's night and took the road to London. . . . She had the quickest fancy, a gift like her brother's, for the tune of words. Like him, she had a taste for the theatre. She stood at the stage door; she wanted to act, she said. Men laughed in her face. . . . She could get no training in her craft. Could she even seek her dinner in a tavern or roam the streets at midnight? Yet her genius was for fiction and lusted to feed abundantly upon the lives of men and women and the study of their ways. At last . . . Nick Greene the actor manager took pity on her; she found herself with child by that gentleman and so . . . killed herself one winter's night and lies buried at some cross-roads where the omnibuses now stop outside the Elephant and Castle.

Virginia Woolf. *A Room of One's Own*. New York: Harcourt, Brace and Company, 1929.

argued polemics against the discrimination against women in public intellectual life. Woolf argued that English letters had failed to provide the world with a tradition of great women writers not because women lacked talent but because social structures never provided them with a room of their own—that is, the social and economic aid to be free to write and think or the encouragement to find outlets for their work. Woolf, a brilliant and intellectually restless woman, passionately resented the kind of society that had barred her from full access to English university life and entry to the professions. Her books were early salvos in the battle for women's rights. Woolf is rightly seen as one of the keenest thinkers of the modern feminist movement, whose authority was enhanced by the position she held as a world-class writer and critic.

In the extract above from *A Room of One's Own*, Woolf imagines what life might have been like for Shakespeare's sister—a sister Woolf named Judith. She is responding to the remark of a bishop that no woman could have written as well as Shakespeare. Woolf ironically agrees with the bishop. The bishop, however, is attributing the distance between the talents of men and women to natural or inborn differences. Woolf argues that there is no evidence for such inborn differences, but that there is ample evidence for cultural or societal forces that create such differences.

SINCLAIR LEWIS U.S. novelist Sinclair Lewis (1885–1951) viciously satirized his country's complacency in the post–World War I period. His novel *Babbitt* (1922) was a scathing indictment of the middle-class love for the concept of "a chicken in every pot and a car in every garage" (Herbert Hoover's 1928 presidential campaign slogan). His humdrum hero, George Babbitt, became synonymous with a mindless materialism in love with gadgets and comfort.

In the following passage from chapter 6, we learn of Babbitt's taste in the arts. The novel was written in 1922. What would have been written, instead, if radio shows and television programs had been available at the time?

3. Wool merchant.

READING 21.7 SINCLAIR LEWIS

From *Babbitt*, chapter 6

Babbitt looked up irritably from the comic strips in the *Evening Advocate*. They composed his favorite literature and art, these illustrated chronicles in which Mr. Mutt hit Mr. Jeff with a rotten egg, and Mother corrected Father's vulgarisms by means of a rolling-pin. With the solemn face of a devotee, breathing heavily through his open mouth, he plodded nightly through every picture, and during the rite he detested interruptions. Furthermore, he felt that on the subject of Shakespeare he wasn't really an authority. Neither the *Advocate-Times*, the *Evening Advocate*, nor the *Bulletin of the Zenith Chamber of Commerce* had ever had an editorial on the matter, and until one of them had spoken he found it hard to form an original opinion.

Later we learn about Babbitt's religious beliefs. They are not particularly deep or thoughtful. As you read this excerpt, you may wish to reflect on the Gospel of Matthew in Chapter 6 of this book: "Beware of practicing your piety before men in order to be seen by them; for then you will have no reward from your Father who is in heaven."

READING 21.8 SINCLAIR LEWIS

From *Babbitt*, chapter 16

Actually, the content of his theology was that there was a supreme being who had tried to make us perfect, but presumably had failed; that if one was a Good Man he would go to a place called Heaven (Babbitt unconsciously pictured it as rather like an excellent hotel with a private garden), but if one was a Bad Man, that is, if he murdered or committed burglary or used cocaine or had mistresses or sold non-existent real estate, he would be punished. Babbitt was uncertain, however, about what he called "this business of Hell." He explained to Ted, "Of course I'm pretty liberal; I don't exactly believe in a fire-and-brimstone Hell. Stands to reason, though, that a fellow can't get away with all sorts of Vice and not get nicked for it, see how I mean?"

Upon this theology he rarely pondered. The kernel of his practical religion was that it was respectable, and beneficial to one's business, to be seen going to services; that the church kept the Worst Elements from being still worse; and that the pastor's sermons, however dull they might seem at the time of taking, yet had a voodooistic power which "did a fellow good—kept him in touch with Higher Things."

ALDOUS HUXLEY The English novelist Aldous Leonard Huxley (1894–1963) saw the unrestrained growth of technology as an inevitable tool of totalitarian control over individuals and society. His 1932 novel *Brave New World* is set in the far distant future: 600 A.F.—the abbreviation for "after Ford," referring to Henry Ford, who has been deified as the founder of industrial society. In this society, babies are born and raised in state hatcheries according to the needs of the state. They are produced in five classes (from Alpha to Epsilon) so that the exact numbers of needed intellectuals (Alphas) and menials (Epsilons) are produced. The goal of society is expressed in three words: Community/Identity/Stability. All sensory experience is supplied either by machines or by a pleasure drug called *soma*. Individuality, family relationships, creativity, and a host of other "unmanageable" human qualities have been eradicated from society by either coercion or programming.

Toward the end of the novel there is a climactic conversation between John Savage (known as "the Savage"), a boy from the wilds of New Mexico raised outside the control of society, and Mustapha Mond, one of the controllers of the "brave new world" of the future. Patiently, Mond explains to the young man the reasons why certain repressions are inevitable and necessary in the society of the future. The reader understands Huxley's warning that the great humanistic achievements—literature, art, religion—are threatening forces to any totalitarian society and as such are logical targets for a scientifically constructed society. His explanations now have a prescient and somber reality to us in the light of what we know about the real totalitarian societies of our own time.

Savage asks why workers in Mond's society waste their time on entertainments such as "feelies"—why they are not permitted to see something of quality, such as Shakespeare's *Othello*. Mond informs him that people in his world would not understand *Othello*.

READING 21.9 ALDOUS HUXLEY

From *Brave New World*, chapter 16

"Because our world is not the same as Othello's world. You can't make flivvers without steel—and you can't make tragedies without social instability. The world's stable now. People are happy; they get what they want, and they never want what they can't get. They're well off; they're safe; they're never ill; they're not afraid of death; they're blissfully ignorant of passion and old age; they're plagued with no mothers or fathers; they've got no wives, or children, or lovers to feel strongly about; they're so conditioned that they practically can't help behaving as they ought to behave. And if anything should go wrong, there's *soma*. Which you go and chuck out of the window in the name of liberty, Mr. Savage. *Liberty*!" He laughed. "Expecting Deltas to know what liberty is! And now expecting them to understand *Othello*! My good boy!"

> The Savage was silent for a little. "All the same," he insisted obstinately, "*Othello*'s good, *Othello*'s better than those feelies."
>
> "Of course it is," the Controller agreed. "But that's the price we have to pay for stability. You've got to choose between happiness and what people used to call high art. We've sacrificed the high art. We have the feelies and the scent organ instead."
>
> "But they don't mean anything."
>
> "They mean themselves; they mean a lot of agreeable sensations to the audience."

Aldous Huxley, "Brave New World." New York: HarperCollins Publishers, 1932, 1946.

What kinds of entertainment do we have today that Huxley might say "mean themselves" and do not necessarily have any additional value or virtue?

THE VISUAL ARTS

The visual arts moved in many directions between the years of 1914 and 1945. There were continuing developments in abstract art, including art influenced by Sigmund Freud's psychoanalytic theory—the view that there was a highly active unconscious mind that sought the expression of primitive impulses of one kind or another. Freud even theorized the existence of a death instinct, Thanatos, which seemed to some a plausible explanation of the horrors of war in the 20th century. Abstract art had raised the question of how accurately an artist should represent his or her subject, but in these years some artists argued that art need not represent anything at all that dwelled in the real world. Many artists

chose realism, of course, even a staid and stolid realism that was rooted in the soil and reflected Midwestern values in the United States. In an era of disillusionment and skepticism, there even arose artists who believed that the purpose of art was to destroy art. Other artists, such as those of the Harlem Renaissance, sought to fuse a variety of styles with their cultural experiences and personal identities. In Germany a new school of architecture, the Bauhaus, sprang up from the ashes and from the late-19th-century adage that form must follow function—raised to a simple but formal aesthetic. No previous era in art could have ushered in such diversity.

Abstract Art

The **Fauves** and German **Expressionists** had an impact on art in the United States as well as Europe. Although the years

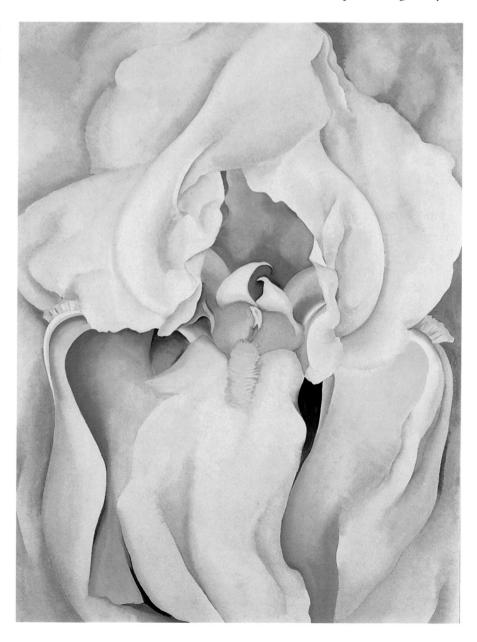

➤ **21.5** Georgia O'Keeffe, *White Iris*, 1924. Oil on canvas, 40″ × 30″ (101.6 × 76.2 cm). Virginia Museum of Fine Arts, Richmond, Virginia. © 2013 Georgia O'Keeffe Museum/ Artists Rights Society (ARS), New York. O'Keeffe helped clear the path for women to join the ranks of the art world by drawing the attention of New York artists as early as 1916. Many of her paintings of flowers appear to be suggestive of female genitalia, but the artist denied any such implications.

before World War I in the United States were marked by an adherence to Realism and subjects from everyday rural and urban life, a strong interest in European Modernism was brewing.

291 GALLERY The U.S. photographer Alfred Stieglitz propounded and supported the development of abstract art in the United States by exhibiting modern European works, along with those of U.S. artists who were influenced by the Parisian avant-garde—Picasso, Matisse, and others—in his 291 gallery (at 291 Fifth Avenue in New York). Georgia O'Keeffe was among the artists supported by Stieglitz.

GEORGIA O'KEEFFE

I said to myself—I'll paint what I see—what the flower is to me but I'll paint it big and they will be surprised into taking the time to look at it—I will make even busy New Yorkers take time to see what I see of flowers.

—GEORGIA O'KEEFFE

Throughout her long career, Georgia O'Keeffe (1887–1986) painted many subjects, from flowers to city buildings to the skulls of animals baked white by the sun of the desert Southwest. In each case, she captured the essence of her subjects by simplifying their forms. In 1924, the year O'Keeffe married Stieglitz, she began to paint enlarged flower pictures such as *White Iris* (**Fig. 21.5**). In these paintings, she magnified and abstracted the details of her botanical subjects, so that often a large canvas was filled with but a fragment of the intersection of petals. These flowers have a yearning, reaching, organic quality, and her botany seems to function as a metaphor for zoology. That is, her plants are animistic; they seem to grow because of will, not merely because of the blind interactions of the unfolding of the genetic code with water, sun, and minerals.

And although O'Keeffe denied any attempt to portray sexual imagery in these flowers (those who saw it, she said, were speaking about themselves and not her), the edges of the petals, in their folds and convolutions, are frequently reminiscent of parts of the female body. The sense of will and reaching renders these petals active rather than passive in their implied sexuality, so they seem symbolically to express a feminist polemic. This characteristic may be one of the reasons that O'Keeffe was "invited" to Judy Chicago's *Dinner Party* (see **Fig. 22.25**).

THE ARMORY SHOW Between 1908 and 1917, Stieglitz brought to 291—and thus to New York City—European modernists, the likes of Toulouse-Lautrec, Cézanne, Matisse, Braque, and Brancusi. In 1913, the sensational Armory Show—the International Exhibition of Modern Art held at the 69th Regiment Armory in New York City—assembled works by leading U.S. artists and an impressive array of Europeans including Goya, Delacroix, Manet and the Impressionists, van Gogh, Gauguin,

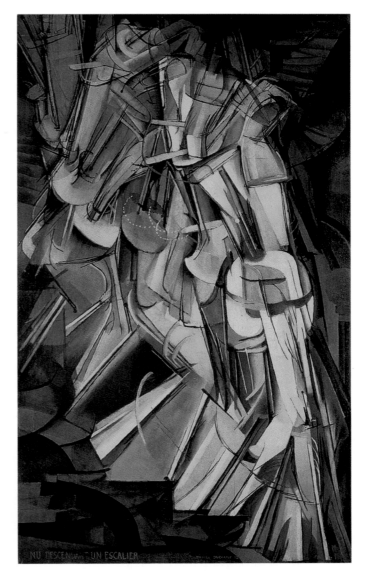

▲ **21.6** Marcel Duchamp, *Nude Descending a Staircase (No. 2)*, 1912. Oil on canvas, 57 7/8″ × 35 1/8″ (147 × 89.2 cm). Philadelphia Museum of Art, Philadelphia, Pennsylvania. © 2013 Artists Rights Society (ARS), New York/ADAGP, Paris /Succession Marcel Duchamp. The painting in effect creates multiple exposures of a machine-tooled figure walking down a flight of stairs. The overlapping of shapes and the repetition of linear patterns blur the contours of the figure. Even though the *New York Times* art critic Julian Street labeled the painting "an explosion in a shingle factory," it symbolized the dynamism of the modern machine era.

Picasso, and Kandinsky. Many more U.S. than European works were exhibited, but the latter dominated the show—raising the artistic consciousness of the Americans while raising some eyebrows. The most scandalous of the Parisian works, Marcel Duchamp's *Nude Descending a Staircase (#2)* (**Fig. 21.6**), which reflects the styles of Cubism and Futurism, was dismissed as a "pile of kindling wood." But the message to U.S. artists was clear: Europe was the center of the art world—for now.

CHARLES DEMUTH In the years following the Armory Show, U.S. artists explored abstraction to new heights, finding ways to maintain a solid sense of subject matter in combination with geometric fragmentation and simplification. Charles Demuth (1883–1935) was one of a group of artists called Cubo-Realists, or Precisionists, who overlaid stylistic elements from **Cubism** and **Futurism** on authentic American imagery. *My Egypt* (**Fig. 21.7**) is a precise rendition of a grain elevator in Demuth's hometown of Lancaster, Pennsylvania. Diagonal lines—contradictory rays of light and shadow— sweep across the solid surfaces and lessen the intensity of the stonelike appearance of the masses. The shapes in *My Egypt* are reminiscent of limestone monoliths that form the gateways to ancient temple complexes such as that at Karnak in Egypt. The viewer cannot help being drawn to Demuth's title, which acknowledges the association of the architectural forms and, at the same time, asserts a sense of American pride and history in the possessive adjective *my*. It seems to reflect the desire on the part of the U.S. artist to be conversant and current with European style while maintaining a bit of chauvinism about subjects that have meaning to their own time and place.

De Stijl or Neo-Plasticism

All painting is composed of line and color. Line and color are the essence of painting. Hence they must be freed from their bondage to the imitation of nature and allowed to exist for themselves.

—PIET MONDRIAN

◄ **21.7** Charles Demuth, *My Egypt*, 1927. Oil on composition board, 35³⁄₄″ × 30″ (90.8 × 76.2 cm). **Whitney Museum of American Art, New York, New York.** The painting is of a grain elevator reduced to its essential forms. It is one of many industrial images the artist painted of his hometown, Lancaster, Pennsylvania.

> **21.8** Theo van Doesburg, *Composition*, 1929. Oil on canvas, 11⁷⁄₈″ × 11⁷⁄₈″ (30.2 × 30.2 cm). Philadelphia Museum of Art, Philadelphia, Pennsylvania. De Stijl works such as these are nonobjective, meaning that they are not derived from any objects in the real world. The artist believed that more spiritual paintings would originate in the mind rather than in real life.

death, was drawn to the purity and precision of geometric shapes and a complete abstraction of reality that would lead to nonobjective works. Van Doesburg drew together like-minded artists and played a principal role in the dissemination of their style and theories through the publication of a magazine called *De Stijl* ("the style").

In van Doesburg's *Composition* (**Fig. 21.8**), black grid-like lines intersect to create geometric zones filled with primary colors. The void space in the composition—the large white area in van Doesburg's painting—becomes an active part of the work as a whole. Flatness was also a fundamental component of De Stijl paintings, as summarized by Piet Mondrian, an artist whose name is virtually synonymous with the style:

Painting occupies a plane surface. The plane surface is integral with the physical and psychological being of the painting. Hence the plane surface must be respected, must be allowed to declare itself, must not be falsified by imitations of volume. Painting must be as flat as the surface it is painted on.[4]

The De Stijl artists' obsessive respect for the two-dimensionality of the canvas surface may be viewed, in one sense, as the culmination of experiments with shallow, compressed pictorial space and the integration of figure and ground. In these works, canvas and painting, figure and ground, are one.

CONSTANTIN BRANCUSI The universality sought by Mondrian through extreme simplification can also be seen in the sculpture of Constantin Brancusi (1876–1957). Yet unlike van Doesburg's, Brancusi's works, however abstract they appear, are rooted in the figure. Brancusi was born in Romania 13 years after the Salon des Réfusés. After an apprenticeship as a cabinetmaker and studies at the National School of Fine Art, he traveled to Paris to enroll in the famous École Nationale Supérieur des Beaux-Arts. In 1907, Brancusi exhibited at the Salon d'Automne, leaving favorable impressions of his work.

Brancusi's work, heavily indebted to Rodin at this point, grew in a radically different direction. As early as 1909, he reduced the human head—a favorite theme he would draw upon for years—to an egg-shaped form with sparse indications

The second decade of the 20th century witnessed the rise of many dynamic schools of art in Russia and Western Europe. **De Stijl**, or Neo-Plasticism, was dedicated to pure abstraction, or nonobjective art. Nonobjective art differs from the abstraction of Cubism or Futurism in that it does not use nature as a point of departure and it makes no reference to visible reality. Compositions by artists associated with De Stijl consist primarily of some combination of geometric shapes, mostly primary colors, and emphatic black lines. In nonobjective art, the earlier experiments in abstracting images by Cézanne and then by the Cubists reached their logical conclusion. Kandinsky (see **Fig. 18.32**) is recognized as the first painter of pure abstraction, although several artists were creating nonobjective works at about the same time.

THEO VAN DOESBURG Van Doesburg (1883–1931), born in the Netherlands just seven years before Vincent van Gogh's

4. Robert Goldwater and Marco Treves (Eds.), *Artists on Art*. London: John Murray Pubs Ltd., p. 426.

of facial features. In this and in other abstractions such as *Bird in Space* (**Fig. 21.9**), he reached for the essence of the subject by offering the simplest contour that, along with a descriptive title, would fire recognition in the spectator. *Bird in Space* evolved from more representational versions into a refined symbol of the cleanness and solitude of flight.

Dada

In 1916, during World War I, an international movement arose that declared itself against art—Dada. Responding to the absurdity of war and the insanity of a world that gave rise to it, the Dadaists declared that art—a reflection of this sorry state of affairs—was stupid and must be destroyed. Yet in order to communicate their outrage, the Dadaists created works of art! This inherent contradiction spelled the eventual demise of their movement. Despite centers in Paris, Berlin, Cologne, Zürich, and New York City, Dada ended with a whimper in 1922.

The name **Dada** was supposedly chosen at random from a dictionary. It is an apt epithet. The nonsense term describes nonsense art—art that is meaningless, absurd, unpredictable. Although it is questionable whether this catchy label was in truth derived at random, the element of chance was important to the Dada art form. Dada poetry, for example, consisted of nonsense verses of random word combinations. Some works of art, such as the Dada collages, were constructed of materials found by chance and mounted randomly. Yet however meaningless or unpredictable the poets and artists intended their products to be, in reality they were not. In an era influenced by the doctrine of psychoanalysis, the choice of even nonsensical words spoke something at least of the poet. Works of art supposedly constructed in random fashion also frequently betrayed the mark of some design.

MARCEL DUCHAMP In an effort to advertise their nihilistic views, the Dadaists assaulted the public with irreverence. Not only did they attempt to negate art, but they also advocated antisocial and amoral behavior. Marcel Duchamp offered for exhibition a urinal, turned on its back and titled *Fountain*. Later he summed up the Dada sensibility in works such as *L.H.O.O.Q. (Mona Lisa)* (see **Fig.**

21.11 in the Compare + Contrast feature), in which he impudently defaced a color print of Leonardo da Vinci's masterpiece with a mustache and goatee.

Fortified by growing interest in psychoanalysis, Dada, with some modification, would provide the basis for a movement called Surrealism that began in the early 1920s.

Surrealism

Surrealism began as a literary movement after World War I. Its adherents based their writings on the nonrational, and thus they were naturally drawn to the Dadaists. Both literary groups engaged in automatic writing, in which the mind was to be purged of purposeful thought and a series of free associations were then to be expressed with the pen. Words were not meant to denote their literal meanings but to symbolize the often seething contents of the unconscious mind. Eventually the Surrealist writers broke from the Dadaists, believing that the earlier movement was becoming too academic. Under the leadership of the poet André Breton, they defined their movement as follows in a 1924 manifesto:

Surrealism, noun, masc., pure psychic automatism by which it is intended to express either verbally or in writing, the true function of thought. Thought dictated in the absence of all control exerted by reason, and outside all aesthetic or moral preoccupations.

Encycl. Philos. Surrealism is based on the belief in the superior reality of certain forms of association heretofore neglected, in the omnipotence of the dream, and in the disinterested play of thought. It leads to the permanent destruction of all other psychic mechanisms and to its substitution for them in the solution of the principal problems of life.[5]

From the beginning, Surrealism expounded two very different methods of working. **Illusionistic Surrealism**, exemplified by artists such as Salvador Dalí and Yves Tanguy, rendered the irrational content, absurd juxtapositions, and metamorphoses of the dream state in a highly illusionistic manner. The other, called **Automatist Surrealism**, was used to divulge mysteries of the unconscious through abstraction. The Automatist phase is typified by Joan Miró and André Masson.

FREUD, THE UNCONSCIOUS, AND SURREALISM In 1899, on the threshold of the century, the Viennese physician Sigmund Freud (1856–1939) published *The Interpretation of Dreams*, one of the most influen-

➤ **21.9** Constantin Brancusi, *Bird in Space*, 1924. Polished bronze, 56 1/2" (143.8 cm) high, including base, 17 3/4" (45 cm) circumference. Philadelphia Museum of Art, Philadelphia, Pennsylvania. © 2013 Artists Rights Society (ARS), New York/ADAGP, Paris. This particular sculpture is one of a series begun in 1923. It represents the movement of the bird in flight; the wings and feathers are not shown, the body is lengthened, and the head is severely abstracted.

5. André Breton, from *Le Manifeste du Surréalisme*. Paris: *Éditions du Sagittaire* 1924.

READING 21.10 SIGMUND FREUD

From *The Interpretation of Dreams*, VI. The Dream Work (continued). E. Representation in Dreams by Symbols: Some Further Typical Dreams

Dreams employ . . . symbolism to give a disguised representation to their latent thoughts. . . . The Emperor and the Empress (King and Queen) in most cases really represent the dreamer's parents; the dreamer himself or herself is the prince or princess. . . . All elongated objects, sticks, tree-trunks, umbrellas (on account of the opening, which might be likened to an erection), all sharp and elongated weapons, knives, daggers, and pikes, represent the male member. . . . Small boxes, chests, cupboards, and ovens correspond to the female organ; also cavities, ships, and all kinds of vessels. A room in a dream generally represents a woman; the description of its various entrances and exits is scarcely calculated to make us doubt this interpretation. The interest as to whether the room is open or locked will be readily understood in this connection. . . . The dream of walking through a suite of rooms signifies a brothel or a harem. . . . Steep inclines, ladders and stairs, and going up or down them, are symbolic representations of the sexual act. Smooth walls over which one climbs, facades of houses, across which one lets oneself down—often with a sense of great anxiety—correspond to erect human bodies, and probably repeat in our dreams childish memories of climbing up parents or nurses. Smooth walls are men; in anxiety dreams one often holds firmly to projections on houses.

Tables, whether bare or covered, and boards, are women, perhaps by virtue of contrast, since they have no protruding contours. . . . Of articles of dress, a woman's hat may very often be interpreted with certainty as the male genitals. In the dreams of men, one often finds the necktie as a symbol for the penis; this is not only because neckties hang down in front of the body, and are characteristic of men, but also because one can select them at pleasure, a freedom which nature prohibits as regards the original of the symbol. . . . It is quite unmistakable that all weapons and tools are used as symbols for the male organ: e.g., ploughshare, hammer, gun, revolver, dagger, sword, etc. To play with or to beat a little child is often the dream's representation of masturbation. The dream-work represents castration by baldness, hair-cutting, the loss of teeth, and beheading. . . . As an insurance against castration, the dream uses one of the common symbols of the penis in double or multiple form and the appearance in a dream of a lizard—an animal whose tail, if pulled off, is regenerated by a new growth—has the same meaning. Most of those animals which are utilized as genital symbols in mythology and folklore play this part also in dreams: the fish, the snail, the cat, the mouse (on account of the hairiness of the genitals), but above all the snake, which is the most important symbol of the male member. Small animals and vermin are substitutes for little children, e.g., undesired sisters or brothers. To be infected with vermin is often the equivalent for pregnancy.—As a very recent symbol of the male organ I may mention the airship, whose employment is justified by its relation to flying, and also, occasionally, by its form.

tial works of modern times. According to Freud's **psychoanalytic theory**, deep in the unconscious mind—which he called the *id*—were chaotic emotional forces of life and love (a life instinct called *Eros*) and death and violence (a death instinct called *Thanatos*). These unconscious forces, often at war with each other, are kept in check by the *ego*, which is the more conscious self, and the *superego*, which is the formally received training of parental control and social reinforcements. Human life is shaped largely by the struggle between the id, ego, and superego to prevent the submerged drives of the *unconscious* from emerging. One way to penetrate the murky realm of the human unconscious, according to Freud, is via dreams. In the life of sleep and dreams, the ego and superego are less likely to be able to keep primitive impulses repressed. "The dream," Freud wrote, "is the royal road to the unconscious." To put it simply, Freud turned the modern mind inward to explore those hidden depths of the human personality where he believed the most primitive and dynamic forces of life dwell.

After the Great War, Freud's ideas were readily accessible to large numbers of European intellectuals. His emphasis on nonrational elements in human behavior seemed logical to those who had been horrified by the carnage of the war. Surrealists were particularly interested in using Freud's theories about the dream world of the unconscious as a basis for a new aesthetics. In the following chapter we shall see that Abstract Expressionists, including Jackson Pollock, also based much of their work on psychoanalytic concepts.

Surrealism was both a literary and an artistic movement, gathered around the journal *Littérature*, edited in Paris by the French critic André Breton. In 1924, Breton published his first *Surrealist Manifesto*, which paid explicit homage to Freud's ideas on the subjective world of the dream and the unconscious. Throughout the 20th century, in fiction, poetry, drama, and criticism, other writers explored the implications of Freud and his followers.

SALVADOR DALÍ Modesty was not his strong suit. One of the few household names in the history of art belongs to a leading Surrealist figure, the Spaniard Salvador Dalí (1904–1989). His reputation for leading an unusual—one could say surreal—life would seem to precede his art, because many people not familiar with his canvases had seen Dalí's outrageous mustache and knew of his shenanigans. Once, as a guest on Ed Sullivan's television show, he threw open cans of paint at a huge canvas.

Dalí began his painting career, however, in a somewhat more conservative manner, adopting, in turn, Impressionist,

Mona Lisa: From Portrait to Pop Icon

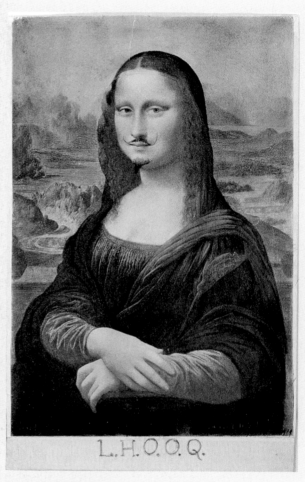

If you were asked to close your eyes and picture the top five works of art in all of history, surely one of the first couple that would come up on your memory screen would be none other than Leonardo's *Mona Lisa* (**Fig. 21.10**). The portrait has captivated poets and lyricists, museumgoers, and artists for centuries. Simply put, that face has been everywhere. Why and how did it attain this icon status? The *Mona Lisa* is almost definitely an actual portrait, although the identity of the sitter has not been verified. Giorgio Vasari, the painter and art historian of the Renaissance, claimed that the woman in the painting is Lisa di Antonio Maria Gherardini—the wife of a wealthy Florentine banker—hence the title *Mona Lisa*.

In its own day, though, it was quite an innovative composition. Among other things, Leonardo rejected the

∧ **21.11** Marcel Duchamp, *L.H.O.O.Q. (Mona Lisa)*, 1919. Rectified ready-made; pencil on colored postcard reproduction of Leonardo da Vinci's *Mona Lisa*, 7³/₄″ × 4⁷/₈″ (19.7 × 12.4 cm). Private collection. © 2013 Artists Rights Society (ARS), New York/ADAGP, Paris/Succession Marcel Duchamp.

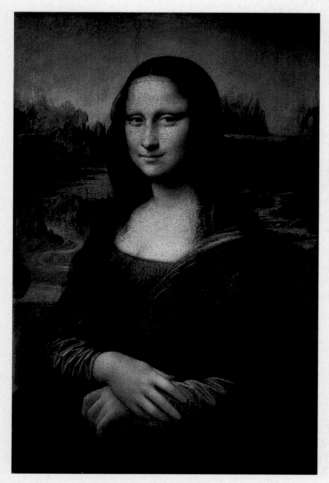

∧ **21.10** Leonardo da Vinci, *Mona Lisa*, ca. 1503–1505. Oil on wood panel, 30¹/₄″ × 21″ (77 × 53 cm). Musée du Louvre, Paris, France.

traditional profile portrait bust in favor of a three-quarter-turned, half-length figure. The inclusion of the hands in a natural position, for the most part uncharacteristic of earlier portraiture, was essential for Leonardo as a method of exploring and revealing the personality of the sitter: "A good painter has two chief objects to paint, man and the intention of his soul; the former is easy, the latter hard, because he has to represent it by the attitudes and movements of the limbs." A new look at portrait painting, to be sure. But there is still the matter of that enigmatic smile. And those eyes, which many have vouched follow the viewer's movements across a

room. The *Mona Lisa* is a beautiful painting, but does that account for why a visitor in search of the masterpiece in Paris's Louvre Museum need only look for the one painting that cannot be viewed because of the crowd surrounding it?

The selection of images in this feature represents but a sampling of work that attempts to come to terms with Mona Lisa: The Icon. One of the most infamous revisions of Leonardo's painting is by the Dada artist Marcel Duchamp (1887–1968), who in 1919 modified a reproduction of the original work, graffiti style, by penciling in a mustache and goatee (**Fig. 21.11**). Beneath the image is Duchamp's irreverent explanation of that enigmatic smile: if you read the letters "L.H.O.O.Q." aloud with their French pronunciation (ell osh oh oo coo) using a slurred, legato style, the sound your ears will hear is "elle a chaud au cul." (Rough PG-13-rated translation: "She has a hot behind.") The manifesto of the Dada movement contended that the museums of the world are filled with "dead art" that should be "destroyed." Dadaists also challenged the premises of originality and validity in in works of art. How, would you say, did Duchamp question those premises in *L.H.O.O.Q.*?

By using a reproduction of the Mona Lisa, an example of what he called a *ready-made*, Duchamp took what had become, on one level, a hackneyed image and transposed it into a work of art—simply because he chose it, modified it, and presented it as such. Is the artist's say-so enough

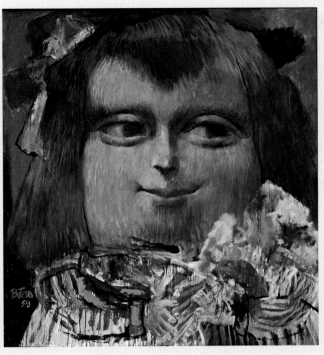

▲ **21.13** Fernando Botero, *Mona Lisa, Age Twelve*, 1959. Oil and tempera on canvas, 6'11⅛" × 6'5" (211 × 195.5 cm). Museum of Modern Art, New York, New York. © Fernando Botero, courtesy Marlborough Gallery, New York.

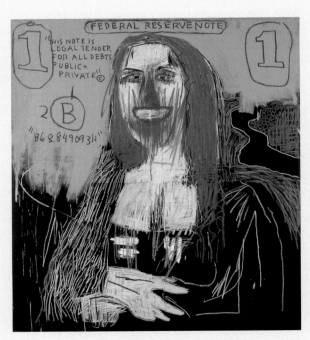

▲ **21.12** Jean-Michel Basquiat, *Mona Lisa*, 1983. Acrylic and pencil on canvas, 66¾" × 60¾" (169.5 × 154.5 cm). Private collection. © 2013 Estate of Jean-Michel Basquiat/ADAGP, Paris/ARS, New York.

to define an object as a work of art? What are the variables that you would list in your definition of a work of art? With works like *L.H.O.O.Q.*, Duchamp pressed the issue of whether one can—or even should—define art.

Duchamp's controversial work is also a commentary on the commodification—what the dictionary calls the inappropriate treatment of something as if it can be acquired or marketed like all other commodities, that is, articles of trade or commerce—of art. Jean-Michel Basquiat's (1960–1988) appropriation of Leonardo's famed portrait as a replacement for the head of George Washington on a U.S. one-dollar bill (**Fig. 21.12**) adds to the critical conversation about art and the forces that drive the art market.

The *Mona Lisa*. That smile. Those eyes. That eternal beauty. One might say that they would be recognized anywhere. It is just these idiosyncratically charming features that Fernando Botero (b. 1932) captures in his imagined portrait *Mona Lisa, Age Twelve* (**Fig. 21.13**). Far from the idealized, dignified, serene countenance of Leonardo's mature lady, the painting nonetheless bears telltale signs of the signature beauty and allure that the little girl will eventually grow to possess. The disproportions that characterize Botero's style have a special irony here, in that Leonardo was a keen student of the perfect proportions of the human body. Botero reminds us that the celebrities we iconize—and against whom perfection is measured—were, at one time, ordinary people.

◄ **21.14** Salvador Dalí, *The Persistence of Memory*, 1931. Oil on canvas, 9½" × 13" (24.1 × 33 cm). Museum of Modern Art, New York, New York. Copyright © Salvador Dalí, Fundació Gala-Salvador Dalí/Artists Rights Society (ARS), New York, 2013. In this work, which the artist called a "dream photograph," Dalí uses precise representation of Surrealistic objects. The melted watches and the swarming ants are suggestive of decay. The fleshy shape in the center, with a watch draped over its side, suggests the profile of the artist's own face.

pointillist, and Futurist styles. Following these forays into contemporary styles, he sought academic training at the Royal Academy of Fine Arts in Madrid. This experience steeped him in a tradition of illusionistic realism that he never abandoned.

In what may be Dalí's most famous canvas, *The Persistence of Memory* (**Fig. 21.14**), the drama of the dreamlike imagery is enhanced by his trompe l'oeil technique. Here, in a barren landscape of incongruous forms, time, as almost all else, has expired. A watch is left crawling with insects like scavengers over carrion; three other watches hang limp and useless over a rectangular block, a dead tree, and a lifeless, amorphous creature that bears a curious resemblance to Dalí. The artist conveys the world of the dream, juxtaposing unrelated objects in an extraordinary situation. But a haunting sense of reality threatens the line between perception and imagination. Dalí's is, in the true definition of the term, a surreality—or reality above and beyond reality.

JOAN MIRÓ

My way is to seize an image that moment it has formed in my mind, to trap it as a bird and to pin it at once to canvas. Afterward I start to tame it, to master it. I bring it under control and I develop it.

—Joan Miró

Not all of the Surrealists were interested in rendering their enigmatic personal dreams. Some found this highly introspective subject matter meaningless to the observer and sought a more universal form of expression. The Automatist Surrealists believed that the unconscious held such universal imagery, and they attempted to reach it through spontaneous, or automatic, drawing. Artists of this group, such as Joan Miró (1893–1983), sought to eliminate all thought from their minds and then trace their brushes across the surface of the canvas. The organic shapes derived from intersecting skeins of line were believed to be unadulterated by conscious thought and thus drawn from the unconscious. Once the basic designs had been outlined, a conscious period of work could follow in which the artist intentionally applied his or her craft to render them in their final form. But because no conscious control was to be exerted in determining the early course of the designs, the Automatist method was seen as spontaneous, as employing chance and accident. Needless to say, the works are abstract, although some shapes are amoebic.

Miró was born near Barcelona and spent his early years in local schools of art learning how to paint like the French Modernists. He practiced several styles, ranging from Romanticism to Realism to Impressionism, but Cézanne and van Gogh seem to have influenced him most. In 1919, Miró moved

to Paris, where he was receptive to the work of Matisse and Picasso. A use of native symbols and an inclination toward fantasy further shaped Miró's unique style.

Miró's need for spontaneity in communicating his subjects was compatible with Automatist Surrealism, although the whimsical nature of most of his subjects often appears at odds with that of other members of the movement. In *Painting* (**Fig. 21.15**), meandering lines join or intersect to form the contours of clusters of organic figures. Some of these shapes are left void to display a nondescript background of subtly colored squares. Others are filled in with sharply contrasting black, white, or bright-red pigment. In this work, Miró applied Automatist Surrealism in an aesthetically pleasing, decorative manner.

By 1930, Surrealism had developed into an international movement, despite the divorce of many of the first members from the group. New adherents exhibiting radically different styles kept the movement alive.

FRIDA KAHLO Although Frida Kahlo (1907–1954) was not a self-described Surrealist, those in that circle claimed her as one of their own. In her self-portraits, the Mexican painter used her life as an emblem for human suffering. At age 18, she was injured when a streetcar slammed into a bus on which she was a passenger. The accident left her with many serious wounds, including a fractured pelvis and vertebrae and chronic pain. Kahlo's marriage to the Mexican muralist painter Diego Rivera was also painful. She once told a friend, "I have suffered two serious accidents in my life, one in which a streetcar ran over me. . . . The other accident was Diego."[6] As in *Diego in My Thoughts* (**Fig. 21.16**), her face is always painted with extreme realism and set within a compressed space, requiring the viewer

6. Frida Kahlo, quoted in Martha Zamora, *Frida Kahlo: The Brush of Anguish* (San Francisco: Chronicle Books, 1990), 37.

◄ **21.15** Joan Miró, *Painting*, 1933. Oil on canvas, 68 1/2" × 77 1/4" (174 × 196.2 cm). Museum of Modern Art, New York, New York. © 2013 Successió Miró/Artists Rights Society (ARS), New York/ADAGP, Paris. Clusters of organic figures, representing nothing in the real world, float in space. The overall impression of many such works is intentionally childlike—what the artist referred to as an "assassination" of traditional painting.

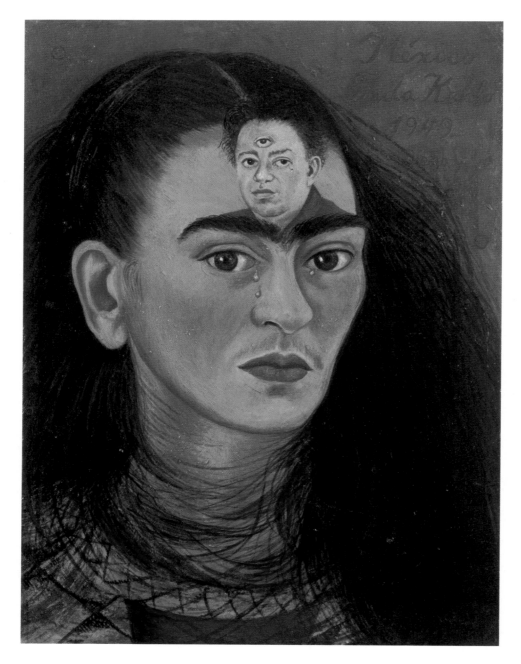

◄ **21.16** Frida Kahlo, *Diego in My Thoughts (Diego y yo)*, 1949. Oil on canvas, mounted on Masonite, 11⅞″ × 8¾″ (29.5 × 22.2 cm). Private collection. © 2013 Banco de México Diego Rivera Frida Kahlo Museums Trust, Mexico, D.F./Artists Rights Society (ARS), New York. Although Kahlo did not think of herself as a Surrealist, Surrealist artists claimed her as one of their own.

to confront the "true" Kahlo. When asked why she painted herself so often, she replied, "Porque estoy muy sola" ("Because I am all alone"). Those who knew Kahlo conjecture that she painted self-portraits in order to "survive, to endure, to conquer death."

The Harlem Renaissance

Also in the early part of the 20th century, a cultural movement was taking root in a section of New York City known as Harlem. There, a concentration of African American writers, artists, intellectuals, and musicians produced such a conspicuous body of specifically African American work that the movement became known as the **Harlem Renaissance**. There were explorers of African American culture like Zora Neale Hurston, James Weldon Johnson, and Alain Locke; poets like Countee Cullen, Helene Johnson, Langston Hughes, and Claude McKay; artists like Hale Woodruff, Sargent Johnson, Augusta Savage, Romare Bearden, Aaron Douglas, and Jacob Lawrence.

When one reads the poetry and fiction produced during the 1920s and 1930s by the Harlem Renaissance writers, it is easy to detect abiding themes of African American experi-

READING 21.11 LANGSTON HUGHES

"I, Too, Sing America"

I, too, sing America.
I am the darker brother.
They send me to eat in the kitchen
When company comes,
But I laugh,
And eat well,
And grow strong.
Tomorrow,

I'll be at the table
When company comes.
Nobody'll dare
Say to me,
"Eat in the kitchen,"
Then.
Besides,
They'll see how beautiful I am
And be ashamed—
I, too, am America.

ences: the ancestral roots in Africa; the quest for dignity in a culture of racism; the debate over the degree to which African American values should be part of—as opposed to distinct from—the majority culture; and the role of the church in life.

Behind most of these questions was the one posed at the beginning of the century by the African American intellectual W. E. B. Du Bois (1868–1963): what self-identity do African Americans affirm who must hold in balance their identity as being African, their place in American life, and the racism they endure? Those issues burn at the heart of Harlem Renaissance debates, as suggested by the poem in Reading 21.11 by Langston Hughes (1902–1967). The title of the poem is reminiscent of Walt Whitman's "I Hear America Singing."

AARON DOUGLAS Aaron Douglas (1899–1979) was born in Kansas and died in Tennessee, but beginning in his 20s he played a leading role in the Harlem Renaissance. At first he found work as a magazine illustrator, but soon he became known for his paintings that depicted the cultural history of African Americans. One of his aims, as those of the Harlem Renaissance in general, was to cultivate black pride.

Noah's Ark (**Fig. 21.17**) translates a biblical story into a work that speaks to African Ameri-

can sensibilities. One of seven paintings based on James Weldon Johnson's book *God's Trombones: Seven Negro Sermons in Verse* (1927), it expresses Douglas's powerful vision of the great flood. Animals enter the ark in pairs as lightning flashes

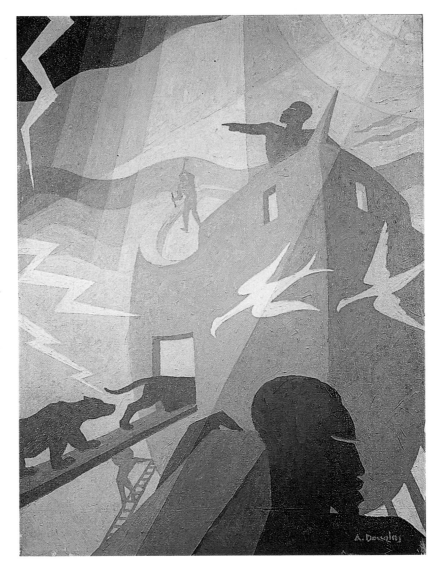

➤ **21.17** Aaron Douglas, *Noah's Ark*, ca. 1927. Oil on masonite, 48″ × 36″ (121.9 × 91.4 cm). Fisk University Art Galleries, Nashville, Tennessee. © Aaron Douglas. Courtesy of the Aaron and Alta Sawyer Douglas Foundation. Forms are partially abstracted but recognizable. The painting, as with many of the artist's others, has hard edges, flat forms, and repeated geometric shapes. The color changes where planes of color intersect.

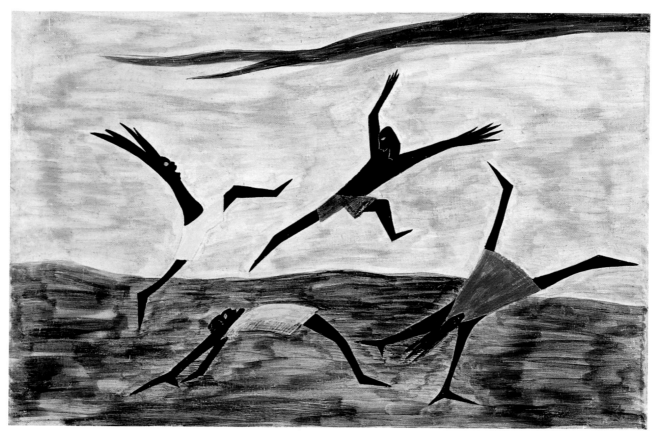

▲ **21.18** Jacob Lawrence, *The Life of Harriet Tubman*, No. 4, 1939–1940. Casein tempera on gessoed hardboard, 12″ × 17⅞″ (30.5 × 45.4 cm). Hampton University Museum, Hampton, Virginia. © 2013 The Jacob and Gwendolyn Knight Lawrence Foundation, Seattle/Artists Rights Society (ARS), New York. The diagonal lines contribute to the sense of movement. Lawrence termed his style "dynamic cubism," although he asserted that the visual elements of Harlem provided his main inspiration.

➤ **21.19** Grant Wood, *American Gothic*, 1930. Oil on beaverboard, 30¾″ × 25¾″ (78 × 65.3 cm). Art Institute of Chicago, Chicago, Illinois. Art © Figge Art Museum, successors to the Estate of Nan Wood Graham/Licensed by VAGA, New York, New York. The couple in the painting clearly lead an austere, rural life. The artist's style is representative of the U.S. movement called Midwestern Regionalism.

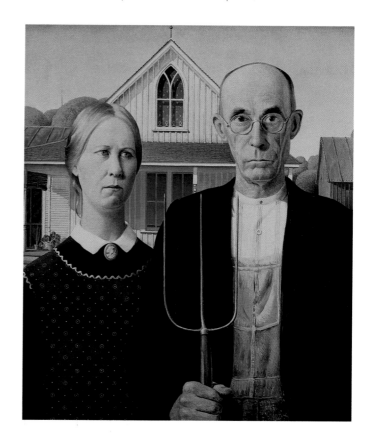

about them, and the sky turns a hazy gray-purple with the impending storm. African men, rendered in rough-hewn profile, ready the ark and direct the action in a dynamically choreographed composition that takes possession of and personalizes the biblical event for Douglas's race and culture.

JACOB LAWRENCE Born in New Jersey, Jacob Lawrence (1917–2000) moved to Harlem with his family as a teenager. He, like Aaron Douglas, would bring features reminiscent of African masks into his paintings. His best-known works address themes such as slavery, African American migration northward from the South, Harlem lifestyles, and World War II.

Lawrence used assertive sticklike diagonals to give the slave children in his painting *Harriet Tubman Series, No. 4* **(Fig. 21.18)** a powerful sense of movement and directionality. While the horizon line provides a somewhat stable world,

the brightly clad children perform acrobatic leaps, their branchlike limbs akin to the wood above. The enduring world implied by the horizon is shattered by the agitated back-and-forth of the brushed lines that define ground and sky. Such turmoil presumably awaits the children once they mature and realize their lot in life.

Figurative Art in the United States

Although most of the groundbreaking artists in the United States and Europe were creating abstract art, some artists chose to continue to work with **figurative art**. The term *figurative* does not just refer to human or animal figures, but to any art that contains strong references to people and objects in the real world. Two such artists working in the Depression era and during World War II were Grant Wood and Edward Hopper.

GRANT WOOD Grant Wood (1891–1942) was a proponent of a style known as Midwestern Regionalism. He trained in Europe during the 1920s, but rather than returning home with the latest developments in European abstract art, he was drawn to the realism of 16th-century German and Flemish artists.

The weatherworn faces and postcard-perfect surroundings in Grant Wood's *American Gothic* (**Fig. 21.19**) suggest the duality of rural life in the modern United States—hardship and serenity. The painstakingly realistic portrait is also one of our more commercialized works of art; images derived from it have adorned boxes of breakfast cereal, greeting cards, and numerous other products. Note the repetition of the pitchfork pattern in the man's shirtfront, the upper-story window of the house, and the plant on the porch. He is very much tied to his environment. Were it not for the incongruously spry curl falling from the woman's otherwise tucked-tight hairdo, we might view this composition—as well as the sitters therein—as solid, stolid, and monotonous.

EDWARD HOPPER Edward Hopper (1882–1967) was also a realist painter who took commonplace subjects, but unlike Wood, he often made them into metaphors for rootlessness and loneliness. He was fascinated by bleak New England architectural vistas that were either bereft of people or emptied of people by the artist. Yet he often used strong light playing off these buildings.

The architecture, hairstyles, hats, and shoulder pads—even the price of cigars (only five cents)—all set Hopper's *Nighthawks* (**Fig. 21.20**) in an unmistakably American city during the late 1930s or 1940s. The subject is commonplace

▾ **21.20** Edward Hopper, *Nighthawks*, 1942. Oil on canvas. 33⅛″ × 60″ (84.1 × 152.4 cm). The Art Institute of Chicago, Chicago, Illinois. Photography (Robert Hashimoto) © The Art Institute of Chicago

The painting is one of those in which Hopper takes an ordinary scene or event and imbues it with a sense of desolation. The men in the painting, other than the counter worker, can be read as somewhat sinister. The corner setting places the people—again, other than the counter worker—against the black glass of the farther window. The diner setting and the apparel of the people have a distinctly American quality.

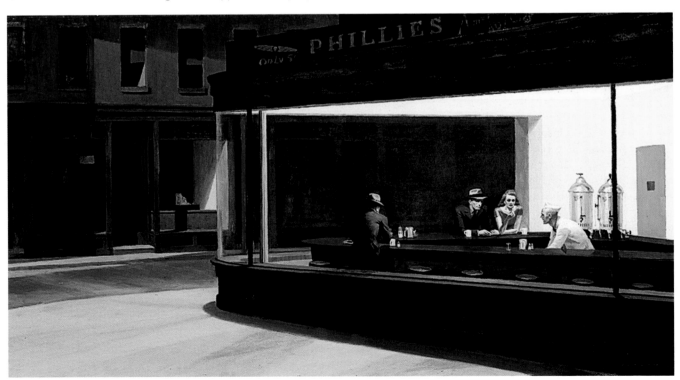

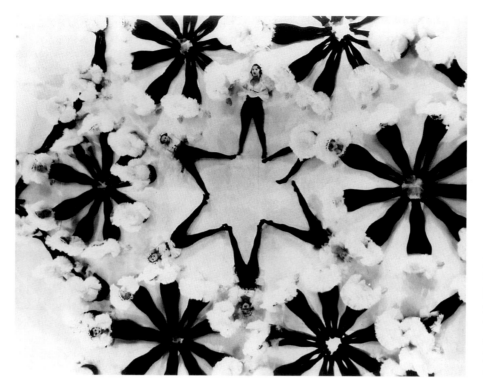

◄ **21.21 Busby Berkeley, "Tutti Frutti," still of production number in *Dames*, 1934.** Uplifting musicals such as those of the choreographer Busby Berkeley were popular during the Great Depression. The leads in *Dames* are Ruby Keeler and Dick Powell, and Keeler sings "I Only Have Eyes for You."

then on, the recording of sound on film would shape the future of cinema.

For the most part, the Busby Berkeley musicals of the 1930s (**Fig. 21.21**) were shot on indoor stages that pretended to be nothing but stages. The motion picture had not yet broken free from the stage that had preceded it. The musicals of the 1930s were everything that the photographs of Dorothea Lange and the other Depression photographers were not: bubbly, frivolous, light, even saucy. Perhaps they helped Americans make it through these difficult times. Some musicals of the 1930s showed apple-cheeked kids getting their break on the Great White Way. Others portrayed the imaginary shenanigans of the wealthy few in an innocent era when Hollywood believed that they would offer amusement and inspiration to destitute audiences rather than stir feelings of social conflict through depiction of conspicuous consumption and frivolity.

Visual artists such as the Surrealist Salvador Dalí also worked in film. Dalí collaborated with Luis Buñuel on *Un Chien Andalou* (**Fig. 21.22**), which disdains order or meaning in the traditional sense. In the shocking opening scene, normal vision is annulled by the slicing of an eyeball. The

and uneventful, though somewhat eerie. There is a tension between the desolate spaces of the vacant street and the corner diner. Familiar objects become distant. The warm patch of artificial light seems precious, even precarious, as if night and all its troubled symbols are threatening to break in on disordered lives. Hopper uses a specific sociocultural context to communicate an unsettling, introspective mood of aloneness, of being outside the mainstream of experience. That mainstream of experience at the time of the painting was World War II. We might very well wonder what these people are doing here when so many others are in uniform or otherwise engaged in the war effort.

Film

Following the Great War, commercial movie houses sprang up in France and in the United States, and motion pictures were distributed for public viewing. These were silent films accompanied by live orchestral music and stage shows. The next big step in moviemaking occurred with the first feature film incorporating sound—*The Jazz Singer* (1927). From

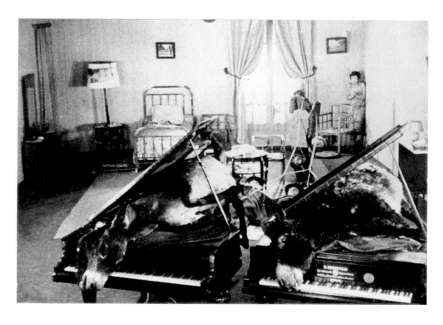

➤ **21.22 Luis Buñuel and Salvador Dalí, still from *Un Chien Andalou (An Andalusian Dog)*, 1929.** The creators of this film stated that nothing in the film symbolized anything, but alternatively allowed that the symbols could be investigated by means of psychoanalysis.

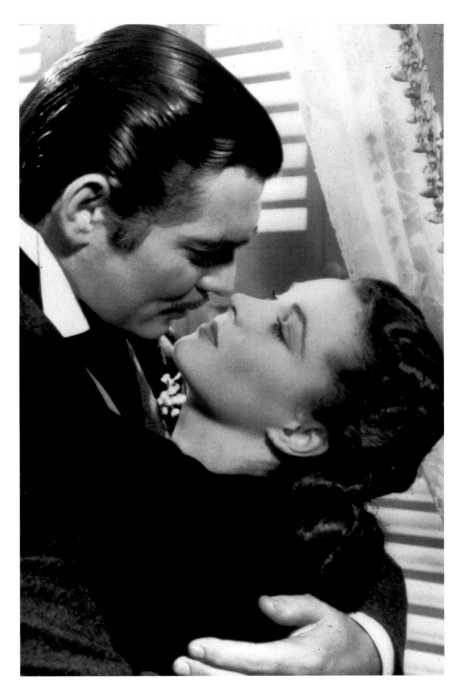

◄ **21.23** **David O. Selznick, still from *Gone with the Wind*, 1939.** The film, starring Clark Gable and Vivien Leigh, was one of Hollywood's earliest epics and, when inflation is considered, one of the film industry's top earners. It is set in the U.S. South during the Civil War era.

audience is then propelled through a series of disconnected, dreamlike scenes. In writing about *Un Chien Andalou*, Buñuel claimed that his aims were to evoke instinctive reactions of attraction and repulsion in the audience, but that nothing in the film *symbolized* anything.[7] Fantastic cinematographers often portray their depths of mind literally. They create on the screen the images that dwell deep within their minds.

Color came into use in the 1930s. One early color film, *The Wizard of Oz*, shot the farm world of Kansas in black and white and the imaginary Oz in glorious, often Expressionistic color. The screen version of Margaret Mitchell's *Gone with the Wind* was one of the first color epics, or "spectaculars." It remains one of the highest-grossing works of all film eras. In addition to the sweeping panoramas of the Civil War battlefield wounded and the burning of Atlanta, *Gone with the Wind* included close-ups of the passion and fire communicated by Clark Gable as Rhett Butler and Vivien Leigh as Scarlett O'Hara (**Fig. 21.23**).

During the 1930s, Walt Disney's studio began to produce full-color stories and images that have become part

7. Luis Buñuel, "Notes on the Making of Un Chien Andalou," in *Art in Cinema*, a symposium held at the San Francisco Museum of Art (repr., New York: Arno Press, 1968).

▲ **21.24** Walt Disney Productions, still from *Snow White and the Seven Dwarfs*, 1937. *Snow White and the Seven Dwarfs* is one of the most popular animated film features of all time. According to one common Disney formula, the heroine is apparently without family protection, is menaced by a wicked female force, and is saved by a "Prince Charming." The film, like other Disney features, also has several songs. Here we see Snow White in a song-and-dance number with the dwarfs—Bashful, Doc, Dopey, Grumpy, Happy, Sleepy, and Sneezy.

of our collective unconscious mind. Disney characters such as Mickey Mouse, Donald Duck, Bambi, Snow White (**Fig. 21.24**), and Pinocchio are national treasures. Mickey Mouse and Donald Duck also moved seamlessly into children's comic books.

THE PROPAGANDA FILM Propaganda is the presentation of a point of view with the intention to persuade and convince. We usually think of it in political terms. Throughout history, propagandists have used books, art, and music to spread their ideas, but the rise of film in the early part of the 20th century added immeasurably to propagandists' weapons. During the period between the wars, at a time when totalitarian governments rose dependent on a cooperative population, people began to understand the power of film to educate, persuade, and shape public opinion. Film most successfully blended propaganda with attempts at an artistic vision.

SERGEI EISENSTEIN Sergei Eisenstein (1898–1948), a Soviet filmmaker, remains one of the most influential artists in the history of the cinema. A dedicated supporter of the Russian Revolution, Eisenstein appreciated Lenin's observation that the cinema would become the foremost cultural weapon in winning over the proletariat to the Rev-

olution. From his early film *Strike* (1925) to his last work, *Ivan the Terrible, Part I* (1944) and *Part II* (1946), Eisenstein was conscious of the needs of the working class and what he saw as the inevitable triumph of communism—themes dear to the official line of Stalin's Soviet Union. His *Alexander Nevsky* (1938) had an impressive musical score by Sergei Prokofiev, and the two men collaborated to integrate musical and visual concepts. The vast *Ivan the Terrible* was indebted to a study of El Greco's paintings in which Eisenstein was inspired by the cinematic possibilities in that artist's striking canvases.

Eisenstein's most influential film, *Battleship Potemkin* (1925), is the story of the 1905 naval mutiny on the battleship *Potemkin* and the subsequent riot in Odessa that was crushed by the tsarist police. The Communists saw that incident as a foreshadowing of the October Revolution of 1917, which brought the **Bolsheviks** to power.

The scene in *Battleship Potemkin* of the crowd cheering the mutineers on a broad flight of stairs in Odessa and the subsequent charge of the police is a classic sequence in film history. In that sequence, Eisenstein uses the device of **montage** (the sharp juxtaposition of shots by film cutting and editing) with such power that the scene became a benchmark for subsequent filmmakers.

His close-ups were meant to convey a whole scene quickly: A shot of a wounded woman cuts to a close-up of a clenched hand that slowly opens, telling the story of death in a moment. An erratically moving baby carriage is a macabre metaphor for the entire crowd in panic and flight. Shattered eyeglasses and blood pouring from an eye (**Fig. 21.25**) symbolize tsarist oppression of the populace.

LENI RIEFENSTAHL For sheer explicit propaganda, one must turn to two documentary films made in Nazi Germany in the 1930s by the popular film actor and director Leni Riefenstahl (1902–2003). Her first great film was a documentary of the 1934 Nazi Congress in Nuremberg, called *Triumph of the Will* (1935). Designed to glorify the Nazi Party and to impress the rest of the world, the film made ample use of the great masses of party stalwarts who gathered for their rally. That documentary allowed the young filmmaker to show the party congress as a highly stylized and ritualistic celebration of the Nazi virtues of discipline, order, congregated might, and the racial "superiority" of the Teutonic elite of the party members.

Riefenstahl's other great film, and arguably her masterwork, was a long documentary made at the Berlin Olympics of 1936 and issued in 1938 under the title *Olympia*. Riefenstahl used five camera technicians and 38 assistants, as well as footage shot by news-agency photographers, to make her film. The completed documentary, divided into two parts, pays tribute to the Olympic spirit of ancient Greece, develops a long section on the carrying of the Olympic torch to Berlin, records the homage to Hitler and the Nazi Party, and shows most of the major athletic competitions.

As a film, *Olympia* is matchless in its imaginative use of the camera to catch the beauty of sport (**Fig. 21.26**). The vexing question is to what degree the film is political beyond the obvious homage paid to the German Third Reich, which sponsored the Olympics in 1936. Many critics note its elitist attitude to justify their contention that it is propaganda, albeit of a high and subtle quality. Athletes are depicted as superior beings who act beyond the range of ordinary mortals. They give all and seem almost demigods. The film praises the heroic, the conquest, the struggle. It praises the ritualized discipline of the crowds and lovingly seeks out examples of the adoring Berlin masses surrounding the party leaders.

WORLD WAR II Although there is some early (and choppy) footage of World War I, cinematography was ready for World War II. In fact, while many American actors were embattled in Europe and the Pacific, future president Ronald Reagan was making films for the United States that depicted the valor of the Allied soldiers and the malevolence of the enemy.

▼ **21.25** **Sergei Eisenstein, still from** *Battleship Potemkin*, **1925.** A classic shot in the history of film, this single close-up from the Odessa steps sequence represents the horror of the entire scene.

▼ **21.26** **Leni Riefenstahl, still from** *Olympia*, **1938.** This shot from the diving sequence shows the unique camera angles Riefenstahl used. Such angles became a model for documentary filmmakers.

MUSIC IN THE JAZZ AGE

Born out of the unique experiences of Americans of African heritage, jazz is a distinctively American contribution to Western culture. The matrix out of which jazz was born is an imperfectly documented history of a process that combined intonations, rhythmic patterns (especially repetition), and melodic lines that came from the African ancestors of African Americans and the tradition of the black spiritual, Christian hymns sung both in the slave culture of the South and in the free churches of blacks after the Civil War. In addition, jazz drew on the ineffable music of the blues, developed in the Deep South, with its characteristic and instantly recognizable **blue note** (a melody note bent a half step down). The blues existed mainly as an oral tradition in the rural Deep South in the 19th century, with one singer passing down songs to another, but it became a popular, public entertainment in city life from the 1920s onward. Musicians like W. C. Handy (the "Grandfather of the Blues") and singers like Mamie Smith, Ethel Waters, Ma Rainey, and Bessie Smith were immensely popular in the 1920s. And finally, jazz adapted certain European songs, especially French quadrilles and polkas, into a slightly different style of music that became known as *ragtime*.

Ragtime

Although **ragtime** music has undergone many revivals, and is in fact still composed and performed today, it reached its height in popularity during the approximately 20-year period stretching from the last decade of the 19th century to the second decade of the 20th. Its single most important feature is rhythmic syncopation: the accentuation of melodic notes not coinciding with the tune's beat. (Indeed, many believe that the designation "ragtime" derives from the longstanding African American tradition of playing music in syncopated or "ragged" time.) In the typical rag, a solo pianist's left hand defines the regular beats of the piece by playing a steady bass line in an upbeat march meter, while the right hand plays the melody with opposing beats, creating the rhythmic push and pull that gives the genre its distinctive feel.

SCOTT JOPLIN Scott Joplin (1868–1917), the unrivaled "King of Ragtime," scored his biggest success with the "Maple Leaf Rag," composed in 1897 and published as sheet music in 1899. The publication sold over 1 million copies, making it by many accounts the first platinum hit of all time. Its irresistible appeal still can be felt today in the jaunting, forward-driving rhythms, the effective contrast between the piano's high and low registers, and the remarkable variety: it packs four distinct sections, each repeated at least once, into less than three and a half minutes of music.

GO LISTEN! SCOTT JOPLIN
"Maple Leaf Rag"

The history of the recording of the music selection is itself of some interest. Shortly before his death in 1916, Joplin recorded his ragtime hits onto a piano roll—a perforated roll of paper that, when inserted into a mechanized apparatus, makes it possible for a piano essentially to play itself. Thus we are able to hear Joplin's performance of his own song, but in much higher fidelity than would have been possible using the standard audio recording technology of his day.

The Emergence of Jazz

Jazz rose to prominence early in the 20th century in cities throughout the U.S. South and Midwest. Without question, however, the epicenter of the jazz boom was New Orleans, Louisiana. The rich and varied musical culture of the city—including African American, French, Cuban, and other Caribbean idioms—made it the ideal locale to spark a new, progressive musical genre, one that has now become so revered as to be referred to as "America's Classical Music." The musicians, who were African Americans, performed without written music and were self-taught. They formed bands and played in the streets and in the cabarets of the city. By the end of World War I, many of these musicians had migrated north to Chicago, which, in the early 1920s, was the center of jazz music. From there, jazz spread to St. Louis, Kansas City, Harlem in New York City, and other urban centers on both coasts.

GO LISTEN! JOE "KING" OLIVER,
"West End Blues," Louis Armstrong and His Hot Five

So profound was the influence of the blues on the emergence of the earliest jazz idioms that it is entirely appropriate that the first true jazz compilation carries the word *blues* in its title. In "West End Blues," blues elements are featured prominently throughout the song. The piece begins with an expressive and virtuosic trumpet introduction, performed by Louis Armstrong—not only the most prominent exponent of New Orleans jazz, but also among the most important and revered U.S. musicians of the 20th century. Armstrong's Hot Five then launch into the **12-bar blues** form that will persist throughout the rest of the song. In a 12-bar blues, a fixed series of chords, 12 bars (or measures) in length, is restated continuously throughout the piece. What maintains the musical interest in such a seemingly repetitive form is the ongoing variation that occurs above the chords; it is as if

with each pass through the series, the ensemble offers a new perspective on a familiar story.

Armstrong's recording of "West End Blues"—a piece composed originally by Joe "King" Oliver with lyrics by Clarence Williams—features five passes through the 12-bar form. The first (beginning at 0:15) is something of a communal effort, with Armstrong's solo trumpet accompanied by lively, responsorial interplay between the clarinet and trombone, while the rhythm section provides the beat steadily underneath. The second time through (0:49–1:23), Armstrong's trumpet gives way to a soulful, bluesy trombone solo, featuring repeated bends and slides in pitch, often exploring the spaces *between* the pitches that Western ears are used to, and in the process passing through countless blue notes. The third statement of the form (1:23–1:57) shifts to a *call-and-response texture*—another hallmark of blues practice—between Armstrong and his clarinetist. Here, the clarinet takes the lead, performing short phrases, and Armstrong, **scatting** (singing improvised syllables with no literal meaning), first imitates and then embellishes them, before the two voices perform the last phrase together in parallel harmony. The piano takes over with a lively solo for the fourth statement of the form (1:57–2:30), before the full band returns for the final pass (2:31), with trumpeter Armstrong taking the lead once again, beginning impressively by holding a single pitch fully 16 beats. Finally, the piano initiates a flashy solo passage that leads to the song's concluding strains, which the full band plays in rich harmony. We hear Ella Fitzgerald scatting in the nearby music selection, "Blue Skies."

GO LISTEN! ELLA FITZGERALD

"Blue Skies"

Jazz as Swing

By the 1930s, the influence of jazz in the United States had moved into the cultural consciousness of the country at large. Jazz was now commonly referred to as *swing*, and swing bands toured the country. By far the most popular jazz ensemble during the 1930s and 1940s, the swing band or big band, typically consisted of between 12 and 25 musicians: sections of trumpets, trombones, and saxophones and clarinets (each section featuring approximately three to five musicians), as well as a rhythm section made up of drums, bass, piano, and guitar. In contrast to the improvised nature of New Orleans jazz, swing-era jazz pieces were arranged in advance by the band leader and read from sheet music or "charts" by the band members in performance. The genre is characterized by intricate, lush arrangements with a danceable "swing" feel.

GO LISTEN! BILLY STRAYHORN

"Take the 'A' Train," Duke Ellington Orchestra

The song "Take the 'A' Train" unquestionably holds a place among the most popular, influential, and enduring of all big-band-era jazz standards. Its title and lyrics refer to the "A" subway line running through New York City's Brooklyn, Harlem, and Manhattan. Edward Kennedy "Duke" Ellington (1899–1974), a giant in the history of jazz, gained fame at the glamorous Cotton Club in Harlem in the 1920s. This recording showcases his skills as an arranger and bandleader, creating a lively, creative, and varied instrumental showpiece. The piece was to become the signature number for Duke Ellington and his big band, and has been performed and recorded by countless jazz luminaries.

After an introduction by piano (performed by Ellington) and drums, the piece lays out its AABA form: A (0:06–0:17), A (0:17–0:28), B (0:28–0:39), A (0:40–0:50). After this initial iteration of the melody and chord progression (the "head," in jazz parlance), the rhythm section repeats the AABA progression while a muted trumpet performs an improvisatory solo (0:50–1:35). After the trumpet solo, the AABA pattern is unexpectedly interrupted by a lively call-and-response sequence (the brass call and the winds respond) that executes a **modulation** (a shift to a new key). After this brief interlude, the AABA form repeats, now in the new key (beginning at 1:41). Here, the winds and solo trumpet alternate and interweave phrases before a brilliant, staggered, "stop-time" passage (2:12–2:14) leads to a coda that repeats the A melody in subdued fashion as the piece draws to a close.

Today Ellington is known not only for his virtuoso orchestral skills but, with such popular works as "Mood Indigo," is considered the most important composer in big-band jazz. But he was also a true original in his attempt to extend the musical idiom of jazz into a larger arena. After World War II, Ellington produced many works for symphonic settings. His symphonic suite *Black, Brown, and Beige* had its first hearing at Carnegie Hall in 1943. This work was followed by others—whose titles alone indicate the ambition of his musical interests: *Shakespearean Suite* (1957), *Nutcracker Suite* (1960), *Peer Gynt Suite* (1962), and his ballet *The River* (1970), which he wrote for the dance company of Alvin Ailey, a notable African American choreographer.

Benny Goodman, known as "the king of swing," was a brilliant impresario. He set the musical world on its heels in 1938 by staging a swing and jazz concert in New York's Carnegie Hall—the inner sanctum of classical music. He also was one of the few band leaders to incorporate African American musicians into a predominantly European American band. As a musician, his greatest talent was performance on the clarinet. As we see in the nearby music selection, "Sing, Sing, Sing," Goodman's clarinet solos set a standard for speed, pattern, and flawless execution that other reed players tried to copy.

GO LISTEN! **BENNY GOODMAN**

"Sing, Sing, Sing" (1936)

Trombonist and band leader Glenn Miller created a distinctive, almost instantly recognizable sound. His smooth, danceable jazz captured the romance of the swing era. His original song "Moonlight Serenade" (1939) and his arrangements of "Tuxedo Junction" (1939) and the music selection "In the Mood" (1940), contributed to the popularity of his band. His death in a plane crash in 1944, after enlisting in the Air Force and leading an Air Force orchestra, made Miller a legend.

GO LISTEN! **GLENN MILLER**

"In the Mood"

The Influence of Jazz

Jazz as a musical and cultural phenomenon was not limited to the United States in the period after World War I. It had a tremendous following in Paris in the 1920s, where one of the genuine celebrities was the African American singer and dancer Josephine Baker (**Fig. 21.27**). Furthermore, just as Pablo Picasso had assimilated African sculptural styles in his painting, so serious musicians on the Continent began to understand the possibilities of this African American music for their own explorations in modern music. As early as 1913,

Igor Stravinsky (1882–1971) utilized the syncopated rhythms of jazz in his path-breaking ballet *The Rite of Spring*. His *L'Histoire du soldat* (1918) incorporates a ragtime piece that he composed based only on sheet music he had seen of such music. Other avant-garde composers in Europe also came under the influence of jazz. Paul Hindemith's (1895–1963) piano suite "1922" shows the clear influence of jazz. Kurt Weill's (1900–1950) *Dreigroschenoper* (*Threepenny Opera*; 1928), with a libretto by Bertolt Brecht, shows a deep acquaintance with jazz, demonstrated notably in the song "Mack the Knife."

GO LISTEN! **LOTTE LENYA**

"Mack the Knife"

Most music can be placed on one side or the other of the classical/popular divide. Mozart's Symphony No. 40 in G Minor (K. 550) is an unequivocally classical symphony; Usher's "Love in This Club" falls comfortably into the popular genre. But a number of artists have made efforts to straddle or cross over this border—British pop star Sting's *Songs from the Labyrinth* is a collection of Renaissance composer John Dowland's material; and classical cello virtuoso Yo-Yo Ma collaborates with renowned fiddler Mark O'Connor, bluegrass artist Alison Krauss, and singer/songwriter James Taylor on *Appalachian Journey*.

Many of the extremely talented musicians of the popular swing era were able to cross musical boundaries. Benny Goodman recorded Mozart's Clarinet Quintet with the Budapest String Quartet in 1939. In the same year, the African

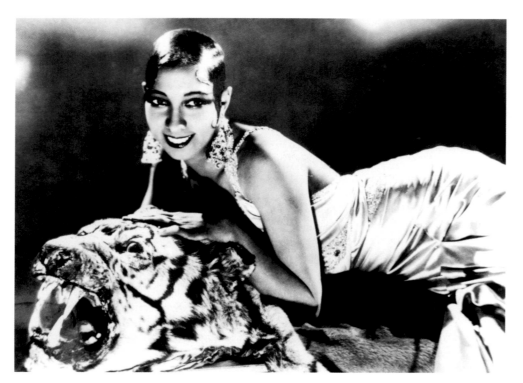

◀ **21.27 Josephine Baker, Paris, ca. 1925.** Josephine Baker, shown here lying on a tiger rug in a silk evening gown and diamond earrings, was born in St. Louis, Missouri. She first danced for the public on the streets of St. Louis and in the Booker T. Washington Theater, an African American vaudeville house there. Her first job in Paris was at the Folies-Bergère, where, nicknamed Black Venus, she became a tremendously popular jazz entertainer. Just before the onset of World War II, she renounced her U.S. citizenship to become a citizen of France; during the war she worked for the French Resistance.

American jazz pianist Fats Waller wrote his London Suite, an impressionistic tribute to that city. Such crossovers were the exception rather than the rule, but they underscore the rich musical breadth of the jazz movement.

Among the most fascinating crossover musicians in history is George Gershwin (1898–1937), who strove to bring African American idioms into contemporary American classical music. Gershwin's fascination with African American music predated his American opera *Porgy and Bess* (1935); many of his compositions had drawn on ragtime, blues, and jazz (the latter most famously in his *Rhapsody in Blue* of 1924). Nevertheless, *Porgy and Bess* represents Gershwin's magnum opus, and one of the most ambitious attempts ever to integrate traditional African American cultural and musical characteristics with those of classical music. The opera incorporates jazz rhythms and "shouting" spirituals of the Carolina coastal black churches into a libretto written by the Southern novelist DuBose Heyward and Gershwin's brother, Ira. Some of its most famous songs, such as "Summertime" and "It Ain't Necessarily So," have become standards.

GO LISTEN! GEORGE AND IRA GERSHWIN

"Summertime," *Porgy and Bess*

Porgy and Bess features an all-black cast of characters and is set in the fictional Catfish Row, an African American neighborhood in South Carolina in the 1920s. In the first scene, Clara, a fisherman's wife, sings the opera's most popular song, "Summertime," to her baby as a lullaby. The tension between the supremely optimistic text of the libretto ("the livin' is easy . . . the fish are jumping . . . your daddy's rich and your momma's good looking") and the anxious chromaticism of the minor key foreshadows the profound tension that is to persist throughout this tragic story of poverty, murder, drugs, and betrayal. The longevity of the song, and especially the diverse nature of subsequent renditions, is perhaps a testament to Gershwin's success in integrating popular and traditional African American idioms into the operatic medium. Indeed, most listeners are likely to be more familiar with the variety of jazz recordings of the piece—from Louis Armstrong and Ella Fitzgerald to Billie Holliday to John Coltrane—than with the full-throttle operatic version performed by Camilla Williams in the music selection.

Porgy and Bess was not an immediate success in New York, but later revivals in the 1940s and after World War II established its reputation. In 1952 it had a full week's run at the La Scala opera house in Milan; in 1976 the Houston Opera mounted a full production, with earlier deletions restored, that was seen subsequently at the Metropolitan Opera in New York. It now ranks as a classic.

Ultimately, as Gershwin's opera perhaps foreshadowed, jazz itself would move away from popular music for dancing and toward classical music for the listener. In the post–World War II era, John Birks "Dizzy" Gillespie (1917–1993)

and Charlie "Bird" Parker (1920–1955) would lead the way in the transformation of swing to bebop and modern jazz, and John Coltrane (1926–1967) and Miles Davis (1926–1991) would later experiment with *new wave* or cool jazz that further extended the definition and range of jazz.

BALLET

In the period between the world wars, one form of culture where the genius of the various arts most easily fused was the ballet. The most creative experiments took place in Paris, and the driving force was Serge Diaghilev (1872–1929). A Russian-born impresario, Diaghilev founded a dance company called the Ballets Russes, which opened its first artistic season in 1909. Diaghilev brought from Russia two of the most famous dancers of the first half of the century: Vaslav Nijinsky (1890–1950) and Anna Pavlova (1881–1931).

Ballet, like opera, is an art form that lends itself to artistic integration. To enjoy ballet, one must see the disciplined dancers in an appropriate setting replete with theatrical sets and costumes, hear the musical score that at once interprets and guides the movements of the dancers, and follow the narrative or "book" of the action. Seeking out and nurturing the efforts of the most creative artists of his era, Diaghilev had a particular genius for recruiting artists to produce works for his ballet. Over the years, the Ballets Russes danced to the commissioned music of Igor Stravinsky, Maurice Ravel, Sergei Prokofiev, Claude Debussy, and Erik Satie. In that same period, sets, costumes, and stage curtains were commissioned from such artists as Pablo Picasso, Georges Rouault, Naum Gabo, Giorgio de Chirico, and Jean Cocteau.

PARADE Diaghilev produced a one-act dance called *Parade*, which debuted in Paris in 1917. This short piece (revived in 1981 at the Metropolitan Opera with sets by the English painter David Hockney) is an excellent example of the level of artistic collaboration Diaghilev could obtain. The story of the interaction of street performers and men going off to war was by the poet Jean Cocteau (1891–1963), and the avant-garde composer Erik Satie (1866–1925) contributed a score replete with street sounds, whistles, horns, and other accoutrements of urban life. Pablo Picasso designed the curtain drop, the sets, and the costumes. *Parade* had much to say about musicians, players, and street performers, so the production was ready-made for Picasso's well-known interest in these kinds of people.

The collaborative effort of these important figures was a fertile source of artistic inspiration for Picasso, who had a great love for such work and returned to it on several occasions. He designed the sets for the ballets *Pulcinella* (1920), with music by Igor Stravinsky; *Mercury*, with music by Erik Satie; and *Antigone*, based on Jean Cocteau's French translation of Sophocles' Greek tragedy.

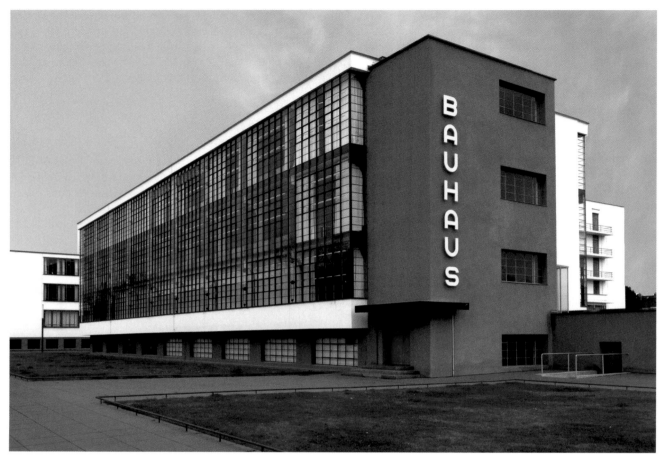

∧ **21.28 Walter Gropius, technical wing, Bauhaus School, 1925–1927. Dessau, Germany.** The school consisted of three arms radiating from a central hub. Each arm was bent into an L shape, and each served a distinct purpose: studios and dormitories, workshops, and classrooms.

ARCHITECTURE

In 1919, the year after Germany accepted the Weimar constitution at the conclusion of World War I, Walter Gropius organized the **Bauhaus**, a school founded on the desire to integrate craft, art, industrial design, and architecture.

WALTER GROPIUS Walter Gropius's (1883–1969) basic principles, in full reaction against Romanticism, emphasized simplicity, rationality, and functionality. The Bauhaus was one of the most important artistic influences in the period between the wars—a period that almost exactly coincides with the physical life of the school (**Fig. 21.28**). Its faculty offered courses in art, graphics, typography, and domestic and industrial design. Paradoxically enough, the school did not teach architecture as such until 1927. Its faculty designed everything from factories and apartment complexes to furniture, typefaces, and household items. Gropius's successor, Ludwig Mies van der Rohe, oversaw the school when it moved from Weimar to Dessau. The interim director, the Swiss Hannes Meyer, was a militant Communist whose political views brought unwelcome attention to the Bauhaus from the Nazi authorities in the early 1930s. Meyer fled to the Soviet Union when the school was closed in 1933. The Bauhaus was judged "decadent" and a front for communist activities.

Walter Gropius found refuge in the United States, settling at Harvard University's School of Design. Mies moved to Chicago. Both architects had an enormous influence on the subsequent history of American architecture, where both, in their own ways, laid the foundations for what is now known as modernist architecture. Other members of the Bauhaus school, like Marcel Breuer, were instrumental in the field of design as well as architecture.

The Bauhaus "style" is almost a synonym for "modern" architecture and design—a movement so powerful, especially in the United States, that it was a major voice in American building, with its characteristic unity of glass, steel framing, and clean lines. Its influence persisted well into the last quarter of the 20th century and lingers today.

FRANK LLOYD WRIGHT During the early years of the 20th century, Frank Lloyd Wright (1867–1959), as always, went his own way. His Kaufmann House (**Fig. 21.29**), which has also become known as Fallingwater, shows can-

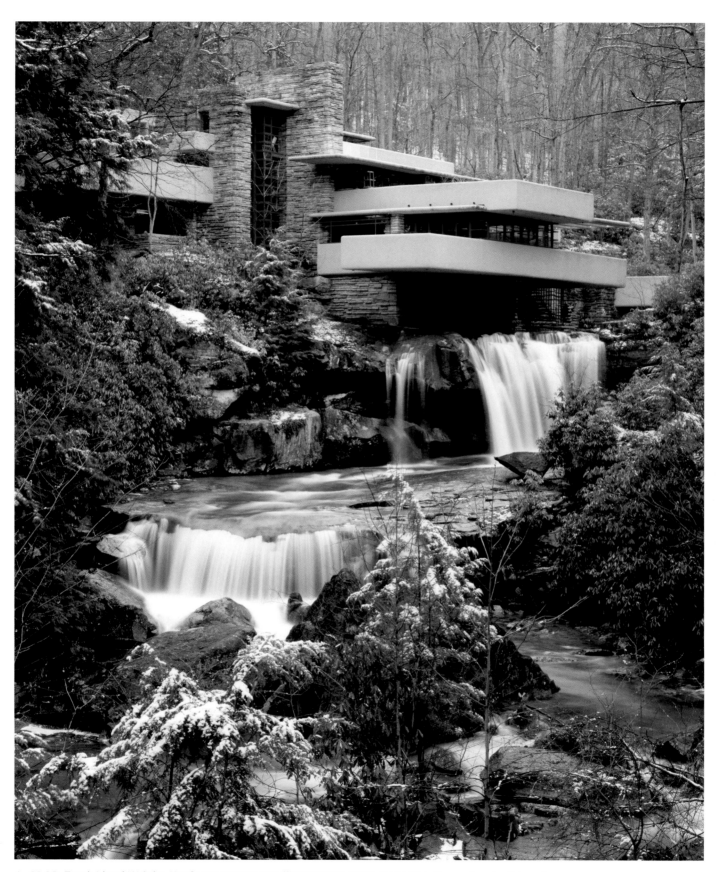

∧ **21.29** **Frank Lloyd Wright, Kaufmann House ("Fallingwater"), 1936. Bear Run, Pennsylvania.** Edward Kaufmann, a first lieutenant in World War I and the owner of the upscale Kaufmann's department store in Pittsburgh, commissioned the house. Wright's naturalistic style fully integrated the building with its picturesque site.

tilevered decks of reinforced concrete rushing outward into the surrounding landscape from the building's central core, intersecting in strata that lie parallel to the natural rock formations. Wright's **naturalistic style** integrates the building with its site. In the Kaufmann House, reinforced concrete and stone walls complement the sturdy rock of the Pennsylvania countryside.

For Wright, unlike the Bauhaus architects, modern materials did not warrant austerity; geometry did not preclude organic integration with the site. A small waterfall seems mysteriously to originate beneath the broad white planes of a deck. The irregularity of the structural components—concrete, cut stone, natural stone, and machine-planed surfaces—complements the irregularity of the wooded site.

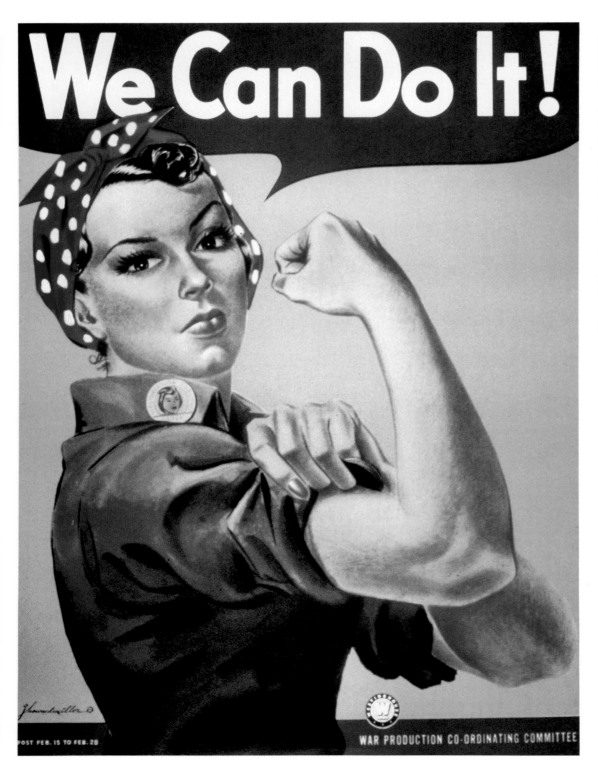

◄ **21.30** J. Howard Miller, "We Can Do It" (also called "Rosie the Riveter"), 1942. Color lithograph, 93" × 120" (236.2 × 304.8 cm). National Museum of American History, Smithsonian Institution, Washington, DC. With millions of men in uniform during World War II, industries retooled for the manufacture of war materials and turned to women to fill jobs on production lines. Posters like "We Can Do It" were part of an appeal to women to join the war effort. They also suggested to traditionalists that there was no place for division between gender roles in a country at war.

WORLD WAR II

It was as if the world had not learned the lessons of the Great War, which would come to be renamed World War I. Japan invaded China in 1937; in the West, an effort to roll back Hitler's invasion of Poland began in 1939. Britain and France, allied with Poland, declared war on Germany within two days. In 1940, the Netherlands, Belgium, and France were taken by a German blitzkrieg—literally, "lightning war"—which involved an overwhelming attack by artillery, tanks, and air power. Hitler was considering invading Britain across the English Channel, and might very well have succeeded. Germany bombed Britain, especially London, mercilessly in order to soften up the country, but in the Battle of Britain the outnumbered Royal Air Force held out—successfully stemming the German onslaught.

Also in 1941, Hitler made what was probably his biggest mistake of the war—invading the Soviet Union. A rabid anti-Semite, he also began slaughtering Jews wherever he found them, eventually killing one of every three Jews on the planet. The mass slaughter of Jews is called the Holocaust. The word *holocaust*, with a lowercase *h*, means a conflagration—a killing by flames, as in a city or forest aflame. With a capital *H*, it refers specifically to the genocide of the Jews.

At first the movement into the Soviet Union by Hitler and his allies—Romanians, Hungarians, and Italians—was swift. Hitler reached Leningrad (now Saint Petersburg) in the north and Stalingrad (now Volgograd) in the east. But he never reached Moscow, the capital, nor the vital oil fields in the Crimea. He also became bogged down in Stalingrad, which the Soviets held with fierce though costly resistance. As time went on, the Soviets were able to secretly amass an army that ultimately surrounded and defeated the attackers of Stalingrad, turning the war in the east in 1943. The Russians then lost the largest tank battle in history at Kursk. More Soviets than Germans died in every battle, but the Soviets seemed to be without number and their armaments, reinforced with supplies from the United States, became more sophisticated and also seemed limitless.

A couple of "details" will provide a sense of the German–Soviet horror. Some 90,000 Germans and their allied forces were taken prisoner at Stalingrad. They were marched to prisoner-of-war camps. Of this number, about 5000 survived to eventually return home. Stalingrad was left a ruin, with more than a million dead. The Germans had dubbed Stalingrad "das Kessel"—"the kettle."

The United States declared war on Hitler's East Asian ally, Japan, after the Japanese attacked Hawaii's Pearl Harbor on December 7, 1941, sinking an important part of the U.S. Pacific Fleet. President Franklin Delano Roosevelt called December 7th "a day that will live in infamy." Although at first the West Coast of the United States appeared to be vulnerable to a Japanese invasion, U.S. productive power (**Fig. 21.30**) and military strategy decisively defeated the Japanese navy at Midway in 1942, not ending the war but terminating the possibility of a Japanese invasion or victory. But in the same year, Hitler sped up the murder of Jews in death camps, most notably Auschwitz in captured Poland, where some 17,000 people were gassed and cremated *every day* (**Fig. 21.31**).

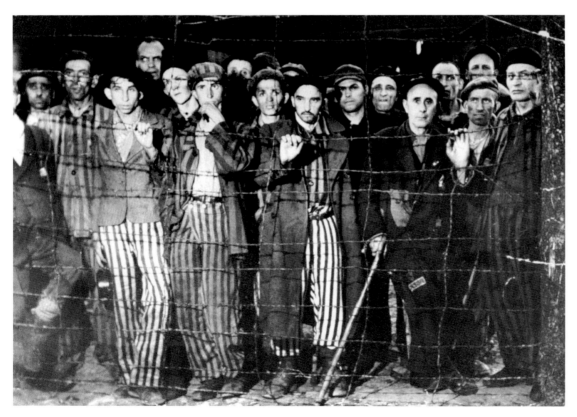

◀ **21.31** Margaret Bourke-White, *The Living Dead at Buchenwald, April 1945*, 1945. **Photograph.** The photograph was taken for *Life* magazine when Bourke-White and her colleagues accompanied General George Patton's Third Army in the spring of 1945. The few survivors of genocide stare out disbelievingly at their Allied liberators.

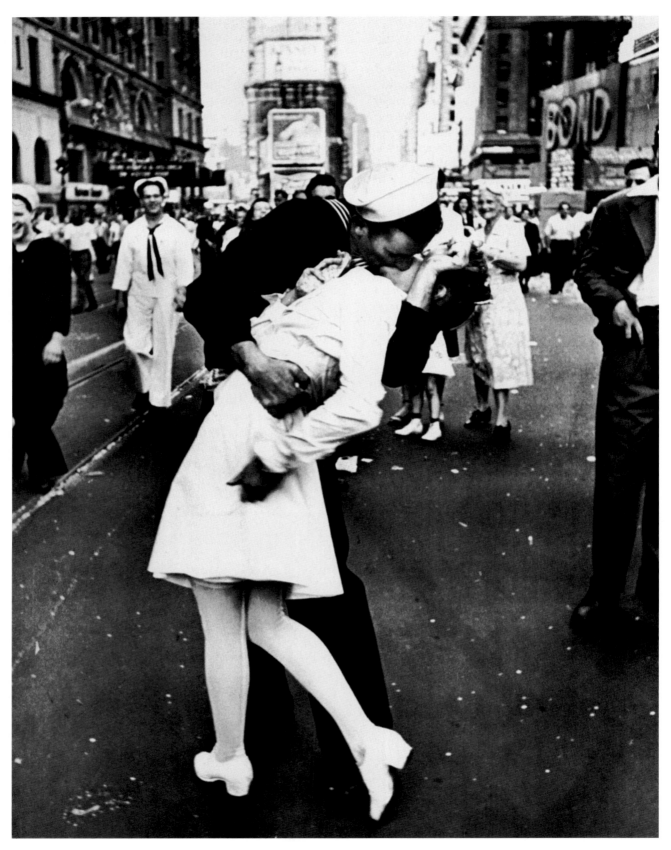

▲ **21.32 Alfred Eisenstaedt, *The Kiss*, August 14, 1945. Photograph.** A sailor kisses a nurse in Times Square, New York City, on Victory over Japan Day. The iconic photo was published along with others in a 12-page section in *Life* magazine called "Victory." Eisenstaedt happened to catch a spontaneous event. The nurse, apparently surprised, clutches her skirt and purse.

There had been fighting in North Africa, and the Allies, mainly the United States and Great Britain, defeated the Germans there in artillery duals and tank battles. They then invaded Germany's ally, Italy, in 1943. Italy surrendered and, after removing its fascist dictator, Mussolini, from power, turned about-face and declared war on Germany. On D-Day, the sixth of June, 1944, the Allies landed on the beaches of Normandy, a French region on the English Channel, which had been in the hands of the Germans. The Germans were now attempting to defend multiple fronts—with the Soviets approaching from the east and the Americans, British, and other allies driving in from the west and coming up through Italy and southern France. The Germans could not succeed. Meanwhile, in the Pacific, Americans were taking Japanese-occupied island after island, at immense cost, moving ever closer to Japan proper.

Events in 1945 were fast and furious. Auschwitz was liberated, although very few prisoners there remained alive. The Soviets reached Berlin. Hitler and many of his inner circle committed suicide, and a German field marshal surrendered, for Germany, on May 7. The president of the United States, then Harry S. Truman, concluded that an invasion of Japan would be too costly and instead dropped atom bombs on Hiroshima and Nagasaki. More Japanese lives were actually lost in an earlier firebombing of Tokyo, but the message was clear. The Japanese surrendered on August 14 (**Fig. 21.32**).

The casualties were unprecedented in warfare. It is estimated that some 20–25 million Soviets died and some 6–9 million Germans. Other deaths included 10–20 million Chinese, 2–3 million Japanese, 1–3 million Indians, and hundreds of thousands of British, French, and Americans. Add these and other losses to the 6 million Jewish civilians—men, women, and children—slaughtered for no reason except they were Jewish. It adds up to 60–80 million people, combined military and civilian.

The United States occupied Japan. Germany was split into four areas of occupation—by the United States, Britain, France, and the Soviet Union, which took what would become called East Germany. The capital of Berlin, although within the Soviet sphere of occupation, was similarly split four ways. The Soviets also maintained a tight fist on nations they had captured in Eastern Europe, from Poland in the north to Albania in the south. The war over, hostility between the capitalist and socialist West and the communist Soviet Union soon resumed. But that is a story for another chapter.

GLOSSARY

12-bar blues (p. 808) A form of blues in which a fixed series of chords, 12 bars (or measures) in length, is restated continuously throughout the piece.

Automatist Surrealism (p. 794) A form of **Surrealism** in which the artist or writer freely associates to the task at hand in the belief that the work is being produced by the unconscious mind.

Bauhaus (p. 812) A school of design established in Germany by Walter Gropius based on functionalism and employing techniques and materials used in manufacturing.

Blue note (p. 808) A melody note bent a half step down.

Bolshevik (p. 806) A member of a left-wing party that adopted the communist concepts of Marx and Lenin.

Cubism (p. 792) A 20th-century style of painting developed by Picasso and Braque that emphasizes the two-dimensionality of the canvas, characterized by multiple views of an object and the reduction of form to cube-like essentials.

Dada (p. 794) A post–World War I movement that sought to use art to destroy art, thereby underscoring the paradoxes and absurdities of modern life.

Degenerate art (p. 781) The term used by Hitler for art, including most modern art, that did not fit his definition of good German art.

De Stijl (p. 793) An early-20th-century art movement that emphasized the use of basic forms, particularly cubes, horizontals, and verticals; also called *Neo-Plasticism*.

Epiphany (p. 785) A sudden realization of the meaning or nature of something.

Expressionism (p. 790) A modern school of art in which an emotional impact is achieved through agitated brushwork, intense coloration, and violent, hallucinatory imagery.

Fascism (p. 781) A radical authoritarian national political ideology.

Fauve (p. 790) An artist working in an early-20th-century style of art characterized by the juxtaposition of areas of bright colors that are often unrelated to the objects they represent, and by distorted linear perspective.

Figurative art (p. 803) Art that represents forms in the real world, especially human and animal forms.

Futurism (p. 792) An early-20th-century style of art that portrayed modern machines and the dynamic character of modern life and science.

Harlem Renaissance (p. 800) A renewal and flourishing of African American literary, artistic, and musical culture following World War I in the Harlem section of New York City.

Illusionistic Surrealism (p. 794) A form of **Surrealism** that renders the irrational content, absurd juxtapositions, and changing forms of dreams in a manner that blurs the distinctions between the real and the imaginary.

Jazz (p. 808) A musical style born of a mix of African and European musical traditions at the beginning of the 20th century.

Modulation (p. 809) In music, the shift to a new key.

Montage (p. 806) The sharp juxtaposition of scenes by film cutting and editing.

National Socialism (p. 781) A right-wing, **fascist**, anti-Semitic, and anti-Communist movement that developed in Germany; also known as *Nazism*.

Naturalistic style (p. 814) Frank Lloyd Wright's architectural style, in which a building's form is integrated with its site.

Prohibition (p. 784) The period in the United States from 1920 to 1933, during which the 18th Amendment prohibited the manufacture or sale of alcoholic beverages.

Propaganda (p. 806) The presentation of a point of view with the intention to persuade and convince.

Psychoanalytic theory (p. 795) Sigmund Freud's theory of personality, which assumes the presence of unconscious conflict and the mental structures of the id, ego, and superego.

Ragtime (p. 808) A syncopated (off-beat) musical style popular between about 1899 and 1917. A forerunner of jazz.

Scatting (p. 809) The singing of improvised syllables that have no literal meaning.

Stream of consciousness (p. 786) A literary technique that is characterized by an uncensored flow of thoughts and images, which may not always appear to have a coherent structure.

Surrealism (p. 794) A 20th-century style of art and literature whose content and imagery is believed to stem from unconscious, irrational sources and therefore takes on fantastic forms, although often rendered with extraordinary realism.

THE BIG PICTURE THE WORLD AT WAR

Language and Literature

- Poets of the Lost Generation wrote poetry during World War I.
- Joyce wrote novels such as *Ulysses* (1922) in which he used stream of consciousness.
- Lewis wrote the novel *Babbitt* (1922), which is an indictment of the intellectual vacancy of the middle class and its pressure to conform.
- Hughes's writings (e.g., "I, Too, Sing America," 1925) reflected the movement known as the Harlem Renaissance.
- Kafka wrote stories and novels in which people are trapped by dangerous, incomprehensible forces (e.g., *The Trial*, 1925).
- Hemingway published short stories (e.g., "In Another Country," 1927) and novels about World War I and the Spanish Civil War.
- Woolf wrote *A Room of One's Own* (1929), in which she protests the relegation of women to second-class status.
- Huxley published the novel *Brave New World* (1931), in which the effort to create stability results in a mechanistic society that uses selective breeding of humans so that they will be content with menial labor.

Art, Architecture, and Music

- The functionalist Bauhaus movement was innovated by Gropius in Germany in 1919.
- Ragtime and jazz developed from African and European musical styles, with Joplin considered the "King of Ragtime."
- O'Keeffe and Demuth were among those who created abstract art in the early-20th-century United States.
- Armstrong popularized New Orleans jazz after World War I.
- Chagall created abstract paintings and stained-glass works that often reflect Jewish themes.
- Ballet blossomed between the wars, particularly in France and Russia.
- Van Doesburg and Mondrian worked in the De Stijl movement.
- Duchamp worked in the Dada style, in which art is used to destroy art.
- Gershwin's *Porgy and Bess* was first staged in 1935.
- Wright designed buildings in the naturalistic style, including "Fallingwater" in 1936.
- Photographers such as Lange and Evans recorded the desperation of ordinary citizens during the Great Depression.
- De Chirico created Fantastic art.
- Freud's psychoanalytic theory was used as an inspiration for Surrealism (and, after World War II, for Abstract Expressionism).
- Dalí, Magritte, Miró, and Kahlo created artworks in the Surrealist style.
- Douglas and Lawrence's paintings represented the flourishing of the Harlem Renaissance.
- Berkeley's films entertained during the Great Depression; *Gone with the Wind* was an early Hollywood color epic.
- Propaganda films were made by Eisenstein in the Soviet Union and Riefenstahl in Germany.
- Picasso painted *Guernica* in 1937 as a protest against the bombing of civilians in the Spanish Civil War.
- Wood and Hopper created figurative artworks in the United States.

Philosophy and Religion

- Disillusionment reigned following World War I.
- Communism came to power in Russia in 1917.
- Fascism came to power in Germany, Italy, and Spain in the 1930s and was defeated in Germany and Italy in 1945.

The Contemporary Contour

PREVIEW

In the summer of 1950, a radio broadcaster named William Wright interviewed the artist Jackson Pollock, who by that time had become somewhat of a household name. Just one year earlier, *Life*—a weekly magazine with 50 pages of pictures and the news condensed to accompanying captions—featured a four-page spread on Pollock that carried the headline, "Is he the greatest living painter in the United States?" He was certainly the most famous.

When Pollock died in a car crash in the summer of 1956, *Life* magazine dubbed him "Jack the Dripper." His signature style—drips, spatters, and looping skeins of enamel paint flung from sticks and brushes onto a canvas spread on the studio floor—was called "action painting," the byproduct of a dynamic, choreographed process in which Pollock's body, his gestures, was fully invested. He defied the traditional relationship of the artist to the easel, departed from conventional materials, and prioritized the notion that "technique is just a means of arriving at a statement."

In 2012, the *New York Times Magazine* and the *Huffington Post* Internet newspaper both ran stories on Martin Klimas, a German artist who has been called a "3-D Jackson Pollock." Posing the question "What does sound look like?," Klimas combines paint, music, photography, and technology to produce transfixing images whose unique character is determined not by the artist's hand but by relationships among these elements that occur outside of his direct control (**Fig. 22.1**). His work is influenced by the studies of wave phenomena and of the effect of vibrations on liquids and powders undertaken by the Swiss scientist Hans Jenny. These effects, Jenny concluded, are not unregulated chaos but rather a dynamic but ordered pattern.

Klimas begins a project by placing paint directly on a scrim on top of a sound speaker, after which he turns up the volume on a specifically chosen piece of music (anything from the jazz trumpet of Miles Davis to the sixties rock tunes of the Velvet Underground and the electronic music of Kraftwerk). The vibrations created by the music blasting though the speaker create explosive patterns of shape and color that are captured by Klimas with his Hasselblad camera at a shutter speed of 1/7000th of a second. One of his projects, which resulted in 212 printed images, used an average of six ounces of paint per shot and a total of 18.5 gallons of paint. The number of blown speakers: two.

It is hard to imagine Klimas's work outside of Pollock's legacy (see **Fig. 22.5**). With his radical experimentation with materials and processes, Pollock cast a wide net of possibilities that would, in its own way, make Klimas's possible work. Pollock's painting defined, and was of, his age, just as it would be inconceivable to separate Klimas from the digital age in which he lives. In his interview with Pollock, Wright asked this question: "Mr. Pollock, there's been a good deal of controversy and a great many comments have been made regarding your method of painting. Is there something you'd like to tell us about that?" Pollock answered: "My opinion is that new needs need new techniques. And the modern artists have found new ways and new means of making their statements. It seems to me that the modern painter cannot express this age, the airplane,

◄ **22.1** Martin Klimas, *Untitled* (Miles Davis, "Pharaoh's Dance," from "Bitches Brew"), 2011. Lambda print facemounted on acrylic, 20″ × 18⅛″ (52 × 46 cm). © Martin Klimas. Image courtesy of the artist.

the atom bomb, the radio, in the old forms of the Renaissance or of any other past culture. Each age finds its own technique."[1]

TOWARD A GLOBAL CULTURE

Now that we have entered the 21st century, the events that happened just after 1945 seem to recede into distant history. It is difficult to remember what has happened to U.S. culture in the three generations since the end of World War II. Events that occurred in the past more than four decades ago are still perhaps too close to know whether they have permanently changed us as a people. Was the moon landing of 1969 really a watershed in our consciousness as humans? Has the "American Century," so proudly forecast by commentators at the end of World War II, drawn to a close? Has the revolution in communications—the age of information—changed the way we learn? Are microtechnology, new forms of communication, and the computer going to usher in a new, wonderful era or an anti-utopia?

The decades following World War II were rightly called the Atomic Age. Developed largely by refugee scientists during that war, atomic weaponry placed an ominous shadow over all international tensions and potentially belligerent situations. It is not merely a question of nuclear bombs being bigger or deadlier weapons, although they are surely that. Nuclear weapons can have long-term and little-understood consequences for both nature and the individuals who might survive the first blast. Today, with a precariously balanced peace, the real fear of nuclear weapons is their possible use by rogue nations or terrorist groups.

First, because modern warfare was so far beyond the power of the postwar human intellect to imagine, artists turned to satire as a way of expressing their fear and hatred of it. Novels like Joseph Heller's *Catch-22* (1961) and Thomas Pynchon's *Gravity's Rainbow* (1973) sketched out war in terms of absurdity, irrationality, and the blackest of humor, while Stanley Kubrick's brilliant movie *Dr. Strangelove* (1964) mounted a scathing attack on those who speak coolly about "megadeaths" and "mutual assured destruction" (MAD in military jargon). Any attempt at mere realism, these artists seemed to say, pales into triviality.

Second, at the end of World War II, the United States emerged both as a leading economic power in the world and

1. Jackson Pollock, interview by William Wright in "Pollock: A Catalogue Raisonné", ed. Francis V. O'Connor and Eugene Victor Thaw. New Haven: Yale University Press, 1978.

The Contemporary Contour

1945 CE	1950 CE	1960 CE	1970 CE	1990 CE
United States drops atomic bombs on Hiroshima and Nagasaki in 1945	Korean War begins in 1950	East Germany erects the Berlin Wall in 1961	Supreme Court decision in *Miller v. California* effectively ends censorship in 1973	East and West Germany reunite in 1990
World War II ends in Europe and Japan in 1945	United States explodes first hydrogen bomb in 1952	Soviet Union launches first human into space in 1961	United States withdraws from Vietnam in 1975	Soviet Union is dissolved in 1991
United Nations General Assembly meets for first time in 1946	Korean War ends with a truce in 1953	An American orbits the earth in space in 1962	Microsoft is established in 1975	Google is incorporated in 1998
The transistor is invented in 1947	School segregation is outlawed by the U.S. Supreme Court in 1954	A TV signal crosses the Atlantic via a satellite in 1962	Apple Computer is established in 1976	Terrorists attack World Trade Center and Pentagon in 2001
Israel becomes an independent state in 1948	U.S. civil-rights movement begins in the South	U.S. president John F. Kennedy is assassinated in 1963	1981 Space shuttle first flies	United States invades Afghanistan in 2001
Mao Zedong becomes leader of Communist China in 1949	Sputnik, the first artificial satellite, is launched by the Soviet Union in 1957	United States builds up troops in Vietnam in 1964	Communist governments of Eastern Europe fall beginning in 1989	United States invades Iraq in 2003
		National Organization for Women is founded in 1966		Facebook is launched in 2004
		Martin Luther King Jr. and Robert Kennedy are assassinated in 1968		United States withdraws from Iraq in 2011
		A U.S. astronaut takes the first walk on the moon in 1969		

as the leader of the "free world" in its struggle against communism. This preeminence explains both the high standard of living in the country and the resentment of those who did not share it. However, economic supremacy does not permit a nation to live free from outside forces. The energy crises, the need for raw materials, the quest for labor, and the search for new markets today bind many nations together in a delicate economic and social network of political relationships. The United States depends on other countries; the shifting patterns of economic relationships among North America, Europe, the developing world, China, Japan, and the oil producers of the Middle East are all reminders of how fragile that network really is. That is why we can speak of a global economy. With the collapse of communism in Eastern Europe, new patterns of culture slowly began to emerge, as the vigor of the Pacific Rim nations attest. We do not know exactly how the new world order will operate. What we do know is that our lives are not insulated: our stereos are assembled in Malaysia, our vegetables may come from Mexico, our blue jeans are sewn in Bangladesh, and our sneakers manufactured in Romania.

The Demand for Rights

The material satisfactions of Western life spawned other kinds of dissatisfaction. While we may be the best-fed, best-housed, and best-clothed citizens in history, the hunger for individual and social meaning remains a constant in our lives. For instance, many sociopolitical movements in this country are signs of that human restlessness that will not be satisfied by bread alone. These movements are not peculiar to North America, as democratic movements in other parts of the world so readily attest.

The incredible achievements of modern society have exacted their price. Sigmund Freud shrewdly pointed out in *Civilization and Its Discontents* (1929) that the price of advanced culture is a certain repression of the individual, together with pressure for that individual to conform to the larger will of the community. North Americans have always been sensitive to the constraints of the state, because their history began as a revolt against statist domination.

The Western world tends to view repression in terms more social than political. The complexity of the technological management of modern life has led many to complain that we are becoming mere numbers or ciphers under the indifferent control of data banks and computers. Such warnings began as early as George Orwell's political novel *1984* (1946), written right after World War II; progressed through David Riesman's sociological tract of the 1950s, *The Lonely Crowd*; to the futurist predictions of Alvin Toffler's *Future Shock* in the 1970s. Now, in the new millennium, many more such analyses are sure to appear.

The 1960s

Dramatic changes occurred in American attitudes and behavior during the "Swinging Sixties." Society was on the threshold of major social upheaval, in science, politics, fashion, music, art, cinema, and sexual behavior. Many of the so-called Woodstock generation, disheartened by commercialism and the Vietnam War, followed the advice of Harvard University professor Timothy Leary to "tune in, turn on, and drop out." That is, many of them tuned in (to rock music), turned on (to drugs), and dropped out (of mainstream society). The heat was on between the hippies and the hard hats. Long hair became the mane of men. Bell-bottomed jeans flared. Films became sexually explicit. Hard rock music bellowed the message of rebellion and revolution.

The 1960s were also the heart of the sexual revolution. Social movements such as the sexual revolution often gain momentum from a timely interplay of scientific, social, political, and economic forces. The war (in Vietnam), the bomb (fear of a nuclear holocaust), the pill (the introduction of the birth-control pill), and the mass media (especially television) were four such forces. The pill lessened the risk of unwanted pregnancy, permitting young people to engage in recreational or casual sex, rather than procreative sex. Pop psychology movements, like the Human Potential Movement of the 1960s and 1970s (the "Me Decade"), spread the message that people should get in touch with and express their genuine feelings, including their sexual feelings. "Do your own thing" became one catchphrase; "if it feels right, go with it" became another.

Film scenes of lovemaking became so commonplace that the movie rating system was introduced to alert parents. And censors lost the battle to keep everything that had been banned in the arts—the visual arts, the performing arts, literature, and music—under wraps.

THE INTELLECTUAL BACKGROUND

The philosophy that most persistently gripped the intellectual imagination of the Western world in the period immediately after World War II was **existentialism**. Existentialism is more an attitude than a single philosophical system. Its direct ancestry can be traced to the 19th-century Danish theologian and religious thinker Søren Aabye Kierkegaard (1813–1855), who set out its main emphases. Kierkegaard strongly reacted against the great abstract philosophical systems developed by such philosophers as Georg Wilhelm Hegel (1770–1831) in favor of an intense study of the individual person in his or her actual existing situation in the world. Kierkegaard emphasized the single individual ("the crowd is untruth") who exists in a specific set of circumstances at a particular time in history with a specific consciousness. Philosophers like Hegel, Kierkegaard once noted ironically, answer every question about the universe except "Who am I?," "What am I doing here?," and "Where am I going?"

This radically subjective self-examination was carried on throughout the 20th century by philosophers like Friedrich

Nietzsche and novelists like Fyodor Dostoyevsky, who are regarded as forerunners of modern existentialist philosophy (**Fig. 22.2**). In the 20th century, writers like Franz Kafka, the German poet Rainer Maria Rilke, the Spanish critic Miguel de Unamuno, and, above all, the German philosopher Martin Heidegger gave sharper focus to the existentialist creed.

JEAN-PAUL SARTRE The postwar writer who best articulated existentialism both as a philosophy and a lifestyle, however, was the French writer and philosopher Jean-Paul Sartre (1905–1980). Sartre believed it the task of the modern thinker to take seriously the implications of atheism. If there is no God, Sartre insisted, then there is no blueprint for what a person should be and no ultimate significance to the universe. People are thrown into life, and their very aloneness forces them to make decisions about who they are and what they shall become. "People are condemned to be free," Sartre wrote. Existentialism was an attempt to help people understand their place in an absurd world, their obligation to face up to their freedom, and the kinds of ethics available to them in a world bereft of absolutes.

Sartre began his mature career just as Germany was beginning its hostilities in the late 1930s. After being a prisoner of war in Germany, Sartre lived in occupied France, where he was active in the French Resistance, especially as a writer for the newspaper *Combat*. Sartre and the feminist writer Simone de Beauvoir (1908–1986) were the major voices demanding integrity in the face of the absurdities and horrors of war-torn Europe. Such an attitude might be

considered a posture if it were not for the circumstances in which these existentialist writers worked.

The appeal of existentialism was its marriage of thought and action, its analysis of modern anxiety, and its willingness to express its ideas through the media of plays, novels, films, and newspaper polemics. After the close of the war in 1945, there was a veritable explosion of existentialist theater (Samuel Beckett, Harold Pinter, Jean Genet, Eugène Ionesco) and existentialist fiction (Albert Camus, Sartre, Beauvoir) in Europe. In the United States, themes of existentialism

▼ **22.2 Writers in the Existentialist Tradition**

Søren Kierkegaard (1813–1855)—Danish

Fyodor Dostoyevsky (1821–1881)—Russian

Friedrich Nietzsche (1844–1900)—German

Miguel de Unamuno (1864–1936)—Spanish

Nicholas Berdyaev (1874–1948)—Russian

Rainer Maria Rilke (1875–1926)—Czech/German

Martin Buber (1878–1965)—Austrian/Israeli

Jacques Maritain (1882–1973)—French

Karl Jaspers (1883–1969)—German

Franz Kafka (1883–1924)—Czech/German

José Ortega y Gasset (1883–1955)—Spanish

Martin Heidegger (1889–1976)—German

Jean-Paul Sartre (1905–1980)—French

Albert Camus (1913–1960)—French

READING 22.1 JEAN-PAUL SARTRE

From "Existentialism Is a Humanism"

Atheistic existentialism, of which I am a representative, declares with greater consistency that if God does not exist there is at least one being whose existence comes before its essence, a being which exists before it can be defined by any conception of it. That being is man or, as Heidegger [the German philosopher] has it, the human reality. What do we mean by saying that existence precedes essence? We mean that man first of all exists, encounters himself, surges up in the world—and defines himself afterwards. If man as the existentialist sees him is not definable, it is because to begin with he is nothing. He will not be anything until later, and then he will be what he makes of himself. Thus, there is no human nature, because there is no God to have a conception of it. Man simply is. Not that he is simply what he conceives himself to be, but he is what he wills, and as he conceives himself after already existing—as he wills to be after that leap towards existence.

Man is nothing else but that which he makes of himself. That is the first principle of existentialism. And this is what people call its "subjectivity," using the word as a reproach against us. But what do we mean to say by this, but that man is of a greater dignity than a stone or a table?

For we mean to say that man primarily exists—that man is, before all else, something which propels itself towards a future and is aware that it is doing so. Man is, indeed, a project which possesses a subjective life, instead of being a kind of moss, or a fungus or a cauliflower. Before that projection of the self nothing exists; not even in the heaven of intelligence: man will only attain existence when he is what he purposes to be. Not, however, what he may wish to be. For what we usually understand by wishing or willing is a conscious decision taken—much more often than not—after we have made ourselves what we are. I may wish to join a party, to write a book or to marry—but in such a case what is usually called my will is probably a manifestation of a prior and more spontaneous decision. If, however, it is true that existence is prior to essence, man is responsible for what he is. Thus, the first effect of existentialism is that it puts every man in possession of himself as he is, and places the entire responsibility for his existence squarely upon his own shoulders. And, when we say that man is responsible for himself, we do not mean that he is responsible only for his own individuality, but that he is responsible for all men.

Jean-Paul Sartre, "Existentialism and Humanism." Methuen Publishing Ltd, 1952.

Woody Allen's Universe: On Being, Nothingness, and Laughter

Adam Cohen, a chronicler of the life, existentialist anxieties, and writings of Woody Allen, writes that Allen may have been "philosophically traumatized" as a child when he was told that the universe was expanding. As a result, he decided that doing his homework was pointless.

But Allen, comedian and filmmaker, immersed himself in the writings of existentialists such as Jean Paul Sartre, author of Being and Nothingness, and grew obsessed with the idea of life as random, without purpose or meaning. Allen brought existentialism into his stand-up comedy routine in New York's Greenwich Village: "What if everything is an illusion and nothing exists?" mused Allen. "In that case, I definitely overpaid for my carpet."

Making something from nothingness in his film Play It Again, Sam (1972), Allen's nerdish character decides to flirt with a young woman he encounters in an art gallery:

ALLEN: That's quite a lovely Jackson Pollock, isn't it?
WOMAN: Yes, it is.
ALLEN: What does it say to you?
WOMAN: It restates the negativeness of the universe, the hideous lonely emptiness of existence, nothingness, the predicament of man forced to live in a barren, godless eternity, like a tiny flame flickering in an immense void, with nothing but waste, horror, and degradation, forming a useless bleak straightjacket in a black absurd cosmos.
ALLEN: What are you doing Saturday night?
WOMAN: Committing suicide.
ALLEN: What about Friday night?

Opportunity is opportunity.

Much of Allen's comedy is based on challenging traditional ideas with what if—what if we find out in the future that smoking is good for you, what if you can actually get away with murder. And what if The Three Stooges—Larry, Curly, and Moe—a comedy team whose slapstick farces populated the stage and the silver screen in the middle of the 20th Century, suddenly turned into angst-ridden existentialists? The Three Stooges had grown famous not for spouting philosophy, but for twisting one another's noses and poking each other in the eye. In a story from Mere Anarchy (2007), Allen revisits the Three Stooges as if they had earned an A in a Sartre seminar:

"Calmly and for no apparent reason [Moe] took the nose of the bald man (Curly) in his right hand and slowly twisted it in a long, counterclockwise circle. A horrible grinding sound broke the silence . . . 'We suffer,' [Moe] said. 'O woe to the random violence of the human condition.'

"Meanwhile Larry [had] somehow managed to get his head caught [in a] jar. Everything was suddenly terrifying and black as Larry groped blindly around the room. He wondered if there was a god or any purpose at all to life or any design behind the universe when suddenly [Moe] entered and, finding a large polo mallet, began to break the jar . . . With pent-up fury that masked years of angst over the empty absurdity of man's fate, [Moe] smashed the crockery. 'We are at least free to choose,' wept Curly, the bald one. 'Condemned to death but free to choose.' And with that, Moe poked his two fingers into Curly's eyes. 'Oooh, oooh, oooh,' Curly wailed, 'the cosmos is so devoid of any justice.'"

In Hannah and Her Sisters (1986), Allen's character manages to grasp misery from the jaws of pleasure: Observing joggers in Central Park, he says "Look at all these people, trying to stave off the inevitable decay of their bodies."

Similarly, in his story "Getting Even" (1971), he asks his uncle, "Could it not simply be that we are alone and aimless, doomed to wander in an indifferent universe, with no hope of salvation, nor any prospect except misery, death, and the empty reality of eternal nothing." His uncle replies, "You wonder why you're not invited to more parties."

Despite Allen's negativity, there are apparently some practical advantages to his brand of skepticism: "Whosoever shall not fall by the sword or by famine shall fall by pestilence, so why bother shaving?"

were taken up eagerly by intellectuals and writers who were attracted to its emphasis on anxiety and alienation.

THE BEAT GENERATION The so-called Beat writers of the 1950s embraced a rather vulgarized style of existentialism filtered through the mesh of jazz and the African American experience. Beat writers such as Jack Kerouac (1922–1969), William S. Burroughs (1914–1997), and Allen Ginsberg (1926–1997) embraced the existentialist idea of alienation even though they rejected the austere tone of their European counterparts. Their sense of alienation was united with the idea of experience heightened by ecstasy of a musical, sexual, or chemical origin. The Beats, at least in that sense, were the progenitors of the 1960s hippies.

Jack Kerouac's On the Road could be said to follow in the tradition of Homer's Odyssey. It illuminates the inner geography of the mind as well as the contours and peoples of the lands it navigates. On the Road, published by Viking Press in 1957, is a landmark of the Beat Generation, following young, rootless people as they traverse—against a background of drugs, jazz, and poetry—the nation's highways and byways in the era before the social and cultural turmoil of the 1960s.

From On the Road

We were all delighted, we all realized we were leaving confusion and nonsense behind and performing our one noble function of the time, move.—Part 2, Ch. 6

I woke up as the sun was reddening; and that was the one distinct time in my life, the strangest moment of all, when I didn't know who I was—I was far away from home, haunted and tired with travel, in a cheap hotel room I'd never seen, hearing the hiss of steam outside, and the creak of the old wood of the hotel, and footsteps upstairs, and all the sad sounds, and I looked at the cracked high ceiling and really didn't know who I was for about fifteen strange seconds.—Part 1, Ch. 3

LA is the loneliest and most brutal of American cities; New York gets god-awful cold in the winter but there's a feeling of wacky comradeship somewhere in some streets.—Part 1, Ch. 13

Isn't it true that you start your life a sweet child, believing in everything under your father's roof? Then comes the day of the Laodiceans,[2] when you know you are wretched and miserable and poor and blind and naked, and with the visage of a gruesome, grieving ghost you go shuddering through nightmare life. —Part 1, Ch. 13

Whither goest thou, America, in thy shiny car in the night?—Part 2, Ch. 3

So in America when the sun goes down and I sit on the old broken-down river pier watching the long, long skies over New Jersey and sense all that raw land that rolls in one unbelievable huge bulge over to the West Coast, and all that road going, and all the people dreaming in the immensity of it . . . and tonight the stars'll be out, and don't you know that God is Pooh Bear? The evening star must be drooping and shedding her sparkler dims on the prairie, which is just before the coming of complete night that blesses the earth, darkens all rivers, cups the peaks and folds the final shore in, and nobody, nobody knows what's going to happen to anybody besides the forlorn rags of growing old . . .—Part 5

ALBERT CAMUS The existentialist ethic remained alive mainly through the novels of Albert Camus (1913–1960). In works like *The Stranger* (1942), *The Plague* (1947), and *The Fall* (1956), Camus—who disliked being called an existentialist—continued to impress his readers with heroes who fought the ultimate **absurdity** of the world with lucidity and dedication and without illusion.

Today, existentialism is mainly a historical moment in the postwar culture of Europe and America. Its importance, however, resides in its capacity to formulate some of the most important ideas of modernity: the absence of religious faith, the continuous search for meaning, the dignity of the individual, the concern for human subjectivity.

VISUAL ARTS

Being an artist now means to question the nature of art.

—Joseph Kosuth

2. Literally, inhabitants of ancient Laodicea, but referring to Laodiceans' indifference to religion.

VALUES

Liberation

If we understand *liberation* in the deep social sense as freedom *to* realize one's full human potential as well as freedom *from* oppressive structures, we would then have to say that the desire for, and realization of, liberating freedom is one of the hallmarks of modern world culture. This was especially true in the second half of the 20th century.

Liberation has come both for millions from the totalitarian regimes of fascism, Nazism, and Marxism as well as freedom from the colonial powers in areas as diverse as India and Africa. These liberation movements have their mirror image in the struggle for civil rights for people of color, for women, for exploited social minorities, as well as struggles to end poverty, hunger, and the exploitation of children.

What energizes these quite different movements for freedom and liberation? A partial answer is to be found in the power of mass communication to let people know that they are victims of oppression. There is also the power of certain fundamental ideas derived, in the West, from Greek philosophical thought and biblical prophetism, which crystallized in the Enlightenment that held forth the promise of the right to "life, liberty, and the pursuit of happiness."

The struggle for social and political liberation has involved many communities, with some spokespersons standing out both because of their personal bravery and the power of their convictions. We think immediately of Mohandas Gandhi in India; Martin Luther King Jr. in the United States; Desmond Tutu and Nelson Mandela in Africa; Lech Walesa and Vaclav Havel in Eastern Europe, as well as the many unnamed people who put their lives on the line to live free.

There is a saying, once thought to be a Chinese curse, that reads, "May you live in interesting times." Whatever its origin, it captures the value of stimulation and novelty, even at the expense, perhaps, of tranquility. When it comes to contemporary art, we live in nothing if not interesting times. Louise Bourgeois, who was born in 1911 and continued to work avidly until her death at age 98, noted that "there are no settled ways," there is "no fixed approach." Never before in history have artists experimented so freely with so many media, such different styles, such a wealth of content. Never before in history have works of art been so accessible to so many people. Go to Google Images, and the world of art and artists is a mouse click away.

In this section, we discuss the visual arts that have appeared since the end of World War II—the art of recent times and of today.

Postwar Expressionism: Existentialism in the Visual Arts

One of the early effects of the Second World War on the arts was to bring existentialism to them. Europe was devastated by the war to a much greater degree than the United States, which had been protected by two oceans. Cynicism and atheism were abroad, with many arguing that the explanations for how bad things could happen to good people had run their course and were now in the gutter. The artist Alberto Giacometti rode the wave of postwar pessimism.

ALBERTO GIACOMETTI The Swiss sculptor Alberto Giacometti (1901–1966) was a friend of Sartre and made many drawings of him. Sartre returned the favor by writing about Giacometti, as in "La recherche de l'absolu"—"The Search for the Absolute," an undertaking that must meet with failure for an existentialist, since nothing is certain in life in that philosophy.

It has also been remarked that there are no casual or disinterested viewers of Giacometti's work, that its rawness touches, well, raw nerves. Such is the case with *Man Pointing No. 5* (**Fig. 22.3**). The man is something of a stick figure roughed up with the harsh kneading of the sculptor's fingers. The figure is unnaturally elongated and skeletal, shedding the imagined odors of death and destruction. The figure is at the very least alienated and alone, pointing, perhaps, at the severe abstraction of the postwar world.

The New York School: The First Generation

After the war, the center of the art world shifted to New York following its long tenure in Paris, for several reasons. A wave of migrant European artists, some of whom had escaped the Nazis, had settled largely in New York. Among them were Mar-

cel Duchamp, Fernand Léger, Josef Albers, and Hans Hofmann. The Federal Art Project of the Works Progress Administration, a New Deal program spearheaded by Franklin Delano Roosevelt, had also nourished the New York artist community during the Great Depression. Some of these artists, such as Jackson Pollock, Willem de Kooning, and Mark Rothko, constituted what became known as the first-generation New York School.

The influences of earlier nonobjective painting, the colorful distortions of Expressionism, Cubism, the automatist processes of Surrealism, and a host of other factors—including interest in Zen Buddhism and Jungian psychology—all seemed to converge. It was in this artistic melting pot that **Abstract Expressionism** flowered. As with other art movements that appeared radical, critics reacted to it with both intrigue and skepticism. Writing in the *New Yorker* in 1945, Robert M. Coates commented:

> [A] new school of painting is developing in this country. It is small as yet, no bigger than a baby's fist, but it is

▼ **22.3** Alberto Giacometti, *Man Pointing*, 1947. Bronze, 70½" × 40¾" × 16⅜" (179 × 103.4 × 41.5cm). Museum of Modern Art, New York, New York. Art © 2013 Alberto Giacometti Estate/Licensed by VAGA and ARS, New York. The sculpture, heavily kneaded by the artist, appears to capture the existential anxieties following World War II.

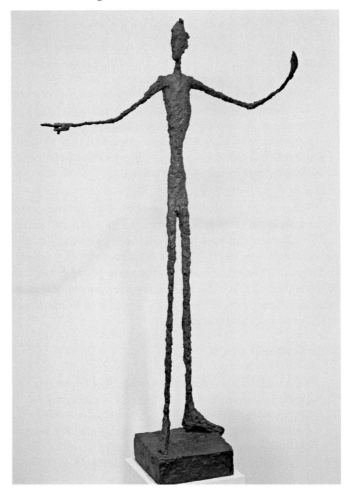

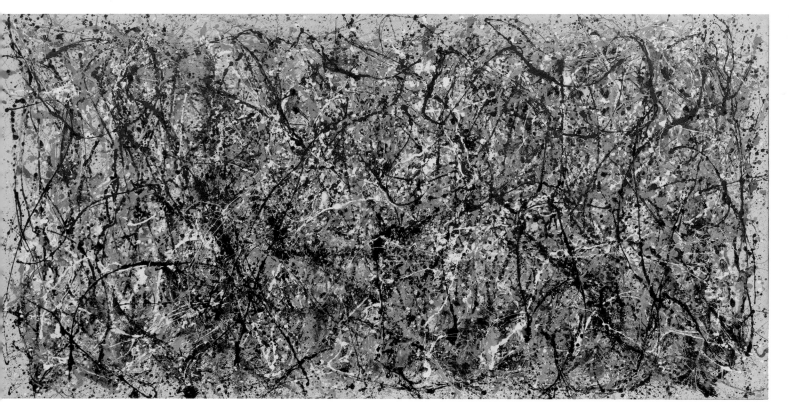

▲ **22.4** Jackson Pollock, *One: Number 31*, 1950, oil and enamel paint on canvas, 8'10" × 17'5 ⅝" (269.5 × 530.8cm). The Museum of Modern Art, New York, New York. © 2013 The Pollock-Krasner Foundation/Artists Rights Society (ARS), New York. Pollock would walk across the surface of the canvas, dripping and splashing paint, as if in the thrall of primitive impulses and unconscious urges. "Accident" is a prime compositional element in his painting.

noticeable if you get around to the galleries much. It partakes a little of Surrealism and still more of Expressionism, and although its main current is still muddy and its direction obscure, one can make out bits of Hans Arp and Joan Miró floating in it, together with large chunks of Picasso and occasional fragments of [African American] sculptors. It is more emotional than logical in expression, and you may not like it (I don't either, entirely), but it can't escape attention.[3]

Spontaneity, gestural brushstrokes, nonobjective imagery, and fields of intense color characterize Abstract Expressionism. Many canvases are quite large, seeming, at any proximity, to envelop the viewer in the artist's distinct pictorial world. Some lines and shapes seem to reference East Asian calligraphy, but their rendering is expansive and muscular compared with the gentle, circumscribed brushstrokes of Chinese and Japanese artists.

JACKSON POLLOCK

Pollock's talent is volcanic. It has fire. It is unpredictable. It is undisciplined. It spills itself out in a mineral prodigality not yet crystallized. It is lavish, explosive, untidy. . . . What we need is more young men who paint from inner compulsion without an ear to what the critic or spectator may feel—painters who will risk spoiling a canvas to say something in their own way. Pollock is one.[4]

Jackson Pollock (1912–1956) is probably the best known of the Abstract Expressionists. Photographs or motion pictures of the artist energetically dripping and splashing paint across his huge canvases are familiar to many people. Pollock would walk across the surface of the canvas as if controlled by primitive impulses and unconscious ideas. Accident became a prime compositional element in his painting. Art critic Harold Rosenberg coined the term **action painting** in 1951 to describe the outcome of such a process—a painting whose surface implies a strong sense of activity, as created by the signs of brushing, dripping, or splattering of paint.

Born in Cody, Wyoming, Pollock went to New York to study with Thomas Hart Benton at the Art Students League. The 1943 quote from Clement Greenberg that begins this section shows the impact that Pollock made at an early exhibition of his work. His paintings of this era frequently depicted actual or implied figures that were reminiscent of the abstractions of Picasso and, at times, of Expressionists and Surrealists.

Pollock was in psychoanalysis when he executed his great drip paintings. He believed strongly in the role of the unconscious mind, of accident and spontaneity, in the creation of art. He was influenced not only by the intellectual impact of the Automatist Surrealists but also by what must have been his impression of walking hand in hand with his own uncon-

3. Robert M. Coates, "The Art Galleries," *New Yorker*, May 26, 1945, 68.

4. Clement Greenberg, quoted in the introduction to the catalog *Jackson Pollock*, Art of This Century Gallery, New York, November 9–27, 1943.

scious forces through the realms of artistic expression. When asked about the meaning of such paintings, Pollock would say, "Any attempt on my part to say something about it . . . could only destroy it."[5]

Aside from their own value as works of art, Pollock's drip paintings of the late 1940s and early 1950s made several innovations that would be mirrored and developed in the work of other Abstract Expressionists. Foremost among these was the use of an overall gestural pattern barely contained by the limits of the canvas. In *One* (**Fig. 22.4**), the surface is an unsectioned, unified field. Overlapping skeins of paint create dynamic webs that project from the picture plane, creating an illusion of infinite depth. In Pollock's best work, these webs seem to be composed of energy that pushes and pulls the monumental tracery of the surface.

Before his untimely death in a car crash in 1956, Pollock returned to figural paintings that were heavy in impasto and predominantly black. One wonders what might have emerged if the artist had lived a fuller span of years.

LEE KRASNER Lee Krasner (1908–1984) was one of relatively few women in the mainstream of Abstract Expressionism. Yet despite her originality and strength as a painter, her work, until fairly recently, took a critical backseat to that of her famous husband—Jackson Pollock. She once noted:

I was not the average woman married to the average painter. I was married to Jackson Pollock. The context is bigger and even if I was not personally dominated by Pollock, the whole art world was.[6]

Krasner had a burning desire to be a painter from the time she was a teenager and received academic training at some of the best art schools in the country. Like Pollock and the other members of the Abstract Expressionist school, she was exposed to the work of many European émigrés who came to New York in the 1930s and 1940s.

Both Pollock and Krasner experimented with allover compositions around 1945, but the latter's work was smaller in scale and exhibited much more control. Even after 1950, when Krasner's work became much freer and larger, the accidental nature of Pollock's style never took hold in her work. Rather, Krasner's compositions might be termed a synthesis of choice and chance.

Easter Lilies (**Fig. 22.5**) was painted in 1956, the year of Pollock's fatal automobile accident. The jagged shapes and bold black lines against the muddy greens and ochers render the composition dysphoric; yet in the midst of all that is harsh are the recognizable contours of lilies, whose bright whites offer a kind of hope in a sea of anxiety. Krasner once

5. Jackson Pollock, quoted in Sidney Janis, *Abstract and Surrealist Art in America* (New York: Reynal & Hitchcock, 1944), 112.

6. Lee Krasner, quoted in Roberta Brandes Gratz, "Daily Close-Up— After Pollock," *New York Post*, December 6, 1973.

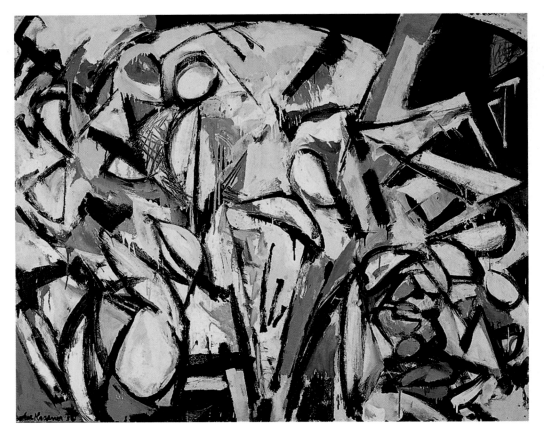

◀ **22.5** Lee Krasner, *Easter Lilies*, 1956. Oil on cotton duck, 48¼″ × 60⅛″ (122.655 × 152.7 cm). Private collection. © 2013 The Pollock-Krasner Foundation/ Artists Rights Society (ARS), New York. Whereas Pollock's action paintings have an almost accidental quality to them, Krasner's imagery seems to be more controlled.

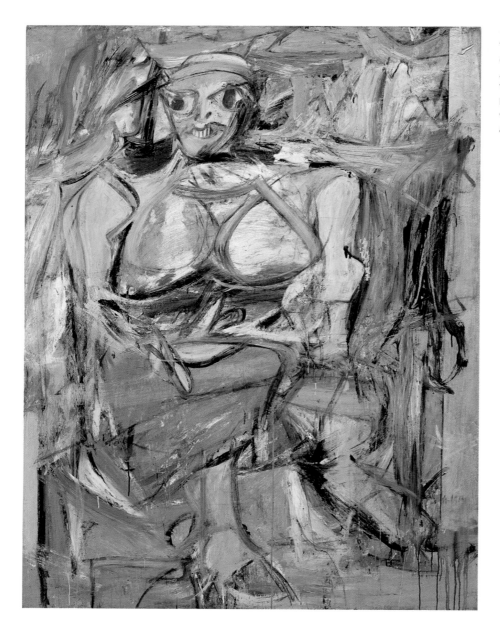

◄ **22.6** Willem de Kooning, *Woman, I,* 1950–1952. Oil on canvas, 753⁷/₈″ × 58″ (192.7 × 147.3 cm). Museum of Modern Art, New York, New York. © 2013 The Willem de Kooning Foundation/Artists Rights Society (ARS), New York.** The woman in this painting exudes eroticism and a sense of power.

remarked of her work, "My painting is so autobiographical, if anyone can take the trouble to read it."[7]

WILLEM DE KOONING Born in Rotterdam, Holland, Willem de Kooning (1904–1997) migrated to the United States in 1926, where he joined the circle of Gorky and other forerunners of Abstract Expressionism. Until 1940, de Kooning painted figures and portraits. His first abstractions of the 1940s, like Gorky's, remind one of Picasso's paintings. As the 1940s progressed, de Kooning's compositions began to combine biomorphic, organic shapes with harsh, jagged lines. By the mid-20th century, his art had developed into a force in Abstract Expressionism.

De Kooning is best known for his series of paintings of women that began in 1950. In contrast to the appealing figurative works of an earlier day, many of his abstracted women are frankly overpowering and repellent. Faces are frequently resolved into skull-like masks reminiscent of fertility figures; they assault the viewer from a loosely brushed backdrop of tumultuous color. Perhaps they portray what was a major psychoanalytic dilemma during the 1950s—how women could be at once seductive, alluring, and castrating. In our own liberated times, this notion of women or of eroticism as frightening seems sexist or out of joint. In any event, in some of his other paintings, abstracted women communicate an impression of being unnerved, even vulnerable.

Woman, I (**Fig. 22.6**) is among the more erotic of the series. Richly curved pastel breasts swell from a sea of spontaneous brushstrokes that here and there violently obscure the imagery. The result is a free-floating eroticism. A primal urge has been cast loose in space, pushing and pulling against the picture

7. Lee Krasner, quoted in Cindy Nemser, "A Conversation with Lee Krasner," *Arts Magazine*, April 1973, 48.

plane. But de Kooning is one of the few Abstract Expressionists who never completely surrendered figurative painting.

De Kooning's work frequently seems obsessed with the violence and agitation of the "age of anxiety." The abstract backgrounds seem to mirror the rootlessness many of us experience as modern modes of travel and business call us to foreign towns and cities.

MARK ROTHKO For some Abstract Expressionists, the creation of pulsating fields of color was more important than the gestural quality of the brushstroke. These canvases are so large that they seem to envelop the viewer with color, the subtle modulations of which create a vibrating or resonating effect. Artists who subscribed to this manner of painting, such as Mark Rothko and Barnett Newman, had in common the reworking of a theme in an extended series of paintings. Even though the imagery often remains constant, each canvas has a remarkably different effect as a result of often radical palette adjustments.

Mark Rothko (1903–1970) painted lone figures in urban settings in the 1930s and biomorphic surrealistic canvases throughout the early 1940s. Later in that decade, he began to paint the large, floating, hazy-edged color fields for which he is renowned. During the 1950s, the color fields consistently assumed the form of rectangles floating above one another in an atmosphere defined by subtle variations in tone and brushwork. They alternately loom in front of and recede from the picture plane, as in *Magenta, Black, Green on Orange (No. 3/No. 13)* (**Fig. 22.7**). The large scale of these canvases absorbs the viewer in color, and the often blurred edges of the rectangles have a vibratory effect on the eyes.

Early in his career, Rothko favored a broad palette ranging from pale to vibrant and highly saturated colors. During the 1960s, however, his works grew somber. Reds that earlier had been intense, warm, and sensuous were now awash in deep blacks and browns and took on the appearance of worn cloth. Oranges and yellows were replaced by grays and black. Light that earlier had been reflected was now trapped in his canvases.

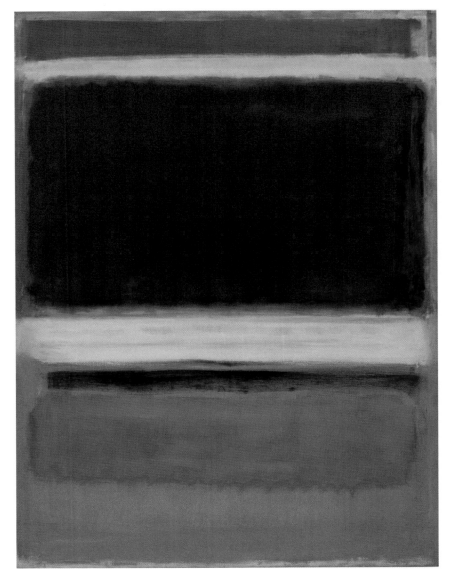

◄ **22.7** Mark Rothko, *Magenta, Black, Green on Orange (No. 3/No. 13)*, 1949. Oil on canvas, 85 3/8″ × 65″ (216.5 × 164.8 cm). Museum of Modern Art, New York, New York. © 1998 Kate Rothko Prizel and Christopher Rothko/Artists Rights Society (ARS), New York. When one sits or stands in front of works such as this one, the subtle differences in color create something of a pulsating effect.

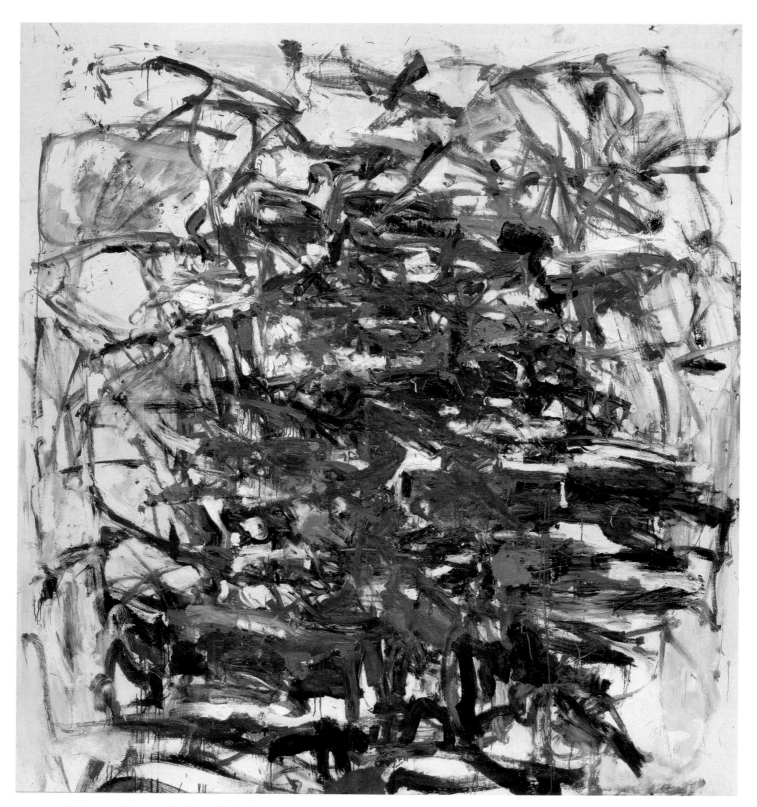

∧ 22.8 Joan Mitchell, Untitled, 1957. Oil on canvas 94 1/8″ × 87 5/8″ (239.1 × 222.6 cm). © Estate of Joan Mitchell. Courtesy of the Joan Mitchell Foundation and Cheim & Read Gallery, New York. Embracing all-over painting with the expansiveness and power of this untitled painting, Mitchell, as did virtually all of the Abstract Expressionists, worked on a large scale. She emphasized materials and process but kept subject matter central to her paintings. Trying to paint a feeling as precisely as possible, she often described her paintings as "memories of feelings" or "memories of feelings of or about landscapes."

Despite public acclaim, Rothko experienced depression during his last years, and his paintings of that period may reflect this.

The New York School: The Second Generation

Abstract Expressionism was a movement in part defined by its rogue nature, steeped in the intellectual and political discourse of the war years, heroic in scale, brash in its masculinity. The artists were in and of the city and symbolized, in many ways, the true grit required to make art in spite of poverty and to "make it" in the midst of an unforgiving urban universe. The second-generation New York artists, who inherited the mantle of Abstract Expressionism, were less likely to have been influenced by the community culture of Greenwich Village—its bars and hangouts—and more by the experience of the university or art academy where they learned to paint. Beyond a few common features, their styles were quite different. Some, like Joan Mitchell, expanded on Abstract Expressionism's gestural approach, while others, like Helen Frankenthaler, de-emphasized it.

JOAN MITCHELL There is no question but that the members of the circle of Abstract Expressionism were predominantly male. The intense physicality of action painting had the effect of masculinizing the movement and artist statements at the time did little to dispel that notion: Pollock, for example, famously referred to his canvas as "an arena." The "boys' club" image was underscored by appearances. Around the same time that Joan Mitchell (1925–1992) painted one of her many untitled works (**Fig. 22.8**), 28 artists considered the leading figures in New York painting were brought together for a photograph; only one was a woman—a painter named Hedda Sterne—whose work, though gestural, was much less aggressive in character than that of her male colleagues. Mitchell did not pose in the photograph, but she is widely considered to have been the most important woman to work in the gestural idiom of Abstract Expressionism in the 1950s. Her sweeping brushstrokes, liberal use of color, and intense, raw energy create a sense of urgency and mood of turbulence.

HELEN FRANKENTHALER Helen Frankenthaler (1928–2011) was a **color-field painter** whose works share the pouring of paint with Pollock and the creation of color fields with Rothko, but delete the brushstroke entirely. She literally poured paint onto the canvas, declaring that a painting is composed of nothing more than pigment on a surface. *The Bay* (**Fig. 22.9**) is less about extending the inner world of the artist and more

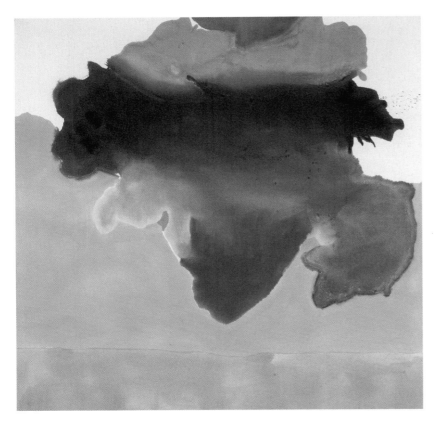

◀ **22.9** Helen Frankenthaler, *The Bay*, 1963. Acrylic on canvas, 80 ³/₄" × 81 ³/₄" (205.1 × 207.7 cm). Detroit Institute of Arts, Detroit, Michigan. © 2013 Estate of Helen Frankenthaler/Artists Rights Society (ARS), New York. Before applying her paints, Frankenthaler thinned them to the consistency of washes.

about creating sensuous, beautiful surfaces. The canvas is awash in color. Broad expanses of pigment—like translucent veils—seep into the fibers of the canvas, softening the edges of the colorful floating shapes; intermittent flowing lines, splotches, and splatters of paint keep our eyes attuned to the decorative surface. With stain painting such as this, the image—open, billowing, abstract—and the canvas are now literally one.

Minimal Art

Frankenthaler removed the brushstroke from abstract art, but another group of artists sought to reduce their ideas to their simplest forms. They created geometric shapes or progressions of shapes or lines using minimal numbers of formal elements—for example, the minimum amounts of colors and textures. Nor did they attempt to represent objects. Their school of art is called **Minimalism**.

FRANK STELLA Over the course of his career, Frank Stella (b. 1936) has produced drawings, paintings, sculptures, and architectural enclosures with a sculptural quality. However, he is largely credited as a key founder of the Minimalist school. His *Mas o Menos* (**Fig. 22.10**), which is Spanish for "more or less," is one of many works that represent no object in the real world and repeat basic lines—here, pinstripes arranged into geometric patterns. Stella restricts his palette to a single color. The design of the work tends to "push and pull," however, in that there are figure–ground reversals. When you continue to gaze at this particular work, "walls" that once looked as if they were receding from you may suddenly shift direction such that they appear to be moving toward you. Consider the two "panels" on the left. Is the vertical axis between them farther back than the "edges," or is it closer to the picture plane? Either interpretation is possible, as is viewing the picture as completely flat. We noted Pollock's response to questions about abstract paintings; Stella's remark on his own work was, "What you see is what you see."

Except for the fact that *Mas o Menos* is abstract, it is difficult to imagine work farther removed from that of the Abstract Expressionists. There is no gestural brushwork. There is no sense of existential anxiety; discipline replaces the feeling that primitive impulses might be rising to the surface of consciousness.

▼ **22.10** Frank Stella, *Mas o Menos (More or Less)* 1964. Metallic powder in acrylic emulsion on canvas, 118″ × 164½″ (300 × 418 cm). Musée National d'Art Moderne, Centre Georges Pompidou, Paris, France. © 2013 Frank Stella/Artists Rights Society (ARS), New York. In this work, Stella sought repetition of a single formal element of art: the line.

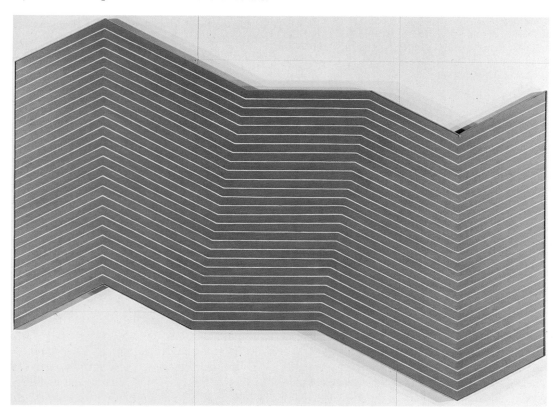

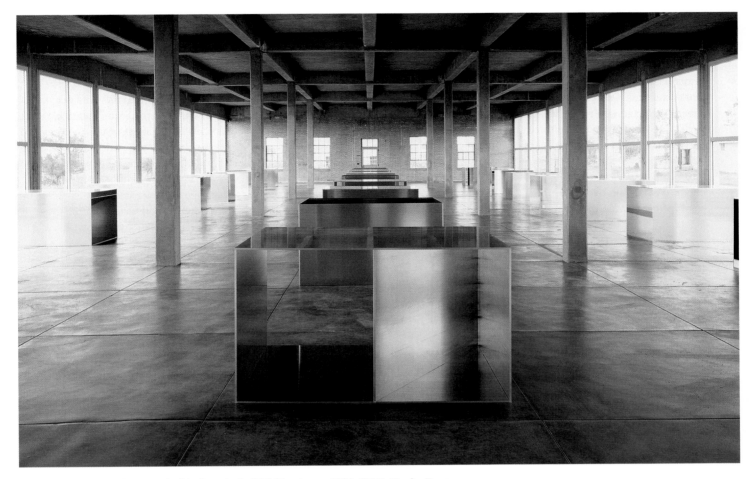

▲ **22.11** Donald Judd, *100 Untitled works in Mill Aluminum,* 1982–1983. Marfa, Texas. **Machined aluminum boxes housed in abandoned building (renovated by Judd) on the former U.S. Army base Fort D. A. Russell. Art © Judd Foundation. Licensed by VAGA, New York, New York.** Minimalists sought a purity in their art by reducing the number of formal elements, such as color and texture in this work.

DONALD JUDD Sculptor Donald Judd (1928–1994) brought Minimalism into three dimensions. He chose shapes and materials that were pure and simple, mounted on walls or set on the floor in a steady, evenly spaced pattern. The installation *100 Untitled works in Mill Aluminum,* shown in **Figure 22.11**, features 100 identical metal boxes housed in two former military artillery sheds. Although they are absolutely identical, the impression is somewhat more varied because Judd opened opened one or more panels, not necessarily the corresponding ones. As light streams through the windows and reflects off the surfaces, the boxes cast shadows of various lengths on the floor and on each other.

Judd's shapes and materials are fabricated in factories from industrial or nontraditional materials. Because skilled workers (and not the artist) created Minimalist works according to the artist's specifications, the traditional relationship between the idea of art and its literal creation—as we shall see in Conceptual Art—is subverted.

Conceptual Art

We noted Joseph Kosuth's statement that being an artist in our times means challenging what is meant by *art.* Traditionally speaking, an artist has been expected to master his or her craft, be it painting, sculpting, architecture, filmmaking—whatever is the chosen medium. Yet we also noted that many painters forgo the brushstroke; Frankenthaler poured paint on canvas. Some artists have used found objects; Duchamp took a urinal, flopped it over on its back, and labeled it *Fountain,* and the art world generally concedes that it is art. Michelangelo wrote that he conceptualized the figures in blocks of stone and used the chisel to release them. But where, then, in Michelangelo lies the art? In the artist's mind or in the carved product? The **Conceptual Art** movement, which began in the 1960s, asserts that art does in fact lie in the mind of the artist; the visible or audible or palpable product is merely an expression of the

idea. Artist Sol LeWitt expressed his views on Conceptual Art as we see in Reading 22.3.

JOSEPH KOSUTH The charge Kosuth (b. 1945) gave to himself to change the meaning of art led to the creation of works such as *One and Three Hammers* (1965) and *One and Three Chairs* (1965; **Fig. 22.12**). Each of these works has three parts: the object itself, a photograph of the object, and the dictionary definition of the object. The artist displays what he considers to be the concept of "chairness" as it exists in his mind. It is not in the execution of the art that the art exists. We see no exquisite drawing or painting. We do not even have a found object that is converted into art; the chair is a chair. The photograph is unremarkable. The definition is . . . the definition. (As Stella remarked: "What you see is what you see.")

BARBARA KRUGER Barbara Kruger's (b. 1945) recent installation of graphic text on the walls and ceiling of the Guild Hall in East Hampton, New York—*Money Makes Money and a Rich Man's Jokes Are Always Funny, and You Want It. You Need It. You Buy It. You Forget It* (**Fig. 22.13**)—is very different from the works of Kosuth and LeWitt, yet it also prioritizes the idea of the work over the object, emphasizing the artist's thinking and often de-emphasizing traditional artistic techniques. Much of Kruger's work has

READING 22.3 **SOL LEWITT**

From "Paragraphs on Conceptual Art"

I will refer to the kind of art in which I am involved as conceptual art. In conceptual art the idea or concept is the most important aspect of the work. When an artist uses a conceptual form of art, it means that all of the planning and decisions are made beforehand and the execution is a perfunctory affair. The idea becomes a machine that makes the art. This kind of art is not theoretical or illustrative of theories; it is intuitive, it is involved with all types of mental processes and it is purposeless. It is usually free from the dependence on the skill of the artist as a craftsman. It is the objective of the artist who is concerned with conceptual art to make his work mentally interesting to the spectator, and therefore usually he would want it to become emotionally dry. There is no reason to suppose, however, that the conceptual artist is out to bore the viewer. It is only the expectation of an emotional kick, to which one conditioned to expressionist art is accustomed, that would deter the viewer from perceiving this art.

Sol LeWitt, "Paragraphs on Conceptual Art," *Artforum*, June 1967, 79–83.

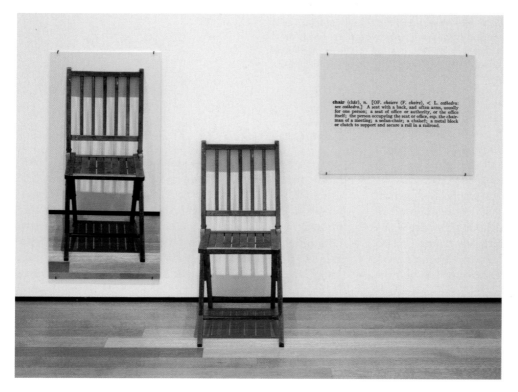

◄ **22.12** Joseph Kosuth, *One and Three Chairs*, 1965. Wooden folding chair, mounted photograph of a chair, and mounted photographic enlargement of the dictionary definition of "chair"; chair: 32 3/8″ × 14 7/8″ × 20 7/8″ (82 × 37.8 × 53 cm); photographic panel: 36″ × 24 1/8″ (91.5 × 61.1 cm); text panel: 24″ × 24 1/8″ (61 × 61.1 cm). Museum of Modern Art, New York, New York. © 2013 Joseph Kosuth/ Artists Rights Society (ARS), New York. Kosuth sought to communicate the concept of "chairness" from his mind to the viewer as directly as possible.

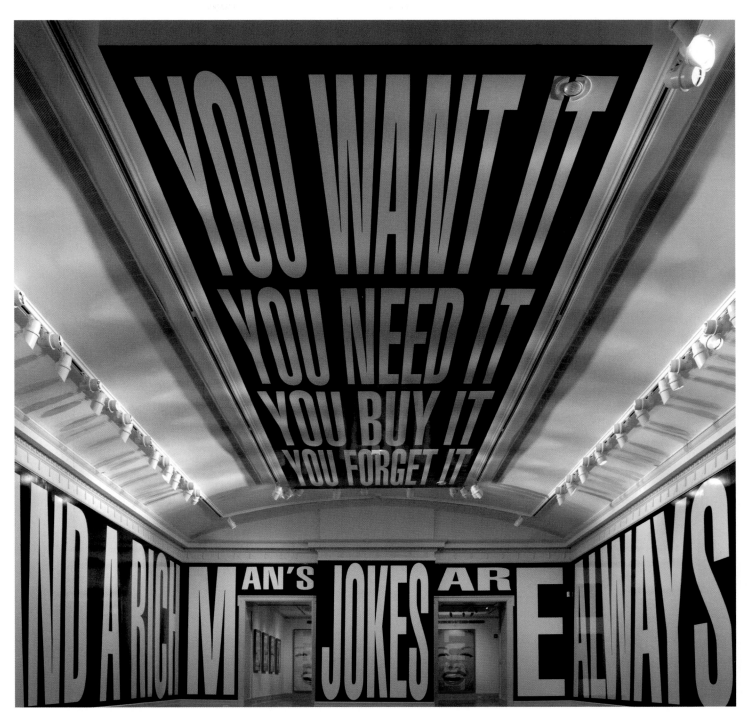

▲ **22.13** Barbara Kruger, *Untitled ("Money makes money and a rich man's jokes are always funny")* and *Untitled ("You want it You need it You buy it You forget it")*, details of 2010 installation titled "Plenty" at the Guild Hall, East Hampton, New York. Acrylic ink on adhesive vinyl, dimensions variable. Copyright © Barbara Kruger. Courtesy Mary Boone Gallery, New York. Kruger confronts viewers with the importance of money in their lives and the way that the social prominence of a person with money can be exaggerated.

been political, emphasizing issues relating to feminism and power. The visual aspect of Kruger's text in *Money Makes Money* relates to the billboards, magazines, and commercial advertising that saturate our cultural landscape, and reminds us of the constant media bombardment in our lives. Conceptually, the installation compels us to think about the impersonal information systems of our era and the degree to which we are affected by their subliminal messages. In this piece, Kruger asks the viewer to think about the cult of materialism and the adage "Money talks." The scale of the type and almost claustrophobic installation make confronting ourselves, our morals, and our way of life inescapable.

Site-Specific Art

Site-specific art is distinguished from other art that is typically created in a studio with no particular spatial context in mind. A site-specific artwork is produced in or for one location and—in theory, at least—is not to be relocated. The work is in and of its site, and often the content and meaning of the work are inextricably bound to it. By this description, the history of art is full of examples of site-specific art, such as the sculptural decoration on the Parthenon (**Fig. 3.4**) and Michelangelo's Sistine Chapel ceiling (**Figs. 13.12**). But the term *site-specific* came into use in the 1960s and 1970s as a blanket category for art that was created for or in a specific location. That location might be a museum or gallery, a public space, or a site in the natural landscape.

ROBERT SMITHSON Robert Smithson's (1938–1973) *Spiral Jetty* (**Fig. 22.14**) is an example of a type of site-specific art called **land art**. Land art is created or marked by an artist within natural surroundings. Sometimes large amounts of earth or land are shaped into sculptural forms. These works can be temporary or permanent and include great trenches and drawings in the desert, bulldozed configurations of earth and rock, and delicately constructed com-

▼ **22.14** Robert Smithson, *Spiral Jetty*, 1970. Black rocks, salt, earth, water, and algae, 1500′ × 15′ (457.2 × 4.6 m). Great Salt Lake, Utah. Art © Estate of Robert Smithson/Licensed by VAGA, New York, New York. Scale is one of the powerful elements in *Spiral Jetty*. It can be easily seen from an airplane flying at 35,000 feet.

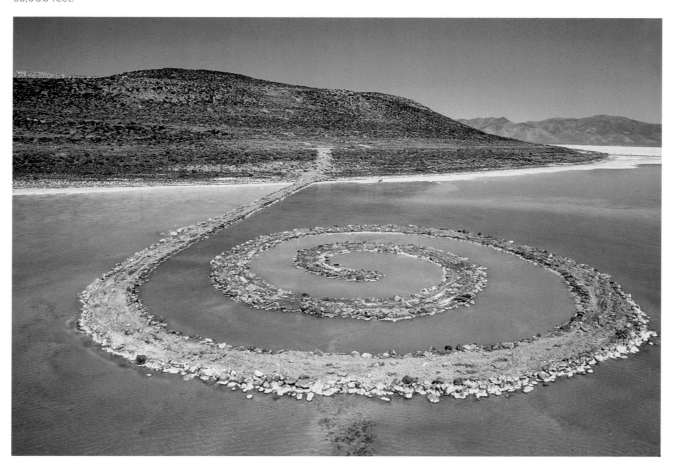

‹ 22.15 Maya Ying Lin, Vietnam Veterans Memorial, 1982. Washington, DC. Polished black granite with names inscribed, 492′ (150 m) long. Visitors leave flowers and notes and make rubbings of the names of their loved ones.

positions of ice, twigs, and leaves. What such works have in common is the artist's use of local materials to create pieces that are unified with or contrapuntal to the landscape.

Spiral Jetty is composed of basalt and earth bulldozed into a spiral formation in Utah's Great Salt Lake. The spiral shape of the jetty was inspired by a whirlpool, as well as by the configuration of salt deposits that accumulate on rocks bordering the lake. After its creation, the jetty lay submerged underwater for many years. With a prolonged drought, the spiral began to reemerge in 1999, and depending on the water levels of the lake, it now comes and goes.

MAYA YING LIN

It terrified me to have an idea that was solely mine
to be no longer a part of my mind, but totally public.

—MAYA YING LIN

This was Chinese-American artist Maya Ying Lin's (b. 1959) reaction to winning the competition—out of 1421 entries— to design the Vietnam Veterans Memorial on the National Mall. When we walk the mall, we are awed by the grand obelisk that is the Washington Monument. We are comforted by the stately columns and familiar shapes of the Lincoln and Jefferson Memorials. But many people have not known how to respond to Lin's monument, in the form of two 200-foot-long black granite walls that form a V as they recede into the ground of their two-acre site (**Fig. 22.15**). There is no label— only the names of 58,000 victims chiseled into the silent walls. In order to read the names, we must descend gradually into the earth, and then just as gradually work our way back up. This progress is perhaps symbolic of the nation's involvement in Vietnam.

The eloquently simple design of the memorial stirs controversy, as did the war it commemorates. Architecture critic Paul Gapp of the *Chicago Tribune* argued, "The so-called memorial is bizarre ... neither a building nor sculpture." One Vietnam veteran had called for a statue of an officer offering a fallen soldier to heaven. The public expects a certain heroic quality in its monuments to commemorate those fallen in battle, but Lin's work is antiheroic and anti-triumphal. Whereas most war monuments speak of giving up our loved ones to a cause, her monument speaks only of giving up our loved ones.

Another viewer observed:

As we descend along the path that hugs the harsh black granite, we enter the very earth that, in another place, has accepted the bodies of our sons and daughters. Each name is carved not only in the stone, but by virtue of its highly polished surface, in our own reflection, in our physical substance. We are not observers, we are participants. We touch, we write [letters to our loved ones], we leave parts of ourselves behind. This is a woman's vision—to commune, to interact, to collaborate with the piece to fulfill its expressive potential.[8]

8. Lois Fichner-Rathus, "A Woman's Vision of the War," *New York Times*, August 18, 1991.

COMPARE + CONTRAST

Heizer's *Rift #1* with Libeskind's Jewish Museum

In 1967, Michael Heizer (b. 1944) took to the bottom of a dry lake bed for *Rift* (Fig. 22.16), one piece in his land art series called *Nine Nevada Depressions*. Almost three decades later,

Daniel Libeskind (b. 1946) used a startlingly similar shape for his extension of the Berlin Museum dedicated to the Holocaust and Jewish art and life (Fig. 22.17). Libeskind's

▼ 22.16 Michael Heizer, *Rift #1*, 1968, first of *Nine Nevada Depressions*, 1968–1972. Displacement of 1.5 tons of earth, 518'5" × 14'9" × 9'10" (158 × 4.5 × 3 m). Massacre Dry Lake, Nevada. Photograph by Michael Heizer. Copyright © Triple Aught Foundation 2010.

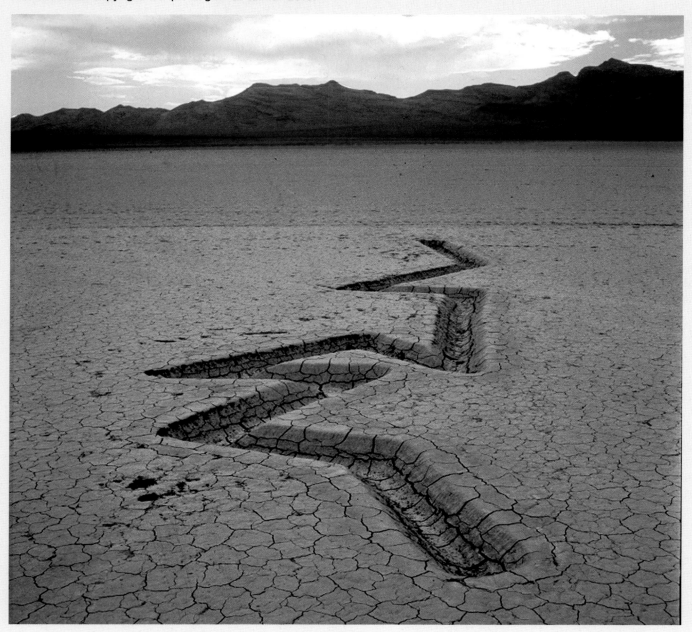

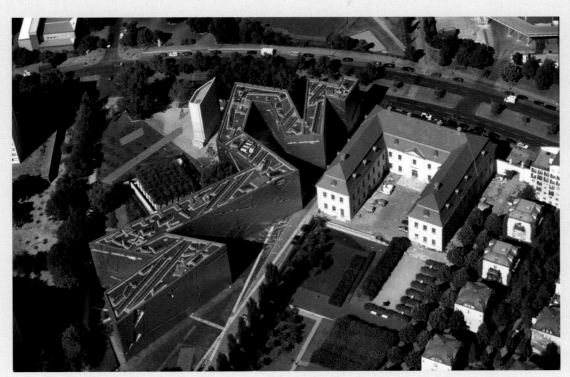

⌃ **22.17 Daniel Libeskind, Jewish Museum Berlin, 1989–1996. Extension of the Berlin Museum, Berlin, Germany. Reinforced concrete with zinc façade. Photograph © Günter Schneider.** The extension of the Berlin Museum is the zinc structure with the zig-zag shape on the left side of this aerial photograph.

zigzag design was derived mathematically by plotting the Berlin addresses of Jewish writers, artists, and composers who were killed during the Holocaust. The building's jagged shape reads as a painful rift in the continuity of the neighborhood in which it stands; it is punctuated by voids that symbolize the absence of Jewish people and culture in Berlin.

Heizer's *Rift* consists of a displacement of local materials such that the normalcy of the landscape is interrupted. For Heizer, the process is perhaps less about symbolism than it is about artistic elements. His depressions play with the relative scale of humans and nature; he is as much interested in the disintegration of his piece by natural processes over time as he is with the initial creative act. Heizer's jagged "scar" on the earth faded over time and then disappeared. How did Libeskind use this shape to try to ensure that the story of the Jews of Berlin would not fade or disappear? Is there something inherent in these shapes in contrast to their surroundings that suggests a certain symbolism or elicits a certain emotional response? How much do content and context influence our analysis of works with such visual congruities?

⌃ 22.18 Christo and Jeanne-Claude, *The Gates, Central Park, New York, 1979–2005.* 7,503 vinyl "gates," each hung with a panel of deep saffron-colored nylon fabric, along 23 miles (37 km) of pathways. Photograph by Spencer Rathus with permission of Christo and Jeanne-Claude. A serene view of *The Gates* after the snowfall.

CHRISTO AND JEANNE-CLAUDE As if intentionally timed to shake New York City out of its winter doldrums, 7503 sensuous saffron panels were gradually released from the tops of 16-foot-tall gates along 23 miles of footpaths throughout Central Park. It was the morning of February 12, 2005—a date that marked the end of artists Christo (b. 1935) and Jeanne-Claude's (1935–2009) 26-year odyssey to bring a major project to their adopted city. For a brief 16 days, the billowy nylon fabric fluttered and snapped, obscuring and framing New Yorkers' favorite park perspectives (**Fig. 22.18**). The park's majestic plan of ups and downs, of lazy loops and serpentine curves (as originally designed by Frederick Law Olmsted and Calvert Vaux), was being seen or reseen for the first time as visitors—participants—wove their walks according to the patterns of the gates. The artists have said that "the temporary quality of [our] projects is an aesthetic decision"; that it "endows the works of art with a feeling of urgency to be seen."

As with all of Christo and Jeanne-Claude's works of environmental art, every aspect of the *Gates* project was financed by the artists. The project required more than 1 million square feet of vinyl and 5300 tons of steel. Hundreds of paid volunteers assembled, installed, maintained, and removed the work, and most of the materials were recycled. The estimated cost of the project—borne by the artists alone—was $20 million. The artists finance their environmental sculptures—which have included *Wrapped Reichstag, Berlin, 1971–1995; Surrounded Islands, Biscayne Bay, Greater Miami, Florida, 1980–1983; Running Fence, Sonoma and Marin Counties, California, 1972–1976;* and others—by selling preparatory drawings and early works by Christo.

Pop Art

If one were asked to choose the most surprising, controversial, and also exasperating contemporary art movement, one might select **Pop Art**. The term "Pop" was coined by the English critic Lawrence Alloway in 1954 to refer to the universal images of "popular culture," such as movie post-

ers, billboards, magazine and newspaper photographs, and advertisements. Pop Art, by its selection of commonplace and familiar subjects—subjects that are already too much with us—also challenges commonplace conceptions about the meaning of art.

Whereas many artists have strived to portray the beautiful, Pop Art intentionally depicts the mundane. Whereas many artists represent the noble, stirring, or monstrous, Pop Art renders the commonplace, the boring. Whereas other forms of art often elevate their subjects, Pop Art is often matter-of-fact. In fact, one tenet of Pop Art is that the work should be so objective that it does not show the "personal signature" of the artist. This maxim contrasts starkly, for example, with the highly personalized gestural brushstroke found in Abstract Expressionism.

RICHARD HAMILTON Despite the widespread view that Pop Art developed purely in the United States, it actually originated during the 1950s in England. British artist Richard Hamilton (1922–2011), one of its creators, had been influenced by Marcel Duchamp's idea that the mission of art should be to destroy the normal meanings and functions of art.

Hamilton's tiny collage *Just What Is It That Makes Today's Homes So Different, So Appealing?* (**Fig. 22.19**) is one of the earliest and most revealing Pop Art works. It functions as a veritable time capsule for the 1950s, a decade during which the speedy advance of technology found many buying pieces of the American dream. What is that dream? Comic books, TVs, movies, and tape recorders; canned hams and TV dinners; enviable physiques, Tootsie Pops, vacuum cleaners that finally let the "lady of the house" clean all the stairs at once. It is easy to read satire and irony into Hamilton's work, but his placement of these objects within the parameters of art encourages us to truly *see* them instead of just coexisting with them.

ROBERT RAUSCHENBERG American Pop artist Robert Rauschenberg (1925–2008) studied in Paris and then with Josef Albers and others at the famous Black Mountain College

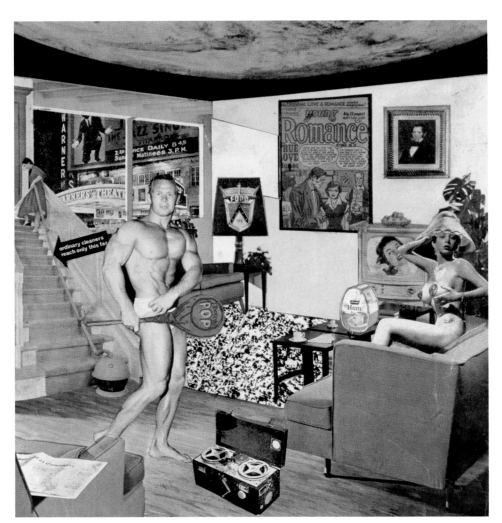

◄ **22.19** Richard Hamilton, *Just What Is It That Makes Today's Homes So Different, So Appealing?*, 1956. Collage, 10 ¼" × 9 ¼" (26 × 23.5 cm). Kunsthalle Tübingen, Tübingen, Germany. © R. Hamilton. All Rights Reserved, DACS 2013. The objects in this tiny collage make it very much a time capsule of its day.

in North Carolina. Before developing his own Pop Art style, Rauschenberg experimented with loosely and broadly brushed Abstract Expressionist canvases. He is best known, however, for introducing a construction referred to as the **combine painting**, in which stuffed animals, bottles, articles of clothing and furniture, and scraps of photographs are attached to the canvas.

Rauschenberg's *Bed* (**Fig. 22.20**) is a paint-splashed quilt and pillow, mounted upright on a wall as any painting might be. Here the artist toys with the traditional relationships between materials, form, and content. The content of the work is actually its support; rather than a canvas on a stretcher, the quilt and pillow are the materials on which the painter has dripped and splashed his pigments. Perhaps even more outrageous is Rauschenberg's famous 1959 work *Monogram*, in which a stuffed goat—with an automobile tire wrapped around its middle—is mounted on a horizontal base that consists of scraps of photos and prints and loose, gestural painting.

JASPER JOHNS Jasper Johns (b. 1930) was Rauschenberg's classmate at Black Mountain College, and their appearance on the New York art scene was simultaneous. His early work also integrated the overall gestural brushwork of the Abstract Expressionists with the use of found objects, but unlike Rauschenberg, Johns soon made the object central to his compositions. His works frequently portray familiar objects, such as numbers, maps, color charts, targets, and flags, integrated into a unified field by thick gestural brushwork.

One "tenet" of Pop Art is that imagery is to be presented objectively, that the personal signature of the artist is to be eliminated. That principle must be modified if we are to include within Pop the works of Rauschenberg, Johns, and others, for many of them immediately betray their devotion to expressionistic brushwork. Johns's *Three Flags* (**Fig. 22.21**) was painted with encaustic (a combination of liquid wax and pigment) and newsprint on three canvases of increasing size that are superimposed on one another. The result yields a distinct surface texture that informs the viewer that she or he is not looking at a painting and not at actual machine-made flags. The work requires the viewer to take a new look at a most familiar object.

ANDY WARHOL Andy Warhol (1928–1987) once earned a living designing packages and Christmas cards. Today he epitomizes the Pop artist in the public mind. Just as Campbell's soups represent bland, boring nourishment, Andy Warhol's appropriation of hackneyed portraits of celebrities, his Brillo boxes, and his Coca-Cola bottles (**Fig. 22.22**) elicit comments that contemporary art has become bland and boring and that there is nothing much to be said about it. Warhol also evoked contempt here and there for his underground movies, which have portrayed sleep and explicit eroticism (*Blue Movie*) with equal disinterest. Even his shooting (from which he recovered) by a disenchanted actress seemed to evoke yawns and a "What can you expect?" reaction from the public.

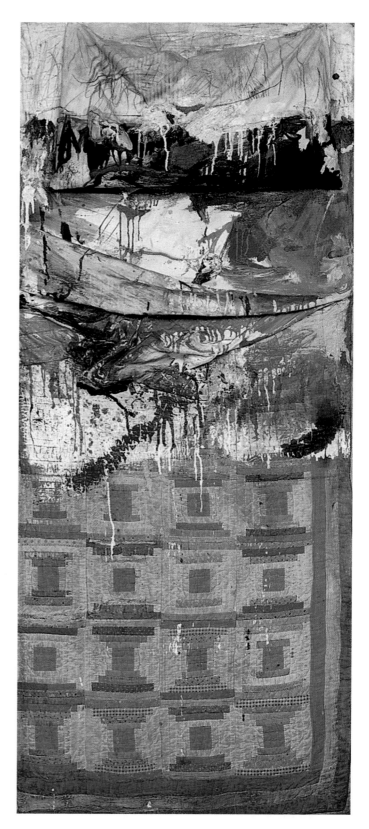

▲ **22.20** Robert Rauschenberg, *Bed*, 1955. Combine painting: oil and pencil on pillow, quilt, and sheet on wood supports, 75¼" × 31½" × 6½" (191.1 × 80 × 20.3 cm). Museum of Modern Art, New York, New York. Art © 2013 Robert Rauschenberg/ Licensed by VAGA, New York, New York. The gestural brushwork and the drips provide some of the "personal signature" of the artist.

➤ 22.21 Jasper Johns, *Three Flags*, 1958. Encaustic on canvas, 30⁷/₈″ × 45¹/₂″ × 5″ (78.4 × 115.6 × 12.7 cm). Whitney Museum of American Art, New York, New York. Art © Jasper Johns/ Licensed by VAGA, New York, New York. Unlike an actual flag, the painting has a pronounced surface texture, reinforcing the fact that it is not an attempt to create the illusion of a real flag.

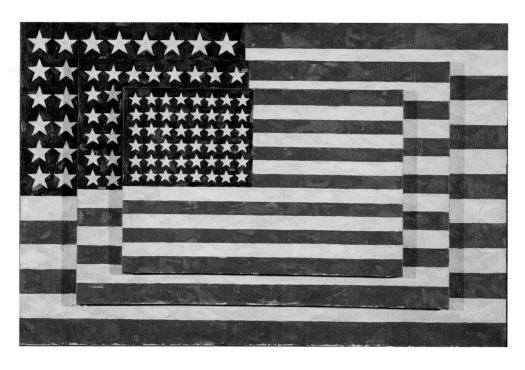

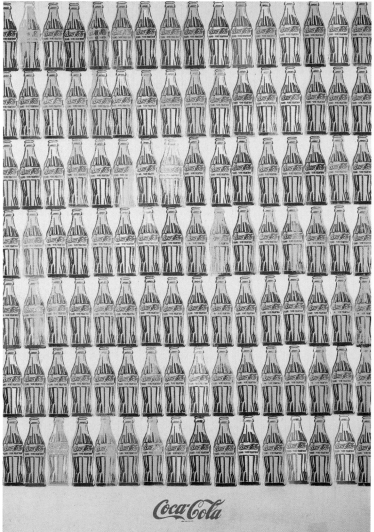

◀ 22.22 Andy Warhol, *Green Coca-Cola Bottles*, 1962. Synthetic polymer, silk-screen ink, and graphite on canvas, 82³/₈″ × 57″ (209.2 × 144.8 cm). Whitney Museum of American Art, New York, New York. © 2013 The Andy Warhol Foundation for the Visual Arts/Artists Rights Society (ARS), New York. Many of Warhol's works involve the repetition of ordinary objects or hackneyed images of celebrities.

Warhol painted and printed much more than industrial products. During the 1960s, he reproduced multiple photographs of disasters from newspapers. He executed a series of portraits of public figures such as Marilyn Monroe and Jackie Kennedy in the 1960s. Marilyn Monroe and Jacqueline Kennedy were both tortured American personas whose images became overused and ubiquitous in the 1960s. Monroe, the movie star, was the nation's first "blonde bombshell," married, sequentially, to such popular figures as the playwright Arthur Miller and the New York Yankees baseball "hero" Joe DiMaggio. The White House, occupied by Jack and Jackie Kennedy and their children, became widely known as Camelot, the legendary dwelling place of King Arthur of Britain. The Kennedy family, especially in the early 1960s, was as close as the modern United States came to having its own royal family. President Kennedy was assassinated in Dallas, Texas, in November 1963. Warhol turned to portraits of political leaders such as Mao Zedong in the 1970s. Although his silk screens at least in their technique met the Pop Art objective of obscuring the personal signature of the artist, his compositions and expressionistic brushing of areas of his paintings achieved an individual stamp.

CLAES OLDENBURG Claes Oldenburg (b. 1929) is a Swedish American artist best known for his oversized sculptures in public places, such as the 45-foot-tall *Clothespin* in Philadelphia and the 19-foot-tall *Typewriter Eraser, Scale X* in the sculpture garden of the National Gallery of Art in Washington, DC. The scale of these ordinary objects is responsible for their impact. Other works by Oldenburg owe their impact to their subversion of our senses, such as *Soft Bathtub* and *Soft Toilet* (**Fig. 22.23**). We know these objects to be hard, cold, and unmovable, but Oldenburg constructs them with vinyl stitching and stuffs them with kapok, a silky natural fiber.

Superrealism

Superrealism, or the rendering of subjects with sharp, photographic precision, is firmly rooted in the long realistic tradition in the arts. But as a movement that first gained major recognition during the early 1970s, it also owes some of its impetus to Pop Art's objective portrayal of familiar images. Superrealism is also in part a reaction to the Expressionistic and abstract movements of the 20th century. That is, Superrealism permits artists to do something that is very new to the eye even while they are doing something very old.

AUDREY FLACK Audrey Flack (b. 1931) was born in New York and studied at the High School of Music and Art, at Cooper Union, and at Yale University's Graduate School. During the 1950s she showed figure paintings that were largely ignored, in part because of the popularity of Abstract Expressionism and in part because women artists, in general, did not receive the critical attention that their male colleagues received. Yet throughout these years, Flack persisted in a sharply realistic or trompe l'oeil style. The technical precision of a painting such as *Jolie Madame* (**Fig. 22.24**) was achieved by projecting a color slide onto a blank canvas, drawing over

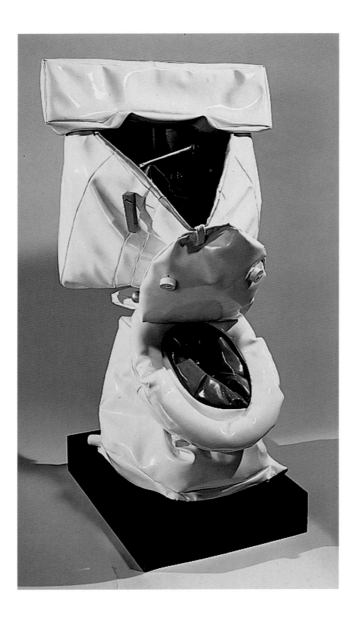

◄ **22.23** Claes Oldenburg, *Soft Toilet*, 1966. Wood, vinyl, kapok fibers, wire, and Plexiglass on metal stand and painted wood base, 57″ × 28 3/4″ × 28″ (144.9 × 70.2 × 71.3 cm). Whitney Museum of American Art, New York, New York. © 1966 Claes Oldenburg. We know toilets to be cold, hard, and unbendable. *Soft Toilet* defeats all these expectations.

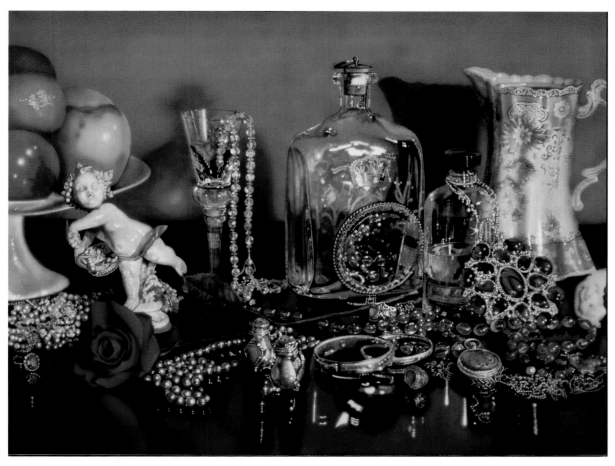

▲ 22.24 Audrey Flack, *Jolie Madame*, 1973. Oil over acrylic on canvas, 71½″ × 95¾″ (181.5 × 243 cm). National Gallery of Australia, Canberra, Australia. © Audrey Flack, courtesy Gary Snyder Gallery, New York. The artist's juxtaposition of objects such as the jewels, porcelain, fruit, and fresh-cut flower encourage the viewer to meditate on the fragility of life and its transitory nature.

the image, and then rendering the nuances of surfaces using a combination of controlled airbrushing and layers of primary colors in transparent glazes. Flack is fascinated by the ways in which a wide variety of contrasting textures reflect light. Some of her still life compositions offer meaning, however, beyond their dazzling surfaces. In Jolie Madame, the array of elaborate adornments bring into focus the questionable premium placed by society on a certain standard of beauty; the inclusion of such things as a compote of ripe fruit, a perfect cut, long-stemmed rose, and a pocket-watch, symbolize the transitory nature of that beauty.

Art, Identity, and Social Consciousness

Art has always reflected the society in which it was created, but today the individual would appear to be paramount, and artists are just as likely to use art to express who they are

as people, or women, or members of various ethnic groups, and how they react to the societies in which they find themselves.

JUDY CHICAGO AND MIRIAM SCHAPIRO In 1970, a Midwestern artist named Judy Gerowitz (b. 1939)—who would soon call herself Judy Chicago—initiated a **feminist** studio art course at Fresno State College in California. One year later, she collaborated with artist Miriam Schapiro (b. 1923) on a feminist art program at the California Institute of the Arts in Valencia. Their interests and efforts culminated in another California project—a communal installation in Hollywood called Womanhouse. Teaming up with students from the University of California, Chicago and Schapiro refurbished each room of a dilapidated mansion in a theme built around women's experiences: The Kitchen, by Robin Weltsch, was covered with breast-shaped eggs; Menstruation Bathroom, by Chicago, included the waste products of female menstruation cycles in a sterile white environment. Womanhouse called

attention to women artists, their wants, their needs. In some ways, it was an expression of anger toward the injustice of art-world politics that many women artists experienced—lack of attention by critics, curators, and historians; pressure to work in canonical styles. It announced to the world, through shock and exaggeration, that men's subjects are not necessarily of interest to women; that women's experiences are significant. And perhaps of most importance, particularly in light of the subsequent careers of its participants, the exhibition exalted women's ways of working.

Chicago has since become renowned for her installation *The Dinner Party* (**Fig. 22.25**), in which the lines between life and death, between place and time, are temporarily dissolved. The idea for this multimedia work, which was constructed to honor and immortalize history's notable women, revolves around a fantastic dinner party, where the guests of honor meet before place settings designed to reflect their personalities and accomplishments. Chicago and numerous other female artists have invested much energy in alerting the public to the significant role of women in the arts and society.

CINDY SHERMAN Photographer Cindy Sherman (b. 1954) is her own exclusive subject, adopting diverse personae for her photographs. In many of her photos of the 1970s she placed herself in domestic settings, aproned and staring vacuously at the camera across a crowded kitchen counter. She shot herself in other feminine roles as well: as a naïvely buxom librarian reaching for a book on a high shelf, a chic Italian-style starlet contemplating stepping out of her hotel room into the sun, a sexy wife lounging dreamily in underwear in her bedroom.

Then she undertook a new series of photographs. Sherman recalls a mundane, early inspiration for her new approach: "I had all this makeup. I just wanted to see how transformed I could look. It was like painting in a way."[9] Soon she set herself before elaborate backdrops, costumed in a limitless wardrobe. Dress designers began to ask her to use their haute couture in her photographs, and works such

9. Cindy Sherman, quoted in Gerald Marzorati, "Imitation of Life," *ARTnews*, September 1983, 84–85.

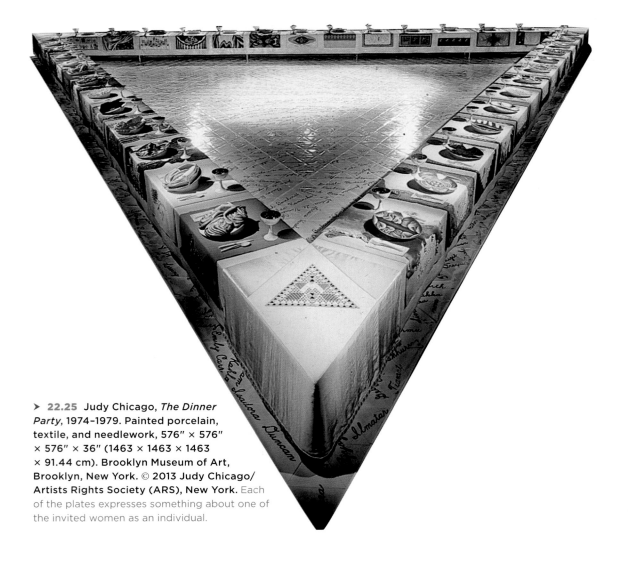

> **22.25** Judy Chicago, *The Dinner Party*, 1974–1979. Painted porcelain, textile, and needlework, 576" × 576" × 576" × 36" (1463 × 1463 × 1463 × 91.44 cm). Brooklyn Museum of Art, Brooklyn, New York. © 2013 Judy Chicago/ Artists Rights Society (ARS), New York. Each of the plates expresses something about one of the invited women as an individual.

◄ **22.26** Cindy Sherman, *Untitled* (#138), 1984. Color coupler print, 71 ⅝″ × 48″ (181.9 × 121.9 cm). © **Cindy Sherman, courtesy Metro Pictures.** The French *Vogue* magazine commissioned Sherman to do an advertising shoot, and this photograph was one of the results.

as *Untitled* (#138) (**Fig. 22.26**) were actually shot as part of an advertising assignment for French *Vogue*. The result is less a sales device than a harsh view of the fashion industry. Sherman appears as a disheveled model with a troubling expression. Something here is very wrong. Regimented stripes go awry as the fabric of her dress is stretched taut across her thighs and knees. Her hands rest oddly in her lap, fingertips red with what seems to be blood. And then there is the smile—an unsettling leer implying madness.

GUERRILLA GIRLS During the 1980s, something of a backlash against inclusion of women and ethnic minorities in the arts could be observed.[10] For example, a 1981 London exhibition, *The New Spirit in Painting*, included no women artists. A 1982 Berlin exhibition, *Zeitgeist*, represented 40 artists, but only one was a woman. The 1984 inaugural exhibition of the Museum of Modern Art's remodeled galleries, *An International Survey of Recent Painting and Sculpture*, showed the works of 165 artists, only 14 of whom were women. The New York exhibition *The Expressionist Image: American Art from Pollock to Today* included the works of 24 artists, only two of whom were women. And so it went.

To combat this disturbing trend, an anonymous group of women artists banded together as the Guerrilla Girls. The group appeared in public with gorilla masks and proclaimed themselves to be the "conscience of the art world." They

10. Whitney Chadwick, *Women, Art, and Society* (London: Thames and Hudson, 1990).

WHEN RACISM & SEXISM ARE NO LONGER FASHIONABLE, WHAT WILL YOUR ART COLLECTION BE WORTH?

The art market won't bestow mega-buck prices on the work of a few white males forever. For the 17.7 million you just spent on a single Jasper Johns painting, you could have bought at least one work by all of these women and artists of color:

Bernice Abbott
Anni Albers
Sofonisba Anguisolla
Diane Arbus
Vanessa Bell
Isabel Bishop
Rosa Bonheur
Elizabeth Bougereau
Margaret Bourke-White
Romaine Brooks
Julia Margaret Cameron
Emily Carr
Rosalba Carriera
Mary Cassatt
Constance Marie Charpentier
Imogen Cunningham
Sonia Delaunay

Elaine de Kooning
Lavinia Fontana
Meta Warwick Fuller
Artemisia Gentileschi
Marguérite Gérard
Natalia Goncharova
Kate Greenaway
Barbara Hepworth
Eva Hesse
Hannah Hoch
Anna Huntingdon
May Howard Jackson
Frida Kahlo
Angelica Kauffmann
Hilma af Klimt
Kathe Kollwitz
Lee Krasner

Dorothea Lange
Marie Laurencin
Edmonia Lewis
Judith Leyster
Barbara Longhi
Dora Maar
Lee Miller
Lisette Model
Paula Modersohn-Becker
Tina Modotti
Berthe Morisot
Grandma Moses
Gabriele Münter
Alice Neel
Louise Nevelson
Georgia O'Keeffe
Meret Oppenheim

Sarah Peale
Ljubova Popova
Olga Rosanova
Nellie Mae Rowe
Rachel Ruysch
Kay Sage
Augusta Savage
Vavara Stepanova
Florine Stettheimer
Sophie Taeuber-Arp
Alma Thomas
Marietta Robusti Tintoretto
Suzanne Valadon
Remedios Varo
Elizabeth Vigée Le Brun
Laura Wheeling Waring

Information courtesy of Christie's, Sotheby's, Mayer's International Auction Records and Leonard's Annual Price Index of Auctions

Please send $ and comments to: **GUERRILLA GIRLS** CONSCIENCE OF THE ART WORLD
Box 1056 Cooper Sta. NY, NY 10276

▲ **22.27** Guerrilla Girls, *When Racism & Sexism Are No Longer Fashionable, What Will Your Art Collection Be Worth?* 1989. Poster, 17″ × 22″ (43.2 × 55.9 cm). Copyright © Guerrilla Girls, Courtesy www.guerrillagirls.com. You will find many of the women artists listed on the poster in this book.

mounted posters on buildings in Manhattan's SoHo district, one of the most active centers in the art world today. They took out ads of protest.

Figure 22.27 shows one of the Guerrilla Girls' posters. This particular poster sardonically notes the "advantages" of being a woman artist in an art world that, despite the "liberating" trends of the postfeminist era, continues to be dominated by men. It also calls attention to the blatant injustice of the relative price tags on works by women and men. Note that at this writing, the inequity persists.

ROBERT MAPPLETHORPE Photographer Robert Mapplethorpe (1946–1989) created many black-and-white images

▶ **22.28** Robert Mapplethorpe, *Ken Moody and Robert Sherman*, 1984. Platinum print, edition of 10, 19 1/2″ × 19 5/8″ (49.5 × 49.9 cm). Solomon R. Guggenheim Museum, New York, New York. © The Robert Mapplethorpe Foundation. Courtesy Art + Commerce. Some of Mapplethorpe's photographs drew the country's attention to elements of what it was like to be gay and living in the United States at the end of the millennium.

of people struggling in a world that was hostile toward them because of their sexual identity. He grabbed that world by the throat and shook it. He used his photographic skills to shoot not only his acquaintances and friends—artists, musicians, and socialites—but also the first winner of the Women's World Pro Bodybuilding Championship, Lisa Lyon; pornographic film stars; and people from the S&M (sadism and masochism) underground. Many of these latter photographs were sexually explicit, and there were debates as to whether the government, through the National Endowment for the Arts, should be helping to support exhibitions that certain members of Congress felt were "obscene."

Figure 22.28 shows a gay couple, black and white, shot in black and white. The artist shows them with shaved heads so that even a slight similarity in hair color has been eliminated. Although different, the couple are very much together—the white man resting against the black man's back, the black man apparently pleased with the contact. Genital organs are not shown, but the men seem to be at their most raw and basic. Although the figures are still, there is a diagonal line of intensity rising form the lower right into the center of the composition.

Mapplethorpe was diagnosed with AIDS in 1986 and died three years later.

ROMARE BEARDEN Some critics have noted that Abstract Expressionism was essentially an exclusive group of white male artists. Few, if any, women artists or artists of color were counted among the household names associated with the movement. But others adopted the idiom of Abstract Expressionism, and scholars and curators have rediscovered their work.

The African American artist Romare Bearden (1911–1988), like many in the New York School, began painting as a Works Progress Administration artist and studied at the Art Students League. After military service during World War II, he left for Paris to study philosophy on the GI Bill. During the late 1940s and 1950s, he swapped his Social Realist style for a version of Abstract Expressionism, but in the early 1960s he defined the signature artistic vocabulary, combining painting and collage, that would become characteristic of his mature style. Bearden's work began to include references to African life and culture that continued throughout his career.

A work such as *The Dove* (**Fig. 22.29**) represents a synthesis of Cubism and Abstract Expressionism, constructed through the lens of African American experience. We are drawn into a Harlem street scene composed of clipped, irregularly shaped fragments of photographs—varying in scale and density—pasted onto a regimented backdrop that feels almost like a Cubist grid. The imagery spreads across the field uniformly, with no particular focal point—much the way Abstract Expressionists created their allover compositions. As in viewing a Pollock painting, we experience the tension between surface and depth: the overlapping lines

◀ **22.29** Romare Bearden, *The Dove*, 1964. Cut-and-pasted paper, gouache, pencil, and colored pencil on cardboard, 13 3/8″ × 18 3/4″ (33.8 × 47.5 cm). Museum of Modern Art, New York, New York. Art © The Romare Bearden Foundation/Licensed by VAGA, New York, New York. The artist experimented with various styles and media, but his collages have been some of his best-known work.

in *One* draw us into the compressed space of the painting and then fix our eyes again on the surface. In *The Dove*, the clarity of some images in relation to others, and the shifts and subversions of scale, leads our eyes to believe that some figures are near and some are distant. Shape and scale shifting creates a similar tension between surface and depth. Works like *The Dove* reflect Bearden's desire to capture flashes of memory that read like a scrapbook of consciousness and experience particular to his own life and times—from his childhood in North Carolina to his life and work in Harlem. The writer and literary critic Ralph Ellison wrote of Bearden's art:

> Bearden's meaning is identical with his method. His combination of technique is in itself eloquent of the sharp breaks, leaps in consciousness, distortions, paradoxes, reversals, telescoping of time and surreal blending of styles, values, hopes and dreams which characterize much of [African] American history.[11]

FAITH RINGGOLD Faith Ringgold was born in New York City's Harlem neighborhood in 1930 and educated in the public schools of New York City. Raised with a social conscience, she painted murals and other works inspired by the civil-rights movement in the 1960s, and a decade later took to feminist themes after her exclusion from an all-male exhibition at New York's School of Visual Arts. Ringgold's mother, a fashion designer, was always sewing, the artist recalls, and at this time the artist turned to sewing and related techniques—needlepoint, beading, braided ribbon, and sewn fabric—to produce soft sculptures.

More recently, Ringgold has become known for her narrative quilts, such as *Tar Beach* (**Fig. 22.30**), which combine traditions common to African Americans and women—storytelling and quilting. Here Ringgold tells the story of life and dreams on a tar-covered rooftop. *Tar Beach* is a painted patchwork quilt that stitches together the artist's memories of family, friends, and feelings while growing up in Harlem. Ringgold is noted

for her use of materials and techniques associated with women's traditions as well as her use of narrative or story-telling, a strong tradition in African American families. A large, painted square with images of Ringgold, her brother, her parents, and her neighbors dominates the quilt and is framed with brightly patterned pieces of fabric. Along the top and bottom are inserts crowded with Ringgold's written description of her experiences. This wonderfully innocent and joyful monologue begins:

> I will always remember when the stars fell down around me and lifted me up above the George Washington Bridge . . .

JEAN-MICHEL BASQUIAT Jean-Michel Basquiat (1960–1988) was a Haitian-Hispanic artist who dropped out of school at 17, rose quickly to fame and fortune in his early 20s, and died at 27 of a drug overdose. He is now considered to have been one of the most talented artists of his gen-

11. Ralph Ellison, introduction to *Romare Bearden: Paintings and Projections* (The Art Gallery of the State University of New York at Albany, Albany, New York, 1968).

> ➤ **22.30** Faith Ringgold, *Tar Beach*, 1988. Acrylic on canvas, bordered with printed, painted, quilted, and pieced cloth, 74 ⅝″ × 68 ½″ (189.5 × 174 cm). Solomon R. Guggenheim Museum, New York, New York. © Faith Ringgold 1988. Why do you think this quilt is titled *Tar Beach*?

In the center of the piece, a German tank appears to separate the golden hair from the darker, incinerated hair in the distance (at the top of the work).

eration, as well as a symbolic casualty of the cycle of work, success, and burnout that characterized the 1980s in the United States.

Basquiat's origins as an artist were not propitious. The themes, symbols, and strokes for which he is known first appeared on downtown New York City walls as graffiti. With Andy Warhol as a mentor, he brought his own complex form of collage to canvas, combining photocopies, drawing, and painting in intricate and overworked layers. In virtually all of Basquiat's art, there is a complex iconography at work. References to African American experiences—from slavery and discrimination to hard-won successes of African Americans such as jazz musician Charlie Parker or athlete Jesse Owens—pour across the canvases in images, symbols, and strands of text. Basquiat sought to emphasize the process of painting while never losing focus of the essential role of narrative (see **Fig. 21.12**).

ANSELM KIEFER Anselm Kiefer (b. 1945) comes from a very different background from Basquiat's. He is a (white) German painter and sculptor wracked with feelings of horror and guilt concerning the Holocaust. Kiefer synthesizes an Expressionistic painterly style with strong abstract elements in a narrative form of painting that makes multiva-

lent references to German history and culture. The casual observer cannot hope to decipher Kiefer's paintings; they are highly intellectual, obscure, and idiosyncratic. But at the same time, they are overpowering in their scale, their larger-than-life subjects, and their textural, encrusted surfaces.

Dein Goldenes Haar, Margarethe (**Fig. 22.31**) serves as an excellent example of the artist's formal and literary concerns. The title of the work, and others of this series, refers to a poem by Holocaust survivor Paul Celan— "Your Golden Hair, Margarethe"—that describes the destruction of European Jews through the images of a golden-haired German woman named Margarethe and a dark-haired Jewish woman named Shulamith. Against a pale gray-blue background, Kiefer uses actual straw to suggest the hair of the German woman, contrasting it with thick black paint that lies charred on the upper canvas, to symbolize the hair of her unfortunate counterpart. Between them a German tank presides over this human destruction, isolated against a wasteland of its own creation. Kiefer here, as often, scrawls his titles or other words across the canvas surface, sometimes veiling them with his textured materials. The materials function as content; they become symbols to which we must respond emotionally and intellectually.

READING 22.4 PAUL CELAN

From "Death Fugue," lines 28–35

Black milk of daybreak we drink you come night
we drink you come midday Death is a German-born master
We drink you come evening come morning we drink you and
drink you
Death is a German-born master his eye is so blue
He shoots with lead bullets he shoots you his aim is so true
a man lives at home the gold of your hair Margarete
he lets his hounds loose on us grants us a grave in the air
he plays with his vipers and dreams a dream Death is a
German-born master

From *The Bedford Anthology of World Literature: The Twentieth Century, 1900—The Present*. BOOK 6. Paul Davis, Gary Harrison, David M. Johnson, Patricia Clark Smith, and John F. Crawford (Eds) Translated by John Felstiner, p. 528, lines 29–39. © Bedford/St. Martin's, 2003. Reprinted by permission of John Felstiner.

SHIRIN NESHAT

I see my work as a pictorial excursus on the topic of feminism and contemporary Islam—a discussion that puts certain myths and realities under the microscope and comes to the conclusion that these are much more complex than many of us had thought.

—Shirin Neshat

The photographer and video artist Shirin Neshat (b. 1957) came to the United States from Iran as a teenager, before the shah, or monarch, was removed from power in 1979, and returned in 1990 to witness a nation transformed by the rule of Islamic clergy. She was particularly concerned about how life had changed for Iranian women, who now had limited opportunities outside the home and were veiled behind black chadors. **Figure 22.32** is one of a series called *Women of Allah*, in which guns or flowers are frequently juxtaposed with vulnerable though rebellious faces and hands that emerge from beneath the veil. The exposed flesh is overwritten with sensual or political texts by Iranian women in the Farsi language. Although the calligraphic writing is visually beautiful and elegant, there is no mistaking its purpose as one of resistance. The photos are unlikely to be seen and "decoded" by the eyes of Iranians living in Iran, but the message of the artist to the world outside is clear.

Sculpture

True experimentation in the medium of sculpture came with the advent of the 20th century, and contemporary sculptors owe much to the trailblazing predecessors who embraced unorthodox materials, techniques, and influences. Style, content, composition, materials, and, from midcentury onward, *scale* were completely up for grabs.

DAVID SMITH American artist David Smith (1906–1965) moved away from figurative sculpture in the 1940s. His works of the 1950s were compositions of linear

◄ **22.32** Shirin Neshat, *Allegiance with Wakefulness*, 1994. Black & white RC print & ink (photo taken by Cynthia Preston). Copyright © Shirin Neshat. Courtesy Gladstone Gallery, New York and Brussels. The artist's feet are inscribed with militant messages in Farsi.

steel that crossed back and forth as they swept through space. Many sculptors of massive works create the designs but then farm out their execution to assistants or to foundries. Smith, however, took pride in constructing his own metal sculptures. Even though his shapes are geometrically pure (**Fig. 22.33**), his loving burnishing of their highly reflective surfaces grants them the overall gestural quality found in Abstract Expressionist paintings.

ALEXANDER CALDER Trained as a mechanical engineer, Alexander Calder (1898–1976) made **mobiles** that move with currents of air. They are among the most popular examples of

⋀ **22.34** Alexander Calder, *The Star*, 1960. Polychrome sheet metal and steel wire, 35 ³/₄″ × 53 ³/₄″ × 17 ⁵/₈″ (90.8 × 136.5 × 44.8 cm). Art Museum at the University of Kentucky, Lexington, Kentucky. © 2013 The Calder Foundation, New York/Artists Rights Society (ARS), New York. Calder's mobiles are designed to adjust to currents of air.

sculpture in the 20s century. Viewers generally enjoy them for their simple shapes, pure colors, and predictable seriation in size, and, incidentally, tend to watch for a while to see whether and how they will move. One does not view a Calder mobile and suspect that deep meanings lie within the work. *The Star* (**Fig. 22.34**) is composed of petallike pieces of different sizes and colors that are cantilevered from metal rods in such a way that they can rotate horizontally—in orbits—in the breeze. However, the center of gravity remains stable, so that the entire sculpture is hung from a single point. The composition changes according to air currents and the perspective of the observer. The combinations of movements are for all practical purposes infinite, so that the observer will never see the work in quite the same way.

LOUISE NEVELSON The Russian-born American sculptor Louise Nevelson (1899–1988) made wood assemblages of recognizable found objects, integrating them in novel combinations that take on meanings of their own—

meanings that are more than the sum of their parts. *Royal Tide IV* (**Fig. 22.35**) is a compartmentalized assemblage of rough-cut geometric shapes and lathed wooden pieces including posts and finials, barrel staves, and chair slats— the pieces of a personal or collective past, of lonely introspective journeys amid the cobwebs of Victorian attics. Even though some of the objects are familiar and recognizable, Nevelson's unifying coat of paint de-emphasizes their distinct identities.

JANINE ANTONI Janine Antoni (b. 1964) has stated, "For me, creativity is about unlocking memories within the body. It's also about thinking with the body."[12] Her sculpture *Gnaw* (**Fig. 22.36**) may pay tongue-in-cheek homage to a Minimal-

12. Janine Antoni, quoted in "Visual Arts Faculty: Janine Antoni, 'Move: Choreographing You,'" Columbia University School of the Arts, accessed May 15, 2012.

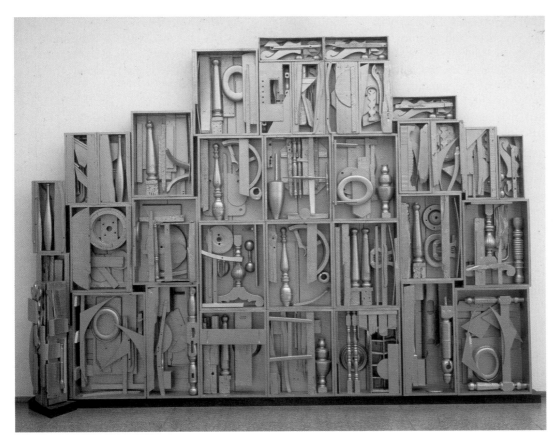

ist geometric sculpture, but it holds some sensory surprises: Antoni's material is chocolate and her "carving" tools consist of what nature has endowed her with—a strong set of teeth. The surface texture of the piece records the process of a performance centered on the piece, and Antoni characterizes process as the most important element of her art. *Gnaw* was one of three companion pieces—the others were a cube of lard, and lipstick in a display case—which she bit and chewed.

RACHEL WHITEREAD Born in 1963, Rachel Whiteread is an English artist whose

sculptures are often cast—made of liquid poured into a mold and allowed to solidify. Many of her casts are of ordinary objects, but she also often fills the spaces between, creating heavy geometric structures. We would be hard-pressed to conjure a better exemplar of mass than Whiteread's Holocaust

Memorial in Vienna (**Fig. 22.37**). It possesses the gravity of a stone pyramid and evokes the simplicity and serenity of a mausoleum. Built of concrete and weighing 250 tons, the memorial is designed as an inverted library—the "books" protrude on the outside—in recognition of the significance of study to the Jewish people, "the people of the book." But the doors to this "library" are bolted, making the books inaccessible. In the wake of the destruction of the Austrian Jewish community, there is no longer any use for them. The names of the places to which the country's Jews were deported for annihilation are inscribed in alphabetical order around the exterior. There is murder, death, and loss here, and the massiveness of the memorial shapes a sense of gloom that cannot be lifted.

ARCHITECTURE

After World War II, architecture moved in many directions. Some of these were technological advances that allowed architects to literally achieve greater heights, as in the skyscraper, and to create more sculptural forms, as in Le Corbusier's Chapel of Notre-Dame-du-Haut. Millions of U.S. soldiers returned to their homes and established new families, giving birth not only to what we now call the baby boomers, but also to vast housing tracts like Levittown that dotted suburbs that had earlier been farms, small towns, or wilderness. All these and more were examples of modern architecture.

Modern Architecture

Modern architecture rejected the ideals and principles of Classical tradition in favor of the experimental forms of expression that characterized many styles of art and literature from the 1860s to the 1970s. *Modernism* also refers to approaches that are ahead of their time. *Modern* suggests, in general, an approach that overturns the past; by that definition, every era of artists doing something completely new can be considered modern in their time.

Modernism is a concept of art-making built on the urge to depict contemporary life and events rather than history. Modernism was a response to industrialization, urbanization, and the growth of capitalism and democracy. Modern architects, like modern artists, felt free to explore new styles inspired by technology and science, psychology, politics, economics, and social consciousness.

▼ **22.37** Rachel Whiteread, Judenplatz Holocaust Memorial, 2000. Steel and concrete, 33′ × 23′ × 12′6″ (10 × 7 × 3.8 m). Vienna Austria. Whiteread used a slightly porous concrete so that rain and snow could get in, giving the sculpture a worn appearance.

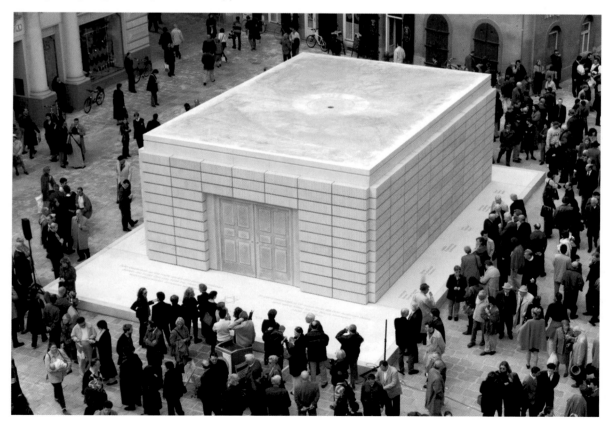

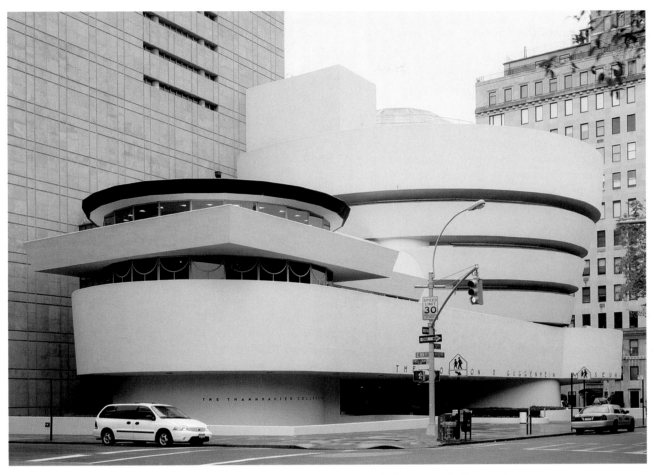

∧ **22.38** Frank Lloyd Wright, Solomon R. Guggenheim Museum, 1943–1959. New York, New York.
The structure of the building is made of reinforced concrete, and the outer surface is finished with sprayed concrete (gunite).

As we see in the differences among Wright's Guggenheim Museum, Le Corbusier's Notre-Dame-du-Haut, and Mies's Seagram Building (designed in collaboration with Philip Johnson), Modernism in architecture never comprised just one style. Rather, it serves as an umbrella term that encompasses the many architectural visions.

FRANK LLOYD WRIGHT One of the most influential U.S. architects of the 20th century was Frank Lloyd Wright (1869–1959), a disciple of Louis Sullivan (1856–1924). Sullivan had built the first skyscrapers in the United States in the last decade of the 19th century. Like Sullivan, Wright championed an architecture that produced buildings designed for their specific function, with an eye focused on the natural environment in which the building was to be placed and with a sensitivity to what the building should "say." "Form ever follows function" was Sullivan's famous aphorism for this belief. For Wright and his disciples, there was something ludicrous about designing a post office to look like a Greek temple and then building it in the center of a Midwestern U.S. city. Wright wanted an *organic* architecture—an architecture that grew out of its location rather than being superimposed on it.

For decades Wright designed private homes, college campuses, industrial buildings, and churches that reflected this basic philosophy. In the postwar period, Wright finished his Solomon R. Guggenheim Museum (**Fig. 22.38**), initially conceived in 1943.

This building is a capsule summary of Wright's architectural ideals. Wright was interested in the flow of space rather than its obstruction ("Democracy needs something basically better than a box"), so the Guggenheim Museum's interior is designed to eliminate as many corners and angles as possible. It is essentially one large room with an airy central core—a long, simple spiraling ramp six stories high, cantilevered from supporting walls. A museumgoer can walk down the ramp and view an exhibition without encountering a wall or partition. The viewing of the art is a continuously unwinding experience. But there have been critics: some argue that the building and not the art becomes the exhibition; others complain about the problems of setting

⌃ **22.39** Le Corbusier, **Chapel of Notre-Dame-du-Haut, 1950–1954. Concrete and stone structure. Ronchamp, France.** The roof is supported by columns, so that the architect was able to punch windows into the walls at will.

horizontal and vertical works of art in a continuously slanting space.

But the overall shape of the building abundantly demonstrates the possibilities inherent in reinforced concrete—a building material that became available in the 20th century. In reinforced concrete, or **ferroconcrete**, steel rods or steel mesh are inserted into concrete slabs at the points of greatest stress before they harden. Alternately, the concrete can be formed around the steel.

Ferroconcrete has many of the advantages of stone and steel, without some of the disadvantages. The steel rods increase the tensile strength of concrete, making it less susceptible to tearing or pulling apart. The concrete, in turn, prevents the steel from rusting. Reinforced concrete can span greater distances than stone, and it supports more weight than steel. It can assume curved shapes that would be unthinkable in steel or concrete alone. Curved slabs take the forms of eggshells, bubbles, seashells, and other organic shapes. The surface of the building is also made of concrete— sprayed concrete, also known as *gunite*.

The Guggenheim Museum, with its soft curves and cylindrical forms, stands in contrast to the boxy angles and

corners of most of the buildings found in New York City. The museum takes on the quality of sculpture.

LE CORBUSIER The Swiss architect Charles-Édouard Jeanneret, known as Le Corbusier (1887–1965), argued that buildings should be lifted off the ground by reinforced concrete pylons; have walls that do not support the structure, thereby allowing the architect to freely form the façade; have an open floor plan (as few walls as possible); and, when possible, have a roof garden to compensate for the vegetation lost to the building. His Chapel of Notre-Dame-du-Haut (**Fig. 22.39**) follows some of these principles. The roof is supported by concrete columns and not the wall, for example, such that it seems to float above the walls—as happens in many cathedrals with clerestories. But there is no roof garden.

The design is an example of what has been referred to as the "new brutalism," deriving from the French *brut*, meaning "rough, uncut, or raw." The steel web is spun, and the concrete is cast in place, leaving the marks of the wooden forms on its surface. The white walls, dark roof, and white towers are decorated only by the texture of the curving reinforced concrete slabs. In places, the walls are incred-

ibly thick. Windows of various shapes and sizes expand from small slits and rectangles to form mysterious light tunnels; they draw the observer outward more than they actually light the interior. The massive voids of the window apertures recall the huge stone blocks of prehistoric religious structures.

LUDWIG MIES VAN DER ROHE AND PHILIP JOHNSON The Seagram Building (**Fig. 22.40**), the U.S. headquarters for the Canadian distiller Joseph E. Seagram & Sons, was built across Park Avenue from its equally famous and equally Modernist neighbor, Lever House. Designed by Ludwig Mies van der Rohe and Philip Johnson, it is another signature example of the Modernist credo "form ever follows function." There is no ornamentation. The vertical I beams of bronze-coated steel form a perfectly regular pattern across the elevations of the structure and emphasize its upward reach. Mies, who abhorred irregularity, even specified that the window coverings for the building be uniform, so that from the outside, the windows would never look chaotic or messy. The sharp-edged columns at the entry-level plaza complement the stark grid of the building but also define a softer, transitional space—with trees and fountains—between the chaos of the surrounding city and the austere serenity of the building's interior.

Postmodern Architecture

By the mid-1970s, the clean Modernist look of buildings such as the Seagram Building was overwhelming the cityscape. Architectural critics began to argue that a national proliferation of steel-cage rectangular solids was threatening to bury the nation's cities in boredom. Said John Perrault in 1979, "We are sick to death of cold plazas and 'curtain wall' skyscrapers."

➤ 22.40 **Ludwig Mies van der Rohe and Philip Johnson, Seagram Building, 1958. New York, New York.** The building reaches the height of the modern aesthetic.

In response—or in revolt—by the end of the 1970s, architects continued to create steel-cage structures but drew freely from past styles of ornamentation, including classical columns, pediments, friezes, and a variety of elements we might find in ancient Egypt, Greece, or Rome. The architectural movement was termed **Postmodernism**; the idea was to once more "warm up" buildings, to link them to the architectural past, to a Main Street of the heart or mind—some sort of mass architectural nostalgia. Postmodernist structures rejected the formal simplicity and immaculate finish of Modernist architecture in favor of whimsical shapes, colors, and patterns. Postmodern architects revived the concept of the decorative in architecture, a practice that was completely antithetical to the purity of Modernism in the 20th century.

MICHAEL GRAVES Michael Graves's (b. 1934) Humana Building (**Fig. 22.41**) looks to ancient Egypt for its historic reference. Tall, tightly arranged pillars (as in an Egyptian **hypostyle** hall) and a grid of square windows lighten the otherwise heavy rectangular solids, which seem to anchor the building firmly to the ground. The overall impression recalls the great pylons, or gateways, of Egyptian temple complexes such as the one at Karnak (see **Fig. 1.34**). The office building is set behind the entry in such a way that the overall contour mimics the blocklike seated body position in ancient statuary (see **Fig. 1.30**). The curved shape at the top of the front elevation, "adorned" with a projecting rectangle, recalls a pharaonic headdress.

RENZO PIANO AND RICHARD ROGERS The architects of the Georges Pompidou National Center for Arts and

◄ **22.41 Michael Graves, Humana Building, 1985. Louisville, Kentucky. Photo © Michael Graves & Associates, Inc.** The building is reminiscent of an Egyptian pharaoh sitting on a throne.

▲ **22.42** **Renzo Piano and Richard Rogers, Georges Pompidou National Center for Arts and Culture, 1977. Paris, France.** Different utilities—water, heating and cooling, electricity—are color coded.

Culture in Paris (**Fig. 22.42**) were an Italian, Renzo Piano (b. 1937), and a British man, Richard Rogers (b. 1933). This genesis, perhaps, is one of the reasons that many Parisians were initially critical of the building, which differs from modern architecture in that it wears its skeleton on the outside. Staid modern buildings, such as the Seagram Building, have a central service core that carries heating and air-conditioning ducts, electricity, and water—and, of course, elevators and stairways. The various pipes that cover these utilities are coded with different colors to enable workers and repair people to readily locate them. The pipes are also coded in—or rather, on—the Pompidou Center, but they are part of the façade of the building and allowed the architects to splash the building with color. Even the elevator is on the outside—a transparent conveyer that delivers a grander view of the city as it delivers its occupants to the upper floors.

Deconstructivist Architecture

What we have known as modern architecture is no longer modern, at least not in the sense of relating to the present. It's not even Postmodern, if we want to pigeonhole style. As we move forward in the third millennium, the world of architecture seems completely enmeshed in a movement called **Deconstructivism**.

The Deconstructivist movement originated in the 1960s with the ideas of the French philosopher Jacques Derrida. He argued, in part, that literary texts can be read in different ways and that it is absurd to believe that there can be only one proper interpretation. Similarly, in Deconstructivist architectural design, the whole is less important than the parts. In fact, buildings are meant to be seen in bits and pieces. The familiar elements of traditional architecture are taken apart,

∧ **22.43** Frank Gehry, Guggenheim Museum Bilbao, 1997. Bilbao, Spain. The museum has made Bilbao into a tourist attraction.

discarded, or disguised so that what remains sometimes seems randomly assembled.

Deconstructivist architects deny the modern maxim that form should follow function. Instead, they tend to reduce their structures to purer geometric forms made possible by contemporary materials, and they make liberal use of color to express emotion.

FRANK GEHRY The Guggenheim museums have always been on the cutting edge of design, beginning with Frank Lloyd Wright's monument on New York City's Fifth Avenue. Canadian-born architect Frank Gehry (b. 1929) designed the no-less-remarkable Guggenheim Museum Bilbao (**Fig. 22.43**), which brings thousands of tourists each year to that industrial Spanish city. Gehry is now designing yet another Guggenheim museum, for Abu Dhabi in the United Arab Emirates. He refers to the Bilbao Guggenheim as a "metallic flower." Others have found the billowing, curvilinear shapes to be reminiscent of ships, linking the machine-tooled structure that is perched on the water's edge to the history of Bilbao as an international seaport. It is as if free-floating geometric shapes have collided on this site, bending them this way and that, such that if the collision had occurred on another day, they might have assumed a different configuration.

Gehry was commissioned to design the Ray and Maria Stata Center at the Massachusetts Institute of Technology, a building that would house classrooms, research facilities, an auditorium, fitness facilities, and a childcare center. His Deconstructivist design solution again features fragmentation and sculptural shapes (**Fig. 22.44**). Here, as in Bilbao, we have a collision of forms; but here they are more rectilinear, and it appears as if a block of row houses somehow collapsed

inward or on each other. The Stata Center is a **green building**, meaning that its design is consistent with principles of conservation such as using recirculating storm water, using as much airflow as possible to reduce the use of fossil fuels for heating and cooling, providing operable windows for natural ventilation, reusing construction waste from other projects, and even designing the landscaping to use rainwater.

SANTIAGO CALATRAVA Spanish architect Santiago Calatrava's (b. 1951) architecture seems to be going up everywhere: a symphony center in Atlanta; a museum in Milwaukee; 30 bridges, including three that will span the Trinity River in Dallas; a transportation hub for the World Trade Center site that is scheduled to open in 2015 (**Fig. 22.45**); a residential tower composed of 12 cubes cantilevered from a concrete core overlooking the East River in New York City. *Time* magazine named Calatrava one of the 100 most influential people of 2005, and the American Institute of Architects awarded him their coveted gold medal in the same year. As we see in the transportation hub, Calatrava—also a sculptor and a painter—has erased the lines between architecture and sculpture. Saarinen's TWA Terminal has been said to look like a bird in flight. So will Calatrava's transportation hub (although it also looks something like the plated back of a stegosaurus), but most of the hub is underground. It will have a body of glass and steel at street level, and two canopies that extend upward, creating the impression of wings. The practical purpose to the design is to bring abundant natural light into the train platform, which is 60 feet below. Calatrava remarked that the building materials are steel, glass, and light. Train passengers arriving at the hub will be greeted by an uplifting drenching of natural light.

⋏ **22.44** Frank Gehry, Ray and Maria Stata Center for Computer, Information, and Intelligence Sciences, 2005. Massachusetts Institute of Technology, Cambridge, Massachusetts. Although visitors are most impressed with the building's appearance, it also functions as a green (energy-saving) building: it collects and recycles rainwater, it uses air-conditioning exactly where and when it's needed, and it was even partially constructed from recycled building materials.

⋎ **22.45** Santiago Calatrava, World Trade Center Transportation Hub, scheduled to open in 2015. New York, New York. The ribbed windows will spray the platform 60 feet below with natural light.

VIDEO

Video technology was invented for television, which debuted to the masses in 1939 at the New York World's Fair in Flushing Meadows, Queens. Over about 75 years, television has radically altered U.S. culture at home and placed it before the world. In 2010, one of the authors of this textbook stopped at a rest area in Egypt between Alexandria and Cairo and observed a young Muslim woman in a hijab (headscarf) and blue jeans watching *Desperate Housewives* in Arabic on a large flat-panel display in the lobby. Commercial television broadcasts many of the images that reflect and create our common contemporary culture—from reality programming like MTV's *Jersey Shore*, Bravo's *Real Housewives of* (fill in your favorite location), and Fox's *So You Think You Can Dance* to original programming like HBO's *The Sopranos*, *The Wire*, and *True Blood*, and AMC's *Mad Men*. Children spend as many hours in front of a TV set as they do in school, and congressional committees debate effects such as childhood obesity and the impact of televised violence.

Television has also flooded our screens with live coverage of disasters, and the effect has been to change history. Millions watched live and in horror as John F. Kennedy was assassinated in 1963 and the space shuttle *Challenger* exploded in 1986. It has been suggested that TV footage of the Vietnam War contributed to that war's unpopularity and the United States' pullout from the country in 1975. Viewers who came to be called "gulf potatoes"[13] seemed to be addicted to the coverage of the Gulf War, the nation's first real video war—which began with CNN's live description of fighter-bombers over Baghdad in 1991. In 2001, viewers watched the destruction of the World Trade Center live—whether from the suburbs of New York or from Chicago or Los Angeles—and in January 2011, the world witnessed the peaceful protests leading to revolution in the country of Egypt. Viewers become, so to speak, a community connected by wireless broadcasting and by cable.

Commercial television programming, broadcast in the United States by privately owned media corporations, offers a wide variety of options to viewers, including news and commentary, sporting events, situation comedies, reality programming, and films. Video art as a medium, distinguished from the commercial efforts of the television establishment, was introduced in the 1960s.

BILL VIOLA Bill Viola's (b. 1951) *The Crossing* (**Fig. 22.46**) is a video and sound installation that engulfs the senses and aims to transport the viewer into a spiritual realm. In this piece, the artist simultaneously projects two video channels onto separate 13-foot-high screens or on the back and front of the same screen.

On one side of the screen, a human form slowly approaches from a great distance through a dark space. The figure gradually becomes more distinct, and we soon recognize a man walking straight toward us, all the time becoming larger. When his body almost fills the frame, he stops moving and stands still, staring directly at the viewer in silence.

A small votive flame appears at his feet. Suddenly, brilliant orange flames rise up and quickly spread across the floor and up onto his body. A loud roaring sound fills the space as his form rapidly becomes completely engulfed by a violent raging fire. The fire soon subsides until only a few small flickering flames remain on a charred floor. The figure of the man is gone. The image returns to black and the cycle repeats anew.

On the other side, we again see a dark human form approaching. He slowly moves towards us out of the shadows, in the same manner as the other figure. Finally, he too stops and stares, motionless and silent. Suddenly, a stream of silver-blue water begins pouring onto his head, sending luminous trails of splashing droplets off in all directions. The stream quickly turns into a raging torrent as a massive amount of water cascades from above, completely inundating the man as a loud roaring sound fills the space. The falling water soon begins to subside and it trails off, leaving a few droplets falling on a wet floor. The figure of the man is gone. The image then returns to black and the cycle repeats anew.

The two complementary actions appear simultaneously on the two sides of the screen, and the viewer must move around the space to see both images. The image sequences are timed to play in perfect synchronization, with the approach and the culminating conflagration and deluge occurring simultaneously, energizing the space with a violent raging crescendo of intense images and roaring sound. The two traditional natural elements of fire and water appear here not only in their destructive aspects, but manifest their cathartic, purifying, transformative, and regenerative capacities as well. In this way, self-annihilation becomes a necessary means to transcendence and liberation.

Critics speak about the spiritual nature of Viola's work, but it is also about the here-and-now reality of the viewer's sensory experience elicited by the encounter with the work.

PIPILOTTI RIST Pipilotti Rist (b. 1962) is a Swiss video-performance artist whose most common subject is her own nude body afloat in an endless sea. Her work has been projected in venues as diverse as New York's Times Square and the Baroque ceiling of an Italian church (the Chiesa di San Stae) during the 2005 Venice Biennale, an international art exhibition. The first artist to adapt a music-video aesthetic, she creates videos that are saturated with psychedelic color and play against a soundtrack of her own music (she created the all-women band Les Reines Prochaines—The Next Queens). Rist's installations are sensuous and joyous; the "walls liquefy and wash over the people like a psychic Jacuzzi, in order to set them afloat."[14] New York's Museum of Modern Art commissioned Rist to produce a site-specific installation that bathed several walls of the second-floor atrium of the museum in 25-foot-high images (**Fig. 22.47**). At any one time, scores of viewers could be seen walking through the

13. A play on the term *couch potato*.

14. Pipilotti Rist in *Art Now*, ed. Uta Grosenick (Cologne, Germany: Taschen, 2005), 442.

▲ **22.46** Bill Viola, *The Crossing*, 1996. Video/sound installation, edition number 1 of 3, 16:00 minutes. Two channels of color video projections from opposite sides of large dark gallery onto two large back-to-back screens suspended from ceiling and mounted to floor; four channels of amplified stereo sound, four speakers. Room dimensions: 4.9 × 8.4 × 17.4 m. Performer: Phil Esposito. Photo: Kira Perov. Solomon R. Guggenheim Museum, New York, New York. © Bill Viola. Courtesy Bill Viola Studio. A large double-sided projection screen stands in the middle the room, its bottom edge resting on the floor. Two video projectors mounted at opposite ends of the room project images onto the front and back sides of the screen simultaneously, showing a single action involving a human culminating in a violent annihilation by the opposing natural forces of fire and water.

◄ **22.47** Pipilotti Rist, installation view from *Pour Your Body Out (7354 Cubic Meters)*, 2008. Multichannel video (color, sound), projector enclosures, circular seating element, carpet. Museum of Modern Art, New York, New York. © 2013 Pipilotti Rist, courtesy Luhring Augustine, New York and Hauser & Wirth. Rist designed the seating herself to assure that viewers would have optimal vantage points.

space, sitting on the floor beneath the projections, or lounging on a cushioned island designed by the artist.

MATTHEW BARNEY Stephen Holden, the *New York Times* film critic, considers Matthew Barney (b. 1967) to be "the most important American artist of his generation." Contemporary artists continue to challenge the use of traditional mediums, and Barney is no exception, having fashioned dumbbells of tapioca pudding and an exercise bench of petroleum jelly. But Barney is best known for his *Cremaster* series of five films. The characters in the films include nymphs, satyrs, and other legendary figures who are, or are not, what they seem to be. The narratives, enhanced with eclectic soundtracks, circle around various ritual masculine athletic challenges and a good deal of symbolic pagan pageantry. Much of *Cremaster 2* takes place in the wide-open spaces of the Wild West, accompanied by folk songs, the singing of the Mormon Tabernacle Choir, and other music. One scene transports the

➤ **22.48** Matthew Barney, *CREMASTER 2*, 1999, Production still. © 1999 Matthew Barney. Photo by Michael James O'Brien. Courtesy Gladstone Gallery, New York and Brussels. In this scene, Barney (right) appears with the novelist Norman Mailer.

READING 22.5 NORMAN MAILER

From *The Naked and the Dead*, chapter 1

Nobody could sleep. When morning came, assault craft would be lowered and a first wave of troops would ride through the surf and charge ashore on the beach at Anopopei. All over the ship, all through the convoy, there was a knowledge that in a few hours some of them were going to be dead.

A soldier lies flat on his bunk, closes his eyes, and remains wide-awake. All about him, like the soughing of surf, he hears the murmurs of men dozing fitfully. "I won't do it, I won't do it," someone cries out of a dream, and the soldier opens his eyes and gazes slowly about the hold, his

vision becoming lost in the intricate tangle of hammocks and naked bodies and dangling equipment. He decides he wants to go to the head, and cursing a little, he wriggles up to a sitting position, his legs hanging over the bunk, the steel pipe of the hammock above cutting across his hunched back. He sighs, reaches for his shoes, which he has tied to a stanchion, and slowly puts them on. His bunk is the fourth in a tier of five, and he climbs down uncertainly in the half-darkness, afraid of stepping on one of the men in the hammocks below him. On the floor he picks his way through a tangle of bags and packs, stumbles once over a rifle, and makes his way to the bulkhead door. He passes through another hold whose aisle is just as cluttered, and finally reaches the head.

viewer to the 1893 World's International Exhibition, in which the novelist Norman Mailer (1923–2007) impersonates the escape artist Harry Houdini (**Fig. 22.48**), standing next to the artist in the guise of a bizarrely attired Gary Gilmore.

Mailer was the author of *The Naked and the Dead* (1948), a positively reviewed novel based on his military experiences in World War II that made him famous. The book showed how officers sometimes used foot soldiers as pawns in something of a game when they were bored; and it was made into a movie in 1958. Mailer had also written a book, *The Executioner's Song*, about convicted murderer Gary Gilmore, who was executed by a firing squad in 1977. Along with writers such as Tom Wolfe, Joan Didion, and Truman Capote, Mailer was an originator of **creative nonfiction**, or new journalism, a genre that related true stories with the artifice of fiction. In any event, Gilmore, unlike Houdini, did not escape.

At the beginning of *The Naked and the Dead*, (Reading 22.5), U.S. troops are in the Pacific, being shipped from island to island to fight Japanese troops.

SOME TRENDS IN CONTEMPORARY LITERATURE

By the end of World War II, literary figures who had defined the Modernist temperament, including T. S. Eliot and James Joyce, were dead or already past their best work. Their passionate search for meaning in an alienated world, however, still inspired the work of others. The great Modernist themes received attention from other voices in other media. The Swedish filmmaker Ingmar Bergman (1918–2007) began a series of classic films starting with his black-and-white *Wild Strawberries* in 1957, which explored the loss of religious faith and the demands of modern despair. The enigmatic Irish playwright Samuel Beckett (1906–1989)—who lived in France and wrote in French and English—produced plays like *Waiting for Godot* (1952), absurdist literature that explores a world beyond logic, decency, and the certainty of language.

SAMUEL BECKETT *Waiting for Godot*, for all its apparent simplicity, is maddeningly difficult to interpret. Beckett places two characters, Vladimir and Estragon, at an unnamed and barren crossroads, where they wait for Godot. Their patient wait is interrupted by antic encounters with two other characters. In the two acts, each representing one day, a young boy announces that Godot will arrive the next day. At the end of the play, Vladimir and Estragon decide to wait for Godot, although they toy momentarily with the idea of splitting up or committing suicide if Godot does not come to save them.

The language of *Godot* is laced with biblical allusions and religious puns. Is Godot God? And does the play illuminate the nature of an absurd world without final significance? Beckett does not say and critics do not agree, although they are in accord with the judgment that *Waiting for Godot* is a classic—if cryptic—statement about language, human relations, and the ultimate significance of the world.

ELIE WIESEL Gradually, as the war receded in time, other voices relating the horrors of the war experience began to be

15. One who officiates at a religious ceremony,

READING 22.6 ELIE WIESEL

From *Night*

Ten thousand men had come to attend the solemn service, heads of the blocks, Kapos, functionaries of death.

"Bless the Eternal. . . ."

The voice of the officiant[15] had just made itself heard. I thought at first it was the wind.

"Blessed be the Name of the Eternal!"

Thousands of voices repeated the benediction; thousands of men prostrated themselves like trees before a tempest.

"Blessed be the Name of the Eternal!"

Why, but why should I bless Him? In every fiber I rebelled. Because He had had thousands of children burned in His pits? Because He kept six crematories working night and day, on Sundays and feast days? Because in His great might He had created Auschwitz, Birkenau, Buna, and so many factories of death? How could I say to Him: "Blessed art Thou, Eternal, Master of the Universe, Who chose us from among the races to be tortured day and night, to see our fathers, our mothers, our brothers, end in the crematory? Praised be Thy Holy Name, Thou Who hast chosen us to be butchered on Thine altar?"

. . .

Never shall I forget that night, the first night in camp, which has turned my life into one long night, seven times cursed and seven times sealed. Never shall I forget that smoke. Never shall I forget the little faces of the children, whose bodies I saw turned into wreaths of smoke beneath a silent blue sky.

Never shall I forget those flames which consumed my faith forever.

Never shall I forget that nocturnal silence which deprived me, for all eternity, of the desire to live. Never shall I forget those moments which murdered my God and my soul and turned my dreams to dust. Never shall I forget these things, even if I am condemned to live as long as God Himself. Never.

heard. The most compelling atrocity of the war period, the extermination in the Nazi concentration camps of 6 million Jews and countless other dissidents and enemies, has resulted in many attempts to tell the world that story. The most significant voice of the survivors of the event is the Romania-born Elie Wiesel (b. 1928), a survivor of the camps. Wiesel describes himself as a "teller of tales." He feels a duty, beyond the normal duty of art, to keep alive the memory of the near extermination of his people. Wiesel's autobiographical memoir and arguably his greatest work, *Night* (1960), recounts his own years in the camps. It is a terribly moving book. One theme is the loss of Wiesel's faith in God as he witnesses the horrors of the camp and thinks that God is allowing his "chosen" people to be exterminated.

American Literature

In the United States an entirely new generation of writers defined the nature of the American experience. Arthur Miller's play *Death of a Salesman* (1949) explored the failure of the American dream in the person of its tragic hero Willie Loman, an ordinary man defeated by life. J. D. Salinger's *The Catcher in the Rye* (1951) documented the bewildering coming of age of an American adolescent in so compelling a manner that it was, for a time, a cult book for the young. Southern writers like Eudora Welty, William Styron, Walker Percy, and Flannery O'Connor continued the meditations of William Faulkner about an area of the United States that has tasted defeat in a way no other region has. Poets like Wallace Stevens, Theodore Roethke, William Carlos Williams, and Marianne Moore continued to celebrate the beauties and terrors of both nature and people.

Existentialism was well suited to the postwar mood. One aspect of existentialism's ethos was its insistence on protest and human dissatisfaction. That element of existential protest has been very much a part of the postwar scene. The civil-rights movement of the late 1950s and early 1960s became a paradigm for other protests, such as those against the Vietnam War; in favor of the rights of women; and for the rights of the dispossessed, the underprivileged, or the victims of discrimination. The literature of protest has been an integral part of this cry for human rights.

JOHN UPDIKE John Updike (1932–2009) wrote novels, poems, and short stories. His best-known books are about a former high-school basketball star, Harry "Rabbit" Angstrom, who, at 6 feet 3 inches stands above (most of) the crowd and spends the remainder of his life adjusting to the fact that his glory days have vanished into his past—as will all of our glories (and other endeavors). The first of the series, *Rabbit, Run* (1960), begins with Reading 22.7 in which a group of youngsters is playing basketball. They are concerned about the tall stranger watching them, but the alienated Harry Angstrom is no threat. For much of the novel, he drives aimlessly through suburban and rural Pennsylvania,

READING 22.7 JOHN UPDIKE

From *Rabbit, Run*

Boys are playing basketball around a telephone pole with a backboard bolted to it. Legs, shouts. The scrape and snap of Keds on loose alley pebbles seems to catapult their voices high into the moist March air blue above the wires. Rabbit Angstrom, coming up the alley in a business suit, stops and watches, though he's twenty-six and six three. So tall, he seems an unlikely rabbit, but the breadth of white face, the pallor of his blue irises, and a nervous flutter under his brief nose as he stabs a cigarette into his mouth partially explain the nickname, which was given to him when he too was a boy. He stands there thinking, the kids keep coming, they keep crowding you up.

His standing there makes the real boys feel strange. Eyeballs slide. They're doing this for themselves, not as a show for some adult walking around town in a double-breasted cocoa suit. It seems funny to them, an adult walking up the alley at all. Where's his car? The cigarette makes it more sinister still. Is this one of those going to offer them cigarettes or money to go out in back of the ice plant with him? They've heard of such things but are not too frightened; there are six of them and one of him.

as if seeking clues to his future. Updike meticulously lists the songs and commercials on the radio as Rabbit drives, and drives. There are four novels in the Rabbit series. In one of them, which takes place during the height of the civil-rights movement, Rabbit becomes involved with an African American family. In another, he becomes strangely wealthy via ownership of a Toyota dealership, which is an ironic commentary on the United States' new relationship with the rest of the globe and the key role former enemies play in daily U.S. life. After all, the country has also imported hundreds of thousands—if not millions—of Volkswagens and Mercedes Benzes from Germany.

EDWARD ALBEE The playwright Edward Albee (b. 1928) is best known for his plays *The Zoo Story* (1958), *The Sandbox* (1959), and *Who's Afraid of Virginia Woolf?* (1962), in the latter of which a learned couple sings the title to the tune of "Who's Afraid of the Big, Bad Wolf?" It was made into a wonderful 1966 movie starring Elizabeth Taylor and Richard Burton (**Fig. 22.49**), who had recently starred together in *Cleopatra*. One of the cultural subplots is that the story finds the Technicolor royalty of ancient Egypt and Rome in a black-and-white, claustrophobic New England college town. Burton is a burned-out professor (George) in the history department; his wife (Martha, as played by Taylor) derides him for, after many years, still being a "bog" in the history department rather than being *the* department (that is, the department chair). In the scene, she nicknames him "boggy." The battling, puffy couple have a young couple—a new pro-

▲ **22.49 Ernest Lehman, still from *Who's Afraid of Virginia Woolf?*, 1966, from the play by Edward Albee, 1962.** Martha (Elizabeth Taylor) is stuck with George (Richard Burton), a professor at a college in a New England college town. They regularly destroy one another verbally. Alcohol, sex, and existential angst play their roles, and we eventually discover that the mutual assured destruction pact is something of a game that keeps the couple entertained and moving (sideways?)—an almost daily occurrence.

fessor and his wife—over for dinner. "Having for dinner" can be construed in different ways, as Martha winds up sleeping with the young professor, played by George Segal, while her husband shows angst and the young wife, played by Sandy Dennis, remains vacant and clueless. George and Martha pretend to have a child, upon whose description they seem confused—for example, referring to him as a "blond eyed, blue haired" child. Unlike George and Martha Washington, this George and this Martha will never be parents of a nation, or of a child. But after the inevitable blowup, we discover that this is just a typical evening for George and Martha.

African American Literature

First and foremost, one can trace African Americans' struggle for dignity and full equality through the literature they produced, especially in the period after World War I. The great pioneers were those writers who are grouped loosely under the name of the Harlem Renaissance (discussed in Chapter 21). By refusing the stereotype of the Negro, they crafted an eloquent literature demanding humanity and unqualified justice. The work of these writers presaged the powerful torrent of African American fiction chronicling racial injustice in America. Two novels in particular, Richard Wright's *Native Son* (1940) and Ralph Ellison's *Invisible Man* (see Reading 22.8) (1952), have taken on the character of American classics. James Baldwin's *Go Tell It on the Mountain* (1953) fused vivid memories of African American Harlem, jazz, and the intense religion of African American churches into a searing portrait of growing up African American. Alice Walker explored her Southern roots in the explosively powerful *The Color Purple* (1982).

African-American women writers, important voices in contemporary literature, have explored the interwoven issues of race and gender inequality in poetry, fiction, and biography. Gwendolyn Brooks (1917–2000), who was tied to the writers of the Harlem Renaissance, was the first African American woman to win a Pulitzer Prize for poetry (1950). Her life in inner city Chicago—and encounters with racial prejudice—is reflected in her work (see Reading 22.9).

READING 22.8 RALPH ELLISON

From *Invisible Man*

One night I accidentally bumped into a man, and perhaps because of the near darkness he saw me and called me an insulting name. I sprang at him, seized his coat lapels and demanded that he apologize. He was a tall blond man, and as my face came close to his he looked insolently out of his blue eyes and cursed me, his breath hot in my face as he struggled. I pulled his chin down sharp upon the crown of my head, butting him as I had seen the West Indians do, and I felt his flesh tear and the blood gush out, and I yelled, "Apologize! Apologize!" But he continued to curse and struggle, and I butted him again and again until he went down heavily, on his knees, profusely bleeding. I kicked him repeatedly, in a frenzy because he still uttered insults though his lips were frothy with blood. Oh yes, I kicked him! And in my outrage I got out my knife and prepared to slit his throat, right there beneath the lamplight in the deserted street, holding him by the collar with one hand, and opening the knife with my teeth—when it occurred to me that the man had not *seen* me, actually; that he, as far as he knew, was in the midst of a waking nightmare! And I stopped the blade, slicing the air as I pushed him *away*, letting him fall back to the street. I stared at him hard as the lights of a car stabbed through the darkness. He lay there, moaning on the asphalt; a man almost killed by a phantom. It unnerved me. I was both disgusted and ashamed. I was like a drunken man myself, wavering about on weakened legs. Then I was amused. Something in this man's thick head had sprung out and beaten him within an inch of his life. I began to laugh at this crazy discovery. Would he have awakened at the point of death? Would Death himself have freed him for wakeful living? But I didn't linger. I ran away into the dark, laughing so hard I feared I might rupture myself. The next day I saw his picture in the *Daily News*, beneath a caption stating that he had been "mugged." Poor fool, poor blind fool, I thought with sincere compassion, mugged by an invisible man!

The poet and activist, Nikki Giovanni (b. 1943) was influenced by the civil rights movement and the "black power" activism of the 1960s. Her work is a poetic blend of African American history and female consciousness in which she celebrates pride in her blackness and her femininity.

One of the most widely known figures in contemporary African American literature, Maya Angelou (b. 1928), has had a multi-faceted career that includes novels, poetry, and dramatic literature. She is also a producer, director, and outspoken civil rights advocate. *I Know Why the Caged Bird Sings* (1969) is the first in a series of autobiographical works in which she unflinchingly explores the realities of the African American experience, including the double-edged sword of being black *and* being female, the bitter inequities of social justice and opportunity, and the psychological and physical consequences of captivity—both real and imagined.

READING 22.9 GWENDOLYN BROOKS

"The Last Quatrain of the Ballad of Emmett Till"

after the murder,
after the burial
Emmett's mother is a pretty-faced thing;
the tint of pulled taffy.
She sits in a red room,
drinking black coffee.
She kisses her killed boy.
And she is sorry.
Chaos in windy grays
through a red prairie.

Angelou's poem "Caged Bird" speaks of a lack of social justice, of psychological as well as physical captivity, and of frustration.

READING 22.10 MAYA ANGELOU

From *I Know Why the Caged Bird Sings*

The Black female is assaulted in her tender years by all those common forces of nature at the same time she is caught in the tripartite crossfire of masculine prejudice, white illogical hate and Black lack of power.

The fact that the adult American Negro female emerges a formidable character is often met with amazement, distaste and even belligerence. It is seldom accepted as an inevitable outcome of the struggle won by survivors and deserves respect if not enthusiastic acceptance (Ch. 34).

A recurrent theme in I Know Why the Caged Bird Sings *is Angelou's perception of difference, beginning, as a very young child, with her observations of white and black people. These visual impressions are poeticized in her now-adult voice:*

A light shade had been pulled down between the Black community and all things white, but one could see through it enough to develop a fear-admiration-contempt for the white "things"—white folks' cars and white glistening houses and their children and their women. But above all, their wealth that allowed them to waste was the most enviable (Ch. 8).

A sense of alienation—or displacement—that can accompany "difference" is powerfully described in the opening pages of the book:

If growing up is painful for the Southern Black girl, being aware of her displacement is the rust on the razor that threatens the throat. It is an unnecessary insult (Prologue).

"I Know Why the Cage Bird Sings" is also the title of a poem by Angelou in which the African American condition is symbolized in the juxtaposition of the caged and the free bird. Similarly, in the book, Angelou poignantly connects her own emerging voice (she did not speak for five years after being abused and raped as a young child) to those of her black poet-ancestors whose voices were stifled, silent, mute:

Oh, Black known and unknown poets, how often have your auctioned pains sustained us? Who will compute the lonely nights made less lonely by your songs, or by the empty pots made less tragic by your tales?

If we were a people much given to revealing secrets, we might raise monuments and sacrifice to the memories of our poets, but slavery cured us of that weakness. (Ch. 23)

Toni Morrison (b. 1931) has written several novels about the African American experience and was awarded the Nobel Prize in Literature in 1993. Her most recent novel, *Home* (2012), tells of an African American man's return to the segregated United States after serving in the Korean War. In *The Bluest Eye* (1970), Morrison's first novel, Claudia MacTeer relates the events in the year prior to her friend's rape by her father and the loss of her baby. No marigolds bloomed that year, Claudia tells us. In Reading 22.11, Claudia relates her experience when given a blue-eyed, blond-haired doll for Christmas.

Feminist Perspectives

A brief consideration of literature by women cannot begin to scratch the surface of the myriad ways that women writers have internalized and voiced feminism's ideological and socio-political positions. Contemporary heirs to the feminism inspired by foremothers such as Mary Wollstonecraft, Jane Austen, and Virginia Woolf have approached gender and gender issues from a number of perspectives. These include content—representing female experience from a female's point of view—and style—what feminist critic Elaine Showalter defines as "the inscription of the feminine body and female in language and text."

The scope and variety of feminist perspectives is but merely suggested in two literary works by contemporaries and friends, Sylvia Plath (1932–1963) and Anne Sexton (1928–1974). Both used the imagery of traditional gender roles to examine the restraints of their positions. Plath wrote poetry and prose; Sexton wrote only poetry.

Plath's autobiographical novel, *The Bell Jar*, was written in the post World War II era of conservatism during which women's roles, opportunities, and sexuality were circumscribed. Grappling with the construction of identity as a writer, Plath sheds light on the tenuous interrelatedness of personal goals

READING 22.11 TONI MORRISON

From *The Bluest Eye*, chapter 1

It had begun with Christmas and the gift of dolls. The big, the special, the loving gift was always a big, blue-eyed Baby Doll. From the clucking sounds of adults I knew that the doll represented what they thought was my fondest wish. I was bemused with the thing itself and the way it looked. What was I supposed to do with it? Pretend I was its mother? . . . Picture books were full of little girls sleeping with their dolls. Raggedy Ann dolls usually, but they were out of the question. I was physically revolted and secretly frightened of those round moronic eyes, the pancake face, and orangeworms hair.

The other dolls, which were supposed to bring me great pleasure, succeeded in doing just the opposite. When I took it to bed, its hard unyielding limbs resisted my flesh—the tapered fingertips on those dimpled hands scratched. If, in sleep, I turned, the bone-cold head collided with my own. It was a most uncomfortable, patently aggressive sleeping companion. To hold it was no more rewarding. The starched gauze or lace on the cotton dress irritated any embrace. I had only one desire: to dismember it. To see of what it was made, to discover the dearness, to find the beauty, the desirability that had escaped me, but apparently only me. Adults, older girls, shops, magazines, newspapers, window signs—all the world had agreed that a blue-eyed, yellow-haired, pink-skinned doll was what every girl child treasured. "Here," they said, "this is beautiful, and if you are on this day 'worthy' you may have it." I fingered the face, wondering at the single-stroke eyebrows; picked at the pearly teeth stuck like two piano keys between red bowline lips. Traced the turned-up nose, poked the glassy blue eyeballs, twisted the yellow hair. I could not love it. But I could examine it to see what it was that all the world said was lovable. Break off the tiny fingers, bend the flat feet, loosen the hair, twist the head around, and the thing made one sound—a sound they said was the sweet and plaintive cry "Mama," but which sounded to me like the bleat of a dying lamb, or, more precisely, our icebox door opening on rusty hinges in July. Remove the cold and stupid eyeball, it would bleat still, "Ahhhhhh," take off the head, shake out the sawdust, crack the back against the brass bed rail, it would bleat still. The gauze back would slit, and I could see the disk with six holes, the secret of the sound. A mere metal roundness.

READING 22.12 SYLVIA PLATH

From *The Bell Jar*

I knew just how to go about it.

The minute the car tires crunched off down the drive and the sound of the motor faded, I jumped out of bed and hurried into my white blouse and green figured skirt and black raincoat. The raincoat felt camp still, from the day before, but that would soon cease to matter.

I went downstairs and picked up a pale blue envelope from the dining room table and scrawled on the back, in large, painstaking letters: I am going for a long walk.

I propped the message where my mother would see it the minute she came in.

Then I laughed.

I had forgotten the most important thing.

I ran upstairs and dragged a chair into my mother's closet. Then I climbed up and reached for the small green strongbox on the top shelf. I could have torn the metal cover off with my bare hands, the lock was so feeble, but I wanted to do things in a calm, orderly way.

I pulled out my mother's upper right-hand bureau drawer and slipped the blue jewelry box from its hiding place under the scented Irish linen handkerchiefs. I unpinned the little key from the dark velvet. Then I unlocked the strongbox and took out the bottle of new pills. There were more than I had hoped.

There were at least fifty. . . .

I pinned the key back into the jewelry box . . . put the jewelry box back into the drawer under the handkerchiefs, returned the strongbox to the closet shelf. . .

Then I went downstairs into the kitchen. I turned on the tap and poured myself a tall glass of water. Then I took the glass of water and the bottle of pills and went down into the cellar.

A dim, undersea light filtered through the slits of the cellar windows. Behind the oil burner, a dark gap showed in the wall at about shoulder height and ran back under the breezeway, out of sight. . . .

It took me a good while to heft my body into the gap, but at last, after many tries, I managed it, and crouched at the mouth of the darkness, like a troll.

. . . The dark felt thick as velvet. I reached for the glass and bottle, and carefully, on my knees, with bent head, crawled to the farthest wall.

Cobwebs touched my face with the softness of moths. Wrapping my black coat round me like my own sweet shadow, I unscrewed the bottle of pills and started taking them swiftly, between gulps of water, one by one by one.

At first nothing happened, but as I approached the bottom of the bottle, red and blue lights began to flash before my eyes. The bottle slid from my fingers and I lay down.

The silence drew off, baring the pebbles and shells and all the tatty wreckage of my life. Then, at the rim of vision, it gathered itself, and in one sweeping tide, rushed me to sleep.

and the "pre-ordained" societal expectations of women, daughters, wives, and mothers. Such anxieties are at the center of the novel, as is Plath's awareness of and unqualified description of the mental illness she suffered—what she described as "owl's talons clenching my heart." Plath attempted suicide, perhaps numerous times, before she succeeded on a February morning in 1963. Reading 22.12 from *The Bell Jar* documents her first attempt to do so by taking prescribed sleeping pills that had been hidden from her by her mother.

Like some of Sylvia Plath's writing, Anne Sexton's work is described by critics as "confessional"; that is, it reveals intimate personal details about the author's life. Sexton, a Pulitzer Prize winner for poetry, wrote about her own mental illness (she, too, committed suicide) as well as her relationship with her husband and children. Her poem "In Celebration of My Uterus" not only raises the physical, psychological, and female identity issues attached to her anticipated hysterectomy, it is also a rallying cry for all women, in Sexton's words, to follow her "in celebration of the woman I am and of the soul of the woman I am" and to affirm their own identities.

MUSIC

After World War II, many avant-garde composers moved toward greater and greater complexity of musical organiza-

tion, coupled with an increasing use of new kinds of sound. At the same time, other musicians, disturbed by their colleagues' obsessive concern for order, have tried to introduce an element of chance—even chaos—into the creation of a work of music. In taking these directions, modern "classical" or "serious" musicians seem, at least superficially, to have made virtually a complete break with past traditions. Furthermore, much of their work seems remote from our actual experience. Developments in painting or architecture are visible around us in one form or another on a daily basis, and modern writers deal with problems that affect us in our own lives. Many creative musicians, however, have withdrawn to the scientific laboratory, where they construct their pieces with the aid of machines and in accordance with mathematical principles.

Popular music, on the other hand, seems to be anything but remote. Rock operas, musicals, rock and roll, hip-hop and rap speak to listeners of their social and financial concerns of the day. Musicians are as likely to come from "the 'hood" as the academy. As in the past, the success of all these new forms of music will be judged by generations to come.

STRUCTURALISM The principle of precise musical organization had already become important in 20th-century music

READING 22.13 ANNE SEXTON

In Celebration of My Uterus

Everyone in me is a bird.
I am beating all my wings.
They wanted to cut you out
but they will not.
They said you were immeasurably empty
but you are not.
They said you were sick unto dying
but they were wrong.
You are singing like a school girl.
You are not torn.

Sweet weight,
in celebration of the woman I am
and of the soul of the woman I am
and of the central creature and its delight
I sing for you. I dare to live.
Hello, spirit. Hello, cup.
Fasten, cover. Cover that does contain.
Hello to the soil of the fields.
Welcome, roots.

Each cell has a life.
There is enough here to please a nation.
It is enough that the populace own these goods.
Any person, any commonwealth would say of it,
"It is good this year that we may plant again
and think forward to a harvest.
A blight had been forecast and has been cast out."
Many women are singing together of this:
one is in a shoe factory cursing the machine,
one is at the aquarium tending a seal,
one is dull at the wheel of her Ford,
one is at the toll gate collecting,

one is tying the cord of a calf in Arizona,
one is straddling a cello in Russia,
one is shifting pots on the stove in Egypt,
one is painting her bedroom walls moon color,
one is dying but remembering a breakfast,
one is stretching on her mat in Thailand,
one is wiping the ass of her child,
one is staring out the window of a train
in the middle of Wyoming and one is
anywhere and some are everywhere and all
seem to be singing, although some can not
sing a note.

Sweet weight,
in celebration of the woman I am
let me carry a ten-foot scarf,
let me drum for the nineteen-year-olds,
let me carry bowls for the offering
(if that is my part).
Let me study the cardiovascular tissue,
let me examine the angular distance of meteors,
let me suck on the stems of flowers
(if that is my part).
Let me make certain tribal figures
(if that is my part).
For this thing the body needs
let me sing
for the supper,
for the kissing,
for the correct
yes.

with the serialism of Arnold Schönberg. Schönberg's ordering of pitch (the melodic and harmonic element of music) in rigidly maintained 12-tone rows has been extended by recent composers to other elements. Paavali Jumppanen (b. 1925), for example, constructed rows of 12-note durations (the length of time each note sounds), 12 levels of volume, and 12 ways of striking the keys for works like his Second Piano Sonata (1948) and Structures for two pianos (1952). In this music, every element (pitch, length of notes, volume, and attack) is totally ordered and controlled by the composer in accordance with his predetermined rows, because none of the 12 components of each row can be repeated until all the other 11 have occurred.

GO LISTEN! PIERRE BOULEZ

"Piano Sonata No. 2"

Structuralism eliminates any sense of traditional melody, harmony, or counterpoint, along with the emotions they evoke. Instead, the composer aims to create a pure and abstract musical structure that deliberately avoids any kind of subjective emotional expression. There remains, however, one element in these piano works that even Boulez cannot totally control: the human element. All of the composer's instructions, however precise, have to be interpreted and executed by a performer, and as long as composers depend on performers to interpret their works, they cannot avoid a measure of subjectivity. Different pianists will inevitably produce different results, and even the same pianist will not produce identical performances on every occasion.

ELECTRONIC MUSIC In order to solve this "problem," some composers in the 1950s began to turn to electronic music, whose sounds are produced not by conventional musical instruments but by an electronic oscillator, a

machine that produces pure sound waves. A composer could order the sounds by means of a computer and then transfer these to recording tape for playback. The process of manipulating electronic sound has been simplified by the *synthesizer* (an electronic instrument that can produce just about any kind of sound effect). In combination with a computer, the synthesizer can be used for either original electronic works or the creation of electronic versions of traditional music, as in the popular *Switched-On Bach* recordings of the 1960s.

From its earliest days, electronic music alarmed many listeners by its apparent lack of humanity. The whistles, clicks, and hisses that characterize it may be eerily appropriate to the mysteries of the Space Age but have little to do with traditional musical expression. Composers of electronic music have had considerable difficulty inventing formal structures for organizing the vast range of sounds available to them. In addition, there still exists no universally agreed-on system of writing down electronic compositions, most of which exist only on tape. It is probably significant that even Karlheinz Stockhausen (1928–2007), one of the leading figures in electronic music, tended to combine electronic sounds with conventional musical instruments. His *Mixtur* (1964), for example, was written for five orchestras, electronic equipment, and loudspeakers. During performance, the sounds produced by the orchestral instruments are electronically altered and simultaneously mixed with the instrumental sound and prerecorded music. In this way an element of live participation has been reintroduced.

For all its radical innovations, however, *Mixtur* at least maintains the basic premise of music in the Western tradition: that composers can communicate with their listeners by predetermining (composing) their works according to an intellectual set of rules. The laws of Baroque counterpoint, Classical sonata form, or Stockhausen's ordering and altering of sound patterns all represent systems that have enabled composers to plan and create musical works. One of the most revolutionary of all recent developments, however, has been the invention of **aleatoric music**. The name is derived from the Latin word *alea* (a dice game) and is applied to music in which an important role is played by the element of chance.

JOHN CAGE AND ALEATORIC MUSIC One of the leading exponents of this genre of music was the American composer John Cage (1912–1992), who had been much influenced by Zen philosophy. Adopting the Zen attitude that one must go beyond logic in life, Cage argued that music should reflect the random chaos of the world around us and not seek to impose order on it. His Concert for Piano and Orchestra (1958) has a piano part consisting of 84 different "sound events," of which some, all, or none are to be played in any random order. The orchestral accompaniment consists of separate pages of music, of which some, all, or none can be played by any (or no) instrument, in any order and combination. Clearly, every per-

formance of the Concert is going to be a unique event, largely dependent on pure chance for its actual sound. In other pieces, Cage instructed the performers to determine the sequence of events by even more random methods, including the tossing of coins.

GO LISTEN! JOHN CAGE
"Piano Sonata II"

Works like these are more interesting for the questions they ask about the nature of music than for any intrinsic value of their own. Cage partly reacted against what he regarded as the excessive organization and rigidity of composers like Boulez and Stockhausen, but at the same time he also raised some important considerations: What is the function of the artist in the modern world? What is the relationship between creator and performer? And what part, if any, should the listeners play in the creation of a piece of music? Need it always be a passive part? If Cage's own answers to questions such as these may not satisfy everyone, he at least posed the problems in an intriguing form.

The New Minimalists

A very different solution to the search for a musical style has been proposed by a younger generation of U.S. composers.

STEVE REICH Steve Reich (b. 1936) was one of the first Western musicians to build lengthy pieces out of the multiple repetitions of simple chords and rhythms. Critics sometimes assume that the purpose of these repetitions is to achieve a hypnotic effect by inducing a kind of state of trance. Reich stated that his aim is, in fact, the reverse: a state of heightened concentration.

In *The Desert Music*, a composition for chorus and instruments completed in 1983, Reich's choice of texts is helpful to an understanding of his music. The work's central section consists of a setting of words by the U.S. poet William Carlos Williams (1883–1963):

> It is a principle of music
> to repeat the theme. Repeat
> and repeat again,
> as the pace mounts. The
> theme is difficult
> but no more difficult
> than the facts to be
> resolved.

The piece begins with the pulsing of a series of broken chords, which is sustained in various ways, chiefly by tuned mallets. This pulsation, together with a wordless choral

vocalization, gives the work a rhythmic complexity and richness of sound that is at times reminiscent of some African or Balinese music.

GO LISTEN! STEVE REICH

"The Desert Music Third Movement"

PHILIP GLASS The works of Philip Glass (b. 1937) are even more openly influenced by non-Western music. Glass studied the Indian tabla drums for a time; he is also interested in West African music and has worked with Ravi Shankar, the great Indian sitar virtuoso. Many of Glass's compositions are based on combinations of rhythmic structures derived from classical Indian music. They are built up into repeating modules, the effect of which has been likened by unsympathetic listeners to a needle stuck in a record groove.

Length plays an important part in Glass's operas, for which he has collaborated with the U.S. dramatist Robert Wilson. Wilson, like Glass, is interested in "apparent motionlessness and endless durations during which dreams are dreamed and significant matters are understood." Together they produced three massive stage works in the years between 1975 and 1985: *Einstein on the Beach*, *Satyagraha*, and *Akhnaten*. The performances involve a team of collaborators including directors, designers, and choreographers; the results have the quality of a theatrical "happening." Although a description of the works makes them sound remote and difficult, performances of them have been extremely successful. Even New York's Metropolitan Opera, not famous for an adventurous nature in selecting repertory, was sold out for two performances of *Einstein on the Beach*. Clearly, whatever its theoretical origins, the music of Glass reaches a wide public.

GO LISTEN! PHILIP GLASS

"Music in 12 Parts"

Traditional Approaches to Modern Music

Not all composers have abandoned the traditional means of musical expression. Musicians like Benjamin Britten (1913–1976) and Dmitri Shostakovich (1906–1975) demonstrated that an innovative approach to the traditional elements of melody, harmony, and rhythm can still produce exciting and moving results, and neither can be accused of losing touch with the modern world. Britten's *War Requiem* (1962) is an eloquent plea for an end to the violence of contemporary life, whereas Shostakovich's entire musical output reflects his uneasy relationship with Soviet authority. His Symphony No.

13 (1962) includes settings of poems by the Soviet poet Yevgeny Yevtushenko on anti-Semitism in the Soviet Union and earned him unpopularity in Soviet artistic and political circles.

GO LISTEN! DMITRI SHOSTAKOVICH

"Symphony #13 (Babi Yar) II Humour"

Both Britten and Shostakovich did not hesitate to write recognizable "tunes" in their music. In his Symphony No. 15 (1971), the last he wrote, Shostakovich even quoted themes from Rossini's *William Tell Overture* (the familiar *Lone Ranger* theme) and from Wagner. The work is at the same time easy to listen to and deeply serious. Like much of Shostakovich's music, it is concerned with the nature of death (a subject also explored in his Symphony No. 14). Throughout its four movements, Shostakovich's sense of rhythm is much in evidence, as is his feeling for orchestral color, in which he demonstrates that the resources of a traditional symphony orchestra are far from exhausted. The mysterious dying close of Symphony No. 15 is especially striking in its use of familiar ingredients—repeating rhythmic patterns, simple melodic phrases—to achieve an unusual effect.

If Shostakovich demonstrated that a musical form as old-fashioned as the symphony can still be used to create masterpieces, Britten did the same for opera. His first great success, *Peter Grimes* (1945), employed traditional operatic devices like arias, trios, and choruses to depict the tragic fate of its protagonist, a man whose alienation from society leads to his persecution at the hands of his fellow citizens. In other works, Britten followed the example of many of his illustrious predecessors in turning to earlier literary masterpieces for inspiration. *A Midsummer Night's Dream* (1960) is a setting of Shakespeare's play, while *Death in Venice* (1973) is based on the story by Thomas Mann. In all of his operas, Britten writes music that is easy to listen to (and, equally important, not impossible to sing), but he never condescends to his audience. Each work deals with a recognizable area of human experience and presents it in a valid musical and dramatic form.

Modern Approaches to Traditional Music Genres

Britten's *Peter Grimes* was written in 1945 but the story takes place almost a century earlier. One of the characteristics, however, of contemporary opera is its currency, with many subjects inspired by recent or relatively recent events. *Nixon in China*, for example, by composer John Adams is based on the U.S. president's historic visit to China in 1972, an overture intended to break the diplomatic log-jam in relations between the United States and Communist countries. The score for Adams's opera makes references to the minimalist music of Philip Glass, but also to that of classical 19th-century

composers Wagner and Strauss. Adams has also written operas on the subject of the making of the first atomic bomb (*Dr. Atomic*) and the 1985 murder of the disabled U.S. senior citizen Leon Klinghoffer after Palestinian terrorists hijacked the cruise ship on which he was vacationing (*The Death of Klinghoffer*).

ROCK OPERA In the 1960s, a number of rock musicians created a new genre—Rock Opera—that merged contemporary sound and songwriting with more-or-less traditional operatic structure. The first of these to be billed from the start as a Rock Opera was *Tommy* (1969) by Pete Townshend and The Who. Drawing on conventions of classical opera, *Tommy* has essentially no spoken dialogue, although some spoken lines are scattered throughout the piece. Two years later, *Jesus Christ Superstar* by Andrew Lloyd Webber opened on Broadway, a rock opera that is sung through completely—without spoken words. Webber's opera, with lyrics by Tim Rice, is a loosely constructed story that posits the emerging celebrity of Jesus Christ and its psychological impact on Him. Relationships between Jesus and Judas and Jesus and Mary Magdalene are presented as more complex than the Bible would have us believe, emphasizing the human nature of these larger-than-life figures. *Jesus Christ Superstar* was also a trailblazer in the contemporizing of familiar stories for opera and stage musicals.

GO LISTEN! ANDREW LLOYD WEBBER

"Superstar" from *Jesus Christ Superstar*

Contemporary Rock Opera composers also have paid homage to beloved operatic repertory. *Miss Saigon* (1989, music by Claude-Michel Schonberg and Alain Boublil with lyrics by Boublil and Richard Maltby, Jr.) brought the more current event of the Vietnam War to the story line of Giacomo Puccini's *Madame Butterfly* in which an overseas marriage between an American lieutenant and a naïve and hopeful Japanese girl ends in tragedy when he returns to the States and embarks on another, more conventional life without her. The main characters in *Madame Butterfly* are replaced with an American G.I. and a young Vietnamese orphan-girl whom he meets in a nightclub where bar girls compete for the dubious title of "Miss Saigon," the "prize" of a Marine, and the dream of being taken away from the war-ravaged country to a better life in America. The musical number, "The Heat is On in Saigon," sung by the soldiers and bar girls in the steamy, sexually charged atmosphere of the club. It contrasts dramatically in tone with "The Movie in My Mind" in which the contest winner, Gigi, leads the bar girls in a sorrowful song that reflects their (likely unfulfilled) fantasies about life as it would be in America in the arms of a "strong G.I."

GO LISTEN! CLAUDE-MICHEL SCHÖNBERG

"The Heat Is On in Saigon" from *Miss Saigon*

Operatic structure and style have also made their way into works written for the musical theatre; *Porgy and Bess* is a good example of a work that opened on Broadway but is now considered part of contemporary opera repertory. Broadway musicals such as *The Phantom of the Opera* (also by Andrew Lloyd Webber), *Evita* (by Webber with lyrics by Tim Rice), or *Sweeney Todd: The Demon Barber of Fleet Street* (by Steven Sondheim with a libretto by Hugh Wheeler) employ a number of conventions typical of traditional opera.

MUSICALS *The Phantom of the Opera*, although operatic in feel and tone, was staged as a work of musical theatre—a book musical—with songs, dance, and acting. Musical theatre performers are often referred to as "triple threats" for their superior skills in all of these disciplines. Combining music and theatre as we know it goes back at least to the 19th century with lyricists and composers such as Gilbert and Sullivan, but the book musical, written from the outset to combine the disciplines with a dramatic story, exploded as an art form distinguishable from opera in the 20th century.

MUSICALS AND SOCIAL CONSCIOUSNESS The variety of book musicals would seem endless and consideration of each type—operatic musicals, musical plays, musical comedies, and more—would fill more space than this discussion allows. An interesting sub-category for our purposes, however, is what we may describe as the "socially conscious" musical—a musical that addresses contemporary themes social issues. *South Pacific,* by the renowned musical theatre partners Richard Rodgers (music) and Oscar Hammerstein (lyrics), premiered in 1949, just four years after the Japanese surrender to the Allies in August 1945. Based on James A. Michener's 1947 novel, *Tales of the South Pacific,* the centerpiece of the musical is the love affair between an American nurse (Nellie Forbush) stationed on a naval base in the South Pacific and a French plantation owner (Emile de Becque) who, as is ultimately revealed, is a widower and father of two mixed-race children. The subject of contemporary racial views and prejudice is a powerful subtext in the narrative, further highlighted by a secondary story line featuring a love interest between an island girl (Liat) and American lieutenant (Joseph Cable). As both de Becque and Cable become entangled in the consequences of racial prejudice, de Becque asks Cable why Americans hold these views. Cable answers that they are not inborn but, rather, they are learned. In his musical number, "You've Got to Be Carefully Taught," Cable tells the Frenchman that children are taught by adults "to hate and fear."

GO LISTEN! RODGERS AND HAMMERSTEIN

Matthew Morrison, "You've Got to Be Carefully Taught" from *South Pacific*

In *West Side Story* (1957, music by Leonard Bernstein, lyrics by Steven Sondheim, book by Arthur Laurents), ethnic

prejudice and social problems take center stage in a musical that contemporizes Shakespeare's story of Romeo and Juliet and the tragic impact of their feuding families on the two young lovers. New York City's Upper West Side neighborhood in the mid-1950s is the backdrop for a gang rivalry between the Jets (white boys from the working class) and the Sharks (young Puerto Rican immigrants). As in *Romeo and Juliet*, a young man (Tony) who belongs to one group, the Jets, falls in love with the sister of the leader of the Sharks (Maria). Conflict escalates between the gangs and, in the heat of a moment, one murder leads to another; Tony is guilty of killing Maria's brother. The musical numbers convey many dimensions of ethnic suspicion and blind hatred on both sides, but the tragic trajectory of the story is mitigated by some songs that cloak social issues in more comedic terms. One of these, "Gee Officer Krupke," sung by the Jets, is a mock-plea to a beat-cop and the juvenile courts to spare young hoodlums like them by pointing to the sociological circumstances that give rise to their behavior.

Hair: The American Tribal Love-Rock Musical (music by Galt McDermot), which opened in an Off-Broadway theatre in 1967 and a year later moved to Broadway to become a sensation, tells the story of a group of long-haired hippies who personified hallmarks of the so-called counter-culture of the sixties: sexual freedom, use of illegal drugs, anti-Vietnam War sentiment, and social liberalism. *Hair*, like *West Side Story*, was set in the present. It was intended to cast light on the big divide between pro- and anti-war factions within the U.S. citizenry, between "establishment" and "anti-establishment" views on patriotism, authority, and other societal principles. Both musicals, one could say, were intended to promote tolerance and to effect social change.

GO LISTEN! GALT MACDERMONT

"Hair" from *Hair*

So too with *Rent* (1996, music and lyrics by Jonathan Larson), a rock musical based on another Puccini opera, *La Boheme*, which premiered in 1896 (one hundred years before the opening of *Rent*). Puccini's opera told the story of nearly starving artists—bohemians—living in a Parisian garret, and the untimely death of one of the artist's girlfriends from tuberculosis. At the time that Puccini was writing, tuberculosis was referred to as the Great White Plague, ravaging the populations of inner cities that were prone to crowding and unsanitary conditions. *Rent* finds its analogy in a struggling artist community living in New York City's Lower East Side and the HIV/AIDS epidemic among homosexuals and drug users in the late 1980s and early 1990s. Just as death from tuberculosis in the 19th century seemed almost unavoidable, HIV/AIDS among these societal groups "at the end of the millennium" seemed inevitable. In Larson's adaptation of the Puccini opera, the lead male character, Roger, is living with the disease and has become depressed and isolated in the wake of the suicide of his girlfriend after learning that they

were both infected. A musician and composer, Roger's state of mind has had a paralyzing effect on his ability to continue to write songs. His desperation to leave his mark, even as he faces the harsh reality of impending death, is the subject of the musical number, "One Song, Glory." Groundbreaking in its focus on people living with and dying from HIV/AIDS, *Rent* was the recipient of numerous Tony Awards and the Pulitzer Prize for Drama.

GO LISTEN! JONATHAN LARSON

"One Song Glory" from *Rent*

Popular Music

ROCK AND ROLL Rock and roll, the egalitarian American genre of music that evolved in the 1930s and 1940s, exploded on the cultural and entertainment scene in the mid-50s. The music was exciting, young, sexual, and extraordinarily popular. Its influence was felt in movies, in radio and television, in dance and even language. Disc jockeys spun rock and roll records on the radio while Dick Clark's TV show "American Bandstand" had teenagers dancing to its rhythms. The movie *Blackboard Jungle* (1954) featured what was arguably the first true rock and roll song, "Rock Around the Clock." The same year, Elvis Presley's first hit, "I'm All Right Mama," became an overnight sensation.

The stylistic basis for rock and roll was multicultural, with a heavy emphasis on African and African American musical traditions. It combined a black church gospel style, the blues, boogie-woogie piano music, and European-based folk tunes. To learn and absorb this synthesis, Elvis visited black segregated barrooms and dance halls in Mississippi before he recorded his first songs. Rock and roll's basic sound features a blues rhythm against the constant background beat of a snare drum. Other typical instruments include two electric guitars, a bass guitar, and drum set, often along with a piano and saxophone. The driving visceral rhythms appealed to the young and rebellious and quickly spread all over the world.

GO LISTEN! ELVIS PRESLEY

"Heartbreak Hotel"

In the egalitarian spirit of rock and roll, many women singers made the hit parade. Willa Mae (Big Mama) Thornton recorded the old African American blues tune, "Hound Dog," in 1952, which was a success on the rhythm and blues charts three years before the Elvis Presley version became a rock and roll hit. Many "girls" groups (as they were called then) contributed to rock and roll. The first black girls' group to become a success was the "Chantels." With Arlene Smith as the lead singer, they recorded the top hit, "Maybe" in 1958. Teenagers were also swinging to the songs "Be My

Baby" and "Walking in the Rain" by Ronnie Spector and the Ronettes in the early 1960s. Their producer was the legendary Phil Spector, who invented the "big wall of sound," an echo chamber effect that made his recordings unique. These early Rock and roll tunes could be heard over European, Asian and African radio shortly after being recorded in the United States. Rock and roll was among the first examples of American mass culture to have an international impact.

ROCK MUSIC Rock and roll was the foundation of rock music, a genre that took on many and widely different styles starting in the 1960s. One of the most—if not *the* most—versatile, influential, and commercially successful bands in history—The Beatles—was formed in the English port city of Liverpool in 1960. Nicknamed the "Fab Four," they became international stars in just a few short years. Their popularity was so universal that the word "Beatlemania" was coined to describe the phenomenon; sales of their music to date have been estimated at over 1 billion.

The Beatles drew heavily on rock and roll for their earliest tunes, along with jazz, blues, and folk music. Their first worldwide smash hit was "I Want to Hold Your Hand," co-written by John Lennon and Paul McCartney. The song was also included on the album *Meet the Beatles* which was released to the American market and ultimately sold more copies than the single. Along with several other tunes (including "She Loves You," "I Saw Her Standing There," and "All My Loving"), "I Want to Hold Your Hand" was sung before a live audience on American television's *The Ed Sullivan Show* on Sunday night, February 9th, 1964. Over 73 million viewers tuned in to see the group's first live U.S. performance—45.3% of homes with TV sets. The success of The Beatles in this country paved the way for what was called the "British Invasion," bringing rock bands like The Bee Gees, the Dave Clark Five, the Moody Blues, Rolling Stones, and The Who to radio Billboard Charts and the lucrative American market.

Critical reviews of *The Ed Sullivan Show* performance were mixed, with some predicting that The Beatles would be here today and gone tomorrow. The group stayed together until 1969 and, over the course of almost a decade, their music and lyrics, affected by the 1960s counterculture, became more experimental. References to other pop music styles, eastern music, psychedelic rock, and even classical music pervaded their compositions and yielded continuously unexpected results. A good example of their ingenious synthesizing is "Back in the U.S.S.R.," written by McCartney as a tongue-in-cheek homage to the American rock band, The Beach Boys, and their song, "California Girls," by Brian Wilson. Written in the middle of the Cold War when little was known about life and culture within the Soviet Union, McCartney fantasizes a parallel between the girls The Beach Boys sang about and their counterparts in the Communist state.

GO LISTEN! THE BEATLES
"I Want to Hold Your Hand"

GO LISTEN! THE BEATLES
"Back in the U.S.S.R."

The Beach Boys, called "America's Band," hailed from Southern California and while they, like most contemporary rock bands, were influenced by the British Invasion, their songs could not have been more uniquely American—or even more specifically, Californian. Tunes like "Surfin' USA," "Surfer Girl," and "California Girls" glamorized the California youth culture—cars, surfing, "endless summers." The band's close vocal harmonies became their signature style, which gained international popularity quickly. By the mid-1960s, however, The Beach Boys—like The Beatles—had moved on to more complex arrangements with experimental instrumentation. "Good Vibrations," one of their most familiar songs, was a trailblazer in psychedelic rock, a genre inspired by the sensations of mind-altering, hallucinogenic drugs like LSD that had become part of the sixties counter-culture.

GO LISTEN! THE BEACH BOYS
"California Girls"

HIP-HOP AND RAP The word "rap" came into usage in African American dialect in the 1960s and referred to talking or conversation. Today, rapping denotes a music genre that melds speech, poetry, and song. It is typically connected to the urban scene and often has socio-political content. Rap began loosely in the early 1980s with pieces that featured a certain "flow," or rhythms, rhyme schemes, and enunciation. The genre has expanded to include many, many variations and has spawned a host of rappers with unique musical perspectives.

Rap is a central element in the African American hip-hop subculture that originated in block parties in the Bronx, New York in the 1970s. Elements of hip-hop also include beatboxing (a vocal technique that reproduces the sounds of percussion instruments), breakdancing (a style of street dance), and graffiti. One of the most acclaimed and influential acts to hit the hip-hop scene in the 1980s was Run-D.M.C.—a group of three musicians from Hollis, Queens, New York. Inducted into the Rock and Roll Hall of Fame in 2009, Run-D.M.C. is widely viewed as having created the sound of hip-hop music, along with the style: the fedora hat, gold name plates, Cazal glasses, and white, laceless Adidas brand sneakers. Their international hit, "Walk This Way," which was a cover for a song written by Steven Tyler and Joe Perry of the hard rock group Aerosmith, was groundbreaking in its interfacing of hip-hop musical style with rock.

POP MUSIC AND THE MUSIC VIDEO The combination of music and moving images has a lengthy history ranging from music shorts (one- or two-reel musical films running under half an hour) that date back to early 20th century to feature-length films in which a music track was sprinkled with dialogue sequences that loosely framed a story. Two early examples of music feature films are *A Hard Day's Night* (1964) and *Help!* (1965)—both starring The Beatles. Critics have traced the music video as we know it to these films.

Music videos as marketing tools and art forms unto themselves hit their stride with the launch of MTV (music television) in 1981. Recording artists like Madonna created and starred in music videos, some of which, like her *Immaculate Collection*, featured a whole album of songs that was also sold as a VHS tape. Arguably the most well-known and influential music video is Michael Jackson's *Thriller* (**Fig. 22.50**). The big budget, iconic choreography, cinematography, and running time (almost 14 minutes) set standards in the industry for generations of recording artists.

▼ **22.50 Michael Jackson (center) in still from *Thriller*, 1983. Music video directed by John Landis.** Michael Jackson's innovative and elaborate music video of his performance of the song of the same name set the standard for music videos for a generation to come.

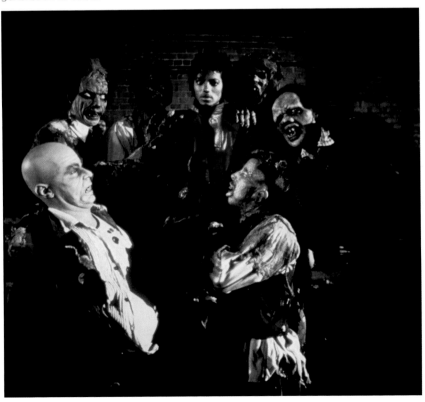

A NOTE ON THE POSTMODERN SENSIBILITY

In the past generation some critics have been insisting, with varying degrees of acceptance, that much of contemporary art has moved beyond the Modernist preoccupation with alienation, myth, fragmentation of time, and the interior states of the self. The most debated questions now are: What exactly followed Modernism that makes it distinctively Postmodern? Does it have a shaping spirit? What do the artists in all media hold in common that permits them to be considered representative Postmodernists?

Some critics see the Postmodernists as those who push the Modernist worldview to its extreme limit. This is hardly a satisfactory definition, because rather than define a new sensibility, it merely elasticizes the definition of modern to include more of the same. While Postmodernism must build on what Modernism has accomplished, it must also find its own voice.

It is impossible to create art today as if Cubism or Abstract Expressionism had never existed, just as it is impossible to compose music as if Stravinsky had never lived. Furthermore, we cannot live life (or even look at it) as if relativity, atomic weapons, and Freudian explorations of the unconscious were not part of our intellectual and social climate. If art is to be a genuine part of the human enterprise, it must surely incorporate its past without being a prisoner of it, reflect its present, and point to the future. In fact, most of the great achievements in the arts have done precisely that; they have mastered the tradition and then extended it.

It may well be that the key word to describe the contemporary situation in the arts is *pluralism*: a diversity of influences, ideas, and movements spawned by an age of instant communication and ever-growing technology. In an age when more people than ever before buy books, see films, watch television, go to plays and concerts, use the Internet, and listen to radios, iPods, and DVDs, what we seem to be seeing is the curious puzzle the Greek philosophers wrote about millennia ago—the relationship of unity and diversity in the observable world: we are one, but we are also many.

GLOSSARY

Abstract Expressionism (p. 827) A style of painting and sculpture of the 1950s and 1960s in which artists expressionistically distorted abstract images with loose, gestural brushwork.

Absurdity (p. 826) The condition of existing in a meaningless and irrational world.

Action painting (p. 828) A contemporary method of painting characterized by implied motion in the brushstroke and splattered and dripped paint on the canvas.

Aleatoric music (p. 876) Music whose composition comprises an element of chance.

Color-field painter (p. 833) A painter who uses visual elements and principles of design to suggest that areas of color stretch beyond the canvas to infinity; figure and ground are given equal emphasis.

Combine painting (p. 844) A contemporary style of painting that attaches other media, such as found objects, to the canvas.

Conceptual art (p. 835) Art that seeks to communicate a concept or idea to the viewer, not necessarily involving the creation of an actual art object such as a painting or piece of sculpture.

Creative nonfiction (p. 869) A genre of writing that relates true stories as though they were works of fiction, lending drama to the plots and characters.

Deconstructivism (p. 863) A Postmodern approach to the design of buildings that disassembles and reassembles the basic elements of architecture, challenging the view that there is one correct way to approach architecture; the focus is on the creation of forms that may appear abstract, disharmonious, and disconnected from the functions of the building.

Existentialism (p. 823) A philosophy that emphasizes the uniqueness and isolation of the individual in a hostile or indifferent universe, regards human existence as inexplicable, and stresses freedom of choice and responsibility for the consequences of one's actions.

Feminist (p. 847) Relating to the doctrine that advocates that women have social, political, and other rights that equal those of men; a person who holds such a view.

Ferroconcrete (p. 860) Concrete reinforced with steel rods or mesh.

Green building (p. 864) A building that is designed to conserve materials and energy.

Hypostyle (p. 862) In architecture, a structure with a roof supported by rows of piers or columns.

Land art (p. 838) Site-specific work that is created or marked by an artist within natural surroundings.

Minimalism (p. 834) A 20-century style of nonrepresentational art in which visual elements are simplified and reduced to their essential properties. Also a style of 20th century music.

Mobile (p. 855) A sculpture that is suspended in midair by wire or string, and made of delicately balanced parts such as rods and sheets of metal, and so constructed that the parts can move independently when stirred by a gust of air.

Modern architecture (p. 858) Architecture that rejects Classical ornamentation in favor of experimental forms of expression.

Pop Art (p. 842) An art style originating in the 1960s that uses ("appropriates") commercial and popular images and themes as its subject matter.

Postmodernism (p. 862) A contemporary style of architecture that arose as a reaction to Modernism and that returned to ornamentation drawn from Classical and historical sources.

Site-specific art (p. 838) Art that is produced in or for one location and is not intended to be relocated.

Structuralist (p. 875) In music, a composer who uses precise musical organization.

Superrealism (p. 846) The rendering of subjects in art with sharp, photographic precision.

THE BIG PICTURE THE CONTEMPORARY CONTOUR

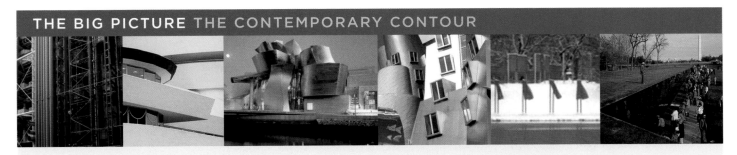

Language and Literature

- Mailer published *The Naked and the Dead* in 1948.
- Playwright Arthur Miller staged *Death of a Salesman* in 1949.
- Kerouac published *On the Road*, Burroughs published *Naked Lunch*, and Ginsberg wrote "Howl" in the 1950s.
- Camus published *The Stranger*, *The Plague*, and *The Fall* in the 1940s and 1950s.
- Beckett wrote *Waiting for Godot* in 1952.
- Wiesel published his autobiographical account of the Holocaust, *Night*, in 1960.
- Updike published his "Rabbit" novels beginning in 1960 with *Rabbit, Run*.
- Ellison (*Invisible Man*), Baldwin (*Go Tell It on the Mountain*), Walker (*The Color Purple*), Angelou ("Caged Bird"), and Morrison (*The Bluest Eye*) wrote about African American experiences.
- Rich, Plath, and Sexton wrote from feminist perspectives.

Art, Architecture, and Music

- Giacometti and Bacon created works of art revealing existentialist angst in the 1940s and 1950s.
- Boulez composed structuralist music in the late 1940s and early 1950s.
- The artists of the New York School—foremost among them, Jackson Pollock—created Abstract Expressionist works in the 1940s and 1950s.
- The artists of the second generation of the New York School—including Mitchell and Frankenthaler—varied Abstract Expressionist themes.
- Electronic music developed in the 1950s.
- Schools of art such as Minimalism, Conceptual Art, site-specific art, and Pop Art developed in the 1950s and 1960s.
- Cage composed aleatoric music.
- The first rock operas (*Tommy*) and rock musicals (*Hair*) were written in the late 1960s.
- Superrealism developed mainly in the 1970s.
- Feminist art developed in the 1970s and continues today.
- Other artists—including Bearden, Ringgold, and Basquiat—communicated their reactions to African American experience.
- Sculptors after World War II followed various directions, including abstract and figurative art.
- Modern architecture had its heyday in the 1950s and 1960s, followed by Postmodern architecture in the 1970s and the 1980s and Deconstructivism in recent years and today.
- Shostakovich continued to compose symphonies through 1971.
- Glass composed operas in the 1970s and 1980s.
- Reich composed *The Desert Music* in 1983.
- Video art has been developing strongly in the past few decades.

Philosophy and Religion

- Sartre delivered his address "Existentialism Is a Humanism" in October 1945.
- The Beat movement infused U.S. writers in the 1950s.
- Deconstructivism became a guiding philosophy among many architects of today.

Glossary
With Pronunciation

Go to Audio Flashcards for audio pronunciations.

12-bar blues A form of blues in which a fixed series of chords, 12 bars (or measures) in length, is restated continuously throughout the piece.

Abstract Expressionism A style of painting and sculpture of the 1950s and 1960s in which artists expressionistically distorted abstract images with loose, gestural brushwork.

Absurdity The condition of existing in a meaningless and irrational world.

A cappella (ah cuh-PELL-uh) Sung without instrumental accompaniment.

Acropolis Literally "high city"; the flat-topped rock in Athens that rises 490 feet above sea level and has buildings that were erected during the golden age, including the Parthenon.

Action painting A contemporary method of painting characterized by implied motion in the brushstroke and splattered and dripped paint on the canvas.

Adagio (ah-DAH-jee-oe) Slow, as in a passage or piece of music.

Agnus Dei (ag-nuhs dee-ahy) Latin for "lamb of god."

Aleatoric music Music whose composition comprises an element of chance.

Allah (ah-luh) The Arabic word for God.

Allegory The expression by means of symbolic figures and actions of a hidden or emblematic meaning, often spiritual in nature.

Allegro (uh-LEH-grow) In music, a quick, lively tempo.

Alliteration A form of rhyme characterized by the repetition of consonant sounds in nearby words.

Ambulatory In a church, a continuation of the side aisles into a passageway that extends behind the choir and **apse** and allows traffic to flow to the chapels, which are often placed in this area (from *ambulare*, Latin for "to walk").

Anabaptist A member of a radical 16th-century reform movement that viewed baptism solely as a witness to the believer's faith; therefore, Anabaptists denied the usefulness of baptism at birth and baptized people mature enough to understand their declaration of faith.

Analytic Cubism The early phase of Cubism (1909–1912), during which objects were dissected or analyzed in a visual information-gathering process and then reconstructed on the canvas.

Anime A Japanese style of animation characterized by colorful graphics and adult themes.

Animism A belief in spiritual beings; a belief that natural objects (such as plants, animals, or the sun) or natural events (such as wind, thunder, and rain) possess spiritual qualities or spiritual beings.

Anthem The English term for a *motet*; a choral work having a sacred or moralizing text; more generally, a song of praise.

Antiphonal singing A form of religious singing in which segments of a congregation chant alternating verses of a psalm.

Antithesis An idea or pattern of behavior that is the direct opposite of another (the **thesis**).

Apartheid In South Africa, the rigid former policy of segregation of the white and nonwhite populations.

Apse A semicircular or polygonal projection of a building with a semicircular dome, especially on the east end of a church.

Arabesque (air-uh-BESK) A surface decoration based on rhythmic patterns of scrolling and interlacing lines, foliage, or tendrils.

Aragonite The primary mineral in mother-of-pearl, the iridescent inner layer of a mollusk shell.

Archivolt (AR-kuh-volt) An ornamental molding around an arched wall opening.

Arian Christians Christians who believe that Jesus was a person created by, and separate and distinct from, God the Father.

Arian controversy The dispute as to whether Jesus was divine and unified with God the Father and the Holy Spirit (the Orthodox Christian view), or whether Jesus, as the created Son, was distinct from the eternal God the Father (the view held by Arius).

Aria (AR-ee-uh) A solo song in an opera, oratorio, or cantata, which often gives the singer a chance to display technical skill.

Ars Nova A 14th-century style of music characterized by freedom and variety of melody, as contrasted with stricter 13th-century music.

Aryan (AIR-ee-uhn) A member of one of the peoples supposedly descended from Indo-Europeans; particularly, a speaker of an Iranian or Indian language in ancient times.

Assonance A form of rhyme characterized by the repetition of vowel sounds in nearby words.

Atman The basic principle of life; the individual self, known after enlightenment to be identical with Brahman.

Atonal Referring to music that does not conform to the tonal character of European Classical music.

Atrium A courtyard, especially as surrounded by a colonnaded arcade.

Aulos (AW-loss) A double-reed musical instrument similar to the modern oboe.

Automatist Surrealism A form of **Surrealism** in which the artist or writer freely associates to the task at hand in the belief that the work is being produced by the unconscious mind.

Avatar An incarnation of an animal or a human.

Ayre A simple song for one voice accompanied by other voices or by instruments.

Baldacchino (bal-duh-kee-noh) An ornamental canopy for an altar, supported by four columns and often decorated with statuary.

Ballade In music, a composition with the romantic or dramatic quality of a narrative poem.

Baroque (buh-ROHK) A 17th-century European style characterized by ornamentation, curved lines, irregularity of form, dramatic lighting and color, and exaggerated gestures.

Barrel vault A continuous arch or vault that looks like a semicircle in cross-section (also called a *tunnel vault*)

Basilica A large, oblong building or hall with colonnades and an apse; used for public functions, such as a court of law, or as a church.

Bauhaus (BOW-house) A school of design established in Germany by Walter Gropius based on functionalism and employing techniques and materials used in manufacturing.

Bel canto An Italian term for opera that is defined by "beautiful singing."

Belle époque French for "beautiful era"; a term applied to a period in French history characterized by peace and flourishing of the arts, usually dated as beginning in 1890 and ending with World War I in 1914.

Beveled Cut to create a slanted edge.

Bhagavad Gita A section of the Mahabharata; considered a great scripture of the Hindu religion.

Bhakti (BAHK-tee) An act of devotion.

Black Death The epidemic form of the bubonic plague, which killed as much as half the population of Western Europe in the mid-14th century.

Black-figure technique A Greek vase-painting technique in which only the figural elements are applied using a mixture of fine clay and water (see **slip**); kiln firings produce the combination of a reddish clay pot with black figures. Details are added to the figures with a fine-pointed implement that scratches away some of the black paint.

Blank verse Unrhymed **iambic pentameter**.

Blue note A melody note bent a half step down.

Bolshevik A member of a left-wing party that adopted the communist concepts of Marx and Lenin.

Boule The ruling council of the Athenian Ecclesia

Brahman In Hinduism, the one true reality, which can not be fully understood by humans.

Brahma The Hindu god of creation.

Bushido The behavioral or moral code of the samurai; a Japanese counterpart to chivalry.

Cadence A modulation or inflection of the voice.

Caliph A spiritual and secular leader of the Islamic world, claiming succession from Muhammad.

Calligraphy Decorative handwriting, particularly as produced with a brush or a pen.

Canon of proportions A set of rules (or formula) governing what are considered to be the perfect proportions of the human body or correct proportions in architecture.

Canon A code of law, an honored list, or an ecclesiastical regulation enacted by a religious council; as in a canon of "great works of literature" or a canon of writings that belong in a bible.

Cantata A short oratorio composed of sections of declamatory recitative and lyrical arias.

Canto carnascialesco A carnival song, written for the carnival season before Lent.

Canto A principal division of a long poem.

Cantor Singer, especially a person who takes a special role in singing or leading songs at a ceremony or at synagogue and church services.

Canzone A song (plural *canzoni*).

Canzoniere (kahn-tsoh-NYEH-reh) A songbook.

Capitalism A way of organizing the economy so that the manufacture and distribution of goods—and the exchange of wealth—is in the hands of individuals rather than the government.

Capital In architecture, the uppermost part of a column on which rests the horizontal lintel.

Capitulary A royal rule or decree, especially one made by a Frankish king.

Carolingian Of Charlemagne.

Caryatid A stone sculpture of a draped female figure used as a supporting column in a Greek-style building.

Caste system A system of rigid social stratification characterized by being heritable and limiting of marriage prospects to a member of one's own caste.

Catacomb An underground cemetery consisting of tunnels or chambers that have recesses for coffins and tombs.

Catharsis A cleansing of the soul, or release of pent-up emotions.

Cella The small inner room of a Greek temple, used to house the statue of the god or goddess to whom the temple was dedicated; located behind solid masonry walls, the cella was accessible only to temple priests.

Censer A container carrying incense that is burned, especially during religious services.

Chanson A song that is free in form and expressive in nature; A French word meaning *song*.

Chiaroscuro (kya-row-SKOO-row) An artistic technique in which subtle gradations of value create the illusion of rounded three-dimensional forms in space; also termed *modeling* (from Italian for "light-dark").

China A translucent ceramic material; porcelain ware.

Chi-rho A symbol for Christ, consisting of the first two letters of the Greek word *christos*.

Choir In architecture, the part of a church occupied by singers, usually located between a **transept** and the major **apse**.

Chorale prelude A variation on a chorale that uses familiar songs as the basis for improvisation.

Chorale variations Instrumental music consisting of a set of variations upon melodies taken from a familiar hymn or sacred song.

Chorus In Greek drama, a company or group of actors who comment on the action in a play, either by speaking or singing in unison.

Christ The Messiah, or savior, as prophesied in the Hebrew Bible; Jesus of Nazareth, held by Christians to be the fulfillment of the prophecy.

Chryselephantine (kris-el-uh-fan-tin) Made of gold and ivory.

Ci poetry A form of Chinese lyric poetry meant to be sung and usually expressing desire.

Classical A term for music written during the 17th and 18th centuries; more generally, referring to serious music as opposed to popular music.

Clerestory (KLEER-stoe-ree) High windows permitting light to enter a building, but not enabling people to look in or out.

Cloister A covered walkway, particularly in a monastery, convent, college, or church, with a wall on one side and a row of columns open to a quadrangle on the other side.

Codex Manuscript pages held together by stitching; an early form of a book.

Collage An assemblage of two-dimensional objects to create an image; a work of art in which materials such as paper, cloth, and wood are pasted to a two-dimensional surface, such as a wooden panel or canvas.

Colonialism A political system in which one nation has control or governing influence over another nation; also known as *imperialism*.

Colonnade A series of columns, usually capped by a lintel, that can support a roof.

Color-field painter A painter who uses visual elements and principles of design to suggest that areas of color stretch beyond the canvas to infinity; figure and ground are given equal emphasis.

Column A vertical weight-bearing architectural member.

Combine painting A contemporary style of painting that attaches other media, such as found objects, to the canvas.

Communion A Christian **sacrament** in which consecrated bread and wine are consumed as memorials to the death of Christ or in the belief that one is consuming the body and blood of Christ.

Conceptual art Art that seeks to communicate a concept or idea to the viewer, not necessarily involving the creation of an actual art object such as a painting or piece of sculpture.

Conceptual representation The portrayal of a person or object as it is known or thought (conceptualized) to be rather than copied from nature at any given moment. Conceptual figures tend to be stylized rather than realistic.

Concerto grosso An orchestral composition in which the musical material is passed from a small group of soloists to the full orchestra and back.

Contrapposto (kohn-truh-pos-toh) A position in which a figure is obliquely balanced around a central vertical axis. The body weight rests on one foot, shifting the body naturally to one side; the body becomes curved like a subtle S.

Corbeled arch An arch in which each successive layer of stone projects slightly beyond the course below.

Counterpoint In music, the relationship between two or more voices that are harmonically interdependent but combine in a harmonic manner.

Counter-Reformation The effort of the Catholic Church to counter the popularity of Protestantism by reaffirming basic values but also supporting a proliferation of highly ornamented Baroque churches.

Couplet A pair of rhyming lines of poetry.

Course A horizontal row of stone or brick.

Covenant Agreement; referring to the "special relationship" between God and the Israelites.

Creative nonfiction A genre of writing that relates true stories as though they were works of fiction, lending drama to the plots and characters.

Credo The profession of faith sung after the Gospel in the Ordinary of the Mass.

Crossing square The area of overlap in a church plan formed by the intersection of the **nave** and the **transept**.

Cross-rhythm A traditional African musical method in which the pattern of accents of a measure of music is contradicted by the pattern in a subsequent measure; also termed *cross beat*.

Crypt An underground vault or chamber, particularly beneath a church, that is used as a burial place.

Cubism A 20th-century style of painting developed by Picasso and Braque that emphasizes the two-dimensionality of the canvas, characterized by multiple views of an object and the reduction of form to cube-like essentials.

Cuneiform (kyoo-NEE-uh-form) A system of writing featuring wedge-shaped characters; used in ancient Akkadian, Assyrian, Babylonian, and Persian writing.

Curia (KYOO-ree-uh) The tribunals and assemblies through which the pope governed the church.

Cyclopean masonry Walls constructed of extremely large and heavy stones.

Cyclopes A mythical race of one-eyed giants known for their inhuman strength.

Dactylic hexameter A poetic meter or rhythm consisting of six feet or units of *dactyls*. A dactyl contains three syllables, the first of which is long is stressed, and the following two of which are shorter or unstressed.

Dadabwaan A kind of Islamic drum.

Dada A post–World War I movement that sought to use art to destroy art, thereby underscoring the paradoxes and absurdities of modern life.

Daguerreotype A 19th-century form of photography in which a thin sheet of chemically treated, silver-plated copper is placed in a camera obscura and exposed to a narrow beam of light.

Daimyo Japanese warlords.

Decalogue Another term for the Ten Commandments, as set forth in the book of Exodus.

Deconstructivism A Postmodern approach to the design of buildings that disassembles and reassembles the basic elements of architecture, challenging the view that there is one correct way to approach architecture; the focus is on the creation of forms that may appear abstract, disharmonious, and disconnected from the functions of the building.

Degenerate art The term used by Hitler for art, including most modern art, that did not fit his definition of good German art.

Delian League A politically neutral organization of Greek city-states that kept a treasury on the island of Delos to fund military defenses in case of an attack.

Der Blaue Reiter German for "the blue rider"; a 20th-century German Expressionist movement that focused on the contrasts between, and combinations of, abstract form and pure color.

De Stijl (duh stahyl) An early-20th-century art movement that emphasized the use of basic forms, particularly cubes, horizontals, and verticals; also called *Neo-Plasticism*.

Devi The gentle and approachable Hindu goddess considered to be the Mother of the Universe.

Dialectics Intellectual techniques involving rigorous reasoning to arrive at logical conclusions.

Die Brücke German for "the bridge"; a short-lived German Expressionist movement characterized by boldly colored landscapes and cityscapes and by violent portraits.

Dies Irae A medieval Latin hymn describing Judgment Day, used in some Roman Catholic requiems for the dead. (Latin for "day of wrath.")

Dithyramb (DITH-uh-ram) A frenzied or impassioned choral hymn of ancient Greece, especially one dedicated to Dionysus, the god of wine.

Doctor of the church A title given by the Roman Catholic Church to 33 eminent saints, including Augustine, who distinguished themselves by soundly developing and explaining church doctrine.

Dome A vaulted roof usually having a circular base and shaped like half a sphere.

Doric The earliest and simplest of the Greek architectural styles, consisting of relatively short, squat columns, sometimes unfluted, and a simple, square-shaped capital.

Dramatic irony The literary technique in which the words spoken by a character have particular significance for the audience although the character himself or herself is unaware of their meaning.

Dromos A narrow passageway leading to a tomb.

Dukkha Suffering.

Dynamism The Futurist view that force or energy is the basic principle that underlies all events, including everything we see. Objects are depicted as if in constant motion, appearing and disappearing before our eyes.

Ecclesia (uh-KLEE-zee-uh) The main assembly of the democracy of Athens during its golden age.

Ekphrasis A literary device in which a work of art is described in such detail that a clear visual picture emerges.

Engaged column A column embedded in a wall and partly projecting from the surface of the wall

Engraving An image created by cutting into or corroding with acid the surface of a metal plate or wooden block, such that a number of prints of the image can be made by pressing paper or paperlike materials against the plate or block.

Ensemble A group of musicians, actors, or dancers who perform together.

Entablature (en-TAB-lauh-chuhr) In architecture, a horizontal structure supported by columns that in turn supports any other element, such as a pediment, that is placed above; from top to bottom, the entablature consists of a *cornice*, a **frieze**, and an *architrave*.

Entasis (EN-tuh-siss) In architecture, a slight convex curvature of a column, which provides the illusion of continuity of thickness as the column rises.

Ephemera (ih-fem-er-uh) Items not of lasting significance that were meant to be discarded.

Epicureanism (ep-uh-kyoo-REE-uhn-ism) A school of philosophy that argues that the world consists of chance combinations of atoms and that happiness or the avoidance of pain and anxiety are the greatest goods, although pleasure is to be enjoyed in moderation.

Epiphany A sudden realization of the meaning or nature of something.

Epithet A descriptive word or phrase that refers to a particular quality in a person or thing.

Ethos Literally "character," but used by Greeks to describe the ideals or values that characterize or guide a community.

Exemplum In literature, a tale intended as a moral example (plural *exempla*).

Existentialism A philosophy that emphasizes the uniqueness and isolation of the individual in a hostile or indifferent universe, regards human existence as inexplicable, and stresses freedom of choice and responsibility for the consequences of one's actions.

Exodus Going out.

Expressionism A modern school of art in which an emotional impact is achieved through agitated brushwork, intense

coloration, and violent, hallucinatory imagery.

Fabliau (FA-blee-oh) A medieval tale told in verse and having comic, ribald themes (plural *fabliaux*).

Fascism A radical authoritarian national political ideology.

Fauve (fohv) An artist working in an early-20th-century style of art characterized by the juxtaposition of areas of bright colors that are often unrelated to the objects they represent, and by distorted linear perspective.

Fauvism From the French for "wild beast"; an early-20th-century style of art characterized by the juxtaposition of areas of bright colors that are often unrelated to the objects they represent, and by distorted linear perspective.

Feminist Relating to the doctrine that advocates that women have social, political, and other rights that equal those of men; a person who holds such a view.

Fenestration The presence and arrangement or design of windows and doors in a building.

Ferroconcrete Concrete reinforced with steel rods or mesh.

Feudalism The dominant social system in medieval Europe from the ninth through the 15th centuries, in which vassals were granted fiefs—estates or property—by their lords and were required to serve under their lords in the event of war.

Figurative art Art that represents forms in the real world, especially human and animal forms.

Flying buttress In architecture, an arched masonry support which carries the thrust of a roof or a wall away from the main structure of a building to an outer pier or buttress.

Foreshortening A perspective technique used to convey the appearance of contraction of a figure or object as it recedes into space.

Forum An open public space in the center of a Roman city (plural *fora*).

Fourth In music, the distance between the lowest note and the fourth note up an octave.

Free love A social movement that originally sought to separate the state from matters such as sex, marriage, birth control, and adultery; more generally, sexual activity without legal sanction.

Free verse Poetry without rhyme or a consistent meter pattern.

French Gothic style A style of architecture that originated in 12th-century France and is characterized by pointed arches, ribbed vaults, and flying buttresses, which enable the use of ample fenestration.

Fresco A type of painting in which pigments are applied to a fresh, wet plaster surface or wall and thereby become part of the surface or wall (from Italian for "fresh").

Frieze In architecture, a horizontal band between the *architrave* and the *cornice* that is often decorated with sculpture.

Frottola A humorous or amorous poem set to music for a singer and two or three instrumentalists.

Fugue (FYOOG) A musical piece in which a single theme is passed from voice to voice or instrument to instrument (generally four in number), repeating the principal theme in different pitches.

Futurism An early-20th-century style of art that portrayed modern machines and the dynamic character of modern life and science.

Galleon A ship with three or more masts used as a trader or warship from the 15th through 18th centuries.

Gargoyle (GAR-goyl) A grotesque carved beast that funnels water away from the roofs and sides of a church while also signifying that evil flees the church.

Gesamtkunstwerk (geh-ZAHMT-KOONST-verk) An artistic creation that combines several mediums, such as music, drama, dance, and spectacle, as in the operas of Wagner. (German for "total artwork.")

Gikuyu In Kikuyu beliefs, the male primordial parent; the father of the Kikuyu people.

Glaze In painting, a semitransparent coating on a painted surface that provides a glassy or glossy finish. Also a coating of transparent or colored material applied to the surface of a ceramic piece before it is fired in a kiln.

Gloria A hymn of praise from the Ordinary of the Mass.

Gospel The teachings of Jesus and the apostles, especially as described in the first four books of the New Testament; also conceived as "good news" in the redemption has become possible.

Gothic novel A kind of novel that shares Romantic roots with tales of horror, as in the novels *Frankenstein* and *Dracula*.

Gothic style A style of architecture that flourished during the High and Late Middle Ages, characterized by pointed arches, rib vaulting, and a visual dissolving of stone walls to admit light into a building.

Great Schism The division in the Roman Catholic Church during which rival popes reigned at Avignon and Rome.

Green building A building that is designed to conserve materials and energy.

Groundling The name given an audience member at a dramatic event who stands in the pit or ground rather than being seated (because admission is generally less expensive).

Ground In drama, an open area in front of the stage.

Guild Generally, an association of people with common interests; in medieval times, typically a group of merchants or artisans who sought to maintain their standards and protect their interests.

Hadith A collection of the sayings of Muhammad and reports of his behavior.

Haiku (HIGH-koo) Three-lined Japanese verse, with a syllable structure of 5-7-5, which usually juxtaposes images, often drawn from nature, to achieve deeper meaning.

Haniwa (hah-nee-wah) Hollow ceramic figures modeled from slabs of clay that Japanese people placed around burial plots in the fifth and sixth centuries CE.

Harlem Renaissance A renewal and flourishing of African American literary, artistic, and musical culture following World War I in the Harlem section of New York City.

Harmony In music, a pleasing combination of lines or voices; in art and architecture, a balanced or unified composition arranged in a pleasing manner.

Harpsichord A keyboard instrument; a forerunner of the modern piano.

Heliography A 19th-century form of photography in which bitumen, or asphalt residue, is placed on a pewter plate to render the plate sensitive to light.

Henotheism (HEN-uh-thee-ism) The belief that there are many gods, but only one is chosen for worship.

Heroic verse The meter or rhythm used in epic poetry, primarily in Greek and Latin.

Hieroglyphics (high-ruh-GLIFF-icks) An ancient Egyptian system of writing that used pictures or symbols.

High relief Sculpture that projects from its background by at least half its natural depth.

Hollow-casting A sculpture technique using molds that are lined with molten material—such as copper or bronze—rather than filled with the material (which would yield a solid rather than a hollow form).

Holocaust Mass slaughter or destruction, as by fire or nuclear war; the name given to the Nazi slaughter of Jews during World War II.

Horarium The daily schedule of members of a religious community, such as a monastery.

Horizon line In linear perspective, the imaginary line (frequently where the earth seems to meet the sky) along which converging lines meet; also see **vanishing point**.

Huaben Chinese short stories of the Ming dynasty.

Hubris (HYOO-briss) Extreme pride or arrogance, as shown in actions that humiliate a victim for the gratification of the abuser.

Hybridity In the arts, the mixing of the traditions of different cultures to create new blends and new connections.

Hyperbole Poetic exaggeration.

Hypostyle In architecture, a structure with a roof supported by rows of piers or columns.

Iambic pentameter A poetic metrical scheme with five feet, each of which consists of an unaccented syllable followed by an accented syllable.

Iambic tetrameter A poetic metrical scheme with four feet, each of which consists of an unaccented syllable followed by an accented syllable.

Icon An image or symbol.

Iconoclastic (ahy-kon-uh-klas-tik) Having to do with the destruction or removal of sacred religious images.

Iconoclastic controversy The dispute as to whether or not it was blasphemous to use images or icons in art, based on the second of the Ten Commandments, in which God forbids the creation and worship of "graven images" the Greek word *iconoclasm* translates as "image breaking" and refers to the destruction of religious icons within a culture.

Iconography A set of conventional meanings attached to images; as an artistic approach, representation or illustration that uses the visual conventions and symbols of a culture. Also, the study of visual symbols and their meaning (often religious).

Illusionistic Surrealism A form of **Surrealism** that renders the irrational content, absurd juxtapositions, and changing forms of dreams in a manner that blurs the distinctions between the real and the imaginary.

Impressionism A late-19th-century artistic style characterized by the attempt to capture the fleeting effects of light through painting in short strokes of pure color.

Indentured servant A person who is placed under a contract to work for another person for a period of time, often in exchange for travel expenses or an apprenticeship.

Induction A kind of reasoning that constructs or evaluates propositions or ideas on the basis of observations of occurrences of the propositions; arriving at conclusions on the basis of examples.

Indulgence According to Roman Catholicism, removal or remission of the punishment that is due in purgatory for sins; the forgiving of sin upon repentance.

In medias res Literally, "in the middle of things"; a phrase used to describe a narrative technique in which the reader encounters the action in the middle of the story, rather than at the beginning.

Intermezzo (in-ter-METT-so) In music, an interlude.

Isorhythm (EYE-so-rih-thuhm) Alloting a repeated single melody to one of the voices in a composition.

Jazz A musical style born of a mix of African and European musical traditions at the beginning of the 20th century.

Jus civile Rules and principles of law as derived from the laws and customs of Rome.

Ka'bah Arabic for "cube"; the cube-shaped building in Mecca, believed by Muslims to have been built by Abraham and to lie directly beneath heaven, that is the holiest site of Islam.

Kabuki (kah-BOO-kee) A type of drama begun during the Edo period of Japan that was based on real-life events.

Kantor Music director, as at a school.

Karma The path according to which one carries out one's duty according to his or her caste.

Kithara A seven-stringed lyre.

Kora A traditional African string instrument which is plucked; eleven strings are plucked by one hand, and ten strings by the other hand.

Kore Literally, "girl"; a clothed female figure as represented in the sculpture of the Archaic period of Greek art, often carved with intricate detail (plural *korai*). A counterpart to the kouros.

Kouros, pl., kouroi (koor-os) Literally, "boy"; a male figure as represented in the sculpture of the Geometric and Archaic periods of Greek art (plural *kouroi*).

Krater A wide-mouthed ceramic vessel used for mixing wine and water.

Kufic (koo-fik) Styles of calligraphy that were largely developed in the Iraqi city of Kūfah.

Kyrie Eleison Repeated phrases in the Ordinary of the Mass that translate as "Lord, have mercy on us."

Lacquer A hard, durable finish for furniture and other objects that is created from the sap of the sumac tree.

Laissez-faire (les-ey fair) French for "let it be"; in economics, permitting the market to determine prices.

Land art Site-specific work that is created or marked by an artist within natural surroundings.

Lapis lazuli An opaque blue, semiprecious stone.

Largo Slow, as in a passage or piece of music.

Latin cross plan A cross-shaped church design in which the nave is longer than the transept.

Latin fathers The early and influential theologians of Christianity.

Leitmotiv (LIGHT-moe-teef) A leading motif; a recurring theme or idea in a literary, artistic, or musical work.

Lekythos An oil flask used for funerary offerings and painted with mourning or graveside scenes (plural *lekythoi*).

Lens A transparent object with two opposite surfaces, at least one of which is curved, used to magnify or focus rays of light.

Lieder (LEE-der) German art songs. (The German word for "songs" [singular *lied*]).

Linear perspective A system of organizing space in two-dimensional media in which lines that are in reality parallel and horizontal are represented as converging diagonals; the method is based on foreshortening, in which the space between the lines grows smaller until it disappears, just as objects appear to grow smaller as they become more distant.

Lintel In architecture, a horizontal member supported by posts or columns, used to span an opening.

Liturgy The arrangement of the elements or parts of a religious service.

Living rock Natural rock formations, as on a mountainside.

Longitudinal plan A church design in which the nave is longer than the transept and in which parts are symmetrical against an axis.

Low relief Sculpture that projects only slightly from its background.

Lyric poetry A form or genre of poetry characterized by the expression of emotions and personal feelings; so called because such poetry was sung to a lyre.

Madrigal (MAD-ruh-guhl) A song for two or three voices unaccompanied by instrumental music.

Maestà From the word for "majesty," a work of art that features the Virgin Mary and Christ child enthroned and surrounded by angels and saints.

Mahabharata (muh-HAH-BAHR-uh-tuh) The Mahabharata (ca. 400 BCE—400 CE), attributed to Krishna Dvaipayana Vyasa, is an epic poem that embellishes probably events of India's heroic age.

Mahdi The redeemer of Islam.

Mandala A religious symbol, often round, that represents the universe.

Mannerism A style of art characterized by distortion and elongation of figures; a sense of flattened space rather than depth; a lack of a defined focal point; and the use of clashing pastel colors.

Materialism In philosophy, the view that everything that exists is either made of matter or—in the case of the mind, for example—depends on matter for its existence.

Mazurka A traditional Polish dance similar to a polka.

Meander A continuous band of interlocking geometric designs

Melisma A group of notes or tones sung to a single syllable of text.

Messiah Savior; from the Hebrew for "anointed one."

Metaphysical Pertaining to a group of British lyric poets who used unusual similes or metaphors.

Metope In architecture, a panel containing *relief sculpture* that appears between the *triglyphs* of the Doric frieze.

Middle Kingdom The period in ancient Egyptian history ca. 2040—1640 BCE

Middle Relief Relief sculpture that is between low relief and high relief in its projection from a surface.

Mihrab A niche in the wall of a mosque that indicates the direction of Mecca so that the congregation can direct their prayers in that direction.

Minaret (min-uh-RETT) A tall, slender tower attached to a mosque, from which a *muezzin* or crier summons people to prayer.

Minbar The pulpit in a mosque.

Minimalism A 20-century style of nonrepresentational art in which visual elements are simplified and reduced to their essential properties. Also a style of 20th century music.

Minuet A slow, stately dance for groups of couples.

Mobile A sculpture that is suspended in midair by wire or string, and made of delicately balanced parts such as rods and sheets of metal, and so constructed that the parts can move independently when stirred by a gust of air.

Modeling In two-dimensional works of art, the creation of the illusion of depth through the use of light and shade (*chiaroscuro*).

Mode In music, the combination of two *tetrachords*.

Modern architecture Architecture that rejects Classical ornamentation in favor of experimental forms of expression.

Modulation In music, the shift to a new key.

Monasticism The style of life under religious vows in which a community of people shares an ascetic existence in order to focus on spiritual pursuits.

Monody From the Greek *monoidia*, meaning an ode for one voice or one actor; in early opera, a single declamatory vocal line with accompaniment.

Monophonic Having a single melodic line.

Monotheism (MAWN-uh-thee-ism) Belief that there is one god.

Montage The sharp juxtaposition of scenes by film cutting and editing.

Monumental style A style of painting during the Song dynasty that lauded the "perfection" of Song rule through symbols such as unreachable mountain peaks.

Mortuary temple An Egyptian temple in which pharaohs worshipped during their lifetimes and were worshipped after death.

Mosaic An image created by assembling small pieces of materials such as glass, stone, or tile.

Mosque An Islamic house of worship (as a synagogue in Judaism or a church in Christianity).

Movement A self-contained section of a larger musical work; the Classical symphony, for example, has four distinct movements.

Muezzin (myoo-EZ-in) The crier who calls Muslims to prayer five times a day.

Mughal (MOE-gul) A Muslim dynasty in India, founded by the Afghan chieftain Babur in the 16th century.

Mullion (MULL-yuhn) In architecture, a slender vertical piece that divides the units of a window or door.

Mumbi In Kikuyu beliefs, the female primordial parent; the mother of the Kikuyu people.

Musica ficta (MOO-si-kuh FICK-tuh) Literally "fictitious music"; the practice of making sounds not written on the page of music.

Narthex (NAR-theks) A lobby or vestibule that leads to the **nave** of a church.

National Socialism A right-wing, **fascist**, anti-Semitic, and anti-Communist movement that developed in Germany; also known as *Nazism*.

Naturalism Representation that strives to imitate appearances in the natural world.

Naturalistic style Frank Lloyd Wright's architectural style, in which a building's form is integrated with its site.

Natural selection The means by which organisms with genetic characteristics and traits that make them better adjusted to their environment tend to survive, reach maturity, reproduce, and increase in number, such that they are more likely to transmit those adaptive traits to future generations.

Nave The central part of a church, constructed for the congregation at large; usually flanked by aisles with less height and width.

Neo-Classicism An 18th-century revival of Classical Greek and Roman art and architectural styles, generally characterized by simplicity and straight lines.

Neolithic (nee-oh-LITH-ick) The New Stone Age.

Neo-Platonism The school of philosophy that develops Plato's concept of the One, the source of all life, which is transcendent and unknowable through reasoning.

New Kingdom The period in ancient Egyptian history ca. 1550–1070 BCE, marked by the height of Egyptian power and prosperity; also referred to as the Egyptian Empire.

Nirvana A state characterized by the absence of suffering.

Nocturne A short piano piece in which a melancholy melody floats over a murmuring accompaniment.

Noh A type of Japanese drama in which actors wear wooden masks.

Nostos Literally, "homecoming"; the theme of the heroes' journeys homeward in the Homeric epics (plural *nostoi*).

Obsidian (uhb-sid-ee-uhn) A black, semiprecious, glasslike substance formed naturally by the rapid cooling of lava.

Octave The interval of eight degrees between two musical pitches whose frequencies have a ratio of 2:1; originated from Pythagorean ideas about harmony.

Oculus A circular opening in a dome that allows the entry of natural light from above.

Ode A form of lyrical poetry, based on Greek models, which usually glorifies events or people, or describes nature.

Old Kingdom The period in ancient Egyptian history ca. 2575–2040 BCE, during which the civilization achieved its first golden age.

Omnipotent All-powerful.

Omniscient (om-nish-uhnt) All-knowing.

Opera A dramatic performance in which the text is sung rather than spoken.

Optical representation The portrayal of a person or object as it is seen at any given moment from any given vantage point.

Oratorio A sacred drama performed without action, scenery, or costume, generally in a church or concert hall.

Order An architectural style as described, primarily, by the design of the columns and frieze.

Organum An early form of **polyphony** using multiple melodic lines.

Orientalizing period The early phase of Archaic Greek art, so named for the adoption of motifs from Egypt and the Near East.

Orthodox Christians Christians who believe in the divinity of Christ and the unity of Jesus, God the Father, and the Holy Spirit.

Orthogonal In perspective, a line pointing to the vanishing point.

Oud (ood) A short-necked stringed instrument that is plucked like a guitar; a lute.

Overglaze The outer layer or **glaze** on a ceramic piece; a decoration applied over a glaze.

Paleolithic (pay-lee-oh-LITH-ick) The Old Stone Age, during which the first sculptures and paintings were created.

Patriarch The male head of a family or a tribe.

Patrician A member of an elite family in ancient Rome.

Patronage In the arts, the act of providing support for artistic endeavors.

Pediment In architecture, any triangular shape surrounded by *cornices*, especially one that surmounts the *entablature* of the *portico façade* of a Greek temple.

Peloponnesian War (PELL-uh-puh-NEE-shuhn) The war between Athens and its allies and the rest of Greece, led by the Spartans.

Pendentive A triangular section of vaulting between the rim of a dome and each adjacent pair of the arches that support it.

Peplos A body-length garment worn by women in Greece prior to 500 BCE.

Peripteral (puh-rip-ter-uhl) Referring to a Greek temple design that has a colonnade around the entire cella and its porches.

Peristyle A series of columns enclosing a court or surrounding a building.

Perpendicular style A form of Gothic architecture developed in England and characterized by extreme vertical emphasis and fan vaulting.

Pharaoh (FAIR-oh) An ancient Egyptian king believed to be divine.

Philologist A person who studies the history of language in written sources; a scholar of the changes in language over time.

Photosensitive Responsive to light.

Picaresque (pik-uh-RESK) Of a form of fiction having an engaging, roguish hero who is involved in a series of humorous or satirical experiences.

Pietà In artistic tradition: a representation of the dead Christ, held by his mother, the Virgin Mary (from the Latin word for "pity").

Pilgrimage church A church on the route of a pilgrimage.

Pillow book Generally, a book of observations and musings, which reveal a period in a person's life.

Pit In drama, an open area in front of the stage.

Plebeian (pluh-BEE-uhn) A land-owning Roman citizen, but not a patrician.

Pointillism A systematic method of applying minute dots of discrete pigments to the canvas; the dots are intended to be "mixed" by the eye when viewed.

Polis A self-governing Greek city-state (plural *poleis*).

Polonaise A traditional Polish dance that is marchlike and stately.

Polymath A person of great learning and achievement in several fields of study, especially unrelated fields such as the arts and the sciences.

Polyphonic Of a form of musical expression characterized by many voices.

Polyphony Music with two or more independent melodies that harmonize or are sounded together.

Polyptych (pol-ip-tik) An arrangement of four or more painted or carved panels that are hinged together.

Polytheism Belief in many gods.

Pop art An art style originating in the 1960s that uses ("appropriates") commercial and popular images and themes as its subject matter.

Portico A roofed entryway, like a front porch, with columns or a colonnade.

Post-and-lintel construction Construction in which vertical elements (posts) are used to support horizontal crosspieces (lintels).

Postimpressionism A late-19th-century artistic style that relied on the gains made by Impressionists in terms of the use of color and spontaneous brushwork but employed these elements as expressive devices. The Postimpressionists rejected the essentially decorative aspects of Impressionist subject matter.

Postmodernism A contemporary style of architecture that arose as a reaction to Modernism and that returned to ornamentation drawn from Classical and historical sources.

Prehistoric Prior to record keeping or the written recording of events.

Prelude In music, a brief instrumental composition; a piece that precedes a more important movement.

Program music Music that describes elaborate programs or plots.

Prohibition The period in the United States from 1920 to 1933, during which the 18th Amendment prohibited the manufacture or sale of alcoholic beverages.

Propaganda The presentation of a point of view with the intention to persuade and convince.

Prophet A person who speaks with the authority of God, either to predict the future or to call people to observance.

Psalm A song, hymn, or prayer from the book of Psalms; used in Jewish and Christian worship.

Psychoanalytic theory Sigmund Freud's theory of personality, which assumes the presence of unconscious conflict and the mental structures of the id, ego, and superego.

Quatrain A verse of poetry with four lines.

Qur'an (kuh-RON) The Muslim holy book, which is believed to have been revealed by Allah to Muhammad.

Ragtime A syncopated (off-beat) musical style popular between about 1899 and 1917. A forerunner of jazz.

Rajput A member of a Hindu people claiming descent from the warrior caste during the Indian Heroic Age.

Ramadan The ninth month of the Islamic calendar; considered a holy month during which there are limitations on eating, smoking, and sex (alcohol is prohibited at all times).

Realism A movement in art directed toward the accurate representation of real, existing things.

Rebab A long-necked stringed instrument played with a bow.

Recitative The free declaration of a vocal line, with only a simple instrumental accompaniment for support.

Red-figure technique A Greek vase-painting technique in which everything *but* the figural elements is covered with a mixture of fine clay and water (see **slip**); kiln firings produce a combination of a black pot with reddish figures.

Refectory A room used for communal dining, as in a monastery or college.

Register A horizontal band that contains imagery; registers are usually placed one on top of another to provide continuous space for the depiction of a narrative (like a comic strip).

Reincarnation One's rebirth into another body, according to one's karma.

Relic In this usage, a part of a holy person's body or belongings used as an object of reverence.

Relief sculpture Sculpture in which figures project from a background to varying depths (see **high relief** and **low relief**); often used to decorate architecture or furniture.

Relieving triangle An open triangular space above a lintel, framed by the beveled contours of stones, that relieves the weight carried by the lintel; seen, for example, in the Lion Gate at Mycenae.

Responsorial singing A form of religious singing in which a cantor intones lines from psalms and the congregation responds with a simple refrain.

Rig-Veda A collection of 1,028 hymns to the Hindu gods.

Rock-cut tomb A burial chamber cut into a natural rock formation (living rock), usually on a hillside.

Rococo An 18th-century style of painting and of interior design that featured lavish ornamentation. Rococo painting was characterized by light colors, wit, and playfulness. Rococo interios had ornamental mirrors, small sculptures and reliefs, wall paintings, and elegant furnishings.

Romanesque (row-muh-NESK) Referring to a style of European art and architecture from the ninth through 12th centuries, descended from Roman styles; in architecture, characterized by heavy masonry, round arches, and relatively simple ornamentation.

Romanticism An intellectual and artistic movement that began in Europe in the late 18th century and emphasized rejection of Classical (and Neo-Classical) forms and attitudes, interest in nature, the individual's emotions and imagination, and revolt against social and political rules and traditions.

Ronin Unemployed samurai, who roamed about seeking employment.

Rosetta Stone An ancient Egyptian stele dating to 196 BCE with text inscribed in three languages: hieroglyphics, demotic Egyptian, and Greek. Discovery of the stone enabled Europeans to decipher the meaning of hieroglyphics.

Sacrament A visible sign of inward grace, especially a Christian rite believed to symbolize or confer grace.

Samurai-dokoro The official in feudal Japan who led legal and military affairs.

Samurai Japanese professional warriors in medieval times.

Sanctus and Benedictus A hymn in the Ordinary of the Mass based on the angelic praise found in Isaiah 6.

Sangha A Buddhist monastery.

Sanskrit An ancient Indo-Aryan language; the classical language of India and Hinduism.

Sarcophagus (sahr-kof-uh-guhs) A coffin; usually cut or carved from stone, although Etruscan sarcophagi were made of terra-cotta (plural *sarcophagi*).

Satyagraha Nonviolent civil disobedience.

Satyr play (SAY-ter) A lighthearted play; named for the satyr, a mythological figure of a man with an animal's ears and tail.

Scatting The singing of improvised syllables that have no literal meaning.

Scherzo (SCAIRT-soe) A fast-moving, lighthearted piece of music. (Italian for "joke" or "monkey business.")

Scholasticism The system of philosophy and theology taught in medieval European universities, based on Aristotelian logic and the writings of early church fathers; the term has come to imply insistence on traditional doctrine.

Scriptorium A room dedicated to writing.

S curve A double weight shift in Classical sculpture in which the body and posture of a figure form an S shape around an imaginary vertical axis or pole.

Semitic A family of languages of Middle Eastern origin, including Akkadian, Arabic, Aramaic, Hebrew, Maltese, and others.

Septuagint (SEP-too-uh-jint) An ancient Greek version of the Hebrew scriptures that was originally made for Greek-speaking Jews in Egypt.

Sexpartite rib vault In architecture, a rib vault divided into six parts and formed by the intersection of barrel vaults.

Shariah (shah-REE-uh) The moral code and religious law of Islam.

Shia The Islamic denomination that believes that Muhammad, as commanded by Allah, ordained his son-in-law, Ali, as the next caliph, and that legitimate successors must be drawn from the descendants of Ali.

Shintoism (SHIN-toe-izm) The native Japanese religion, which teaches of many beneficent gods and love of nature.

Shiva The Hindu god of creation and destruction; the "destroyer of worlds."

Shogun Another term for the **samurai-dokoro**.

Site-specific art Art that is produced in or for one location and is not intended to be relocated.

Slavery A social system or practice in which one person is the property of, and wholly subject to the will of, another person.

Slip In ceramics, clay that is thinned to the consistency of cream; used in the decoration of Greek vases (see **black-figure technique** and **red-figure technique**).

Soliloquy (suh-LILL-uh-kwee) A passage in a play spoken directly to the audience, unheard by other characters, and often used to explain the speaker's motives.

Sonata form A musical form having three sections: exposition (in which the main theme or themes are stated), development, and recapitulation (repetition) of the theme or themes.

Sonata A kind of short piece of instrumental music.

Sonnet A 14-line poem usually broken into an octave (a group of eight lines) and a sestet (a group of six lines); rhyme schemes can vary.

Soothsayer A person who can foresee the future.

Sophist (SOFF-ist) A wise man or philosopher, especially one skilled in debating.

Sphinx A mythical creature with the body of a lion and the head of a human, ram, or cat. In ancient Egypt, sphinxes were seen as benevolent and statues of sphinxes were used to guard the entrances to temples.

Spondee A foot of poetry consisting of two syllables, both of which are stressed.

Sprechstimme Arnold Schönberg's term for "speaking voice," that is, speaking words at specific pitches.

Stele An upright slab or pillar made of stone with inscribed text or relief sculpture, or both. Stelae (pl.) served as grave markers or commemorative monuments.

Stoa A covered colonnade; a roofed structure, like a porch, that is supported by a row of columns opposite a back wall.

Stoicism A school of philosophy with the view that the universe was ordered by the gods and that people could not change the course of events; people could, however, psychologically distance themselves from tragic events by controlling their attitudes toward them.

Stream of consciousness A literary technique that is characterized by an uncensored flow of thoughts and images, which may not always appear to have a coherent structure.

Structuralist In music, a composer who uses precise musical organization.

Studia Schools.

Stupa A dome-shaped reliquary of the Buddha, possibly also of Buddhist texts.

Sturm und Drang German for "storm and stress"; the German manifestation of Romanticism, which emphasized originality, imagination, and emotion.

Style galant A style of elegant, lighthearted music that was popular in France during the early part of the 18th century.

Stylobate A continuous base or platform that supports a row of columns.

Sufism The inner, spiritual dimension of Islam.

Sunken relief In sculpture, the removal of material from a surface so that the figures appear to be cut out or recessed.

Sunni The Islamic denomination that believes that Muhammad's rightful successor was his father-in-law, Abu Bakr, and that the Qur'an endorses the selection of leaders according to the consensus of the Muslim community.

Superrealism The rendering of subjects in art with sharp, photographic precision.

Sura A section of the Qur'an; a chapter.

Surrealism A 20th-century style of art and literature whose content and imagery is believed to stem from unconscious, irrational sources and therefore takes on fantastic forms, although often rendered with extraordinary realism.

Synthesis In Hegelian philosophy, the reconciliation of mutually exclusive propositions—the thesis and the antithesis; more generally, the combining of separate substances or ideas into a single unified object or concept.

Synthetic Cubism The second phase of Cubism, which emphasized the form of the object and constructing rather than disintegrating that form.

Synthetism Paul Gauguin's theory of art, which advocated the use of broad areas of unnatural color and "primitive" or symbolic subject matter.

Talmud A collection of Jewish law and tradition created ca. fifth century CE.

Tenebrism A style of painting in which the artist goes rapidly from highlighting to deep shadow, using very little modeling.

Tercet A group of three lines of verse; characterized in *The Divine Comedy* by the **terza rima** scheme.

Terza rima A poetic form in which a poem is divided into sets of three lines (**tercets**) with the rhyme scheme *aba*, *bcb*, *cdc*, etc.

Tesserae (TESS-er-ray) Small pieces of stone, glass, or ceramic tile used in the creation of a mosaic (singular *tessera*).

Testament Originally, a covenant between God and humans; now referring more often to either of the two main divisions of the Bible: the Hebrew Bible (Old Testament) and the Christian Bible (New Testament).

Tetrachord A group of four pitches, the two outer ones a perfect fourth interval apart and the inner ones variably spaced.

Theatres A round or oval structure, typically unroofed, having tiers of seats rising gradually from a center stage or arena.

The Enlightenment A philosophical movement of the late 17th and 18th centuries that challenged tradition, stressed reason over blind faith or obedience, and encouraged scientific thought.

Thesis An academic proposition; a proposition to be debated and proved or disproved (plural *theses*).

Tholos (THOE-loss) In architecture, a circular building or a beehive-shaped tomb.

Toccata (tow-KAH-tuh) A free-form rhapsody composed for an instrument with a keyboard, often combing extreme technical complexity and dramatic expression.

Tonality The sum of melodic and harmonic relationships between the tones of a scale or a musical system.

Tone poem Richard Strauss's term for a program symphony (see **program music**).

Torah A Hebrew word meaning "teaching" or "law" and used to refer to the first five books of the Hebrew Bible; also known as the *Pentateuch*.

Transcendentalism A 19th century New England literary movement that sought the divine in nature. More generally, the view that there is an order of truth that goes beyond what we can perceive by means of the senses and that it unites the world.

Transept The crossing part of a church built in the shape of a cross.

Trecento (tray-CHEN-toe) Literally, "300"; the Italian name for the 14th century.

Tribune gallery In architecture, the space between the nave arcade and the clerestory that is used for traffic above the side aisles on the second stage of the elevation.

Tribune The title given elected officials in Rome; they could convene the Plebeian Council and the Senate and propose legislation.

Triforium A gallery or arcade above the arches of the **nave**, **choir**, or **transept** of a church.

Triglyph (TRY-gliff) In architecture, a panel incised with vertical grooves (usually three, hence *tri-*) that serve to divide the scenes in a *Doric* **frieze**.

Trilogy A series of three tragedies.

Triumphal arch A monumental structure that takes the form of one or more arched passageways, often spanning a road, and commemorates military victory.

Trochee A foot of poetry consisting of two syllables, in which the first syllable is stressed and the second is unstressed.

Trompe l'oeil Literally, French for "fool the eye." In works of art, trompe l'oeil can raise the question as to what is real and what is illusory.

Trope A literary or rhetorical device, such as the use of metaphor or irony.

Twelve-tone technique A musical method that uses the twelve notes of the chromatic scale—on the piano, all of the black and white notes in a single octave—carefully arranged in a row or series; also called *serialism*.

Tympanum (TIM-puh-nuhm) A semicircular space above the doors of a cathedral.

Übermensch Nietzsche's term for a person who exercises the will to power (plural *Übermenschen*).

Ummah The Muslim community at large.

Underglaze A decoration applied to the surface of a ceramic piece before it is glazed.

Universitas A corporation; a group of persons associated in a guild, community, or company.

Upanishads A series of classical Indian teaching texts addressing issues such as karma, death, and dreams.

Urdu The literary language of Pakistan; similar to Hindi when spoken, but written in the Arabic alphabet and influenced by Persian.

Value As an element of art, the relative lightness or darkness of a color.

Vanishing point In linear perspective, a point on the horizon where parallel lines appear to converge.

Vellum Calfskin, kidskin, or lambskin used as a surface for writing.

Venus pudica A representation of a nude Venus with her hand held over her genitals for modesty.

Vernacular (ver-nak-yuh-ler) The native dialect or language of a region or country, as contrasted with a literary or foreign language.

Virginal An early keyboard instrument small enough to be held in the lap of the player.

Vishnu A Hindu god; the preserver of the universe.

Vocal harmony A traditional musical method in which consonant notes are sung along with the main melody.

Votive chapel A chapel that is consecrated or dedicated to a certain purpose.

Votive In a sacred space like a temple, a voluntary offering to a god, put in place as a petition or to show gratitude; as in votive candle.

Vulgate Bible A late-fourth-century version of the Bible, largely translated into Latin by Saint Jerome.

Yahoo In *Gulliver's Travels*, a crude, filthy, and savage creature, obsessed with finding "pretty stones" by digging in mud—Swift's satire of the materialistic and elite British.

Yakshi A pre-Buddhist voluptuous goddess who was believed to embody the generative forces of nature.

Ziggurat (ZIGG-oo-rat) In ancient Mesopotamia, a monumental platform on top of which a temple was erected. The height of the ziggurat was intended to bring worshipers closer to the gods.

Photo Credits

This page constitutes an extension of the copyright page. We have made every effort to trace the ownership of all copyrighted material and to secure permission from copyright holders. In the event of any question arising as to the use of any material, we will be pleased to make the necessary corrections in future printings. Thanks are due to the following authors, publishers, and agents for permission to use the material indicated.

FRONT MATTER iii: © Steve Vidler/age fotostock **xxxii:** © RMN-Grand Palais/Art Resource, NY

CHAPTER 1 2: 1.1 © Kenneth Garrett/National Geographic Stock **4:** 1.2 © The Field Museum of Natural History (GEO85908 2c), Chicago, Illinois **10:** Map 1.1: © Cengage Learning **12:** 1.16: © Erich Lessing/Art Resource, NY **15:** 1.19: © Scala/Art Resource, NY **17:** 1.22 © The Trustees of the British Museum/Art Resource, NY **19:** 1.23: © Robert Harding World Imagery (David Poole)/Alamy **20:** 1.24: © Cengage Learning **21:** 1.25: © The Trustees of the British Museum/Art Resource, NY **24:** 1.29: © Robert Harding Picture Library Ltd. (Travel Pix)/Alamy **25:** 1.30: © BeBa/Iberfoto/The Image Works **28:** 1.33: © Lois Fichner-Rathus **30:** 1.36: © bpk, Berlin/Ägyptisches Museum/Art Resource, NY **32:** 1.39: © Erich Lessing/Art Resource, NY **34:** 1.42: © Cengage Learning **35:** 1.43: © Gianni Dagli Orti/The Art Archive at Art Resource, NY **37:** 1.46: © Leonard Von Matt/Photo Researchers **38:** 1.47: © Kevin Fleming/Corbis **40:** 1.50: © Nimatallah/Art Resource, NY **11a top:** 1.14 top: From Guide to the Mesopotamian Pantheon of Gods (http://www.ianlawton.com/mesindex.htm). © 2000 by Ian Lawton **11b center:** 1.15A: © Nik Wheeler/Corbis **11c btm:** 1.15B: © Cengage Learning **11c btm:** 1.15B: © Cengage Learning **13a tl:** 1.17 left: © RMN-Grand Palais (J. Schorman)/Art Resource, NY **13b center:** 1.17 center: © Erich Lessing/Art Resource, NY **13c tr:** 1.17 right: © Erich Lessing/Art Resource, NY **13d bottom:** 1.18: © The Granger Collection, New York **16 left:** 1.20: © The Bridgeman Art Library **16 right:** 1.21: © Erich Lessing/Art Resource, NY **22 left:** 1.26 left: © Werner Forman/Art Resource, NY **22 right:** 1.26 right: © Erich Lessing/Art Resource, NY **23a top:** 1.27: © Werner Forman/Art Resource, NY **23b btm:** 1.28: © Yann Arthus-Bertrand/Corbis **27a top:** 1.31: © DEA/G. Sioen/age fotostock **27b btm:** 1.32 © Vanni/Art Resource, NY **29 left:** 1.34 © Scala/Art Resource, NY **29 right:** 1.35: © Sean Gallup/Getty Images **31 left:** 1.37: © François Guenet/Art Resource, NY **31 right:** 1.38: Photo © Boltin Picture Library/The Bridgeman Art Library **33a top:** 1.40: © Gianni Dagli Orti/The Art Archive at Art Resource, NY **33b btm:** 1.41: © Nimatallah/Art Resource, NY **36a top:** 1.44: © Roger Wood/Corbis **36b btm:** 1.45: © Gianni Dagli Orti/The Art Archive at Art Resource, NY **39a top:** 1.48: © SIME/eStock Photo **39b btm:** 1.49: © Vanni/Art Resource, NY **5a top:** 1.3 Photograph by Francesco d'Errico & Christopher Henshilwood/© University of Bergen, Norway **5b btm:** 1.4 © Sisse Brimberg/National Geographic Stock **6a left:** 1.5: © RMN-Grand Palais/Art Resource, NY **6b right:** 1.6 © Erich Lessing/Art Resource, NY **7a tl:** 1.7: © Ancient Art and Architecture Collection Ltd./The Bridgeman Art Library **7b tr:** 1.8 © Gianni Dagli Orti/The Art Archive at Art Resource, NY **7c btm:** 1.9 © Adam Woolfitt/Corbis **8a left:** 1.10: © Brooklyn Museum of Art/Hagop Kevorkian Fund & Designated Purchase Fund/The Bridgeman Art Library **8a right:** 1.11: Photo © Heini Schneebeli/

The Bridgeman Art Library **9a left:** 1.12: © The Granger Collection, New York **9b right:** 1.13 © Danita Delimont/Getty Images

CHAPTER 2 44: 2.1: © The Granger Collection, New York **46:** 2.2: © The Trustees of the British Museum/Art Resource, NY **47:** Map 2.1: © Cengage Learning **48:** 2.3: © Universal Images Group/SuperStock **49:** 2.4: © Cengage Learning **50:** 2.5: Gouache © Siân Frances **51:** 2.6: © Bridgeman Art Library, London/SuperStock **54:** 2.9: © RMN-Grand Palais (Hervé Lewandowski)/Art Resource, NY **55:** 2.10: Photo by Tom Oates **57:** 2.11: Image copyright © The Metropolitan Museum of Art. Image source: Art Resource, NY **61:** 2.14: © Gianni Dagli Orti/Corbis **64:** 2.19: © SuperStock **67:** 2.24: © 2008 Fred S. Kleiner **68:** 2.25: © Lebrecht Music & Arts/The Image Works **52a left:** 2.7: © Smithsonian American Art Museum, Washington, DC/Art Resource, NY **52c br:** 2.8: Photo courtesy of Architect of the Capitol **60 left:** 2.12: © Gianni Dagli Orti/The Art Archive at Art Resource, NY **60 right:** 2.13: Image copyright © The Metropolitan Museum of Art. Image source: Art Resource, NY **62 left:** 2.15: © Nimatallah/Art Resource, NY **62 right:** 2.16: © Nimatallah/Art Resource, NY **63 left:** 2.17: © Scala/Art Resource, NY **63 right:** 2.18: © Nimatallah/Art Resource, NY **65 left:** 2.20: © Scala/Art Resource, NY **65 right:** 2.21: © Scala/Ministero per i Beni e le Attività culturali/Art Resource, NY **66a top:** 2.22: © Cengage Learning **66b btm:** 2.23: © Cengage Learning

CHAPTER 3 78: 3.1: © The Trustees of the British Museum/Art Resource, NY **81:** 3.2: © Yann Arthus-Bertrand/Corbis **83:** 3.3: © Cengage Learning **84:** 3.4: © SuperStock **86:** 3.7: © Peter Horree/Alamy **87:** 3.8: © Marie Mauzy/Art Resource, NY **88:** 3.9: © Scala/Art Resource, NY **90:** 3.12: © Scala/Art Resource **92:** 3.15: © Nimatallah/Art Resource, NY **94:** 3.16: © Mary Evans Picture Library/Courtesy The Everett Collection, Inc. **99:** 3.17: © Studio Kontos, photographersdirect.com **107:** 3.18: © Scala/Art Resource **108:** 3.19: © The Bridgeman Art Library **109 left:** 3.20: © SuperStock **109 right:** 3.21: © Art Resource, NY **110:** 3.22: © AKG/Bildarchiv Steffens **111 left:** Map 3.1: © Cemgage Learning **111 right:** 3.23: © Raga Jose Fuste/age fotostock **112:** 3.24: © bpk, Berlin /Antikensammlung, SMB/Jürgen Liepe/Art Resource, NY **113a top:** 3.25: © Erich Lessing/Art Resource, NY **113b btm:** 3.26: © Araldo de Luca/Corbis **85a top:** 3.5: © Erin Babnik/Alamy **85b btm:** 3.6: © Corbis **89 left:** 3.10: © Marie Mauzy/Art Resource, NY **89 right:** 3.11: © Scala/Art Resource **91 left:** 3.13: © Scala/Ministero per i Beni e le Attività culturali/Art Resource, NY **91 right:** 3.14: © RMN-Grand Palais (Hervé Lewandowski)/Art Resource, NY **98a top:** © Cengage Learning **98b btm:** © Cengage Learning

CHAPTER 4 116: 4.1: © Andrea Jemolo/Scala/Art Resource, NY **119:** © Cengage Learning **120a**

Top: 4.2: © Araldo de Luca/Corbis **120b btm:** 4.3: © The Bridgeman Art Library **121a top:** 4.4: © Araldo de Luca/Corbis **121b btm:** 4.5: © SEF/Art Resource, NY **122a top:** 4.6: © Araldo de Luca/Corbis **122b btm:** 4.7: © Charles & Josette Lenars/Corbis **123a top:** 4.8: © Lois and Spencer Fichner-Rathus **123b btm:** 4.9: © Scala/Art Resource, NY **124a top:** 4.10: © Scala/Art Resource, NY **124b btm:** 4.11: © Erich Lessing/Art Resource, NY **130 left:** 4.12: © Cengage Learning **130 right:** 4.13: © SuperStock **131a top:** 4.14: Courtesy of the American Numismatic Society **131b btm:** 4.15: © Nicholas Pitt/Alamy **132a:** 4.16ABC: © Cengage Learning **132b:** 4.16B: © Cengage Learning **132c:** 4.16C: © Cengage Learning **133:** 4.17: © DEA/G. Dagli Orti/age fotostock **134a top:** 4.18: © O. Louis Mazzatenta/National Geographic/Getty Images **134b btm:** 4.19: © Leonard Von Matt/Photo Researchers **136:** 4.20: © Scala/Art Resource, NY **137:** 4.21: © SuperStock **141:** 4.22: Photo © Luciano Romano **142a top:** 4.23: © The Bridgeman Art Library **142b btm:** 4.24: © Giraudon/The Bridgeman Art Library **143:** 4.25: © Scala/Art Resource, NY **144:** 4.26: © Scala/Art Resource, NY **145a top:** 4.28: © Jonathan Poore/Cengage Learning **145b btm:** 4.27: © Cengage Learning **146 left:** 4.29: © UPPA/Topham/The Image Works **146 right:** 4.30: © McCanner/Alamy **147 left:** 4.31: © David Lees/Corbis **147 right:** 4.32: © Liu Jin/AFP/Getty Images **148:** 4.33: © Lois and Spencer Fichner-Rathus **149:** 4.34: © Photo Henri Stierlin, Geneva **151 left:** 4.35 © Cengage Learning **151 right:** 4.36: © Vito Arcomano/Alamy **152 left:** 4.37 © Google Maps **152 right:** 4.38: © Jon Sparks/Corbis **153:** 4.39: © Lois and Spencer Fichner-Rathus **154:** 4.40: © Scala/Art Resource, NY **155:** 4.41: © Scala/Art Resource, NY

CHAPTER 5 158: 5.1: Image © The Metropolitan Museum of Art. Image source: Art Resource, NY **161a top:** 5.2: © Paul Almasy/Corbis **161b btm:** 5.3: © Scala/Art Resource, NY **164:** 5.4: © V&A Images/Alamy **168:** 5.5: © Trans-World Photos/SuperStock **169:** 5.6: © Charles & Josette Lenars/Corbis **170:** Map 5.1: © Cengage Learning **171:** 5.7: © Borromeo/Art Resource, NY **172a top:** 5.8: © Steve Allen/Getty Images **172b:** 5.9: © Tony Waltham/Getty Images **173a top:** 5.10: © The Bridgeman Art Library **173b bl:** 5.11: © RMN-Grand Palais (Daniel Arnaudet)/Art Resource, NY **173c br:** 5.12: © Scala/Art Resource, NY **175:** 5.13: © Giraudon/The Bridgeman Art Library **176 left:** 5.14: © bpk/Museum für Asiatische Kunst, SMB/Jürgen Liepe/Art Resource, NY **176 right:** 5.15: © Pixtal/SuperStock **177a top:** 5.16: © Universal Images Group/age fotostock **177b btm:** 5.17: © Prajakta Palav Aher. Courtesy Grosvenor Vadehra Gallery **178a top:** 5.18: © Asian Art & Archaeology, Inc./Corbis **178b btm:** 5.19: © Arthur M. Sackler Museum, Harvard University Art Museums/Bequest of Grenville L. Winthrop/The Bridgeman Art Library **179:** 5.20: © Mary Evans Picture Library/Alamy **179a top:** Map 5.2: © Cengage Learning **180:** 5.21: © Steve

441: 13.21: © Scala/Art Resource, NY **442:** 13.22: © Scala/Art Resource, NY **443:** 13.23: © National Gallery, London/Art Resource, NY **444:** 13.24: © Scala/Art Resource, NY **445:** 13.25: © The Art Gallery Collection/Alamy **446:** 13.26: © Jonathan Poore/Cengage Learning **447:** 13.27: © The Gallery Collection/Corbis **450:** 13.28: © RMN-Grand Palais (J. G. Berizzi)/Art Resource, NY **452:** 13.29: © The Bridgeman Art Library **453:** 13.30: © RMN-Grand Palais (Harry Bréjat)/Art Resource, NY **455:** 13.31: © Scala/Ministero per i Beni e le Attività culturali/Art Resource, NY

CHAPTER 14 460: 14.1: © Geraint Lewis/Alamy **463:** 14.2: © Scala/Ministero per i Beni e le Attività culturali/Art Resource, NY **464:** 14.3: © akg-images **470:** Map 14.1: © Cengage Learning **472:** 14.4: Courtesy of the National Library of Medicine, Bethesda, Maryland **473:** 14.5: © Cengage Learning **474:** 14.6: © bpk, Berlin/Alte Pinakothek, Munich/Art Resource, NY **475:** 14.7: Image copyright © The Metropolitan Museum of Art. Image source: Art Resource, NY **476:** 14.8: © The Trustees of the British Museum/Art Resource, NY **477:** 14.9: © The Art Archive at Art Resource, NY **478:** 14.10: © bpk, Berlin/Alte Pinakothek, Munich/Art Resource, NY **479:** 14.11: © The Art Archive at Art Resource, NY **480:** 14.12: © Erich Lessing/Art Resource, NY **481:** 14.13: © Erich Lessing/Art Resource, NY **482:** 14.14:© National Gallery, London/Art Resource, NY **483:** 14.15: © RMN-Grand Palais (Hervé Lewandowski)/ Art Resource, NY **484a top:** 14.16: © Jonathan Poore/Cengage Learning **484b btm:** 14.17: © Jonathan Poore/Cengage Learning **485:** 14.18: © RMN-Grand Palais (G. Blot, C. Jean)/Art Resource, NY **486:** 14.19: © V&A Images, London/Art Resource, NY **487:** 14.20: © SuperStock **488:** 14.21: © Lebrecht Music & Arts/The Image Works **492:** 14.22: © Andrea Pistolesi/Getty Images **495:** 14.23: © akg-images

CHAPTER 15 504: 15.1: © Alinari/The Bridgeman Art Library **507:** 15.2: © Raimund Kutter/age fotostock **509:** 15.3: © Scala/Art Resource **510:** 15.4: © Alinari Archives/Corbis **511a top left:** 15.5: Photo © A. H. Baldwin & Sons Ltd., London **511a top right:** 15.5: Photo © A. H. Baldwin & Sons Ltd., London **511b btm:** 15.6: © akg-images/Joseph Martin **512:** 15.7: © Scala/Art Resource, NY **513:** 15.8: © The Bridgeman Art Library **514:** 15.9: © The Bridgeman Art Library **516:** 15.10: © Grant Smith/age fotostock **517:** 15.11: © Scala/Art Resource **518:** 15.12: © Scala/Art Resource, NY **519:** 15.13: © Scala/Art Resource, NY **520:** 15.14: © Alinari/Art Resource, NY **521:** 15.15: © The Gallery Collection/Corbis **522:** 15.16: © Giraudon/The Bridgeman Art Library **523:** 15.17: © The Art Archive at Art Resource, NY **524:** 15.18: © Erich Lessing/Art Resource, NY **525:** 15.19: © Erich Lessing/Art Resource, NY **526:** 15.20: © Erich Lessing/Art Resource **527:** 15.21: © SuperStock **528:** 15.22: © Erich Lessing/Art Resource, NY **529a top:** 15.23: © The Bridgeman Art Library **529b btm:** 15.24: © Private Collection/The Bridgeman Art Library **530:** 15.25: © The Pierpont Morgan Library/Art Resource, NY **531:** 15.26: Image copyright © The Metropolitan Museum of Art. Image source: Art Resource, NY **532:** 15.27: Image copyright © The Metropolitan Museum of Art. Image source: Art Resource, NY **533:** 15.28: Image copyright © The Metropolitan Museum of Art. Image source: Art Resource, NY **534:** 15.29: © RMN-Grand Palais (Robert Polidori)/Art Resource, NY **535:** 15.30:

© Massimo Listri/Corbis **536:** 15.31: © Worcester Art Museum, Massachusetts/The Bridgeman Art Library **537:** 15.32: © Francis G. Mayer/Corbis **542:** 15.33: © Cengage Learning **543:** 15.34: © Scala/Art Resource, NY

CHAPTER 16 554: 16.1: © Erich Lessing/Art Resource, NY **556:** 16.2: © Cengage Learning **557:** Map 16.1: © Cengage Learning **558:** 16.3: © Scala/Art Resource, NY **560:** 16.4: © Wallace Collection, London, UK/The Bridgeman Art Library **561:** 16.5: © Erich Lessing/Art Resource, NY **562:** 16.6: © Scala/Art Resource, NY **563:** 16.7: © Erich Lessing/Art Resource **564:** 16.8: © English Heritage Photo Library/The Bridgeman Art Library **565 left:** 16.9: © National Gallery, London/The Bridgeman Art Library **565 right:** 16.10: © The Granger Collection, New York **566:** 16.11: © Erich Lessing/Art Resource, NY **567:** 16.12: © Jonathan Poore/Cengage Learning **568:** 16.13: Cengage Owned **569:** 16.14: © Erich Lessing/Art Resource, NY **570:** 16.15: © Giraudon/The Bridgeman Art Library **571:** 16.16: Copyright © Kehinde Wiley. Courtesy of Sean Kelly Gallery, New York, Roberts & Tilton, Culver City, California, Rhona Hoffman Gallery, Chicago and Galerie Daniel Templon, Paris. Digital image courtesy of the artist. Used by permission. **572:** 16.17: © Derek Bayes/Lebrecht Music & Arts **573:** 16.18: © Gianni Dagli Orti/The Art Archive at Art Resource, NY **574a top:** 16.19: © Jonathan Poore/Cengage Learning **574b btm:** 16.20: © Angelo Hornak/Corbis **575:** 16.21: © akg-images/A.F.Kersting **577:** 16.22: © Cengage Owned **583:** 16.23: © Antiques & Collectables/Alamy

CHAPTER 17 594: 17.1: © Jonathan Poore/Cengage Learning **597:** 17.2: © Christopher Wood Gallery, London, UK/The Bridgeman Art Library **598a top:** 17.3: © Hervé Champollion/akg-images **598b btm:** 17.4: Courtesy Library of Congress, Prints and Photographs Division (LC-DIG-ppmsca-19211), Washington, DC **603:** 17.5: © The Granger Collection, New York **604:** 17.6: © Fine Art Images/age fotostock **605:** 17.7: © RMN-Grand Palais (R.G. Ojeda)/Art Resource, NY **606a top:** 17.8: © Universal History Arc/age fotostock **606b btm:** 17.9: © Fitzwilliam Museum, Cambridge/Art Resource, NY **607a top:** 17.10: © Alfredo Dagli Orti/The Art Archive at Art Resource, NY **607b btm:** 17.11: © Sylvia Sleigh. **608:** 17.12: © V&A Images, London/Art Resource, NY **609:** 17.13: © Cengage Learning **609:** Map 17.1: © Cengage Learning **610:** 17.14: © Image Asset Management/age fotostock **611:** 17.15: © Scala/Art Resource, NY **612:** 17.16: © Erich Lessing/Art Resource, NY **613:** 17.17: © RMN-Grand Palais (Hervé Lewandowski)/Art Resource, NY **614:** 17.18: © Universal History Arc/age fotostock **615a top:** 17.19: © akg-images/British Library **615b btm:** 17.20: © Universal History Arc/age fotostock **616:** 17.21: © Fine Art Images/age fotostock **617:** 17.22:© bpk, Berlin / Hamburger Kunsthalle, Hamburg, Germany/Elke Walford/ Art Resource, NY **620:** 17.23: © The Granger Collection, New York **622:** 17.24: © V&A Images, London/Art Resource, NY **632:** 17.25: © Fine Art Images/age fotostock **635:** 17.26: © Anne-Christine Poujoulat/AFP/Getty Images **637:** 17.27: © Scala/Art Resource, NY **638:** 17.28: © The Bridgeman Art Library **649:** 17.29: Image copyright © The Metropolitan Museum of Art. Image source: Art Resource, NY **650:** 17.30: © Tomas Abad//age fotostock **651:** 17.31: © SuperStock **652a top:** 17.32: © Olga Bogatyrenko/

Shutterstock **652b btm:** 17.33: © Renaud Visage/age fotostock **653:** 17.34: © Time Life Pictures/Getty Images **654:** 17.35: © The Print Collector/Alamy **655:** 17.36: Courtesy Library of Congress, Prints and Photographs Division, Washington, DC

CHAPTER 18 658: 18.1: © SuperStock/age fotostock **661:** 18.2: Plate IX from Camera Work, 1911 October. Courtesy Library of Congress Prints and Photographs Division (LC-USZ62-62880) Washington, DC **663:** 18.3: © The Bridgeman Art Library **664:** 18.4: © Giraudon/The Bridgeman Art Library **665:** 18.5: © SuperStock/age fotostock **666a top:** 18.6: © DEA Picture Library/age fotostock **666b btm:** 18.7: © Universal History Arc/age fotostock **667a top:** 18.8: © Fine Art Images/age fotostock **667b btm:** 18.9: © CNAC/MNAM/Dist. RMN-Grand Palais/Art Resource, NY **668:** 18.10: © Giraudon/The Bridgeman Art Library **669:** 18.11: Image copyright © The Metropolitan Museum of Art. Image source: Art Resource, NY **670a top:** 18.12 © Alfredo Dagli Orti/The Art Archive at Art Resource, NY **670b btm:** 18.13: © Universal History Arc/age fotostock **671:** 18.14: © Giraudon/The Bridgeman Art Library **672:** 18.15: © Culture and Sport Glasgow (Museums)/The Bridgeman Art Library **673a top:** 18.16: © Erich Lessing/Art Resource, NY **673b btm:** 18.17: © Index/The Bridgeman Art Library **674:** 18.18: © The Gallery Collection/Corbis **675:** 18.19: © The Bridgeman Art Library **676:** 18.20: © Peter Barritt/SuperStock **677:** 18.21: © The Bridgeman Art Library **678:** 18.22: © Francis G. Mayer/Corbis **679:** 18.23: © The Philadelphia Museum of Art/Art Resource, NY **680:** 18.24: Digital Image © The Museum of Modern Art/Licensed by Scala/Art Resource, NY **681:** 18.25: © Yale University Art Gallery/Art Resource, NY **682:** 18.26: © The Bridgeman Art Library **683:** 18.27: © Vanni/Art Resource, NY **684:** 18.28: © Erich Lessing/Art Resource, NY **685:** 18.29: Photo: Archives H. Matisse. © 2013 Succession H. Matisse/Artists Rights Society (ARS), New York. **686:** 18.30: Copyright © 2013 The Munch Museum/The Munch-Ellingsen Group/Artists Rights Society (ARS), New York. Digital image Scala/Art Resource, NY **687:** 18.31: © De Agostini Picture Library/The Bridgeman Art Library **688a top:** 18.32: © 2013 Artists Rights Society (ARS), New York/ADAGP, Paris **688b btm:** 18.33: © 2013 Artists Rights Society (ARS), New York/VG Bild-Kunst, Bonn **689:** 18.34: © 2013 Estate of Pablo Picasso/Artists Rights Society (ARS), New York. Photo © Danita Delimont (Russell Gordon)/Alamy. **690:** 18.35: © 2013 Estate of Pablo Picasso/Artists Rights Society (ARS), New York. Digital image © Tomas Abad/age fotostock **691:** 18.36: © 2013 Estate of Pablo Picasso/Artists Rights Society (ARS), New York. Digital Image © The Museum of Modern Art/Licensed by SCALA/Art Resource, NY **692:** 18.37: © 2013 Artists Rights Society (ARS), New York/ADAGP, Paris, France. Digital image © Giraudon/The Bridgeman Art Library **693:** 18.38: © 2013 Estate of Pablo Picasso/Artists Rights Society (ARS), New York. Digital Image © SuperStock **694:** 18.39: Digital Image © The Museum of Modern Art/Licensed by Scala/Art Resource, NY **695:** 18.40: © 2013 Artists Rights Society (ARS), New York/SIAE, Rome. Digital Image © The Museum of Modern Art/Licensed by Scala/Art Resource, NY **696:** 18.41: © Jonathan Poore/Cengage Learning **697a top:** 18.42: © Art on File/Corbis **697b btm:** 18.43: © Cengage

Literary Credits

This page constitutes an extension of the copyright page. We have made every effort to trace the ownership of all copyrighted material and to secure permission from copyright holders. In the event of any question arising as to the use of any material, we will be pleased to make the necessary corrections in future printings. We thank the following artists, authors, publishers, and agents for permission to use the material indicated.

CHAPTER 2 **Page 52:** Henry Wadsworth Longfellow. Evangeline: A Tale of Acadie. London: David Bogue, 1850, p. 1. **Page 57:** Robert Fagles, trans. Homer, *The Odyssey.* New York: Penguin Books, 1996. **Page 57:** H.A.S. Hartley. *Classical Translations.* London: J. & A. McMillan, 1889, p. 113. **Page 57:** Anne Killigrew. "Penelope" in *Poems by Mrs. Anne Killigrew.* London: Samuel Lownedes, 1686. **Page 57:** "Penelope", from THE PORTABLE DOROTHY PARKER by Dorothy Parker, edited by Marion Meade, copyright 1928, renewed © 1956 by Dorothy Parker; copyright © 1973, 2006 by The National Assoc. for the Advancement of Colored People. Used by permission of Viking Penguin, a division of Penguin Group (USA) Inc. Reprinted in the UK by permission of Gerald Duckworth & Co Ltd.

CHAPTER 5 **Page 170:** Edith Holland. *The Story of the Buddha.* London: George G. Harrap & Company, LTD, 1918. **Page 170:** Edith Holland. *The Story of the Buddha.* London: George G. Harrap & Company, LTD, 1918.

CHAPTER 6 **Page 190:** From Genesis, Revised Standard Version Bible, copyright 1946, 1952, © 1972 by the Division of Christian Education of the National Council, Churches of Christ in the U.S.A. **Page 205:** From John, Revised Standard Version Bible, copyright 1946, 1952, © 1972 by the Division of Christian Education of the National Council, Churches of Christ in the U.S.A.

CHAPTER 7 **Page 223:** H. R. James, trans. *The Consolation of Philosophy of Boethius.* London: Elliot Stock, 1897. **Page 223:** C. R. Haines, trans. *The Communings with Himself of Marcus Aurelius Antoninus,* Loeb Classical Library. London: William Heinemann, 1916. **Page 235:** Jules Leroy and Peter Collin. *Monks and Monasteries of the Near East.* Gorgias Press, 2004.

CHAPTER 8 **Page 243:** From "The Table Spread," in *The Meaning of Glorious Koran,* translated by Mohammed Marmaduke Pickthall, 1930, George Allen & Unwin, an imprint of Harper-Collins Publishers, Ltd., 1930.

CHAPTER 9 **Page 279:** Jo Ann McNamara, trans. Pierre Riché, *Daily Life in the World of Charlemagne.* Philadelphia: University of Pennsylvania Press, 1978. **Page 279:** Jo Ann McNamara, trans. Pierre Riché, *Daily Life in the World of Charlemagne.* Philadelphia: University of Pennsylvania Press, 1978. **Page 279:** Einhard. *The Life of Charlemagne.* Translated by Samuel Epes Turner. New York: Harper & Brothers, 1880.

CHAPTER 10 **Page 325:** Christopher J. Lucas. *American Higher Education: A History.* New York:

St. Martin's Press, 1994. **Pages 330–331:** "The Wife of Bath" in Chaucer. *The Canterbury Tales.* Modern English translation, 2012. Translation Courtesy of Spencer Fichner-Rathus. © 2014 Cengage Learning. All Rights Reserved.

CHAPTER 11 **Pages 342–343:** Edward Hugele, trans. Giovanni Boccaccio, *The Decameron.* The Bibliophilist Library, 1903. **Page 354:** Geoffrey Berenton, trans. Froissart, *Chronicles.* Penguin Books, 1968. **Page 356:** *The Divine Comedy* by Dante Alighieri, translated by John Ciardi. Copyright 1954, 1957, 1959, 1960, 1961, 1965, 1967, 1970 by the Ciardi Family Publishing Trust.

CHAPTER 12 **Page 385:** Anne Borelli, Maria Pastore Passaro, trans., Donald Beebe, ed. *Selected Writings of Girolamo Savonarola: Religion and Politics, 1490–1498.* Yale University, 2006. **Page 395:** Ghiberti, "I commentarii," Book II. Quoted in Elizabeth Gilmore Holt, ed., *A Documentary History of Art, I: The Middle Ages and the Renaissance.* Princeton, N.J.: Princeton University Press, 1981, 157–158. **Page 407:** David L. Quint, trans. *The Stanze of Angelo Poliziano.* Penn State University Press, 1993.

CHAPTER 13 **Page 430:** Herbert Von Einem. *Michelangelo.* London: Methuen and Company, Ltd, 1973. **Page 434:** "From the Italian of Giovanni Strozzi," in Algernon Charles Swinburne. *The Poems of Algernon Charles Swinburne,* Volume III, Poems and Ballads Third Series. New York: Harper & Brothers Publishers, 1898, p. 257. **Page 435:** "From the Italian of Michelangelo Buonarroti," Algernon Charles Swinburne. *The Poems of Algernon Charles Swinburne,* Volume III, Poems and Ballads Third Series. New York: Harper & Brothers Publishers, 1898, p. 257. **Page 451:** W.G. Clark, W. A. Wright, & E. Dowden. *The Complete Works of William Shakespeare Arranged in Their Chronological Order.* Chicago: Morrill, Higgins & Co., 1892.

CHAPTER 14 **Page 500:** "Antony and Cleopatra" from W.G. Clark, W. A. Wright, & E. Dowden. *The Complete Works of William Shakespeare Arranged in Their Chronological Order.* Chicago: Morrill, Higgins & Co., 1892.

CHAPTER 17 **Page 607:** Linda Nochlin, *Women, Art, and Power and Other Essays.* Harper and Row, 1988, pp. 1–2. Copyright 1988 Linda Nochlin. **Page 625:** Charles Armitage Brown, "Life of John Keats" in Hyder E. Rollins, ed. *The Keats Circle: Letters and Papers 1816–78,* Second Edition. (Harvard, 1965), ii. 656. **Page 627:** H. Buxton Forman, ed. *The Poetical Works by Percy Bysshe Shelly,* Vol. I, Third Edition. London: Reeves & Turner, 1892, p. 105. **Page 639:** W.G. Clark, W. A. Wright, & E. Dowden. *The Complete Works of William*

Shakespeare Arranged in Their Chronological Order. Chicago: Morrill, Higgins & Co., 1892.

CHAPTER 18 **Page 703:** G. Norman and M. L. Shrifte, *Letters of Composers.* New York: A.A. Knopf, 1946.

CHAPTER 19 **Page 724:** M. K. Gandhi. *Non-Violent Resistance (Satyagraha).* New York: Schocken Books, 1961. **Page 734:** Jonathan Spence. *Emperor of China. Self-Portrait of Kang-His.* New York: Vintage Books, 1988, p. 72.

CHAPTER 20 **Page 766:** E. Jefferson Murphy, *History of African Civilization.* New York: Crowell, 1972, p. 110. **Page 766:** E. Jefferson Murphy, *History of African Civilization.* New York: Crowell, 1972, p. 172.

CHAPTER 21 **Page 785:** William Butler Yeats. "The Second Coming" 1919. First published in *The Dial* (November, 1920). **Page 785:** T.S. Eliot. "The Love Song of J. Alfred Prufrock" 1911. First published in *Poetry: A Magazine of Verse,* (February 1915).

CHAPTER 22 **Page 876:** William Carlos Williams, "The Orchestra," in Christopher MacGowan, ed. *Collected Poems 1939–1962,* vol. II. Copyright 1953 by William Carlos Williams. Reprinted by permission of New Directions Publishing Corp, p. 251.

READING SELECTIONS

CHAPTER 1 **Reading 1.5, Page 17:** Robert Francis Harper, trans. *The Code of Hammurabi King of Babylon.* Chicago: University of Chicago Press, 1904. **Reading 1.6, Page 28:** John Lawrence Foster, trans, *Ancient Egyptian Literature.* University of Texas Press, 2001. **Reading 1.7, Page 30:** John Lawrence Foster, trans. *Ancient Egyptian Literature.* University of Texas Press, 2001. **Reading 1.8, Page 31:** John Lawrence Foster, trans. *Ancient Egyptian Literature.* University of Texas Press, 2001. **Reading 1.9, Page 31:** John Lawrence Foster, trans. *Ancient Egyptian Literature.* University of Texas Press, 2001. **Reading 1.10, Page 32:** John Lawrence Foster, trans. *Ancient Egyptian Literature.* University of Texas Press, 2001.

CHAPTER 2 **Reading 2.2, Page 55:** J. W. Mackail, trans. *Homer's The Odyssey.* London: John Murray, 1903. Book I, 406–419. **Reading 2.3, Page 55:** J. W. Mackail, trans. *Homer's The Odyssey.* London: John Murray, 1903. Book II, 89–112. **Reading 2.4, Page 55:** J. W. Mackail, trans. *Homer's The Odyssey.* London: John Murray, 1903. Book II, 289–297. **Reading 2.5, Page 55:** J. W. Mackail, trans. *Homer's The Odyssey.* London: John Murray, 1903. Book V, 32–47. **Reading 2.6, Page 56:** J. W. Mackail, trans.

Homer's The Odyssey. London: John Murray, 1903. Book XXIV, 562–570. **Reading 2.9–10, Page 70:** C.A. Elton, trans. *Hesiod.* London: A.J. Valpy M.A., 1832.

CHAPTER 3 **Reading 3.1–3.2, Page 82:** Richard Crawley, trans. *Thucydides History of the Peloponnesian War.* London: J.M. Dent & Sons, 1866. **Reading 3.3, Page 83:** Richard Crawley, trans. *Thucydides History of the Peloponnesian War.* London: J.M. Dent & Sons, 1866. **Reading 3.4, Page 90:** J.J. Pollitt, trans. *The Art of Ancient Greece: Sources and Documents.* New York: Cambridge University Press, 1990, p. 76. **Reading 3.8, Page 97:** Benjamin Jowett, trans. *Aristotle's Politics.* Oxford: Clarendon Press, 1908. **Reading 3.9, Page 98:** E. G. Sihler, ed. *The Protagoras of Plato.* New York: Harper & Brothers, 1881. **Readings 3.10–12, Pages 100:** Robert Fagles, trans. *The Oresteian Trilogy: Agamemnon; The Choephori; The Eumenides.* Penguin Classics, 1973. **Reading 3.13, Page 101:** Robert Fagles, trans. *The Oresteian Trilogy: Agamemnon; The Choephori; The Eumenides.* Penguin Classics, 1973. **Readings 3.14–15, Page 102:** Robert Fagles, trans., *Sophocles: The Three Theban Plays,* translation © 1982 by Robert Fagles. Used by permission of Viking Penguin, a division of Penguin Group (USA) Inc. **Reading 3.16–18, Page 103:** Robert Fagles, trans., *Sophocles: The Three Theban Plays,* translation © 1982 by Robert Fagles. Used by permission of Viking Penguin, a division of Penguin Group (USA) Inc. **Reading 3.19, Page 104:** S. H. Butcher, trans. *Aristotle's Theory of Poetry and Fine Art.* Third Edition, New York: Macmillan & Co., LTD, 1902. **Reading 3.24, Page 106:** Douglass Parker, trans. *Lysistrata.* University of Michigan Press, 1964. **Reading 3.25, Page 108:** J. J. Pollitt. *The Art of Greece 1400–31 BCE: Sources and Documents.* Englewood Cliffs, NJ: Prentice-Hall, 1965, p. 144.

CHAPTER 4 **Reading 4.1, Page 125:** De bello civili: Book 1, from W. A. McDevitte & W. S. Bohn, trans. *Caesar's Commentaries.* New York: Harper & Brothers, 1869. **Reading 4.2, Page 126:** Walter Miller, trans. *Cicero De Officiis.* New York: The Macmillan Co., 1921, p. 293. **Reading 4.3, Page 126:** D.A. Slater, trans. *The Poetry of Catulus.* Manchester: The University Press, 1912. **Reading 4.4, Page 127:** W. E. Leonard, trans. *Of the Nature of Things.* New York: E. P. Dutton & Co., 1921. **Reading 4.5, Page 128:** Moses Hadas, trans. *The Stoic Philosophy of Seneca: Essays and Letters.* New York: W. W. Norton, 1958. **Reading 4.6, Page 128:** W. A. Oldfather, trans. *Epictetus,* Volume II. Loeb Classical Library. Cambridge: Harvard University Press, 1928. **Reading 4.7, Page 128:** C. R. Haines, trans. *The Communings with Himself of Marcus Aurelius Antoninus,* Loeb Classical Library. London: William Heinemann, 1916. **Reading 4.8, Page 135:** Paul MacKendrick & Herbert M. Howe, *Classics in Translation, Volume II. Latin Literature.* Madison, Wisconsin: The University of Wisconsin Press, 1952, p. 365–366. Selection translated by John Paul Heironimus and used by permission of Valerie S. Bayer. **Reading 4.9, Page 138:** Virgil, The Aeneid, Book IV, lines 397–404 in J. W. MacKail, trans. *The Aeneid of Virgil.* London: MacMillan and Co., 1885. **Reading 4.10, Page 138:** Virgil, The Aeneid, Book IV, lines 520–527 in J. W. MacKail, trans. *The Aeneid of Virgil.* London: MacMillan and Co., 1885. **Reading 4.11, Page 138:** Virgil, The

Aeneid, Book VI, lines 238–260 in J. W. MacKail, trans. *The Aeneid of Virgil.* London: MacMillan and Co., 1885. **Reading 4.12, Page 138:** Virgil, The Aeneid, Book VI, lines 661–669 in J. W. MacKail, trans. *The Aeneid of Virgil.* London: MacMillan and Co., 1885. **Reading 4.13, Page 138:** Virgil, The Aeneid, Book VIII, lines 1–9 in J. W. MacKail, trans. *The Aeneid of Virgil.* London: MacMillan and Co., 1885. **Reading 4.15, Page 140:** C. E. Bennett, trans. *The Odes and Epodes of Horace.* Cambridge: Harvard University Press, Loeb Classical Library, 1914. **Reading 4.16, Page 140–141:** "The Third Satire of Juvenal" in *The Miscellaneous Works of John Dryden,* Vol. 4. London: J. and R. Tonson, 1767, pp. 229–230. **Reading 4.17, Page 141:** Samuel Garth, trans. *Ovid's, Metamorphoses.* London: Jacob Tonson, 1717, p. 104, 109.

CHAPTER 5 **Reading 5.1, Page 162:** Chakravari Narasimhan, trans. *The Mahābhārata.* Columbia University Press, 1997. **Reading 5.4, Page 166:** Dominic Goodall, trans. *Hindu Scriptures.* J. M. Dent, a division of The Orion Publishing Group, 1996. **Reading 5.5, Page 166–167:** R. C. Zaehner, trans. *The Hindu Scriptures.* Everyman's Library, 1966. **Reading 5.8–5.9, page 182:** Burton Watson translator and editor. *The Columbia Book of Chinese Poetry: From Early Times to the Thirteenth Century.* Columbia University Press. © 1984, p. 207–210, 212, Reprinted by permission. **Reading 5.10, Page 183:** Stephen Owen, trans. *An Anthology of Chinese Literature: Beginnings to 1911.* New York: W.W. Norton, 1996. Reprinted by permission of Stephen Owen.

CHAPTER 6 **Reading 6.08, Page 203:** Lawrence Cunningham. *The Catholic Heritage,* Wipf & Stock Publishers, 2002.

CHAPTER 7 **Reading 7.4, Page 221:** Saint Augustine. *The Literal Meaning of Genesis.* Mahwah, NJ: Paulist Press, 1982. **Reading 7.5, Page 222:** H. R. James, trans. *The Consolation of Philosophy of Boethius.* London: Elliot Stock, 1897.

CHAPTER 8 **Reading 8.3, Page 257:** Powys Mathers, trans. "The Thousand and One Nights," in *The Longman Anthology of World Literature: Compact Edition,* ed. David Damrosch & David L. Pike, (Upper Saddle River, NJ: Pearson Education, 2008), 1113, 1148, and 1151. **Reading 8.4, Page 257:** Powys Mathers, trans., "The Thousand and One Nights," in *The Longman Anthology of World Literature: Compact Edition,* ed. David Damrosch & David L. Pike, (Upper Saddle River, NJ: Pearson Education, 2008), 1113, 1148, and 1151. **Reading 8.5, Page 258:** Edward Fitzgerald, trans. *The Rubaiyat of Omar Khayyam.* fifth edition, 1889. **Reading 8.6, Page 258:** Edward Fitzgerald, trans. Omar Khayyam. *The Rubaiyat of Omar Khayyam,* fifth edition, 1889.

CHAPTER 9 **Reading 9.1, Page 283:** John Stevens, trans. *The Ecclesiastical History of the English Nation: The Venerable Bede.* London: J.M. Dent & Sons Ltd., 1910. **Reading 9.2–9.3, Page 283:** Sarah Anderson, ed., Alan Sullivan and Timothy Murray, trans. *Beowulf: Longman Cultural Edition.* Longman, 2004. **Reading 9.4, Page 284:** Sarah Anderson, ed., Alan Sullivan and Timothy Murray, trans. *Beowulf: Longman Cultural Edition.* Longman, 2004. **Reading 9.9, Page 288:** Robert Harrison,

trans. *The Song of Roland.* New York: New American Library, Penguin Putnam, 1970.

CHAPTER 10 **Reading 10.2, Page 325:** Robert Kehew, ed., Ezra Pound, W. D. Snodgrass, & Robert Kehew, trans. *Lark in the Morning: The Verses of the Troubadours.* Chicago: The University of Chicago Press, 2005, p. 23. **Reading 10.3, Page 326:** David Damrosch & David L. Pike, eds. *The Longman Anthology of World Literature,* Compact Edition. New York: Pearson Longman, 2008, p. 1183. Translated by David L. Pike and used with his permission. **Reading 10.5, Page 328:** David Damrosch & David L. Pike, eds. *The Longman Anthology of World Literature,* Compact Edition. New York: Pearson Longman, 2008, p. 1187. Translated by David L. Pike and used with his permission. **Reading 10.6, Page 329:** Israël Abrahams. *Jewish Life in the Middle Ages.* MacMillan and Co., Ltd, London, 1896. **Reading 10.07, Page 332:** Lawrence S. Cunningham, trans. *Francis of Assisi: Performing the Gospel Life.* Wm B. Eerdmans Publishing Co., 2004. Reprinted by permission of Lawrence S. Cunningham. **Reading 10.08, Page 333:** Fathers of the English Dominican Province, trans. *The "Summa Theologica" of St. Thomas Aquinas,* Part I. London: Burns Oates & Washbourne Ltd., 1921.

CHAPTER 11 **Reading 11.06, Page 349:** *Translations from Dante, Petrarch, Michael Angelo, and Vittoria Colonna.* London: Kegan Paul & Co., 1879. **Reading 11.7, Page 349:** *Translations from Dante, Petrarch, Michael Angelo, and Vittoria Colonna.* London: Kegan Paul & Co., 1879.

CHAPTER 12 **Reading 12.1, Page 384:** Lorna De' Lucchi, trans. *An Anthology of Italian Poems, 13th–19th Century,* New York: Knopf, 1922. pp. 103, 105. **Reading 12.2, Page 386:** "Oration on the Dignity of Man," translated by Elizabeth Livermore Forbes, in Ernst Cassirer, Paul Oskar Kristeller, John Herman Randall, Jr., eds. *The Renaissance Philosophy of Man.* Chicago: University of Chicago Press, 1948, 223–254. **Reading 12.4, 389:** Margaret L. King and Albert Rabil, eds. *Her Immaculate Hand: Selected Works by and about the Women Humanists of Quattrocento Italy,* Second Revised Edition. Ashville NC: Pegasus Press, © 1997. Used with permission. **Reading 12.5, Page 390:** Diana Robin trans. Laura Cereta, *Collected Letters of a Renaissance Feminist,* Chicago: The University of Chicago Press, 1997.

CHAPTER 13 **Reading 13.4, Page 451:** "On Women" from *The Book of the Courtier* by Baldesar Castiglione, translated by George Bull (Penguin Classics, 1967). Copyright © George Bull, 1967. Reprinted by permission of the publisher Penguin Books, Ltd. **Reading 13.6, Page 454:** Ann Rosalind Jones and Margaret F. Rosenthal, trans. Veronica Franco, *Poems and Selected Letters.* Chicago: The University of Chicago Press, 1998, pp. 38–39. Reprinted by permission of University of Chicago Press. **Reading 13.7, Page 454–455:** Ann Rosalind Jones and Margaret F. Rosenthal, trans. Veronica Franco, *Poems and Selected Letters.* Chicago: The University of Chicago Press, 1998, pp. 38–39

CHAPTER 14 **Reading 14.1, Page 465,** Adolph Spaeth et al., trans. *Works of Martin Luther,* Vol. 1. Philadelphia: A. J. Holman Company, 1915: pp. 29–38. **Reading 14.3, Page 467,** Jonathan Edwards, "Sinners in the Hands of an Angry

God." Sermon delivered in Enfield, Connecticut, 1741. **Reading 14.5, Page 485,** W.G. Clark, W. A. Wright, & E. Dowden. *The Complete Works of William Shakespeare Arranged in Their Chronological Order.* Chicago: Morrill, Higgins & Co., 1892. **Reading 14.8, Page 491:** William Edward Simonds. *Sir Thomas Wyatt and His Poems.* Boston: D.C. Heath and Company 1889, p. 109. **Reading 14.9, Page 491:** Edmund Spenser. *Amoretti.* New York: The Laurel Press, 1901, p. LXXIX. **Reading 14.10, Page 491–492:** Thomas Dibdin. *A Metrical History of England,* Vol. II. London: Joseph Hartnell, 1813, p. 90. **Reading 14.11, Page 493:** A.H. Bullen, ed. *The Works of Christopher Marlow,* Volume the First. London: John C. Nimmo, 1885, pp. 275–276. **Reading 14.12, Page 493:** A.H. Bullen, ed. *The Works of Christopher Marlow,* Volume the Third. London: John C. Nimmo, 1885, p. 283. **Reading 14.13, Page 494:** W.G. Clark, W. A. Wright, & E. Dowden. *The Complete Works of William Shakespeare Arranged in Their Chronological Order.* Chicago: Morrill, Higgins & Co., 1892. **Reading 14.14–15, Page 496:** W.G. Clark, W. A. Wright, & E. Dowden. *The Complete Works of William Shakespeare Arranged in Their Chronological Order.* Chicago: Morrill, Higgins & Co., 1892. **Reading 14.16–17, Page 497:** W.G. Clark, W. A. Wright, & E. Dowden. *The Complete Works of William Shakespeare Arranged in Their Chronological Order.* Chicago: Morrill, Higgins & Co., 1892. **Reading 14.18, Page 498:** W.G. Clark, W. A. Wright, & E. Dowden. *The Complete Works of William Shakespeare Arranged in Their Chronological Order.* Chicago: Morrill, Higgins & Co., 1892. **Reading 14.19–22, Page 499:** W.G. Clark, W. A. Wright, & E. Dowden. *The Complete Works of William Shakespeare Arranged in Their Chronological Order.* Chicago: Morrill, Higgins & Co., 1892. **Reading 14.23–24, Page 501:** W.G. Clark, W. A. Wright, & E. Dowden. *The Complete Works of William Shakespeare Arranged in Their Chronological Order.* Chicago: Morrill, Higgins & Co., 1892.

CHAPTER 15 Reading 15.1, Page 536: *The Poems of Mrs. Anne Bradstreet (1612–1672): Together with her Prose Remains.* The Duodecimos, 1897, p. 17. **Reading 15.2, Page 536:** *The Poems of Mrs. Anne Bradstreet (1612–1672): Together with her Prose Remains.* The Duodecimos, 1897, p. 271. **Reading 15.3, Page 544:** John Vietch, trans. *The Method, Meditations and Philosophy of Descartes.* London: M. Walter Dunne, 1901, pp. 171–172. **Reading 15.4, Page 545:** *Hobbes's Leviathan, Harrington's Oceana, Famous Pamphlets.* London: George Routledge and Sons, 1889, p. 64. **Reading 15.5, Page 545:** John Locke. *An Essay Concerning Human Understanding,* Thirtieth Edition. London: William Tegg & Co., 1849, p. 10. **Reading 15.8, Page 549:** *John Donne Selected Poems, Henry King Elegies, etc., Izaak Walton Verse-Remains.* J.R. Tutin, 1904, p. 9. **Reading 15.9, Page 549:** Samuel Johnson, ed. *The Works of the English Poets, From Chaucer to Cowper.* Volume VI, London: J. Johnson, 1810, p. 560. **Reading 15.10, Page 550:** G. A. Aitken, ed. *The Poems of Andrew Marvell.* New York: Charles Scribner's Sons, 1898, pp. 56–57.

CHAPTER 16 Reading 16.1, Page 581: Joseph B Seabury, ed. *Pope's Essay on Man and Essay on Criticism.* New York: Silver, Burdett and Company, 1900, p. 18. **Reading 16.2, Page 582:** Joseph B Seabury, ed. *Pope's Essay on Man and Essay on Criticism.* New York: Silver, Burdett and Company, 1900, p. 26. **Reading 16.3, Page 582:** Thomas Roscoe, ed. *The Works of Jonathan Swift,* Vol. V. New York: Derby & Jackson 1861, pp. 16–17. **Reading 16.4, Page 584:** Allan Cunningham, ed. *The Complete Works of Robert Burns.* Boston: Phillips, Sampson, and Company, 1853, pp. 105–106. **Reading 16.5, Page 584–585:** Mary Wollstonecraft. *A Vindication of the Rights of Woman: with Strictures on Political and Moral Subjects,* 3rd edition. London: J. Johnson, 1796. **Reading 16.6, Page 585:** Mary Wollstonecraft. *A Vindication of the Rights of Woman: with Strictures on Political and Moral Subjects,* 3rd edition. London: J. Johnson, 1796. **Reading 16.7, Page 586:** Book I, Section 4, "Slavery" in The Social Contract or Principles of Political Right, by Jean Jacques Rousseau (1762), G. D. H. Cole, trans., *Philosophy and Theology: Rousseau's Social Contract.* London: J.M. Dent and Sons, pp. 1–13. **Reading 16.9, Page 589:** John Hal Stewart. *Documentary Survey of the French Revolution.* New York: Macmillan, 1951, pp. 113–115. **Reading 16.10, Page 590:** Declaration of Independence, 1776. Library of Congress, Washington, DC. **Reading 16.11, Page 591:** The Bill of Rights, 1789. Library of Congress, Washington, DC.

CHAPTER 17 Reading 17.1, Page 601: Karl Marx and Friedrick Engels. *Manifesto of the Communist Party.* translated and edited by Fredrick Engels. Chicago: Charles H. Kerr & Company, 1906. **Reading 17.2, Page 602:** Charles Darwin. *On the Origin of Species by Means of Natural Selection.* London: John Murray, 1859, p. 466–468. **Reading 17.3, Page 618:** Anna Swanwick, trans. *Goethe's Faust.* London: George Bell and Sons, 1905, p. 23. **Reading 17.4, Page 618:** Anna Swanwick, trans. *Goethe's Faust.* London: George Bell and Sons, 1905, p. 122. **Reading 17.5, Page 619:** William Wordsworth. *Lyrical Ballads with Pastoral and other Poems,* Vol. I, Third Edition. London: T. N. Longman and O. Rees, 1802, pp. vii-viii. **Reading 17.6, Page 619:** William Blake. *Songs of Innocence.* London: William Blake, 1789. **Reading 17.7, Page 621:** William Blake. *Songs of Experience.* London: William Blake, 1794. **Reading 17.8, Page 621:** William Wordsworth. *Tintern Abbey, Ode to Duty, Ode on Intimations of Immortality, The Happy Warrior, Resolution and Independence, and On The Power of Sound.* London: W & R Chambers, 1892, pp. 5–6. **Reading 17.9, Page 623:** William Wordsworth. *Poems, in Two Volumes,* Vol. II. London: Longman, Hurst, Rees, and Orme, 1807, p. 44. **Reading 17.10, Page 623:** Samuel Taylor Coleridge. *The Rime of the Ancient Mariner.* M.A. Eaton. ed. Boston: Educational Publishing Company, 1906, pp. 21–23. **Reading 17.11, Page 623:** Samuel Taylor Coleridge. *The Rime of the Ancient Mariner.* M.A. Eaton, ed. Boston: Educational Publishing Company, 1906, pp. 30–31. **Reading 17.12, Page 624:** Henry Lytton Bulwer, ed. *The Complete Works of Lord Byron.* Paris: A. and W. Galignani and Co., 1841, p. 254. **Reading 17.13, Page 624:** Henry Lytton Bulwer, ed., *The Complete Works of Lord Byron.* Paris: A. and W. Galignani and Co., 1841, p. 142. **Reading 17.14, Page 624:** Henry Lytton Bulwer, ed. *The Complete Works of Lord Byron.* Paris: A. and W. Galignani and Co., 1841, p. 142. **Reading 17.15, Page 625:** H. Buxton Forman, ed. *The Poetical Works by Percy Bysshe Shelly,* Vol. I, Third Edition. London: Reeves & Turner, 1892, p. 250.

Reading 17.16, Page 625: H. Buxton Forman, ed. *The Poetical Works by Percy Bysshe Shelly,* Vol. I, Third Edition. London: Reeves & Turner, 1892, p. 528. **Reading 17.17, Page 626:** Harry Buxton Forman, ed. *The Poetical Works of John Keats.* London: Reeves & Turner, 1884, pp 269–271. **Reading 17.18, Page 627:** Jane Austen. *Plan of a Novel According to Hints from Various Quarters.* Oxford: The Clarendon Press, 1926. **Reading 17.19, Page 628:** Mary Wollstonecraft Shelley. *Frankenstein; or, The Modern Prometheus.* London: Lackington, Hughes, Harding, Mavor, & Jones, 1818. **Reading 17.20, Page 628:** Victor Hugo. *Les Misérables.* Isabel F. Hapgood, trans., Digireads.com Publishing, 2011, p. 24. **Reading 17.21, Page 638:** Gustave Flaubert, *Madame Bovary,* Eleanor Marx-Aveling, trans., London: W. W. Gibbings, 1892, p. 70. **Reading 17.22, Page 639:** "Father Goriot" in Ellen Marriage, trans. *The Works of Honoré De Balzac.* Philadelphia, Avil Publishing Company, 1901, p. 12. **Reading 17.23, Page 640:** George Sand. *Lelia.* Maria Espinosa, trans. Bloomington: Indiana University Press, 1978. **Reading 17.24, Page 640:** George Sand. *Lelia.* Maria Espinosa, trans. Bloomington: Indiana University Press, 1978. **Reading 17.25, Page 641:** Charles Dickens. *A Tale of Two Cities.* London: James Nisbet & Co., Limited, 1902, pp. 448–449. **Reading 17.26, Page 641:** Charles Dickens. *Oliver Twist.* Vol. I. London: Richard Bentley, 1838, pp. 1–3. **Reading 17.27, Page 642:** Ralph Waldo Emerson, "Self-Reliance," in *Essays,* First Series. Boston: James Munroe and Company, 1850. **Reading 17.28, Page 644:** Henry D. Thoreau. *Walden; or, Life in the Woods.* Boston: Ticknor and Fields, 1854. **Reading 17.29, Page 644:** Edgar Allan Poe. *The Raven and Other Poems.* New York: Wiley and Putnam, 1845. **Reading 17.32, Page 647:** Nathaniel Hawthorne. *The Scarlet Letter: A Romance.* Boston: Ticknor, Reed, and Fields, 1850. **Reading 17.33, Page 648:** Herman Melville. *Moby-Dick; or, The Whale.* New York: Harper & Brothers, 1851.

CHAPTER 18 Reading 18.1, Page 690: Gertrude Stein. *The Autobiography of Alice B. Toklas.* New York: Random House, Inc., 1933. **Reading 18.2, Page 701:** W. S. Gilbert & A. Sullivan. *The Lass That Loved a Sailor.* 1878. **Reading 18.3, Page 707:** Marcel Proust. *Remembrance of Things Past.* Vol. 1, "Swann's Way" and "Within a Budding Grove." The definitive French Pléiade edition translated by C.K. Scott Moncrieff and Terence Kilmartin. New York: Vintage, 1982. **Reading 18.4, Page 708:** Mark Twain. *Roughing It.* Hartford: American Publishing Company, 1872. **Reading 18.5, Page 709:** Mark Twain. *The Mysterious Stranger.* New York: Harper & Brothers, 1916. **Reading 18.7, Page 710:** Oscar Wilde. *The Picture of Dorian Gray.* Leipzig: Bernhard Tauchnitz, 1891. **Reading 18.8, Page 710:** Mona Caird. *In The Morality of Marriage and Other Essays on the Status and Destiny of Women.* London: George Redway, 1897. **Reading 18.9, Page 711:** Fredrick Lawrence Knowles, ed. *A Yearbook of Famous Lyrics.* Boston: Dana Estes & Company, 1901, p. 135. **Reading 18.10, Page 711:** Rudyard Kipling. *Ballads and Barrack-Room Ballads.* New York: The Macmillan Company, 1897. **Reading 18.11, Page 711:** Rudyard Kipling. *Songs from Books.* Garden City: Doubleday, Page & Company, 1912. **Reading 18.12, Page 712–713:** Henrick Isben. "A Doll's House" in Eva Le Gallienne, Trans. *Six Plays by Henrik Ibsen.* New

York: International Creative Management, Inc. 1957. **Reading 18.13, Page 713:** Kate Chopin. "The Dream of an Hour" in *Vogue Magazine*, December 6, 1894.

CHAPTER 19 Reading 19.1, Page 722: "Memoirs of Zehir-ed-Dīn Muhammed Babur, Emperor of Hindustan" written by himself, in John Leyden and William Erskine, trans. *Chaghatai Turki.* London: Oxford University Press, 1921. **Reading 19.2, Page 724:** Munshi Permchand, *The Shroud,* 1936. **Reading 19.3, Page 725:** Krishna Dutta and Andrew Robinson, ed. *Selected Letters Of Rabindranath Tagore.* London: University of Cambridge Oriental Publications Series, 1997. **Reading 19.4, Page 730:** Arthur Waley, trans. *Chin P'ing Mei: The Adventurous History of His Men and His Six Wives.* New York: G.P. Putnam's Sons, 1940, p.429. **Reading 19.6, Page 734:** Witter Bynner, trans. *The Jade Mountain: A Chinese Anthology.* New York: Alfred A. Knopf, 1929. Used by permission of The Witter Bynner Foundation for Poetry. **Reading 19.7, Page 734:** Witter Bynner, trans. *The Jade Mountain: A Chinese Anthology.* New York: Alfred A. Knopf, 1929. Used by permission of The Witter Bynner Foundation for Poetry. **Reading 19.8, Page 741:** Arthur Waley, trans. Murasaki Shikibu. *The Tale of Genji.* by Rutland: Tuttle Publishing, 2010. **Reading 19.9, Page 744:** Matsuo Basho. *Furu ike ya.* 1686.

CHAPTER 20 Reading 20.1, Page 762: Harriet Beecher Stowe. *The Minister's Wooing.* New York: Derby and Jackson, 1859. **Reading 20.2, Page 764:**

Alan Paton. *Cry, The Beloved Country.* New York: Charles Scribner's Sons. 1948, p. 16. **Reading 20.3, Page 764:** Nelson Mandela. *Long Walk to Freedom.* Little, Brown and Company, 1994. **Reading 20.4, Page 765:** A. Thébia-Melsan, ed. *Aimé Césaire, pour regarder le siècle en face,* Paris: Maisonneuve & Larose, 2000. **Reading 20.5, Page 765:** Haberland, Eike, ed. *Leo Frobenius An Anthology.* Wiesbaden, Germany: F. Steiner, 1973. **Reading 20.6, Page 766:** Daniel P. Kunene, trans. Thomas Mofolo. *Chaka.* Portsmouth: Heinemann Educational Publishers, 1981. **Reading 20.7, Page 767:** William Butler Yeats. "The Second Coming" 1919. First published in *The Dial* (November, 1920). **Reading 20.8, Page 767:** Chinua Achebe. *Things Fall Apart.* New York: Random House, 1994.

CHAPTER 21 Reading 21.1, Page 782: Rupert Brook, "The Soldier" in George E. Woodbury. *The Collected Poems of Rupert Brook.* New York: John Lane Company, 1919. **Reading 21.2, Page 783:** Isaac Rosenberg. *Dead Man's Dump.* In Collected Works, 1922. **Reading 21.3, Page 784:** Ernest Hemingway. *Men Without Women.* New York: Charles Scribner's Sons, 1927. **Reading 21.4, Page 786:** James Joyce. *Ulysses.* Mineola: Dover Publications, 2002. **Reading 21.7, Page 789:** Sinclair Lewis. *Babbitt.* New York: Harcourt, Brace and Company, 1922. **Reading 21.8, Page 789:** Sinclair Lewis. *Babbitt.* New York: Harcourt, Brace and Company, 1922. **Reading 21.10, Page 795:** A. A. Brill, trans. Sigmund Freud. *The Interpretation of Dreams.* New York: Macmillan, 1913. **Reading**

21.11, Page 801: "I Too Sing America", from *The Collected Poems of Langston Hughes* by Langston Hughes, edited by Arnold Rampersad with David Roessel, Associate Editor, copyright © 1994 by The Estate of Langston Hughes. Used by permission of Alfred A. Knopf, a division of Random House, Inc. and Harold Ober Associates Incorporated. Any third party use of this material, outside of this publication, is prohibited. Interested parties must apply directly to Random House, Inc. for permission.

CHAPTER 22 Reading 22.2, Page 826: Jack Kerouac. *On the Road.* New York: Viking Press, 1957. **Reading 22.5, Page 868:** Norman Mailer. *The Naked and the Dead.* New York: Rinehart and Company, 1948, p. 3. **Reading 22.6, Page 869:** Stella Rodway, trans. Elie Wiesel, *Night.* New York: Bantam Books, 1987. **Reading 22.7, Page 870:** John Updike. *Rabbit, Run.* New York: Alfred A. Knopf (Random House), 1960. **Reading 22.8, Page 872:** Ralph Ellison. *Invisible Man.* New York: Vintage Books, 1952, pp. 4–5. **Reading 22.9, Page 872:** "The Last Quatrain of the Ballad of Emmett Till" from Blacks by Gwendolyn Brooks. Copyright © 1978 by Gwendolyn Brooks. Reprinted by consent of Brooks Permissions. **Reading 22.10, Pages 872–873:** Maya Angelou. *I Know Why the Caged Bird Sings.* New York: Random House, 1969. **Reading 22.11, Page 873:** Toni Morrison. *The Bluest Eye.* New York: Alfred A. Knopf, 1994. **Reading 22.12, Page 872:** Sylvia Plath, *The Bell Jar.* New York: Harper Perennial, 1971, pp. 167–169.

Index

Page numbers in italics refer to illustrations, footnotes or tables.